The Oxford History of
Western Art

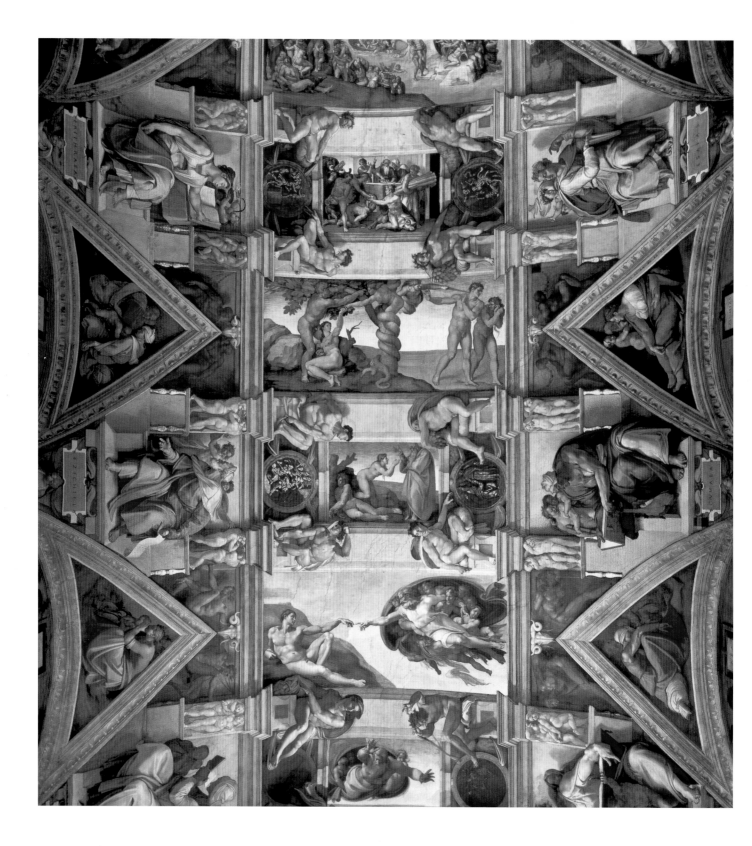

The Oxford History of
Western Art

Edited by Martin Kemp

OXFORD
UNIVERSITY PRESS

OXFORD
UNIVERSITY PRESS

Great Clarendon Street, Oxford OX2 6DP

Oxford University Press is a department of the University of Oxford.
It furthers the University's objective of excellence in research, scholarship,
and education by publishing worldwide in

Oxford New York

Athens Auckland Bangkok Bogotá Buenos Aires Calcutta
Cape Town Chennai Dar es Salaam Delhi Florence Hong Kong Istanbul
Karachi Kuala Lumpur Madrid Melbourne Mexico City Mumbai
Nairobi Paris São Paulo Singapore Taipei Tokyo Toronto Warsaw
with associated companies in Berlin Ibadan

Oxford is a registered trade mark of Oxford University Press
in the UK and in certain other countries

Published in the United States
by Oxford University Press Inc., New York

© In the text: Oxford University Press 2000
© Introduction and compilation: Martin Kemp 2000

The moral rights of the author have been asserted

Database right Oxford University Press (maker)

First published 2000

British Library Cataloguing in Publication Data
Data available

Library of Congress Cataloguing in Publication Data
Data available

ISBN 0-19-860012-7

1 3 5 7 9 10 8 6 4 2

Colour reproduction by
Radstock Reproductions Ltd.
Printed in Great Britain by
Butler & Tanner Ltd.

Frontispiece: Michelangelo's Sistine Chapel Ceiling (1508–12)

Contents

Advisory Panel	vii
The Contributors	viii
Preface	xii
Introduction	2

Part 1
The Foundations: Greece and Rome
*c.*600 BC–AD 410 10

Greek Sculpture ANDREW STEWART	12
Greek Pictorial Arts STELLA G. MILLER	24
Greek Art Beyond Greece NIGEL SPIVEY	32
Roman Sculpture KATHERINE WELCH	38
Roman Painting and Mosaics STELLA G. MILLER	52
Theory and Criticism R. R. R. SMITH	60
Ancient Paradigms from Augustus to Mussolini CHRISTOPHER H. HALLETT	64

Part 2
Church and State: The Establishing of
European Visual Culture 410–1527 68

Early Christian Art JOHN RICHARDS	70
Illuminated Manuscripts JOHN LOWDEN, MARTIN KAUFFMANN	76
Ars Sacra to *c.*1200 T. A. HESLOP	92
Monumental Sculpture to *c.*1300 KATHLEEN LANE	100
Stained Glass SARAH BROWN	108

Painting in the Middle Ages ROBERT GIBBS	124
The Altarpiece LOUISE BOURDUA	130
Ars Sacra *c.*1200–1527 ANDREW SPIRA	138
Monumental Sculpture *c.*1300–1527 FRANCIS AMES-LEWIS	144
The New Painting: Italy and the North JOHN RICHARDS, MARTIN KEMP	152
Domestic Arts BETH L. HOLMAN	162
The Print PATRICIA A. EMISON	170

Part 3
The Art of Nations: European Visual
Regimes 1527–1770 178

The International Style ROBERT WILLIAMS	180
Forms in Space 1527–*c.*1600 CHARLES AVERY	188
Forms in Space *c.*1600–*c.*1700 CAROLE PAUL	196
Free-Standing Sculpture *c.*1600–*c.*1700 CHRISTOPHER BAKER	210
The Picture: Italy and France PAULINE MAGUIRE	216
The Picture: Spain HELENA CIECHANOWSKA, PETER CHERRY	230
The Picture: Dutch and Flemish WALTER LIEDTKE	238
The Picture: England ILARIA BIGNAMINI	246
The Print LINDA C. HULTS	254
The Interior MAURICE HOWARD	262

Contents

Forms in Space *c.*1700–1770 280
MALCOLM BAKER

Academies, Theories and Critics 290
KAREN-EDIS BARZMAN

The International Diaspora 294
TANIA COSTA TRIBE

Part 4
The Era of Revolutions 1770–1914 302

Pictures and Publics 304
JOHN GOODMAN

Sculptures and Publics 340
ALISON W. YARRINGTON, PHILIP WARD-JACKSON, MALCOLM
BAKER

The Print 358
LINDA C. HULTS

Photography 366
IAN JEFFREY

Design and Industry 380
CHARLOTTE BENTON

The Rise of Art History 396
PAUL CROWTHER

Art Criticism and Aesthetic Ideals 400
CAROL M. ARMSTRONG

Art Museums and Galleries 404
CAROL DUNCAN

Part 5
Modernism and After 1914–2000 410

The International Style 412
MIKE O'MAHONY

Alternative Media 442
KENNETH G. HAY

Photography 452
IAN JEFFREY

Alternative Centres: The Soviet Union 470
DAVID JACKSON

Alternative Centres: Latin America 474
TANIA COSTA TRIBE

Alternative Centres: India 478
CLARE HARRIS

Alternative Centres: African and Afro-Caribbean 482
PETRINE ARCHER-STRAW, SALAH M. HASSAN

Alternative Centres: Canada and Australia 490
KYLA C. GUTSCHE, REBECCA HOSSACK

Postmodernism 494
PAUL CROWTHER

Art History 510
PAUL CROWTHER

Critics and Criticism 514
MALCOLM GEE

Art Museums and Galleries 518
BRANDON TAYLOR

Epilogue 524

Chronology 528

Glossary 536

Further Reading 540

Picture Acknowledgements 548

Index 550

Advisory Panel

The Contributors

AS Andrew Stewart was educated at Portsmouth Grammar School, at St Catherine's College, Cambridge, and at the British Schools of Archaeology at Athens and Rome. He was Lecturer in Classics in the University of Otago, Dunedin, New Zealand, and Keeper of Greek and Roman Antiquities at the Otago Museum from 1972 to 1979. From 1979 he was Professor of Art History and Classics in the University of California at Berkeley. He is now Chancellor's Research Professor of Greek Art and Archaeology at Berkeley. In 1969 he was awarded the Wace Medal in Classical Archaeology. He has been a Getty Museum Fellow (1986), Getty Center Fellow (1990–1), and a Guggenheim Fellow (1994–5). He has excavated at the Unexplored Mansion at Knossos, at Long Beach, New Zealand, and (since 1986) at Tel Dor, Israel, as director of the UC Berkeley excavations.

ASp Andrew Spira is a graduate of the Courtauld Institute, now working at the Victoria & Albert Museum. He is a specialist in medieval and Russian art and is currently writing a book on the influence of Russian icons on Russian avant-garde art.

AWY Alison W. Yarrington, BA (Reading) Ph.D. (Cambridge), FSA is Professor of Art History at the University of Leicester. She has published books and articles on eighteenth- and nineteenth-century sculpture, including the *Commemoration of the Hero: British Victors of the Napoleonic Wars 1800–1864*, and co-authored *Edition of the Ledger of Sir Francis Chantry R.A., at the Royal Academy, 1809–1841*. She is currently writing a history of women sculptors c.1700–1914 and is involved in the Public Monuments and Sculpture Association's National Recording Project to catalogue all public sculpture in Britain funded by the Heritage Lottery fund, heading the regional centre for the East Midlands.

BLH Beth L. Holman is an historian of Renaissance art, material culture, and decorative arts. She has been a Fulbright scholar and a senior fellow at the Metropolitan Museum of Art. New York. Currently associate professor at the Bard Graduate Center for Studies in the Decorative Arts in New York City, she has curated the exhibition with catalogue *Disegno: Italian Renaissance Designs for the Decorative Arts* (Cooper-Hewitt National Design Museum, Smithsonian Institution), is currently editing a collection of essays on Renaissance material culture *Bringing the Renaissance Home: Domestic Arts and Design in Italy c.1400–1600*, and is pursuing research on Giulio Romano's designs for the decorative arts.

BT Brandon Taylor is Professor in the Department of History of Art and Design, Faculty of Arts, University of Southampton. His recent publications include *Art and Literature Under the Bolsheviks* (2 vols., 1991 and 1992), *The Art of Today* (1995, published as *Avant Garde and After* in the USA (1995) and as *Kunst Heute* in Germany (1995). He is author of *Art for the Nation: Exhibitions and the London Public, 1747–2001* (1999).

CA Dr Charles Avery is a graduate of Cambridge University and the Courtauld Institute. He is a specialist in European sculpture. Having been Deputy Keeper of Sculpture at the Victoria & Albert Museum for a dozen years, and a director of the auction house Christie's for a decade, since 1990 he has been an independent historian, consultant, writer, and lecturer. His recent books include *Giambologna, the Complete Sculpture* (1987), *Donatello: An Introduction* (1994), and *Bernini, Genius of the Baroque* (1997).

CB Charlotte Benton is an independent architecture and design historian. She was a founder editor of the *Journal of Design History*. Her publications include *A Different World: Emigré Architects in Britain 1928–1958* (1995).

CBk Christopher Baker is responsible for the care of the collection of the Christ Church Picture Gallery, Oxford. He specializes in seventeenth-century painting and sculpture. Co-author of the National Gallery's *Complete Illustrated Catalogue* (1995), he contributed to the catalogue of the National Gallery of Scotland's exhibition *Effigies and Ecstasies, Roman Baroque Sculpture and Design in the Age of Bernini* (1998).

CD Carol Duncan is Professor of Art History in the School of Contemporary Arts, Ramapo College of New Jersey. Her books include *Civilizing Rituals: Inside Public Art Museums* (1995).

CH Christopher H. Hallett studied Classics and Classical Archaeology at Bristol University and at Lincoln College, Oxford. He received a doctorate in Ancient History and Mediterranean Archaeology from the University of California, Berkeley. Since 1993 he has been teaching in the Division of Art History at the University of Washington, Seattle. Significant publications include 'The Origins of the Classical Style in Sculpture', *Journal of Hellenic Studies* (1986), and 'Kopienkritik and the Works of Polykleitos' in W. Moon (ed.), *Polykleitos: the Doryphoros and Tradition* (1995). He is currently writing a book on nude portraiture in the Roman world, entitled *The Roman Nude*.

CHr Dr Clare Harris is Lecturer in Anthropology at the University of Oxford and is curator for Asian collections at the Pitt Rivers Museum. Her research interests are in visual culture in India, China, and Tibet in the twentieth century, the anthropology of art and aesthetics, and issues of cultural representation in museums and elsewhere. She is author of *In the Image of Tibet* (1999).

CMA Carol M. Armstrong is Professor of Art History at the Graduate School and University Center of the City University of New York, where she teaches nineteenth century French painting, theory and criticism, and the history of photography. She is author of *Odd Man Out: Readings of the Work and Reputation of Edgar Degas* (1991), *Scenes in a Library: Reading the Photograph in the Book, 1843–1875* (1998), and numerous articles in *October* and elsewhere on Degas, Manet, and photography. She is presently at work on a book on Manet.

CP Carole Paul's articles on Baroque ceiling painting and programmatic imagery have appeared in *Art Bulletin* (1992) and *Storia dell'arte* (1997). She is also working on articles and book projects concerning the origins of modern museums in France and Italy. One of these is the exhibition and catalogue she is preparing for the Getty Research Institute and the Borghese Gallery in Rome, which will focus on a series of drawings for the late eighteenth-century redecoration of Villa Borghese that are in the Institute's collection.

DJ Dr David Jackson is Lecturer in the Department of Fine Art in the University of Leeds, specializing in nineteenth- and twentieth-century Russian and Soviet art.

FAL Francis Ames-Lewis is Reader in History of Art at Birkbeck College, University of London. In addition to his recent book, *Tuscan Marble Carving, 1250–1350* (1997), he has published extensively on Renaissance drawings—*Drawing in Early Renaissance Italy* (1981), *The Draftsman Raphael* (1986), and several scholarly articles—and articles on the art and art patronage of the Medici in fifteenth-century Florence. He has recently completed a book on the intellectual life of the early Renaissance artist, and is currently writing on fifteenth-century Italian painters' responses to northern European art.

HC Helena Ciechanowska completed her D.Phil. in the History of Art in the University of Oxford in 1998 ('Images of Kingship and the Contesting of Political Power in Naples and the Two Sicilies', c.1734--59). Her teaching and research interests are in seventeenth and eighteenth-century Italian art, and court culture in the early modern period.

IB Ilaria Bignamini earned her *laurea* in the Università Statale, Milan, in 1978 and her Ph.D. at the Courtauld Institute in 1988. She did research at the Paul Mellon Centre, London, from 1988 to 1992 and was a visiting curator at the Tate Gallery, London, from 1994 to 1996. She was a Leverhulme Trust Research Fellow in the Department of the History of Art in the University of Oxford from 1996 to 1999. Her publications include *Hogarth* (1978); *Hogarth*, exhib. cat. with J.-A. Birnie Danzker, 1980, (Vancouver Art Gallery); *The Artist's Model from Lely to Etty*, exhib. cat., with M. Postle, 1991 (Nottingham, University Art Gallery; London, the Iveagh Bequest, Kenwood); *Grand Tour*, exhib. cat., with A. Wilton, 1996–7 (London, Tate Gallery; Rome, Palazzo delle Esposizioni). A specialist in British art, she has written extensively on art institutions of the sixteenth to eighteenth centuries and has recently focused on the Grand Tour and British archaeological excavations in Italy from the eighteenth to the early nineteenth century. She is the organizer of the workshop Archives & Excavations in the Department of the History of Art, University of Oxford, and at the British School in Rome.

IJ Ian Jeffrey has been active as an art critic and photography historian for over twenty years. As well as writing, he has curated numerous photographic exhibitions—for example, *The Real Thing: An Anthology of British Photographs, 1840–1950*, Arts Council of Great Britain, 1975, and *Bill Brandt: Photographs, 1928–1983*, 1983, London, Barbican Art Gallery. In 1989 he organized the British response to the French bicentennial celebrations, *La France: Images of Women and Ideas of Nation*, at the Haywood Gallery, London. He has taught in Goldsmith's College, London, and at the Central European University in Prague, and among his publications are *Photography: A Concise History* (1981), *The Photography Book* (1997), and *Timeframes* (1998).

JG John Goodman is a specialist in European visual culture of the eighteenth and nineteenth centuries who has published widely on the art of the period. He is the editor and translator of *Diderot on Art*, an English-language edition of three important art-critical texts by Denis Diderot (2 vols., 1995) and is preparing a study of Neoclassicism.

JL Dr John Lowden is Reader in the History of Art, Courtauld Institute of Art, University of London. He is a specialist in manuscript illumination, Byzantine and Western, from late antiquity to the end of the Middle Ages. He is the author of three books, including *The Making of the Bibles Moralisées* (2 vols., 1999) and numerous articles.

JR John Richards was educated at Rugby School and the University of Glasgow, where he earned his Ph.D. in 1989 ('Altichiero and Humanist Patronage at the Courts of Verona and Padua 1360–1390'). He was Teaching and Research Fellow in the School of Art History, University of St Andrews from 1993 to 1995 and has been Lecturer in History of Art in the University of Glasgow since 1995. His monograph on Altichiero appeared in 1999. He has written articles on thirteenth- and fourteenth-century Italian art and patronage. His research interests are Italian art and humanist theory before 1430, fifteenth-century art in northern Europe, and Gothic design in the British Isles. He is currently

preparing a study of the rhetorical background to the imitation of the Antique in Italian art around 1400.

KB Karen-edis Barzman has been teaching art history since 1984. She has written numerous articles on sacred imagery and devotional practice in early modern Italy, and on feminist theory and the history of art. Her book, *The Discipline of Disegno: The Florentine Academy and the Early Modern State, 1563–1737*, is forthcoming.

KCG Kyla C. Gutsche is a Canadian art historian currently completing her doctoral degree in the University of Oxford.

KH Kenneth G. Hay was born in Inverness in 1955 and educated at the University of Leeds, the Accademia di Belle Arti, Florence, and the University of Wales, where he completed his Ph.D. on Italian materialist aesthetics (1860-1960). He is Head of the Department of Fine Art at Leeds University where he works as an artist, writer, and educator. His research interests include Italian art from 1860 to the present, Cubism, cyberspace, modernism and postmodernism in the arts and architecture, and philosophical aesthetics. He publishes regularly on these in various European and American journals. His paintings, prints, and digital work have appeared in more than forty exhibitions in the United Kingdom and abroad, including exhibitions in Vancouver, in Houston, and at the Centennial Venice Biennale (1995).

KL Kathleen Lane completed an MA in Early Christian art at the University of Victoria in 1992. Her Ph.D., which examined the forms and functions of architectural sculpture in Romanesque England, was completed at the University of East Anglia in 1997, where she currently is engaged as a part-time lecturer in medieval and nineteenth-century art.

KW Katherine Welch received her Ph.D. in Classical Art and Archaeology in 1994 from New York University's Institute of Fine Arts. She taught Roman art at Harvard University for three years and then returned to the Institute of Fine Arts where she is now Assistant Professor of Fine Arts. She has a book in preparation entitled *The Roman Amphitheater from its Origins to the Colosseum*. Since 1991 she has worked at the Roman site of Aphrodisias in Turkey, where she is involved in two projects: a documentation of the Roman stadium, and the publication of a group of copies of Greek mythological statues from the Hadrianic baths.

LB Dr Louise Bourdua is Lecturer in History of Art at the University of Aberdeen. She has written articles on mendicant art in the Veneto and is preparing a book on artistic patronage and the Franciscan order in this region.

LCH Linda C. Hults received her Ph.D. in Art History from the University of North Carolina in Chapel Hill in 1978 (*Hans Baldung Grien and Albrecht Dürer: A Study in Northern Mannerism*). She has taught at the University of Tennessee, Chattanooga, Northern Illinois University in DeKalb, the University of Tulsa, Oklahoma, and the College of Wooster, Wooster, Ohio, where she now serves as Chair of the Department of Art and as Associate Professor. Her publications include articles on northern Renaissance art, particularly the witchcraft images of Hans Baldung Grien, and nineteenth-century American landscape paintings by Thomas Moran, as well as *The Print in the Western World: An Introductory History* (1996). She also serves on the Board of the College Art Association of America and as the President of the Midwest Art History Society.

MB Malcolm Baker is Deputy Head of Research at the Victoria & Albert Museum, London. He has written widely on the history of sculpture and the applied arts, particularly from the eighteenth century, and is the co-author (with David Bindman) of *Roubiliac and the Eighteenth-century Monument: Sculpture as Theatre*, which was awarded the 1996 Mitchell Prize for the History of Art.

MG Malcolm Gee is Principal Lecturer in Art History at the University of Northumbria, Newcastle upon Tyne. He is the author of

ix

Dealers, Critics and Collectors of Modern Painting: Aspects of the Parisian Art Market 1910–1930 (1981), and edited the volume *Art Criticism since 1900* (1993). His research interests are in the general field of early twentieth-century European art, and of the art market in particular.

MH Dr Maurice Howard is Reader in the History of Art at the University of Sussex. He previously taught at Pennsylvania State University and St Andrews University. He is the author of books on Tudor art and architecture, including *The Early Tudor Country House: Architecture and Politics 1490–1550* (1987) and, jointly with Michael Snodin, *Ornament: A Social History since 1450* (1996).

MK Martin Kemp is Professor of the History of Art in the University of Oxford. His publications include *Leonardo da Vinci* (1989), *The Science of Art* (1992), and (with Peter Humphrey) *The Altarpiece in the Renaissance* (1991). He is currently researching issues of representation in art and science from the Renaissance to the twentieth century.

MKf Dr Martin Kauffmann is Assistant Librarian in the Department of Special Collections and Western Manuscripts, Bodleian Library, University of Oxford, where he has responsibility for medieval illuminated manuscripts. He has recently published on illumination in early fourteenth-century Paris, and is currently completing a study of illustrated saints' lives in thirteenth-century England.

MO'M Mike O'Mahony studied Art History at the Courtauld Institute of Art, where in 1998 he completed a doctoral thesis on *Official Art in the Soviet Union between the Wars*. He has taught at the Courtauld Institute, Winchester School of Art, and Reading University, and has regularly lectured for the Tate Gallery and the Victoria & Albert Museum.

NS Nigel Spivey is Lecturer in Classical Art and Archaeology at the University of Cambridge, and Fellow of Emmanuel College. Amongst his publications are *Understanding Greek Sculpture* (1996) and *Greek Art* (1997).

PAE Patricia Emison is Associate Professor of Art History and Humanities at the University of New Hampshire. Her book, *Low and High Style in Italian Renaissance Art* (1997), studies deliberate deviance from the heroic or epic norm by artists ranging from Mantegna to Michelangelo. She has written articles on Renaissance prints, painting, and sculpture, as well as one on Rococo print *capricci*, and is currently working on a study of the epithet 'divino'.

PAS Dr Petrine Archer-Straw is a Jamaican lecturer and curator who works in the Caribbean and London. She has taught at the Courtauld Institute since 1994 and has curated a number of exhibitions for both Caribbean and British audiences: *Home and Away: 7 Jamaican Artists*, 1994 (London, October Gallery), *New World Imagery: Contemporary Jamaican Art*, 1995–6 (Bristol, National Touring Exhibitions; Kingston, National Gallery of Jamaica, and touring); *Photos and Phantasm: The Photographs of Harry Johnston*, 1998 (British Council). She is the author of *Jamaican Art* (1990) and is currently writing *Negrophilia: The Darker Side of Paris's Modernity*.

PC Professor Paul Crowther of the University of Central Lancashire was formerly Reader in Aesthetics and the History of Art in the University of Oxford, where he was a Fellow of Corpus Christi College. His books include *Critical Aesthetics and Postmodernism* (1993) and *The Language of Twentieth-Century Art: A Conceptual History* (1997).

PCh Peter Cherry is Lecturer in the History of Art at Trinity College, Dublin. He is, with William Jordan, the author of *Spanish Still Life from Velázquez to Goya* (1995), with Marcus Burke of *Collections of Paintings in Madrid 1601–1755* (1998), and of a monograph on Francisco de Zurbarán (1999).

PM Pauline Maguire received her Ph.D. from Columbia University in 1995, specializing in the study of Baroque art. Currently she is Visiting Assistant Professor of Art History at the University of Delaware and Assistant Curator of Academic Programs at The National Gallery of

Art, Washington, DC. She is a contributing author to *The Collections of the National Gallery of Art, Systematic Catalogue, French Paintings* (forthcoming). Other publications include 'Towards the Publication of Leonardo's *Trattato della Pittura*: Some Omitted Chapters and their Impact on Nicolas Poussin's Early Landscapes', *Studies in the History of Art* (1998).

PWJ Philip Ward-Jackson is an art historian and photographer. His work in the Conway Library of the Courtauld Institute has involved him in compiling a visual documentation of all aspects of European and North American sculpture in the nineteenth century. He has published numerous articles on specific topics relating to this subject.

RG Robert Gibbs is Senior Lecturer in the Institute of Art History at the University of Glasgow, where he has taught since 1969. His publications include *L'Occhio di Tomaso* (1979), *14th-century Art in Scottish Collections* (1988), *Tomaso da Modena* (1990) and numerous papers on Bolognese and Geoese painting and illumination and other aspects of fourteenth-century art. He is currently working on the iconography of Bolognese and North Italian law manuscripts, and on the Scottish nineteenth-century Gothic architect F. T. Pilkington.

RH Rebecca Hossack read Arts and Law at Melbourne University before earning a diploma in Art History from Christie's, London. Since 1988 she has managed her own art gallery in London, specializing in Australian art. From 1994 to 1997 she was Cultural Attachée at the Australian High Commission in London. She contributes regularly to the *Independent*, the *Daily Express*, and *Resurgence* magazine.

RRRS R. R. R. Smith taught at the Institute of Fine Arts in New York from 1986 to 1995 and is now Lincoln Professor of Classical Archaeology and Art in the University of Oxford, where he lectures on Greek and Roman art. He has worked on the publication of the marble sculpture from Aphrodisias in Turkey since 1985 and has been project director of the excavations there since 1991.

RW Robert Williams is Associate Professor of the History of Art in the University of California, Santa Barbara. His principal scholarly interest is Italian Renaissance art theory. He is author of *Art, Theory, and Culture in Sixteenth-Century Italy: From Techne to Metatechne* (1997).

SB Sarah Brown is an architectural investigator with the Royal Commission on the Historical Monuments of England and author of a number of books and articles on stained glass. From 1988 to 1998 she was editor of the *Journal of Stained Glass* and is a Trustee of the Stained Glass Museum at Ely Cathedral. She serves on the national committee of the British Corpus Vitrearum Medii Aevi and the Council of the British Society of Master Glass-Painters.

SMH Salah M. Hassan is Assistant Professor of African and the African Diaspora Art History and Visual Culture at the Africana Studies and Research Center in Cornell University. He has also taught in the Department of History of Art in the State University of New York at Buffalo, and was a J. Paul Getty Postdoctoral Fellow for 1992/3. He is the author of *Art and Islamic Literacy Among the Hausa of Northern Nigeria* (1992), editor of *Gendered Visions: The Art of Africana Women Artists* (1997), and co-editor, with Philip G. Altbach, of *The Muse of Modernity: Essays on Culture as Development in Africa* (1996). He has also served as curator of several exhibitions including *Seven Stories About Modern Art in Africa*, 1995 (London, Whitechapel Art Gallery). He is co-editor of *NKA: Journal of Contemporary African Art*, and serves as consulting editor for *African Arts* and *Atlantica*.

SGM Stella G. Miller is Rhys Carpenter Professor of Classical Archaeology at Bryn Mawr College. Her publications include articles on Greek and Roman paintings and mosaics. Her research interests are particularly in Macedonia. She is the author of *Two Groups of Thessalian Gold* (1979) and *The Tomb of Lyson and Kallikles: A Painted Macedonian Tomb* (1993).

TAH T. A. Heslop was educated at Cheadle Hulme School and did a foundation year at Leeds College of Art before completing a degree in

the History of Art at the Courtauld Institute (1971). He has since worked as a photographic librarian and, from 1976, as Lecturer in Medieval Art at the University of East Anglia, Norwich. In 1997/8 he was Slade Professor of Fine Art at Cambridge. He has researched and written on medieval secular architecture, manuscript production, medieval art criticism, metalwork and ivory carving, and the imagery and function of seals.

TCT Tania Costa Tribe was born in Brazil. She lectures in Art History and Theory in the Department of Art and Archaeology, School of African Studies, University of London. Her doctoral thesis analysed cycles of eighteenth-century figurative tile paintings in Portugal and Brazil, and a substantial part of her published work reflects her long-standing interest in Latin American and African-American art. She is currently working on the relationship between words and images in Latin American and African-American painting.

WL Walter Liedtke is Curator of European Painting at the Metropolitan Museum of Art, New York. He earned a BA from Rutgers University (1967), an MA from Brown University (1969), and his Ph.D. from the Courtauld Institute (1974). He has taught at Ohio State University and the Institute of Fine Arts, New York. His publications include *Architectural Painting in Delft* (1982), *Flemish Paintings in the Metropolitan Museum of Art* (1984), *The Royal Horse and Rider: Painting, Sculpture and Horsemanship 1500-1800* (1989), *Flemish Paintings in America* (1992, with Guy Bauman), the main essay and 55 catalogue entries in Walter Liedtke and Hubert von Sonnenburg, *Rembrandt/Not Rembrandt in the Metropolitan Museum* (1995), contributions to several other standard collection and exhibition catalogues, and about fifty articles and reviews. Honours include Knight in the Order of Leopold, awarded by the King of Belgium in 1993. His present work is on the catalogue of Dutch paintings in the Metropolitan Museum and the *Vermeer and the Delft School* exhibition, 2000 (London, National Gallery) and 2001 (New York, Metropolitan Museum).

Preface

Any editor of an elaborate enterprise of collaborative writing is bound to incur debts more numerous than can be signalled adequately in a brief preface. First and foremost, the individual authors, some fifty in number, have literally made this book possible. They have accepted with stoic good grace the imposition of an intricately modular structure which did not follow standard patterns, and they have reacted in creatively various ways to the challenge of the picture spreads, which are the most conspicuous visual feature of the volume. Not least, the authors have struggled tolerantly with the problem that no one was given as much space as they would have liked. As one of the authors myself, I can claim that I have not been spared the pain of squeezing hundreds of years of wonderful activity into a page or two.

The advisers have played an invaluable role, reviewing the first, complex draft for the structure for the book, recommending and sometimes contacting potential authors, and selectively reviewing the results. They have been unfailingly supportive of the project, and generously ready with open criticism, particularly when the editor's patchy understanding was resulting in various kinds of misjudgement. Much of what is good in the book would have been impossible without them, while responsibility for any enduring faults in the final product is to be laid at the door of the editor.

The project was initiated by Michael Cox at Oxford University Press more than five years ago, when he discussed with me the possibility and desirability of a volume on the history of art in the fine series of Illustrated Histories, which has established such a distinctive way to introduce generations of readers and students to important historical topics. An 'Illustrated History of Western Art' sounded distinctly oxymoronic. It was impossible for me to envisage a book on art history without illustrations—though I felt tempted to speculate that some styles of art history were so weak in acts of visual analysis that they might find appropriate expression in an 'Unillustrated History'. In any event, as the project grew and developed, it moved outside the precise model of the Illustrated Histories, while taking their imaginative use of illustrations as a point of inspiration. The scheme, as developed in consultation with Michael Cox and the designers, grew substantially from the original conception, and I am profoundly grateful for the faith of all of those involved at the Press in making such a major investment in what must be one of the most heavily illustrated single volumes ever published.

My own work on the book coincided with my move to the Chair at Oxford and with an apparently inexorable rise in public commitments, in spite of campaigns to say no to projects in which I might have liked to participate. In this climate of ever more compressed time, the commitment and high skill of Stuart McCready, has, without exaggeration, saved the day. He has acted as executive editor, communicating with authors, combining persistence, firmness, tact, sensitivity, and patience in an exemplary way. These qualities have been tested to beyond any reasonable limits by the editor himself, and have never been found wanting to the slightest degree. Stuart read each submission and recommended editorial changes with the highest professionalism and perspicacity. And, not least, he worked tirelessly to fit everything together into a whole, shoe-horning texts and illustrations into their constrained spaces. The manifest success of the picture spreads owe much to his design skills.

With the support of Rosanna Peers, Sandra Assersohn and Sophie Hartley have researched and acquired the many illustrations, from places far and near, expeditious and slow, easy and difficult. The formulation of the initial design concept was in the hands of Paul Luna, and the visual fine-tuning has been accomplished by Nick Clarke. Carol Alexander has been responsible for production quality. On my 'side of the fence', Caroline Dawnay, my literary agent, has as ever helped beyond the call of duty, and close friends have patiently endured too many frantic moments. Sheila Ballard, within the Department of the History of Art, has brought such order into my professional affairs as it is possible to bring. To Marina Wallace, who has frequently needed to keep the lid on the boiling kettle, no thanks are big enough.

MARTIN KEMP

Oxford, March 2000

The Oxford History of
Western Art

Introduction

2 To someone educated in the Western tradition, the notion that there is something called 'Art'—often with a capital 'A'—and, as a corollary, that there are 'Artists', is so taken for granted that the making of art is assumed to be a universal or constant feature of human existence. We speak of Pre-Historic Art, Egyptian Art, Pre-Columbian Art, African Art, Maori Art, and so on. That the cultures in question appear not to have formulated anything resembling our idea of making art does not appear to deter us from thinking that they were doing so. We also have a sense of what is meant by 'Western', and it is generally accepted that Western Art has a 'History', which of course it does, in as much as it has existed for over two and a half thousand years. However, this begs the question as to whether it can be said to have any kind of free-standing history, and, if so, what distinguishes art history from other histories. Is it, to put it at its simplest, a matter of the evolution of visual qualities told through stylistic developments or is it a branch of social history, in which the work of art is essentially, as one historian has put it, 'a deposit of a social relationship'. Since all three terms in our title raise big questions, I think it will be helpful to begin by outlining how they are interpreted in the present context.

Art

What we mean by art, though endlessly subject to debate by philosophers, centres around a series of generally shared assumptions—that there is some kind of indefinable quality (normally described as aesthetic) embedded in art, that it is a valued and civilized thing to do or to enjoy (if not of any apparent utility), that it requires imagination, creativity and originality, that it demands a special kind of genius to do it at the highest level, that there are higher forms called the 'Fine Arts' and lower forms called the 'Applied Arts', that there are people who are, by ability or experience, especially equipped to say what is best and why, that it is worth collecting (if we have the funds), and that it is likely to appear in special places, normally called art galleries.

Alongside these and related assumptions run a series of ideas that stand, if we think carefully about them, in contradictory positions to greater or lesser degrees—that what is regarded as good is a matter of taste, that it is subject to shifts of fashion, increasingly rapid and extreme in recent times, that it cannot be explained in words, and that all we can do in the last resort is to adopt the formula, 'I know what I like'.

The strange syndrome of symptoms which serves to diagnose 'Art' is, historically speaking, very recent and very specific to a particular culture—however much it has been successful in insinuating its views into the other cultures it has encountered. Its origins lie in the Latin term 'ars', which means approximately 'skill', with the implication that it involves something beyond what can be learnt by everyone with equal degrees of success. Something of that sense survives in such expressions as 'the art of conversation', 'the art of cooking', 'the art of goal-scoring', and 'the art of making friends' (or 'enemies'). The transformation of ars as 'skill' into the elevated 'Belle Arti', 'Beaux Arts', or 'Fine Arts' is one of the stories that will emerge during the course of this book. We will find that by the mid-nineteenth century, the profession of art, in keeping with initiatives of other groups in society, was in the process of defining its own autonomous criteria, centred upon specialized training in its intellectual and practical requirements. We can witness comparable moves in a series of sciences, technologies, and humanities, including medicine.

From a point of broad if imprecise consensus about art, the twentieth century has witnessed a succession of challenges from individuals and movements who have aspired to overturn its canons and its institutions. The question, 'is it art?' reverberates around many of the more radical movements in the twentieth century. The response of the art world has been to allow the concept of art such protean elasticity that in effect anything goes, provided someone of status is prepared to call it art. Such a concept would have lain far beyond the understanding of any of the 'artists' in the earlier periods covered by this book.

Given the cultural specificity of our concept of 'Art', and its stretching to a point at which it resists stable definition, we may reasonably wonder if it still serves effectively as the name for what we are examining in the present book. I think there are three main reasons why it still does a good job, and can be used unapologetically—albeit with due acknowledgement of its shortcomings.

The first reason is pragmatic. Within our system of cultural reference, now of such global spread, the designation of something as 'Art' is conveniently and generally taken to refer to an object made specifically for viewing rather than primarily for practical utility. There is some common assent as to what sort of thing we are talking about, and as to where we might expect to go to see examples and what kind of book to read if we want to find out more. Art has proved to act as a convenient label for a series of items that can be discussed meaningfully in relation to each other, not least in their cultural settings and within a conceptual framework that involves such elements as beauty, representation, naturalism, abstraction, expression, decoration, and skill.

The second draws upon human values. If, on the one hand, we cannot safely extend the modern notion of art into other cultures, often remote in time or place, on the other, we cannot safely exclude it. Just as it would be wrong to assume that no one appreciated a glowing sunset before anyone had written about it, so, in the case of a society that has left no evidence of having formulated a developed concept of art, we cannot jump to the conclusion that we should avoid attributing artistic impulses either to those who produced artefacts or those who looked at them. It may be that barring other cultures from the cultural territory we claim as art is at least as arrogant as imposing the term 'art' upon them. The best we can do is to behave with sensitivity and generosity, granting the continuity of human instincts as makers of visually compelling objects as much chance to prove itself as the more readily documented transformations and differences.

The third justification is historical. Concerned as we are with the Western tradition, we find a reasonably consistent sense, starting with Classical Greece, that the forming of a piece of sculpture, the painting of a picture or the production of a beautiful object is a special kind of activity, demanding special abilities from their makers and asking for a special kind of response from their viewers. Although the status of sculptors and painters and their products in antiquity did not reach the heights implicit in our system of the arts, the endowing of an artistic practice with foundations in theory, together with the recorded reputations of the greatest masters and their master-pieces, indicates that key ingredients of the system were in place. The legacy of Christian iconoclasm and the circumscribed role for visual images in the early Middle Ages restricted the philo-sophical and social frameworks within which the producers of images could operate, but we should not fall into the sunset fallacy described above; that is to say assuming that the inhibitions on what it was possible to say in theory meant that the artistic mastery went unrecognized. In any event, during the fifteenth and sixteenth centuries, above all in Italy, we witness a growing assertiveness behind the intellectual and social claims of an élite group of artists, and growing roll-call of individual practitioners who laid conscious claims to be recognized as the heirs to Praxiteles, Apelles, and the other renowned masters of ancient Greece. Once such self-consciousness entered the system, particularly in written form, it was never to go away. Indeed, it seems safe to say that the determining feature of the post-Renaissance Western tradition has been artistic self-consciousness, centring on such attributes as creativity, originality, and individuality. The artist progressively came to live and work within a house named 'Art', and the views from its windows determined the operating horizons for the making of objects intended for our delectation. Later attempts to knock down the walls seem to have resulted only in a rambling series of extensions.

Western

In talking about the 'Western' tradition, we are again using a term that is generally understood with a readiness that belies its culturally specific origin. Since we live on a globe, everything is, if we travel far enough, west of everything else, or east of every-thing, or of itself for that matter. The west, for an American, might well mean the 'Wild West', with Boston irredeemably easterly, while for a Londoner it could well mean the westerly counties of Devon and Cornwall. The global notion of the 'West', defined as not the 'East', depended initially on a broad band of European cultures, roughly corresponding to what we now think of as western, central, northern, and southern Europe. With the rise of America, and its cultural annexation of the idea of the west, coupled with the erection of the iron curtain by the communist regimes, the west came roughly to mean anything east of Los Angeles, west of Hungary, and, somewhat in defiance of geographical logic, north of Africa and the Panama canal—with some conceptual extension to embrace Australia and New Zealand. The lifting of the iron curtain has rendered the eastern boundaries more blurred, as they were for much of history, but the cultural concept of 'Western' still effectively serves to refer to recognizable continuities in the European notions of art and their transplantation (and transformation) in America. Here it is used as a convenient label.

History

That 'Western Art' has a 'History' seems self-evident. It has existed over two and a half millennia, and has undergone a series of transformations. At one time, it seemed reasonably clear what comprised that history. It consisted of a succession of artistic styles and latterly of artists in a more or less linear succession along a mainstream with various tributaries and side channels, subject to occasional damming (as with Iconoclasm) and inter-mittent bouts of flooding with quality (as in the Renaissance). The central story consisted of cycles of innovation, influence, absorption, and innovation, supported by an implicit notion of progress, even though we ceased to believe that a naturalistic Greek statue was 'better' than a stiff *kouros*, that Raphael was superior aesthetically to Giotto, or that Picasso was necessarily to be valued more highly than Cézanne because he went further towards abstraction. The fact that the levels of naturalism

achieved in the nineteenth century looked in retrospect to have been hard won, step-by-step, from the Renaissance—paralleling in important respects what had happened in Greece—gave considerable impetus to a directional history. Such a developmental history is not so much wrong, according to its own criteria, as leading to an incomplete version of artistic 'progress' in terms of its own autonomous laws of inevitability—just as the kinds of ultimate abstraction and minimalism of the 1950s and 1960s could in retrospect seem to be what the artists of the earlier twentieth century were working inexorably towards.

At its best, when it avoids such fallacies, style-driven history was and is a powerful and elastic method, equipped with subtle tools of visual analysis, and capable of embracing broad aspects of patronage, meaning, and art theory, rather than being restricted to formal analysis. However, even the most responsive form of traditional art history did not give prominence to the question, 'whose art history?'

Of the perspectives which have permitted the writing of art history from alternative standpoints, feminism has been most prominent. The key achievement of feminist art history seems not to be the use of artistic production to demonstrate the dominance of male, patriarchal values in the institutions of the West (which, once said, becomes a commonplace); nor is it to show how many of the terms within which art has come to be framed, such as entrepreneurial originality, are susceptible to analysis in terms of the predominantly masculine values of the expanding capital economies of early modern Europe; nor even to give due and much needed prominence to women practitioners. Rather its most creative role has been to demonstrate more subtly how women actually negotiated their positions within cultural activities, and acquired particular roles in the changing processes of the making and viewing of art.

The other major alternative stance is that of a loose coalition of those who have aspired to unravel the assumptions that have underlain our whole edifice of Western artistic and literary culture. The challenged assumptions range from notions of a stable meaning, through which the author or maker communicates with the reader or viewer, to the rejection of the implicit superiority of the Western world-view. From the specific standpoint of art history, the most significant of the challenges has been the argument that under the veil of 'aesthetic value' the Western system of art has concealed the series of political and social attitudes through which art became a commodity to be made, traded, and brandished in the interests of those who held and hold the reigns of power.

We do not need to accept the political and philosophical bases of such challenges—often grouped under the headings of 'Post-Structuralism' and 'Deconstruction'—to recognize increasingly how Western art embodies both knowingly and inadvertently many worthy and unworthy features of the societies that produce it. However, the way that the artist actually operates, and the way that the artefact can evoke responses in viewers, persistently seems to transcend the social generalizations which provide one of the tools of the historian's trade. Again and again, neighbouring artists from the same society bear witness to distinctly different and humanly compelling visions, even though apparently hedged in by the same body of artistic and social mores.

As a historian, I feel no need to be apologetic about the achievements of Western Art and the literature that has grown up to support it, any more than it is necessary to regard it as having established some kind of privileged standpoint from which to view other cultures. Western Art is its own kind of thing, and there is a huge story to be told—or rather a rich series of stories to be told from varying perspectives. We could write the economic history of art, its social history (as has been done on a number of occasions), the history of its viewing, reception, and criticism, the history of patronage and collecting, historical developments in the depiction of non-Western places and peoples, the history of techniques, the conceptual history of art itself, and so on—in addition to the traditional core of style history.

Each history brings a different body of evidence into view, or highlights different aspects of the same material. At its most effective, each history serves to make the artefacts 'look' different to some degree, because we notice different things in them. We cannot, within the compass of a single manageable book, do all these things at once. In selecting what to do and what to include, the business of deciding what to leave out has been at least as taxing as what to include.

What the present book aspires to do, in as varied and suggestive a manner as possible, is to look at the core of the Western tradition in its own terms, while remaining alert to what these terms are, and their limitations. It is also intended to reach out generously into some areas that are generally mentioned only in passing, if at all, in most existing histories. For instance, the 'Applied Arts' are accorded a more prominent presence than is normal in a book essentially concerned with the 'Fine Arts'. Looking, albeit selectively and within the constraints of space, at the transplanting of Western systems into other cultures, such as that of Africa, provides another example of how the book aspires to open a few of the often closed boundaries of the subject. Since choices have been made, both of a creatively inclusive and an uncomfortably exclusive nature, I think it will be helpful to give the reader some open insights into how the book has come to assume its present appearance.

The concept

The founding principle of the book, and a constant throughout its writing and production, has been to use groupings of pictures to give some sense of the visual 'texture' of the various periods and episodes. The idea is that the illustrations should create their own effect, as a kind of extensive visual tour, not so much through a procession of individually 'great' works viewed in isolation, but through juxtapositions that create visual environments and sometimes give a more literal sense of the settings in which the works were and are located. At the same time the pictures have been individually selected to illustrate the text in the more conventional way. The types of picture groups range from juxtaposed paintings to sets of images showing the public 'consuming' art. A reader undertaking a tour of the whole or any parts of this book, will quickly become aware that it looks different from standard histories. The idea is that the shape and nature of the visual presentation should themselves prove stimulating—and not only in ways consciously planned by the editor and authors.

The other aspect of the book's presentation that gives it a different feel is its organization in sections other than the conventional periods of Medieval, Renaissance, Baroque, Rococo, and so on, or under such stock headings as Romanticism and Impressionism. The standard classifications are still apparent in various ways. To have omitted them entirely would place the book and its readers in a perverse position in relation to the ways we have understood art in its historical context, and they have survived because they do a useful job. However, it seemed to me, having the opportunity to look afresh at the long span of Western Art, that the existing period divisions were concealing longer continuities in the roles of imagery in religious and secular societies. I am not intending to suggest that the five big periods in the book should henceforth be considered as *the* way to organize art history, since different forms of organization can provide insights about continuities and change. However, now that we can see the results of asking authors to work within the present framework, I am confident that it does reveal how the major religious and secular functions of art have been forged, sustained, transformed, revived, and revolutionized over the ages, how the institutions of church and state have consistently aspired to make art in their own image, and of how the rise of art itself as a cultural institution has come to provide the dominant conceptual framework within which artists create, patrons patronize, collectors collect, galleries exhibit, dealers deal, and art historians write.

The five big phases have been selected specifically to serve the history of art, not history in the broader sense or other branches of history, though it would be surprising if the act of designating periods in any branch of history failed to intersect tellingly with the periods which other specialist histories have devised to meet their needs. Three of the big dividing points—the fall of Classical Rome in 410, the sack of papal Rome in 1527, and the start of the First World War in 1914—could serve as markers in many branches of Western history, while the fourth, 1770, has been chosen to mark the start of two decades that saw a series of revolutionary transformations, most notably American Independence and the French Revolution, and to mark more generally the simultaneous growth of industrialization and professionalization in those countries that were to contest the imperial stage during the next century and a half. That the first two markers concern Rome is a reflection of that city's central role, not least as a symbolic focus, in the first instance of a pan-European and pan-Mediterranean empire, and in the second as the seat of the successors to S. Peter, the Popes, who claimed spiritual sovereignty over a territory no less ambitious in geographical scope.

A constant thread, perhaps the only one, that runs from Classical antiquity to the religious convulsions of the sixteenth century is the artistic expression of religious values in physical contexts and in material forms made possible by the power and wealth of states and other secular agencies, such as dynasties, regional and civic administrations, and individuals. A dialogue between the *vita activa* of practical deeds in the turbulent world of human affairs and the *vita contemplativa* of cloistered disengagement from the vagaries of political and economic fortune was an enduring feature of Western thought from the time of Socrates in the fifth century BC, to the fall of papal Rome

under the military might of the Holy Roman Emperor in 1527. The modes of art mirror this dialogue, reflecting over the ages shifts in the balances of power and the roles permitted for imagery in the lives of the mind and body. It is generally true that those phases of visual culture that were dominated by ideals of worship through the contemplation of eternal values favoured images that would serve as formalized icons of the venerated subjects and narrate stories which told universal truths, while an emphasis upon a life of active engagement found expression in more complex forms of naturalism that could portray the potential of humans, collectively and individually, to master the world they inhabit.

The church–state axis continues to be hugely significant in the period 1527–1770. However, even in Catholic countries, where the continuities were more likely to be preserved, the greatest determinants of stasis and change were the secular power blocks. The Reformation might well have been embraced within an agenda of church reform had it not been adopted, for a variety of religious and non-religious reasons, by authorities ruling over substantial territories in Europe, while the Catholic Counter-Reformation drew much of its power from the support of major monarchies, most especially that of Philip II in Spain. The impact on the arts could not have been more profound. The old condemnations of 'graven images' gained new force (though Martin Luther himself was no iconoclast) to such effect that a country like Britain surrendered large territories of traditional image-making—reminding us that economic, political, and intellectual vigour are not necessarily accompanied by rich cultures of picture-making and sculpture. The 'golden age' of Dutch art in the seventeenth century, with a preponderance of easel paintings devoted to subjects other than the obviously devotional, owes much of its character to the special role of the reformed church in a merchant society. Yet, paradoxically, it was within the major countries that held most closely to the traditional roles of image-making in a religious context—France, Italy, and Spain—that the new status of the artist was most clearly expressed through the rise of the academies. It seems likely that according the image an elevated role in spiritual acts gave image-makers the scope to claim an elevated status.

By 1770, as a glance at the progression of illustrations will show, the centre of image-making at the highest level and on the largest scales had largely shifted away from the church, and aristocratic courts were no longer such dominant centres of patronage. The talk was increasingly of 'Art' in its own right, as a profession which aspired to the highest goals and as an avocation which could aspire to genius at its loftiest level. It became, in a sense, an industry, involving not only the immediate makers and patrons but also institutions for training, exhibiting, and selling, organizations for marketing and dealing, reproductive media for the dissemination of works, and a host of literary vehicles for the retailing of opinions about art past and present. The era of 'isms', of such 'movements' as Romanticism, Realism, Impressionism, and Cubism, reflects the way that art was seen as having its own doctrines and that the right set of doctrines would lead to the holy grail of aesthetic excellence. Aesthetic excellence might reside in 'Art for Art's Sake', but was more often to be realized in relation to some kind of larger social, human, or spiritual goal.

The rise of art as 'Art' could well have justified the characterization of the period 1770 to about 1970 as the best division in the penultimate section of this book. In this way, the Modernism inaugurated by Picasso, Matisse, and their contemporaries could be seen as a natural expression of the Romantic view of the artist as a creator bound only by the freedom of art. This is, indeed, why it has been decided to run the period from 1770 as far as 1914. However, the radical change in the visual appearance of avant-garde art after 1900 laid the foundations for a series of departures so radical and so geographically wide-ranging that the period after the war seems best treated in its own right as 'International Modernism'. This characterization draws support from its conjunction with other world-wide 'Modernisms'—in science, technology, architecture, literature, and music.

Looking back from a longer perspective, say in fifty years' time, it may seem that the inaugurating of a new phase, the 'Postmodern', in the 1960s or 1970s should be taken as the natural dividing point in the twentieth century. In the present context, concerned with long-distance trends, the few decades of Postmodernism, which have by no means suppressed recognizably Modernist practices, can best be characterized as arising within the same kind of cultural landscape that had earlier nurtured such self-conscious movements as Dada and Surrealism, which involved the making of art about art in the manner that became one of the characteristics of post-1960 practice. In this sense, the Postmodern is a natural extension of the Modern and has exaggerated the extent of its rejection of ideas inherent in the art of the first half of the twentieth century.

Places and periods

Within the framework established by these broad strategic decisions, a more detailed series of choices have to be made about what to include and what to leave out. The inclusions and exclusions depend on a series of judgements exercised in relation to various geographical, chronological, and artistic categories. The best way of signalling the thinking is to look in rather more detail at what the reader (and viewer) will find in the sections.

The first part, 'The Foundations', is, as might be expected, assigned to Classical antiquity, that is to say the visual culture of Greece and its succession in Rome. The earliest Greek image is a fragmentary crater decorated with figures and horses in a geometric style from about 750 BC [20], while the latest Roman image, a marble portrait head of a provincial Governor [79], dates from the fifth century AD. The selection includes some familiar and classic images, but, as in other parts of the book, the authors have taken advantage of the format to explore some more revealing approaches than in the standard surveys, through a series of themes which relate to the function and meaning of the images in the societies that generated them. There are also two sections on what might be called the 'outreach' of the Classical vision, one looking at its geographical diffusion within the period and the other at its enduring legacy.

The main body of the text and illustrations deals with the period between the fifth century BC and the fourth century AD, and embraces some of the canonical images that have inspired generations of later artists across the Western world. The

sculptures from the Parthenon, the so-called 'Elgin Marbles' are regarded as one of the peaks of artistic achievement from any era, attracting crowds of cultural pilgrims to the British Museum in London and becoming a continuing bone of contention between the British and Greek governments in the face of repeated Greek requests for the repatriation of the marbles, claimed as a cultural heritage. Yet, striking though such survivals are, our assessment of ancient art is based upon a very incomplete knowledge of the Greek originals. Many of the acclaimed masterpieces of Greek sculpture are known only through Roman copies, while Greek painting is known only through a series of more or less distant echoes from other places and times, and in other media. In this situation, the written accounts, both historical and theoretical, have played and continue to play an unusually prominent role in our understanding of ancient visual culture. This understanding has undergone vast transformations, not only in the past but also through recent revisions in our historical perspectives. Not the least important of the reassessments presented here concerns the eclectic forms and social functions in Roman figurative art in its own right— not simply as a weak diffusion of Greek accomplishments.

The second part, 'Church and State: The Establishing of European Visual Culture', runs unconventionally across what is normally characterized as a succession of separate 'periods': Early Christian, Byzantine, Medieval, and Renaissance. The greater continuity which provides the rationale for the longer view adopted here is that of the Christian empire initiated by Emperor Constantine in the second decade of the fourth century. Although this part's nominal starting point is the fall of Rome to the Visigoths in 410, the discussion necessarily begins a full century earlier. This untidiness reminds us that great cultural or religious events and political turning points might not coincide as neatly as the historian might like. Indeed, if we look at the cultural aspirations of the 'barbarian' kings after the fall of Rome, we can readily discern their aspirations to emulate Constantine's Roman stature and ideals. Contemporaneous Byzantine culture, centred upon Constantinople (now Istanbul), is here considered only in the European context, with the exception of the inclusion of Byzantine manuscripts from various places of origin in the section on the illuminated book.

The later limit is provided by the Sack of Rome in 1527 by the troops of the Holy Roman Emperor, Charles V, the most recent of the successors to Constantine. The shock provided by the invasion of the sanctuary of the Popes by a 'Holy' Emperor, and Luther's contemporaneous challenge to the Church of Rome, reverberated across Europe with enduring consequences. By this date, Leonardo, Raphael, and Giorgione were dead, and Dürer, towards the end of his career, was adopting the new Lutheran principles. Although two of the pioneers of the 'High Renaissance', Michelangelo and Titian, were to live until 1564 and 1576 respectively, the diffusion and cultural transformation of Italian ideals across Europe after 1527 seem to inaugurate a new phase.

The complex and shifting patterns in national and provincial regimes during the Middle Ages and the Renaissance present a very different picture from the Roman Empire, but do not represent a permanent slackening of institutional and individual ambitions to build, decorate, and broadcast ideology

through imagery. Even with high levels of international cross-fertilization, the diversity across place and time is striking. What was known of the art of Rome remained something that artists repeatedly readdressed, sometimes at considerable degrees of remoteness and at others by more direct adaptation—even though the ancient ideal of naturalistic imitation was not re-adopted as a central goal until late in the period. Viewed in this light, the Renaissance—defined as the rebirth of Classical ideal and styles—is less a radical break than a self-conscious consolidation of scattered and recurrent tendencies which in effect brought together the ancient and Christian components that Constantine had first striven to unite.

During this second period, sculpture and painting remained major vehicles for expression, and a special study is provided of the altarpiece as an exemplary genre of art designed for functional devotion. However, the prominence given here to other types of artistic production reflects the effort and money expended on the smaller sacred genres (devotional objects in precious materials and richly illuminated manuscripts), and on the large-scale glories of stained glass. The dominance of religious imagery in the text and plates does correspond to where the major investments of creativity and funding were made, but the section on 'Domestic Arts' gives some idea of the rising importance of secular artefacts. Again, as a counter-balance to the emphasis normally given to painting, the final section, devoted to 'The Print', stresses that one of the 'lesser' arts played a hugely significant role in conveying imagery to an ever-widening audience.

In this, as in other parts of the book, one consequence of the organization and priorities is to draw emphasis away from the achievement of individual artists. One of the signal characteristics of the Renaissance is the rise of the artists with consciously individual styles, who became the subject of written attention. This development is fully acknowledged, but the story is not chiefly told through an aggregation of careers. In any event, the reader will have no difficulty in finding full-scale treatments of Leonardo, Michelangelo & Co. in other books, not least the many monographs devoted to Renaissance masters. The intention here is to give shape to the contexts within which individual careers were pursued.

The third part, 'The Art of Nations', which runs from 1527 to the eighth decade of the eighteenth century, embraces two normally separate periods, the Baroque of the seventeenth century and the Rococo of the eighteenth. The Baroque, and to some extent the Rococo, are normally characterized in terms of the artists who served church, state, nobility and satisfied the ever-widening market for works of art, most notably for pictures. This remains a conspicuous part of the story, with such 'giants' of the Baroque as Bernini, Caravaggio, Rembrandt, Rubens, and Velázquez featuring prominently. The rise of the picture—the free-standing easel painting—as a central measure of a painter's achievement, and as something to be acquired by competitive patrons, is acknowledged by sections devoted to Italy and France, Spain, Holland and Flanders, and England. However, the organization of this part is also designed to reflect the way that so many works now in galleries were part of programmed complexes or of assemblages put together in a more opportunistic manner. This is not only true of the great

Baroque and Rococo religious and secular schemes involving architecture, sculpture, and painting (as described in the sections on 'Forms in Space') but also of works that were made in the knowledge of their likely settings even if they were not specifically designed for individual sites. The theme of works in settings provides the rationale for the sections on 'The Interior', which embraces a range of objects normally assigned to histories of 'Applied' or 'Decorative' Arts.

During the course of the two and a half centuries, the patronage, production, and collecting of art came increasingly to be dominated by the powerful and wealthy states of France, Holland, Flanders, and Britain. Private patronage, once the prerogative of the uppermost stratum of society, was increasingly extended within the rising bourgeoisie, especially through the rise of the art market as promoted by exhibiting institutions, and, latterly, by dealers and auction houses. Spain, as was its wont, presents a rather special case, with its own vigorous and individualistic schools of painting in various regional centres, and played a special role in the spread of Christian art to Latin America. Italian style set the international agenda during the sixteenth century, and Italy retained a leading place in the founding and consolidation of the Baroque style, through the political and cultural vigour of papal Rome, and to varying degrees the Grand Duchy of Tuscany, the Republic of Venice, the Kingdom of Naples, and the smaller city-states. However, by the end of the period only Venice remained a major centre of native production.

The sharpest differences in the subjects, scales, styles, and patronage of art across Europe correspond primarily to the affiliation of the countries to either Roman Catholicism or one of the forms of Protestantism. However, the contrast between, say, the Stoic restraint of Poussin and the sumptuous complexities of Rubens within Catholic cultures, and the affinities between the painterly richness of Rembrandt in Protestant Holland and Velázquez in Catholic Spain serve to remind us that artists, with the support of patrons, can be wilfully individual as well as acting within defined cultural parameters. There were also sharp differences in the conceptual frameworks within which artists conducted their professional activities. Ambitious academies, increasingly led by that in Paris, set the highest ideals for the highest kind of painting—the telling of great moral stories—and relegated artists pursuing 'humbler' subjects such as landscape and low-life scenes in a subordinate position. By contrast, the great flowering of Dutch vernacular in the seventeenth century was not accompanied by any dominant academic theory.

By 1770, the centre of gravity of artistic innovation had shifted decisively to Paris, albeit with notable national schools arising in Britain and in Germany during the Enlightenment and Romantic periods, not forgetting the extraordinary individual achievement of Goya in Spain. Paris was not to surrender its leadership until well into the twentieth century.

'The Era of Revolutions', which comprises the fourth part, saw the 'Fine' and 'Applied' Arts exercising their impact and striving to achieve new identities in ever-widening public forums. Even the most apparently academic of works, such as Jacques-Louis David's great didactic stories, were items of public attention and, often, of major political moment. Even in Britain, less given to the rhetorical and moralistic grandeur of

history painting, the wealth and variety of artistic production served the social and aesthetic needs of publics who had not previously been in the market for art. These developments are directly acknowledged in the sections on 'Pictures and Publics' and 'Sculptures and Publics'. The advent of photography, and its steady rise as *the* public art, is here seen as a natural extension (and eventual take-over) of what was happening in the smaller-scale and less expensive arts of representation, particularly reproductive prints. In a complementary manner, the industrialization of design placed 'style' in the hands of publics of a social rank below those who had traditionally been able to order fine artefacts from their makers.

The sections devoted to 'Art Criticism and Aesthetic Ideals', 'The Rise of Art History', and 'Art Museums and Galleries' are, in contrast to the kinds of histories that concentrate on sequences of artists and their works, intended to acknowledge that the intellectual and institutional frameworks of the 'Art World' provide essential contexts if we are to understand the period after 1770. In those countries with growing art markets, France and Britain in particular, the key dialogue no longer seems to be between those who commissioned and those who made art but between those who placed their creations before the public and those who set up the frameworks for public interpretation. Inevitably, given the constraints of space, the inclusion of these major themes means less room is available for any extended analysis of individual artists and their masterpieces. In that we are attempting to provide a rounded sense of the shape of what has happened in Western art, this rather unusual priority seems fully justified.

If there is any dominant characteristic that runs through the period—from the Neoclassical doctrines that prevailed at the beginning to the radical disruptions of pictorial representation of Cubism in the early twentieth century—it is the idea of the artist as creative hero. The definition of the aesthetic faculty as the quintessence of human creative power, with the artist as the prophet of an autonomous religion, found its logical expression in the now popular image of the artist as a bohemian outcast, misunderstood, ahead of his or her time and accountable only to the standards of art.

The final part, 'Modernism and After', opens with the international conquests of 'Modern Art' on the basis of foundations laid down before the First World War, and then looks at the extension of art production into non-traditional media, which is one of the signal characteristics of the second half of the century. However, the account of Modernism through its movements and practitioners provides only a part of the total picture. The aim, as in the preceding sections, is to provide a history of art rather than to tell only the story of artists and their works. Even the international triumph of the Modernist avant-garde, so heavily promoted by American initiatives after the Second World War, looks less conclusive from a perspective at the end of the twentieth century than it did three-quarters of the way through. The much-vaunted drive towards specifically artistic values, above all in totally abstract genres of picture-making and sculpture, did not lead to the suppression of figurative expression, either in countries where the avant-garde was dominated by Modernist ideals or in those which adhered to different conceptions of the functions of art. The sections devoted to Soviet Russia and Latin America give some idea of the kinds of alternatives that could thrive in the era of Modernism. In those areas of the world subject to imperial conquest, the Western notion of art was introduced with irreversible consequences, but, as will be apparent in the discussion of African, Caribbean, and Indian modern art, the embracing of internationalism was in more or less constant dialogue with the search for new ways to re-embody native styles, media, and subjects. Comparable stories could be told with respect to Far Eastern art, but in the context of a History of Western Art it seems more practical to concentrate on a few selected examples of the direct extension of Western ideals through long-term colonial regimes, amongst which that of Britain was the dominant geographically.

The roles of the institutional and literary industries of art became increasingly dominant. The patron, in the traditional sense, was replaced by the networks of collectors and dealers, while the state tended to play its role through the funding of intermediate agencies for the exhibition of art and for the financial support of approved practitioners. Artists, however much they might aspire to disdain the machinery of criticism and art history, increasingly produced works for critical reception and instant historical acclaim. The evolution of Picasso's *Guernica*, the great history painting of the Spanish civil war, documented by the eye of the camera, is an early example of art as public performance by a media star. Artists' manifestos, exhibition statements, and their relationships with critics (epitomized by the way that Clement Greenberg, the magisterial critic, orchestrated Abstract Expression in America) became integral parts of the business of being an artist. The sections on 'Art Criticism and Aesthetic Ideals', 'The Rise of Art History', and 'Art Museums and Galleries' provide foundations for our understanding of the broader edifice of 'Art' within which all practitioners have necessarily found themselves.

Assessing the very latest developments is the most subjective part of what throughout has been, inevitably and properly, a subjective exercise in deciding what is significant. However, I think it is already possible to see how what is called 'Postmodernism' is understandable as one consequence of the high self-consciousness and elaborate critical apparatus that supported much Modernist art. Pop Art, Conceptual Art, and the deliberately eclectic mix of historical styles in Postmodern practice, all involve the invention of ideas and the making of images about the making of art. The most prominent forms of art and the most renowned artists become involved in art as public performance, broadcast through a range of specialist and popular media. Even those popular media that pour scorn on pickled sharks and express outrage at the duping of the public by anarchic gestures are part of the system through which art and artists come to prominence and achieve their reputation. The thoroughly institutionalized anti-institutionalism in the teaching, making, and display of art has been matched by the transformation of once revolutionary social theories (most notably Marxism) into modes of cultural analysis now detached from any large-scale political action. Art-historical practice itself has dispersed into a plurality of academic modes, just as the production of art has ceased to be readily definable as the making of a certain kind of thing.

Approaches

The variety of art-historical practice that has developed during the later part of the twentieth century poses great problems for any synoptic volume on the history of art. It is impossible for practical reasons to treat each of the episodes from all the possible standpoints, and the various authors (51 in number) inevitably hold a variety of views as to what the priorities should be in the writing of the history of art. However, the framework devised by myself as editor not only established the territories to be explored by each author, the modular structure of text and picture spreads, and the relative space assigned to each topic, but also signalled the themes that were to be borne in mind. A series of themes were designated as warranting attention, in addition to traditional concerns of stylistic development, functions, content, and modes of expression. The 'flagged' issues were: written evidence, physical contexts, patronage, viewing and reception, techniques, gender issues, centres and peripheries, racial issues, media and condition, the notion of 'art', and current presentations. The editor provided a provisional assessment of the significance of these issues for each section, but left the authors free to take informed decisions about the validity and relevance of the categories. The diverse approaches within the controlled framework reflect in a variety of ways the character of the periods (not least the nature of the surviving evidence) and the individual emphases of the authors. No general attempt has been made by the editor to suppress the variety, since any rounded introduction to the rich tapestry of artistic production over the ages and to the way it responds to different lines of enquiry requires a judicious balance between the imposition of editorial order and the releasing of authorial initiative.

It is my conviction that no single approach has a unique claim to rightness. Each approach, at its best, exhibits its own kind of competence and relevance. For example, a perceptive social analysis produces answers valid within the social area, while stylistic analysis draws attention to an important characteristic that explains how works from different artists, periods, and places look different from each other. Each approach highlights its own kind of relevant evidence. However, the ecumenical stance espoused here does not mean that anything goes. The book, particularly its overall appearance, is founded on my conviction that the centre of the history of art depends upon the analysis of what is irreducibly visual about artefacts. Each surviving work does not present any absolutely stable appearance, either optically or conceptually—an altarpiece, for example, looks different in a church than in an art gallery—but the reconstruction of the historical situation within which it came into being and was viewed, coupled with an understanding of how it may have been relocated and re-interpreted, does I believe provide access to a robust core of visual communication which operates across cultural boundaries. This core corresponds to what we generally mean by 'art', while the massively transformed vehicles and roadways provide the basis for its 'history'. MK

1 The Foundations
Greece and Rome
*c.*600 BC–AD 410

The most substantial artistic legacy from antiquity survives in the form of sculpture, particularly in marble, and it is Roman stone sculpture that best preserves the appearance of the many lost masterpieces of Greek sculpture in both marble and bronze. The sections on sculpture in Greece and Rome therefore provide the cornerstones of this first part of the book, supplemented significantly by a discussion of the literary accounts which tell of the works of the ancient masters and record something of the framework of theory which endowed Greek art with its intellectual aura.

Greek pictorial art, much lauded in the written sources but now virtually unknown in surviving examples, is most substantially represented by vase painting, which shared elements in common with larger-scale painting but also followed its own precepts. For Roman painting and mosaics, we are fortunate to have benefited from the revelations provided by the excavations at Pompeii, Herculaneum, and other locations buried during the eruption of Mt. Vesuvius in AD 79.

The extensive reach of the cultures of Greece and Rome, geographical and chronological, provides the basis for sections on the diffusion of the Greek style outside Greece, and for a review of how the classical ideal has struck recurrent chords in Western cultures, even in the twentieth century—recognizing that any critical review of ancient art is inevitably as much about how it has been and can be reconstructed as an analysis of what remains.

Themes

The ancient Mediterranean world involved more than Greece and Rome, yet these two civilizations produced the major written and visual legacies to which subsequent Western cultures repeatedly referred—in larger or smaller measure, and in a spirit of admiring emulation or critical reaction.

The traditional story of the gradual freeing of ancient art from the hierarchical formulas of Egyptian painting and sculpture and its progressively more naturalistic portrayal of the human body—albeit in apparently idealized modes—still serves as an obvious description of the central trend in those large-scale figurative works that have survived. However, this monolithic story of stylistic evolution does no justice to the way that form and content responded to varied demands made of imagery by different publics at various times and in diverse settings. And it certainly should not be taken as *inevitable*—as somehow predetermined in such a way that each work is seen as a step on an inexorable road. Nor can such a story accommodate the particular and varied nature of Roman art, which, for all its imitation of Greek models, responded in a variety of ways to particular functions for images in the context of Republican, Imperial, religious, and domestic societies.

In retrospect, it was the 'ideal' or 'classicizing' quality of ancient art that attracted admiration. However, what with hindsight might appear idealized may well have appeared at the time to be supremely 'true to nature', according to whatever conception of 'nature' was operative. It is nonetheless apparent that the portrayal of the human figure in marble or bronze at life size or larger was largely devoted to the cultivation of bodily qualities of beauty, grace, strength, and athleticism of exemplary kinds, particularly with respect to the male physique. Whereas there is no secure way to demonstrate that a greater proportion of Greek or Roman men were predominantly homosexual than in present-day societies, a cult of male pleasure in male beauty found expression in a more extensive and open way than was tolerated in the imagery of later Christian cultures.

In tempering the standard perception of the portrayal of the human figure as the central achievement of the period, we need to be alert to a wide range of other imagery, which is substantially lost, and when it survives is likely to be accorded a lesser rank. The achievements of Greek painting in a variety of genres, including narratives, allegories and landscape, are only incompletely discernible through literary accounts and later echoes in such Roman paintings as have been excavated. Greek vase design does provide access to particular achievements in pictorial imagery, but we cannot confidently read in it all the achievements of large-scale, independent painting. However, the fact that we do have written accounts of lost works, know of such supreme masters as Zeuxis and Apelles, and understand something of the aspirations of artists and viewers, is the result of the rise of a genre that was to be as influential as the art itself, namely the art of writing about art. MK

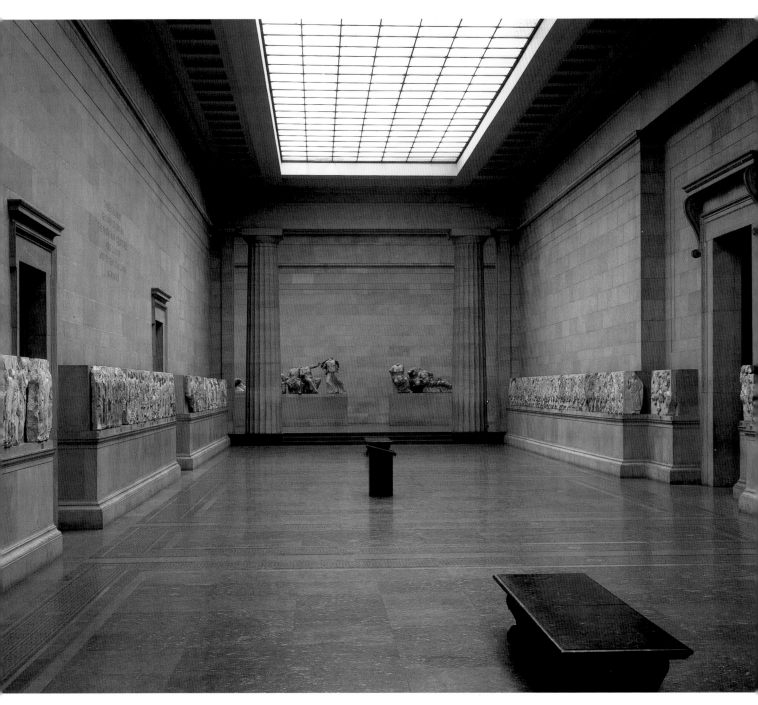

1 The 'Elgin Marbles' from the Parthenon in Athens (fifth century BC), London, British Museum, Duveen Room

Greek Sculpture

Most Greek (and Roman) sculpture is lost for ever. The triumph of Christianity, Rome's collapse in AD 410, and Byzantine iconoclasm eliminated the art's major constituencies, and its pagan subject-matter became increasingly offensive to many. Worse still, its major media were all intrinsically valuable. Gold, silver, and ivory statues quickly vanished; bronzes were recycled into weapons and implements; and marbles were burned into lime for mortar. Thus, for example, of the hundreds of thousands of Greek bronze statues, only three dozen survive [**4, 6, 16**].

Recovery of these remains began during the Renaissance, with excavations in and around Rome and the formation of the first antiquities collections. Editions of the major ancient sources, the encyclopaedist Pliny the Elder (AD 23–79) and the traveller Pausanias (c.AD 170), followed apace. Yet the art's first true history only appeared in 1764; its author, Johann Joachim Winckelmann (1717–68), was an Enlightenment genius who contextualized it in a manner deeply imbricated with his own homoerotic outlook. Others soon began to distinguish Greek originals from Roman copies [**5, 8, 14, 18**]; to identify masterpieces mentioned by ancient writers [**5, 8, 14**]; to publish collections of types; and to investigate problems like polychromy and nakedness. The nineteenth century brought excavations at Athens, Olympia, Delphi, Pergamum, and elsewhere; photographically illustrated *corpora* of gravestones, portraits, and the like [**12, 18**]; museum catalogues; systematic compendia of the sources; and two modern, scholarly histories by Heinrich Brunn (1853) and Adolph Furtwängler (1893).

Twentieth-century scholars have widened the inquiry. Current work ranges from the traditional (including restudy of the vast, often unpublished legacy of the great excavations) to radical reinterpretation of major monuments and engagement with semiotics, gender studies, and other contemporary concerns. Recent opinion is shifting from an optimistic nineteenth-century positivism to a postmodernist scepticism that sees more problems than answers. It questions the Greek origin of many types known in Roman copy; the ancient sources' evidentiary value; the viability of the 'attribution game'; and even the existence of artistic personalities in the post-Renaissance sense.

Definitions

Greek sculpture is surprisingly hard to define. Although one immediately thinks of monumental marbles like the Parthenon sculptures [**1, 2**] and bronzes like those from Riace Marina [**4**], the art's horizons are much broader. Statuettes and plaques in precious metals, bronze, ivory, wood, and terracotta; furniture, utensils, and jewellery with animal or human embellishments; even coin images—all are technically sculpture, and beg for consideration.

Nor is Greek terminology helpful, for many words overlap and several shifted meaning over the centuries. *Agalma*, 'delight', is a good example. At first comprising temple statues, architectural sculpture, and any offerings that pleased the gods—statues, utensils, and live, sacrificial bulls(!) included—its compass gradually shrank until by c.300 BC it generally denoted only statues of gods or deified mortals. Furthermore, the Greeks had no word for 'sculptor', preferring to distinguish practitioners by medium or genre—for example, 'bronzesmith', 'stoneworker', or 'god-maker' (*agalmatopoios*). Clearly, these men had no special status *as artists*: theirs was a craft (*techne*) like carpentry or cooking. As one scholar comments, early Greeks judged all craftsmanship—sculpture included—like we judge cars, focusing on quality, stylishness, and glamour, admiring the 'splendid', 'beautiful', and 'wonderful to see'.

By 400 BC, however, some writers were exploring specifically representational issues like illusion and regarded leading artists as more than artisan-labourers (*banausoi*). Yet even when some sculptors achieved reputations for being uniquely gifted, became rich, received civic honours, and won important civic offices, old habits died hard. For regardless of their talent, they still worked with their hands and for others in what Aristotle called 'a kind of limited slavery'. Snobs could therefore still segregate them from their creations: as Plutarch remarked, no well-bred youth looking at the Zeus at Olympia (one of the Seven Wonders of the World) would want to be a Phidias, for admiring the work doesn't mean that you give its maker the time of day.

Yet Pliny and Pausanias, our two most informative sources, do treat monumental sculpture and painting and their practitioners as special, and other ancient critical writing tends to do the same. So their modern counterparts tend to leave the small bronzes, terracottas, and so on to the specialists—unless, of course, the monumental record is deficient, or these significantly enrich it.

Contexts

Greek sculpture was a creature of the independent city-state (*polis*), and never ceased to serve it even after Alexander the Great (reigned 336–323 BC) [**17**] massively expanded Greek horizons. Even then, when a sculptor signed his work abroad, he normally included his city's name (*ethnic*) alongside his father's (*patronymic*).

Though image-worship of some sort perhaps survived the upheavals of the twelfth–eleventh centuries BC, and some ritual

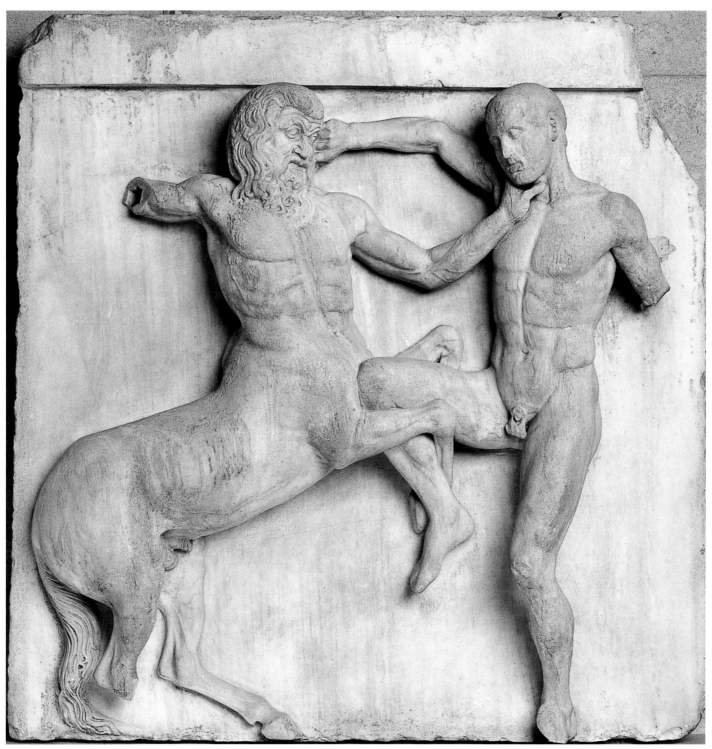

2 Workshop of Phidias (?) (*fl.* 470–430 BC), south metope 31 from the Parthenon on the Athenian Acropolis: Centaur and Lapith (447–442 BC), marble, 1.32 m. (52 in.) high, London, British Museum

use of figurines continued, Greek monumental sculpture begins in the eighth and seventh centuries, when polis culture was finally consolidating. Basically religious in function, it divides into broad subcategories: temple, votive, and funerary. Patrons range from the polis itself (temples and major votives) to individual members of the élite (votives and funerary sculpture). The great international sanctuaries at Delphi, Olympia, and Delos depended upon subsidies from the same clientele.

By the fifth century BC the art had spread across the Greek world, from the Black Sea colonies and those in Egypt and Libya to the Italian and Sicilian ones in the West. Repercussions are felt even further afield. Thus in Cyprus an unadventurous tradition

of Hellenizing limestone sculpture lasts until the Roman conquest; in Etruria, temple and votive sculpture in terracotta and bronze is similarly long-lived but startlingly expressive; and in Spain, recent discoveries have revealed an even more idiosyncratic version of the Archaic style in limestone.

As for types and genres, the earliest large-scale temples and the earliest cult-images must go together, for the former were houses for the latter. These mud-brick and wood buildings were too light to carry architectural sculpture, which first appears on

the limestone temple of Artemis on Corfu c.575 BC. This sculpture is also in limestone or (occasionally) terracotta, but marble becomes standard in the Aegean area by c.500 BC; thereafter, only the Western Greeks, lacking convenient marble quarries, continued to favour limestone [13]. Other buildings that soon came to carry architectural sculpture include treasuries [7] and stoas. Subjects are diverse: myths connected with cult and city appear alongside others that seem unrelated to either, though here our defective evidence may be to blame.

Greece's most extensive temple-building programme was instituted by the politician Pericles (c.495–429 BC) [18] at Athens, to repair the effects of the Persian sack of 480. Yet the project went far beyond mere reconstruction, aiming to turn the city into an 'education to Greece' and the worthy capital of a maritime empire. Its crown jewel was the Parthenon. From its 100-foot wide pediments showing Athena's birth and installation in Athens to Phidias' 40-foot high statue of her in its main cult room (a wooden colossus covered with gold drapery and ivory flesh), it was crammed with sculpture celebrating the goddess, her favourite city, and civilization's triumph over barbarism [7]. Though the Peloponnesian War broke out in 431 and Pericles died in 429, his programme continued for almost a generation, until Athens' surrender in 404.

The first marble funerary and votive statues, the so-called *kouroi* and *korai* [3, 11] begin c.625 BC, and marble votive reliefs and gravestones two generations later. Manufactured in great numbers, these registered the concerns, aspirations, and fantasies of the élite quite concretely: equating them with the 'best and brightest' of the heroes [3]; showing off their daughters [11]; and proclaiming their wealth, brilliance, and piety before deity and city. By c.500 BC the first properly secular genre had emerged, the Olympic victor-statue [6]. Part of the victor's prize, hollow-cast in bronze, and often accompanied by a publicly performed victory ode, these were sometimes dedicated to Zeus anyway, for propriety's sake.

Around 500 BC, too, the Athenians erected bronzes of the two men whose assassination of the tyrant Hippias' brother in 514 had opened the door to freedom. Soon bronze portraits of generals and politicians appeared in some cities, perhaps prompted by an enhanced sense of personal achievement and euphoria at the expulsion of the Persians [18]. Athens began to commission honorary bronzes of benefactors (generals, statesmen, intellectuals, even foreign potentates) in the fourth century BC, and soon many city-centres were crammed with them [16, 17].

Non-Greeks got into the act as early as c.500 BC. Persians and Lycians began to hire Greeks to produce work that ranged from pure Persian (at Persepolis) to almost pure Greek in style (at Xanthos). Yet the first occasion when a 'barbarian' commanded the best in Greek sculptural talent was when King Mausolus of Caria (reigned 377–353 BC) persuaded five or six leading sculptors to embellish his enormous tomb, the prototypical Mausoleum, at Halicarnassus. Sacrificial remains have been recovered from its foundations, and Mausolus' choice of themes placed him firmly among the heroes, if not the gods.

With Alexander's conquests came a new diaspora, new clients, and new genres. The clients included the kings themselves, and groups like philosophical schools and professional associations of traders and actors [15]. The new charismatic

ruler-portraits [17] were erected by a variety of patrons, from rulers to cities and individuals anxious to flatter them, even to the extent of paying them cult. Bronzes were the rule except in Egypt, where imported marble was popular and the native élite favoured hybrid Greco-Egyptian portraits in granite, diorite, and other hard stones. Bronzes of intellectuals [16] were commissioned by the philosophical schools, by individuals, and sometimes by cities grateful for their advice or educational skills. In the East, sculpture appears wherever new cities were founded, even as far as Ai Khanoum in northern Afghanistan, where some pieces prefigure Indian Ghandaran work, whose Greco-Roman roots are clear but whose exact origins have long been a mystery.

The Hellenistic kings were lavish patrons, enjoying ephemera like the statues displayed on floats in royal processions, or on royal barges. Of their more solid contributions, little has survived except at Pergamum. The dynasty's successes against invading Celts and others inspired many dedications, including battle-groups [8], portraits, temples, and even a library with a marble replica of Phidias' Athena Parthenos—a monument to culture rather than cult. The centrepiece was the Great Altar, whose extensive friezes celebrated the Gods' defeat of the Giants [10] and the life of the city's legendary founder, Telephos. Unfortunately, this lavish patronage ceased abruptly when the last king died in 133 BC, willing his kingdom to Rome.

Royal palaces and their grounds were also decorated with sculpture, and increasing affluence soon prompted some private individuals to follow suit. Yet the sculpture-rich houses of second-century Delos are the exception, for its Levantines, Asiatics, and Italians grown rich off slavery and other business had little use for old inhibitions. Even so, much of this work was still nominally religious, being placed in shrine-like niches and occasionally dedicated to particular divinities [15]. The same clientele sustained a flourishing portrait industry, whose hard-boiled colossi [19] break decisively with traditional norms.

The Romans began to loot Greek sculpture in the third century BC as they expanded into south Italy and Sicily, celebrating their successes by embellishing their capital with temples, victory-dedications, and their own portraits. By 200 BC they had moved into Greece itself, and Greek sculptors appear in Rome shortly thereafter—though looting continued apace [16]. Importation of decorative sculpture began by c.100 BC, as wealthy Romans eager for the trappings of Hellenism sought to deck out their town houses and villas with the best that money could buy. These reproductions of earlier masterpieces [14, 18] soon became many Greek workshops' staple fare.

Aims

Commemorative, celebratory, and supplicatory in function, Greek sculpture echoed the poets' enthusiasm for praise and blame. Like the Greek poets, sculptors could idealize gods and heroes with breathtaking artistry or they could demonize the wicked at will.

Yet if one had asked a Greek sculptor what he really aimed at, he would probably have replied, 'beauty' (*to kalon*). Some went further. The most 'scientific' of all, Polyclitus of Argos (*fl.* 460–410 BC), began his treatise or *Kanon* ('The Rule') with the words, 'Perfection comes about little by little through many numbers.' His terminology, taken from contemporary

philosophy, signals the absolutism of his claims. Perfect beauty, he argued, can only come about through the exact commensurability (*symmetria*) of every limb and feature to every other. Exemplified by his bronze Doryphoros or 'Spearbearer' [**5**], his proportional canon marked the summit of idealism in Greek art, projected upon that most powerful of all Greek images, the warrior.

This obsession with proportion had begun with the Doryphoros' ancestors, the *kouroi* [**3**], which were planned on an Egyptian-style grid. Yet Egyptian and Greek aims in sculpture were fundamentally different. While both transformed a practical design aid into a tool of prescriptive anthropometry, and so of replication, the Egyptian canon was imposed from above. It encoded a world-view that was simultaneously anonymous, authoritative ('spoken by the ancestors'), infinitely replicable, and uniquely Egyptian. All of this put its privileged trustee—the sculptor charged with preserving and disseminating it—into a quite paradoxical position. For immediately he took up his measuring-rod and chisel he immediately became its hapless slave as well. Greek canons, on the other hand, were individual, experimental, and seldom replicated outside the sculptor's own workshop or following. They served his own and his immediate clients' fantasy of 'the most beautiful'.

This fantasy was no disinterested Apolline affair. Projected upon the naked *male* body, the canon represented the first step towards the sculptor's ultimate goal: to seduce the eye of the normative spectator, the citizen male. Winckelmann was right: this art was fundamentally homoerotic. Although the origins of Greek nakedness in both art and athletics are obscure, its *effects* are clear: whether *kouros* or athlete, hero or god [**3–6**], these beautifully proportioned, poised, and finished bodies spoke eloquently to a culture in which homoerotic desires were given freer reign than in later eras. The Greek sculptor's dedication to naturalism, his obsessive investigation of the male body's minutiae, exploited this unrestricted climate.

Though no one is recorded to have authored a canon for the naked *female* body, measurement of the Roman copies of the Knidia [**14**] indicates that Praxiteles (*fl.* 375–325 BC), at least, must have developed one. Though his predecessors were not immune to female charms [**11–13**], this was the first monumental naked Aphrodite, caught unawares as if by a voyeur, her sex-appeal enhanced by devices ranging from the modesty of her posture and gesture to Praxiteles' use of the finest crystalline marble for her body and the subtlest polychromy for her skin. Hitherto restricted to rape victims and other females in liminal or compromising situations, the female nude [**15**] soon became second only to the male in popularity—though in Greece, decorum mandated that the nude was never used for female portraits.

Development

Textbooks usually present Greek sculpture as developing serenely from stiff to relaxed and from schematic to natural. This view comes from Roman literature via Winckelmann, and there

is some truth to it. As long as one does not see the changes as deterministic (a conscious drive to realism), uniform, and prescriptive in the particular case, this model offers a reasonable approximation to reality.

Living in a culture acutely aware of life's instability, Archaic sculpture (*c.*625–480 BC) creates schemata or formulae to regulate the flux of life—bodies, their features, and (where appropriate) their dress. Certain locales swiftly develop their own local norms, devising different standards of proportion, contour, and modelling which may develop little throughout the period [**3**, **11**]. Catering to a very Greek disposition to regard beauty as specific and the glance as particularizing, sculptors tend to elaborate formulae to the point of over-determination. By *c.*500 BC, one senses a growing clash between inherited formula and direct observation, between the authority of stereotypes like the *kouros* with his fixed smile and sleep-walker stride, and narration, or at least action, which to be convincing requires some fluidity of movement and freedom from convention [**7**].

Classical sculpture (*c.*480–330 BC) may or may not be the child of the Persian Wars, though the Persian sack of Athens required that city, at least, to make a fresh start. Sculptors now seek consistency, clarity, and the supremacy of formal design, putting the whole before the part. Smiles give way to a neutral expression suitable for any occasion and easily illuminated by expressive gesture or posture—now formalized into a co-ordinated and antithetical response of engaged and relaxed limbs named, after its Renaissance successor, *contrapposto*. After an early, 'Severe' phase [**4**, **9**], the Parthenon (447–432 BC) inaugurates the full classical [**2**], presumably under Phidias' direction, along with Polyclitus' Doryphoros (*c.*440 BC) [**5**]. A 'Rich' phase follows: postures relax, expressions intensify, flesh softens, and drapery becomes transparent and flamboyantly independent of the body [**12**, **13**]. Finally, around 350 BC, Praxiteles of Athens, Skopas of Paros (the Mausoleum's leading master), and Lysippos of Sikyon (Alexander's court portraitist) each create a new synthesis that codifies and exploits the 'Rich' style's exploration of femininity, emotion, and elegance under the guise of enhanced realism [**6**, **14**].

The transition to Hellenistic sculpture (*c.*330–30 BC) is marked by no sharp break corresponding to that of *c.*480 BC. Praxiteles, Skopas, Lysippos, and their contemporaries had laid the foundations, and Alexander's conquests soon did the rest. Across-the-board stylistic development vanishes and genre-styles become the norm: the Lysippic for athletes [**6**]; the Lysippic or Attic for ruler-portraits [**17**]; the Attic alone for philosophers [**16**]; and the Phidian and Praxitelean for divinities [**15**]. A 'baroque' style of emotional excitation and rhetorical hyperbole, also prefigured in the fourth century BC, finds its fullest expression at Pergamum, in celebration of its triumphs over the invading Celts [**8**, **10**]. Finally, a new 'hard-boiled' style emerges for portraits of Italians [**19**], while decorative sculpture for the same clientele is often neoclassic [**14**, **18**]. AS

15

The male nude

The male nude was Greek sculpture's central genre, just as the citizen male himself was the polis's master, model, and microcosm. Its development begins with the *kouros* [3]: young, autonomous, beautiful, and happy—and visually seductive. This *kouros* memorializes Kroisos, whom 'raging Ares destroyed one day, fighting in the foremost ranks'—the most glorious

end the polis could envisage. Later sculpture differentiates the type and exploits a new technique: hollow-cast bronze. Riace Warrior A [4] is a hero: an Agamemnon or Diomedes? Once bearing shield, spear, and perhaps helmet too, massively muscled and intimidating, he turns to address a companion. His lips are coppered, teeth silvered, and eyes inlaid to intensify the effect. Polyclitus' bronze Doryphoros [5] is only known in

copy, from which this careful reconstruction was made in 1921. The perfectly measured man, he is a mesomorph whose behaviour is as calculated as his physique: an ethical standard for the classical polis. He perhaps represented Achilles, the 'best of the Achaeans' who fought at Troy. Finally, the Getty bronze [6], an Olympic victor fingering his crown of olive. His slim body and smaller head are Lysippic, increasing his elegance

and apparent height. His face is portrait-like and he gazes out into space, a proud professional echoing the self-assertive Kroisos [3] and Riace Warrior A [4].

AS

16

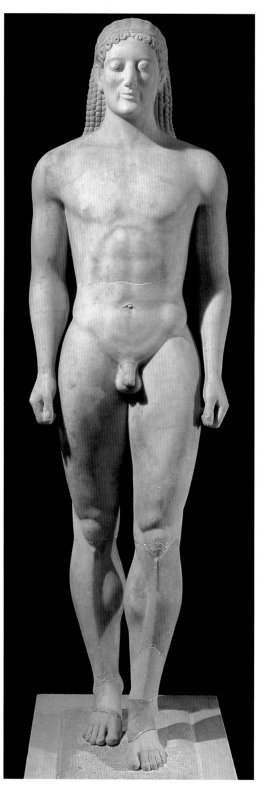

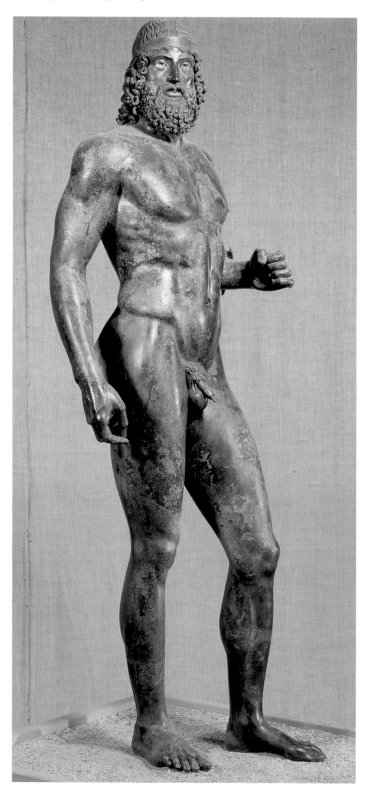

3 Right: *Kouros* from Finikia (Attica), commemorating the dead Kroisos (*c.*540 BC), marble, 1.94 m. (76½ in.) high, Athens, National Museum

4 Far right: Warrior A from the sea off Riace Marina, Italy (*c.*450 BC), bronze, with bone, glass paste, silver, and copper inlay, 1.98 m. (78 in.) high, Reggio di Calabria, Museo Nazionale

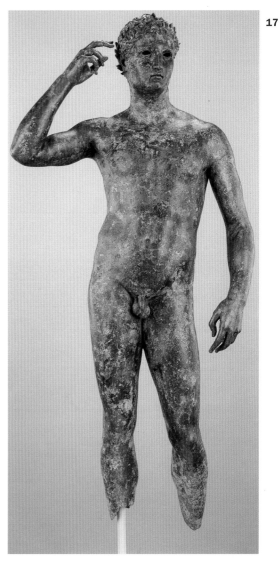

6 Right: Follower of Lysippos (*fl.* 390–320 BC), Olympic victor (*c.*300 BC), bronze, preserved 1.51 m. (59½ in.) high, Malibu, J. Paul Getty Museum

5 Left: Georg Roemer, after Polyclitus of Argos (*fl.* 460–420 BC), reconstruction of the Doryphoros or Spearbearer (1921, after Roman copies of the original of *c.*440 BC), bronze, 2.12 m. (83½ in.) high, formerly Munich University, destroyed in 1944

Hybris and nemesis

The victory of *nemesis* (retribution) over *hybris* (arrogance) was a staple of Greek sculpture. It embellished many buildings, cast in a narrative mode that was representationally more experimental and advanced than the male nude's [3–6]. The Siphnian Treasury frieze [7] shows the Gods defeating the Giants, and the Aphaia Temple's east pediment [9] Heracles and the local hero Telamon sacking Troy. The Giants, whose uncontrollable desires led them to storm Olympos, are characterized as mere mortals by their phalanx formation, while the Trojan, shot in the chest, slumps grimacing in a death-agony, his eyes closing, his strength failing, his muscles relaxing, his heart pumping its last through his veins. The Parthenon metope [2] shows another *hybristes*, the Centaur, locked in mortal combat with a Lapith—an image inspired by contemporary wrestling holds. In the Hellenistic period these transgressors were joined by the Celts, whose ferocity led the Greeks to demonize them as the ultimate Other. A Celtic trumpeter [8] from a Pergamene victory monument slumps to the ground like [9], blood (originally rendered in copper) pouring from his chest. Yet his frame lacks the other's rational structure (contrast 3–6), his flesh is leathery, and his face and hair coarse 'like a satyr's or Pan's'—beings of legendary incontinence [15]. Finally, the Great Altar [10] celebrates Pergamene triumphs by resurrecting the Gigantomachy in an operaticizing, 'baroque' mode. Giants are now hideous hybrids, with snaky legs, wings, and sometimes animal bodies—deviants to be exterminated at all costs. AS

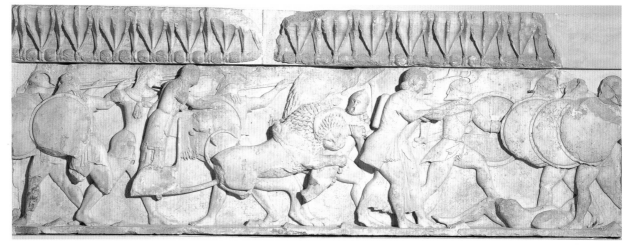

7 Right: Perhaps Aristion of Paros, Gigantomachy frieze from the Siphnian Treasury at Delphi: Dionysus, Themis, Apollo, and Artemis fight the Giants (*c*.525 BC), marble, 64 cm. (25⅕ in.) high, Delphi Museum

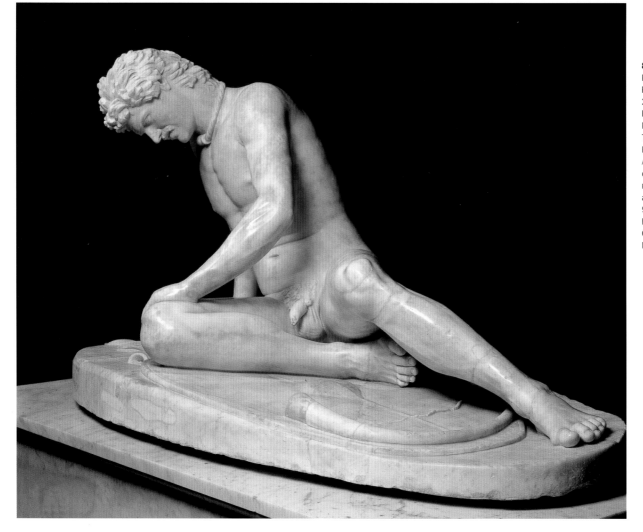

8 Left: After Epigonos of Pergamum (*fl.* 230–200 BC), Roman copy of a Dying Celtic Trumpeter, from Rome (*c*.50 BC–AD 50, after an original of *c*.225 BC), marble after an original bronze, 93 cm. (36½ in.) high, Rome, Capitoline Museums

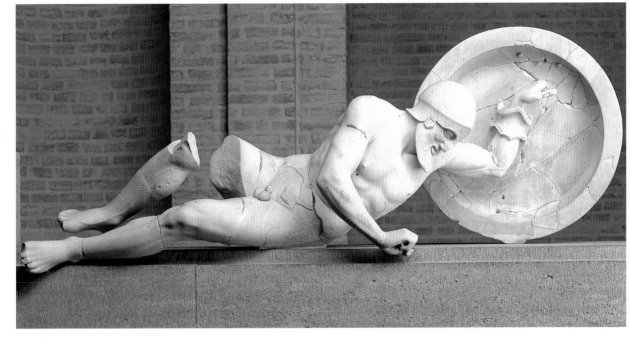

9 Trojan warrior from the east pediment of the Temple of Aphaia at Aegina (*c*.475 BC), marble, 1.85 m. (73 in.) long, Munich, Staatliche Antikensammlung und Glyptothek

10 Below: Gigantomachy frieze of the Great Altar of Pergamum: the triple-bodied Hecate and Artemis fight the Giants (*c*.160 BC), marble, 2.28 m. (89½ in.) high, Berlin, Pergamon-museum

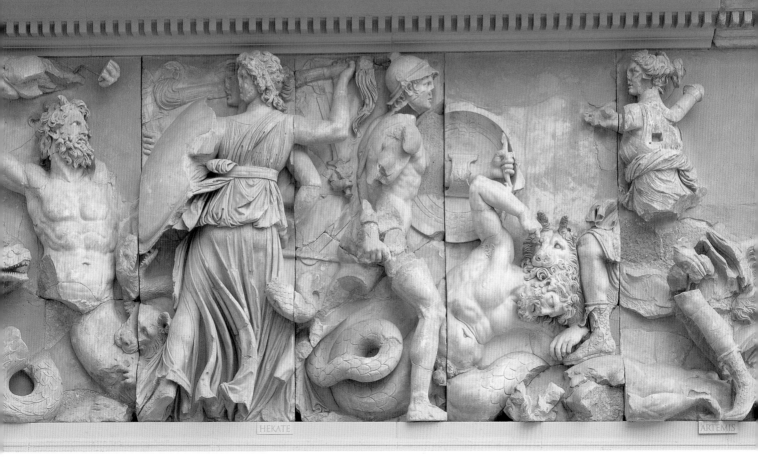

HEKATE · ARTEMIS

Women and goddesses

These images are less straightforward than the men's, since polis culture regarded women as 'unfinished' men and constrained them by strict behavioural codes; goddesses, however, were autonomous and all-powerful. The gorgeously attired *kore* [11] stands with slightly downcast eyes, offering Athena an apple: a virgin votive to a virgin goddess. Yet her body is a mutated man's, and a century later the sculptor of the windswept, self-confident, and authoritative Getty goddess [13] would do no better. (Her extremities are of imported marble, and her limestone drapery was coloured in red, blue, and green; her head-covering is now lost.) Hegeso [12], decidedly more feminine, is a demure Athenian lady attended by her slavegirl. Her head-covering symbolizes her chastity, while her transparent drapery somewhat paradoxically puts her body on display for the spectator—announcing that her husband had the most desirable wife in Athens. In his Knidian Aphrodite [14], shown after her bath, Praxiteles logically concluded that since the essence of the love-goddess was her body, and his business was to reveal essences, then it had to be revealed. Yet being a goddess, she still had to maintain her distance: hence the ethereal S-curve that suffuses her body, her dreamy, sideways glance, and her instinctively modest gesture, artfully constructing the worshipper as voyeur. The 'Slipper-slapper' [15], on the other hand, dedicated by a Lebanese merchant to his Native Gods, playfully and somewhat coarsely burlesques the whole subject.

AS

20

11 *Kore* from the Athenian Acropolis (*c*.520 BC), marble, preserved 1.14 m. (45 in.) high, Athens, Acropolis Museum

12 Gravestone of Hegeso daughter of Proxenos, from Athens (*c*.400 BC), marble, 1.58 m. (62¼ in.) high, Athens, National Museum

13 Opposite, left: Colossal goddess from south Italy or Sicily (*c*.400 BC), limestone with marble head, arms, and feet, 2.37 m. (7 ft. 9½ in.) high, Malibu, J. Paul Getty Museum

14 Opposite, top right: After Praxiteles of Athens (*fl*. 375–325 BC), Roman copy at reduced scale of the Aphrodite of Knidos (*c*.50 BC–AD 50, after the original of *c*.350 BC), marble, 1.65 m. (65 in.) high, Munich, Staatliche Antikensammlung und Glyptothek

15 Opposite, bottom right: Aphrodite, Pan, and Eros, dedicated by Dionysios of Berytos (Beirut) in the Clubhouse of the Poseidoniasts (shippers and traders) on Delos (*c*.100 BC), marble, 1.32 m. (52 in.) high, Athens, National Museum

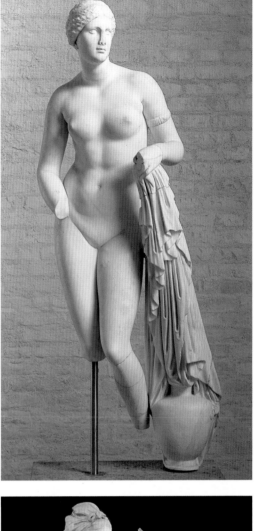

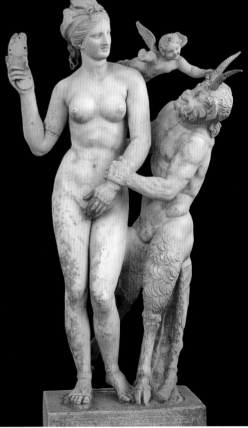

Portraits

Greek portraiture begins in the fifth century BC, singling out pre-eminent individuals for representation as exemplary citizens.

Kresilas' Pericles [18], probably dedicated posthumously on the Acropolis by his sons, supplements the physiognomy of the typical, bearded, mature citizen male with a helmet that identifies him as a general (*strategos*), the elected office that underpinned his political supremacy. His body was probably a slighter version of Riace A's [4], furnished with cloak and spear.

Alexander [17], on the other hand, is a golden youth, a second Achilles out to make the world anew. His glorious mane of hair proclaims him a lion among men; his intense gaze sweeps horizons as yet unconquered; and his idealized physiognomy suggests a god on earth. He was also probably shown naked, striding forward with the spear that symbolized his rule by right of conquest.

Against all this, the piercing intellect of the old philosopher [16] burns with existential doubt; his face is a map of experience, and his shabby cloak (fragmentary and not shown) proclaims his contempt for worldly things.

Finally, the brash Italian businessman [19] hijacks the genre to proclaim his own superiority, based on Rome's unassailable power and his own commercial acumen. AS

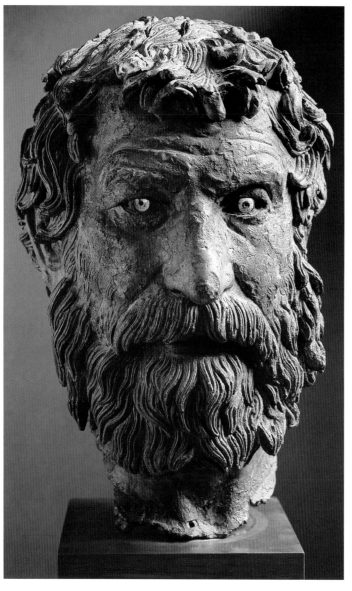

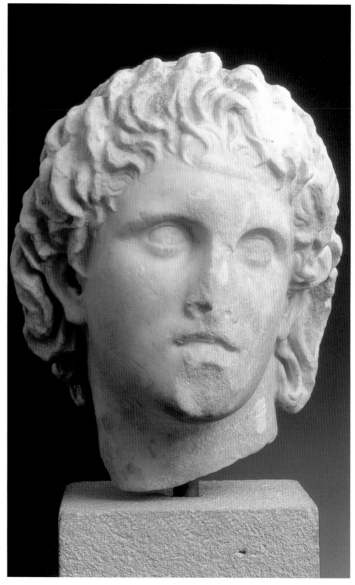

16 Above left: Philosopher from a late Hellenistic wreck off Antikythera (*c*.200 BC), bronze with copper, enamel (?), and white stone or paste inlay, 29 cm. (11½ in.) high, Athens, National Museum

17 Above: Portrait of Alexander the Great, from Yannitsa, Macedonia (*c*.300–275 BC), marble, 30 cm. (11¾ in.) high, Pella Museum

18 Opposite, left: After Kresilas of Kydonia (*fl.* 440–400 BC), Roman copy (2nd century AD) of a portrait of Pericles, from Lesbos (*c*.425 BC), marble (original bronze), 54 cm. (20½ in.) high, Berlin, Staatliche Museen

19 Opposite, right: Colossal portrait of an Italian businessman, from Delos (*c*.100 BC), marble, 2.55 m. (8 ft. 4½ in.) high, Athens, National Museum

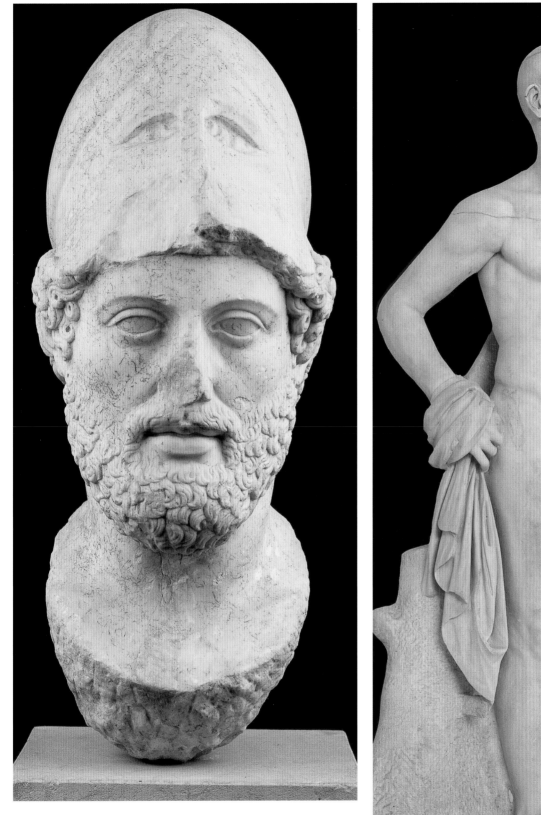

Greek Pictorial Arts

The world of Classical Greece was visually rich and colourful. Vivid reds and blues vied with dazzling white marble on temples, and statuary boasted garments enlivened with painted figures to mimic weaving or embroidery. Public buildings contained great murals and everyday lives were enriched with pictorial images decorating everything from household crockery to plaques of wood, clay, stone, and metal. Today, however, the pictorial arts are under-represented because of the fragility of most two-dimensional media that range from cloth, leather, and wood to friable stuccoed surfaces. Written testimony can rescue a part of what is missing, figured pottery supplies at least a basis for discussion, and ongoing excavations are doing their part to augment the record.

Ceramic vases provide a chronological continuity for figured imagery throughout much of Greek history. The earliest phases of pictorial art in the so-called Geometric period (c.900–700 BC) are dominated by scenes initially involving simple animal motifs against a background of geometric motifs on vases of different shapes and sizes. The introduction of human figures into the repertoire marks a significant step. Thereafter, much iconography focuses on funerary preparations and warriors whose activities were to suggest those of the deceased [20]. Increasingly entering the vase painters' repertoire, however, are what seem to be mythological scenes derived from the heroic epic cycles circulating at the time. This new interest, nourished surely by aristocratic concerns, was shared by other craftsmen, witness the series of bronze fibulae with engraved catchplates that feature scenes ranging from possible illustrations of Trojan War episodes to the feats of Heracles [21]. Critical in these developments was a growing interaction with the sophisticated cultures of the East through direct contact with the Phoenicians and Syrians. Imports ranging from raw materials and technical know-how to finished goods like jewellery and ivory (to say nothing of the introduction of the alphabet) encouraged the burgeoning local industry and its supporting clientele.

The eighth century BC also saw the beginning of a long tradition of clay votive plaques with painted representations, both mythological and heroic. A sixth-century BC plaque, though funerary in nature, represents the medium in later times [23]. Wooden plaques must have existed as well though they are only known from isolated later examples [22]. Then too, it is possible that story-telling 'tapestries', the counterparts to burial cloths woven by Penelope and other Homeric heroines, graced the walls of the élites. A Classical descendant comes from the Crimea [30].

Developments internally and externally continued apace in the seventh century BC. These include the growth in local 'city-states' of leadership under single individuals known as 'tyrants' whose artistic patronage can be assumed if not always adequately documented.

Pictorially, the story-telling interests of craftsmen expanded as the epic and mythological repertoire was explored. Attention to detail led to elaboration of figure style. Towards the end of the seventh century BC, large-scale painting first appears in the form of painted metopes with mythological themes. Mural painting may also have its beginnings in this era if scrappy bits of polychrome stucco and limestone blocks incised with preliminary sketch lines are correctly interpreted. If so, they may be part of the same phenomenon that produced the first colossal stone *kouroi* and *korai* [3, 11].

The sixth century BC provides a rather more coherent basis for discussion. Herodotus (c.484–c.420 BC) must have seen the painting he describes in the sanctuary of Hera at Samos, a dedication by the Samian engineer Mandrocles. Noteworthy is its depiction of historical reality: a bridge at the Bosphorus built by the donor in 512 for the Persian King Darius I (d. 486 BC). Anatolia (covering much of today's Turkey) had an age-old tradition of wall painting, and it is not surprising to find early evidence of the craft on the eastern borders of the Greek world. Indeed, wall paintings in Archaic tombs have survived in western Anatolia and give vivid testimony to the cultural interchange existing between Ionian Greeks and their eastern neighbours [7].

Meanwhile, panel paintings document current trends in Greece itself. Surviving artefacts in clay, bronze, stone, and wood indicate their importance. Their uses were either votive or funerary with iconography adjusted accordingly. Leading producers were Corinth and Athens. Thus a rare surviving polychrome plaque from the Corinthia shows pious dedicants approaching an altar [22]. It may be compared to the lamentation on an Athenian clay funerary plaque in black-figure technique, characterized by its use of incision with white and occasional purple for details [23]. Noteworthy are the painted inscriptions on the wooden plaque that include dedicants and apparently the craftsman's name, now missing, as well. Such signing, appearing sporadically since the late eighth century BC, is a phenomenon seen intermittently in the pictorial arts through the centuries. Two later mosaics illustrate this [29, 31].

The Classical period, embracing the years between the defeat of the Persians in 479 BC and the death of Alexander the Great in 323 BC, is a high point in Greek history, clearly manifested in the visual arts as well as through the corpus of poetic and dramatic works. Athens, whose imperialistic ambitions are well represented by the iconic Parthenon, fostered

a climate conducive to the highest quality in the arts. State patronage, already strong in the Archaic period under the 'tyrants', continued to flourish in the new-found democracy.

Athenian vase painters of the fifth century BC, having now abandoned the outline-and-incision technique of black-figure seen on the funerary plaque [23], embraced the subtleties offered by red-figure achieved by brush strokes alone [25]. They even experimented with white-ground which, though physically unstable, offered a truly painterly 'canvas' [26]. A closely related effect is found on a nearly contemporary ivory plaque [24]. Similarly, the engraver, probably an Athenian, who produced a silver gold-figure phiale [27] was also familiar with developments in figured pottery. In any case, the Athenian vase-painting industry fully dominated the market with customers like Etruscans and Thracians eager to buy. Subject-matter continued to focus on the gods but certain religious, athletic, and domestic scenes entered in as well. New is a growing interest, shared across media, in the world of women [24].

The tradition of painting votive panels clearly continued, though few survive. Dramatists refer to them, they appear in vase paintings, and one is painted hanging on a tree on the so-called Tomb of Philip [28]. A fifth-century innovation was the figural decoration of mosaics in carpet-like floorings for both public and, increasingly, private buildings. The craft, utilizing natural pebbles with the occasional addition of lead, glass, and even paint, was to reach an artistic high point in the later fourth century BC [31]. Though mythological scenes were favoured, some—like the stag hunt from Pella—may represent mortals in heroic pursuits.

Figured textiles emerge again in the written record. Dramatists like Euripides (d. 406 BC) let fabrics crowded with mythological images play pivotal stage roles. The worth of these fabrics assured them a place in temple treasuries along with objects of intrinsic value like gold and silver. A fourth-century burial cloth embellished with mythological stories is a rare survivor from the Crimea [30].

Written sources also help gauge the role that monumental wall painting played in public life. Critical to our understanding are the extensive descriptions by the inveterate travel-writer Pausanias (fl. c.AD 150). Thanks to his personal observations at places like Athens and Delphi, painters like Polygnotos and Mikon become more than mere names. From Pausanias' figure-by-figure accounts we learn that subject-matter ranged from predictable renditions of the Trojan War to real historical battles. Together with their sculptured counterparts on temples and other public places, such paintings clearly reflect a demand for programmatic themes that celebrated the optimistic mood of the Athenians in their 'Golden Age'. Innovative uses of space and narrative techniques are among the novelties that emerge from Pausanias' chronicle. Certain contemporary vase painters may reflect the distinctive up-and-down placement of figures in the frieze [25], but attempted reconstructions of the missing murals on this evidence remain conjectural.

Recovery of wall paintings from the public domain is rather unlikely. In recompense, however, paintings survive from areas like Macedonia that buried their dead in built funerary chambers. Themes range from the abduction of Persephone by Hades [32] to heroic scenes that may relate to real-life activities like hunting on the so-called Tomb of Philip [28]. Panel paintings, some of which eventually made their way westward with the Roman conquest (168 BC), must have decorated the Macedonian palace at Pella, now preserved only in its foundations. By the same token, those aristocratic houses at Pella that boasted elaborate floor mosaics [31] most likely had portable paintings and maybe 'tapestries' on their walls as well.

During the fourth century BC Macedonia rose to global fame and fortune under Philip and his mercurial son Alexander the Great. The arts flourished under courtly patronage which set the stage for the whole Hellenistic period. A taste for the ornate encouraged a preference for relief wares whose plasticity added dramatic qualities only suggested in two-dimensional media. Yet the popularity of mosaics and paintings must have continued unabated though the record of recovery is sparse and intermittent.

After Alexander's death in 323 BC his unwieldy empire splintered into kingdoms ruled by one or another of his fractious generals. Hellenic art was thus dispersed over wide territories, though how it fused with local traditions varied under differing circumstances. One of the paths of artistic development may be traced in Egypt under Ptolemy I (367/6–282 BC) and his descendants through Cleopatra VII (69–30 BC) and the arrival of the Romans. Among Ptolemaic pictorial arts there are funerary paintings indebted to Macedonian heritage, but top quality is best preserved in mosaics. Outstanding among them is a signed floor mosaic of a female, possibly copied from an earlier wall painting, often identified as Queen Berenice II (c.273–221 BC) or, alternatively, as the personification of Alexandria [29]. Stylistically, it is basically Greek, though the great rounded eyes add an age-old Egyptian characteristic. Technically, Sophilos worked with tiny cut stone, glass, and faience *tesserae* in what is known as *opus vermiculatum*, a Hellenistic contribution to the craft first encountered in Alexandria. Rapidly embraced for its superior pictorial qualities, this innovation changed the medium profoundly. SGM

Death, life, and the gods

Issues of life and death were major preoccupations in antiquity. So too were relations with the gods whose control seemed absolute, especially to early Greeks living in an uncertain world threatened by unseen powers.

The dead were honoured with carefully controlled rituals that varied over time and space. In Attica, early customs among the élite dictated forms of visual remembrance that are well embodied in monumental funerary vessels used to mark the burial spot [20]. On these vases scenes involving burial preparations are surrounded by representations of warriors and battles by land or at sea. Whether or not such heroic depictions reflected actual activities of the deceased, they served to

21 Right: Detail of Boeotian fibula or safety-pin, possibly Heracles and the Moliones (*c.*700–675 BC), engraved bronze, catchplate 6 cm. (2⅓ in.) high, Athens, National Museum

20 Below: Attributed to the Dipylon Master, fragmentary Attic Late Geometric crater (*c.*750 BC), paint on clay, 58 cm. (1 ft. 11 in.) high, Paris, Louvre

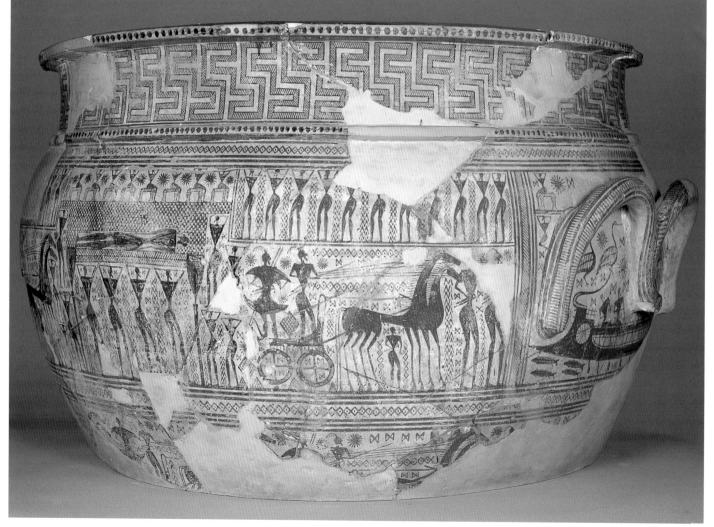

emphasize his social persona. Shifts in burial rituals occurred in Archaic Athens, but the basic notions of honouring the dead remained. Thus, though figured plaques replaced great vessels over aristocratic graves, activities connected with death were still articulated [**23**]. Emphasis on family groupings hints at generation and continuity but it also introduces an emotional element even if identifications of 'father', 'mother',

'brother' written on certain of the plaques are themselves generic.

In life, precautions against evil forces were critical and thus personal items ranging from armour to clothing fasteners carried amuletic motifs. Of them, exploits of mythical heroes like Heracles were thought particularly appropriate for men [**21**]. To ensure more general protection, however, temples were prominently decorated with apotropaic motifs; in

this capacity the adventure of Perseus slaying Medusa became a virtual cliché. Finally, the gods themselves required attention with proscribed rituals involving gifts and sacrifice. It was a masculine world but women enjoyed a public role in the religious sphere that was scarcely thinkable in other contexts [**22**].

SGM

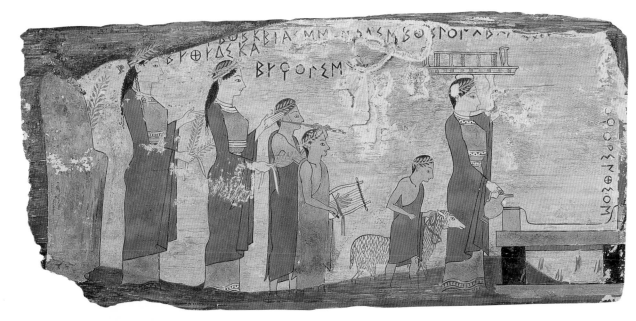

22 Left: Corinthian votive plaque from Pitsa, near Sicyon (*c.*540 BC), polychrome paint on wood, *c.*15 × 30 cm. (5⅘ × 11⅘ in.), Athens, National Museum

23 Below: Attributed to the Sappho Painter, Athenian funerary plaque (*c.*500 BC), Attic black-figure clay, 13.5 × 26.5 cm. (5⅓ × 10⅔ in.), Paris, Louvre

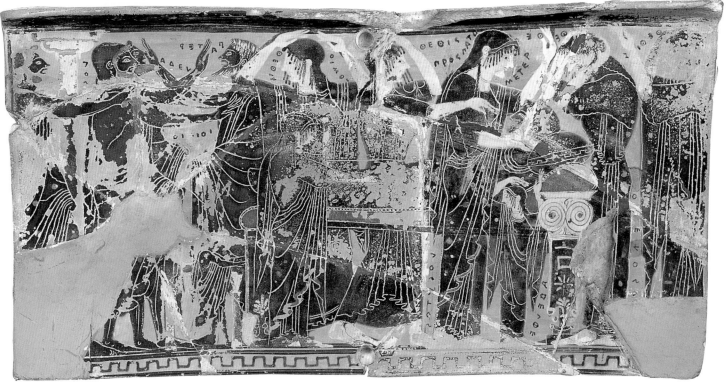

Athenian exports and influences

Athenian products of the fifth century BC were much desired and frequently functioned as prestige goods in areas bordering the Mediterranean. Simultaneously acting as vehicles of transmission, such objects were highly prized as grave goods, itself a prime indicator of perceived value. Many of the finest Attic figured wares of the fifth century, for instance, are found in Etruscan tombs, having likely been acquired through exchange for raw materials [**25**, **26**].

In Thrace, on the other hand, we may surmise that intrinsically valuable objects of gilt silver with distinctively Attic motifs will have served in gift exchange ceremonies with local leaders [**27**]. The importance of this formality, laden with obligations, is underscored by textual evidence regarding diplomatic negotiations undertaken by Athens with Thracians in the later fifth century.

Trade may lie behind the presence of Attic-style ivory work in a Scythian burial [**24**]. Classical Athens was heavily dependent for grain on the Black Sea region and may have bartered such luxury goods from its active ivory industry. On the other hand, it is also possible that Greek craftsmen or even locals trained by them were working on the spot, ready to provide the social élites with prestige goods on demand. SGM

24 Fragmentary plaque from a funerary *kline*, detail of Judgment of Paris showing Athena and Aphrodite with Eros (late fifth century BC), incised polychrome ivory, 20 cm. (7⅞ in.) high (from a Scythian burial in the Kul Oba Barrow, Crimea), St Petersburg, Hermitage

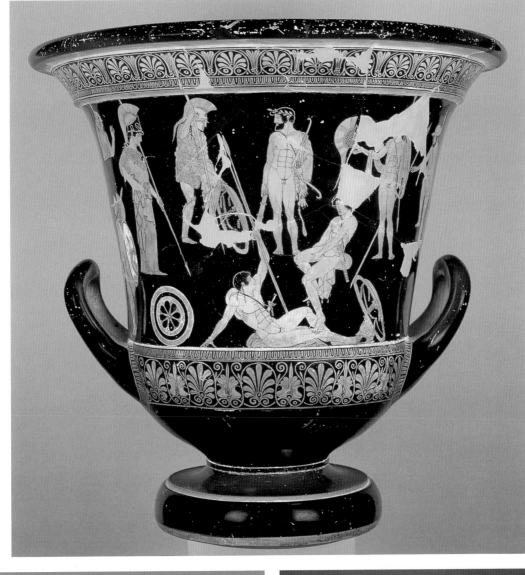

25 Right:
Attributed to the
Niobid Painter,
Attic calyx-crater,
Athena, Heracles,
and other heroes
(*c*.455–450 BC),
red-figure paint on
clay, 54 cm. (1 ft.
9 in.) high (from
an Etruscan burial
near Orvieto,
Italy), Paris,
Louvre

26 Below left:
Attributed to the
Phiale Painter,
Attic calyx-crater,
Hermes delivering
baby Dionysus to
the nymphs and
Papposilenus
(*c*.440–435 BC),
polychrome paint
on white-ground
clay, 32.8 cm.
(1 ft. ⅞ in.) high
(from an Etruscan
burial at Vulci,
Italy), Rome,
Vatican Museums

27 Below right:
Mesomphalic
phiale, chariot
race (end of fifth
century BC),
engraved and
gilded silver, 20.5
cm. (8 1/16 in.) in
diameter, 428
grams (15
ounces) (from a
Thracian burial at
Duvanli, Bulgaria),
Plovdiv,
Archaeological
Museum

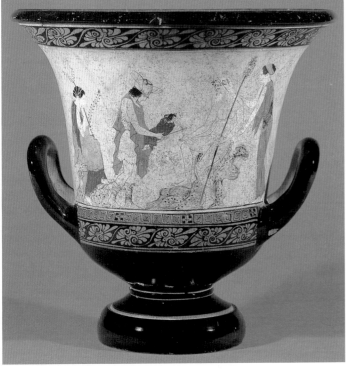

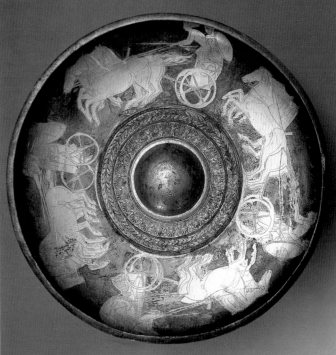

Pictures on floors and walls

Floors and walls offered ample opportunity for artists to exercise their talents. In a tradition that stretches far back in time, though it is only intermittently preserved, painters, weavers, and mosaicists sought creative ways to embellish these surfaces with figural scenes.

Textiles, important vehicles for preserving and transmitting cultural heritage [30], served as prototypes for figured pebble mosaics in the fifth century BC. During the fourth century BC, however, mosaicists explored more pictorial qualities [31] that imitated characteristics of painting [28, 32]. The best paintings and mosaics of that period [28, 31, 32] show complete mastery of linear perspective as well as colour shading. Compositionally,

30

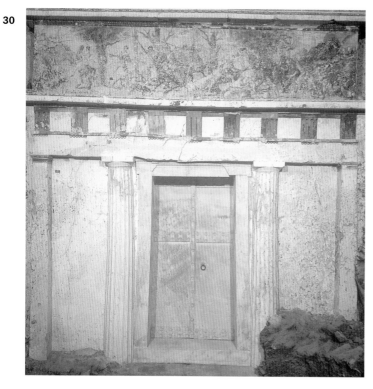

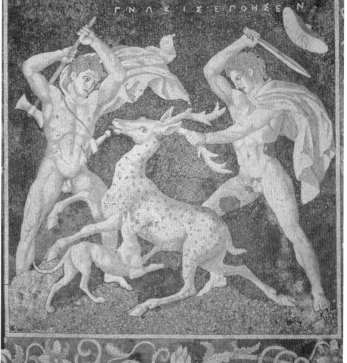

28 Above: Facade of Vergina Tomb II, the so-called Tomb of Philip, wild animal hunt (second half of the fourth century BC), fresco, 5.56 × 1.16 m. (18 ft. 2½ in. × 3 ft. 9⅝ in.), Vergina, in situ

29 Right: Signed by Sophilos (*c.*200 BC), mosaic floor, personification of Alexandria, from Thmuis, Nile delta, Mosaic, *opus vermiculatum*, 85 × 86 cm. (33½ in × 33⅞ in.) (emblema), Alexandria, Graeco-Roman Museum

there is great diversity ranging from the 'pyramidal' composition of Gnosis' mosaic [**31**] to the expanded narrative of the hunt frieze with landscape setting that anticipates developments in Roman times [**28**]. Technically, comparison of Gnosis' hunt [**31**] with Sophilos' portrait of one hundred years later [**29**] illustrates the change from pebble mosaic to cut stone *tesserae* in *opus vermiculatum* technique.

In terms of artists, Gnosis and Sophilos signed their mosaics but paintings remain so far anonymous. Modern attempts at attributing these paintings to great names, otherwise known only from Roman authors, falter for lack of signed originals as a basis for comparison. SGM

30 Opposite and above: Detail of story cloth, the Nereid Eulimene (early fourth century BC), woven wool (resist-painted, mended in antiquity), c.27 cm. (10¾ in.) long (from a Scythian burial in the Crimea), St Petersburg, Hermitage

31 Opposite and below: Signed by Gnosis (last quarter of the fourth century BC), detail of mosaic floor from the House of the Abduction of Helen at Pella, stag hunt, pebble mosaic, 3.10 × 3.10 m. (10 ft. 2 in. × 10 ft. 2 in.) (emblema), Pella, in situ

32 Right: Detail of painting from Vergina Tomb I, Hades abducting Persephone (after the middle of the fourth century BC), fresco, c.1 m. (39⅜ in.) high, Vergina, in situ

Greek Art beyond Greece

Greek artists were footloose. By tradition and vocation they went wherever work was on offer. They travelled between the various city-states of the Greek-speaking world; to the colonial outposts of Greek cities across the Mediterranean basin and on the shores of the Black Sea; and beyond Asia Minor, as far as the Hindu Kush, and the deserts of Shiraz. Upholding the doggerel of 'East is East, and West is West, and never the twain shall meet' is impossible in this context. Nor can we keep faith in any systematic effort to contrive a pattern of 'core' and 'periphery'.

There was never a central academy for the instruction of art at Athens or anywhere else in the Greek world. But not only were Greek artists prone to wander, Greek artists were not always Greek. In the trade of making and painting vases at Athens during the sixth century BC we have names to suggest a considerable ethnic mix amongst the producers of these quintessentially 'Greek' works of art: Lydian and Carian, Thracian and Scythian, Sicilian, perhaps even Egyptian.

Still it is not a symptom of Western cultural arrogance to identify a 'Greek influence' operating upon the figurative traditions of non-Greek peoples in antiquity. 'Hellenistic' is a term precisely devised to cover the phenomenon of artists and patrons in the ancient world consciously 'Hellenizing', or favouring recognizably Greek styles of expression. We now use the word 'Hellenistic' to denote a specific historical period: usually from the death of Alexander the Great in 323 BC to the battle of Actium in 31 BC, which effectively launched Octavian (Augustus) as the first Roman emperor. But in practice 'Hellenistic'—whether an artistic commitment or an ideological choice of style on the part of a patron—should be located several centuries earlier.

Towards the end of the sixth century BC the Achaemenid dynastic rulers of Persia undertook the construction of a series of permanent palatial and administrative centres—at Susa, Pasargadae, and Persepolis. It is easily forgotten that the Persians were an originally nomadic people, more accustomed to tents than to masonry. Official inscriptions and stone-workers' graffiti reveal how that problem was surmounted. Darius and successive Persian monarchs called in (or compelled) outsiders for the job. Amongst them were Greek sculptors from Ionia. These Ionian sculptors were not at liberty to dictate the motifs of regal symbolism, nor control overall design. However, where they could—in the cut of draperies, or certain nuances of bodily modelling—the Greeks left hints of their presence.

The extension of Persian imperial power upon the settlements of Greeks in Asia Minor and the eastern Aegean may itself have driven a number of Greek artists westwards. In any case artists naturally followed the course of Greek colonization

in the West, pioneered by Euboeans in the early seventh century BC. We know the name of one of these artists, because he left it on one of his works, a mixing-vessel for wine and water found in a tomb at Cerveteri, in Etruria. *Aristonothos epoiesen*, we read: 'Aristonothos made [me]'. The script (in the Euboean variant of the Greek alphabet) runs in retrograde above a scene which we can easily identify. Five men ram a stake into the face of a huge figure slumped beastwise and clutching a drinking-cup. This must be Odysseus and his crew blinding Polyphemus, the one-eyed giant or Cyclops—as related in Book IX of Homer's *Odyssey*. Or must it? Mythographers have located literally hundreds of folk-tales that are geographically distinct but which share the same basic plot ('The hero is at the mercy of a giant shepherd in a cave; he blinds the giant and escapes from the cave with the help of the giant's sheep')—so how can we be sure that Aristonothos had the words of Homer ringing in his ears as he constructed this epic 'illustration'?

Iconographic clues—the indication of the giant's drunken state; and an object above him plausibly taken to be a cheese-basket, specifically mentioned by Homer—offer some certainty. But this vase painted by Aristonothos serves as a small paradigm of what Greek artists might provide to their non-Greek patrons or customers. They carried not only saleable expertise—the skill or *techne* for which they were primarily valued at home—and the asset of a definable style. They were also loaded with ideas, stories, and cosmologies. Once those items of cultural baggage became perceived as symbols of status, then 'Hellenization' turned quasi-missionary. Greek artists could court barbarian patrons with images and artefacts not only reflective of aristocratic privilege, but part of its definition. Along with certain social protocols, such as the peer-group drinking-party or *symposium*, Greek objects became part of prestigious living: ideologically twinning, say, a Carian satrap with a Celtic warlord.

Greek art as an élite acquisition is perhaps most transparently vaunted in the archaeological record of the Etruscans. Most of the Greek vases now displayed in the world's museums are conserved thanks to their hoarding as grave goods in Etruria. For Etruscan aristocrats such imports came integrally with the adoption of Greek customs of wine-drinking, athletic exercise, and votive performance. But Etruscans offered direct employment to immigrant Greek artists—in particular at the coastal centres of Cerveteri and Tarquinia. Distinctively east Greek styles of painting can be picked out in the late sixth- and early fifth-century painted tombs of Tarquinia, even when the imagery itself belongs to local rites. A typical compromise of Greek and indigenous elements here might be the depiction of participants at an Etruscan funerary banquet indulging in the

characteristically Greek drinking-game of *kottabos* (in which players toss the contents of their cups at an agreed target).

Greek-influenced delineations of the luxurious lifestyle have been recovered from painted tombs elsewhere on the fringes of the Greek world: at Thracian Kazanluk, for example, and certain inland sites of Lydia and Lycia. But at what level were Greek images actually comprehended by their non-Greek owners and viewers? In Etruria, there is little doubt (though not much direct proof) that versions of Greek-originated mythology were translated into the Etruscan language and circulated as high-class entertainment. The Etruscan fondness for engraved mirrors and gems, however, reveals both a pedantic level of acquaintance with details of such stories as the Trojan War and the Seven Against Thebes, and a penchant for generating fresh Etruscan-based adventures for favourite Greek heroes such as Heracles (whom the Etruscans knew as *Ercle*).

Unlike their compatriot travelling bards, Greek artists wielded the universal language of figurative expression. We may imagine multiple instances of twisting interpretation as images were locally glossed or deciphered. Yet to locate 'errors' or 'banalization' in the transmission of Greek myth and epic to non-Greek peoples is misguided. Canonical texts or 'classics' of Greek literature were in time acknowledged, especially after the consolidation of the great libraries at Alexandria and then Pergamum during the third century BC. But the Greek package of cogent and enchanting stories remained irresistibly open to local or personal manipulation.

To foreign eyes the persuasive appeal of Greek style was peculiarly bound up with the content of Greek imagery. If Ernst Gombrich is right in imputing the ascendancy of naturalism in Greek figurative art precisely to the Greek mode of epic and mythic narration—focusing passionately upon the *how* of a story unfolding, not the *what*—then this is not so surprising. Effectively it means that the reception and response to Greek art outside of Greece was highly conditioned by the opportunities of this or that barbarian patron to enter vicariously the fantasy world of heroes and monsters and divinities so vividly conjured by the Greeks. Where a non-Greek culture had already established its own elaborate system of icons and mythographies, Greek artists made less impact: in Egypt virtually no impact at all, until the Ptolemaic period.

'Barbarian' carries no necessarily pejorative significance as used in its Greek sense, to denote anyone not using the Greek language. But reconstructing the barbarian motives for 'sharing' Greek images is necessarily problematic when explanatory texts are lacking. Gazing over the registers of martial activity sculpted on the tomb-chapel of a Lycian royal couple, we can only presume that this non-Greek potentate cast himself as a second Achilles: hence asked for free-standing Nereids to front the monument, indicating Achilles' mother Thetis and her band of sea-nymphs. On the other side of the Mediterranean basin, at Obulco (Porcuna) in Spain, one local magnate instructed Greek (or Greek-trained) sculptors to show him triumphant over gryphons and other foes. And we know that the programmatic decoration of the colossal monument to the Carian dynast Mausolus, featuring Greeks against Amazons, was underpinned by the supporting presence of Greek rhapsodes, who hymned the ancestry of Mausolus as Heracles, and the Heraclean seizure of the girdle of the Amazonian queen (a relic of his family past which Mausolus claimed to possess).

Modern scholarly jargon overestimates the ancient sensitivity towards 'otherness'. Or rather, we underestimate the capacity for compromise and syncretism between the Greeks and 'others'. In the Commagene kingdom (in southeast Turkey) a genuine blend of Greek and Persian iconography was manifested in the first century BC when Commagenian rulers (in full Persian attire) were shown shaking hands with brawnily nude representatives of the Greek pantheon such as Zeus and Heracles. Or so it seems: closer inspection reveals that these deities are actually composites, albeit in palpably Greek guise. Heracles doubles as the Persian worthy Verethragna, and one figure enjoys fourfold veneration as Apollo-Mithras-Helios-Hermes.

'Graeco-Persian'; 'Graeco-Phoenician'; 'Graeco-Etruscan', 'Graeco-Roman'—we reach for such portmanteau terms when faced with the responsive adoption and adaptation of the Greek figurative style by non-Greeks. But perhaps none is more curious than 'Graeco-Buddhist', conceived to account for the sculpture known as 'Gandharan'. Buddhism, like Christianity, began as a religion void of images relating to the appearance of its founder. The Buddha died in 553/4 BC; when Alexander the Great reached Gandhara (now roughly north-west Pakistan and parts of Afghanistan) in 327 BC there was no tradition of Buddhist devotional imagery. But there were artists in Alexander's entourage, and Greeks subsequently settled on the Oxus River, at Ai Khanoum. A figurative identity for the Buddha and his devotees duly arose.

Rudyard Kipling speaks of 'forgotten workmen' in Gandhara, 'whose hands were feeling, and not unskilfully, for the mysteriously transmitted Grecian touch'. Taking a wider view, we may deny the mystery here. Itinerant Greek artists were simply doing what they had been doing for centuries, wherever they went: capitalizing upon a well-honed dedication to naturalistic anthropomorphism.

NS

Greek artists at large

Greek sculptors and masons helped to build the monumental centres of ancient Persia—under duress to produce the notoriously repetitive files of processional figures on the friezes of Persepolis [**33**].

Elsewhere their patrons were more pliable. The Etruscans of central Italy not only collected vases made in Greece (mainly Athens and Corinth), but also sponsored work from immigrant Greek artists such as Aristonothos [**34**].

Large-scale painting by Greeks abroad does not generally survive, except in tombs [**35–6**]: examples of tombs decorated in Greek or pseudo-Greek fashion are plentiful in Etruria, and also known from Thrace and Asia Minor. Banqueting and drinking, hunting and horse-ownership, dancing and music are the usual signifiers of the patron's status (or aspired status). Recent discoveries of Asiatic wall paintings in Asia Minor, especially in Lycia and Lydia, illustrate the vitality of local interaction with the Greek world in the sixth century BC and the cultures from which the Persian Great King drew the craftsmen for the figure decorations of his palaces. NS

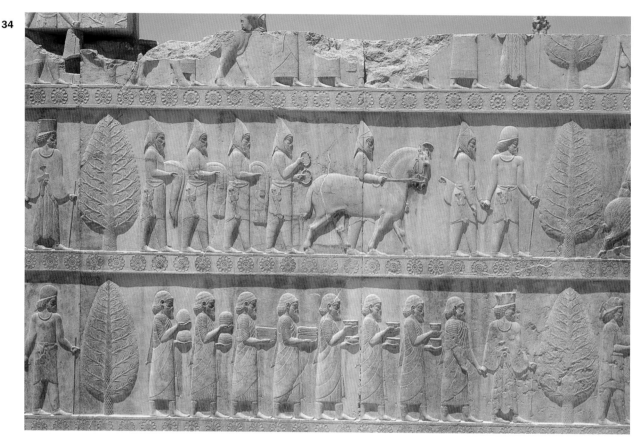

33 Left: Frieze from Persepolis (in situ), (late sixth century BC)

34 Below left: Mixing-vessel signed by Aristonothos, the blinding of Polyphemus (painted c.650 BC), found in a tomb at Cerveteri (Etruria), Rome, Capitoline Museums

35 Below right: Detail of the Tomb of the Black Sow, the banqueters raise their cups for a game of *kottabos* (painted c.450 BC), Tarquinia, in situ

36 Above: Detail of a Thracian princely tomb at Kazanluk (Bulgaria), (painted c.300 BC), in situ

37 Right: Detail of a tomb painting from Uşak (Lydia), showing a figure sniffing a lotus-bud (late sixth century BC), Ankara, Museum of Anatolian Civilizations

Greek heroes and gods at large

An ostentatious acquaintance with Greek mythology has displayed a sort of cliquish erudition throughout the course of Western art. Within a century of their definitive composition (during the eighth century BC), the epic tales of Homer were circulating as similarly 'prestige'

artefacts, along with the gift of literacy.

A few barbarian potentates will have learned Greek as a means of access to Greek poetry and drama; many more relied upon images for mediation. Greek artists themselves became generally literate during the seventh century BC, though many will have learned their stock of stories by oral transmission. In any case it was a strength of such stories that they were

38 Right: Warrior figure from Porcuna (*c*.450 BC), Jaén, Museo Provincial de Bellas Artes

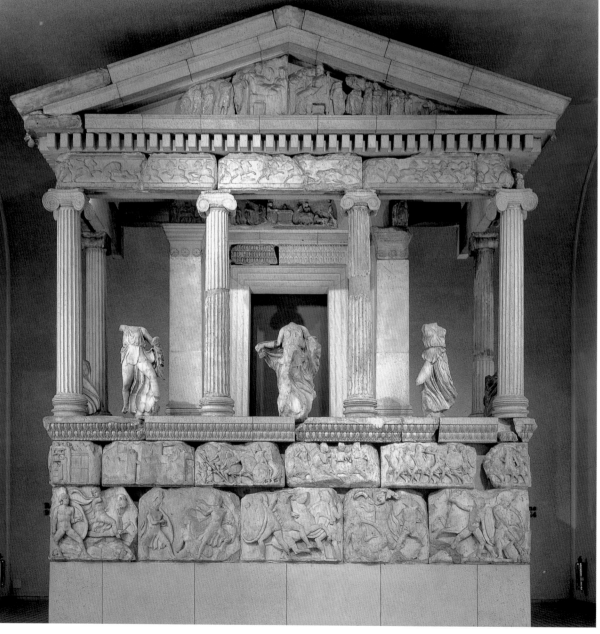

39 Left: The Nereid Monument from Xanthos, Lycia, erected (*c*.400 BC) by an unknown Lycian potentate, London, British Museum

mutable, as local circumstances demanded.

Some aniconic or image-shunning cultures were downright hostile to the Greek fetish of anthropomorphism—deities in human form: for precisely that reason Greek art was largely ignored in the Jewish areas of the Middle East. Others compromised. The Persians, whose religion was pantheistic and non-reliant upon images, tolerated syncretistic efforts to mix and match the Greek Olympians with their own Zoroastrian heroes and prophets. In the former Persian-ruled territory of Gandhara, the local slate stone (schist—'fresh rock, dark blue as an elephant's ear', as one poet describes it) was used to make stepped ascents for Buddhist pilgrims, with sculpted reliefs expounding the Buddha's life and system. The draperies swathed around the Buddha's form, the musculatures of his supporting cast, and the inclusion of Greek hybrid animals, or Greek architectural columns, betray the Greek stimulus in Gandharan sculpture [40]. NS

40 Relief panel from Gandhara, showing six standing boatmen or river spirits—framed by a single Corinthian column (probably second century BC), London, British Museum

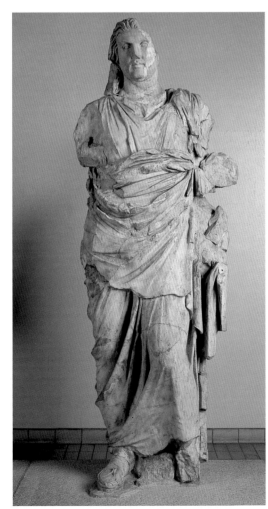

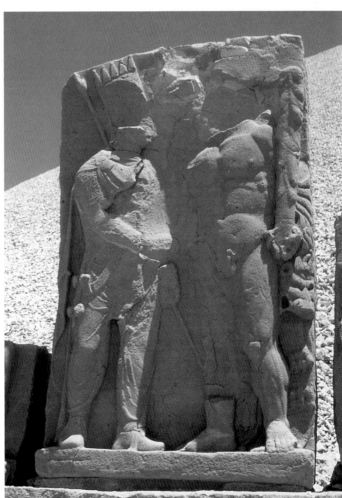

41 Left: 'Mausolus'—the presumed honorand of the Mausoleum at Halicarnassus in Caria (c.360 BC), London, British Museum

42 Right: Relief showing the Commagenian king Antiochus I shaking hands with Heracles-Verethragna (first century BC), at Arsameia on the Nymphaios River, in situ

Roman Sculpture

Visitors to ancient Roman cities encountered urban landscapes that were dense with statuary. Public squares and buildings, private homes, as well as tombs outside the city were decorated with statues and reliefs, all of which were charged with various meanings. On monumental arches and columns, for example, reliefs displayed the civic and military qualities possessed by a good emperor. In temples, cult statues of gods and goddesses were infused with divine power. A portrait statue in a forum conveyed the living presence of a person who had done good work for the community. In private villas, decorative statues of Greek gods and heroes encouraged the viewer to fantasy, as well as advertising the cultural standing of the villa's owners. The messages conveyed by these sculpted monuments ranged from straightforward to exquisitely subtle. Meanings were crafted by the manipulation of iconographic details (component visual parts of an image) and by style (the particular way that these components were represented), and the impact of statues was further enhanced by inscriptions and architectural settings.

At first glance, Roman sculpture looks much like that of the Greeks. This is because the figurative types it employed, as well as its stylistic and iconographic elements, depended for the most part on Greek models. Moreover, the deployment of large numbers of marble and bronze statues in public spaces was not original to Rome but was derived from the Greek world. What is distinctively 'Roman' about the sculpture produced in the Roman world is seemingly elusive. Some have attempted to define Roman sculpture by the Romanness of its subject-matter. But the presentation of Roman sculpture as if it consisted solely of portraits of Romans and of reliefs representing Roman subjects distorts the overall picture of Roman-period sculptural production, because at least half of it was Greek in both style and subject-matter. In fact, Classical and Hellenistic sculpture is known largely through Roman copies and versions in marble. Others have tried to detect the Romanness of Roman sculpture in certain 'original' characteristics, such as continuous narrative in relief and realism in portraiture. It has been shown, however, that these aspects were not original to Roman sculpture, but had antecedents in Greek art. In the absence of any obvious unity of style, iconography, or subject-matter, meaning in Roman sculpture has been sought through a chronological model that traces an overarching stylistic development from Republic to late antiquity, mirroring the *Zeitgeist* of successive political epochs and dynasties. The applicability of this approach is limited, though. While it is possible to trace changes in both style and technique in imperial portraits (those of emperors and their relatives) over the course of time, such exact chronological development did not exist in private (non-imperial) portraiture.

Furthermore, in analysing ideal sculpture the chronological model is of little use because Greek-style decorative and cult statuary did not evolve significantly from the first century BC to the third century AD. Yet another approach has looked to regional variation as a key to understanding Roman sculpture. Here also problems arise, because at the top level of sculptural production, there is a remarkable homogeneity across the Roman Empire, from Spain to Syria—a dramatic testimony of the attraction of belonging, or appearing to belong, to Rome.

The principal reason why Roman sculpture is so resistant to definition is its stylistic variety, but it is precisely here that its distinctiveness is to be found. In the Roman view, sculpture had already been perfected by the Greeks, and it was not worth attempting to compete. Therefore, when the Romans began to commission monumental sculpture in the second century BC, they directed artists to employ the style of earlier Greek works. Ironically, this very stricture on artistic creativity made possible a kind of innovation, as artists started to combine once disparate elements of earlier Greek sculpture. In accommodating their Roman patrons, sculptors began to select from the full repertoire of Greek sculpture—Archaic (seventh–sixth centuries BC), Classical (fifth–fourth centuries BC), and Hellenistic (third–second centuries BC). What is distinctively Roman about Roman-period sculpture is the unrestricted way in which artists drew upon what was considered best about Greek sculpture, and manipulated these different, inherited forms and styles, often in the very same monuments, to express a range of messages.

Whereas today the making of sculpture is associated with the individual creativity of an artist who produces a commentary on the society in which he or she lives, in Roman times sculpture was more of a patron-driven kind of production. The artist's job was to apply his discrimination in the uses of different forms and styles and his best technical skill, in proportion with his wages, to create exactly the kind of sculpture wanted by his patron. Roman statues are therefore primary historical documents for reconstructing the sensibilities of different types of Roman patrons during different periods and in different parts of the Empire. In museums today one can easily and pleasurably appreciate pieces of Roman sculpture on their own terms at a purely aesthetic level; but Roman statues can offer us much more if we attempt to situate them in their original context by reconstructing the intention of the Roman patron and the patterns of reception of different categories of ancient viewer.

The late Republic

Sculptural production began on a large scale in Rome during the late Republic (second–first centuries BC), a time of pivotal

cultural change. The conquest of the Mediterranean world and in particular of the Greek East had brought about a sudden concentration of wealth and political power in Roman hands. This, combined with an increased cultural sophistication, fuelled an energetic demand by Romans for marble and bronze sculpture. The most important categories of production during this period were portraiture and ideal sculpture (Greek-style decorative and cult statuary). Both need to be understood in relation to the circumstances of their inception in the republican period.

From at least the beginning of the first century BC Romans regularly commissioned portraits of themselves in a straightforward, mundane style of heightened realism. This was a Roman variation on the theme of the late Hellenistic individual portrait that went beyond its basic Hellenistic model to create a distinctively Roman visual identity. Unlike most late Hellenistic portraits, late republican portraits could be extremely differentiated in terms of physiognomic traits. This republican style could be formulated in a variety of ways. Some portraits are more sophisticated than others in sculptural technique. But all have one thing in common: the features of individualism and age are not disguised; often they are heightened ([**59**] right). Flesh sags, lips are tight, warts and scars may be carefully rendered. In male portraits, hair is often short-cropped, generating a military look. Facial expressions range from approachable to dour to aggressive. Youthful features are conspicuously absent.

To the modern eye, such portraits may seem to be unflattering to their subjects. For ancient Romans, however, there was nothing pejorative about this style. On the contrary, it was the visual expression of the most positive qualities of the élite republican male: gravity, authority, severity and above all aggressive masculinity. Significantly, a similar image style with an emphasis on age was used in this period for the portraits of many Roman women [**48**], where it conveyed the impression of a severe and loyal matriarch. It seems that to Roman viewers a portrait of a woman in her fifties could be preferable to contemplate than that of a woman in her twenties. Nor would this be surprising, because respectable Roman women played their most important roles in life not as objects of physical beauty but as the producers and supporters, the mothers and wives, of Roman men in service of the Roman state.

Another feature of late republican portraiture that distinguishes it from late Hellenistic portraiture (and which becomes a defining aspect of subsequent Roman imperial portraiture) is that it gives a striking impression of individual presence. Not only did republican portraiture convey the social category of a person by the type and style of the image, but it allowed the viewer to see the person as a specific individual. In conveying

the living presence of the represented person, the portrait of an aspiring politician in a town square could thus more effectively compete with other such portraits for the public's attention and recognition. The portrait of a *paterfamilias* (head of family) in the atrium of his house could thus better function as an exemplar and regulator of conduct for members of the household, as well as provide his clients with something vivid to contemplate while they waited to be admitted to his presence.

In defining a Roman self-image, this portrait style of heightened realism and individual presence was arrived at for three main reasons. First, it was a continuation of an indigenous Roman tradition of self-representation in life-like ancestor masks worn during funeral processions. Second, it allowed Romans to define themselves in opposition to the youthful, dynamic portrait style used by many of the Hellenistic kings, their sometime political and cultural rivals. Finally, the republican style was so minutely differentiated in physiognomic traits that it allowed members of the élite a means of standing out as individuals in a way that they could not—or were not supposed to—do in society that put tight constraints on individual self-assertion.

Aside from portraiture, the other major category of sculptural production during the republican period was ideal sculpture (statuary from the Greek mythological and divine realm) which was markedly different in conception and style, and was relegated almost exclusively to temples and to the private sphere. The introduction of ideal sculpture to Rome began on a large scale in 211 BC with the sack of Syracuse by the Roman general M. Claudius Marcellus. It was the custom for plundered statues to be carried in a triumphal procession, then displayed temporarily in wooden stage buildings where the Roman populace as a whole could admire them, before they were transferred to their permanent display context: a temple constructed by the triumphant general. Such temples could be crammed with war booty comprising statues of different periods and styles—Archaic, Classical, Hellenistic—which were all displayed together, along with captured armour and trophies. More often than not, the statues bore no particular relation to the space of the buildings in which they were housed. Nor did there exist a correlation between the sculptures and other types of decorative spoils, such as wall painting. It is here in the outfitting of temples with plundered statues that we have the seeds of the decorative aesthetic of eclecticism that figures so largely in later Roman villas where Greek-style statues of the most diverse types and styles stood one next to the other. It is perhaps no coincidence, then, that the same republican generals who built and decorated these temples with war booty were among the first to build and decorate private luxury villas.

By the late Republic a century of Roman plunder had caused the supply of Greek original sculptures to dwindle. Moreover, as the Romans gained familiarity with Greek culture, certain ethical considerations had begun to dictate against the pillaging of Greek statues (this had to do with the fact that, since the creation of the Roman provinces of Achaea and Asia in the second century BC, the Greek world was no longer considered to be enemy territory). As a result, Romans began decorating their villas with copies of Greek statues, rather than with original ones. In order to meet the ever-increasing demand of the Roman villa market for decorative sculpture, an industry developed that manufactured copies, versions, and workshop-generated new creations, based on earlier Greek statuary. An example of a copy is the Doryphoros of Polyclitus [5], which in its Roman context functioned as a symbol of the cultured ambience of the Greek gymnasium. An example of a new creation is the so-called Esquiline Venus [52], which functioned as an inducement to pure sensual fantasy. New creations often featured the recombination of different body types and styles of earlier Greek statues. The Esquiline Venus is in fact a reworking of the Hellenistic Aphrodite Anadyomene (Aphrodite tying up her hair) with an early Classical body type and face, and an Apollo-like hairstyle. Such strange confections of retrospective eclecticism owe their creation solely to the peculiar conditions and needs of the Roman villa market. Other products of this statue industry were copies of portraits of famous Greeks of the past which could, at least in theory, stimulate literary conversation or recall famous historical episodes. One of the most abundant types of sculptural decoration in villas were figures from the circle of the god Dionysus. This category of decorative sculpture facilitated relaxation with the necessary sanction of Greek myth but without any intellectual demands, thus helping rich Romans to escape from the churning pressures of public life.

It was the tension between Rome's traditional view of itself as a frugal culture and its seemingly unlimited appetite for Hellenic cultural amenities that was responsible for the peculiarly Roman contradiction between the public disparagement of the effects of Greek art and the private consumption of it. This disharmony between public and private life in the second and first centuries BC helps to explain the extremities in the sculptural record of the late Republic: the use of a style of heightened realism in portraiture, and the employment of an ideal or genre style in cult statuary, with very little overlap between the two. At the same time, however, that the sculptural decoration of villas may be read as a celebration of Greek culture in the privacy of the domestic sphere, the eclectic manner in which the statues were displayed had its origins in an aesthetic of spoils that did not revere Greek culture *per se* but rather its conquest by Rome.

The imperial period

While the late republican period was marked by political upheaval, the imperial period was characterized by a stable form of government introduced under Augustus that did not change significantly until the third century. This form of government, which was a military autocracy disguised as a revitalized Republic, required that the emperor be many things to many people. On the one hand, the emperor was portrayed at Rome in ways that conformed to traditional, republican-period

expectations [45]. On the other hand, people across the Empire were permitted to conceive of the emperor as they wished him to be, and they adapted the formulation of the emperor's image to fit their particular conceptions [46]. Sculptural representations of the emperor were flexible, serving a variety of guises, responding to different expectations in different quarters.

In the imperial period, portraits continued to be displayed in both private and public contexts. However, the dramatic distinction between the styles of portrait and ideal sculpture began to be blurred, largely because of artistic innovations and influence in the court of Augustus. As a visual expression of a new type of government under Augustus, a novel portrait style was devised for Augustus and his Julio-Claudian successors: a youthful sub-Classical image [43] which departed dramatically from prevailing republican portrait norms. This style was at first used only by Augustus and his family but was soon imitated by many private citizens who began to use a similar portrait formulation characterized by an Augustan-style coiffure with artfully arranged forehead locks and stiffly rendered physiognomical surface ([59] left). Individual-looking facial details such as noses, ears, and chins set off these images from those of the emperor and his family.

Alongside this new style, the traditional, realistic-looking republican portrait style continued through the first century AD, especially for the portraits of middle-aged and older individuals [47]. This clean-shaven, plain Roman style eventually gave way to the more sophisticated, cultivated portraits of Hadrian and the Antonines who wear styled and artificially curled hair and beards. In second-century portraiture, then, the visual signs of traditional Roman simplicity were replaced by those of refined elegance [49]. This new style represents an ideological shift in self-representation from the military ethos of the Republic to that of urbane civility. It may also reflect a less ambivalent attitude in Roman society towards Greek rhetoric and letters (Greek orators and philosophers had worn beards). The changing of real fashions of hair and beard-wearing in this period fuelled new technical advances in marble working such as subtle surface textures and elaborate use of the drill and different polishes. These advances, together with the enlivening device of drilling and engraving eyes introduced during the reign of Hadrian, make the best specimens of second-century portraiture stunning in their sheer technical brilliance [49].

A change occurred in the early third century AD when the emperor's civilian posture of first among equals began to lose ground to a purely military image, and a clean-shaven military portrait style again became fashionable. This came to be combined in the later third century with a partial manipulation of the naturalistic canon in portraiture, seen in the intensification and accentuation of certain traits, especially eyes. By the fifth century, this pattern is especially striking in the portraits of governors and consuls [50]. Their portrait images are characterized by severe facial expressions, with downturned mouths and furrowed brows (old visual signs of traditional Roman morality). The most impressive feature of these late portraits is the unnatural intensity of the eyes, a device that conveyed penetrating vision and strength.

Elaborate narratives in marble relief were a Roman speciality, especially in the imperial period. The purpose of such

reliefs was to provide a visual account of imperial virtues: military prowess, piety to the gods, collegial relations with the senate, and care of the Roman people. In the Augustan period, historical relief helped to bolster the civic image of the new regime by its appropriation of a purist Classical style. The use of a Classical style was not new (it had been used for cult and decorative statues in the republican period); the novelty was its application to ostensibly real subject-matter [45].

Another important stylistic aspect of historical relief is that different styles could be used for reliefs of the same period. Two reliefs from the time of Domitian illustrate this: one from the Arch of Titus in Rome, and one from the so-called Cancelleria reliefs [55, 56]. The Cancelleria relief is more dry and Classical in style and the Arch of Titus relief more plastic and dynamic. With the Dacian campaigns in the early second century, war ideology became more central to the imperial image and new types of imperial narration were introduced in relief sculpture. We may look at two examples. The first is a panel from the Great Trajanic Frieze [57], a masterwork of relief sculpture, which shows the emperor engaged in a variety of symbolic activities, including charging into battle—something he would never have done in reality. The Column of Trajan [58], on the other hand, pretends to give a real account of the Dacian Wars. It shows the emperor in a series of stock scenes—sacrificing, giving speeches, overseeing battles, offering clemency to humbled enemies—interspersed with scenes from the Dacian Wars, all arranged in a narrative sequence. The prosaic narrative style used for the documentary scenes on Trajan's column presents a startling contrast to the highly elevated, epic style of narration used for the Great Trajanic Frieze. Yet these two monuments were set up at the same time by the same person (Trajan) for the same context (the Forum of Trajan in Rome). In reliefs such as these, different styles were chosen for different kinds of subject-matter (real versus allegorical). This pattern continues throughout the imperial period, with no obvious stylistic development related to chronology.

In contrast to historical relief, there is a clear pattern of evolving tastes in the formulations of funerary sculpture over the course of the Roman period. The Roman élite adorned their tombs with minimal sculptural decoration. This class had the public sphere available for self-representation and so did not need to decorate the facades of their tombs with a great deal of sculpture. For other classes, on the other hand, the funerary sphere offered a context for self-display denied elsewhere. In the absence of conspicuous military exploits and family lineages, members of the middle strata of Roman society advertised their civic status and financial worth. Freed slaves, who were often of foreign extraction, seem to have been especially concerned to represent themselves publicly as Roman citizens ([59] right). They did so by setting portraits of themselves into the facades of their family tombs, with the conservative physiognomical articulation of the republican style and the pedantic use of correct dress.

Later in the first century AD there was a shift in emphasis in funerary sculpture from portraiture to the display of pictorial reliefs which advertised—with explicitness and all-inclusiveness—the occupations and civic activities of the deceased [60]. Here the proprietor of the tomb could make reference to his public munificence or could invoke the source of his wealth (with a representation of a building crane or cargo ship, for example). For artists, the problem with generating this type of relief sculpture was that there were no models available for it in the inherited Greek repertoire. The solution, which evidently did not displease the patrons, was to convey as much information as possible in whatever relief space was available, no matter how small, without letting artistic considerations interfere. This resulted in a partial distortion of the naturalistic canon and proportional illogicalities of space in this type of funerary relief. Such images are a striking illustration of the stylistic flexibility of Roman-period sculpture.

At Rome such mundane tomb reliefs did not continue much beyond the middle of the second century AD. Instead, a new type of funeral monument came into fashion: the traditional, Greek-style sarcophagus. The sudden popularity of these lavish coffins arose because marble had become available on a large scale at the same time that a renaissance of Greek culture was in full swing. The earliest sarcophagi for the most part feature Greek mythological scenes. Whether the particular myths in question were seen as deeply symbolic, loosely allegorical, or purely decorative depended on the sensibilities of both the patron and viewer. A mid-second-century sarcophagus in Berlin [61], for example, shows the story of Medea's killing of her rival Creusa with the gift of a poisoned cloak on the eve of the latter's marriage to Jason. A bereaved family could have selected this myth because it functioned as an appropriate allegory for the death of an unmarried daughter who could be identified with the tragic figure of Creusa.

A shift in emphasis in the themes of relief decoration on sarcophagi is discernible later in the second century when, because of civil war and foreign invasion, there was a great deal more at stake in Rome's military involvement than there had been for quite some time. Battle scenes were now added to the relief repertoire. A good example is the Ludovisi battle sarcophagus, datable to the first half of the third century [62]. It shows the deceased on horseback at the moment of triumph in a battle over barbarians. Aside from subject-matter, there are several instructive stylistic differences between the Ludovisi sarcophagus and the earlier sarcophagus [61]. The scene on the earlier sarcophagus is stagy but ordered. It uses shallow relief, and features little overlap of figures, giving a smooth, Classical effect. The later, battle sarcophagus is teeming with disordered movement. It uses deeper relief and virtuoso undercutting of surfaces with the drill. In funerary sculpture, then, there is a broadly discernible pattern of changing tastes in subject-matter and styles over the course of the Roman imperial period.

While many of the individual elements of the figurative language of Roman sculpture were Greek in origin, Roman sculpture was innovative in compelling ways. It exhibited great stylistic variety and flexibility. The choices of style, iconography, and display context for Roman sculpture combine to tell us much about Roman patrons and by extension about Roman culture. After monuments of Roman sculpture had been set up by the patron, they continued to play a role in shaping the ideas of viewers who beheld them over successive generations. Works of Roman sculpture were not simply manifestations of Roman culture; they informed its development. KW

41

The imperial portrait

A critical factor in the success of Roman rule was that the emperor's image displayed a remarkable degree of adaptability to the needs of people in different parts of the Empire and of varying social classes.

The emperor's aristocratic peers in Rome (senators) were putatively of a similar status to the emperor, and to them he presented himself as first among equals. This is evident on the *Ara Pacis Augustae*, the Augustan Altar of Peace [**45**], dedicated by the senate in 9 BC. Here Augustus (who ruled from 27 BC to AD 14) appears as he might have appeared in reality, walking in a religious procession in the company of priestly colleagues alongside whom he does not stand out in position, size, or dress as being of a significantly higher status.

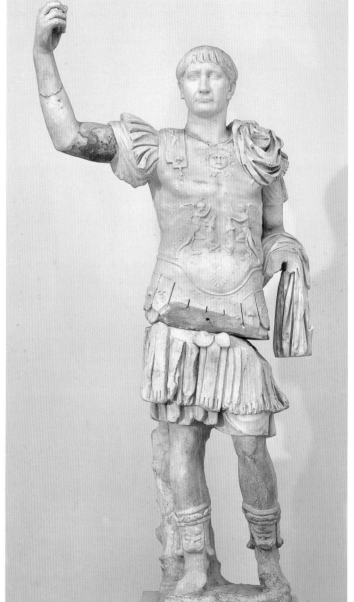

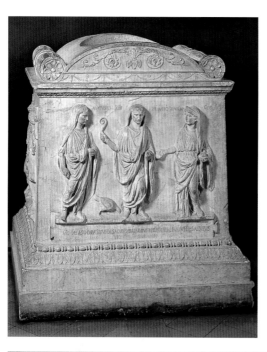

43 Far right: Statue of Trajan from the headquarters of the ship-builders at the Roman port of Ostia (mid-second century AD), marble, 1.95 m. (76¾ in.) high, Ostia Antica, Museo Archeologico

44 Right: Augustus (centre) and family members on an altar of the deities of the crossroads (early first century AD), marble, 1.5 m. (49¹⁄₁₆ in.) high, Florence, Uffizi

45 Right: Augustus (third from left) and colleagues on the south frieze of *Ara Pacis Augustae* (Augustan Altar of Peace) (9 BC), marble, 1.55 m. (61 in.) high, Rome, in situ

46 Opposite: Panel showing Augustus and Victory, with trophy and captive between, from the Sebasteion at Aphrodisias (mid-first century AD), marble, 1.59 m. (62⅝ in.) high, Aphrodisias Museum

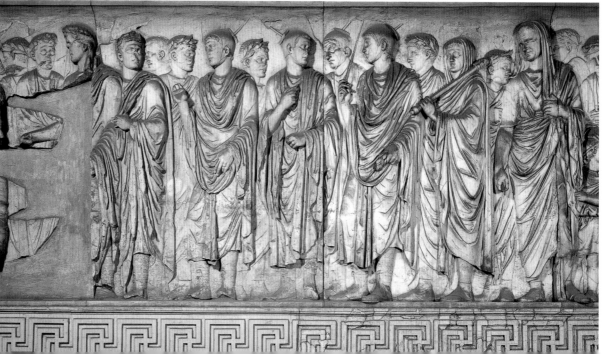

For the inhabitants of the Empire's municipalities and for the army, the emperor was benefactor and *imperator*, that is permanent commander-in-chief of the army. This conception is evident in a statue of Trajan (AD 98–117) in military dress set up by the ship-builders in their local headquarters at Ostia [**43**].

To the people of Rome, the emperor was personal patron [**44**], and in their neighbourhoods at the crossroads they set up small altars with representations of the emperor and his family.

To members of the provincial élite in the Greek East—heirs to the tradition of Hellenistic kingship—the emperor was king, god, and saviour. For example, on a relief from Aphrodisias [**46**], Augustus appears nude in the company of the goddess Victory—an elevated form of representation that would have been impossible in a state relief in Rome during the reign of Augustus.

A comparison between the crisply elegant representation of Augustus on the Altar of Peace, commissioned by the Roman senate, and the rather pedestrian representation of him on the crossroads altar, commissioned probably by an association of tradesmen, shows how the quality of Roman sculpture varies considerably according to its level of production. KW

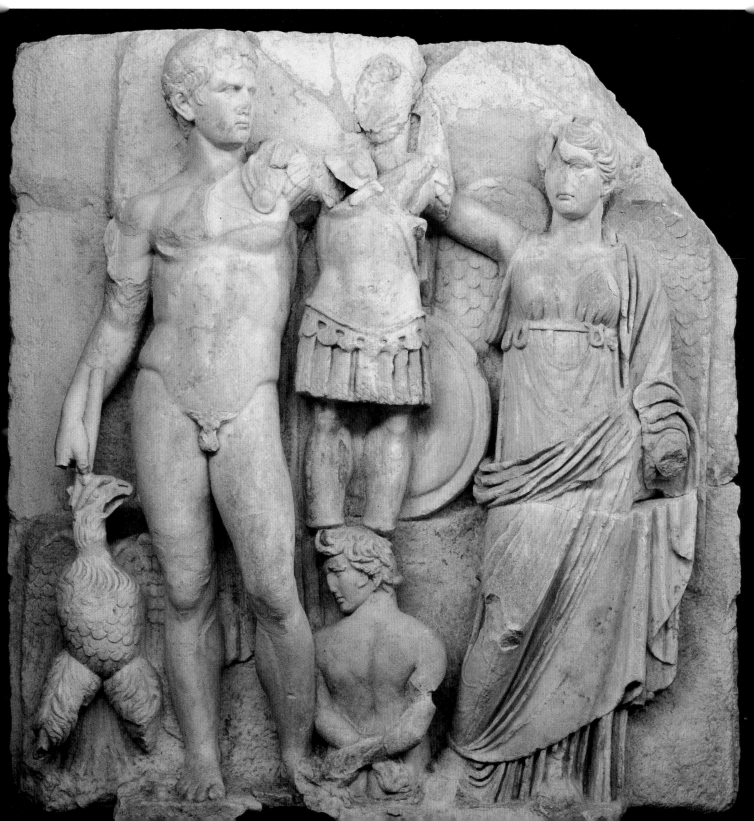

Private portraiture

A distinguishing characteristic of Roman portraiture is that it generated the impression of an individual presence. This is well illustrated by four examples of private portraiture (that of individuals not related to the imperial family) from different eras.

Picture **48** shows a Roman matron of the republican period (about the mid-first century BC). The portrait head, which was originally inserted into a draped statue, is rendered in an aggressively plain style. The face has a dour expression and a tight-lipped mouth accentuated by prominent lines around the nose and at the corners of the mouth—signs of mature severity. The straight positioning of the head and direct frontal gaze gives the portrait a sense of the momentary.

This plain, realistic-looking style is most closely associated with the republican period but continued to be used in the first century AD, as illustrated by a spectacular gilded bronze equestrian statue of a man from a municipal context [**47**].

This style was eventually eclipsed by the more sophisticated, cosmopolitan portraits of the mid-second century that display curled hair and luxuriant beards, seen in a portrait bust of a young man [**49**].

By late antiquity artists had begun to experiment with a manipulation of the naturalistic classical canon for specific expressive ends. This is shown by the portrait on an ivory diptych of a member of the Lampadii family, who was a consul in Rome some time during the first half of the fifth century [**50**]. The figure wears a heavily decorated toga, typical of late antiquity. In his left hand is a consular

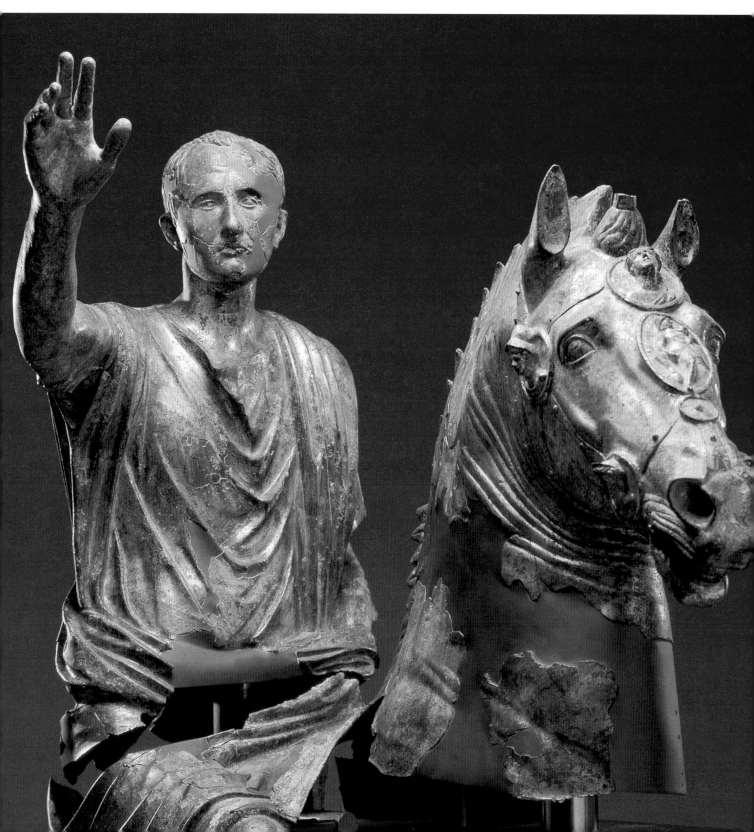

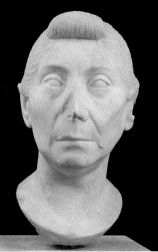

sceptre, and in his right is a *mappa*, or handkerchief, which he would drop from his box in the circus to signal the start of the chariot races—seen taking place below. He has a middle-aged face, a light beard, and a contemporary flat, mop-like hairstyle. The portrait is given a non-natural intensity by the treatment of the large, wide-open eyes. This, along with the immobile posture, conveyed intensity, strength, and rectitude. KW

47 Opposite: Equestrian statue of a man from Cartoceto (first century AD), gilded bronze, statue 2.36 m. (7 ft. 8⅞ in) high, head 24 cm. (9½ in.) high, Ancona, Museo Nazionale della Marche

48 Above: Portrait of a woman (mid-first century BC), front and side views, marble, 32 cm. (12⅝ in.) high, Rome, Museo Nazionale delle Terme

49 Below: Bust of a young man (mid-second century AD), marble, 70 cm. (27⅝ in.) high, Copenhagen, Ny Carlsberg Glyptotek

50 Right: A consul in his box at the circus (first half of the fifth century AD), ivory diptych, 29 cm. (11½ in.) high, Brescia, Civici Musei d'Arte

Ideal sculpture

Images from the Greek mythical and divine realm were among the most versatile in the Roman sculptural repertoire. They carried symbolic value at a general level, but their specific connotations depended on their display context as well as the iconographic and stylistic formulation of the sculptures themselves. A case in point is Aphrodite/Venus, goddess of erotic love. Displayed in a villa she connoted pleasure of the senses [52]. In a temple she functioned as a cult statue [51]; on a sacrificial altar she had a political function, appearing with Mars as the divine forebear of the Julio-Claudian dynasty [53]; in commemorative relief she acted as the tutelary divinity of a city [54].

Sculptures of divinities such as these did not evolve stylistically over the course of the Roman period. What

46

51 Bust of the cult statue of Aphrodite from Aphrodisias, dedicated by a certain Theodoros (second century AD), marble, 57 cm. (22½ in.) high, Aphrodisias Museum

52 Statue of Aphrodite/Venus (the 'Esquiline Venus') (second century AD), marble, 1.55 m. (61 in.) high, Rome, Museo dei Conservatori

did evolve were the possibilities for their sculptural display.

Before the time of Augustus, such sculpture had been relegated largely to temples and to private contexts such as villas. In the imperial period, as part of a new programme of imperial munificence aimed at the Roman people, it came to decorate a whole range of public buildings, especially those associated with plebeian recreation.

The life of luxury, of which the decorative display of sculpture was an important element, was no longer restricted to the private villas of the wealthy but came to be extended to common people. This phenomenon occurred first in Rome and then, by extension, in provincial cities.

Ideal statuary now decorated public fountains, theatres, even the facades of amphitheatres and the barriers of circuses, so that all could experience the amenities of villa culture when they went to be entertained at public expense.

More than any other type of public building, baths most effectively simulated the atmosphere of a private Roman villa. For at the baths, people were not regulated as to where they could go, but could move about as they wished. A decorative statue of Aphrodite/Venus such as the 'Esquiline Venus' [**52**] could be admired with equal freedom and entitlement by a senator in a private villa or by a tradesman relaxing in a public bath. KW

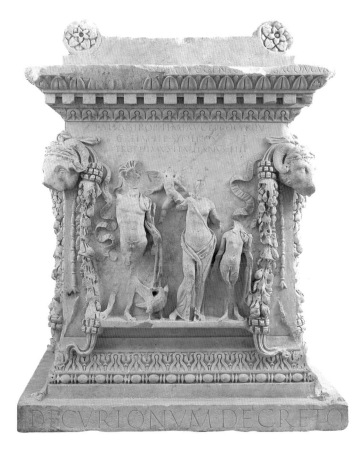

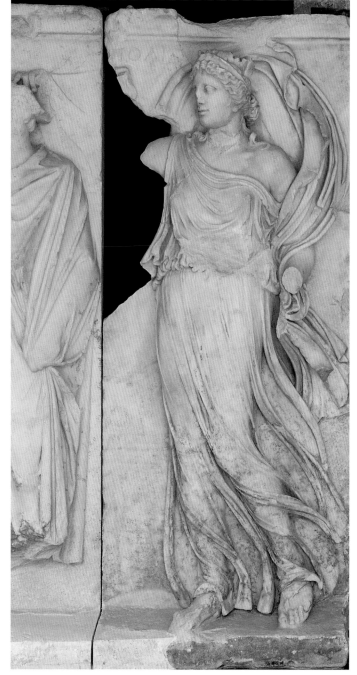

53 Above: Altar with representations of Venus and Mars from Ostia (first century AD), marble, 1.1 m. (43¼ in.) high, Rome, Museo Nazionale delle Terme

54 Right: Personification of the city of Aphrodisias (Polis) from a frieze commemorating Iulius Zoilos (late first century BC), marble, 1.85 m. (72⅞ in.) high, Aphrodisias Museum

Historical relief

While statues offered static representations of the emperor, reliefs showed the emperor in action. In historical reliefs, real events were filtered through ideological agendas so that every action of an emperor, whether in peace or in war, became exemplary.

A good emperor had an appetite for campaigning. Ceremonies such as the emperor's departing and returning from war were therefore popular subjects. A departure is shown on one of the so-called Cancelleria reliefs [**55**]. Second from the left is the god Mars with beard and helmet, followed by the goddess Minerva, and to their right appears the emperor Domitian (with his portrait recut as his successor Nerva) wearing a short tunic and travelling cloak. To his right is a female figure with helmet, one breast bared, and with her hand placed under the emperor's left arm. This is a personification of *virtus* (military courage) who is supporting the emperor. To her right are personifications of the Roman senate (bearded figure wearing a toga) and Roman people (youthful figure with bare chest and horn of plenty). This is a good example of an important innovation of Roman historical relief: the free juxtaposition of human and divine figures for symbolic effect.

Another significant aspect of historical relief is that different styles could be used for different reliefs of the same period. The Cancelleria relief is dry and classical in style, while the contemporary relief from the Arch of Titus [**56**] is more plastic and dynamic in style. The stylistic differences between the two monuments might simply reflect different workshop preferences. But it is likely that a more elevated, Classical style was

48

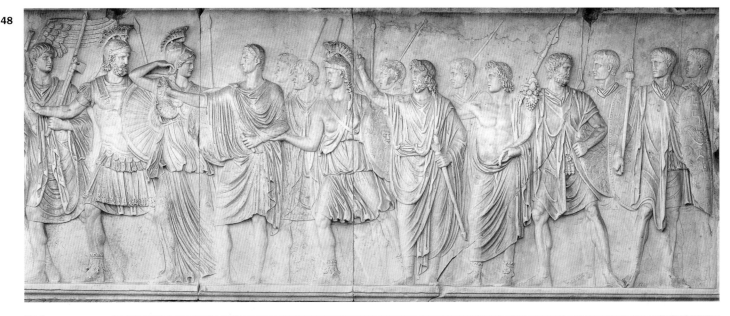

55 Above: Cancelleria relief showing a scene of the emperor embarking on a military campaign (last quarter of the first century AD), marble, 2.06 m. (6 ft. 9⅛ in.) high, Rome, Museo Gregoriano Profano

56 Right: Arch of Titus, passageway relief showing triumphal procession (last quarter of the first century AD), marble, 2 m. (6 ft. 6¾ in.) high, Rome, in situ

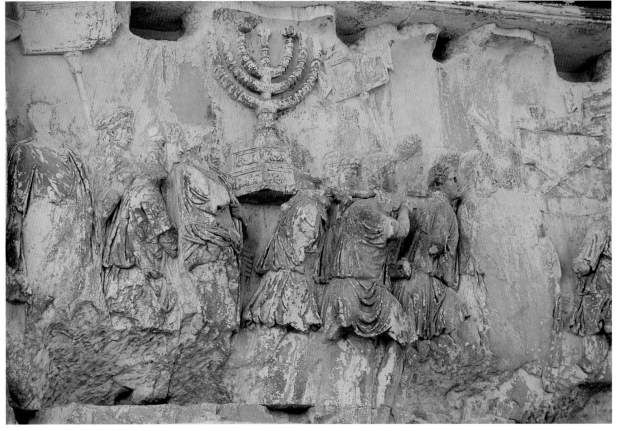

chosen for the Cancelleria relief because it depicts timeless, symbolic subject-matter, whereas the Arch of Titus panel purports to show a momentary glimpse of a real event (the triumphal procession following Titus' sack of Jerusalem in AD 71).

The use of different styles for allegorical and real subject-matter is also illustrated by the striking contrast between the Great Trajanic Frieze [**57**] and the Column of Trajan.

A point worth noting is that ancient Roman sculpture was rendered more dramatic by the fact that it was painted. The effect of such painted sculpture is nicely captured by a nineteenth-century cast of a scene from the Column [**58**]. KW

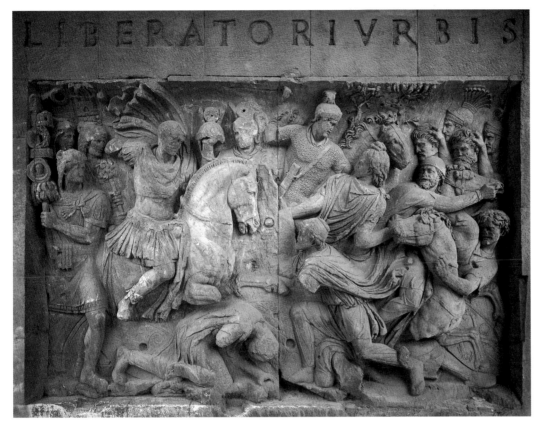

57 Left: Battle scene from the Great Trajanic Frieze, Trajan at left on horseback (AD 112), marble, 2.95 m. (9 ft. 8⅛ in.) high, Rome, in situ

58 Below: Battle scene from the Column of Trajan (AD 112), painted cast, 91 cm. (35⅞ in.) high, nineteenth century, Rome, Museo del Foro

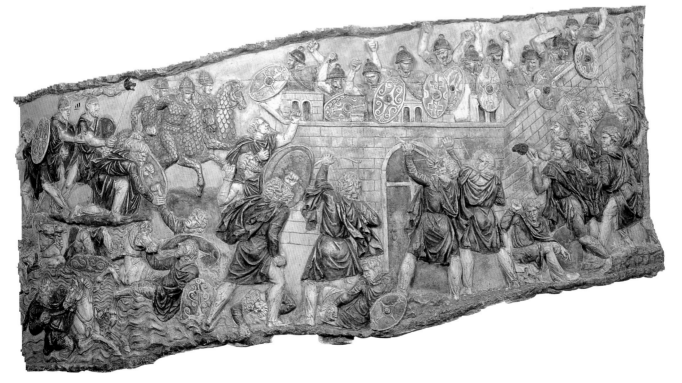

Funerary monuments

In Roman religious thinking, life after death was not guaranteed. The most efficient way of overcoming death was to commemorate oneself in a public monument. Monuments to members of the élite appeared in public buildings such as fora and basilicas, but sculpture does not seem to have decorated their tombs to any great extent. For other Romans, public self-

representation was confined largely to the funerary sphere.

Freed slaves, for example, put portraits of themselves into the facades of tombs. In **59** the older freedman (right) is portrayed by means of the conservative republican style, while the younger freedman (left) is portrayed in a realistic manner that also includes some fashionable portrait quotations from the repertoire of Augustus and his family,

50

59 Top: Funerary relief with busts of older and younger freedmen with tools of their trade, smithing and carpentry, on the top and right; and on the left, the rods and staff used in the ceremony of freeing a slave (late first century AD), marble, 69 cm. (27⅛ in.) high, London, British Museum

60 Right: Tomb of the Haterii, showing the tomb under construction with crane at left and with representation of the deceased on funeral couch above (late first or early second century AD), marble, 1.04 m. (40⅞ in.) high, Rome, Museo Gregoriano Profano

61 Opposite: Sarcophagus depicting the story of Medea and Creusa (mid-second century AD), marble, 65 cm. (25⅝ in.) high, Berlin, Pergamon-museum

62 Opposite: Ludovisi sarcophagus, depicting a battle between Romans and barbarians (first half of the third century AD), marble, 1.53 m. (60¼ in.) high, Rome, Palazzo Altemps

such as the stiffly rendered brow line and artfully arranged locks of hair.

The middle levels of Roman society sometimes included scenes that made reference to the source of their wealth. In **60**, for example, a building contractor's trade is remembered in a tomb-construction scene employing a crane.

With the introduction of the sarcophagus in the early second century, the events of life and death came to be filtered through Greek mythology. For example, the tragic death of Creusa [**61**] is used allegorically to represent the death of a young unmarried woman. At left Creusa appears seated with her nurse and a male relative; Jason looks on from far left as his two children (by Medea, his rejected lover) present Creusa with a poisoned mantle and crown as wedding gifts. At centre Jason (with male companion in back-ground) and Creusa's father Creon look on as Creusa, having donned the mantle, is burned alive. Immediately to the right is Medea with sword drawn, looming over her unsuspecting children. At far right Medea, with dead children slung over her shoulder, flees in a dragon chariot.

Other scenes on sarcophagus relief mirrored the deceased in life. In the Ludovisi battle sarcophagus [**62**] the deceased is singled out by his central position (at the top and centre riding his horse, with his right hand extended in an exultant gesture of imminent victory) and by the fact that he has an individualized portrait (the faces of the other figures are all pseudo portraits). The deceased man may have commanded troops in life, or this scene may have been chosen simply to appropriate, on his behalf, the symbolic virtues associated with military leadership. KW

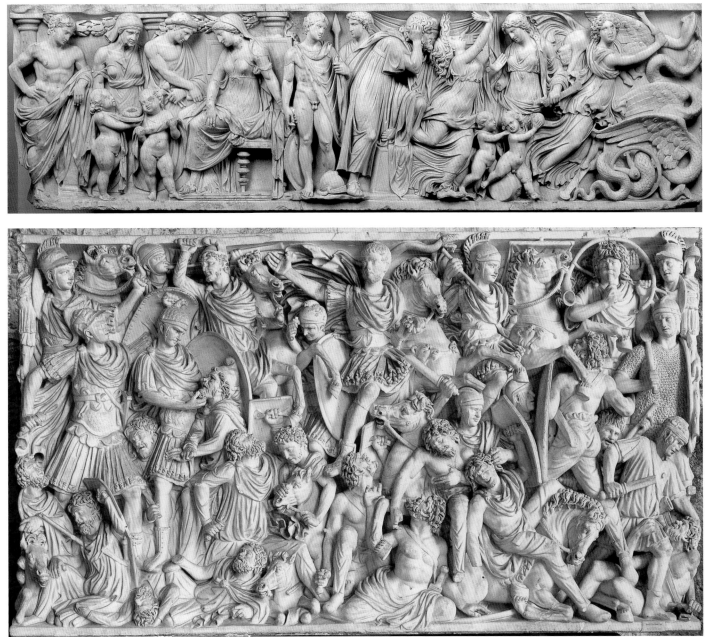

51

Roman Painting and Mosaics

Roman buildings, public and private, were ablaze with colour. Marble veneers, white outside and multi-coloured within, sheathed important structures, while for private homes fantastic imitations were created using moulded plaster and paint. Paintings might be incorporated into this framework or hung against it to dazzling effect. Polychrome mosaics covered floors and eventually walls and ceilings as well. A wealth of evidence documents creations of the first centuries before and after the Christian era, thanks to the eruption of Mt. Vesuvius in AD 79 that enveloped Pompeii and other cities of Campania. Scholarly focus is therefore typically on this period and indeed on selected top-quality monuments within it, especially since earlier material is sadly fragmentary while later it is highly diffused, diverse, and chronologically problematic.

Roman pictorial styles evolved out of several traditions, one Italic and another, ultimately the more important, which came from Greece and the eastern Mediterranean. Little is known about the earliest Roman paintings apart from literary references in later authors to various paintings and the names of a few painters like Fabius Pictor (*fl.* late fourth century BC) and Pacuvius (*c.*220–130 BC). The sources emphasize paintings of historical battles, perhaps as early as the third century, that decorated Roman temples. Thematically related were panel paintings commissioned by third- and second-century military victors which were hung in public places. Some surely originally accompanied triumphal processions that displayed spoils of war.

The earliest preserved Roman paintings, deriving from third- to second-century tombs on the Esquiline, are themselves military scenes. Labelled figures in one are thought to represent participants in the fourth-century Samnite Wars [**63**]. Preoccupation with historical documentation is in any case a hallmark of Roman public art; witness the military exploits detailed on sculptured columns of imperial times [**57, 58**]. Yet Roman wall painting, otherwise known primarily from private contexts, is generally uninterested in history, preferring, with a few exceptions, to rely heavily on Greek themes or newly created subjects of their own devising.

Roman authors provide insight into Roman tastes, including a deep-rooted penchant for Hellenic culture. Direct confrontation with Greek art began with the Roman conquest and looting of Greek cities in the late third century and continued over the next two centuries. According to written testimony, sculpture and paintings were major items in the triumphal processions that wound their way through Rome. The triumph of Aemilius Paullus over the Macedonian king Perseus in 168 BC, vividly described by Plutarch (d. after AD 120), included vast quantities of art treasures with sculptures and paintings that may have come from the Macedonian Palace itself. Metrodorus, an Athenian artist hired to undertake Paullus' victory paintings, joined a sprinkling of other Greeks, named in the sources but otherwise unknown, who worked in late republican Rome.

Many Greek panel paintings were put on public display in Roman temples and porticoes, others were kept in private collections. Roman authors provide insight into these holdings, usually giving subject-matter, often the names of artists, sometimes their sources, and frequently their locations in Rome. Among the Greek paintings were works of a few fifth-century painters like Polygnotus, but there was special preference for those of the fourth when, according to Pliny, the craft reached its acme with Apelles, the painter most favoured by Alexander the Great (356–323 BC). These 'old master' paintings must have helped shape Roman taste though one should not underestimate the importance of local traditions. Nor should one ignore the influence of aesthetic judgements by Roman authors in our own times. Pliny's biases have long prejudiced modern attempts at reconstructing the history of Greek art including the search for copies of lost Greek originals. A prime case in this hazardous pursuit is the Alexander Mosaic [**64**].

The Alexander Mosaic comes from a wealthy Pompeiian house renovated in the late second century BC, to which time it is usually dated. Alternative views, however, suggest its creation early in that century for some palatial setting in the eastern Mediterranean. Either way, the mosaic is generally thought to copy a painting of Philoxenus of Eretria (*fl.* 330 BC) who, according to Pliny, painted a Battle of Alexander and Darius for the Macedonian king Cassander (d. 297 BC). Wherever the mosaic was made, few have questioned the attribution to Philoxenus though it is in fact tenuous; other battle paintings existed in antiquity including some that featured Alexander.

Nevertheless, the Romans clearly did copy, or at least adapt, Greek art with great enthusiasm. Indeed, for sculpture there exists a virtual copying industry by the later second century BC. In the pictorial arts illuminating evidence may be cited in the form of 'twin' images of masked comic actor-musicians coming from different places, at different dates, and even in different media. A mosaic from Pompeii, for instance, signed by a Greek, Dioscurides of Samos, and dating to around 100 BC [**67**] is essentially repeated, however clumsily, in a painting from Stabiae of more than a century later [**68**]. A common prototype is usually sought, in circular fashion, among lost third-century Hellenistic paintings. This scarcely known body of material is thought to have included illustrations of the New Comedy flourishing in Athens at the time, a genre that

itself was adapted into Latin by the poet Plautus (*fl. c.*205–184 BC). Whatever the immediate source of inspiration, vehicles of pictorial transmission, some perhaps remote from the originals, must have existed either in the form of artefacts or some sort of hypothetical copy books.

Acquiring such works implies wealth. The late republican period indeed saw a great rise in prosperity brought about both by conquest as well as by trade in the eastern Mediterranean. House owners in small-town Pompeii who could afford major expansions with rich embellishments like pictorial mosaics were surely well off and upwardly mobile. Their models in this pursuit lay conveniently close among the sprawling villas Roman aristocrats built in the Campanian countryside.

Questions of sources also surround the Odyssey Landscapes from a long-destroyed house in Rome that dates from the middle to late first century. Preserved are eight panels of a great frieze separated by illusionistically painted pillars [**65**]. Illustrating adventures from the *Odyssey*, the frieze is the earliest surviving example of 'mythological landscapes' in which the landscape dwarfs the human figure. This represents a departure from earlier representations (compare the so-called Tomb of Philip [**28**]) as does the use of 'continuous narrative' technique which allows an individual figure to reappear periodically as a story unfolds. The frieze with its figures identified in Greek (sometimes misspelled), and clearly not intended for an elevated position by reason of its perspective, is usually thought to copy some Hellenistic prototype. Once again, however, precise antecedents are hazy and it may represent an Italian development of a stage still undocumented.

A different sort of frieze of the same period decorates a room of the Villa of the Mysteries at Pompeii [**69**]. Here, against a red faux-panelled backdrop, life-sized humans intermingle with mythological figures. Interpretation remains controversial, but this unique composition may involve rituals of female initiation. Details and figure types suggest Greek prototypes but the unified conception and seamless combination of elements, to say nothing of the theme itself, are purely Roman.

Roman creativity also lies behind the garden paintings from the Villa of Livia at Primaporta of around 20 BC [**66**]. One of several domiciles associated with the imperial circle, this house contained a chamber painted as a fictive garden complete with birds, fruits, and flowers. A low trellis with balustrade behind are, together with a band of sky, the only suggestions of structural illusion. No direct antecedents for this type of painting exist—nature for nature's sake—but it was much favoured, though on reduced scale, in dwellings at Pompeii around this time, along with gardens.

Much admired were idyllic landscapes, cityscapes, and seascapes which were appropriately incorporated into decorating the Campanian luxury villa at Boscotrecase usually associated with Augustus' grandson, Agrippa Postumus [**71**]. The contemporary architect Vitruvius describes the vogue for such vignettes while deploring the mannered, spindly structural elements that surround them. Meticulous attention to detail is a hallmark of the style as is a rather impressionistic air. Houses fashionable during Pompeii's final years revived an interest in simulating effects of depth. Typical is the way that glimpses of architecture alternate with large mythological pictures to bold and impressive effect [**70**].

After Pompeii, the volume of material shrinks though it covers an expansive geographic territory across the sprawling Empire. Much of it is difficult to date and, though more diverse, it lacks the spark of new ideas. Exceptions can be found such as the painted wooden mummy portraits best known from the Graeco-Roman Fayum in the mid-first to mid-third centuries AD [**72**]. Represented are descendants of Greek mercenaries who, themselves the product of dual traditions, chose for Egyptian-style burials to adopt realistic portraits modelled on styles current in Rome. Roman Egypt thus supplies an element missing from the homeland record where panel painting must have continued uninterrupted since early times.

Wall painting soon lost ground to other media, especially mosaics where considerable effort was expended, often to great effect. Older styles lingered or were revived; witness the Neoclassical vogue under Hadrian (reigned AD 117–138). A case in point is a mosaic with doves [**73**] from the imperial villa at Tivoli, eccentrically decorated by Hadrian with diverse copies of Greek artefacts. Regarding the dove mosaic, opinions are in fact divided: is it a superb Hadrianic copy or might it be a Hellenistic original by Sosos of Pergamum as described by Pliny?

In the provinces, subject-matter and styles vary in answer to regional concerns. A widespread interest in hunt motifs can be documented, and a huge, polychrome floor from the palatial early fourth-century villa at Piazza Armerina in Sicily may represent the phenomenon [**75**].

Contemporary with the Sicilian mosaic are ceiling-paintings from Trier, possibly deriving from its imperial palace [**74**]. Featuring a series of male and female busts interspersed with cupids, the subject of this material is much discussed. Whatever the identities of these images, whether portraits or personifications, and whatever the prototypes that may stand behind them, the Trier paintings represent a late reappearance of the classicizing tradition that held such a grip on Roman artistry from the start. SGM

Patrons and themes

How the Romans chose pictorial themes is unclear. Social standing will have played a role and surely choices for funerary paintings will have differed from those of dwellings.

The small corpus of republican tomb paintings centres on military pursuits, perhaps even of historical nature [**63**]. While alluding to the valour of the deceased, they testify to the Roman taste for factual documentation.

Possible historical interests lying behind the Alexander Mosaic at Pompeii are indeterminable [**64**]. The palatial House of the Faun is in several ways unique, not least because it retained old-fashioned First-Style wall decoration while assembling a highly eclectic group of figural mosaics. Its early owners, probably non-Roman Samnites, may have sought an

63 Military painting showing M. Fannius and Q. Fabius (third–second century BC), from a tomb on the Esquiline, Rome, fresco, 84.5 × 46 cm. ($33\frac{1}{4} \times 18\frac{1}{8}$ in.), Rome, Conservatory Museum

64 Alexander Mosaic (second century BC), from the House of the Faun, Pompeii VI,12,2–5, mosaic, *opus vermiculatum*, 12 × 2.71 m. (39 ft. $4\frac{1}{2}$ in. × 8 ft. $10\frac{3}{4}$ in.), Naples, Archaeological Museum

65 Opposite: Odyssey Landscapes (*c.*50–40 BC), sections 8 and 9, Odysseus at the entrance to the Underworld (left) and scenes in the Underworld (right), from a house on the Esquiline, Rome, fresco, frieze 1.16 m. ($45\frac{5}{8}$ in.) high, Rome, Vatican Museums

66 Opposite and below: Garden painting (*c.*20 BC), from the Villa of Livia, Primaporta, north wall, fresco, 5.9 × 3 m. (19 ft. $4\frac{1}{4}$ in. × 9 ft. $10\frac{1}{8}$ in.), Rome, National Museum

54

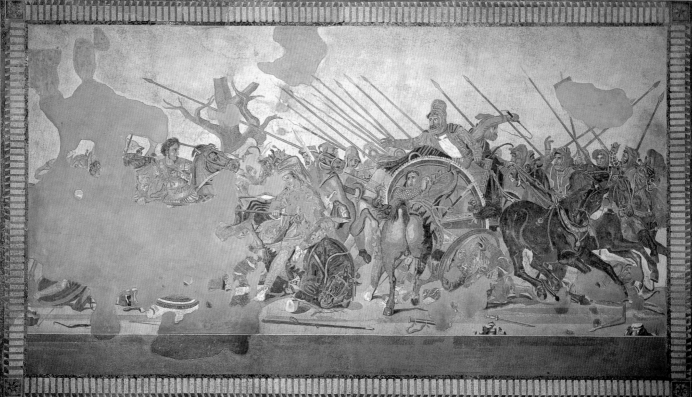

ambience in some way reminiscent of luxurious villas of Hellenistic times and specifically, perhaps, of Macedonia.

Greek interests are also apparent in the remains of the house on the Esquiline featuring the Odyssey Landscapes [**65**]. Were its owners aristocrats flaunting their erudition? The subject was popular enough, however, for Vitruvius to include it among his selections of current wall-painting motifs. Garden paintings in Livia's villa, by contrast, represent Roman invention and patrician tastes [**66**] as the illusionistic counterpart to lavish outdoor gardens popular at the time. SGM

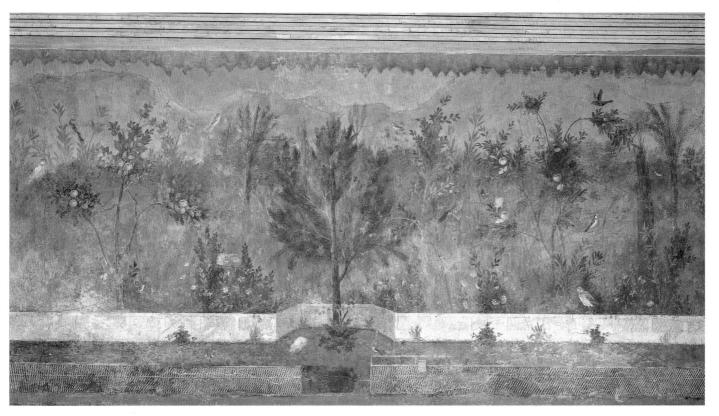

Campanian tastes

The eruption of Mt. Vesuvius in AD 79 blanketed towns, country estates, and seaside villas, cutting through a large cross-section of society. The remains are a goldmine for art and social historians with their phenomenal range of decoration and artefacts that run the gamut from sublime to banal.

Decor presumably suggests interests of owners but what those interests may have been is not always obvious. Illustrative are images from wealthy houses in Pompeii and Stabiae. The frieze in the Villa of the Mysteries invites speculation that its owners belonged to a priestly class [69] but we cannot assume that representations of actors elsewhere point towards theatrical involvement or even great erudition [67, 68]. Nor is it obvious what mythologicals in the house of the wealthy Vettii meant to the inhabitants [70]. Pure ostentation, the emulation of tastes of social superiors, or even simple appreciation of artistry may have played a determining role.

Yet it is clear that we must study pictorial decoration in its total context before drawing conclusions. Only the high quality of workmanship would lead one to suspect that the landscape paintings [71] from the villa at Boscotrecase reflect imperial tastes of the family of the emperor. SGM

56

68 Below: Street musicians (first century AD), from Stabiae, fresco, 29 cm. (11⅜ in.) high, Naples, Archaeological Museum

67 Above: Signed Dioscurides of Samos, street musicians (late second to early first century BC), from the Villa of Cicero, Pompeii, mosaic, *opus vermiculatum*, 44 cm. (17⅜ in.) high, Naples, Archaeological Museum

69 Right: Mysteries Room (c.60–50 BC), Villa of the Mysteries at Pompeii, fresco, figured frieze 1.62 m. (63¾ in.) high, Pompeii, in situ

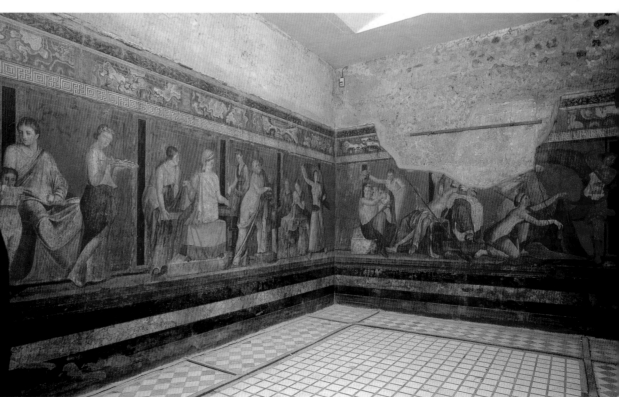

71 Right: Idyllic landscape (after 11 BC), red room of the so-called Villa of Agrippa Postumus at Boscotrecase, fresco, Naples, Archaeological Museum

57

70 Below: Ixion Room (*c.*AD 62–79), House of the Vettii at Pompeii, VI,15,1, fresco, Pompeii, in situ

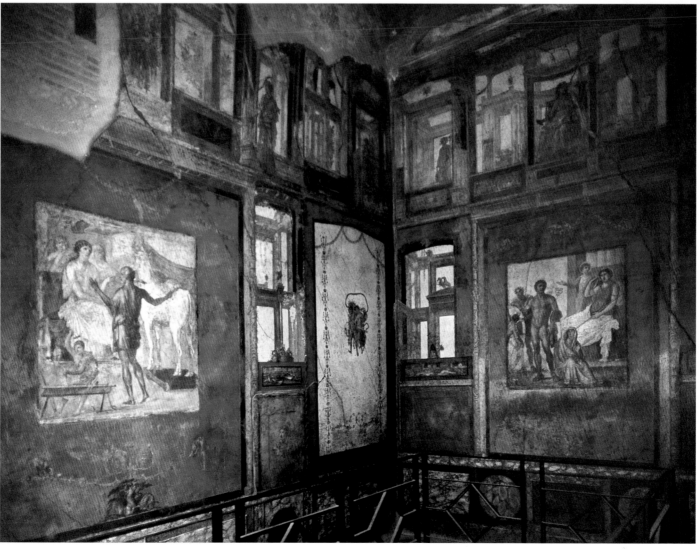

Technical matters

Scientific analysis of Roman paintings and mosaics has revealed various procedures of ancient craftsmen. Supporting evidence comes from finds like ancient painters' equipment and paintings showing craftsmen at work as well as from Vitruvius' treatise on the subject.

Fresco, painting on damp plaster, was the primary technique for wall painting though details could be added dry in tempera [74]. First, multiple layers of lime and marble-dust plaster were applied segmentally, working from top to bottom, to facilitate painting on still-damp walls. Incised guidelines marked out decorative patterns before final painting and burnishing occurred. Paint came from natural pigments except for blue frit (so-called 'Egyptian blue').

Inserted picture panels (*emblemata*) executed by specialists, were sometimes transferred ready-made, even second-hand. For them, preliminary drawings were often rendered in red or yellow ochre. After final painting details could still be added in tempera, paint mixed with some water-soluble binding agent, usually animal glue.

Encaustic painting is best preserved on Roman mummy portraits, wood or linen, from Egypt [72] though beeswax exists on Roman walls in England. Scientific analysis reveals that several types of encaustic were used: either hot beeswax mixed with resin or cold wax with egg and sometimes a little linseed oil. Tools were brushes (for cold wax) or spatulas, heated or cold. Mixed techniques are common.

Roman mosaics were typically made of cut stone *tesserae* often using

58

72 Mummy portrait of military officer (*c*.AD 160–70), said to be from er-Rubayat in the Fayum, encaustic on limewood, 40 × 25 cm. (15¾ × 9⅞ in.), Windsor, Eton College, Myers Museum

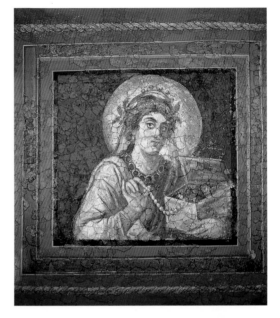

74 Female bust (before AD 326), from ceiling of house underneath the cathedral of Trier, fresco, Trier, Episcopal Museum

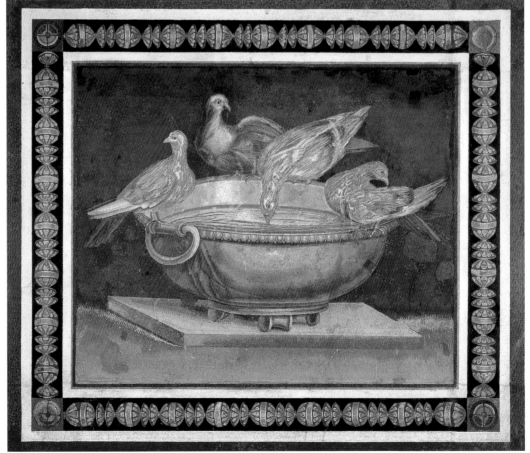

73 Doves (after AD 118), from Hadrian's Villa, Tivoli, mosaic, *opus vermiculatum*, 85 × 98 cm. (33½ × 38⅝ in.), Rome, Capitoline Museums

additional materials like glass, faience, and terracotta. Mosaics in *opus tessellatum* technique were composed of relatively larger *tesserae* [**75**], those in *vermiculatum* are millimetre-sized and specially shaped [**67**].

Mosaics were set on a bedding of layered stones mixed with mortar and additives like crushed tile. On a top layer of mortar, cartoons could be incised or painted as a guide for the *tesserae*. Templates for border motifs are also known. Panel pictures could be prefabricated (*emblemata*), set into surrounding frames, and even moved for reuse [**67**]. SGM

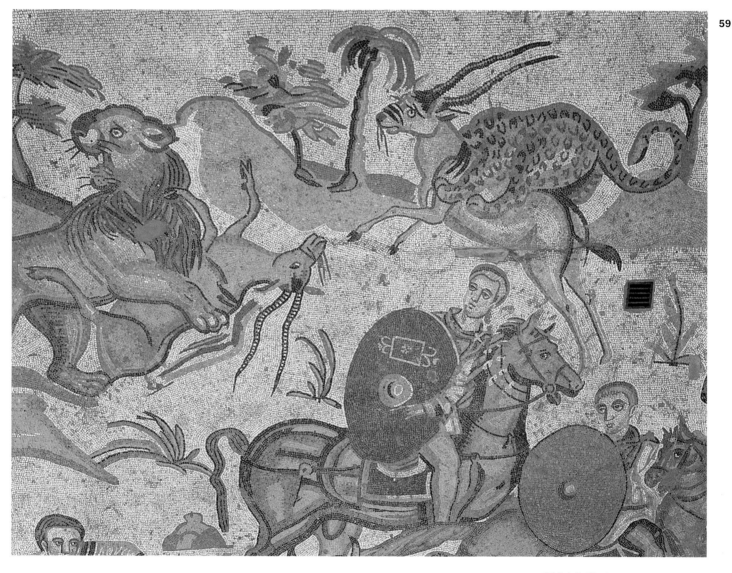

75 Detail of hunt (*c.*AD 300–25), Piazza Armerina, Sicily, mosaic, *opus tessellatum*, Piazza Armerina, in situ

Theory and Criticism

The ancient world was filled with painted and sculptured images of a bewildering variety—so diverse in function that it is difficult to subsume it all under the modern heading of 'art'. Life-size statues, for example, were ubiquitous in sanctuaries, cemeteries, public squares, and public buildings, and were also dotted through the country landscape at isolated tombs and shrines. These images made a deep impact on contemporaries and leave a rich written trace in ancient literature. The Greeks and Romans were remarkably voluble about their art, at least about some aspects of it.

A basic theory or premiss informed most of this world of images—that an image should have a relationship of verifiable likeness to the object it portrayed. This was the 'Classical' heritage: images, whatever else they may do, should closely resemble their subjects in shape and colour. This theory and its practice was not something indigenous to Greek culture from the beginning. It had a precise historical beginning whose context and language can be partly recovered.

The theory of visual truth

A lively verbal reception of well-wrought objects and images is attested in poetry and inscriptions of the Greek Archaic period (eighth–sixth centuries BC), but this remained effectively a long pre-theoretical time in which craftsmen deployed unselfconsciously local versions of eastern figured languages. The overt recognition of a close and desirable connection between visual appearances and images as the goal or norm of representation came suddenly, and for observable political and social reasons, during the first half of the fifth century BC. This was a new way of seeing and representing that we call, misleadingly, 'early Classical'. It was a bold, simple style driven on the political and social planes by a morally puritanical, anti-eastern, warrior ethic and one which today looks anything but 'realistic'. It embodies such strident social norms that generations have naturally attributed to it a higher 'ideal' purpose. The new 'Classical' visual language, however, came accompanied on the theoretical plane by an astonishingly explicit conceptual underpinning that set out a rather different visual agenda.

The theory is preserved for us now in a few quotations and paraphrases in later writers (notably Galen, the great doctor and medical writer of the second century AD) who commented on the visual systems and theoretical writings of sculptors of the early and mid-fifth century BC: Pythagoras of Rhegion, Myron of Athens, Polyclitus of Argos. The key terms were *symmetria* ('commensurability'), *rhythmos* ('rhythm' in posture and composition), *akribeia* ('accuracy'), and *alētheia* (literally, 'truth'), and

the theory was worked out in relation to the human figure, in particular figures of athletic males.

Symmetria referred to the observable, measurable proportions of the human body—as a treatise of Polyclitus had it, 'of the parts to each other, and of each part to the whole'. Figures should have an overall scheme of lifelike, commensurable proportionality, controlled and checked by measurement against real bodies not other images. *Rhythmos* referred to the

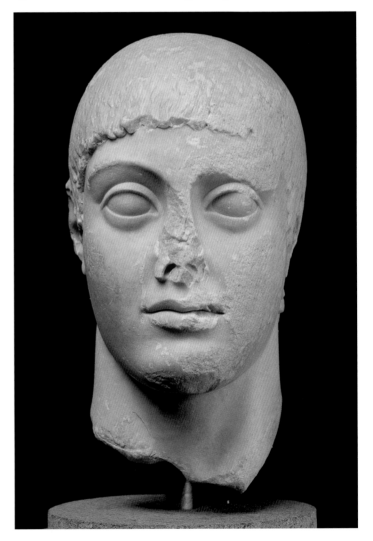

76 Male head of an athlete, hero, or god (*c*.470 BC), marble copy of the Roman period, 34 cm. (13⅜ in.) high, from the Baths of Diocletian, Rome, Museo Nazionale Romano

Visual truth attempted. Statues of the early fifth century BC embodied the first self-conscious attempt to show a verifiable correspondence between images and their subjects. They also contained the strong controlling norms of a bold and austere contemporary Greek identity—norms which were only much later interpreted as an 'ideal' attempting something better than reality.

posture of the figure thus correctly proportioned—to the lifelike posture, stance, and composition of the standing or active figure. *Rhythmos* and *symmetria* were what Archaic statues had so conspicuously lacked. *Akribeia* was the 'accuracy' or 'refinement' with which observed systems of proportion were applied, while the ultimate theoretical goal and touchstone of this visual project was *alētheia* or 'truth', which in this context refers to the fidelity or truthfulness of the image to reality, to the object portrayed. Only statues so constructed would be good and fine.

Truth advanced: pictorial illusionism

The medium in which the application of the theory was carried forward most strikingly was that of panel painting. Painting of the early Classical period (480–450 BC) had deployed statuesque figures with lifelike proportions and postures, but they were handled rather as large coloured drawings, without pictorial sophistication. In the fourth century, the period of Zeuxis and Apelles, the full panoply of pictorial illusionism—fore-shortening, (some) perspective, shading, highlights, chiaroscuro, cast shadows, reflections, colour mixing—was fought for and won. And each of these new 'inventions' was born with a sophisticated descriptive vocabulary to go with it. Painters could now make real-looking rounded figures stand out from their pictures, and it was the brilliant accessible quality of this first ancient illusionism that excited a widespread 'popular' reception of art.

Abundant ancient texts delight in the palpable living realism and illusionistic effects of ancient painting—birds eating painted grapes, viewers pulling at painted curtains, horses neighing at their own image. Such texts embody, in a different literary register, the same 'truth' theory as that of the fifth century; they merely describe works that were in terms of the theory much more successful. Plato's famous fulminations about visual art were in essence provoked by and aimed at the heightened 'truth' claim of the new painting's illusionism, in which he saw only deception.

The theory of ideal representation

It was only in the Hellenistic period (third–first centuries BC) that a theory of 'ideal' representation was first formulated. Looking back from the more nuanced realism and sophisticated individuality of early Hellenistic art—seen, for example, in the brilliant character statues of Menander or Demosthenes—which had been driven by vigorous application of the truth theory, the art of the fifth century came in retrospect to look rather strange, indeed inadequate when measured strictly by the truth scale. Its high normative quotient stood clearly revealed.

Since, however, this art had provided the defining representations of the gods and heroes of the dominant culture at an acknowledged height, a theoretical strategy was evolved asserting that the art of this period was not below reality on the truth scale (which of course it was) but *above* it—*supra verum* ('above truth'). Fifth-century visual norms were simply recalibrated as superior and so became in our terms 'ideal': they had been striving for something better and higher than mere

77 Portrait statue of Demosthenes (set up in Athens in 280 BC), marble copy of the Roman period, full height 2.02 m. (6 ft. 7½ in.), Copenhagen, Ny Carlsberg Glyptotek

Truth mastered. The statue of Demosthenes both expresses the idea of powerful inner thought and defines with ease the features of an apparently recognizable individual. It was from the perspective of a world inhabited by such sophisticated images in the Hellenistic period that earlier representations, such as **76**, took on the aura of an 'ideal'.

61

represented reality, whose conquest had now been thoroughly internalized. Thus was born the theory of Phidian idealism some two centuries after Phidias had lived.

The first art histories

Serious critical and historical writing on earlier art—art history as we know it—began in the early Hellenistic period, in the third century BC. The realization that the art of the Classical period had been in some ways different, special, superior prompted serious investigation and recording of its monuments, its history, and its artists. There were detailed accounts of monuments to be found in particular sanctuaries. There were highly coloured Vasari-style biographies of famous artists (such as those of Douris of Samos). And there were teleological art histories (such as that of Xenocrates of Sicyon) tracing various trajectories in the rise and efflorescence of the art of close resemblance. Together these art histories and biographies invented and established the influential theoretical idea that art and artists were autonomous cultural phenomena developing under their own imperatives. The distinctive flavour of these ancient art histories can still be sampled in the chapters on sculpture and painting in Pliny the Elder's encyclopaedic *Natural History* (Books 34–6).

For the earliest art histories, written in the third century BC, the accepted theory of art was one of resemblance, and they traced a linear progression of successive discoveries or 'inventions' by which artists became better at realizing lifelike effects. Each advance in the convincing representation of such things as proportions, action postures, veins, hair, shading, highlights, and abrupt foreshortening was associated with one of a succession of great names who came to make up an art-historical canon. In sculpture, for example, there were Myron, Polyclitus, Phidias, and their pupils in the fifth century, followed by the marked improvements brought by Praxiteles, Lysippus, and their pupils in the fourth century, down to the 'present' in the early third century.

Some later Hellenistic art histories took instead the 'ideal' theory as the yardstick of good art, and traced a quite different, 'classicizing' trajectory. They set the peak of achievement a hundred years earlier, in the generation of Phidias. The Phidian summit was preceded by a swift, steep development from simple and stiff to noble and perfect already in the mid-fifth century, and was followed in the fourth century by increasingly realistic representation and by outright decadence in the third century, when no art worth the name was produced. It was this version of Greek art history that gave birth to the powerful idea of an absolute ideal 'beauty' in visual representation that could only be realized by and was the goal of the greatest artists.

Cicero later described this visionary process: 'In his mind resided a certain refined conception of beauty; watching it and keeping his mind fixed on it, he [Phidias] directed his art and mind to a representation of its likeness.' The resemblance of the finest representations should not be to life but to some Olympian improvement on life conceived in the eye of the master's mind. It was the hallmark of this theory that 'beauty' was conceived in opposition to close resemblance.

This idealizing (and tendentious) art history had immense influence, since it was taken up and amplified at Rome and transmitted in Pliny to Winckelmann and to twentieth-century scholarship. For lack of competitors it has often, then and now, been taken as a good, true historical description of the development of ancient art.

Classic art on a Roman pedestal

In the Roman period, a wide gulf opened between theory and practice, between theories, histories, and criticism of art on the one hand and contemporary practice and production of figured images on the other. In as far as art was talked about and written about, it developed many of the characteristics that much of our society would still attribute to things called 'fine art'. The best art was old, classic, and usually ideal in subject; it required no ostensible function—it was for its own sake; and it could sometimes be the subject of cultivated discussion.

78 Painted funerary portrait from a mummy (first century AD), tempera on linen, with gold leaf over stucco for the earrings and necklace, 42.5 cm. (16¾ in.) high, from Hawara, in the Fayum, Egypt; found with an inscribed gravestone for a woman called Aline, daughter of Herodas, aged 35 years, Berlin, Ägyptisches Museum

Truth intensified. A provincial woman wearing a fashionable hairstyle of the early imperial period is portrayed in a sharply objective manner that defined a distinctive 'Roman' social morality. Only in the Roman period was this intensified portrayal of likeness extended to the representation of women.

For art made at Rome, on the other hand, that is, contemporary images serving Roman functions, there simply was no established genre of writing or terms of aesthetic discussion. For complex historical reasons, to do partly with the Roman élite's own self-styled cultural identity, the magnificent series of images and artefacts that for us make up Roman art—portraits, imperial cameos, historical reliefs, tomb sculptures—had no written art theory, art criticism, or art history. Such monuments, it was felt, served a different, more important real-life function from the one that had now been assigned to fine art. 'Art' in the sense of things of explicit aesthetic interest in themselves was now ideal, antique, and a commodity.

There did exist extensive and varied critical writing on art in the Roman period, especially by Greek authors such as Dio of Prusa, Lucian, and Pausanias, but it is remarkable how exclusively it was concerned with the art of the 'classic' Hellenic past and how wholly it was under the sway of the 'ideal' version of art history.

There was thus from the later Hellenistic period onwards a near-complete divorce between art theory and criticism in literature and contemporary artistic practice, which continued to be based tacitly on the inherited truth theory of close resemblance. We see its vigorous, intensified application, for example, in the realm of Roman portrait art. There simply was no written art history of the long period of ancient visual production after the first century BC.

The truth theory modified and maintained: late antiquity

The conversion of Constantine and the long slow Christianization of the Empire in the fourth–sixth centuries AD saw no sudden change in the inherited theories and practices of ancient representation. The old view of an all-embracing aesthetic revolution, from a Classical art of resemblance to an anti-Classical 'abstract', medieval art of inner, spiritual, otherwordly values is not something visible in the full range of visual products now available for this period.

Nor is it supported by texts or critical writing. Plotinus, a neo-Platonic philosopher writing still under the Empire of the third century, has sometimes been said to display an 'incipiently medieval' attitude to art. But when, as a Platonist, he is not simply being anti-art and anti-representation, he expresses the 'ideal' theory of a higher divine beauty that philosophers and great artists of old, such as Phidias, may visualize. Plotinus' views on art are inconsistent, and no more reflect late antique visual practice than Plato's did that of the fourth century BC.

The late antique period saw some new concerns and priorities realized in art, but they could still be accommodated comfortably within the resemblance and ideal theories of representation which had been forcefully expanded to cater for Roman society's wide representational needs during the imperial period. And it was some time before Christianity's theoretical problems with images, inherited from Judaism, had any practical effect. Theoretical opposition to images, like that within the Classical tradition, was not allowed to affect popular, aristocratic, or imperial appetites for real-looking visual representation.

The already much-broadened stream of the Classical aesthetic simply became wider to cater to new late antique needs and to newly favoured media. At the same time, however, the overall volume of image production slowed drastically. Fine marble statues, reliefs, sarcophagi, and mosaics were being made through the sixth century but in sharply reduced numbers. As demand subsided, the great reservoir of technical skill on which the whole tradition rested dried out.

Classical *techne* withered in the West during the disastrous fifth century, in the East in the disastrous seventh century. New patrons came slowly and with new ideas. The art of late antiquity did not experience an aesthetic conversion, rather it atrophied late in the day owing to lack of customers, its original 'truth' theory of the fifth century BC still intact, much adapted and expanded but still recognizable.

RRRS

79 Head from a statue of a late Roman provincial governor (fifth century AD), marble, 27.5 cm. (10¾ in.) high, found in the South Agora of Aphrodisias in Caria, Aphrodisias Museum

Truth maintained and modified. Late Antiquity stretched the Classical aesthetic for new ends, while at the same time maintaining its basic premiss of close resemblance. The numerous statues of provincial governors of the fifth century AD exhibit the widespread interest of the period in intensely powerful vision but set still in the traditional framework of real-looking, physiognomically accurate images.

63

Ancient Paradigms, from Augustus to Mussolini

Historians regularly invoke 'the classical tradition', meaning the great stream of continuity in art and literature that links the ancient with the modern world, to explain the consistent European fascination with certain themes, images, and ideas, even across centuries of social and historical change. It is so self-evident a feature of European intellectual history that it is easy to take it for granted. The expression itself is problematic, however, for it encourages us to think in terms of a unified, monolithic movement in European art, when on closer examination this tradition turns out to embrace a multiplicity of different currents, many of them not 'traditional' at all, but all in one way or another taking their lead from models offered by the Greek and Roman world. Here I wish to emphasize the complexity of this phenomenon rather than its unity, and to view it rather as a plurality of inherited paradigms.

The Roman appropriation of Greek art

It was the Hellenistic Greeks who first looked back with nostalgia to the achievement of artists of the preceding 'Classical' period (the fifth and fourth centuries BC), and gave them

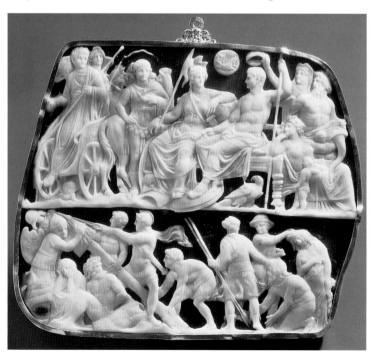

80 Gemma Augustea (c. AD 5), sardonyx cameo, 19 × 23 cm. (7½ × 9 in.), Vienna, Kunsthistorisches Museum

A classicizing exercise in a wholly Hellenistic genre—the cameo. In the upper register the emperor Augustus, with the perfect body and costume of a Classical Greek god, sits enthroned beside the goddess Roma, amidst a throng of divinities and personifications.

something like 'classic' or 'old master' status, organizing their work into a recognizable canon. Classical artists were thought to have particularly excelled in representing the majesty of the gods, so that Classical cult images often became highly prized cultural icons, in which whole communities could take pride. But these early efforts to chart the Greek heritage in the visual arts were soon completely overshadowed by the programmatic revival and redeployment of Greek art by the Romans: first on private initiative, by victorious generals in their triumphal dedications, and by wealthy collectors in their luxurious villas; and then, more importantly, in the public building projects of Augustus, the first emperor, as part of his programme of Roman cultural renewal.

The monuments of Augustus' imperial regime represent the first major appropriation and reworking of the style of Classical Greek art, in order to create a new style which could express the majesty of the Roman Empire and help define the new state which the first emperor was fashioning [**80**]. A self-consciously idealizing, retrospective style was created, which is visually consistent, and looks completely different from the stylistic eclecticism of earlier republican monuments. It is designed to lend Augustan public imagery something of the authority of the most admired 'classic' Greek art, and to distance it from earlier Roman art, having all the while an obvious elevating effect on the content.

Christianity and the philosopher portrait

Christianity initially rejected the idolatry of paganism, but soon felt the need for images itself, and took over from the ancient world a quite different paradigm. When medieval artists represented Christ and his saints they were less interested in style for its own sake, more in expressing content. They drew extensively on the authoritative image of the bearded holy man or sage, which represents the final stage in the development of the Greek philosopher-portrait. This image had evolved over the course of seven hundred years specifically to embody the wisdom and inspired vision of the charismatic teacher; and it is clearly recognizable both behind the imposing depictions of Christ and the elderly, long-bearded saints and martyrs whom we find in the icons and mosaics of Byzantine art [**81**]. Such representations of the divinely inspired leaders of the Christian church were also usually clothed in some form of Classical costume, so that many of the techniques developed for the rendering of elegantly draped garments were kept alive for hundreds of years in Byzantine art (albeit as frozen formulae), to be rediscovered and mastered by the artists of the Italian Renaissance.

The rebirth of the 'living' art of antiquity

The Italian Renaissance looked back not to one single style, or one authoritative image, but regarded all surviving antiquities as offering models for imitation and appropriation. From Greek and Latin literature artists and antiquarians rediscovered the idea of 'art' itself, as a highly esteemed cultural endeavour, parallel to literature, and possessing its own rules and achievements. And this new respect for the visual arts helped to revive arguably the most important goal of all Greek art—the instilling of a credible illusion of life in artistic representations. This was probably the most important ancient paradigm that attracted Renaissance admiration and provoked direct imitation; and in order to attain this goal artists carefully studied antique figures to acquire a perfect mastery of human anatomy.

But antiquity offered other material for appropriation too. Interested patrons commissioned artists to revive Classical subject-matter—the gods and heroes of pagan mythology. The reasons for this are complex, but one aspect may be highlighted here. The Greek and Roman gods had been used in ancient art and literature to personify the forces of nature (Poseidon/ Neptune—the sea, Aphrodite/Venus—love) or various aspects of culture (Ares/Mars—war, Apollo—music/poetry). They permitted symbolic representations of the world of human

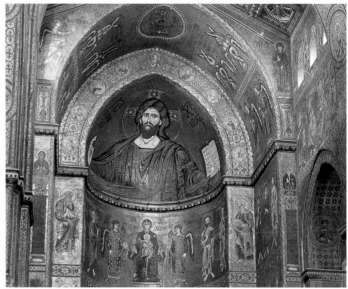

81 *Christ Pantocrator* (1174–82), mosaic, apse of Monreale Cathedral, Sicily

Christ is represented as the lord of creation, with long hair and beard, and wearing flowing Classical robes, in the tradition of the late antique sages—the last philosophers of the ancient world. The inscription, in Greek and Latin, reads 'I am the light of the world' (John 8:12).

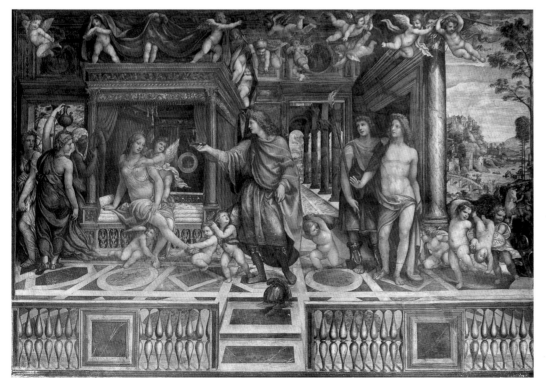

82 Giovanni Antonio Bazzi (Il Sodoma) (1477–1549), *The Wedding of Alexander and Roxanne* (c.1515), fresco, 4.60 × 6.73 m. (15 ft. 1 in. × 17 ft.), from the bedroom of Agostino Chigi, Rome, Villa Farnesina

On occasion Renaissance artists even tried re-creating famous Classical masterpieces, known from detailed descriptions in the ancient writers. Sodoma here re-creates a famous painting by Aetion (described by Lucian, *Herodotus*, 4–7). The many cupids effectively symbolize the power of love, in a manner wholly familiar from ancient art. The great conqueror Alexander the Great could also personify war, so that the image becomes an allegory of the triumph of Love over War.

experience. With the old religion safely dead, its gods could be revived in order to construct elaborate allegories about the cosmos, the world, and man's place in it. The Greek myths could also be employed in this way—to embody particular ideas or to stimulate certain kinds of moralizing discourse—as could Greek and Roman history [**82**]. Such allegories often embody quite esoteric learning, connecting the Classical gods with astrology and the planets, and much else that figured in the late medieval systems of knowledge. They are thus sometimes difficult to interpret, and differ quite radically from their ancient equivalents.

European Neoclassicism

In the eighteenth century there began, partly as a reaction against the excesses of contemporary taste (the styles we call Baroque and Rococo), a new movement in art which self-consciously sought to emulate the art of antiquity. This movement found its champion in the influential critic J. J. Winckelmann, who recognized, mostly from his careful reading of ancient literature, the primacy of Classical Greek art in the art of antiquity. He also discerned in the surviving ancient works qualities diametrically opposed to the art of his own day: 'a noble simplicity and quiet grandeur'. He believed that ancient art offered the best models for contemporary artists, and became a passionate advocate of the imitation of Greek sculpture. Looking directly back beyond the Renaissance to antiquity, sculptors like Antonio Canova (1757–1822) and Bertel Thorvaldsen (1770–1844) explicitly rejected the emotionalism and theatricality of Baroque art, and prized instead qualities like sobriety and restraint which Winckelmann had encouraged them to find in antique statues.

The dramatic political events of the century also played a role. The French painter Jacques-Louis David (1748–1825) devised a striking new style, and introduced a whole series of new 'Classical' subjects, often drawn from the legendary history of the early Roman Republic (rather than from Greek myth), which to contemporaries seemed to embody the aspirations of the times (the stormy period leading up to and embracing the French Revolution). They explicitly celebrated republican values—the patriotism and self-sacrifice of figures like the Horatii [**442**], or the consul Marcus Junius Brutus—and were intended to have a resonance in contemporary revolutionary politics. David's style was based on close imitation of antique models, endowing his (often Classically nude) figures with a sculptural stillness, a nobility or grandeur which was felt to have a moral dimension. This deliberately austere style at once strengthened and enhanced the serious tone and high-mindedness of the subject-matter.

After Napoleon became emperor, however, the favoured antique paradigm also changed. French artists now looked to the monuments of the Roman Empire to provide the models for Napoleon's triumphal arches and columns erected to celebrate his victories. In particular, Napoleon's portrait was sculpted in close imitation of Augustus'. Canova's colossal nude portrait was created directly in this tradition, as was Greenough's giant statue of George Washington [**83**], father of another revolution.

Nineteenth-century Romanticism

To the nineteenth-century Romantic imagination Classical antiquity offered a fascinating alternative to contemporary society. The cultural achievements of the Greeks and Romans formed the basis for all higher education; yet the ancients had lived in a strange and alien world, which presented attractive possibilities for escape—whether from the confines of strict Victorian morality, or the ugliness of the Industrial Revolution. The ancient paradigm to be appropriated here was that of a civilized world *before* Christian prudery; a world of unspoilt nature. Many could find refuge in idyllic Grecian landscapes filled with images of sensual nude beauty, and haunting dream-like visions of Odysseus and the Sirens, Leda and the Swan, or the garden of the Hesperides. Classical myths gave nineteenth-century artists considerable scope to indulge their love of the fantastic, the melodramatic, the exotic. And the 'decadence' and cruelty of the ancient world offered the allure of forbidden pleasures (the slave market, the Roman arena, the Roman bath) which was sanctioned by being part of a higher culture.

The contemporary rise of archaeology also had two very interesting effects. First, an increased knowledge of the material conditions of ancient life transformed artists' visualizations of Classical subjects. Archaeology could provide artists with authentic detail to flesh out their creations [**84**]. Nevertheless, these more 'authentic' images of antiquity often seem merely anecdotal, and to have no higher goal than picturing a striking incident from history, or giving a charming, sentimental evocation of ancient life. It was this kind of academic Classicism—immensely successful at the end of the nineteenth century, both in France and in England—that was to be so violently rejected by the Impressionists and the Modern Movement in general.

Then there was the allure of classical ruins. Painters had long been making paintings of the overgrown but often spectac-ular remains of ancient buildings. To the Romantics, ruins—dramatizing the passage of time, and provoking melancholy thoughts of the fragility of all human achievement—could now be more interesting than complete buildings. At the same time the practice of 'restoring' broken statues, universally practised since the Renaissance, now went out of fashion. The battered but beautiful fragment was now revered as more aesthetically satis-fying than the whole. Eventually sculptors like Rodin deliberately created such fragments for exhibition. The shattered ruins of antiquity offered in this way a different paradigm—this time of suggestive incompleteness—to feed the Romantic imagination.

Classical paradigms in the service of Fascism

The Classical architectural orders have, of course, been employed by European architects since the Renaissance, and even in the twentieth century artists too have found inspiration in Classical art (Picasso [**596**]). More particularly, though, the twentieth century has seen the creation of a new imperial art and architecture based on the Classical models—a style which followed directly on the Neoclassical art of the French Revolution. The Romans had appropriated the Greek archi-tectural orders and created a monumental style embodying imperial might. Mussolini's architects took the familiar motifs of this Roman Classicism, which could be recognized by all as authoritative, traditional—even quintessentially Italian—and attempted to combine them with the clean lines of modernism, and the gigantic scale of the railway stations and factories of the

Clockwise from bottom left

83 Horatio Greenough (1805–52), *George Washington* (1832–40), marble, 3.45 × 2.59 × 2.08 m. (11 ft. 4 in. × 8 ft. 6 in. × 6 ft. 10 in.), National Museum of American Art, Smithsonian Institution

Washington is here represented just as Augustus was [**80**], his costume and pose derived from Classical Greek representations of Zeus, in one of the latest such portraits of great men portrayed in Neoclassical 'idealizing' mode. Such images were a little 'radical' even in their own day, and when the statue went on display in the Capitol in 1841 the artificiality of the costume generated considerable controversy.

84 Sir Lawrence Alma-Tadema (1839–1912), *Antony and Cleopatra* (1883), oil on panel, 65.4 × 92.1 cm. (25¾ × 36¼ in.), private collection

The painting displays the artist's considerable archaeological knowledge. The head of Cleopatra was based on a bust identified as her mother, Queen Berenice; the golden cartouche on the side of the barge contains the queen's name correctly written in Egyptian hieroglyphics; and in the background we see Mark Antony's Roman warships with their banks of oars. Such paintings provided much of the inspiration for the spectacular epic films of the twentieth century, like *Ben Hur*, *Quo Vadis*, or *The Ten Commandments*, and have earned Alma-Tadema the appellation, 'The painter who inspired Hollywood'.

85 Giovanni Guerrini, Ernesto Bruno La Padula, and Mario Romano, the Palazzo della Civiltà Italiana, now called the Palazzo del Lavoro (1938–42), Esposizione Universale di Roma (EUR)

The gigantic Fascist buildings in EUR represent an imperial architecture created for the twentieth century on the ancient Roman model. In retrospect, with their names changed and their strident ideological agenda muted, they have something of the surreal character of the deserted cityscapes of de Chirico.

industrial age [**85**]. The results can best be appreciated at the Esposizione Universale di Roma (EUR), Mussolini's model city, built as a new suburb of Rome. The Fascist mission was in part reactionary, and to varying degrees deliberately set itself against the avant-garde, receiving massive state sponsorship in Mussolini's Italy and Hitler's Germany as did similar manifestations, to a lesser extent, in Franco's Spain and Stalin's Russia. The direct association with these totalitarian regimes has for the time being killed off almost all appreciation for artists and architects who worked in this style. Nevertheless, monuments like the Palazzo della Civiltà Italiana are a powerful reminder of this phase of twentieth-century Classicism, and do nothing to discredit the power of the Classical models, or their continuing hold on the European artistic imagination. CHH

2 Church and State
The Establishing of European Visual Culture 410–1527

The second part of this book is devoted to the long sweep of time from the emergence of a Christian art in the last stages of the Roman Empire to the invasion of papal Rome in 1527—traversing as one, in contrast to standard histories of art, the chronological territories normally demarcated as Early Christian, Byzantine, Medieval, and Renaissance. This is, in effect, to propose that a fresco cycle in a Renaissance chapel stands as a lineal heir to the first large wall paintings and mosaics that decorated basilicas of early Christendom.

The substantial role, in terms of both function and cost, played by media other than painting and sculpture is recognized by the prominent sections devoted to manuscript illumination, sacred art in precious materials, and stained glass. Monumental sculpture, most notably on the outside of ecclesiastic buildings, stood supreme as a public expression of the power of the church, and, to an increasing extent in the later parts of the period, as a manifestation of secular authority.

Painting, both in the form of murals and pictures on panels (and later on canvas) served story-telling and devotional functions, especially in ecclesiastical contexts. As the period proceeded, pictorial art, including tapestries, became ever more prominent in secular contexts, and the paradigms of Classical art—never entirely absent in the Middle Ages—were revived in form and content. During the final hundred years, an independent literature on the theory of art was developed, and the final fifty saw the rise of the print as a major medium of religious and secular communication.

Themes

During the centuries that followed the establishing of Christianity as the religion of the Holy Roman Emperors, figurative imagery speaks of religious life underpinned by secular power and secular life articulated by religious observance. The content of images, particularly those that have survived, is predominantly religious, yet the choice of subject and mode of presentation seamlessly combine the values of religious institutions with the interests of those who held the purse-strings. For a religion which in biblical theory prohibited 'graven images', the richness of artistic production is astonishing. The richness is both metaphorical, in artistic scope and wealth of craftsmanship, and often literal, in the sumptuousness of materials.

There were significant continuities with Roman art, just as philosophical theology drew heavily upon the Latin transmission of Plato and Aristotle, but the central purpose of imagery was decisively diverted into the illumination of those spiritual values that might ensure the eternal life of our souls in paradise. The king, prince, or wealthy patron possessed riches that both promised the purchase of a privileged seat in heaven and presented a potentially crippling disability, in that it was 'easier for a camel to pass through the eye of a needle than for a rich man to enter heaven'.

Traversing more than a millennium, it is not surprising to find that huge changes occurred. In visual terms, the greatest transformation occurs in degrees of naturalism. The range extends from the iconic formality of the most hieratic Byzantine image of the god-head to the extraordinary verisimilitude achieved by Italian and Netherlandish artists in the fifteenth and early sixteenth centuries. Increasingly the legibility of the 'book of nature' was seen as specifically designed for human beings—God's supreme creation. Yet the inculcation of awe in the presence of divinity remains constant, on the one hand through the glory of an omnipotent god, and on the other through the human reality of the corporeal presences of Christ and the Saints on earth.

The progressive 'humanizing' of the images of divine persons and the portrayal of individualized individuals is common to religious observance (notably with S. Francis), the rise of secular powers (extending from nation-states to wealthy merchants), and the philosophical-cum-literary movement known as Humanism (in which individual perception becomes the 'measure of all things'). The period also witnesses an increasing production of secular artefacts, the survival of which is particularly patchy. The conscious invasion of non-religious themes into realms of scale and significance previously reserved for Christian subjects is the culmination of a long-standing trend which accompanies the rise of international market economies.

Ending with the sack of Rome by the troops of Emperor Charles V is not intended to signal that everything was henceforth different, but it does provide a potent sign of the secular challenge to the Papacy's invulnerability on earth, just as the Reformation inaugurated by Martin Luther destroyed the claims of Rome to be the infallible centre of the 'Universal Church' on behalf of heaven.

MK

86 Opposite: The Master of S. Giles, *The Mass of S. Giles* (c.1500), showing the ninth-century altar frontal of the basilica of Saint-Denis, Paris (known from documents but now destroyed), raised to the position of a dossal, London, National Gallery

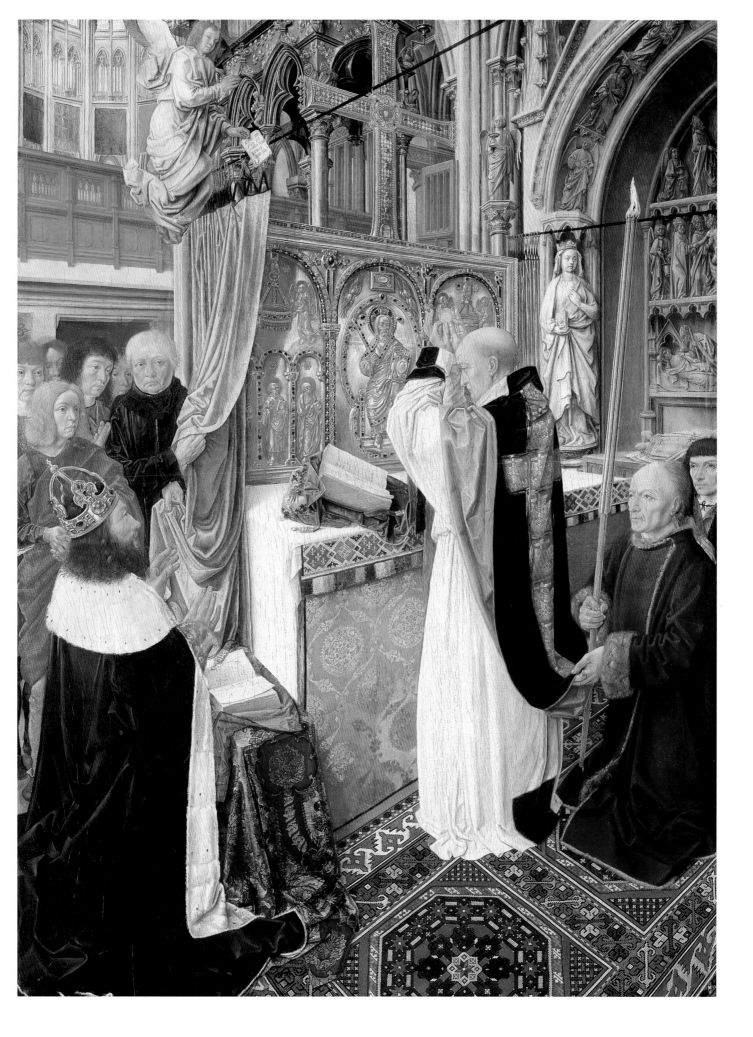

Early Christian Art

Early Christian art eludes easy definition. Its history begins within the ambit of late classicism and culminates in the art of the Byzantine empire, which has been more or less consistently viewed since the Renaissance as the antithesis of Classical style. This over-simplified view was seemingly supported by Renaissance analysis of the Arch of Constantine [**88**], which makes an easily distinguished turning point in Roman history, after which the inexorable rise of Christianity to dominance throughout the Roman world entered its final phase. Raised in AD 315 to celebrate that emperor's seizure of power in 312, the arch mixes relief panels looted from monuments of earlier emperors like Trajan and Marcus Aurelius with work done specifically for the arch by fourth-century sculptors. For Renaissance critics and their followers the stylistic gulf between the two bodies of sculpture appeared as incontrovertible evidence of a decline from the standards of the first and second centuries and was easily explained as a consequence of the changed cultural climate of Rome under Constantine, the first Christian emperor. For Renaissance historians like Giorgio Vasari (1511–74) Constantine's later abandonment of Rome for his new capital on the Bosphorus, Constantinople (founded c.330), further served to hasten the irrevocable decline of classicism in the Roman world.

The relationship between Christianity and the artistic ethos of Classical Rome is both more complex and less drastic than this reading suggests. Once the difficulties raised by the prohibition of imagery in the second commandment and the anti-representational hostility of the Platonic tradition within Christianity had been quelled, the new religion was free to develop an art which met its particular needs.

The bulk of the earliest Christian art is associated with funerary rites, in the form of catacomb paintings and sarcophagi. The style and formats of the catacomb decorations, of which the most significant collection is in Rome, develop almost seamlessly from existing models. A cluster of the commonest funerary images was taken over more or less wholesale, to the extent that it is often only from the context that their adaptation to Christian purpose is clear. Early approaches to the person of Christ himself tend to portray him in symbolic terms via an established pagan image like that of the Good Shepherd, ubiquitous in the art of the early Christian centuries [**92**]. What had been a symbol of philanthropy in the deceased was easily translated in Christian terms via the several scriptural references which apostrophize Christ along these lines. Pagan imagery of the vine, associated with the cult of Bacchus, was as readily reworked as symbolic of the Christian 'True Vine' (S. John 15: 1). The third-century roof mosaic of the mausoleum of the Julii beneath S. Peter's combines the vine with an extraordinary image of Christ adapted from that of the sun god Helios [**87**]. Only the cross-shaped nimbus makes the Christian significance apparent.

After 313, when the Edict of Milan established the legality of Christianity throughout the Empire and from which date all subsequent emperors save Julian 'the Apostate' (reigned 361–3) were themselves Christians, the interpenetration of Christian and imperial imagery accelerated. As the emperors took on increasingly priestly guise so the iconography of Christ and his church took on a correspondingly imperial flavour. The key image

87 *Christ-Helios* (mid-third century), detail of mosaic, vault of the Mausoleum of the Julii (c.2.5 m.—8 ft. 2½ in.—long), Rome, Grotte Vaticane

associated with the supremacy of the Roman church was the *Traditio Legis*, in which a Christ figure of often openly imperial type hands the Law to S. Peter and S. Paul, Apostles martyred in Rome and over whose graves the emperors raised vast churches (S. Peter's from *c.*319, and S. Paolo fuori le mura from 384). Just as the architectural format of the old Roman basilica, the seat of imperial or other authority, had been adapted as the basic design of the Christian church, so the image of the kind of authority exercised within such a structure was adapted to Christian purpose. The *Traditio Legis* from the sarcophagus of the Roman city prefect Junius Bassus (d. 359) [**89**] presents this quasi-imperial image of Christ enthroned above the sky god Caelus in openly Classical guise.

By the end of the fourth century Christianity was established as the official religion of the Roman Empire, now divided into two administrative spheres, the eastern of which was ruled from Constantinople. Artistic developments during this period followed a number of paths. That Late Antique naturalism of an accomplished kind survived is demonstrated by an ivory panel of the *Three Maries at the Sepulchre* and the *Ascension* of *c.*400 [**90**]. Its style inhabits a seemingly different world from that of the silver dish (*missorium*) of Theodosius I, made in 388 [**91**]. The image of the emperor and his sons Arcadius and Valentinian II presents them in hierarchical proportion—Theodosius much the largest and sporting a halo—and devoid of any attempt at individualized portraiture. The drapery, albeit derived from Classical forms, is weightless, expressing little of the body beneath (compare the Junius Bassus figure). It is an image of a power structure and the emperor's political and theological status. That this denatured style was a matter of conscious choice in response to the particular needs of the image is confirmed by the lower part of the dish, where the figure of Abundance reclines in full Classical guise.

In 410 Rome was sacked by the Visigoths. In 476 the last emperor of the West was deposed and Italy came under the rule of 'barbarian' kings. The ruler of the eastern, Byzantine, empire accordingly regarded himself as sole legal ruler of the Roman world. In no significant sense did these events initiate, as Renaissance theory insisted, a cultural collapse. The greatest of the Ostrogothic kings of Italy, Theodoric (reigned 471–526), actively promoted Classical learning and supported the upkeep and repair of Roman monuments.

Theodoric's capital was at Ravenna, where he built (*c.*490) a church of the Redeemer, later rededicated as S. Apollinare Nuovo. He continued the tradition of large-scale mosaic decoration in Ravenna, already represented in the exquisite mausoleum of the empress Galla Placidia (*c.*425), with an extensive scheme on the walls of his new basilica, including the earliest surviving narrative cycle of the Life of Christ. The stylistic vagaries of the period are well characterized here, a highly reductive manner coexisting with a more ambitious Late Antique illusionism.

Ravenna continued to play a prominent role in the sixth century, when it served as the springboard for the attempted reconquest of Italy under the greatest of Byzantine emperor-builders, Justinian (reigned 527–65). The failure to secure Italy for the Empire in the long term actually contributed to the survival of the greatest body of early Byzantine mosaics in the West. The decoration of the sanctuary of the church of S. Vitale (consecrated 547) stands as one of the supreme pictorial monuments of the Christian empire and a summary of the complex relationship between its art and that of the empire of Augustus and Hadrian. The apse mosaic of Christ with S. Vitalis, Bishop Ecclesius and two Archangels [**95**] derives as clearly from the earlier 'imperial' images of Christ as the great flanking mosaics of Justinian [**94**] and Theodora with their retinues do from the processional reliefs of Augustan Rome. When required, there is a high degree of naturalism, as in the pungently characterized portrait of Archbishop Maximian, but the Hellenistic solidity of Augustan style is dissolved in a shimmering play of light, a substance of enormous symbolic significance in Byzantine culture.

The highly selective use of the naturalistic modes of antiquity in Early Christian and Byzantine art reflects a profound shift in the understanding of art. Representation of the material world was embraced where appropriate, but the overall purpose of images like the S. Vitale mosaics was directed at an experience transcending nature and the world of appearances. It is one of the distinctive achievements of Early Christian art that it developed a range of pictorial formats on the basis of the artistic language of a Roman world whose concerns were so different, initially, from its own. Central to Christian doctrine is the intractably difficult question of the nature of Christ; wholly God and yet wholly Man, an issue that fuelled often violent debate in the early church. It is against this background of a religion that seemingly embraces but also rejects the phenomenal world that the synthesis of Classical and non-Classical, naturalistic and supra-naturalistic styles in the art of the period should be seen. The active relationship between apparently mutually opposed approaches to art, often expressed in the repeated interplay of overlapping Classical survivals and revivals, was a constant throughout the millennium of Byzantine and Western medieval art which followed. JR

The Christian empire

Monumental sculpture, free-standing and relief, was one of the major art forms of the Classical world. The requirements of the Christian empire were rather different, and many of its most characteristic art works took the form of small-scale relief carvings. These vary in their sculptural technique, from the genuinely monumental, albeit on a reduced scale compared with the reliefs of the Arch of Constantine [88], to what is effectively a pictorial art. The fourth-century Constantinian reliefs abandon all sense of Classical proportion and subordinate the figures to a diagrammatic structure which serves to clarify the political significance of the image. The sarcophagus of Junius Bassus [89] achieves the same clarity while retaining the deep cutting, naturalistic figures and Classical drapery of earlier

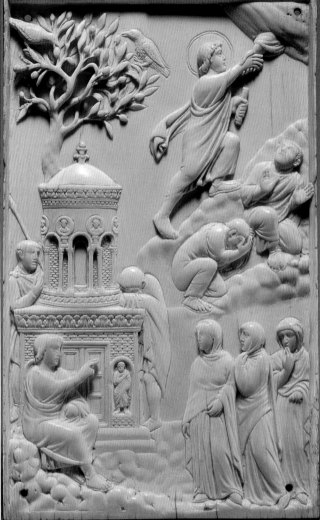

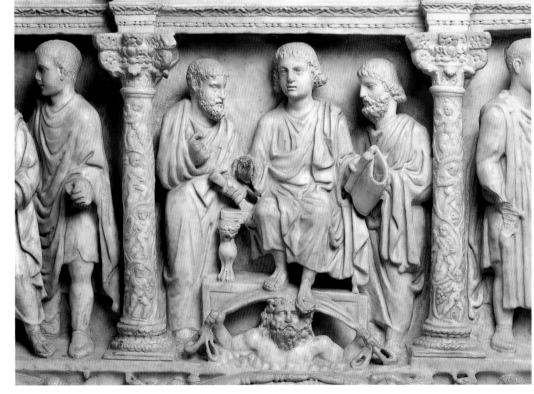

88 Above: Detail of the Arch of Constantine (315), Rome

89 Right: *Traditio Legis*, sarcophagus of Junius Bassus (*c.*359), marble, whole sarcophagus 2.43 × 1.41 m. (7 ft. 11⅝ in. × 4 ft. 7½ in.), Rome, Grotte Vaticane

90 Above: *Three Maries at the Sepulchre* and *Ascension* (*c.*400), ivory relief panel, 18.7 × 11.6 cm. (7⅜ × 4½ in.), Munich, Bayerisches Nationalmuseum

91 Opposite: *Missorium* of Theodosius I (388), silver, diameter 74 cm. (29⅛ in.), Madrid, Academia de la Historia

styles. Most fourth-century art lies between these two poles.

Towards the end of the century the stylistic contrasts widened. The Munich *Ascension* panel [**90**] is typical of surviving Classical tendencies, as well as the level of refinement found in many ivories of this period. The production of panels carved from ivory, a luxury material, was restricted to consular and imperial circles, and most commonly

used for the diptychs issued by consuls to mark their tenure of office, or for official gifts. The Munich panel also establishes the point that naturalism and Christian iconography were not inherently incompatible.

The *Missorium* of Theodosius I [**91**] had a commemorative function too, issued to mark the emperor's Decennalia in 388. Here the Classical origins of the figures, their drapery, and the architectural setting are as

clear as the extent to which the final effect is quite unclassical; the vocabulary of imperial art transformed to make of the imperial presence a visionary experience. The style, which may now be called Byzantine, is a consequence of the image's function and the underlying reinterpretation of its subject, rather than of any collapse of artistic ambition. Art, like the society it served, was subjected to change, not annihilation. JR

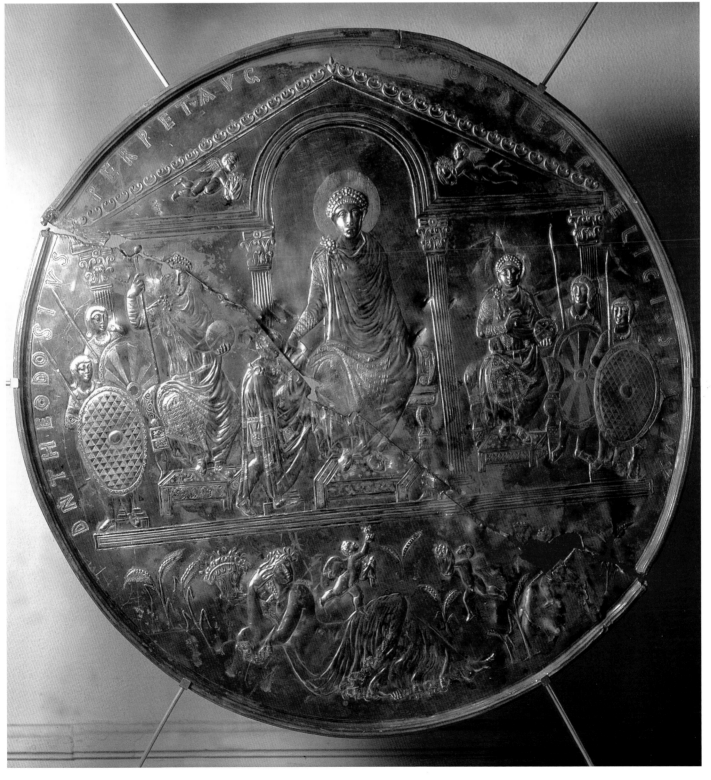

Mosaics in Rome and Ravenna

Mosaic was one of the most widely used decorative media of Early Christian and Byzantine art. Earlier Roman art made extensive use of the medium, though usually for floor coverings. It was only from the fourth century onwards that the practice of sheathing entire interiors became commonplace. The countless number of *tesserae*, usually coloured glass but sometimes stone, metal, and even semi-precious stones like Justinian's cornelian brooch, gave to wall surfaces a luminous, dematerialized quality. Early Christian mosaics, like the Vatican *Christ-Helios* [87], define form by means of thick outlines and evenly set *tesserae*. The increasing refinement of later workshops allowed for the arcadian illusionism of the Galla Placidia *Good Shepherd* [92] and the exquisite balance between the natural and the transcendent in the image of Justinian offering gifts to the new church of S. Vitale [94], turning for a moment to confront the spectator, a second's pause extended into a kind of eternal dialogue. The careful grading and placement of the S. Vitale *tesserae* allows for great subtlety in the suggestion of light and shade and the principals' identities.

Comparison with the semi-abstraction of the S. Apollinare *Last Supper* [93], where the disciples recline to eat, Roman-fashion, emphasizes the wide stylistic range of the medium and the flexibility of its practitioners' relationship with the naturalistic legacy of Classical Rome. JR

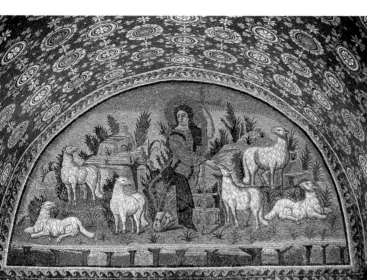

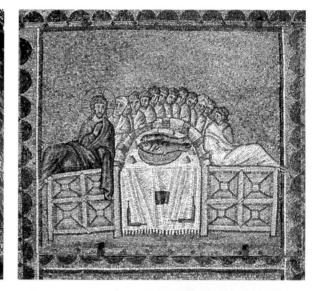

92 Above: *The Good Shepherd* (*c*.425), lunette mosaic above the entrance, Ravenna, Mausoleum of Galla Placidia

93 Above right: *Last Supper* (*c*.490), mosaic of upper nave wall, Ravenna, S. Apollinare Nuovo

94 Right: *Justinian and His Retinue* (*c*.547–8), mosaic of upper wall of left side of apse, Ravenna, S. Vitale

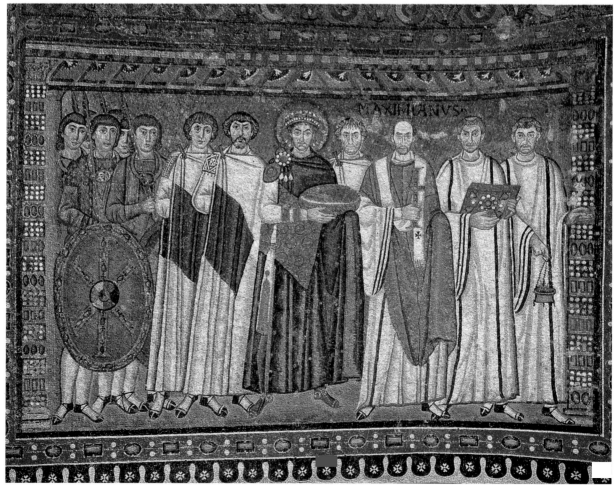

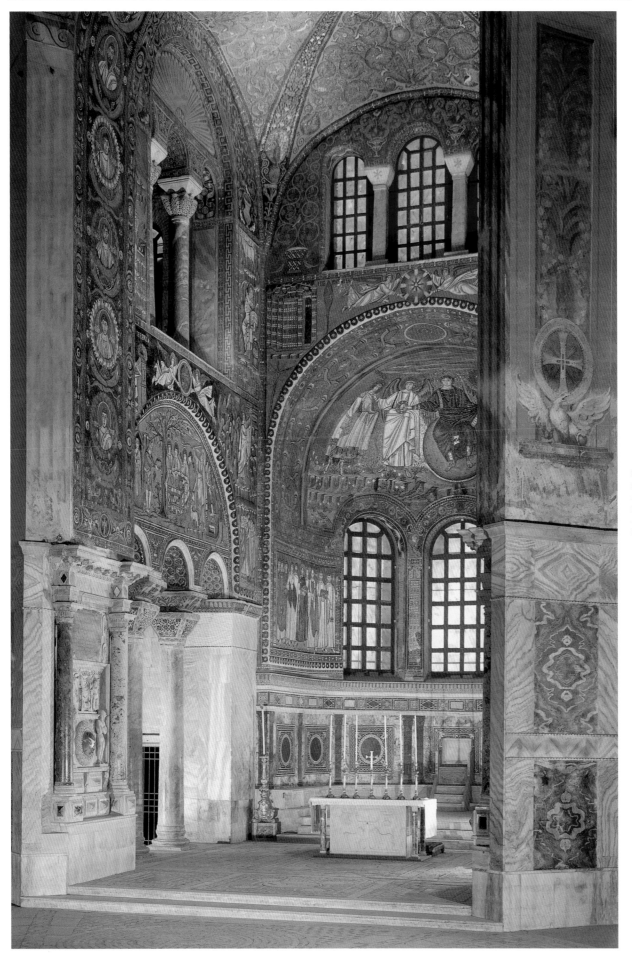

95 Interior of the
sanctuary (church
*c.*520–48;
mosaics
*c.*547–8),
Ravenna, S. Vitale

Illuminated Manuscripts

Medieval manuscripts are hand-made books, and the illumination found in them is an art of the book; there is almost no area of the study of this art in which this fact is not fundamental. Generally speaking, 'books' in Classical antiquity existed in the form of scrolls made of papyrus. Anyone who has handled a long text in the form of a scroll will have little difficulty in understanding the advantages, from the point of view of handling, of the codex (manuscript of bound pages). The codex seems first to have appeared in the first century AD, and was soon adopted by Christians; but it achieved widespread acceptance perhaps only in the fourth century. The Vatican Vergil [**105**] and the Gospels of S. Augustine [**107**] are rare survivals from the beginnings of a great tradition.

Medieval books were also written on a different material: parchment (sometimes referred to as vellum, which strictly refers to calfskin). Parchment can be made from the skin of almost any animal. It is thus more widely available than papyrus, though it demands that those who want to make books in any number must have the resources to involve themselves, either directly or by proxy, in animal husbandry on a large scale. The individual sheets of parchment are folded into quires or gatherings: four folded sheets, making a quire of eight pages, is the unit most commonly found. The individual quires were sewn not only to each other but also to leather cords or thongs which could then be attached to wooden boards, resulting in a strong structure and protective binding. It is this protection which has resulted in the survival of so much manuscript illumination in marvellously fresh condition. What has very often been lost are the precious bindings of metal and ivory which covered some books, mostly those displayed in the liturgy—though such coverings survive for the manuscripts shown in [**113**] and [**120**].

The parchment book was a far better vehicle for painting than the papyrus scroll: parchment provided a good support, and the finished result was not subjected to the process of rolling and unrolling. Drawing (like writing) was carried out with a quill or reed pen, using either carbon or metal gall inks. The range of colours used in painting with the brush was a matter of cost and availability. There were often several possible sources of the same or a similar colour: most of the blue we see in medieval manuscripts is not lapis lazuli transported at great expense, ultimately from Afghanistan, but azurite, a blue stone rich in copper found in many countries of Europe. Pigments were tempered with a variety of substances, most commonly white and yolk of egg (egg glair and egg tempera). Gold, both as leaf laid on gesso, and powdered into paint, was used in many of the most luxurious books; so was silver, which has often

blackened through oxidization. A small number of texts survive transmitting recipes for the materials and processes of manuscript illumination; but it seems likely that it was most common for techniques to be handed down by example in the workshop.

The luxury book in Byzantium

The history of the luxury book in Byzantium falls into three very different sections. In the early period (now often termed 'late antiquity') the bound book as we know it today supplanted the scroll. The introduction of images into such books, however, and notably into books of religious content, only seems to have gained momentum after the early fifth century. Within a few generations anonymous craftsmen had experimented with virtually every significant possibility in terms of how, why, and where images should be included in a book [**96**]. This period is now represented by a small number of often very fragmentary survivals. The second period is defined by the iconoclast controversy (726–843), when the validity of using images in any religious context was fiercely questioned, but eventually legitimated. No luxury books survive from this period, nor from the troubled century or so before iconoclasm, or the generation or so after its final defeat. The third period extends from the ninth to the fifteenth century, with a political but not an art-historical hiatus generally recognized during the occupation of Constantinople (1204–61) which resulted from the diversion of the Fourth Crusade. This period is often termed 'Middle' and 'Late' Byzantine. The greatest number of luxury books appear to have been made between very approximately 950 and 1200 [**97–9**, **103**, **104**].

It is characteristic of Byzantine culture (notably after iconoclasm) that it sought to manifest what to us must seem a fictitious continuity with its early history, and even with apostolic times, through adherence to tradition and the avoidance (or disguise) of innovation [**97**]. As a result Byzantine art can look unchanging over centuries. Yet many of the circumstances of the production and consumption of luxury books altered over the Byzantine millennium. New pictorial subjects were frequently introduced in response to newly composed texts, but they were generally 'disguised' by the skilful adaptation of familiar formulae. The resulting complex relationship with the past has been seen in modern studies in terms of a series of 'renaissances' (such as the Macedonian [**97**] and Palaiologan [**100**] of the tenth and thirteenth–fourteenth centuries—named after the ruling dynasties—even a 'Justinianic renaissance' in the sixth century), and Byzantine art has been praised according to the degree of Graeco-Roman illusionism it has been found to convey. In practice this approach reveals

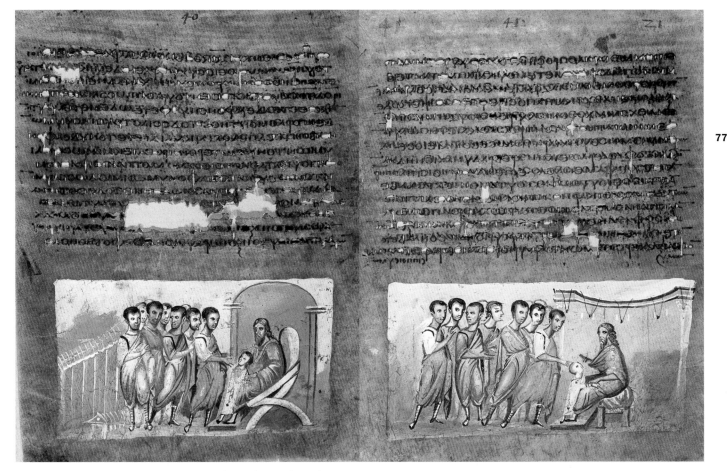

96 *Joseph's Brothers with Benjamin before Jacob* (sixth century), Vienna, Österreichische Nationalbibliothek, MS theol. gr. 31, 'Vienna Genesis', folios 20v–21r

more about modern art-historical prejudices than it does about Byzantine ideas and practices. The intellectual basis of Byzantine illumination was provided by the seemingly contradictory nature of religious belief: images had to express the coexistence of the divine and the human, the historical and the eternal.

The Byzantines had a particular interest in using precious materials in their art work, and in gleaming and reflective surfaces. This is conspicuous in their luxury books, which make extensive use of gold-leaf grounds for images and large panels of decoration, contrasted with a highly polished parchment surface. A technical drawback of this aesthetic is the loss of pigment owing to flaking which has affected many Byzantine manuscripts. Where the paint surface is missing it is characteristic that only the simplest and most schematic underdrawing is found. A greater contrast with contemporary manuscript production techniques elsewhere in Europe, with their highly detailed preparatory drawings, could hardly be imagined. Byzantine miniaturists must generally have created their images directly with pigments: theirs was an essentially painterly art.

Little is known or recorded about the individuals who alone or in collaboration were responsible for the production of luxury books. Many different scenarios can be reconstructed by detailed examination of the works themselves. Some books were made by monastic craftsmen (or -women) for use 'in house' [**98**]. Some were produced by laymen (or -women) in urban shops, working on commission from wealthy patrons (male [**99**]

and female [**100**]). Some artists produced figured images, ornament, and were also scribes. Sometimes there was a division of labour amongst several hands. Constantinople seems always to have been the principal (but never the sole) centre for the production and consumption of luxury books.

In churches and monasteries luxury books were extra to normal requirements, and doubtless carefully preserved for use on special occasions. More workaday volumes would have been used until they wore out, and then replaced. The situation with regard to private ownership of books is less clear; quite often such books would find their way eventually into religious foundations at the wish of the owner. The Byzantines were clearly able to recognize books of unusual antiquity thanks to the change in script form from majuscule to minuscule in around the ninth century, although a version of majuscule was sometimes retained for the principal text of Gospel lections used in the liturgy. These Gospel lectionaries were held, like the cross, to be an image of Christ, and were the books most likely to receive a precious cover, in the early period (it would seem) constructed of ivory plaques, in the middle and late periods of metalwork, notably decorated with enamels. Such covers, intrinsically more valuable in material terms than what they contained, rarely survive on the books for which they were made.

Because of the inaccessibility of their Greek texts, even luxury Byzantine books were little known in western Europe until systematic collections began to be formed, beginning in the mid-fifteenth century. JL

The medieval West

A limited amount is known about the processes and circumstances of manuscript illumination. Until about 1200 the majority of illuminated books were produced in, by, and for monasteries; in the wake of the collapse of the urban culture of the Roman Empire, these institutions had emerged as the only places with the material resources and the literate skills to carry on such an undertaking. But the majority of medieval artists, in books as in other media, did not sign their works. Though many were undoubtedly monks, there is evidence that professional illuminators were active in the monastic context; since professionals could move from one monastic house to another in response to demand, this poses problems for the traditional identification of particular styles with particular monastic houses.

The variety of elements in a decorated book, as well as the process of production in separate quires, perhaps encouraged a division of labour. The analysis of the process of production is aided by the survival, in surprisingly large numbers even amongst the smartest books, of unfinished illumination. The person who sketches a composition using a lead point—the graphite pencil was mostly unknown in the Middle Ages—need not be the same as the person who paints the miniature; the person who lays gold leaf need not be the same as the person who paints a decorative border; the person who paints a figurative composition need not be the same as the person who paints a decorated initial letter. This can render the identification of individual hands a treacherous exercise, especially when the aim was to achieve a coherent whole, rather than to stress artistic individuality. The most basic collaboration was between scribe and artist. Though we cannot be sure how often these were the same person, it seems likely that the more the decoration is bound up with the writing of the text, the more likely it is that these elements were performed by the same individuals: it has been convincingly argued that both the script and the decoration of the Lindisfarne Gospels [118] were the work of a single individual, Eadfrith. But if scribe and artist were not one and the same, it is important to realize how many of the crucial decisions had already been made before the artist set to work. Whether the illumination consisted of initial letters (either decorated or historiated), or miniatures set into the text, often at the head of each chapter or major division of a work, the positioning of the illumination had already been determined by the spaces left in the text by the scribe. In some cases instructions for an artist as to the subject of a composition, or the letter required for an initial, or even the colours to be used, are still visible in the margin of the page—though whether this represents someone else's wishes being conveyed to an artist, or the *aide-mémoire* of the artist for himself, or a senior artist's instructions for one of his assistants, is difficult to reconstruct.

Beyond such instructions, how did artists decide what to draw and paint? Occasionally we meet sketches in the margins, though as with written instructions it is difficult to be sure of

their place in the design process. Sometimes it is clear that a rubric or chapter-heading works also as a guide to an illustration; at other times the inspiration seems to have been provided by a cursory reading of the first few lines of a chapter of the text, in which case the episode chosen by the artist may not represent the most important events described. It is not necessary to believe that all artists involved in book decoration were more than functionally literate: misunderstandings, both of texts and previous compositions, are common. Most important by far was the copying of compositions from one book to another. The texts of most medieval books are not original compositions; they are more or less accurate copies of already existing texts. Pictures were copied along with the texts to which they were attached. Sometimes this can be inferred from a composition, without its model having survived. Even more occasionally, both the model and its copy have survived. This is the case with the Utrecht Psalter [106], which must have been taken to Canterbury by about 1000; three copies of it survive from the next two centuries. Though the source of the copies is immediately identifiable, it is also striking how each of the copies has transformed its model. This is important, because in their search for lost models and lines of transmission art historians have perhaps failed to explain why they believe that medieval art develops at all. And yet it does, constantly. In a conservative tradition, small departures from the model may carry great significance. Often a composition may be copied, but its style transformed. This has led some to posit the existence of two different kinds of pattern book, one carrying compositions, the other a repertoire of figures and decorative motifs; the use of both in combination might allow the former to be brought to life in terms of the latter. Nevertheless, very few pattern books or sheets survive. Nor would it be right to assert that medieval illuminators were unable or unwilling to invent new compositions. In some cases, such as saints' lives, texts composed centuries before acquired illustrations at a particular moment, often one in which the monastic community possessing the relics of the saint wished to give new impetus to the cult of their patron. Even then, just as Christian saints and their biographers received their inspiration from the life of Jesus and its record in the Gospels, so artists, in illustrating these hagiographies, could seek inspiration from illustrated Gospel books.

Like all religions founded upon written texts, Christianity places great emphasis on the production of copies of its scriptures. It is in Gospel books that the noblest, most formal script and the finest decoration are found in the early Middle Ages. Illustrated books were carried from Rome to Canterbury [107], and from Northumbria back to the continent of Europe, by founders and missionaries for whom the embellishment of the word of God formed part of the tools of evangelization. The Insular Gospel books from Ireland and northern Britain [108, 118] are amongst the most magnificent books ever created. Despite this fact there has been a tendency, inspired by those who have looked at the Middle Ages from the vantage point of Classical antiquity or the Renaissance, to define medieval art in terms of its relation to concepts of 'naturalism', and thus to see even the Book of Kells in terms of a decline. Yet it would be even stranger for human society to have changed and for art not to have changed with it. In confronting the arrested Christ of

Kells, we should note that the posture is the Classical 'orans', denoting prayer and intercession; but instead of seeing the figure and its draperies as a flattened echo of a Classical idea, we should be struck by a powerful new aesthetic. The iconic Christ commands the attention of the viewer: there is no possibility of distraction. All elements of the picture are subordinated to the central idea. And in an art produced by those whose form of social organization was designed to shield them from the distractions of the world, in order to allow them to concentrate on a higher spiritual reality, the central idea was unlikely to be anything so banal as the imitation of nature. Perhaps this is why the depiction of other-worldly figures and events is achieved with such perfect conviction.

Yet for those engaged in the search for spiritual truth, might not even pictures of sacred subjects prove a distraction? The medieval West never experienced the doubts on the nature and role of art which provoked the crisis of iconoclasm in the Greek east; hence it never had to develop as sophisticated a theology of pictorial art. The standard justification for pictorial images in the West was that defined early on by Pope Gregory the Great: that pictures were the books of the illiterate, and could help to teach religious truth to those unable to read for themselves. Yet this justification is surely inappropriate for a context in which, almost by definition, most of those who came into contact with the pictures were also engaged in the reading of the text—though we should not forget that a large book being read aloud by one person might simultaneously be seen by others. There were occasional expressions of dissent—most famously that of S. Bernard in the twelfth century, the leading light of the ascetic Cistercian order, which does seem for a time to have limited the degree of luxury with which its books could be embellished. But on the whole, whatever their other austerities, medieval monks seem to have been content to devote their not inconsiderable resources to the production and decoration of books, alongside the construction of churches and manufacture of objects for liturgical service. Indeed, alongside Bibles and Gospel books, liturgical books were the other necessity for a monastic house [**110**, **118**, **120**]. At the heart of the divine service of the monastic life was a book of the Old Testament, the Psalms; and it was the psalter which emerged as the vehicle for the most extensive picture series of the Life of Christ, often as a prefatory pictorial cycle distinct from the text. Yet monastic libraries could also contain a wide variety of other texts: not only the works of the Early Christian Fathers, such as Augustine and Jerome, crucial to the interpretation of scripture, but also pagan classics. Almost none of the Latin classics survive in copies dating back to Classical antiquity; they survive because they were copied by Christian monks, whose admiration for them was often justified in terms of the elegance of their Latin style. Occasionally, as with the plays of the Roman comedy writer Terence, a set of illustrations was also faithfully transmitted.

Monastic houses might also produce illustrated books for important laymen, underlining the contact that in fact existed between the cloister and the outside world. Though the Emperor Charlemagne patronized a court school of painting at Aachen, the Gospels of Otto III [**113**] were probably produced at the island monastery of Reichenau on Lake Constance. But

from the end of the twelfth century, it can no longer be said that monasteries retained their pre-eminence in book production and decoration. The growing prosperity and urbanization that had contributed to the spread of the Romanesque style throughout Europe also encouraged the formation of new forms of social organization capable of providing books for themselves. The professional craftsmen who had previously moved from monastery to monastery now settled in towns, where they could obtain commissions from those teaching or studying in the newly founded universities, as well as from the mendicant orders of Franciscans and Dominicans set up to minister to the increasing urban population. Whilst in the twelfth century, Bibles had been produced in large, multi-volume sets, in the thirteenth the one-volume portable Bible, produced on parchment of tissue thinness, makes an appearance. The evidence suggests that professional illuminators like William de Brailes in Oxford—and it is perhaps no coincidence that more are known to us by name—lived in close proximity to other members of the book trade in a particular area of the town, combining to manufacture books for payment—though this is still a bespoke trade. At the same time we can also see the patronage of a wider range of illustrated books by the aristocracy, some of them with texts in the vernacular rather than Latin [**114**]. In the fourteenth and fifteenth centuries some royal or aristocratic collectors were to commission sufficient numbers of books—of history, literature, and science, as well as biblical and devotional texts—to build up considerable libraries. What we might identify as the hallmarks of the Gothic style—a sense of linear elegance and courtly refinement, as well as an increasing attention to naturalistic detail—might most profitably be explored as the response to the tastes of a new set of patrons. Many of the manuscripts produced in these new circumstances—the law book from the university of Bologna, or the Arthurian romance from Paris—fall into familiar types, and were clearly mass-produced in a way that no books previously had been. Though often modest, the minor decoration in such books plays an important role in helping to articulate and organize the text—even merely to enliven it, a function well captured in the account of a legal document in *Bleak House*: 'an immense desert of law-hand and parchment, with here and there a resting-place of a few large letters, to break the awful monotony, and save the traveller from despair'.

The survival in their thousands of Books of Hours from the later Middle Ages is testimony to the spread of literacy and book ownership down the social scale. If a middle-class family possessed a single book, it was more likely to be such a devotional book than the text of the scriptures *tout court*. Though the presence of illustrations seems to have been an integral part of such books, they could nevertheless range in quality from the finest works of art [**116**, **117**] to the humblest of objects. At the same time, wealthy humanist patrons were collecting manuscripts of the rediscovered Classical texts which might be seen as the scriptures of the Italian Renaissance. As Peter Ugelheimer of Frankfurt proudly boasted on the frontispiece of the copy of Aristotle which he owned, and whose publication he had probably supported [**122**]—a frontispiece bursting with Classical motifs—'Peter Ugelheimer has brought Aristotle forth to the world'. MKm

Imaging the Bible

Most luxury books made in the Byzantine world were religious in content. Amongst such books the Bible held a special place. Attempts to produce the entire Bible—in one or more volumes—were rarely made, however. Instead, one or more biblical books were selected for special treatment. The most widely made luxury book contained the four Gospels (hundreds of copies still survive). The next most popular was the Psalter: the Psalms and Odes (or Canticles) and other hymns and prayers. Sections of the Old Testament, such as the Prophets, or even Genesis, might be made as a single volume. The appearance of the images in these books, however, is far from predictable.

The Vienna Genesis was made in the sixth century [96]; it is a picture book, with every page given over half to text and half to an image, executed on purpura-dyed ('purple') parchment and written with silver ink.

The Paris Psalter (mid-tenth century, [97]) is a massive volume containing a vast body of commentary. Its images are on leaves that were inserted as prefaces; the David and Melody is assumed to reproduce a Late Antique Orpheus composition.

The Turin Prophet Book—late tenth century [99]—gathers together medallion 'portraits' of the twelve prophets (from Hosea to Malachi) as a joint frontispiece.

The Theodore Psalter—dated 1066 [98]—provides images as a form of marginal commentary. It was made for the abbot of the Studios monastery in Constantinople by a senior priest, Theodore, who was possibly both scribe and artist.

The Palaiologina Gospels [100] were made at the end of the thirteenth

80

97 *David and Melody* (mid-tenth century), Paris, Bibliothèque Nationale, MS gr. 139, Paris Psalter, folio 1v

98 The end of Psalm 76 and opening of Psalm 77 (1066), London, British Library, MS Add. 19352, 'Theodore Psalter', folios 99v–100r

century for a female member of the ruling dynasty, probably Theodora, widow of Emperor Michael VIII (reigned 1261–82). Her monogram appears in the Canon Tables, concordances of parallel passages in the Gospels. This book looks back to products of *c.*1100 in terms of its ornament, and to books of *c.*975 in terms of its figure style.

A crucial aspect of the visual impact of all such luxury books on viewers and readers (today as well as in the past) involves their design as a series of double-page openings. Unfortunately this feature is all too often lost in reproductions. Continuity or symmetry between one page and the next might be particularly sought for [**96**, **99**, **100**], but the effects of disjuncture and contrast could also be used to highlight aspects of particular significance [**98**].

These effects were carefully planned and routinely achieved even when the diptych-like result was the product of more than one specialist craftsman working on physically separate sheets of parchment which would only be brought permanently into their present juxtaposition when the finished book was sewn and bound. As is generally the case in highly skilled craft products, the viewer apprehends the result (sometimes perceived as 'obvious' or 'predictable') without awareness of the techniques and decisions that brought it about. JL

81

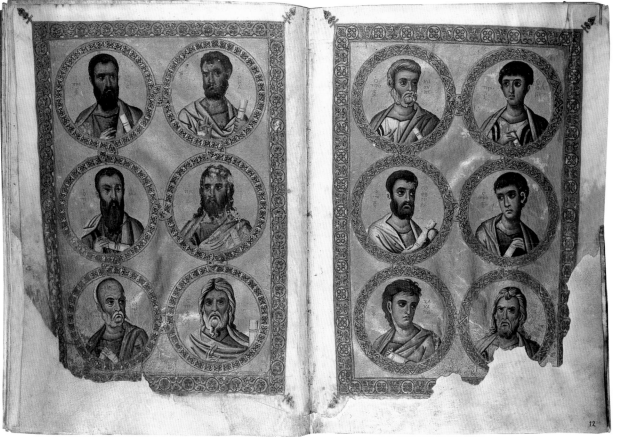

99 *The Twelve Minor Prophets* (late tenth century), Turin, Biblioteca Nazionale, MS B.I.2, 'Turin Prophet Book', folios 11v–12r

100 Decorated Canon Tables (end thirteenth century), Rome, Biblioteca Apostolica Vaticana, MS gr. 1158, 'Palaiologina Gospels', folios 5v–6r

Imperial books

The Byzantine world had a highly complex social structure. The position of the emperor (or empress) at the pinnacle of this structure, beneath God, was rarely questioned. Luxury books played an important role in making imperial power manifest. Imperial books, as the term is now understood, are self-selected on the basis of some explicit imperial link. This leaves open the question of whether such books were gifts from the imperial family, within the imperial family, or to the imperial family from outside.

The manuscript known as the Paris Gregory [101] contains homilies of the fourth-century Bishop Gregory of Nazianzus, prefaced by portraits of Emperor Basil I and his family. Datable to 880–3, the manuscript's full-page frontispieces may have been devised by the learned Patriarch Photios.

The Menologion of Basil II—c.1000 [103]—is an illustrated calendar devised as a picture book with an image and sixteen-line text on every page, and several commemorations for each day. Its connection to the emperor is established in prefatory verses that seem to refer to an image (no longer present).

The Emperor Nicephorus Botaneiates (1078–81) was represented in a copy of John Chrysostomos's homilies [104] receiving the book from the saint (or giving it to him) in the presence of Archangel Michael, and on the facing page listening to the text as it is read to him by a certain monk Sabas.

In the manuscript now called Paris grec 1242 [102] the former emperor John VI Kantakouzenos (abdicated 1354) was represented

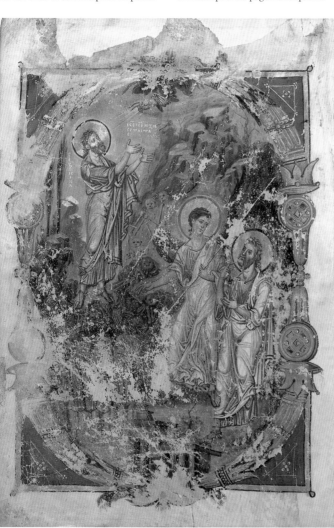

82

101 *Vision of Ezechiel* (880–3), Paris, Bibliothèque Nationale, MS gr. 510, 'Paris Gregory', folio 438v

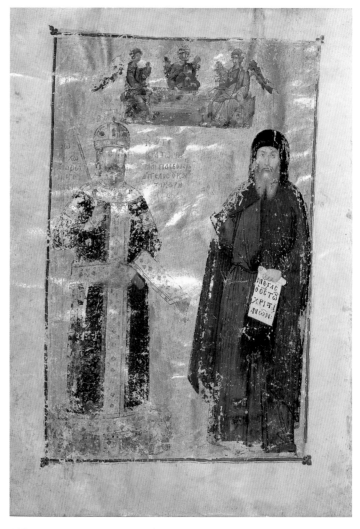

102 *John VI Kantakouzenos as Emperor and as the Monk Ioasaph* (mid-fourteenth century), Paris, Bibliothèque Nationale, MS gr. 1242, folios 123v–124r

twice in a single image in a copy of his own theological works: at the left he is shown as emperor, and at the right in retirement as the monk Ioasaph.

An easily overlooked but functional aspect of these imperial books, as of all luxury books, is that they were intended to be seen by only a tiny number of people. The messages of the images in such books were believed to be appreciated constantly by God and the saints, but they were not able to influence more general perceptions. The great extent to which our modern views are shaped by reproductions of the images in such books is thus problematical.　　　　JL

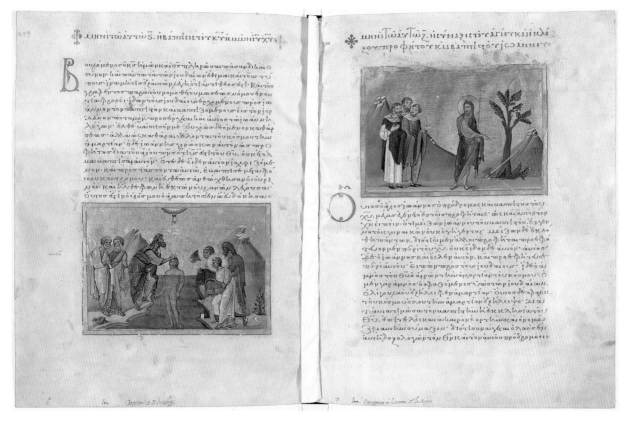

103. 'Menologion of Basil II', pages 299–300 (*c*.1000), Rome, Biblioteca Apostolica Vaticana, MS gr. 1613

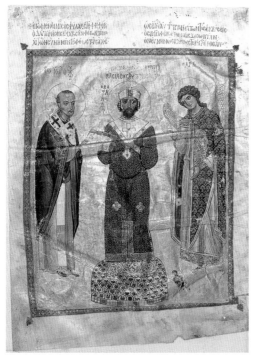

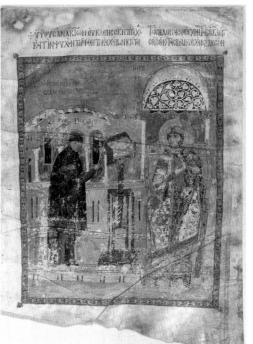

104 *Emperor Nicephorus Botaneiates with S. John Chrysostomos and Archangel Michael, Monk Sabas with the Emperor* (late eleventh century), Paris, Bibliothèque Nationale, MS Coislin 79, folios 2bisv–2r

Classical and Christian

The most important surviving example from late antiquity of an illustrated book of Classical literature is the fragmentary Vatican Vergil [105]. Christians had been swift to adopt the codex form for their own writings. The Gospels of S. Augustine [107] is traditionally identified as one of the books supplied by Pope Gregory the Great for the mission of

S. Augustine of Canterbury; the 'portrait' of the Evangelist Luke is derived from the author portraits of Classical poets and philosophers.

The new religion had flourished in Ireland from the middle of the fifth century, and had developed its own traditions of script and decoration. In the scene of the arrest of Christ from the Book of Kells [108], the painterliness of the Classical tradition has been replaced by a rhythmically

linear style; and the viewer is confronted by the mesmerizing gaze of Christ. On the continent of Europe, Charlemagne's efforts to create a Christian Roman Empire are reflected in the mixture of Christian and Classical texts illustrated in the Carolingian Renaissance. In the Utrecht Psalter [106] the text of each Psalm is combined with a pen drawing which literally portrays the concrete images of the words. The

sketchy style of the drawings, as well as the script, were modelled on Late Antique manuscripts. MKm

84

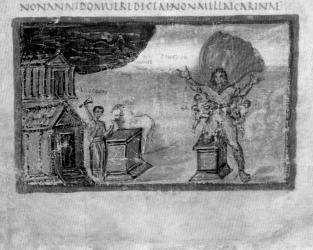

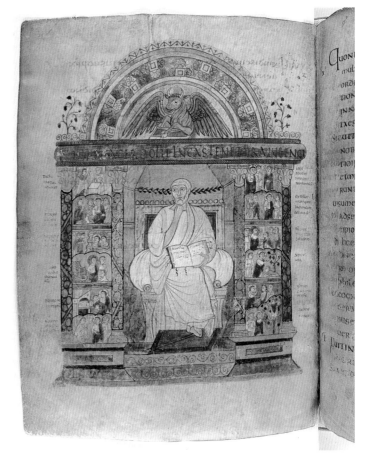

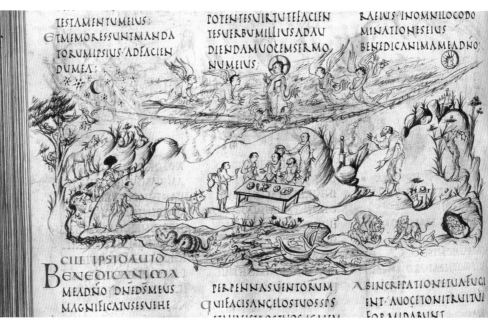

105 Above: Rome, Vatican Vergil (early fifth century), Vatican City, Biblioteca Apostolica Vaticana, Vat. Lat. 3225, folio 18v

106 Right: Reims, Utrecht Psalter (second quarter of the ninth century), Utrecht, University Library, MS 32, folio 59v

107 Above: Rome, Gospels of S. Augustine (late sixth century), Cambridge, Corpus Christi College, MS 286, folio 129v

108 Opposite: Iona?, Book of Kells (eighth or early ninth century), Dublin, Trinity College, MS 58, folio 114r

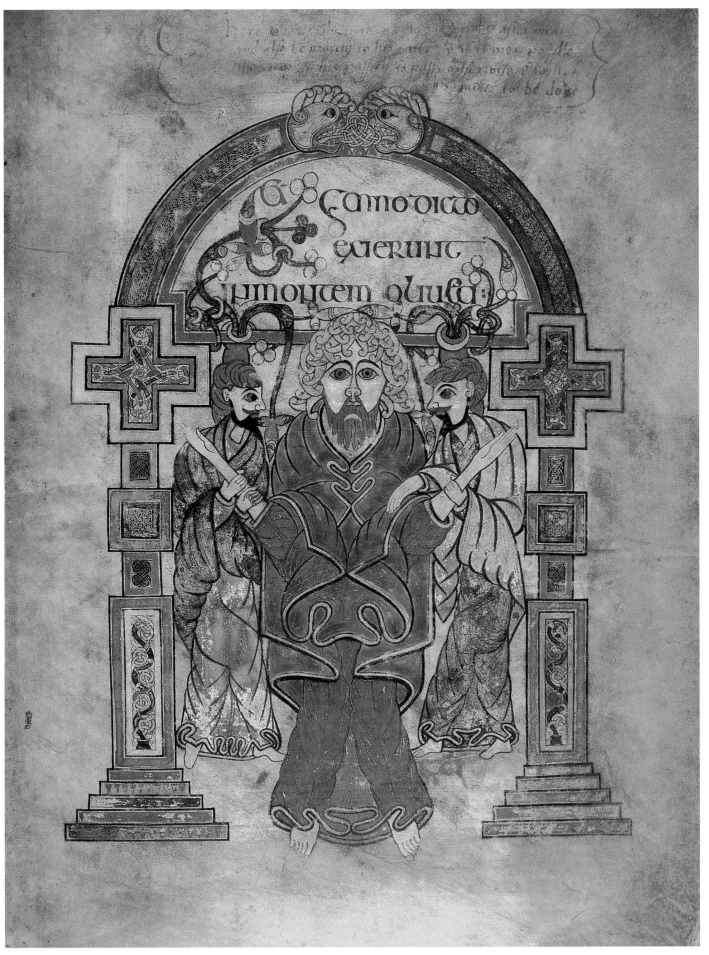

The monastic age

Until about 1200 monasteries were the chief producers of illuminated manuscripts in Europe. At the abbey of Monte Cassino near Naples, where S. Benedict had composed his monastic rule in the first half of the sixth century, illustrations were composed around 1070 to accompany a collection of texts in celebration of the saint's life [**111**].

In England S. Aethelwold, Bishop of Winchester, was one of the leaders of the Anglo-Saxon monastic reform movement; the scene of the holy women meeting the angel at the tomb of Christ [**110**] comes from a benedictional (a book of episcopal blessings) made for him. The combination of restless, animated drawing with the heavily foliated framework is characteristic of manuscripts illuminated in Winchester.

In Spain a strong pictorial tradition was associated with the commentary on the Apocalypse written about 776 by the Asturian monk Beatus of Liébana. The striking colours and double-page composition in this later copy [**109**] are typical of a pictorial tradition isolated from the rest of Europe.

By contrast the Romanesque style of the Lambeth Bible [**112**] forms part of the first truly European medieval artistic movement. The tree of Jesse leads through the Virgin Mary to the bust of Christ. The figures in the roundels on either side give pictorial expression to complex theological doctrines. MKm

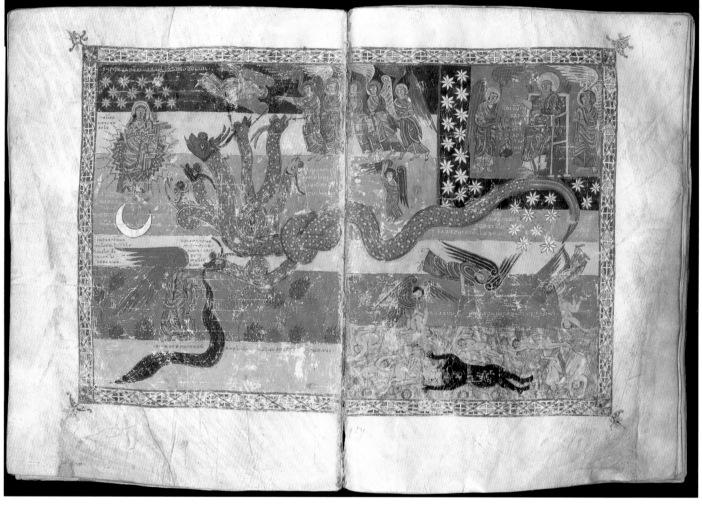

109 Morgan Beatus (Tábara, Léon?, mid-tenth century), New York, Pierpont Morgan Library, MS 644, folios 152v–153r

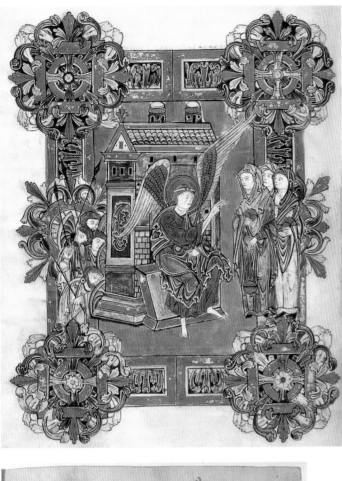

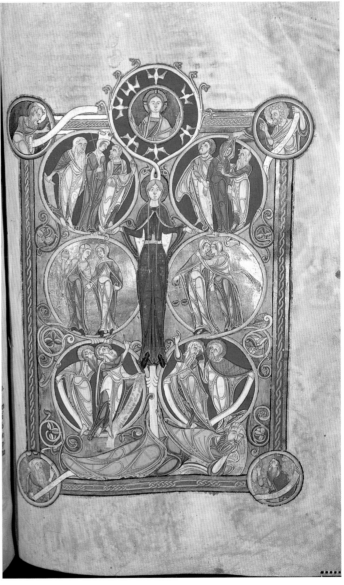

110 Top left:
Winchester,
*Benedictional of
S. Aethelwold*
(*c*.970–80),
London, British
Library, Add. MS
49598, folio 51v

111 Left: Monte
Cassino, *Life of
S. Benedict*
(1071?), Vatican
City, Biblioteca
Apostolica
Vaticana, Vat. Lat.
1202, folio 36r

112 Above:
Canterbury,
Lambeth Bible
(mid-twelfth
century), London,
Lambeth Palace
Library, MS 3, folio
198r

Patronage of the laity

Medieval rulers had themselves portrayed in books which emphasized divine sanction for their power, as well as the cultivation and luxury of their courts. In the Gospel book of the German Emperor Otto III [**113**], Otto is shown seated in majesty as he is approached in homage by female personifications of Rome and the provinces of the Empire. The thirteenth century saw the first large-scale patronage of illuminated book production by the aristocratic classes. In the Trinity Apocalypse [**114**] the text is in the vernacular, not Latin; the aristocratic lady shown leading the fight against the beast may represent the patron. The illustrations of the Manesse Codex [**115**] are a record of the poetic culture, both amorous and chivalric, of noble society; the minnesinger engage in tournaments under the gaze of their mistresses. The Book of Hours contained prayers to be said by devout laypeople at different times of day. The opening of the office for the dead in the Rohan Hours [**116**] represents the judgement of man by his maker; the majestic figure of God looks down with an expression of tender pity at the emaciated body, as S. Michael does battle with a devil for possession of the man's soul. Reading their devotional texts, laypeople imagined themselves witnessing sacred events and conversing with holy figures. In her Book of Hours [**117**], Mary of Burgundy is shown reading in an oratory. Beyond the still life on the sill, the window opens into a church where she is again shown, kneeling before the Virgin and Child. MKm

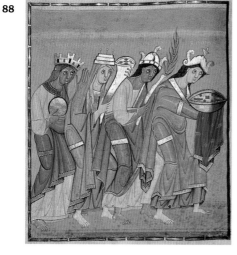

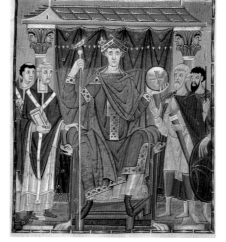

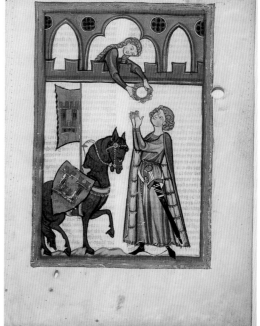

114 Below: England, Trinity Apocalypse (*c*.1255–60), Cambridge, Trinity College

113 Above left and right: Reichenau, Gospels of Otto III (*c*.998–1001), Munich, Bayerische Staatsbibliothek

115 Right: Zurich, Manesse Codex (early fourteenth century), Heidelberg, Universitätsbibliothek, Cod. Pal. germ. 848, folio 54r

116 Right: France, Rohan Hours (1420s), Paris, Bibliothèque Nationale

117 Opposite: Ghent?, Hours of Mary of Burgundy (late 1470s), Vienna, Österreichische Nationalbibliothek

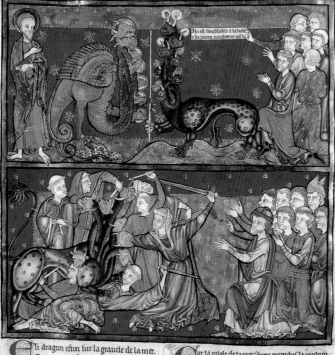

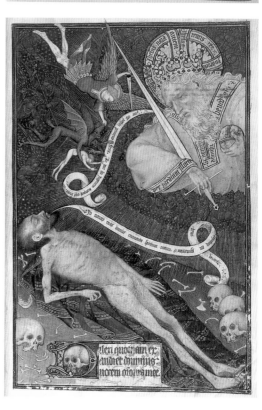

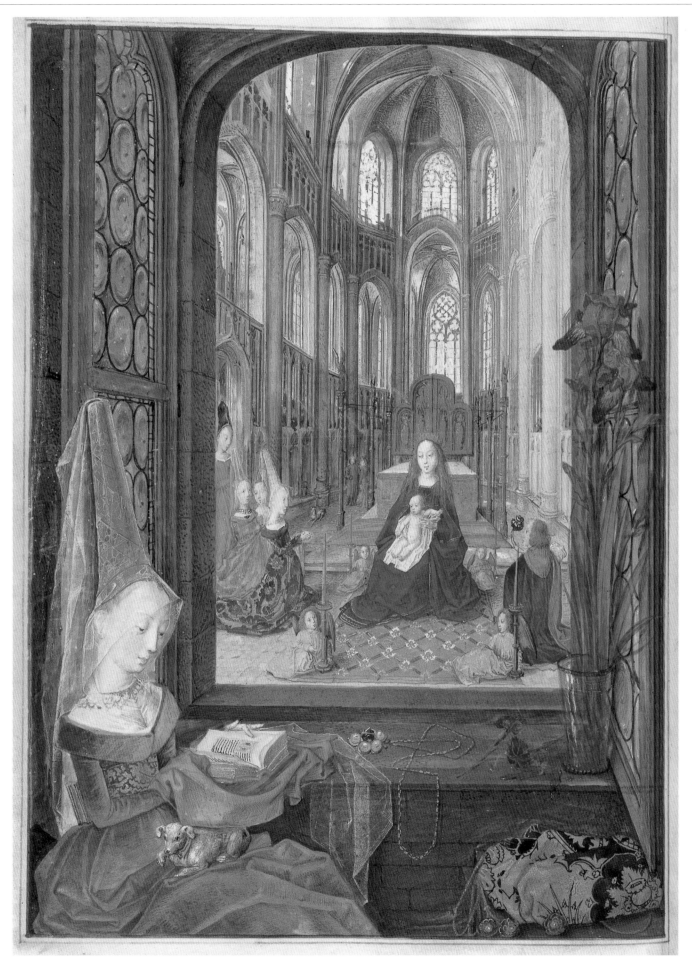

The letter and the page

Throughout the Middle Ages artists experimented with the relationships between texts and their decoration, and especially with the embellishment of initial letters. In the Lindisfarne Gospels [118], the opening words of S. John's Gospel, which speak of the Word becoming flesh, acquire a talismanic significance. The cross with the lamb at its centre dominates a page from a sacramentary (the book used by the celebrant at mass) from Chelles, a double monastery of monks and nuns [119]. The letters formed of birds and fish are typical of Merovingian ornament, and contrast with the interlace, frets, and spiral patterns of the Lindisfarne Gospels.

In another sacramentary [120], made a century later for Bishop Drogo of Metz, the narrative scenes are accommodated within an initial which is itself entwined by acanthus stems. In the Ormesby Psalter [121], the historiated initial to Psalm 109 is combined with a border on all four sides of the text; in such cases the vignettes in the margins often satirize the illustrations of the sacred stories found within the text space.

Even after the invention of printing, it was initially common for luxury books to be decorated by hand. The frontispiece from an edition of the works of Aristotle [122] depicts a grandiose monument, with Aristotle and his commentator Averroës at the top, and satyrs and putti at the bottom—all apparently seen behind a torn piece of parchment on which the text is printed. MKm

90

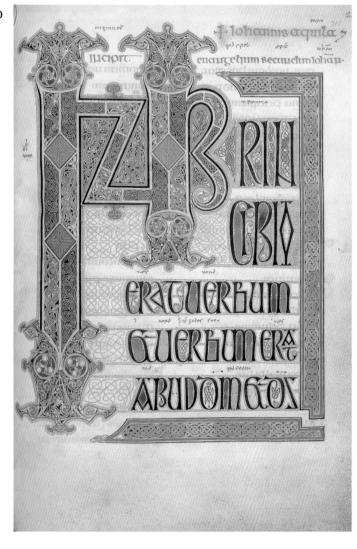

118 Lindisfarne, Lindisfarne Gospels (*c*.698), London, British Library, Cotton MS Nero D.IV, folio 211r

120 Opposite: Metz, Drogo Sacramentary (*c*.844-55), Paris, Bibliothèque Nationale, MS lat. 9428, folio 58r

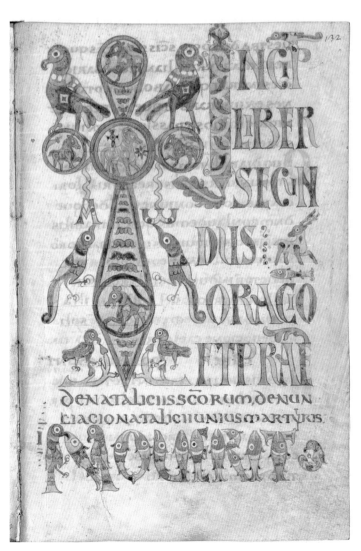

119 Chelles, Gelasian Sacramentary (mid-eighth century), Vatican City, Biblioteca Apostolica Vaticana, Vat. Reg. Lat. 316, folio 132r

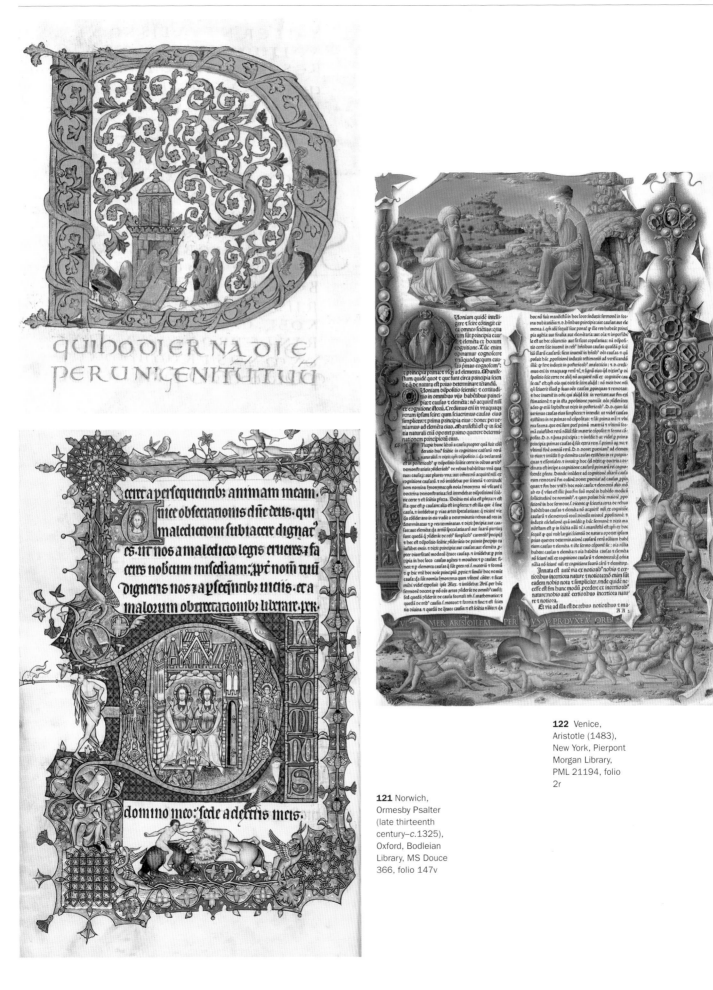

121 Norwich,
Ormesby Psalter
(late thirteenth
century–*c.*1325),
Oxford, Bodleian
Library, MS Douce
366, folio 147v

122 Venice,
Aristotle (1483),
New York, Pierpont
Morgan Library,
PML 21194, folio
2r

Ars Sacra to c.1200

The notion of 'Sacred Art' in the context of medieval Christianity derives from the Old Testament. In various passages, but particularly in the descriptions of the work on the Tabernacle and on Solomon's Temple, certain types of object and craftsmanship are given divine sanction. For the Tabernacle, the chosen artist was Bezaleel: who was 'filled with the spirit of God, in Wisdom and understanding, and in knowledge of all manner of workmanship…in gold and in silver and in brass. And in the cutting of stones [i.e. gemstones], to set them, and in carving of wood…to work in all manner of work of…the embroiderer, in blue and in purple and in scarlet and in fine linen, and of the weaver' (Exodus 35: 31–5). The objects commissioned included the Ark of the Covenant, which was a wooden box covered with sheet gold, the altar vessels and a seven-branched candlestick of gold (cf. **126**, **130**), the priestly vestment, such as the robe, tunic, and mitre, the breastplate set with twelve gems, each engraved with the name of one of the twelve tribes, and curtains hanging around the courtyard. Although not comprehensive, this list of objects and techniques contains most of the categories which were later to comprise the ornaments of the sanctuaries of Christian churches and the contents of their treasuries. Among the materials we might have expected, but which are absent, is ivory. However, it is mentioned in many positive contexts—for example as a suitable tribute to a king, and Solomon's throne was carved from it (2 Chronicles 9; cf. **125**).

The virtues of gold and jewels in particular were also evident from another set of associations. At the creation God had made four rivers to flow out of Eden, the first of which, Pison, flowed into the land of Havilah, 'where there is gold, and the gold of that land is good: there is bdellium [an aromatic resin like myrrh] and the onyx stone' (Genesis 2: 10–12). The inference that such incorruptible and beautiful substances were fragments of earthly paradise, washed out of Eden, was bolstered by the facts that the main sources of such materials was the East and that they were indeed often found in rivers. It also helped to explain their widely believed protective properties.

The nexus of associations of paradise, salvation, and protection made these precious materials particularly appropriate for embellishing vessels to contain either the eucharistic bread and wine or relics of the saints [**127**, **129**]. But as may be inferred from the biblical sources themselves, their prestige and virtue was far older and more dispersed. We have to reckon with the inherent attractiveness of colour, durability, and certain light-reflecting properties. In other words, the texts give reinforcement to widespread responses.

Equally understandable was the stress placed on the expertise necessary to do justice to the materials. The knowledge and skill required to cast metal or to polish and engrave gemstones imputed to the craftsman almost magical powers which might indeed seem to come from heaven. As a result, both within and outside the Judeo-Christian tradition names such as Bezaleel's were noticed—Wayland the Smith being an equivalent folk hero in Germanic lore. Perhaps for these reasons, some saints, notably Eligius (a seventh-century bishop of Noyon) and Dunstan (a tenth-century Archbishop of Canterbury), were credited with skill in working precious materials, whereas painting and sculpture as we understand them are hardly mentioned.

The most substantial medieval treatise on the subject of artistic production, the *De diversis artibus* by a German monk and metalworker who called himself 'Theophilus', devotes twice as much space to discussing metalworking as to the arts of painting and stained glass together. Compiled in the third decade of the twelfth century, Theophilus's manual refers in several places, directly and indirectly, to biblical precedent, for example comparing his own mission to that of making the adornments of Solomon's Temple. He also refers to gold of Havilah as the finest gold and discusses the craftsman's knowledge and understanding as a gift of the Holy Spirit, though acknowledging that this has to be developed by diligence.

But for all the appeals to precedent, certain aspects of the goldsmith's art, such as enamelling, were more recent. From purely decorative beginnings and in the context of personal adornments, such as jewellery and war gear, enamelling was developed to provide figurative embellishment for ecclesiastical furniture. The prestige form was gold cloisonné, in which pure gold provided the background, surround, and partitions for cells of translucent coloured glass. Less expensive, and therefore largely responsible for the massive increase in the scale of enamel production from the twelfth century onwards, was gilt copper champlevé enamelling. In this form particles of opaque glass of various colours were placed in cells engraved in copper sheeting. Only after all the different glasses had been melted and fused in the furnace was the surface polished smooth and the gilding applied to the copper. To begin with, copper champlevé imitated the forms of gold cloisonné, but by the mid-twelfth century was developing the medium in new directions and on an even grander scale.

Ivory too seems initially to have been more widely used in secular contexts, for inlaying furniture or for prestigious writing tablets, and only gradually to have become common in a sacred context. The development of the medium was largely dependent upon the availability of the raw material. At many periods through the Middle Ages, because of the disruptions of trade routes, elephant tusks were a very rare commodity in Europe. In

some cases, scarcity led to the recarving of older ivories, in some instances to their reuse in Christian contexts. However, the ancient traditions of the medium meant that Classical figure styles and decoration, for example acanthus foliage, were perpetuated in some places well into the twelfth century. Thus it was that the twelfth-century abbot of Saint-Denis, Suger, commented on an ancient pulpit in his church that it was 'admirable for the most subtle and in our own time unattainable carving of its ivory plaques, which exceeded human valuation in the representation of ancient histories'. Antique ivories still adorn another pulpit, made for the imperial church in Aachen by order of the Emperor Henry II in the early eleventh century.

The rarity of elephant ivory added to its prestige, and also to the desire to imitate its forms and effects. By the late tenth century, particularly in the British Isles, but later more widely, walrus tusks were an alternative. They had an evenness of texture and creamy colour which was the equal of elephant ivory, but they never exceeded 80 mm. in width. Nonetheless, it was possible for some classes of object, such as processional and altar crosses, to be made from the tusks of either. In the north walrus was used, for example in the cross made for Gunhilda, daughter of King Sweyn Estrithsson of Denmark, whereas in the south elephant tusks were more readily available [**131**].

Of the various techniques employed for sacred vestments and hangings the most important were tapestry, embroidery, and weaving. Silk was the prestige material, and to the Latin Middle Ages the use of the word 'purpura' to describe textiles in the Jewish Tabernacle and Temple would have meant the most lustrous woven silk fabric. The cloth was often worked with gold and colours, for example the high priest's robe which is blue with a border of gold bells and embroidered fruit. Medieval inventories, such as one from Canterbury Cathedral, itemize garments made in imitation of the biblical account. But in addition to such appeals to authority, surviving vestments also reveal a remarkable degree of freedom. Imagery of various kinds—figures, foliage, and animals stitched on to or woven into the basic material—could be combined with pearls and precious and semi-precious stones and even small enamels applied to the surface [**133**].

We are poorly informed about the designers and craftsmen and -women to whose skill the surviving masterpieces of the sacred or precious arts should be attributed. The glimpses we get are incidental references within some other context, for example a saint's life or a charter. Before the age of legal contracts commissioning work and of formally constituted guilds, which emerge fully only in the thirteenth century, we have little idea of training, career structures, or degrees of specialization. It is quite likely that some artists were very versatile. Stories about the monk Tuotilo of Saint-Gall, in Switzerland *c*.900, suggest that he painted and carved ivory. Master Hugo at Bury St Edmunds in the first half of the twelfth century was a bronze caster, a carver, and a manuscript illuminator, and his contemporary 'Theophilus' in his treatise devotes books to metalwork, painting, and stained glass. Whatever the techniques, skill in drawing seems to have been regarded as primary: the apprentice of a Parisian metalworker is described in a late twelfth-century 'dictionary' practising drawing foliage on a waxed or whitened board, and we are told that his master must be 'skilled in the work of the pen'. But though these instances suggest that the division between the working of precious materials and painting and sculpture is an artificial one, there is also good reason to distinguish them. As already noted, metalworking was prestigious because of biblical precedent, and the products were more likely to end up in a treasury or sanctuary and be glimpsed from a distance than be permanently on view in the ways that painted windows or walls or the stone sculpture on a facade were. In other words, the category *ars sacra* describes the behaviour patterns of patron, owner, and audiences as much as it implies certain materials and techniques.

To some extent this also distinguishes sacred and secular uses of closely similar artistic developments. For while the treasury of a church was fixed, the treasury of kings and aristocrats, in the form of their expensive clothes, tapestry wall hangings, jewellery, and precious tableware, would usually have travelled with them from estate to estate in iron-bound chests on the backs of pack animals. Thus it was that secular treasure was captured in battle or lost in transit. However, there are clearly substantial areas of overlap—for example in coronation regalia which emphasized the quasi-sacerdotal status of kingship. Many of the trappings of majesty, thrones, and crowns, for example, also have biblical prototypes, and one can see that it would misrepresent medieval categories to separate these classes of object from *ars sacra*, not least because many of them chose to employ religious imagery [**132**]. Furthermore the wealth of secular society was often donated to churches and remains preserved there. This is true from the varied treasures of Queen Theodolinda, still at Monza Cathedral, through to the pieces of personal jewellery physically incorporated as offerings to the gold reliquary statue of S. Faith at Conques [**127**]. But if we should be cautious of attempting a rigidly inclusive or exclusive definition of *ars sacra*, it is clear that the example of sacred texts, particularly the Bible, provided both justification and a source of ideas for patrons and artists for the first millennium of European Christianity.

TAH

Biblical models

Several objects made for churches are very obviously based on descriptions in the Bible. Seven-branched candlesticks often follow the vegetal imagery of flowers and nuts of the original (Exodus 37) while adding a range of figural subjects [126]. The central knop here shows the Journey of the Magi, while below on the base are Old Testament scenes. A similar process of Christianization is seen on the much earlier ivory throne made for Maximian, Bishop of Ravenna [125]. Solomon's throne too had been made of ivory (1 Kings 10) and was rounded at the back and with two arms, but here the combination of figures of the evangelists and episodes from Christ's nativity and ministry in addition to the Old Testament story of Joseph brings the history of Salvation up to date while maintaining the authority of the archetype. The Liège Font [124] also has Solomonic references, in this case the large bronze basin in the forecourt of the Temple which stood upon twelve oxen, but because its function has been transformed, Christ's own baptism and other appropriate New Testament scenes adorn the bowl. Sometimes, however, the points of reference are less obvious. The Susanna Crystal [123], for example, with its scenes of Daniel's intervention and judgement in the case of Susanna and the Elders, seems to refer to the breastplate of justice worn by the Jewish High Priest. The subject-matter and material, engraved precious stone, are appropriate, and even in the eighteenth century the crystal was being worn by the Abbot of Waulsort (in modern Belgium) on his chest. The original metal surround for the stone was, improbably, attributed to the workmanship of S. Eligius. TAH

94

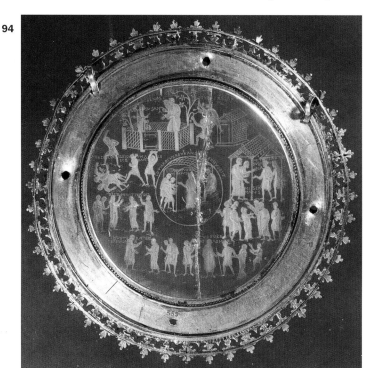

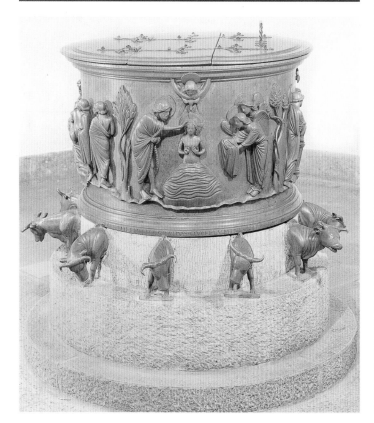

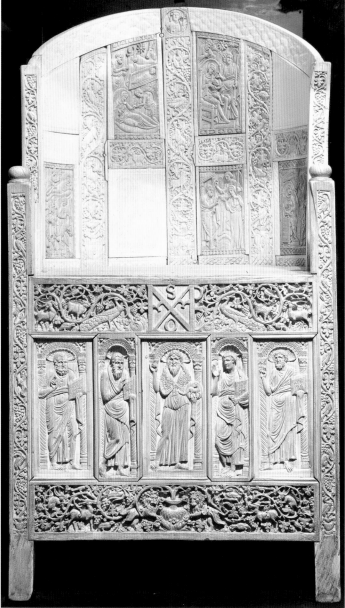

123 Left: Aachen? The Susanna Crystal (855–69), rock crystal, 11 cm. diameter (4⅜ in.), London, British Museum

124 Below left: 'Rainer of Huy' (*fl. c.*1100–20) the Liège Font (1107–18), copper alloy, bowl 80 × 60 cm.(31½ × 23⅝ in.), overall diameter 103 cm. (40½ in.), Liège, Church of S. Bartholemew

125 Below: The Byzantine empire (Egypt?), The Throne of Bishop Maximian (545–53), ivory, 1.50 × 0.60 m. (59 × 23⅝ in.), Ravenna, Archiepiscopal Museum

126 Opposite: England or France?, The Trivulzio Candlestick (*c.*1200 and later), copper alloy, 5 m. (16 ft. 6 in.), Milan Cathedral

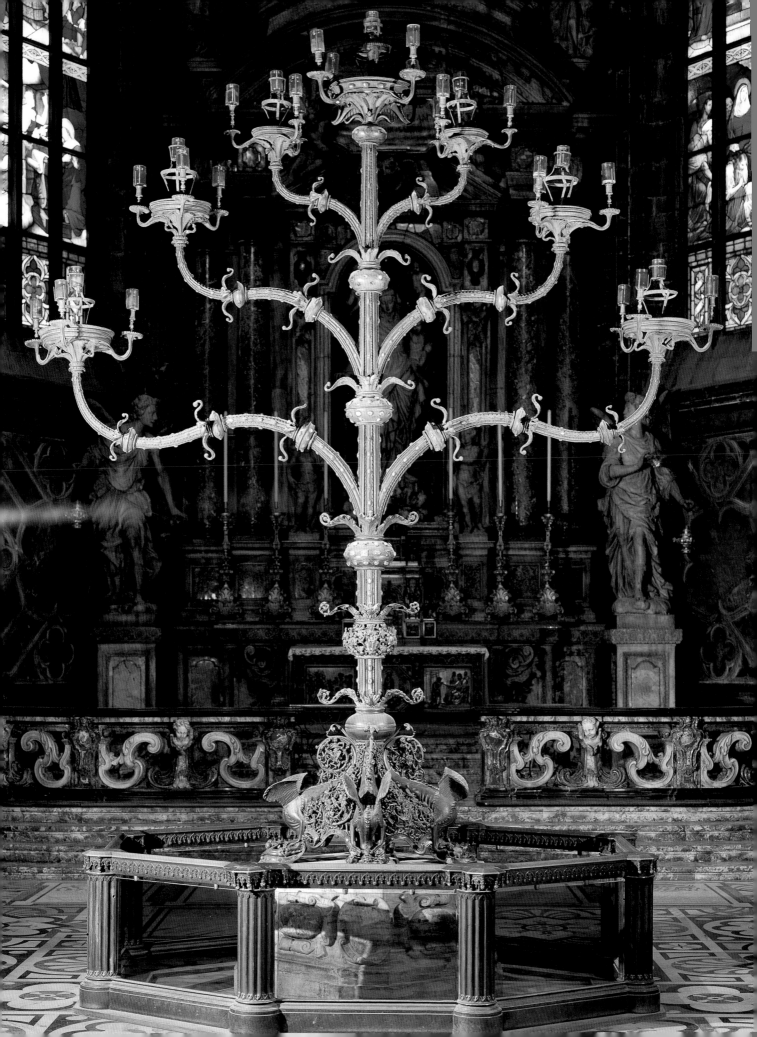

Spiritual riches

The preciousness of the sacred arts was enhanced by exotic materials, particularly those thought to come from the East, by antiquity and by apparently superhuman manipulation of hard substances such as gemstones. When bodies believed to be those of the three kings or magi who brought gifts to Christ were discovered, it was particularly appropriate that their reliquary should be covered with such trophies [**129**]. Not only were they the archetypal gift givers to whom the faithful could now make offerings in kind, but they too came from the ancient East famed for luxury goods. This may explain the high number of engraved cameos and gemstones which adorn their golden shrine. But if a special effort was made on their behalf, it merely emphasized an established practice. The gold-sheathed reliquary figure of S. Faith is also studded with gems, some still set in the mounts they occupied when worn as jewellery by their donors [**127**].

Other focal set-pieces of religious ritual were similarly embellished. Ancient sardonyx vessels were incorporated into chalices, both in eastern [**128**] and western Christendom. The stone was thought particularly fitting for the eucharistic wine since it combined the colours of the water and wine mixed for mass. But large bowls of semi-precious stone could also be used, like giant gems, in large-scale compositions. In addition great ivories, already hundreds of years old and carved with mythical subjects were provided to frame the central cross of stones and evangelist portraits in gold repoussé.

TAH

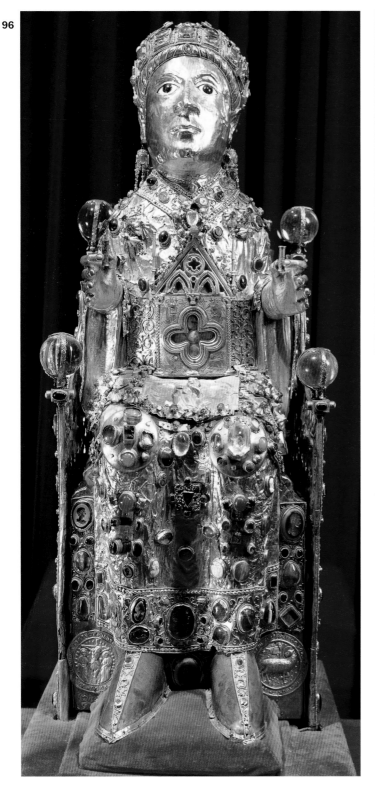

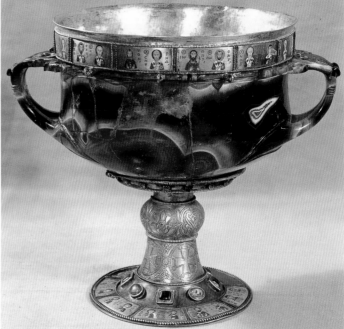

127 Left: Conques?, Reliquary of S. Faith (mid-tenth century?), gold, silver, enamel, gemstones, and pearls on wood, 85 cm. high (33½ in.), Conques, Abbey Treasury

128 Above: Constantinople (Istanbul), Romanos Chalice (bowl first century AD?, metalwork 959–63), gold, silver, enamel, sardonyx, and glass, 25 × 28 cm. (9⅞ × 11 in.), Venice, Treasury of San Marco

129 Opposite: Nicholas of Verdun and others, *Shrine of the Three Magi* (*c*.1185–1230), gold, silver, enamel, and gem-stones on wood, 1.55 × 1.10 × 2.2 m. (5 ft. 2 in. × 3 ft. 7¼ in. × 7 ft. 2½ in.), Cologne, Cathedral

96

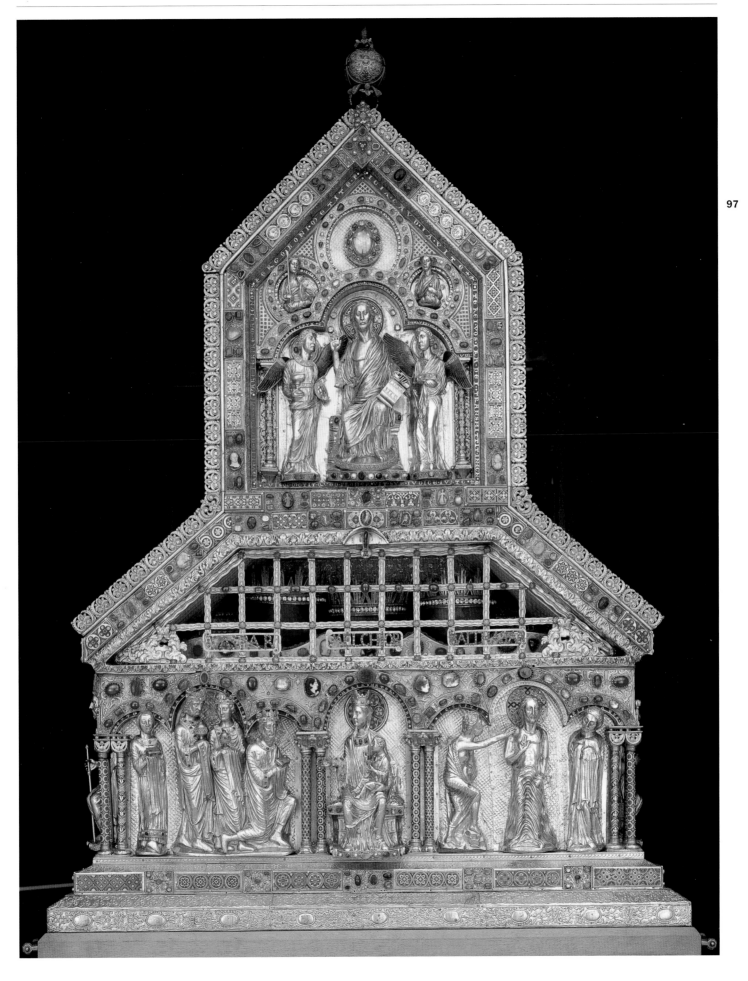

Regal splendour

The association of the sacred arts with rulership was ancient. Kings made lavish and sumptuous gifts to shrines and in return they received divine support, often also given material expression in the form of precious objects. But as well as giving shrines and relic collections to churches [130], rulers also had their own treasuries and private chapels which

they adorned as part of their display of wealth and piety. Such was the case at S. Isidoro, León, where the bene-factions of King Ferdinand and Queen Sancha to their dynastic necropolis included two reliquaries of ivory and precious metal and an intricately carved cross [131]. As part of a recip-rocal reinforcement of power, God and the saints could be represented on royal ornaments such as crowns [133], and spectacular displays of skill in

manipulating precious materials were part of coronation regalia, from the quasi-priestly vestments [132] down to the utensils used in anointing the king [134]. TAH

130 Northwestern Spain, The Arca Santa of Alfonso the Great (866–910), silver gilt and paste inlay on wood, 30 cm. wide (11¾ in.), Astorga Cathedral

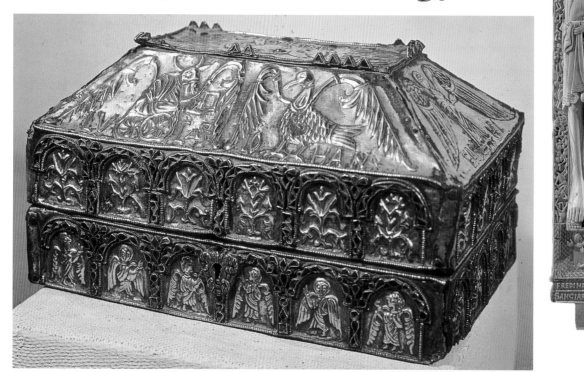

131 León?, Cross of King Ferdinand and Queen Sancha (1063), elephant ivory, 54 × 34 cm. (21¼ × 13⅜ in.), Madrid, Museo Arqueo-logico Nacional

132 Below: Palermo, Coronation Cope of Roger II of Sicily (1133–4), silk, gold, enamels, gemstones, and pearls, 1.46 × 3.45 m. (4 ft. 9½ in. × 11 ft. 3⅜ in.), Vienna, Kunst-historisches Museum

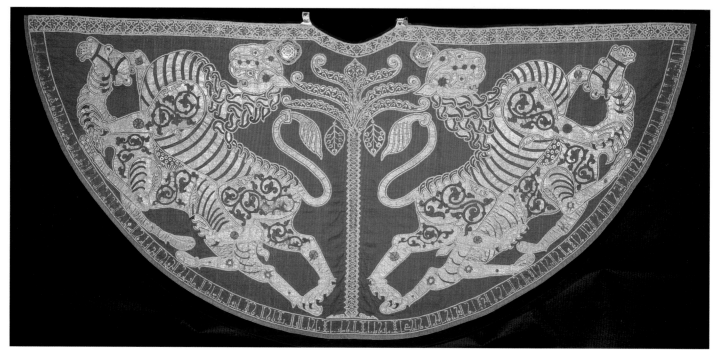

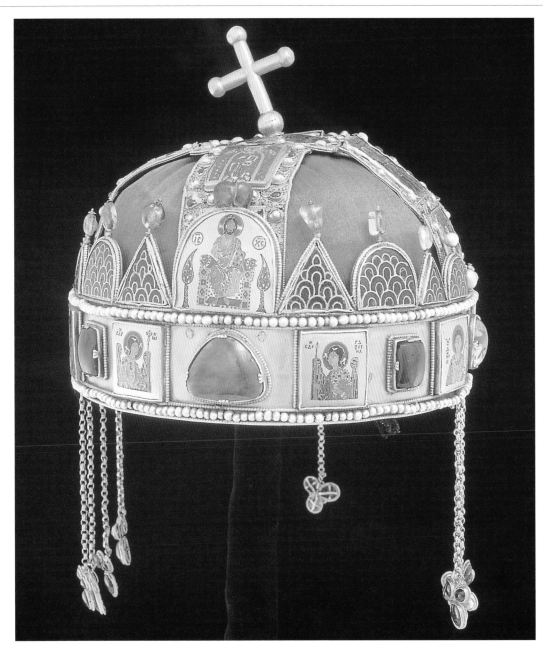

133 Hungary? The Royal Crown of Hungary (main circlet 1074–7, arched super-structure early to mid-twelfth century), gold, enamels, gemstones, and pearls, 19 × 22 cm. (7½ × 8⅝ in.), Budapest, Hungarian National Museum

134 England, The Coronation Spoon (*c.*1100), silver gilt, enamels, and pearls, 26 cm. (10¼ in.), Tower of London, the Crown Jewels

Monumental Sculpture to *c.*1300

The carved embellishment of architecture and large-scale stone monuments was not an art form which was practised steadily in western Europe between 476 and 1300. In marked contrast with the Classical era, the use and quality of architectural sculpture declined sharply during the early medieval period and only began to flourish after the second half of the eleventh century. In the eastern Roman Empire, carving continued to be employed inside buildings and one of the best examples of sixth-century sculpture in the West comes from a church built under Byzantine authority in Ravenna, the interior of which has elaborate marble capitals imported from Constantinople [95].

Monumental sculpture in early medieval Europe was practised in a few regions only, notably Visigothic Spain, Anglo-Saxon England, Celtic Ireland, and Scotland, and some parts of the Carolingian and Ottonian empires. It was used on capitals and, in a few instances, on narrow friezes or courses of stone, and was usually carved in low relief or with shallow incised lines. Motifs consisted of figures and abstract designs characterized by flat, linear patterning. Quite exceptionally, a few capitals from late seventh-century Spain depict biblical events such as the Sacrifice of Isaac, anticipating by almost four centuries developments in Romanesque sculpture.

The medieval concentration on relief sculpture—as opposed to free-standing figures—is another major contrast with Classical times. It was a consequence of the associations which had been harboured since the Early Christian period between statues and idolatry. These attitudes intensified during the iconoclastic controversy, a dispute regarding the veneration of religious images which gripped the Byzantine empire in the eighth and ninth centuries, echoes of which were felt in the West. Despite the eventual triumph of the party which advocated the use of images, the distance already established between statuary and Christian contexts was to persist for several more centuries.

Early medieval sculpture of the highest quality was not found in architectural contexts but on tall, free-standing crosses produced in the British Isles. Most high crosses were carved on both front and back into a series of panels with plants, abstract forms, animals, or religious figures. On the early eighth-century high cross in Ruthwell [136], carvings of Christ, saints, and a vine-scroll ornament inhabited with birds display a naturalism, depth, and quality that are not only classically inspired but also unparalleled in the West at this time.

From the late tenth century onwards, Europe witnessed an outburst of architectural activity. Factors contributing to this upsurge included the renewal of monasticism, spearheaded by the order of Cluny and its church-building abbots; the expand-ing cult of relics and popularity of pilgrimages; the rivalry between communities for larger or more elaborate buildings; a rise in secular patronage; and technological advances, such as more efficient methods of cutting stone. This upsurge in building was noted at the turn of the first millennium by the monk Raoul Glaber, who observed, 'it was as though the very world had shaken herself and cast off her old age, and were clothing herself everywhere in a white garment of churches.' In this intense and stimulating environment, monumental sculpture, sometimes signed by the sculptors, experienced a rebirth.

Important steps in architectural sculpture occurred in the early eleventh century in northeast Spain and southwest France, with carving on capitals and lintels. Motifs were often executed in a style common to ivories, and metalwork was often followed, suggesting that carvers in the early Romanesque period had been trained in small-scale sculpture, an art form which had been practised continuously since antiquity. Architectural sculpture developed rapidly and soon was used on buildings well beyond the Pyrenees. It appeared on arches, on the tympanum, the semicircular space between the lintel and the arch of the doorway, on areas of wall adjacent to the door [145], as well as on towers, arcades, and other prominent sites [139]. Arches and capitals tended to receive the widest variety of sculpted forms, encompassing vegetal and geometric patterns, animals, fantastic beasts, or religious subjects. Carving evolved from flat, low relief to more deeply undercut, moulded forms, but regard-less of its forms and styles, sculpture remained fixed to the architectural setting of which it was an intrinsic part [137, 143].

Sculptural attention continued to focus on the doorway, which by the early twelfth century had become an elaborate composition of columns, capitals, and round arches, successive orders of which receded towards the opening. Tympana were often used over doors, their size and surface well suited for displaying imagery; at times they became huge assemblies of stone requiring a central pillar, or trumeau, to support their massive weight [138].

Depictions of Christ in Majesty, the Last Judgement and apocalyptic imagery were common subjects for the doorway. At Moissac in southwest France, the tympanum of the south portal (*c.*1115–20) is carved with Christ, the symbols of the evangelists and two angels, along with the 24 elders of the apocalypse who stare at the imposing figure of Christ [138]. A large, forbidding Christ also dominated the tympanum in images of the Last Judgement, but the viewer's attention was likely preoccupied by the most dramatic part of the scene: the gruesome fate of those condemned to hell on Judgement day. Although this subject continued to appear at portals, by the later twelfth century its

focus became less harsh, stressing the salvation offered through Christ more than the punishments awaiting the damned.

The carved elements of the portal were seldom a random collection of motifs, but were linked together thematically in a carefully planned composition. At the west front of Chartres Cathedral (*c*.1145–50), an influential early Gothic monument, sculpture on the three doorways refers to Christ from the beginning to the end of time, culminating in the central tympanum of him at the Second Coming. The lintel [**137**], capitals, arches, and columns at Chartres are neither plain nor ornamental but are carved with figural groups which amplify the theological content of the overall scheme. The coherence of the sculpture unites the triple portal into an iconographic whole, the visual and didactic impact of which was striking.

Doorways varied considerably in form and content throughout the Romanesque and Gothic periods. For example, the tympanum was not an essential architectural component and was omitted at many doors, while religious subjects were sometimes carved on friezes inserted on the facade [**145**]. Different regional trends meant that sculpture at some portals was used more as ornament than as a vehicle for narrative. In addition, the scale and quality of most sculptural schemes were modest in comparison with Moissac while few could rival the sophisticated intellectual content of Chartres. Whatever the monument, however, whether cathedral or minor church, its main doorway was normally singled out for the most distinctive sculpture on the building.

Sculpture appeared on numerous places beyond the doorway [**135**, **142**]. An intriguing form of sculpture occurred on corbels, the stones projecting at right angles from the wall in order to support the weight of an arch or the eaves of a roof. Despite their small size and remote location, they were frequently carved into droll and grotesque heads and collectively constitute a substantial amount of sculpture deployed on architecture [**137**]. Sculpture also embellished a diverse range of religious and secular buildings in addition to the church, such as the chapter-house, cloisters, and castles [**140–2**], as well as pulpits, choir screens, and tombs [**135**].

In the first half of the thirteenth century, further changes occurred in the form, style, and content of sculpture. Motifs were carved with increasing depth and stood out in much greater relief from their backgrounds than before, seeming to deny the architecture to which they were attached. More faithful attention to natural proportions and human forms also characterizes sculpture from this period [**146**], reflecting a closer observation of nature as well as first-hand study of antique models.

Some of these developments can be seen on the west facade of Amiens Cathedral (*c*.1225–40). Although its triple-door format is similar to that at Chartres, the amount of sculpture used is dramatically greater, owing in part to the deep recession of the portals which allows for multiple orders of pointed arch as well as the placement of several column-figures on each side of the doorways [**139**]. Carving extends over the tiered lintel and tympanum, arches, columns, trumeau, and even the wall space below the column-figures. The column-figures have advanced substantially from those at Chartres: enlivened by projecting limbs and animated poses, these deeply carved figures obscure and seem independent of their columnar supports.

No major new developments occurred in the content or form of sculpture at portals after the mid-thirteenth century. French sculpture was widely emulated in Europe, partly because workshops travelled from important centres, such as Paris, Amiens, and Reims, to places within and beyond the French kingdom, though most regions tempered French styles with their own characteristics. Influences from France were less extensive in Italy, owing to the continuing impact exercised by Classical models.

The growing veneration of the Virgin and emphasis on her role as an intercessor which permeated society in this period was also reflected in sculpture. At Strasbourg Cathedral, a cycle of Mary's death, burial, assumption, and coronation was carved on the tympana and lintels of the double portal of the south transept. The representation of the Death of the Virgin (*c*.1225–30) is notable for its eloquent emotion as well as the realistic proportion of the figures, the attention to hands, faces, and drapery, and the high degree of relief in which the figures are carved [**144**].

Realism reached an apogee in the astonishingly lifelike figures set in the west choir at Naumburg Cathedral in the mid-thirteenth century [**146**]. An increasing acknowledgement was made of the secular world at this time, for these are not religious figures but representations of the eleventh-century founders of the cathedral. In a different context, that of a bishop's tomb in Léon Cathedral, the scene of the distribution of food is genre-like in its variety of realistic gestures, expressions, and conditions amongst the crowd [**135**].

Monumental sculpture had only begun to revive in the eleventh century, and yet it was an art form which, within a very short time, became highly accomplished and widespread throughout western Europe. This was a remarkable achievement, a large testament of which survives today and which, it is to be hoped, will be preserved for the future.

KL

The compass of monumental sculpture

A wide range of medieval architecture and monuments was embellished with sculpture. This carving encompassed a variety of decorative, vegetal, and figural forms which were deployed on numerous settings on both religious and secular buildings, though by far the greatest amount of sculpture survives on the outside of ecclesiastical monuments [**137**].

This sculpture by definition maintained an intimate connection with its setting, whether confined to a single capital or spread across several architectural members to form a highly elaborate composition [**135**]. Such sophistication was not seen in the early medieval period, a time when monumental sculpture was seldom practised. As a result, the most

102

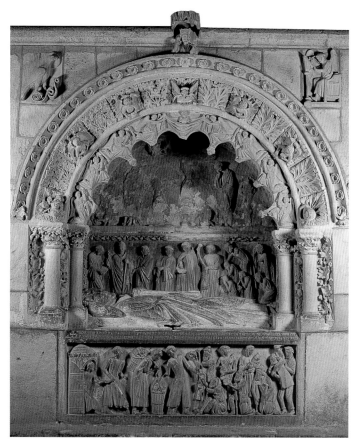

135 The tomb of Bishop Martín II Rodríguez (*c.*1260), León Cathedral, north transept, west wall

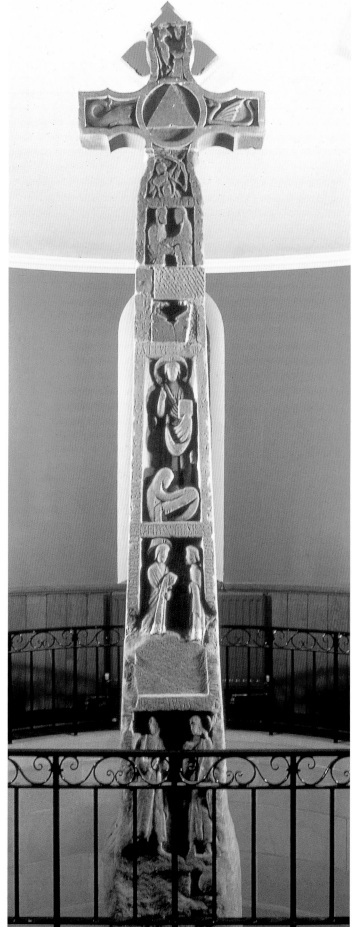

136 The Ruthwell Cross (*c.*700–25), red sandstone, 5.53 m. (18 ft.) high Ruthwell, Dumfriesshire

impressive examples of sculpture come from free-standing high crosses. Most high crosses were located outdoors, where they served as places for service and intercession. As a result, the majority of them have suffered from weathering or deliberate damage, but the superb quality of a few remains largely unimpaired [**136**].

Although carving continued to appear in Byzantine architecture

[**95**], little direct influence was exercised by Byzantium after the revival of monumental sculpture in the West. The most striking difference in the use of architectural sculpture between East and West is reflected on the exterior of buildings, for it was only in western medieval Europe that the facade came to be carved with an elaborate range of sculpture, much of which was figural [**137**].

As the upsurge in building activity had stimulated the revival of sculpture in the eleventh century, so architectural and artistic developments continued to influence aspects of its use in the later Middle Ages. Stained glass, for example, sometimes replaced spaces once occupied by carved tympana at portals. Throughout the Romanesque and Gothic periods, however, sculpture continued to thrive. KL

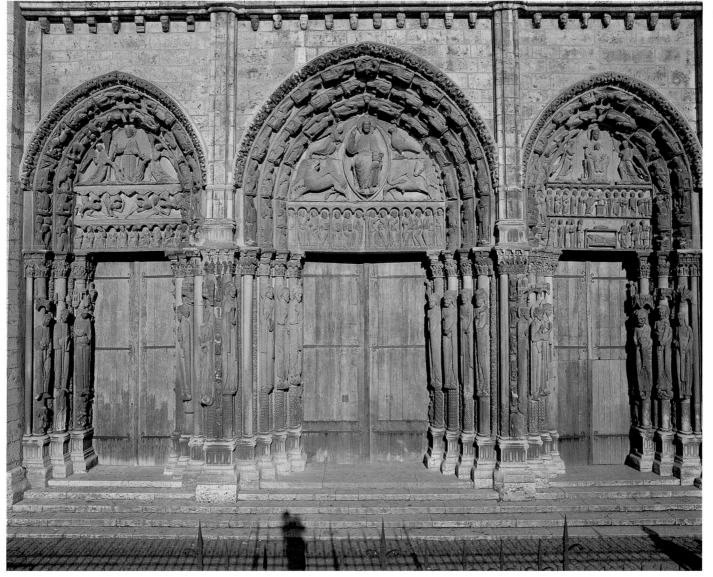

137 The west portal (*c*.1145–50), Chartres Cathedral

Contexts and meanings

A fundamental characteristic of sculpture was to articulate and emphasize significant sites of architecture. Given the public nature of this art form, sculpture was particularly suited for the exterior of buildings. This elaboration enhanced the status of a building that was typically the most imposing in the local community, while the sculpted forms of its doorway often served to illustrate the teachings of the church [**138, 139**]. Subjects of widespread currency, such as Christ in Majesty, were probably understood by both literate and illiterate audiences, but the meanings of details contained within these works could be obscure, even to those who were educated.

Sculpture was also employed at important sites on the interior of a variety of buildings. The magnificent

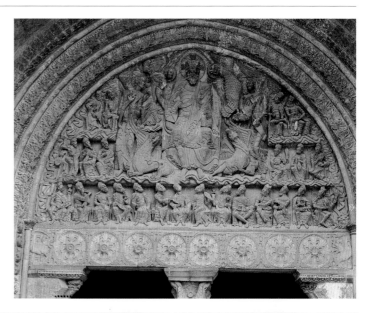

138 *Christ of the Apocalypse* (*c*.1115–20), south portal, detail, lintel 5.68 m. (18 ft. 6 in.) long, Moissac Abbey

104

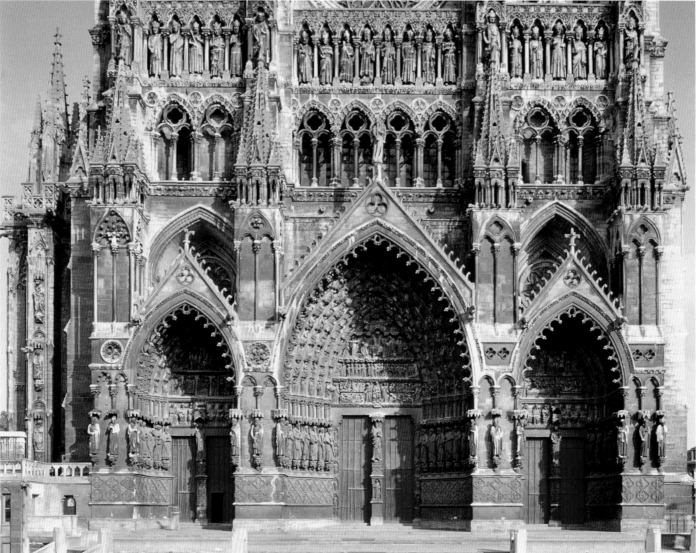

139 West facade, detail (*c*.1225–40), Amiens Cathedral

archway formerly leading to a Great Hall in Durham Castle is rivalled by few monuments, secular or ecclesiastical, and created an impression worthy of its powerful patron [**140**].

With the exception of explicitly religious subject-matter, no carved forms appear to have been reserved for use in either a secular or an ecclesiastical context. The bulk of the sculptural vocabulary occurred across the range of architectural monuments, for example, although the cloister and chapter-house were exclusively monastic structures, their sculptural decoration did not differ from the forms used in public spaces, such as the portal. Some sculpture in the cloister contained religious subjects [**141**], but other carvings in the cloister, especially those on capitals, were humorous, even grotesque, prompting some religious figures to question their suitability for a monastic audience. The blind arcades and geometric patterns elaborating the Bristol chapter-house [**142**] offer no meaning in a didactic or iconographic sense, but the use of such intricate sculpture was appropriate for a building which was second only to the church in importance in a monastic complex. KL

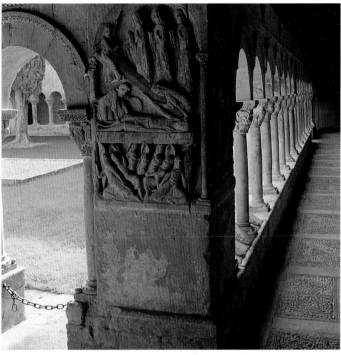

141 Cloister (*c*.1095–1100), S. Domingo de Silos

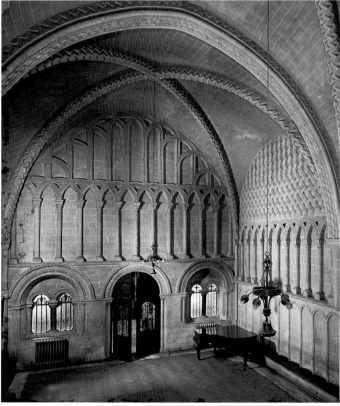

140 Norman archway (*c*.1170–80), Durham Castle

142 Chapter-house, interior (*c*.1165–70), Bristol Cathedral

Details and variety

Sculpture exhibited a diverse range of decorative and figural forms. Animals and hybrid beasts were popular subjects and were often carved in pairs confronting each other across the face of a capital in playful or belligerent poses [**143**]. Religious events also constitute a large amount of the carving on Romanesque and Gothic architecture. At Modena

Cathedral, episodes from Genesis were carved on a frieze [**145**]. The use of a frieze format is an important development in Romanesque sculpture, but tympana continued to be used more widely than friezes for displaying narrative [**144**]. On the other hand, the name of the sculptor of the frieze at Modena, Wiligelmo, is known, an unusual occurrence at a time when the names of artists were recorded only infrequently.

The sculpture at Strasbourg not only reflects the increasing cult of the Virgin but also the move towards greater naturalism in depicting figures, plants, and objects from the natural world, as well as carving in higher relief, both characteristic of Gothic sculpture [**144**, **146**].

Sculpture was usually painted, although this is difficult to appreciate since much of it has been removed or has worn away. The statues of

Ekkehard and Uta are greatly enlivened by the use of colour on drapery and features of their hands, faces, and hair [**146**]. KL

106

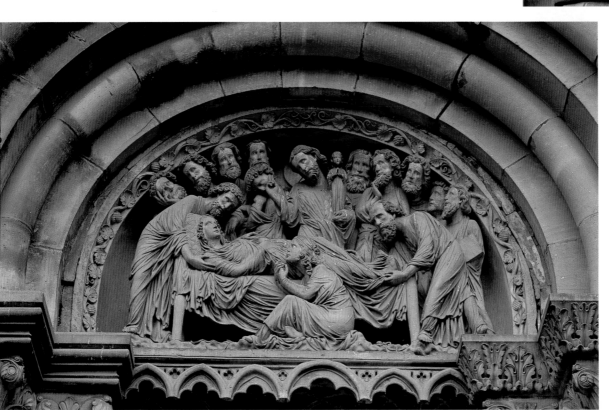

143 Above: S. Gabriel's Chapel, capital (*c.*1100), Canterbury, crypt

144 Left: *Death of the Virgin* (*c.*1225–30), Strasbourg, tympanum (1.98 m.— 77½ in.—wide) over west door

145 Below: Wiligelmo, *Scenes from Genesis* (*c.*1110–20) Modena, west front, detail of frieze 92 cm. (36 in.) high

146 Opposite: *Ekkehard and Uta* (*c.*1249–55), Naumburg, west choir, 1.86 m. (6 ft. 1½ in.) high

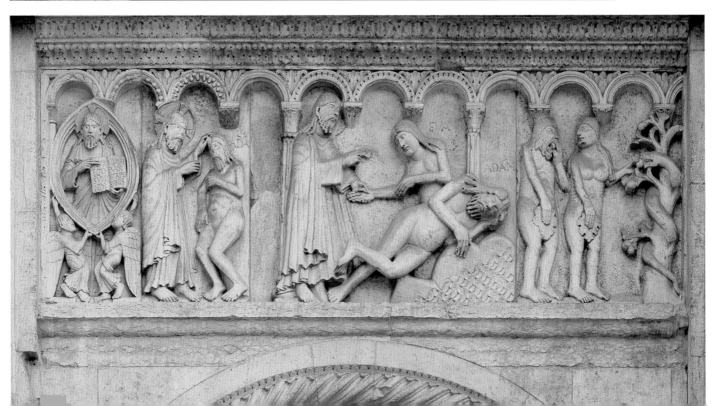

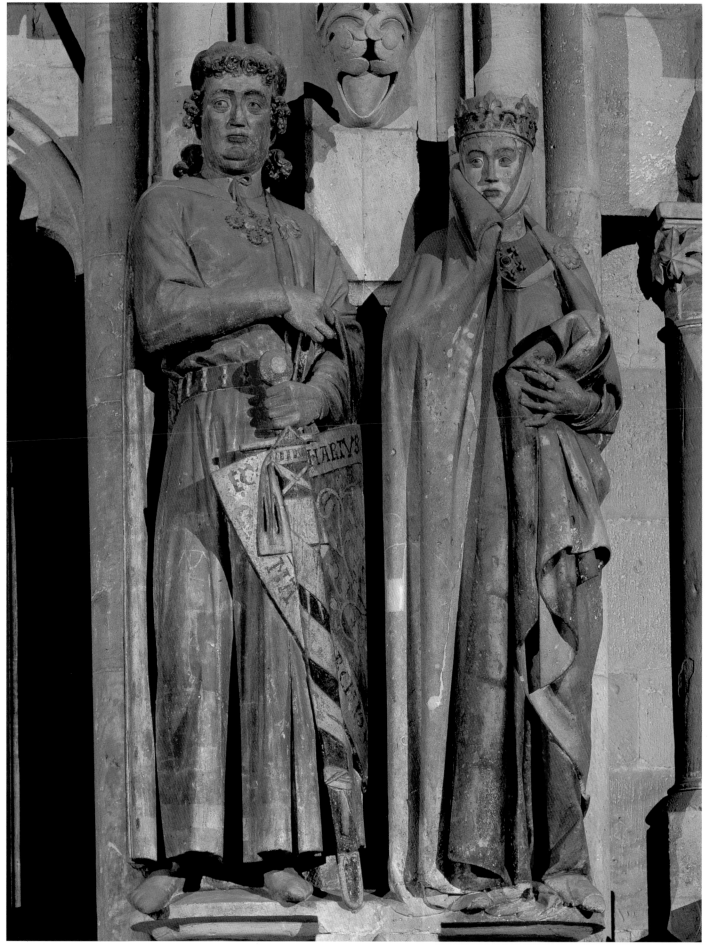

Stained Glass

Glass is an ancient material and was well known to the Romans as one of a number of more-or-less translucent materials suitable for weather-proofing windows. It was the Christian church, however, that first exploited the symbolic significance of a medium that admitted light and colour to a religious interior. In the book of Genesis the first words attributed to the mouth of God are 'Let there be light' (Genesis 1: 3), and the very act of Creation had involved the division of light from darkness. Christ described himself as 'the Light of the World' (John 8: 12). The Heavenly Jerusalem, of which any church was only a pale and earthly shadow, was described as 'like unto clear glass' (Revelation 21: 18). To the medieval mind the relationship between glass and light was an intriguing mystery. S. Bernard (c.1090–1153), for example, compared the splendour of the sun, which passed through glass without breaking it, with the unsullied virginity of the Virgin Mary penetrated by the Holy Spirit.

While archaeological evidence for the nature of stained glass before the year 1000 is very limited, literary evidence suggests that coloured and possibly figural painted glass was made for churches from the fourth century onwards. The Spanish poet Prudentius (348–c.410), the historian Procopius of Caesarea (mid-sixth century), and the poetry of Paulus Silentarius (fl. 527–65) all mention the use of coloured, decorative glass in the basilicas of Constantinople. Literary sources also provide evidence of coloured windows in churches in northwest Europe in the same period. Sidonius Apollinaris (c.423–c.480), bishop of Clermont, for example, mentioned multicoloured figures in the windows of the church of the Maccabees in Lyons, while Gregory of Tours (c.540–94), bishop of that city, described the theft of coloured glass from the windows of the church of Yzeure. The collapse of the Roman occupation of Britain resulted in a loss of craft skills, including glazing, and its reintroduction was entirely due to its use in churches. In his life of S. Wilfrid (c.633–709), Eddius Stephanus describes the refurbishment of York Minster (c.669–678), including the installation of glazed windows. In his *Lives of the Abbots* Bede (673–735) describes how, in 675, Abbot Benedict Biscop of Monkwearmouth and Jarrow sent to Gaul for skilled glaziers. Shaped glass fragments recovered from pre-Viking contexts at Monkwearmouth and Jarrow display a range of colours, but no paint, suggesting that the coloured glass was arranged in decorative mosaic patterns, probably geometric in nature. The windows in which these coloured mosaics were situated were small, set into thick masonry walls.

The reference to the gift to the church of Saint-Rémi in Reims of 'various windows containing histories' by Archbishop Adalberon (d. 989) is surely a description of painted glass windows. The date at which painted detail was first fired on to window glass will probably never be known. The earliest surviving fragment bearing painted detail was recovered from the foundations of the mid-sixth-century cloister at S. Vitale in Ravenna, depicting Christ and the alpha and omega, although whether the paint had been fired to the glass has been disputed. A mosaic panel of a cross recovered from the abbey site at Séry-les-Mézières (Aisne) apparently combined unpainted green and red pieces with painted palmettes. A date as early as the seventh century has been claimed for the panel, which was destroyed during the First World War, although it has more plausibly been dated to the ninth century. Painted fragments dated to c.900 have been found on the site of the Old Minster in Winchester, with larger quantities of painted glass dated c.966–1066 found at Old Minster and Nunnaminster.

The most spectacular finds of early painted glass have undoubtedly been the head of Christ of ninth-century date from the site of the abbey of Lorsch (now in the Hessisches Landesmuseum at Darmstadt), the late tenth-century head found in the foundations of the north transept of the abbey church at Schwarzach and the head of Christ [168] from the abbey of Wissembourg of perhaps c.1060. A head of possibly eleventh-century date recovered at Magdeburg in 1926 is known only from a photograph, having been lost in the Second World War.

The spectacular full-length figures of four prophets (Daniel, Hosea, David, and Jonah [147]) of c.1100 preserved in the nave clerestory of Augsburg Cathedral offer tangible proof that by the beginning of the twelfth century stained glass had attained full maturity as a monumental art form. Two texts from the first half of the twelfth century shed light on the development of the craft and the esteem in which it was held. The German Benedictine monk and priest known as Theophilus provides a completely practical account of the making of painted glass windows. His account reads as if written by someone who, if not personally involved in stained glass manufacture, was at least fully conversant with its techniques. Abbot Suger of the royal abbey of Saint-Denis near Paris, probably writing just after the consecration of the chevet (the east end of the church, with its radiating chapels) on 11 June 1144, describes the windows at the abbey in the language of gemstones. The sapphire blue glass is especially remarked upon, and gemstone terminology is also reflected in the traditional description of red glass as ruby. The thieves of Yzeure had believed the yellow glass to contain gold, which they unsuccessfully tried to extract. Suger was able to call upon master craftsmen from many different regions in the making of his windows and such was their value 'on account of their wonderful execution and the

profuse expenditure of painted glass and sapphire glass', that a master was appointed to care for them.

While twelfth-century glass is today valued for its rarity, Suger's testimony that there were masters working in many regions is borne out by the survival of glass from a number of European countries. While Theophilus acknowledged Germany as the most skilled nation in metalworking, he considered France the most remarkable for 'her precious variety of windows'. Much of what survives from the twelfth century is in the form of single figures or devotional images. The prophet figures from Augsburg and the figure of S. Timothy (c.1145–50) from Neuwiller-lès-Saverne (Bas-Rhin, now Paris Musée de Cluny) conform to the former image type, while the stylized seated Virgin and Child from La Trinité at Vendôme (second quarter of the twelfth century) or the Crucifixion window from Poitiers (c.1165–70) represent the latter. It is clear, however, that the narrative potential of stained glass was quickly appreciated. Many of Suger's windows have been destroyed or removed from his church, but his description of mid-twelfth-century Saint-Denis includes not only an account of the design of the first Gothic church, but also the arrangement of probably the first coherent narrative glazing, with the tree of Jesse in the axial window of the chevet. Supported by iron armatures set within the single lancet openings, panels of glass in a variety of geometric shapes separated by deep, richly coloured foliage borders, allowed a complex narrative to unfold, a cycle that included the infancy of Christ and the Life of the Virgin, an 'Anagogical window' (a window explaining spiritual mysteries), a Moses window, and a dramatic grisaille window with griffins. The influence of Suger's tree of Jesse was quickly felt at Chartres in a window for the west wall, made c.1145–55, accompanied by a narrative infancy window. Its influence was not confined to France, however, for similar Jesse tree windows are also found in York Minster (c.1170–80) and at Canterbury Cathedral (c.1200).

The extensive late twelfth- to early thirteenth-century glazing of Canterbury Cathedral reveals the extraordinary versatility of the designers and craftsmen in organizing material into different types of window suited to different architectural spaces and different audiences, recognition of the tremendous potential of stained glass as a narrative medium. The reglazing of the cathedral's eastern arm followed its rebuilding after a disastrous fire in 1174. The project had been given tremendous impetus and financial stability by the canonization of Archbishop Thomas Becket (1118–70) in 1173. The Trinity Chapel was designed expressly as a shrine area, to which Becket's body was moved in 1220. The glazing scheme was arranged to suit the topography of the building and the liturgical and devotional purposes of its different parts. In the single lancets of the high clerestory the geneaology of Christ unfolded in a symbolic play upon light and dark, represented by north and south sides of the church. The sequence of monumental figures, one above another, began on the dark north side with a figure of the Creator (lost), above Adam delving, and culminated in figures of the Virgin Mary and Christ, the second redemptive Adam, on the south side (both figures now lost). The monastic choir was illuminated with images in glass of its earlier saints, S. Alphege and S. Dunstan, whose lives and miracles were depicted in the triforium, while the choir aisles were illuminated by a series of 12 typological windows (in which Old Testament events were shown to prefigure New Testament ones), explained by complex Latin inscriptions. The 'public' face of the cathedral was inexorably linked to the promotion of the cult of S. Thomas. Consequently, two of the windows of the Trinity Chapel ambulatory, the route followed by pilgrims to the shrine, contained prefatory scenes from the life of the saint, while the remaining eight windows contained shorter narrative cycles depicting S. Thomas's posthumous miracles [148]. The visual emphasis in these windows is on the efficacy of personal and physical contact with either the crypt-tomb or the Trinity Chapel shrine, a kind of advertisement for the pilgrimage experience.

The single lancet containing small-scale figures in scenes arranged within complex geometric shapes separated by wide foliage borders became a standard window type in the thirteenth century. Individual panels were defined and supported by the elaborate metal armatures set into the masonry. Analysis of the variety of sophisticated narrative modes of considerable variation and complexity that developed in the thirteenth century demonstrates the importance of the tradition of secular pantomime and religious drama in the evolution of a language of gesture. In the thirteenth-century glass of Chartres, Bourges, Canterbury, and Salisbury, for example, scenes are conceived in terms of figures silhouetted against coloured grounds, animated by light. This also has implications for our appreciation of the audience who 'read' these monumental windows.

The architectural development of the Gothic style was undoubtedly critical to the continued and growing prominence of stained glass as a monumental art form. Buildings appeared in which there was an elaboration of window tracery and an increasing diminution of solid wall in favour of windows. The Sainte-Chapelle in Paris (consecrated in 1248) or the chapter-house of Westminster Abbey in London (complete by 1253) could be taken as paradigm. They provided hitherto unparalleled opportunities for glaziers. Unlike vestments,

liturgical vessels, and books, stained glass was on permanent, and thanks to its elevated position, very public view.

By the end of the thirteenth century, a taste for a more brightly illuminated interior together with the new proportions and discipline imposed by the introduction of multi-light mullioned window tracery resulted in new stained glass forms. At Salisbury Cathedral [149] and in the transepts of York Minster, enormous windows were filled with foliage grisaille, in which white glass (actually often greyish-green as a result of impurities in the glass) is decorated with trails of conventionalized stiff-leaf foliage, with only small quantities of colour used to pick out interlacing geometric shapes. While aesthetic considerations probably determined the choice of grisaille in both these locations, where a high proportion of dark Purbeck marble contrasts with lighter stone, elsewhere grisaille could be preferred for reasons of economy, practicality, or even religious principle. The Cistercian Order, for example, proscribed the use of figural stained glass as early as the second quarter of the twelfth century and many of their twelfth- and thirteenth-century churches contain grisaille glass, some painted and some unpainted. The survival of 'Cistercian' grisaille patterns in cathedrals and parish churches outside the order (York Minster, Salisbury Cathedral, Notre-Dame de Valère, Sitten in Switzerland, and several English parish churches) suggests that the Cistercians were adapting for their own use motifs and glazing types already current.

In contexts where the narrative function was a requirement, experimentation with combinations of full-colour figural panels and panels of grisaille took place. Vertical alternations of colour and grisaille were favoured in the abbey church of Saint-Père-en-Vallée in Chartres (now the parish church of S. Pierre), glazed in the period c.1250–1315. A more satisfactory arrangement was one of horizontal alternation, now commonly described as 'the band window'. One of its earliest manifestations was in the glazing of the choir clerestory of Tours Cathedral (c.1260). Horizontal zones of grisaille were used in conjunction with darker, coloured figural scenes that continued to be framed in geometric shapes (as in the collegiate church of S. Urbain in Troyes, glazed c.1270, or the former Augustinian church (now the parish church) of Chetwode, Buckinghamshire, c.1270–80), but more commonly began to be displayed under architectural canopies that emulated the architecture of the building and grew increasingly complex, becoming an important decorative device in their own right. In the same period recognizably naturalistic foliage replaced conventionalized forms. The chapel glazing of Merton College, Oxford (c.1294), for example, employs canopies above single figures throughout its 14 side windows, while its grisaille and foliage borders are filled with identifiable plant forms [162].

The development of the medium in the thirteenth and fourteenth centuries was, of course, shaped equally by liturgical and devotional requirements. The concept of post-mortem punishment in Purgatory emerged in more clearly defined terms in the course of the thirteenth century. While the pains of Purgatory were greatly feared, there was a hopeful expectation that unshriven sin could be expiated and the soul purified before the ultimate and irrevocable test of the Last Judgement. The debt of sin could be lessened in a number of ways, one of

the most efficacious being the intercession of the saints. While Christ himself, or his Virgin mother, were the most powerful intercessors, the canonized saints were, perhaps, more accessible. Stained glass provided an ideal medium for the depiction of their images, and a multi-light window could contain a number of single iconic figures under canopies in a form of illuminated reredos ideal for personal and parochial devotion. That these images were used to instruct can be inferred from the fact that they are commonly identified by attributes and symbols that would have been unintelligible to the illiterate without verbal interpretation.

The prayers of the living could assist those in Purgatory, and commemorative masses proliferated at specially established chantries. While a chantry chapel or elaborate tomb with intercessory inscription was within reach for some, a stained glass window could be a very attractive and more affordable alternative, for unlike a chantry, it did not require giving over land for its support. For this reason, stained glass became an increasingly popular vehicle for commemoration for wealthy lay people and clerics alike. The individual and non-clerical donor was increasingly acknowledged by the inclusion of donor 'portraits', often accompanied by inscriptions requesting the prayers of the passer-by. The so-called Heraldic window in the nave of York Minster, commissioned c.1307–12 by Canon Peter de Dene, contains the appeal *Priez pur Magister Peter de Dene* (Pray for Master Peter de Dene) beneath his kneeling image.

It was the donor who exerted the greatest influence in determining the form and content of a window. Corporate donors and the exceptionally wealthy individual, wielding considerable purchasing power, could monopolize the most attractive religious subjects, which explains why the taverners and wine-merchants of Chartres were able to claim for themselves S. Lubin [163], second only to the Virgin Mary in the cathedral's devotional hierarchy. In welcoming the greater participation of laymen and -women in the provision of stained glass, Deans and Chapters and Abbots and Priors could be forced to relinquish a degree of control over the iconographic coherence of a glazing scheme. The windows of the nave of York Minster, for example, glazed in the period c.1310–39, were provided by a variety of clerical and lay donors, and although the Dean and Chapter managed to preserve the band window formula throughout, the choice of subject-matter reflects the devotional preferences of the individual. Peter de Dene, canon, royal servant, and scholar, chose to honour S. Catherine, international patron saint of scholars, while Richard Tunnoc, goldsmith, bell-founder, and former mayor of York, chose S. William of York, never a popular saint outside his own city. Heraldry became an increasingly important means of integrating personal commemoration into religious art and no more so than in stained glass windows. In the choir clerestory windows of Cologne Cathedral, for example, glazed in the first quarter of the fourteenth century, figures of Kings and Prophets stand above shields commemorating the nobility of church and state. The nobility engaged in the Scottish wars of Edward I and Edward II were commemorated in the nave clerestory of York Minster.

In the second quarter of the fourteenth century, artists north of the Alps became aware of the spatial experimentation and narrative innovation originating in the work of Italian panel

and mural painters in the early years of the century. In France these ideas appear to have transmitted via the Parisian illuminators, notably the atelier of Jean Pucelle, whose *Hours of Jeanne d'Evreux* and *Belleville Breviary* contain a series of scenes depicted within doll's-house architecture with convincing three-dimensional substance, although the loss of all Parisian stained glass of the period makes it difficult to judge the impact of Pucellian art in this medium. A small group of East Anglian manuscripts produced in the 1330s reveals English familiarity with Italianate art and iconography, perhaps conveyed through portable media such as panel paintings, while in York, the workshop of Master Robert (responsible for the Minster's west window of 1339) produced a number of panels with an imperfectly assimilated version of Pucellian architectural forms. In the glazing of the Franciscan church of Königsfelden (Aargau, Switzerland), built and glazed c.1325–30 as a memorial to the murdered Habsburg Albrecht I (d. 1308), three-dimensional forms are convincingly depicted as the settings for a series of biblical scenes and lives of the saints [**151**]. The scenes are enclosed in geometrical frames, which in France and England had been superseded by architectural canopies, but within the frames, the scenes are placed on strongly projecting platforms and are surmounted by multi-storeyed structures.

By the fifteenth century stained glass had become a truly international medium. In the last quarter of the fourteenth century the rapid evolution of painting styles and techniques had accelerated the development of a sophisticated, painterly 'soft style' common to the International Gothic in all media. The psychological drama of narrative was increasingly expressed in characterful physiognomies, sometimes ugly and in contrast to the refined elegance of the fourteenth century, and owing a great deal to the observation of the real world. Such is the international nature of Gothic art in this period that comparisons can usefully be made between the work of Thomas of Oxford in Oxford (c.1380–6) and Winchester (c.1393) and the windows of Bourges Cathedral made for the Duke de Berry (c.1395–1405), perhaps under the direction of André Beauneveu.

The tendency to elaborate the architectural features in a window, creating ever more complex, vertiginous, and richly inhabited forms, characterizes the period 1350–1450. The retention of flat, diapered (geometrically decorated) or rinceau-decorated (foliated) backgrounds, usually in rich colours contrasting with the white glass and yellow stain in which the architecture is executed, served to maintain the essentially two-dimensional decorative quality of the medium. Only in the second half of the fifteenth century did glass-painters begin to display a disinclination to be restrained by the confines of the architecture of window tracery. As early as c.1450 the artist commissioned by silversmith and merchant Jacques Cœur to make the Annunciation window for Bourges Cathedral [**167**] sets the scene under a spangled vault that ignores the mullions dividing the window and spans the scene across four lights.

It is in this period that glass-painters were organizing their craft in more formal ways, seeking to control entry to their profession and improve its status and their own economic position. It had long been an urban occupation, and was now recognized in a series of city statutes governing the craft. Ordinances were issued in London in 1364/5, in York c.1380 and in 1463/4, and

Paris in 1467. In other cities, such as Prague and Antwerp, the glass-painters joined other artists in the Guild of S. Luke. The prestige of a particular glazing workshop could ensure that its products were distributed over considerable distances. In England the leading glazier of the day could expect to become King's Glazier, a post that can be identified in embryo from the middle of the thirteenth century. In 1440 John Prudde was appointed to the post and was to have use of 'a shedde called the glasyer logge' within the Palace of Westminster. It was here that he made the sumptuous glazing of the Beauchamp Chapel, Warwick, commissioned in 1447. The mid-fifteenth-century glazing of the S. Chapelle in Riom (Switzerland) was made for the Bourbon duke Charles I by the same atelier responsible for Jacques Cœur's Annunciation window at Bourges. The work of Strasbourg glass-painter Peter Hemmel was exported to Ulm, Salzburg, Munich, Nuremberg [**154**], and Freiburg in Breisgau.

If the rewards were sufficiently attractive the artists themselves were prepared to relocate themselves. In 1405 Coventry glass-painter John Thornton was persuaded to move to York to work for the Dean and Chapter, and remained the dominant force in York stained glass until the 1440s. The artist Arnold of Nijmegan began his career in Tournai in Flanders, but moved to Rouen in 1502, making windows for the churches of S. Godard and S. Ouen. He returned to Tournai in 1513, remaining in contact with his Rouen colleagues and pupils. In Spain and Italy, where stained glass traditions were less firmly established, the arrival of foreign artists could have a major impact. The work of Frenchman Guillaume de Marcillat, invited to Rome by Pope Julius II in 1506, came to the notice of Vasari, who described his windows in Arezzo Cathedral as 'marvels fallen from heaven for the consolation of men'. Flemish stained glass artists had been working in England since the 1480s, but in 1497 Barnard Flower was appointed King's Glazier to Henry VII and ensured the successful penetration of the English market by Netherlandish artists and their associates, an incursion that had long been resisted by the London Glaziers' Guild. Flower's work at Westminster Abbey has nearly all been lost, but the glazing of Fairford Church in Gloucestershire (c.1500–15) exemplifies the artistic achievements of the immigrant glass painters [**165**].

By the second half of the fifteenth century new pictorial sources were having an impact, and with the advent of printing techniques, they could be disseminated across national and cultural borders. The typological representations of the biblical narrative developed in the blockbook *Biblia pauperum*, for example, evolved in the Netherlands in the early 1460s, were known to the glass-painters working c.1466–80 at Holy Trinity, Tattershall (Lincs.), and the glaziers at Fairford. Churches in Paris and Rouen glazed c.1500 (S. Etienne-du-Mont and S. Merry in Paris and S. Godard in Rouen) contain scenes derived in part from compositions in the manuscript illuminations of the *Little Hours of Anne de Bretagne*, although several of the scenes were reproduced in almost identical form in a woodblock book of hours published in Paris in 1496 and 1498. The influence of Albrecht Dürer was international thanks to the circulation of engraved versions of his compositions. The east window of Balliol College, Oxford, for example, made for the original chapel constructed in 1522–9, depicts the Agony in the Garden and the Ecce Homo derived from Dürer's engraved Passion. SB

111

Light and colour

The earliest surviving monumental stained glass yet found, the four figures of prophets of *c.*1100 in Augsburg Cathedral [**147**], formed part of a series of perhaps as many as 21 figures of the ancestors and precursors of Christ. They were, however, visually discreet, linked by a common theme rather than by any narrative or psychological relationship. In the lives of saints and biblical narratives related by windows of the late twelfth- and thirteenth-century cathedrals the story-telling potential of stained glass was developed to the full [**148**], with windows divided into separate but related narrative compartments, separated by wide borders of conventionalized stiff-leaf foliage. The division of windows into tall narrow lights separated by mullions necessitated a rethink in the disposition of figural and decorative elements within a window. In France and England in particular, this led to the adoption of architectural canopies over figures or scenes, although in the countries of the Holy Roman Empire cusped medallions continued in favour. A general lightening of windows can also be detected in the late thirteenth and fourteenth centuries as increasing amounts of grisaille glass [**149**] were used, most commonly arranged in horizontal alternation with the historiated panels. The windows of *c.*1330 in S. Ouen at Rouen exemplify this refined style [**150**], with elegantly posed figures beneath buttressed canopy forms highlighted against counterchanging rinceau backgrounds. Foliage forms are now fully naturalistic. Yellow stain, the revolutionary pigment introduced *c.*1300, is used to give the white glass a silvery quality. SB

112

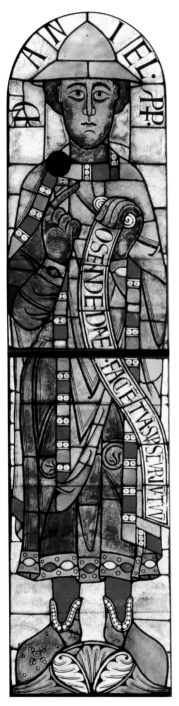
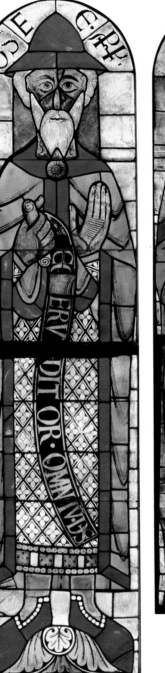
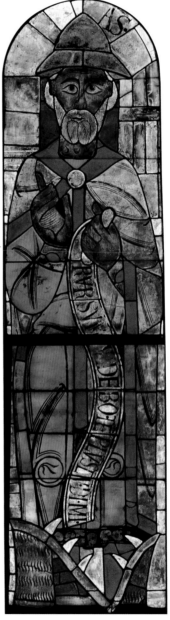
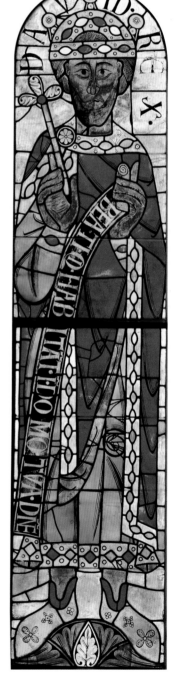

147 The prophets Daniel, Hosea, Jonah and David (*c.*1100), Augsburg Cathedral, south nave clerestory

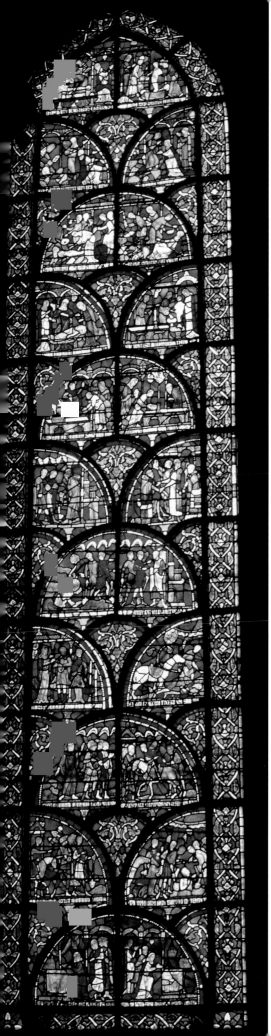

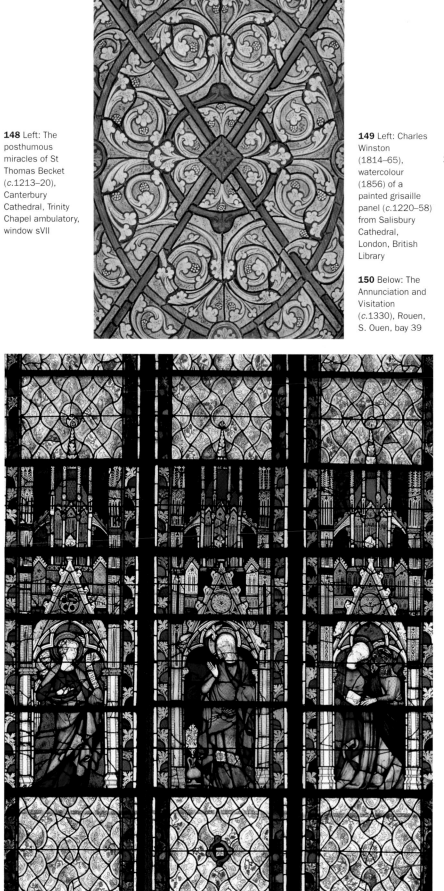

148 Left: The posthumous miracles of St Thomas Becket (*c*.1213–20), Canterbury Cathedral, Trinity Chapel ambulatory, window sVII

149 Left: Charles Winston (1814–65), watercolour (1856) of a painted grisaille panel (*c*.1220–58) from Salisbury Cathedral, London, British Library

150 Below: The Annunciation and Visitation (*c*.1330), Rouen, S. Ouen, bay 39

Architecture and space

The architectural forms in windows became the principal means of expressing a growing interest in pictorial space. In the fourteenth century contact with Italian art acted as a catalyst and this influence can be seen in the multi-storey structures enclosing figures in the window of the Franciscan church at Königsfelden (c.1325–30) [**151**].

By the fifteenth century the illusionistic architecture within a window had become as inventive and elaborate as the sculpture and architecture of the surrounding building. In the Volckamer window [**154**] of c.1481 in the church of S. Lorenz, Nuremberg, for example, the canopies occupy approximately one-third of the height of the window and have taken on the quality of limewood sculpture.

By the end of the first quarter of the sixteenth century Classical architectural forms and fully-conceived three-dimensional interiors [**152**] and landscapes were introduced into window design, emulating the achievements of Netherlandish panel painters.

Little is known of medieval domestic and secular stained glass and little survives. Documentary evidence makes it clear that only high-status houses were glazed with painted glass, and the value of these windows was such that they could be removed from one house and installed in another. An important collection of roundels, some in situ in quarry-glazed wooden-framed windows, has been preserved from a house in Leicester [**153**], probably the residence of Lord Mayor Roger Wigston (d. 1507). SB

114

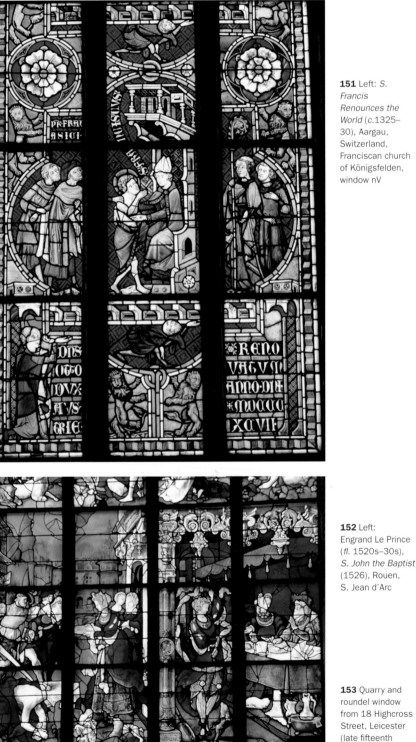

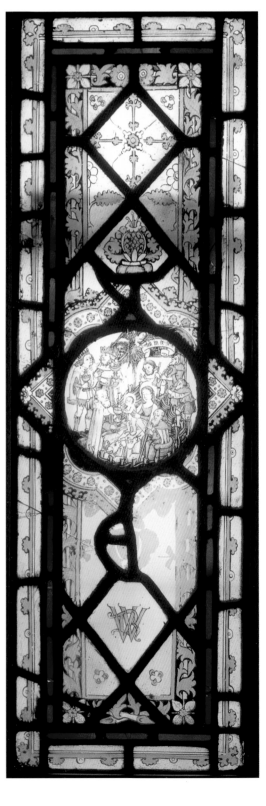

151 Left: *S. Francis Renounces the World* (c.1325–30), Aargau, Switzerland, Franciscan church of Königsfelden, window nV

152 Left: Engrand Le Prince (fl. 1520s–30s), *S. John the Baptist* (1526), Rouen, S. Jean d'Arc

153 Quarry and roundel window from 18 Highcross Street, Leicester (late fifteenth century), Leicester Museum

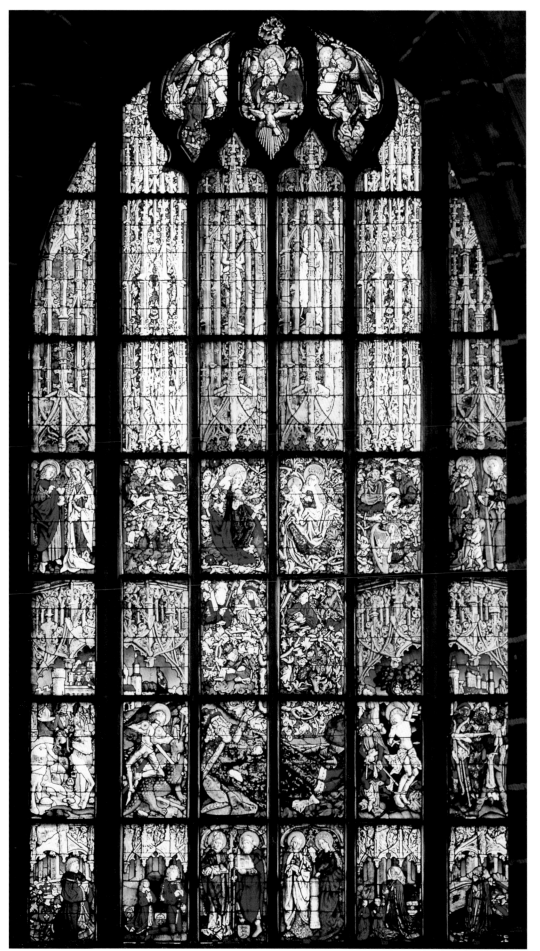

154 Strasbourg workshop of Peter Hemmel (active in second half of the fifteenth century), Volckamer window (window sIII) (*c.*1481), Nuremberg, church of S. Lorenz

Sharing ideas

From at least the twelfth century stained glass was made in many parts of Europe and was an increasingly urbanized occupation. Stained glass artists therefore had plenty of contact with artists working in other media. The preparation of small-scale sketch designs would often have been entrusted to artists and designers outside the glazing studio. Large-scale building projects brought together masons, sculptors, glaziers, and painters and provided another conduit for the exchange of ideas.

Craftsmen drawn from all over England worked on the building projects of Henry III (1215–72) and Edward I (1272–1307). In the last decade of the thirteenth century delicate micro-architectural forms decorated shrines, choir furniture, and tombs (for example, the tomb chest of Edmund Crouchback (d. 1296), in Westminster Abbey [**155**]) and found an echo in the decoration of two-dimensional media, notably tiles (for example, the Chertsey Abbey tiles made for Westminster Abbey, c.1293–8 [**156**]) and stained glass (for example, the chapter-house vestibule, York Minster, c.1295 [**157**]). The image of kingship found in the Chertsey Abbey tiles is also a feature of the York chapter-house vestibule windows, reflecting Edward I's preoccupation in the 1290s with his claim to the Scottish throne. From 1292 the court spent considerable amounts of time in York prosecuting the Scottish wars.

By the end of the fifteenth century the greater availability of paper facilitated the preservation and exchange of specific designs. Sketch designs and even full-size cartoons could now be preserved, exchanged,

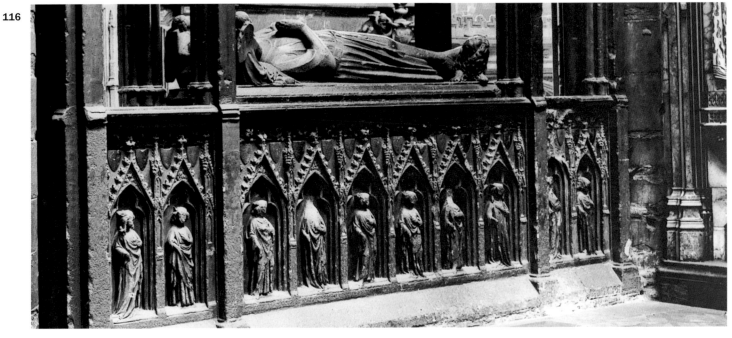

155 Above: Tomb chest, monument of Edmund Crouchback, earl of Lancaster (d. 1296), London, Westminster Abbey

156 Right: Figures of Archbishop, King and Queen, Chertsey Abbey tiles (c.1293–8), made for Westminster Abbey?, London, British Museum

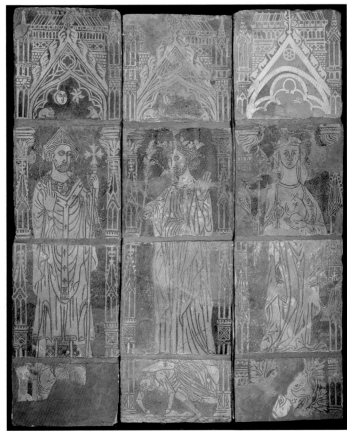

and bequeathed. Cennino Cennini's fifteenth-century *Book of Art* gives instructions for the gluing together of sheets of paper for the preparation of cartoons. This development probably had the greatest impact on the production of 'off the peg' panels for domestic and secular settings, most commonly in the form of small-scale yellow-stained roundels. The story of Sorgheloos (Carefree), a Netherlandish secularized version of the story of the Prodigal Son, was popularized by the secular theatrical groups found in many towns and soon found expression in painting [**159**] and stained glass [**158**]. SB

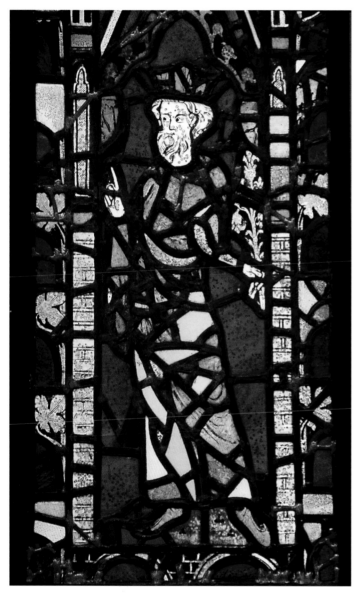

157 Above:
Figure of king
(*c*.1295), York
Minster, chapter-
house vestibule,
window nVIII

158 Above:
*Sorgheloos in
Poverty* (*c*.1520),
painted and
yellow-stained
roundel, London,
Victoria & Albert
Museum

159 Right:
Pieter Cornelisz (?)
*The Lost Son in
Poverty* (undated),
distemper on linen,
Basle, Öffentliche
Kunstsammlung,
Kunstmuseum

The donor's image

The donor, whether a wealthy individual, churchman, noble, religious fraternity, or commercial corporation, exerted the greatest influence on the content and appearance of a window.

The donor's influence would most commonly be defined in the form of a sketch design (a *vidimus*, 'we have seen'), a certified drawing that formed part of the contract between donor and craftsman. A collection of 24 small sketches of this type from *c*.1526–9, made for Cardinal Thomas Wolsey's chapel at Hampton Court, came to light in 1983. In part of the lower right register of the window [**160**] the Cardinal Archbishop of York (1471–1530) kneels in prayer.

Images of donors appear at a very early date. The glass-painter Gerlachus is depicted as both creator

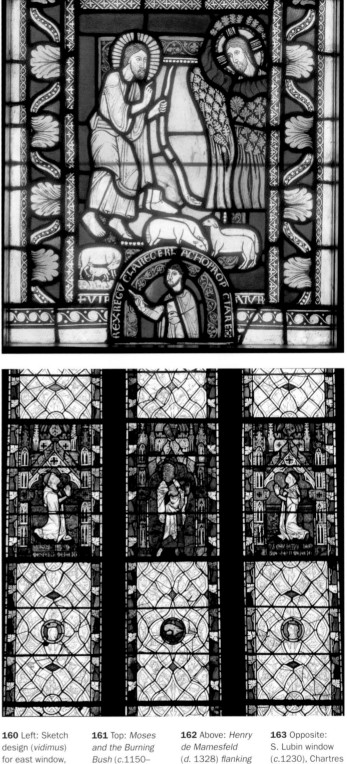

160 Left: Sketch design (*vidimus*) for east window, Hampton Court Chapel (*c*.1526–9), Brussels, Musées Royaux des Beaux-Arts

161 Top: *Moses and the Burning Bush* (*c*.1150–60), with portrait of the glass-painter Gerlachus, from the abbey church of Arnstein-an-der-Lahn, now in Munster, Westfälisches Landesmuseum

162 Above: *Henry de Mamesfeld* (*d*. 1328) *flanking the apostle Thomas* (*c*.1294), Oxford, Merton College chapel

163 Opposite: S. Lubin window (*c*.1230), Chartres Cathedral, north nave aisle, bay 45

and donor in glass of *c*.1150–60 from the Premonstratension abbey of Arnstein-an-der-Lahn [**161**], but it is unlikely that the glass-painter was the intellectual author of the pictorial programme.

An anxiety to be remembered by posterity presumably prompted the immodest representation of Henry de Mamesfeld, who claims authorship of 12 of the 14 side windows of Merton College chapel, Oxford, in inscriptions: *Henricus de Mamesfeld me fecit*. His 'portrait' [**162**] appears 24 times in the windows of the chapel, which was completed in 1294. Devotional and commercial benefits mingle in the S. Lubin window in Chartres Cathedral of *c*.1230 [**163**], chosen by the taverners and wine-merchants of the city partly because the bishop saint had served as cellarer of his abbey, but also because he was second only to the Virgin Mary in the devotional life of the cathedral. The scenes concerned with wine are dominant in the window, distinguished from the hagiographical elements by their central position, the colour of their contrasting backgrounds, and the way in which they overlap the surrounding panels. SB

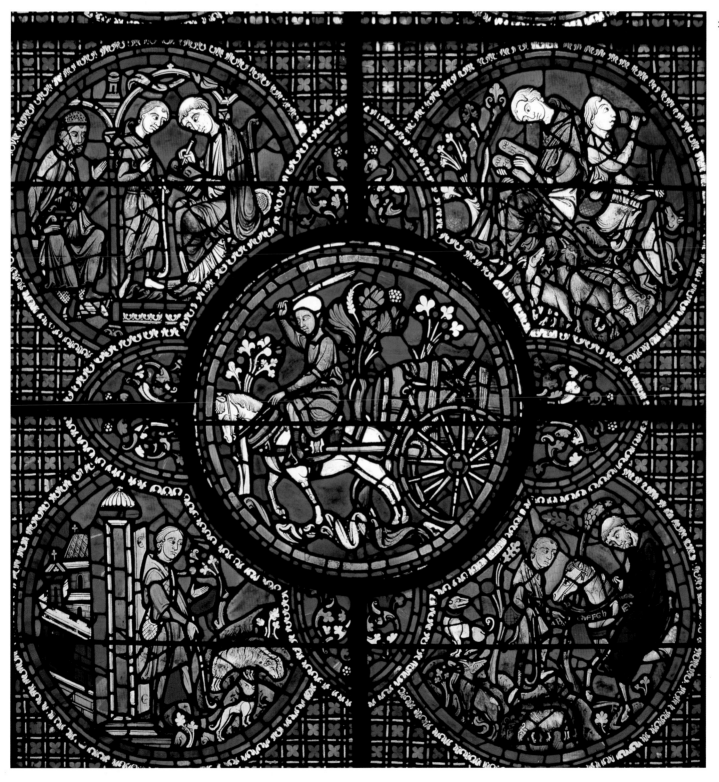

Glazing techniques

Once a design had been prepared and agreed upon in the glazing contract, the glaziers would prepare a full-scale cartoon, which served as a guide when the transparent glass was placed over it for both the cutting and for the leading-up of the painted and fired pieces.

For most of the medieval period the cartoon was prepared on a whitened table, which was washed and rewhitened after use. While this was an efficient means of reusing a single cartoon for repeated motifs —canopies, backgrounds, and so on—it also imposed a discipline on the workshop—all the canopies or figures to be made from that particular cartoon would have to be cut, painted, fired, and leaded up before the cartoon was cleared off the table. A single surviving table like

120

164 Left: Fourteenth-century glaziers' table used to make windows for Gerona Cathedral

165 Right: The head, hair, and halo of the Virgin Mary cut from a single piece of glass (c.1500–15), Fairford, Gloucestershire, S. Mary's Church, window nIV

166 Right: *King David* (c.1500), girdle and buttons of the tunic abraded out of a flashed ruby glass, from the Jesse tree in the parish church of Llanrhaeadr, Wales

those described in the twelfth-century treatise of Theophilus is preserved at Gerona (Catalonia). Early fourteenth-century canopies and a figure can be identified as having been made on it [**164**].

Medieval glaziers cut and shaped glass using a notched metal tool called a grozing iron, which left a distinctive 'nibbled' edge to the glass pieces. Notwithstanding the relative crudity of the tool, complex shapes

were cut. The 'cut-line' not only defined the shapes and sizes of glass pieces to be cut, but also determined the position of the H-sectioned lead strips, or calmes (from the Latin *calamus*) which held the glass pieces together. The lead lines would be carefully integrated into the design, to strengthen outline rather than distract the eye [**165**].

Such was the cutting skill of the medieval glazier that circular

insertions could be cut or drilled into a piece of glass to enable 'jewels' of contrasting colour to be inserted, for example, into haloes and the hems of gowns [**167**]. This time-consuming and thus expensive technique was extensively used in the later fifteenth century, particularly by those work-shops employed by the wealthiest donors. Red (ruby) glass was opaque unless manufactured in the form of a laminated sheet of red on white. The

glaziers could take advantage of its sometimes streaky quality, using it for flames, for example, but would also grind away some of the ruby surface to reveal the white base. 'Abraded ruby' [**166**] was valuable in the depiction of heraldic charges or the embellishment of drapery. SB

167 *The Annunciation with S. James the Greater and S. Catherine*, with numerous inserted 'jewels' in hems and haloes, commissioned (*c.*1448) by Jacques Cœur for Bourges Cathedral

121

Glass Lead
Core Flange

Leads Above: Like this one, most H-sectioned lead strips (calmes) that hold stained glass windows together have rounded tops, but tops can also be flat or filleted. The core is almost always about 1.5 mm. (1/16 in.) wide. The flanges are typically 5 mm. (1/5 in.) wide.

Painting the glass

The coloured glass used by the stained glass studio was purchased in sheets from the manufacturers and merchants of the material. Its colour and tone could be altered in the studio by mechanical means (abrasion) [166], but it was the application of pigment that really altered its quality, by controlling the amount of light able to pass through it.

The glass paint was made from a mixture of iron oxide, ground glass as a flux, and gum arabic, with wine or urine as a binder. A variety of animal-hair brushes were used to apply the diluted paint (the broadest brush is actually called a badger), which could be used in the form of thick, solid trace lines, a dense overall matt for reserved decoration, or a thin modelling wash. The earliest surviving glass paintings, such as the Wissembourg

122

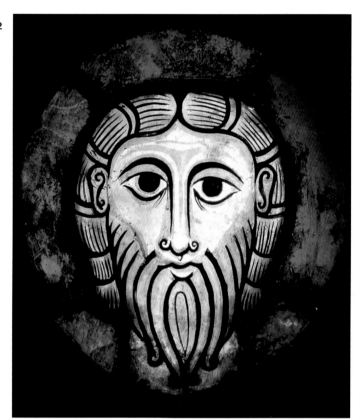

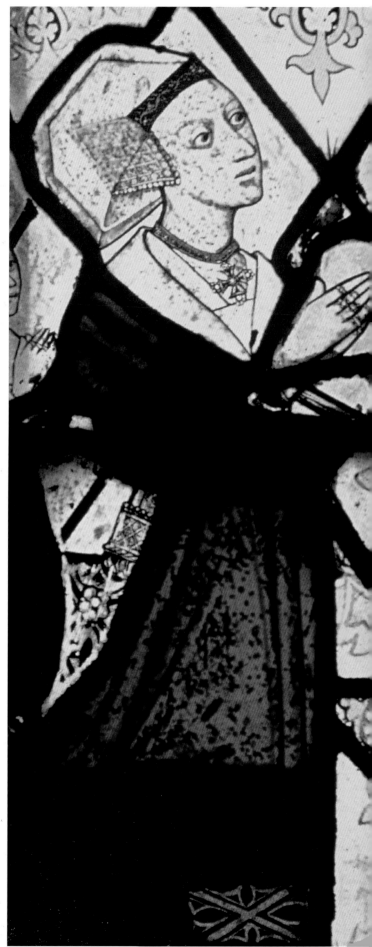

168 Above: Head of Christ from the abbey of S. Peter and S. Paul, Wissembourg, Bas-Rhin (*c*.1060), painted in the three-tonal painting technique described by Theophilus, Strasbourg, Musée de l'Oeuvre Notre Dame

169 Right: The head of Margaret FitzEllis (*c*.1461–9), illustrating stipple shading, scratching out, and backpainting of the upper part of the lozenge of the headdress, Waterperry, Oxfordshire, church of S. Mary

head of *c*.1060 [**168**], display a mastery of both trace line and modelling washes. The end of a dry brush was used to stipple the drying paint, while a variety of needles and sticks were used to pick out highlights or reserved ornament. Both surfaces of the glass could be painted.

The full panoply of glass-painting techniques, including the painting of the exterior surface in order to achieve the gauzy effect of the veil, is illustrated in glass of the 1460s at Waterperry [**169**]. It was the process of firing in the kiln that fused the pigment to the surface, making it permanent.

In the first decade of the fourteenth century yellow stain (also called silver stain)—a solution of silver nitrate or sulphide, which on firing turns white glass yellow or blue glass green—was introduced to the glass-painter's repertoire. It was used extensively for architectural details, as in glass of the 1380s at New College, Oxford [**170**]. Only near the end of the fifteenth century were additional coloured stains (the reddish haematite-based pigments, sanguine and carnation) added to this pigment range. Recent conservation at Fairford, Gloucestershire, has revealed that sanguine was added to warm the tone of basic glass paint [**171**]. SB

170 Thomas Glazier, architectural detail (glazed *c*.1388–96) in which yellow stain, first used in the early years of the century, enlivens the white glass, Oxford, New College (glazed *c*.1388–86)

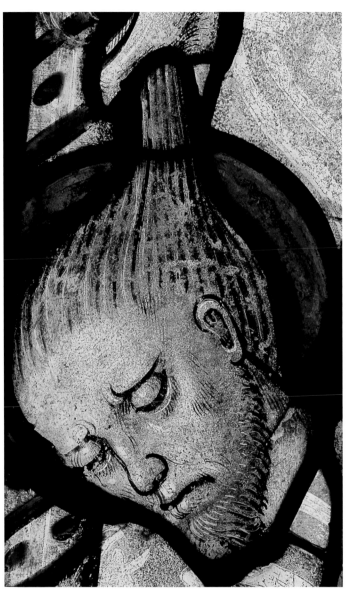

171 Detail of the head of Nero's victim (*c*.1500–15), with sanguine pigment added to the glass paint to warm the tone of the hair, Fairford, Gloucestershire, S. Mary's Church, north nave clerestory

Painting in the Middle Ages

The different stylistic phases into which the art of the 'Middle Ages' is conventionally divided are not the result of conscious changes in artistic ambitions as those of later periods are, and there is no theoretical literature of the time to explain them. Some ideals of taste are implied in references such as Burchard of Halle's description of 'Gothic architecture' as work in the French manner (*opus francigenum*), a term reflecting the influence of French culture and politics upon Europe as a whole between 1100 and 1350. The predominant ideal for much of this period was the emulation of Roman art and culture, which generally meant for western Europe that of Byzantium through which the Roman Empire had been kept alive. But the overriding concern of European culture was the service of the Christian faith which governed public and private, spiritual and political activity. Apart from purely decorative work painting was concerned primarily with content, with didactic and devotional purposes. Descriptive and aesthetic achievement was of little consequence in the first centuries of Christian art in the West and for some commentators to be positively discouraged. Increasingly, however, the depiction of the material world became an important part of the didactic function, particularly as the lives of the saints and a growing devotional literature needed to be made meaningful to a wider audience. Although neither schematic murals nor the tiny detail of stained glass windows could really have served as the 'bible of the illiterate' advocated by Gregory the Great, preachers could refer to them to illustrate sermons and engrave their images on the memories of their audience. By 1200 descriptive skill evidently became a major concern for artists working for sophisticated patrons.

The art of western Europe between 1000 and 1175 is generally called 'Romanesque', though its distinctive features continue later than this in central and southern Europe, and it is not obviously closer to Roman art than its successors. We know little of secular art in this period, but substantial parts remain of church interiors and their furnishings, particularly in Italy and northern Spain. Where artists and churchmen were aware of Byzantine precedent their walls were framed in bands of rich foliate ornament to present images of Christ and the Virgin Mary in Majesty, rows of saints and their stories set against a blue background (frequently corroded from blue azurite to malachite green) or, ideally and much more expensively where mosaic could be afforded, a golden one. The painted grounds were often divided into green, blue, and yellow panels, stripping them of the pictorial space evident in their Greek sources. The rather disembodied figures of Byzantine art were further schematized in Western art, and their crumpled draperies stylized into triangular panels framed with parallel lines, known

to art historians as 'dampfold' because they cling to a visibly three-dimensional body like a wet cloth. Rich borders of palmette and acanthus foliage in contrasting tones are typical of murals and illumination in this period.

In western France, however, the artists reflect early medieval tradition with a more vigorous linear figure style and generally set against a white background. As Gothic architecture raised the importance of mouldings and windows at the expense of the wall-surface, this lighter tonality came to dominate French and British church decoration, generally reduced to fictive masonry patterns and ribs or cells of foliage scroll, red lines on white, while the figurative programmes were moved to the stained glass windows and the increasingly lavish enhancement of the altars with frontals and dossals of metalwork or painted sculpture. Increasingly panel paintings took the place of these other media.

In the late twelfth century a new figurative style arose, drawing directly on Classical inspiration and best exemplified by Nicholas of Verdun's Klosterneuburg pulpit (1181). This new style dominates metalwork, French and English cathedral sculpture, manuscripts and a small number of high-quality surviving murals. A roundel depicting the Virgin and Child in the Bishop's Palace Chapel at Chichester [176] shows the simplification of this style by the emergent Gothic aesthetic of the thirteenth century: a lightening of form and sweetness of expression, an emphasis on rhythmic contours, and a contrast between its blue background, red, yellow, and green framing, and the light tones of the figures themselves and the white plaster around it. The '1200 Style' is also the basis of the German *Zackenstil* ('Jagged Style'). These developments acquired a new significance in the decision of the German (but essentially Sicilian) emperor Frederick II to re-create the visual language of Antiquity to reinforce his renewal of the dignity of the Empire itself: this is the ultimate historical origin of the fifteenth-century Renaissance.

By the middle of the thirteenth century a heavier drapery style evolved under the influence of sculpture: tunics and mantles smoothly modelled in light and shade to suggest rich fabrics swirl around figures given evocative body rhythms inspired by Classical *contrapposto* but reversing it to give an S-shaped swing to most standing figures. The finest thirteenth-century example in northern Europe is probably **173**.

For the figurative arts the strongest technical advances were probably not between 'Romanesque' and 'Gothic' but, first, between the '1200 Style' and the mature Parisian figure style of sculpture (*c.*1240) and painting (*c.*1260). Even more important was the introduction of pictorial space under the

influence of the Palaiologan Renaissance. The liberation of the Byzantine Empire from Western occupation coincided with a conscious revival of the Classical tradition in its art by the new Palaiologan dynasty, generally using tenth-century models in which the sensuality and painterly qualities of Antique painting were well preserved. Its preference for panoramic 'bird's-eye' viewpoints was transformed by Giotto di Bondone (c.1270–1337) and contemporary Roman painters through an essentially frontal viewpoint. The third major change arose from the transformation of European dress around 1340 into highly tailored garments distinguishing between the sexes and stressing the curves of the body. The interest in natural detail already found in the margins of manuscripts was rapidly added to this concern for fashion and social difference in all forms of painting from illumination to frescoes.

The development of pictorial space seen from in front, as in the classic fifteenth-century manner advocated by Alberti, owed much to the conservative decorative practices of the Italians, whose churches gave little scope for stained glass windows or the light masonry and foliage patterns that accompanied them. Instead, the rich colours and large-scale imagery of the Romanesque church were gradually modified to allow more monumental spaces and more illusionistic designs to fill much of the available wall space, permitting large narrative cycles that were both didactic and emotive. The crucial example of their potential was probably the second *Life of S. Francis* [**177**] painted in the upper nave of S. Francesco, Assisi, his burial church and head of the order he founded. Here the Roman curia organized his commemoration in a modern illusionistic cycle, apparently dissolving the wall surface into vistas of S. Francis preaching and realizing miracles among his familiar Umbrian towns and hills. Their pictorial space depends both on the aerial viewpoints of Byzantine and Roman painting and the frontal impact of the carvings upon Roman sarcophagi. New artistic skills, rooted in the re-creation of old or Byzantinized Roman techniques, served to make Francis's life immediate for spectators a hundred years later. This essentially Roman workshop, which may have included the boy Giotto (to whom the cycle has been attributed), established the predominant characteristics of fourteenth-century Italian painting.

Giotto himself designed the Nativity frescoes for the lower church at Assisi. The geometric measurement of space within the architectural structures of the *Purification* and *Christ and the Elders in the Temple* [**178**] and the quiet observation of momentous actions from within it set the standards for much of European painting for more than a century; these designs were imitated from Siena to Prague and Westminster.

The degree of pictorial decoration provided for in any living space depended upon the result of its social importance and the economic strength of its owners or providers. Chambers of the Palace of the Popes at Avignon or the English kings at Westminster were decorated with paintings of foliage, social occupations like hunting, and the lives of appropriate saints such as the canonized kings of England. The greatest non-religious painting to survive from the period is the *Allegory of Good and Bad Government* (1337–40, partly repainted c.1370–5) [**179**], by Ambrogio Lorenzetti (*fl.* 1319, d. 1348) and Andrea Vanni (*fl.* 1353–1413) or a colleague. The repaintings of this social allegory of prosperous and disastrous cities illustrate both the shift from loose-fitting garments to tailored ones around 1340 and the social change from a restricted oligarchic city government to a more open one threatened by soldiers and brigands. The later artist abandoned Ambrogio's control of space and scale to maximize the visual information being presented, with unfortunate consequences for the grandeur of the council scene. This flattening of space and loss of emotive power has been seen as a retrograde step in later fourteenth-century Tuscan painting, associated rather implausibly with an anti-worldly reaction to the horrors of the Black Death, 1348–9; no such artistic consequences of the Plague can be seen elsewhere in Italy or Europe, however.

Most painting, and other artistic activity in the High Middle Ages, was commissioned and paid for by the clergy of the major churches and the nobility in the case of their own palaces, though the latter frequently supported the activities of the church too. The creative role of the artist's patron familiar later is largely absent. However, a few individuals seem to have had an exceptional involvement with such activity, none more than the Emperor Charles IV, who inspired a huge programme of building and artistic commissions to mark the new eminence of Bohemia. The Holy Cross Chapel of his imperial stronghold at Karlstejn [**180**] was encrusted with semi-precious stones and a wall-to-wall set of panel paintings, mainly imaginary portraits of the saints. Master Theodoric (*fl.* 1359–68) was rewarded for this work in 1365. Their subtle modelling and larger than life characterization show that Theodoric had mastered Italian techniques of representation and was looking for more detailed observation and emotional impact, qualities evident in North European art throughout the next century. The shift from mural to portable painting, and the incorporation of earlier paintings by Theodoric and Tommaso da Modena (*fl.* 1325/6–1368) into this scheme show the beginnings of a move to transforming the panel painting from altarpiece or devotional object to an independent art work in its own right. RG

From the Romanesque to the Gothic

The Drunkenness of Noah [172] forms part of an Old Testament cycle on the barrel vault of the church; the reaction of Noah's sons to his mishap is an antetype of the Last Judgement. The outline drawing and flat areas of colour, the long paralloid limbs of the figures and their lively gestures are part of a native French tradition reaching back to Late Roman art. In contrast the fine 'dampfold' modelling and orderly layout of the frescoes in the chapel at Berzé-la-Ville [174] show a self-conscious emulation of Byzantine murals, though far less Classical in technique. The Catalan artists of Tahull [175] have captured a similar spirit but with a spontaneous linear technique closer to S. Savin; the vitality of their extremely unclassical approach to the Byzantine tradition has captured the imagination of twentieth-century artists through their fascination with the 'Primitive'.

In the *Noah* the casual representation of buildings in the background floating behind the scene shows the lingering of Classical ideals of art contrasting with the bubble-like frame in which Noah is enclosed. An altogether more formal bubble, or *mandorla*, encloses the figure of Christ in the two apse paintings where its rainbow-like section evokes the arc of the Heavens and symbolizes universal power.

The Virgin became a major focus for private worship from around 1100 as the human mother of Christ, who was considered both human and divine in opposition to heretical views. The Chichester Virgin [176] shows in her intense gaze and Christ's embrace how her humanity could be evoked to

172 Above: West French artists, *The Drunkenness of Noah* (late eleventh century), tempera or distemper on dry plaster, one of four murals on the barrel vault of Saint-Savin-sur-Gartempe

173 Left: Unknown English painter, Westminster Retable (*c*.1270–80), oil and tempera on oak with tinfoil inlay, cameo, and gemstones on the setting, 0.96 × 3.34 m. (3 ft. 1¾ in. × 10 ft. 11½ in.), London, Westminster Abbey

126

help ordinary mortals. Her mantle still shows the soft pleats of the '1200 Style', but her triangular face and strong outline are typical of thirteenth-century drawing. Angels cense her; their gilded thuribles have oxidized, staining the plaster.

The dramatic modernization of style emanating from Paris is evident in the Westminster Retable [173] a few years later, in which Christ himself, together with S. Peter, the patron of the abbey, and three damaged saints or angels commanded the viewer's devotion. Christ's own miracles testify to his redeeming power. The velvety modelling is fully illusionistic; the frame creates an actual architectural setting for Christ and the saints, though it is the elegance of the figure style and the ornament that is most striking of all. The frontal viewpoint and the illusionistic painting technique within quasi-architectural framing give this painting most of the aesthetic properties of sculpture or even a frozen drama. Gothic art is above all the use of convincing naturalism to promote the activities and beliefs of the Christian faith within a theocratic society. RG

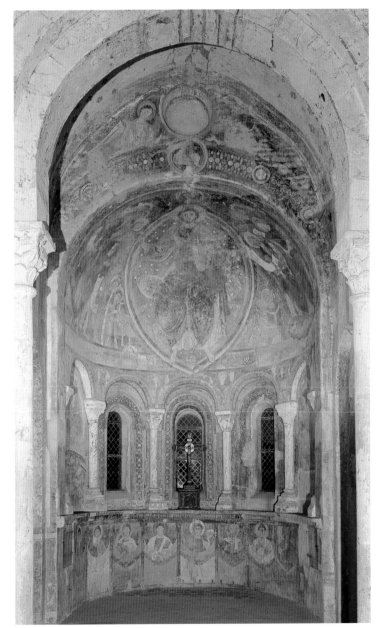

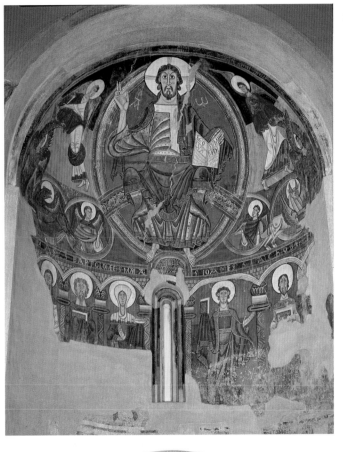

174 Above left: Burgundian artists, apse of chapel with Christ in Majesty (between 1103 and c.1150), tempera on dry plaster or fresco, Berzé-la-Ville

175 Above right: Catalan artists, apse of chapel with Christ in Majesty (between 1103 and c.1150) from S. Clemente de Tahull, tempera on dry plaster or fresco, Barcelona, National Museum of Catalan Art

176 Right: Unknown English painter, *Virgin and Child* (c.1250–60), tempera or dis-temper, silver and gold, on dry plaster, roundel 80 cm. (32 in.) in diameter, Chichester, Bishop's Palace Chapel

The Roman ideal in the fourteenth century

Each bay of the fresco of the *Life of S. Francis* is divided into three scenes by spiral columns evoking Solomon's Temple. At the centre of the first Francis begins his mission with an act of charity [**177**]. We can recognize the character of the landscape around Assisi; its pictorial space depends both on the aerial viewpoints of Byzantine and Roman painting for the hills and the frontal impact of Roman sarcophagi sculpture for the figures themselves. Giotto simplified and unified these spatial tensions. His frescoes in the lower church at Assisi were realized largely by teams of assistants, but his designs for them were imitated from Siena to Prague and Westminster. The interior of the Temple in which the boy Christ instructs the Jewish elders [**178**] has the front wall removed for us to see inside, like a doll's house. The recession of its roof and benches is geometrically precise. The figures are composed in the horizontal rows of Classical art and involving us directly through their introversion in the revelation. Architecture and draperies show a massive version of northern Gothic style, however.

For his *Allegory* [**179**] in Siena, Ambrogio drew principally upon the iconography of Bolognese law manuscripts for the rulers and figures of Justice and the Virtues on the end wall, as well as for scenes of daily life in town and country. The classic majesty of composition and the frontal view of the scenes derives from Giotto, but Ambrogio uses the high viewpoint of Byzantine landscape, exploited already by the Sienese

128

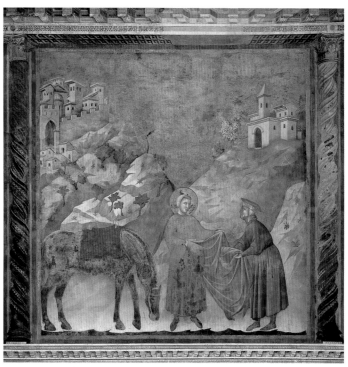

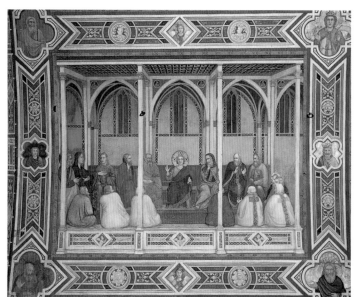

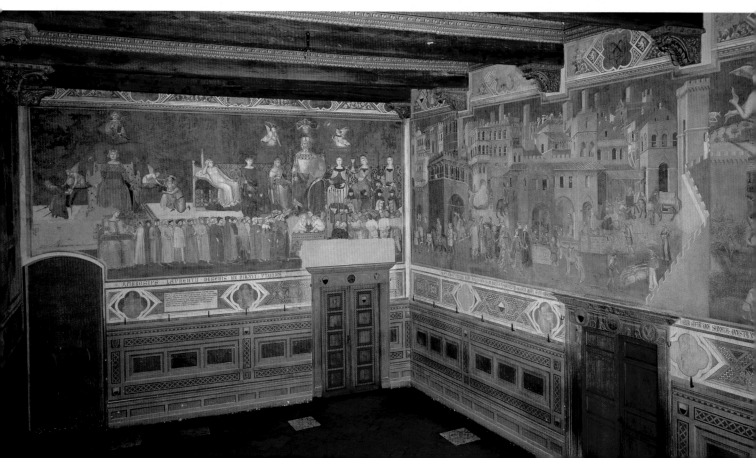

painter Duccio, to show the city rising above the spectator and the countryside unfolding below its walls. His figures still wear fairly loose clothes, but Vanni [?] shows more distinctive and detailed fashions. The quality of his painting and picture space is much inferior, however: Vanni is more concerned with details of fashion and programmatic precision than the artistic evocation of emotions that distinguishes

Ambrogio's work and the Giottesque tradition.

Master Theodoric [180] incorporated two earlier triptychs above the niche containing the imperial treasury at the heart of Karlötejn Castle and a new Crucifixion panel above it. This barbaric-looking splendour was intended to create a unique interior, drawing upon Byzantine iconostases, Germanic jewellery and S. John's vision of the

Heavenly Jerusalem. Its mysticism typifies late medieval devotions, but the earthy realism of Theodoric's characters also reflects its broadening consciousness of the material world. Theodoric was creating for the most modern of emperors a fusion of the otherworldly ideal of the Christian empire governed by mysteries reaching back into the 'Dark Ages' with modern Italian art, created by a republican society driven by

commerce and able to pass mentally without difficulty from the material into the spiritual worlds evoked by Dante. RG

177 Opposite, left: Roman workshop, First Master of the S. Francis Legend, *S. Francis Gives His Cloak to a Poor Knight* (c.1295), fresco, about 3 m. (9 ft. 10 in.) square per scene, Assisi, upper church of S. Francesco, first bay of north wall dado

178 Opposite, right: Giotto di Bondone (c.1270–1337), with members of his Stefaneschi Altarpiece and Bardi Chapel workshops, *Christ and the Elders in the Temple* (c.1315–20), fresco, Assisi, lower church of S. Francesco

179 Opposite: Ambrogio Lorenzetti (c.1295/1300–48) and a Sienese late fourteenth-century artist (Andrea Vanni?, recorded 1353–1413), *Allegory of Good and Bad Government* (1337–40, partially repainted c.1370–5), fresco, Siena, Palazzo Pubblico, Sala dei Nove

The three layers of a fresco

Using a cartoon

Dots of deposited charcoal on the *Intonaco*

Pricked holes

Bag of charcoal dust

Cartoon

1 *Intonaco*

2 *Arriccio* (rough plaster underlay)

Water-based paint on the damp plaster

Sinopia drawing on the *arriccio*

3 Wall

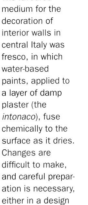

Fresco techniques

The favoured medium for the decoration of interior walls in central Italy was fresco, in which water-based paints, applied to a layer of damp plaster (the *intonaco*), fuse chemically to the surface as it dries. Changes are difficult to make, and careful preparation is necessary, either in a design on the underlying plaster of the wall (the *arriccio*) in the form of a *sinopia* drawing, or in full-sized drawings, called cartoons, which are transferred by pricking (*splovero*) or incision with a sharp tool. 'True fresco' was widely augmented by techniques for painting on the dried surface (*a secco*).

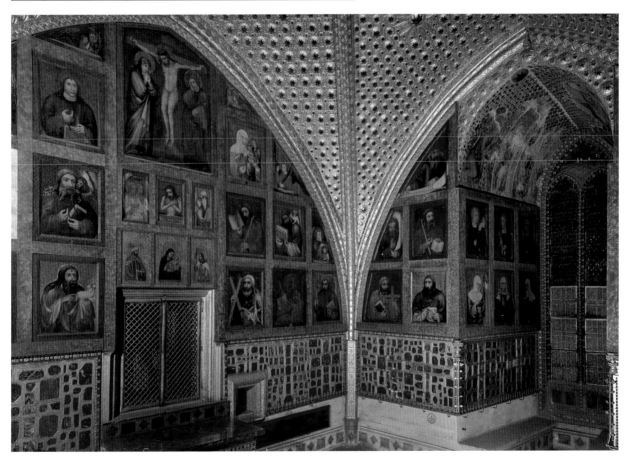

180 Above: Master Theodoric (active 1359–68, d. before 1381), including earlier work by Tommaso da Modena (1320–c.1379) and himself, *Crucifixion*, Passion Triptych, Virgin and Child with SS Wenceslas and George (by Tommaso) and Saints, tempera and oil on beech (Theodoric's panels), tempera on poplar (Tommaso's), gilded pastiglia (largely restored); garnet and semi-precious stone cladding, *Crucifixion* 2.1 × 1.512 m. (6 ft. 7⅛ in. × 4 ft. 11½ in.), Karlštejn Castle, Holy Cross Chapel, altar wall

The Altarpiece

Tracing the development of the altarpiece is fraught with difficulties caused by the poor survival of actual objects, the frequent loss of original settings and missing documentation. Another problem has been the tendency to view nearly all painted wooden panels as altarpieces; it is now clear that panels of various shapes and sizes hung in a number of locations. Recently, the importance of the roodscreen, the monumental structure which separated the laity from the choir, has been emphasized, particularly as an alternative site, well suited for both gable-ended panels and crucifixes.

Moreover, the physical examination of neglected aspects of wooden panels, such as their framing elements and backs, has revealed more about hanging arrangements. For instance, the discovery of nine original iron rings behind the *Rucellai Madonna* [**182**] of 1285 by Duccio (active 1278, d. 1318) makes it more likely that it hung against a wall rather than stood on an altar table. However, this is not to say that a votive painting on a wall could not act as an altarpiece; indeed the *Crucifixion* fresco (1379–84) by Altichiero (*fl.* 1369–84) , on the east wall behind the altar of the oratory of S. George in the basilica of S. Anthony

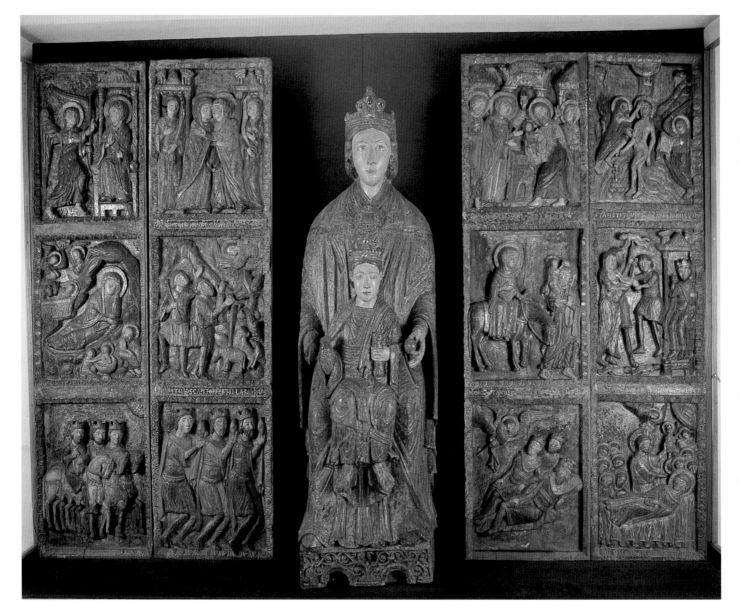

of Padua, served this purpose. Altarpieces were also made of various materials: the use of stone, as in *Virgin and Child* [**188**] of the 1360s by Tommaso Pisano (*fl.* 1363–72), or wood, as in wooden altarpieces of Friuli, was not unusual.

The origins of the altarpiece have been explained in a number of ways. A simple solution is to search for an existing form and give it a new use: in this way an earlier panel known as the *antependium* (or altar frontal), with extant examples from the eleventh century, may have migrated to the top of the altar perhaps to serve as a backdrop to a new liturgical ritual, namely the elevation of the host, which took place after 1215, the year in which transubstantiation became a universal feast. An alternative more complex solution is to identify the transformation of an object already present on the altar into an altarpiece. For instance, wooden statues of the Virgin Mary and Child with painted side extensions (such as the *Madonna and Scenes from the New Testament* in S. Maria Maggiore, Alatri [**181**], first half of thirteenth century) or other reliquaries or containers for the Holy Sacrament are proposed as possible models for gable-ended painted panels.

Evolution of form

The form and the development of the altarpiece varied according to local taste and fashion. Patterns of development will vary considerably depending on the prototype chosen. For instance, were we to argue that the altarpiece stemmed from a transformed *antependia*, we would then describe the first examples as rectangular dossals or retables constructed with horizontal wooden planks. This is a convenient solution but it means that we are unable to state securely whether a panel such as *The Virgin and Child Enthroned, with Scenes of the Nativity and the Lives of the Saints* by Margarito of Arezzo (active 1262?) was a retable or an altar frontal [**183**].

The next step is its organic progress: from the horizontal dossal to a gable-end, through an increasing interest in separating the figures by colonnettes or arcades, to a panel in which the upper contours are transformed by several gables: Vigoroso da Siena (*fl.*1276–92), *Madonna with Saints* (1282/3), Perugia, Galleria Nazionale dell' Umbria. Finally, to satisfy the need for greater height and width, the horizontal structure was replaced by vertical sections.

Alternatively, beginning with a sculpted reliquary shrine of the Virgin and Child with painted wings, the development looks rather different. The carved Madonna would be replaced by a two-dimensional gabled version with or without wings; the narratives could easily have migrated to the single panel. Either this panel of the Virgin and Child or a variant displaying S.

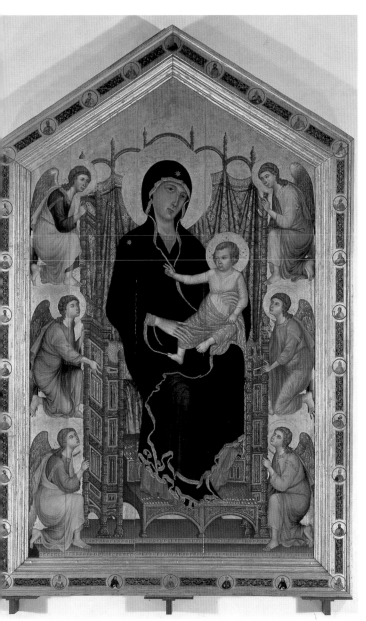

Francis of Assisi, would become models for serial upright panels. A sideways expansion could be supposed; ending in a series of vertical sections forming polyptychs such as the *Virgin and Child with Saints* [**189**] of 1319 by Simone Martini (1284–*c*.1344), originally in the church of S. Catherine, Pisa.

However, the altarpiece did not reach a set form, so that all 'quality' commissions by a certain date—say by the mid-fourteenth century—would conform. Only one example need be cited to demonstrate that some patrons were keen to imitate earlier forms. The shape of the dossal depicting *The Virgin and Child with Ten Saints* ascribed to Andrea di Bonaiuto da Firenze (*fl.* 1346–79), in the National Gallery London, seems to belong in the thirteenth century but it is in fact from the 1360s. To explain such oddities, we refer to a little-known clause found in certain contracts and known as the *modo et forma*. This is a stipulation that the work under order should be carried out according to the 'manner and form' of another work. A related area in which one might find further solutions is the systematic study of altars and audiences, but we know little about viewers' habits and responses made to particular forms of decoration.

Patronage

The first altarpieces were commissioned for ecclesiastical rather than secular contexts. As the emphasis on private devotion increased and the laity and civic corporations sponsored family chapels in churches, palaces, and homes, secular forces came into play, and altars and altarpieces left the church: one such example is the Wilton Diptych [**184**] of *c*.1377–*c*.1399.

The Mendicant orders, especially Franciscans and Dominicans, are often seen as significant promoters of altarpieces in thirteenth- and fourteenth-century Italy. It has even been argued that the meetings of friars were useful 'transfer points' for ideas regarding both design and iconography. For instance, the Franciscans are credited with favouring narrative

representation and the development of the gable-ended panel with a saint standing in the centre surrounded by episodes from his life, such as the *Pescia panel* (1235) of Bonaventura Berlinghieri (*fl.* 1228–74), and the Dominicans promoted more meditative representations and the Sienese polyptych, beginning with Simone Martini's S. Catherine altarpiece [**189**].

Surviving contracts and records of payments help us gain an understanding of production processes. In many documented cases patrons supplied the painter with the panel to be painted: in 1285, the painter Duccio received a panel provided by the *Laudesi* confraternity of Santa Maria Novella, Florence; the same was done for Sassetta (Stefano di Giovanni di Consalvo da Cortona, *c*.1392–1450) nearly 200 years later when he took over the commission for the high altar of S. Francesco at Borgo Sansepolcro (1437–40). Contracts are often quite limited since patrons are there concerned with obtaining value for money with regards to materials, such as the best gold leaf and ultramarine blue, and the guaranteed work of the artist within a set time frame. The documentation for Sassetta's high altarpiece, however, is an exception since it is abundantly detailed, including the written programme agreed between the Franciscans and the painter some two years after he had been commissioned. This reveals that the friars collaborated closely with the carpenter, then the painter and specified structural and iconographic models, the images, and the narratives. Interestingly, the initial lay patron of the altarpiece does not appear to have asked the friars to include specific images on her behalf but in the end her namesake saint (Lucy) did appear as one of many saints. LB

183 Margarito of Arezzo (active 1262?), *The Virgin and Child Enthroned, with Scenes of the Nativity and the Lives of the Saints* (second half of thirteenth century?), tempera on wood, 92.5 × 183 cm. (3 ft.⅜ in. × 6 ft.), London, National Gallery

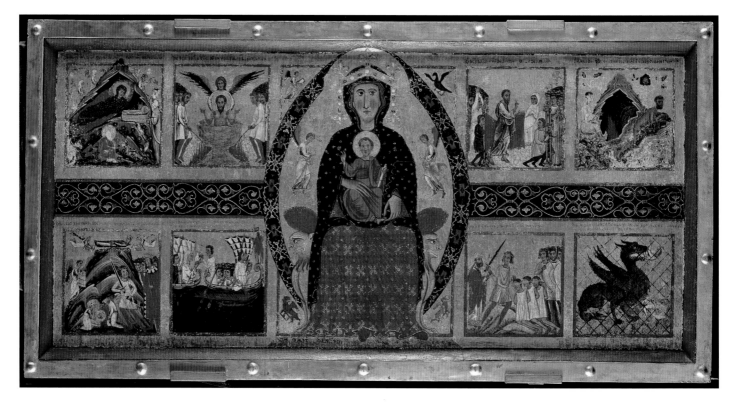

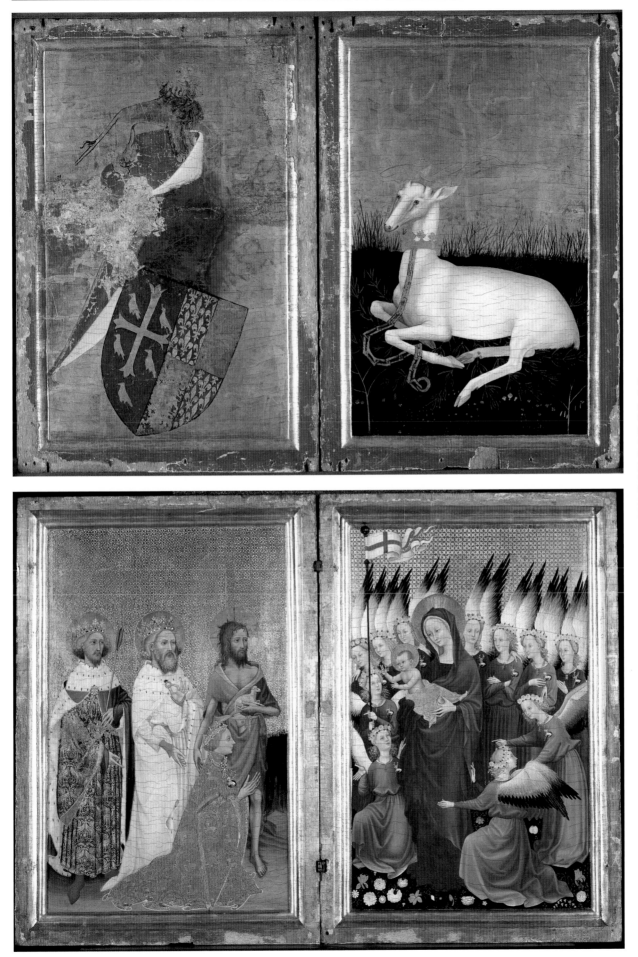

184 English?, Wilton Diptych (*c.*1377–*c.*1399), tempera on chalk ground on oak, outer panels (above) and inner panels (below) each panel 47.5 × 29.2 cm. (18¾ × 11½ in.), London, National Gallery

Evolution and construction

Both wooden altar frontals and altarpieces were constructed using basically the same methods and techniques [**182, 183**]. The carpentry, which could be complex, was usually the responsibility of a specialist: in 1285, the painter Duccio received a panel provided by the patrons (the

Laudesi confraternity of S. Maria Novella, Florence) on which he was to paint a Virgin Mary and Child with angels, known as the *Rucellai Madonna* [**182**]. This was made up of five vertical planks united by oak dowels. On the back, a framework of well-finished cross-battens fastened to the front plank with long nails helped minimize warping.

In the case of double-sided high altarpieces such as Duccio's *Maestà*

[**185**] painted for Siena Cathedral (1308–11), the front side was thicker and made up of eleven 7-cm.-thick vertical poplar planks, while the reverse side was constructed of 4-cm.-thick horizontal planks attached to the front with nails. The nails were countersunk and covered with beeswax to ensure a smooth surface for painting. All panels were then prepared with gesso ground, gilded, and finally painted using egg tempera.

Portable altarpieces such as the Wilton Diptych [**184**] of *c*.1377–*c*.1399 had hinged wings that folded inwards, allowing them to be closed and carried safely, but also enabling further views on the wings when closed; in this case the emphasis is on the patron Richard II's heraldry.

LB

134

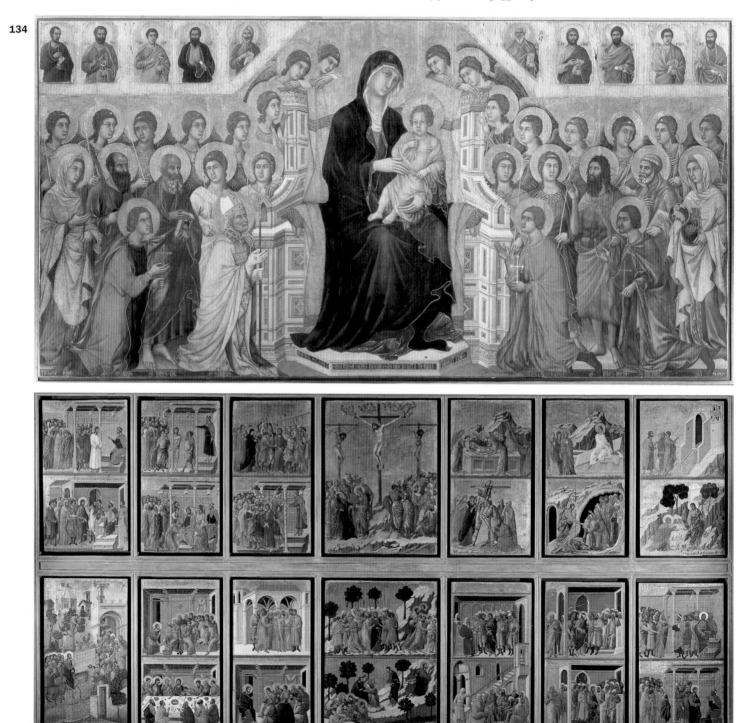

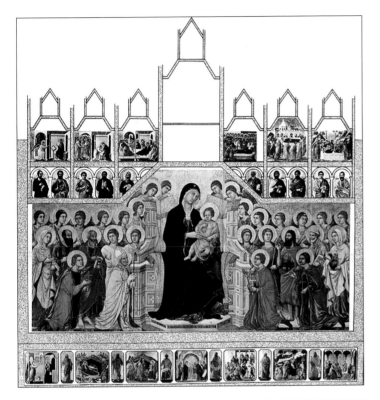

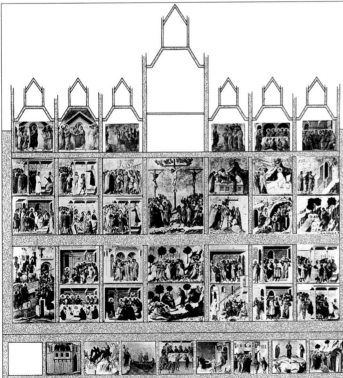

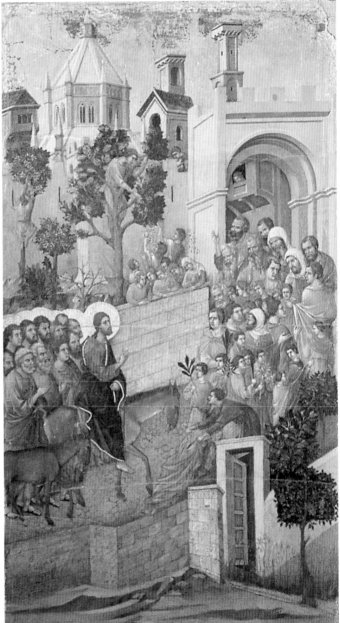

185 Opposite: Duccio (active 1278, d. 1318), *Maestà*, tempera on poplar, present state, front (above) and back (below) Siena, Museo dell' Opera Metropolitana

186 Left: Reconstruction of **185** by J. White

187 Above: Detail of **185**

The support system

Altarpieces are heavy structures. Ingenious systems were needed to secure them. Thinner, lighter panels could be bolted to the back of the altar with metal brackets. The predella (dais), if contained within a frame box, could act as a steady support: wooden panels could be slotted into it while marble tiers would sit more easily as in Tommaso Pisano's altarpiece [188] of the 1360s for S. Francesco at Pisa. Heavier polyptychs made up of multiple tiers needed a stronger support system which consisted of frame buttresses which adjoined the sides and distributed the weight to the ground. The unique survival of this system as seen in Giovanni del Biondo's polyptych of 1379 in the Rinuccini chapel in S. Croce, Florence [190], has allowed scholars to reconstruct similar arrangements for earlier and later works, including that of Simone Martini's polyptych in S. Catherine, Pisa [189], of 1319. LB

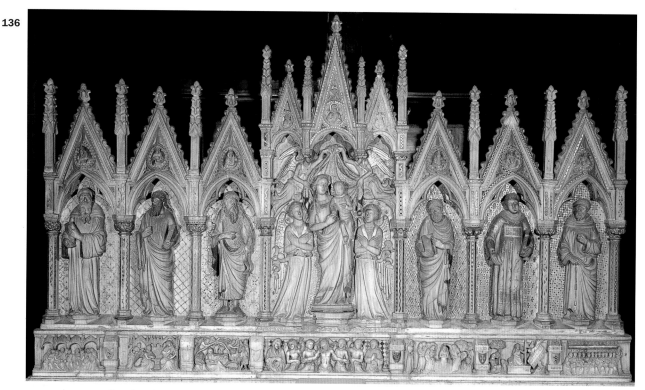

188 Left: Tommaso Pisano (*fl.*1363–72), *Virgin and Child, Angels, Saints and Christological Cycle* (end 1360s), polychrome marble, 210 × 390 × 22 cm. (6 ft. 10¾ in. × 12 ft. 9½ in. × 8⅝ in.), Pisa, church of S. Francesco

189 Below: Simone Martini (1284–*c.*1344), *Virgin and Child,* S. Catherine altarpiece (1319), 1.95 × 3.40 m. (6 ft. 4¾ in. × 11 ft. 2 in.), Pisa, Museo Nazionale di Matteo

190 Opposite: Giovanni del Biondo (*fl.* 1356, d. 1398), Rinuccini Polyptych (1379), tempera on panel, Florence, S. Croce, Rinuccini chapel

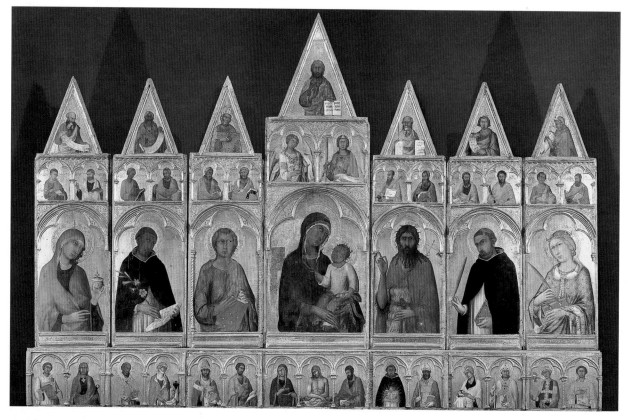

Ars Sacra c.1200–1527

Between the thirteenth and sixteenth centuries, the liturgical arts developed in ways that directly reflected the religious, social, and philosophical orientation of Europe. Their history epitomizes the monumental transition that took place between the High Gothic and Renaissance periods. At the beginning of this time, liturgical objects were developed to express the notion that the sacraments are absolute; in the sixteenth century, they also came to express the 'Reformation' of that notion.

The high point in the development of the liturgical arts was reached at the beginning of the thirteenth century when the church came closest to attaining its ideal of absolute and inherent power. The basis of this power was formulated through the theory of transubstantiation. This theory, officially sanctioned as dogma at the Fourth Lateran Council in 1215, stated that the sacramental bread and wine actually become the body and blood of Christ at the time of consecration. The church's monopoly of this power would eventually be achieved through the theory of papal infallibility, according to which the Pope was believed, by virtue of his office, to be incapable of making incorrect pronouncements. Through the sacrament of ordination the unique authority and efficacy of 'office' was extended throughout the priesthood. The theory decreed that it is the blessed status of the priestly role, rather than the virtue of the individual priest, that is the bearer of the sacred tradition. As a result of this development, the focal point of the Mass gradually shifted away from congregational communion, as practised in the early Middle Ages, towards the priestly activity of consecration and elevation of the host. The stipulation that all priests should say Mass at least once a day led to a proliferation of altars—and side chapels to accommodate them—in churches. In the twelfth century, daily communion was gradually withdrawn from the laity and reserved for the celebrating priest alone (the laity were generally permitted to receive communion once a year). For this reason, chalices and patens from this period are significantly smaller than their predecessors.

The church achieved its ideal of absolute spiritual power to the extent that it succeeded in investing the possibility of salvation in its own ritual activity. The material sign of this power was the Eucharist, which it continued to glorify and empower throughout the Middle Ages by means of the liturgical arts. The liturgical arts revolved around the moment of communion, whether engaged directly, once a year, or vicariously, through the priest or vicar, God's representative on earth. The focal point of communion was the altar, the adornment of which was determined by liturgical practices. In the early Middle Ages, when communion was regularly offered to the laity, the priest stood behind the altar facing the congregation, like Christ in images of the Last Supper. The altar was customarily decorated with a frontal, the size and shape of which were determined by the size and shape of the altar itself. In the thirteenth century, when communion in both kinds (via the bread and the wine) was withdrawn from the laity, the celebrating priest was required to stand in front of the altar with his back to the congregation. As his body hid the consecration of the host, the practice of elevating it evolved in order to make it visible. At the same time, because the front of the altar table was also partly obscured, the decorated frontal was raised and moved to the back of the altar, where it could continue to be seen from the nave. In compensation for the withdrawal of edible communion, it developed into the vastly expanded backdrop to the liturgical drama that we see in altarpieces in churches all over the world.

Despite striving to perfect the theory of absolute power, the medieval church never ultimately achieved its ideal. The laity continued to crave some form of active participation in the ritual activity of communion that brought salvation. This craving led to the generation of secondary forms of communion that the church was not always able to control. Although they were inferior to the Eucharist, they were nonetheless considered to be effective. One of these forms was 'optical' or 'spiritual' communion; another was the veneration of relics; a third was engaged through what might be called 'imaginative communion'—a process of intensively imagining the physical reality of Christ.

Optical communion consisted of communing with the blessed sacrament by gazing at it contemplatively. The origins of the practice can be traced back to the twelfth century, just at the time when regular 'edible' communion was being withdrawn from the laity and the elevation of the host, which could be seen by the congregation, was becoming the focal point of the Mass. It was not, however, until the Fourth Lateran Council imposed conditions on receiving annual communion (confession, tithe-paying, and a period of sexual abstinence) that the practice became widespread. It gathered further momentum when Pope Urban IV formally instituted the feast of Corpus Christi in 1264.

The feast of Corpus Christi was an extension of the veneration paid to the blessed sacrament at the moment of its elevation in the Mass. The high point of its celebration was a grand procession of the sacrament, exposed for all to see, around the cathedral, parish, or town. The sacrament was carried in a monstrance, a new form of liturgical vessel which reserved the consecrated host, previously kept in a closed ciborium, in such a way that it could be seen and contemplated.

Significantly, a similar development took place in the design of reliquaries. Whereas Romanesque and earlier

reliquaries are almost always entirely closed, Gothic reliquaries usually reveal a part of the relic they contain through a covering of clear glass or rock crystal. In the case of architectural reliquaries (one of the commonest types of reliquary), this process of opening up was directly paralleled by the process of glazing and dematerialization that characterized the architecture of the High Gothic cathedrals. Indeed, some of the most ambitious reliquaries are light-pervaded configurations of buttresses, piers, and pinnacles—exactly like their monumental prototypes; their relics are entirely exposed. One of the most famous and venerated relics of the period was the Crown of Thorns, worn by Christ at the Crucifixion. This treasure was one of a huge number of relics from the Holy Land that were brought to Europe following the crusaders' sack of Constantinople in 1204; it was purchased by King Louis IX of France (1226–1270). Reversing the metaphor of reliquary-as-church, Louis had the S. Chapelle in Paris built (consecrated in 1248) for the Crown of Thorns as an entirely glazed reliquary on a monumental scale suggesting that, in High Gothic architecture as in High Gothic reliquaries and monstrances, optical vision had become a medium of divine blessings.

Prestigious relics such as the Crown of Thorns were not always available for veneration by the faithful. Besides being dispersed throughout Europe, some relics were kept in private chapels, others were only brought out on feast days. As a result of this limitation on the sacramental activity of the public, and in response to the public's persistent longing for personal communion with Christ, the later Middle Ages saw the birth of a new type of image that offered a new kind of personal relationship with Christ. Unlike the schematic images of the Romanesque period, these highly emotive images were designed to induce emotional and intensely *imaginative* responses in their viewers by magnifying the impression of the historical reality of Christ's Passion. This tendency characterized the devotional art of the late Middle Ages. One image in particular—representing the instruments of Christ's Passion (the *Arma Christi*)—attempted to take this imaginative approach towards images so far that the process of contemplating them became quasi-sacramental. The *Arma Christi* were frequently separated from their narrative context and were presented in total isolation as if they were relics. Sometimes, the exact measurements of the originals were written beside the images in order to intensify the sense of the latter's realism. The quasi-sacramental nature of the *Arma Christi* was further enhanced by the fact that, in many cases, the act of contemplating them was explicitly associated with the granting of indulgences.

Although the church was largely responsible for the spiritual vision and social stability of medieval society, its desire for absolute control over the religious life of the people also led to abuses on both sides. On the one hand, the church was criticized for taking advantage of its political power; on the other hand, many of the faithful were criticized for their superstitious belief in the power of relics and images.

The disjunction between institutional and popular attitudes towards religion led to the crisis of late medieval culture. In the secular realm, Classical values acted as a catalyst for the emergence of a new world-view. This is reflected in the gradual development of naturalism and secular iconography in Renaissance art. But in the religious sphere, this process of gradual transformation was ultimately thwarted because the church was unable to accept the secular principles on which it was based. Significantly, the liturgical art of the Renaissance, which was controlled by the church hierarchy, continued to use medieval forms in its overall decoration and design.

It is arguable that the dramatic Reformation of religious culture in the sixteenth century took place because a more gradual Renaissance was impossible. When Martin Luther nailed his 95 protestations against the abuse of indulgences to the door of the castle church in Wittenberg in 1517, he did not intend to create a new religion; he intended to purify the clergy of their political manipulations and realign Christianity to its ancient and authentic principles. But because the church was unable or unwilling to accept his criticisms, a division and ultimate break became inevitable, and the Protestant and Catholic churches became polarized in their views. The Protestant rejection of the priestly monopoly of access to communion with Christ led to a rejection of the principle of sacramental participation in the body of Christ through the Mass and relic veneration. In many parts of northern Europe, communion became a commemorative event accessible to all comers and the process was stripped of its ritual accoutrements (censers, paxes, monstrances, and so on). Besides a pair of altar candlesticks, only the paten and chalice—renamed 'communion cup'—survived. Communion cups, which were larger than chalices so as to accommodate the whole congregation, were redesigned after the manner of secular vessels in order to shed the ritual associations of the medieval forms. The principle of venerating relics was also thoroughly undermined and countless hundreds of reliquaries were destroyed. The Catholic Church responded by reassessing and redefining its own position, codified at the Council of Trent (1545–65), but it was too late to heal the split between the churches that has continued up to the present day. ASp

The setting for communion

Early medieval chalices, such as the Trzemeszno chalice [**191**], with an overall height of 17 cm., were large enough to hold the sacramental wine for an entire congregation. Towards the end of the twelfth century, communion 'in both kinds' was withdrawn from the laity and was reserved for the celebrating priest alone. Chalices became smaller with steeper-sided less ample bowls. The smaller example shown here [**192**], together with its paten, dates from approximately two hundred years later (*c*.1350) and measures only 14 cm. in height. It was found in Hamstall Ridware in Staffordshire.

In Reformation England, chalices and patens were melted down to be reused in communion cups and patens. As communion cups were required to contain wine once again for the entire congregation, they grew in size, using approximately twice as much metal. Their designs were specifically intended to imitate secular vessels in order to free themselves of the sacramental associations of medieval forms [**193**].

For the medieval laity, the moment of communion came to be associated with the elevation of the host. The decoration of altars had previously been confined to frontals, such as **194** dating from *c*.1120, which depicts Christ in Majesty with the twelve apostles. At the end of the twelfth century the decoration was raised and removed to the back of the altar where it could be clearly seen from the nave. The *Mass of S. Giles* [**86**] shows the ninth-century altar frontal of Saint-Denis, Paris (known from documents but now destroyed), raised

140

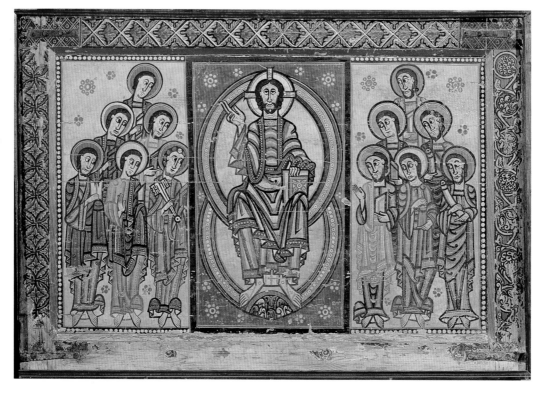

191 Above: Trzemeszno chalice (*c*.1170), overall height 17 cm. (6¾ in.), Gniezno Cathedral Treasury, Poland

192 Above middle: Hamstall Ridware chalice and paten (*c*.1350), height of chalice 14 cm. (5½ in.), Lichfield, the Lichfield Heritage Centre

193 Above: English, communion cup (1564), height without lid 21.3 cm. (8⅜ in.) Oxford, All Soul's College

194 Left: Spanish, altar frontal depicting Christ in Majesty with the twelve apostles (*c*.1120), Barcelona, the Museum of Catalan Art

to the back of the altar as a dossal or altarpiece. The new position was customary from the beginning of the thirteenth century when the elevation of the host, also shown here, was introduced.

Whereas the iconography of altar frontals was usually theophanic or visionary, when altarpieces became stage settings for the celebration of the Eucharist, they developed iconographic programmes that placed the liturgy in its biblical and theological context. The altarpiece in **195**, made by Michel Pacher for the church of S. Wolfgang near Salzburg from 1471–81, can be opened in three stages. When closed it shows the miracles of S. Wolfgang; when half open it shows scenes from the life of Christ, and when fully open it reveals a sculpted *Coronation of the Virgin*.

ASp

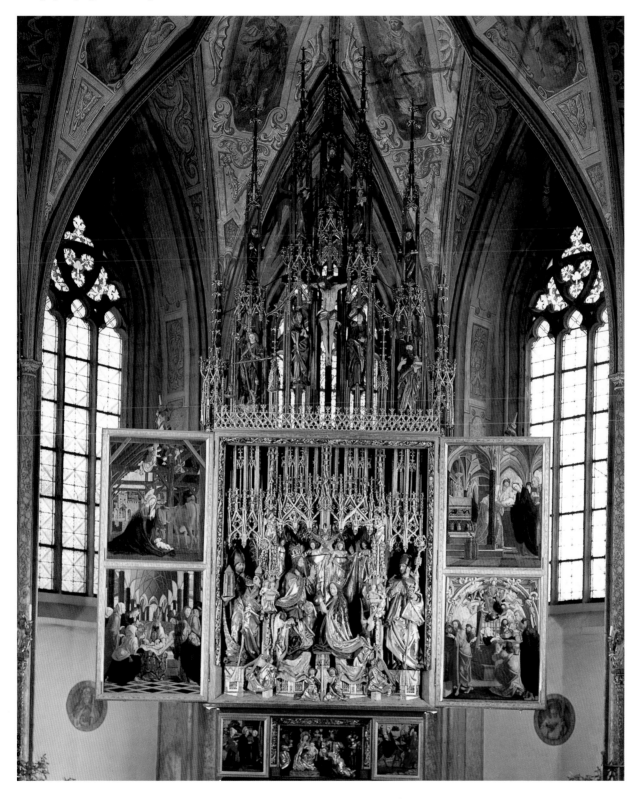

195 Michel Pacher (*c*.1430/5–98), altarpiece (1471–81), near Salzburg, church of S. Wolfgang

Extending the Eucharist

Communion with the host by gazing at it contemplatively in a monstrance was one of a number of practices that evolved when 'edible' communion was withdrawn from the laity towards the end of the twelfth century.

Monstrances (from the Latin word '*monstrare*', to show) were taken on procession on the feast of Corpus Christi, instituted in 1246. Illustration **196** is an early sixteenth-century German example, resembling the cross-section of a Gothic nave with aisles, vaults, and flying buttresses.

Many Gothic reliquaries were made in the form of the body part from which their relic was taken— a finger, a hand, a foot, or a head. Reliquaries had previously been closed, concealing the relic. Many now incorporated an opening through which the relic could be seen [**198**].

Architectural reliquaries [**197**] evolved from the earlier form of the closed reliquary casket. Their development paralleled that of Gothic architecture, with figurines and enamelled panels imitating monumental sculpture and stained glass windows respectively. Illustration **199**, an illumination from a fifteenth-century Sienese *gradual* depicts angels contemplating the sacrament in an architectural monstrance.

Images of the *Mass of S. Gregory*, in which Christ miraculously appeared to S. Gregory in order to dispel the doubts of a member of the congregation, became popular from the thirteenth century. The image often includes the *Arma Christi* or instruments of Christ's Passion, abstracted from their narrative context for individual contemplation. The text at the bottom of **200** grants an indulgence of 14,000 years to

142

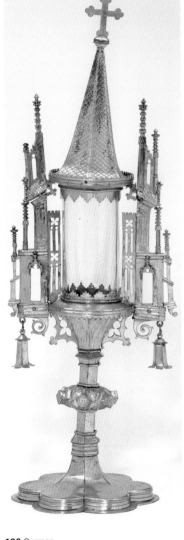

196 German reliquary (early sixteenth century), London, Victoria & Albert Museum

197 Right: Reliquary shrine of S. Taurin (1240–55), Évreux, S. Taurin

198 Below: Arm reliquary of S. Lawrence (*c.*1170–80), Berlin, Staatliche Museum

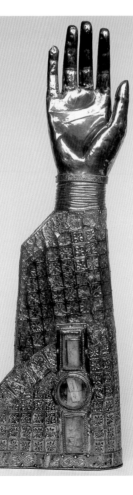

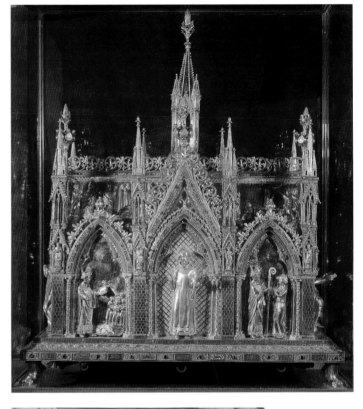

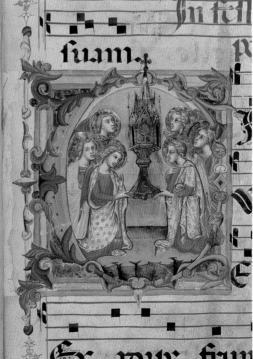

199 Left: Illumination from a fifteenth-century Sienese *gradual*, Siena, Biblioteca Communale degli Intronati

anyone who humbly repents in front of it, reciting the appropriate prayers.

Inconsistent with the progressive mood of contemporary painting and sculpture, fifteenth-century liturgical art was often conservative, retaining the style of medieval artefacts for the sake of their traditional associations. Although the figure style of the Virgin and Child in **201** reflects that of contemporary works by such artists as Donatello or the young Raphael, the architectural setting is entirely medieval in style, bearing no resemblance whatsoever to contemporary Italian architecture (for instance, Bramante's Classical Tempietto in Rome). The kissing of the pax formed part of the late medieval piety and was one of the ritual practices that was outlawed by Protestant reformers in the sixteenth century. ASp

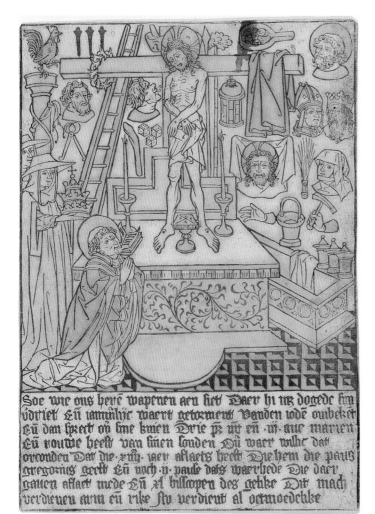

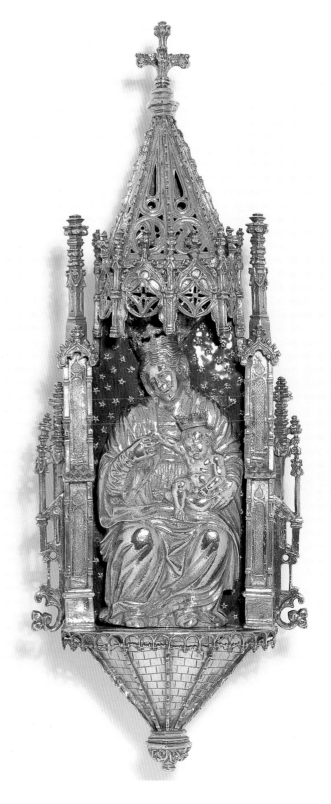

200 Above: Netherlands, Pietà with *Arma Christi* (*c*.1460), Nuremberg, Germanisches Nationalmuseum

201 Right: Sicily, Pax (*c*.1500), London, Victoria & Albert Museum

Monumental Sculpture c.1300–1527

By the late thirteenth century many central Italian city-states had developed a high degree of international economic power. To fulfil aspirations of making their cities more beautiful, civic amenities like fountains were richly decorated with sculpture, although all but the majestic *Fontana Maggiore* in Perugia (1278) have been swept away by later changes in town planning and civic identity. Communal patronage continued into the Renaissance period, but the growing power of princely rulers meant that sculpture was increasingly used to celebrate individuals. The increasing wealth of both private and ecclesiastical patrons ensured that churches and cathedrals were provided with new and ever more splendid furnishings, such as pulpits and altarpieces.

Late medieval cathedrals were embellished with external sculpture as cities competed to assert their splendour and prestige. In 1296 construction work started on the new Florence Cathedral, and a new cathedral for Orvieto was complete by 1310. A relief cycle of the Life of the Virgin decorated the facade of Florence Cathedral, whereas the programme of the Orvieto facade reliefs stretches encyclopaedically from the Creation of the World to the Last Judgement. This cycle reflects the sculptural cycles that decorate the portals of the great thirteenth-century cathedrals of northern France. The Creation story on the *Genesis* pilaster [202] is told in low-relief narrative vignettes set into the tendrils of a vine. This arrangement is characteristic of the vocabulary of brilliant naturalism adopted at Orvieto from northern Gothic sources. The figures too are realistic: nude forms are finely articulated, and faces are crisply carved and expressively characterized.

Economic misfortune throughout western Europe and the Black Death of 1348 slowed down the momentum in facade and portal decoration that had built up during the previous century. Nevertheless, work continued, if slowly, on cathedral facades like those of Strasbourg, Exeter, and Wells. They were provided with extensive cycles of monumental figure sculpture. At Exeter, for example, the horizontal screen [203] that extends right across the west front has numerous seated figures. Although now badly weathered, these were originally carved in fine detail, with recognizable attributes and facial expressions, and were richly polychromed. The contrast between the systems of figural articulation at Orvieto and at Exeter vividly demonstrates the range of design possibilities available to late Gothic sculptors.

The Florentine figure

Early in the fifteenth century Florentine consciousness of the need to reassert civic identity and independence stimulated several monumental sculptural projects in the cathedral precinct, such as the commission from Lorenzo Ghiberti (1378–1455) of a new pair of Baptistery bronze doors. But the principal focus of public sculpture was the guild church of Or San Michele [204]. Between 1410 and 1425 most guilds commissioned lifesize figures of their patron saints to be placed in niches around the exterior of this rectangular building. The intention was both further to beautify the city with public statuary and, by adopting styles and forms from Classical Roman sculpture, to assert visually Florence's claim to be the successor to republican Rome. The wealthy Bankers' Guild demonstrated its prestige by commissioning from Ghiberti a statue in bronze, which was about ten times as expensive as a marble figure. Underlining the rivalry between the guilds, the contract document requires that this *S. Matthew* should be 'at least as large, if not larger than' the Cloth-workers' Guild's *S. John the Baptist* cast by Ghiberti some seven years earlier. *S. Matthew* leans forward from his niche towards the onlooker in an evolved, classicizing *contrapposto* stance. With a stern expression he points eloquently towards his open Gospel as though reading out loud. Both movement and gesture are emphasized by the residual Late Gothic looping swathe of drapery folds across his stomach. Other guilds, such as the Armourers' for whom Donatello (Donato di Betto Bardi, *c.*1386–1466) carved the *S. George* next to the *S. Matthew* on the north side of the building, commissioned marble figures from sculptors who were more responsive to the styles and resonances of Classical Roman statuary. The *S. George* stands firmly with his legs apart, his shield and sword (originally held in his right hand) prominent, and his torso and alert face twisted round in readiness. In no sense plagiarizing, Donatello's figure shows his profound engagement with, and assimilation of, the styles of Classical Roman sculpture.

The keen alertness visible in Donatello's *S. George* also imbues the *David* of Michelangelo Buonarroti (1475–1564). After the expulsion of the ruling Medici family in 1494 the restored republican regime reasserted Florentine independence by installing Michelangelo's heroic figure at the main entrance to the Palazzo della Signoria [268], the hub of civic government. The greatest image of civic pride produced during the Renaissance, the *David* demonstrates more clearly than any other work of the late medieval and Renaissance periods the expressive power of monumental sculpture.

Stories in churches

Civic-minded people often commissioned church sculpture to the glory of God and to increase the church's splendour. Giovanni Pisano (*c.*1250–*c.*1315) carved new pulpits for S.

Andrea, Pistoia (1298–1300) and for Pisa Cathedral (1302–11): grander and sculpturally richer, the latter was later dismantled. The Pistoia pulpit [**205**] is a hexagonal structure with five marble panels carved with New Testament scenes in relief. The *Sibyls* at the corners between the Gothic spandrels are boldly carved with deep undercutting for dramatic effect, and some anatomical distortion to allow for the observer's angle of view from beneath. In the reliefs, Giovanni's activated figures communicate the narratives with intense immediacy. Innovations in church sculpture can also be seen in northern Europe later in the fifteenth century. For several decades before the Reformation depressed production of religious images, limewood carving flourished in south Germany, giving rise to increasingly large, winged, multi-panelled altarpieces. The development culminated in the monumentally grand altarpiece by Veit Stoss (*c.*1450–1533) for S. Mary's, Kraków [**206**]. A dramatic *tableau vivant* showing the *Death of the Virgin*, enacted by lifesize apostle figures, is bracketed by wings which display scenes of the Life of the Virgin in low-relief carvings. At much the same time as south German limewood carvings were becoming increasingly dramatic, north Italian sculptors like Guido Mazzoni (*c.*1450–1518) produced lifesize *Pietà* groups in polychromed terracotta [**207**], in which highly realistic figures use their chapel settings as though theatrical stages to enact the drama with moving intensity. Seldom has sculpture been used to such powerful expressive effect as in these emotionally stirring works by Stoss and Mazzoni.

Monuments and memorials

With increasing construction of funerary monuments from the later thirteenth century onwards, commemoration became increasingly a major function of monumental sculpture. In England and France tomb monuments usually took the form of free-standing rectangular chests surmounted by recumbent effigies. The English tradition of a chantry chapel containing the tomb culminated in the Chapel of Henry VII built on to the east end of Westminster Abbey, which encases the tomb of Henry VII and Elizabeth of York (1512–18) [**208**] by Pietro Torrigiani (1472–1528). Although this monument reflects the pattern of Late Gothic royal tombs, such as the earlier series in the basilica of Saint-Denis, near Paris, it is entirely Renaissance in style.

The Italian tradition of the funerary wall-monument culminates in the High Renaissance with monuments like the tomb of Doge Andrea Vendramin [**211**] by Tullio Lombardo (*c.*1455–1532). Designed on a grand scale, the Vendramin monument deliberately recalls the forms and proportions of a Classical triumphal arch. The sculptural decoration includes niched figures of classicizing soldiers and Christian virtues, reliefs of mythological subjects such as Labours of Hercules, and traditional elements such as a recumbent effigy and a presentation group of the resurrected Doge kneeling before the Virgin and Child. Combining the forms of the funerary chapel and the wall-tomb, Michelangelo's planned monuments for members of the Medici family in the New Sacristy of S. Lorenzo, Florence, is one of the most grandiose commemorative projects of the Renaissance. The principal tomb on the end wall of the chapel was scarcely begun, but the monuments to the *capitani* on the side walls are nearly complete. Pensively gazing towards the Madonna and Child of the principal tomb, Lorenzo de' Medici [**209**] sits in a high niche above two monumentally conceived figures of Dusk and Dawn.

Commemoration also took other forms. Donatello's grandest project was perhaps the equestrian monument to the mercenary general Erasmo de' Narni (called *Gattamelata*, d. 1443) [**213**], set up in 1453 outside the Basilica di S. Antonio in Padua. This commanding commemoration of military prowess deliberately echoed the values enshrined in the principal surviving classical equestrian monument, the *Marcus Aurelius* in Rome. As a major achievement in both commemorative and technical terms, the *Gattamelata* presented a challenge to later generations, more than met by Andrea del Verrocchio in his pugnacious and dramatic *Colleoni Monument* (Venice, Campo di SS Giovanni e Paolo), completed in 1496. Another commemorative type revived in the Renaissance is the Triumphal Arch. Emulating Classical precedent, Alfonso of Aragon processed beneath a temporary triumphal arch as he entered Naples in 1443 to become King Alfonso I of Naples. This event is commemorated in the Triumphal Arch erected across the entrance portal of the Castelnuovo in Naples [**212**]. The sculptural decoration, carried out by a large and heterogeneous workshop over a lengthy period, sets out in visual form an extensive iconographical programme, including Christian virtues, a (now lost) equestrian group, probably in bronze, a low-relief representation of the triumphal procession, and high-relief groups of soldiers.

Finally, patronage of sculpture was also an activity of princes. This may have stimulated production in an important genre of commemorative sculpture reintroduced in the mid-fifteenth century, the portrait bust. Male portrait busts, whether carved in life or after death, generally have a sharply characterized realism, but female portrait busts, such as the demure portraits of Aragonese princesses [**210**] by Francesco Laurana, (*c.*1430–1502?) have decorously downcast eyes and sealed lips, true to courtly expectations of female virtue. FAL

Civic sculpture in context

Monumental public sculpture needs to be understood with reference to its physical context and civic meanings. In enriching the exteriors of their buildings, and by erecting grandiose figure sculpture, urban communities displayed their sense of civic identity and pride. A competitive desire for

splendour and prestige can be seen in the sculptural enrichment of the late medieval facades of the central Italian cities of Siena, Florence, and Orvieto. The *Genesis* pilaster of the Orvieto Cathedral facade [**202**] was carved between 1310 and 1330 with vividly naturalistic figures, animals, trees, and plants.

In northern Europe, too, the tradition of enriching facades with sculpture continued. Now badly

weathered, the figures in the screen across the west front of Exeter Cathedral [**203**], dating between 1329 and 1422, were originally richly polychromed. Their dramatic, complicated poses and sharp details produce a striking visual impact on the beholder.

Figure sculptures also fill the niches of the guild church of Or San Michele in Florence [**204**]. At the northwest corner the Bankers' Guild

commissioned from Lorenzo Ghiberti in 1419 a bronze *S. Matthew* who gestures rhetorically as he steps towards the beholder. Donatello's adjacent marble *S. George*, carved *c.*1417 for the Armourers' Guild, established a new model for the vigorous youthful hero.

Carved from a huge block of marble, Michelangelo's *David* [**268**] takes its lead from Donatello's hero. The superbly realized muscular forms,

202 Right:
Lorenzo Maitani?
(*c.*1260–1330)
and workshop,
Genesis pilaster
(1310–30),
marble, Orvieto
Cathedral

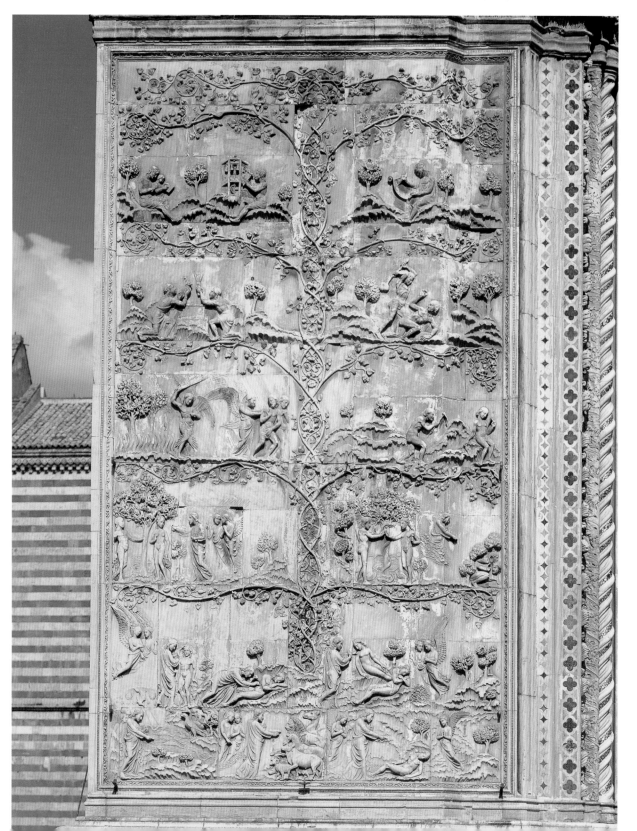

and the concentrated, authoritative facial expression emphasize the strength and youthful vitality of the fighter for freedom over Goliath's tyranny. The Florentine republican authorities acquired the *David* and set it up in front of the town hall as a civic image of the victory of liberty over oppression. FAL

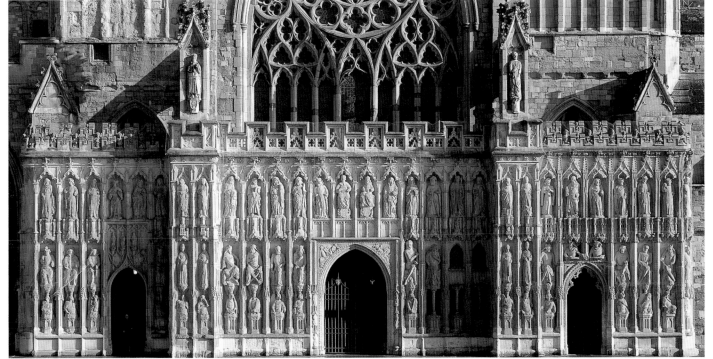

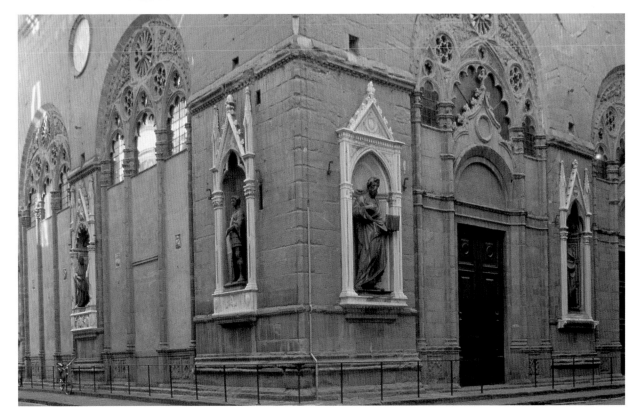

203 Above: Detail of Exeter Cathedral (1329–76), west front, limestone

204 Left: Florence, Or San Michele, north and west sides, showing on northwest corner (left) Donatello (Donato di Betto Bardi) (*c*.1386–1466), *S. George* (1417), marble, and (right) Lorenzo Ghiberti (1378–1455), *S. Matthew* (1419–22), bronze

Sculpture for the church interior

As well as having practical purposes church furnishings could have civic resonances, and thus were sometimes richly carved with figures and narrative scenes. In the S. Andrea, Pistoia, pulpit [**205**] (1298–1300) by Giovanni Pisano, the drama of the *Massacre of the Innocents* relief highlights the wailing mothers' passionate emotions, and the corner figures of *Sibyls* twist and sway in violent reaction to divine inspiration.

Sculpture for interior settings may be made of materials that are unsuitable for exterior display. In the principal scene of the massive altarpiece carved by Veit Stoss between 1477 and 1489 for S. Mary's, Kraków [**206**], an impression of high emotion is generated by brightly gilded and polychromed figures gesticulating, who pour out their grief with exaggerated gestures and facial expressions. Dramatic too are the lifesize figures of Guido Mazzoni's *Pietà* [**207**]. Modelled in clay which was then baked (terracotta), and originally polychromed, this group also demands the emotional involvement of the beholder.

Major cathedral patrons sometimes built large funerary chapels to commemorate their families. Henry VII of England died in 1509 and was buried in the chapel that he built on to Westminster Abbey. His tomb, the first truly Renaissance sculptural work produced in England, between 1512 and 1518, is by Pietro Torrigiani [**208**]. The design, a tomb-chest and recumbent effigies, follows tradition, but the materials are exceptionally splendid and costly.

FAL

148

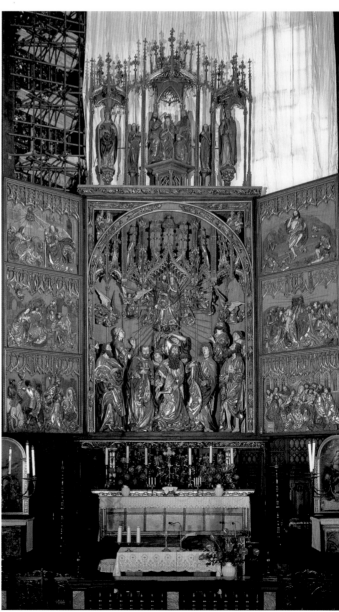

205 Left: Giovanni Pisano (*c*.1250–*c*.1315), pulpit, showing the *Massacre of the Innocents* (1298–1300), relief in marble, Pistoia, S. Andrea

206 Below: Veit Stoss (*c*.1450–1533), *Altarpiece of the Death of the Virgin* (1477–89), limewood, gilded and polychromed, Kraków, S. Mary

207 Opposite, top: Guido Mazzoni (*c*.1450–1518), *Pietà* (1492), terracotta, originally polychromed, Naples, S. Anna dei Lombardi

208 Opposite, bottom: Pietro Torrigiani (1472–1528), tomb of Henry VII and Elizabeth of York (1512–18), black and white marble, and gilt bronze, London, Westminster Abbey, Chapel of Henry VII

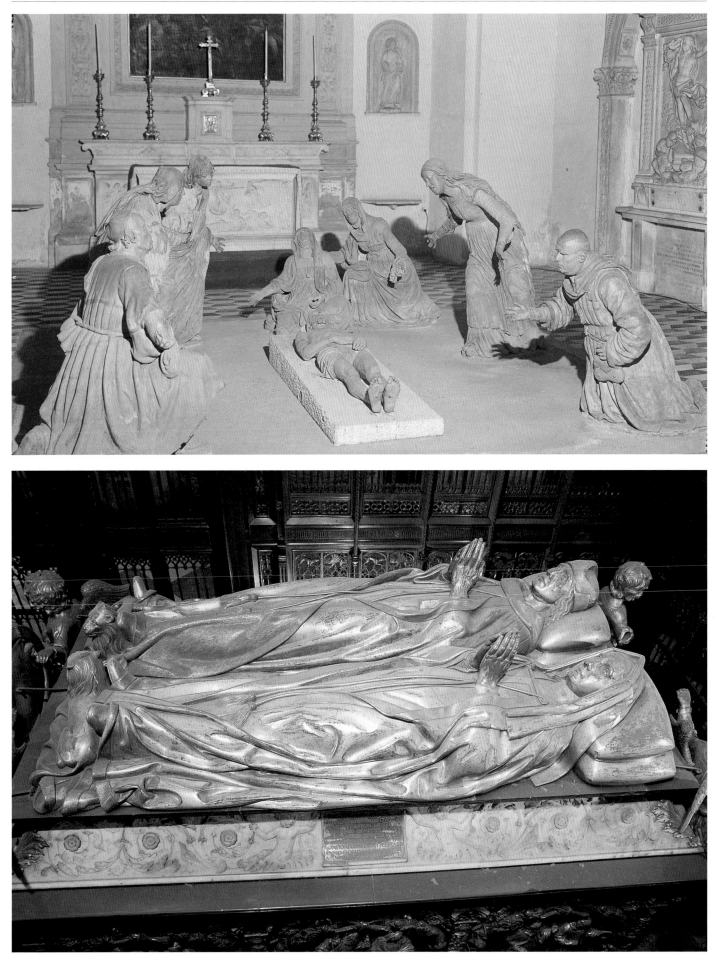

Commemorative sculpture

Much late medieval and Renaissance sculpture was produced to commemorate individuals, both in life and after death. The Tomb of Doge Andrea Vendramin (d. 1478), erected in SS Giovanni e Paolo, Venice, in 1494 [211], was designed and carved by Tullio Lombardo, who of all Renaissance sculptors used perhaps the purest Classical style.

Like Henry VII at Westminster Abbey, the Medici Pope Leo X built a new chapel on to the family church of S. Lorenzo in Florence which contains Michelangelo's unfinished wall-tombs for members of the Medici family [209]. The tomb of Lorenzo de' Medici shows the impressively articulated duke seated above figures representing Dusk and Dawn, who lie

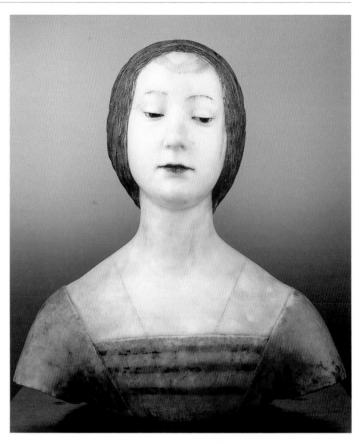

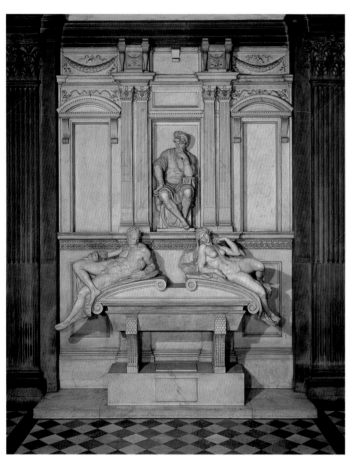

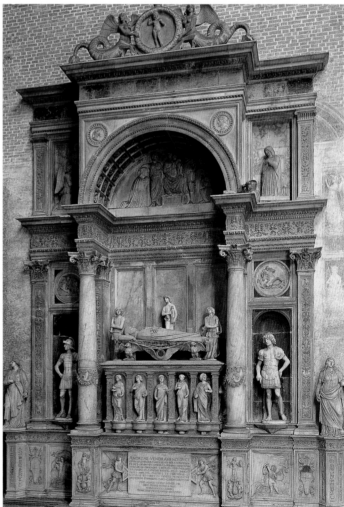

209 Above: Michelangelo Buonarroti (1475– 1564), tomb of Lorenzo de' Medici (1524– 34), marble, Florence, S. Lorenzo, New Sacristy

210 Top: Francesco Laurana (*c*.1430– 1502?), bust of Isabella of Aragon? (late 1480s?), marble, polychromed, Vienna, Kunsthistorisches Museum

211 Right: Tullio Lombardo (*c*.1455–1532), tomb of Doge Andrea Vendramin (1494), marble, Venice, SS Giovanni e Paolo

in complex, twisting poses on the sarcophagus.

Donatello's _Gattamelata_ [**213**], modelled and cast in Padua between 1447 and 1453, is the first lifesize bronze equestrian monument since antiquity and established a pattern for commemorating military men and rulers. Holding his general's baton and clothed in richly ornamented _all'antica_ armour, Gattamelata stares impassively ahead. The Triumphal Arch built between the twin entrance towers of the Castelnuovo in Naples commemorates the triumphal entry of Alfonso of Aragon in 1443 [**212**]. Its sculpture was carved between 1452 and 1466 by a team of sculptors which included Francesco Laurana among others. It is now impossible fully to disentangle the individual contributions of these sculptors.

Renaissance palaces provided settings for commemorative portrait busts. Usually carved to celebrate the sitters' betrothals, Francesco Laurana's elegant busts of Aragonese princesses, which date mainly from the 1470s–80s, display a crystalline ideal of femininity [**210**]. FAL

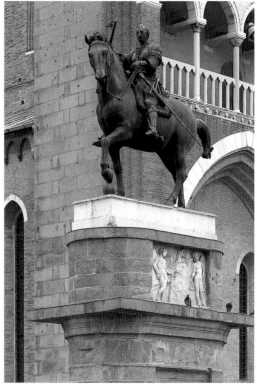

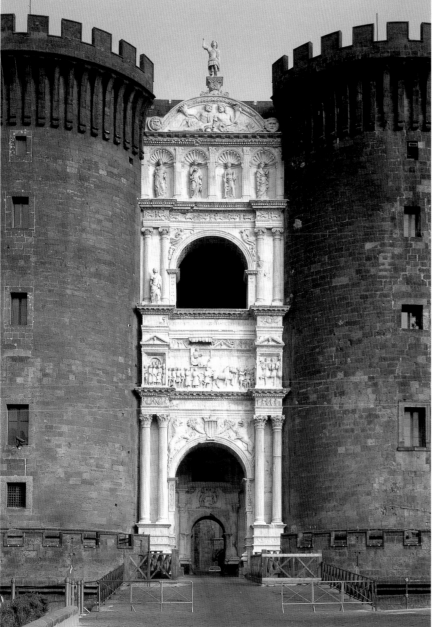

212 Left: Francesco Laurana (_c._1430–1502?) and others, triumphal arch (1452–8, 1465–6), marble, Naples, Castelnuovo

213 Above: Donatello (Donato di Betto Bardi) (_c._1386–1466), _Gattamelata_ (1447–53), bronze, Padua, Piazza del Santo

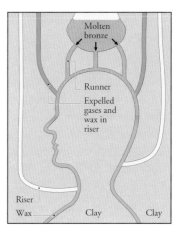

Lost-wax casting
Wax sculpted over a clay base is encased in a clay mould provided with 'runners'— tubes by which molten bronze can descend into the mould to drive off and replace the wax, which escapes by means of 'risers'.

The New Painting: Italy and the North

When Leon Battista Alberti (1404–72) dedicated the Italian version of his seminal little book *On Painting* (1436) to the architect Filippo Brunelleschi (1377–1446), he credited Donatello (Donato di Betto Bardi) (*c*.1386–1466), Lorenzo Ghiberti (1378–1455), Masaccio (Tommaso Guidi) (1401–28), and Filippo himself with 'a genius for every laudable enterprise in no way inferior to any of the ancients'. In so doing, he encapsulates two of the key notions behind what came to be called the Renaissance. One is that progress in the arts could arise only from a reinstatement of the qualities of Classical antiquity. The other is that propagandists for the cultural values of Florence laid claim to that city's leading role in the 'revival' of a truly 'ancient' style. Although both these claims are huge over-simplifications, it is true that the architect, the two sculptors, and the one painter named by Alberti pioneered a Florentine style that involved newly critical attitudes towards the immediate legacy of the Middle Ages, coupled with attempts to embrace principles and motives from surviving Classical texts and works of art. A central aim was to revive what were believed to be the naturalistic goals of ancient painting and sculpture.

Donatello's sculptures for the cathedral and the Guild Hall of Or San Michele and Brunelleschi's architectural innovations provided the foundations for one of the two dominant modes of painting in the second decade of the fifteenth century, namely the austere, sculptural, and perspectival style of Masaccio. The alternative to the 'Renaissance' innovations of Masaccio was provided by the detailed and decorative natural-ism of Gentile da Fabriano (*c*.1385–1427), which shares much in common with Ghiberti's first set of Baptistery doors. It is customary to identify Gentile with the persistence of a 'Gothic' sensibility, but the visual richness of his Strozzi Altarpiece [**219**] established a strong following in Florence and was much appreciated by humanist authors and patrons, including the rich banker, and patron of the new learning, Palla Strozzi.

Masaccio and beyond

It may be significant that three of the pioneers of the Early Renaissance style were from 'better' families than most artisans, and were probably educated to a higher level. Donatello was a member of the Bardi family, bourgeois traders of some status, while Masaccio was the son of a notary, as was Brunelleschi.

For early critics it was Masaccio's mimetic abilities which were significant. His figures have massive presence and gravity. They stand and move in a credible, coherent, and continuous pictorial space, constructed according to the new perspective developed by Brunelleschi and codified by Alberti, in which distinctions between the real space of the spectator and the

imagined space of the picture are minimized. The bodies within this space are depicted by means of tonal modelling rather than elaborate surface patterns, and they are free of visual clutter. The influence of the Antique, well assimilated, is profound.

Two of his three most important surviving projects were undertaken in Carmelite churches: the polyptych commissioned in 1426 by a notary in Pisa; and the frescoed decorations in the family chapel of the Brancacci undertaken with the older Masolino da Pannicale (1383–later than 1435). The Pisa altar-piece is now dismembered and its parts dispersed. The central panel of the seated Virgin, cut down at the sides and base, uses a monumental throne with architectural elements in the Roman manner to create mass and depth, not least through the use of perspective and cast shadows. The subject of the Brancacci Chapel frescoes was the life of S. Peter, probably selected to honour the name-saint of Pietro Brancacci, the founder of the chapel. The most substantial field undertaken by Masolino was the double narrative of the *Healing of the Cripple and Raising of Tabitha*, opposite Masaccio's *Tribute Money* [**220**]. Both fields show a notable use of perspective to create deep fields of space, though Masaccio's massively sculptural figures with Roman-style heads, reminiscent of Donatello's statues, occupy the platform of their narrative stage with greater visual conviction.

The other major surviving work from Masaccio's brief career is the *Trinity* in S. Maria Novella [**217**], which stands as one of the most significant landmarks in the history of European art. In essence, it is a modest work. The donors, probably Luigi Lenzi and his wife, pray before the Trinity seeking the interces-sion of the Virgin and S. John for the eternal life of their souls. Below the platform on which they kneel, in a heavily restored section of the fresco, is a skeleton on a bier with an inscription which reminds us of our mortality: 'what you are I was; what I am you will become'. What is most remarkable is the highly developed use of linear perspective to provide an illusionistic 'chapel' for the Saints and the Trinity through the space of the wall, and to set the skeleton, by implication, in front of the wall.

Quattrocento painting after Masaccio's time developed in various ways. In Florence itself the monumental clarity of his style was most consistently pursued by Fra Angelico (Guido di Pietro, 1387–1455), a Dominican friar whose series of paintings in S. Marco combine traditional piety with new narrative and spatial techniques. The younger Fra Filippo Lippi (*c*.1406–69) is more typical of the mid-Quattrocento in his gradual move away from Masaccio to a more elaborate and linear mode of painting influenced by the agitated later manner of Donatello. Angelico and Lippi were involved, with Domenico Veneziano (*fl*. 1438–61) in the reform of the altarpiece, which in its

'modernized' form was dominated by a large central panel with a unified internal space for the figures. The period from 1434, when the Medici family were reinstated after a brief exile, saw Florence fall increasingly under the sway of Cosimo de' Medici and his allies. The move of the later Medici towards a more courtly culture was accompanied by a greatly enriched style of art, of which the most significant exponent was Botticelli (Sandro di Filipepi, 1445–1510). Botticelli's mythological paintings for various branches of the Medici family [215]—complex in meaning and often resistant to easy interpretation—mirror the extent to which the search for the quality of Roman *gravitas* on the part of Masaccio's contemporaries had been obscured by intricate, quasi-aristocratic tastes under Lorenzo de Medici, 'il Magnifico' (1449–92).

Outside Florence the central aspects of the new painting—controlled pictorial space and the use of Antique sources—were given their most consistent treatments by the Umbrian painter Piero della Francesca (*c*.1410/20–92) [221] and the Paduan Andrea Mantegna (1431–1506) [214], both of whom worked for much of their lives in the small humanist courts of central and northern Italy (Urbino and Mantua respectively). The courts of the d'Este at Ferrara, the Gonzaga at Mantua, the Visconti and Sforza in Milan, the Montefeltro in Urbino, and the Aragonese court at Naples all became important centres of patronage, while the papal court now restored from Avignon to Rome began to employ painters (including Fra Angelico), sculptors, and architects to revive the glory of the decayed capital of Christendom.

Mantegna influenced, and was influenced by, Giovanni Bellini (*c*.1430/40–1510), the most significant of the family of painters who came to dominate Venice. Giovanni and his brother, Gentile (1429?–1507), developed a new genre of rich civic narratives in the employ of the Venetian Scuole (civic groupings of laymen for devotion, mutual interest, and charity). Giovanni was responsible for a radiant form of colouristic naturalism in figures, architecture, and landscape in a way that became the signal characteristic of Venetian art. His *Ecstasy of S. Francis* in the Frick Collection [226] exploits the intensity and suggestiveness of light and colour possible in the medium of oil paint, which he had adopted under the inspiration of Antonello da Messina (*c*.1430–79) and Netherlandish painting. What the art of Mantegna and the Bellinis shows is that the broad umbrella of the modes of naturalism and expression developed in the Early Renaissance could accommodate a remarkably wide range of religious, personal, civic, and dynastic ambitions in such different political environments as the despotic court of Mantua and the idiosyncratic Republic of Venice.

The North

Definition of 'Renaissance art' beyond Italy itself is impeded by the overwhelming and self-regarding weight of the Florentine literary tradition. It is clear, though, that in the Quattrocento collectors in Florence, Venice, and Lucca greatly admired the work of Netherlandish masters like Jan van Eyck (*c*.1395–1441). Italian attention was evidently most engaged by the northern ability, using the newly perfected medium of oil paint, to represent with almost forensic clarity the textures of the visible world. This naturalistic capability extends, especially in van Eyck's work, to a pictorial space of extraordinary realism, constructed without mathematical procedures. Other northern painters, like the French Jean Fouquet (*c*.1420–*c*.1481) offered alternatives to the optical formulas of Italian perspective.

The pioneers of the new painting in northern Europe, Jan van Eyck and the Master of Flémalle (probably Robert Campin, 1378/9–1444), both exploit detailed description of light on surfaces to create a seamless fusion of enticing naturalism with symbolic readings from the 'book of nature'. Jan exhibited a coolly intellectual approach to reverent detail, while Campin manifested a more grandly down-to-earth manner. Jan's Ghent Altarpiece (1432) and his *Betrothal of Arnolfini* [218] are achievements that stand alongside Masaccio's and testify that fifteenth-century representations of the seen world can take diverse yet equally compelling forms. Rogier van der Weyden (*c*.1399–1464) and Hugo van der Goes (*c*.1440–82) successively place the descriptive vividness of the new manner in the service of powerful narratives. Rogier's *Deposition of Christ* [223] combines brilliantly telling details, such as the tears of Mary Magdalene, with dramatic spatial compression and unstable pictorial rhythms.

The period around 1550 witnessed the arrival of two of the most extraordinary and individual artists of the Renaissance, Hieronymus Bosch (Jerome van Aken) (*c*.1450–1516) and Albrecht Dürer (1471–1528). Bosch developed a remarkably personal repertoire of symbolic fantasies in pictorial fields characterized by manic energy, exemplified in his *Garden of Earthly Delights* [224]. Dürer stands more in the mainstream, becoming the first artist successfully to merge the northern legacy of his training in Germany with the theoretical aspirations and pictorial modes of Italy.

Dürer's two visits to Italy, in 1495 and 1505–6, residing mainly in Venice, led to fertile visual dialogues with Bellini and Leonardo, the latter of whom he emulated in his writings on art, science, and technology. Alongside his widely admired print-making, he produced a striking series of oil paintings, culminating in his *Four Apostles* [225] completed in 1526 for the

cathedral of his home town, Nuremberg, and deeply imbued with the Reformation teachings of Martin Luther. In different ways, the two leading German masters of the younger generation, Hans Baldung (1484/5–1545) and Albrecht Altdorfer (c.1480–1538), both adopt and creatively adapt Dürer's legacy, while Matthias Grünewald (c.1475/80–1528), particularly in his monumental Isenheim Altarpiece), sets figures of unrivalled expressive power in compelling spaces irradiated with dynamic light and emotional colour.

The High Renaissance in Italy

154 Towards 1500 Italian art entered a new phase, the so-called 'High' Renaissance. For most critics since Vasari this represents the climax of a long cycle that began with Giotto di Bondone (1267/77–1337). Of the three main figures of the Florentine High Renaissance—Leonardo da Vinci (1452–1519), Michelangelo (Buonarroti) (1475–1564), and Raphael (Raffaello Sanzio, 1483–1520)—it was Leonardo who made the decisive contribution. His work from the late 1470s onwards marked a rejection of the intricacy and linear elaboration of the late Quattrocento style. These qualities were replaced by painting of larger conception, and compositions of tightly interlocked organic cohesion, reflecting the specific requirements of the subject-matter rather than existing models. From Leonardo's Last Supper of c.1495–7 to Michelangelo's Sistine ceiling (1508–12) and Raphael's papal apartments in the Vatican, the Stanze (1509–20) [216], the High Renaissance established a standard of complex, supremely controlled, and monumentally ambitious picture-making which transformed European art.

Leonardo's unfinished Adoration of the Magi (1478–81) and Last Supper [222] established the dynamic narrative power and grand organizational principles that were to be the goals for subsequent artists of the High Renaissance, just as his portraits, most notably the Mona Lisa (c.1503–13), introduced new ambitions in characterizing the psychological relationship between subject and viewer. The sheer range of Leonardo's intellectual explorations and practical activities in painting, sculpture, architecture, civil and military engineering, geometry, physics, the natural and human sciences, geology, and the theory of all the arts has left a magnificent if unfinished and incomplete legacy of drawings and notes. In the pictorial arts, his reform of drawing styles, ranging from the invention of a 'brainstorm' sketching technique for preliminary designs to red-chalk studies of parts of figures, radically affected all the leading masters who followed.

Trained as a painter under Domenico Ghirlandaio (1448/9–1494) and as a sculptor with Bertoldo di Giovanni (c.1430/40–91), who was a member of the Medici household, Michelangelo participated in the reshaping of pictorial ideals after 1500, not least through his cartoon for the Battle of Cascina, undertaken in rivalry with Leonardo's Battle of Anghiari for the Florentine Council Hall, though these major components in the republican decorative scheme were never to be completed. Reluctant though Michelangelo was to become a specialist painter, the four years spent in the execution of the Sistine ceiling resulted in the definitive image of how the monumental human figure could serve as a vehicle for the highest philosophical and theological ideals. Raphael's Stanze

[216], begun for the same hugely ambitious Pope, Julius II, not only combined the compositional principles of Leonardo with Michelangelo's figure style but also extended narrative art into realms of rhetorical complexity that were to become the academic norm for succeeding centuries. By the time of his early death in 1521, his large and industrious workshop had come to dominate almost every type of religious and secular painting in Rome and beyond.

For all the apparent affinities in their figure styles, Leonardo, Michelangelo, and Raphael founded their art on quite different convictions. Leonardo aspired to re-make nature on the basis of empirical 'experience' of the sensory knowledge through which God manifests his mastery of design, while Michelangelo sought the inner 'ideas' in his dialogue between the material and spiritual realms, increasingly striving for a level of visionary insight which might transcend the materiality of his media. Raphael, by contrast, applied a more pragmatic intellect to an all-round mastery of picture-making across the full range of subject-matter, adapting his mode, like a master of rhetoric, to tasks ranging from devotional imagery to virtuoso decoration.

The other major centre of High Renaissance art was Venice. Drawing upon the poetic colourism of Giovanni Bellini, two younger painters, Giorgione (Giorgio da Castelfranco), (c.1476/8–1510) and Titian (Tiziano Vecellio) (c.1485–1576), created a painterly style that came to epitomize Venetian art. Giorgione worked on a large scale with Titian on the exterior murals of the German Warehouse in Venice (1513–14), but is more generally seen as the master of the small fantasia (or poesia), in which moody narratives are evoked in atmospheric settings. The so-called Tempesta [227], which an early source calls a painting with a 'soldier' and a 'gypsy', exemplifies the suggestive interplay between elusive human sentiment and the moods of nature for which the short-lived Giorgione is now famed.

Titian shares the imaginative largeness of Florence with an expressive and freer use of colour and texture, something increasingly prized by his patrons, for whom the master's personal handling, his 'touch', came to be valued almost irrespective of subject-matter. By the second decade of the century, when he completed his altarpiece of the Assunta for the Frari (1516–18) and his mythologies for Alfonso d'Este in Ferrara, he established himself as the dominant Venetian artist, and he rose in subsequent decades to renown throughout Italy and Europe. In this, together with the international fame of Michelangelo, modern appreciation of the artist's individuality and the related awareness of art's autonomous cultural value began to be realized for the first time. What began with the precocious explanation of Giotto's superiority ends with the cult of the 'divine' Michelangelo, and the emperor Charles V's willingness, to the horror of his courtiers, to pick up Titian's brush for him when the old painter dropped it.

The rise of theory

Writing about art in the Middle Ages was not about 'Art' as we know it, but concerned the justification and use of devotional images and religious decorations. Such justification was very necessary in view of the Bible's injunctions against 'graven images', and iconoclastic proclivities remained an incipient

threat throughout the eras of Christian art. The key justifications were formulated by the Council of Nicea in 787. The Council decreed that representations of divine figures and stories served as 'books for the unlettered', as reminders of the divine qualities of Christ and the Saints, and as vehicles for devotion. Of the writings on theological matters that discussed the use of images, Bishop Durandus's thirteenth-century *Rationale divinorum officiorum* became the standard point of reference throughout the Middle Ages and Early Renaissance in defining the role of images and the spiritual ends of religious decoration. Of the few treatises that dealt directly with the practice of art—as a high 'craft' rather than as an intellectual pursuit—the *De Diversis Artibus* by a twelfth-century German Benedictine monk known as Theophilus (probably Roger of Helmershausen) is the most informative about the forms and techniques of painting, glass, and metalwork, but nowhere does he suggest that 'Art' involves the autonomous production of aesthetic objects .

The first signs of a significant change in the theoretical climate occurred in the fourteenth century, when the Italian writer Petrarch (Francesco Petrarca) (1304–74) and his humanist followers discussed the work of Giotto in terms which soon became the common currency of Renaissance writing on visual art. The significance of Giotto lay in his having, as these writers saw it, rescued the art of painting from the decline into which it had fallen following the fall of the Roman Empire in the West. The terms of these discussions were mostly simple, concentrating on Giotto's powers of representation—'figures painted by his brush seemed to live and breathe' (Filippo Villani, *c*.1400)—but they formed the basis for the much larger and more sophisticated body of art history and art theory which followed. Petrarch's own, more challenging, insistence that Giotto's art had qualities of intellectual (as opposed to merely visual) distinction underlies the Renaissance view of art as closer to the ancient Liberal Arts (Grammar, Logic, Rhetoric, and so on) than to other mere 'mechanical' arts. It was in the Paduan succession to Petrarch that the Tuscan painter Cennino Cennini (*c*.1370–*c*.1440) wrote his *Libro dell'Arte* (*Book of the Art*), which inserts precocious claims for the *scienzia* of painting into a treatise predominantly concerned with technical 'recipes'.

Fundamental to the idea of rebirth was Petrarch's division of history into three periods: the Antique, the 'Middle' age, during which most Classical standards were supposedly abandoned, and the modern era. The intellectual programme of Italian 'humanism', the systematic study of Antique culture, was directed at the revival of classical values in the politically unstable Italy of Petrarch's lifetime: in literature, in civic life, and only latterly in art. Petrarch's historical model of achievement, decline, and (eventual) revival was easily adapted to art history. This adaptation received its definitive statement in the *Lives of the Artists* (1550; 2nd edn 1568) by Giorgio Vasari (1511–74), in which the history of art is narrated according to a great pattern of recurring peaks and troughs, with Michelangelo presented as the culminating peak.

In 1434 the architect and writer Leon Battista Alberti (1404–72) returned to Florence after years of exile. What Alberti saw in early Quattrocento Florence made an impact on him which helped establish, through his writings, a quality of self-awareness which distinguishes the Italian Renaissance from

the many earlier Classical revivals. In the preface to the 1436 translation of his Latin treatise *On Painting* (1435), Alberti wrote that he had formerly 'believed ... that Nature ... had grown old and weary, and was no longer producing intellects', but the achievements of the Florentine artists rapidly convinced him otherwise. Above all, Brunelleschi's great dome of Florence cathedral, a feat 'probably equally unknown and unimaginable among the ancients', demonstrated for Alberti that the 'rebirth' was indeed happening. The standard against which the art of his contemporaries is to be judged is that of the Antique, a standard to which their work more than measures up: in some respects it has surpassed it.

Alberti's short treatise deals in three parts with the geometrical 'roots within Nature' (that is, perspective), the composing of a picture through a mastery of design, light, and colour in the service of narrative clarity, and the worth of painting as defined above all the ancients. The importance of *On Painting* is that it is the first modern treatise that explicitly defines painting as having a status equivalent to one of the Liberal Arts. Much the same claims were made in the apparently unfinished *Commentaries* by Ghiberti, which deal with an outline of the history of ancient art garnered largely from Pliny the Elder's *Natural History*. An account of the rise of 'modern' art from the time of Cimabue (Cenni di Pepi) (*c*.1240 to later than 1302) and Giotto, it was a description of the achievements of his own career, and a complex anthology of translated excerpts from medieval texts on optics. The optical aspects of fifteenth-century theory found their most developed expression in the *De Prospectiva Pingendi* (before 1482) by Piero della Francesca, who also wrote on practical mathematics and the geometry of polyhedra. The rising claims for the 'science of art' were accompanied by a growing sophistication in humanist criticism and by the earliest artistic biographies, most notably the *Life of Brunelleschi* (early 1480s) by Antonio Manetti (1423–97). The great architect was accorded the privilege of a memorial in Florence Cathedral that speaks of his 'divine talent'. Two other architects, Filarete (Antonio Averlino) (*c*.1400–*c*.1469) and Francesco di Giorgio (*c*.1439–1501), wrote elaborate treatises on architecture and related arts and technologies, largely in emulation of the ancient Roman author Vitruvius.

The most all-embracing theory of painting as a 'science' was developed by Leonardo—so all-embracing that it was destined never to be realized in publishable form. In his notebooks he claimed that painting was the supreme art as 'the sole imitator of all the manifest works of nature', and that it consisted of the remaking of nature on the basis of a comprehensive understanding of natural laws, which had themselves been drawn from nature on the basis of 'experience'. The extreme demands he placed on the painter with respect to optics, anatomy, natural science, geology, dynamics, statics, expression, narrative, and the painter's personal probity were such that it is less surprising that he completed relatively few works than that he completed any at all. It was his vision of art as the ultimate expression of visual knowledge that was to be taken up in various ways in subsequent theory, not least in the published treatises on measurement and proportion by Dürer. Once such self-conscious theorizing had taken hold, an irreversible change had taken place in the notion of 'Art'. JR, MK

'The pure radiance of the past'

Central to Renaissance theory was the conviction that it was exposure to the art of antiquity that enabled Italian artists from Nicola Pisano onwards to free themselves from the supposed constraints of the immediate past. For Early Renaissance artists the Antique offered a rich variety of adaptable visual formats. After 1400 the use of such sources became both more erudite and more systematic. The range of readings with which the later Renaissance invested the Antique was considerable and occasionally surprising.

Mantegna depicts S. Sebastian [214], early Christian martyr and former Roman officer, in the guise of a heroic Classical nude, surrounded by the ruins of a shattered antiquity.

Botticelli borrows the Classical *Venus Pudica* format for his painting [215], but in a context of contemporary humanist reinterpretation of her significance.

The Stanza della Segnatura [216], painted by Raphael for Julius II (Pope 1503–13), is the ultimate Renaissance synthesis: images of pagan philosophy, Christian theology, poetry from Homer to Petrarch, and Roman Law depicted as facets of a unified humanist culture; papal Rome, the true heir of the Roman Empire.

JR, MK

156

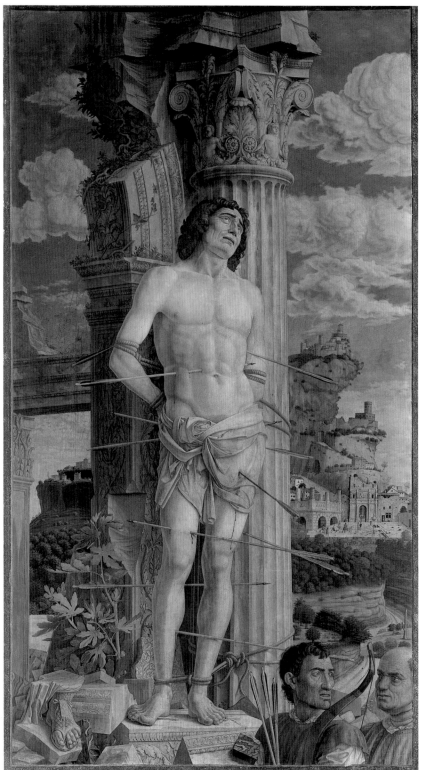

214 Left: Andrea Mantegna (1431–1506), *S. Sebastian* (1459), tempera on panel, 2.75 × 1.42 m. (9 ft. $\frac{1}{4}$ in. × 4 ft. 7 $\frac{7}{8}$ in.), Vienna, Kunsthistorisches Museum

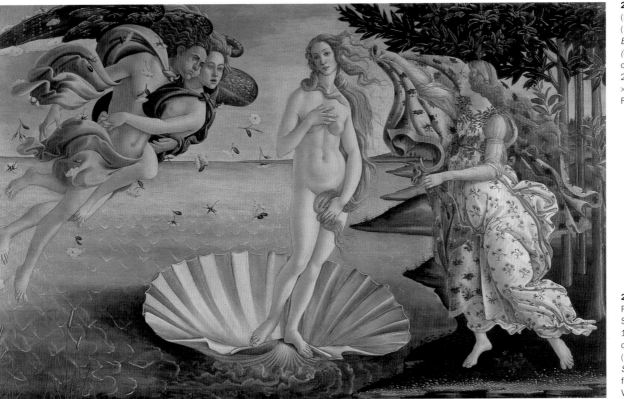

215 Botticelli (Sandro di Filipepi) (1445–1510), *Birth of Venus* (c.1482), tempera on canvas, 1.73 × 2.79 m. (5 ft. 8 in. × 9 ft. 1½ in.), Florence, Uffizi

216 Below: Raphael (Raffaello Sanzio) (1483–1520), Stanza della Segnatura (1509–11) with *School of Athens*, fresco, Rome, Vatican Palace

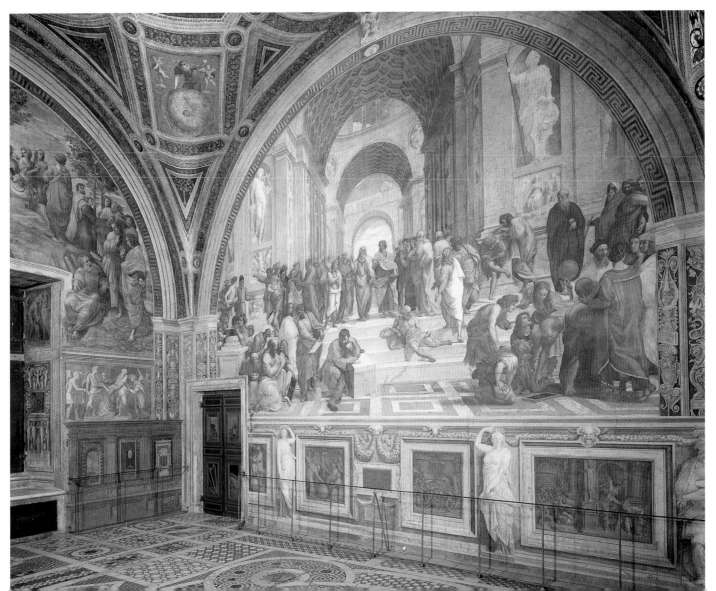

Pictorial space and perspective

The creation of a credible illusion of space behind the picture surface was fundamental to Renaissance art. In Giotto's time, and in northern Europe from c.1400, this was achieved empirically and by the use of established workshop devices with no pretence to strict optical or scientific accuracy. The interior space of van Eyck's painting [218] is of a piece with the phenomenal naturalism of the whole. The receding lines (orthogonals) meet along a vertical axis around which the composition is organized. Pictorial space of this kind owes a great deal to the inventions of Giotto and his school.

Van Eyck's Italian contemporaries went a stage further. Alberti, following experiments by Brunelleschi, set out a method by which pictorial space was continuous, optically accurate, mathematically coherent and related to the scale and position of the spectator.

Masaccio's *Trinity* [217] is an early demonstration of this new perspective, all orthogonals meeting at a single vanishing point pitched at the eye level of the spectator standing before the fresco. The illusion of continuity between the real space of the spectator and the fictive space of the painting is complete. His *Tribute Money* [220], telling the story of the provision of tax to enter a city, uses perspective to establish a deep stage for the narrative, while Gentile da Fabriano's sumptuous Strozzi Altarpiece [219] exploits rich textural description, accomplished foreshortening, and intricate landscape to present the grand procession of the three kings. Piero's

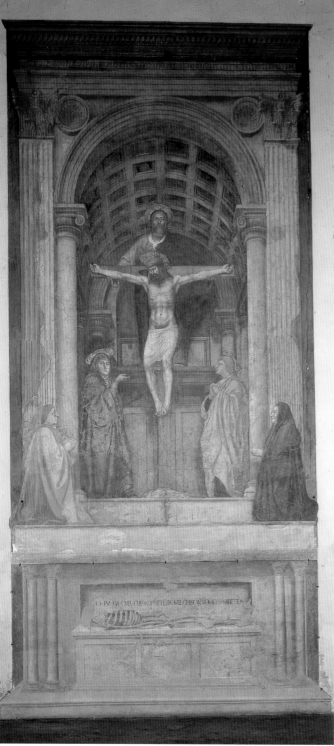

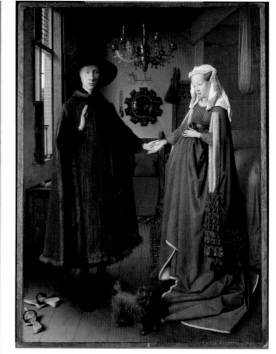

217 Far left: Masaccio (Tommaso Guidi) (1401–28), *Trinity* (c.1425/7), fresco, 3.17 m. (10 ft. 4¾ in.), Florence, S. Maria Novella

218 Left: Jan van Eyck (c.1395–1441), *Betrothal of Arnolfini* (1434), oil on panel, 81.8 × 59.7 cm. (32¼ × 23½ in.), London, National Gallery

219 Below: Gentile da Fabriano (c.1385–1427), *Adoration of the Magi* (the Strozzi Altarpiece, 1423), 3 × 2.83 m. (9 ft. 10 in. × 9 ft. 3½ in.), Florence, Uffizi

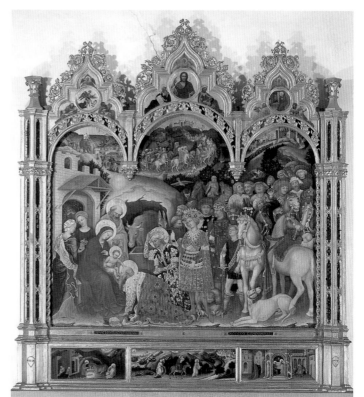

Flagellation [**221**] perfects the system, with a pictorial space of immaculate optical and mathematical credibility, every internal distance and the scale of every object within the space demonstrably in proportion.

In Leonardo's *Last Supper* [**222**] the space, apparently constructed along Albertian lines, has a more paradoxical relationship with the real space of the monastic refectory setting, a reflection of Leonardo's increasing scepticism about linear perspective's claims to optical truth.

The basic geometry was first codified in Alberti's *De Pictura* in 1435. It establishes the convergence of parallel lines to a 'vanishing point' and the location of horizontal sub-divisions. JR, MK

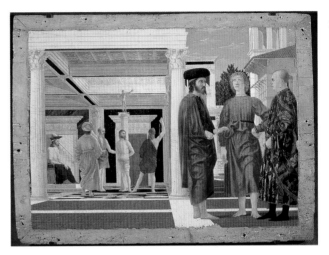

The linear perspective construction

ABCD – plane of the picture

V – vanishing point to which the orthogonals **DV** and **CV** converge, as do all other parallels at right angles to the picture plane

EF – viewer, at distance **CF** from the picture plane

With **BC** now serving to define the picture plane, **D** seen from **E** will appear at the level **G** on the picture plane

HI is drawn at the level of **G**

DHIC is a foreshortened square

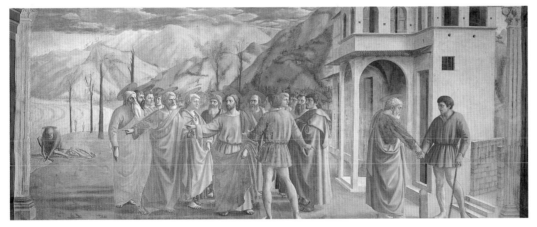

220 Masaccio (Tommaso Guidi) (1401–28), *Tribute Money* (c.1427), fresco, 2.47 × 5.97 m. (8 ft. 1⅓ in. × 19 ft. 7¼ in.), Florence, S. M. del Carmine, Brancacci Chapel

221 Piero della Francesca (c.1410/20–92), *The Flagellation of Christ* (c.1465), tempera on panel, 59 × 81.5 cm. (23¼ × 32 in.), Urbino, Galleria Nazionale

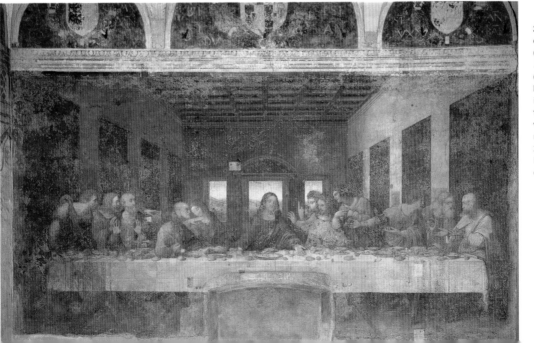

222 Leonardo da Vinci (1452–1519), *Last Supper* (c.1495–7), before restoration in 1980s–90s, tempera and oil on wall, 4.19 × 9.09 m. (13 ft. 9 in. × 29 ft. 9¾ in.), Milan, S. Maria delle Grazie

Oil painting: the North and Venice

Jan van Eyck's perfection of the medium of oil painting as a vehicle for superbly naturalistic effects of light, colour, and texture distinguished early Netherlandish art from the contemporary Italian works in tempera and fresco. Compared to Jan's intellectual restraint, Rogier van der Weyden

exploited the descriptive potential of the new naturalism in the context of deeply expressive compositions. In his Prado *Deposition* [223] the ravaged body of Christ, saturated with Eucharistic meaning, elicits vividly characterized grief from the three Marys, including meticulously rendered tears.

Bosch, in a more idiosyncratic manner, creates a teeming panorama of detailed narratives and symbolic

fantasies which serves as a microcosm of spiritual and earthly pleasures, and demonstrates the nature of punishments attendant on the latter [224].

Dürer's paired images of John the Evangelist, Peter, Mark, and Paul (reading from left to right [225]), presented to Nuremberg to serve as his own memorial, embody both northern colourism and Italian monumentality to evoke the four temperaments: sanguine, phlegmatic,

choleric, and melancholic. The bases of the panels are occupied by inscribed texts from the Bible, selected for their Lutheran tone.

Oil paint was adopted across Italy during the late fifteenth and sixteenth centuries, but it was in Venice that it received its most imaginative treatment. Giovanni Bellini, who effectively founded the distinctive Venetian school, exploits his Netherlandish command of

160

223 Rogier van der Weyden (*c*.1399–1464), *Deposition of Christ* (*c*.1442), oil on panel, 2.2 × 2.62 m. (7 ft. 2½ in. × 8 ft. 7 in.), Madrid, Prado

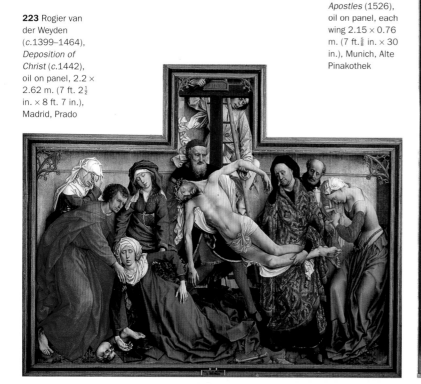

225 Albrecht Dürer (1471–1528), *Four Apostles* (1526), oil on panel, each wing 2.15 × 0.76 m. (7 ft. ⅝ in. × 30 in.), Munich, Alte Pinakothek

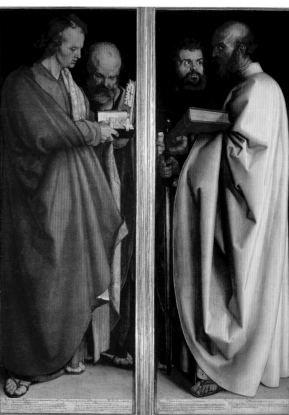

224 Hieronymus Bosch (Jerome van Aken) (*c*.1450–1516), *Garden of Earthly Delights* (*c*.1504), oil on panel, central panel 2.2 × 1.95 m. (7 ft. 2½ in. × 6 ft. 4¾ in.), wings 2.2 × 0.97 m. (7 ft. 2½ in. × 3 ft. 2¼ in.), Madrid, Prado

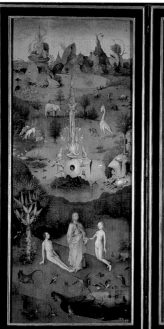
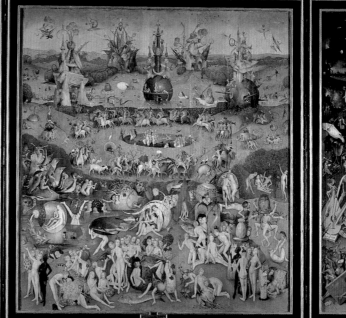
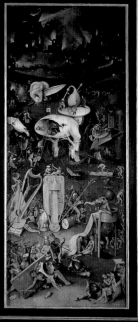

naturalism in oil paint within spatial settings infused with directional light. His S. Francis [**226**] looks to the divine radiance emanating from the seraph (trimmed from the upper left), while the varied topography is sensuously traversed by the natural light of the sun.

Giorgione [**227**], using the medium in a freer manner, immerses his enigmatic figures, described by an early observer as a 'soldier' and a 'gypsy', suggestively within an atmospheric landscape with less precise detail, in a picture with an improvised air that came to be known as a 'poesia'.

Titian [**228**], on the large scale of his Frari Altarpiece, orchestrates grand motions and sonorous chords of colour to convey the Virgin's spiritual ascent to viewers both close to and far away from the High Altar in the large Gothic church. In the hands of Titian, Veronese, and Tintoretto, large-scale oil painting exercised a profound impact on the European conception of religious and secular subjects. MK

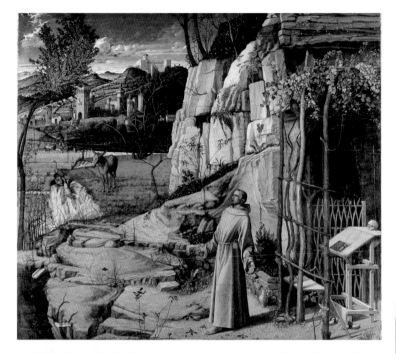

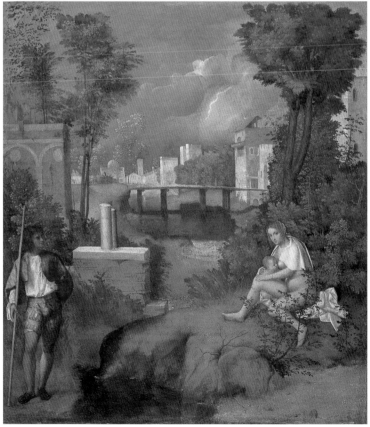

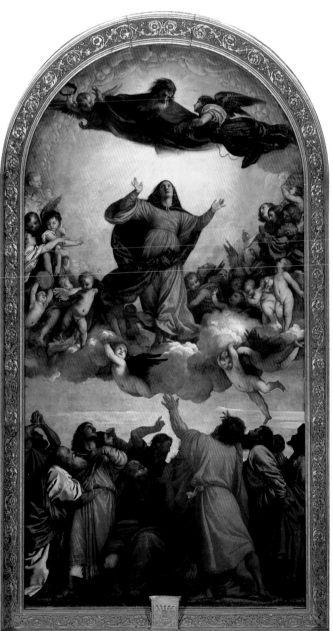

226 Left: Giovanni Bellini (*c.*1430/40 –1510), *The Ecstasy of S. Francis* (mid-1470s), tempera and oil, 1.2 × 1.37 m. (47¼ × 54 in.), New York, Frick Collection

227 Bottom left: Giorgione (Giorgio da Castelfranco) (1476/8–1510), *Tempesta* (*c.*1506), oil on canvas, 83 × 73 cm. (32¾ × 28¾ in.), Venice, Galleria dell' Accademia

228 Below: Titian (Tiziano Vecellio) (*c.*1485–1576), *Assunta* (1516–18), 6.9 × 3.6 m. (22 ft. 7½ in. × 11 ft. 10 in.), Venice, S. Maria Gloriosa degli Frari

Domestic Arts

Medieval and Renaissance objects of domestic life were often executed in lavish materials, exquisitely crafted and decorated with images that ranged from the literary and learned to light-hearted and humorous. Unfortunately, these secular objects were also vulnerable to the vagaries of use, fashion, and financial necessity, greatly diminishing their chances of survival. More-over, their intended destination—church or home—is often indeterminate or unclear; domestic furnishings frequently included religious imagery. When interpreted in conjunction with written documents and descriptions, however, the domestic arts aid in the reconstruction of daily life and its changes over time and locale. Some of the developments can be linked to technological advances, in the creation of ceramics and textiles, for example. Others, such as the increased quantity and variety of domestic luxury goods in the Renaissance, reflect changes of economics, consumer habits, and the evolution of customs.

Textiles were a staple of international trade throughout Europe and Asia. They provided portable, easily interchange-able decoration as well as comfort and warmth, from wall hangings to cushions and bed covers. Textiles also could be among the most expensive items in a home, particularly when made of precious materials such as silk, gold, and silver threads; coloured with expensive dyes (such as purple from the eastern Mediterranian murex mollusc and kermes red from insects); and woven or finished by complex and laborious means.

In the early Middle Ages, Byzantium was the centre for the production of costly silks on drawlooms, in which the figure harness raised or lowered the warp (vertical) threads for the weaving of patterns. The state-controlled industry reserved the best silks for court use and diplomatic gifts. The latter function probably explains why some of the best surviving examples are in church treasuries and tombs of western Europe. By the eleventh century, silk weaving spread to Byzantium's western Grecian provinces, and then to the Muslim courts of Sicily and Spain. Beginning in the fourteenth century, Italian cities such as Lucca, Florence, Venice, and Genoa rivalled and then replaced Byzantium as suppliers of luxury textiles to western Europe. Particularly prized were Italian velvets and brocades, with patterns created by means of three-dimensional, multi-textural, and tonal effects, often in combination. Velvets had contrasting cut and uncut tufts (*cesellato*), ground weave and pile ('voided'), and pile heights ('pile-on-pile' or 'high-and-low'). The precious metal threads were flat or crinkled (*frisé*), massed in two heights (*riccio sopra riccio*) or dispersed in individual loops to create precious highlights (*allucciolato*).

In the later Middle Ages and Renaissance, wool tapestries, often with silk and metallic threads, were among the most expensive forms of wall decoration. Tapestry weaving, in which the coloured weft threads can be introduced at any place in the design, is particularly suited to pictorial depiction. Tapestry workshops in Paris (until the early fifteenth century), Arras, Tournai, Lille, and Brussels specialized in large-scale series with themes from history (Classical, biblical, contemporary), chivalric romance, allegory, and courtly and pastoral life. Often the same set of designs was repeated. The Trojan War series provided by Pasquier Grenier of Tournai was given by the district of Bruges to Duke Charles the Bold of Burgundy by 1472; other versions were later owned by King Henry VII of England, King Charles VIII of France, King Matthias Corvinus of Hungary, and Duke Federico da Montefeltro of Urbino. Smaller decorative tapestries were also sold ready-made or ordered as a suite of room decorations (called a 'chamber') that might include bed hangings, cushions, bench cloths, and back cloths.

Byzantine and medieval houses, even among the affluent, were rather sparse in beds, tables, and chairs. The amount and variety of furnishings increased significantly by the fifteenth and sixteenth centuries, contemporary with a boom in palace construction. Different types of chairs, for example, indicated not only form or fashion ('in the French style', 'in the Pisan style') and function ('for women', 'for the field'), but also status with the addition, for example, of back and arms. Seats might also be built into a larger ensemble with writing desk, reading lectern, and cupboard or might have multiple functions, such as the chest-bench ('*cassapanca*'). Often the creation of furniture was a collaborative effort, involving carpenters, painters, gilders, stucco and intarsia workers, and so on.

Storage was always an important household concern—from large chests to small boxes. The mythological imagery and playful overtones of many Byzantine ivory boxes is suggestive of a secular clientele. Traces of polychromy in blue, green, red as well as gold gilding demonstrate that, contrary to their present appearance, many of these ivory or ivory and bone surfaces were vividly coloured. In the later Middle Ages, centres of ivory carving included Paris, Cologne, Mainz, Exeter, Milan, and Venice, where the Embriachi workshop produced polygonal caskets with ivory panels framed by inlay (*certosina*) of ivory, bone, and dark wood in the late fourteenth and early fifteenth century. The themes shifted to chivalric epics, scenes of lovers, and allegories of romance (such as the Storming of the Castle of Love) on ivory and wood coffers (particularly small German 'love' boxes or *minnekästchen*), combs, mirror backs—perhaps indicating that they were intended as courtship or bridal gifts.

Marriage provided an occasion for (re)furnishing the home. The groom's family often ordered pairs of wedding chests

(also called *cassoni*) to contain the bride's dowry, which was paraded through the streets when she processed to her new home. These chests were ornamented with painting, relief (in wood or gesso/*pastiglia*), and/or inlay. Sometimes fictive textiles were represented on the backs and lids, or perhaps a reclining youth or nude female inside the lid. The fronts were decorated with small-figured narratives from mythology, the Bible, or more recent history, set against architectural backgrounds or panoramic landscapes. The themes, with their familial or civic overtones, were similar to those found on later fifteenth- and early sixteenth-century *spalliere*—middle-register wall panels and backboards for beds, benches, chests, cupboards, and so on.

The procreative purpose of marriage was celebrated in painted birth trays (*deschi da parto*). Ostensibly created to carry foods to the mother during her lying-in period, birth trays were prized long after and are recorded in bed chambers. The earliest known examples of painted chests and birth trays date from the late fourteenth century, and in the fifteenth century leading Renaissance artists, such as Botticelli, were also engaged in painting furnishings for the domestic chamber. Some workshops, such as that run by Apollonio di Giovanni (*c*.1415–65) and Marco del Buono (*c*.1403–*c*.1480), specialized in such decorations. Painted wedding chests and birth trays apparently fell out of favour in the early sixteenth century. The *deschi da parto* may have been replaced by the ceramic birth service (*tazze da impagliata*), comprised of bowl, plate, drinking-cup, salt cellar, and cover that fit together in a candelabrum shape.

Feasts for familial, religious, civic, or political occasions provided the opportunity for extravagant public display. Foods were imported and served in abundance; silver and gold plate was set out on a credenza. The dining area was hung with rich textiles, while the table was laid with linens and vessels of precious materials. The seat of honour might be marked by the ceremonial nef, a ship-shaped vessel that held salt, utensils, and/or napkin. Even the perfumed water for handwashing, a frequent ritual since fingers were used for eating, was poured from elaborately fashioned ewers or aquamaniles. Ingenious table fountains and food constructions provided entertainment as well as sustenance.

The ceramic arts underwent rapid and dramatic change in Renaissance Italy—not only in large urban centres with traditions of craft industries (such as Florence and Venice), but also in smaller towns such as Urbino, Gubbio, Castel Durante, Faenza. Some of the innovations were based on medieval Hispano-Moresque technologies: the use of tin glaze to provide an opaque, white ground for an increasingly wide range of colours, and metallic lustres which created an iridescent sheen

(copper for red and or silver-based for gold). Italian Renaissance maiolica painters, however, transformed the nature of pottery decoration with the introduction of elaborate narrative (*istoriato*) scenes taken from Classical and biblical sources. The images were often derived—whole or piecemeal—from prints, itself a new medium. Large services were commissioned by aristocratic patrons, in Italy and abroad. In view of the lack of wear on many pieces, it seems that there were earthenware pieces reserved for display. By the sixteenth century, Italian maiolica replaced Hispano-Moresque ware in the export market and was imitated, for example, in France and the Low Countries.

A more intimate form of display took place in the *studiolo*, a small room which combined the functions of study, library, and treasury. Its origins have been traced to the fourteenth century—to the papal palace of Avignon and French royal châteaux as well as homes of humanists and merchants such as Petrarch and Francesco Datini. Among the Renaissance élite such as the Medici of Florence and the Gonzaga of Mantua, the *studiolo*, with its decoration and precious objects, became a site of privileged reception for distinguished guests. The walls and cupboards of these studies were often decorated in intarsia, the art of wood inlay that reached its height in the fifteenth and early sixteenth centuries. Intarsia workers (also called 'masters of perspective') created illusionistic representations that were praised as rivals to painting.

The *studiolo* was a site also associated with collecting—of manuscripts and precious vessels, ancient coins and cameos, bronze and marble sculptures as well as curiosities of nature such as sharks' teeth ('serpents' tongues') and unicorn horns. The design of utilitarian accoutrements—containers for writing implements, inkwells, candlesticks, and oil lamps—also reflected the culture of this humanist milieu. In 1430, Guarino Guarini of Verona (1374–1460), tutor to Leonello d'Este, was given a 'beautiful and elegant' terracotta inkstand, decorated with putti, leaves, and branches. By the end of the fifteenth century, there was extensive production of small bronzes, particularly in the university town of Padua which was also known for its bronze foundries. Advancements in casting techniques among north Italians also made possible the production of multiple replicas and hollow figures with thin metal walls that were lighter and easier to handle. Among the best-known small bronzes are the lively satyrs by Andrea Briosco (il Riccio) of Padua (*c*.1470–1532), the monsters by Severo Calzetta of Ravenna (also active in Padua) (*fl. c*.1496–1543), and the miniature versions of famous ancient sculptures by the Mantuan Pier Jacopo Alari-Buonacolsi (known as Antico) (*c*.1460–1528). BLH

Textiles

Textiles were among the most luxurious of domestic goods. The silk cloth with elephants framed by medallions was made in Constantinople, as indicated by the textile's inscription [**229**]. It represents the pinnacle of Byzantine silk drawloom weaving; the complex and large-scale elephant pattern required at least 1,440 manipulations of the warp threads for each repeat. The impressive polychrome silk of five colours (beige, yellow, green, blue, red) probably travelled west as a diplomatic gift before being placed in the tomb of Emperor Charlemagne (d. 814) in Aachen, perhaps around AD 1000 by Emperor Otto III (reigned 983–1002), whose mother was the Byzantine princess Theophanou.

Italian brocades and velvets dominated the luxury textile market

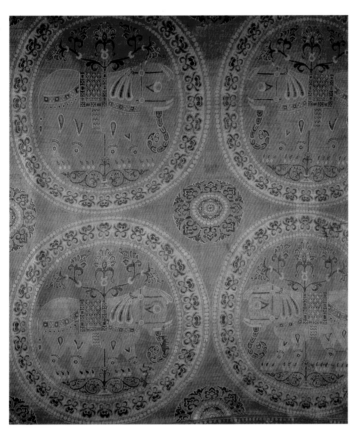

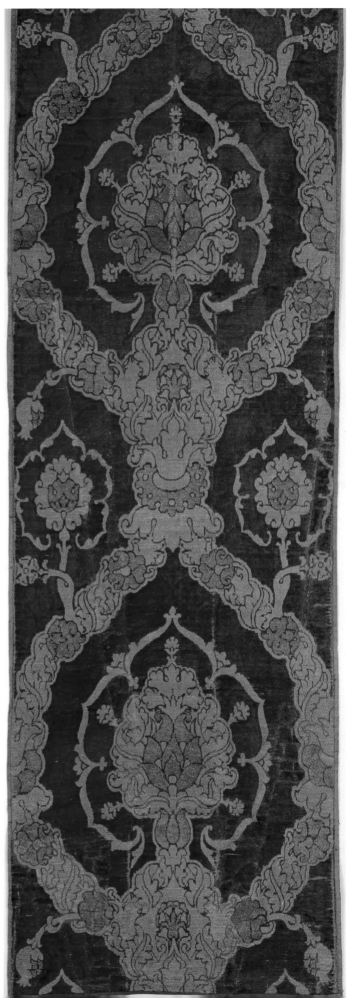

229 Above: Byzantium (Constantinople), elephant silk (late tenth century), silk, weft-faced, compound twill weave, 1.62 × 1.37 m. (63¾ × 54 in.), Aachen, Cathedral Treasury

230 Right: Italy, brocaded velvet cloth (fifteenth century) silk, gold thread, 3.76 × 0.58 m. (12 ft. 4 in. × 23 in.), New York, Metropolitan Museum of Art

of Renaissance Europe. The design of this panel [**230**] is subtly enriched by a variety of techniques: contrasting flat and looped metal threads of the brocade as well as high and low piles that create another pattern in the velvet background.

Fifteenth- and sixteenth-century brocades frequently featured stylized floral motifs such as palmettes, branches, pinecones, and pomegranates. In this example, pineapples are framed by ogival lobes and intertwined festoons.

From the late fourteenth century, series of tapestry panels were an important form of large-scale, pictorial wall coverings throughout Europe. In the set of six pieces with the arms of the Viste, a family of wealthy lawyers from Lyons, an elegantly dressed lady and her maid are engaged in courtly pastimes that also refer to the five senses [**231**]. The background is covered with a small-scale floral motif (*mille fleurs* or 'thousand flowers') that was popular in the fifteenth century and also used on smaller pieces for furniture coverings and decoration. BLH

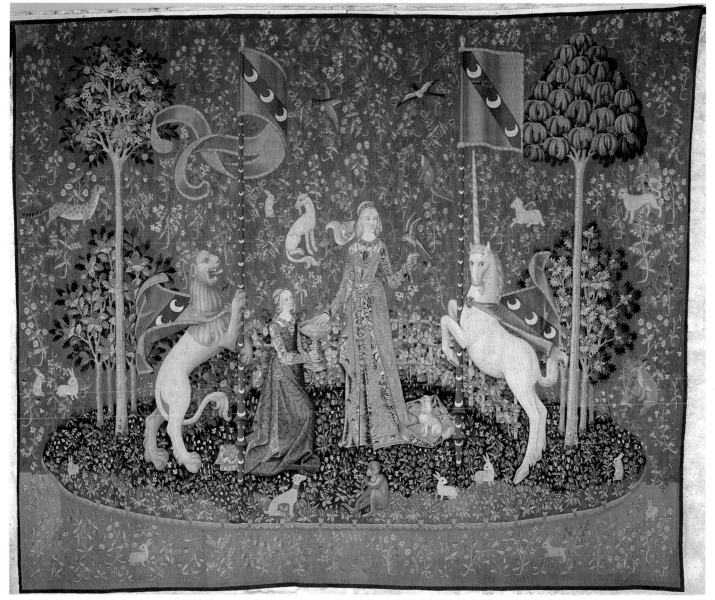

231 Flanders, Allegory of Taste from Lady and Unicorn tapestries (late fifteenth century), wool and silk, 3.7 × 2.9 m. (11 ft. 11¾ in. × 9 ft. 6 in.), Paris, Musée du Moyen Age

Furnishings, marriage and birth

Secular themes and personal imagery are often found on domestic furnishings. The Byzantine Veroli casket [**232**], with its deep and precise undercutting, is among the most skilfully carved examples of Byzantine ivory. Its imagery is complex and sophisticated—an eclectic combination of mythological scenes, including the rape of Europa, the sacrifice of Iphigenia, and the triumph of Dionysus, interspersed with playful *putti*. In the late fourteenth and fifteenth centuries, panel paintings with secular narratives are found on household furnishings such as chests and birth trays. Often these panels were subsequently removed from their original context and preserved as independent paintings. The Strozzi chest [**233**], with the depiction of the fall of Trebizond (1461), is one of the few painted chests to survive intact. The stencilled textile patterns on its lid and back may reflect the function of such chests to hold linens and other cloth goods. Both the chest and chair from the Florentine palace begun in 1489 by Filippo Strozzi are ornamented with the family insignia, a moulting falcon. Such emblems and heraldry marked an owner's personal imprimatur and family identity on both palace and furnishings. Despite its seeming simplicity, the *sgabello* (stool) is an example of sophisticated refinement, with a flat octagonal seat on three, tapering legs and a tall, narrow back [**234, 235**]. The chair is decorated with inlaid geometric patterns (*toppi*). Its crowning medallion is ringed by pierced and once gilded crescents, a motif taken from the family arms. The frame and

232 Byzantium (Constantinople), Veroli casket (second half of the tenth century), ivory and bone with traces of gilding on wood core and with metal mounts, 11.2 × 40.5 × 16 cm. (4⅜ × 16 × 6¼ in.), London, Victoria & Albert Museum

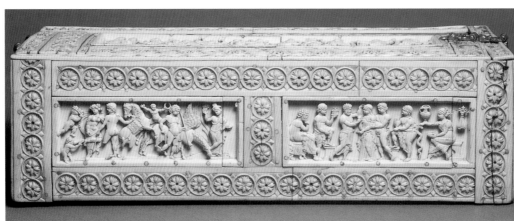

233 Below: Workshop of Apollonio di Giovanni (*c*.1416–65) and Marco del Buono (1403?–after 1480), *Cassone with the Conquest of Trebizond* (after 1461), wood, gesso, paint, gilding, 100.3 × 195.5 × 83.5 cm. (3 ft. 3½ in. × 6 ft. 5 in. × 2 ft. 8⅞ in.), New York, Metropolitan Museum of Art

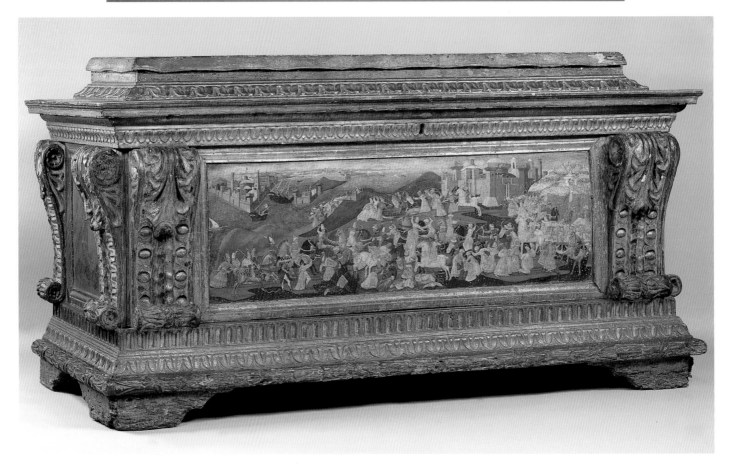

reverse on the birth tray of Lorenzo
de' Medici (b. 1449) [**236**] display his
parents' coats of arms and his father's
emblems—ostrich feathers, a
diamond ring and the motto *Semper*
(Always). The birth tray, with its
auspicious representation of the
Triumph of Fame (based on
Boccaccio and Petrarch), was still
displayed in Lorenzo's room at his
death in 1492, along with portrait
busts of his mother and father. BLH

234 Left: Floren-
tine, *Sgabello*
from Strozzi
Palace, (*c.*1490),
wood, traces of
red paint and
gilding, 147.4 cm.
(58 in.) high, 48.8
cm. (19¼ in.)
deep, New York,
Metropolitan
Museum of Art

235 Right: Detail
of back of **234**

236 Below:
Giovanni di Ser
Giovanni (called lo
Scheggia), (1407–
86), birth tray of
Lorenzo de' Medici
(1449), panel
painting, 62.5 cm.
(24⅝ in.) diameter
(painted surface),
New York,
Metropolitan
Museum of Art

The banquet and the study

Feasts were intended to appeal to all the senses—sight, touch, hearing, smell, and taste—and to delight the mind. The silver-gilt Gothic ensemble [237] with pointed arches, rib vaults, tracery, crockets, and gargoyles is the only known example of a medieval table fountain to survive more or less

168

intact (the lower basin is now lost). Its castle-like form, replete with towers and battlements, was typical of table fountains once owned by Count Louis of Flanders (1311), Queen Jeanne de Bourgogne (d. 1348), and Louis d'Anjou (who had 38 in 1365), as well as medieval food sculptures called *entremets*. The fantastic creatures, seated figures, and human and animal heads contain pipes that dispensed water or wine, causing wheels to turn

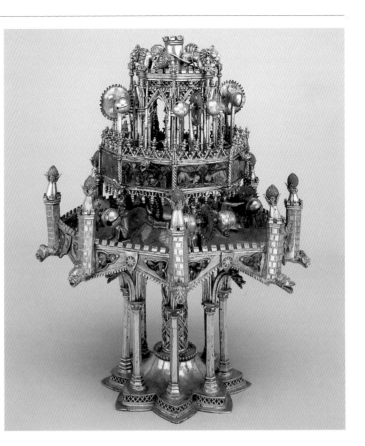

237 French, table fountain (fourteenth century), silver gilt, basse-taille enamel (re-enamelled in the nineteenth or twentieth century), 31.1 × 24.1 cm. (12¼ × 9½ in.), Cleveland Museum of Art

238 Nicola da Urbino (*fl.* 1520–1537/38), plate with the *Contest between Apollo and Marsyas* from the maiolica service for Isabella d'Este (*c.*1524), 27.5 cm. (10¾ in.) diameter, New York, Metropolitan Museum of Art, Lehman Collection

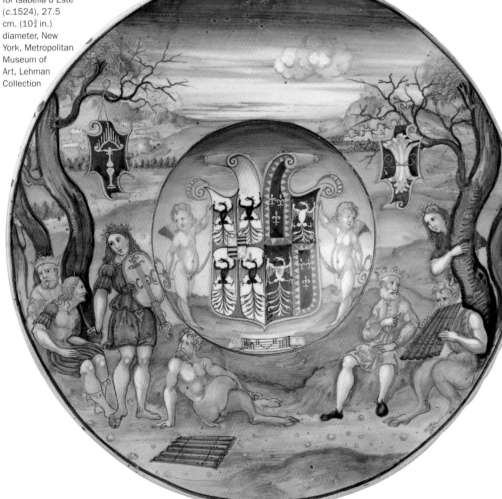

239 Below: Andrea Briosco (il Riccio) (*c.*1470–1532), satyr, bronze, 35.7 cm. (14 in.), New York, Metropolitan Museum of Art

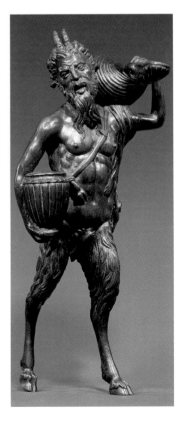

and bells to ring. Even earthenware was fashioned into sophisticated objects of luxury. One of the best-known maiolica services of the Renaissance belonged to Isabella d'Este, marchioness of Mantua, a cultivated patron of the arts, whose arms and emblems appear on each of the 21 surviving dishes [238]. In 1524, her daughter Eleanora Gonzaga, Duchess of Urbino, sent a maiolica set, perhaps this one, for

Isabella's suburban villa of Porto. Many of the plates have vividly coloured scenes from Ovid, set in landscapes.

Private studies displayed the personal tastes, accomplishments, and culture of a patron. The objects depicted in the wall panelling of the *studiolo* of the Duke Federico da Montefeltro (1422–82)—armour and weapons of war as well as books, writing implements, and instruments

of music and science—represent the active and contemplative life of the ideal prince [240]. With their carefully constructed perspective and their representations of cast shadows and reflected light, the trompe-l'œil images composed of inlaid wood are also demonstrations of the science of optics. Studies often housed collections of ancient art—coins, cameos, and sculptures—that provided inspiration for the

Renaissance production of medals, intaglios, and bronzes. The small satyrs by the Paduan sculptor Riccio [239] translated the mythological woodland creature into lively sculptures that, combined with shells and cornucopiae for inkwells and candle holders, were both display and functional objects.　BLH

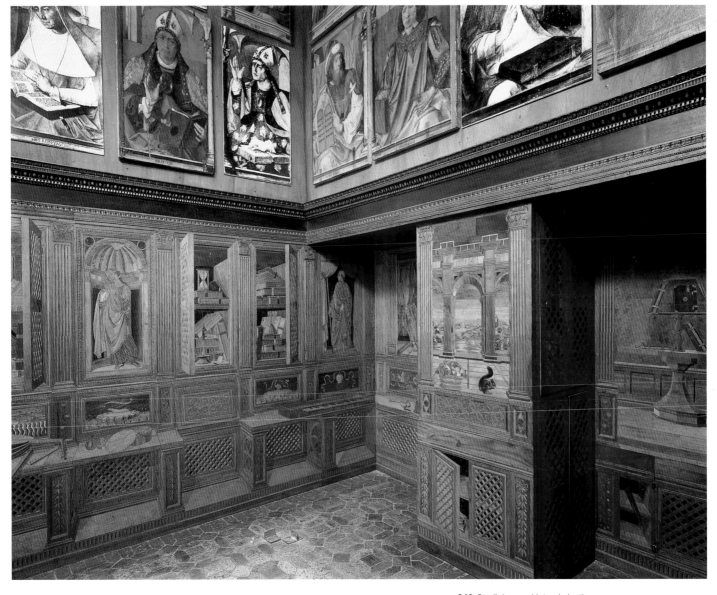

169

240 *Studiolo*, wood intarsia by the Maiano workshop, Florence, paintings by Justus of Ghent (finished 1476), room axes 3.6 × 3.35 m. (11 ft. 10 in. × 11 ft.), room 4.94 m. (16 ft. 2 in.) high, intarsia panelling 2.22 m. (7 ft. 3½ in.) high, Urbino, Ducal Palace

The Print

Although the improvements in the press engineered by book printers proved useful to artists, woodcuts and engravings were already being made by the time Johann Gutenberg (c.1390–1468) published his Bible in Mainz (1452–6). Woodblocks were printed on textiles before paper, but were being used for print-making by the beginning of the fifteenth century. Blockbooks, the most famous being the *Biblia pauperum praedicatorum* (1470–80), involved no movable type and were produced in quantity from mid-century until the 1480s, especially in the north. The *Apocalypse* of 1498 by Albrecht Dürer (1471–1528) first accorded woodcut illustrations a full page. Engravings were being made in the upper Rhine valley by the 1430s, but it was not until the mid-sixteenth century that engraved book illustration started to displace woodcuts. Etchings likewise were made first in Germany, by the Hopfers, armourers of Augsburg, around 1500. They used iron plates. Lucas van Leyden (1494–1533) was the first to use copper, which was not subject to rust and more regular in its reception of the acid.

Our best early record of established dealers in prints is the Florentine inventory of 1528 for the holdings of Alessandro Rosselli (d. 1525), nephew of the painter Cosimo Rosselli (1439–1507). He owned over 50 blocks and about 75 plates, identified by subject. The impressions in stock are only in rare instances identified by artist—Raphael (Raffaello Sanzio) (1483–1520) or Baccio Bandinelli (1493–1560)—sometimes by subject (often maps or navigational charts), and other times merely by size. Raphael is said to have designated a German, 'il Baviera', to sell prints out of his workshop. Prints were sold at fairs in the north, some of them by Dürer's wife, Agnes.

Some prints were sold as prized objects: occasionally woodcuts were printed with gold; some engravings were printed on vellum. A few impressions come down to us with monograms added in pen, presumably by the artist. Especially in the fifteenth century coloured inks were sometimes chosen for engravings: slate blue or brown, for instance. Privileges were applied for, the earliest of these being a copyright for four years for the six-block *View of Venice* by Jacopo de' Barbari (c.1460/70–1516), granted to the publisher Anton Kolb of Nuremberg in 1500, fourteen years after a similar privilege had first been granted to a book printer. That bird's-eye perspective of the lagoon is about as big as woodcuts became (1.39 × 2.82 m.; $54\frac{3}{4}$ × 111 in.); Francesco Rosselli (1448–after 1508), father of Alessandro, made an exceptionally large, two-sheet engraving of the *Assumption of the Virgin* (82.6 × 86 cm.; $32\frac{1}{2}$ × $33\frac{7}{8}$ in.). On the other end of the scale, Albrecht Altdorfer (c.1480–1538) made both woodcuts and engravings the size of postage stamps. Unauthorized editions, exacting copies, and even forgeries seem

to have been made from early on, a famous incident being reported in a letter of 1475, in which Andrea Mantegna (1430/31–1506) is accused of hiring thugs to revenge himself on a renegade engraver. Lucas van Leyden's daughter told his early seventeenth-century biographer that he had burned unacceptable impressions. Letters survive from Dürer to his patron Jacob Heller of Frankfurt, in which the artist complains that he would have been better off to have put his time into engraving rather than the laborious process of panel painting.

By being composed of the least valuable materials possible yet sometimes demanding the most acute connoisseurship, prints changed the map of art collecting. There were popular prints and élite ones, but this was more a matter of subject than of medium; there were engravings of prodigies and woodcuts for collectors. The Emperor Maximilian commissioned woodcuts. The prices of prints made them generally affordable to both courtiers and lords, both bank employees and bank owners. On his trip to the Netherlands in 1520–1 Dürer gave or sold prints to people as various as Margaret of Austria, Regent of the Netherlands, goldsmiths and a glazier, and even the servant of an innkeeper's brother-in-law. Someone who might have hoped to commission one work of art in his lifetime now could own a portfolio. This art no longer served as an attribute of the patron's public persona; its function instead was as various as that person's private intellectual life.

The intaglio prints of the third quarter of the fifteenth century by Mantegna, Antonio del Pollaiuolo (c.1430–98), Martin Schongauer (c.1440/5–91), and the Master of the Housebook (1470/1500), boldly differ from any previous works of art in either the decorative or monumental media. Often they are secular, often downright irreverent towards established norms, tweaking pictorial and social mores at once. Yet they also include dignified examples of the most profound of themes. These prints did not expand only the low end of the range, but broadened and extended the entire pictorial repertoire.

In the hands of Dürer, both intaglio and relief prints reach a state of sophistication, visually and conceptually, which rendered even the proud Italians respectful. Raphael is said to have hung Dürer's prints around his studio. With images of moral decrepitude and corporeal entanglement of various sorts, of detailed and extensive landscape spaces, and with richly luminous and textured interiors, Dürer laid out major avenues for future artists, particularly for members of the Danube school who developed nonfigural landscape subjects in the 1520s. He did so across the print media, distributing what by the measure of precedent must be judged bizarre ideas in woodcut, engraving, and etching.

Lucas van Leyden developed sophisticated games between depth and surface, arranging the story in the secondary pictorial spaces and exploring genre topics in the primary ones. Alternatively, he created autonomous sheets containing what might have been no more than background figures, ones whose anonymity when thrust into principal roles leaves them oddly ambiguous. By finding that cusp between a documentary image of daily life and standardized moral commentary, Lucas managed to convert the lustiness of some of the pioneering engravings into an earthy physicality that is neither chiding nor naughty. Even when the subject is biblical, the flavour of his art is untaintedly mundane.

In Italy the most innovative prints after the early spurt by Mantegna and Pollaiuolo belong to Giulio Campagnola (c.1482–1515), who overcame the seemingly inherent linearity of the medium and made it responsive to pictorial goals by massing pointillist pricks. Decades before Hendrick Goltzius (1558–1617) would show off his versatile imitation of other artists' styles, Giulio recognized the stylistic pliability of engraving. Working after Mantegna, Titian, Giorgione, and Sebastiano del Piombo, he produced an artistic conundrum: an incoherent œuvre, at a time when the very idea of individual style was still new and period style scarcely thinkable. Marcantonio Raimondi (c.1480–1534), although he similarly worked after numerous designers, soon perfected not only a trademark technique, based on his systematic crosshatching, but also a trademark style, generic classicism as much as it was Raphaelesque. Without the engravings of Marcantonio and his school (loosely so described), visually binding together as they do the work of Michelangelo, Raphael, and Giulio Romano (1492/9–1546), the notion of grand manner might not have coalesced as it did.

By the 1520s certain prints so overstepped the customary bounds that they were ordered confiscated and destroyed. In the notorious case of *I Modi* (c.1527), Marcantonio Raimondi engraved designs after Giulio Romano showing the gods making love, published together with sonnets by Pietro Aretino. Vasari commented coyly on the prominent households from which impressions were confiscated. This accords with the report, also by Vasari, that members of the papal circle adjudicated a dispute between Marcantonio and Baccio Bandinelli over whether the engraving adequately rendered the latter's drawing. Vasari, no friend of Bandinelli's, reported that the decision was in the engraver's favour.

Very quickly prints were used to convey factual visual knowledge about the world, in maps, floras and faunas, anatomical and surgical treatises, and cosmographical charts, even in tracts on arms, armaments, and engineering. When Sebastiano Serlio (1475–1554) started regularizing architectural

practice with his illustrated Books on Architecture beginning in 1537, he was benefiting from decades of standardized visual information in other practical disciplines. The whole notion of collecting specimens, so crucial to the development of science, has precedent in the collecting of printed images.

For the Italians, the phenomenon of printmaking offered an innovative art, even in the context of an age that prided itself upon the innovativeness of all its art, and which was highly cued to the verbal core of the culture. The notion of *invenzione* (discovery), promoted explicitly in prints, derived from rhetorical theory. Its resonance lies with booklearning; it was the concept whereby the artist matched the author as one who provides ideas but not manual labour. An 'Inventor' of prints produced non-autograph art, a new proof, following on that of systematic perspective, that artists were no more dependent on a pen than a writer. The sketch, spontaneous oil painting with impasto, and etching developed sympathetically: all depended upon a belief that the visual object need not be 'perfect' in itself. The circulation of unsigned prints amongst connoisseurs made palpable the phenomenon of visual style and thereby raised questions about the adequacy of praising art merely on account of its lifelikeness. No print could claim the illusionistic power of painting or sculpture, but many displayed 'art' and 'style'.

In the north, prints satisfied a passion for surface detail that was itself incompatible with Classical style. The rich textures of landscapes, organized only by swathes of light and shadow, and the particularities of genre subjects, studied microscopically by the engraver, led seamlessly from a Late Gothic sensibility to one ripe for scientific revolution. Dürer's *Knight, Death and Devil* [**254**], for instance, serves as a pivot between the two: as ornamental as it is analytical. Reformation artists such as Lucas Cranach the Elder (1472–1553) and (temporarily) Sebald Beham (1500–50) developed the resources of printmaking in support of political and religious issues in the 1520s. Martin Luther himself called printing 'God's highest and most extreme act of grace, whereby the business of the Gospel is driven forward'.

As an artistic medium, prints are distinguished by the complete absence of a primitive or trial stage. Building as they did on the foundation of decorative arts such as metalworking, they were complex and sophisticated from the start. By 1527 their information value was clear; but not yet their susceptibility to hack work, both in their own production and as a shortcut for painters and sculptors. Reproductive printmaking had scarcely begun. Printmaking had, however, developed from an anonymous, profuse, winsomely chaotic art to a business focused on issues of attribution, authenticity, precedence, and rarity. PAE

New graphic techniques

Printmakers experimented in two areas: quality of line and tonal effects. Engraving and woodcut produced generous editions, several hundreds and up to thousands, respectively, and both produced a regular, pen-like line. Etching and drypoint yielded much smaller editions, and were characterized by a relatively ragged line, but were faster and easier to make. The process of drawing on the plate then replicated the freedom of using pen or chalk on paper.

In **241** and **242** two contrasting uses of drypoint can be seen. The former survives in only three impressions. In general the Master used drypoint for its freedom of touch and for the informality of subject possible on paper, rather than to produce a commercial edition. Here he mocks social and gender conventions, for the amusement of his aristocratic circle. Dürer, who experimented with drypoint only three times, each one a religious subject, produces a velvety richness of tone.

The chiaroscuro woodcut [**245**] made possible broad tonal description rather than the linear complexity of Dürer's woodcuts [**246**], by which he had transformed the medium from crude to pictorial graphic effects. Dürer himself never chose to use the multiple blocks of the new technique. Giulio Campagnola used a painstaking net of fleck marks, rather like stipple engraving of the eighteenth century. There are no lines in **243**. Daniel Hopfer's equally experimental etching [**244**] was made by allowing the acid to bite the surface of the plate, using the ground to protect the parts which printed white. PAE

172

241 Right: Master of the Housebook (of the Amsterdam Cabinet) (1470/1500), *Coat of Arms with a Peasant Standing on His Head* (1485/90), drypoint, 13.7 × 8.5 cm. (5⅜ × 3⅜ in.), Amsterdam, Rijksprentenkabinet, van Leyden Collection

242 Far right: Albrecht Dürer (1471–1528), *S. Jerome* (1512), drypoint, 20.8 × 18.5 cm. (8¼ × 7¼ in.), London, British Museum

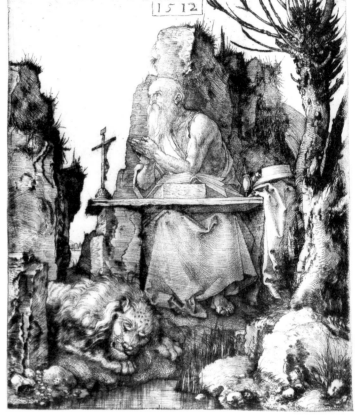

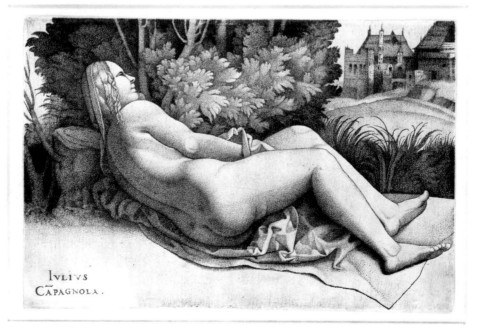

243 Giulio Campagnola (c.1482–1515), *Venus Reclining in a Landscape* (c.1508/9), engraving, 11.9 × 18.3 cm. (4⅝ × 7¼ in.), Cleveland Museum of Art

244 Daniel Hopfer (*c.*1470–1536), *Two Cupids with Sudarium* (*c.*1510?), experimental etching on iron, state II, 8.6 × 12.1 cm. (3⅜ × 4¾ in.), London, British Museum

245 Above: Ugo da Carpi (1479–1532) after Titian (*c.*1485–1576), *S. Jerome* (*c.*1516), chiaroscuro woodcut, 15.6 × 9.6 cm. (6⅛ × 3¾ in.), London, British Museum

246 Right: Albrecht Dürer (1471–1528), *The Whore of Babylon*, from *Die heimlich Offenbarung Iohnis / Apocalipsis* (1498), woodcut, 39.2 × 28.4 cm. (15½ × 11⅛ in.), London, British Museum

Pictorial complexity

Illustration **247** has been called the most influential northern European print of the period; it demonstrated that the pictorial complexity possible in engraving could compete with that of painting. Marcantonio's engraving after Raphael [**248**] took motifs from ancient sarcophagi and worked them into a new unity featuring a pictorial novelty, the nude Athena, who stands facing into the middle of the composition. The Latin inscription on the left credits beauty (FORMA) above intelligence, worldly wealth, and even virtue.

Jacopo de' Barbari's *View of Venice* [**249**] mixes the contemporary with the antique, in this case the divinities who cluster benevolently around the lagoon. The publisher was licensed by the Venetian Senate to sell the woodcut for 3 ducats a copy, three times the price of Aldus' edition of Herodotus.

Dürer's great etched landscape [**250**] led the development of landscape as a pictorial genre, practised particularly in that medium. The landscape, as God's creation, may be meant to be understood as allied with the cannon, emblem of Christian power. Made one year after Luther initiated the Reformation, the etching perhaps exhorts the Germans to Christian unity. Christian motifs (the spire and shrine on a post in the middle ground) are sprinkled through the landscape like territorial markers edging out the exotic, seemingly eastern and Muslim figures on the far right. Cannon on wheels became common in the 1460s and large cannon were important symbols of power. PAE

174

247 Right: Martin Schongauer (*c*.1440/45–91), *Procession to Calvary* (*c*.1480), engraving, 28.4 × 42.6 cm. (11⅛ × 16¾ in.) Basle, Öffentliche Kunstsammlung, Kupferstichkabinett

248 Below: Marcantonio Raimondi (*c*.1480–1534) after Raphael (Raffaello Sanzio) (1483–1520), *Judgement of Paris* (*c*.1517), engraving, 29.2 × 43.3 cm. (11½ × 17 in.), London, British Museum

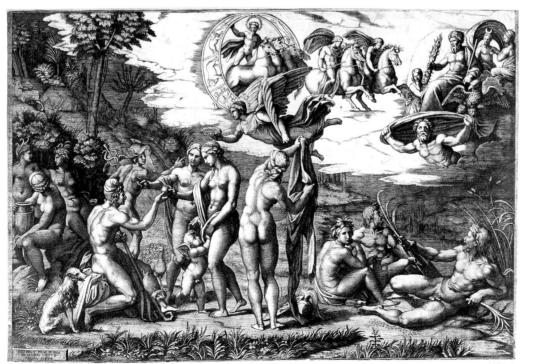

249 Opposite, top: Jacopo de' Barbari (*c*.1460/ 70–1516), *View of Venice* (1500), woodcut in six blocks, 1.39 × 2.82 m. (54¾ × 111 in.), London, British Museum

250 Opposite, bottom: Albrecht Dürer (1471– 1528), *Landscape with a Cannon* (1518), etching, 21.7 × 32.2 cm. (8½ × 12¾ in.), London, British Museum

The heroic and the humble

The male, athletic nude, the prototypical Classical subject, has been transmogrified in Pollaiuolo's *Battle* [253] into a knot of grimacing fanatics bent on mutual death. Dürer's *Knight* [254], which he referred to merely as the Rider, has been interpreted either as a stalwart figure or the fool of the demons around him. The pathetic Hagar [252] accepts the symbolically laden vessel from the father of her son, as the reprehensible patriarch Abraham orders her into the wilderness with the child, who carries bread. Her legitimated rival, Sarah, eyes her with hatred from the middle-ground, clutching her trophy heir, born in wedlock, while in the background, Hagar appears again, succoured by the angel in the wilderness.

251 Right: Andrea Mantegna (1430/31–1506), *Madonna and Child* (c.1470), engraving with the effect of drypoint, 34.5 × 26.8 m. (13½ × 10½ in.), London, British Museum

252 Far right: Lucas van Leyden (1494–1533), *Expulsion of Hagar* (c.1508), engraving, 27.5 × 21.4 cm. (10¾ × 8⅜ in.), Amsterdam, Rijksprenten-kabinet

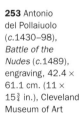

253 Antonio del Pollaiuolo (c.1430–98), *Battle of the Nudes* (c.1489), engraving, 42.4 × 61.1 cm. (11 × 15¾ in.), Cleveland Museum of Art

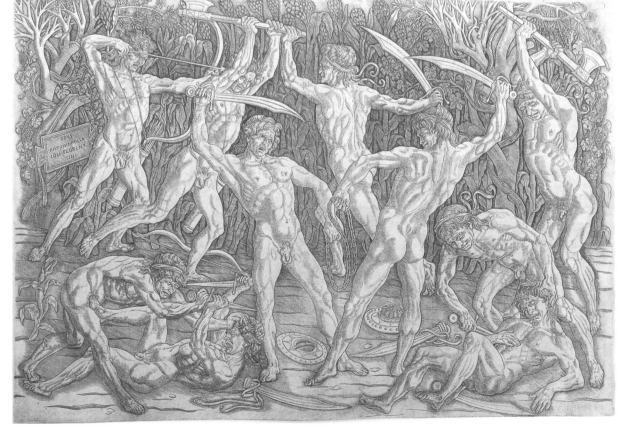

Just as each of these took what might have been a religious theme—indifference to death, fortitude, and the unwinding of God's covenant with Abraham—and developed the psychological implications of a realistic depiction to such an extent as to complicate any straightforward response, so Mantegna's humble Madonna [251] with no halo has proved confusable with an ordinary mother, seen tenderly cheek-to-cheek with her baby. Dürer's woodcut again collects male nudes, or almost nudes [255], irreverently, in this case with all the humour, accidental and deliberate, of casual conflations such as that on the left, of the cock with the loins. The arc of nudes across the front likely refers systematically to four types of temperament: melancholic, choleric, sanguine, and phlegmatic. *The Round Dance* [256] renders the male nude ridiculous, as it satirizes enslavement to the long-haired temptress holding aloft an insinuating ring.

Rather than providing straight-forward and familiar examples of virtue, prints often offered less orthodox fare. No patron's public reputation needed to be promoted or protected, so artists felt free to tweak the pictorial conventions—and in doing so might do the same for social conventions. PAE

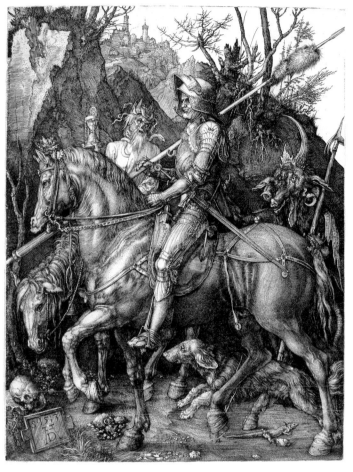

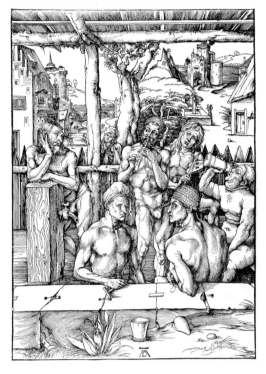

255 Albrecht Dürer (1471–1528), *The Men's Bath* (c. 1496), woodcut, 39.6 × 29 cm. (15⅝ × 11¾ in.), London, British Museum

254 Above: Albrecht Dürer (1471–1528), *Knight, Death, and the Devil* (1513), engraving, 25 × 19 cm. (9⅞ × 7½ in.), London, British Museum

256 Right: Unknown Florentine artist, *Round Dance in the Antique Manner* (c.1460s), engraving, 24.5 × 19.7 cm. (9⅝ × 7 in.), Istanbul, Topkapi Museum

3 The Art of Nations
European Visual Regimes
1527–1770

The two predominant goals of Renaissance art, the imitation of nature and emulation of Classical antiquity, set the tone not only for the immediate international diffusion of Italianate ideals in the sixteenth century but throughout the period to 1770—even when alternative styles were actively sought. This common strand runs through the two periods that are normally characterized separately, namely the Baroque and the Rococo.

The two predominant types of figurative art are the large-scale ensemble, in which paintings and three-dimensional components are combined, and the easel painting, which was increasingly made and traded as an item to be prized as an example of the master's work. The essays on 'Forms in Space' are designed to acknowledge the extent to which many works now in galleries and museums need to be re-envisaged in their original settings. The sections on the picture in Italy, France, Spain, northern Europe, and Britain demonstrate the wide range of national variations around the central themes of religion, secular power, and nature. Free-standing sculpture retained its potency in asserting the magnificence of secular authorities, and, in Catholic countries, the glories of the church. Art conceived according to these functions was exported by the imperial powers to the territories that they progressively subjugated.

The way that the climate for the production of art was radically affected by the supporting structures which grew up to promote its status is recognized in the section devoted to academies, theories, and critics. Throughout, it is apparent that definable 'publics' for painting, sculpture, prints, and domestic decoration were served by new and revived genres of art.

Themes
In a period punctuated by large-scale wars and more localized instability, a significant number of the nation-states of Europe assumed a more-or-less enduring shape, even to the extent that territorial and religious conflicts effectively became institutionalized. The relations between church and state remained crucial, but there was no longer (even in name) a single European church and each of the varied states struck its own political bargains with the institutions within its geographical compass. The contrasts ranged from the federated Protestant states of Holland to the militant Catholic monarchy of Spain.

In a succession of states, academies arose which both aspired to meet the demands of 'intellectual' practitioners of the 'Fine Arts' and became organs through which rulers could shape the institutions and practice of art at an official level. The doctrines promulgated by the academies enshrined the concept that had become the shared aspiration for internationally minded artists during the sixteenth century, namely the achieving of a style of absolute validity, based on the 'scientific' principles of the imitation of nature, under the guidance of the beauty, heroic grandeur, and narrative decorum attributed to ancient art.

Yet accompanying the Latin ideal was the increasing assertiveness of national vernaculars, as manifested through ever more widely ranging bodies of writing, not only poetry and fiction but also on such learned subjects as science. The pictorial equivalent to the literary vernaculars may be seen in the increasing portrayal of 'everyday' subjects—genre paintings, topographical art, domestic portraiture, and still life—which reached its apogee in seventeenth-century Holland, where religious subjects were restricted by Protestant mores, and where the owning of pictures extended far beyond the traditional nobility and very rich.

In sharpest contrast is the marvellous flowering of Baroque and Rococo complexes of painting, sculpture, and architecture, led by the re-invigorated grandeur of papal Rome. Yet the Catholic countries did not share altogether common visual currencies. The highly individual blend of intense spirituality and painterly naturalism in Spain, and indeed the strong regional accents in Spain itself, indicate how far the period resists sweeping generalization. It was an era in which the autonomous 'easel' painting came into its own, yet one in which large-scale painting played a dynamically integrated role in religious and secular decoration, and in which the domestic 'interior' itself became a work of art.

In thinking of the figurative arts, we should not forget that the 'Fine Arts' were part of a wide spectrum of illustrative imagery, in maps, prints, and above all in books, ranging from the 'facts' of science and technology to the 'fictions' of literature. The extended reach of sophisticated imagery into new levels of society affected the academies, which became more and more involved in public exhibitions, led by the French Salon. The academies and other forums for the display and marketing of art were exposed to tastes not preconditioned by traditional ideals, and occasioned the birth of 'art criticism'. By 1770 we can legitimately talk of a 'public' for art. MK

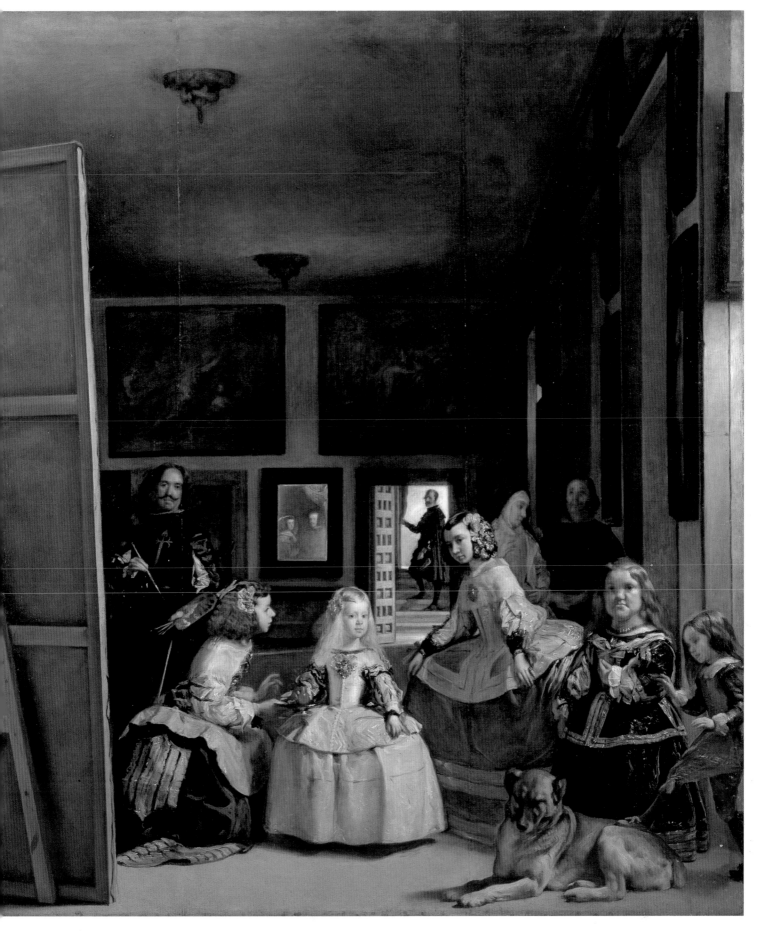

257 Diego Velázquez (1599–1660), *Las Meninas* (1656), oil on canvas, 3.21 × 2.81 m. (10 ft. 8½ in. × 9 ft. 4 in.) Madrid, Prado

The International Style 1527–c.1600

The most striking feature of European artistic life in the sixteenth century is the pervasiveness of Italian influence. The movement of artists from the peninsula to other countries and the practice, widespread among foreign artists, of spending a period of study in Italy, are but an aspect of this process, less a cause than a symptom. And though in some cases the phenomenon may seem to involve a simple dissemination of 'style' among artists, or of 'taste' among patrons, a comprehensive view yields more complex and profound motives, ones that can be said to revolve around the emergence of a new sense of what art is or should be. This redefinition was itself part of a larger cultural pattern: the admiration and imitation of things Italian extended to literature, speculative thought, and polite conduct. If we recall that the emperor Charles V was said to have kept three books by his bed wherever he went—the Bible, Machiavelli's *Prince* (1532), and Baldassore Castiglione's *Courtier* (1514)—we have a clear indication of both the immense importance of Italian culture and of the context within which Italian artistic achievements were understood and valued.

Much of the authority of Italian art depended on what was felt to be its relation to Classical antiquity. An 'Italian', especially a 'Roman', style usually signified 'classical', and classical, of course, meant 'universal'—not the style of a particular time and place so much as simply 'good' style, the right and proper way to do things. The idea that such a universal art had been recovered in Italy, principally in Florence and Rome in the decades around 1500, was widespread: it was given compelling expression in

258 Right: Giambologna (Jean Boulogne, Giovanni Bologna) (1529–1608), *Astronomy* (*c*.1573), gilt bronze, 39 cm. (15⅜ in.), Vienna, Kunsthistorisches Museum

259 Opposite: Wenzel Jamnitzer (1507/8–85), table ornament (1549), silver, partly gilt and enamelled, 100 cm. (39⅜ in.), Amsterdam, Rijksmuseum

Giambologna, a Northerner who settled permanently in Florence, became famous for bronze figures in which he demonstrated his knowledge of anatomy and of Classical ideals, yet also treated the body with striking freedom: his personification of Astronomy, for instance, draws attention to the elegant artifice of its formal arrangements. Jamnitzer's table ornament makes use of Classical forms and ideas: a Latin inscription identifies the female figure as a personification of Earth. The object as a whole thus becomes a celebration of fertility, and one which, by virtue of its astonishing technical refinement, invites reflection upon the theme—something of a commonplace in sixteenth-century thought—of the relation of art to nature.

Giorgio Vasari's (1511–74) *Lives of the Artists* (1550, 1568) and is substantially endorsed, for instance, by the Netherlandish artist-writer Karel van Mander (1548–1602), author of *The Book of Painting* (1604)—an endorsement that did not prevent van Mander from setting a high value on the achievements of his own countrymen. Because Italian art was commonly believed to be universal, it makes more sense to think of Italian influence as part of a process of internationalization. And because something more than mere style was at stake, because Italian art was as much a set of practices and values as a particular 'look', it offered room for creative adaptation.

The dissemination of Roman style throughout Italy began even before the disastrous sack of the city by imperial troops in 1527: the decline in patronage attending the pontificate of Adrian VI, for instance, persuaded many artists to seek employment elsewhere. Giulio Romano (*c*.1499–1546), who had been the chief assistant of the great Raphael (Raffaello Sanzio) (1483–1520), moved to Mantua in 1524, spending the rest of his life in the employ of the ruling family, the Gonzaga. Another assistant of Raphael's, Perino del Vaga (1501–47), went to Genoa after the sack, where he served Andrea Doria; a third, Polidoro da Caravaggio (1499–1543), worked in Naples and Sicily. All three practised in a variety of media: Giulio was an architect and interior decorator as well as a painter; like Perino and Polidoro he also produced designs for ornamental tableware. The ideal of omnicompetence these artists seemed to embody was as much a legacy of Raphael as the style of their work.

Another legacy of Raphael was a distinctive approach to the creative process. Having mastered a somewhat provincial late fifteenth-century style in the course of his training, he was perceived to have deliberately borrowed and synthesized the best features of forward-looking painters such as Leonardo da Vinci (1452–1519), Michelangelo Buonarroti (1475–1564), and Fra Bartolommeo (Baccio della Porta) (1475–1517). The result was not just a new style of his own, but a new approach to the problem of artistic self-fashioning, one that became a model for many younger artists: part of its appeal was the fact that it seemed to offer an alternative to the limitations of the traditional apprenticeship system. This approach became the basis of the new type of artistic education developed in 'academies', associations of artists that began to proliferate in the sixteenth century, first as informal clubs, then as formally incorporated institutions. To understand why Raphael was so immensely important, we must realize that he was felt to have shown more effectively than anyone else how imitation might become a path to individuality.

Yet another influential aspect of Raphael's achievement, closely related to the issue of education, was the organization of his workshop. As he became more sought-after, he devoted most of his energy to design, delegating much of the responsibility for execution to his numerous assistants. This arrangement seems to have been highly structured, and to have pointed towards the ideal of a wholly rationalized working process. We no longer regard such systematization as a positive aesthetic value, but Renaissance artists found it exciting, in part because it seemed to show that their work was of a rational kind, deserving of the esteem commonly reserved for the highest intellectual pursuits.

Not only Raphael's students were involved in the dissemination of Roman style. The Florentine painter Francesco Salviati (1510–63) spent a formative period in Rome, returning to his native city in 1545, where his fresco decoration for a large room, the Sala d'Udienza, in the Palazzo Vecchio introduced what was understood to be a 'Roman' style—and dependent upon Raphael, even though modern art historians, attentive to its exaggeration and conspicuous artificiality, usually classify it as 'mannerist'. The Florentine sculptor and architect Jacopo Sansovino (1486–1570), who had also worked in Rome, fled to Venice at the time of the sack, where he spent the rest of his life: he was credited with having brought the 'true manner' of ancient architecture to Venetian territory. Even Venetian painting did not remain impervious to central Italian influence: the painter Tintoretto (Jacopo Robusti) (1519–94) wanted to com-

bine the colourism of Titian with the drawing of Michelangelo in a kind of synthetic process modelled on Raphael's.

In France, the vigorous cultivation of Italian art began under Kings Charles VIII and Louis XII, reaching a climax under Francis I. Francis imported artists such as Leonardo da Vinci, Andrea del Sarto (1486–1530), and Benvenuto Cellini (1500–71). The enlargement and decoration of his country estate of Fontainebleau was entrusted to the supervision of Rosso Fiorentino (1494–1540), a Florentine who had spent some years in Rome and had fled the sack, and Francesco Primaticcio (1504/5–70), a Bolognese who had trained under Giulio Romano at Mantua. These artists, along with their French collaborators, developed a style distinctive for its extravagant and deliberate artificiality. Among the artists who adapted this style in an individual and highly creative fashion were the sculptor Jean Goujon (c.1510–c.1565), the architect Philibert de l'Orme (1514–70), and, somewhat later, the printmaker Jacques Bellange (c.1575–1616). Italian taste swept over Spain a little

260 Below: Pieter Bruegel the Elder (c.1525/30–69), *Peasant Dance* (c.1568), oil on panel 1.14 × 1.64 m. (45 × 64½ in.) Vienna, Kunsthistorisches Museum

Bruegel's scene of peasant life avoids classicizing idealization, yet its style, so well suited to its subject-matter, acknowledges the possibility that other styles might be appropriate to other subjects: it might thus be said to signal its place in a hierarchy of stylistic possibilities in which classicizing idealism is reserved for heroic themes.

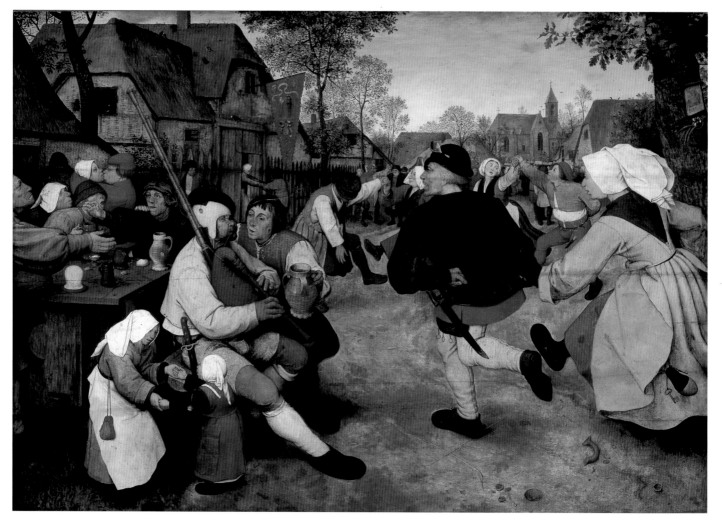

later, but again it was linked to royal patronage. The climax of the process is the great architectural complex called the Escorial, begun in 1562 for Phillip II, which was planned by two Spaniards, Juan Bautista de Toledo (c.1515–67) and Juan de Herrera (c.1530–97), though the design for the church was supplied by an Italian, Francesco Paciotto (1521–91), and much of the decoration carried out by Italians. Remote, monumental, and austere, the Escorial could not be more unlike Fontainebleau, an indication of the fact that the appeal of Italian classicism was multifaceted.

Whereas in France and Spain Italian influence was associated primarily with royal patronage, in the Low Countries and German-speaking lands the situation does not lend itself to such easy generalization. The process seems to have been driven by the professional ambition of the artists themselves, accompanied by a gradual shift of taste among several classes of patrons. The shift in taste may only in part have worked its way down from above: the emperors, especially Charles V, favoured Classical style—its associations being especially appropriate to those who saw themselves as the heirs of Caesar Augustus. Some aristocratic patrons seem to have followed the lead of the imperial family, and this process certainly had an impact on the lower nobility and non-noble patrons, but the independent role of commercial and scholarly networks should not be overlooked. The involvement of Albrecht Dürer (1471–1528) with Italian art, for instance, seems to have been sparked by his own curiosity and encouraged by the concerns of the humanists with whom he associated.

Netherlandish artists had certainly always been aware of developments in Italy, but a marked 'Romanism' becomes apparent in the work of certain painters shortly after 1500. Jan Gossaert, called Mabuse, of Antwerp (c.1478–1532), painted mythological scenes featuring Classical architectural settings and figures dependent on ancient statuary: his interests may have been stimulated by his patron, the Habsburg prince, Phillip of Burgundy, who took him to Italy early in his career. Jan van Scorel (1495–1562), in Italy between 1519/20 and 1524, returned to Utrecht and worked in a style combining elements from Venetian painting, Raphael, and Michelangelo.

Romanism gathers momentum in the next generation. Maerten van Heemskerck (1498–1574) worked in Italy in the period 1532–5, then returned to Haarlem, where he remained active until 1574. In addition to paintings, he produced a large number of designs which were engraved and printed by others: the emphasis thus placed on his 'invention' rather than his 'execution' served to identify him as an artist in the mould of Raphael. Many of his designs concern allegorical or mythological themes, and were developed with the help of the scholar Hadrianus Junius: this kind of collaboration was also associated with Italian practice. Lambert Lombard of Liège (1505–66) worked in Italy between 1537 and 1538/9, returning to found an academy on the model of those he had encountered during his stay; he also produced designs for engravings executed by others. Frans Floris of Antwerp (1519–70), in Italy from 1541/2 to 1545, was an important influence until his death in 1570, as much through his teaching as his own work: van Mander noted that his large shop was organized according to Italian models.

Three painters who spent extensive periods in Italy towards the end of the century were Bartholomeus Spranger (1546–1611; in Italy 1565–75), Hans von Aachen (1552–1615; in Italy c.1574–1587), and Joseph Heintz (1564–1609; in Italy 1584–c.1591), all later employed by that most cosmopolitan of patrons, Emperor Rudolf II. Their work is characterized by great technical refinement, an assured yet understated, often witty synthesis of Italian sources. The brilliant draughtsman and printmaker Hendrick Goltzius (1558–1617) of Haarlem, active at the end of the century, showed similar sophistication and stylistic range.

Several Netherlandish artists remained in Italy, where they became leading figures in artistic life: the painters Jan van der Straet (known as Stradanus or Stradano) (1523–1605) in Florence and Denis Calvaert (c.1540–1619) in Bologna are examples. The best-known, Jean Boulogne (1529–1608) of Douai, who settled in Florence in 1558/9, where he came to be known as Giovanni Bologna (or Giambologna), became the most successful and influential sculptor in Italy between Michelangelo and Bernini. Lambert Sustris of Amsterdam (c.1510/15–c.1560) found lifelong employ in Venice, in the studio of Titian. His son, Friedrich (c.1540–99), born in Venice, worked under Vasari in Florence in the 1560s before being called to Munich, where he served the royal family of Bavaria in a wide range of artistic projects, as Vasari had served the Duke of Florence and Giulio Romano the Duke of Mantua.

If all this seems to suggest a wholesale abandonment to Italian influence, one must remember that some artists of the first rank, such as Hieronymus Bosch (c.1450–1516) and Matthias Grünewald (c.1475/80–1528) at the beginning of the century, escaped it entirely, and that others engaged it in a complex, dialectical fashion. The classic case is that of the German painter and printmaker Albrecht Dürer of Nuremberg, who made two trips to Venice (1495, 1505–7). He appropriated the colourism characteristic of Venetian painting, but was also prompted to undertake a sustained study of perspective, anatomy, and ancient standards of ideal beauty. At the same time, his work testifies to a deep conviction that his native tradition possessed virtues worth preserving.

Pieter Bruegel the Elder (c.1525/30–69), possibly a native of Breda, also went to Italy in his youth (1551–c.1554), but the influence of this experience is far less obvious in his work than in that of any other Northerner who made the trip. He developed a style that pointedly avoids classicizing idealization, ostensibly in the interests of a more direct and honest rendering of nature. This style was felt to be especially appropriate to the scenes of peasant life for which he came to be known: some of these pictures, at least, seem to be positive celebrations of folk culture, and even of specifically local traditions. To the extent that his work can be said to posit an 'alternative aesthetic', it presupposes a profound understanding of what it defines itself against. Yet a taste for Bruegel did not require adherence to any such aesthetic: one of his principal patrons also owned a large collection of pictures by Frans Floris.

The internationalization of European art continues into the seventeenth century and beyond: perhaps its most outstanding representative is Peter Paul Rubens (1577–1640), who spent a period of study in Italy between 1600 and 1608. RW

Monumental decoration

These images illustrate the dissemination of a style of monumental decoration developed in early sixteenth-century Rome. The frescoes illustrating episodes from the myth of Cupid and Psyche in the suburban villa of the wealthy banker Agostino Chigi were designed by Raphael but executed by his assistants [**261**]. The treatment of the myth combines a reverence for ancient art—several of the figures are quotations of famous ancient statues—with a lively eroticism. Considered appropriate to a private setting, removed from the serious business of urban life, this combination of artistic sophistication and liberated sensuality says a great deal about the values associated with Classical antiquity, and it was widely imitated. Giulio's illustration [**262**] of the same story in the Palazzo del Te, a suburban villa belonging to the Lords of Mantua, was surely intended to refer explicitly to Raphael's famous frescoes. Rosso's paintings at Fontainebleau [**263**] are similar in subject-matter and treatment; the elaborate and refined stucco work that surrounds them was also based on a style developed in Rome, in imitation of the Antique. RW

184

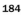

261 Raphael
(Raffaello Sanzio)
(1483– 1520) and
assistants, Loggia
di Psiche (1517–
19), Rome, Villa
Farnesina

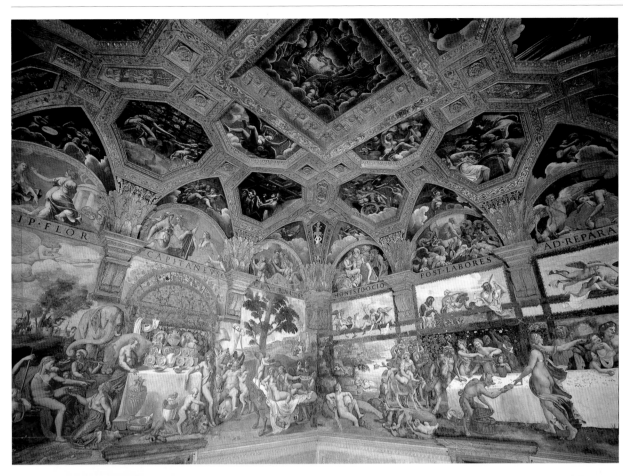

262 Giulio Romano (c.1499–1546), Sala di Psiche (1528–30), Mantua, Palazzo del Te

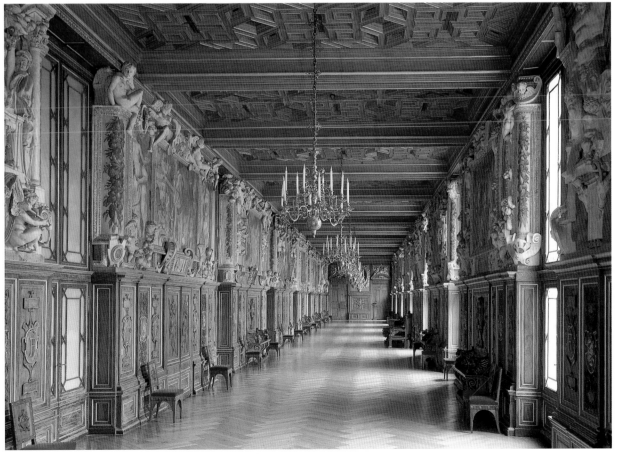

263 Rosso Fiorentino (1494–1540), Galerie François I (1533–40), Fontainebleau

The human figure

Gossaert's *Neptune and Amphitrite* [266] is one of the earliest attempts by a northern European to address the challenge of Italian art. The artist takes pains to demonstrate his mastery of anatomy and of an ideal of physical beauty derived from ancient statuary. He seems to want to make his figures look like statues, an effect that emphasizes their artificiality. Van Heemskerck's picture [264], painted shortly after his return from Italy, refers to a passage of Virgil's *Aenied* (VIII, 416–53), and shows a careful appropriation of elements from ancient sculpture, Raphael, Michelangelo, and their Italian imitators. The unknown artist of the School of Fontainebleau who painted the elegant portrait of Diane de Poitiers, a mistress of the king of France, in the guise of the Goddess Diana [267], drew upon the style of the Italian Primaticcio, himself dependent upon Parmigianino and Raphael. Spranger's facile elegance and wit [265] reflect an easy familiarity with Italian models and the taste for such sophistication among patrons like the emperor Rudolf II.

RW

186

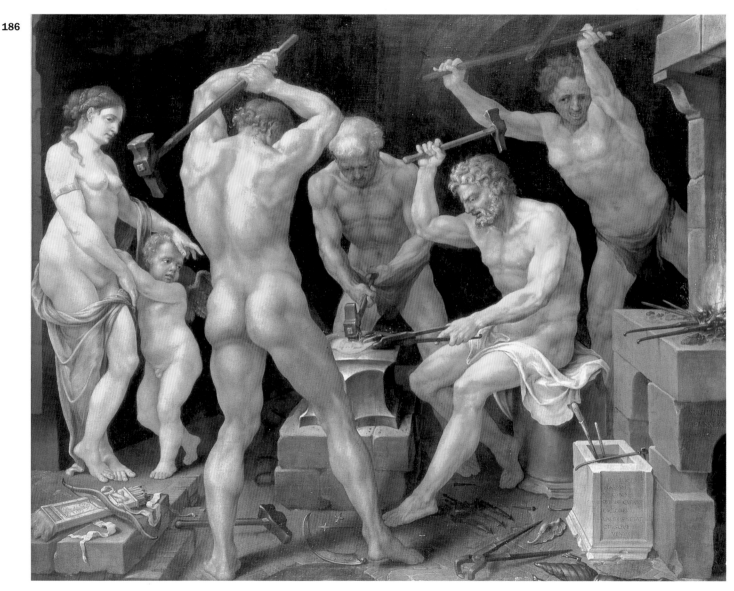

264 Maerten van Heemskerck (1498–1574), *Venus and Cupid in the Smithy of Vulcan*, (1536), oil on canvas, 1.67 × 2.07 m. (65¾ × 81½ in.), Prague, National Gallery

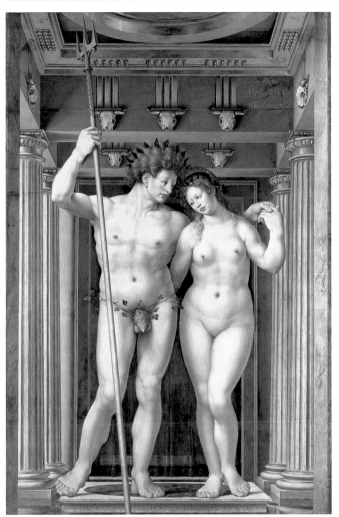

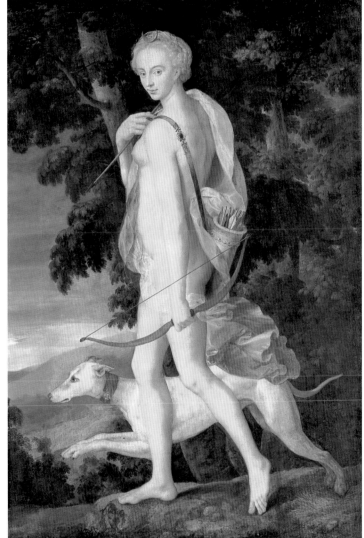

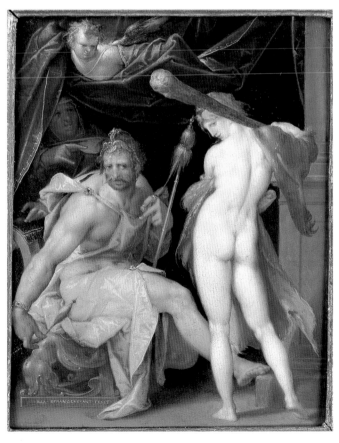

265 Left:
Bartolomeus
Spranger
(1546–1611),
*Hercules and
Omphale*
(*c.*1585), oil on
copper, 24 × 19
cm. (9½ × 7½ in.),
Vienna,
Kunsthistorisches
Museum

266 Above left:
Jan Gossaert
(Mabuse)
(*c.*1478–1532),
*Neptune and
Amphitrite* (1516),
oil on panel, 1.88
× 1.24 m. (74 ×
48¾ in.), Berlin
(formerly
Staatliche
Museen)

267 Above right:
School of
Fontainebleau
(sixteenth
century), *Diana
the Huntress*
(*c.*1559/60), oil
on panel, 1.92 ×
1.33 m. (75¾ ×
52⅜ in.), Paris,
Louvre

Forms in Space 1527–*c.*1600

188 The key role of Italy in this period owed much to the predominance of Michelangelo Buonarroti (1475–1564), whose talents were so awesomely superhuman (*terribilità*) that he was regarded as 'divine'. He had matched the achievements of Classical sculptors, especially the celebrated statues in the Belvedere court in the Vatican, as well as those of his immediate predecessors. By the time Michelangelo left Florence for Rome in 1534, he had carved the majority of his sculpture, and yet only half of the statuary intended for the Medici tombs was completed, while the tomb of Pope Julius II was severely curtailed: none of the famous *Slaves* or *Victories* was installed, but only the statue of *Moses*. He did carve two new statues, *Rachel* and *Leah*, to go with it around 1542, but thereafter only managed to make botched beginnings on two groups of the *Pietà* (Florence, Museo dell'Opera; Milan, Castello Sforzesco).

Nevertheless, Michelangelo's presence loomed from Rome over the younger generation. Baccio Bandinelli (1493–1560) made vain attempts to emulate Michelangelo, but the characterization of his figures was weak. It was characteristic of the period to set up academies in order to put into practice the principles of current artistic theory and Bandinelli founded one in Rome in the 1540s, while he readily delegated work to trained assistants. In sculpture such delegation is even more necessary than in painting, for hewing blocks of marble, or preparing wax models for casting into bronze, is far more laborious. Benvenuto Cellini's (1500–71) description in his *Autobiography* of how he cast his *Perseus and Medusa* [**269**] is indicative of the travail involved. The codification of art practice as a theoretical and intellectual endeavour was performed for sculpture and goldsmithing by Cellini in his *Treatises* (1571).

In the mid-sixteenth century, nearly every sculptor tried his hand at themes hallowed by Michelangelo. His intention of placing on the tomb of Pope Julius II a series of *Victories* was well known. This occasioned a succession of variations on the theme, beginning in 1534 with Bandinelli's *Hercules and Cacus* [**268**]. Other sculptors followed suit, but the prize for emulating Michelangelo goes to a Flemish-trained immigrant, Giovanni Bologna (also called Jean Boulogne or Giambologna) (1529–1608). In 1560 he was commissioned to realize in marble *Samson Slaying the Philistines*, a subject for which Michelangelo had left a wax model (preserved in bronze casts). Giambologna depicted a mortal struggle that was more realistic and dramatic—indeed more classical—than most of its predecessors. Next, he made a pair to Michelangelo's own group of *Victory*, reverting to the initial idea of a female victor, with a topical political theme, *Florence Triumphant over Pisa.* Finally, Giambologna set his mark on the Piazza della Signoria—and on the history of

sculpture—in 1583, when he unveiled a group of three figures—again a challenge of Michelangelo's [**269**].

While this series of groups forms the backbone of the Italian sculptural tradition, other subjects—notably portraits—and other sorts of sculpture—bronzes and narrative reliefs that Michelangelo had not attempted—were also being produced. The sheer size and potential of sculpture for display in the open air, its consequent impression of grandeur and permanence, and hence its connection with the ideals of the ancient world offered considerable potential for political propaganda. A ruler's authority could be promoted by an image in armour and/or on horseback in public, while his munificence could be stressed by, for example, the construction of a fountain in a city centre, which apart from being a delight for the eye had a practical value in supplying fresh water for his subjects: most famous are Bartolommeo Ammannati's (1511–92) *Fountain of Neptune* in Florence [**271**] and Giambologna's one in Bologna (1563–7).

Such sculptures—be they portraits or allegories—were also often the focus of squares or crossroads: indeed the crowning glory of the Piazza della Signoria was Giambologna's bronze statue of Duke Cosimo [**270**]. The idea of an equestrian image like a Roman emperor proved so alluring to rulers that Giambologna purveyed them as far afield as Paris and Madrid, while local sculptors imitated them in London and Innsbruck.

In Venice, Jacopo Sansovino (1486–1570), while principally employed as Architect of S. Mark's, managed to find time to generate models in wax for casting into bronze. Rapid modelling produced expressive tactile effects, suggesting movement and drama, in his *Miracles of S. Mark* on the singing galleries in the Basilica [**275**] (*c.*1557–42) and in his scenes from the *Passion of Christ* on the bronze door of the Sacristy (1546–72). Sansovino also produced models for bronze statues (four allegorical *Virtues of Venice* (1540–5) on the Loggetta beneath the Campanile) and for statuettes (*Four Evangelists* on the altar-rail of S. Mark's). The involvement of various other sculptors and foundrymen in the manufacture of these important projects initiated a veritable school of bronze statuary in Venice, the leading lights being Girolamo Campagna (1550–1626) and Alessandro Vittoria (1525–1608). They also all produced work in marble, stone, terracotta, or stucco [**274**].

In Florence Giambologna, after the signal success of his monumental bronze figures on the *Fountain of Neptune* and statue of *Flying Mercury*, both in Bologna (*c.*1563), paid as much attention to making statuettes [**277**]. A commercial success, this disseminated examples of the finest Florentine craftsmanship across Europe—for example, to Dresden, London, and Prague, where Emperor Rudolf II built up the finest collection in the

world (Vienna, Kunsthistorisches Museum), as well as to bourgeois art-collectors in Antwerp. These artefacts created bridgeheads which Giambologna's followers were able to exploit: Hubert Gerhard (*c*.1550–1622) worked in Augsburg and Munich; Hans Reichle (*c*.1570–1642) in Munich; and Adriaen de Vries (pre-1546–1626) first in Augsburg [**280**] and then, principally, in Prague for Rudolf II.

This was one of the greatest cultural diasporas ever known, re-educating the taste and reviving the enthusiasm of northern Europe, where the development of sculpture and architecture had been gravely interrupted by continual wars of religion. An extreme manifestation of Protestantism was the destruction of religious imagery, heretofore a mainstay of sculpture. Even worse traumas occurred in the Low Countries, where the partition of Protestant north from Catholic south led to such total destruction that the event was called the 'Storming of Statues': as a result, the life's work of some sculptors was decimated and of others totally dispersed. For example, the greatest series of bronze statuary, depicting the ancient gods, by Jacques Jongheling (1530–1606), a pupil of Leone Leoni in Milan and later Master of the Mint in Antwerp, is in Madrid (Palacio Real). In the Roman Catholic realm of Spanish Flanders, however, alabaster and wood carving of Christian imagery flourished unabated: indeed the market was enhanced by the demise of former rivals in Nottingham for alabaster altarpieces; and in Holland for oak retables and house-altars.

In France sculpture flourished under the patronage of King François I, his courtiers, and his successors, often tending towards the sensuous, pagan subjects and intricate quasi-architectural ornament of the School of Fontainebleau. After the sack of Rome, the king hired two Italian Mannerist painters, Francesco Primaticcio (1504/5–70) and Fiorentino Rosso (1494–1540) to head a team for the interior decoration of his new palace of Fontainebleau with frescoes framed by ornamental stucco sculpture. They were joined between 1540 and 1545 by Cellini, who created in beaten silver some statues of Classical deities as mobile candelabra for the great gallery (lost, but recorded in a drawing and bronze models). To frame the 'Golden Gate' of Fontainebleau, he cast in bronze a grandiose lunette of the *Nymph of Fontainebleau*, now in the Louvre, and a pair of *Satyr-Caryatids*. Cellini contributed to the advanced Mannerist style of Fontainebleau, and, returning in 1545, he reintegrated it into the Florentine tradition. His group of *Perseus and Medusa* is a characteristic manifestation [**269**], though his masterpiece was in his own craft, goldsmithing [**276**].

Profoundly influenced by Michelangelo too was the native French sculptor Germain Pilon (1525–90), who worked on

several major, royal projects, most importantly on the tomb in the basilica of Saint-Denis of King Henri II (1565–6) [**281**]. A rival, Barthélémy Prieur (*c*.1536–1611), alongside a succession of projects involving monumental sculpture, went in for the serial production of bronze statuettes with a wide range of subjects, from images of the kings and queens of France to sleek nude girls at their toilet: religious subjects he avoided, being Protestant.

Most sculpture in Spain continued to be carved out of wood (usually walnut or chestnut) or alabaster and constructed into huge retables reaching up from behind altars in churches to the full height of the chancels: the wooden ones were totally painted and gilded. A tendency towards hyper-realism in the faces and other flesh parts and a morbid fascination with the more gruesome episodes of the lives of Christ and his saints create a unique effect, constituting one of the greatest 'schools' in Europe. Even here the influence of Michelangelo made itself felt, through the work of Alonso Berruguete (*c*.1488–1561), who on an extended visit to Italy became one of the early Mannerist painters. But he was also a marvellous wood-carver who enhanced with paint his brilliantly contrived figures, all of which are charged with emotion [**278**].

Spain also imported sculpture—or sculptors—from Italy: for the decoration of his newly founded monastery of El Escorial, King Philip II commissioned sculpture from Leone Leoni (1509–90) and his son Pompeo (*c*.1533–1608), Milanese admirers of Michelangelo. Over the years, they produced an impressive array of dynastic statues in bronze (1548–56; Madrid, Prado), but their masterpiece consists of two life-size groups of members of the Habsburg imperial family, kneeling atop the tombs that flank the chancel of El Escorial [**279**]. The vast retable behind the high altar also contained 15 lifesize statues in gilt bronze by Pompeo Leoni.

In Germany, from 1522, Luther's ecclesiastical reforms occasioned wholesale destruction of altars, choirstalls, screens, and so on. Sculptors' livelihoods were threatened, but a few abandoned traditional Catholic iconography for the novel, pagan subjects popularized by Italian Renaissance prints.

After the Council of Trent (1545–63), Catholic Germany once again provided patronage for religious sculpture, with stone pulpits and polychromatic carved altarpieces and statues of saints in decorative, Italianate surrounds. The mid-century hiatus had made Germany especially open to Italian influence and an eager recipient of the new international style, but this would in turn slowly evolve into the early northern Baroque, which was to be an authentically German creation. CA

Sculpture in the Piazza della Signoria

This square in Florence was the traditional focus of government, where the populace voted on issues proposed from the platform in front of the city hall. From about 1495, when Donatello's statue of *Judith and Holofernes* (confiscated from the Medici Palace) was re-erected here,

the piazza became a forum for statuary with political overtones. Within a decade, Michelangelo's colossal *David* had been sited, like a sentinel, beside the portal [268], so that he looked southwards in the direction of Rome, from where the republic was threatened. A matching group was furnished by Bandinelli, a victorious Hercules, proudly surveying the piazza. In the Loggia dei Lanzi [269], adjacent to the palace

and to these statues, Cellini unveiled his group of *Perseus and Medusa*; this was intended to match Donatello's *Judith* (by then under the right-hand arch), a logical pairing that was broken when Giambologna's group of the *Rape of a Sabine* was substituted. From about 1560–70, a fountain was added at the northwestern corner of the palace, fed by a new conduit ordained by Cosimo de' Medici and centred on Ammannati's *Neptune*

[271]: influenced by the Counter-Reformation, the sculptor repented in a public letter of this shameless display of sensuous nudity (1582). The last arrival in the square was Giambologna's monument to Cosimo I (d. 1574) [270]. It thus took a century to create one of the most influential series of statuary in the world. CA

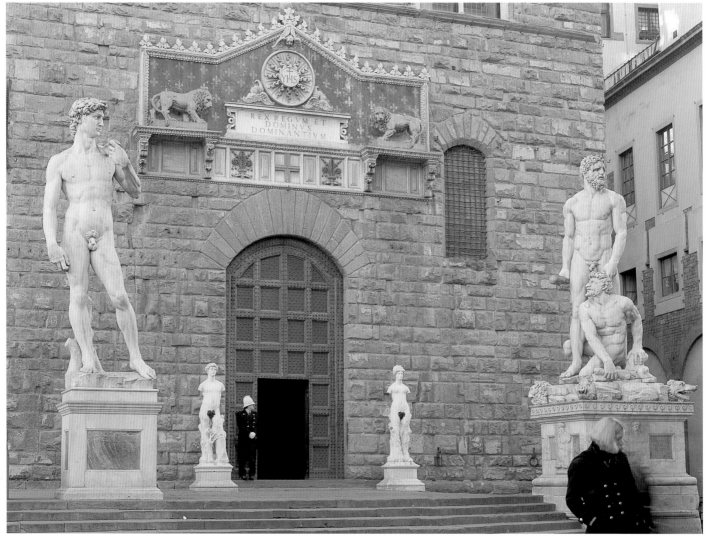

268 Above: Left foreground, after Michelangelo Buonarroti (1475–1564), *David* (1501–4)—copy (1905: original removed to Accademia, Florence, 1873), marble, *c*.4 m. (13 ft. 2 in.).

Right foreground: Baccio Bandinelli (1488–1560), *Hercules and Cacus* (1534), marble, *c*.4 m. (13 ft. 2 in.), Florence, Piazza della Signoria—flanking the portal of the Palazzo della Signoria

269 Opposite top: Left foreground, Benvenuto Cellini (1500–71), *Perseus and Medusa* (1554), bronze, 3.20 m. (10 ft. 6 in.).

Right foreground: Giambologna (1529–1608), *Rape of a Sabine* (1583), marble, *c*.4.10 m. (13 ft. 5½ in.), Florence, Piazza della Signoria—Loggia dei Lanzi

270 Opposite bottom left: Giambologna (1529–1608), *Equestrian Monument to the Grand Duke Cosimo I de' Medici* (*c*.1590), bronze, *c*.4.50 × 4 m. (14 ft. 9 in. × 13 ft. 1½ in.), marble pedestal with bronze reliefs, Florence, Piazza della Signoria

271 Opposite bottom right: Bartolommeo Ammannati (1511–92), *Fountain of Neptune* (1560–75), marble, *c*.9 m. (30 ft.), with subsidiary lifesize mythological figures in bronze, Florence, Piazza della Signoria (1898)

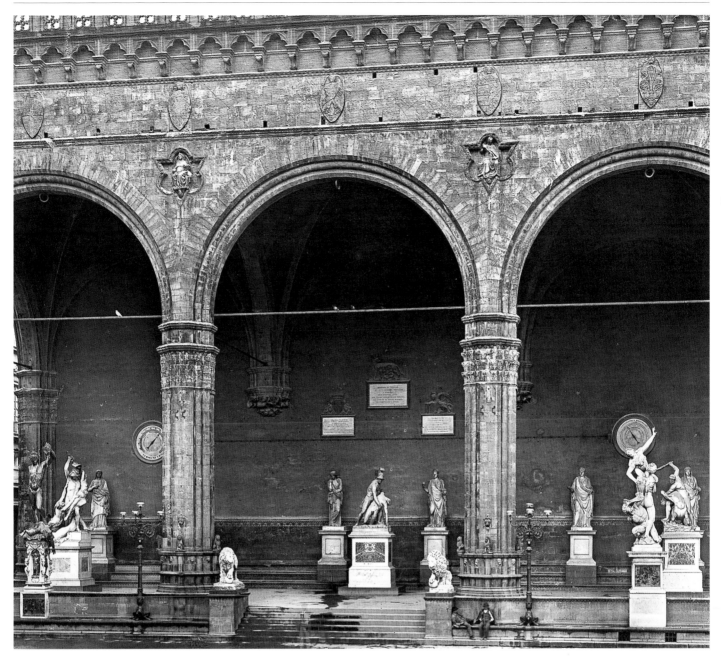

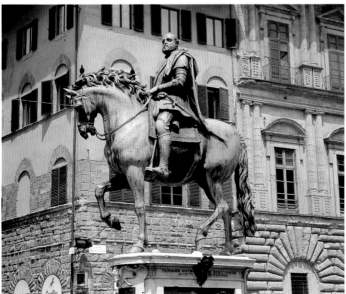

The world of the Mannerist sculptor

Garden sculpture, reliefs, portraits, and statuettes—fields that Michelangelo neglected—offered scope to his successors.

Duke Cosimo started the fashion for garden sculpture in about 1540 with the construction of a new 'water-garden' at Il Castello, a villa just outside Florence. It was lavishly furnished with statues, monumental fountains, and an ornamental grotto, populated with groups of animals in coloured stone and a flock of bronze birds by Giambologna (1567; now Florence, Bargello). The superintendent was Niccolò Tribolo (1500–50), who had briefly helped Michelangelo on the New Sacristy: here he adapted the serious style of his master to more light-hearted ends [272].

Shortly afterwards Cosimo's Duchess began to lay out the Boboli Gardens in a similar manner with fountains and statues of Classical figures and of country-folk—a diverting novelty. Bernardo Buontalenti (c.1531–1608) later created here the 'Great Grotto' [273].

In the Great Grotto, Buontalenti even employed Michelangelo's unfinished *Slaves* as supports at the corners (now plaster copies). A pergola and open sky with animals and birds were frescoed on the vault. Even such an apparently light-hearted scheme had an intellectual basis: the myth of creation according to the Classical account. The next Medici grand dukes built another even more extensive villa at Pratolino, in the foothills of the Apennines. It had subterranean grottoes animated by water-powered automata enacting stories, while outside there were

192

272 Left: Niccolò Tribolo (1500–50) and Bartolommeo Ammannati (1511–92), *Fountain of Hercules* (c.1500), marble and bronze, Florence, Villa il Castello

273 Above: Bernardo Buontalenti (c.1531–1608), the Great Grotto (1583–7), edifice made out of lava, marble, fresco painting, Florence, Boboli Gardens, near the Pitti Palace

274 Left: Alessandro Vittoria (1525–1608), *Self-portrait* (c.1570), terracotta, 80 cm. (31½ in.), London, Victoria & Albert Museum

water-features, enlivened with genre statues—washerwomen and fisherfolk. The masterpiece is a brick and stucco crouching giant by Giambologna (*c*.1580), so big that there are rooms inside the body: his humped back represents the Apennines. Similar, formally laid-out gardens full of jokes (*scherzi*), ornamental statues, and water displays (*giuochi d'acqua*) were built all over Italy at the period, some of the most

marvellous being those in and around Rome, but the fashion spread through southern Germany and France as far as England.

Sansovino took up the tradition, which caught his imagination in Venice and Padua, of producing vivid narrative reliefs in bronze [**275**]. His follower, Vittoria, also produced myriad small reliefs in stucco, picked out with gilding (for example, his 'Golden Staircases' in the Ducal

Palace and the Library of S. Mark's), while he became the greatest portraitist of the century [**274**].

Meanwhile, Giambologna emerged in Florence as the master *par excellence* of the bronze statuette, producing in series a number of sophisticated male and female nudes, composed in serpentine attitudes, such as the *Flying Mercury* [**277**]. Equally sensuous is the salt-cellar composed intellectually by Cellini,

like a piece of sculpture [**276**]. Its two nude figures represent sea and land, respectively presiding over the condiments of salt and pepper. Figures in ovals below are inspired by Michelangelo's *Times of Day*. CA

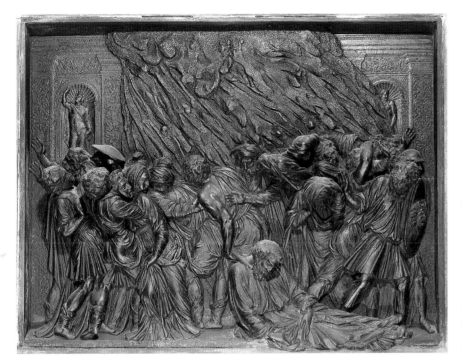

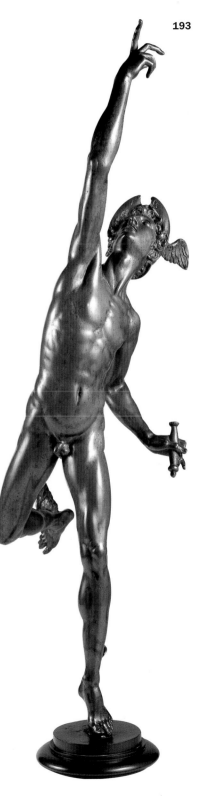

193

275 Left top: Jacopo Sansovino (1486–1570), *S. Mark's Corpse Dragged through the Streets of Alexandria* (1537), bronze, 48.5 × 63.5 cm. (19⅛ × 25 in.), Venice, S. Mark's Basilica, Choir Galleries

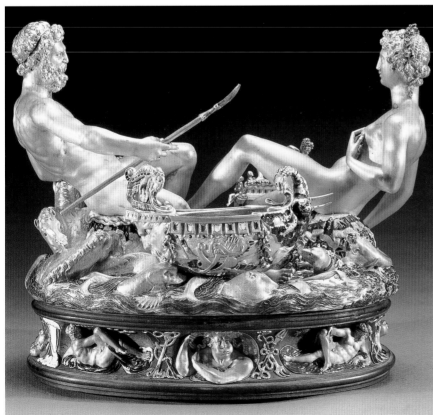

276 Left bottom: Benvenuto Cellini (1500–71), salt-cellar, with Neptune and Ceres (1540–3), gold and enamel, 26 × 33.5 cm. (10¼ × 13¼ in.), Vienna, Kunsthistorisches Museum

277 Right: Giambologna (1529–1608), *Flying Mercury* (1570–80), bronze, 62.7 cm. (24¾ in.), Vienna, Kunsthistorisches Museum

Sculpture in Spain and northern Europe

Owing to the warlike spread of Protestantism over much of northern Europe, the scope of sculpture was greatly curtailed. Christian imagery survived chiefly in the Roman Catholic areas, notably in Spain, where carved retables were painted and gilded (with leaf made out of gold from conquests in the Americas). The paint was applied over the gold and then partially 'scratched' off so as to let it show through [**278**]. It is indicative of Italian artistic supremacy that the greatest complex of portrait and figurative sculpture in gilt bronze of this period—the Habsburg tombs and the retable in El Escorial [**279**]—is to be found abroad. In France advances in anatomical knowledge were reflected in the depiction of patrons

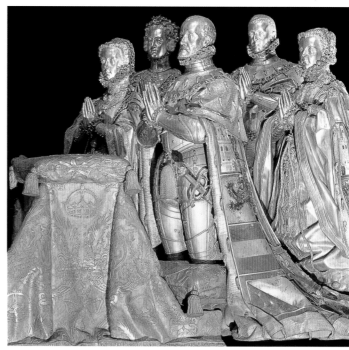

278 Below: Alonso Berruguete (*c.*1488–1561), *The Sacrifice of Isaac* (1532), from the Retablo di S. Benito, wood painted and gilded, 95 cm. (37⅜ in.), Valladolid, Museo Nacional de Escultura

279 Above right: Leone (1509–90) and Pompeo Leoni (*c.*1533–1608), funerary statues of King Philip II and his family (1597–1600), bronze, gilded and enamelled, life-size, El Escorial, S. Lorenzo el Real

280 Below right: Adriaen de Vries (pre-1546–1626), *Fountain of Hercules* (1602), *c.*8 m. (26 ft.), Augsburg, Maximilianstrasse

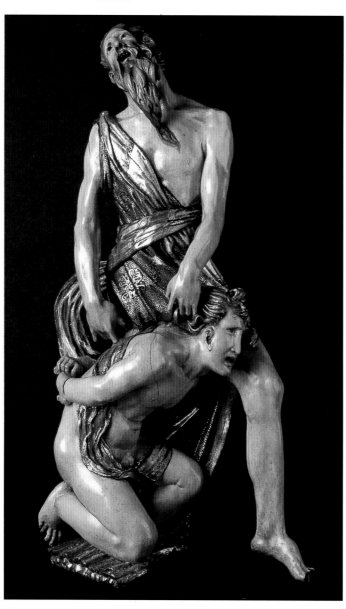

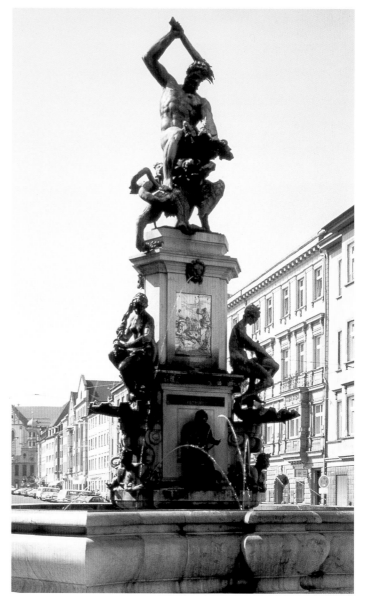

194

on their tombs as corpses [281], as well as in lifelike kneeling statues. A similar obsession with mortality—the *Dance of Death*—featured in small-scale sculpture (*Kleinplastik*) in Germany [282].

Classical subjects were also eagerly collected by nobility and bourgeoisie alike, in their newly fashionable art-cabinets (*Kunstkammer*). Peter Flötner (*c*.1490–1546) and Hans Daucher (*c*.1485–1538) produced a series of small reliefs in fine-grained limestone, which could be reproduced as decoration by casting in lead. The workshop of the Vischer family in Nuremberg produced some very Italianate bronzes, while over 4,000 medals with accurate portraits were produced during the sixteenth century in south Germany. Through these collectors' items, as well as by public fountains with monumental statuary in bronze (in Augsburg [280], Munich, and Nuremberg), the Germans were gradually introduced to the Late Mannerist style.

Sculpture was also aligned with goldsmithing, for three-dimensional models in wood were necessary in producing the elaborate domestic silver and ornaments popular at the time, often providing sumptuous mounts for natural curiosities such as coconuts, ostrich eggs, or nautilus shells.

The dukes of Bavaria enhanced S. Michael's in Munich with sculpture by Giambologna's associates. Splendid limewood retables and organ-cases began to be produced once again, with a profusion of ornament, colour, and gilding, while even in the Lutheran parts of Germany there was between 1560 and 1600 a demand for carved pulpits. CA

195

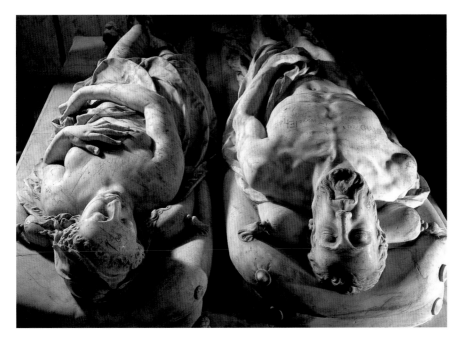

281 Germain Pilon (1525–90), tomb of King Henri II of France and Queen Catherine de' Medici: detail, marble, life-size effigies, Saint-Denis, abbey church, Royal Basilica

282 Right: Hans Leinberger (*fl*. 1516-30), *Deathling* (*c*.1520), carved pear-tree, 22.5 cm. (8 9/10 in.), Innsbruck, Kunsthistorisches Museum

Forms in Space, *c.*1 00–*c.*1700

One of the most characteristic and compelling phenomena of seventeenth-century art was the production of ensembles of programmatic imagery, related in form and content to the functions and contexts of the various types of spaces—secular, sacred, 'private', and 'public'—that they adorned. Truly multi-media enterprises, these complexes often combined independent and architectural sculpture with painted ornamentation to form self-contained environments, increasingly sustained through the development of more and more spectacular illusionistic effects. At their most seductive, these fictive worlds, merged with the observer's own, were designed to stimulate and control viewer experience, beckoning one into another—usually celestial—realm. Though some of the artists involved may have been skilled in more than one medium, such schemes were generally group projects, conceived and directed by individual artists, often working with the input of patrons and/or literary advisers; thus, their success ultimately depended upon the ability of painters, sculptors, architects (and a host of artisans) to join together and subordinate their personal inclinations to the cohesiveness of the whole.

These kinds of ensembles originated and evolved in Italy, departing from earlier sorts of decorative complexes, such as chapels with programmes of painted and/or sculpted adornments, their vaults appropriately ornamented to represent the heavens. Michelangelo's sixteenth-century decorations in the Sistine Chapel at the Vatican, along with the older fresco cycle on the lower walls, are a famous and monumental variation of this type. Painting on the walls and vaults of spaces in palaces and villa buildings also provided important precedents. At the Villa Farnesina in Rome, for example, the vault of the Loggia di Psiche on the ground floor, opening on to the garden, is fittingly frescoed to simulate a bower across which are strung tapestries depicting episodes from the myth of Cupid and Psyche, the Olympian setting of the scenes exemplifying a pagan alternative for the celestial locations appropriate to ceiling painting [261]. The plot of seduction, love, and marriage also befits the private residence of the wealthy banker Agostino Chigi and the mistress whom he eventually wed, while the ancient provenance of the story and its classicizing treatment was further suitable to the pretensions of the patron and his suburban villa in the Antique style.

In sacred spaces, exploitation of the illusory possibilities of decorative cycles was no doubt buoyed by the recommendations of Counter-Reformatory writers in the later sixteenth century for imagery that was intelligible and naturalistic, while at the same time offering an emotional stimulant to piety; but this does not fully explain the development, as we also see it in the secular domain. Perhaps the most literal expressions of such religious ideals are to be found in the decorations, beginning in the Renaissance, of the *Sacri Monti* in Lombardy, hillside groups of chapels and churches marking the venerated sites of Christ's life and Passion. Popular devotional simulacra for those pilgrims to whom the Holy Land was inaccessible, these chapels were adorned with frescoes and lifesize, unidealized polychromed wood or terracotta figures composing tableaux, such as the *Ecce Homo* Chapel at Varallo [283], ornamented in 1609–13 by Il Morazzone (1571–1626) and Tanzio da Varallo (1575–1635).

It was, however, Rome, the seat of Catholic recovery, that became the centre for the artistic developments we will be following into the seventeenth century. Attracted by hopes of papal and aristocratic patronage as well as the opportunity to study the city's unparalleled artistic heritage, artists came from all over Italy and Europe, integrating local influence into the

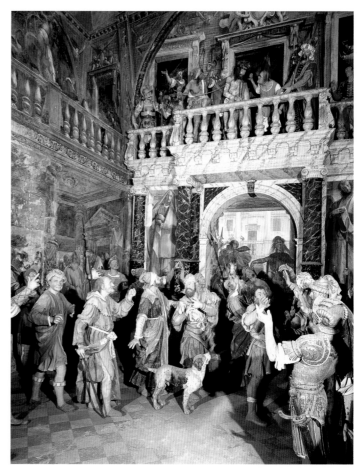

283 Il Morazzone (1571–1626) and Tanzio da Varallo (1575–1635), *Ecce Homo* (1609–13), Varallo, Chapel XXXIII

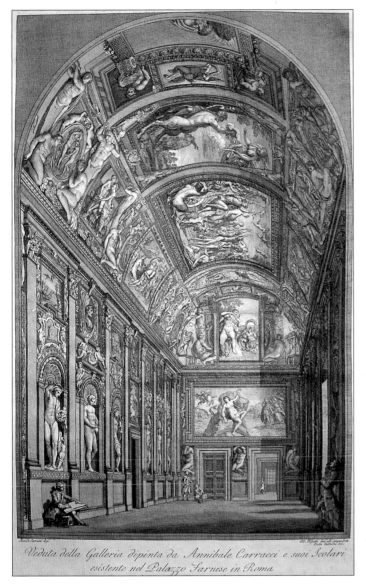

Veduta della Galleria dipinta da Annibale Carracci e suoi Scolari esistente nel Palazzo Farnese in Roma

284 Giovanni Volpato (1740–1803), *View of the Farnese Gallery* (1777), engraving

universality of Roman art. Just at the turn of the century Annibale Carracci (1560–1609) of Bologna and Michelangelo Merisi da Caravaggio (1571–1610) of Milan decorated the Cerasi Chapel in the church of S. Maria del Popolo [**289**]. Annibale painted the altarpiece of the *Assumption of the Virgin* in the highly idealized 'academic' style for which he is best known, based, in this instance, upon the art of Raphael, but the emotional tenor of the work and its dynamic relationship to the viewer's space was wholly current. The large-scale, voluminous figures crowd the picture plane with their dramatic gestures and expressions, the hand of S. Peter and the foot of S. Paul in the right foreground threatening to break its bounds.

Even more dynamic are the paintings on the side walls by Caravaggio of the *Crucifixion of S. Peter* [**287**] and the

197

Conversion of S. Paul [**288**], the radical foreshortening of the protagonists taking into account the worshipper's oblique viewpoint from the entrance to the chapel. The scale of the figures and the simplicity of the compositions are also in accord with Annibale's painting, but the style could not be further removed. Nothing short of revolutionary, Caravaggio's history paintings introduced the unidealized figures in modern dress from his earlier genre works into dark, blank backgrounds, the popularizing treatment of the figures recalling the appeal of the *Sacri Monti* decorations of his native Lombardy. The artist further emphasized the importance of the scenes as moments of faith and revelation by the use of a dramatic, raking light; it has been suggested that the 'divine' source of this illumination is to be found in the dove of the Holy Spirit, frescoed in the centre of the vault of the chapel's anteroom, presumably by Giovanni Battista Ricci (1537–1627). From the side walls of the anteroom carved tomb portraits of the chapel's patron, Monsignor Tiberio Cerasi, the treasurer general under Pope Clement VIII, and his father, Stefano, look towards the high altar, as does Peter in his martyrdom.

Annibale's work was also important for the ornamentation of secular space, especially for the development of the role of ceiling painting in ensemble decoration. A few years before he painted the *Assumption*, in 1597, Annibale began, with the help of his brother Agostino and other young painters from his native Bologna, his greatest enterprise, the decoration of the ancient sculpture gallery in the Farnese Palace in Rome [**284**, **292**]. Ceiling painting had of course been popular in palaces and churches throughout the Renaissance, and Annibale's fresco, deriving from sixteenth-century types, may serve to illustrate the typical compositional conceit: the vault is painted with *quadri riportati*, or framed pictures of the sort used to adorn walls. The Farnese fresco is on a grander scale than most such ceiling paintings, which consisted only of a central *quadro riportato* in a stucco frame. The fictive framework of the Farnese vault, with its sculpted herms, bronze medallions, and 'real' nudes, draws upon the intimidating example of Michelangelo's Sistine Chapel ceiling, further emphasizing the illusionism of materials. This is complemented by the treatment of the corners of the vault, painted as if 'opened' to the sky.

Annibale's fresco was commissioned by Cardinal Odoardo Farnese and depicts the amorous adventures of the Olympian gods and goddesses in a playful, voluptuous fashion, expanding upon the lively sensuality of the decorations of the Loggia di Psiche. In accordance with this theme, it is now generally accepted that the cycle was intended to celebrate the marriage of the cardinal's older brother, Duke Ranuccio, the secular head of

the family, to Margherita Aldobrandini, the niece of the reigning Pope Clement VIII. Extending the function of the space as a gallery for the display of antiquities, Annibale's scenes literally bring the deities whose statues adorned the walls to life by presenting them in colour and narrative context; his *quadri riportati* serve as mock ancient paintings, modern works designed to vie with those of the past. Within the decorative scheme, in fact, it was the fresco that occupied the superintending position, establishing the theme to which the antiquities were linked, an inversion of earlier trends in the display of statuary.

The relationship between painting and sculpture continued to play an important role in the decorative ensembles of the next generation, largely through the brilliant innovations of a single artist, Gianlorenzo Bernini (1598–1680). Bernini worked as a sculptor, architect, and designer, fusing his talents as he fused the media in his transformative schemes for interior decoration. Characterized by contemporaries as the first to attempt to unify architecture with sculpture and painting in such a way as to make of them all a beautiful whole (*un bel composto*), he was also recognized to have done so by occasionally departing from the 'rules', without actually violating them.

The greatest and most well-known example of this notion of *bel composto* is Bernini's decoration of 1645–52 of the Cornaro Chapel in the church of S. Maria della Vittoria in Rome, dedicated to S. Teresa of Avila (1515–77), an important Counter-Reformatory figure of the Discalced Carmelite order in Spain [**290**]. In the centre of the chapel, over the altar, the white marble group of Teresa and an angel enact miraculous events from the saint's life: the angel is piercing her heart with a fiery arrow of divine love, marking Teresa's union with Christ, but this is conflated, as she hovers in a bank of clouds, with her experience of levitation.

The sensual treatment of the figures [**291**]—their expressions, gestures, and even drapery—conveys the saint's ecstasy with the remarkable clarity with which she described her visions in her autobiography. The divinity of the drama is further reinforced by the golden rays of light shining down upon the figures, illuminated by a hidden window that Bernini had constructed behind the pediment of the altar's framework. In the side walls of the chapel, in high relief, Bernini portrayed the patron, Cardinal Federigo Cornaro, Patriarch of Venice, and deceased members of his family, six others of them cardinals, witnessing and discussing the vision along with the worshipper, mediating his relationship to the mystical scene in a far more animated way than the busts in the Cerasi Chapel.

The Cornari kneel behind prie-dieux in spaces illusionistically carved in lower relief to appear to recede further behind them. The white marble of the figural sculpture contrasts with the richly coloured marbles of Bernini's architectural setting, imposed upon which are the painted heavens opening in the vault, executed by Guidobaldo Abbatini (1600–56), but made possible by Bernini's idea of moulding stucco over other—even dimensional—decoration. Based upon schemes such as the Cerasi Chapel, Bernini carried the integration and manipulation of painting, sculpture, architecture, and even natural light to new limits in his efforts to simulate a visionary world.

Bernini's remarkable innovations paralleled—and influenced—the evolution of dazzling illusionistic effects in the ceiling-painting cycles that formed the most monumental decorative ensembles of the period. The seminal figure in this development was Bernini's contemporary, Pietro Berretini, known as Pietro da Cortona (1596/7–1669) from the small town in the Tuscan mountains where he was born. Cortona worked primarily in Rome as a painter, architect, and decorator, joining his diverse talents much as did Bernini, with whom he collaborated early in his career. His novel style, a kind of painted counterpart to Bernini's sensual sculpture, offered a complex and integrated synthesis of pre-existing regional traits—central Italian classicism, Emilian energy and richness, and Venetian colour, luminosity, and painterly brushwork. But Cortona's achievement is further distinguished by the success with which he applied this style to organize the compositions of ceiling paintings of the grandest scale. In his ceiling fresco of *Divine Providence*, painted between 1633 and 1639, Cortona codified a new scheme in vault decoration [**294**].

The *Divine Providence* was commissioned by Cardinal Francesco Barberini, nephew of the reigning Pope Urban VIII, and frescoed in the large, centrally located *Salone* of his family palace in Rome. A sizeable cast of characters interacts across the surface of the room's vast, curved vault, the structure of which is articulated by a fictive (painted) architectural framework. On the coving of the vault mythological and allegorical figures in various scenes celebrate the virtues of the Barberini family. In the flat centre of the ceiling the personification of Divine Providence gestures for the figure of Immortality to bestow her starry crown of eternal glory upon the bees, the Barberini heraldic symbol. At the same time the Theological Virtues frame the bees with laurel and personifications of Religion and Rome hold aloft the papal keys and tiara, forming the personal coat-of-arms of Urban. The scene thus alludes to the role of Divine Providence in the election of the Barberini pope.

The treatment of space within the painting is brilliantly conceived to convey its propagandistic content: the architectural framework gives way to open sky, so that the surrounded scenes appear to compose a celestial vision. This conceit is corroborated by the foreshortening of the figures and forms in the central area, which are represented *di sotto in su* or perpendicular to the picture plane and thus literally seem to be overhead of the viewer who has just entered the room. Unlike the fictive architecture in most earlier ceiling paintings, such as in the Farnese Gallery, the framework here helps to organize the space, but the figures are not strictly compartmentalized by it. They overlap and even break through the architecture to interact and group with one another, and the sense of cohesiveness that this lends to the composition is further enhanced by their expansive gestures and vigorous poses. It is both the degree and synthesis of cohesiveness and complexity that distinguishes the *Divine Providence* from earlier monumental painting.

Like the *Divine Providence*, Cortona's other important ceiling paintings are to be found in the urban palaces of nobles and ecclesiastics that functioned as their theatres of power. These seventeenth-century Italian palaces, with their series of reception and audience rooms in suite, were partly designed to facilitate the socio-political ritual of visiting. Generally, the visitor followed a planned route through a suite or suites of

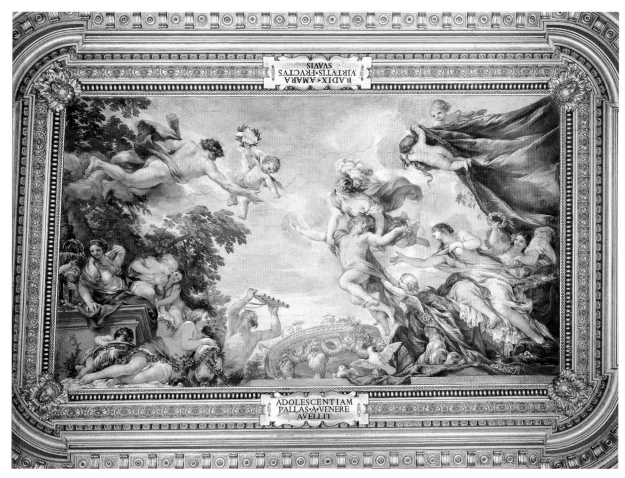

285 Pietro da Cortona (Pietro Berretini) (1596/7–1669), ceiling of the Sala di Venere (1641–2), fresco and gilded stucco, Florence, Pitti Palace

rooms, culminating in his audience with the prince, cardinal, pope, and so on. It was conventional to decorate such suites (as well as more private apartments) with series of ceiling paintings, thematically linked to each other and to the functions and patronage of the rooms they adorned. Some of Cortona's ceiling frescoes were co-ordinated to form narratives along such spaces, the best example being his cycle of 1641–65 at the Pitti Palace in Florence, where the visitor would have followed, through five rooms, the education of an ideal Medici prince under the tutelage of a series of planetary deities, each room dedicated to a different Olympian.

The ceiling paintings of the so-called Planetary Rooms, commissioned by Grand Duke Ferdinando II de' Medici in hopes of the heir who was born during their production, are treated differently from the *Divine Providence*. Enclosed in elaborate, gilded stucco frames ornamented with various figures, which were also designed by Cortona, they vary from the exuberant *di sotto in su* handling of the Sala di Marte to the modified *quadro riportato* in the Sala di Venere [**285**], a form that continued to be used in ceiling painting, especially for smaller rooms and those shaped—even if not functioning—like galleries.

Cortona was by far the most influential painter in all of Italy in his day, and his monumental compositions were acclaimed as innovatory from the first. His novel stylistic synthesis and the visual language he developed to express the absolutist ideologies of popes and monarchs garnered many followers and initiated a long tradition in European art, establishing an international style in palace and villa decoration.

Even Charles Le Brun (1619–90), director of the French Royal Academy of Painting and Sculpture from 1663 to 1683, who advocated a style of restrained classicism in his teachings, was profoundly influenced by Cortona's rich, exuberant work in his decorations for the crown. Lebrun made the requisite sojourn to study art in Italy in 1642–6 and modelled his original ornamentation of the Grand Apartments of the royal Château de Versailles, considered the epitome of the 'Style Louis XIV', on the Planetary Rooms at the Pitti Palace. From 1671 to 1680, with the help of assistants and advisers, Lebrun adorned each of the seven-room suites of the king and queen with an ensemble of ceiling paintings dedicated to planetary deities and surrounded by elaborate stucco frames. Like the Pitti Palace cycle, the ones at Versailles [**293**] were derived from the Ptolemaic solar system and Apollo was therefore placed in the central rooms of each apartment, an iconography appropriate for the Sun King and his queen, especially since Louis' Salon d'Apollon was his throne room.

Artists of succeeding generations continued to carry the Cortonesque tradition throughout Italy and Europe; Luca Giordano (1634–1705), for example, created monumental ceiling frescoes in Florence and Naples, and served ten years as court painter in Madrid. Giambattista Tiepolo's (1696–1770) grandest ceiling frescoes, brilliant and idiosyncratic transformations of the Cortonesque formula, are to be found in and near Venice and in central Europe. Matthäus Günther (1705–88) and Franz Anton Maulbertsch (1724–96) painted Cortonesque ceiling frescoes in central Europe throughout the eighteenth century.

These and earlier artists also decorated churches, adjusting Cortonesque ceiling painting to ecclesiastical space in a way that ultimately derived from one of the master's own works as well, his fresco cycle of 1647–65 in the Chiesa Nuova (S. Maria in Vallicella) in Rome. The fresco on the nave vault, depicting S. Philip Neri's vision of the Virgin during the construction of the church, is actually a variation of the *Divine Providence*: the Chiesa Nuova picture is painted *di sotto in su*, but instead of covering the entire surface of the vault, it is cleanly framed and confined to the central area in the manner of a *quadro riportato* [**295**]. Therefore, there are no subsidiary episodes, though there are supernumerary figures—attendant angels replacing the allegorical and mythological ones of secular scenes.

The Chiesa Nuova fresco formed the archetype for sacred vault decoration, just as the *Divine Providence* had for secular sites. Cortona's schemes proved popular because they so well succeeded in relating form to content and context. The densely populated, highly movemented compositions provided ideal models for decorating vast vault surfaces and their treatment of the ceilings as open to the sky, in which is enacted an illusionistically foreshortened scene, fulfilled a kind of spatial logic that both uniquely suited their architectural contexts and accorded perfectly with the sorts of subject-matter usually chosen, such as grand celestial themes of apotheosis and glorification.

In the Chiesa Nuova Cortona also adapted the idea of ensemble decoration from his palace schemes by relating the main fresco in the vault to his scenes in other central and important areas of the church, taking the kind of unified decoration of the Cerasi and Cornaro Chapels to a monumental scale. In the vault the Virgin appears to Neri, sustaining part of the roof of the old church that threatened to collapse and was located above an old and venerated image of her. In the semi-dome of the apse above the high altar the Virgin appears again in the scene of her Assumption, gesturing towards the fresco of the Holy Trinity in the metaphorical 'heaven' of the main dome over the crossing. These crowded, energetic scenes, also *di sotto in su* in perspective, draw upon a tradition in dome decoration going back to the Renaissance. Cortona separated the various areas of fresco with rich stucco-framing elements, much like those in the Planetary Rooms.

The illusionistic potential of the Chiesa Nuova cycle—especially the fresco in the vault—was further exploited in later seventeenth-century church decoration in Rome. The fresco of 1676–9 by Giovanni Battista Gaulli (called Baciccio) (1639–1709) in the nave vault of Il Gesù, the church of the Jesuits, exemplifies one direction in which this development was taken [**296**]. In a glowing empyrean, the artist created the illusion of both profound spatial recession and projection into the worshipper's domain, the latter by painting figures on stucco over the framing ornamentation of the vault. Presumably inspired directly by Bernini in his *bel composto*, Baciccio carried the treatment of the vault of the Cornaro Chapel to a grand scale, integrating painting with its architectural setting in a way that Cortona had eschewed.

In the Gesù vault the faithful bow before the shining name of Jesus, represented by the monogram IHS (*Iesus Hominum Salvator*, Jesus, Saviour of Mankind), while the damned are cast out of heaven and down into the nave. The iconography derives from a passage in the Epistle of S. Paul to the Philippians: 'Wherefore God also hath highly exalted him, and given him a name which is above every other name: That at the name of Jesus every knee should bow, of things in heaven, and things in earth, and things under the earth.' As with the Chiesa Nuova cycle, the scene in the nave relates to the frescoes in the semi-dome of the apse and the main dome, where we see the *Adoration of the Lamb* (1680–3) and a *Vision of Heaven* (1672–5), also painted by Baciccio.

Another spectacular kind of illusion was created in the nave vault of the church of S. Ignazio, dedicated to S. Ignatius Loyola, founder of the Jesuit order. The fresco of 1691–4 covers the entire vault, fictively extending its boundaries into deep space with an elaborate architectural framework [**286**]; it was painted by Andrea Pozzo (1642–1709), a Jesuit priest and author of a treatise on perspective, the mastery of which is demonstrated in this sort of illusionistic architectural painting, known as *quadratura*.

Pozzo's composition represents a complicated allegory of the missionary work of the Jesuits. The artist explained the iconography in a letter of 1694 to the Prince of Liechtenstein, then Austrian Ambassador to the Holy See. At the centre of the heavens the light of divine inspiration emanates from Christ and God the Father, infusing S. Ignatius, on a cloud bank below and to the right, and from there disseminates to all who populate the painting, such as S. Francis Xavier, Apostle to the Indies, on a lower cloud bank to the left. Beneath S. Francis, on the short side of the vault, rays sent from heaven are caught in a shield inscribed with the name of Jesus and used to light the flames of divine love in a golden cauldron, these to be distributed by angels. On the opposite side of the vault avenging angels threaten those who resist the light of faith with divine wrath in the form of thunderbolts and javelins. On the long sides of the vault four groups of allegorical figures represent the spread of the Jesuit apostolate to the four corners of the earth, triumphing everywhere over the forces of paganism. The scene in the nave of the church again relates to that in the semi-dome of the apse, Pozzo's fresco of *S. Ignatius in Glory*. The main dome was, however, never constructed, and in 1685 Pozzo had painted the illusion of one in *quadratura* on canvas to take its place.

The astonishing effects and propagandistic messages of the decorations of the Gesù and S. Ignazio were well suited to the missionary zeal of the Jesuit order. In the nave frescoes of these churches the evolution of illusionistic ceiling painting reached its culmination. A more restrained mode came, by and large, to predominate in monumental ecclesiastical ceiling painting of the eighteenth century, though ensemble decoration continued to develop, particularly in the churches of central Europe. Exemplary of this trend is the small pilgrimage church of 'Die Wies' in Upper Bavaria [**297**], built and decorated in 1744–54 by Dominikus Zimmermann (1685–1766) and his brother, Johann Baptist Zimmermann (1680–1758), who painted the *di sotto in su* frescoes in the vault. Dominikus' lavish interior architecture of white stucco with gilding transmutes into rocaille ornamentation in the vault, creating free-form frames that seem to amalgamate effortlessly with Johann Baptist's light-filled paintings.

CP

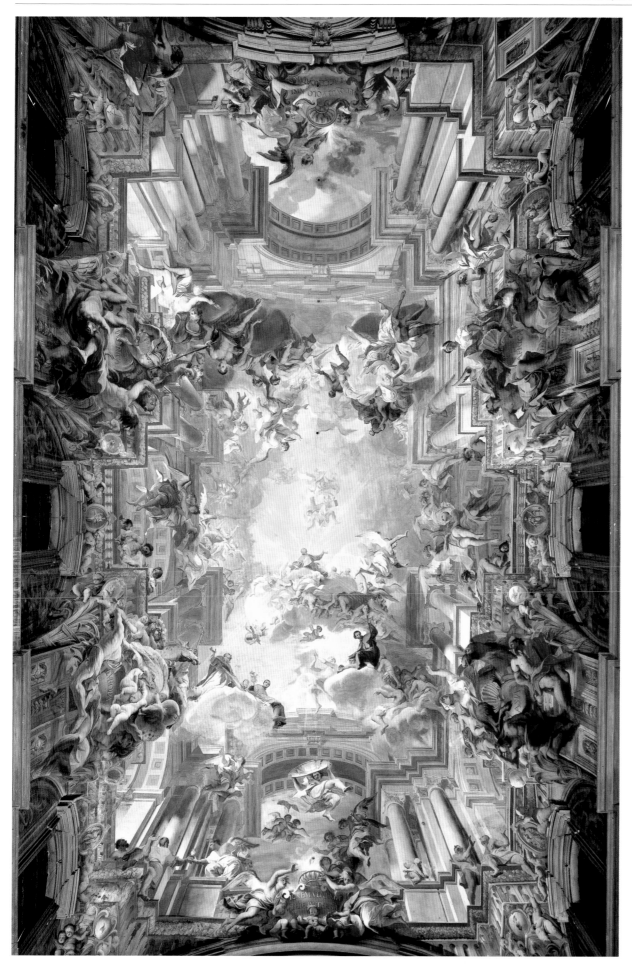

286 Andrea Pozzo
(1642–1709),
*Allegory of the
Missionary Work
of the Jesuits*
(1691–4), fresco,
Rome, S. Ignazio

Chapel decorations

Early seventeenth-century chapel decorations derived from Renaissance traditions and continued to reflect the influence of Counter-Reformatory thought on the nature of religious imagery.

Groups of artists worked together and with a variety of media to create ensembles that are unified in form and content. The veristic tableaux of the devotional chapels of the *Sacri Monti* of Lombardy, such as the *Ecce Homo* at Varallo [283], composed of frescoes and unidealized polychromed figures, had great popular appeal.

The ornamentation of the funerary chapel of Monsignor Tiberio Cerasi and his father [289] with paintings and sepulchral monuments is exemplary of the kind of adornment commissioned for such sites by wealthy patrons. The paintings by Annibale and Caravaggio [287–9], though in some ways vastly different, share in their figural scale and dynamic relationship to the worshipper's space. The apostles from Caravaggio's images on the side walls are also featured prominently in the lower foreground of Annibale's altarpiece.

CP

202

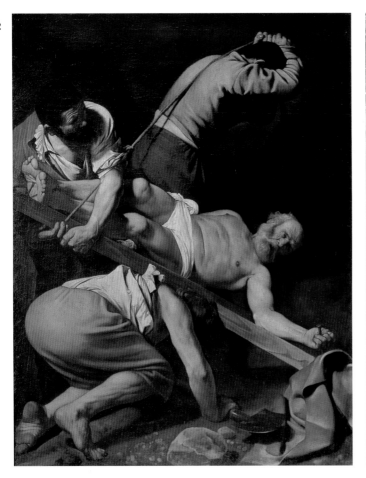

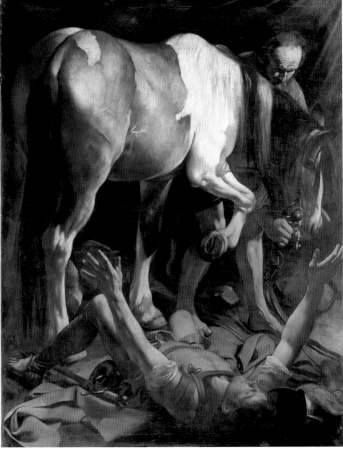

287 Above: Michelangelo Merisi da Caravaggio (1571–1610), *Crucifixion of S. Peter* (1600–1), oil on canvas, 2.30 × 1.75 m. (7 ft. 6½ in. × 5 ft. 9 in.), Rome, S. Maria del Popolo, Cerasi Chapel

288 Above: Michelangelo Merisi da Caravaggio (1571–1610), *Conversion of S. Paul* (1600–1), oil on canvas, 2.30 × 1.75 m. (7 ft. 6½ in. × 5 ft. 9 in.) Rome, S. Maria del Popolo, Cerasi Chapel

289 Opposite: Cerasi Chapel (1600–1), Rome, S. Maria del Popolo. Annibale Carracci (1560–1609), *Assumption of the Virgin* (c.1600), oil on panel, 2.45 × 1.55 m. (96½ × 61 in.)

Ensembles with painting and sculpture

Decorative ensembles of the seventeenth century combined painting and sculpture in various ways. In the Farnese Gallery [**284**, **292**], Annibale's ceiling fresco depicted the amorous adventures of the Olympian deities whose ancient statues adorned the walls below, creating a spatial ensemble around a theme appropriate to a secular setting. The fresco is compartmentalized into painted *quadri riportati* or framed pictures of the sort used to ornament walls, forming a 'modern' picture collection to complement—and compete—with the antiquities.

In the Cornaro Chapel [**290**] it is the famous sculpted altarpiece [**291**], dramatically illuminated by a window hidden behind the pediment of the altar's framework, that forms the focus of the programme, while members of the Cornaro family, carved in high relief, look on. But instead of separating statuary from painting and emphasizing their differences, Bernini innovatively melded them together in his decorative scheme, creating the painted heavens in the vault of the chapel by moulding stucco over dimensional ornamentation. CP

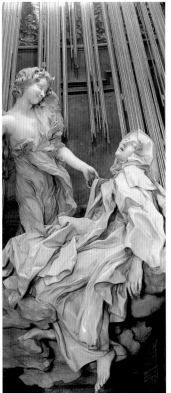

290 Left: Cornaro Chapel (1645–52), Rome, S. Maria della Vittoria

291 Below: Gianlorenzo Bernini (1598–1680), *The Ecstasy of S. Teresa* (1645–52), marble and gilded wood, figure group 3.5 m. (11 ft. 5¾ in.), high, Rome, S. Maria della Vittoria, Cornaro Chapel

292 Opposite: Annibale Carracci (1560–1609), Farnese Gallery ceiling (1597–1600), fresco, 20.4 × 6 m. (67 × 20 ft.), Rome, Farnese Palace

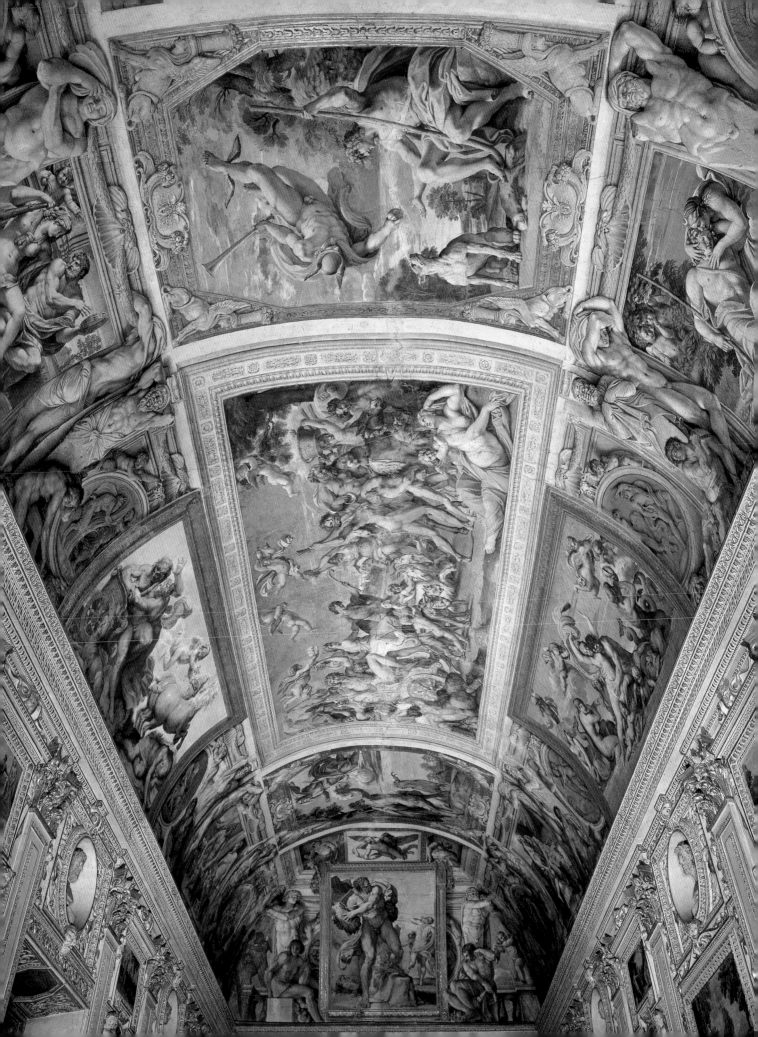

Secular ceiling painting

In the mid-seventeenth century, Pietro da Cortona codified innovative schemes in ceiling painting, establishing an international mode of palace and villa decoration. He combined a novel stylistic synthesis with illusionistic effects and developed a visual language to express the absolutist ideologies of popes and monarchs, garnering many followers and initiating a long tradition in European art.

His most acclaimed work has always been the monumental ceiling fresco at the Barberini Palace in Rome [294], its allegorical imagery alluding to the role of Divine Providence in the election of the Barberini pope. This propagandistic content is conveyed by a complex yet cohesive composition that seems to form a celestial vision. In the central area of the fresco the figures are represented *di sotto in su* or foreshortened to appear perpendicular to the picture plane and thus as if overhead of the visitor who has just entered the room.

In the Pitti Palace in Florence Cortona ornamented a series of smaller rooms with ceiling paintings for the Medici Grand Duke. These chronicle the education of an ideal Medici prince, who is instructed by various planetary deities, and vary from the *di sotto in su* treatment in the Sala di Marte to the modified *quadro riportato* in the Sala di Venere [285], surrounded by a gilded stucco frame. The planetary cycles of ceiling paintings created for the French monarchs at the royal Château de Versailles [293] were directly inspired by the Pitti Palace ensemble. CP

206

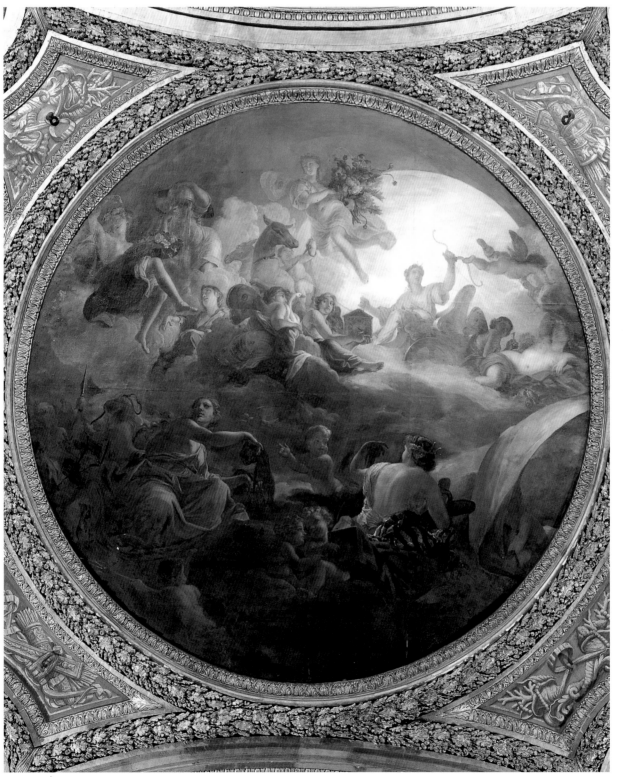

293 Left: Gabriel Blanchard (1630–1704), *The Chariot of Diana* (1674–80), oil on canvas and stucco, Versailles, Royal Palace, Salon de Diane

294 Opposite: Pietro da Cortona (Pietro Berretini) (1596/7–1669), *Divine Providence* (1633–9), fresco, Rome, Barberini Palace

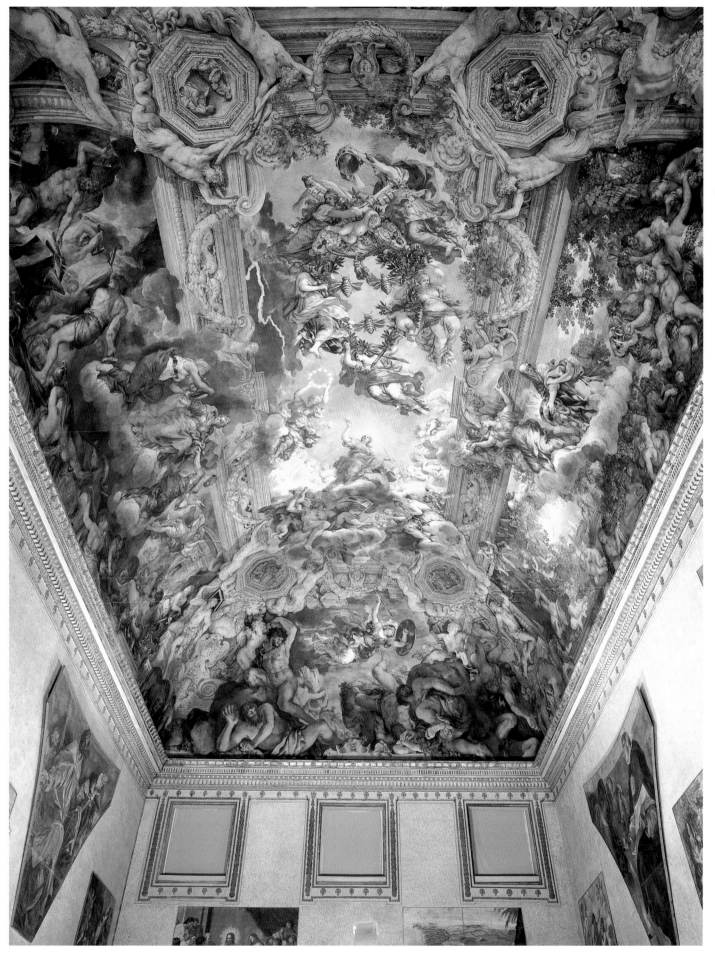

Ecclesiastical ensembles

In the mid-seventeenth century, Pietro da Cortona also formulated an international archetype for ecclesiastical vault decoration on a grand scale. His fresco in the nave of the church of S. Maria in Vallicella in Rome [295] is actually a variation of the *Divine Providence*: though an energetic *di sotto in su* composition, it is framed and confined to the central area in the manner of a *quadro riportato*, rather than covering the whole surface of the vault.

Cortona adapted the idea of ensemble decoration from his secular programmes by relating the painting in the nave, both formally and iconographically, to his frescoes in the main dome and semi-dome of the apse. Later artists took this scheme in different directions, particularly exploiting the potential for illusionism in the nave fresco. In the vault of the Gesù in Rome [296], Baciccio created the illusion not only of deep spatial recession, but also projection into the nave of the church by superimposing the frame of the fresco with painted stucco, creating a *bel composto* in the manner of Bernini.

Andrea Pozzo, the priest who decorated S. Ignazio, another Jesuit church in Rome, frescoed the entire vault [286], seemingly extending its boundaries upward with an illusionistic architectural framework.

In the eighteenth century more restraint prevailed in ecclesiastical ceiling painting, which continued to form an important part of the harmonious decorative ensembles developed in the Rococo churches of central Europe, such as 'Die Wies' [297]. CP

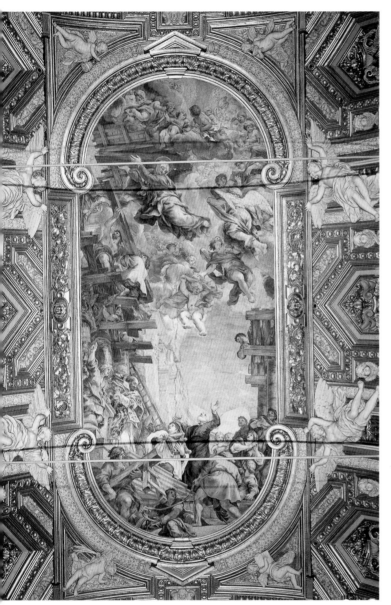

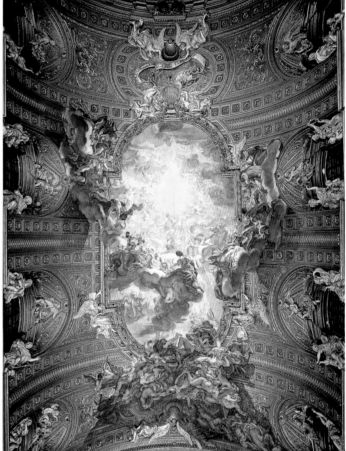

295 Left: Pietro da Cortona (Pietro Berretini) (1596/7–1669), *Vision of S. Philip Neri* (1664–5), fresco, Rome, S. Maria in Vallicella

296 Above: Giovanni Battista Gaulli (Baciccio) (1639–1709), *Triumph of the Name of Jesus* (1676–9), fresco, Rome, Il Gesù

297 Opposite: Dominikus Zimmermann (1685–1766) and Johann Baptist Zimmermann (1680–1758), Die Wieskirche (1746–54), Wies, Upper Bavaria

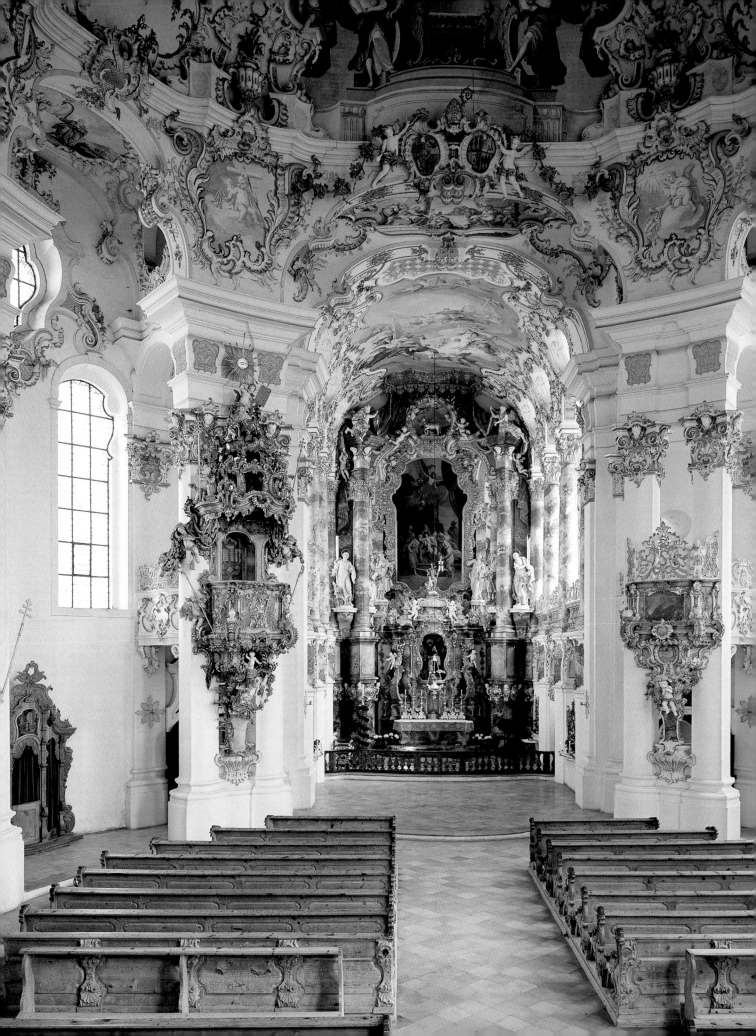

Free-Standing Sculpture
*c.*1600–*c.*1700

Often sensual and engaging, and invariably technically complex, seventeenth-century sculpture has until relatively recently not been so widely studied as contemporary painting. However, as an index of taste, and both secular and sacred values, it provides rich rewards for the historian.

Although humble and crude statuettes, usually of saints, could be found in many domestic interiors across Europe, commissioning sculpture remained the preserve of the wealthy because of the considerable expense involved; consequently patronage tended to be concentrated on church, courtly, and aristocratic projects. There was, however, also a large constituency of private connoisseurs and collectors who acquired fine sculpture. Protestant opposition to imagery within churches meant few religious commissions in northern Europe in the sixteenth century, although a demand for tomb sculpture survived. By contrast, the Catholic Church actively encouraged the use of imagery—preferably vigorous, naturalistic, and decorous—to guide the faithful, and sculptural works became a vital, persuasive, devotional tool. Although other centres were important, cities such as Rome, Bologna, and Madrid emerged as among the most innovative and spectacular arenas for sculptural projects, because of the riches and vision of the clerical patrons. Sacred sculpture tended to form part of larger ensembles (facades, chapels, tombs, or altarpieces) where it was integrated with paintings and architecture. But free-standing religious works were also created, such as Alessandro Algardi's (1598–1654) robust, marble group of the *Beheading of S. Paul* [**305**], which powerfully explores the dignity and stoicism of the saint. It could, however, be argued that it was in the realm of secular genres—portraiture, mythological groups, and fountains—that the most significant technical and aesthetic innovations were realized early in the century.

They were largely the achievement of one man, the most influential sculptor of the age—Gianlorenzo Bernini (1598–1680). His series of marble mythological groups of the 1620s made for Cardinal Scipione Borghese [**298**], which remain in the cardinal's villa on the outskirts of Rome, are among the most influential of such projects. In each the climactic moment of the narrative is chosen, the group is choreographed with the presumption of an audience to engage, and is pictorially conceived (that is, originally meant to be set and viewed against a wall), unlike sixteenth-century sculpture-in-the-round. Bernini evolved a new sense of dramatic clarity, based on the study of ancient sculptures and contemporary pictorial developments, such as the frescoes of the Carracci (for example, **292**). He also developed a profound preoccupation with exteriorizing interior states—whether ecstasy or terror—through gesture, expression,

and the enlivening of draperies to underscore an agitated state of mind. Such visual rhetoric was adapted in many of the sculptor's mature works to suit religious commissions, and came to match very closely the often passionate, visionary spirituality of the Counter-Reformation Church. Such developments are effectively illustrated by his *Angel with the Crown of Thorns* of the 1660s [**303**], which was one of a set of ten figures, all displaying objects associated with Christ's Passion, that Bernini designed for the Ponte Sant'Angelo, Rome. Every element of the angel is conceived as fluid and restless and invites engagement with the torment and transcendent nature of the theme.

The Villa Borghese was an élite, private space which acted as a showcase for the young Bernini and his discerning patron; it was filled with contemporary, High Renaissance and ancient works which allowed informed (and usually male) visitors to judge how recent developments either built on or surpassed the art of the past. Other types of sculpture bridged the private and public arenas—notably fountains, which adorned the gardens of villas, but also became an increasingly important part of urban planning. They fulfilled a number of agendas, being both practical and decorative, and an embodiment of familial or corporate status and wealth. This duality also applied to sculpture within churches, as the spiritual message was invariably combined (perhaps through an inscription or coat of arms) with a clear reminder of the source of patronage—whether a confraternity or individual.

Direct commemoration through portraiture remained in demand, and was still (with the notable exception of state portraits) the least lucrative of a sculptor's activities. Innovations in this field were once again instigated by Bernini and matched by contemporaries such as Algardi and Giuliano Finelli (1601–57); they sought not merely to record a likeness, but rather the assertion of the strength of character, so you could, to use Macbeth's phrase, 'read the mind's construction in the face'. Bernini especially set up an active relationship with the onlooker (as he had with his mythological groups) by making his subjects appear as though they were in the act of discussion; as he explained, 'to be successful in a portrait ... a moment must be chosen and then followed through. The best moment for the mouth is just before or just after speaking.' This approach, coupled once again with energized drapery, and realized through astounding technical skill, created a new and enormously influential portrait type. A novel dynamism was also injected into the formulas of equestrian portraiture, resulting in dashing works such as Francesco Mochi's (1580–1654) bronze *Equestrian Monument to Alessandro Farnese* (1620–9) in the Piazza dei Cavalli at Piacenza.

Marble and bronze, which was sometimes gilded, were the favoured materials for portraiture and monumental sculpture in Italy, France, and Britain, and became increasingly manipulated with a rich variety of surface effects, and mixture of materials and colours. Moreover, attempts were often made to deny the inherent constraints of materials in a new and almost painterly manner—so that the most unyielding of stone through deep undercutting and drilling became the lightest of draperies—the intention being to create a semblance of reality, and allow the viewer to marvel at the ingenuity displayed. Where marble was not readily accessible, as in the German states, alabaster might be used, and more traditional media like polychromed and gilded wood. Such materials were also widely employed in Spain, and their manipulation was brought to a very high level of technical competence by artists such as José de Mora (1642–1724). His *Virgin of Sorrows* [**306**] achieves an intense and disturbing naturalism through the sophisticated use of wood, paint, and inserts of glass, which invites close contemplation of the Virgin's grief after Christ's entombment.

For large projects a single artist was often commissioned, but a whole team of specialists frequently collaborated under his direction (founders, cutters, carvers, gilders, stucco-workers, polishers, and so on). Smaller sculptures for collectors, which were invariably concentrated displays of virtuosity, sometimes involved the use of an even wider range of skills—such as those of the lapidary or goldsmith—and a richer diversity of materials. These might include silver, amber, and especially ivory, which was prized for its exotic and tactile qualities and brilliantly worked by sculptors such as the German Georg Petel (1601/2–*c.*1634). His salt-cellar [**302**] in Copenhagen is a particularly impressive example of such skill. It was carved after a design by the great Flemish painter Peter Paul Rubens (1577–1640) in whose home the sculptor lived in 1624, and was recorded in Rubens's possession at his death. Such pieces would be displayed and admired in the context of a private museum, a *studiolo*, or *Kunstkammer*.

Increasingly an interest was taken in the process of the sculptor's art and so small terracotta models (*bozzetti*) also featured in such collections. They were originally used to establish compositions, gain approval from a patron before proceeding on a larger scale, and give guidance to assistants. They became valued because, like drawings, they were considered close to the artist's original conception.

The distinction between fine and decorative or applied arts which is now widely drawn would have meant little in the seventeenth century as sculptors, particularly in the context of a court, had to design everything from carriages and candlesticks, to sugar sculptures for banquets and floats for processions. The last might mark the arrival of ambassadors, accession of rulers, or annual religious festivals. Many of these ephemeral works are now only recorded in drawings and prints, but in many ways they should be seen as the most public and prolific of sculptors' 'free-standing' productions.

A few visual records also supply evidence of how and where sculptors worked [**299**], and the contexts in which their creations were displayed. However, written sources often prove more compelling when attempting to reconstruct patrons' intentions or working procedures. These range from contracts and correspondence relating to commissions, to biographies and inventories of collections, and even court records. Occasionally unlikely sources prove especially fruitful; for example, the *Diary* written by the French courtier Chantelou, which records Bernini's visit to Paris in 1665, describes in exhaustive detail the gestation of his marble bust of Louis XIV [**300**] which took 40 days to create. The process involved carefully choosing the marble, making preparatory drawings of the king carrying out his daily activities, working on small models while an assistant roughed out the bust, borrowing pieces of armour and taffeta to copy for the clothes, and sculpting directly during the 13 sittings that Louis allowed, before finally designing a complex pedestal.

Bernini's visit to Paris is often considered a symbolic event, because although he succeeded in creating a memorable portrait of the king, his plans for other architectural projects were rejected. This has been cited as marking the ascendancy of French taste and the decline of the power of Rome. Put simply, French sculpture passes from the output of artists like Pierre Puget (1620–94), which owed a great deal to the expressive and kinetic power of Bernini's creations, to works of greater restraint, created by sculptors such as François Girardon (1628–1715). Girardon was trained within the academic tradition which became increasingly important during the second half of the century. The French Academy, founded in 1648, provided practical guidance, theoretical instruction, and opportunities for exhibition. The training of sculptors became more systematic and a new orthodoxy emerged, which involved a very respectful study of paradigms of ancient art. Girardon, as an advocate for such values, created groups which are essentially a homage to the Antique, unlike Bernini and his followers who had used antiquity as a point of departure. The French Academy laid the foundations for the Neoclassicism of the eighteenth century. However, in Spain and parts of Germany it continued to develop, and was also exported ultimately much further afield, with the spread of missionary zeal to South America and Asia. CBk

Secular sculpture

Seventeenth-century free-standing sculpture which explored secular and usually mythological themes was often, intended for a private rather than public space. It became a vehicle for technical virtuosity and narrative skill which the patron could admire.

Such works also frequently featured the nude, which was not considered indecorous because it was sanctioned by ancient precedents. Many of the most important patrons and collectors of sculpture were churchmen (such as Cardinal Scipione Borghese, who commissioned Bernini's *Apollo and Daphne*, [**298**]) who had distinctly secular tastes, which were not perceived as incompatible with their public personas, as the sculptures were displayed as part of a collection, and admired as 'art' objects, as distinct from functional, devotional works; their role was to delight, instruct, and intrinsically commemorate the achievement of the patron.

Abraham Bosse shows a group of *Venus and Cupid* [**299**] being admired in a studio by richly attired men and women, who are perhaps potential patrons. The sculptor, whose tools lie on the pedestal and the ground, compares a much smaller version of the group, which could be a preparatory study or a reduced variant made for separate sale, with the full-scale work. The latter might ultimately have been intended for a palatial, villa, or garden setting where it could play a decorative or allegorical role.

In certain contexts myth could take on contemporary political relevance, as Girardon's outdoor group [**301**] from later in the century effectively illustrates. Set in the gardens at Versailles, it shows Apollo,

212

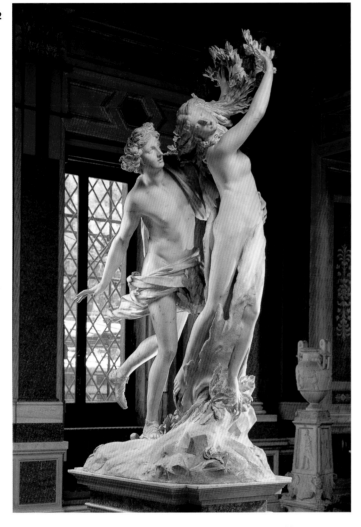

298 Above: Gianlorenzo Bernini (1598–1680), *Apollo and Daphne* (1622–5), white Carrara marble, 2.43 m. (7 ft. 11¾ in.) high, Rome, Villa Borghese

299 Above right: Abraham Bosse (1602–76), *The Sculptor in His Studio* (1642), engraving, New York, Metropolitan Museum of Art

300 Right: Gianlorenzo Bernini (1598–1680), *Bust of Louis XIV* (1665), white marble, 80 cm. (31½ in.) high, Versailles, palace

the sun god, attended by nymphs. As Apollo formed part of the iconography of Louis XIV, the Sun King, who created Versailles, the implication that the monarch, like the god, was deserving of deference would have been clear to a contemporary viewer. His exalted status was further implied because the figure of Apollo is based on an illustrious Classical model, the *Apollo Belvedere* (Rome, Vatican). CBk

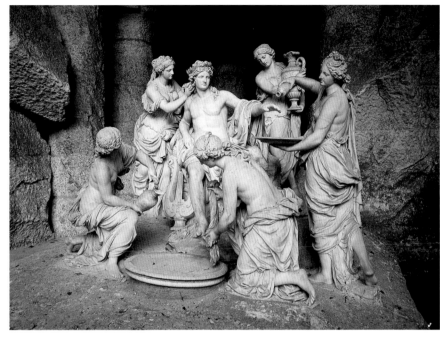

301 Above: François Girardon (1628–1715), *Apollo Tended by the Nymphs* (1666–75) white marble, 2.5 m. (8 ft. 2½ in.) high, Versailles, park

302 Right: Georg Petel (1601/2–*c*.1634), Salt-cellar with the *Triumph of the Sea-born Venus* (1627–8), ivory and silver-gilt, 32 cm. (12⅝ in.) high, Copenhagen, Kungl. Husgeråds-kammaren

Sacred themes

Religious sculpture of the period often sought a direct emotional appeal, and so illustrated the notion that through empathy faith could be inspired and sustained. This newly available active role for a pilgrim or member of a congregation conformed with the decrees of the Catholic Church's Council of Trent which had in the sixteenth century reaffirmed the importance of papal supremacy, the role of the saints as intercessors, and the sacraments; it had also sanctioned the use of art to convey these messages, which might be realized through the quieter dignity of classicizing works or high drama of full-blown Baroque imagery.

Algardi's *Beheading of S. Paul* [**305**], a work of great control and poise, is set behind the high altar of the church which is dedicated to the

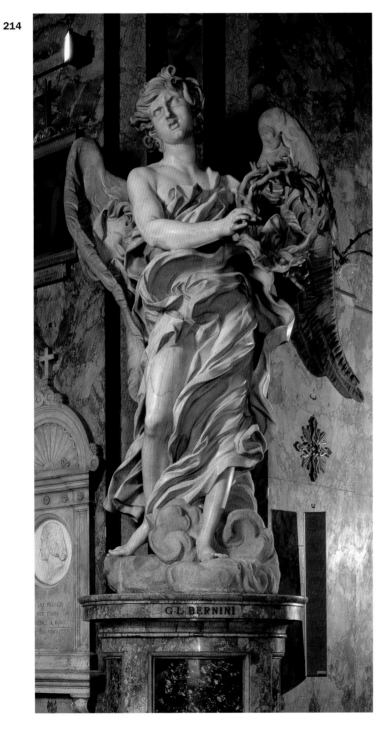

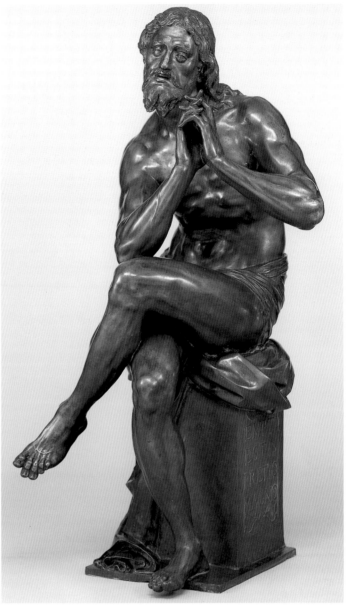

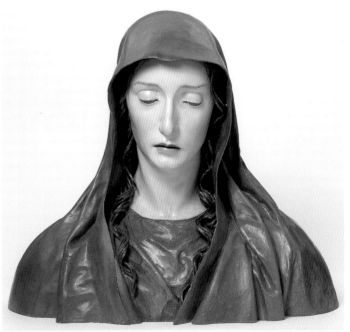

214

saint in Bologna, and conveys the appalling inevitability of his suffering, thereby illustrating his martyrdom as a model of faith. De Vries, a Dutch artist who trained in Italy, created his *Man of Sorrows* [**304**] while sculptor to the court of Rudolph II in Prague. It is partially based on a print by Albrecht Dürer, but was converted by the artist into a heroic image of torment which owes much—in terms of the physique of the figure—to ancient sculptural precedents.

Both of these works illustrate the classicizing strand in seventeenth-century sculptural practice which ran in parallel with, and sometimes in opposition to, the novel, dynamic, and more theatrical sacred sculpture of Bernini and his many followers. When brought to a very high pitch, as in the artist's *Angel with the Crown of Thorns* [**303**], it no longer alluded to sculptural precedents, but sought to translate painterly effects of movement and illusion into the service of devotion. CBk

303 Opposite, left: Gianlorenzo Bernini (1598–1680), *The Angel with the Crown of Thorns* (1667–9), white marble, Rome, Sant' Andrea delle Fratte

304 Opposite, top right: Adriaen de Vries (pre-1546–1626), *Man of Sorrows* (1607), bronze, 1.49 m. (4 ft. 10¾ in.) high, Vaduz, Royal Collection of Liechtenstein

305 Right: Alessandro Algardi (1598–1654), *The Beheading of S. Paul* (1634–44), white marble, 2.82 m. (9 ft. 3 in.) high, Bologna, S. Paolo Maggiore

306 Opposite, bottom right: José de Mora (1642–1742), *The Virgin of Sorrows* (*c.*1680–1700), painted pinewood with glass and ivory inlay, 48.5 × 49 cm. (19⅛ × 19¼ in.), London, Victoria & Albert Museum

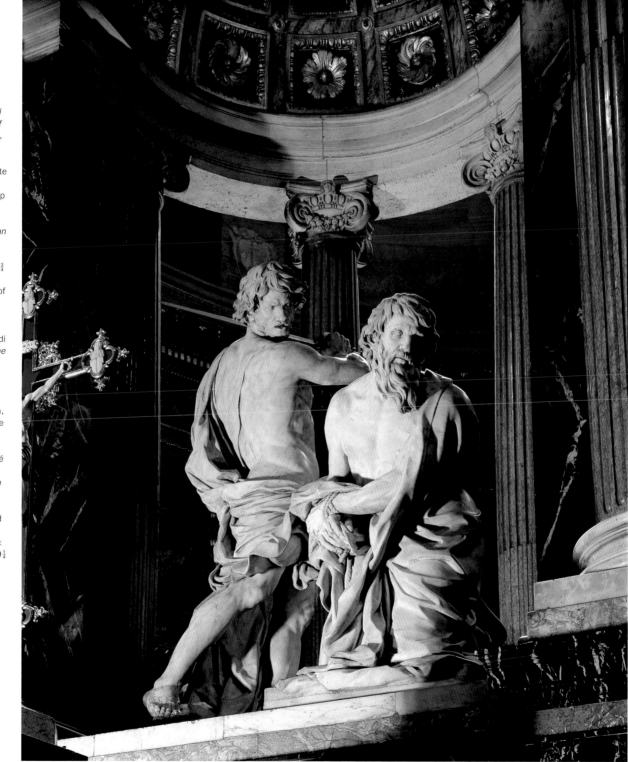

The Picture: Italy and France

In sixteenth-century Italy, the Republic of Venice and the ducal courts of Florence, Parma, Ferrara, Mantua, and Urbino were flourishing centres of art and art patronage. Common to the culture of these humanist societies was a predilection for Classical antiquity as the model and source of inspiration for works of art as well as a taste for the sensual and erotic. Cosmopolitan patrons, often collectors and connoisseurs of antiquity, with a broad visual culture, delighted in works exhibiting virtuoso effects, poetic and visual allusions, and Classical references, in subjects drawn directly from ancient sources or from the artist's own imagination. In responding to the demand thus placed on his inventive powers and painterly skills, the ambitious artist emerged from the role of anonymous skilled craftsman of medieval and Early Renaissance times and came to be seen as kin to the poet (*ut pictura poesis*—as is poetry, so is painting), admired and sought after for the individual style and ability that distinguished his work. In this context, the portable easel painting (as distinguished from the fixed wall painting or altarpiece), varying in size from very small to very large and generally commissioned for private use, came into prominence. The appearance of new subject-matter and styles that accompanied the innovation may be seen as a significant development in the gradual trend away from religious art— which continued nevertheless to be the most widely produced type of subject throughout the seventeenth and eighteenth centuries—towards the secular art of modern times.

In the context of changing relationships between artist and patron, equals in a creative dialogue in pursuit of a common objective, the patron-collector-connoisseur with sharpened eye and informed judgement came to play a conspicuous role in the seventeenth and eighteenth centuries in the formation of collections that today are at the heart of some of the major European museums. As taste and society changed over the course of the sixteenth to the eighteenth centuries, so did the nature of the subject-matter and style of the easel painting as well as systems of patronage, art markets, and the roles of the amateur and the critic.

Titian (Tiziano Vecellio) (*c.*1485–1576), the quintessential international artist, dominated painting in Venice for sixty-five years. From mid-career (*c.*1532–3), he worked almost entirely for noble patrons throughout Europe, providing easel paintings with a broad range of subject-matter, both religious and secular. His contribution to portraiture, endowing his figures as he did with psychological presence [**307**], is commensurate with that of Raphael. It was for 'his genius in painting likenesses' that he was created a knight of the Golden Spur by Charles V. Early easel paintings such as the *Sacred and Profane Love* (*c.*1515) show

Titian's supreme mastery of the largely Venetian innovation of using oil paint on canvas rather than on panel, in defining forms through gradations of tones and in uniting figures and luminous landscapes in a palpable atmosphere, evoking an Arcadian world of classical bucolic poetry. Style, theme, and technique derive from his teacher Giorgione (Giorgio da Castelfranco) (1476/8–1510), one of the first artists to work almost exclusively for the new market of private patrons and collectors in Venice, producing easel paintings of similar nature. In the *Venus of Urbino* (*c.*1538), painted for Guidobaldo della Rovere, Duke of Urbino, Titian transforms Giorgione's *Sleeping Venus in a Landscape* (1507–8) into a picture of a more blatantly nude woman reclining on rumpled sheets in a Venetian interior who invitingly returns the gaze of the implied male viewer. Titian's carefully observed halftones of light and shadow that play across the nude figure applied in soft brush strokes combine to heighten the sensuous and openly erotic nature of the subject. A number of half-length paintings of beautiful women, possibly portraits of Venetian courtesans, by Titian and his contemporaries, Paolo Veronese (Paolo Caliari) (1528–88) and Palma Vecchio (Jacopo Negreti) (*c.*1480–1528), identified by such titles as *Flora*, *Lucretia* or simply *La Bella*, attest to the market for such pictures [**311**]. In the last decades of his life, in some of his most beautiful works, Titian produced a series of mythological paintings from Ovid's *Metamorphoses* for Philip II of Spain [**308**]. Apparent in these pictures is the freedom of brush stroke, rich opaque colours applied in layers resulting at times in thick impasto, characteristic of his late style. Artistic form unites with content to evoke the spirit of a sensuous mythological world. The works deserve the name that Titian himself gave them: *poesie* or visual poems.

Antonio Allegri (*c.*1489–1534), known as Correggio, working in the small provincial court of Parma, created a series of four mythological paintings drawn from Ovid, depicting the loves of Jupiter, for the palace of Federico Gonzaga, Duke of Mantua. In his *Jupiter and Io* (*c.*1532) [**310**], Correggio in a synthesis of Classical form and soft naturalism produces a highly erotic feminine sensuality and luminous grace that is characteristic of his classicism. The younger artist Parmigianino (Francesco Mazzola) (1503–40) also working in Parma, in the last years of his short life introduced a sophisticated and refined Mannerism into Emilian art characterized by a new canon of feminine beauty, slender elongated limbs and neck and delicately small heads with classicizing profiles, as seen in his *Amor* (1531–4).

Jacopo Bassano (dal Ponte) (*c.*1510–92), the head of a large family enterprise of painters working in the provincial

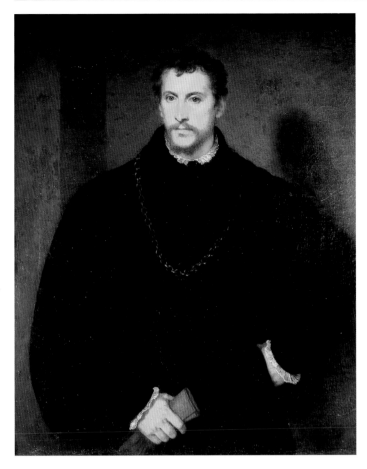

307 Titian (Tiziano Vecellio) (c.1485–1576), *Portrait of a Man (Young Englishman)* (c.1545), oil on canvas, 111 × 93 cm. (43¾ in. × 36½ in.), Florence, Galleria Palatina, Pitti Palace

town of Bassano in the Veneto, introduced a different kind of subject-matter into easel painting that was enormously popular at the time and in subsequent centuries, especially among collectors throughout Europe. In the 1560s, he created the biblical pastoral, in which he displays a superb naturalism and sensitive description of pastoral landscape, rustic figures, and animals, within the context of a biblical story. In the 1570s, he and his workshop produced 'nocturnes' as well as several series of '*quadri campestri*'—invented specifically for collectors— allegories of the elements and of the seasons in country settings, and narratives from the life of Noah in which the biblical stories are subordinate to the genre elements and landscape settings of the compositions.

In contrast to the naturalism, soft sensuality, and painterliness of Venetian and Emilian painting, a hard-edged, intellectual, formal Mannerism with an emphasis on drawing and the human form, ultimately based on the art of Michelangelo Buonarroti (1475–1564), evolved at the court of Cosimo I de' Medici in Florence. Thirty-four small, highly finished, multi-figured easel paintings on slate and copper by a variety of artists, treating the theme of the relationship between art and nature, made for Cosimo's son Francesco's *studiolo* (1570–3) in the Palazzo Vecchio, manifest the Florentine taste for refinement, highly finished surface and preciosity. Portraits of courtiers by Jacopo Pontormo (Jacopo Carucci) (1494–1557), and especially those by Agnolo Bronzino (Angelo di Cosimo di Mariano) (1503–72), depict self-confident aristocratic figures in artfully

contrived, often difficult to define, spaces. An interest in psychological presence is replaced by greater attention to artifice and to rendering details of costume, conveying an air of aristocratic ease, elegance, and distance. The Medici, supreme collectors as well as patrons of the arts, were among the first to exploit the potential of art for enhancing the power and prestige of the ruler. Portable paintings were used as gifts in the exercise of diplomacy. The essential elements of Florentine Mannerism may be seen in the *Allegory of Venus, Cupid, Folly, and Time* [**309**] by Bronzino, commissioned by Cosimo I as a gift to King Francis I of France, where the Italian style was now thriving at his court at Fontainebleau [**263, 267**].

France and Italy in the seventeenth century

By the beginning of the seventeenth century, Rome had again become the vital centre of art in Italy that it had been before the sack of the city by imperial troops in 1527. Artists converged from all parts of Italy, France, and the Netherlands, enticed by the promise of patronage and the lure of the eternal city's rich artistic heritage. The result was a fertile confluence of intellectual and artistic cross-currents. The Papacy in the Counter-Reformation functioned as a court and art was central to its display of both temporal and spiritual power. Patronage came from many levels among the ranks of cardinals and intellectuals as well as secular officials surrounding the Pope, many of whom were discriminating collectors. With the influx of northern artists, new types of painting were introduced and gained popularity during the century: still life, landscape, and scenes of everyday life.

Annibale Carracci (1560–1609) together with his brother Agostino (1557–1602) and their cousin Ludovico (1555–1619) are credited with reforming painting from the artifice of Mannerism and returning it to the ideals of the High Renaissance in which nature served as principal model for the artist. This reforming trend is evident in Bologna in the 1580s in a number of easel paintings of subjects from everyday life that one could call pure genre—Annibale's *Boy Drinking* (c.1582–3), the *Bean Eater* (c.1583–4) [**312**], and the *Butcher Shop* (c.1583). These works suggest a familiarity on Annibale's part with the paintings of Vincenzo Campi (1530/5–91) in Cremona and Bartolomeo Passerotti (1529–92) in Bologna: scenes of markets, butchers' shops, and moralizing genre subjects, all ultimately derived from northern art. On the vaulted ceiling of the Farnese Palace in Rome [**292**] in frescoes depicting scenes from Classical mythology celebrating the loves of the gods, Annibale combines his close study of nature with a study of antiquity and High Renaissance models to create a synthesis of form that was a

crucial element in the development of the new idealizing language of Baroque art in Rome.

Annibale's contemporary Michelangelo Merisi da Caravaggio (1571–1610), himself a reformer of painting, is best known for the realism of his powerful religious paintings in which he employs dramatic lighting and brilliant saturated colour to stunning effect. In easel paintings such as the *Boy with a Basket of Fruit* (1593–4) [**314**], the *Boy Bitten by a Lizard* (*c*.1593), *Bacchus* (*c*.1595) and others, the still-life elements are accorded equal attention with the human figures. The paintings exhibit a greater degree of refinement and finish than is present in Annibale's genre paintings but are no less faithful to nature. Caravaggio popularized subjects associated with northern art such as his half-length figures in the *Fortune Teller*, *Cardsharps*, and *Concerts*. In the first two decades of the seventeenth century, a number of Caravaggio followers popularized this kind of subject-matter. Themes such as the *Fortune Teller* and *Cardsharps* were treated by the French artists Simon Vouet (1590–1649) and Valentin de Boulogne (1594–1632), and, most notably, by the mysterious painter from Lorraine, Georges de La Tour (1593–1652). La Tour's *Fortune Teller* (*c*.1625?) shows remarkable naturalism in his attention to the rendering of figures and costumes; his later works, primarily candle-light scenes such as the *Penitent Magdalene* (*c*.1638–43?), tend to stark abstraction through which he successfully conveys a profound meditative stillness. Artemisia Gentileschi (1593–*c*.1652), the best-documented female Italian artist of the period, who worked for most of her career in Naples, painted themes of heroic biblical women such as *Judith and the Head of Holofernes* (*c*.1612) in which the violence of the scene is forcefully depicted.

History painting was the most elevated and respected category of painting and it was in this genre that the artist was able to attain the highest reputation. Nicolas Poussin (1594–1665), one of the most renowned history painters, worked principally for private patrons of intellectual bent in Italy and in France, creating easel paintings, otherwise called cabinet pictures, for their private collections. In the *Death of Germanicus* (1627) [**315**], painted for Cardinal Francesco Barberini, nephew of Pope Urban VIII, Poussin depicts the tragic story from the *Annals* of Tacitus of the death of the victorious general Germanicus, poisoned by his father-in-law the Emperor Tiberius, who was jealous of his fame. Poussin chose to depict the moment when the dying hero commends his family to the care of his comrades and calls upon them to avenge his death. The artist achieves a powerful effect through the grouping of figures in the composition, contrasting the mourning women with the stoic attitudes of the soldiers. Poussin drew inspiration for his composition from ancient sarcophagi and the art of his contemporary Peter Paul Rubens (1577–1640). The treatment of elevated, noble subjects with clarity and gravity of emotion displayed in such compositions of Poussin's were to serve as important models for later artists, notably Jacques-Louis David (1748–1825).

Landscape painting emerged as a separate genre in the seventeenth century. Specifically northern elements were introduced by the Flemish painter Paul Bril (1554–1626) and the German artist Adam Elsheimer (*c*.1578–1610), whose exquisite nocturnal scenes on copper display a virtuoso handling of light and shadow to convey a sense of mystery in the landscape. Contemporaneously, Annibale Carracci and his Bolognese follower Domenichino (Domenico Zampieri) (1581–1641) established the clearly lit Classical landscape in Italy, a genre that was brought to its highest state of grandeur in the heroic and ideal landscapes of Nicolas Poussin and Claude Lorraine (Claude Gellée) (1600–82) [**316**]. A contrasting 'romantic' landscape with storms, twisted trees, cliffs, and ruins was introduced by Salvator Rosa (1615–73), a solitary, proto-romantic artist known best for his landscapes, marine paintings, and battle pieces, but a painter as well of histories of obscure subject-matter.

In France, paintings by the brothers Le Nain—Louis (*c*.1593–1648), Antoine (*c*.1600?–48), and Mathieu (*c*.1607–77) —whose individual hands are still difficult to distinguish, depict, among other types of genre subjects, scenes of peasants without narrative content and with the figures often staring fixedly out of the picture, psychologically detached from one another [**317**]. Neither idealized nor satirized, the figures are sympathetically portrayed in a narrow range of colours and tonal values and in carefully composed groups. So little is known of the clientele for this type of painting, and of the artists themselves, that it is difficult to ascertain what meaning such works were intended to convey.

In 1648, the brothers Le Nain were among the founding members of the Royal Academy of Painting and Sculpture in Paris. Initially intended primarily to free painters from the constraints of the professional painters' guild, the Academy was reorganized in 1663 under Louis XIV (1643–1715) and his minister Jean-Baptiste Colbert (1619–83) as a teaching institution. Under the guidance of its director, the painter Charles Le Brun (1619–90), lectures or *conférences* as they were called, were held in which members of the Academy focused discussions on selected cabinet pictures from the King's collection and from such discussions principles of an ideal theory of academic art were formulated. A hierarchy of the categories of painting was firmly established with history painting as the most illustrious, for which Poussin's paintings served as exemplary model, followed by portraiture, landscape, and still life. The resulting theories guided French academic art for the next 250 years. Only history painters were accorded full honours. The Academy under Colbert marked the institutionalization of the arts in France in the service of the crown. The imposing portrait of Louis XIV by Hyacinth Rigaud (1659–1743) [**318**] is emblematic of the period during which France established a cultural hegemony in Europe and power and art were located in the person of the king at the court of Versailles.

France in the eighteenth century

Although the Royal Academy of Painting and Sculpture continued throughout the eighteenth century to dictate artistic policy in France, the style identified with the court of Louis XIV at Versailles gradually acquired a more dispersed and public character in response to the innovative tastes of a wealthy and cosmopolitan nobility and a prosperous and growing urban society centred in Paris. Art of a more intimate character was

found to be better suited to the changing social conditions. Jean Antoine Watteau (1684–1721), an outsider to the circle of court artists, created a new genre of painting of his own invention, the *fête galante*, which gained him admission to the Academy in 1717 [**319**]. In the *fête galante*, Watteau, in an open and brushy style inspired by sixteenth-century Venetian painting and the art of Rubens, depicts elegant figures in contemporary dress mingling with others in theatrical costumes, engaged in conversation or music-making in secluded park settings. The new type of painting won enormous popularity and opened the way for artists of lesser categories to take their place in the Academy alongside the history painter.

The visual expression of love created by Watteau was adapted by François Boucher (1703–70) and Jean-Honoré Fragonard (1732–1806) who brought it to its full Rococo maturity. In order to attract clients in his search for private patrons, Boucher painted a variety of cabinet pictures: mythologies, pastorals, and interiors depicting both high and low life. For the last 20 years of his life, he worked for Madame de Pompadour, who became his most enthusiastic patron and encouraged the production of some of his most frivolous subject-matter: pastorals with shepherds and shepherdesses depicted as sentimental lovers, scenes of putti, known as '*les enfants de Boucher*' (the children of Boucher), engaged in adult activities, and semi-nude women in various guises from the pretended scenes of Venus [**320**] to frank portrayals of contemporary women. Though narrative subjects and mythologies continued to provide subject-matter, stylistically such paintings came to be regarded more as decorative, exhibiting the light-filled, pastel colours and vibrant brushy strokes of Fragonard's *Rinaldo and Armida* [**321**].

More quotidian subject-matter and sober style are seen in the work of Jean-Baptiste Siméon Chardin (1699–1779), who was accepted into the Academy in 1728 as a painter of 'still life and animals'. In both still-life and genre scenes, he endowed everyday objects and everyday scenes with the gravity and dignity of history painting [**323**].

The Royal Academy of Painting and Sculpture sponsored exhibitions of the work of its members free of charge to the public in annual Salons from 1737 to 1751, and thereafter biennially. The month-long exhibitions were consistently well attended. Paintings were hung from floor to ceiling in the Salon Carée in the Louvre (hence the name 'Salon') and catalogues of the works exhibited were produced and sold to the public. It was a way of showing what the Academy was producing as well as securing commissions for the artists from a wider audience. Images of the events of the Salon in the watercolours of Gabriel de Saint-Aubin (1724–80), as well as in the works of other artists, show the great diversity of subject-matter in French painting at the time. As a direct result of the popularizing of art through the Salon, the art critic gained rapid influence, as evidenced by mid-century by the publication of a number of pamphlets and journals containing critical reviews of the Salon exhibitions. As art became a more public business and works of art a commodity, the *marchand-amateur* or art dealer-connoisseur emerged to mediate between the artist and the growing number of new buyers and collectors of paintings.

In the ever-changing intellectual and social climate of Paris, towards the middle of the century, Denis Diderot (1713–84), while acknowledging Boucher's abilities as a painter, condemned him for catering in his art to what Diderot saw as the taste of a depraved society. Increasingly, critics like Diderot and Etienne La Font de Saint-Yenne (1688–1771) were demanding works that appealed to the intellect. For Diderot, a painting such as *The Marriage Contract* (1761) by Jean-Baptiste Greuze (1725–1805) [**322**] was exemplary for the moralizing content that Diderot believed endowed it with the dignity of history painting. By the final quarter of the century, the change in the prevailing taste of society saw the Rococo style replaced by the Neoclassical.

Italy in the eighteenth century

In eighteenth-century Italy, Venice emerged for a second time as a leading centre of the arts, a magnet for sophisticated and wealthy patrons, both visitors and residents, and foreigners making the Grand Tour. Two new types of painting were developed, the *veduta* or view of the picturesque scenery of Venice and its environs, and the *capriccio*, in which fanciful landscapes frequently filled with ruins suggest the ancient cultural heritage claimed for Venice. The *capriccio* was largely developed by Marco Ricci (1676–1730) into an evocative scene combined with a powerful architectural composition of echoing forms [**324**]. The *veduta*, a depiction of an actual scene, was introduced by the Dutch artist Gaspar van Wittel called Vanvitelli (1653–1736) and brought to its highest state by Giovanni Antonio Canale (called Canaletto) (1697–1768). Canaletto's numerous views of Venice [**326**] display the Venetian love of brilliant light and colour, and while he frequently adjusts buildings to improve his compositions, his exactitude in details lends his paintings a powerful sense of realism. In Rome, the ever-popular *veduta* was provided for the tourist by, among others, Giovanni Paolo Panini (1691/2–1765/8) whose large paintings of Roman interiors capture the grandeur of the architecture of the city [**325**].

The greatest Venetian painter of the time, Giambattista Tiepolo (1696–1770) and his son Giovanni Domenico Tiepolo (1727–1804), best known for their altarpieces and spirited frescoes that enlivened the vast walls and ceilings of noble palaces from Germany to Spain, also created easel paintings of histories, mythologies, and genre scenes, filled with light and colour combined with extraordinary freedom of brush stroke characteristic of Giambattista's frescoes and drawings. Giovanni Battista Piazzetta (1683–1754) offered a more robust alternative in paintings of religious themes, mythologies, and genre, executed in his dark chiaroscuro manner. The taste for small paintings of Venetian interiors and scenes of Venetian street-life [**327**] were supplied largely for a local wealthy clientele by Pietro Longhi (1702–85). Francesco Guardi (1712–93) introduced the typical Venetian freedom of spirited brush work and flecks of light to the subjects of landscape and *vedute* as in his *Doge Embarking on a Bucintoro* (1770–5) [**328**]. Particularly when used in his *capricci* and his *vedute* of the quiet edges of towns far beyond the major tourist monuments, Guardi's manner has frequently been seen as a striking precursor of later developments in French Impressionism. PM

219

Portable easel paintings on canvas

In the sixteenth century, the Venetian artists Giorgione and his follower Titian were largely responsible for creating a vogue for a new type of picture: the portable easel painting on canvas. Sensuous and secular in nature and intended primarily for private delectation, the new type of commissioned painting served the taste of a sophisticated clientele largely among the nobility.

Titian's rendering of *Danaë* [**308**], commissioned by Philip II of Spain, like Correggio's *Jupiter and Io* [**310**] for the Duke of Mantua, is devoid of the Florentine Mannerist ambiguity that characterizes Bronzino's *Allegory of Venus* [**309**]. In Bronzino's panel, the artifice and intellectual complexity of the allegorical subject-matter as well as the studied disposition of the figures were as much a source of delight at the sophisticated courts of Cosimo I in Florence and Francis I at Fontainebleau as was the erotic subject-matter. The hard-edged surface and clearly defined contours of Bronzino's painting are in marked contrast to Titian's soft atmospheric handling of form, illustrating the stylistic polemic of the day between Florentine attention to drawing and Venetian attention to colour.

Such easily transportable pictures readily changed hands and by the second half of the sixteenth century they were beginning to find their way into great collections, valued by connoisseurs as autonomous works of art for the artistry they displayed independent of any professed function. Illustrative of this trend at a later date in its development is the

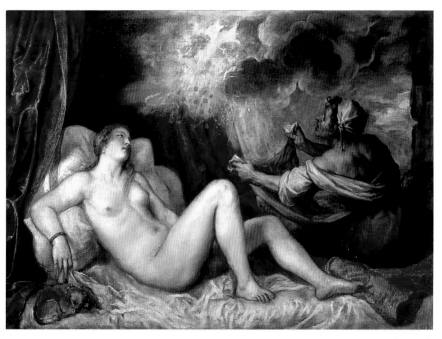

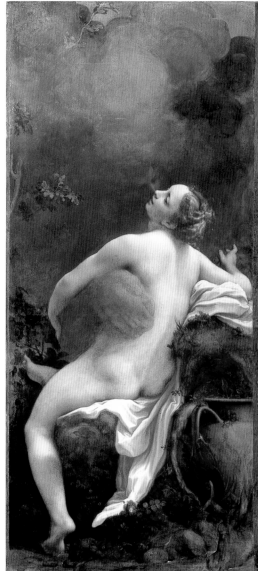

220

308 Above: Titian (Tiziano Vecellio) (*c.*1485–1576), *Danaë* (1554), oil on canvas, 1.29 × 1.80 m. (50¾ × 71 in.) Madrid, Prado

309 Right: Agnolo Bronzino (Angelo di Cosimo di Mariano) (1503–72), *Allegory of Venus, Cupid, Folly, and Time* (*c.*1546), oil on panel, 1.46 × 1.16 m. (57½ × 45¾ in.), London, National Gallery

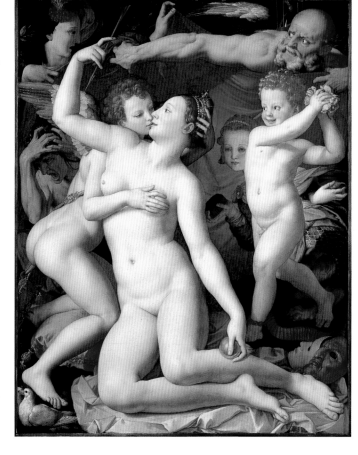

310 Correggio (Antonio Allegri) (*c.*1489–1534), *Jupiter and Io* (*c.*1532), oil on canvas, 1.63 × 0.74 m. (64 × 29⅛ in.), Vienna, Kunsthistorisches Museum

painting by David Teniers of Archduke Leopold Wilhelm's seventeenth-century picture gallery [311], which by 1656 numbered 1,400 works and formed the heart of the Habsburg collection. Today it is the core of the collection at the Kunsthistorisches Museum in Vienna. The Archduke's picture gallery displays a taste similar to that behind the formation of other great seventeenth-century collections: a decided preference for sixteenth-century Venetian works.

. In Teniers' painting, religious devotional images hang side by side with portraits and mythologies displaying female nudes. Recognizable are works by Titian displayed in the top row as well as in the lower right where images of single female figures similar to those painted by Veronese and Palma Vecchio also appear. Very different in type, but as avidly sought by collectors in the sixteenth and seventeenth centuries, were the rustic genres, biblical pastorals, and *quadri campestri* of Jacopo and Francesco Bassano who introduced a northern taste for genre into the idealizing art of their contemporaries. PM

221

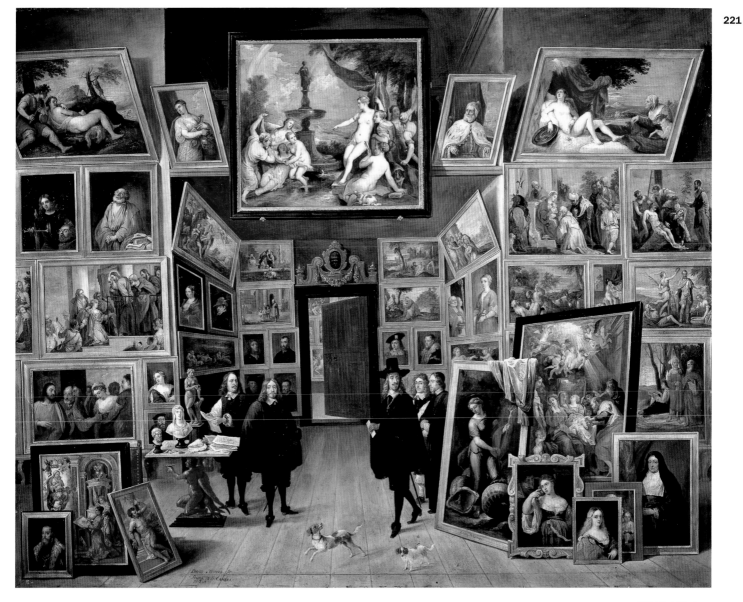

311 David Teniers the Younger (1610–90), *The Picture Gallery of Archduke Leopold Wilhelm of Austria* (*c*.1651–3), oil on copper, 1.06 × 1.29 m. (41¾ in. × 50¾ in.), Madrid, Prado

Naturalism in Rome

Annibale Carracci's *Bean Eater* [312], with its roots in the northern comic genre tradition, displays a meticulous observation of nature, a hallmark of Annibale's work and an important influence on the emerging naturalism present throughout seventeenth-century Baroque art.

Caravaggio's *Boy with a Basket of Fruit* [314] displays a similar prefer-ence for painting from the live model. His realism could at times be brutal in its unidealized treatment of subject-matter. In certain instances, particularly with regard to his altarpieces, this resulted in the condemnation and even rejection of his work by patrons.

A new type of patron was emerging, however, from the circle of prelates, intellectuals, and secular officials surrounding the Pope, assembling important collections of the new art with discriminating taste and judgement. Representative of these was Cardinal del Monte, who owned the *Boy with a Basket of Fruit*, the homoerotic nature of which may have reflected the collector's personal taste.

A nascent market for new genre subjects based largely on northern models made an appearance in seventeenth-century Rome. This was largely the result of an influx into the city of northern artists whose numbers soon outran the demand for commis-sioned work and who sought an alter-native outlet for their art in markets and fairs.

Some of the northern artists began to specialize in a new type of easel painting depicting scenes of everyday life in and around seventeenth-century Rome, often meeting with notable financial success. Pre-eminent among this group was the Dutch genre

222

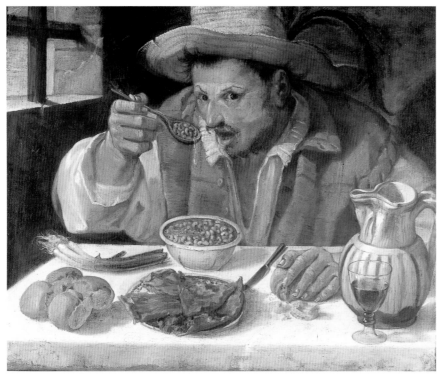

312 Left: Annibale Carracci (1560–1609), *Bean Eater* (*c.*1583–4), oil on canvas, 57 × 68 cm. (22½ × 26¾ in.), Rome, Galleria Collona

313 Below: Pieter van Laer (1599–*c.*1642) *Shepherd and Washerwoman* (*c.*1630), oil on copper, 29 × 43 cm. (11½ × 17 in.), Amsterdam, Rijksmuseum

314 Opposite: Caravaggio (Michelangelo Merisi) (1571–1610), *Boy with a Basket of Fruit* (1593–4), oil on canvas, 70 × 67 cm. (27½ × 26⅜ in.), Rome, Borghese Gallery

painter Pieter van Laer, nicknamed *il Bamboccio* ('ugly doll' or 'puppet') on account of his physical appearance, who arrived in Rome around 1628. The naturalistic, low-life scenes he [313] and his followers painted were in turn called *bambocciate*, and his followers *bamboccianti*.

The newer markets and enlightened collectors such as Cardinal del Monte, together with the growing demand for easel paintings, freed the artist from total dependence on official commissions for large murals and altarpieces, which were few in number and difficult to secure.

PM

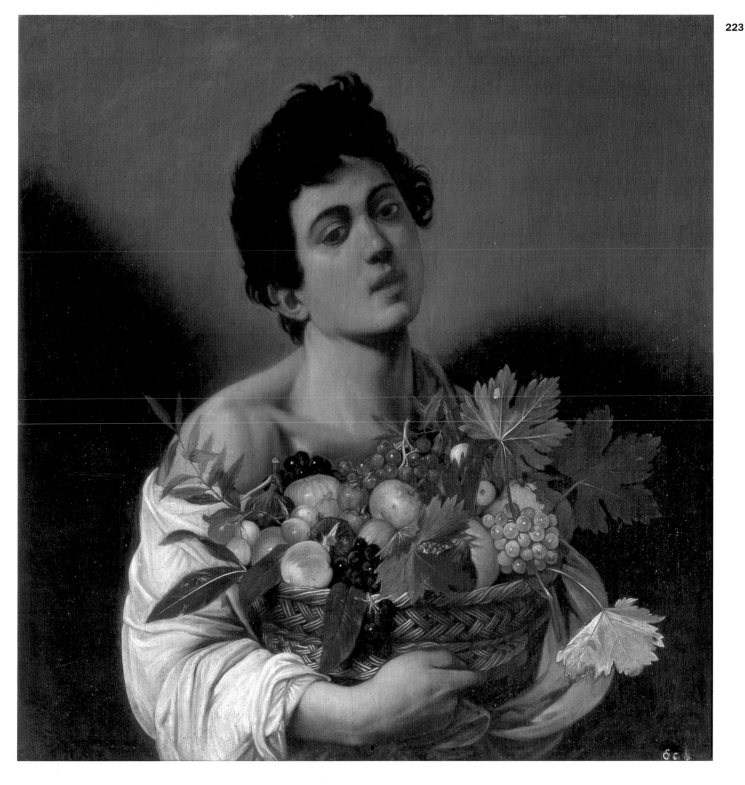

The hierarchy of the genres in France

From the late 1620s on, Nicolas Poussin worked almost exclusively for private collectors in Italy and France, producing such intellectually rewarding easel paintings (also called cabinet-pictures) as the *Death of Germanicus* [**315**]. At a time when artists were judged chiefly by their ability to paint large-scale mural paintings and altarpieces, classical authority for the idea that cabinet-sized pictures placed superior demands on the artist's talents was firmly grounded in the ancient Roman author Pliny, who maintained that 'no artist enjoys real glory unless he has painted easel paintings'. Poussin's biographer André Félibien states that Poussin found in the limited dimensions of such easel paintings all the space he required to demonstrate his mastery of painting.

Claude Lorraine, who, like Poussin, worked almost his entire career in Rome, appealed to a different clientele. The wealthy Roman nobility particularly favoured Claude's idealized atmospheric landscapes evocative of the Roman campagna, often containing subordinate mythological subjects such as his *Cephalus and Procris Reunited by Diana* [**316**].

Claude's landscapes became so popular during his lifetime that illicit copies were produced in such numbers to meet the demand that the artist was prompted to keep a record of his own work in a book called the *Liber Veritatis*, in which *Cephalus and Procris* is number 91.

In France, the brothers Le Nain produced genre paintings of peasant groups in interior settings devoid of narrative content, the figures

224

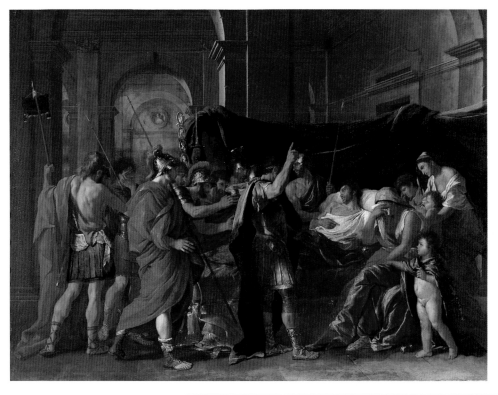

315 Nicolas Poussin (1594–1665), *Death of Germanicus* (1627), oil on canvas, 1.48 × 1.98 m. (58¼ × 78 in.), Minneapolis Institute of Arts

316 Claude Lorraine (Claude Gellée) (1600–82), *Cephalus and Procris Reunited by Diana* (1645), oil on canvas, 1.02 × 1.32 m. (40 × 52 in.), London, National Gallery

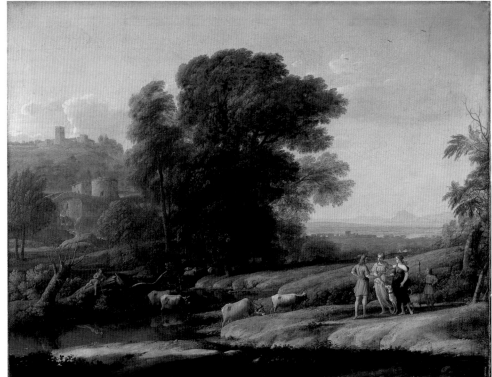

psychologically detached from one another, enigmatically gazing out at the viewer [**317**]. In the last third of the seventeenth century, there was a shift of focus from Italy as the centre of artistic life to France. There the rise of Academic art theory and the establishment as doctrine of a rigid hierarchy of genres was accompanied by a diminished interest in the lesser types of genre pictures in favour of the grand manner of history painting, allegories, and mythologies glorifying the king and his court at Versailles. In his portrait of Louis XIV [**318**], Hyacinth Rigaud created an exemplary image of the absolute monarch as the embodiment of the power and cultural supremacy of France. PM

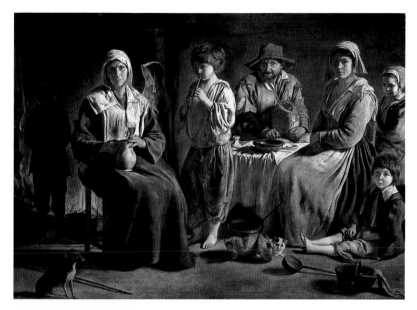

317 The Le Nain brothers, probably Louis (*c*.1593–48), *Family of Peasants* (*c*.1642), oil on canvas, 1.13 × 1.59 m. (44½ in. × 62⅝ in.), Paris, Louvre

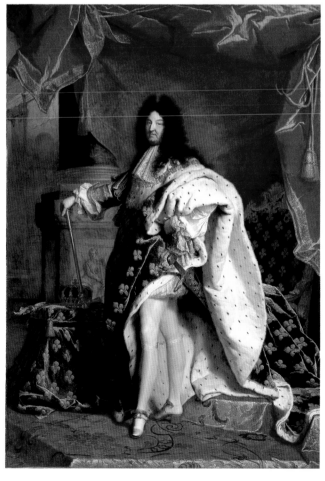

318 Hyacinth Rigaud (1659–1743), *Louis XIV* (1701), oil on canvas, 2.77 × 1.94 m. (9 ft. 2 in. × 6 ft. 4¾ in.), Paris, Louvre

New tastes, new pictures

By the beginning of the eighteenth century, the migration of the court from Versailles to Paris was well under way. Fashionable new residences proliferated in the newly developed *faubourgs* of Saint-Germain and Saint-Honoré on opposite banks of the Seine. Constructed on generous plots of land, the new *hôtels particuliers*, as they were called, were characterized by a closer integration of house and garden, larger windows, smaller, more intimate rooms, and a taste for brighter interiors of white walls embellished with gilded arabesques and mirrors, replacing the tapestries and dark brocades of the previous century. New tastes in living were accompanied by new tastes in pictures.

Watteau's *Pilgrimage on the Isle of Cythera* [319], his *morceau de réception* (reception piece, gaining him admission to the Royal Academy), epitomizes the new genre he created: the *fête galante*—imaginative scenes in idyllic park-like settings featuring elegantly attired figures in uneventful social gatherings, echoing the favoured pursuits of aristocratic Parisian society. In Watteau's painting, elegant couples leisurely await their turn to re-embark on the fanciful barge that has borne them to the legendary island of Cythera, home of Venus, goddess of love, whose statue at the right presides over the scene.

Boucher and Fragonard, both of whom were received into the Academy at the highest level as 'history painters', earned their lasting reputations, however, from the lucrative business of producing easel paintings of more light-hearted,

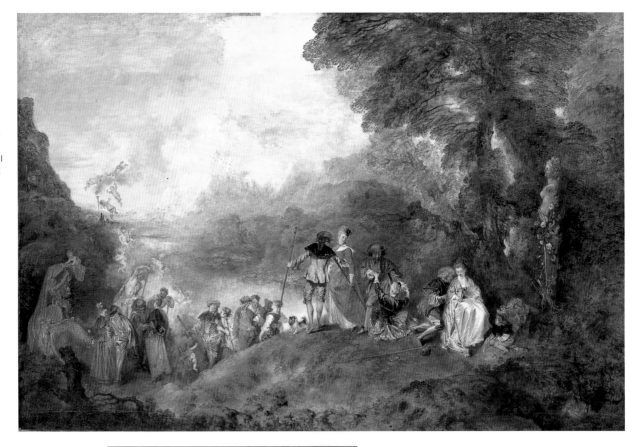

319 Jean Antoine Watteau (1684–1771), *Pilgrimage on the Isle of Cythera* (1717), oil on canvas, 1.29 × 1.94 m. (50¾ × 76⅜ in.), Paris, Louvre

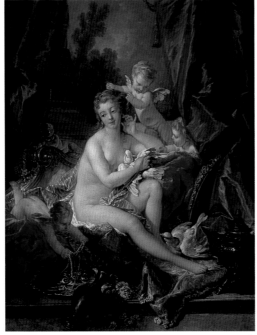

320 François Boucher (1703–70), *The Toilet of Venus* (1751), oil on canvas, 108 × 85.3 cm. (42⅝ × 33½ in.), New York, Metropolitan Museum of Art

decorative subjects. Boucher, whose remarkable range of talents included designing tapestries and porcelain and creating stage settings for ballets and operas, is perhaps best known for his sensual subjects such as the *Toilet of Venus* [**320**], an erotic theme with scant narrative content. In his *Rinaldo and Armida* [**321**], Fragonard draws his subject from Torquato Tasso's popular *Gerusalemme Liberata* (1581), a fruitful source of subject-matter for painters since the sixteenth century. Fragonard's painting, however, rendered in fluid brush strokes with light-filled pastel colours, imparts to the subject the decorative quality that so appealed to sophisticated Parisian society.

In contrast, Chardin's scenes of middle-class domestic interiors and still lifes of everyday objects [**323**], rooted in the seventeenth-century Dutch genre tradition, provided collectors with a more sober alternative. Treated with great attention to realism and rendered in a narrow range of colours and tonal values, his paintings are endowed with a meditative quality that has given them lasting appeal. By the middle of the century, it was paintings such as Greuze's *Marriage Contract* [**322**] that provoked the influential critic Denis Diderot to hail Greuze as the creator of a new genre, *la peinture morale* (moral painting), in which he found cause to hope that this new genre would rescue painting from the frivolous subject-matter in the tradition of Boucher and Fragonard. Diderot saw in Greuze's painting a forthright directness and clarity of gesture and emotion capable of eliciting a moral response from the viewer not unlike the response that was the desired aim of history painting. PM

227

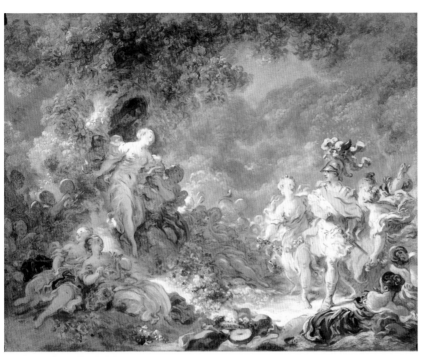

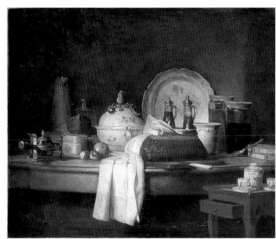

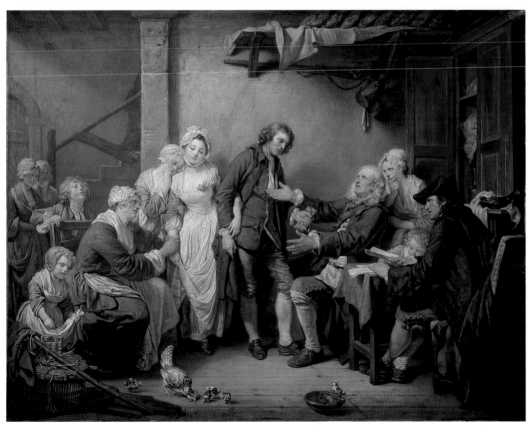

321 Above left: Jean-Honoré Fragonard (1732–1806), *Rinaldo and Armida* (1764), oil on canvas, 72 × 91 cm. (28⅜ × 35⅞ in.), Paris, private collection

322 Left: Jean-Baptiste Greuze (1725–1805), *The Marriage Contract* (1761), oil on canvas, 92 × 117 cm. (36¼ × 46 1⁄16 in.), Paris, Louvre

323 Above: Jean-Baptiste Siméon Chardin (1699–1779), *The Breakfast Table* (c.1763), oil on canvas, 38 × 46 cm. (15 × 18⅛ in.) Paris, Louvre

Views of Rome and Venice

Venice in the eighteenth century enjoyed a second flowering of the arts for which it became renowned throughout Europe. In the course of extensive travels to undertake foreign commissions or to seek patrons, artists such as Giambattista and Domenico Tiepolo, Sebastiano and Marco Ricci, and Canaletto spread the fame of the city abroad. While commissions tended to be principally for works in the great Italian tradition of large-scale frescoes and altarpieces, there was at the same time a growing demand for smaller easel paintings of mythological and historical subjects and genre scenes.

The demand among visitors and collectors for evocations of the luminous city fostered a market for two new genres: the *capriccio*, a fanciful landscape often with ruins, perfected by Marco Ricci, as in his *Capriccio of Roman Ruins* [324], and the *veduta* or topographical view, perfected by Canaletto. In his *Regatta on the Grand Canal* [326], Canaletto records one of the most lavish displays of Venetian pageantry.

Concurrently, in Rome, the climactic stop on the Grand Tour, the majesty of the city's architecture was conveyed in *vedute* by Giovanni Paolo Panini in such works as the *Interior of S. Peter's* [325]. Aware of the great tradition of Venetian painting, knowledgeable visitors who flocked to the city made it a point to seek out the best artists of the day.

Commissions were facilitated by the noted collector, patron, and art dealer Joseph Smith, a wealthy banker who for many years acted as British consular representative in Venice and

324 Marco (Antonio) Ricci (1676–1730), *Capriccio of Roman Ruins* (1720s), tempera on kid or goat skin, 31 × 45.5 cm. (12¼ × 17⅞ in.), Washington, DC, National Gallery of Art

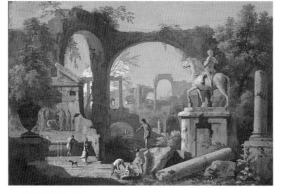

325 Below: Giovanni Paolo Panini (1691/2–1765), *Interior of S. Peter's, Rome* (c.1754), oil on canvas, 1.54 × 1.97 m. (60¾ × 77½ in.), Washington, DC, National Gallery of Art

326 Opposite, top left: Canaletto (Giovanni Antonio Canale) (1697–1768), *Venice: A Regatta on the Grand Canal* (c.1733–4), oil on canvas, 77.2 × 125.7 cm. (30⅜ × 49½ in.), Windsor, Royal Collection

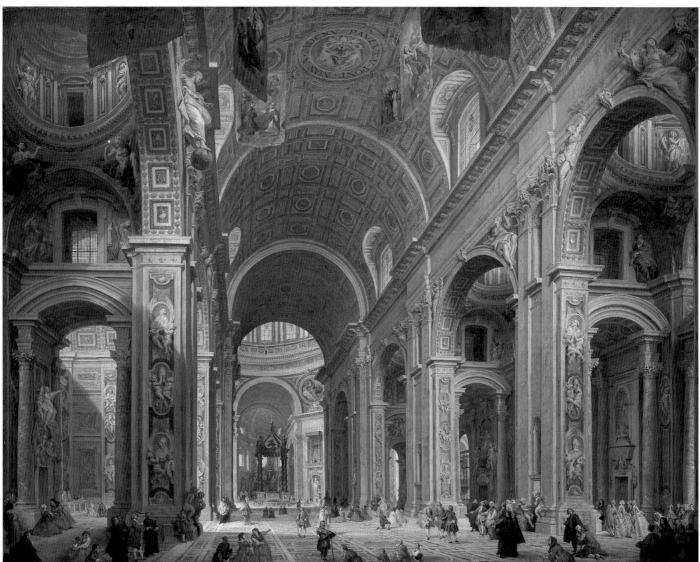

whose palazzo on the Grand Canal was a noted gathering place for visiting members of the British nobility and other foreign dignitaries. Here, visitors could choose from an array of views of the city by Canaletto, and Consul Smith would arrange to have the chosen motif painted by the artist. Smith supported the publication of several volumes of prints of Canaletto's work, which served the dual purpose of a catalogue of the type of views one could order from the artist and a catalogue of Smith's own unrivalled collection of Canaletto's paintings, subsequently acquired by George III.

In contrast to Canaletto, Francesco Guardi and Pietro Longhi served a predominantly local clientele, Longhi, with his representations of high- and low-life Venetian interiors and street scenes. His *Masked Figure with a Fruit Seller* [327] shows upper-class Venetians, in the company of street vendors, wearing the traditional carnival mask, the *bauta*, that permitted unfettered intermingling among all strata of Venetian society. Guardi endowed his images with his own unique rendering of the effects of light and atmosphere, as shown in his *Doge Embarking on a Bucintoro* [328], from a series of 12 views based on drawings by Canaletto. The Napoleonic Wars brought an end to the Venetian republic in 1797 and, with it, the end of the city's second golden age. Expatriot artists such as Giovanni Piranesi (1720–78), Bernardo Bellotto (1721–80), and Antonio Canova (1757–1822), however, carried on the tradition of Venetian art in exile, with a strong influence on both the Neoclassical and the Romantic movements of the late eighteenth and early nineteenth century. PM

229

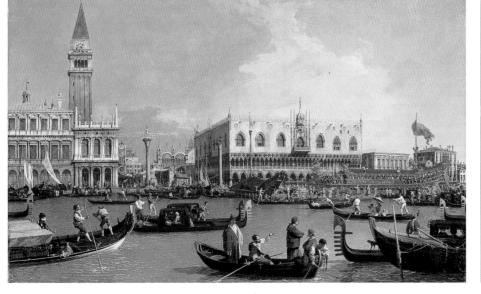

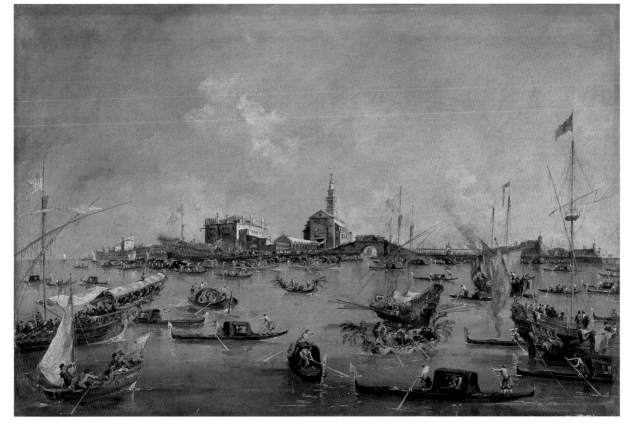

327 Above: Pietro Longhi (1702–85), *Masked Figure with a Fruit Seller* (c.1760), oil on canvas, 62 × 51 cm. (24⅜ × 20 in.), Venice, Ca' Rezzonica

328 Left: Francesco Guardi (1712–93), *Doge Embarking on a Bucintoro* (1770–5), oil on canvas, 67 × 100 cm. (26⅜ × 39⅜ in.), Paris, Louvre

The Picture: Spain

During the Middle Ages, Spain had been both a participant in the international nature of Gothic art, most notably along the pilgrimage route to Santiago de Compostella, and developed its own national style, typified by fervent elaboration. The powerful Moorish political and cultural presence, exemplified by the Alhambra, was both contested and assimilated by Spanish Christian authorities. The fertile dialogue between internationalism, promoted by the trans-European and ultimately trans-Atlantic ambitions of the Spanish monarchs, and idiosyncratic expressions of national and regional values remained a central characteristic of Spanish art throughout the period. Typically, a directness of optical and spiritual vision conveys deeply felt meanings which not only speak of religious and secular power but also embody the intensity of 'popular' devotion.

By 1500 the fragmented kingdoms of Spain had been brought into some kind of unified order, through the marriage of Ferdinand of Aragon and Isabella of Castile, and the conquest of Moorish Granada in 1492, the year that also marked the expulsion of the Jews. Naples was successfully retaken in 1503, and the impact of Spanish might in Italy steadily grew. The accession in 1516 of Charles V, a Flemish prince of the house of Habsburg, extended the reach of the Spanish monarchy to Flanders and Germany, with enormous consequences for the religious, political, and cultural fortunes of the whole of Europe.

Sixteenth-century Internationalism

Painting was still largely harnessed to the needs of the church during Charles's reign. The long periods the king spent abroad as Holy Roman Emperor coupled with the lack of a fixed royal court concentrated artistic patronage in the hands of regional religious authorities. While Late Gothic assemblies of painted and sculpted imagery originating in northern Europe still predominated, in Valencia Fernando Yáñez (Yáñez de la Almedina) (fl. 1505–31) and Fernando de Llanos (fl. 1506–16) pioneered the introduction of a style of painting heavily influenced by Leonardo da Vinci (1452–1519) which they had both probably learned in Florence. Their large, multi-imaged altarpieces were characterized by monumental figural and architectural forms and a soft, shadowy handling of facial expression.

Under Philip II (1556–98) Spain rose to prominence as the largest monarchy in the Western world and the most powerful in Europe. The enormous impact which this new status would have on painting was felt first in portraiture as the King, a well-travelled and prodigious art collector with sophisticated, cosmopolitan tastes, immediately set about fashioning a new royal image. Unable to persuade his favourite painter Titian (Tiziano Vecellio) (c.1485–1576) to leave Venice for Spain,

Philip briefly secured the Brussels-based artist Antonis Mor (1516/20–c.1576) as court painter. Mor's method of painting figures lifesize and against austere backgrounds to set off a real interest in the intricacies of their dress and expression established the definitive royal portrait type, one which would endure for generations to come through the work of his Spanish-born pupil Alonso Sánchez Coello (c.1531/2–88) and Juan Pantoja de la Cruz (c.1553–1608).

The creation of a permanent court in Madrid in 1561 to rival those the King had seen abroad rapidly transformed the city into the most important Spanish artistic centre and key source of patronage, to which painters flocked in search of work. An ambitious royal building programme was soon in place, triggering a demand for elaborate painted decorative schemes. Appointed royal painter in 1562, Gaspar Becerra (c.1520–68) drew on his earlier experience in Rome to devise ornate fresco cycles which represented scenes from Classical mythology, previously rare in Spanish art, painted in an unfamiliar Italian Mannerist style. Serial views of Spanish cities commissioned to adorn palace walls and corridors, like those by the Flemish artist Anton van den Wyngaerde (c.1512–71), functioned both as topographically accurate records of the kingdom and as emblems of the might of Habsburg power, and were assembled on a scale entirely without precedent in Europe.

It was another royal project, the Escorial, the immense monastery-palace built beyond Madrid and the confines of the court between 1563 and 1584, which established new, exacting standards for the form and function of religious painting. Conceived as a dynastic monument centred on the tomb of Charles I, the unique complex emerged as the most thorough-going visual articulation of the Spanish monarchy's mission to defend the Catholic Church against Protestantism. As the first European ruler to embrace the tenets of the Council of Trent (1545–63), the blueprint for Catholic spiritual reform, Philip above all valued a clear, intelligible style and strict adherence to doctrinal orthodoxy in devotional imagery. Two generations of Spanish and Italian painters including Juan Fernández de Navarrete (also known as 'El Mudo'—the mute) (c.1538–79), Federico Zuccaro (c.1542–1609), and Pellegrino Tibaldi (1527–96) worked on the Escorial altarpieces and frescoes, fusing iridescent colour with bold handling of form in a manner that derived from Roman Counter-Reformation practice.

329 Opposite: In situ copy of El Greco (Domenikos Theotokopoulos) (1541–1614), *Assumption of the Virgin* (1577), Toledo, church of S. Domingo el Antiguo; original oil on canvas, 4.01 × 2.29 m. (13 ft. 2 in. × 7 ft. 6 in.) at Art Institute of Chicago; originals of El Greco's *S. John the Baptist* (bottom left) and *S. John the Evangelist* (bottom right) remain in situ; original *Holy Trinity* (top) and *S. Benedict* (middle right) in Prado Museum, Madrid; present whereabouts of *S. Bernard* (middle left) unknown

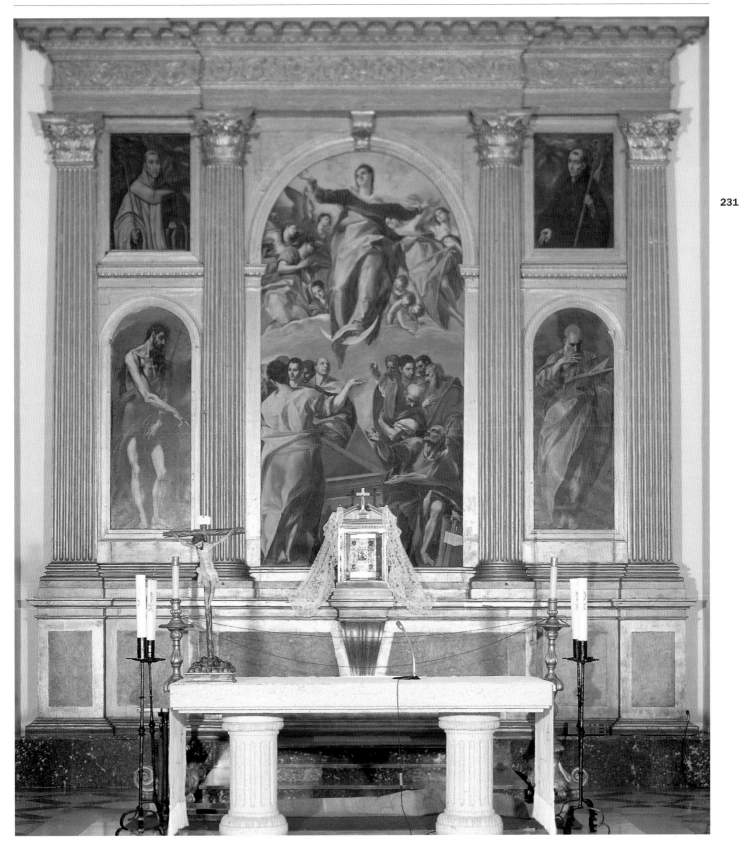

The preoccupation of the sixteenth-century Spanish church with the Counter-Reformation found its fullest visual expression in Toledo and the art of El Greco (Domenikos Theotokopoulos) (1541–1614), the Cretan-born painter who adopted the city as his home from 1577. Anxious to infuse a new devotional fervour into local worship, the clerical élite of the richest and most powerful see in the kingdom recognized the immense expressive possibilities of El Greco's compositions. The kind of Italianate altarpiece he introduced to Spain, comprising either a large, dominant or even solitary painting, simply framed, created a more legible, immediate image of the type which new meditative modes of prayer sought to promote. In the *Assumption of the Virgin* [**329**], the focus of one such altarpiece, tightly grouped gesturing figures, chromatic colour, and the compression of space all work to establish the spiritual intensity of the scene. HC

Baroque variations

The main centres of painting in Spain were Madrid (the capital and court), Seville, and Valencia. In Madrid painters occupied a lowly social status in the eyes of their high-born patrons, often equated with the ranks of artisans, and this anomaly drove the more ambitious to seek courtly preferment and distinction. The most favoured artist of the period was Diego Velázquez (1599–1660), who was royal painter to Philip IV (1621–65) and primarily employed as a portrait painter. Velázquez respected the time-honoured Habsburg traditions of formal royal portraiture, but painted in a style of optical naturalism which is entirely his own [**336**] and which represents one of the most significant developments in European painting of the period.

Outside the court, the clergy remained the main patron of painting in seventeenth-century Spain. *Retablo* altarpieces were the focus of devotion in most Spanish churches, elaborate architectural ensembles comprising sculptures and paintings, which were likened to great visual sermons. The religious orders were a vital source of ecclesiastical patronage for most painters, normally commissioning series of narrative paintings of the life of their founder and saints. While monastic patrons tended to artistic conservatism, this suited Francisco de Zurbarán (1598–1664), whose artistic career was dependent upon commissions from Dominicans, Mercedarians, Franciscans, as well as the Hieronymite and Carthusian orders.

The conviction that painting was a primary instrument of the Counter-Reformation in propagating the Roman Catholic faith was taken very seriously in Spain. Francisco Pacheco (1564–1644), the erudite Sevillian painter and teacher of Velázquez, expressed unequivocally the view of the paramount didactic function of religious painting in his *Arte de la pintura* (1649). In his words, the vocation of the artist was in the service of the church, the principal end of painting was to 'instil piety and to lead people to God' by the representation of 'the sacred stories and divine mysteries which teach the faith, the works of Christ and the Virgin, [and] the lives and deaths of the holy martyrs, confessors and virgins'.

In the indoctrination of the devout masses through paintings, a premium was set on the veracity, clarity, and immediacy of the religious message. Orthodoxy was also an overriding concern. Pacheco became Censor of Sacred Images in Seville in 1618 and a lengthy appendix to his treatise specified the correct form of representation of sacred stories and the most common saints. The iconography of newly commissioned works was strictly supervised by the bishops and priors, who sometimes provided artists with print sources to follow. This was the case with Francisco de Zurbarán's *S. Peter Nolasco's Vision of the Crucified S. Peter* [**330**], which followed a print model but whose figures were painted from live models. Images of the Immaculate Conception which proliferated in Spain [**331**] all obeyed a rigidly standardized pictorial formula which artists endlessly varied. In such a strongly Marian culture as that of Spain, these paintings responded to a popular fervour in honour of this mystery which the Pope officially recognized in the seventeenth century, although it did not become dogma until 1854.

Since painting was the proverbial 'Bible of the illiterate', a familiar repertoire of representations of Christ, the Virgin, and the saints provided inspiring exemplars upon which the devout fed their faith and modelled their lives. The virtue of Charity, for instance, was exemplified in Bartolomé Esteban Murillo's (1617–82) painting of the Spanish saint Thomas of Villanueva [**333**] distributing alms, which emphasized the efficacy of Works of Mercy in response to Protestant belief in redeeming faith alone. Murillo's depiction of the deep humanity of the saint and the painting's direct appeal to the viewer's emotions is typical of much Spanish religious painting of this time, which was so successful in moving devout viewers of all social classes.

The same religious themes were represented in all the Catholic countries—Spanish art is distinguished by its candour and factualness. The often noticed 'realism' of Spanish painting in the seventeenth century actually served religious ends. Transcendent religious truths were articulated through paintings which invoked familiar, everyday reality in order to bring the mysteries and miracles of the faith within the realm of experience of the faithful and make these messages more immediately comprehensible. Zurbarán has depicted a vision as an intelligible event of concrete materiality [**330**]. We empathize with the reactions of the poor to S. Thomas of Villanueva's act of charity [**333**]. The domestic setting and homely details of Zurbarán's *Christ and the Virgin in the House at Nazareth* [**332**] were instantly recognizable and also held symbolic meaning for contemporaries. Christ's mission is clear even in childhood; he has pricked his finger on the crown of thorns in a prefiguration of his coming Passion, a fact understood by his weeping mother and by the viewer who would have read the two tear-shaped pears on the table, for instance, as symbols of redemption.

Paintings of Classical history and mythology were almost exclusively painted by artists in Madrid, where the taste of the king and his courtiers was coloured by the humanistic conventions of Italian art. The most notable mythological paintings are those of Diego Velázquez, who visited Italy twice, and which are characterized by their mundane, naturalistic treatment [**335**]. While erotic mythologies paintings with large nude figures depicting the Loves of the Gods from Ovid's *Metamorphoses*, for example, were commonly painted by Italian and Flemish artists, these did not prosper in Spain, where great importance was attached to the moral content of painting and where religious decorum amounted to a taboo against the nude. Indeed, Francisco Pacheco, among other Spanish authors of the period,

advised against representing nude females in art; where these were absolutely necessary, he recommended drawing from ancient and modern statuary, prints, and studying the faces and hands of only the most chaste live models. In 1762 and again in 1792, there were even moves to burn 'indecent' mythological paintings in the Spanish royal collection which were painted by some of the greatest masters of the genre, including Titian and Peter Paul Rubens (1577–1640). *Education of Cupid* [**338**] by Louis-Michel van Loo (1707–71) was acceptable because of its decorously treated nudes and serious allegorical content.

In this highly conformist culture, however, there was room for the innocuous secular genre of landscape and still-life painting and the predominance of religious and devotional subject-matter in private collections was leavened with these. Despite the enormous popularity of landscape as a decorative subject, the genre was never highly developed by Spanish artists, who continued to refer to foreign models. However, Spanish still-life painters did make a significant contribution in this genre, their works characterized by a concentration on a limited number of highly ordered elements, in which the viewer is invited to admire and ponder the spellbinding descriptive powers of the painter [**334**]. Genre painting was not widely practised in Spain. However, Velázquez's genre paintings, painted in Seville between 1618 and 1623 as early exercises in naturalism, are among the most compelling works painted anywhere. Murillo's genre paintings depicting children sometimes follow northern prototypes and were perhaps aimed at the large foreign merchant class living in Seville. Even his works, however, may not be pure genre but encode religious messages.

Most Spanish painters of the first half of the seventeenth century worked in naturalistic styles of painting. Zurbarán remained faithful throughout his career to tenebrist naturalism modelled on the works of Michelangelo Merisi da Caravaggio (1571–1610) and his followers. In Valencia, the severe naturalism of Francisco Ribalta (1565–1628) was continued by Jerónimo Jacinto de Espinosa (1600–67). At the court of Madrid, however, Vicente Carducho (1576–1638), the royal painter of Florentine origin, promoted an idealizing 'classical' style in his paintings and in his treatise *Diálogos de la pintura* (1633). The art of Velázquez, his Spanish rival, evolved into a highly original 'impressionistic' ocular naturalism [**335**, **336**], which was not followed after his death, except by his son-in-law Juan Bautista del Mazo (*c.*1612–67).

In the 1640s, however, painting in Madrid moved towards more painterly, colouristic styles stimulated by the importation of large numbers of paintings by Rubens and Anthony van Dyck (1599–1641), as well as sixteenth-century Venetian masters, which were voraciously collected by Philip IV and his courtiers. Traditionally, Spanish royal and aristocratic patrons held Flemish and Italian art in high esteem and it was natural for native painters to emulate such models. Some of the most admired paintings by Rubens in Spain were the copies the Flemish master had painted in Madrid in 1628 of the Titians in the Spanish royal collections, and which inspired a reappraisal of the Venetian manner of paint handling. The art of painters to King Charles II (1665–1700)—Juan Carreño (1614–85), Francisco Rizi (1614–85), and Francisco de Herrera the Younger (1627–85)—is characterized by such neo-Rubensian,

neo-Venetian terms of reference. Despite Velázquez's painterly handling, his art was regarded as too grounded in the recording of objective reality to suit the taste for the ostentation, triumphalism, and 'theatrical' effects which characterized much religious imagery at court in the second half of the century.

The death of Charles II brought to an end the Habsburg dynasty in Spain. The accession to the Spanish throne of the French Bourbon king Philip V (1701–46) marked the beginning of the domination of French art and taste in Spain, as well as a gradual 'Italianization' of painting at court through the patronage of his Italian second wife Isabel Farnese of Parma, whom he married in 1714. A number of highly esteemed Spanish artists continued to prosper under the new regime, including Antonio Palomino (1655–1726), painter, theorist, and artists' biographer, who perpetuated the Late Baroque style of painting in works for ecclesiastical patrons, who were largely unaffected by modish developments at court.

French artists were appointed as royal painters; Michel-Ange Houasse (in Madrid 1715–30), Jean Ranc (in Madrid 1722–35), and Louis-Michel van Loo (in Madrid 1737–52). They were responsible for redefining the austere portrait traditions in Spain in favour of a more lavish royal image suited to the new dynasty (cf. van Loo, *The Family of Philip V*, 1743, Madrid, Prado). In 1744, van Loo was appointed Director of Studies of the Preparatory Assembly of artists established prior to the official foundation of the Royal Academy of Fine Arts of San Fernando in Madrid in 1752, and for which he painted the *Education of Cupid by Venus and Mercury* [**338**] as a reception piece. This painting is a consummate statement of the dominant French artistic style, distinguished by its idealization and extreme technical refinement, and is an allegory of the pedagogic ambitions of the Academy, in which Venus, representing aesthetic beauty, directs the education of her son Cupid, guided by Mercury, god of wisdom and protector of the fine arts.

The old Spanish royal palace, the Alcázar, was destroyed by fire in 1734, and the New Palace was designed by Italian architects. Italian artists were also preferred to fresco its state rooms; Fernando VI (1746–59) called the Neopolitan painter Corrado Giaquinto (1703–66) to Spain in 1753 for this purpose and Charles III (1759–88) employed the Venetian fresco painter Giambattista Tiepolo (1696–1770) in 1762. Giaquinto was made the first Director of the Madrid Royal Academy of Fine Arts. His Rococo style, officially endorsed by his directorship of the Academy, was highly influential for succeeding generations of Spanish painters, including his Spanish pupil Antonio González Velázquez (1723–94), Francisco Bayeu (1734–95), and Francisco de Goya (1746–1828). Giaquinto is the source for the fluent, spontaneous touch and the harmonious compositional rhythms of Bayeu's *S. James Being Visited by the Virgin with a Statue of the Virgin of El Pilar* [**337**], which translates a section of the fresco painted by his master González Velázquez in the basilica of El Pilar in Zaragoza. Far from representing the demise of Spanish painting, the presence of foreign artists and their works in Spain in the eighteenth century was responsible for the regeneration of the native school of painters and the emergence of the greatest names of the later part of the century, including Luis Paret y Alcázar (1746–99), Mariano Salvador Maella (1739–1819), and, of course, Francisco de Goya. PCh

Naturalistic religious painting

Zurbarán's *Vision of S. Peter Nolasco* [**330**] formed part of a cycle of 22 narrative paintings from the life of the founder of the Shod Mercedarian order, commissioned for their Seville house in 1628, which cemented the artist's future reputation as the foremost Andalusian monastic painter. The visionary subject, in which the Apostle Peter appeared to S. Peter Nolasco to endorse his founding of a new religious order, is treated with Zurbarán's habitual directness and sincerity. His *Christ and the Virgin in the House at Nazareth* [**332**], also conceived in naturalistic terms, was widely copied in Seville and the New World. Murillo's painting of *S. Thomas of Villanueva Giving Alms* [**333**] formed part of an ensemble of 18 pictures for the *retablo* of the high altar and lateral altars of the Franciscan church of the Capuchins in Seville, which are no longer *in situ*. The artist believed this painting one of his best works. Its warm, soulful religious sentiment is distant from the objective gravity of Zurbarán's art, with a greater emphasis on the human dimension of the subject bathed in an all-enveloping soft, atmospheric lighting.

Alonso Cano's beautiful *Immaculate Conception* [**331**] shows that even the cold theological abstraction of Mary's freedom from Original Sin could be endowed with a warmth of feeling proportionate to the devotional ardour of contemporary viewers. PCh

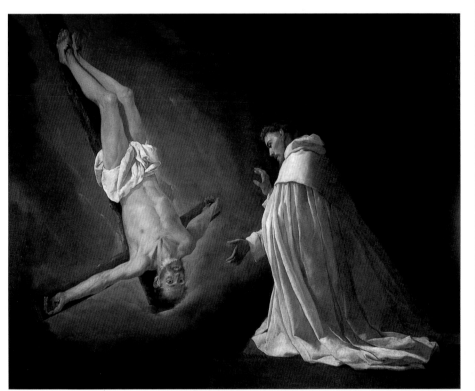

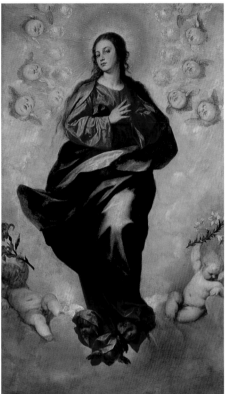

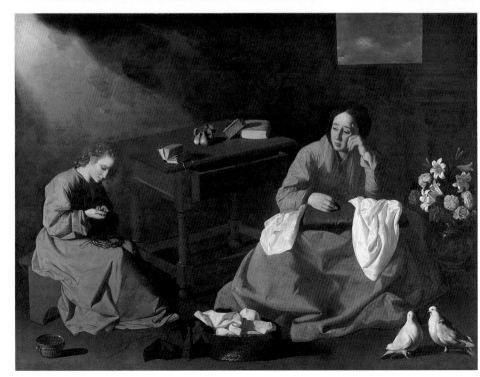

330 Above: Francisco de Zurbarán (1598–1664), *S. Peter Nolasco's Vision of the Crucified S. Peter* (1629), oil on canvas, 1.79 × 2.23 m. (5 ft. 10½ in. × 7 ft. 3¾ in.), Madrid, Prado

331 Above: Alonso Cano (1601–67), *Immaculate Conception* (1650), oil on canvas, 1.83 × 1.12 cm. (72 × 44⅛ in.), Vitoria-Gasteiz Museo Diocesano

332 Francisco de Zurbarán (1598–1664), *Christ and the Virgin in the House at Nazareth* (1640), oil on canvas, 1.65 × 2.18 m. (5 ft. 5 in. × 7 ft. 1¾ in.), Cleveland Museum of Art

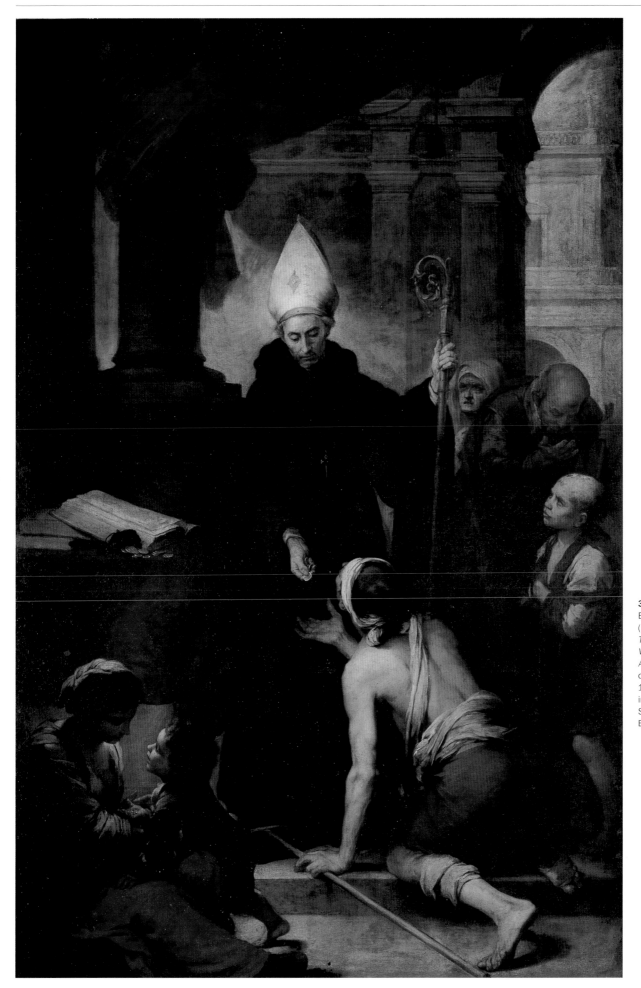

333 Bartolomé Esteban Murillo (1617–82), *S. Thomas of Villanueva Giving Alms* (1665–8), oil on canvas, 2.83 × 1.88 m. (9 ft. 3½ in. × 6 ft. 2 in.), Seville, Museo de Bellas Artes

The secular genres

Velázquez's portrait of Philip IV acknowledges the austere formal conventions of the Habsburg state portrait [**336**] and shows the king as he appeared during public audiences. However, the sketchy, 'impressionistic' handling of the embroidered details of the costume conjures up observed reality in a way familiar to us from nineteenth-century developments in painting. This kind of naturalism is a world apart from the meticulous description of objects in Juan Sánchez Cotán's still life [**334**] and a prerequisite of this genre. Velázquez's *Mars* [**335**], which is painted directly from a live model, is even more daringly painted, in which the artist's total command of a wet-in-wet technique evokes the qualities of living flesh. The stylistic alternatives of the eighteenth century are shown by the cool, high finish emulating marble sculpture which suited van Loo's rendition of a Classical subject [**338**], as opposed to the energetic Rococo fluency of Bayeu's facture. This latter painting [**337**], showing the Virgin presenting the miraculous statue of the Virgin of El Pilar housed in Zaragoza Cathedral to S. James Major, the patron saint of Spain, has clear nationalistic overtones and its style reflects the future direction of painting in Spain. PCh

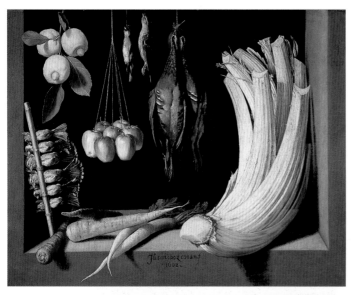

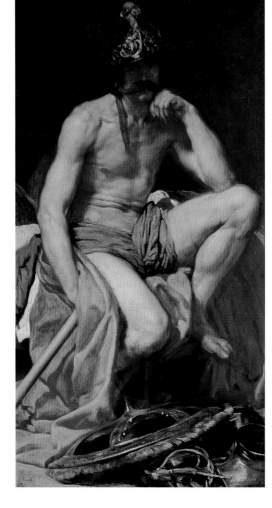

334 Above: Juan Sánchez Cotán (1560–1627), *Still Life with Game Fowl, Fruit, and Vegetables* (1602), oil on canvas, 68 × 89 cm. (26¾ × 35 in.), Madrid, Prado

335 Right: Diego Velázquez (1599–1660), *Mars* (1640), oil on canvas, 1.67 × 0.97 m. (65¾ × 38⅛ in.), Madrid, Prado

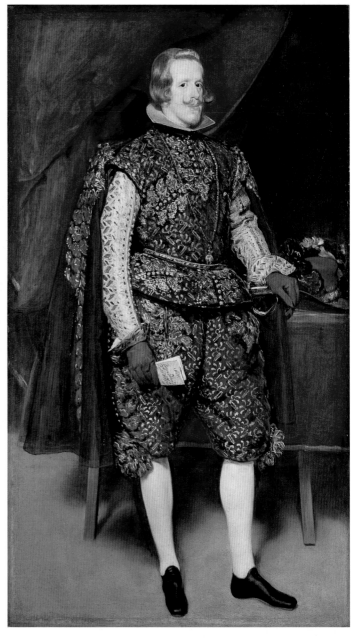

336 Diego Velázquez (1599–1660), *Philip IV in Brown and Silver* (1634–5), oil on canvas, 1.95 × 1.1 m. (76⅘ × 43⅓ in.), London, National Gallery

337 Francisco Bayeu (1734–95), *S. James Being Visited by the Virgin with a Statue of the Virgin of El Pilar* (1760), oil on canvas, 53 × 84 cm. (20⅞ × 33 in.), London, National Gallery

338 Louis-Michel van Loo (1707–71), *Education of Cupid by Venus and Mercury* (1748), oil on canvas, 2.27 × 1.62 m. (7 ft. 5⅜ in. × 5 ft. 3¾ in.), Madrid, Real Academia de Bellas Artes de San Fernando

The Picture: Dutch and Flemish

The great age of Dutch and Flemish painting is filled with familiar names such as Pieter Bruegel the Elder (c.1525/30–69), Peter Paul Rubens (1577–1640), Anthony van Dyck (1599–1641), Frans Hals (1581/5–1666), Rembrandt van Rijn (1606–69), and Johannes Vermeer (1632–75). There were actually hundreds of important artists working in Flanders, as the southern or (at that time) Spanish Netherlands are often called, and in the United Provinces of the northern Netherlands.

A broad distinction may be drawn between north and south. From about 1580 onward the Catholic Church and several great courts (above all, those of Spain, France, and England)—were the principal patrons of Flemish artists, whereas the vast majority of Dutch pictures were intended for private homes. Belgium's cultural heritage includes public projects like Rubens's altarpieces [**341**] and palace decorations, and van Dyck's princely portraits [**356**]. Dutch painting, by contrast, comprises an extraordinary diversity of private portraits, landscapes, still lifes, and images of everyday life ('genre scenes'). About 70,000 paintings were produced in each year of Holland's 'Golden Age'.

However, this contrast requires qualification. The entire tradition of Netherlandish art, both northern and southern, depended upon the fortunes of a few great cities: Antwerp in the 1500s and during the Twelve Years' Truce (1609–21); Amsterdam, Haarlem, Leiden, and Utrecht c.1600–50; and Amsterdam c.1650–75. Flemish merchants like Nicolaas Jongelinck—who owned Bruegel's 'Months' [**342**]—and Rubens's patrons, Nicolaes Rockox and Cornelis van der Geest, acquired secular and religious pictures for their private collections. Large altarpieces, including Rubens's famous *Raising of the Cross* of 1610–11 and *Descent from the Cross* of 1616–17 (both now in Antwerp Cathedral), were commissioned not by the church but by private individuals and professional guilds. Rubens also worked privately for the courts in Brussels, Madrid, and Munich. Many other Antwerp studios, such as those of Jacob Jordaens (1593–1678) and the still-life specialists Jan Breughel the Elder (1568–1625) and Frans Snyders (1579–1657), exported thousands of religious and secular works. Even Dutch collectors purchased Flemish pictures, despite the hostilities that preceded Dutch independence in 1648.

Many Flemish artists spent years abroad. Rubens's fluency in the visual language of Baroque art was largely acquired in Italy (1600–8), when he worked for the Duke of Mantua, Genoese noble families, and the major religious orders of Rome. At 21 van Dyck was painter to James I in London. Then he spent six years in Italy (1621–7), four years based in Antwerp, and most of his last decade (from 1632) in England where he, like Rubens,

was knighted by Charles I. Several Flemish artists, in particular the stylish Mannerist Bartholomeus Spranger (1546–1611), served at the court of Emperor Rudolf II in Prague.

In Italy van Dyck cultivated a deep admiration for Titian. Rubens's experience of Italy was more comprehensive, and a key episode in the long tradition of Mediterranean sojourns which transformed Flemish and to a lesser extent Dutch art. Jan Gossaert, called Mabuse (c.1478–1532), Frans Floris (1516–70), and several 'Caravaggesque' painters such as Theodoor Rombouts (1597–1637) went from Antwerp to Rome and studied antiquity, Michelangelo, Mannerism, and after 1600 the Carracci and Caravaggio. Pieter Bruegel, by contrast, travelled in Italy but brought home mostly memories of the Alps, which according to the artist's biographer, Karel van Mander (1604), he swallowed and spit out in his work at home. Jordaens, who like Bruegel painted history pictures and genre scenes (both are famous for their depictions of Flemish proverbs), was more responsive to international trends, but his earthy exuberance reflects the fact that he never studied abroad.

Early historians described Dutch art as consisting almost solely of everyday subjects rendered naturalistically, for the delight of middle-class merchants living in a Protestant democracy. Yet about a third of the population in the 1600s remained Catholic and many Dutch artists, especially in the former bishopric of Utrecht, painted devotional pictures for Catholic homes and 'hidden churches'. The artist himself might be a staunch Catholic, like Abraham Bloemaert (1594–1651), or Protestant like Hendrick ter Brugghen (1588–1629). Numerous Utrecht artists went to Rome, including the most influential Caravaggesque painter, Gerard van Honthorst (1590–1656), and 'Italianate' landscapists such as Cornelis Poelenburgh (c.1586–1667) and Jan Both (c.1615–52). The Dutch, too, had studied in Italy since the early sixteenth century. Jan van Scorel (1495–1562) worked for Pope Adrian VI in the 1520s (they were both from Utrecht), and in the following decade Scorel's pupil, the Haarlem master Maerten van Heemskerck (1498–1574), was overwhelmed by Michelangelo. The Late Mannerist idiom which the Flemish immigrant van Mander brought to Haarlem in the form of Spranger drawings was ultimately derived from Italian models. However, when the celebrated engraver Hendrick Goltzius (1558–1617) went from Haarlem to Rome in 1590 he abandoned his sophisticated 'Sprangerism' in favour of High Renaissance models and studies from life. An aspect of this shift in taste, which influenced artists throughout the Netherlands, was a revival of interest in prints by Dürer and by Lucas van Leyden (1494–1533). Rembrandt, also from Leiden, much admired the latter, and devoted his early years (c.1625–31) to

studies of living models and their surroundings. His dismissive remark to the courtly connoisseur Constantijn Huygens, about being too busy for Italy, has been seen as a sign of loyalty to local tradition, but Rembrandt absorbed a wide range of influences, including his teacher Pieter Lastman (1583–1633), who had formulated his theatrical way with figures and lighting in Rome, and Rubens, who, chiefly through reproductive engravings, inspired Rembrandt's Baroque style of the 1630s in Amsterdam.

The cosmopolitan culture of the court at The Hague encouraged Dutch interest in Flemish art. Prince Frederick Hendrick, the son of William the Silent who served as stadholder from 1625 until his death in 1647, and his adviser Huygens were enamoured of Rubens and van Dyck in the early 1630s, when Rembrandt painted his first large-scale portraits, followed by dramatic mythological and religious scenes (including five paintings of Christ's Passion for the prince). Artists who worked regularly for the Dutch court include Poelenburgh and above all Honthorst (who also served Charles I in London).

The longest career as court artist—that of the conservative portraitist Michiel van Miereveld (1567–1641)—reflects the preponderance of portraiture in Dutch art. If a Protestant household had only two paintings they would likely have been portraits of husband and wife; if six, one would expect pairs depicting their parents. Van Miereveld's widely emulated manner combined the reserved poses and expressions of Spanish court portraits with Netherlandish attention to particulars.

In Haarlem, by contrast, Frans Hals employed loose brush work and a broad range of browns, greys, and blacks (27 of the latter, according to Van Gogh) to suggest movement, daylight, and atmosphere in portraits of middle-class sitters and in genre scenes. Rubens and the young Jordaens must have influenced the more colourful early works by Hals [**348**], who was born in Antwerp and returned there briefly in 1616.

From the late 1560s onward Haarlem and other Dutch cities absorbed waves of Flemish immigrants, who fled the south for religious or economic reasons. The north gained thousands of skilled workers, artists and craftsmen, merchants and bankers. The Dutch cut off Antwerp's access to the sea and Amsterdam took its place as the great port of northern Europe. Given limited land, increasing income went into investments, urban housing, and luxury goods. Many Dutch pictures, such as still lifes and genre scenes, illustrate Holland's prosperity, and occasionally reflect mixed responses to material things. Still lifes by Pieter Claesz (1597/8–1660) and Willem Claesz Heda (1593/4–1680), whose monochrome manner [**347**] resembles Hals's and that of Haarlem landscapists such as Jan van Goyen (1596–1656) and Salomon van Ruysdael (1600/3?–70), include

luxurious tableware, mince pies, imported fruits, and tobacco, but also watches, broken glasses, fleeting reflections, and other indications of life passing by. Similarly, genre paintings like Hals's *Yonker Ramp and His Sweetheart* [**348**] offer vicarious pleasure and edification at the same time. For contemporary viewers the inn scene would have been a topical reminder of the Parable of the Prodigal Son.

The moral dimension of Dutch art has roots in Antwerp, especially in scenes of everyday life during the decades before the iconoclastic rebellion (1566) and the city's economic decline. In Calvinist Holland, which condemned church art, secular subjects often embodied values conveyed previously by religious imagery. However, many religious pictures were painted for Protestant homes, often of Old Testament subjects, or New Testament themes that were especially relevant to modern life (for example, The Woman Taken in Adultery).

Apart from a few subjects that traditionally decorated town halls (such as the Judgement of Solomon), the only major form of public art in the northern Netherlands was the group portrait of civic-minded citizens, for example Hals's very large 'Civic Guard Companies', and *The Night Watch* by Rembrandt. Somewhat more sedate group portraits represent various professions (as in 'Anatomy Lessons'; **345**), guilds, trades, and charitable institutions.

Van Mander's remark about Bruegel and the Alps continues: '…so remarkably was he able to follow these and other works of nature'. Nature and the faithful description of actual experience are central aspects of Dutch art. Parallels may be found in other countries but the United Provinces excelled in explorations of the natural world, not only in the arts but in sciences such as astronomy, botany, and zoology. At the same time, the Dutch valued what was already familiar, such as their distinctive landscape and cities (which were matters of local and national pride), their work, homes, and families.

Amsterdam's ascent to the world stage encouraged foreign influences, such as van Dyck's on portraiture. The refinement found in late works by Vermeer and Pieter de Hooch (1629–84), in the Leiden school of 'fine painting' headed by Gerard Dou (1613–75), and in decorative pictures of birds and game are signs of these prosperous and cosmopolitan times. Eighteenth-century Dutch art continued in this direction, although the Dutch art market was never the same after the French invasion of 1672. The most successful Dutch artists of the late seventeenth and eighteenth centuries, such as the flower painters Jan van Huysum (1682–1749) and Rachel Ruysch (1664–1750), and the genre, history, and portrait painter Adriaen van der Werff (1659–1722), worked for princely patrons in Germany. WL

The religious dimension

In this age of religious wars and sectarian conflict, sacred images reveal extraordinary diversity. Luther and Calvin denounced what they saw as idolatry, which led to waves of iconoclastic destruction (many Netherlandish altarpieces were lost in 1566) and a profoundly changed art market in Protestant parts of Europe. Faith, according to Reformed authorities, should be founded upon the study of scripture, which was to be made more accessible by translations and sermons.

Numerous Dutch and some Flemish paintings express this view, for example, by depicting Christ or John the Baptist preaching to attentive crowds which often resemble modern society (as in Pieter Bruegel's panel in Budapest). Devout types, such as 'Rembrandt's mother', appear absorbed in a biblical passage, and S. Paul is shown as a writer sunk in thought. Actual preachers, like Rembrandt's Mennonite associate Cornelis Anslo, were represented in the act of earnest exposition, and this Protestant mode of worship was a standard theme in paintings of actual or typical Dutch church interiors [**339**]. In the latter, families gather together to hear the gospel and timely commentary.

Dutch artists also painted thousands of religious pictures for private homes. Protestant patrons favoured interpretations of Old Testament stories, or New Testament subjects treated in a sympathetic way. Rembrandt's conception of the Presentation of Christ in the Temple [**340**], for example, was based on ordinary experience as well as a review of the text and pictorial precedents. In its small scale and precise description

240

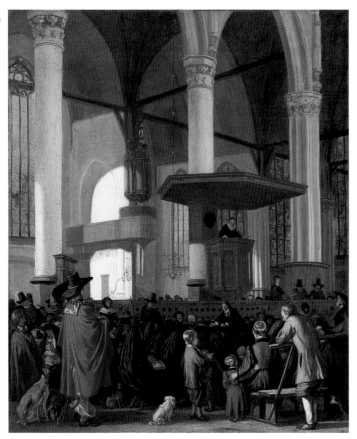

339 Emanuel de Witte (*c*.1616–1691/2), *The Old Church in Amsterdam during a Sermon* (*c*.1654), oil on canvas, 50.5 × 41.5 cm. (19$\frac{7}{8}$ × 16$\frac{3}{8}$ in.) The Hague, Mauritshuis

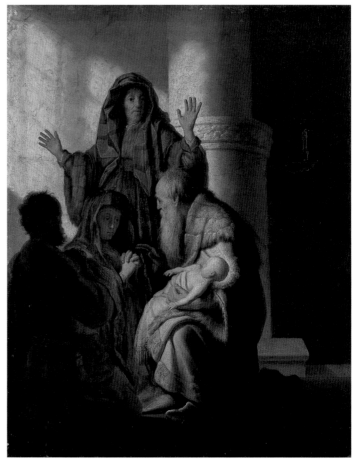

340 Rembrandt van Rijn (1606–69), *Simeon in the Temple* (1627–8), oil on wood, 55.4 × 43.8 cm. (21$\frac{7}{8}$ × 17$\frac{1}{4}$ in.), Hamburg Kunsthalle

the panel is a private and contemplative work. The setting resembles the last sunlit corner of a Leiden church, to which a humble couple have come with their infant. The prophetess Anna and the silhouetted figure of Joseph help focus attention on Simeon's gesture and expression. Mary, her eyes wide with wonder, seems to gather the message of the Annunciation from the old priest's words.

In Flanders the Protestant challenge to the cults of saints and sacraments was met by renewed insistence on their significance. The Catholic Church found one of its most compelling advocates in Rubens, who with his workshop in Antwerp made dozens of majestic altarpieces and other works for churches at home and abroad. The monumental canvas in Lille [**341**] was painted for the then Flemish city's Capuchin convent. The

Classical idealism evident in Rubens's style during the first five years after his return from Italy (*c.*1609–14) diminished in his subsequent work for the leading religious orders of the Counter-Reformation. Here the cumbersome act of lowering Christ's dead body from the cross is rendered with a realism and emotionalism recalling Late Gothic sculpture as well as Caravaggio. The Virgin, the Magdalene, and S. John almost press

their faces to the Saviour's wounds, which is a visceral reminder of the Eucharist. In the work of Rubens and the best of his followers, above all van Dyck, doctrine is not learned but experienced, and holy visions take on the weight of ancient tragedy. WL

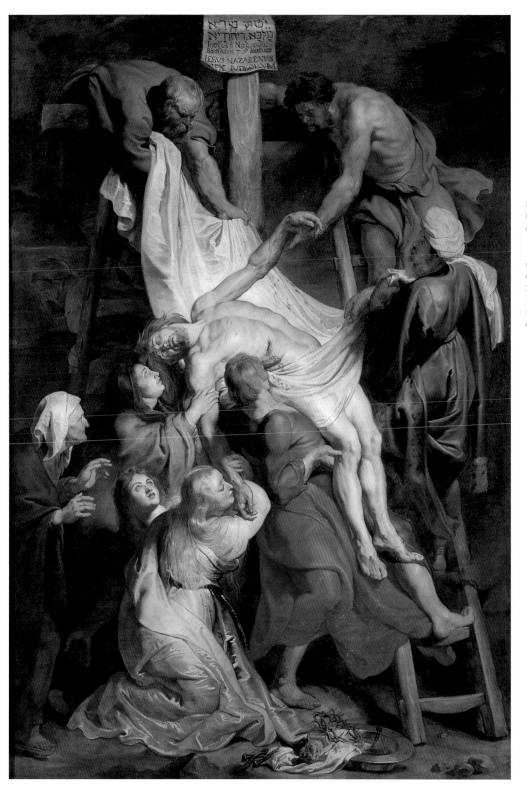

341 Peter Paul Rubens (1577–1640), *The Descent from the Cross* (1616–17), oil on canvas, 4.25 × 2.95 m. (13 ft. 11¼ in. × 9 ft. 8¼ in.), Lille, Musée des Beaux-Arts

Looking at 'man' and nature

The period embraced by the lifetimes of Galileo (1564–1642) and Sir Isaac Newton (1642–1727) saw many advances in science and exploration, with some of the most important coming from the Netherlands. However, discoveries in astronomy, biology, physics, and so on did not overturn the conviction that all nature is God's creation. Images of the natural world exhibit striking evidence of empirical observation and simultaneously address well-established beliefs and artistic themes.

In the long history of Netherlandish landscape painting, which effectively began with the Antwerp specialist Joachim Patinir (*c*.1485–1524), Pieter Bruegel's series of six panels depicting the Twelve Months are among the most memorable images. Like the other four surviving pictures (one in Prague, three in Vienna), *The Harvesters* [342] represents rural life as it might be witnessed at particular times of the year. The overall programme and the importance of human activity recall calendar pages in medieval Books of Hours, but Bruegel's panorama and sympathetic view of ordinary people were unprecedented in his day.

Contemporary interest in optics and astronomy has been connected with Elsheimer's *Flight into Egypt* [343], which includes various light effects and a realistic description of the Milky Way. As in Bruegel's 'Months' and many later landscapes, however, a sense of mood and of man's small place in the great scheme of things are essential aspects of the tender scene. Van Ruisdael's *View of Haarlem* [346] also relates heaven and

242

342 Pieter Bruegel the Elder (1525/30–1569), *The Harvesters* (1565), oil on wood, 1.18 × 1.61 m. (46½ × 63¼ in.), New York, Metropolitan Museum of Art

343 Below: Adam Elsheimer (1579–1610), *The Flight into Egypt* (1609), oil on copper, 31 × 41 cm. (12⅕ × 16⅛ in.), Munich, Alte Pinakothek

344 Below: Roelant Savery (1576–1639), *A Bouquet of Flowers* (1612), oil on wood, 49.5 × 34.5 cm. (19½ × 13⅝ in.), Vaduz, Collection of the Prince of Liechtenstein

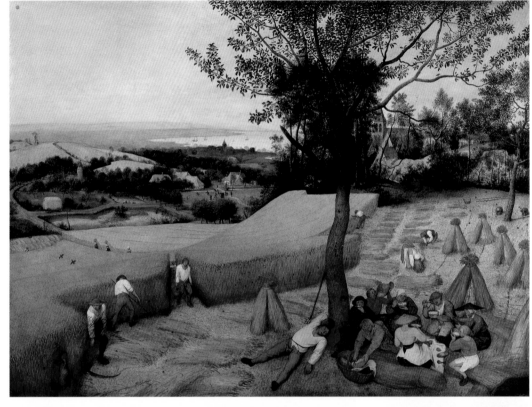

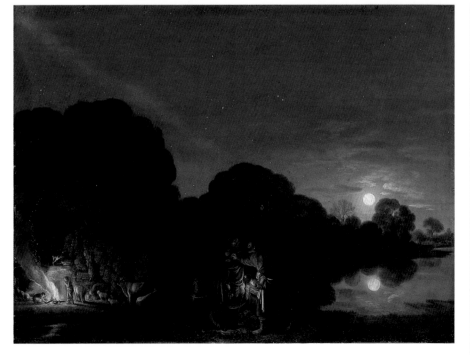

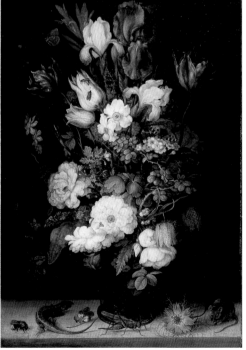

earth, here with the help of S. Bavo's, windmills, and light falling on bleaching fields. That the subject involves local industry and civic pride but also recalls Bruegel and Elsheimer indicates how rich in meaning Dutch landscapes could be for contemporary viewers.

The Flemish landscape and flower painter Roelant Savery shared deep interests in botany and zoology with his patron Rudolf II in Prague. About 150 varieties of flowers and 70 insects and small animals occur in his 20

known still lifes [344], which also treat the Seasons, the Elements, and the brevity of life. The latter conceit is often conveyed in portraiture, if rarely so adroitly as in Rembrandt's record of Dr Nicolaes Tulp and other Amsterdam surgeons [345]. Tulp's writings suggest that such a dissection not only compared actual evidence with accepted authority (the great sixteenth-century anatomist Andreas Vesalius) but also revealed Divine Wisdom at work. WL

345 Rembrandt van Rijn (1606–69), *The Anatomy Lesson of Dr Nicolaes Tulp* (1632), oil on canvas, 1.7 × 2.17 cm. (5 ft. 7 in. × 7 ft. 1¼ in.), The Hague, Mauritshuis

346 Right: Jacob van Ruisdael (*c.*1628/9– 1682), *View of Haarlem with Bleaching Grounds* (*c.*1670), oil on canvas, 55.5 × 62 cm. (21⅞ × 24⅜ in.), The Hague, Mauritshuis

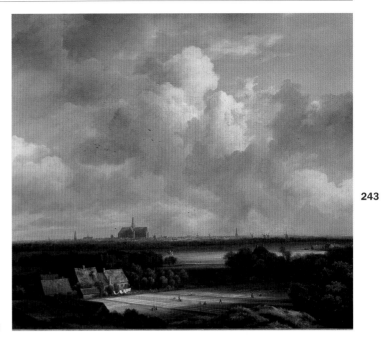

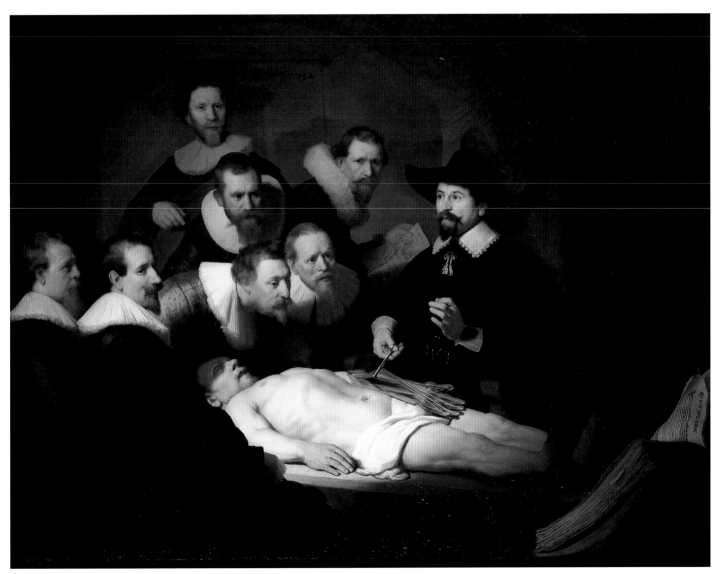

Contemporary life

Dutch and Flemish pictures reveal a preoccupation with contemporary life, whether in conventional statements of status such as formal portraits, or descriptions of fashionable behaviour and things. Even in portraiture, the most conservative secular art form, many innovations were made. Some of the most influential were introduced by van Dyck, who adopted Titian's natural movements, graceful poses, and aristocratic settings to transform courtly portraiture throughout Europe [356].

Stylish clothes and easy living come in for amused disapproval from Frans Hals, whose modern equivalent of the Prodigal Son [348] finds two new friends in a tavern. Genre scenes like this one, and some contemporary still lifes [347], treat sensual delights as seductive in a double-edged way.

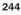

244

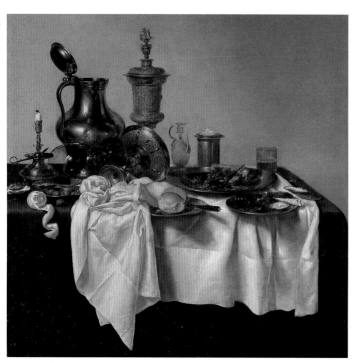

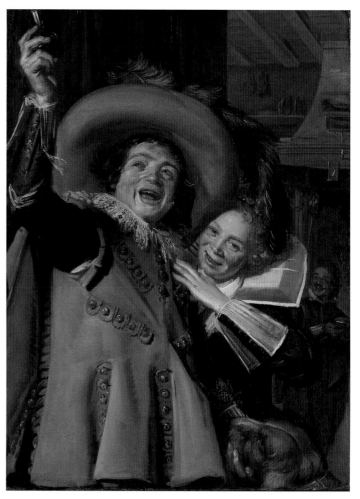

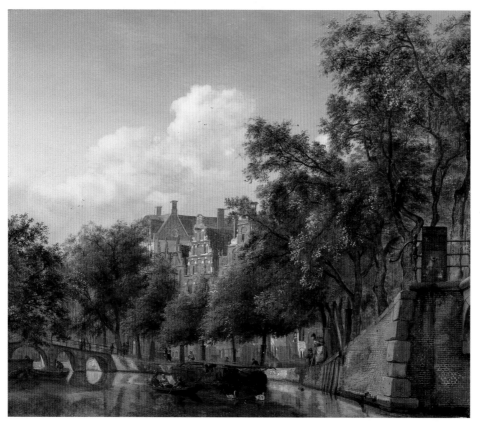

347 Top left: Willem Claesz Heda (1593/4–1680), *Banquet Piece with Mince Pie* (1635), oil on canvas, 107.4 × 105 cm. (42½ × 43½ in.), Washington, National Gallery of Art

348 Above: Frans Hals (1581/5–1666), *Young Man and Woman in an Inn ('Yonker Ramp and His Sweet-heart')*, (1623), oil on canvas, 105.4 × 79.4 cm. (41½ × 31¼ in.), New York, Metropolitan Museum of Art

349 Left: Jan van der Heyden (1637–1712), *A View of the Herengracht in Amsterdam* (c.1670), oil on wood, 33.5 × 39.7 cm. (13¼ × 15⅝ in.) Los Angeles, Collection of Mr and Mrs Edward William Carter

350 Opposite: Johannes Vermeer (1632–75), *Young Woman with a Water Jug* (c.1662–4), oil on canvas, 45.7 × 40.6 cm. (18 × 16 in.), New York, Metropolitan Museum of Art

The tabletop of costly or delicious temptations has an abandoned look, as if the diners, like the candle, had suddenly met their fate.

The interpretation of signs and symbols in Netherlandish art strongly depends upon the particular context: the picture, the artist, his time, and place. Vermeer's woman with a pitcher and basin (in earlier times a Marian symbol of purity) has a jewellery box on the table [350], but she seems less the bearer of bad tidings about material riches than the very (male) image of domestic tranquillity. In a broader view, Vermeer's subject, which is exquisitely complemented by his poised composition and palette, is a reflection of Dutch life during a brief period of peace and prosperity.

A similar sense of well-being is found in De Witte's views of congregations [339] and in Jan van der Heyden's precisely crafted pictures of Amsterdam canals [349]. Even these architectural paintings are about Dutch identity, if less obviously than professional, state, or private portraits [345]. The first attempts to define Holland's 'Golden Age' were made by artists and writers who lived through it. WL

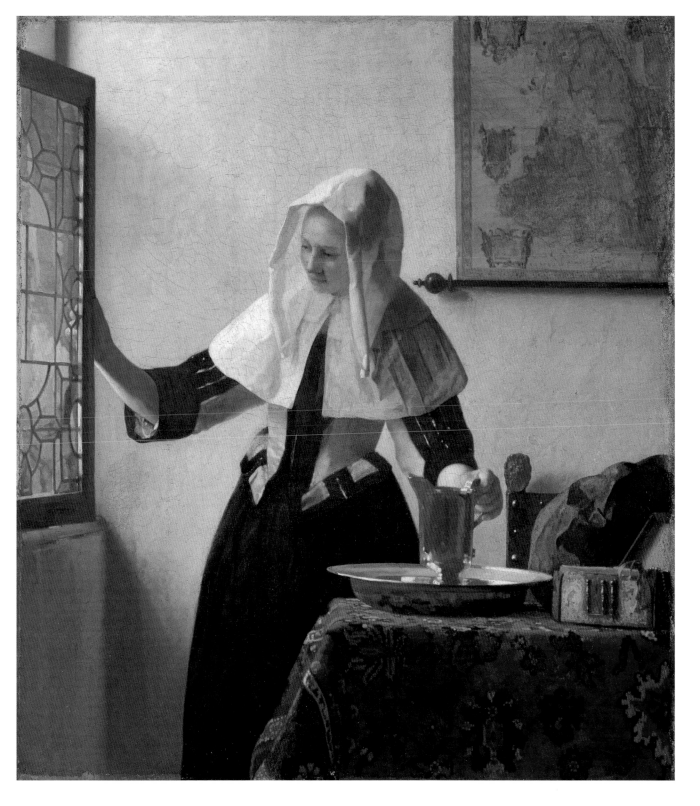

The Picture: England

In 1531 the Convocation of Canterbury acknowledged the king as supreme head of the church in England. The consequences included an end to the medieval period in English art, with religious subjects proscribed and ecclesiastical patronage of the arts losing its former significance. The demand for paintings, mostly portraits of monarchs and powerful courtiers, would now pivot round the courts of Henry VIII, Edward VI, Mary I, and Elizabeth I. Since there was no school of native painters, the genre was mostly practised by visiting or immigrant artists, notably German, Flemish, and Dutch—Hans Eworth [352], Marcus Gheeraerts [354], Hans Holbein [351], Antonis Mor (1517–76), Guillim Scrots (fl. 1537–53). Holbein, who settled in England in 1532 and became painter to Henry VIII in 1537, was the foremost of them. There were a few English portraitists of name—including George Gower (c.1540–96), Robert Peake (fl. 1576–1623)—but the most successful was a limner (a painter of miniatures), Nicholas Hilliard [353], who was also the author of the first English treatise, the *Arte of Limning* written in 1598–1602/3 but left unpublished for more than three centuries. The contents of Hilliard's book were, however, circulated among patrons, amateurs, and artists, and were echoed in technical treatises of the seventeenth century. Hilliard taught miniature painting to Isaac Oliver (1565/7–1617), who had come as a child from France to England in 1568, and was as successful as his master; he was made limner to Queen Anne of Denmark in 1604 and had a monopoly of Prince Henry's portraits in miniature. The art of Hilliard and Oliver was influenced by the Italian and French Renaissance, and it testifies to discussions about the ideal education for noblemen and gentlemen which included drawing and painting. The translations of Baldassare Castiglione's *Courtiers* appeared in 1561 and that of Giovanni Paolo Lomazzo's *Trattato dell'Arte della Pittura* in 1598.

Art collections, which developed outside the court and the houses of powerful courtiers during the sixteenth century, were scarce and fairly modest. Evidence for them is provided by post-mortem inventories of prosperous merchants, shopkeepers, craftsmen, and clergymen. In contrast to monarchs and courtiers, who commissioned mostly portraits, they owned mostly Old and New Testament stories, but it is not known how many of them were made by English artists and most appear to have been imported from the Low Countries.

The Grand Tour of Europe and the Tour of Italy undertaken by the Earl and Countess of Arundel in the company of the architect Inigo Jones (1537–1652) in 1613–14 marked the beginning of a new era. Large and important collections of works of art were formed not only by munificent monarchs such as Charles I [356] but by aristocrats such as Arundel, who also formed the first real collection of Classical sculpture [355]. The King, the Earl of Arundel and the Duke of Buckingham owned splendid collections of Old and Modern Masters, chiefly Venetian and Flemish, which mirrored the seventeenth-century taste for history painting, then at the pinnacle of the academic hierarchy of genres. No royal or official academy of art was established in England, but in place of such institutions 'virtual academies' circulated 'lessons' as art treatises and drawing-books. They were addressed to patrons, amateurs, professional artists, craftsmen, and also house-painters. The earliest of them, Henry Peacham's *Art of Drawing* (1606) and *Gentleman's Exercise* (1612), encompassed a course of drawing, painting, and art history. With his *Compleat Gentleman* of 1634, Peacham also contributed to define the English gentleman as a virtuoso, that is to say a collector of antique statues, inscriptions, and coins, but the meaning of this Italian word was later extented to all the arts and sciences. Virtuosi were both art collectors such as Arundel and the owners of heterogeneous collections such as the Musaeum Tradescantium established by John Tradescant at South Lambeth, London, around the mid-century. These contributed to making the educated public (including gentle-women and members of the middle class) familiar with the idea that almost anything might be collected to please the curiosity of the owner, amaze and instruct the visitors, and enable men who were neither great nor powerful but simply well-off to be prominent. During the Civil War and the Commonwealth (1642–60) these ideas were circulated by countless educational projects, which were addressed to all the social classes.

After the Restoration (1660) the aristocracy was more independent of the court and better educated, and the middle class more affluent and ambitious. Post-mortem inventories of the last quarter of the century indicate that the number and value of paintings owned by London merchants, shopkeepers, craftsmen, lawyers, and physicians grew in parallel with the expansion of consumption and the rise of modern professions. The growing demand for works of art, combined with new educational facilities offered by art academies (the first dates from c.1673) and by new outlets (the first auction house started in 1692), prepared the ground for the English School of painters and the development of the modern art market. Both immigrant and native artists and dealers contributed to this transformation. From the beginning, the English artistic community had a multi-national character. In the first half of the century the two greatest Flemish painters of the period arrived in England: Peter Paul Rubens (1577–1640), who visited on a diplomatic mission in 1629–30, and was responsible for the ceiling of the Banqueting House (installed in 1636), and Anthony van Dyck [356], who

settled in London in 1632, where he laid the foundations of high-style portraiture. Rubens and van Dyck excercised a long-lasting influence on English painting, on its colouring, composition, postures and, more generally, on its aesthetics. Native portraitists of name included William Dobson (1611–46), Henry Stone (1616–53), Robert Walker (1605/6–c.1660), and Isaac Fuller (1606–72). The sensuous portraits of Peter Lely (1618–80) flourished during the reign of Charles II. His most serious rival was John Michael Wright (1617–1700), while Willem Wissing (c.1655–87) found particular favour with James II, and John Riley (1646–91) and Godfrey Kneller (1646–1723) were appointed Principal Painters to the Crown under William III in 1688.

Between the end of the seventeenth and the beginning of the eighteenth century decorative painting came to the fore as the aristocracy grew in power and erected magnificent country and town houses. French and Venetian decorators and history painters arrived. By then, however, the English School had produced its first history painter and decorator of name, James Thornhill (1675–1734) [**358**].

The creation of a private, but well-attended, academy of art in Great Queen Street, London, in 1711 under the governance of the portraitist Kneller marked the beginning of a new period, which culminated with the establishment of the Royal Academy of Arts in 1768 [**363**]. Contrary to Italy and France, the official academy in England was not generated by a system of patronage centred upon the court but was the result of the rise of a decentralized system of interacting institutions, of the development of the art market and the growth of a public for art. The English academy resulted from economic and social transformations activated by the Revolution of 1640. For almost a century (1673–1768), it was an unregulated and self-supporting private body created and democratically directed by the artists in response to growing market demands; it was open to all artists with no discrimination of nationality, religion, or professional expertise. The academy was continued by the Huguenot refugee Louis Chéron (1660–1775) in St. Martin's Lane (1720–4) and by William Hogarth [**359**] and others, again in St. Martin's Lane (1735–68). In the meantime other institutions had been created: art clubs (notably the Virtuosi of St. Luke, 1689–1743, and Rose and Crown Club, c.1704–45), and annual exhibitions of contemporary art organized by the Society of Artists and Free Society of Artists from 1760. The attendance was 12,000 in 1761, while the following year there were 13,000 paying visitors. The rise of art history and theory paralleled the growth of the English School, of patronage, collecting, and the art public. Two members of the academy of 1711, the engraver George Vertue (c.1648–1756) and the portraitist Jonathan Richardson the Elder (1665–1745), were the authors of important works; the first history of English art since the Renaissance was written by Vertue in c.1711–51 (*Musaeum pictoris Anglicanum*, published in 1929–50), while the first works covering the whole realm of art, from its production to its reception, were published by Richardson in 1715–19 (*Theory of Painting, Essay on the Art of Criticism, and Science of a Connoisseur*). These works were written by authors who were fully aware of the potentialities of an institutional system based on the market, that is to say independent from court or state patronage and control. Were it, in fact, left to the Hanoverian monarchs (George I, George II, and George III) and their governments, no English School would have existed. Some patronage for contemporary art came from Frederick, Prince of Wales, and a few high-rank aristocrats, but the majority of upper-class collectors bought Old and Modern Master paintings, notably Italian, and ancient marbles, mostly Roman, imported or purchased in the course of the Grand Tour to Italy.

During the eighteenth century, especially after the end of the Seven Years War (1763), the Grand Tour became an important educational experience for patrons and artists, and it acted as a powerful 'virtual' academy. It is telling that the Society of Dilettanti (established in 1732) should be created in this period; its members were all Grand Tourists. It is also significant that they commissioned Joshua Reynolds (1723–92) to paint their group portraits in 1777. Reynolds, who became the first President of the Royal Academy, had studied the Antique and Old and Modern Master paintings during his stay in Italy in 1749–52. In London, he adapted Italian models and Richardson's precepts—'to raise the Character ... is absolutely necessary to a good Face-Painter'—to native sitters whether aristocrats or commoners; Reynolds' *Commodore Augustus Keppel* is a modern English *Apollo Belvedere* [**361**]. This was exactly the type of 'imitative' painting that Hogarth, a great enemy of the Grand Tour and of the idea of a Royal Academy, had fiercely fought against. He, like other great painters of the period, belonged to a different tradition, more northern and patriotic, that is well represented by institutions like the Society of Antiquaries whose fellows, unlike the italophile and classical-minded Dilettanti, encouraged research on different fields of antiquity, but above all on ancient and medieval British remains, that is to say on the native roots of British culture and art.

The establishment of the Royal Academy, although its first president was the 'Grand Tourist' Reynolds, eventually proved a key event for all the artists, patriots included; it sanctioned the institutionalization of English Art before the English and the European public, an official acknowledgement without which it could have hardly been regarded a major national school. IB

The Tudor image

Potraiture was the dominant pictorial genre in sixteenth-century England. Demand for portraits came from monarchs and powerful courtiers. It was met mostly by foreign painters. Nicholas Hilliard [353], a limner from Exeter, is an exception. Patrons such as Henry VIII mostly appreciated a painter's ability 'in making Physiognomies', his powers of imitation and his technical virtuosity, as in Holbein's *Ambassadors* [351], which includes a skull viewed as if in a distorting mirror. Portraits, especially full-length, were usually of large size. The small portrait of Lord Darnley and his brother [352], however, looks like a large miniature, or limning, a technique for more private portraits as iconic emblems in jewelled settings. Miniatures of actual sitters, or ideal figures [353] of a 'tantalizing intimacy', as Hilliard described them, became fashionable in the later years of Queen Elizabeth's reign. Hilliard had worked in France in 1576–8 and was influenced by the Italian Renaissance. He was *de facto* the Principal Painter to the Queen. Large portraits of Elizabeth I in oil were also in demand. To own at least one was almost compulsory for courtiers and high-ranking aristocrats anxious to please the Queen. Her ageless 'cult images' became, especially after the defeat of the Spanish Armada (1588), more and more fantastic, magnificent, and eleborate. The Ditchley Portrait [354], which was painted to commemorate her visit to Ditchley in 1592, shows the Queen's hieratic figure standing on top of a globe, more precisely a map of England, her foot resting near Ditchley. IB

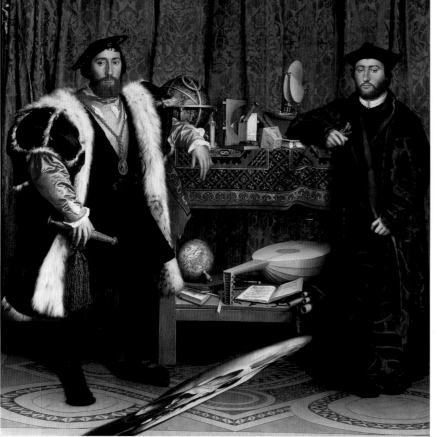

351 Hans Holbein the Younger (1497/8–1543), *Jean de Dinteville and Georges de Selve: 'The Ambassadors'* (1533), oil on oak, 2.07 × 2.09 m. (6 ft. 9½ in. × 6 ft. 10¼ in.) London, National Gallery

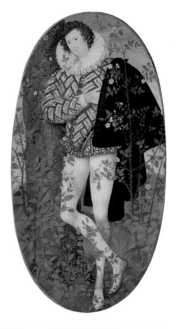

353 Right: Nicholas Hilliard (1546/7–1618), *Young Man among Roses* (c.1587), vellum, 13 × 7 cm. (5⅛ × 2¾ in.) London, Victoria & Albert Museum

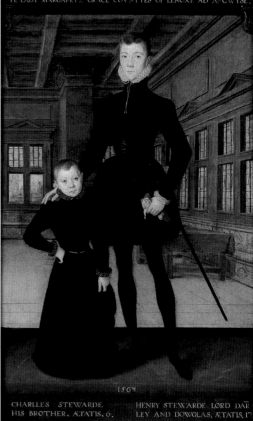

352 Hans Eworth (*fl.* 1540–74), *Henry Stewart, Lord Darnley, and his brother Charles Stewart, Earl of Lennox* (1563), oil on panel, 6.85 × 3.81 m. (22 ft. 5 in. × 12 ft. 6 in.), Royal Collection, Windsor Castle

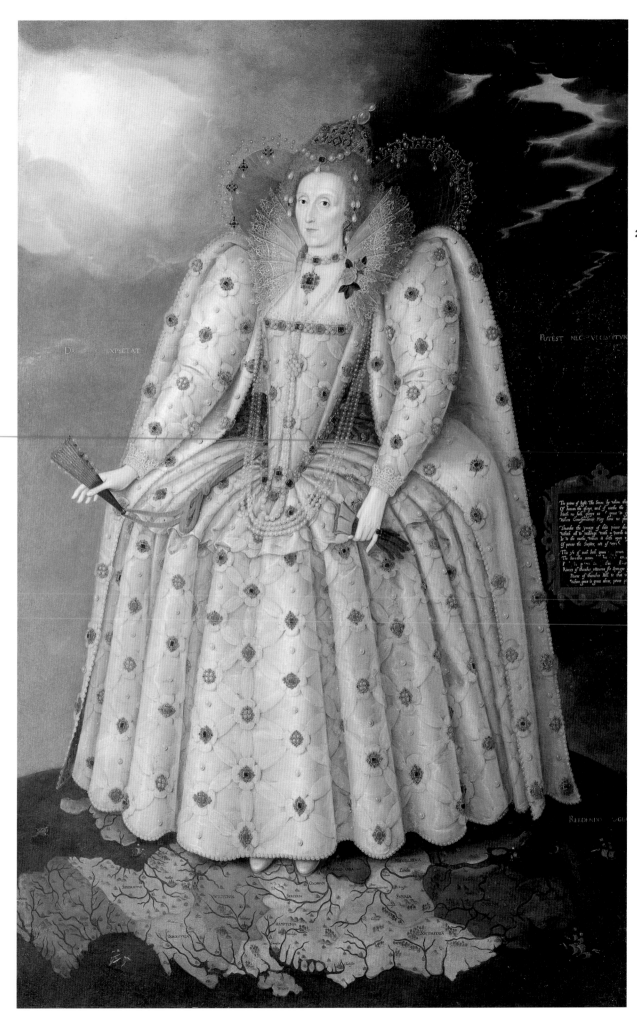

354 Marcus Gheeraerts the Younger (1561/2 –1636), *Queen Elizabeth I*: 'The Ditchley Portrait' (*c.*1592), oil on canvas, 2.41 × 1.52 m. (7 ft. 11 in. × 4 ft. 11⅞ in.) London, National Portrait Gallery

Larger ambitions

History painting was at the pinnacle of the seventeenth-century hierarchy of pictorial genres, but in England potraiture remained the genre most in demand among monarchs [356] and aristocrats [355]. Large collections of Old and Modern Masters were equally formed by monarchs such as Charles I and aristocrats such as the Earl of Arundel. Daniel Mytens's pair of portraits of Arundel and his wife are a sort of manifesto of the new taste for collecting Classical sculptures and paintings, and for displaying them in newly built galleries.

Grand style portraiture was practised by Anthony van Dyck who, after a long stay in Italy (1620–7), settled in England in 1632, became painter to Charles I, was knighted, and became a denizen (citizen) in 1638. Van Dyck imported from

250

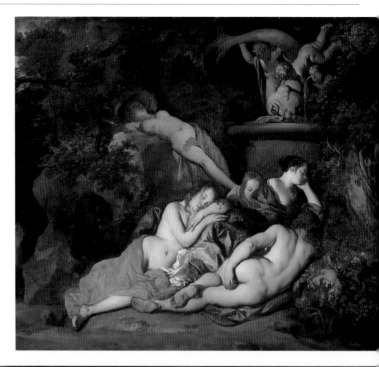

357 Right: Sir Peter Lely (1618–80), *Sleeping Nymphs by a Fountain* (early 1650s), oil on canvas, 1.29 × 1.45 m. (50¾ × 57 1/16 in.) London, Dulwich Picture Gallery

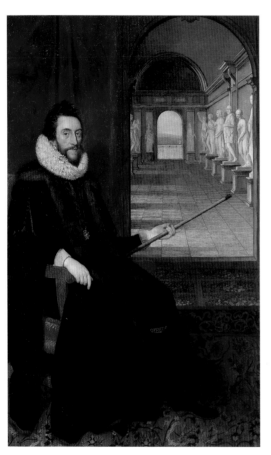

355 Daniel Mytens (*c*.1590–1647), *Thomas Howard, Earl of Arundel* (*c*.1618), oil on canvas, 2.07 × 1.27 m. (6 ft. 9½ in. × 4 ft. 2 in.), London, National Portrait Gallery

356 Sir Anthony van Dyck (1599–1641), *Charles I on Horseback* or *Equestrian Portrait of Charles I* (*c*.1637–8), oil on canvas, 3.67 × 2.92 m. (12 ft. ½ in. × 9 ft. 7 in.), London, National Gallery

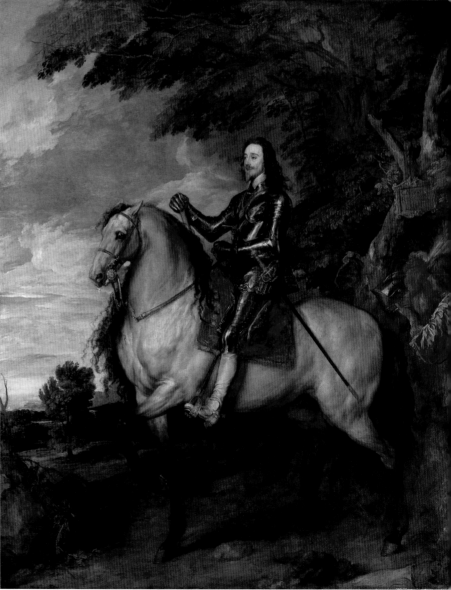

Flanders and Italy elegant solutions for all types of grand portraits, from half-length to spectacular full-length and equestrian [356]. Ennobling postures and psychological insights of the sitters are characteristic of van Dyck's style.

His successor was Peter Lely, who, after training in Holland, moved to England in 1641–3 and became painter to Charles II in 1661. His portraits were not as powerful and

elegant as van Dyck's but they were more sensual and provided English artists with a wider range of standard postures. Lely's *Sleeping Nymphs* [357] focuses attention on the study of the undressed model and the role he played as the forefather of the English School of painting and the Academy of Art. Lely supervised drawings after the living model at a private academy in London in *c.*1673, the first educational institution for

artists documented in England.

Lely was a conventional history painter, while James Thornhill, the first native painter to compete with foreign decorators and to obtain major commissions, was responsible for allegorical paintings illustrating recent events of English history. For the Painted Hall at Greenwich Hospital [358] he executed an allegory of the Protestant Succession showing the achievements of the

Protestant monarchs since 1688. Artists of the English School were stimulated by Thornhill to produce modern histories relating to their own country. IB

251

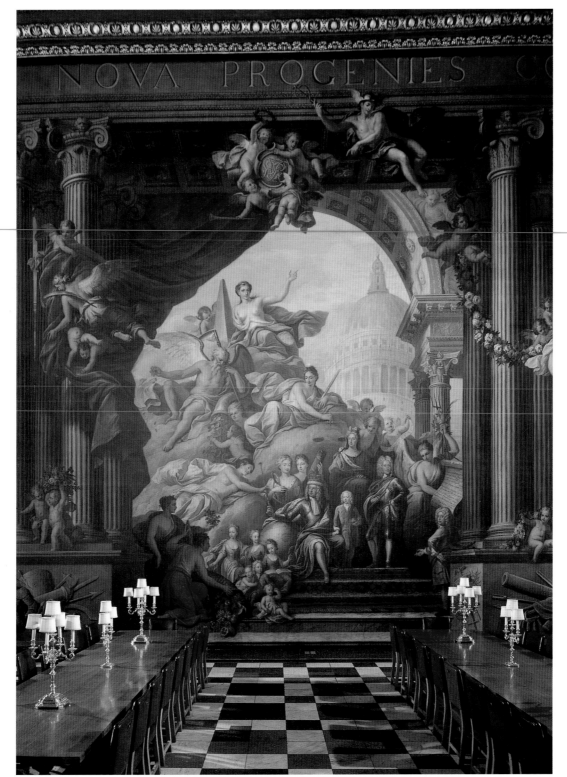

358 Sir James Thornhill (1675–1734), *George I and His Family*, with Thornhill's self-portrait on the right (1722–4), mural decoration, Greenwich, Royal Naval Hospital, Upper Hall,

The emergence of an English school

All the pictorial genres flourished during the eighteenth century, when English painting became a major school in its own right. Painters formed a multinational community pivoting around art clubs, private academies and, after 1768, upon the Royal Academy of Arts, which offered them the possibility of drawing after the Antique and the living model, and of studying anatomy [363].

Painters worked both for traditional patrons (monarchs and aristocrats) and new patrons (members of the gentry and the urban middle class). They worked as decorators for the theatre, for leisure gardens (for example, Vauxhall, c.1738–51), and charitable institutions (Foundling Hospital, c.1740–57).

They also worked for publishers as designers, and exhibited and sold their works at annual exhibitions (the first was held in 1760 and, after 1769, prestigious exhibitions were organized by the Royal Academy).

The genre most in demand was portraiture, which is exemplified at its best by the grand (Classical) style of Joshua Reynolds [361] and by the elegant (natural) style of Thomas Gainsborough [362].

A new genre, the conversation piece (an informal group portrait of family or friends engaged in some favourite occupation), became fashionable from the 1720s [363].

Traditional history painting was not as popular as the modern, moral, and comic histories based on observations of daily life created by Hogarth [359]. Topographical painting was transformed by the visit of Canaletto (1746–51), who

252

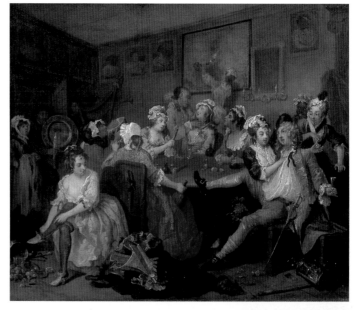

359 William Hogarth (1697–1764), *The Rake's Progress, III* (c.1733), oil on canvas, 62 × 75 cm. (24⅜ × 29½ in.), London, Sir John Soane's Museum

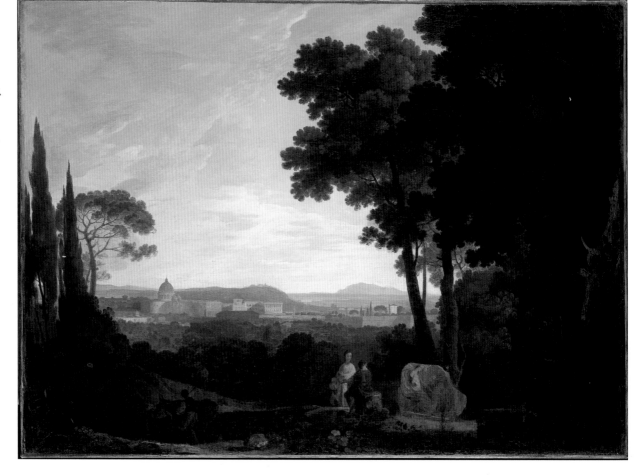

360 Richard Wilson (1713–82), *Rome: S. Peter's and the Vatican from the Janiculum* (1753–4), oil on canvas, 1 × 1.39 m. (39⅜ × 54¾ in.), London, Tate Gallery

stimulated Samuel Scott (1702–72) to paint beautiful views of the Thames. Ideal landscape inspired by French models was practised, above all, by Richard Wilson [360]. Dutch-inspired landscapes were painted by Gainsborough, while more sublime and picturesque renderings were later painted by among others Joseph Wright of Derby [447].

Remarkable results were obtained by watercolour painters—for example, Alexander Cozens (c.1717–86) and his son John Robert Cozens (1752–99).

Sporting painting was especially popular among the landed classes. Some of the production of George Stubbs (1724–1806) fits within this genre, but his approach was quite different; he was a great animal painter and portraitist with a remarkable knowlege of animal, human, and comparative anatomy. IB

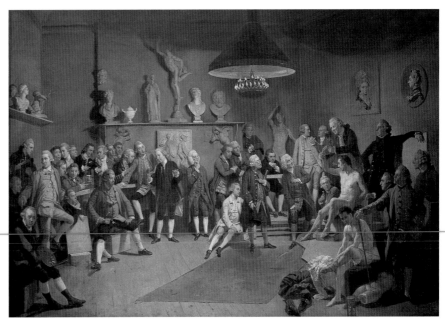

363 Johann Zoffany (1733–1810), *The Academicians of the Royal Academy* (1771–2), oil on canvas, 1 × 1.47 m. (39⅜ × 57⅞ in.), Royal Collection, Windsor Castle

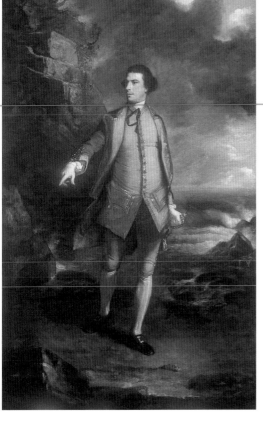

361 Joshua Reynolds (1723–92), *Commodore Augustus Keppel* (begun 1752), oil on canvas 2.39 × 1.47 m. (7 ft. 10⅛ in. × 4ft. 9⅞ in.) London, Greenwich, National Maritime Museum, Caird collection

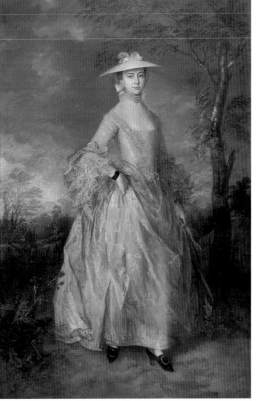

362 Thomas Gainsborough (1727–88), *Mary, Countess Howe* (c.1763–4), oil on canvas, 2.43 × 1.54 m. (7 ft. 11⅝ in. × 5 ft. ⅝ in.), London, Kenwood

The Print

Albrecht Dürer (1471–1528) greatly augmented the technical and conceptual range of engraving and woodcut, experimenting early with etching and chiaroscuro woodcut. In his wake, Danube School etchers such as Albrecht Altdorfer (*c*.1480–1538) turned the landscape backgrounds of Dürer's prints into self-sufficient subjects that celebrated a Germanic vision of nature [**364**]. Also in Dürer's wake, the Nuremberg *Kleinmeister* (Little Masters) produced small engravings valued by collectors for their jewel-like precision and the ease with which they could be pasted in books or otherwise housed in collectors' cabinets. *Kleinmeisters* such as the brothers Hans Sebald Beham (1500–50) and Barthel Beham (1502–40) continued Dürer's interest in Italianate subjects and the nude to satisfy the tastes of sophisticated collectors [**369**]. Another Dürer-pupil, Hans Baldung Grien (1484/5–1545) is less known for technical finesse than boldness in woodcuts such as the enigmatic *Bewitched Groom* of 1544.

Woodcut's affinity for the printing press and for social satire and commentary was strengthened during the Reformation. Lucas Cranach the Elder (1472–1553) illustrated Luther's September Bible of 1522, and strident polemical woodcut broadsheets summarized religious issues. The iconoclasm fostered by Protestantism presented an opportunity for prints of all types. In contrast to painting, sculpture, and stained glass, prints were circulating, privately collected, and seemingly more ephemeral objects that circumvented strictures against idolatry. And, the opening up of secular subject-matter that accompanied restrictions on religious images was a golden opportunity for printmakers, who quickly filled collectors' desires for landscapes, and mythological or genre scenes.

The history of engraving seems to have taken a decisive turn at the death of Raphael (Raffaello Sanzio) (1483–1520), when the supply of original drawings to Marcantonio Raimondi (*c*.1480–1534) [**370**] and his assistants was cut off, and the plates made from Raphael's drawings probably went to Raphael's agent, 'il Baviera'. Heretofore, the primary use of engraving other than as an original medium had been the collaborative prints made after an artist's drawings, as exemplified by Andrea Mantegna (1430/1–1516) and his engravers. This practice continued, but now professional engravers also turned to painted compositions or to re-engraving existing images on new plates. Thus, the true 'reproductive' print was born, and its function—to provide inexpensive, circulating graphic versions of paintings and other original works of art—fell almost entirely to professional engravers.

Reproductive engraving thrived from the second half of the sixteenth century until the advent of photographic reproduction in the mid-nineteenth century. In Antwerp, following the model of Italian print-publishing firms, Hieronymus Cock (*c*.1510–70) ran *Aux Quatre Vents* (At the Sign of the Four Winds). Cock's engravers made prints after drawings by Pieter Bruegel the Elder (1525/30–69), and Italianate images by Frans Floris (*c*.1516–70) or Maerten van Heemskerck (1498–1574). They were crucial for the development of professional printmaking: Philipp Galle (1537–1612) established his own print-publishing house; Giorgio Ghisi (1520–82) went to France and back to Italy; Cornelis Cort (1533/6–78) went to Italy to produce engravings after Federico Barocci (1535–1612) and Titian (Tiziano Vecellio) (*c*.1485–1576). Dynasties of reproductive engravers and print publishers began from Cock's example. But perhaps the most remarkable personality in late sixteenth-century northern engraving was Hendrick Goltzius (1558–1617), who worked for Cock's firm and came under Cort's influence in Italy, then moved with Dirck Volkertsz Coornhert (1519–90)—another of Cock's engravers—to Haarlem, where he set up his own publishing firm. Goltzius experienced all stages of professional printmaking. He was a reproductive engraver; he collaborated with Bartholomeus Spranger (1546–1611) on engravings made after drawings; he produced prints that blur boundaries between 'original' and 'reproductive' such as his virtuoso engravings in the manner of graphic masters like Dürer [**371**] and Lucas van Leyden (1494–1533); he supplied designs for other engravers to copy. In the end, he gave up printmaking for painting—the final step in his upwardly mobile career.

Etching matured by the end of the sixteenth century to a viable technique for painters for original prints—the two major intaglio techniques split irreparably. Only French etcher Jacques Callot (1592–1635) and his pupil Abraham Bosse (1602–76) really reconciled the two media by forcing etching to imitate engraving. Callot's etched *œuvre* captures the paradoxical combination of pageantry and violence characteristic of Baroque Europe. When they wanted to produce original prints, Italian painters after Parmigianino (also called Francesco Mazzola, 1503–40), favoured a fluid, rapid etching style [**366**] that contrasted with the slickly elegant graphic syntax (the system of lines and marks) of professional engravings: a contrast embodied in prints by the brothers Agostino (1557–1602) and Annibale (1560–1609) Carracci. Also in seventeenth-century Italy, Salvator Rosa (1615–73) produced etchings that reflected his painted compositions, but always in such a way that their character as prints was clear. Another Italian Baroque etcher, Giovanni Benedetto Castiglione (1610?–70), produced vigorous gestural etchings and invented soft-ground etching and monotype, neither of which was widely explored until later.

Fed by Dutch nationalism, a new range of secular subject-matter, and an affluent audience of eager, middle-class collectors, etching found its fullest expression in the Dutch Republic. Suites of landscape prints by early seventeenth-century Haarlem artists, inspired in part by the Danube School, heralded a fresh, new vision of nature based on the indigenous countryside. Low points of view put print owners inside these landscapes instead of hovering overhead as in Bruegel's, enabling them to take vicarious walks through the Dutch countryside. An exception to this naturalistic approach among Haarlem landscape printmakers was Hercules Pietersz Seghers (or Segers, 1589/90–1633/8), whose eccentric prints depended on observed motifs, such as a humble larch, but who expressed those motifs in an otherworldly style [**365**].

Rembrandt van Rijn (1606–69) was influenced by Seghers' technically experimental approach to printmaking. He augmented the Dutch tradition of landscape prints with etchings like [**367**] and *The Goldweigher's Field* (1651) that are still unequalled in their breathtaking sense of space and atmospheric realism. Of all Rembrandt's contributions to printmaking, however, his religious prints stand out as innovative responses to his audience's devotional needs. Gradually incorporating more drypoint into his prints, Rembrandt ended his graphic career with *Christ Presented to the People* (1655) and *The Three Crosses* (1653–60?), drypoints whose radical state changes exemplify the audacity of this exemplary *peintre-graveur*.

The connoisseurship and collecting of Rembrandt's prints after his death mark the beginnings of the valorization of original over reproductive printmaking that would culminate in the etching revival of the 1860s. In the meantime, reproductive printmaking was spectacularly successful. Peter Paul Rubens (1577–1640), inspired by Goltzius as well as by Titian's astute use of both collaborative and reproductive engravers and woodcutters in Venice to promulgate his fame, employed such printmakers as Cornelis Galle (1576–1650) and Lucas Vorsterman (1595–1675) [**372**], and the talented woodcutter Christoffel Jegher (d. 1652). Rubens's star pupil Anthony van Dyck (1599–1641) etched the ravishing first states of the portraits in his *Iconography* (c.1626–36) that were eventually finished by the detailed engraving dictated by prevalent tastes. In France, even the original portrait engravings of Robert Nanteuil (1623–78) took on this polished look, and the relationship between engraving and academic history painting was firmly established by the numerous prints after Nicolas Poussin (1594–1665).

In the eighteenth century, French reproductive engravers such as Pierre Drevet (1663–1738) and his son and nephew perfected a complex syntax of burin marks to convey painted surfaces. The use of etched lines as a foundation for finishing by the burin was an alternative approach to reproduction taken, for example, by printmakers working for collector Jean le Jullienne (1686–1766) in his *Recueil Jullienne* (1735), a remarkable graphic record of Jean-Antoine Watteau's (1684–1721) *œuvre* [**374**].

The tonal methods of intaglio printmaking—mezzotint (invented in 1642), the crayon manner (1757), and aquatint (1760s)—represent a further subservience of prints to other media: painting, chalk drawing, and watercolour or ink wash respectively. Mezzotint was particularly well suited to reproduce elegant portraits by Sir Joshua Reynolds (1723–92). The introduction of colour to tonal techniques, whether through selective *à la poupée* inking of plates or through the use of multiple, registered plates (as in the pastel manner, the colour version of the crayon manner), reinforced this subservience. Colour tonal processes were used for less expensive graphic counterparts (*les estampes galantes*) of the paintings of the Rococo masters such as Jean-Honoré Fragonard (1732–1806). When framed and hung, these prints decorated Rococo interiors. Prints in the crayon and pastel manners were also credible, inexpensive reproductions of chalk or pastel drawings, eagerly collected in the eighteenth century.

An astonishing level of technical skill marks eighteenth-century reproductive prints, even though today we esteem original printmaking more highly. In England, William Hogarth's (1697–1764) prints, generally combinations of etching and engraving, were related to his paintings, but sustain their independence as prints promulgating his satirical view of British society [**373**]. Moreover, Hogarth greatly boosted printmakers' ability to protect their designs from theft by his promotion of the Copyright Act of 1735.

In France, Gabriel de Saint-Aubin (1724–80) produced charming, atmospheric etchings; in Italy, Giambattista Tiepolo (1696–1770) and his son Giovanni Domenico Tiepolo (1727–1804), Giovanni Antonio Canal (called Canaletto) (1697–1768), and Giovanni Battista Piranesi (1720–78) carried on the Italian tradition of original etching. The elder Tiepolo approached etching offhandedly, but nevertheless his etchings were eagerly sought by print connoisseurs, and his enigmatic fantasies set the stage for the *Caprichos* (1799) of Francisco de Goya (1746–1828). Canaletto and Piranesi were important exemplars of architectural etchers, both of the topographical view (*veduta*) and the architectural fantasy (*capriccio*). The second edition of Piranesi's *Prisons* (1761–78), however, went beyond architectural fantasy to excite the Romantic imagination. LCH

Original etching

By the seventeenth century, etching developed into a favoured medium for original printmaking. Parmigianino's *Entombment* [366] is freely conceived with a rapid, fluid handling of the etching needle. Etching was used for landscape prints by Danube School artists such as Altdorfer [364] and by the Dutch, who took a naturalistic approach to the indigenous

countryside, enabling urban collectors to take vicarious walks. Rembrandt's printed landscapes follow in this tradition, although *The Three Trees* of 1643 [367] is symphonic in its treatment of nature and technically complex.

Along with Castiglione, Seghers is the most experimental Baroque etcher. The eerie, Danube School-inspired *Mossy Tree* [365], printed on painted paper, may be a very early

256

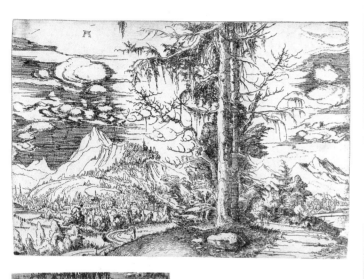

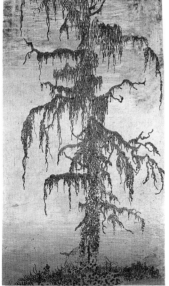

364 Top left: Albrecht Altdorfer (*c*.1480–1538), *Landscape with a Double Pine* (*c*.1520–3), etching, 11 × 16.2 m. (4¼ × 6⅜ in.), London, British Museum

365: Above: Hercules Pietersz Seghers (or Segers) (1589/90–1633/8), *The Mossy Tree* (undated) etching on painted paper with added body-colour, 16.9 × 9.8 cm. (6⅝ × 3⅞ in.), Amsterdam, Rijksmuseum

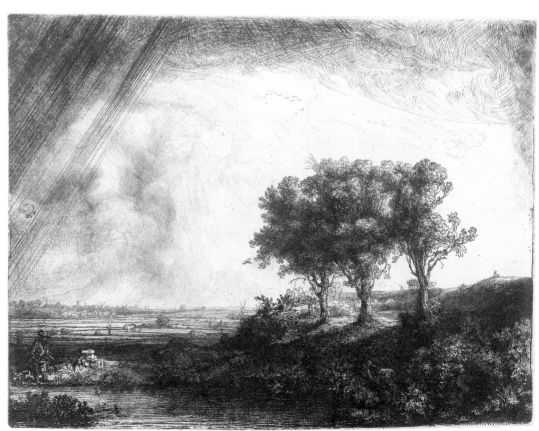

example of sugar-lift or lift-ground etching, in which a syrupy substance is painted on to the plate under the ground, and then swells and lifts off when the plate is immersed in water, exposing the area to be etched. Seghers also experimented with hand-colouring, coloured inks and papers, printing on cloth, taking impressions from impressions (counterproofing), and cutting and reprinting plates.

Original etching contrasts with professional reproductive engraving, at its peak in the eighteenth century. The elaborate system of lines and marks in these engravings contrasts with the ragged lines of original etching, epitomized by Piranesi's *The Prisons* [**368**]. Even if it can be interpreted as a hymn to the stern justice of the Roman Republic, the second edition of *The Prisons* exceeds expectations for the

architectural *capriccio* by becoming a statement of the uncertainty and transitoriness of the human condition. The sublime spaces of *The Prisons* herald the Romantic era, in which original printmakers like William Blake (1757–1827) and Goya found their voice against the continuing success and increasing systematization of the reproductive print. LCH

257

366 Opposite, top right: Parmigianino (Francesco Mazzola) (1503–40), *The Entombment*, second version, etching with some drypoint, 33.1 × 24 cm. (13 × 9⅜ in.), Washington, National Gallery of Art

367 Opposite, bottom right: Rembrandt van Rijn (1606–69), *The Three Trees* (1643), etching with drypoint, 21.1 × 28 cm. (8¼ in. × 11 in.), London, British Museum

368 Right: Giovanni Battista Piranesi (1720–78), *The Drawbridge*, Plate VII of *The Prisons*, second edition (1761–78), etching and engraving, 55.7 × 41.2 cm. (21⅞ in. × 16¼ in.), Cincinnati Art Museum

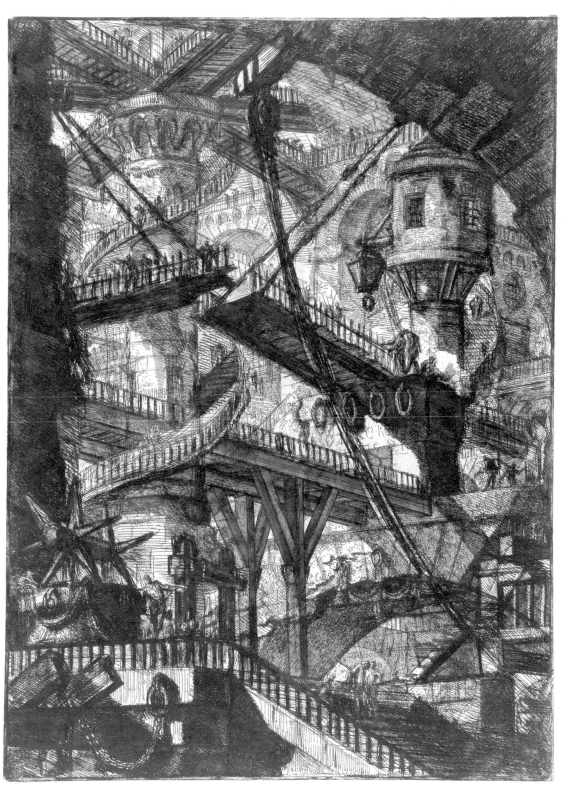

The reproductive enterprise

Engraving gradually relinquished its role as the primary medium for original prints in this period. The *Kleinmeister* carried out Dürer's engraving style and his interest in Italianate subjects, such as erotic nudes [369], in tiny engravings prized by collectors. But reproductive engraving developed after Raimondi and his engravers lost access to plates after Raphael's drawings and turned to engraving his painted compositions or to re-engraving images on to new plates (this may have happened with the two versions of *Massacre of the Innocents* [370]).

Goltzius's brilliant career spanned all aspects of printmaking. His engravings 'in the manner of' other artists [371], although not reproductive, show this skill as well as a growing awareness among collectors of the individual touch of master printmakers. Goltzius and other engravers developed a repertory of burin marks that expanded upon Dürer's and was adaptable to reproduce even Rubens's painterly works [372]. However, Rubens did not want a virtuoso engraver known for his touch but one who would subordinate himself to the paintings, and this would be the path taken by engraving.

French reproductive engravers in the eighteenth century used the burin only, or the burin over an etched foundation, as in the graphic catalogue of Watteau's *œuvre* [374]. This method was used by Hogarth for his series *Marriage à la Mode* [373] castigating arranged marriage.

258

369 Right: Hans Sebald Beham (1500–50), *Night* (1548), engraving, 10.8 × 79 cm. (4¼ × 3¹⁄₁₆ in.), London, British Museum

370 Far right: Marcantonio Raimondi (*c.*1480–1534), after Raphael (Raphael Sanzio, 1483–1520), *The Massacre of the Innocents* (version without fir tree), (undated), engraving, 28 × 42.5 cm. (11 × 16¾ in.), London, British Museum

371 Far right: Hendrick Goltzius (1557–1617), *The Circumcision in the Manner of Dürer*, from *The Meesterstukje* (1594), engraving, 46.5 × 35.1 cm. (18⅜ in. × 13⅞ in.), Chicago, Art Institute

372 Right: Lucas Vorsterman (1595–1675), after Peter Paul Rubens (1577–1640), *The Descent from the Cross* (1620), engraving, 56.9 × 43 cm. (22⅜ × 16⅞ in.), London, British Museum

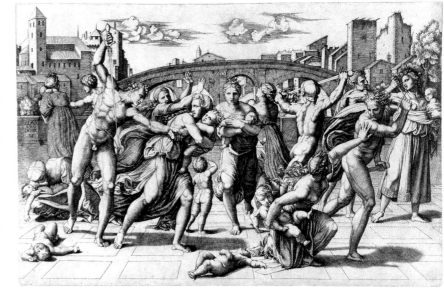

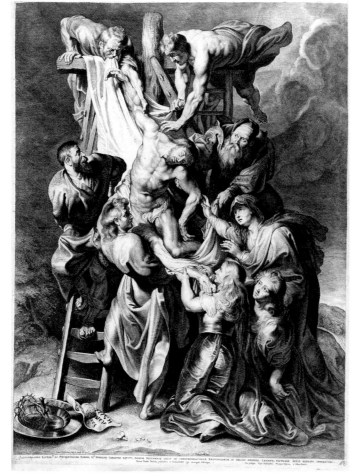

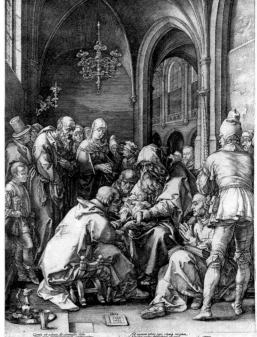

He recruited professional engravers to mimic French reproductive engravings to appeal to the élite classes the series was intended to reach. Alternatively, Hogarth made cheaper prints aimed at lower classes in a deliberately cruder style. His graphic series may duplicate painted series, but convey his didactic message more effectively because of print-making's capacity to reach a larger audience. LCH

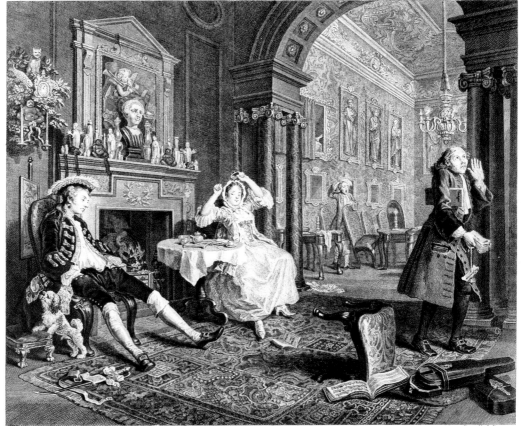

373 William Hogarth (1697–1764), *The Tête à Tête* or *The Breakfast Scene*, Plate II from *Marriage à la Mode* (1745), engraving and etching, 38.3 × 46.5 cm. (15⅛ × 18¼ in.), London, British Museum

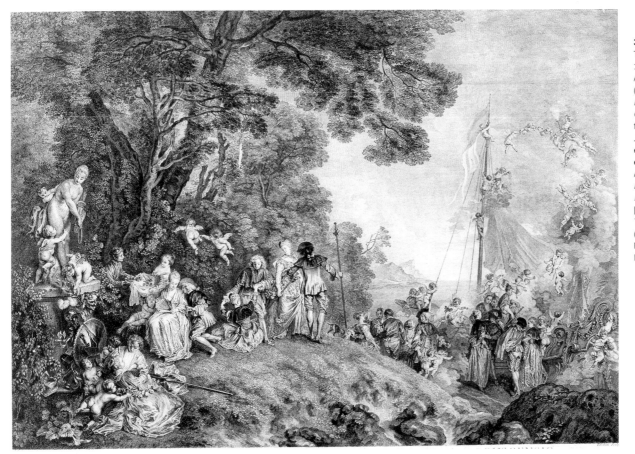

374 Nicolas-Henri Tardieu (1674–1749), after Jean-Antoine Watteau (1684–1721), *Embarkation for Cythera* (1733), from the *Recueil Jullienne* (1735), etching and engraving after Antoine Watteau *Pilgrimage on the Isle of Cythera* [**319**], 54.6 × 76.2 cm. (21½ × 30 in.), Philadelphia Museum of Art

Tone and colour

In the most systematic reproductive engravings, the individual marks of the burin merge visually into an imitation of painted surfaces but can still be seen as discrete flecks, stipples, or lines at close range. But in the tonal methods there were only areas of value. The mezzotint, or 'English manner', was produced from a plate that had been thoroughly scored with a spiked instrument called a rocker and then smoothed out by scraping and burnishing to produce higher values—a laborious but effective means of reproducing paintings such as the elegant portraits by Sir Joshua Reynolds. Circulated as prints, such portraits increased the knowledge of one's wealth, fame, beauty, or virtue.

Tonal methods also developed from etching. In aquatint, grains of acid-resistant resin adhere to the heated plate, so that the acid etches around them yielding tones that look like ink or watercolour washes. The crayon manner utilized spiked roulettes and mattoirs to cut through an etching ground to imitate chalk (crayon) lines—a reflection of the eighteenth-century craze for collecting chalk drawings. The prints were more affordable versions of the drawings.

When colour was added to tonal techniques, usually by the method of multiple-plate printing, the imitative capacity of the print was dramatically increased. Sanguine and pastel drawings, watercolours—even oil paintings—were all credibly imitated by reproductive media. LCH

260

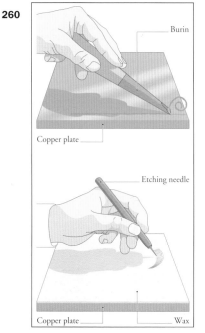

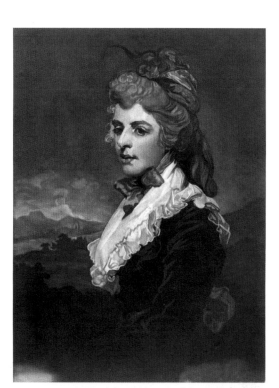

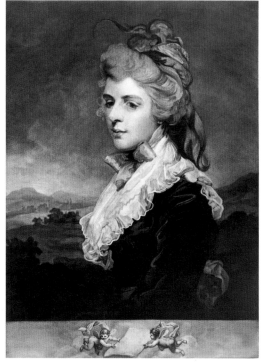

Engraving Top left: A wedge-shaped tool (a burin) is pushed against a plate, typically copper, to carve a deep and regular groove.

Etching Above: An etching needle is used to slice through an acid-resistant ground on the surface of the plate, exposing it to the corrosive acid when the plate is immersed in an acid bath.

375 Top centre: An eighteenth-century engraving of two mezzotint rockers (A and C; B a side-view of A) shown with supplementary tools. Fine teeth (a b) score the surface of the plate as the tool is pushed against it and rocked back and forth, London, British Museum.

376 Bottom left: First proof—an impression of the completely rocked plate—for John Jones (1745?–97), after Sir Joshua Reynolds (1723–92), *Miss Frances Kemble* (1784), London, British Museum

377 Top right: Proof of **376** after scraping to produce areas of light tone

378 Bottom right: Final proof of **376** before lettering was added to the bottom margin

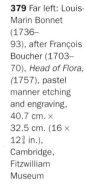

379 Far left: Louis-Marin Bonnet (1736–93), after François Boucher (1703–70), *Head of Flora,* (1757), pastel manner etching and engraving, 40.7 cm. × 32.5 cm. (16 × 12¾ in.), Cambridge, Fitzwilliam Museum

380 Left: An eighteenth-century engraving of tools for engraving textured lines, with samples of the textures they produced, London, British Museum

381 Below: Abraham Bosse (1602–76), *Intaglio printing* (1642), etching, London, British Museum

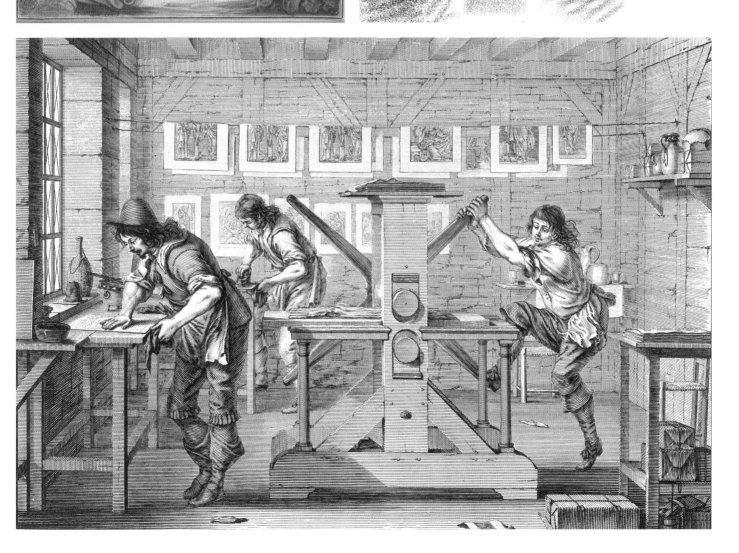

The Interior

Whilst the medieval period had certainly seen a great deal of exchange between countries of those goods and materials that made up the chattels of contemporary domestic life, it is the sixteenth century which presents a new, recognizably international pattern to the use of space, to decoration, and to the furnishing of interiors across Europe. To a large extent, particularly at courts and among aristocratic levels of society, this was due to the competitiveness of European nation-states to use interiors, as with visual art generally, to impress on the spectator the power and wealth of the patron. Certain spaces in which this competition was played out became recognizably similar throughout the Continent; rooms designed for ceremony and reception, private life or private collecting, took similar forms in great palaces and houses. Whilst many room spaces remained varied in use, and therefore varied also in the way they were temporarily furnished according to occasion, a greater sense of specifically dedicated function came into being across a range of types from rooms intended for parade and display, such as long galleries, to the private cabinets, restricted of access, where the owner's most private possessions were housed and to which only intimates were allowed access. The beginnings of a new formality is also manifest in the development of great staircases, of key importance to ceremonial, and now given room spaces of their own and devised structurally with ever greater ingenuity.

Sources and documentation

The history of the interior between 1527 and 1770 can be said to hinge on two inter-related factors. First, this period was deeply engaged with the exploitation of sources from the Antique world and their recasting for modern purposes. These sources were partly visual and partly textual. The increasing understanding of the exteriors of Antique Roman structures suggested the use of a range of building materials to create a richness of pattern and ornament. Knowledge of Antique interiors was more fragmentary, though the key discovery in the late fifteenth century of the remains of areas of stuccoed and painted wall surfaces from the Roman emperor Nero's palace, the *Domus Aurea*, dating from the middle of the first century AD, exerted an enormous influence and established the popularity of the species of ornament known as 'grotesque', incorporating vase, candelabrum, and trailing sinuous lines with naked cherubs and fabulous beasts. Vitruvius' first-century treatise on architecture outlined a notion of decorum in building and by extension to domestic interiors, of the use of appropriate decoration for public and private spaces. These ideas were further explored by the fifteenth-century writings of Leon Battista Alberti (1404–72).

The second factor important for the interior was the emergence of the architect who commanded great building commissions and exerted an increasing concern for the structure and appearance of the interiors of the buildings for which he was responsible. This led to the extension of architectural rules and means of ornament originally devised for the outside of buildings to their interiors. The order, rule, and proportion of exteriors became the means of governing the appearance of internal spaces; later, in the age of the Rococo, the overt opportunities taken to break those rules were based on the presumption that everyone understood they were normally firmly in place. This 'architecturalization' of interiors made features of significant fittings in the room, such as doors and fireplaces, the keys to an understanding of internal proportions and the point of focus within the space. The governing role of a major architect increasingly meant a unity of decoration in terms of motifs, colours, shapes, and sizes, with one part of the room echoing another, not only in the fixed parts of the structure such as the mirror image of a ceiling design in a tiled floor, but often also in its movable furniture and the kinds of objects on display.

Common sources in the works of key architects and their craftsmen, evident from the remaining physical evidence of interiors from the period under review, are paralleled by common types of documentary evidence across Europe that tell us what interiors looked like and what goods they contained. Among written sources, inventories of this period are far more plentiful than from earlier centuries, often because new legislation in countries such as England and France demanded they be attached to the wills of everyone of substance from minor landowners to leading aristocrats and high-ranking officials of the church. Among painted and printed sources representing the domestic environment, many fifteenth- and sixteenth-century examples are the setting for religious narratives suitable in this mode, such as the birth of the Virgin Mary or the private lives of royal or aristocratic Early Christian saints. During the seventeenth century contemporary interiors provided the setting for moralistic scenes, notably by the French and more significantly the Dutch schools of painters. International politics played a crucial role in the burgeoning of documentary evidence also; the very spirit of competition between centres of artistic consumption meant that the eye of the foreign observer was often sharp and analytical on behalf of the master being served. In this, the age of the first permanent embassies between nation-states, foreign ambassadors are the chief chroniclers of the physical appearance of royal palaces and their contents, especially on the occasions of festivity when temporary decoration transformed the appearance of interiors.

Italy: domestic and religious interiors

In Italy, the unity that became characteristic of the makers of the domestic interior was undoubtedly initially successfully brought to fruition in church interiors, and particularly in the decoration of small, private chapels. In these, painted illusionism in the fifteenth century gives way to an ability in the sixteenth century to handle a complexity of materials and their integration, prefiguring the achievements of later, Baroque decoration. In the chapel painted by Filippino Lippi (1457–1504) for the Strozzi family in S. Maria Novella, Florence (commissioned in 1487 but completed only in 1502, after a visit to Rome), the narratives of lives of the two SS John, Baptist and Evangelist, are placed within the framework of a richly painted architecture, reflecting recent discoveries of Antique applied decoration. Later, in the chapel made for the Sienese banker Agostino Chigi, in the church of S. Maria del Popolo, Rome, begun about 1513, Raphael (1483–1520) brought together a greater wealth of real materials, including marble, mosaic, and porphyry. In this small space the forms are now handled with more grandeur and with a sense of using the public (the funeral form of the obelisk and cenotaph) and the private forms of the Antique world to forge a new unity of meaning and surface richness.

Political events determined that the role of Italian craftsmen was crucial in accelerating a Europe-wide interest in both style derived from Antique precedent and the technological means to make the products which would display it, most significantly, in their first wave of influence, the use of stucco. Italian painters and craftsmen had been lured to the courts of Europe ever since the French invasions of Italy in the 1490s. The year 1527 witnessed a new turn in this development; the sack of Rome by imperial troops led to the subsequent dispersal of the expertise of various artistic workshops, initially to other parts of the Italian peninsula and subsequently to other centres in western Europe. Master painters and decorators trained in the workshop of Raphael and their followers moved to other centres. These included the stuccoist Giovanni da Udine (1487–1561/4), who moved to Venice where he created the stuccoed interiors of the Palazzo Grimani from 1537 to 1540, and the architect-painter Giulio Romano (1492/9–1546), who created the Palazzo Te for the Duke of Mantua in the years after 1526 . In 1532 the painter and stuccoist Francesco Primaticcio (1504/5–70) joined the Florentine artist Rosso Fiorentino (1494–1540) at the court of Francis I of France at Fontainebleau. The technical knowledge gathered there subsequently spread to England, where Nicolas Bellin' da Modena (c.1490–1569), previously employed at Fontainebleau and poached from there by Henry VIII, was responsible for the programme of narratives in stucco that decorated the exterior of the inner court of the king's new palace of Nonsuch, begun in 1538. The influence of Italians throughout Europe after 1527 proved especially strong because the impact of their work was reinforced through the medium of illustrated treatises (particularly the works of Sebastiano Serlio (1475–1554), whose designs for doorways, ceilings, and fireplaces were widely admired) and ornament prints, especially of 'grotesque', suggesting new forms of design which proved adaptable to native traditions of both indigenous ornament and local materials. French, German, and Flemish engravers followed the lead set by Italians. The ornament prints of the Antwerp-based Hans Vredeman de Vries (1527–c.1604), first published in 1565, were of great importance for the arts of interior design all over northern Europe and firmly established such key decorative elements as strapwork, which first appeared in the decorative schemes at Fontainebleau.

Very few sixteenth-century interiors survive with their original furnishings intact, largely because so much of the contents of rooms at this period was moved from room to room as circumstances, whether domestic or ceremonial, demanded. Some fixed furniture survives in civic interiors, especially where forms of government survived until a much later period, such as the high-backed wooden benches around the walls in the series of apartments created in the 1570s and 1580s for the Doge's Palace in Venice. Wall hangings (tapestry at the most expensive level, painted or stained cloths at the most mundane) created the appropriate theme for the room, as well as providing warmth in northern climates. Wooden furniture at this time was rarely padded and certainly not upholstered; cushions were the primary means of providing comfort and carpets at this time were usually imported from the Middle East and very rarely placed on the floor. In royal and aristocratic houses, a greater degree of ceremony encouraged the creation of more and more private spaces for retirement from public life. Sequences of state rooms for both king and queen, comprising guard chamber, presence chamber, privy chamber, and bedroom, followed by closet and other private spaces are replicated in the royal palaces of France and England created for Francis I and Henry VIII, usually on the upper floor around a courtyard, moving away from the arrangement of stacked lodgings in a great stronghold or tower, found in medieval times.

Simulation and illusion: the seventeenth century

Sixteenth-century interiors were principally designed to give the effect of a richness of contrasting surface textures even where the message of each of the constituent parts reinforced the

message of the other, as in the panelling of the lower half of the wall, gilded with the French king's initial, with stuccoes framing fresco in the upper half in the gallery at Fontainebleau of the 1530s, or in the High Great Chamber at Hardwick Hall, England (*c.*1600), where a plaster frieze of hunting scenes, both mythological and contemporary, surmounts tapestry.

Everywhere in Europe, however, the simulation of materials is evident at this time, often seeking to challenge the eye to question where the real marble of fireplace or doorway ends and the painted wall surface begins. Further illusion is often offered by the use of complex perspective in woodwork, originating as an idea in the choir stalls of Italy but manifest in the domestic environments of northern Europe. This was nowhere more true than in Germany, where elaborate panelled rooms present the fullest development of dado, surmounted by a series of framed arches through which perspective vistas are created by inlay and stained woods, and a massive entablature above these. Illusion is offered with a lighter content in the decoration of villas as they developed in sixteenth-century Italy. Here an alternative was offered to the moralistic or propagandistic tone of wall painting or tapestry in the royal or ducal palace. The interior walls of some of Andrea Palladio's (1508–80) villas in the Veneto, especially the Villa Barbaro at Maser of *c.*1560, are extended through painted illusion in the frescoes of Paolo Veronese (1528–88) into a fictitious space populated with house servants or rustic views of local countryside.

Baroque interiors also took illusion as a starting point for the spectator's conception of the room space but it was now used in a more directed way to control the viewer's experience. Again, the church interior prefigures and encapsulates the development. Gianlorenzo Bernini's (1598–1680) S. Andrea al Quirinale, Rome (1658–70), a relatively small oval-shaped interior, uses a range of media (marble, paint, stucco, and gilding) to direct the eye upwards to the cupola, where S. Andrew, martyred in the painted altarpiece in an enclosed tabernacle separated from the viewer in the main body of the church, floating in front of the drum of the dome in stucco on his way to heaven, is finally received into the arms of God. In the secular interiors of the seventeenth century fixed decoration supported rooms of an increasingly focused and specified use where the eye was directed towards a particular point on the ceiling, over the fireplace, in the recess or behind the balustrade where the state bed stood, where that specialized function was clearly symbolized or made evident. The growth in the market for portable oil paintings, particularly in northern Europe, by Dutch and Flemish masters, generated paintings for specific localities; fruit and game pieces for dining rooms, mythological scenes of love or sleep for bedrooms. The wider availability of mirror glass also made possible the illusion of extended space since illusionistic effects were as potent in small as in large rooms. Some of the most significant and influential rooms of the seventeenth century were designed by architects, such as those by François Mansart (1598–1666) at the Château de Maisons where gilding and other surface decoration are eschewed in the expression of space. Interiors were designed in relation to one another so as to underline the architectural coherence of the building as a whole; hence the *enfilade* of doors next to the window wall gave the viewer a vista through a series of spaces,

emphasizing the rooms in sequence and stressing the repetition of a module through to the end of the building range. Often pairs of doors, in some cases false and in other cases giving on to subsidiary rooms, were found at each end of the wall facing the windows, pointing to an internal symmetry that was an essential part of the room's coherence. Ideas of symmetry and vista are also found in furniture; great cabinets of this period opened up to reveal interior perspectives formed of inlaid woods, mirror glass, and semi-precious stones.

With this greater specific use of each room came suites of upholstered furniture for the first time. Arranged formally around the walls of rooms of state large sets of upholstered chairs and stools reflect the waiting time spent in rooms designed for ceremonial or, more often, their ante-rooms. In more private apartments they marked a greater degree of comfort than in earlier periods. Suites of furniture were expensive and commissioned only on important occasions in the life of a great family or for reasons of state. State beds and their accompanying suite were often the perquisite of leading officials at the great European courts when the ruler to whom they belonged died; two such suites came into the possession of the Earl of Dorset, Lord Chamberlain in the Royal Household, at the death of Queen Mary II of England in 1694, and survive at the country house of Knole.

Versailles and royal patronage of manufactures

It was unquestionably the court of Louis XIV of France at Versailles that set fashion for interior design and furnishings throughout Europe in the second half of the seventeenth century. The early years of the development of Versailles, from the 1660s to the 1680s, continued the Italian manner of painted ceilings of mythological themes echoing the exploits of the present incumbent of the palace. In this field, Versailles was the training-ground of ceiling painters who subsequently went to other courts and great houses of Europe, such as the Neapolitan Antonio Verrio (*c.*1639–1707) and the Frenchman Louis Laguerre (1663–1721), who both went to England. Versailles was also noted for its elaborately inlaid furniture and tables with mirrors en suite with them in silver—167 items in solid silver were counted in the state apartments in 1687); they were all sacrificed to pay for the French king's wars at the end of the century, but a few of their progeny made for English and German patrons survive.

The grand architectural interiors of the later 1680s at Versailles, with their use of marble and mirror wall revetment, and the richness of the textiles and inlaid furniture of other cabinets and apartments, were made possible by the earlier foundation of the Manufacture Royale des Meubles de la Couronne of 1662, whereby the whole range of craft skills needed for palace furnishings was supplied under royal patronage. This too became a template for other royal courts in Europe. Just as prints had provided a common currency for the applied ornament of interiors and their furnishings in the sixteenth century, so the first publication of prints showing complete state interiors with all their furnishings matching each other spread fashionable ideas across Europe. The French Huguenot refugee Daniel Marot (1661–1752), employed in England and Holland by William III, first made such prints.

It was with reference to the interior of the 'cabinet' at Versailles in 1665 that Sir Christopher Wren (1632–1723) castigated the transitory nature of changing fashions by stating that the interior was subject to the same rules as the building as a whole: 'Building certainly ought to have the attribute of eternal, and therefore the only Thing uncapable of new Fashions.' By this period, the supremacy of the architectural treatise in setting out the rules for architecture was unquestioned and the design of the interior was often included only as an extension to those rules, as part of the planning process of the building. The issue of decorum not only determined the suitability of different kinds of ornament for different interiors—so that an eighteenth-century room of public assembly in the spa towns of England and Germany, for example, would be decorated differently from a room of reception in a private house—it might also govern the hierarchy of decoration within a given structure. The section of an English town mansion of 1774 by the architect John Yenn (1750–1821) shows a Doric Order in the basement, Ionic in the entrance hall, and Corinthian in the vestibule of the first floor, used for entertaining.

Some of the bending of these rules of decorum and the consequent rules of correct proportion and clear separation of each of the rooms' constituent parts came about through the emergence of the Rococo style. This was adumbrated at Versailles itself in changes to some of the smaller rooms after 1700 which moved away from the architectural articulation of walls and the rejection of marble for lighter materials and colours. But it was in the new-found confidence of the patronage of the French aristocracy following the curtailing of royal power during the crisis years of foreign wars and famines at home in the later years of Louis XIV that the style was truly developed. Rococo is most markedly manifest in the more private rooms and salons of the town houses of Paris, such as the Hôtel Soubise of the 1730s, and other French provincial centres. If, as has often been argued, women patrons seem to have played a greater role in this period than heretofore, then it was precisely because of the increased significance of private space and such rooms as the salon for conversation, the traditional places to which high-born women had been confined, as opposed to the great public spaces of palace and government.

Craftsmen in France competed fiercely at this time for work, so that some of the highest standards of furniture-making ever achieved characterized their output. The Rococo style denied the earlier predominance of meaning through narrative and symbolism in ornament but still used the complexity of viewpoint of the Baroque with a new lightness of surface treatment, often emphasized by the presence of as much natural lighting as possible through windows to floor level. The style was rarely used throughout a single room (often confined, say, to the ceiling design) in England and the legacy of Baroque proved strong in Italy (though the factory at Capodimonte, founded in 1743 by the King of Naples, produced interiors of porcelain whose delicacy of surface, denial of the right-angled corner, and intricacy of motif paralleled Rococo interiors elsewhere). Rococo proved, however, to be most creatively used in the German states, where rivalry between princes encouraged some of the most famous interiors of the period, such as those for the Elector of Bavaria at Nymphenburg in the 1730s.

Rococo invoked fierce critical debate along nationalist lines. Whilst these Bavarian interiors were made under the direction of the Frenchman François de Cuvellis (1695–1768), in Prussia Frederick the Great used French designs for buildings and interiors but employed German craftsmen to carry them out. Part of the attack on the style in France signalled a call to order not just for the sake of earlier architectural coherence but also in defence of a French 'school' of interior design that was felt to reflect an earlier and more glorious phase of French history.

Neoclassicism: the last phase of decorative unity

Until the mid-eighteenth century the precepts of the Classical style as suggested by the fragmentary literary and visual remains of antiquity set standards of proportion, decorum, and the limits of excess. With the discovery of the stuccoes and wall paintings of Pompeii (where excavations began in 1748) and Herculaneum (where they began a decade earlier) it was believed for the first time that genuinely domestic Roman interiors could be re-created with a far greater degree of accuracy of colour and ornament. This led Robert Adam (1728–92) to champion his own style of small-scale Classical ornament in contrast to the earlier heavy internal architecture of William Kent (1684–1748), whom he accused of using a style suitable for public architecture, with heavy mouldings and tabernacle frames, in unsuitable private spaces. The Neoclassical interiors of Adam of the 1760s made fashionable a new range of bright tinted colours, moving away from the cool tones advocated by his contemporary Sir William Chambers (1723–96). In this Adam was echoing the move towards brighter fields of colour first used in France in earlier decades. His light relief of wall surface was equally matched in the Neoclassical interiors created for Louis XVI and Marie Antoinette in their private apartments at Versailles and elsewhere. By 1770, when Adam was on the verge of creating his 'Etruscan Room' at Osterley Park for the wealthy banking family of Child, the brightness and seeming fragility of some Neoclassical interior design was part of the new repertoire of decorators across Europe.

Yet at this time the interior still retained, for all the changes of fashion, some of the major characteristics of earlier centuries: the overall command of the architect-decorator, the dominance of the Classical past, the integrity of the decor of the room as a whole, the specific function of each space in a public or private sense. All this was to be challenged in the succeeding half century as patrons, notably the Englishmen Horace Walpole and William Beckford, led new fashions for decoration not from the point of view of good, accepted taste but from the need to express their own individual characters and personalities. The emergence of the 'Romantic' interior of the late eighteenth and early nineteenth centuries saw the retrieval of the historic past of individual countries and their artefacts, often transplanted from one setting to another; so the medieval tomb canopy became the design for a fireplace, for example. In this, the Classical became but one more period from a continuous and evolving history. During the nineteenth century, many interiors were seen to be multi-functional and therefore were far more hybrid in their decoration and contents than their eighteenth-century predecessors.

MH

Illusionistic interiors

Painted interiors and other means of illusion began in Italy and found their fullest development there. Illusion often suggested some link with the Classical past, whether evoking the pastoral literature of ancient times, or using the stories of ancient history and mythology to provide a reflection of the deeds and virtues of present-day figures of power.

Illusion could suggest the interior space was something other than itself, such as a gallery painted as if it were an open loggia. It could seem to extend the space of the room outwards to idealized gardens or country-side around the building, through the fictitious, painted architectural opening up of each wall, denying the real physical boundaries. Equally, in contrast to appearing to paint away the wall surface, illusionistic devices

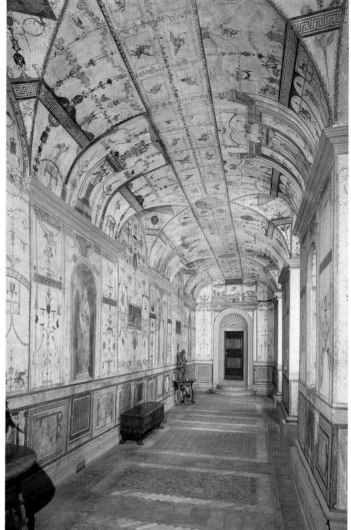

382 Right: The Loggie of Raphael (Raffaello Sanzio) (1483–1520) (*c*.1520), Rome, Vatican

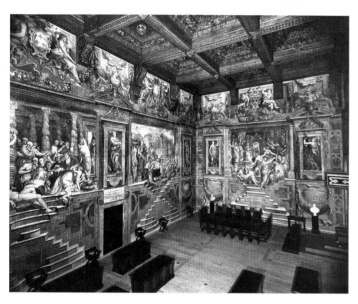

383 Above: Giorgio Vasari (1511–74) and workshop, Sala dei Cento Giorni (1546), Rome, Cancelleria Palace

384 Right: Paolo Veronese (1528–88), Room of Bacchus (*c*.1561), Maser, Villa Barbaro

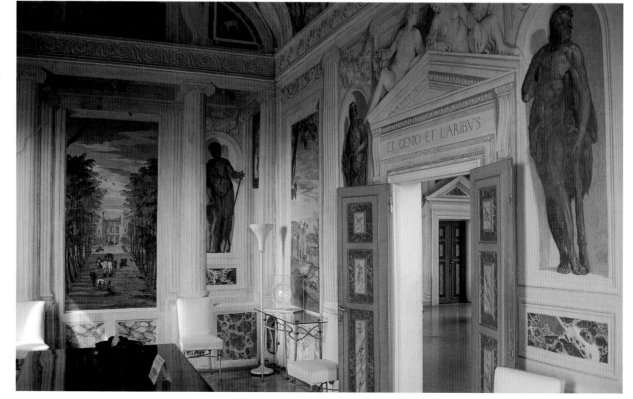

could show framed easel paintings or sculpture, suggesting that objects invaded or projected into the space.

The increasing cheapness of mirror glass led to the glittering rooms of the seventeenth and eighteenth centuries, where great expanses of mirrors reflected public or private events; mirror glass was exploited both alongside marble in the state rooms at Versailles and alongside stucco and intricately carved wood to extend the fantasy of the eighteenth-century Rococo interior.

With the discovery of Pompeii and Herculaneum and the wider passion for a more exact archaeology in the eighteenth century, illusion was used for the first time to evoke the re-creation of interiors such as they might have existed in ancient times, employing a new range of colour and delicacy of ornament to suggest a room 'Etruscan' or 'Pompeiian'. MH

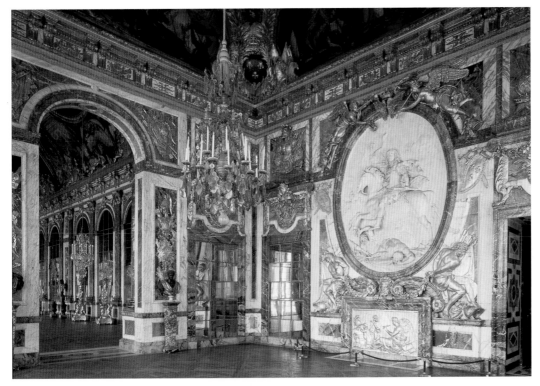

385 Charles Le Brun (1619– 90) and Jules Hardouin-Mansart (1646–1708), Salon de la Guerre (1678–86), Versailles

386 Robert Adam (1728–92), the Etruscan Drawing Room (1770s), Osterley Park, England

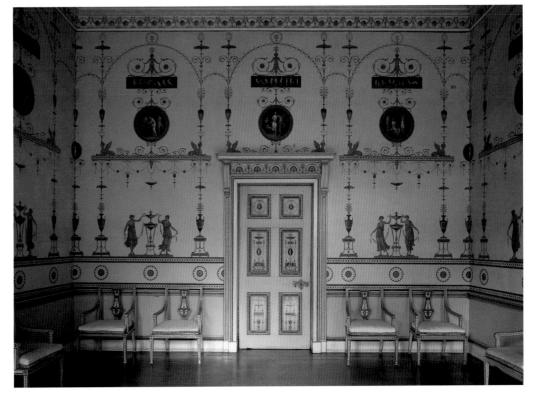

Ceilings

In the fifteenth and sixteenth centuries, technological changes resulted in the different forms that were to remain the choice of ceilings for architects and interior craftsmen down to the nineteenth century. A ceiling could sometimes be of emphatically different material and decoration from the walls of a room, such as of wood when the walls were of plaster. In other cases, vaulting would be used to extend the notional physical shape of the space, especially in rooms of some grandeur such as state reception rooms and great, open-well staircases.

Where vaulting was required, the stone or brick cross vaults of the Middle Ages were replaced by ceilings observed from Roman remains, with the vault springing from corbels framing lunettes along the tops of the

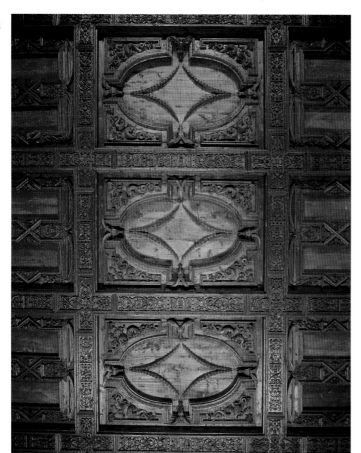

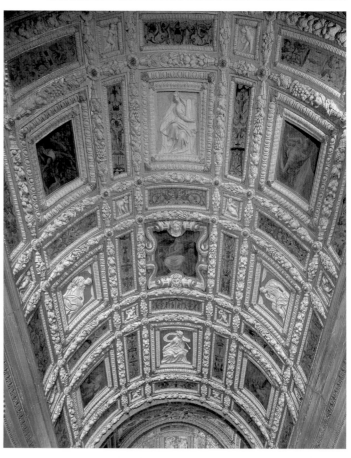

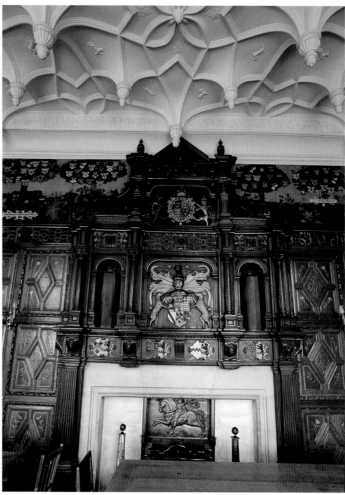

387 Above: Wooden ceiling (1530s) after a design by Michelangelo, Florence, Biblioteca Medicea-Laurenziana

388 Top right: The vault of the Scala d'Oro (c.1585), Venice, Doge's Palace

389 Right: The Great Chamber (c.1585), Gilling Castle, England

walls. When plastered or stuccoed, these became the field for painted illusion, either architectural or figurative. Wooden, beamed ceilings by contrast showed their exposed structure and remained popular, especially in sixteenth-century northern Europe, where they were often painted with heraldic motifs or the colours of the owner's coat of arms.

A wooden version of Antique coffering (such as that seen in the vault of the Pantheon of the first century AD) was widely used; designs for variants of this were disseminated through the books on architecture of Sebastiano Serlio. Deeply carved large wooden coffers, bearing coats of arms and symbolic devices, were used a great deal for large public rooms, especially in Renaissance Venice, and were also used for the naves of large Italian churches on a basilical plan. Coffering in stone or stucco proved useful for barrel-vaulted staircases, often carrying emblems or heraldic devices, and first appeared in Italy but then were most notably developed in France.

England saw the emergence of a particularly inventive school of richly modelled and fantastical plasterwork ceilings with elaborate pendants and ribs looking back to the shapes and linear style of the native Gothic tradition. MH

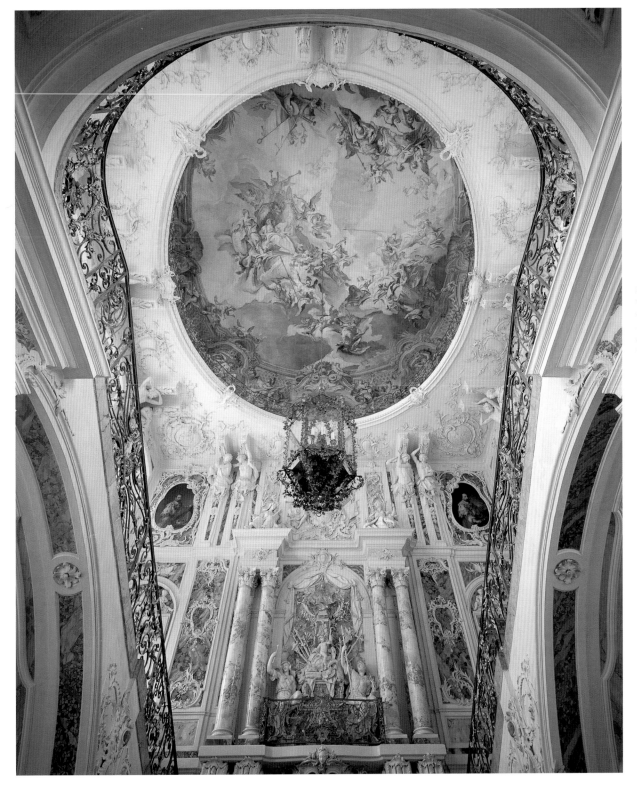

390 Staircase with illusionistic ceiling (1743–8), Schloss Brühl, Augustusburg, Germany

Floors

Floors were an important means of denoting the functions of rooms and the precise location of people and objects within them. In important spaces, they were designed to signify where specially made furniture was to be placed, and where people could stand or pass through.

In Renaissance Italy, mosaic inlaid floors were used in certain prestigious interiors such as those in the Vatican. Floors of tiles, known in Italy as *mattoni*, made of brick earths and glazed, could equally denote different parts of the room and could suggest, by their pattern, a repeat of the basic shapes of the ceiling above. In many sixteenth-century interiors, however, including high-status interiors in England, for example, stone or wooden floors were conventionally covered by rushes, often loosely spread but sometimes woven into matting, which would then be replaced at intervals. Comparatively few wooden floors remain intact from this period, since they were often replaced in the nineteenth century, but some seventeenth- and eighteenth-century survivals have remarkable inlay.

Carpets were expensive items, originally imported from the Middle East, and were kept over tables and rarely laid on floors save in great window bays and before chairs of state until the late seventeenth century. After that, European carpet manufacturers, like the great French firm of Aubusson, followed the practice of earlier floor patterns by issuing carpets custom-made to reflect specific ceiling designs. The earliest machine-made carpets date from the 1730s. MH

391 Left: Pavement of the Room of Leo X (*c.*1520), Florence, Palazzo Vecchio

392 Below left: German artist, *Elizabeth I Receiving Dutch Ambassadors* (*c.*1585), gouache, 244 × 37.5 cm (95⅝ × 14⁷⁄₁₀ in.) Kassel, Staatliche Museen

393 Opposite: The Mirror Room (1740s), Schloss Weissenstein Pommersfelden, Germany

394 Below right: Arthur Devis, *John Bacon and His Family* (*c.*1742–3), oil on canvas, 76.6 × 131.1 cm (30 × 51⅝ in.), New Haven, Yale Center for British Art

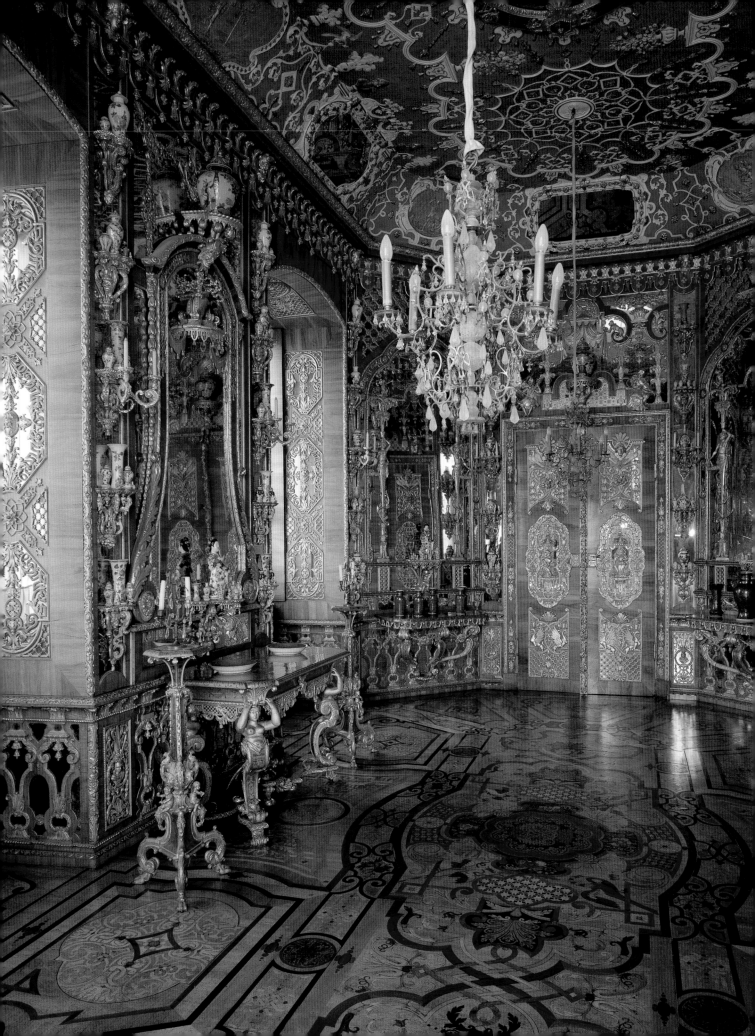

Panelling

Wooden panelling was especially common in northern Europe, where it provided insulation from the cold; in England rooms were often described as being 'seeled with wainscot', graphically denoting the exclusion of draughts.

By the early sixteenth century, the most common form of panelling was the lining of a wall with crossed wooden battens into which were inserted small, decorated panels. This decoration often took the form of heraldry or carried a motif resembling folded cloth, later described by nineteenth-century historians as 'linenfold'. The scale, intimacy, and opportunity for close inspection of battens and panels remained the panelling of choice for small, often private rooms until well into the seventeenth century. Increasingly, however, larger rooms which allowed more expression of order and proportion were panelled in a way more resembling external architecture, with dado, main field of ornament (perhaps with pilasters), and frieze.

Illusionistic panelling through staining or by the elaborate inlay of different woods originated in Italy in choir stalls and private rooms such as the *studioli* of the Duke of Urbino in the fifteenth century. By the late sixteenth century, central European countries developed such techniques to their greatest degree, inspired by pattern books of the period. Wooden interior porches further protected the heat generated within the room.

Seventeenth- and early eighteenth-century developments saw the greatest extent of architectural panelling with heavy pedimented doors and bolection mouldings, often framing

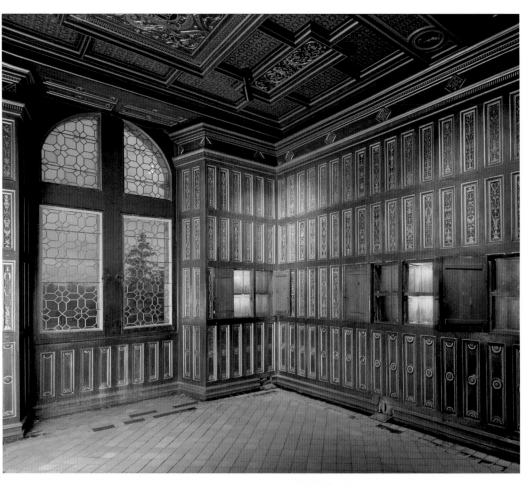

395 Right: Chamber of secret cupboards (*c*.1550), Château de Blois, France

396 Below: The Long Gallery (*c*.1600), Haddon Hall, England

397 Below: The Dining Room (*c*.1700), Beningbrough Hall, England

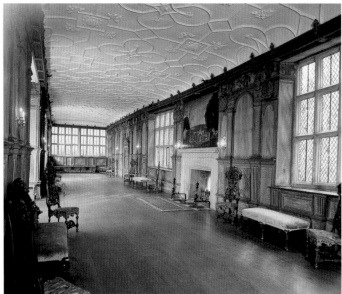

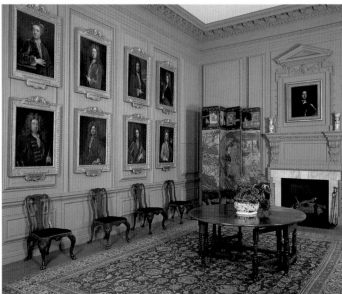

pictures. Lighter treatment of form, with the use of lighter-coloured woods marked the accomplishment of Rococo craftsmen, in whose rooms it is often difficult to distinguish carved wooden ornament from that in plaster, since wall and ceiling are often continuous and corners obscured.

By 1770, panelling was less fashionable, giving way to the dominance of the sheer plastered or stuccoed wall, and was not to enjoy widespread popularity again until the Arts and Crafts movement of the late nineteenth century. MH

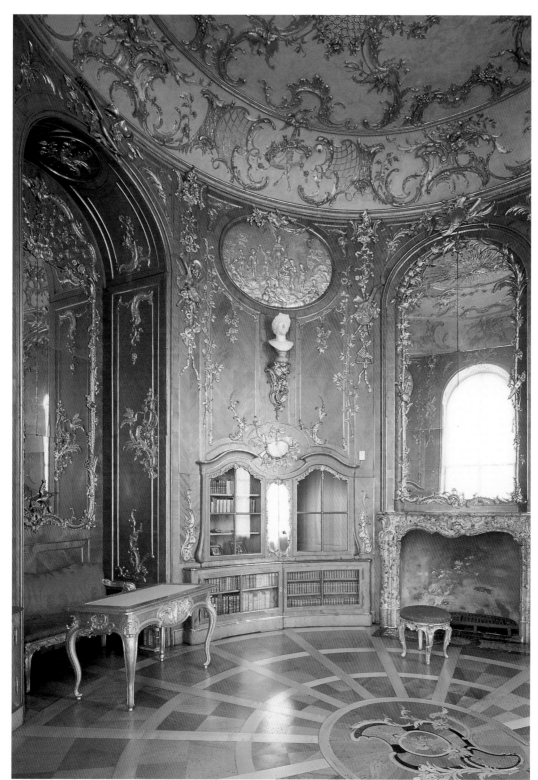

398 The Library (1746–7), Schloss Sanssouci, Potsdam, Germany

Wall hangings

By the early sixteenth century, tapestry was the most luxurious means of decorating and insulating wall surfaces where panelling was not preferred and Flemish cities like Tournai and Brussels were the chief centres of production. Tapestry was valued highly, usually listed at the beginning of the contents of any inventoried room, whilst stained or painted cloths were a cheaper form of hanging and were frequently replaced.

In the first half of the sixteenth century, older styles of tapestry, portraying dense foliage, floral patterns, or the deeds of biblical or mythical figures, were giving way to newer styles, with fewer and often larger-scale figures. These were inspired initially by the arrival in the Netherlands of Raphael's cartoons for tapestries for the Sistine Chapel, Rome. In the eighteenth century, certain great European artists, such as Rubens, continued to design tapestries of similar heroic themes.

By the eighteenth century, in the domestic interior at least, the convention for movable tapestry had partly given way to one where hangings were fixed in place above a dado and were often *en suite* with upholstered furniture. Earlier illusionistic design now changed for simpler, more pastoral narratives set in circular or oval frames against a single colour field.

Hangings of leather were popular in the seventeenth century; they are often known as 'Spanish' work because the technique was originally developed in Moorish Spain, but they were in fact also produced in the Low Countries, France, and England. The 'gilding' was created by embossing with tin-foil, which was sometimes painted. By the late seventeenth

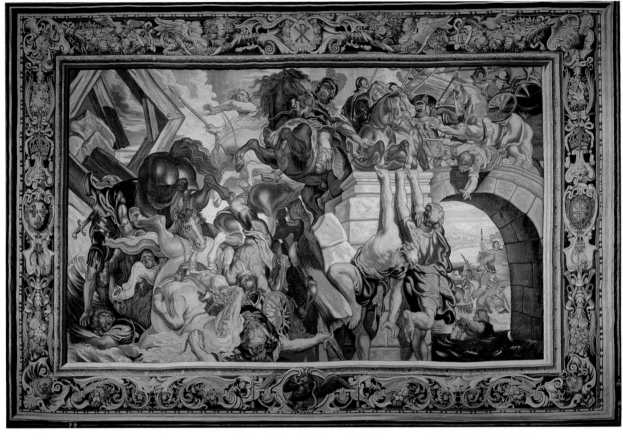

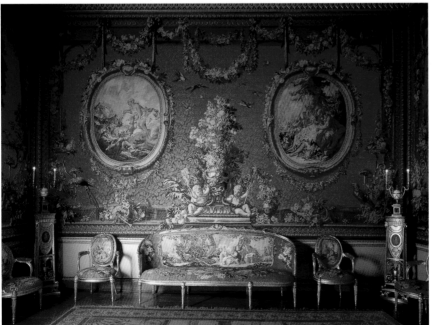

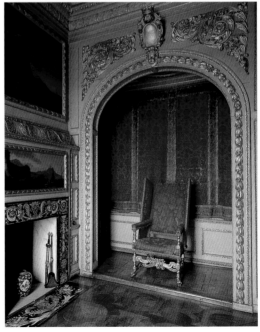

274

century, a wide variety of textile wall-coverings were becoming available, usually given the generic name of 'damask' whereby the warp and weft of a single material, or a mixture, such as wool and silk, created the illusion of raised patterns, usually of floral motifs. Wallpaper is known to have been made as early as the sixteenth century, usually to a black and white design, or coloured to some degree with the use of stencils, but only fragments of this early work survive. 'Flock' wallpaper was common by the end of the seventeenth century and the medium of wallpaper generally really took off as a fashionable wall-covering in the eighteenth century when the import of Chinese wallpaper set new expectations of quality and ambitious design. MH

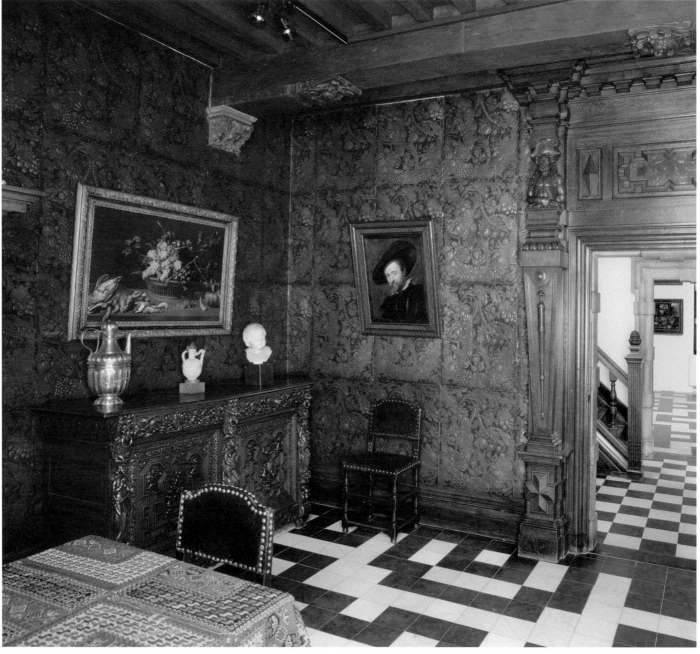

399 Opposite, top: Tapestry of the Battle of Milvian Bridge (c.1623–5), designed by Rubens, Philadelphia Museum of Art

400 Opposite, bottom left: The Tapestry Room (1770s), with hangings from the French Gobelins factory, Osterley Park, England

401 Opposite, bottom right: The Queen's Closet (1670s), with brocaded satin hangings edged in striped silk, Ham House, England

402 Above: Dining room with seventeenth-century leather hangings, Antwerp, Rubens House

Upholstered furniture

Until the sixteenth century, great households in many parts of Europe were constantly on the move and objects of comfort made of textiles, such as cushions and hangings, were improvised in use over the hard surfaces of wood and stone where required. From the sixteenth century, furniture became more comfortable, though it was a long time before padded and upholstered furniture became common.

In the seventeenth century, upholsterers were more responsible than architects for the final, overall decorative unity of a room as suites of upholstered furniture became common in the palaces and homes of the wealthy and powerful. The 'architectural' dimension of their work became evident in the careful design, supplemented by scale drawings, of bedheads, testers, and pelmets. At the end of the century, the designs of Daniel Marot were widely used across Europe to achieve unity of appearance, particularly in rooms such as state bedchambers and rooms of formal reception such as throne rooms. This formal use meant that only rarely, however, were particular items made for individual comfort, as in some of the first 'wing' chairs of this period.

It was in the eighteenth century, and especially in France, that furniture makers treated the padding of chairs to take account of every part of the body with which they had contact; chair backs were curved and padded stools made to a convenient height. MH

403 Right: Daniel Marot (1661–1752), design for a state bedchamber (*c.*1690), etching, London, Victoria & Albert Museum

404 Below: Bedchamber of Queen Hedvig Eleonora (1683, textiles 1740s), at Drottningholm Palace, Sweden

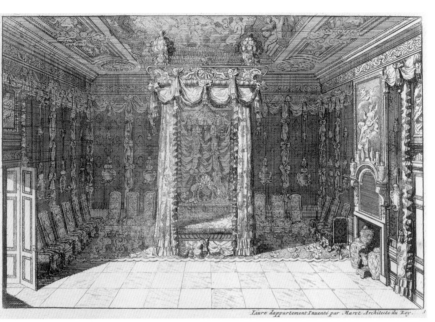

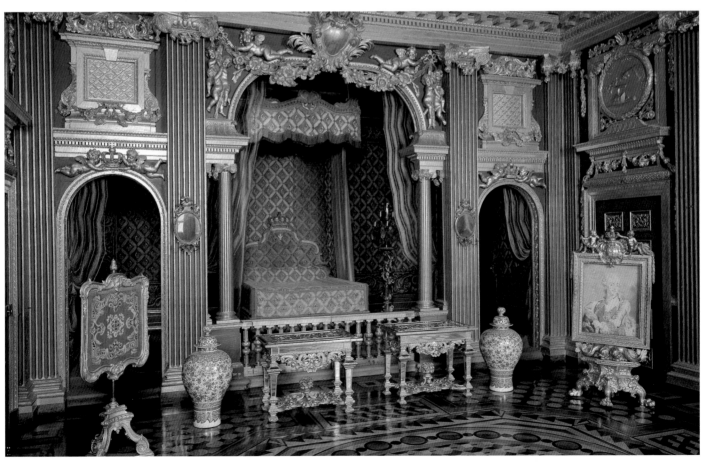

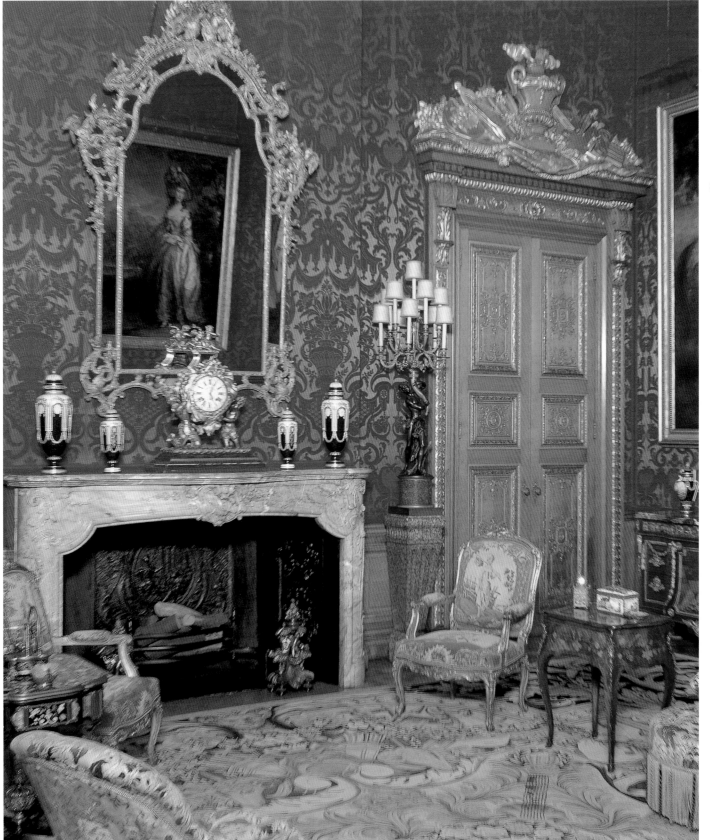

405 Above: French armchair (*c*.1760), with tapestry covering of the 1740s, Waddesdon Manor, England

Ceramics

Between the sixteenth and the eighteenth centuries, Europe took to using fired materials (the generic term 'ceramic' is one that came into common use only in the nineteenth century) not only for practical purposes (tiled floors and stoves) but for the decoration of interiors (displays of Chinese porcelain and Delft ware).

The maiolica workshops of Urbino seem to have been responsible for the transmission of the technology for the making of decorated floor tiles to the Netherlands, where the Italian Guido di Savino was working in Antwerp by 1512. Maiolica tiles were exported from here to French, German, and English patrons. Chinese export porcelain was reaching Europe by the later Middle Ages but by the late sixteenth century the trade was so established that Chinese factories were producing wares specially for the European market, adapting the physical shape of objects and the content of ornament to European tastes. It was the particular fashion for blue and white Chinese porcelain that inspired the growth of production of tin-glazed earthenware in Delft during the seventeenth century and particularly great objects of display such as the tall *tulipieres*. Together Chinese and Delft formed some of the earliest great displays of china, often placed over doors and on purpose-built shelved overmantels from the end of the century. In the eighteenth century, command in Europe of the techniques of making porcelain was such that whole rooms were created where walls and ceiling were entirely made up of interlocking porcelain panels, such as those at Capodimonte, Naples, and Aranjuez in Spain. MH

406 Flemish tiles with Roman and Flemish heads (1520s), probably exported to an English patron for his country house, The Vyne, England

407 Left: Sala di Porcellana (1740s), Aranjuez, Spain

408 Opposite: Daniel Marot (1661–1752), design for a lacquered room decorated with porcelain (*c*.1700), etching and engraving, London, Victoria & Albert Museum

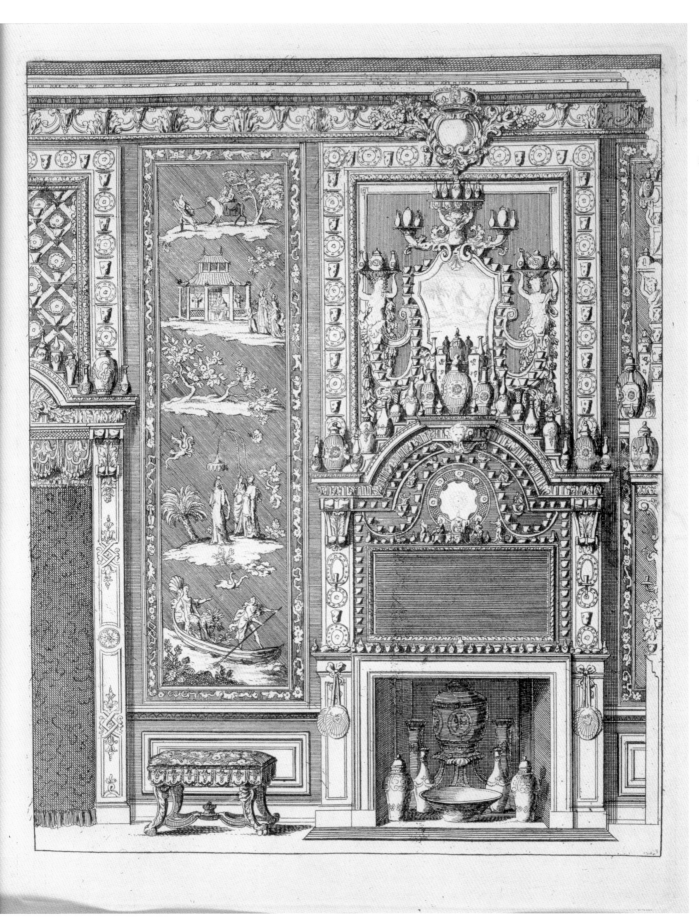

Forms in Space *c.*1700–1770

In the first decade of the eighteenth century few complexes could rival in grandeur, scale, or fame the palace of Versailles as it was being enriched in the last years of Louis XIV's reign. Described in contemporary guidebooks and imitated on a smaller scale by other rulers, Versailles showed how sculpture, painting, and architecture could be combined to celebrate and make visible the absolute power and might of the monarch. One particular ensemble that would have impressed a visitor in 1700 was the Grotto of Thetis [**409**], with its central group of Apollo, with whom the sun king Louis would have been identified. In 1738, when the newly refurbished pleasure gardens at Vauxhall, with its statue of the composer Handel as Orpheus, were opened by the entrepreneur Jonathan Tyers, both ensembles involving sculpture, architecture, and painting and the mythological imagery of the Late Baroque continued to be employed.

While the Apollo group was a sculpture closely linked to court ritual, commissioned by the king to be viewed predominantly by members of or visitors to his court, the figure of Handel, represented as Orpheus and holding Apollo's lyre, was made for an entrepreneur intent on attracting a wider public to his pleasure gardens, even though admittance was by ticket and ostensibly limited to those with claims to 'politeness'. The composer is portrayed as a lifesize marble statue and so in the most elevated form of public sculpture, but he is nonetheless shown dressed in rumpled stockings, an untidily open shirt, and with one slipper falling off. Through the immediacy of the figure's style (sometimes described as Rococo) the viewer is given the impression of momentary surface movement and fleeting gestures, an illusion that would have been heightened by both the lighting effects and the music being played within the gardens at night. While being a virtuoso work of both figure composition and marble carving, the setting up of the Handel statue at Vauxhall involved the parodying of an earlier tradition of public sculpture and the linkage of this elevated form of image to a more popular and carnival-like mode of public imagery. The spectator was drawn into this knowing playfulness.

Even when we take account of the very different political and social conditions in England and France, the differences between these two ensembles signal significant shifts in the use and viewing of visual images and the ways in which such images operated within social spaces. One such shift was the growing demand and increased market for independent small-scale works that could be used in domestic settings. Nonetheless, painting and sculpture continued also to be produced as parts of larger complexes. As earlier, artists and their patrons continued to take account of the intended contexts when commissioning or executing sculptural groups or paintings and these settings provided a framework within which they were viewed and understood. But the spaces in which such complexes appear have changed markedly by the middle of the century in many countries, just as patronage had become less closely linked to the court and the nobility. During the second half of the century viewing spaces were being established in which a different, and wider, public was being admitted and the familiarity with the visual arts, as with literature, became a mark of politeness among those who, through commercial success, had greater purchasing power for luxury goods, especially within growing urban centres. The wider consumption of works of art and the development of an art market in Paris, Amsterdam, and London were accompanied by an increasing tendency to travel to view sites and collections, sometimes as part of the Grand Tour. Artists responded to, and encouraged, such changes in the way they represented themselves and negotiated with potential patrons. Intent on raising their status, they separated themselves from artisanal trades and were increasingly being trained not only in the studio but in the academies that were being established in many European cities. This shift was reflected in the emergence of new spaces in which painting and sculpture, which were increasingly being thought of as 'art', were displayed, sold, and viewed.

During the first half of the century the combination of architecture, painting, and sculpture seen at Versailles continues to serve as benchmark against which the palaces of rulers elsewhere in Europe could be judged, even though the variants of this model differed strikingly and sometimes referred as much to Venice or Florence as Versailles. In Dresden, Augustus the Strong, Elector of Saxony and recently crowned King of Poland, employed the Italian-trained sculptor Balthasar Permoser (1651–1732) and the architect Matthaes Daniel Pöppelmann (1662–1736) to design and execute the elaborately decorated buildings that surrounded the courtyard known as the Zwinger [**410**], where court festivities were staged.

Another German rival to Versailles was created by the architect Balthasar Neumann (1687–1753) for the Prince-Bishops of Würzburg. Shortly after the philospher David Hume had visited Würzburg and thought the palace 'less than Versailles … [but] more compleat and finish'd', the Venetian painter Giambattista Tiepolo (1696–1770) was commissioned to paint the ceiling of the staircase hall. Tiepolo and his patron adopted the conventional Baroque scheme showing Apollo with the four continents [**411**], and the two-dimensional figures, as in these earlier ensembles, merge with the three-dimensional figures in stucco at the corners. But instead of being conceived, like earlier Baroque ceiling paintings, so as to be comprehensible

as a whole from one viewpoint, Tiepolo's composition prompts the viewer to read the various friezes partially, progressing up the staircase and pausing at various points to focus on individual groups of figures. The viewer is drawn into an engagement not only with the fugitive effects of rapidly changing light and contrasting textures of material but also with the complex turning of the individual figures and the instability at which they hint.

By the mid-century even the most aristocratic of patrons were often turning their attention and money to the decoration of smaller, more intimate spaces with subjects of friendship and love. When Mme du Barry, mistress of Louis XV, was planning the interior of Louveciennes she at first commissioned from Jean-Honoré Fragonard (1732–1805) a series of paintings, later rejected, representing the Progress of Love [412], in which gardens and garden sculpture figure far more prominently than any grand mythological themes. In the Netherlands, as in England, painting and sculpture were being used in domestic spaces not only by the nobility but also by patrons of 'the middling sort' as a sign of participating in the polite sociability of the sort represented in Cornelis Troost's double portrait of the art collector Jeronimus Tonneman and his son [413].

During the eighteenth century the divisions between public and private spaces became less fixed, as the patrons and buyers of art widened and new forms of imagery were formulated so as to reflect their polite concerns. In some areas churches continued to be adorned with painting and sculpture in traditional formats, though in a new style, as with Ignaz Günther's (1725–75) altarpiece at Rott am Inn, Bavaria [415]. But imagery within ecclesiastical spaces could also serve new functions, as at Westminster Abbey [416], where the nave of the thirteenth-century building was increasingly enriched by monuments viewed (with guidebooks) by a polite audience in this expanding urban centre, the same audience that would have visited Vauxhall Gardens. Some of those who admired Louis-François Roubilliac's (1702/5–62) monuments in Westminster Abbey or his statue of Handel [417, 418] would also have been impressed on their visits to Rome—the Grand Tour was no longer something for the nobility alone—by the most recently completed addition to that city's urban landscape, the Trevi Fountain [420]. On their way to Rome, they might also have been struck (or, in the case of Thomas Rowlandson's (1756–1827) English visitors, shocked) by the statues of monarchs that formed such a prominent feature of the squares of major French cities [421], including Reims, where Jean-Baptiste Pigalle's bronze figure of Louis XV had been erected at the expense of the municipality [419].

These various examples of painting, sculpture, and architectural spaces and decoration being used in combination

employed visual imagery in new and unexpected ways but the settings were in most cases familiar from the previous century. By the mid-eighteenth century, however, new viewing spaces had begun to be established in which politeness, commerce, and newly formulated notions of aesthetics together encouraged the display and viewing of painting and sculpture as autonomous works of art. The artist's studio became one space in which art was viewed and traded as well as produced and the painting by Pierre Subleyras (1699–1749) of his own studio in Rome [422] employs a well-established pictorial convention for a more self-conscious presentation of the artist and his work. But the studio was only one of a number of spaces in which art was exhibited, viewed, bought, and sold. One feature of the marketing of art in a commercial society brought with it a growth in auctions, sale catalogues, and dealers who acted as middlemen. One such dealer was Gersaint, who produced elaborate catalogues of the shells, Chinese porcelain, and paintings that he sold to a fashionable Parisian clientele. In his shop sign painted by Jean-Antoine Watteau (1684–1721) (whose career he claimed to have advanced) Gersaint's shop is represented as a place where dealer-connoisseur and potential buyer engage in polite conversation about and close inspection of paintings that were being sold along with other products of the luxury trades [424]. A connection between aesthetic judgement and the production and marketing of art is also made, though in a different relationship and to different ends, by Hogarth in his *Analysis of Beauty* [423] when he chose a sculptor's yard to illustrate examples of different features of figure composition.

Another new space for viewing art—and one that signalled its emergence as a separate and elevated category to be valued for its aesthetic qualities—was the exhibition. In France from 1735 onwards the biennial Salon at the Louvre provided a public setting for the display of paintings and sculpture that, along with the burgeoning art criticism in contemporary periodicals and pamphlets, played a major role in establishing the professional status of the artist. Linked with the growth of exhibition spaces was the development of collecting of art, both old and new, as a polite activity. The collecting and display of art as worthy of attention in its own right was already well established in early eighteenth-century Amsterdam through connoisseurs such as Tonnemano. It was a familiar and readily recognized mark of social status by 1783 when Charles Towneley was represented by Johann Zoffany (1733–1810) among the Classical marbles that were shortly to be bequeathed to the recently founded British Museum. They would be seen by a public whose notion of art was very different from that of the Versailles court a century or so earlier. MB

Courtly spaces

At the beginning of the eighteenth century in many European countries the court remained a major source of patronage for artists and many of the most ambitious ensembles of architecture, paintings, and sculpture were for spaces used for the ceremonies and rituals of the court. Traditional mythological imagery, such as the Apollo theme employed at Versailles [409], continued to be used but this was increasingly given a more informal emphasis and familiar forms and types of imagery received unexpected twists. The sculptural decoration of the Zwinger at Dresden [410], for example, made use of half-length caryatid figures but these now took the form of grimacing satyrs. Similar imagery was used on a smaller scale for the porcelain groups produced at Meissen also under Augustus the Strong's patronage. With this change in the uses of imagery went the development of compositions and figure styles that simulated transient effects of light and movement, changing a Late Baroque manner into a Rococo style. While the German courts, such as that of the Prince-Bishop at Würzburg [411], remained important centres of artistic patronage, painters and sculptors in France were increasingly employed not by the king but by a wider range of nobility and newly rich financiers. This shift away from court patronage was more marked still in England where a culture of commerce and politeness led to the growth of a new group of patrons drawn from both the aristocracy and wealthy entrepreneurs, keen to decorate both their London houses and their country houses and estates.　　MB

282

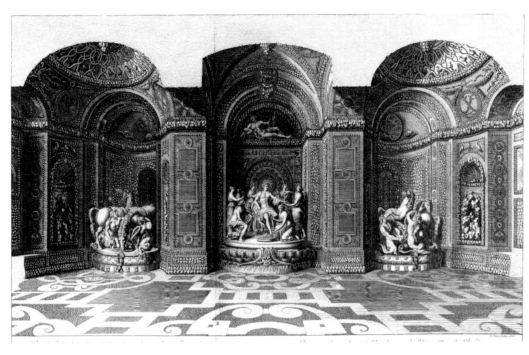

409 Left: Jean Lepautre (1618–82) after François Girardon (1628–1715) and others, *The Grotto of Thetis, Versailles* (1666–75) (engraving 1676)

411 Opposite: Balthasar Neumann (1687–1753) and Giambattista Tiepolo (1696–1770), The Treppenhaus with *The Four Continents with Apollo* (1752–3), Würzburg

410 Right: Matthaes Daniel Pöppelmann (1662–1736) and Balthasar Permoser (1651–1732), the Zwinger (begun 1711), Dresden

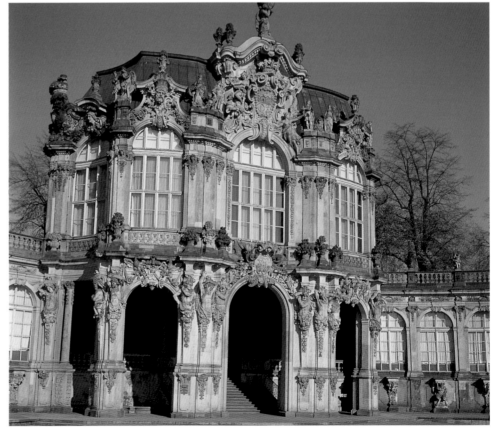

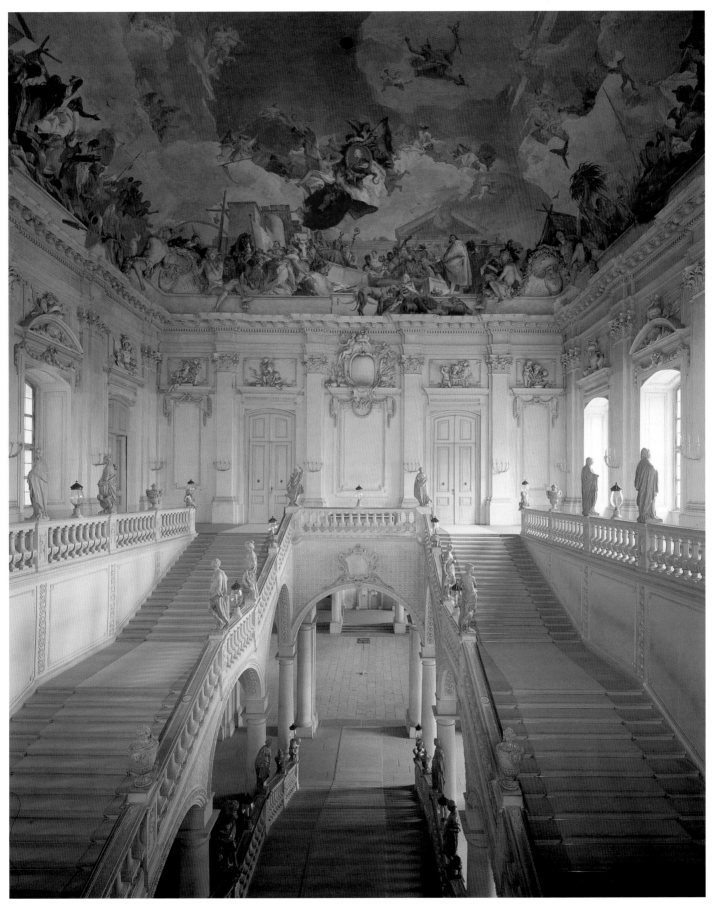

Domestic spaces

By the 1730s artists were often being employed to decorate smaller-scale, domestic interiors with imagery of a more informal and intimate type. In some cases these images were commissioned by aristocratic patrons, such as Louis XV's mistress, Madame du Barry, for whom Fragonard painted a series of pictures about love and friendship. Although rejected in favour of images more Neoclassical in manner, these paintings were well suited in their combination of the decorative and the narrative, the natural and the cultivated, to her garden pavilion at Louveciennes [**412**].

Other works for domestic interiors were produced for merchant patrons such as Jeronimus Tonneman, whose portrait in a fictive interior [**413**] implicitly refers to a culture involving luxury commodities as well as polite sociability and conversation about art and literature. Some of these elements, as an oblique reference to the estates from which a landed élite drew their wealth, are seen in Nebot's view of Sir Thomas Lee's gardens at Hartwell [**414**], in which sculpture is shown used in an informal landscape setting. Although few gardens retain their original sculptural decoration, which was often rearranged even in the eighteenth century, the garden was a context for ambitious and complex groups. MB

284

412 Jean-Honoré Fragonard (1732–1806), *The Progress of Love: The Meeting* (1771–3), oil on canvas, New York, Frick Collection

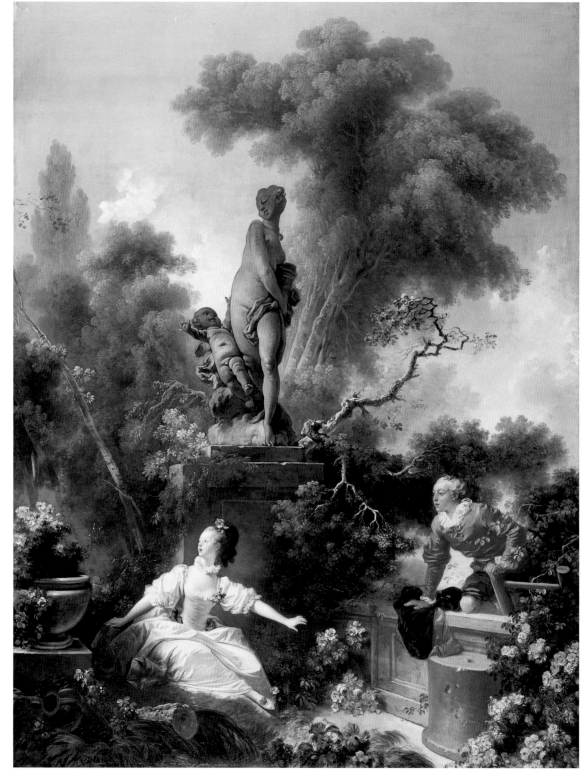

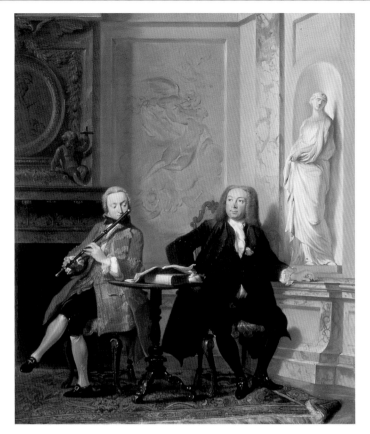

413 Right:
Cornelis Troost
(1697–1750),
*Jeronimus
Tonneman and
His Son* (1736),
Dublin, National
Gallery of Ireland

414 Below:
Balthasar Nebot
(*fl.* 1729–62), *The
Wilderness at
Hartwell* (1738),
oil on canvas,
Aylesbury,
Buckinghamshire
County Museum

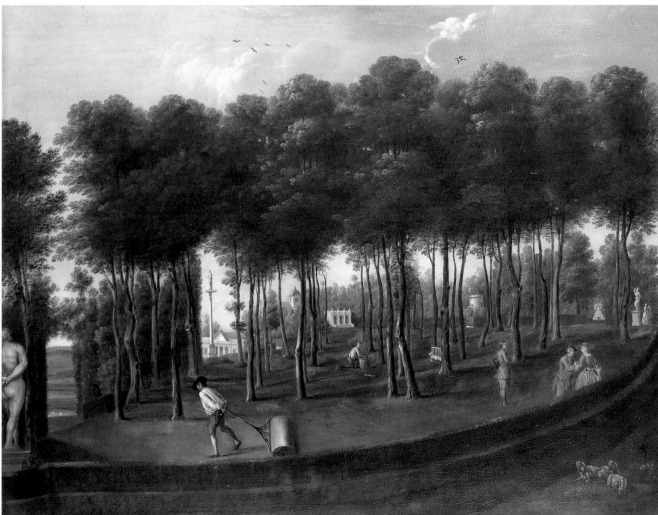

Public spaces

The church continued to be a significant space for large-scale ensembles of painting and sculpture. Some of the most spectacular of these were the altarpieces erected in South Germany, such as Günther's high altar at Rott am Inn [415], where the Rococo decorative and figurative styles, involving transient effects of light and drapery textures, were employed for devotional purposes. By contrast, the thirteenth-century interior of Westminster Abbey in London [416] was increasingly being used as a public space frequented by the polite public of a growing urban centre and from the 1730s onwards it became the setting for ever more ambitious monuments that began to be viewed as works of art in their own right.

A response to the concerns of an urban audience is also evident in a papal commission such as the Trevi Fountain [420]. But the most striking case of new forms being developed for emerging publics 'of the middling sort' was to be seen in London at Vauxhall Gardens, where Roubilliac's statue of Handel [417, 418] was placed in proximity to the supper boxes decorated with paintings drawing on a tradition of popular imagery usually seen as distinct from that of high art. Roubilliac's statue itself inverts some of the conventions of full-length portrait sculptures of the type used by Pigalle for his statue of Louis XV at Reims [419]. Such figures were used for propaganda purposes by the monarch, though the response of English observers such as Rowlandson [421] called into question the effectiveness of such visual rhetoric. MB

415 Left: Ignaz Günther (1725–75), high altar (1759–62), polychromed wood, oil on canvas, Rott am Inn, Bavaria

416 Below left: Thomas Bowles (b. *c.*1712), *The Inside of Westminster Abbey* (about 1753), hand-coloured engraving, London, Westminster

417 Below: J. S. Müller, after Samuel Wale (1721–86), *Triumphal Arches, Mr Handel's Statue &c. in the South Walk, Vauxhall Gardens* (*c.*1751), engraving, London, British Museum

418 Below right: Louis-François Roubilliac (1702/5–62), *Handel* (1738), marble, London, Victoria & Albert Museum

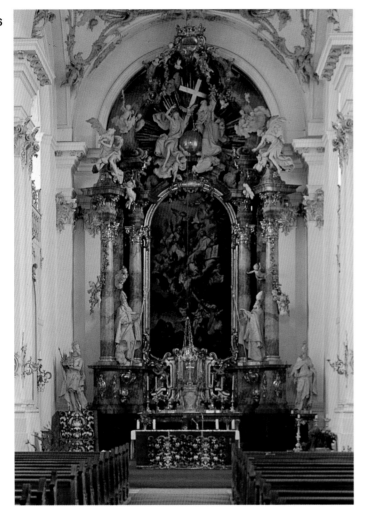

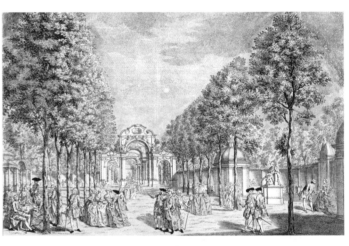

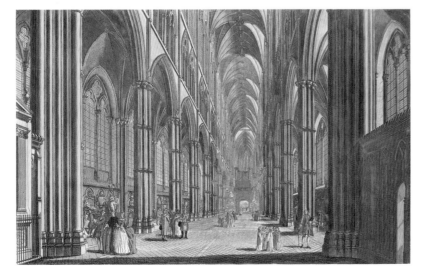

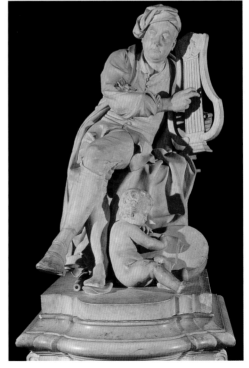

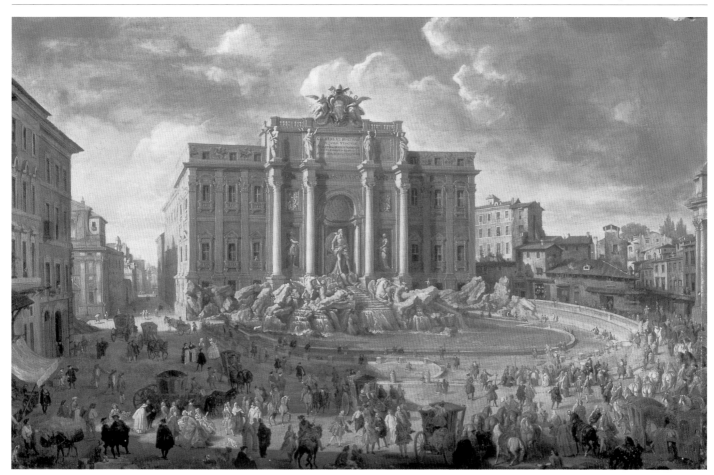

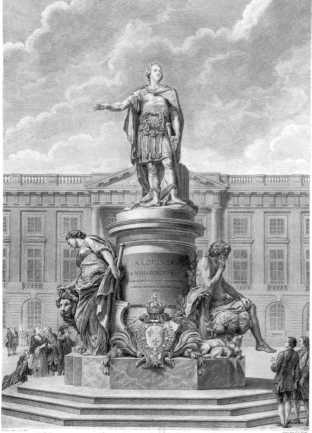

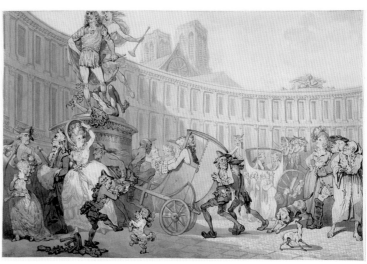

419 Left: Charles-Nicolas Cochin (1715–90) after Jean-Baptiste Pigalle (1714–85), *Monument to Louis XV, Reims*, engraving

420 Top: Giovanni Paolo Panini (*c.*1691/2–1765/8), *The Inauguration of the Trevi Fountain* (after 1744), oil on canvas, Moscow, Pushkin Museum

421 Above: Thomas Rowlandson (1756–1827), *The Place des Victoires, Paris* (about 1780–90), pen and ink and watercolour over graphite on laid paper, New Haven, Yale Center for British Art

Spaces for art

The artist's studio or workshop, as shown in Subleyras's painting [**422**] or still more schematically in Hogarth's engraving [**423**], was one place where art might be displayed and negotiations between artist and patrons conducted. But the commodification of art through a growing art trade, on the one hand, and the separation of art as a distinctive aesthetic category, on the other, involved the establishment of new spaces for the viewing of paintings and sculpture by a wider range of publics.

One such space was the Paris Salon, as shown in Saint-Aubin's view [**426**] with its combination of different genres of work—history paintings, portraits, landscapes, portrait busts, and plaster models for sculpture—arranged in a visual

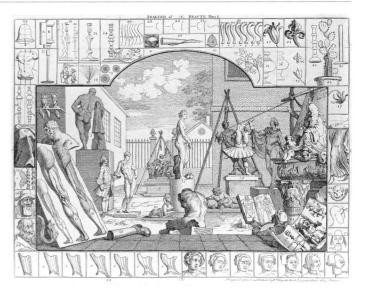

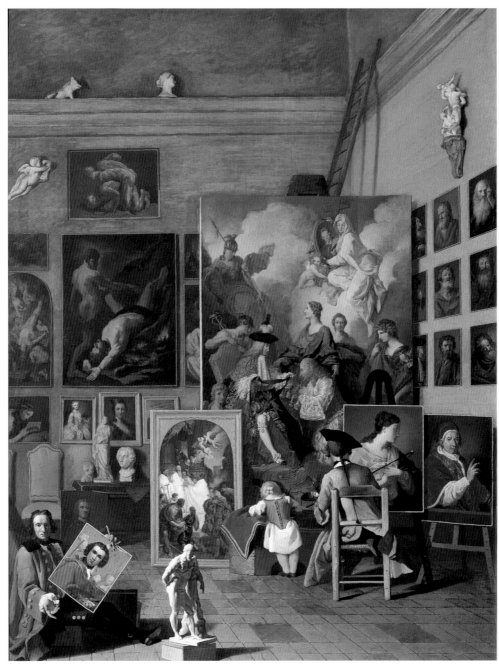

422 Pierre Subleyras (1699–1749), *The Painter's Studio* (after 1740), oil on canvas, 125 × 99 cm. (32 × 25⅓ in.), Vienna, Gemäldegalerie der Akademie der bildenen Künste

423 Above: William Hogarth (1697–1764), *The Analysis of Beauty*, Plate I, engraving (1753), London, Victoria & Albert Museum

424 Opposite, top left: Jean-Antoine Watteau (1684–1721), *L'Enseigne de Gersaint* (1720–1), oil on canvas, Berlin, Charlottenburg

425 Opposite, top right: Johann Zoffany (1733–1810), *Charles Towneley's Library in Park Street* (1781–3), oil on canvas, 127 × 99 cm. (50 × 39 in.), Burnley, Towneley Hall Art Gallery and Museum

426 Opposite, bottom: Gabriel Jacques de Saint-Aubin (1724–80), *The Salon of 1767* (1767), water-colour and gouache, private collection

hierarchy with the Salon Carré in the Louvre. These exhibitions were extensively discussed in contemporary periodical articles and guidebooks that set out to direct the attention of a growing public audience.

Art was also to be seen in the premises of dealers, such as Gersaint, whose shop is represented in his shop sign by Watteau [424] as a place of polite refinement and discriminating judgement. It was just this judgement—a mark of polite behaviour, along with the ability to converse about art—that lay behind the collecting activities of Charles Towneley. Although Zoffany's portrait of him with his collection of antique sculpture [425] does not depict the arrangement of the collection in his house it signals clearly how such sculpture was now being considered of aesthetic, rather than merely antiquarian, interest. The way in which the works are concentrated in one space hints at how galleries designed specifically and solely for the display of sculpture were to become an important setting for art as it was being conceived in the late eighteenth century. MB

289

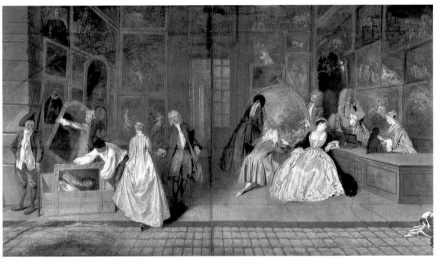

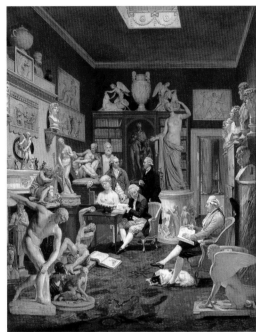

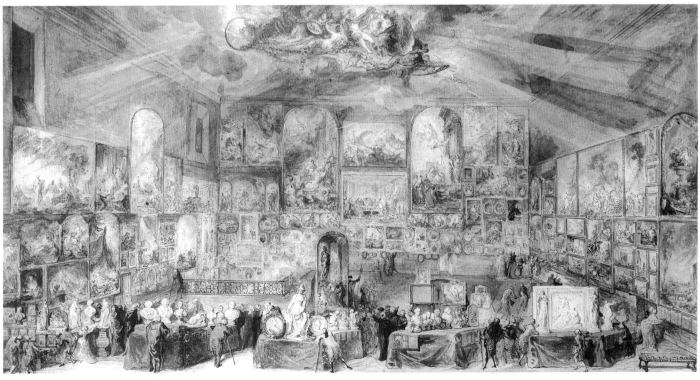

Academies, Theories, and Critics

Princely patronage was first extended to artists' discussions of their business and their craft in Italy at the turn of the sixteenth century. Lorenzo de' Medici's garden 'school' in Florence (*c*.1490), where Michelangelo studied in his youth, and the reception of artists and poets in the garden of the Bentivoglio in Bologna (*c*.1505) provide two examples. Baccio Bandinelli's 'Academia' (1531) in the Vatican complex operated under the eye of the Medici pope, Clement VII, while something akin to an academy functioned under the sponsorship of Andrea Doria in Genoa, where the sculptor Giovann' Agnolo Montorsoli (1507–63) studied anatomy and architecture, and discussed his work with physicians and artists, in Doria's presence (1540s).

Official academies of state begin with the Accademia del Disegno, incorporated in Florence in 1563 under the protection of Duke Cosimo I de' Medici (crowned Grand Duke of Tuscany, 1569). This unprecedented institution, with formal statutes to regulate its affairs and the conduct of its members, operated as a confraternity as well as a school; in 1571 it acquired the functions of a guild, adjudicating cases concerning the production and purchase of objects included under the banner of *disegno* (painting, sculpture, architecture and, by the seventeenth century, engraving). An extension of the court in its early years, with its chief administrators appointed by the Grand Duke, the academy conferred distinctions upon those who joined its ranks; 'academicians' were distinguished from the general membership or 'body' of the institution, which consisted of the younger or less experienced artists. Social distinctions that prevailed outside the academy pertained within it as well, with artists (who still ran shops through which they received commissions) remaining subordinate to the aristocratic amateurs who began to join in the late sixteenth century. Nonetheless, artists were no longer ranked according to their profession (painters over sculptors or architects), on the assumption that they had parity as practitioners of *disegno*.

Disegno comprised an Aristotelian formulation of 'imitation' (the latter, a concept also applied to poetry), which, in the Florentine academy, meant the representation of that which one comes to know about nature, rather than the representation of that which one perceives in the phenomenal world. Nonetheless, perception or study of the world provided the point of departure for the practice. The theoretical writings of the painter and architect Giorgio Vasari (1511–74) and the sculptor Vincenzo Danti (1530–76), both founding members of the academy, contain exemplary definitions of the concept. From its inception, the academy's programme of instruction included Euclidean geometry, perspective, anatomy, drapery studies, astronomy, and geography; in the seventeenth century figure-drawing classes were added. These subjects were held to aid in the practice of the arts of *disegno*.

The study of mathematics provided a foundation for the use of linear perspective and shadow projection. The other topics of instruction were justified by the primacy of figurative art (narrative and allegorical) within contemporary critical discourse, which posited connections between knowledge of the functions and proportional relations of the parts of the body and the ability to render figures that speak through a language of gesture and facial expression. Notes for a lecture delivered in the academy in the 1570s deal with the effects of geography and the humours on temperament and physiognomy (including the texture of hair and the colouring of flesh), an important subject for artists concerned with the expressive human form. The unsigned lecture contains learned references to Aristotle, Plato, Galen, and Hippocrates, which suggests the presence of erudite amateurs in the audience; indeed, the speaker asserted that his primary intention was to bring marvel and delight, thus engaging a growing community of dilettantes who joined the academy in increasing numbers in the seventeenth century. In fact, by the eighteenth century, amateurs in Florence outnumbered artists in the academy by more than two to one.

Functionaries and civil servants, including men from a new middle class who rose with the expansion of the Grand Ducal bureaucracy, these amateurs emerged in the academy as qualified speakers in new discursive realms, for example in the developing practices of connoisseurship, and in new forms of collecting and display, which were related to activities previously associated with a courtly élite. Perhaps most important among these activities were the exhibitions of master-works on the Feast of S. Luke (the academy's patron saint), which, although held only sporadically in the late seventeenth and eighteenth centuries, were ambitious in scope. Featuring paintings by Old Masters (Pierino del Vaga, Francesco Salviati, Giorgione, Titian, Pordonone, Annibale Carracci) and contemporary artists (mostly non-Florentine), they provided occasions for the academy's collectors to display their taste and rehearse their erudition as amateurs and connoisseurs of art. Their predilection was clearly for north Italian schools, with resident artists virtually unrepresented, despite membership in the academy.

The presence and activity of literally hundreds of amateurs in the Accademia del Disegno had significance beyond connoisseurship and the critical reception of art. As centralized power weakened in Tuscany in the seventeenth and early eighteenth centuries, the Florentine academy became detached from the court and fell under the influence of its amateurs, who opened up within it, on the threshold of modernity, a public discourse

about political economies of rule. This was prompted, in part, by the crisis of dynastic succession in Tuscany, with the end of the Medici line in 1737; yet it was also symptomatic of a trend in eighteenth-century Europe, which, in France, eventually led to revolution and the overthrow of monarchy. In Tuscany, where 'enlightened monarchy' would prevail, the academy's amateurs were caught up in a wave of neo-republicanism and free-masonry—evidence of a corporatism that transcended shared interests in collecting and art.

The Florentine academy was conceived in the sixteenth century in a climate of debate about the nature and status of artistic production. Benedetto Varchi's public lectures in the 1540s on epistemology and the relative primacy of the arts (particularly painting and sculpture) continued to frame Florentine art theory and criticism for the next generation: Vasari, Danti, Alessandro Allori (1535–1607), Ludovico Cigoli (1559–1613). In the late sixteenth century, the Council of Trent (1545–63) had an impact on discussions of production and reception, for example in the writings of Raffaello Borghini (1537–88), while, in the seventeenth century, the thinking of the French Rationalist philosopher René Descartes (1596–1650) and the experimental method of the Italian physicist Galileo Galilei (1564–1642) came to inform academic practice. (Galileo himself was active in the academy and close to several of its prominent members.) However, it is not clear that the production of commissioned works was driven by the views of theorists or critics in any consistent or significant way. Reception was another matter, involving the gradual emergence of protocols of interpretation and viewing pleasures from critical interventions not easily identified with particular individuals or specific texts. The seventeenth-century historiographer and amateur academician Filippo Baldinucci (1625–96) provides a notable exception, with his promotion of drawings and the appreciation of 'academies'—red-chalk studies of the male nude, often in a position of abandon, which were the products of academic practice and required a kind of interpretation foreign to the 'reading' of narratives or allegories. The critical debate and connoisseurial practices developed in the academy, along with the institutionalization of pedagogy for practising artists and the organization's staging of discursive events for amateurs, contributed to the formation of the modern 'bourgeois' subject who, in the eighteenth century, began to espouse the ideals of liberalism in public spaces that included Masonic lodges, cafés, salons, and academies of art.

Instruction in architecture in the Florentine academy, which was formalized only in the seventeenth century, placed an emphasis on civil and military engineering and preparation for projects of public works, including land-surveying and hydraulics. In Rome, by contrast, instruction in the Accademia di San Luca stressed architectural theory and the proper application of the classical Orders in contemporary building projects (chapels, churches, monastic colleges, palaces, villas), with such texts as Vignola's *Rule of the Five Orders* (1562) as a guide. In the seventeenth century, academic competitions (*concorsi*) in Rome provided opportunities for the practice and public scrutiny of this kind of training. Authorized by Gregory XIII in 1577, invoked by Romano Alberti (1555–1604) in his treatise on the nobility of painting (1585), reapproved by Sixtus V in 1588, the Accademia di San Luca began to operate only in 1593, during the pontificate of Clement VIII and under the direction of the painter Federico Zuccaro (*c*.1540/41–1609), a member of the Florentine Academy in the 1560s and 1570s. It was initially conceived as an élite body of painters within a guild and confraternity that included gold-beaters and embroiderers, who were granted a lesser status in the new organization; the academy's relation to the guild, however, remained ambiguous in the seventeenth century, despite papal Briefs that periodically reaffirmed their conjunction. On the model of the academy in Florence and the Roman confraternity of the Virtuosi at the Pantheon, Zuccaro had called for the inclusion of sculptors and architects among the academy's members. The institution, however, did not sustain the interest of any of its artists until the mid-seventeenth century, when the reconstruction of its church, in one of Rome's prominent civic centres (between the Capitoline and the Roman Forum), was undertaken by the painter and architect Pietro da Cortona (1596/7–1669) (head or *principe* of the academy, 1634–7). Amateurs joined the Accademia di San Luca, receiving the title of 'Honorary Academician', yet their numbers did not rival those in the Accademia del Disegno. Effectively, the academy in Rome established an institutional boundary between artists and a critically engaged public, quite unlike the situation in Florence.

Until the Roman academy's aggregation with the French Academy in the 1670s, its ties with a centralized court were few and variable. In the absence of papal dynastic lineage, the Vatican did not provide continuity or consistency in patronage; in fact, there were no concerted efforts on the part of the popes, until Clement XI in the eighteenth century, to define policy within the academy or to give shape to its practices. None-theless, grand building projects formed the core of early modern papal spectacle and cultural politics in the Eternal City, to which academy members responded, from the mid-seventeenth century on, with lectures and student competitions structured around actual or anticipated commissions (the new facade for

the Cathedral of S. John Lateran), or constituting critical reflections on commissions already completed (the church of Sant'Agnese in the Piazza Navona). Competitions were also held in painting and sculpture; after the union of the French and Roman academies, the subjects assigned to the participating artists in these professions (which included scenes from the life of Alexander the Great, a model of the sovereign embraced by Louis XIV) were clearly intended to flatter the French Crown. The competitions in painting, sculpture, and architecture were regularized and transformed into public events under the influence of the French in the second half of the seventeenth century; under Clement XI, the award ceremonies were staged with great pomp on the Capitoline.

As in Florence, figure-drawing became a core part of the Roman academy's curriculum; in 1754, Benedict XIV established a separate seat for this activity, near the new public galleries he had opened on the Capitoline, in what came to be called the Scuola or Accademia del Nudo. Expenses there were underwritten by the Pope. Critical investments in classicism, articulated clearly by the antiquarian and art critic Giovanni Pietro Bellori (*Lives of the Artists*, 1672; *Description of the Stanze of Raphael*, 1695) meant that drawing after ancient sculpture, casts of ancient work, and 'modern' masterpieces in the classicizing manner were to complement study of the human figure itself. Underpinning the programme was to be instruction in mathematics, again, to enable artists to discern the underlying structure of the objects of their imitation and to endow finished works with order and unity. Nonetheless, mathematics did not become a constant subject of instruction as it had in Florence, where classes in Euclidean geometry (along with 'mixed mathematics', including perspective and even mechanics and the design of fortifications) were taught with regularity throughout the seventeenth and early eighteenth centuries.

In a treatise composed in 1704, the painter Ludovico David (1648–1730) publicly criticized the Roman academy for allowing instruction in mathematics to lapse, an allegation seemingly contradicted by the centrality given to geometry and perspective in an allegorical drawing of the academy by the painter Carlo Maratta (1625–1713) (c.1685). Nonetheless, the inscription in the image, below a series of geometric and perspectival designs, 'so much and then enough' (*tanto che basti*), indicates Maratta's belief that such study could be taken too far. The same inscription accompanies an *écorché* figure used in the study of human anatomy, which appears to the left. In contrast, the words 'never enough' (*mai abbastanza*), next to the antique sculpture in the middle, reveal the unqualified primacy of classicism in Roman academic circles, the 'modern' exemplars of which were held to be the painters Raphael (Raffaello Sanzio) (1483–1520), the Carracci—Annibale (1560–1609), Agostino (1557–1602), and Ludovico (1555–1619)—and the French expatriate Nicolas Poussin (1594–1665). By the eighteenth century, a canon of Antique sculpture was also defined; the pre-eminence of works in the papal collection (the *Laocoön, Apollo Belvedere, Belvedere Torso*) was secured by the likes of Johann Joachim Winckelmann (1717–68) and Gotthold Ephraim Lessing (1729–81)—the former, a fixture in Rome in antiquarian and art circles in the 1750s and 1760s; the latter, a member of a growing republic of literary men who fostered pan-European

debates on subjects including the nature, purpose, and development of art.

The little-known Ludovico David had written during Maratta's ascendance in the Roman academy. A favourite of Clement XI, who named him permanent head of the academy in the early eighteenth century, Maratta was a friend of the champion of the classicizing manner, Giovanni Pietro Bellori (1613–96). His restoration of the *Stanze* in the Vatican, under Bellori's supervision, illustrates the investment they shared in Raphael and in High Renaissance qualities of expression as well as formal elements of style. Maratta cut an imposing figure in Rome for over fifty years, until his death (1715). Yet authority in the academy continued to accrue to architects as well, who played an increasingly prominent role in the papal consolidation of the city as a centre of cultural capital and tourism.

Indeed, eighteenth-century Rome comprised an impressive cosmopolitan centre, with 'foreign' scholars and amateurs of art taking up residence and making careers, under the patronage of élite society. These included Winckelmann, whose historiographic discussions of the art of antiquity, including classification by period styles, set a precedent for the history of art still felt today. The painter from Dresden, Anton Raphael Mengs (1728–79), belonged to this circle as well. 'Principe' of the Roman academy in 1771, he had come under the influence of Winckelmann in the 1750s; as court painter in Madrid in the 1760s, he brought the ideals of Roman academicism and Winckelmann's refined analysis of ancient art to Spain, where he promoted the reform of the Real Academia di San Fernando, an institution of the Spanish Crown that became a model for academies in Latin America (important instruments in European cultural imperialism in the 'New World').

The Spanish academy, approved by Ferdinand VI in 1752, virtually falls outside the period here under discussion, as does the Royal Academy in London, which George III approved only in 1768, although both came of prolonged efforts to organize a community of artists around programmes of pedagogy. The royal academy in France, however, is central to this study. The Académie Royale de Peinture et de Sculpture in Paris, with approval from the Crown in 1648, was conceived in an entirely different context from the Roman or Florentine academies, both of which, nonetheless, served as models in terms of organization and disciplinary practices. Italian theorists had argued successfully for the separation of painting, sculpture, and architecture from the mechanical arts or crafts on epistemological grounds, an argument given institutional expression in the foundation of Italian academies in the sixteenth century. And while these academies did not displace traditional shops, in which artists still apprenticed, nor release artists from the supervision of guilds (the Florentine academy was even incorporated as a guild itself), they did raise the artist's social standing in a field of practitioners whose work still depended on the hand.

Seventeenth-century France lacked any comparable tradition with which to effect or rhetorically secure the separation of the arts from the crafts or trades. On the other hand, a division already existed among artists themselves. Those favoured by the Crown with *lettres de brevet* (letters of royal licence) enjoyed privileges that released them from membership in the 'Maîtrise' (the Parisian guild for painters and sculptors);

and, perhaps inevitably, this division led to tensions between the élite corps at court and the artists in the guild, who outnumbered the *brevetaires* but enjoyed no royal patronage. The French academy was formed in this climate of tension, during the period of the Fronde, when the monarchy (with Louis XIV still a boy) was under attack by the Parlement, and the guild, with parliamentary backing, attempted to limit the number and privileges of the court artists. The painter Charles Le Brun, a *brevetaire* of the Queen Regent and recently returned from Rome, played a key role in the formation of an academy that won Bourbon approval, if not immediate royal funding, which would begin in the 1650s, with the end of the Fronde and the consolidation of centralized monarchic rule.

The curriculum in the French academy was similar to those in Florence and Rome. With an emphasis on figure-drawing, the academy also sponsored lectures in anatomy, geography, geometry, and perspective. As in Florence, demonstration-pieces were required from members (although Florentines submitted them with far less regularity), and lectures were open to an interested public, as was also the case in Rome. It differed from the earlier academies, however, in significant ways. It did not admit architects nor did it address architectural concerns, which were formally taken up only in 1671, in the newly created Académie d'Architecture. Moreover, it was conceived as an entity distinct from the commerce and culture of the guilds; its members were even prohibited from running conventional shops and from holding banquets and other social events that typified guild life. In effect, however, it came to function as something of a closed shop itself. By the 1660s, with the rise of Jean-Baptiste Colbert as chief counsellor to the king, all royal *brevetaires* were required to join or forfeit their privileges, and all commissions from the Crown were channelled through the institution. Le Brun, named 'First Painter to the King' (*Premier Peintre du Roi*) and director of all royal decorative works, was appointed Director of the academy as well. Yet the Crown, through Colbert, maintained an upper hand in establishing policy and requirements for the production of royal commissions, as well as control of the production of a coherent body of discourse to promote and facilitate the interpretation of a style suitable for the publicity of the king. That style was identified with classicism. Colbert assumed the highest administrative post in the academy, 'Protector', and appointed functionaries under his influence as 'Honorary Academicians' (*amateurs honoraires*) with responsibilities that included the composition, reading, and recording of the academy's lectures or *conférences*, which Colbert insisted upon keeping open to a growing public. This public was, in part, constituted by the academy's staged events.

More than in Rome or even Florence, there was a regime in place in France that made performative demands upon amateurs as well as artists, in the interests of shoring up the absolutist state. André Félibien (1619–95), Charles Perrault (1628–1703), and, later, Roger de Piles (1635–1709) all belonged to the small, select group of *amateurs honoraires* (many amateurs attended the academy's events, but most were not officially admitted to the body or given voting privileges, as were the honorary academicians). And these honorary members, along with certain artists, delivered lectures and published tracts in which they attempted a systematic explanation of the principles of art (primarily painting), expounding upon invention (what we might call iconography and compositional organization) and upon subjects ranging from physiology and a general theory of human expression to the use of colour and the dramatic effects intended by the arrangement of light and shadow. The works of Poussin, supreme in the eyes of Le Brun, served as examples, along with other paintings in the royal collection. Discussion of the relation of form and content predominated in the development of precepts to be used as a standard or gauge in production and reception. The results were mixed, particularly over time, as is evident with the emergence of the Rococo style and its refusal of the gravity of high-minded narratives. A hierarchy of genres also emerged, with history painting granted the most elevated status. Drawn from established traditions in theory and criticism—for example, the fifteenth-century writings of Leon Battista Alberti (1404–72)—this hierarchy also served to affirm the status of a form of publicity favoured by the Bourbon Crown—narrative paintings and allegories praising Louis's rule.

The Académie de France in Rome, a seat for students who won the privilege of studying there at the expense of the king (the *Prix de Rome*), opened in 1666. Poussin (d. 1665) had been appointed as Director, a further indication of the defining aspects of his work for the promoters of French academicism. With twelve *pensionnaires* sent annually, each for four years, French artists established a sizeable presence in Rome and, by 1676, under Colbert's supervision, they effected the union of the Accademia di San Luca with their parent institution, the Académie Royale, a move that served the interests of the Crown in multiple ways. Roman artists derived few advantages from the aggregation. In 1689, Bellori (who dedicated his artists' *Lives* to Colbert) received honorary membership in the royal academy, but upon his own request; he never went to France and did not participate in the life of the institution.

In the 1660s, new statutes called for public exhibitions of work by academy members in Paris, to be held every two years. These exhibitions ('Salons' in the eighteenth century, after the round room or *salon carré* in which they were held in the Louvre) were not mounted with regularity until the 1730s. Unlike the exhibitions in Florence, featuring art owned by the academy's amateurs, these events comprised the public display of works produced by the French academy's professional members, which were given as evidence of princely patronage and royal initiatives, to promote the glory of the state. The exhibitions also constituted an invitation to critical responses, among which stand the reviews or 'Salons'of the encyclopaedist Denis Diderot (1713–84), published between 1759 and 1781 for a courtly readership outside Paris. Repudiating the style and content of the Rococo, Diderot called for a return to the Antique and the classicizing manner of the sixteenth and seventeenth centuries, in which form and content worked together at elevated levels of moral discourse. Positing connections, as did Winckelmann, between political orders and art (liberty, not tyranny, he argued, fostered the great art of antiquity), Diderot opened the way for such figures as Jacques-Louis David (1748–1825), whose work met the formal and rhetorical criteria articulated by Diderot, and whose own politics would lead him to shake the French academy as an instrument of absolutism, in the spirit of revolution, at the end of the eighteenth century. KB

293

The International Diaspora

The conquest of the Americas by Europeans in the sixteenth century forced the indigenous cultures to come within the Western sphere of influence, with the gradual establishment of several culturally mixed colonies. The strategies adopted by the European newcomers to control the conceptual life of Native Americans often involved intense artistic activity, leading to changes in local ways of thinking and to the production of unique art forms. A previously unknown need for illusionistic representation and perspectival depth was introduced, as in the portraits of indigenous Mexican nobles illustrated in post-conquest codices. Pre-Hispanic civilizations in Mexico had been structured in the image of the indigenous cosmos, and expressed by means of strictly marked hierarchies. Disrupted by the Spanish conquest, the memory of this ordered universe could be somewhat recovered in these illustrated codices, albeit in a new composite visual language. Embodying bygone power and splendour, the nobles illustrated in the *Codex Ixtlilxóchitl* (late sixteenth century) [**427**], for instance, recalled European conventions and anatomical proportions, their bodies presented in a frontal view that had so far been absent from local forms.

In the wall paintings of Ixmiquilpan parish church (state of Hidalgo, Mexico) [**428**], pre-Hispanic motifs were incorporated into the Christian subject-matter of the battle between good and evil. New iconographic and stylistic religious forms, however, were persistently offered to the native population, contributing to the effective spread of Christian rhetoric. While in the sixteenth century the Maya lords had been able to 'read out' the Christian cross planted at the entrance to Franciscan monasteries as their own stylized 'Great Tree of the World', with its Four Directions, in the following century the message connoted by a painting attributed to the French priest Frère Luc (Claude François) (1614–85) entitled *France Bringing the Faith to the Indians of New France* [**431**] was not so easily misconstrued. It depicts a Québecois native on the banks of the St Lawrence River, humbly kneeling before a personification of Royal France. She displays a painting depicting the Trinity and the Holy Family, while at the same time pointing to the heavens and the Holy Family itself. This female personification might represent Queen Anne of Austria, regent for her son Louis XIV from 1643 to 1660, when missionary zeal in New France was at its height.

Relatively large numbers of Renaissance and Baroque Flemish paintings reached the Latin American colonies. A single shipment of paintings to New Spain in 1599, for instance, contained fifty works from Flanders. The painter Francisco de Zurbarán (1598–1664), an entrepreneur in the Indies trade, is known to have exported nine Flemish landscapes to Peru. Northern landscape painting influenced, for instance, the work of Diego Quispe Tito (1611–81), an important painter of the Cuzco School. And in Mexico, Flemish-inspired landscape features were regularly employed as a background to religious compositions. Illustrated books and single-leaf prints also reached the Americas in large numbers, exposing locally trained artists to Flemish, German, Spanish, and Italian influences.

Local reinterpretations of contemporary European art forms gradually led to the formation of truly independent, easily recognizable local styles. A painting done in seventeenth-century Bolivia by a follower of Diego Quispe Tito, for instance, entitled *S. Sebastian's Carriage*, reinterprets the theme of the Classical Triumph within the distinct context of South American Baroque art. Part of a series of fifteen Triumphs painted for the parish church of S. Anne in Cuzco, capital of the Viceroyalty of Peru, the composition portrays Inca nobles following a festive procession which is dominated by S. Sebastian's allegorical car. Such Triumphs met a clear political need, particularly the triumphal feast of the Eucharist, which functioned as a symbolic replacement for the traditional Inca sun festival of Inti Raymi. All the social groups that took part in these celebrations—the Spanish and indigenous aristocracies, traders, artisans, blacks, mestizos, and mulattos—are represented in the scene, mirroring Peruvian contemporary society, which is presented as a cohesive, non-problematic whole.

Genuine Christian devotion coexisted with overt political and religious rhetoric, for instance in the clay sculptures produced in seventeenth-century Brazil by a Portuguese Benedictine monk, Friar Agostinho da Piedade (before 1600–61). Having arrived at an early age in Brazil, where he remained until his death in 1661, Piedade also fashioned a number of silver reliquary busts. Among his best-known devotional pieces is a clay representation of *S. Peter Repentant* [**429**]. The saint's contorted position, dramatic tears, and bulging veins point to an emotional understanding of religious worship which echoes the new and dramatic forms of devotion that dominated European religion in the seventeenth century, particularly those of S. Francis of Sales, S. Teresa of Avila, and S. John of the Cross. In contact with the South American indigenous context, the original European religious iconography was often to take on added overtones specific to each locality. Among the numerous pieces produced by indigenous sculptors trained at the Jesuit missions of Paraguay, Brazil, and Argentina is a representation of the Virgin Mary portrayed as an indigenous woman, her face framed by long, straight hair [**430**].

Throughout the Americas the distinct nature of the local cultures was often expressed by means of unique iconographic motifs. When the image of Mary was copied and interpreted by

the Peruvian artists of seventeenth- and eighteenth-century Cuzco, for instance, it displayed distinct stylistic variations such as a gold brocade stencil decoration applied to garments and the inclusion of gold jewellery and haloes to convey the opulent effect that characterizes the Cuzco School. Moreover, Cuzco representations of the Virgin often mixed up her original attributes, associating, for instance, the Immaculate Conception with the Virgin of the Rosary, the Virgin of the Candlestick, and so on. The Andean Virgin was also portrayed as or within a mountain, as in a representation of the Virgin of the Potosí Mountain painted in Bolivia [432]. She recalls the female deity Pachamama, the agricultural Earth Mother of the Andes. Tiny figures dot her gown/mountain, representing the indigenous population. In the bottom register of the composition, inside a globe, an image of the same Potosí Mountain is framed by a pope, a cardinal, and a bishop on one side and Emperor Charles V and an indigenous figure on the other. The painting thus succeeds in visually unifying all the disparate members of contemporary Bolivian society, bringing them together in worship. A representation of an Inca ruler on the gown/mountain, displaying a bright emblem of the sun on his breast, reiterates the complex, composite nature of Andean religious experience.

Throughout the sixteenth and seventeenth centuries, an elaborate emblematic artistic language reached the Americas, providing the educated élite with the humanistic metaphors that filled the emblem books of Europe. With their educational drive, the Jesuits in particular were an important vehicle for the dissemination of this visual–verbal culture, which they implemented through their widespread application of Aristotelian-based didactic principles. Alciati's emblem book was particularly well known in colonial Latin America, and emblematic thinking influenced the organization and design of Baroque festivities as well as local literary production—for instance, the poetic work of the seventeenth-century Mexican nun Juana Inés de la Cruz—and the visual arts.

In contrast to the Spanish territories to the south, the puritan colonies of eastern North America produced relatively little art in their early years. By the late seventeenth century, however, educated New Englanders were developing a more sophisticated taste and began to share the humanistic rhetoric, as can be seen in a self-portrait of Captain Thomas Smith (c.1690), considered to be one of the masterpieces of early Baroque portraiture in America. The Dutch had kept their New Amsterdam colony (now New York) until 1664, and Smith's work reflects this influence as well as that of Peter Lely [357]. Conceived in dramatic chiaroscuro, his composition contains a window in the wall overlooking a harbour, a fortress, and

battling ships—a scene which may point to Smith's own naval career. A further metaphorical layer is added by the skull on which Smith's hand rests, a visual motif which clearly comments, in true Baroque fashion, on the transience of human life.

The brief but significant Dutch presence in Brazil in the seventeenth century also led to a rich artistic production. Reflecting the emergence of the scientific gaze during this period, and the Dutch preoccupation with an accurate rendering of the material world, painters like Albert Eckhout (c.1610–65) produced numerous works designed to describe the astonishing variety of that newly encountered tropical environment [433]. Expressing Enlightenment views on natural philosophy, eighteenth-century artists in Mexico and elsewhere in Latin America again sought to catalogue the widespread reality of the multiracial, multicultural societies they encountered. In Mexico, a strict system of caste classification had developed, conceived in terms of clear-cult racial categories, and was represented in a number of 'didactic' paintings portraying the different mixtures of races.

At the top of this social pyramid, the members of the élite had their status and power expressed in formal portraits, such as Miguel Cabrera's (1695–1768) likeness of Mexican-born grandee Don Juan Joachín Gutiérrez Altamirano Velasco, sixth count of Santiago de Calimaya (1711–52) [435], who held the office of accountant to the apostolic court of the Holy Crusade. Despite the strict social hierarchy of colonial American cultures, however, everywhere mestizos had started to play an increasingly important role in the religious, cultural, administrative life of the continent, as architects, sculptors, painters, and musicians. During three centuries of colonial rule, some educated members of the locally born élite gradually developed an intellectual and political tradition of their own. They began to acknowledge the complexity of their history and to see the American context as distinct, an attitude which culminated in the move towards independence throughout the continent. This can be seen in a painting by North American artist Benjamin West (1738–1820), *The Death of General Wolfe* (1770) [437], where the classical hero is taken from the recent past and shown as part of the local reality. Wolfe had died in 1759 on the Plains of Abraham outside Quebec, in the war against the French, and West's composition upholds the eighteenth-century understanding of grand art. Witnessing the event, however, in the foreground, is the seated figure of a contemplative Indian. Despite his idealized and almost romantic expression, which embodies the notion of the noble savage and reflects the European fascination with 'natives', he connotes to the viewer the undeniable significance of the native contribution to the American context. TCT

Images of a changing world

The first Viceroy of Mexico, Antonio de Mendoza, was a patron of Santa Cruz College in Mexico City, and of mestizo aristocrats, some of whom, descended from Indian princesses married to conquistadores, took part in cultural gatherings like any European humanist. Among the graduates from Santa Cruz College was Don Fernando de Alvarado Tezozomoc, grandson of the last independent Mexican leader, Moctezuma, and author of two chronicles, one in Spanish (c.1598) and the other in Nahuatl (1609).

Magnificent colonial manuscripts dealing with Amerindian everyday life, history, music, and medicine were written and illustrated. The historian Fernando de Alva Ixtlilxóchitl, a member of this educated circle, shared its interest in local ancestral traditions, while also drawing on classical authors and the Christian scriptures.

His illustrated *Codex Ixtlilxóchitl* (late sixteenth century) [427] deals with gods and rites in this new, verbal–visual language, combining texts in Spanish with figures portrayed in more European-like postures and gestures.

Wall paintings in Ixmiquilpan Church, Hidalgo (c.1550) [428], preserve an even stronger memory of pre-Hispanic forms of pictorial expression, conveyed in their highly stylized linear design and their symbolic understanding of the human figure, which is reminiscent of indigenous ideographic writing. TCT

296

427 Attributed to Fernando de Alva Ixtlilxóchitl (sixteenth century), *A Lord* (late sixteenth century), *Codex Ixtlilxóchitl*, Paris, Bibliothèque Nationale

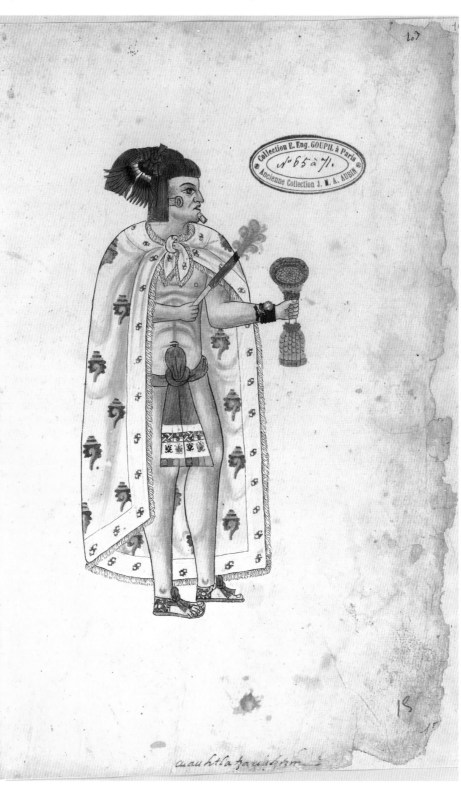

428 Opposite: Unknown artist, polychrome frescoes (c.1550), Hidalgo, Mexico, church of Ixmiquilpan

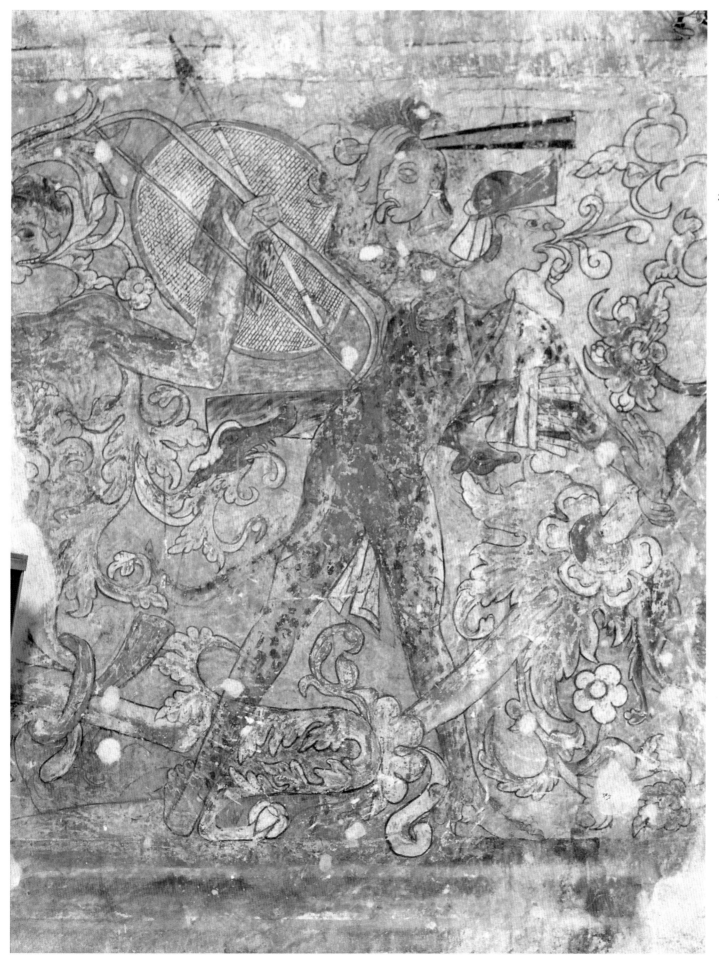

Devotion and rhetoric

Members of religious orders working in Latin America sometimes became artists themselves and produced works that played an active part in their missionary activities and devotion.

In Brazil the Portuguese Benedictine monk Agostinho da Piedade produced clay sculptures, such as his *S. Peter Repentant* [**429**], reflecting his belief in the Divine Heart of Jesus. This widespread devotion in seventeenth-century Europe understood the relationship between God and the soul as fiery and passionate, and lay at the basis of S. Francis of Sales's influential *Treatise on the Love of God* (1616).

The painter Claude François, trained by Simon Vouet (1590–1649), was one of six Recollect priests who travelled from France to Quebec. He had joined the Recollects in 1644, becoming a painting teacher and taking on the name Frère Luc, after the patron saint of painters. He spent only a year in Canada (1670), but his interest in that country continued on his return to France and may have inspired the famous rhetorical painting that is normally attributed to him [**431**].

Meanwhile, in South America Jesuit priests trained Guaranis in their missions in the Paraguay–Paraná basin. Around two thousand sculptures such as the one shown here [**430**] were produced by converts between 1610 and 1767. They fulfilled a strictly didactic function, providing visual support for religious sermons, particularly for those Amerindians who remained illiterate.

Contrasting with the severe style of the Guaranis' work, the paintings developed in the Cuzco region of

298

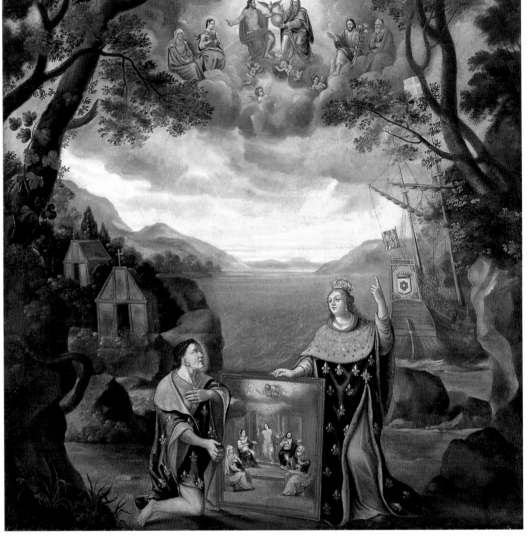

429 Top left: Friar Agostinho da Piedade (before 1600–1661), *S. Peter Repentant* (*c*.1636), fired clay, 76 cm. (30 in.) high, Salvador, Bahia, Brazil, Mosteiro de São Bentoda Bahia

430 Bottom left: Unknown artist, *Nossa Senhora da Conceição* (seventeenth century), 1.08 m. (42½ in.) high, Porto Alegre, Rio Grande do Sul, Brazil, Museu Júlio de Castilhos

431 Above: Attributed to Frère Luc (Claude François) (1614– 85), *France Bringing the Faith to the Indians of New France* (*c*.1675), oil on canvas, 2.18 × 2.18 m. (86 × 86 in.), Québec, Monastère des Ursulines

Peru, especially in the eighteenth century, employed a profusion of unique decorative elements and an abundance of gold leaf in a technique known as *brocateado*.

Combining local taste with European techniques and motifs, a native master like Diego Quispe Tito was able to accept important commissions, including an invitation by the bishop to produce paintings for Cuzco Cathedral. Cuzco painters also developed truly local iconographic forms, as in the representation of the Virgin Mary as the mountain Potosí [**432**], which echoes Andean pre-Hispanic cultural beliefs. TCT

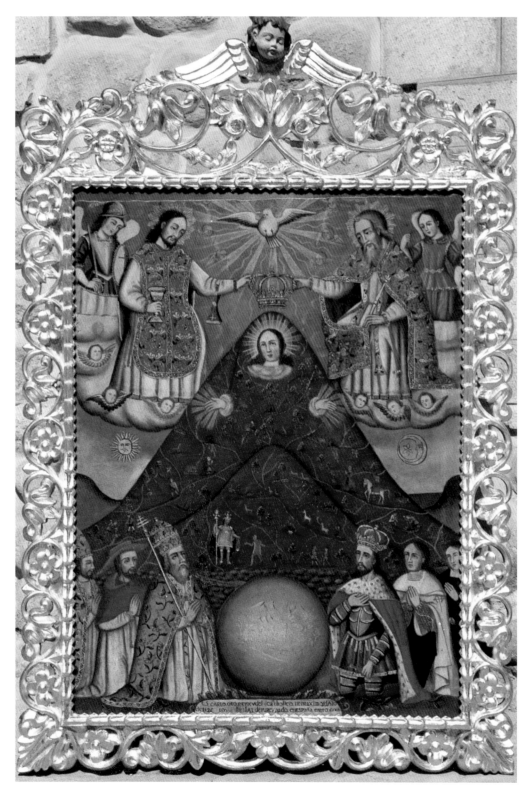

432 Unknown artist, *The Virgin of the Mountain* (late seventeenth/early eighteenth century), oil on canvas, 1.35 × 1.05 m. (53 × 41½ in.), Potosí, Bolivia, Casa Nacional de Moneda

Ordering God's creation

Although they regarded painters as little more than artisans, seventeenth-century North American colonists saw portraits as a useful vehicle for the expression of status. More than four hundred portraits painted in North America after the 1660s survive, mostly linear and schematic renderings with the sitter positioned against a flat background.

Sophisticated works, influenced by the chiaroscuro language of European Baroque, were usually produced by artists of Dutch origin working in the New Amsterdam (New York) area.

Despite the Dutch interest in emblematics, the artists who accompanied Count Nassau to the north-eastern areas of Brazil (1630–54) concentrated on carefully describing their new environment. Their

utilitarian and commercial interests, coupled with their Baconian approach to the ordering of human knowledge, were expressed in detailed landscapes and still lifes, which carefully reproduced the appearance of selected specimens of tropical flora and fauna. Albert Eckhout portrayed Amerindians in a series of works which function as a form of taxonomy [433].

This taxonomic interest persisted

throughout the eighteenth century in Hispanic America, signalling the growing influence of the Enlightenment among the élite. *Casta* paintings [434] visually categorized the hierarchy of colonial society, based on race and national origin. Miguel Cabrera's portrait of New Spain grandee Don Juan Joachín Gutiérrez Altamirano Velasco [435] reinforces the reality of this hierarchy. This unavoidable composite reality is also

300

433 Right: Albert Eckhout (Dutch, c.1610–65), *Dance of the Tapuias* (c.1641), oil on canvas, 1.71 × 2.94 m. (5 ft. 7$\frac{1}{3}$ in. × 9 ft. 8$\frac{2}{3}$ in.), Copenhagen, National Museum of Denmark

434 Below: Luis de Mena (Mexican, eighteenth century), caste painting (c.1750), oil on canvas, Madrid, Museo de América

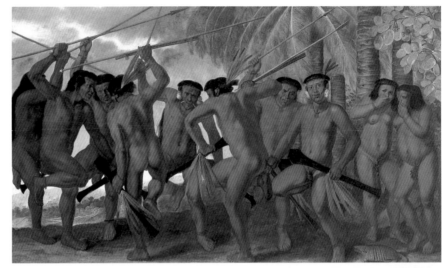

435 Below: Miguel Cabrera (Mexican, 1695–1768), *Don Juan Joachín Gutiérrez Altamirano Velasco* (c.1752), oil on canvas, 2.06 × 1.36 m. (81$\frac{5}{16}$ × 53$\frac{1}{2}$ in.), New York, Brooklyn Museum of Art

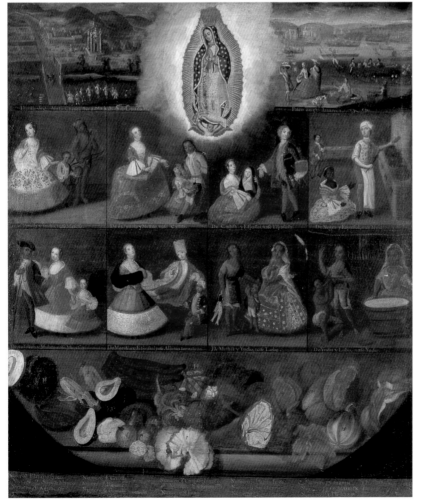

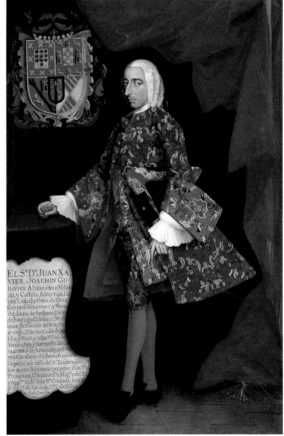

acknowledged in Benjamin West's *Death of Wolfe* [**437**], in which the painter deliberately translated his impression of Italian Antique sculpture into the figure of the grieving Mohawk Indian.

Emulating European Rococo taste, painters like Joseph Blackburn set out to produce fashionable portraits of the North American élite, continuing the tradition started in the previous century. Executed in Boston

in 1757, *The Winslow Family* [**436**] was one of his finest works.　　TCT

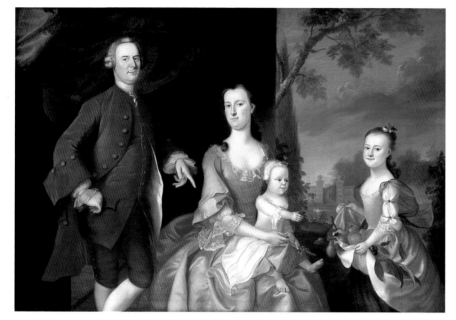

436 Joseph Blackburn (active 1752–74), *The Winslow Family* (1755), oil on canvas, 138.4 × 201.3 cm. (54½ × 79¼ in.), Boston, Museum of Fine Arts

437 Below: Benjamin West (1738–1820), *The Death of General Wolfe* (1770), oil on canvas, 152.6 × 214.5 cm. (59½ × 84 in.), Ottawa, National Gallery of Canada

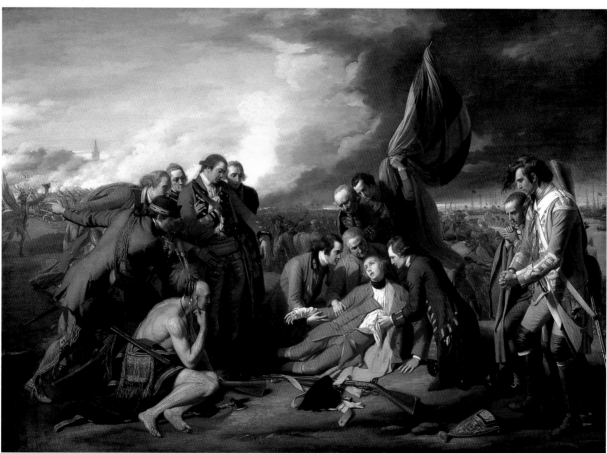

4 The Era of Revolutions
1770–1914

The prominence of art made for consumption beyond the circles of rich and aristocratic patrons is acknowledged here not only in the sections devoted to 'Pictures and Publics' and 'Sculptures and Publics', but also in the essays on objects designed for the growing consumer markets, the new art of photography, and art galleries. Set-piece religious art fades from view, to be replaced by secular subjects. The grandest of the genres comprised edifying or moving narratives on modern and ancient themes, while large-scale public sculpture retained its propagandist functions, but the main vehicle for innovation was the rendering of 'modern life' in a variety of styles.

The long view here spans what are normally characterized as separate 'movements', Neoclassicism, Romanticism, Pre-Raphaelitism, Realism, Impressionism, Post-Impressionism, Symbolism, Cubism, and Fauvism. This span recognizes that the autonomous status of artistic creation proclaimed by the movements of the later part of the period rests upon the assertion of the artist's right to personal expression in Romantic aesthetics.

The inexorable rise of the 'art industry' is represented not only in the section on galleries, but also by those devoted to critics and art history. The period is marked by a large body of professional writing, ranging from highly developed philosophical theories about the forms and functions of the fine arts to journalistic accounts of exhibitions and occurrences of note. Those who produced art and those who determined the climate worked in a complexly reciprocal relationship to determine the rapid successions of 'isms' that characterize the later part of the period.

Themes

Perhaps the period might best be described as the *incomplete* era of revolutions. By 1914, only two major revolutionary regimes were fully consolidated: the French Republic, following a succession of empires and reinstated monarchies, and the fledgeling great power of the United States of America. Elsewhere, autocratic governance was consolidated, not least through imperial expansion, both in colonies heavily peopled by European immigrants and in countries with substantial non-white civilizations. Even the eruption of traditional enmities, such as between France and Britain, though apparently destructive to general prosperity, drove aspects of technological innovation, while the businesses of conquest, international trade, and manufacture generated new wealth and scope for the production of imagery.

Perhaps the most profound revolutions occurred not within the uppermost political strata but in the power of various 'publics', not least as economic groups involved in consumption and travel, especially with the advent of the train. This was an age that saw the birth of the visual spectacle as public entertainment—the panorama, the diorama, the great international expositions, and grand permanent museums of world-wide artefacts—together with the widespread dissemination of visual information through the popular print, encyclopaedia, instructive book and, latterly, the photograph. It was photography that became the super-public art, placing the production of naturalistic imagery and personal record in the hands of those without artistic training.

By definition, those who wished to sustain the 'higher' values of 'Fine Art' resisted its identification with vulgar tastes. However, the once élite arts of painting and sculpture (historical and contemporary) became inexorably subject to diktat by the educated public, being ever more widely exhibited, viewed, subject to commentary, and marketed by dealers, at the same time as continuing to provide exclusive vehicles for regal, noble, state, and institutional imagery. Like other professional activities in the nineteenth century, art became subject to its own exclusive forms of systematic training—beyond the academies—in schools with specialized curriculums.

Alongside the professionalization of art training ran a succession of rebellions. One of the most characteristic was the regressive search for something less corrupted by modern values, not so much through the normal recourse to Greece and Rome, but via a quest for 'primitive' styles. There was a proliferation of 'isms', some self-named and others defined from outside. Realism may be recognized as the direct precursor of such as Impressionism, Cubism, and Futurism—as self-conscious avant-gardes that floated into public view on rafts of hostile and acclamatory criticism, sometimes driven by ringing declarations of self-intent. Such 'movements' were characteristic of the Parisian scene, but not exclusively so. By the early years of the twentieth century, there was no country with a developed art tradition, from Austria to Australia, that had not spawned its own avant-garde groupings, aspiring to reform practice on bases that might embrace various combinations of philosophy, aesthetics, social and political convictions (especially for design), national sentiment, and sheer desire to make a mark. By 1914, art had apparently undergone more revolutions than the political systems seem to have accomplished. MK

438 Opposite: Detail of Eugène Delacroix (1798–1863), *Liberty Leading the People* (1830), oil on canvas, 2.6 × 3.25 m. (8 ft. 6½ in. × 10 ft. 8 in.), Paris, Louvre

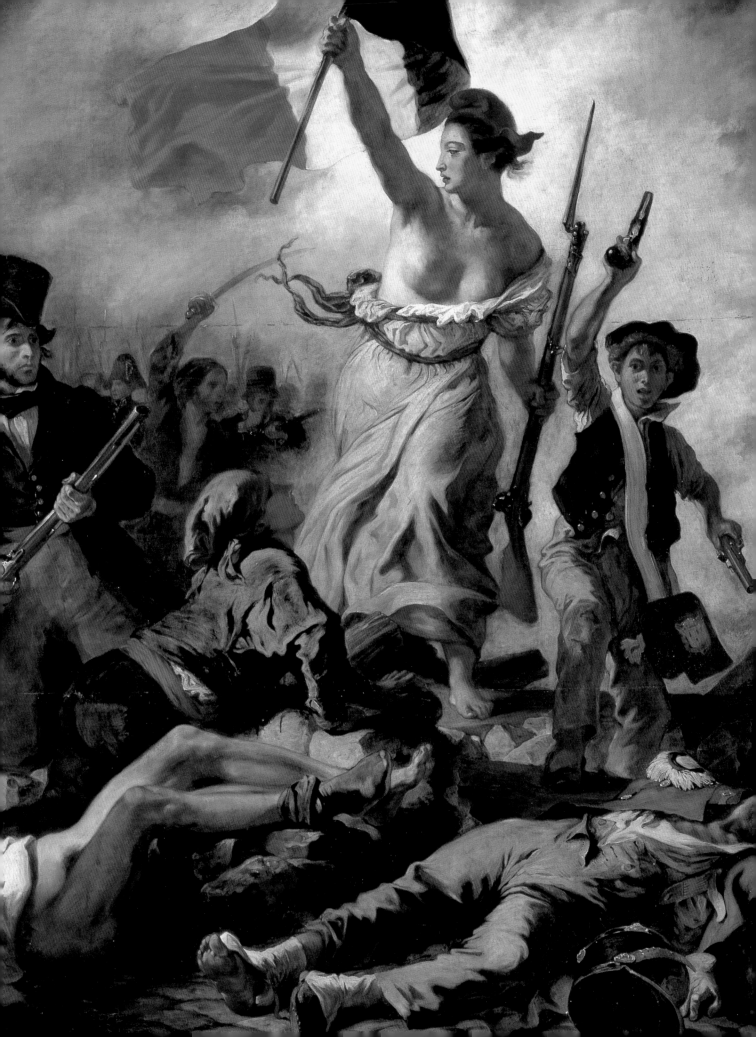

Pictures and Publics

The period extending from the American revolution to the First World War saw epochal change in the West: the emergence of a capitalist economy, the rise of the urban middle class, and the progressive establishment of democratic values. These developments altered the conditions of artistic production and reception almost beyond recognition. The academies that had long functioned as both training grounds and arbiters of artistic achievement gradually lost their authority. Patronage, too, changed irrevocably: religious and aristocratic commissions became less crucial to artistic success. Across the Atlantic, a new world of artistic enterprise took shape in North America, where the absence of an institutional base presented a host of novel challenges and opportunities. On both continents, however, artists had to deal with an outspoken critical press that influenced their formal goals as well as their professional strategies. For better and worse, unorthodox works of art could now occasion scandal on a scale unimaginable before the inundation of opinion expressed in journals and newspapers that was one of the period's most remarkable developments.

Dealers became crucial to artists' economic survival. Beginning in the 1850s, commercial galleries and the art press coalesced into synergistic networks conducive to accelerated shifts in taste and the turnover of stock. The emergence of this critic–dealer system fostered a creative dynamic of unprecedented volatility. Never before had the pace of artistic change been so rapid. In Paris alone, the artistic capital of the West throughout this period, Realism, Impressionism, Neo-Impressionism, Symbolism, Fauvism, and Cubism emerged successively as important movements in just over half a century.

Scientific discoveries, technological advances, and the advent of new institutions also influenced artistic evolution. Invention of the railroad, the telegraph, and photography transformed attitudes towards space, time, and perception, spurring artists to devise techniques conducive to the depiction of transitory effects—and in some cases, capable of expressing the emergent tensions and contradictions of modern life. More and more artists laid claim to experimental freedoms analogous to those accorded scientists, stressing subjective vision over naturalist fact, broaching controversial subject-matter, and shaking up high-art traditions with invigorating transfusions from unexpected quarters, notably the alien worlds of cheap popular prints and Japanese woodblock prints. The proliferation of museums and reproductive engravings made it possible for artists to pick and choose their models from a vast array of exemplars, a development that fostered an aesthetic relativism crucial to the nineteenth-century visual imagination.

The period began with two artistic movements whose relationship to one another has occasioned much debate in recent years, Neoclassicism and Romanticism. Neoclassical artists modelled their work after Antique sculpture and vase painting, often—though by no means always—seeking to achieve a formal austerity and ethical gravity redolent of ancient republicanism. The phenomenon of Romanticism is much more difficult to characterize, for it did not look to any specific formal models. More an attitude than a stylistic tendency, its core characteristic was a rejection of all norms. Its credo was fidelity to the individual imagination, and many of its paradigmatic themes were violent: cataclysm, suffering, death. In some ways, its penchant for disaster and extreme emotional states was a reaction against the complacent rationalism associated with Enlightenment utopianism, which was widely believed to have spawned the horrors of the French Revolution and the Napoleonic Wars. But the Romantic era also saw many revivalist movements, indexes of the growing historical self-consciousness—shaped by the proliferation of museums and reproductive prints—that is another feature of the Romantic sensibility. For this reason, it is not incorrect to regard Neoclassicism as an early manifestation of Romanticism.

The case of the French painter Jacques-Louis David (1748–1825), the archetypal Neoclassicist, exemplifies many of the professional, political, and artistic tensions central to the Romantic period. With his *Oath of the Horatii* (1784–5) [**442**], David introduced a new artistic genre: the modern manifesto-painting, an ambitious public work executed with the intent to provoke, thereby drawing attention to both the artist's gifts and his reformist aims. Painters had begun to answer polemical calls for anti-Rococo reform—notably those issued by the French writer Jean-Jacques Rousseau (1717–78) and the Prussian antiquarian Johann Joachim Winckelmann (1717–68)—as early as the 1760s, but none of the resulting work approached the trenchancy of David's large canvas, which electrified its first viewers. Combining Poussin-inspired idealism with Caravaggesque naturalism, it is informed throughout by an almost palpable formal tension. One senses the moral urgency underlying its smooth finish and taut, crisply delineated forms, conceived as a rebuke to Rococo fluency. The slick handling and unorthodox composition (planar, additive, asymmetrical) struck some observers as anti-academic and thus politically suspect—a view that the artist did not discourage, for personal ambition, stylistic innovation, and a maverick social persona had become fused in his mind.

This conflation of artistic and political concerns was reinforced by subsequent events in the artist's career. After 1789,

David planned many of the Revolutionary political festivals in Paris, was elected to the National Assembly, voted for the execution of Louis XVI, and, after the fall of Robespierre, with whom he had become allied, was very nearly guillotined himself. His later artistic and political history is complex, not least because of the enthusiasm with which he worked for Napoleon, but his trajectory from prickly artistic innovator to ardent revolutionary made him a crucial, if problematic, point of reference for later artists and critics. The notion that art is intimately linked to the health of the body politic—that artistic productions can serve as communal social boosters or, alternatively, as catalysts for social change—assumed special importance in the nineteenth century. The period's political volatility, in tandem with the decline of the church as a guarantor of social cohesion, prompted many to invest art with an almost talismanic significance, almost as if it were a new religion whose guardians were ever on the lookout for dangerous heretics. In such circumstances, David's singular identity as both regicide and artistic genius made him a powerful presence in the European imagination, especially in the first half of the nineteenth century.

Hence the importance of his peculiar relation to the Neoclassical movement, which he both epitomized and undermined. The *Oath* made David a cult figure among young artists, but this was more the result of his singular vision than of his adherence to any artistic programme. In so far as Neoclassicism can be identified with a return to Classical models in view of discrediting the wayward formal language of the Rococo, David is its preeminent figure, but the fervour with which he infused many of his greatest works rang the death knell of the didactic conception of art propagated by the Enlightenment.

The period of upheaval inaugurated by the storming of the Bastille entered a new phase when Napoleon Bonaparte seized power in France and launched the imperialist juggernaut that transformed the map and mind-set of Europe. The havoc wrought by his campaigns in Italy, Austria, Prussia, Spain, and Russia deepened pervasive anxieties caused by Revolutionary violence, raising doubts about the viability of Enlightenment utopianism that proved difficult to dispel. Here timing was all: human cruelty was not new to the European scene, but its re-emergence in the post-Revolutionary period on an epic scale, from seeds planted in the name of freedom and liberty, made the dark side of human nature seem doubly sinister. If such horrors could eventuate from the loftiest motives, where could ethical men and women place their hopes? If a charismatic leader presenting himself as the personification of altruism could transform the entire continent into a vortex of death and destruction,

in what consisted the advance of egalitarian ideals over absolutism? A significant legacy of the momentous quarter-century between 1789 and Waterloo, then, was a pervasive pessimism coupled with a sense of psychic and social disorientation.

One cultural response to the resulting malaise was a turn inward, towards exploration of the individual subjectivity. This reaction was most fully developed in theoretical terms in the German-speaking nations, where the 'Copernican' revolution of Immanuel Kant's critical philosophy—inaugurated by *The Critique of Pure Reason* (1781), which set out to demonstrate the inherent limitations of human knowledge—prompted a revival of nature mysticism and a new ethos of self-examination championed by Friedrich von Schlegel (1772–1829). In the wake of Napoleon's invasion of Prussia, this subjectivist tendency took on a paradoxically communal character, mutating into a heightened sense of nationalist identity. But the belief that 'the universe is within us' (in the words of the German poet Novalis, 1797) became an article of faith not only in Prussia but throughout Europe, gradually undermining academic precepts by discrediting the very notion of a common expressive language.

When the French monarchy was restored in 1815, David's complicity in the regicide of Louis XVI obliged him to seek exile in Brussels, where he spent his final decade, but his students long remained in the forefront of French art. The most important of these were Anne-Louis Girodet (1767–1824), François Gérard (1770–1837), Antoine-Jean Gros (1771–1835), and Jean-Auguste-Dominique Ingres (1780–1867). Collectively, they demonstrate David's greatness as a teacher, for their work is remarkably various. Three of them helped to usher in French Romantic painting, which, thanks to David's immense prestige, long remained primarily an art of the human figure as opposed to landscape. Girodet's portraits of children are infused with a sullen melancholy. Gérard's *Cupid and Psyche* [**440**] treats its mythological subject with Davidian formal economy, but its evocation of troubled longing anticipates the thematic preoccupations of the coming decades. But it is Gros who took the decisive step; his immense depictions of Napoleonic subjects have a Rubensian ardour and colourism that was to inspire Théodore Géricault (1791–1824) and Eugène Delacroix (1798–1863). Ingres is a case apart: he came to be regarded as the grand old man of the Davidian tradition, as the guardian of linear probity in a world beset by colourist equivocation, but his work is idiosyncratic in ways that belie this reductive characterization. In his maturity he claimed to detest painting portraits, but he excelled in such works, investing them with high ambition like Reynolds, yet with a more personal blend of thematic allusion and formal manipulation [**466**].

In Gros's *Napoleon in the Plague House at Jaffa* [**443**], a fictionalized rendition of an episode from the disastrous Egyptian campaign (1798–9), the emperor's heroic figure is almost literally upstaged by the spectacular Near Eastern architecture and, especially, by the powerful foreground depictions of the dead and dying. The picture succeeds in elevating the Napoleonic saga to the realm of myth, but it harbours equivocal messages curiously at odds with the patron's propagandist aims. In this respect, it points to a difficulty henceforth confronted by many artists: how to honour both the dictates of their artistic consciences and the demands of powerful patrons. Such tensions were not new, but growing acceptance of the prerogatives of the artistic imagination tended to weaken the bargaining power of collectors avid for works by specific painters.

Like Gros, Géricault was partial to modern themes, but he chose them for himself, and he favoured controversial subjects. His most famous painting, *The Raft of the Medusa* [**446**], was designed to embarrass the authorities, and at the time of his early death—a circumstance that fostered his elevation to Romantic sainthood—he was planning large works that would have been even more abrasive: depictions of a contemporary slave market and a murder whose grotesque particulars were ripped from the headlines. Géricault's influence on French painting was considerable, but few artists followed the perilous example he set in the *Raft*, directly challenging the government on a monumental scale.

Despite his unorthodox subjects, Géricault's style was essentially consistent with academic precepts. His friend Delacroix, the other leading light of French Romanticism, could almost be said to have reversed this equation, at least in his maturity. He cultivated a more organic approach to composition and championed the expressive power of colour. After a trip to Morocco in 1832 that confirmed these tendencies, he represented scenes from North African life and canonical themes drawn from the Bible and the Classics, with an occasional foray into Shakespeare, Byron, and Sir Walter Scott. But at the start of his career he broached more controversial subjects (the Greek war of independence, the 1830 Revolution), and his pre-eminent position in French art was assured by *The Death of Sardanapalus* [**453**], a work of resplendent colourism and salacious violence. Shown at the Salon of 1827 with Ingres's *Apotheosis of Homer* [**452**], to which it provided an irresistibly convenient stylistic and thematic foil, the *Sardanapalus* marked Delacroix forever in public memory as a Romantic firebrand. The persistence of this persona later irritated him: in the end, his was a profoundly aristocratic temperament, and the most ambitious undertaking of his maturity was a cycle of ceiling paintings for the library of the French Senate in which he explored themes drawn from the Classical tradition. Nonetheless, the antithetical relationship between Ingres and Delacroix, as defined in 1827, proved tenacious as a critical framework for the assessment of contemporary French production.

Ambitious figure painting imbued with the Romantic sensibility flourished outside of France, too. The greatest Spanish artist of the era was Francisco de Goya (1746–1828). His early work is in a charming Rococo style, but in the 1790s he turned to bleak subjects and experimental handling—not only in his oils but in his prints, a medium in which he produced unforgettable images that are stridently anticlerical and reformist. This is remarkable, for from the mid-1780s he worked for the Spanish Crown and in 1799 was named first painter to the king. Goya went so far as to paint official portraits of Charles IV and his family that, at least to modern eyes, are blatantly unflattering. His many depictions of violence, madness, and disaster can still unsettle [**448**], as can his *The Third of May, 1808* [**444**]. While it served to re-establish Goya's credibility with the restored Bourbon king Ferdinand VII (the artist had worked for Joseph Bonaparte during the French occupation), he transformed this rendition of French soldiers executing Spanish resisters into a searing indictment of all political violence, using brusque handling to underscore the slaughter's brutality.

In England, the academic ideals defined by Reynolds's *Discourses* were increasingly contested after his death. William Blake (1757–1827), the great poet who also produced visionary illustrations of his own texts, found Reynolds's influence pernicious. Blake was a loner from the start, but the same cannot be said of James Barry (1741–1806), who devoted himself to history painting at the urging of Reynolds himself but later attacked the master's memory; injudicious remarks about his colleagues led to his expulsion from the Royal Academy, and he ended his life in abject poverty [**449**]. Henry Fuseli (1741–1825), an artist of Swiss origin who settled in London, was more tactful in expressing his dissent. He pursued the grand manner, but in ways distinctly at odds with Reynolds's pedagogic agenda, cultivating stylized forms, extravagant gestures, and horrific subject-matter. Even so, he long served as president of the Royal Academy, an indication that such institutions were not always the bastions of aesthetic intolerance they are sometimes made out to be.

The first half of the nineteenth century was an exceptionally rich one for landscape painting, which assumed new forms consistent with contemporary theoretical preoccupations and market conditions. Neoclassical landscapes in the tradition of Claude and Poussin continued to be produced, but they were less indicative of pervasive trends than other modes more responsive to subjectivist priorities.

The greatest German landscape painter of the Romantic period was Caspar David Friedrich (1774–1840), whose work was greatly influenced by contemporary German philosophy, notably the Jena school. Echoing Novalis, he maintained that the artist should paint 'what he sees within himself' as well as 'what he sees before him'. Picturing misty mountaintops, seaside vistas, cemeteries, and forests in a style simultaneously meticulous and mysterious, his canvases have a modern character that transcends their Romantic motifs. This is due in part to the spareness of their compositions, which often have an emblematic quality bordering on abstraction. To an even greater degree, however, it results from Friedrich's distinctive way with landscape conventions. He used them to stimulate reflection about the dynamics of human cognition, a project analogous to the philosophical one of Johann Gottlieb Fichte (1762–1814) and Georg Wilhelm Friedrich Hegel (1770–1831). In Friedrich's hands, a heightened formal tension between foreground and background can evoke the enigmatic interplay between inner life and outer world. His pictures often showcase figures seen from

behind, a device that simultaneously facilitates and frustrates the viewer's psychological entry into the picture, in effect restaging the estrangement from the natural world that, according to the German idealist philosophers, is a precondition of human self-consciousness [**455**]. These works have a power that it is tempting to call spiritual, infusing the landscape with a northern sense of wonder, a quality they share with the primeval forests of Albrecht Altdorfer (*c*.1480–1538). Their emphatically indigenous imagery was shaped by the rise of nationalist feeling in the wake of the Napoleonic occupation, which long made German artists wary of French influence.

In England, John Constable (1776–1837), an almost exact contemporary of Friedrich, pursued very different goals. Raised by a relatively prosperous family living near the Stour River in Suffolk, he devoted most of his creative energies to depicting the tranquil, cultivated landscape of Dedham Vale, familiar to him since childhood. He shared with seventeenth-century Dutch landscape painters a taste for windswept skies and picturesque natural incident, but his was a peculiarly English vision with affinities to the poetry of William Wordsworth (1770–1850). Focusing on the earthy particulars of farming and milling, he rendered trees, canals, hedgerows, and even dungheaps with a loving hand. His eye for the telling detail was sharp, but as he grew older his handling became increasingly free, often boldly calling attention to the movement of his brush. This evolution registered his growing desire to evoke, through select particulars, the mysterious flux of natural process. This aim is most apparent in agitated oil studies and precisely observed watercolours of cloud formations not intended for exhibition, but it also informs many of his finished paintings [**456**].

Joseph Mallord William Turner (1775–1851) produced large-scale works that were even more experimental, specializing in effects of atmosphere and colour that tend to dissolve form. Although widely censured for his lack of finish ('pictures of nothing, and very like', quipped one observer in 1816), he was supported by his fellow academicians, partly because of his preference for prestigious subject-matter. He venerated Claude, the Classical landscape painter *par excellence*; indeed, he combined this master's atmospheric tonalism with epic imagery consistent with modern theories of the sublime [**445, 454**].

Turner's work had little influence in France prior to the 1860s, but Constable was much admired there from 1824, when he exhibited at the Paris Salon. His summary handling, exuberant greenery, and sparkling reflections were admired by Delacroix as well as by members of the Barbizon School of landscape painters. This group takes its name from the town that served as its unofficial headquarters, situated some thirty miles southeast of Paris in the middle of the Forest of Fontainebleau, an area rich in tempting natural prospects. Like Constable, the Barbizon painters offer a vision of nature under human dominion, but instead of ordered English fields and canals they picture marshes, overgrown paths, and unruly vegetation. Frequently there are no figures, but just as often livestock, or rickety constructions make us aware of tenuous civilizing impositions. In short, these artists underscore the conditional status of the human mastery over nature. Their work was long deemed excessively undisciplined by much of the French art establishment; Théodore Rousseau (1812–67), widely regarded as the group's leading light, was excluded from the Paris Salon between 1836 and 1848. But his works, like those of Jules Dupré (1811–89) [**457**] and Charles-François Daubigny (1817–78), were studied closely by the Impressionists, who learned much from their free handling and seemingly casual compositions.

The wave of accumulated revolutionary energies that swept across Europe in the century's middle years, cresting in the uprisings of 1848 and the establishment of universal male suffrage in France, was paralleled by discordant developments in the visual arts. Conveniently designated by the term Realism, they consisted of a rejection of idealist aesthetic models and canonical subject-matter in favour of the unblinking depiction of harsh contemporary realities. While such goals were not unprecedented, their implementation assumed a new urgency in the context of contemporary political events—and in light of the burning ambition of a new generation of young artists anxious to make names for themselves.

In Paris, the epicentre of programmatic Realism, the most ardent and influential advocate of such reform was Gustave Courbet (1819–77). Raised near the Swiss border of France, in 1839 he headed to Paris, where he trained himself as best he could outside of the official academic system. Despite his provincial origins, Courbet was no peasant (his father was the wealthiest landowner in his native village of Flagey), but he soon realized that he could turn his rough edges to account by refashioning them into a high-profile contrarian persona consistent with his artistic ambitions. In the heady liberal atmosphere of the short-lived Second Republic, Courbet, parroting one of his critics, wrote that his aim was indeed to 'drag art down from its pedestal', and he did not reject the label 'Socialist painter'. Even so, he was alert to the dangers posed by a conception of artistic practice that was too narrowly ideological. In the breakout moment of his career (1848–55), he managed to translate his socialism into a bold visual poetry.

In *The Stonebreakers* (1849, destroyed in the Second World War), Courbet depicted an old man, aided by a young boy, wielding his hammer over a pile of rocks. The faces of the two figures are obscured to indicate the dehumanizing quality of their work; the implication that the boy will end up just like his elder colleague is clear. Courbet had an unparalleled ability to manipulate paint in ways that press home its origins as humble matter. Here he used such handling to produce an emblematic expression of the ideals of the 1848 Revolution, which brought the issue of French rural labour to the forefront of political discourse for the first time. The figures are rendered almost lifesize, a gesture that both ennobles their exertions and intimates a threat. After the Revolution, there was considerable anxiety in Paris about the recent enfranchisement of the rural population, a circumstance Courbet deftly embedded in his picture: if the man were to rise from his bent-knee crouch, he would literally burst the bounds of the containing visual field. The much larger *A Burial in Ornans* (1849) [**460**], a frieze-like depiction of an interment outside Courbet's native town, likewise manipulates the rhetoric of contemporary painting in unorthodox ways consistent with Courbet's radical politics. Here, members of various social strata are represented as cohering—awkwardly—into a single, sacred communal

organism, the virtual alignment of the figures' heads serving to convey their equal status before Death, the ultimate leveller—given extraordinary immediacy by having the grave bleed into the viewer's space. The fact that the composition's additive character was largely determined by the circumstances of its execution—the dimensions of Courbet's studio in Ornans, where the canvas was painted, precluded his moving very far back to assess the effect, and the number of locals lobbying for inclusion grew day by day—makes the thunderous power of the result still more impressive.

Courbet was far from alone in broaching such themes; there was a veritable explosion of depictions of French rural life in the post-1848 Salons, but few adepts of Realism managed to fuse ideological audacity and formal invention with anything like his success. One candidate, however, is Jean-François Millet (1814–75), who early allied himself with the maverick Barbizon landscape painters. While sympathetic to republican ideals, by temperament Millet was more conciliatory than Courbet. *The Gleaners* (1857) [**461**] is a relatively frank depiction of women performing back-breaking work, but Millet's visual language is resonant of Poussin and Virgil, mainstays of the Classical tradition; while ennobling these labourers, his acknowledgements of contemporary political developments are oblique. As a result, many collectors and critics found Millet's work more palatable than Courbet's, but both artists were deemed 'dangerous' by conservative reviewers unnerved by the social and political sea-changes transforming the world around them.

The mid-century turn towards visual fact was not limited to France. In Germany, Adolf von Menzel (1815–1905) produced ambitious treatments of modern subjects, notably an iron-rolling mill, but he is most compelling in works that embody the tensions between his academic training and the dispersed, disorienting quality of modern experience [**479**]. Wilhelm Leibl (1844–1900), one of many German artists greatly influenced by Courbet, reconciled crystalline handling with meticulous draughtsmanship and monumental form, as evidenced by his grave yet affecting *Three Women in Church* [**463**].

In certain respects, the agenda of the English Pre-Raphaelite Brotherhood falls squarely within Realist parameters. Founded in 1848 by William Holman Hunt (1827–1910), Dante Gabriel Rossetti (1828–82), and John Everett Millais (1829–96), the group aimed to sweep deadening idealist formula from British art by following the example set by fifteenth-century Italian and northern masters, whose naturalist particularism and ardent sincerity they sought to make their own. One of their most striking innovations, sanctioned by Flemish precedent, was technical: the application of thin layers of oil over a wet white ground. They often painted out of doors, a practice that fostered the sometimes garish brilliance of their canvases. Ford Maddox Brown (1821–93) was never a member of the group, but he shared many of its goals, notably its relentless quest for visual fidelity, as evidenced by *The Last of England* [**462**], a depiction of a family emigrating to Australia that almost makes us hear the snap of the sea wind.

Victorian artists with less self-consciously reformist goals also contributed to the anti-idealist trend. The case of William Powell Frith (1819–1909) reveals how a naturalist style could serve ends that were anything but critical. His panoramic depictions of a resort beach, a train station, and a race course [**464**] treat emblematic modern subjects that would soon be taken up by the Impressionists, but his anecdotal, essentially narrative approach resulted in works that exploited rather than challenged accepted notions of aesthetic viability.

French Realism was given a new orientation in the 1860s: colour schemes grew brighter, handling became freer, and, while landscape remained an important genre for the new generation, urban subjects moved centre stage. Painters now sought to express both the exuberance and the dispersed, alienated quality of modern metropolitan life, focusing not on the lower orders but on the urban middle class. This redirection was pioneered by Édouard Manet (1832–83), a bridge to the Impressionists whose work nonetheless stands apart from theirs, despite his adoption of many of their formal procedures in his final decade. His best early paintings combine modern subjects and self-conscious borrowings from the Old Masters with tangy brushwork, bold contrasts, and awkward juxtapositions, playing Realist imagery against aestheticist formal pleasures in an entirely new way. It is no wonder that these works outraged many of their first viewers, for incongruity is their method, and their deadpan tone can still perplex.

Take *Le Déjeuner sur l'herbe*, a picture of two couples on an afternoon picnic in the woods that provoked scandal when it was exhibited in 1863 at the Salon des Refusés, an exhibition of works rejected by the Salon jury (organized by the government in response to widespread complaints of excessive harshness). One of the women has stripped and stares coolly at the viewer. The juxtaposition of two nattily attired young men with a female nude in the open air was inspired by Giorgione's *Le Concert champêtre* (*c*.1510), one of the Louvre's most celebrated treasures, but Manet reframed this Renaissance allegory in terms of modern bourgeois leisure. The poses of the two men are lifted from a famous print after Raphael (*The Judgement of Paris* [**248**], where they are struck by river gods), a jokey visual quote whose precise meaning is still unclear. The inconsistent handling casts doubt on the relevance of conventional qualitative distinctions: the still life in the lower left is a luscious exercise in summary notation, but the figures' faces do not cohere, and the landscape has a distinctly artificial quality, rather like a stage drop. The awkward fit of these various elements, and the questions of conscious intention versus rank ineptitude inevitably entailed by their juxtaposition, go far towards explaining a cryptic but unforgettable remark made by the poet and critic Charles Baudelaire (1821–67) in a letter to Manet: 'You are the first in the decrepitude of your art.'

Manet used analogous tactics in *Olympia* (1863) [**465**], a depiction of a contemporary high-class prostitute and her black servant. Modelled after a famous work by Titian, it exposes the hypocrisy of the salacious goddess-nudes that populated the walls of the Salon. The elimination of half-tones typical of Manet in this period gives the painting a poster-like starkness which reinforces its impact, stripping away illusionistic felicities in ways consistent with the artist's critical project.

Manet's ambition to depict contemporary Parisian subjects using a bold technique made him an important model for a group of younger artists who banded together in 1874 to organize exhibitions independent of the Salon. Dubbed the

Impressionists on that occasion (by a hostile critic), they included Claude Monet (1840–1926), Pierre-Auguste Renoir (1841–1914), Camille Pissarro (1830–1903), Alfred Sisley (1839–99), Edgar Degas (1834–1917), Paul Cézanne (1839–1906), and Berthe Morisot (1841–95). The exhibition enterprise was short-lived, but the core Impressionists pursued common artistic goals for several years. Avoiding the ironic stance characteristic of Manet's early work, they treated modern themes with bold colour contrasts, sketchy handling, and compositional schemes designed to suggest direct, 'instantaneous' experience. Condemnation of the first Impressionist exhibitions was far from universal, many critics having realized that the group's aims were consistent with the need for cultural renewal in the wake of France's defeat in the Franco-Prussian War and the brief ensuing civil war known as the Commune (1870–1). Nonetheless, the unorthodox formal procedures of the Impressionists aroused the suspicion of some reviewers, who cast doubt on their sincerity and—again—associated their rejection of artistic norms with political radicalism.

The Impressionist adventure began as early as 1869, when Monet and Renoir, working side by side along the Seine, painted canvases that staked out a new path for the medium. Applying touches of pure colour with a frankness previously found only in preliminary oil sketches, they captured the polychromatic dazzle of reflections in rippling water with a compelling immediacy [**478**]. Monet remained faithful to the aesthetic of contingency underlying these images throughout his long career. This consistency was of a piece with his devotion to landscape, a genre intimately linked to shifting effects of light, colour, and atmosphere. Renoir, by contrast, was primarily a figure painter, which may have been a factor in his later emulation—in an utterly sincere way, without Manet's irony—of Antique and Renaissance models, notably Titian.

Pissarro and Cézanne worked together in the rural landscape around Pontoise in 1873, an encounter that benefited both artists. Cézanne's commitment to 'realizing his sensation' dates from this period, when Pissarro introduced him to the basic Impressionist principle of truth to the fleeting individual perception. While Cézanne exhibited in the first Impressionist exhibition, he gradually diverged from the group's aesthetic, devising a method that, while honouring the provisional character of vision, resulted in idiosyncratically reconstructed wholes [**484**].

Degas was primarily a figure painter. His incisive draughtsmanship set him apart from other members of the Impressionist group, but he was gifted at devising compositions that create a heightened sense of immediacy [**480**]. The novel framings and the emphasis on linear design typical of his work likewise figure in that of Gustave Caillebotte (1848–93), who exhibited at several of the Impressionist exhibitions [**482**].

By the mid-1880s, many of the Impressionists felt that they had reached a creative impasse, but their responses to this realization varied considerably. Renoir went to Italy to study the Antique and gradually solidified his flickering forms. Monet began to pursue more frankly formalist, decorative effects, notably in serial paintings of a single motif—wheat stacks, poplars, and Rouen Cathedral—studied under different lighting and atmospheric conditions [**487**]. Cézanne, whose

engagement with core Impressionist goals in the 1870s had been brief, began using a regularized 'constructive stroke' to impose an organizing armature on his canvases. All three artists, though, remained committed to working from nature. In these same years, however, a young artist named Georges Seurat (1858–91) appeared on the scene whose acute grasp of the historical moment led him to forge a new idiom that encompassed its cultural and social tensions. He, too, worked from nature, but with a difference. Seeking to reconcile the Impressionist emphasis on perception with the idealist tradition, he devised the 'divisionist' or 'pointillist' technique. This mode of handling exploited the theory of optical mixture, according to which discreet applications of complementary colours, if placed side by side, will fuse in the beholder's eye to create a new colour. Executing hazy open-air studies in the little dots he thought would intensify Impressionist colourism, he then returned to his atelier, using them to work up larger compositions that, while redolent of the Classical tradition, inflect it in unmistakably modern ways. The dots, while by no means mechanically applied, incorporate the repetitive quality of contemporary industrial processes into the nitty-gritty of studio practice, something that the Impressionists never attempted. But the tone of the results is equivocal, seeming sometimes gravely lyrical and sometimes ironic—but always poetic, as in Seurat's manifesto-painting, *A Sunday Afternoon on the Island of La Grand Jatte* [**483**]. Shown at the last Impressionist exhibition in 1886, it effectively brought the Impressionist moment, narrowly defined, to a close.

Defending Manet's work from the 1860s, the writer Émile Zola wrote that the art he most valued could be described as 'a corner of nature seen through a temperament'. In 1886, the critic Gustave Kahn articulated an opposing position. Attacking the relentless focus on contemporaneity central to both Realism and Impressionism, he asserted that the 'essential aim' of art should be 'to objectify the subjective (the exteriorization of the idea), instead of subjectifying the objective (nature seen through a temperament)'. Kahn's manifesto signalled a crucial shift away from naturalism towards an anti-materialist, quasi-idealist programme. Although much Symbolist work has an allegorical cast, it tends to be more connotative than denotative, to evoke moods and associations rather than convey specific messages. Many Symbolist painters were fascinated by the operas of Richard Wagner (1813–83), finding his chromatic harmonies and expressive intensity consistent with their own aims. By and large, the emphatically subjective character of late nineteenth-century Symbolist imagery distinguishes it from the visual rhetoric of academic idealism, but the boundary between them is porous, and around 1900 the Symbolist attitude sometimes surfaces in unexpected quarters.

Symbolism had important forerunners in France, Germany, and England whose distancing academic poise, so antithetical to the Impressionist aesthetic of immediacy, gave them a new currency after 1886. Among the most important such figures are Pierre Puvis de Chavannes (1824–98), Arnold Böcklin (1827–1901), Anselm Feuerbach (1829–80), and Gustave Moreau (1836–98). Puvis specialized in large-scale mural paintings of seemingly conservative character, but their Arcadian imagery, stately rhythms, and decorative qualities

made them important models for both Seurat and Paul Gauguin (1848–1903). Böcklin likewise specialized in mythological themes, but Wassily Kandinsky (1866–1944) considered him a precursor of abstraction because of his ability to weave an almost musical spell through the manipulation of form, colour, and line [**488**].

In England, the Symbolist turn was anticipated by Edward Burne-Jones (1833–98), James Abbott McNeill Whistler (1834–1903), and Albert Moore (1841–93), each of whom espoused the art-for-art's-sake agenda championed in London by the Grosvenor Gallery (opened 1877). Burne-Jones, a student of Rossetti, infused mythological and medieval subjects with a languorous melancholy that overpowers their narrative content; his name appears, with Böcklin's, on the list of precursors of abstraction drawn up by Kandinsky. Whistler, an American by birth who studied in Paris and settled in London in 1859, was initially influenced by Courbet and Manet, but in the late 1860s he jettisoned all pretence to Realist verisimilitude in favour of exquisite tonal refinement and rarefied atmospherics, specializing in hazy 'nocturnes' and portraits whose titles aptly privilege their formal qualities (*Arrangement in Grey and Black: Portrait of the Artist's Mother*, 1871). Whistler greatly admired the work of Moore, whose images of aloof, beautifully draped women posed against coolly sumptuous backgrounds epitomize the disdain for engagement with vulgar, here-and-now specifics typical of the English aestheticists. George Frederic Watts (1817–1904) and Frederic Leighton (1830–96) remained in academic good graces throughout their careers, but their late work has certain affinities with Symbolist trends in Britain as well as across the Channel. Watts was adept at devising idiosyncratic allegorical images. Leighton was a more overtly seductive painter; in *Flaming June* [**491**], he transformed draped female figures from the Parthenon pediments—readily accessible to him in the British Museum—into a rapturous evocation of sleep.

The term Post-Impressionist (coined by the English critic Roger Fry in 1910) is often used to describe late nineteenth-century work that is programmatically anti-academic and anti-Impressionist. The most important artists usually placed under this rubric are Gauguin, Vincent van Gogh (1853–90), Ferdinand Hodler (1853–1918), James Ensor (1860–1949), and Edvard Munch (1863–1944). Gauguin participated in the first four Impressionist exhibitions, but in 1888—during a painting campaign in Brittany, where he was inspired by the inhabitants' customs and mores—he began to simplify his forms and increase the brilliance of his palette, using vibrant colours whose relationship to reality was tenuous in the extreme. Disillusioned with modern metropolitan life, in 1891 he moved to Tahiti, where he expected to find a guiltless culture of unblemished purity and freedom. He found no such thing, but the encounter between his longing and inscrutable indigenous realities resulted in paintings of great poignancy and beauty [**486**].

The Dutch artist Van Gogh also sought escape from the psychological and economic pressures of the modern capitalist city, in his case below the warm sunlight of southern France. As with Gauguin, his quest proved personally frustrating but artistically productive. A man of passionate conviction, his ideals were self-consciously political—communal and populist. He spent two years in Paris absorbing the lessons of Impressionism before retreating to the south in 1888, where he painted

canvases of riveting intensity [**485**]. Their emphatic brush strokes and arbitrary colour contrasts—evocative of the 'crude things' such as 'common earthenware' that he loved—are antithetical to Realist conventions, yet their expressive exaggerations were shaped by egalitarian political beliefs not unlike those of Courbet. A similar intensity characterizes the work of the Belgian Ensor, a master of the macabre, and the Norwegian Munch, who produced gripping images of individuals racked by guilt and anxiety. Hodler, a Swiss artist (like Böcklin), devised a cooler style in which meticulous draughtsmanship cohabits with an emblematic compositional simplicity; many of his paintings have a haunting ritual quality, but *Night* [**489**] can still trigger primal fears.

One of the most significant developments in the century's second half was a growing tendency on the part of 'advanced' artists to blur the boundary between the fine arts and applied arts. In England, Burne-Jones designed furniture, stained glass, and tapestries beginning in the 1860s. As the new century approached, variants of the sinuous Art Nouveau style—named after a shop that opened in Paris in 1895—became prevalent throughout Europe and America. In tandem with the growing interest in Japanese prints, whose flat blocks of colour violated the protocols of Western perspective, this trend fostered a new emphasis on surface pattern that left its mark on painting. In addition to influencing the planar qualities central to the achievement of Gauguin, Van Gogh, and Hodler, it shaped much of the work of the Viennese artist Gustav Klimt (1862–1918) [**490**], whose blend of decorative allure and sensual provocation provided a model for his younger compatriot Egon Schiele (1890–1918) [**494**].

The fifteen-year period preceding the outbreak of the First World War saw the final push in the long march towards extreme subjectivism that had continued, before and after the Realist halt, since the Romantic era. The first of the many modern movements that proliferated in the early years of the new century was born in Paris, when Henri Matisse (1869–1954), André Derain (1880–1954), and Maurice de Vlaminck (1876–1958) exhibited paintings at the Salon d'Automne in 1905 and 1906. Their preferred subjects—landscape and single figures—were conventional, but their bold colour schemes and approximate handling prompted a contemporary critic to dub them the Fauves ('wild beasts'), a nickname that stuck. Matisse, the greatest artist of the group, spent the rest of his career exploring the implications of their vitalist colourism [**492**].

The German artists of Die Brücke ('The Bridge'), founded in Dresden in 1905, also used nondescriptive colour and awkward drawing to intensify the effect of their work—Emil Nolde (1867–1956), Ernst Ludwig Kirchner (1880–1938), Max Pechstein (1881–1955), Karl Schmidt-Rottluff (1884–1976), Erich Heckel (1883–1970). Partial to angular forms, they sought to achieve a new purity by reverting to 'primitive' modes of expression, notably early German woodcuts. In 1911, another reformist movement, Der Blaue Reiter ('The Blue Rider'), was founded in Munich by a group of artists including Wassily Kandinsky, Gabriele Münter (1877–1962), and Franz Marc (1880–1916). More internationalist in outlook than Die Brücke, its exhibitions included work by Russian and French

avant-garde artists. Its members were also sympathetic to contemporary Theosophy, which greatly influenced Kandinsky's *On the Spiritual in Art* (1912), which posits that art's spiritual value is directly proportional to its jettisoning of mimetic constraints. Kandinsky produced what are arguably the first wholly abstract paintings while he was writing this book.

Pablo Picasso (1881–1973) began his career in a rather sentimental Symbolist vein, but in 1906–7 he sought to tap more primal reservoirs. Drawing inspiration from Iberian sculpture as well as from African masks, he produced *Les Demoiselles d'Avignon* [**493**], a confrontational depiction of five women in a brothel whose fractured forms broke entirely new ground. The canvas was not exhibited publicly for several decades, and even Picasso's friends initially judged it a mistake, but one of them, Georges Braque (1882–1963), soon revised his views, with momentous consequences. In 1908, he and Picasso began an extended collaboration that led to the invention of Cubism, a style that radically challenged premises long regarded as sacrosanct in Western art. Deconstructing objects into jangling components arrayed within a shallow field, they traded perspectival coherence for inchoate dispersal and replaced discreet form with invasive flux, contravening the notion of visual corporeal integrity [**496**]. In 1912 they took a still more revolutionary step, introducing non-artistic materials—newspaper, wallpaper, oil-cloth—directly into the work of art. The result was collage ('paste-up'), a medium that by its nature blurs the boundary between being and representing. Picasso and Braque were now toying with the mechanics of signification in entirely new ways, suggesting that their productions were not so much depictions of something in the world as independent objects. Many more avant-garde movements blossomed in this remarkably fecund period, but none had the far-reaching impact of Cubism, which influenced most of them in one way or another.

One of the most significant was Italian Futurism, championed by Giacomo Balla (1871–1958), Umberto Boccioni (1882–1916), and Gino Severini (1883–1966). It burst on the international scene in 1909, when the Milanese poet Filippo Tommaso Marinetti published a provocative manifesto in Paris glorifying speed and modern technological warfare, but the artists who embraced his cause became widely known only in 1912, when an exhibition was mounted in Paris, then travelled widely. Their primary aim was to convey the motoric dynamism of contemporary life, and their best work has a whirring, explosive energy that fulfils this brief admirably.

In America, portrait painting long dominated indigenous production. For many years, opportunities for the production of large-scale narrative works were few, to the chagrin of many artists. The aspiring history painters John Singleton Copley (1738–1815) and Benjamin West (1738–1829) were obliged to seek their fortunes in London, where their success was prodigious; in 1792, West succeeded Reynolds as head of the Royal Academy. An American market for genre [**474**] and still-life painting soon emerged, however, and the foundation of the National Academy of Design in New York (1825) was a benchmark event in the establishment of a pedagogic culture analogous to that in Europe. Landscape painting quickly became the genre of choice for ambitious statements, largely

because of the pragmatic directness of its appeal: its practitioners could dispense with canonical literary sources familiar to relatively few Americans but could build upon the foundations of the great European landscape tradition. Furthermore, the stunning grandeur and variety of North America's topographical wonders made them the natural mirror of America's aspirations, the pre-eminent vehicle for the construction of a national iconography invested with spiritual resonances accessible to all. The artists of the Hudson River School—Thomas Cole (1801–48), Asher B. Durand (1796–1886)—and a somewhat overlapping group recently christened the Luminists, after the crisp, cool radiance emanating from their work—Fitz Hugh Lane (1804–65), John Frederick Kensett (1816–72), Martin Johnson Heade (1819–1904) [**476**]—were the founding figures of American landscape painting, which first won international acclaim with the immense canvases of Frederick Edwin Church (1826–1900) [**477**], Albert Bierstadt (1830–1902), and Thomas Moran (1837–1926). The latter works first gave epic artistic expression to the sense of 'manifest destiny' that was to be central to the American self-image through the next century, setting an important precedent for the pioneering Abstract Expressionists of the late 1940s.

Two extraordinary American figure painters reached maturity in the years following the Civil War: Winslow Homer (1836–1910) and Thomas Eakins (1844–1916). Both of them visited Paris in the 1860s, and both were influenced by recent developments there, notably the art of Courbet and Manet. Homer was at his most inspired when painting the sea, but he was also a gifted genre painter: his renderings of blacks from the 1860s imbue them with a complex dignity rare in American art of the period, and his depictions of rural and domestic life have a piercing lyricism [**472**]. Eakins was a portraitist of exceptional formal sophistication and psychological acuity who, in his most ambitious canvases, produced compelling, peculiarly American evocations of heroic resolve [**475**].

American artists continued their dialogue with European art after 1900, when they set about assimilating modernist developments. Many went to Europe expressly for this purpose—Maurice Prendergast (1859–1924), Charles Demuth (1883–1935), Arthur Dove (1880–1946), Joseph Stella (1880–1946), Marsden Hartley (1877–1943). At home, the process was fostered by the photographer Alfred Stieglitz (1864–1946), who proselytized for the modernist cause in his magazine *Camera Work* (1903–17) and in his New York gallery (known as '291' after its address on Fifth Avenue). Initially devoted exclusively to photography, in 1907 the gallery began to showcase the work of advanced European artists in other media (most notably Matisse and Rodin) alongside that of Americans, generating considerable interest among a small circle of sophisticates. The turning point in the American reception of modernism was the so-called Armory Show of 1913, which presented an array of Neo-Impressionist, Symbolist, Fauvist, and Cubist works to some 40,000 people in New York, Boston, and Chicago. As the public at large and many of the critics lacked a frame of reference that would have permitted them to make sense of such productions, the result was scandal. This was not a bad thing, however, for it generated intense debate that ultimately benefited the country's artistic life, inspiring young artists and inciting the interest of future collectors. JG

311

The Neoclassical turn

In the 1750s, a reaction set in against the sensuous and extravagant style known as the Rococo. Increasingly, artists favoured themes drawn from ancient history and mythology, treating them with eyes newly attuned to the formal rigours of Classical art.

Jean-Honoré Fragonard's *Corésus and Callirhoé* [**439**], a large canvas that established the artist's reputation,

represents an androgynous priest stabbing himself, thereby sparing the designated sacrificial victim, a young woman with whom he had secretly fallen in love. Inspired by a Hellenistic literary source, it features swirling draperies, billowing smoke, and fluent handling, all of which declare its affinities to the tradition of Late Baroque history painting.

Such qualities are decidedly absent from Jacques-Louis David's

Oath of the Horatii [**442**], the touch-stone picture of European Neo-classicism. Taut and terse, it is a visual exorcism of Rococo fluency. Picto-graphic postures, piercing light, and anonymous handling combine with compositional asymmetry to produce an image of arresting clarity. But there are dark undercurrents. The painting depicts an episode from the annals of early Rome: we see three brothers of one of the city's leading families who,

about to fight to the death with three champion-brothers from a corres-ponding family of neighbouring Alba, swear a grave oath to their father to achieve victory. The aftermath was bloody: the two clans had previously agreed to intermarry, and the only brother to return alive murdered his sister for lamenting the death of her Alban betrothed. These complexities would have been readily apparent to educated Parisians of the day, who

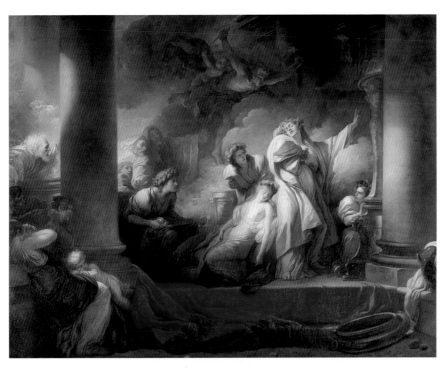

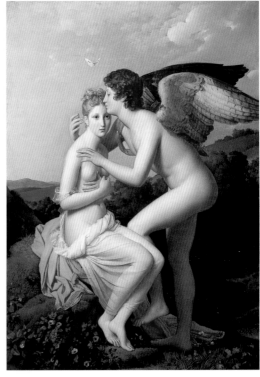

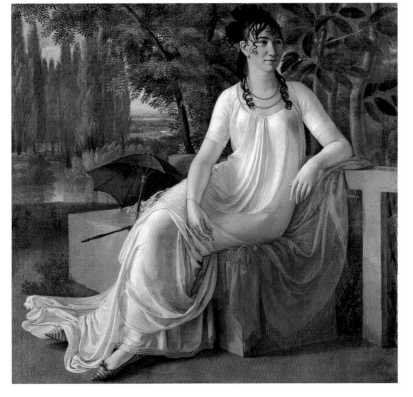

439 Above: Jean-Honoré Fragonard (1732–1806), *The High Priest Corésus Sacrifices himself to Save Callirhoé* (1765), oil on canvas, 3.09 × 4.00 m. (10 ft. 1¾ in. × 13 ft. 1½ in.), Paris, Louvre

440 François Gérard (1770–1837), *Cupid and Psyche* (1798), oil on canvas, 1.86 × 1.32 m. (73¼ × 52 in.), Paris, Louvre

441 Gottlieb Schick (1776–1812), *Wilhelmine von Cotta* (1802), oil on canvas, 1.33 × 1.40 m. (52 × 55 in.), Stuttgart, Staatsgalerie

were familiar with Pierre Corneille's seventeenth-century tragedy treating the same subject.

The Revolution embraced David's austere brand of Neoclassicism as its official visual language; indeed, after 1789 the *Oath* itself was construed post-facto as an unambiguous summons to civic virtue. But the style soon evolved in other directions, even within David's orbit. His student François Gérard

inflected it to lyrical ends in *Cupid and Psyche* [**440**], which depicts the god of Love about to kiss his mortal beloved, to whom he is invisible. One of the work's first critics wrote of 'the romantic vagueness, mute understanding, mysterious and profound unease' expressed by the figure of Psyche, an apt summary of the qualities that make Gérard's painting a bell-wether for nascent Romantic preoccupations.

Between 1785 and 1814, David's Parisian studio was the most important artistic training ground in Europe, drawing students from far and wide. The portrait of Wilhelmine von Cotta by the German painter Gottlieb Schick [**441**], another of his students, reveals how a schematic approach to the definition of form nourished by the study of ancient vase painting could be reconciled with a very modern elegance. JG

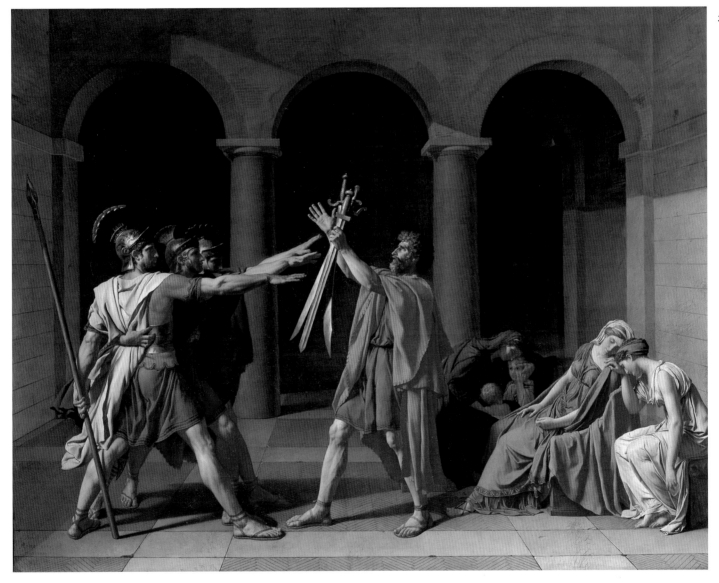

442 Jacques-Louis David (1748–1825), *The Oath of the Horatii between the Hands of Their Father* (1784–5), oil on canvas, 3.30 × 4.25 m. (10 ft. 9¾ in. × 13 ft. 11¼ in.), Paris, Louvre

Romantic quandaries

Large-scale history painting long remained the most prestigious of genres, despite changing circumstances that made the production of such works problematic. Expensive and time-consuming, their only viable purchasers were national governments, yet artists were increasingly drawn to subject-matter unappealing to those in power.

The necessity to negotiate the resulting obstacles—financial, aesthetic, ethical—was an important determinant of high-profile artistic careers in the period.

Antoine-Jean Gros exploited commissions from Napoleon to develop a Rubensian style consistent with both the shifting tenor of contemporary sensibilities and his patron's political interests. His immense *Plague House* [**443**] depicts the French ruler visiting plague-stricken soldiers on his Egyptian campaign. We see him touching one unfortunate's bubo, a gesture evoking the mythical healing power of French kings. But the work's impact is not reducible to its propagandist content. The Christ-like protagonist is surrounded by wrenching depictions of human suffering worthy of a medieval Hell, but one translated into a Near Eastern mosque, elements that allow Gros to sound characteristic Romantic chords of orientalist exoticism and psychic distress.

Goya's *Execution of the Third of May* [**444**] was likewise a royal commission. A depiction of French soldiers executing resisters against Napoleon's occupying forces, it re-established the artist's *bona fides* in the eyes of the newly restored Spanish monarch Ferdinand VII. But Goya seized the occasion to produce a

314

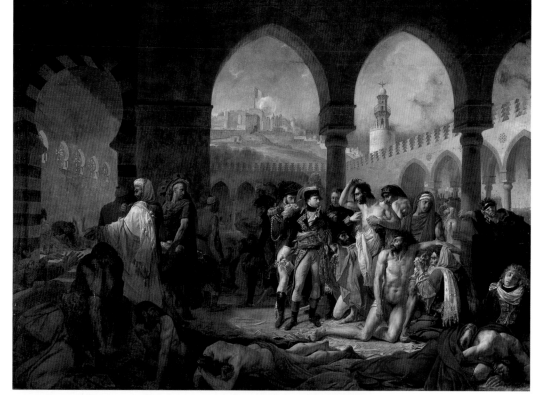

443 Antoine-Jean Gros (1771–1835), *Napoleon in the Plague House at Jaffa* (1804), oil on canvas, 5.32 × 7.20 m. (17 ft. 5½ in. × 23 ft. 7½ in.), Paris, Louvre

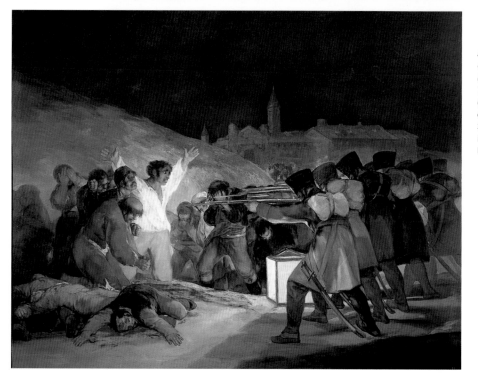

444 Francisco de Goya y Lucientes (1746–1828), *The Third of May, 1808* (1814), oil on canvas, 2.66 × 3.45 m. (8 ft. 8¾ in. × 11 ft. 3¾ in.), Madrid, Prado

searing indictment of all political violence, using audaciously summary technique to heighten the effect of urgency.

Depictions of natural disasters proliferated in the Romantic period and were fostered by contemporary theories of the sublime, but Turner's *Hannibal Crossing the Alps* [445] also evokes the human devastation of Napoleon's campaigns. Its swirling vortex, which dwarfs the figures, captures the pervasive sense of disorientation and peril that gripped much of Europe during these years. Turner breaks new ground by combining a radical lack of formal definition with extreme emphasis on the pictorial material, not in a study but in a large work intended for public exhibition. Experimental in the extreme, *Hannibal* was under-taken entirely at the artist's own initiative and at his own expense.

Géricault's *Raft of the Medusa* [446] is also experimental, but in a different mode. Preceded by rigorous preparatory studies in the best academic tradition and exploiting a pyramidal compositional scheme dear to conservative theorists, the result is highly unorthodox: moving the peripheral pain-wracked bodies of the *Pesthouse* centre-stage, it pictures the appalling aftermath of a contemporary maritime disaster that had acutely embarrassed the French Restoration government. Both a bold indictment of the monarchy and a probing exploration of—masculine—corporeal and mental distress, it established Géricault firmly in the modern pantheon but found no buyer during the artist's lifetime. JG

445 Joseph Mallord William Turner (1775–1851), *Snow Storm: Hannibal and His Army Crossing the Alps* (1812), oil on canvas, 1.45 × 2.36 m. (57 × 93 in.), London, Tate Gallery

446 Théodore Géricault (1791–1824), *The Raft of the Medusa* (1819), oil on canvas, 4.90 × 7.16 m. (16 ft. 1 in. × 23 ft. 6 in.), Paris, Louvre

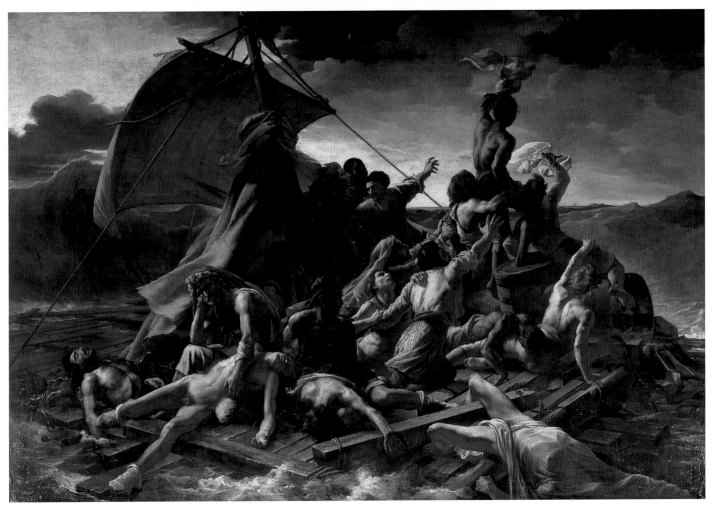

Disquieting images

Even before the prolonged collective trauma occasioned by the French Revolution and the Napoleonic campaigns, a preoccupation with human mortality and psychological vulnerability surfaced in European art. In 1780s Paris, for example, royal officials favouring the production of didactic works were distressed by a growing public taste for 'black subjects' inconsistent with their moralizing agenda. The political upheavals that wracked Europe for a quarter-century after the storming of the Bastille only confirmed this trend, encouraging artists to take up dark themes. The resulting images, often small in size and formally innovative, have a disturbing quality that sets them apart from earlier attempts to grapple with such subjects.

Wright of Derby's *The Old Man and Death* [447] revisits an old subject in a new light—quite literally, for here the old woodsman's encounter with Mortality, in the guise of a skeleton, is illuminated by lambent rays of the setting sun. Standard elements of picturesque landscape—ruined tower, rutted paths, trees, lake—are rendered with a fine-etched clarity that, in the macabre context, is startling.

James Barry's *Jupiter and Juno* [449] pictures a moment from Homer's *Iliad* when the goddess Juno, determined to outwit her husband Jupiter, seduces him so that, after he is asleep, she can aid the Greek army without his interference. The claustrophobic cropping, overlapping profiles, and schematic formal definition infuse the composition with a rare intensity, making this a focused expression of

316

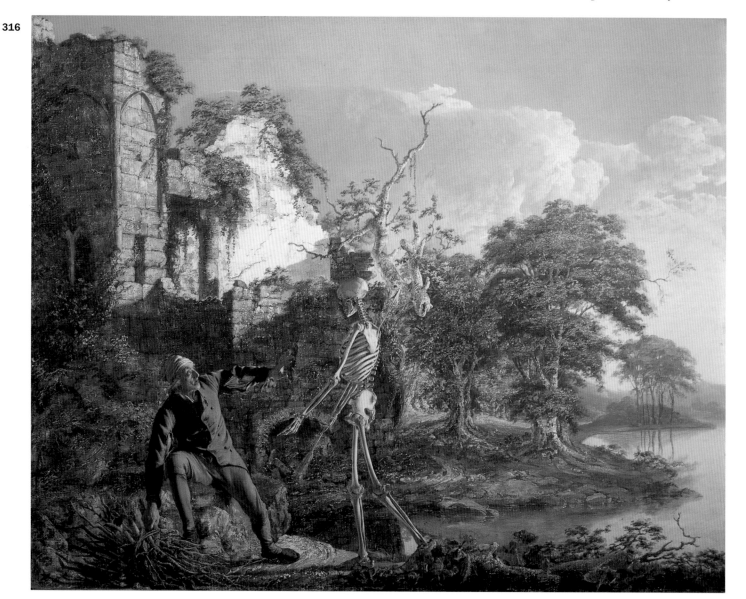

447 Joseph Wright of Derby (1734–97), *The Old Man and Death* (1774), oil on canvas, 101.6 × 127 cm. (40 × 50 $\frac{1}{16}$ in.), Hartford, Connecticut, Wadsworth Atheneum

male anxiety in the face of female sexual power.

Of all the artists treating fraught subjects in the years around 1800, perhaps the boldest—both formally and thematically—was Goya. In addition to his troubling prints, he painted many cabinet pictures depicting witchcraft, murder, and madness whose potent impact belies their modest dimensions. In *Fire* [448], he conveys the chaos and

terror of a disastrous conflagration with a singular economy of means, merging victims and rescuers into a single teeming morass illuminated by an eerie reddish glow.

Géricault's painting of human extremities torn from their bodies [450] is one of several such studies produced while he was working with cadavers in preparation for *The Raft of the Medusa* [446]. Carefully arranged with an eye to formal effect,

their decaying flesh is rendered with a morbid attentiveness. Admired by Delacroix, this canvas exemplifies the Romantic credo that even the most horrific subject-matter was appropriate raw material for the artist. JG

449 Right: James Barry (1741–1806), *Jupiter and Juno on Mount Ida* (*c.*1782–99), oil on canvas, 101.5 × 127 cm. (40 × 50 in.), Sheffield, City Museum and Mappin Art Gallery

448 Below: Francisco de Goya y Lucientes (1746–1828), *Fire* (*c.*1793), oil on tin plate, 48.89 × 32 cm. ($19\frac{1}{4} \times 12\frac{5}{8}$ in.), San Sebastien, Collection José Barez

450 Below, right: Théodore Géricault (1791–1824), *Severed Limbs* (1818), oil on canvas, 52 × 64 cm. ($20\frac{1}{2} \times 25\frac{1}{4}$ in.), Montpellier, Musée Fabre

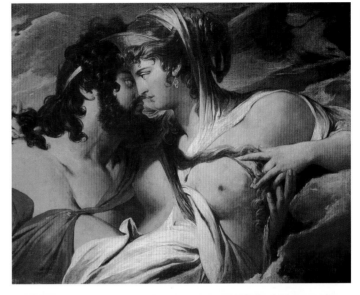

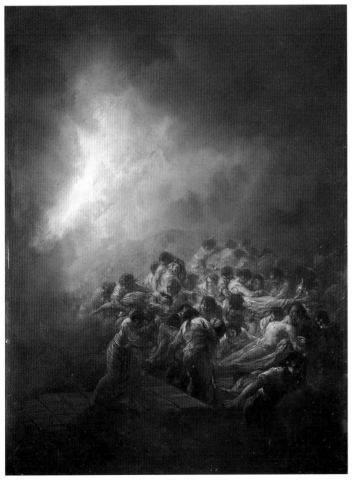

Line or colour?

As so often since the invention of oil painting, in the Romantic period the formal resources of line and colour became identified with opposite expressive poles and aesthetic camps. Line was widely associated with the academic tradition and colour with formal innovation. This interpretive schema must be applied judiciously, but it often proves useful in making sense of artistic developments in the century's first half.

Franz Pforr's *Entry of Emperor Rudolf into Basle in 1273* [451] is an attempt to emulate the meticulous linear style of northern medieval art. Pforr was a founding member of the Nazarene Brotherhood, which sought to revitalize German art by returning it to its indigenous roots. The period saw several artistic crusades to achieve reform through reversion to an idealized past, but none was as nationalistic as the Nazarene movement. A more grandiloquent version of the style, influenced by Renaissance models, proved an ideal vehicle for large-scale official commissions in Germany after the fall of Napoleon.

At the 1827 Salon in Paris, the exhibition of two major paintings by artists of divergent aims crystallized the Romantic–Classic opposition which long functioned as an organizing principle of contemporary artistic production and spectator response. Ingres's *Apotheosis of Homer* [452], commissioned for a ceiling in the Louvre, arrays the artist's cultural pantheon around the Greek bard, who is presented as the founding father of the Western Classical tradition. Here all is serene, muted, magisterial, with Ingres's superb draughtsmanship serving to retain each figure in its assigned place.

318

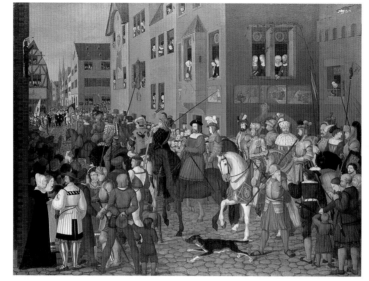

451 Franz Pforr (1788–1812), *Entry of Emperor Rudolf into Basle in 1273* (1808–10), oil on canvas, 90.5 × 119 cm. (35⅝ × 46⅞ in.), Frankfurt, Städelsches Kunstinstitut

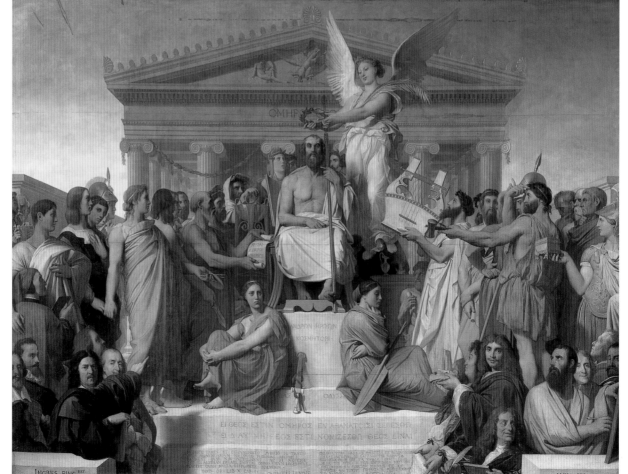

452 Jean-Auguste-Dominique Ingres (1780–1867), *The Apotheosis of Homer* (1827), oil on canvas, 3.86 × 5.15 m. (12 ft. 8 in. × 16 ft. 11 in.), Paris, Louvre

Delacroix's *Death of Sardanapalus* [**453**], by contrast, is a riot of colour and movement. The Assyrian king, intent on denying his approaching enemies the pleasures of victory, has ordered a general conflagration of himself and his servants, concubines, and treasures. Spatial coherence gives way to swirling, orgiastic energy; forms are elastic; brilliant reds and golds vie with luscious flesh tones. The huge canvas reclaimed the space of history painting for indecorous fantasy, as opposed to Ingres's 'official' assertion of hierarchical order. But this paradigmatic pairing should not be used to justify an eductive reading of the period: Delacroix later rejected his Romantic persona, declaring himself 'a pure classicist', while Ingres produced some of the most thematically idiosyncratic and formally adventurous work of his day.

The *Sardanapalus* is the climactic expression of a venerable Western tradition associating unbridled colourism with sensual indulgence and moral decay. While in some ways Turner went farther than Delacroix in exploring the expressive potential of colourism, only rarely did he exploit this long-standing conceptual link. But in the painting illustrated here [**454**]—inspired by stories of dying slaves being thrown overboard for insurance money, collectable only for goods lost at sea—he turned it to appropriately lurid account. JG

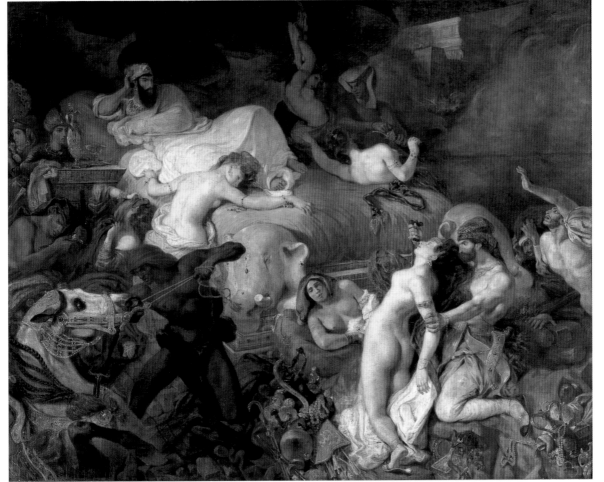

453 Eugène Delacroix (1798–1863), *The Death of Sardanapalus* (1827), oil on canvas, 3.95 × 4.95 m. (12 ft. 11½ in. × 16 ft. 3 in.), Paris, Louvre

454 Joseph Mallord William Turner (1775–1851), *Slave Ship* (1840), oil on canvas, 90.8 × 122.6 cm. (35 11/16 × 48 5/16 in.), Boston Museum of Fine Arts

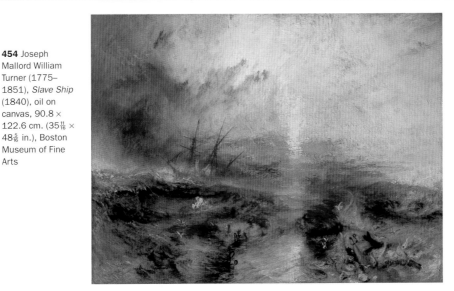

Picturing landscape

Landscape painting assumed a new importance in the nineteenth century, with results of varying character. Increasingly, small-scale work of large ambition came to the fore, partly because compact formats were readily marketable to a growing middle-class clientele.

While the traditional historiated landscape did not disappear, this mode was increasingly displaced by compositions with the spectacular sweep of contemporary dioramas and panoramas.

Caspar David Friedrich sought to instil his canvases with a quasi-religious aura inspired by Friedrich Schelling's nature philosophy, employing to this end formal strategies of exceptional invention. In his *Wanderer above the Mists* [455], a man seen from the back contemplates a prospect of mountains and rocks emerging from clouds. His torso is smack in the centre of the canvas, where two distant ridges clamp it into place visually, activating a tension between illusionistic depth and the picture surface. As viewers, we seem to hover inexplicably above the foreground rocks. The result is an iconic evocation of the mystery of nature, and of the elusiveness of man's place in it.

John Constable's *Dedham Vale* [456] offers a peaceable view of the East Anglian countryside where the artist long resided and which provided him with many of his motifs. There are echoes here of seventeenth-century models, notably Claude [316] and van Ruisdael [346], but the handling is often bold and summary: Constable repeatedly gave his brush strokes their head, sometimes at the expense of representational clarity, as

320

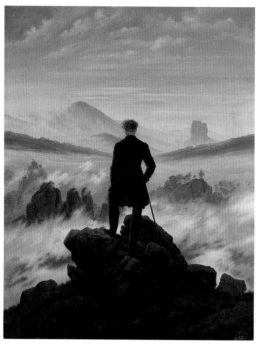

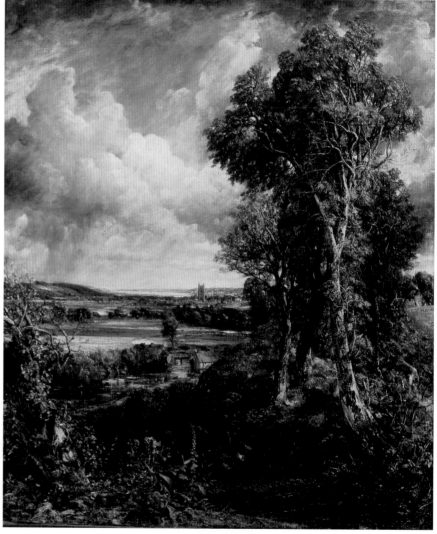

455 Above: Caspar David Friedrich (1774–1840), *Wanderer above the Mists* (*c*.1818), oil on canvas, 84.8 × 74.8 cm. (33⅜ × 29⅜ in.), Hamburg, Kunsthalle

456 Right: John Constable (1776–1837), *Dedham Vale* (1828), oil on canvas, 1.45 × 1.22 m. (57⅛ × 48 in.), Edinburgh, National Gallery of Scotland

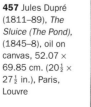

457 Jules Dupré (1811–89), *The Sluice (The Pond)*, (1845–8), oil on canvas, 52.07 × 69.85 cm. (20½ × 27½ in.), Paris, Louvre

with the camping vagrant bottom centre and, at right, the cow caught in the underbrush, both of which blend into the encompassing matrix of paint tracks.

Thomas Cole's *The Course of Empire: Desolation* [458] reveals an ambitious American artist appropriating the grandiose historiated landscape genre then flourishing in Europe, but such high-blown conceptions, while welcomed by New York critics, proved difficult to sell. 'Imagination' was a word then regarded with suspicion by Americans, who preferred landscapes of indigenous motifs presented straight-up, without earnest moral commentary.

København's *View of Lake Sortedam* [459] pictures a modest dock on the outskirts of Copenhagen on which two women await an approaching rowboat. The light is muted, yet objects are crisply defined, textures deftly evoked. The contrasts between darks and lights are stark, but the whole is infused with a quiet poignancy, a poetry of the commonplace. While natural forms predominate, the filigree dock and flagpole—affectingly just off-centre—introduce a framework of domesticating order.

The much smaller work by Dupré [457], a painter of the Barbizon School, also presents a visual dialogue between human constructs and natural forms, but here the exchange is more contentious: the mucky water and disorderly vegetation seem to resist the human presence. The stipple-like technique is quite bold, anticipating the work of the Impressionists, who studied the Barbizon painters closely. JG

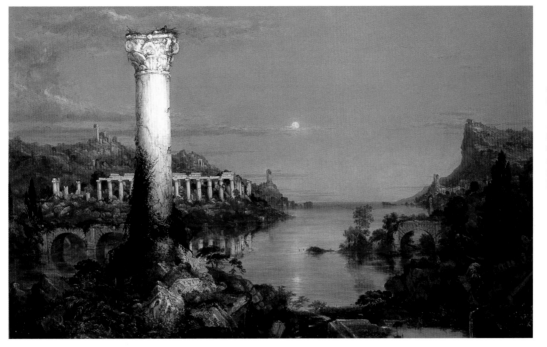

458 Thomas Cole (1801–48), *The Course of Empire: Desolation* (1836), oil on canvas, 99.7 × 160.7 cm. (39¼ × 63¼ in.), New York Historical Society

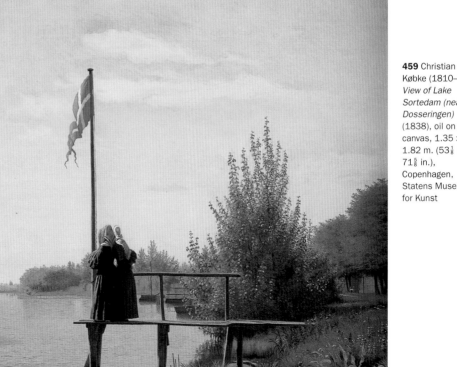

459 Christian Købke (1810–48), *View of Lake Sortedam (near Dosseringen)* (1838), oil on canvas, 1.35 × 1.82 m. (53⅛ × 71⅝ in.), Copenhagen, Statens Museum for Kunst

Realism, critical and otherwise

In the middle years of the nineteenth century, the Realist impulse acquired a new centrality in European art and thought. After the revolutions of 1848, academic idealism and Romantic extravagance alike seemed irrelevant to many artists, who sought to engage with the culture at large by addressing urgent social issues of the day, notably the harsh realities of life among the working poor. But the new Realism took many forms, some of them more palliative than provocative.

Paris was the epicentre of European Realism with a critical edge, and its standard bearer was Gustave Courbet, whose *Burial in Ornans* [**460**] exemplifies his ability to translate socialist convictions into bracing visual poetry. An immense canvas, it confronts the viewer with an expanse of black pigment atop which the mourners' heads, bonnets, and handkerchiefs seem to bob like jetsam on a sinister wave. It would be difficult to imagine a starker rejection of conventional academic compositional formulas.

Jean-François Millet was sympathetic to republican ideals, but his temperament was more conciliatory than Courbet's. His *Gleaners* [**461**] depicts the back-breaking routine of women who made their meagre livelihoods gathering harvest 'leftovers', but he mitigates the subject's shock potential with distancing formal devices: muted but glowing colours, generic figure types, and a landscape of 'timeless' grandeur evocative of Virgil's *Eclogues* and the idealizing canvases of Poussin.

Ford Maddox Brown, while not a member of the Pre-Raphaelite

322

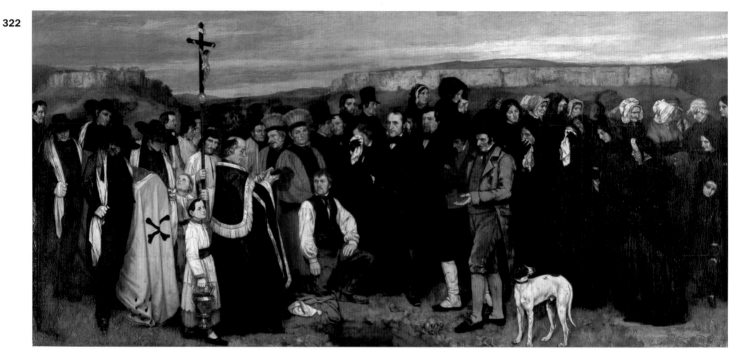

460 Above: Gustave Courbet (1819–77), *A Burial in Ornans* (1849), oil on canvas, 3.15 × 6.63 m. (10 ft. 4 in. × 21 ft. 9 in.), Paris, Musée d'Orsay

461 Right: Jean-François Millet (1814–75), *The Gleaners* (1857), oil on canvas, 0.835 × 1.11 m. (33 × 44 in.), Paris, Musée d'Orsay

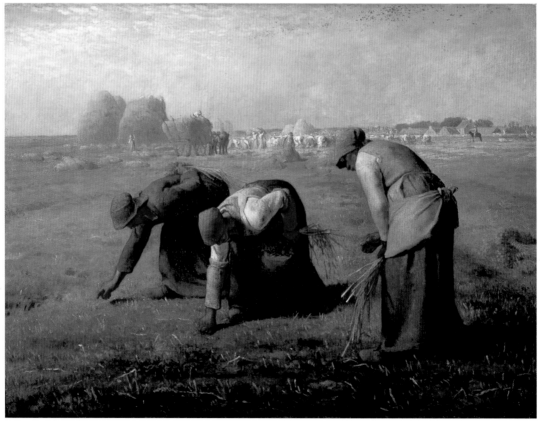

Brotherhood, was sympathetic to many of the group's aims. His *The Last of England* [462] depicts a middle-class couple and their infant bound for a new life in Australia. The picture skirts sentimentality, but the meticulously rendered details, notably the fine English woollens, strike a note of materialist gravitas augmented by the evocation of wind, light, and salt air (much of the panel was painted out of doors).

William Powell Frith aimed to please the crowd, and he succeeded. His panoramic paintings of modern life—like *Derby Day* [464], as packed with human incident as a novel by Dickens—proved immensely successful with the public, which thronged in front of them at the Royal Academy exhibitions. Despite high prices, they always found buyers.

Wilhelm Leibl studied in Paris at the suggestion of Courbet, whom he

met during one of the French artist's trips to Germany. In *Three Women in Church* [463], which monumentalizes three rustic worshippers, he combined recent contemporary developments—note the angled perspective, reminiscent of Degas—with an unblinking attentiveness to fleshly particulars central to the northern tradition since van Eyck.

JG

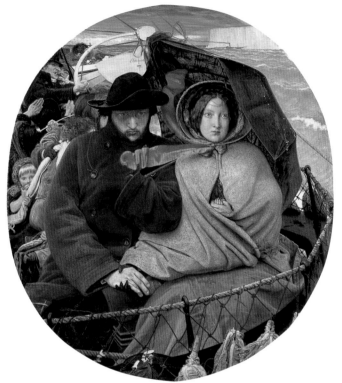

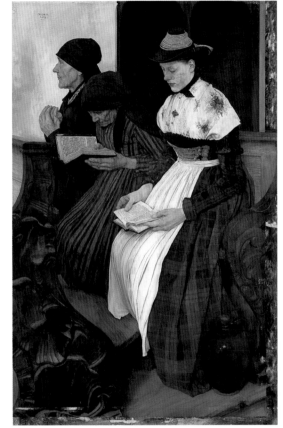

462 Left: Ford Maddox Brown (1821–93), *The Last of England* (1852–5), oil on panel, 82.5 × 75 cm. (32½ × 29½ in.), Birmingham Museum and Art Gallery

463 Right: Wilhelm Leibl (1844–1900), *Three Women in Church* (1878–82), oil on panel, 113 × 117 cm. (44½ × 46 in.), Hamburg, Kunsthalle

464 Below: William Powell Frith (1819–1909), *Derby Day* (1856–8), oil on canvas, 1.02 × 2.24 m. (40 × 88 in.), London, Tate Gallery

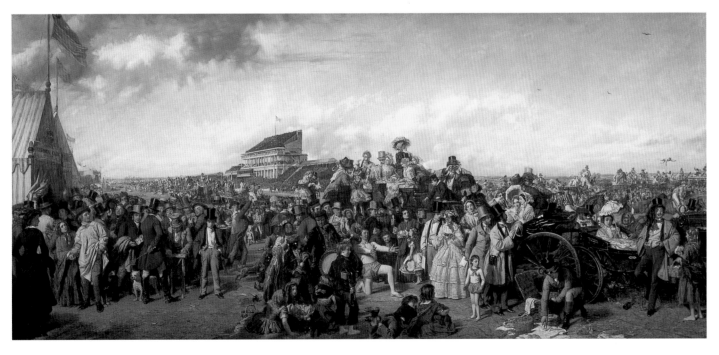

Representing women

Nineteenth-century European women were increasingly forthright in challenging the social and legal constraints imposed upon them. While painting remained essentially a male province, a few women dared to stake a claim on professional status in the field. Male artists remained preoccupied with the female figure; some registered the gradually shifting ground of sexual politics in complex ways, others were largely oblivious to it.

Édouard Manet's *Olympia* [465] works a bold variation on the venerable Western theme of the female nude. Eschewing Classical alibis, he unapologetically presents his subject as a contemporary prostitute; she stares with disarming directness at the viewer, who finds himself—or herself—implicitly positioned as her next client. In addition to challenging the ostensibly disinterested nature of aesthetic response generally, the painting hints that entrenched notions of beauty and the subjection of women may be mutually reinforcing. But the succulent, summary handling—of a kind that made Manet an indispensable precursor of the Impressionists—establishes tensions with the work's critical content that complicate and enrich viewer response.

The pose of Ingres's *Madame Inès Moitessier Seated* [466] was inspired by a Roman fresco from Herculaneum. Despite the eminent respectability of her lavish gown and plush surroundings, the impression created is one of sibylline mystery. The artist's formal manipulations—note the pulpy hand and ghostly mirror double—reinforce this enigmatic quality. We cannot say to what extent this 'portrait' represents Ingres's

324

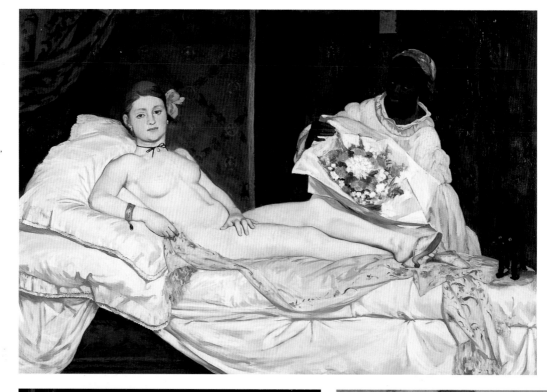

465 Édouard Manet (1832–83), *Olympia* (1863), oil on canvas, 1.30 × 1.90 m. (51⅛ × 74⅞ in.), Paris, Musée d'Orsay

467 Below: Paul Cézanne (1839–1906), *Madame Cézanne in a Red Armchair* (1877), oil on canvas, 72.5 × 56 cm. (28½ × 22 in.), Boston, Museum of Fine Arts

466 Jean-Auguste-Dominique Ingres (1780–1867), *Mme Inès Moitessier Seated* (1844–56), oil on canvas, 120 × 92.1 cm. (47¼ × 36¼ in.), London, National Gallery

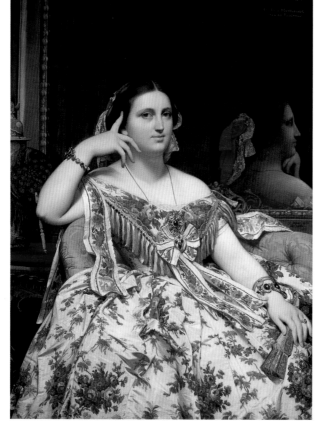

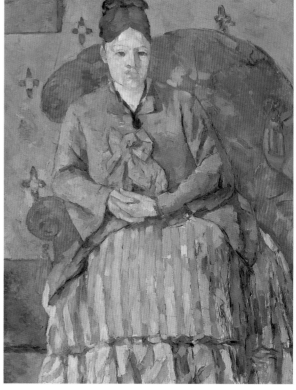

response to the sitter's personality, but her imposing body clearly served his artistic needs.

Cézanne's portrait of his future wife [467] is no mere exercise in crystalline colour harmonies. Beyond his gratitude for the formal opportunities presented by his companion's blocky head and fashion-conscious attire, one senses his begrudging respect for her obdurate character.

When women depicted themselves, they sometimes worked telling variations on themes devised by their male counterparts. In *The Horse Fair* [468], the animal painter Rosa Bonheur slyly inserted a self-portrait—she is the rider in the centre wearing a worker's cap and smock—among the brawny handlers and rearing steeds, thereby assimilating herself to animals whose considerable power is 'bridled' by men. But the

surreptitiousness with which she did so (her figure was only recently identified) makes the painting an allegory of the tenuous position of contemporary women artists.

In *The Boating Party* [469], Mary Cassatt, an American painter closely affiliated with the Impressionist group, performs an analogous operation, but more straightforwardly. Most Impressionist depictions of boating and waterside leisure present

such activities as an escape from domestic obligations, sometimes with intimations of unsavoury sexual dalliance. Cassatt, however, makes the mother-and-child image her central focus, thereby asserting the compatibility of maternity with contemporary fresh-air pleasures— and with high artistic ambition. JG

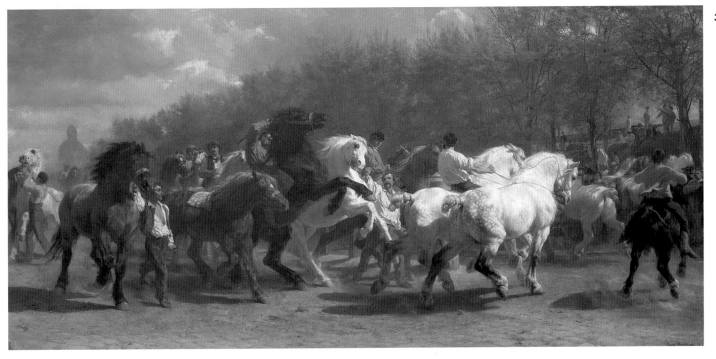

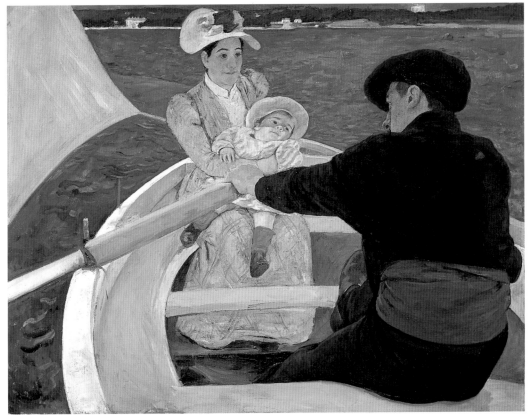

468 Above: Rosa Bonheur (1822–99), *The Horse Fair* (1853), oil on canvas, 244.5 × 506.7 cm. (96¼ × 199½ in.), New York, Metropolitan Museum of Art

469 Right: Mary Cassatt (1844–1926), *The Boating Party* (1893–4), oil on canvas, 90 × 117.3 cm. (35⁷⁄₁₆ × 46⅛ in.), Washington, DC, National Gallery of Art

The rise of genre

In the nineteenth century, the phrase 'genre painting' was widely used to designate depictions of contemporary domestic and social life, most often small in scale and conservative in style. Such pictures were produced in large numbers throughout the century, for they found ready buyers.

But the status of the category became increasingly problematic as the century wore on. A tendency to depict heroic modern subjects in large-scale compositions had emerged long before the advent of Realism, flourishing notably under Napoleonic patronage. This phenomenon was paralleled by a proliferation of small-scale paintings that situated kings and queens of past eras within humanizing, even sentimental domestic contexts with middle-class associations. These developments were signs of an increasingly pervasive blurring of the lines between traditional category distinctions analogous to contemporary reconfigurations in social and political life. Eventually, they issued in the triumph of lowly genre over exalted history painting, for many of the most ambitious and successful works from the second half of the century (notably by the Impressionists) are figure paintings of modern middle-class life.

Kitchen Interior by Martin Drolling [470], a German painter long active in Paris, evokes scenes of domestic industry and contentment by seventeenth-century Dutch genre painters, but the stupefying accuracy of the pots, brooms, vases, and furniture, like the painstaking attention devoted to vicissitudes of light, mark this as an early nineteenth-century production. Gérôme's *Café House, Cairo* [471] also evokes seventeenth-

470 Martin Drolling (1752–1817), *Kitchen Interior* (1815), oil on canvas, 65 × 81 cm. (25⅝ × 31⅞ in.), Paris, Louvre

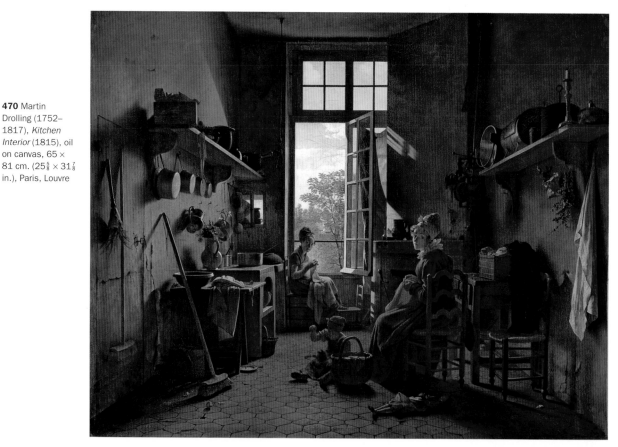

471 Jean-Léon Gérôme (1824–1904), *Café House, Cairo* (c.1883), oil on canvas, 54.6 × 62.9 cm. (21½ × 24¾ in.), New York, Metropolitan Museum of Art

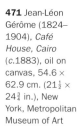

472 Winslow Homer (1836–1910), *The New Novel* (1877), watercolour and gouache on paper, 24.1 × 54.9 cm. (9½ × 20½ in.), Springfield, Massachusetts, Museum of Fine Arts

century Dutch models, but with an orientalist twist. Although an exercise in Egyptian local colour, it is a nineteenth-century analogue to seventeenth-century tavern scenes by the likes of Adriaen Brouwer (Flemish, 1605/6–38) and Adriaen van Ostade (Dutch, 1610–84). Gérôme made a fortune trafficking in such images of Middle Eastern life.

Degas once playfully referred to *Interior (The Rape)* [**473**] as 'my

genre painting', but it is far more ambitious than most such pictures. A troubling narrative is implied, as indicated by its alternative title (of doubtful authenticity), but we cannot decipher it, despite the psychologically suggestive poses and details, for example the corset on the floor. The atmosphere is thick with unspecified hurts; there are hints of sexual violation, but we must guess at the precise nature of the relationship

between the two figures. If this is indeed a genre painting, it is one of an entirely new kind, for its studied ambiguity aligns it with the most advanced art of the day.

Winslow Homer's *The New Book* [**472**] casts a very different spell, one of placid, pleasurable absorption. A visual ode to the delights of reading, it is one of his most captivating watercolours, a medium in which he excelled. JG

473 Edgar Degas (1834–1917), *Interior (The Rape)* (*c*.1868–9), oil on canvas, 81 × 116 cm. (32 × 45 in.), Philadelphia Museum of Art

The American scene

Thanks to the democratic spirit prevailing in America, its artists were somewhat freer to explore contemporary subjects than their European counterparts. Along with landscape and portraiture, likewise popular with critics and collectors, treatments of such themes dominated the developing nation's artistic scene, helping to shape its collective identity. From the beginning, however, Americans maintained an ongoing dialogue with European art of both past and present.

George Caleb Bingham was at home both in New York's nascent art world and along the Missouri River, whose trappers and fur traders were among his preferred subjects. *Raftsmen Playing Cards* [**474**] exemplifies the qualities of his work, which combines a schematic approach to form with lowly subject-matter of a kind traditionally associated with genre painting to achieve a distinctly American monumentality. Even so, the carefully gauged rhythms and planar figure arrangements recall Poussin, while the pervasive atmosphere of charged stillness brings to mind the landscapes of Friedrich. Bingham probably knew much European art through reproductive prints, but his idiosyncratic, democratizing vision utterly transformed whatever continental models inspired him.

Thomas Eakins's *The Gross Clinic* [**475**] is a painting of more sombre, earnest aspect. A depiction of an eminent Philadelphia surgeon, Dr Samuel D. Gross, performing a leg-saving operation on a boy in a surgical amphitheatre, it is Eakins's most ambitious attempt to convey the heroism of modern American life.

328

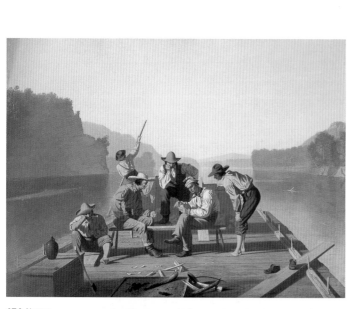

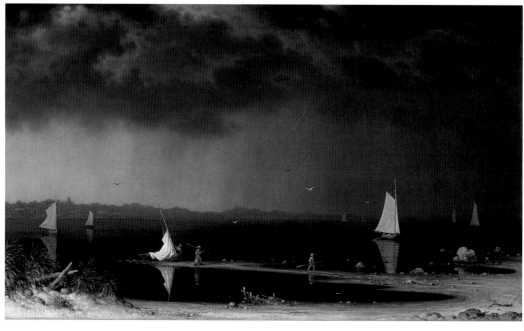

474 Above: George Caleb Bingham (1811–79), *Raftsmen Playing Cards* (1847), oil on canvas, 71.3 × 96.7 cm. (28 1/16 × 38 1/16 in.), The Saint Louis Art Museum

475 Above: Thomas Eakins (1844–1916), *The Gross Clinic* (1875), oil on canvas, 2.44 × 1.98 m. (96 × 78 in.), Philadelphia, The Jefferson Medical College of Thomas Jefferson University

476 Martin Johnson Heade (1819–1904), *Thunderstorm over Narragansett Bay* (1868), oil on canvas, (32 1/8 × 54 1/2 in.), Texas, Fort Worth, Amon Carter Museum

Some of its brooding power may derive from Eakins's self-aggrandizing identification with its central figure, whose bloodied, scalpel-bearing hand is analogous to that of a painter, likewise smeared with colour and wielding an incisive instrument (his brush). Eakins had studied with Gérôme in Paris; the formal command, psychological insight, and thematic density of this canvas place it on a par with the most sophisticated contemporary European painting.

Martin Johnson Heade, another Pennsylvanian, was one of several American landscape painters who cultivated a style characterized by crisp formal definition, high tonal contrast, and emphatic horizontal banding, qualities also found in the American folk-art tradition. The work of the luminists, as these painters are now known, can have a haunting calm, as in Heade's *Thunderstorm over Narragansett Bay* [476], with its white sails standing out unperturbed against the darkening water and sky like emblems of human fortitude in the face of oncoming threat.

Frederick Edwin Church, who studied with Thomas Cole, broadened the geographical horizons of the Hudson River School, seeking out natural evidence of divine immanence in sites as remote as Mexico, South America, and the Middle East. But much of his best work represents American motifs, which he instilled with the crusading self-confidence of New World optimism. *Twilight in the Wilderness* [477] has an epic sweep and glowing colourism redolent of Turner, but with a meticulous attention to natural fact consistent with American pragmatism and no-nonsense spirituality. JG

329

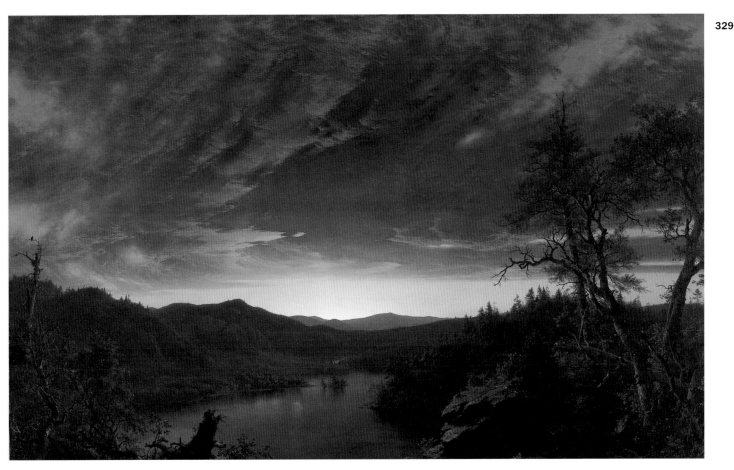

477 Frederick Edwin Church (1826–1900), *Twilight in the Wilderness* (1860), oil on canvas, 101.6 × 162.6 cm. (40 × 64 in.), Cleveland Museum of Art

Pleasure, contingency, modernity

Like the Realists, the Impressionists eschewed imaginary worlds, but they also devised novel techniques for rendering light, atmosphere, and space, in a sense making freshness of vision the very subject of their art. Combining sketchy handling and unorthodox compositional strategies with unmodulated colour, they invented a mode of painting particularly well suited to convey the contingent, fragmentary nature of pleasure, perception, and social life in the modern era.

Claude Monet was, with Auguste Renoir, one of the first artists to demonstrate the potential of such an approach. In 1869, working side by side, the two painters sought to capture fleeting effects of light at a waterside retreat near Paris known as La Grenouillière [478]. While Monet may have executed this canvas as a study for a more finished work, the coupling of deft, summary handling with vibrant colour juxtapositions soon became his stock in trade.

Camille Pissaro began to pursue similar goals in the late 1870s. In [481] he used a scumbled variant of the new handling to produce a calculated rendition of a 'spontaneous' perception in the open air. Radiant patches of orange, blue, and green are held in place by a screen of tree trunks that, like the facture, emphasizes the picture surface. But two tiny figures staring out from the underbrush give the painting a melancholy tinge. While the tone of Impressionist paintings is often celebratory, even the style's core practitioners sometimes used it to more equivocal expressive ends.

330

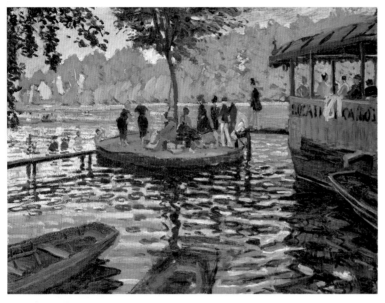

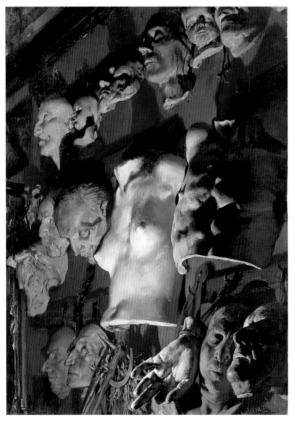

478 Above: Claude Monet (1840–1926), *La Grenouillière* (1869), oil on canvas, 74.6 × 99.7 cm. (29⅜ × 39¼ in.), New York, Metropolitan Museum of Art

479 Left: Adolf von Menzel (1815–1905), *Studio Wall* (1872), oil on canvas, 111 × 79.3 cm. (43¾ × 31¼ in.), Hamburg, Kunsthalle

480 Right: Edgar Degas (1834–1917), *In a Café (The Absinthe Drinker)* (1875–6), oil on canvas, 92 × 68 cm. (36¼ × 26¾ in.), Paris, Musée d'Orsay

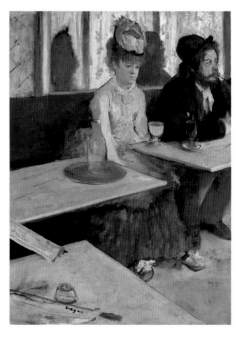

481 Above: Camille Pissarro (1831–1903), *The Côte des Bœufs at l'Hermitage, near Pontoise* (1877), oil on canvas, 114.9 × 87.6 cm. (45¼ × 34½ in.), London, National Gallery

Although Edgar Degas took part in the group's exhibitions, he remained attached to draughtsmanly ideals (he venerated Ingres). Like them, however, he used inventive formal strategies to convey qualities specific to modern life. His *In a Café* [**480**] depicts two bleary-eyed clients in a Parisian establishment, perhaps in the early morning hours. The idiosyncratic viewpoint, with its careening tabletops, gives the work a snapshot immediacy and reinforces the sense of psychological dislocation intimated by the figures' faces and postures.

Gustave Caillebotte likewise favoured crisply delineated forms, but his penchant for modern subjects and novel formal devices allied him with the group. In *Paris, Rainy Weather* [**482**], he combined plunging perspectives and bold cropping with studied compositional rhythms to produce a modern 'history painting' that monumentalizes the dispersed, disaffected character of contemporary urban life even as it savours the chic, sleekness, and bustle of modern Paris.

Adolf von Menzel's *Studio Wall* [**479**], painted by an academically trained German artist who visited Paris in the late 1860s, engages related thematic concerns using very different means. The soft lamplight playing over its oblique array of plaster casts—fragments of ancient statuary as well as masks of Schiller, Dante, Wagner, and the artist himself—accentuates their bereft, provisional character. The result is both a distinctly modern *vanitas* image and a haunting visual requiem for the academic tradition. JG

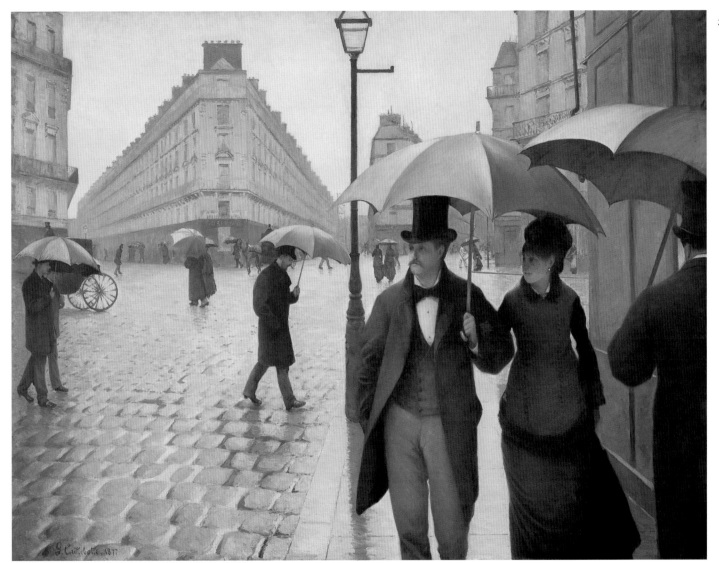

482 Gustave Caillebotte (1848–93), *Paris, Rainy Weather* (1877), oil on canvas, 212.2 × 276.2 cm. (6 ft. 11½ in. × 9 ft. ¾ in.), Art Institute of Chicago

After Impressionism

In the years around 1880, some of the Impressionists, sensing that their work was insufficiently synthetic, altered their handling in ways conducive to greater formal stability. This 'crisis of Impressionism' was shortly followed by the advent of pointillism, a mode of handling with scientific pretensions championed by a younger generation. It was but the first in a long procession of artistic movements to emerge in the wake of Impressionism, whose victory over the regulatory prerogatives of the state-sponsored Salon opened the floodgates of artistic innovation.

The pointillist style was the brainchild of Georges Seurat. His *Sunday Afternoon on the Island of La Grande Jatte* [**483**], its large manifesto picture, represents Parisians relaxing on an island in the Seine just outside the city. Combining a hieratic formal language with the new 'painting by dots' technique premissed on the concept of optical mixture, it represents an attempt to reconcile an idiosyncratic variant of the idealist tradition with scientism. Simultaneously grave and witty, it suggests the social tensions underlying even the most innocuous of modern leisure activities—in an image of extreme formal resolution, no mean feat.

Cézanne's *Still Life with Plaster Cupid* [**484**] also achieves a new kind of formal resolution, but by different means. The spatial construction does not cohere in rational, perspectival terms; visually, however, the effect is one of sensuous harmony—paradoxically attained by indulging the piecemeal, provisional nature of human perception. Juxtaposing things freshly seen with frank formal contrivances, Cézanne here offers a

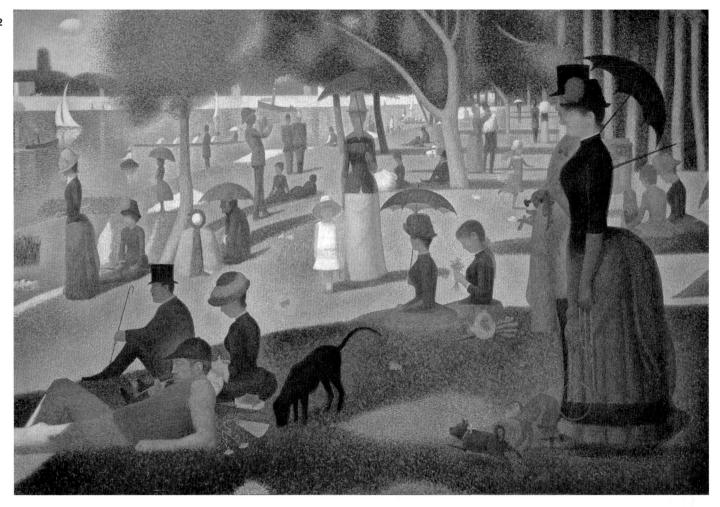

332

483 Georges Seurat (1859–91), *A Sunday Afternoon on the Island of La Grande Jatte* (1884–6), oil on canvas, 2.076 × 3.08 m. (6 ft. 9¾ in. × 10 ft. 1¼ in.), Art Institute of Chicago

poised meditation on the unstable dynamics of creative looking.

The three other works variously exemplify a trend towards a flatter, more schematic articulation of form that emerged around 1890. In the case of Van Gogh and Gauguin, this development was prompted by the desire for an expressive language more direct than that of the Impressionists, whose work was tainted for them by its complicity

with a contemporary urban culture at which they looked askance. Both artists absorbed and then fled from this culture, Van Gogh to southern France and Gauguin, eventually, to Tahiti. Van Gogh sought solace in nature, only to find more questions than answers. Rarely has the wonder of the cosmos been so vividly evoked as in the whirling sky and vatic cypresses of his *Starry Night* [485], which with its stitch-like brush

strokes resembles a sublime sampler. The simplified forms and palette of Gauguin's *Manao-Tupapau* [486] suggest a less complex world, but the spectre serves to remind us that prelapsarian Arcadias exist only in fantasy, making this a cautionary image. Edvard Munch, a Norwegian artist who spent much time in Paris beginning in 1889, was greatly influenced by both Van Gogh and Gauguin. These debts are apparent in

Munch's well-known *The Scream*, an emblematic image of primal anguish in the face of modern uncertainties.

JG

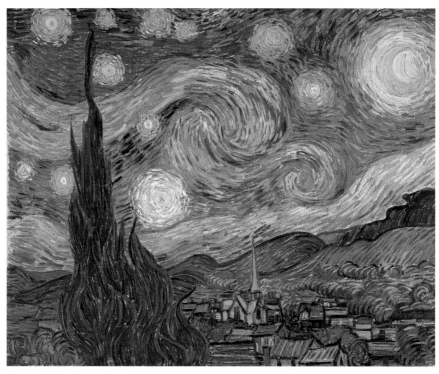

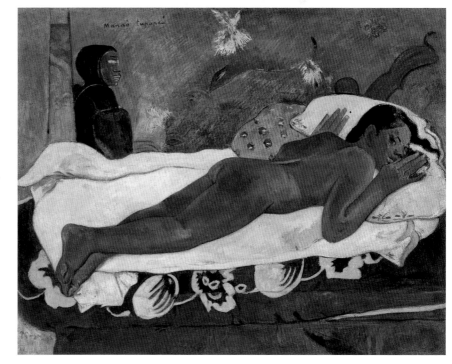

484 Top left: Paul Cézanne (1839–1906), *Still Life with Plaster Cupid* (c.1894), oil on paper, laid on board, 70.6 × 57.3 cm. (27¾ × 22½ in.), London, Courtauld Institute Galleries

485 Top right: Vincent van Gogh (1853–90), *Starry Night* (1889), oil on canvas, 73.7 × 92.1 cm. (29 × 36¼ in.), New York, The Museum of Modern Art

486 Right: Paul Gauguin (1848–1903), *Manao-Tupapau—The Spirit of the Dead Watches* (1892), oil on canvas, 73 × 92 cm. (28½ × 36⅜ in.), Buffalo, Albright-Knox Art Gallery

Daylight and dreams

In the 1880s, Claude Monet altered his approach in ways consistent with post-Impressionist aims, simplifying his compositions and calling attention to the character of paintings as arrangements of colour on a surface. But he never renounced his fundamental commitment to direct visual experience. Specifics of light and atmosphere remained his primary focus, although he now distilled them in ways that dispensed with naturalist clutter, as in *The Four Trees* [**487**], one of a series of radiant works picturing the same trees from different angles at different times of day. Tellingly, when Monet learned that their new owner was about to cut them down, he paid him to postpone this action until the series was completed.

Such perceptual scruples were antithetical to the goals of the Symbolists, who sought—in the words of the Parisian critic Gustave Kahn—to 'objectify the subjective' (1886). There is no coherent style associated with the label, which is loosely applied to late nineteenth-century artists who rejected Realist literalism and the Impressionist preoccupation with sensation in favour of a new subjectivist idealism. Encompassing formal innovators like Van Gogh, Gauguin, and Munch, it is sometimes used to designate the work of less audacious artists whose imagery evokes the realm of dreams or infuses the material world with an aura of esoteric mystery.

Three of the works below exemplify this stylistically conservative Symbolism, which can be allusive and hauntingly poetic. Both Arnold Böcklin's *Island of the Dead* [**488**] and Ferdinand Hodler's *Night* [**489**] conjure images of death. Böcklin

487 Claude Monet (1840–1926), *The Four Trees* (1891), oil on canvas, 81.9 × 81.6 cm. ($32\frac{1}{4}$ × $32\frac{1}{8}$ in.), New York, Metropolitan Museum of Art

488 Arnold Böcklin (1827–1901), *The Island of the Dead* (1886), oil on panel, 80 × 150 cm. ($31\frac{1}{2}$ × 59 in.), Leipzig, Museum der Bildenden Künste

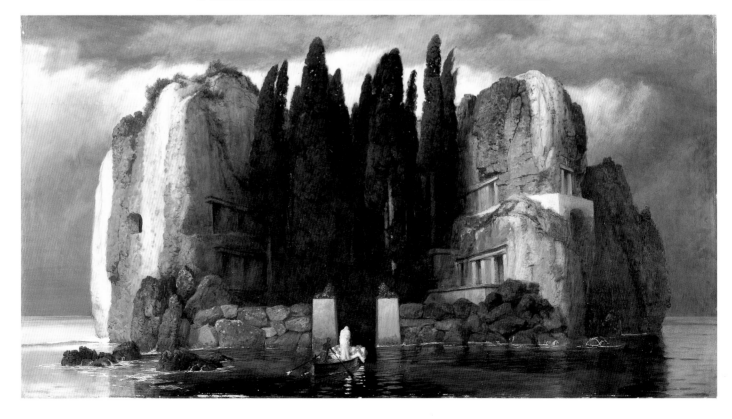

envisages the endpoint of life's journey as a placid though sinister retreat shaped by his recollections of Mediterranean landscape. Hodler presents us with a fraught encounter between a terrified man, prone and naked, and a draped figure ominously crouched over his groin. Here the visual conception is more innovative, incorporating some of the planarity and graphic clarity of recent French painting. As in much Symbolist imagery, one senses analogies with theories that Freud was shortly to elaborate in Vienna (in this case, castration anxiety). Freud's thought was greatly influenced by the visual language of European Symbolism, whose preoccupation with sexuality and death pre-dated his own.

Judith I [**490**] by Gustav Klimt, another resident of Vienna, treats a paradigmatic Symbolist subject in the decorative style endorsed by the city's Secession group. But the biblical subject is mere pretext: this is no ancient heroine but a modern woman—rather, a man's fantasy of same—taking leering, lubricious pleasure in her murderous act.

Frederic Leighton was one of the most admired English academic artists of his day. *Flaming June* [**491**], a rapt paean to sleep influenced by Michelangelo and the Parthenon sculptures, demonstrates that there were latent affinities between Symbolism and self-consciously Classical modes of contemporary art-making. JG

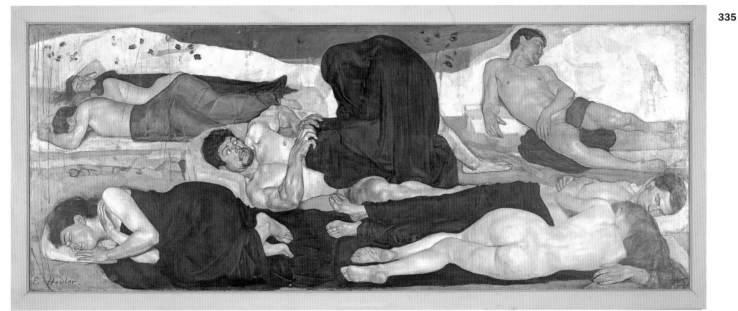

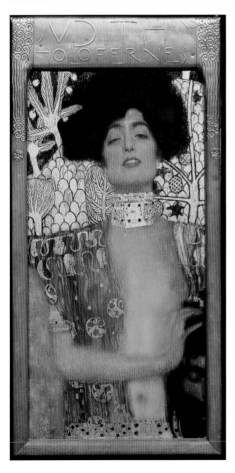

489 Above: Ferdinand Hodler (1853–1918), *Night* (1890), oil on canvas, 1.16 × 2.99 m. (3 ft. 9⅝ in. × 9 ft. 9¾ in.), Berne, Kunstmuseum

490 Left: Gustav Klimt (1862–1918), *Judith I* (1901), oil on canvas, 84 × 42 cm. (33 × 16½ in.),Vienna, Österreichische Galerie Belvedere

491 Right: Frederic Leighton (1830–96), *Flaming June* (1895), oil on canvas, 120.65 × 120.65 cm (47¼ × 47¼ in.), Ponce, Puerto Rico, Museo de Arte

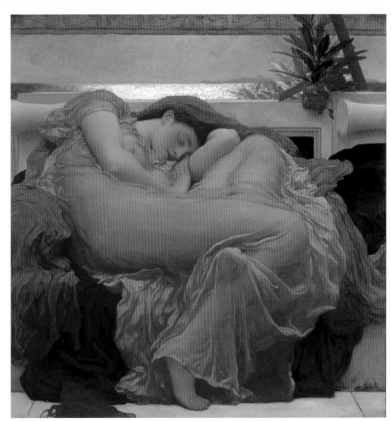

Modernist tensions

As the new century commenced the pace of stylistic innovation accelerated. Descriptive use of colour and form persisted but was increasingly stretched to its limits. By 1914, the Cubists had jettisoned one-point perspective and Kandinsky had produced the first abstract paintings. Two of the moment's pivotal pictures explore the expressive possibilities of stylistic discordance, but other innovative approaches flourished as well.

Matisse's *Happiness of Life* [492] recasts the pastoral landscape tradition in throbbing Fauve colours and sinuous Art Nouveau curves, an uneasy alliance. The figures are circumscribed by tremulous outlines, but the glowing organic patchwork of the surrounding glade threatens to break free of representational constraints. The resulting amalgam, which might be called idyllic vitalism, was altogether new. Simultaneously Classical and Bacchanalian, the picture caused a sensation when publicly exhibited in 1906.

This spurred the competitive instincts of Picasso, whose *Demoiselles d'Avignon* [493] was conceived in part as a riposte to Matisse. A depiction of five prostitutes in a brothel, it, too, juxtaposes different styles, but to more grating effect. The three faces on the left emulate early Iberian sculpture and the two on the right African masks. Forms throughout are aggressively fractured and flattened, but the women's confrontational stances and stares remain clearly legible. Critics have interpreted this 'exorcism picture' (Picasso's phrase) in many ways, notably as evidence of the artist's misogyny and as a document of Western colonialism.

336

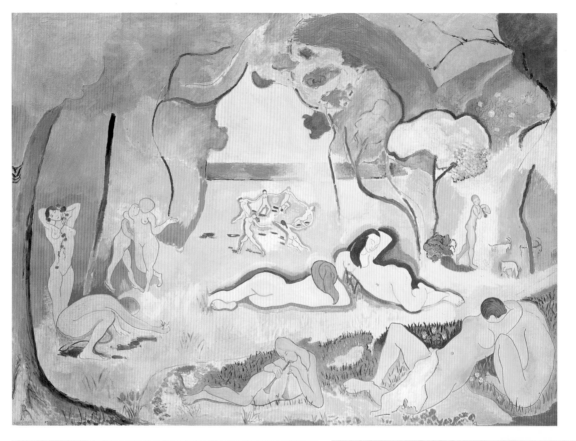

492 Henri Matisse (1869– 1954), *The Happiness of Life* (1905–6), oil on canvas, 175 × 241 cm. (69$\frac{1}{8}$ × 94$\frac{7}{8}$ in.), Merion, Pennsylvania, Barnes Foundation

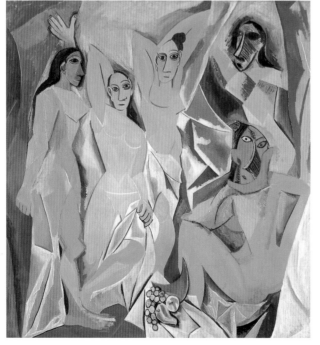

493 Right: Pablo Picasso (1881–1973), *Les Demoiselles d'Avignon* (1907), oil on canvas, 243.9 × 233.7 cm. (96 × 92 in.), New York, The Museum of Modern Art

494 Far right: Egon Schiele (1890–1918), *The Hermits* (1912), oil on canvas, 118 × 118 cm. (46$\frac{1}{2}$ × 46$\frac{1}{2}$ in.), Vienna, Leopold Museum

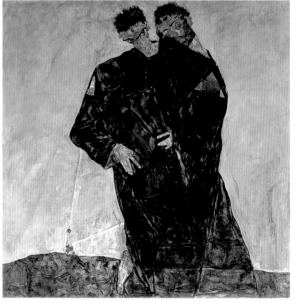

But there is no denying its landmark status as the gateway to Cubism, a style generally credited with having broken the lockhold of Renaissance perspective on Western representation.

Egon Schiele's *The Hermits* [**494**] is stylistically homogeneous, but it, too, is a studied exercise in provocation. The two figures are the artist himself and the older, more established Viennese painter Gustav Klimt, whose vitality is waning and with whom he seems to merge, simultaneously support and succubus. Schiele wears a crown of thorns, a reference to his recent incarceration for questionable behaviour with minors, whom he liked to depict in indecorous poses. He glowers defiantly, as if daring the viewer to challenge his self-proclaimed status as artistic martyr and pre-eminent Viennese modernist. The work's impact is intensified by its graphic clarity, a quality it shares with the work of Hodler and Klimt, both of whom Shiele admired.

Henri Rousseau was a self-taught 'naive' painter, but he was aware of contemporary developments, and his work has a directness and immediacy consistent with the aims of many self-consciously advanced artists. Despite appearances, his *Snake Charmer* [**495**] does not picture a tension-free world: when the strains of this black Orpheus cease, the jungle will revert to predatory violence. With its phallic serpents and encroaching vegetation, it is a very modern allegory of instincts perilously held in check. JG

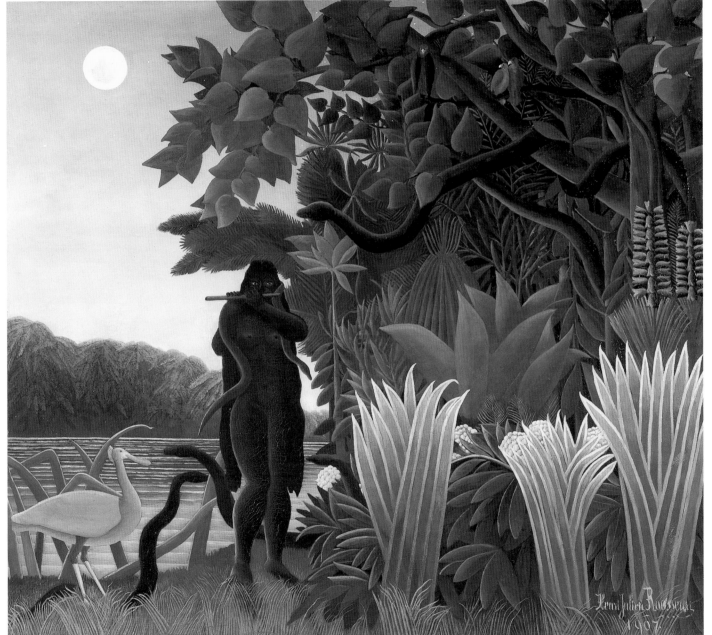

495 Henri Rousseau (1844–1910), *The Snake Charmer* (1907), oil on canvas, 1.69 × 1.90 m. (66½ × 74¾ in.), Paris, Musée d'Orsay

Onward, deconstructors

Cubism opened up entirely new ways of art-making. In addition to breaking down perspectival space, it questioned the epistemological status of illusionistic representation. Its core procedure—the reconfiguration of recognizable forms into increasingly loose concatenations of facet-like elements—was developed jointly by Pablo Picasso and Georges Braque

between 1908 and 1912. This stunning breakthrough was followed by another: the invention of collage, or paste-up, a technique which the two men, again stimulating each other to ever-greater inventive heights, proceeded to manipulate with extraordinary subtlety.

The outbreak of war in 1914 brought this epochal collaboration to an end, but news of its initial achievements spread quickly, and after

1910 many artists took up the Cubist cause with a crusading zeal.

In the eyes of its originators, Cubism was a means of constituting a new kind of visual unity radically independent of perceptual data. 'The senses deform, the mind forms,' wrote Braque in a deft summary of the Cubist credo. But as is demonstrated by his *The Portuguese* [496], the new style was not without debts to the past. The nominal subject—a man

seated in a bar, smoking, and playing a stringed instrument—is presented as if seen through a filtered refracting lens, but illusionism is not so much absent as toyed with. While the matte materiality of the paint is constantly emphasized, there is a strong sense of both atmosphere and shallow depth: Monet's late work is not altogether alien to that of the Cubist pioneers. Likewise, despite manifest stylistic differences, the

338

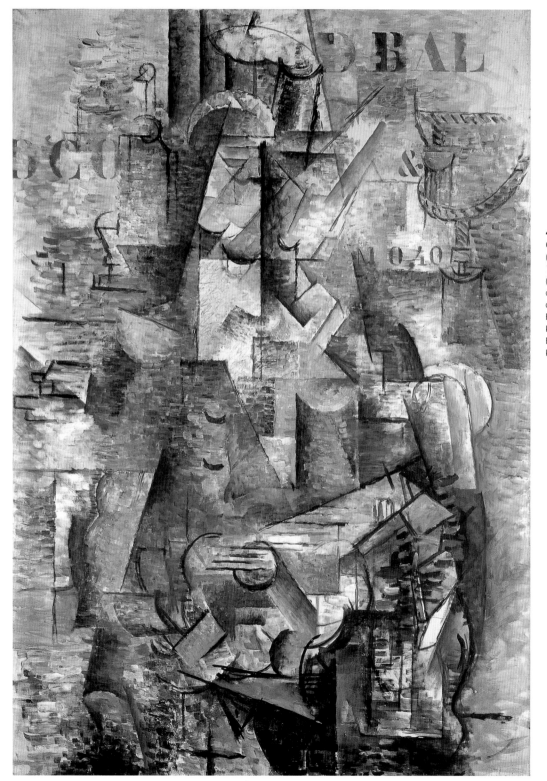

496 Left: Georges Braque (1882–1963), *The Portuguese* (1911–12), oil on canvas, 117 × 81 cm. (46 × 32 in.), Basle, Öffentliche Kunstsammlung Basel, Kunstmuseum

Cubist 'picture-object' is not unrelated to the Symbolist goal to 'objectify the subjective'.

The stencilled letters in *The Portuguese* (fragments of posters) hint at the impending shift from analytic to synthetic Cubism, not least when Cubists began to incorporate collaged elements such as commercial oilcloth. In such works the head-games become positively dizzying. Which is more real, the illusionistic oilcloth or the unabashedly non-imitative Cubist elements?

Although Umberto Boccioni's *The City Rises* [497] exploits conventional heroic imagery, certain affinities with Cubism are discernible. In this paean to modern metropolitan labour all is clamorous, rushing action, as opposed to the meditative games pursued by his great Parisian contemporaries. The construction workers and horses, while attenuated into luminescent particle clouds, somehow remain legible. But a strong tendency to formal disintegration is undeniable. Boccioni would soon proceed farther down the road towards non-objective art, but, like Picasso and Braque, he stopped short of severing all ties to representation.

The first great artists to cross that line were Wassily Kandinsky and Piet Mondrian, but their progress towards abstraction was incremental. Mondrian's transitional *Composition No. 10* [498] serves to remind us of the naturalist roots of the even more austere geometries of his later work.

JG

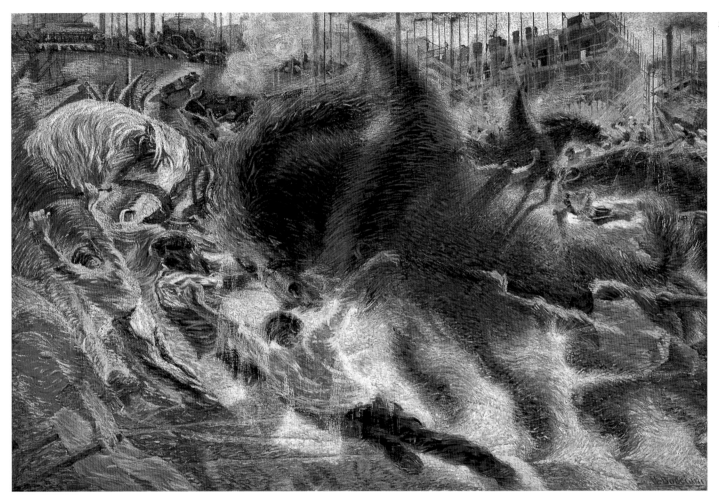

497 Umberto Boccioni (1882–1916), *The City Rises* (1910), oil on canvas, 199.3 × 301 cm. (6 ft. 6½ in. × 9 ft. 10½ in.), New York, The Museum of Modern Art

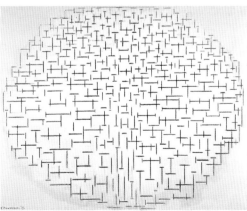

498 Piet Mondrian (1872–1944), *Composition No. 10, Pier and Ocean* (1915), oil on canvas, 85 × 108 cm. (33½ × 42½ in.), Otterlo, Kröller-Müller Museum

Sculptures and Publics

The relationship between sculpture and its publics during the period 1770–1914 was one that was marked by its responsiveness to commerce and national identity. In a period marked by radical shifts in political power, through revolutions and wars, and immense social upheavals, most apparent in the increasing scale of urban development, the demand for public sculpture to display civic, regional, and national identities and to promote imperial ambition increased. Thus sculpture as an art form became more, often ostentatiously, open to the public gaze than ever before. The importance of this area of the sculpture market was at its most visible in large-scale competitions to select designs for public monuments and sculpture. For sculptors these were inviting but dangerous waters that offered the opportunity to work on a magnificent scale and gain commensurate publicity, but also prompted lively debate. The symbolic power of public sculpture, the motivations that lay behind the desire to commemorate one individual or event, meant that it could also act as an unpredictable catalyst of response.

At the end of the eighteenth and in the early years of the nineteenth century the international centre for sculpture was undoubtedly Rome. The Scottish painter David Wilkie (1785–1841) visiting the city in 1826 reported that the sound of hammer and chisel could be heard in every corner. At this time the Roman studios of sculptors such as Bertel Thorvaldsen (1770–1844) [511] attracted an international and fashionable clientele that viewed the sculptors' repertoire on display in the studio in plaster model form, studied current pieces under way, and commissioned further works to enhance their collections. By the end of the century the focus of international sculptural activity had shifted, and whilst foreign sculptors continued to work from Italy, some of the most experimental work was being carried out in the studios of Paris. Privately organized exhibitions dedicated to group or individual activity were a feature of the consumption of contemporary European sculpture, but the huge halls of institutional exhibitions, notably the Paris Salon, and international exhibitions continued to provide its biggest shop windows [509, 510].

The emergence of women as professional sculptors is a feature of the history of sculpture during this period. Whilst women continued to practise in the uncontentious areas of the lower genres of sculpture—notably decorative and wax sculpture—it was difficult for them to penetrate patriarchal institutional structures. Despite the fact that the intellectual and inventive aspect of the sculptor's art [522]—the creation of the idea through the initial model—was seen as the most important act in its making, the physical labour involved was seen as a major obstacle to women's participation at a professional level.

More significant perhaps was the difficulty of obtaining access to anatomy classes and study from the live model, key skills in the training of any sculptor. These were areas of activity largely prohibited to women if they were not born into a family studio or able to obtain private tuition. Throughout the period sculpture as an accomplishment art for women was accepted but the opportunity to gain public commissions or execute works on a large scale was difficult to achieve. However, by the end of the 1800s women sculptors were achieving recognition for their work in the public arena as professionals rather than as distinguished amateurs. The success of Harriet Hosmer (1830–1908) in gaining public recognition demonstrates that women could practise successfully in the public domain [523], often in the face of considerable gender bias (as critical attacks against Hosmer on the spurious grounds of her over-use of studio assistants demonstrates).

Portraiture continued to be one of the major areas of sculptural practice, promising a degree of celebrity and also self-identity. However, within the confines of the academy, as a genre it was considered to be inferior to the ideal (the human form in its perfect state selected by the artist from studies of nature and the Antique, and therefore raised above the copying of mere 'likeness'). The portrait bust or statue, placed in the domestic setting or in a more controlled viewing environment of a private or public pantheon dedicated to a political ideal, could function at many levels. The ability to combine the characteristic appearance of the sitter, her or his specific physiognomy, with the demands of fashion and art was at the heart of this ever-popular sculptural form. Some made their reputations and their fortunes in this area, notably the English sculptors Joseph Nollekens (1737–1823) and Francis Chantrey (1781–1841) who provided sitters with verisimilitude cloaked in Neoclassical decorum. The *bustier* Jean-Antoine Houdon (1741–1828) created portrait busts and statues of French and new world heroes that became iconic images, as his portraits of Voltaire, Diderot, Rousseau, John Paul Jones, Washington, and Franklin [525] demonstrate. The bust, like other forms of sculpture, responded to the developing interest in a greater naturalism of surface and expression that was apparent by the 1830s. Portraits by David d'Angers (1788–1856), Marcello (Adele d'Affry, Duchess Castiglione-Colonna, 1836–79), Christian Daniel Rauch (1777–1857) [526], and Auguste Rodin (1840–1917) [528] show the richness and range of this genre.

Another mainstay of the sculptural profession was the production of sepulchral monuments sited within churches or in the new cemeteries that were established to absorb the dead of the big urban centres. Those in Genoa, Paris, and London

provide evidence of an extraordinary range of sculptural styles and the significance of this area of sculptural practice. For the wealthy, cemeteries provided more and more opportunities to express family lineage and power; funerary monuments were also used in making statements of allegiance to those out of favour with the political regime. Commemorative sculpture was an art form where experimentation and symbolism could be explored in conjunction with the precepts of the patrons and could also act as vehicles for the ideal. In church monuments the dominance of Neoclassical forms, such as the Greek stele, gave way to a far wider range of traditions and revivals—for example, the tomb of Sophia Zamoyska in Santa Croce, Florence [**515**], by Lorenzo Bartolini (1777–1850), which works within a tradition of Renaissance tomb sculpture expressing a sculptural lineage with the past in keeping with the history of the site. The short step from this form of commemorative work to one which was appropriate for ideal sculpture was often exploited by sculptors and was apparent in *Monument to Dante* (1834, destroyed) by Félicie Faveau (1801–86). It was a Gothic tabernacle containing the poetic figures of Paolo and Francesca and was executed, appropriately, in Florence.

The programmes of restoration of cathedrals, particularly in France, also provided sculptors with opportunities to work directly with an earlier, native and non-Classical sculpture. The fashion for the medieval past had particular resonance in the context of seeking to convey the idea of national identity, one that celebrated a previous 'golden age', found, for example, in the equestrian statue of Antoine, duc de Lorraine [**516**], by Jiorné Viard (1823–55). In the German States this was visible in the use of the Gothic with its opportunities for an intricate display of architecture and sculpture. Similarly the cult of Joan of Arc in France provided further opportunities to refer to the medieval past, but in many instances the sculptural figure stayed firmly within the Classical tradition whilst the costume indicated the historical moment. In England one of the most elaborate

commemorative monuments in the so-called Gothic style that moved decisively away from the models from Classical antiquity was the Albert Memorial in London [**503**].

In the main sculpture continued to be, as it had been in the eighteenth century, a part of a wider luxury trade and it should not be forgotten that the success of the larger studios run by well-known sculptors was only the top end of a much larger market primarily dependent upon the demand for small-scale works, the bedrock of the sculptor's business. By the mid-nineteenth century portraits, animal sculpture, statuettes, and decorative works were all reproducible through a variety of new industrial techniques that also made it possible to buy major ideal works in reduced form. Such technological advances impacted upon the market making sculpture available to a wider public than ever before.

In the commercial domain marble merchants such as the Carrara-based Del Medico and Lazzerini families had shops in more accessible locations than their quarries, selling reduced versions of canonical and contemporary works. The Italian Bienaimé workshop similarly supplied garden and decorative sculpture to a European-wide clientele. Bronze foundries, notably Barbedienne, established Paris as a centre for the production of high-quality statuettes with the emulation of Italian Renaissance workshop methods clear in the work of many sculptors practising in this area. The relationship between businesses like Barbedienne and sculptors whose works they reproduced was not always easy, and there are many instances of difficulties arising over ownership and authorship of designs, for example the legal battle between the French sculptor Jean-Baptiste Clesinger (1814–83) [**499**] and Barbedienne. In addition the demands of academies and institutions of art made the relationship between the sculptor and commerce an ambivalent one.

By the later nineteenth century there was an enormous variety of statuettes on the market that used an intricate combination of metals, enamels, patination, ivory, and semi-precious stones to produce sumptuous effects. Many sculptors dabbled in the wider dissemination of such works for commercial gain. The English sculptor Alfred Gilbert (1854–1934), using the revived lost wax technique, created statuettes that particularly appealed to the sensibilities of the Aesthetic Movement in England and the European-wide fascination with symbolism [**517**].

The involvement of Jean-Baptiste Carpeaux (1827–75) in the reproduction of his own works as a commercial venture is an example of the symbiosis that could be achieved between sculpture and industry. Figures from his infamous sculptural group *The Dance* (1867–9) [**521**] made for Charles Garnier's

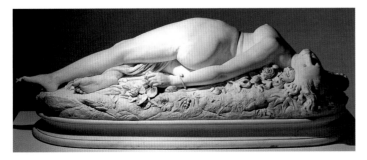

499 Jean-Baptiste Clesinger (1814–83), *Woman Bitten by a Snake* (1847, possibly the version shown at the Salon), marble, 1.80 m. (71 in.) long, Paris, Musée d'Orsay

Paris Opera, the object of a vicious public reaction focused upon the animated dance of the women and prompted by concerns that had little to do with aesthetic response, were sold by the sculptor in reduced form. At the 1878 Exposition Universelle there was a large display of his works within the Salle des Céramiques. This liaison between art and industry was constantly emphasized as well as its possible commercial exploitation through mass-produced Parian ware and terracotta.

As sculpture in all its forms became more accessible to the public so the debates surrounding its production and meanings flourished. As an art form it was considered by traditionalists as one of the last bastions of good taste, linked irrevocably it seemed to antiquity through its dependence upon the study of Classical sculpture. Vast quantities of marble were hewed and bronze cast to provide sculpture that sustained this idea of universalism and continuity throughout Europe and its colonies. Some of the most remarkable visual displays of imperial dominance and control were made for the Asian sub-continent, such as the Jubilee Monument to Queen Victoria in Calcutta [**504**], conceived in 1901 and completed in 1925. Little is known of the contemporary response of the indigenous population to this extravagant display of the power of the British Raj, but elsewhere in India such monuments of the occupation failed to survive independence, either as a result of deliberate removal or from neglect.

European dominance over indigenous peoples was not only expressed through the setting up of monuments in key locations in the colonies, but also through dissemination of an ideal of the colonized 'other' in sculpture that was on display in European cities in a variety of forms. The Great Exhibition of 1851 contained many examples of lifesize wooden and wax models of the indigenous peoples of the third world, a tradition of representation still apparent in the Congo exhibition of 1897 held in Brussels-Tervuren with its three-dimensional 'examples' of African life, or the wax figures of the native peoples of Oceania on display in the Musée d'Ethnographie du Trocadéro in Paris in the 1880s and 1890s. The French sculptor Charles-Henri-Joseph Cordier (1827–1905) made rich, mixed-media busts of the peoples of North Africa as 'specimens' for the Musée d'Histoire Naturelle in Paris [**527**]. In the halls of the public exhibition or the more heady atmosphere of the private gallery the taste for orientalist and exotic subjects became a strong element in later nineteenth-century ideal sculpture. In this context fictional and religious subjects such as Salammbô and Salome provided an opportunity for the display of the erotic. Carvings by Paul Gauguin (1848–1903) made in deliberately 'primitive' mode may be seen as yet another, if differently orientated, part of the wider colonial enterprise.

Sculpture's visibility in the squares of western European cities and towns, on the facades and pediments of their public buildings, or in the halls of public exhibitions was obvious. In the civic context, discreet decorative architectural sculpture such as that produced by Henry Charles Fehr (1867–1940) on the Middlesex Guildhall, London [**506**], was used to emphasize the function and the historical credence of the buildings which it decorated. It could act as significant points in a townscape as was the case with the ornate Brabo Fountain [**507**] by Jef Lambeaux (1852–1908), a work that celebrates the founding

father of Antwerp through a rich display of ornament that bears testament to the commercial wealth upon which the city was founded. Fountains were a popular means of providing a public amenity in the centre of a city or town and allowed a display of sculptural embellishment and inventiveness.

The civic monument could also provide a portrait of a contemporary citizen as a symbol of the strength and quality of the community, as evident in Aimé-Jules Dalou's Monument to Jean Charles Alphand [**508**]. In these public contexts sculpture was used as a protagonist in creating and consolidating a civic identity. When this aim was either ambiguous or seemingly anti-heroic, placing it outside the usual repertoire of the public monument, the response was often angry and confused. This was the case with the *Burghers of Calais* [**505**] by Auguste Rodin (1840–1917) where the expression of individual emotional suffering seemed the antithesis of nobility and heroism to the civic fathers who had commissioned the monument. There was no careful rendering of medieval detail in Rodin's portrayal of the patriotic self-sacrifice of Eustache de Saint-Pierre and his five fellow citizens of Calais who in 1347 offered themselves up as hostages to Edward III in return for the lifting of the siege of their city. The emphasis upon the psychological impact of this group, an expressive embodiment of human suffering and sacrifice, was not clear to a largely bemused public who wished to see a clear patriotic message of historical parallelism to their more recent experiences in the Franco-Prussian War.

Sculpture and the public had a direct and immediate engagement which is recorded in the varied critical responses it evoked. In this context the protective veils of 'art' through which sculpture was viewed when placed in the private sculpture gallery or rooms of the collector were not present. Some of the most virulent criticism that both formed and expressed the public view was aimed at those works that apparently transgressed accepted norms of taste or decorum. In particular the body, the linch-pin of sculptural expression, became the focus of debate and dissent as sculptors moved away from the subtleties of idealized form within the Neoclassical tradition to a more naturalistic representation both in form and colour. This was particularly visible in art created for display in the context of the public exhibitions that became more popular as the century wore on [**509**]. In the context of this mass consumption of the sculptor's art, the nearer the inert form of the sculpted body came to its human source the more difficult it became for the observer to disengage from the troubling issues of gender, sexual orientation, and social class.

In the early years of the nineteenth century the discreetly modulated surfaces of the nude epitomized by marble figures by Antonio Canova (1787–1822) were meant for the delectation of the connoisseurial eye. As such they were accepted within a repertoire of Neoclassical idealism as part of art's known territory and implicit in their viewing was the frisson of a discreet sexual charge. But increasingly sculptors, partly through a different response to antiquity apparent in the reception of the Elgin marbles, searched for a means of suggesting a more natural human body, moving away from the more eviscerated surfaces of Neoclassical sculpture to a greater realism. A striking example of this is found in the voluptuous energy of Clesinger's *Woman Bitten by a Snake* [**499**], closely modelled from the body

of a well-known courtesan, Apollonie Sabatier (with whom the public knew both the sculptor and the patron Alfred Mosselman had had intimate relations). Displayed within the context of the Paris Salon of 1847 it caused a critical dissonance ranging from Thoré and Gautier who admired the sexual abandonment of the pose and its veracity of surface to more conservative critics who found it vulgar and too real for the confines of art. The exquisitely carved marble surface with its fleshiness undoubtedly invited touch, its popularity evident in the Barbedienne edition and other copies and versions that survive.

There is some evidence that Clesinger introduced colour into the flowers upon which *Woman Bitten by a Snake* lay, an example of the increasing interest in colour in sculpture that was to become the dominant theme of European ideal sculpture from the mid-nineteenth century onwards, reaching a climax in the *fin de siècle* with its association with decadence and symbolism. It was not the form of John Gibson's *Tinted Venus* (1851–6)—a clear continuation of Canovian idealism—that stimulated debate about where in sculpture beauty stopped and vulgarity began. It was the flushing of the skin, hair, eyes, and drapery with colour that constituted an act of desecration for some traditionalist critics when it was displayed at the 1862 London International Exhibition, where it met with a mixed reception. However, it was a painter-sculptor who made the most provocative sculptural act in this context. The *Little Dancer Aged Fourteen* [**519**] by Edgar Degas (1834–1917), was exhibited at the 6th Impressionist exhibition of 1881 with hair and real clothing. It took sculpture to its limits, and for many critics over the barrier that seemed to be placed between 'high' and 'low' art. The physiognomy of the adolescent's head and the pose of the body were troubling for the viewer in their apparently deliberate ugliness. Furthermore, connections between Degas's sculpture and contemporary studies of adolescent criminal physiognomies made viewing the *Little Dancer* a complex act whereby it became the focus of concerns about sexuality, morality, and criminality.

New regimes demanded new symbols expressive of (consolidated) ideologies to replace those of the old order and to fix the imprint of the new. Nowhere was this more clearly evident than in France. In the turbulent years following the 1789 Revolution sculpture was used in a variety of ways to focus the minds of the public upon the power of the new order. Whilst Marie Tussaud (1760–1850) was employed to make wax models of the freshly guillotined heads of traitors during the reign of terror, the monuments of the *ancien régime* were removed from their plinths and replaced by statues imbued with new meanings. The destruction of the statue of Henry IV on the Pont Neuf was just one example of revolutionary iconoclasm. During the revolutionary period large-scale, temporary sculptures were raised, often during mass rallies, to focus the attention of the population upon the guiding principles of the new nation. Many such spectacles were designed by the painter Jacques-Louis David (1748–1825) and survive in drawings, prints, and written accounts. In this context sculpture helped to focus and thus formulate a new national identity [**513**]. This democratic impulse was almost an inversion of the sculptural tradition of representing the monarch as the embodiment of the French state, examples of which were then being removed from the Places royales across the country. The intimate relationship between the changing fortunes of political regimes and the symbolic role of sculpture in the nineteenth century is nowhere more evident than in the history of the Vendôme Column in Paris [**502**].

The traditional forms of monument indicating leadership, such as the equestrian statue or the triumphal column or arch, were decorated with images that enforced the idea of heroism, power, and control either through portraits of the leader or of illustrious forebears with whom the leader could be identified, or through an episode from history. Napoleon I was master of using sculptors to disseminate his image as imperial leader just as later the newly restored King Louis XVIII was to reassert the power of the monarchy by raising a series of statues to the kings of France. Similarly Napoleon III, eager to promote historical figures from France's past that would place him in a common lineage with those who protected the country's interests and resisted a common enemy, funded a 22-foot-high statue of the Gaul Vercingetorix to be raised in Alise-Sainte-Reine in 1865.

The Romantic period produced many visionary designs for spectacular public monuments but their realization was a comparatively rare occurrence until later in the nineteenth century. One colossal sculptural work that perhaps more than any other conveyed the idea of the Romantic sublime linking sculpture to its natural source was a memorial to the Swiss Guards who in 1792 had given their lives trying to prevent Louis XVI from being captured by the revolutionary forces who had taken the Tuilleries. The colossal *Lion of Lucerne* [**500**], carved directly into a limestone cliff, commemorated the unswerving steadfastness and loyalty of the Swiss people, the foundation stone of the Swiss national character. This identification with a broader nationalist enterprise of a monument commissioned as a civic monument by the people of Lucerne was underlined by its site, near that of the original foundation of the Swiss Confederation.

As was so often the case here local aspirations and identities were being used to confirm their place within the national spectrum and this inevitably provoked debate amongst the public according to individual political affiliations or motivations. Ernst von Bandel's project to create a monument that would express the aspirations to German unification, the colossal *Arminius* or Hermannsdenkmal [**501**] conveyed this not through a universal, Classical ideal but by representing the national hero in costume and appearance that proclaimed his specific history. The nineteenth century saw the creation of many other colossal monumental works that have now become emblematic of national identities and which echoed earlier visionary schemes. Some of the most well known include the Washington Memorial, Nelson's Column (1839–64, Trafalgar Square, London), and Frédéric-Auguste Bartholdi's (1834–1904) Statue of Liberty [**518**]. The dawn of the twentieth century brought with it avant-garde reactions to traditional subjects with a new emphasis upon truth to materials and direct carving. Nevertheless the strength of sculpture as an art form in the public domain continued until the outbreak of the First World War when older certainties gave way, depending on one's perspective, to radical opportunities or a death of common artistic intentions.

AWY

National images

Sculpture's symbolic function in the creation of national and imperial identities is apparent in the ways in which it was used either overtly or indirectly to proclaim a variety of ideologies to the public.

Such partisan messages could also be mixed, combining civic pride with national identity, as with the colossal *Lion of Lucerne* [500]. It celebrated both the steadfast nature of the Swiss national character and also, by implication, the French royalist cause in its specific commemoration of the Swiss Guards who had died defending Louis XVI in 1792. Carving directly into the rock face enhanced the sense that unyielding loyalty was a natural product of the region.

As time elapsed so meanings could change. In Westphalia the long drawn-out project to raise the colossal Hermannsdenkmal [501] commenced in 1819, at a time when the German people were emerging from a period of crisis following the Napoleonic Wars. The impulse towards national unity that its creator Ernst von Bandel was seeking to promote was essentially realized by the time of its completion in 1875, when it had metamorphosed into a full-blown statement of German triumph over the French in the Franco-Prussian War.

Inevitably, because of its symbolic function, public sculpture was affected by shifts in political power exemplified in the chequered history of a Napoleonic monument, the Vendôme Column [502]. Its original surmounting statue was melted down after Napoleon's defeat to provide material for a statue of Henry IV, a significant act that signalled the monarchy's resurgence. This was followed by further replacements

344

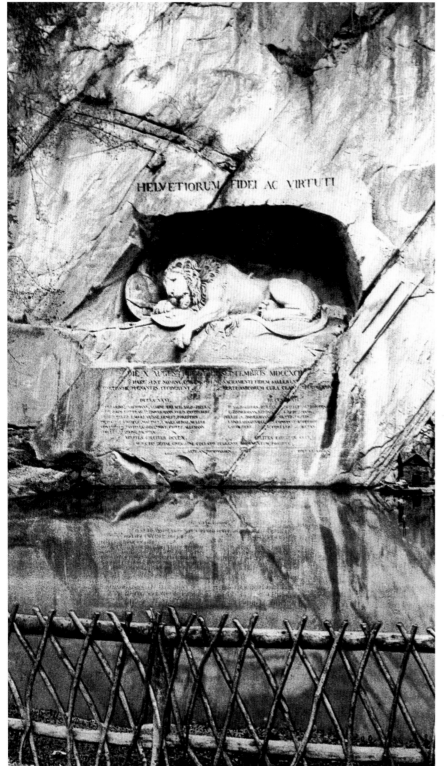

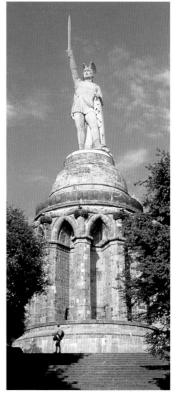

500 Left: Lukas Ahorn (1789–1856), after the model by Bertel Thorvaldsen (1770–1844), *The Lion of Lucerne*: monument to the Swiss Guards of Louis XVI (1819–21), limestone, 9 m. (30 ft.) long, Lucerne

501 Below: Ernst von Bandel, *Arminius* or Hermannsdenkmal (1819–75), statue in copper, 26 m. (85 ft.) high, raised on base 27 m. ($88\frac{1}{2}$ ft.) high, Westphalia, Teutoberger Wald

502 Opposite, left: Vendôme Column—originally the Austerlitz Column (1810), 44 m. (144 ft.) high, winding bronze frieze 290 m. (950 ft.) long in 76 sections, worked by 30 sculptors, Paris, Place Vendôme, destroyed

503 Opposite, top right: John Henry Foley (1818–74), *Asia* (1868), corner group of the Albert Memorial (1863–72), Seravezza marble, London, Hyde Park

504 Opposite, bottom right: George Frampton (1860–1928), Jubilee Monument to Queen Victoria (1897–1901)—architectural setting by Sir George Emerson, bronze, Calcutta, the Maidan, Victoria Memorial

until the column was toppled during the Commune in 1871.

Sculpture located in prime capital city sites could be used to convey to the outside world national power and ambition. Britain's commercial and colonial sphere of influence was celebrated in Queen Victoria's monument to her Consort Albert, emphasizing his pivotal role in the Great Exhibition of 1851. Here sculpture provides a pantheon of the great and the good in the frieze of writers, painters, sculptors, musicians, and architects. But the central statue of Prince Albert underlines the nation's imperial ambition. Colonial domination is implicit in the large corner group *Asia* [**503**].

In the Asian subcontinent itself, sculptural display proclaimed possession and the national identity of the British. In Calcutta the Jubilee Monument to Queen Victoria [**504**] was used as a focal point of the city's Victoria Memorial, one of the grandest statements of imperial domination conveyed through its architecture and wealth of statuary.

AWY

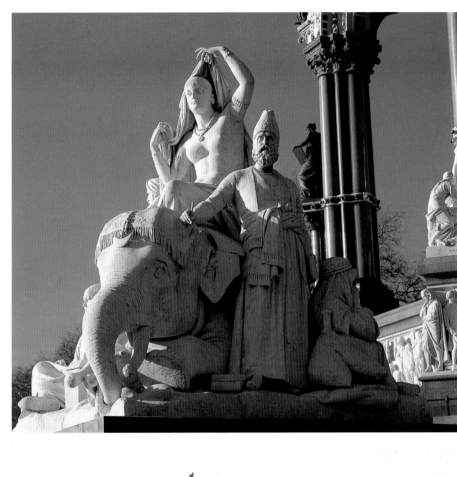

Civic images

Giving the town an image took on a special importance in an age of rapid urban growth. Symbols of authority and tradition were required to offset the often squalid conditions prevailing in nineteenth-century cities, and to provide both citizens and the agents of local government with a sense of identity. From about 1840 an increasing number of statues was raised to those whose achievements were seen to have brought honour to their birthplace. The unveiling of such monuments involved the full panoply of municipal ceremonial. Town halls proudly exhibited paintings and sculptures illustrating the town's history.

In front of the town halls of Calais and Antwerp sculptures by Auguste Rodin and Jef Lambeaux tell respectively of the heroic submission to the English of the medieval *Burghers of Calais* [505], and of Brabo throwing the hand of the giant into the Scheldt, a mythic act which gave Antwerp its name (the Dutch *werpen* means 'to throw' [507].

A less common practice was the glorification of those who had helped to transform the city in modern times. An example may be found in London, in the small monument to the engineer Bazalgette on the Victoria Embankment [506]. But this is far surpassed in variety of imagery by Jules Dalou's monument to the urban planner Jean-Charles Alphand, who is accompanied by his intellectual and artistic collaborators, and also by the manual workers who had physically implemented his improvements [508].

PWJ

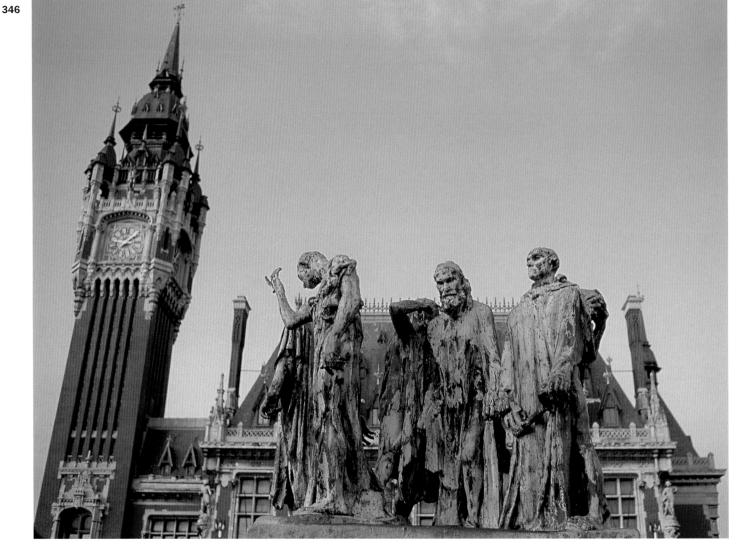

505 Above: Auguste Rodin (1840–1917), *The Burghers of Calais* (1884–95), bronze, Calais, Hôtel de Ville

506 Opposite, top left: Henry Charles Fehr (1867–1940), historical frieze (completed 1913), stone, London, Middlesex Guildhall

507 Opposite, top right: Jef Lambeaux (1852–1908), Brabo Fountain (inaugurated 1887), bronze and stone, Antwerp, Grote Markt

508 Opposite, bottom: Aimé-Jules Dalou (1838–1902), monument to Jean-Charles Alphand (1897), marble, Paris, Avenue Foch

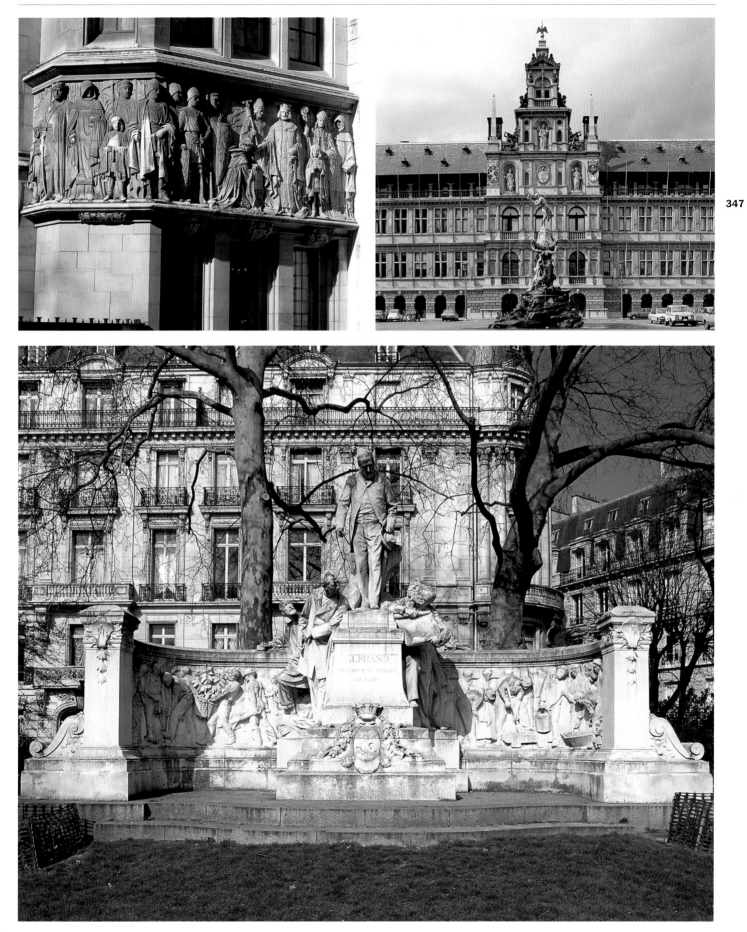

Exhibiting sculpture

Throughout this period new sculpture was shown to the public predominantly in such great national forums as the Paris Salon [**509**] and the Royal Academy in London. Similar, but smaller exhibitions were arranged by local societies for the promotion of the arts.

From 1851, the year of the Great Exhibition [**510**], International Exhibitions staged in the capitals of Europe and America brought together works from all the participating countries. Here statuary was seen against a background of other artefacts, and the industrial sections included sculpture cast in unusual and composite materials, such as vulcanized rubber and *carton-pâte*.

A more discriminating ambience prevailed in the artist's own studio. In the early years of the nineteenth century it was the fashion for foreign visitors to Rome to do the rounds of the studios of prominent artists. Engravings of studios appeared in popular illustrated journals, and sculptors would entertain select visitors with explanations of work in progress [**511**].

In the last decades of the century, commercial dealers began to show sculpture alongside paintings. It was Auguste Rodin who proved on a number of occasions the effectiveness of the one-man show, consisting entirely of his own sculpture and sometimes drawings [**524**]. PWJ

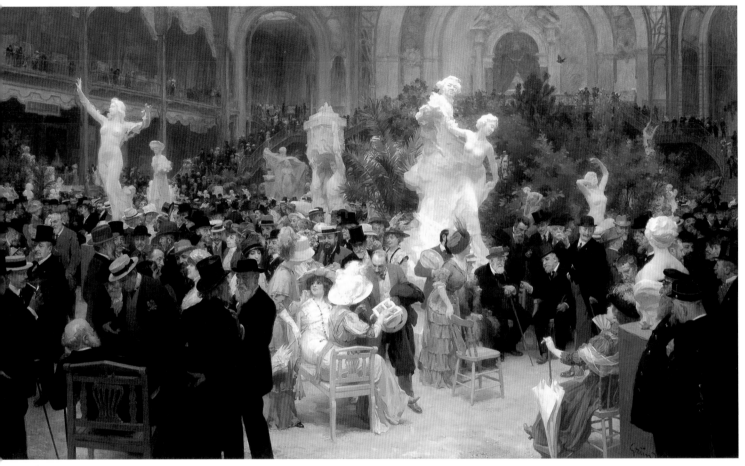

509 Above: Jules-Alexandre Grün (1868–1934), *A Friday at the Salon des Artistes Français* (Salon of 1909), oil on canvas, 3.60 × 6.16 m. (11 ft. 9¾ in. × 20 ft. 2 in.), Rouen, Musée des Beaux-Arts

510 Opposite, top: George Baxter (1804–67), *Gems of the Great Exhibition*, 'Portion of the Belgian Department' (1854), coloured wood-engraving, 12.1 × 24.1 cm. (4¾ in. × 9½ in.), London, British Museum

511 Opposite, bottom: Hans Ditlev Christian Martens (1795–1864), *Pope Leo XII Visiting Thorvaldsen's Studio on S. Luke's Day, 1826* (1830), oil on canvas, 100 × 138 cm. (39⅜ × 54⅜ in.), Copenhagen, Thorvaldsen Museum

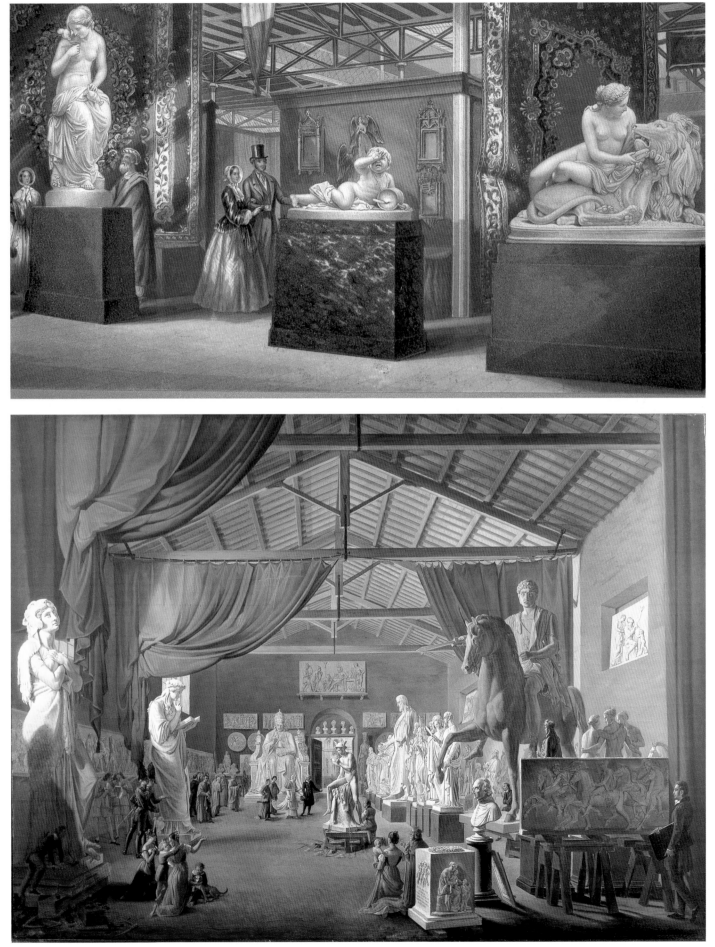

Traditions and revivals

From the later eighteenth century, sculptural production reflected the influence of the new discipline of art history and a fascination with the styles of the European past.

The reason for identifying with a particular period might be personal, political, or religious. Frequently the decision to revive a historical style lay more with the patron than with the artist. It might also be dictated by the context [516].

This is especially true of sculpture forming part of an architectural project. An ambitious undertaking like the new Houses of Parliament in London led to large numbers of sculptors thinking in Gothic terms, and this was still more the case when the reconstruction incorporated surviving parts of earlier building and ornamentation.

As the nineteenth century advanced, the paradigmatic status of Classical sculpture gave way to a more wide-ranging eclecticism. Rather than impose what would have been an alien model, sculptors often sought to enhance local colour. Nineteenth-century tombs in Florence, particularly those of foreign visitors [515], mimic the Renaissance monuments which had begun to make the town a cultural Mecca [514]. Historicism did not necessarily imply a conservative stance. The staunchly republican sculptor Jules Dalou refers to a number of different traditions in his *Triumph of the Republic* [513]. The chariot, with its accompanying personifications, harks back to the designs for French Revolutionary festivities by the painter Jacques-Louis David [512]. PWJ

350

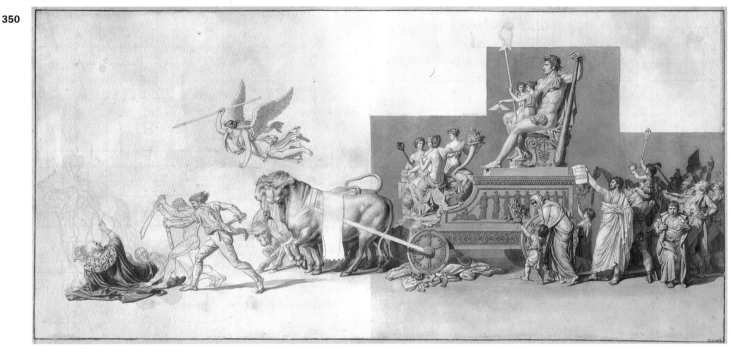

512 Opposite, top: Jacques-Louis David (1748–1825), *Triumph of the People of France* (1794), pen, ink, and wash, 32 × 70 cm. (12⅝ × 27½ in.), Paris, Musée Carnavalet

513 Opposite, bottom: Aimé-Jules Dalou (1838–1902), *Triumph of the Republic* (1879–99), bronze, Paris, Place de la Nation

514 Above left: Bernardo Rossellino (1407/10?–64), monument to Leonardo Bruni (1444), marble, Florence, Santa Croce

515 Above right: Lorenzo Bartolini (1777–1850), tomb of Sophia Zamoyska, Countess Czartoryska (1837), marble, Florence, Santa Croce

516 Left: Jiorné Viard (1823–55), equestrian statue of Antoine, duc de Lorraine (1851), stone, Nancy, Ducal Palace

Materials and technologies

The customary way of making monumental sculptures in this period was to create a model in clay. From the clay a plaster cast was taken, which formed the basis for subsequent interpretation either in marble or bronze. The actual carving was increasingly carried out by specialists. The sculptor would generally supervise operations and might add the final touches. In bronze casting too, division of labour was the order of the day.

The more refined lost-wax method of casting, though revived at the end of the nineteenth century, was to a great extent replaced by sand-casting to produce multiple copies. Sand-moulds, which cannot accommodate forms of great complexity, are destroyed after receiving the bronze. So to facilitate mass-production, original bronze casts were made which could be taken apart, their constituent elements serving as the basis for creating any number of moulds [517]. A few foundries in France and Italy continued to use the lost-wax method for special castings. One of these was the Gonon family firm, and it is Eugène Gonon who is portrayed in Jean-François Raffaelli's painting [520], supervising the casting of Jules Dalou's monumental relief of *Mirabeau Answering Dreux-Brézé*.

By this time, in the latter half of the nineteenth century, electro-magnetic processes were rivalling traditional casting methods. Extended systems of collaboration facilitated the production of such colossal sculptures as The Statue of Liberty [518], made up of a *repoussé* copper skin built initially over a wooden core, but

352

517 Left: Antoine Louis Barye (1795–1875) *Eagle grasping a Heron*, with disassembled parts diagrammed below, bronze, Paris, Louvre

518 Opposite, top left: Frédéric-Auguste Bartholdi (1834–1904), the Statue of Liberty under construction, from *Album des travaux de construction de la statue colossale de la Liberté destinée au port de New York*, Paris (1883), The New York Public Library

519 Opposite, right: Edgar Degas (1834–1917), study in the nude for *Little Dancer Aged Fourteen* (1878–9), red wax and plasticene, 72.4 cm. (28½ in.) high without base, Washington, National Gallery of Art

520 Opposite, bottom left: Jean-François Raffaelli (1850–1924), *At the Foundry* (1886), oil on canvas, 1.28 × 1.16 m. (50⅜ × 45⅝ in.) Lyons, Musée des Beaux-Arts

finally hung upon an elaborately engineered iron skeleton.

Mechanical inventiveness was the most admired feature of such colossal monuments. At the opposite end of the scale, a variety of mechanical devices was used to reduce statuary, so that it could be issued commercially in a range of different sizes suitable for the adornment of the home. The reducing machine of Achille Collas, which made the fortune of the

French bronze founder Frédéric Barbadienne, was compared to the printing press of Gutenberg, because it was supposed to have contributed to the spread of a taste for beauty throughout all classes of society.

In contrast to these highly co-ordinated endeavours, some sculptors in the last quarter of the nineteenth century reverted to direct methods, carved wood, clay and ceramic, and wax. The painter-sculptors

Edgar Degas [519] and Paul Gauguin freed themselves entirely from elaborate workshop practices, and experimented with mixed media and polychromy.

Traditional workshop systems were challenged by these more 'authentic' approaches to sculpture, but survived well into the twentieth century, partly because of the example set by August Rodin, who combined personal vision with elaborate division

of labour. They continued after the First World War, but by the 1920s the divide between believers in direct carving and truth to materials on the one hand and, on the other, the 'official' statuaries, had intensified.

PWJ

353

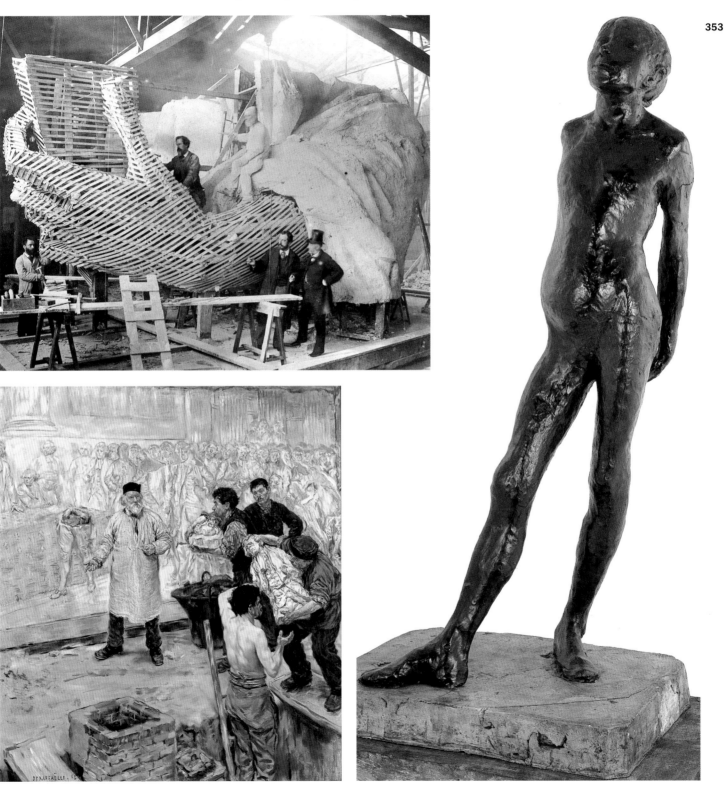

The image of the sculptor

As the processes used for the production of sculpture changed during the nineteenth century so too did the standing of sculptors and the way they were represented.

Towards the end of the eighteenth century Canova [522] was shown with a plaster model for the marble *Cupid and Pysche* (now in the Louvre) while it was being viewed by the painter Henry Tresham, acting as the agent of the Scottish patron Colonel John Campbell, who had commissioned it. By the 1780s Canova had already achieved celebrity as one of the leading artists working in Rome. His fame was to grow still more, making him by 1800 one of the most admired men in Europe and in the process enhancing the reputation of sculpture.

Here he is represented with the model, rather than a group carved in marble, so emphasizing the inventive aspect of the sculptor's work rather than the physical labour of carving.

The sculptor's genius is the subject of Maignan's posthumous image of Jean-Baptiste Carpeaux [521], in which the dying sculptor is shown being visited by his artistic inventions. These include (on the right) his controversial group *The Dance*, erected in 1869 on the exterior of the Paris Opera. Despite the prominence of sculpture in the nineteenth century, attitudes to sculpture and sculptures were ambivalent, involving a tension between the sculptor as an inventive artist (as shown here) and the carver as someone engaged in a mechanical activity.

The American artist Harriet Hosmer [523] was one of a number of nineteenth-century female sculptors,

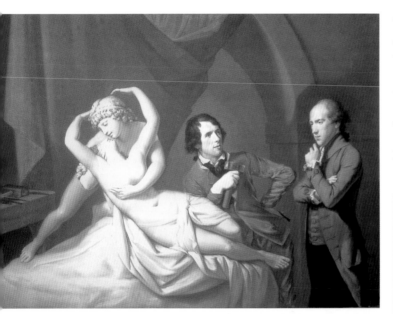

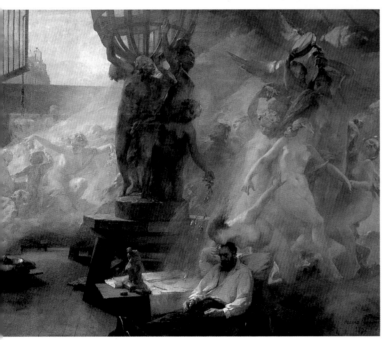

521 Albert Maignan (1845–1908), *Carpeaux* (1892), oil on canvas, Amiens, Musée de Picardie

522 Left: Hugh Douglas Hamilton (1740–1808), *Antonio Canova in His Studio with Henry Tresham and a Model for 'Cupid and Pysche'* (c.1788–9), pastel, 75 × 100 cm. (29½ × 39⅜ in.) London, Victoria & Albert Museum

523 Below: Harriet Hosmer at work on her statue of Senator Thomas Hart Benton (c.1865), photograph, Cambridge, Massachusetts, Schlesinger Library, Radcliffe College

described by Henry James as a 'white, marmorean flock'. This photograph of her on the scaffold with a full-size clay model contrasts Hosmer's appearance as a woman sculptor with that of the 'manly' figure of Senator Benson. Absent here, however, is any evidence of the large team of 24 workmen who helped carve the full-scale marbles or cast the bronze versions. The effect of the full-scale figure was such that when the

fictional Tom Sawyer encountered 'the greatest man in the world (as Tom supposed), Mr Benton, an actual United States senator, proved an overwhelming disappointment—for he was not twenty-five feet high or even anywhere in the neighbourhood of it'.

Few sculptors were more concerned with how they were represented than Auguste Rodin. Numerous photographs were taken of

him with his work. While most show him in his studio, so following an earlier tradition of painted portraits of sculptors, others include him posed among his exhibited works [524], both sculptures and drawings, so relating the sculptor to the display and marketing of his work, rather than its production. MB

524 M. Bauche, Auguste Rodin (1840–1917) in his exhibition pavilion, Place de l'Alma, Paris (1900), aristotype, Paris, Musée Rodin

Sculptural portraits

Portrait busts and statues formed one of the most familiar types of image to be seen in the nineteenth century. Commissioned by individual patrons, civic bodies, and institutions, they were given a prominent place in urban settings. They were also exhibited in large numbers.

Houdon's marble [**525**], executed in France where Franklin represented the newly founded United States, employs a long-established portrait bust convention. Although wearing contemporary dress and distinctive long hair, the sitter is shown without shoulders and facing frontally. The public functions of the portrait bust (continued through the use of this image on banknotes and postage stamps) are here combined with an image of a more private, interior self through an intensity of expression and subtlety of carving that invite close and sustained viewing.

Rauch's plaster double portrait of the German statesman and historian Barthold Georg Niebuhr and his wife [**526**] was the model for a marble relief for the couple's tomb monument, continuing a familiar association of sculptural portraiture with commemoration. The relief composition representing the half-length husband and wife hand-in-hand and in Classical dress is based on Antique reliefs commemorating married couples, considered particularly suitable for a monument to a historian of ancient Rome. Although the faces are idealized, Rauch at the same time represents the deceased couple as distinctive individuals. A traditional form of portraiture is here adapted to form an image appropriate to early nineteenth-century Prussia.

Though primarily used for por-

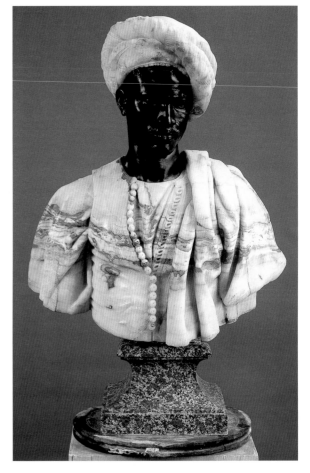

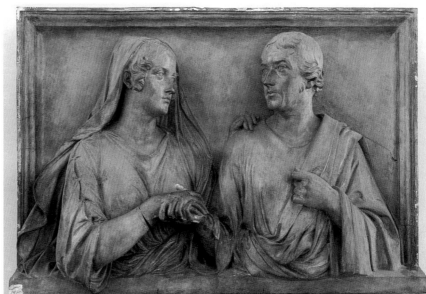

525 Above: Jean-Antoine Houdon (1741–1828), *Benjamin Franklin* (1778), marble, H. with base 57.15 cm. (22½ in.) H. without base 19.05 cm. (17½ in.) New York, Metropolitan Museum of Art

526 Right: Christian Daniel Rauch (1777–1857), relief portrait of Barthold Georg Niebuhr and his wife (1838–41), plaster, painted brown, 45 x 68 cm. (17¾ × 26¾ in.), Berlin, Skulpturengalerie

527 Above: Charles-Henri-Joseph Cordier (1827–1905), *Sudanese in Algerian Dress* (1856–7), marble, onyx, and bronze, 66 cm. (26 in.) high, Paris, Louvre

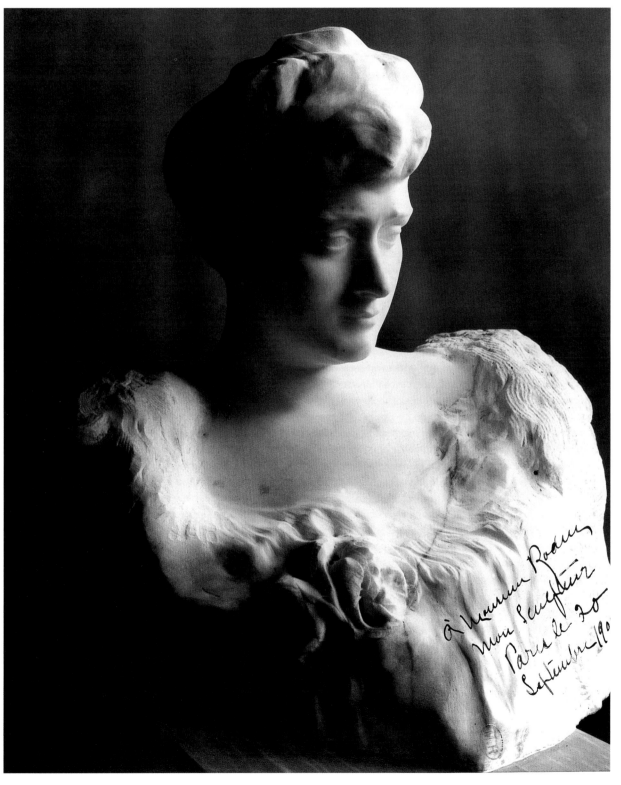

traits of specifically named individuals, the bust form was also employed to characterize racial type in accord with the theories of mid-nineteenth-century ethnography. In 1850 Cordier was commissioned to make a number of busts of the peoples of North Africa as specimens for an ethnographic gallery in the Musée d'Histoire Naturelle in Paris [527]. Cordier's rich, mixed-media busts utilizing materials from both Europe

and the French colony Algeria (where he made his initial studies) were popular in Second Empire France, despite a critical reception that found them difficult to place between the topographical accuracy of the 'low' art of the waxwork and the high level of technical skill and idealism of form encountered in 'high' art.

While retaining the notion of individual likeness, Rodin [528] rejected the conventional formats

used for the portrait bust. Instead of representing the neck and shoulders of the sitter and assuming that the spectator would recognize this as a familiar way of portraying an individual likeness, he draws attention to the fictive nature of the image through the roughly shaped block of marble from which the portrait is carved. This photograph is inscribed to the sculptor by the sitter, who later gave her collection of works

by Rodin to the National Gallery of Art, Washington. MB

357

528 Right: Jacques-Ernest Bulloz (1858–1942), Rodin's bust of Mrs Simpson (*c.*1904), gelatin silver print, Paris, Musée Rodin

Early lithography

Lithography, invented in 1798 and based on the antagonism of grease and water, became one of the most significant printmaking techniques of the modern era. The image is made in any greasy medium on a limestone slab (or zinc plate), and 'etched' into the stone with nitric acid and gum arabic. Wetting the stone prevents the image from encroaching into unmarked areas, and ink adheres only to the greasy marks. Lithographs are printed on a press with a scraper bar that moves across the back of the paper.

Fast, efficient, and relatively durable, lithography was readily adapted for commercial and reproductive purposes. Fine art lithography developed more slowly. Before 1850, perhaps the most impressive lithographs were Daumier's political prints, inserted into Philipon's journals or, like *Rue Transnonain le 15 avril* [**529**], sold to subscribers in his 'Monthly Association', formed to offset censorship fines. *Rue Transnonain* depicts a government massacre of workers as they slept. Political expression has always been an important aspect of lithography.

Nineteenth-century colour lithographs were often commercial images or reproductions (chromolithographs or 'chromos'). But towards the end of the century, original colour lithography blossomed with Lautrec's posters of Montmartre entertainers [**530**]. Although they functioned as advertisements, they were also collected as prints. LCH

360

Lithography
Left: An artist draws on a stone or zinc plate with a greasy medium.
Centre: the stone is 'etched' with a mixture of nitric acid and gum arabic to set the image.
Right: The stone is wetted down, inked, and printed—greasy areas hold the ink and transfer it to the printed sheet.

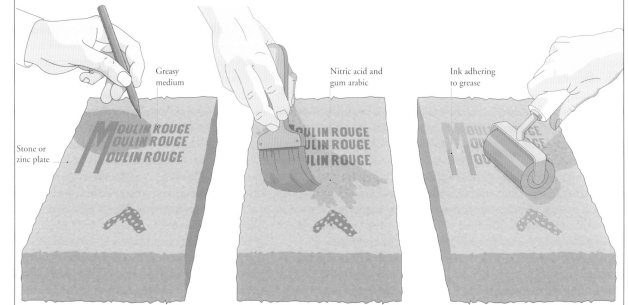

Greasy medium

Stone or zinc plate

Nitric acid and gum arabic

Ink adhering to grease

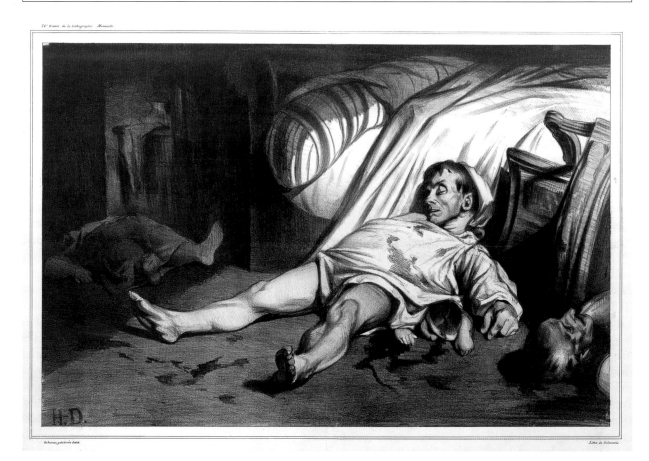

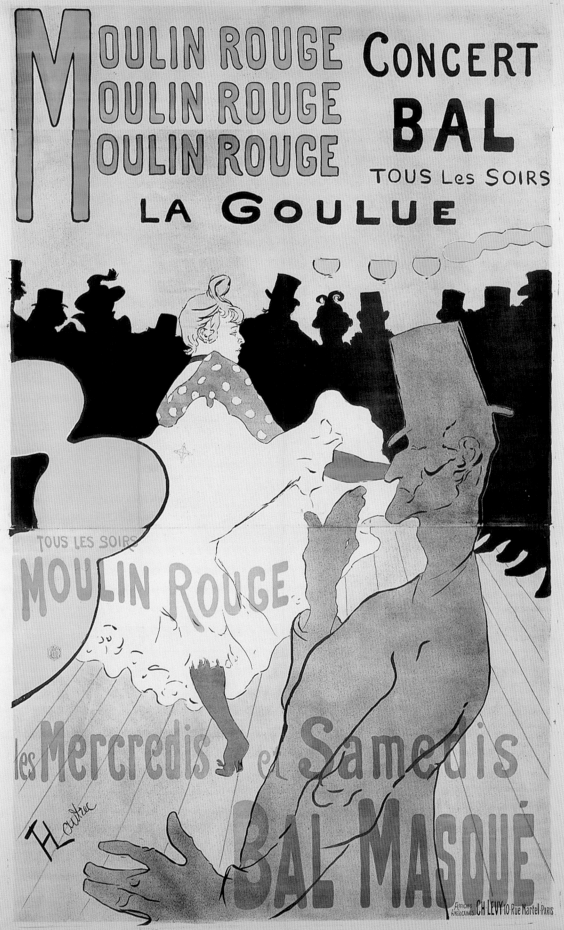

529 Opposite: Honoré Daumier (1808–79), *Rue Transnonain le 15 avril 1834* (1834), lithograph, plate 24 from 'L'Association mensuelle' 29 × 46 cm. (11½ × 18⅛ in.), Washington, National Gallery of Art

530 Right: Henri de Toulouse-Lautrec (1864–1901), *Moulin-Rouge: La Goulue* (1891) colour lithograph on two sheets, 1.91 × 1.17 m. (6 ft. 2 in. × 3 ft. 8 in.), Chicago, Art Institute

Original etching

Etching continued to be the primary technique for original printmaking in this period. William Blake defied his training as a reproductive engraver by using relief etching (the etched parts of the plate do *not* hold ink) and hand-colouring for his illuminated books that seamlessly combine word and image [**531**]. Goya achieved startling tonal contrasts with aquatint etching in his three major print series. The *Disasters of War* depicts the catastrophic events of the Peninsular War and castigates the reactionary forces in Spain [**534**]. Although it ends hopefully, it is an overwhelming statement of the tragedy of war.

Around 1860, an enhanced awareness of the original etching was fostered by publisher Alfred Cadart, who redefined etching against reproductive prints and photography. The etching revival marketed prints by promoting spontaneity, rarity, and variation in impressions [**533**]— through changes in the plate itself (states), inks, wiping techniques, and papers. It revered Rembrandt [**367**] as the quintessential *peintre-graveur*, and raised consciousness of all forms of the print as original, collectable works of art.

Subsequently, major painters such as Impressionist Mary Cassatt took a newly experimental approach to printmaking. Her series of colour aquatints of 1890–1, based on compositional principles of Japanese woodcuts, record contemporary women's lives [**532**]. LCH

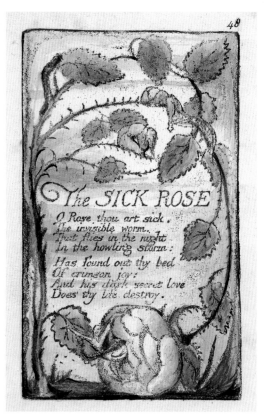

531 William Blake (1757–1827), *The Sick Rose* (1794), from *Songs of Innocence and of Experience* (1789), relief etching with pen and watercolour, 19.1 × 13.3 cm. (7½ × 5¼ in.), New Haven, Yale Center for British Art

532 Mary Cassatt (1844–1926), *The Bath*, seventeenth state (*c*.1891), drypoint and soft-ground etching in yellow, blue, black and sanguine, plate 31.9 × 24.9 cm. (12⁹⁄₁₆ × 9¹³⁄₁₆ in.), sheet 36.7 × 27.5 cm. (14⁷⁄₁₆ × 10¹³⁄₁₆ in.), Washington, National Gallery of Art

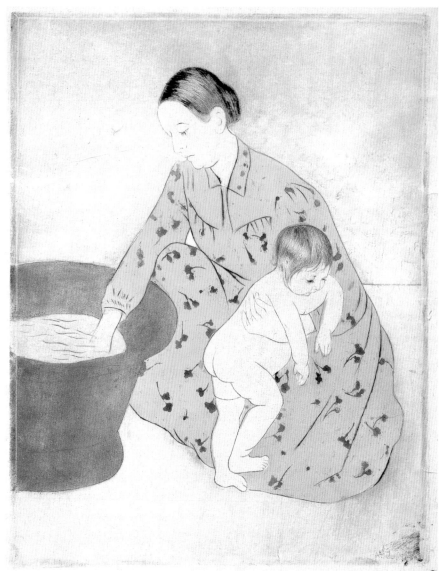

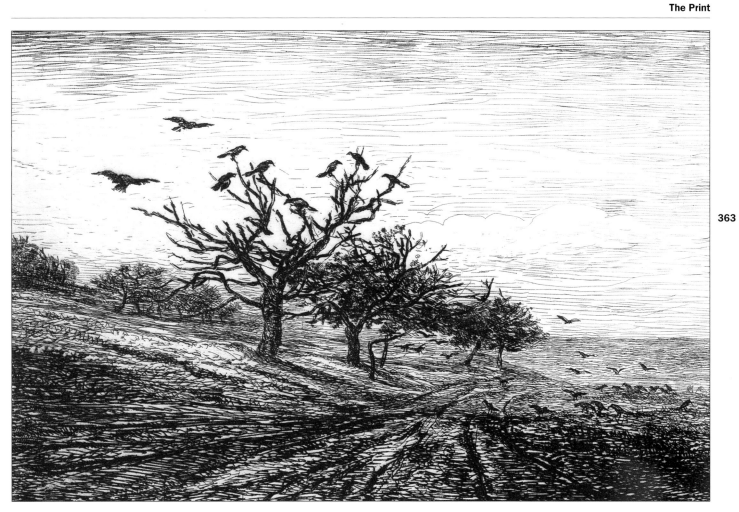

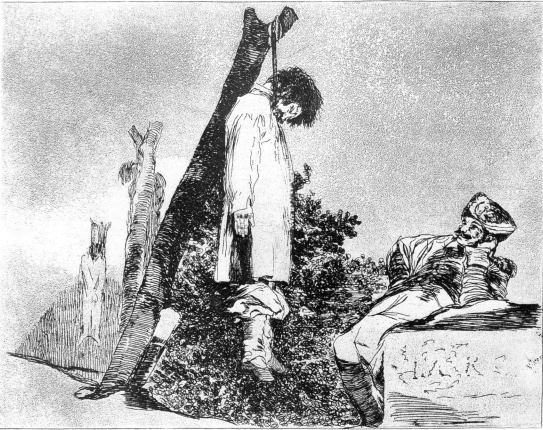

533 Above: Charles-François Daubigny (1817–78), *Tree with Crows* (1867), etching, 18 × 27.8 cm. (7⅛ in. × 11 in.), New Haven, Yale University Art Gallery

534 Francisco de Goya (1746–1828), *Tampoco (Not in This Case Either)* (c.1810–14), Plate 36 from the *Disasters of War*, etching and aquatint, 15.5 × 20.5 cm. (6⅛ × 8 in.), New York, Metropolitan Museum of Art

From Symbolism to Modernism

Symbolist artists Paul Gauguin and Edvard Munch were crucially important for relief printmaking. They shared a love of the textures of wood, incorporated into the formal conceptions of their prints, and both experimented with inking and printing blocks. With his jigsaw method of cutting blocks apart and printing the parts in different colours and on varied papers, Munch achieved an extraordinary variety of impressions in his woodcuts. Gauguin's suite of Tahitian woodcuts loosely accompanying his text *Noa Noa* [535] is a revelation of the expressive power of relief print-making. The primitivistic yet delicate carving and vague, suggestive print-ings by Gauguin and his son Pola (b. 1883) could not contrast more with the ubiquitous wood-engraved illustration—the typical relief print of the nineteenth century.

Wood-engravings were often designed for journals by major artists such as Winslow Homer, but they were carved on end-grain blocks of wood by artisans working collabor-atively to produce the crisp, detailed images against which Gauguin and Munch reacted. Homer's designs, however, often commented upon or even critiqued the texts that they illustrated [536].

With their radically new tech-niques and primitivistic or angst-ridden visions of the human condition, Gauguin and Munch inspired the first major German Expressionist group, Die Brücke, founded in Dresden in 1905. Under the leadership of Ernst Ludwig Kirchner (1880–1938), Brücke artists developed a complex

364

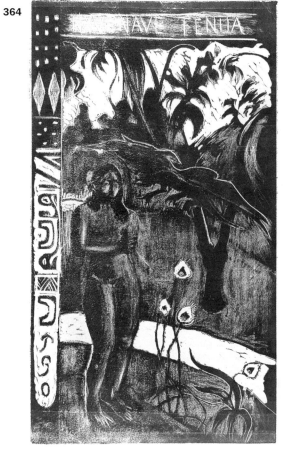

535 Above: Paul Gauguin (1848–1903), *Nave Nave Fenua (Delightful Land)* (1894–95), from the *Noa Noa Suite*, woodcut, 35.6 × 20.3 cm. (14 × 8 in.), Washington, National Gallery of Art

536 Above right: Winslow Homer (1836–1910), *The Army of the Potomac—A Sharp-Shooter on Picket Duty*, for *Harper's Weekly*, 15 November 1862, wood-engraving, 23.3 × 35 cm. (9⅛ × 13¾ in.), The New York Public Library

537 Right: Käthe Kollwitz (1867–1945), *Woman with Dead Child* (1903), etching, soft-ground etching, with gold tone printed litho-graphically, 42.2 × 48.7 cm. (16⅝ in. × 19⅛ in.), London, British Museum

vision of the modern print as a politically communicative vehicle that was still a collectable object, albeit with unconventional aesthetic criteria. Brücke artists handled printmaking rawly and 'incorrectly', inking the edges of lithographic stones, for example, and pursuing Munch and Gauguin's innovative approach to woodcut, but more aggressively. Through various themes, such as the image of a corrupt modern city [**538**],

Brücke prints expressed hope that art could transform a tired society.

Käthe Kollwitz is the most distinctive independent Expressionist printmaker in the late nineteenth and early twentieth centuries. Following Goya and Daumier, she produced a prolific body of graphic art in all media, focusing on the hardships of the urban proletariat and the plight of its women and children that she witnessed through her husband's practice as a

doctor in Berlin. For Kollwitz, a socialist, prints were vehicles of social and political reform, but she was also a superlative draughtsman and graphic technician. Her intaglio prints are especially notable for their aesthetic beauty and technical subtlety [**537**].

In the first decade of the twentieth century, Expressionism made the most effective use of printmaking, but it was also important for other avant-garde movements. Pablo Picasso was one of

the most innovative printmakers of the first half of the twentieth century. His graphic career began with works such as *The Frugal Repast*, an etching of 1904, and his Analytic Cubist prints (*c*.1910–12) that conveyed the ephemeral quality of this style [**539**]. Picasso would continue to experiment with lithography, linocut, and aquatint etching during the course of his long career. LCH

538 Ernst Ludwig Kirchner (1880–1938), *Women on Potsdamer Platz, Berlin* (1914), woodcut, 52 × 37.5 cm. (20⅜ in. × 14¾ in.), Berlin, Staatliche Museen zu Berlin-Preußischer Kulturbesitz, Kupferstich-kabinett

539 Pablo Picasso (1881–1973), *Mademoiselle Léonie Seated on a Chaise Longue* (1910), Plate III of *San Matorel* by Max Jacob, etching and dry-point, 19.7 × 14.1 cm. (7¾ × 5½ in.), Cambridge, Massachusetts, Fogg Art Museum, Harvard University Art Museums

Photography

The earliest photographs are modest, of commonplace subjects simply stated. The first, taken in 1822 by Nicéphore Niépce (1765–1833), is a view of rooftops seen from an upper window in Le Gras, near Châlons-sur-Saône. Niépce, a French civil servant, devised a way of taking positive pictures on metal plates coated with an emulsion made from bitumen of Judea, which was a kind of asphalt, dissolved in oil of lavender. Another early picture by Niépce—from 1829 and on a glass plate—is of a table top, with a white cloth, wine bottle, and a place setting for one. The first negative by William Henry Fox Talbot (1800–77), dated 1835, features a latticed window in his home at Lacock Abbey. Hippolyte Bayard, who in 1839 found a way of making positive prints on silver chloride paper, took several pictures of windmills in Montmartre in Paris.

The year 1839 was an important year in the history of the medium, for it was then that Fox Talbot in England and Louis Jacques Mandé Daguerre (1787–1851) in France published their respective photographic processes. Fox Talbot introduced what he called 'photogenic drawing', which at first involved placing an object, such as a leaf, on a sheet of sensitized paper and then exposing the paper to light. Further chemical treatment halted the process and the resultant negative image was placed over another sheet of sensitized paper to produce a positive. This was then subject to chemical enhancement or 'physical development' [540, 541, 543]. The most significant consequence of the negative–positive process was that it allowed any number of positives to be made from a single negative. In Daguerre's system [542], on the other hand, each picture was unique, and had to be copied and reproduced by wood-engraving, for instance. Daguerreotypes also showed the image reversed. They were taken on silver-coated copper plates which had been treated with iodine and bromine vapours, making a light-sensitive halide. After exposure the plate was developed over a dish of heated mercury, and the image was then fixed in sodium thiosulfite. They also had to be protected under glass. By 1840–1 the process had been refined and speeded up sufficiently to be used for portraiture, and despite its obvious disadvantages remained in use for portraiture until the mid-1860s, especially in the USA. During the 1840s Daguerre's process was popular, in part because the French government compensated the inventor and offered the process free to the world. Fox Talbot, by contrast, took out patents throughout the 1840s and tried to control and to benefit commercially from his discovery.

Fox Talbot called his positive prints 'calotypes', from the Greek *calos* (beautiful). They were made on uncoated paper soaked with light-sensitive silver salts: silver chloride, but sometimes silver iodide, silver bromide, or silver oxalate. The salts were not immediately light-sensitive, and had to be sensitized by exposure to silver nitrate just before use. Calotypes often have a ghostly or ephemeral look, as if the image is barely registered on its paper base. The process was complicated and most easily undertaken by scientists, chemists in particular. Negative–positive photography remained laborious until the 1870s, when industrially prepared dry gelatin plates began to be marketed.

There was constant technical development from the beginning. In the early 1850s, for instance, the great French photographer Gustave Le Gray (1820–62) invented waxed paper negatives. He applied rice water, sugar of milk, iodide of potassium, cyanide of potassium, fluoride of potassium, white honey, and egg-white to waxed paper, which was then sensitized with an acid solution of nitrate of silver and developed with gallic acid. These negatives could be prepared up to two weeks before use and developed several days after exposure. In the 1840s, by contrast, negatives had to be prepared on the day before use and developed immediately after exposure. Le Gray worked for the Committee of Historic Monuments in France, and the waxed paper process made it much easier to take pictures in remote localities. Waxing produced sharper images, which was also true of albumen printing, another development of the 1850s. In this process paper was treated with a mixture of salt and egg-white and allowed to dry, before being sensitized with silver nitrate. At first albumen was diluted with salt water to give a matte effect, like that in the salted paper prints of the 1840s, but this was soon discontinued in the interests of more and more lustrous effects. Albumen was also applied to glass plates to produce negatives with enhanced definition. Collodion, too, was introduced in the 1850s. This was a medium made from guncotton dissolved in ether and named after the Greek word *collos* (glue), and it served as a basis for new emulsions which cut down substantially on exposure times.

Fox Talbot's attempts to control the new medium were inhibiting—in Britain at least. In 1844 he set up an organization to print pictures on a commercial scale for use as book illustrations, but the venture failed because early calotypes tended to fade. In Britain the process was used during the 1840s mainly by amateurs. It was in France, oddly enough, that photography by the negative–positive process was most thoroughly improved. The French had been at first infatuated by Daguerre's invention, but from 1844 Louis-Désiré Blanquart-Evrard (1802–72), a businessman and chemist from Lille, began to experiment with photography on paper. He managed to make prints far more

resonant than anything achieved by his contemporaries in Britain. His successes encouraged further experiments in France, and led to an appreciation of photographic prints as artworks in their own right. The painters Charles Nègre (1820–79) and Gustave Le Gray took up photography, and in 1852 Nègre carried out a photographic survey of the French Midi, published in 1854–5 in Paris by H. de Fonteny's Imprimerie Photographique.

Another important year was 1851. Not only did de Fonteny set up his printing firm in Paris but Blanquart-Evrard too went into business as a printer in Loos-lès-Lille. Between them they did the printing for a number of admirable topographical and archaeological books during the 1850s. In addition to printing the pictures for Nègre's book on the Midi, de Fonteny contributed to the *Album des Pyrennées* (1853) by Viscount Joseph Vigier (d. 1862) and to the magnificent *Egypte et Nubie* (1858) by Felix Téynard (1817–92). Blanquart-Evrard made the plates for *Egypte, Nubie, Palestine et Syrie* by Maxime du Camp (1822–94), *Le Nil* (1854) by John Beasley Greene (*c.*1832–56), and *Jerusalem* (1856) by Auguste Salzmann (1824–72). Maxime du Camp had been sent to Egypt and Palestine in 1849–51 by the Ministry of Public Instruction to photograph ancient sites—accompanied by the writer Gustave Flaubert, who detested Egypt. There had been previous photographic excursions to the East in 1845–6, most notably by Fox Talbot's connections, Calvert Richard Jones (1804–77) and the Reverend George Bridges (1788–1864) in 1845–6. Many thousands of negatives were exposed, and many of them printed by Nicolaas Henneman, Fox Talbot's assistant. Bridges intended a book on Palestine, but in the end nothing emerged.

Salzmann's *Jerusalem* was Blanquart-Evrard's last book. The business closed, for financial reasons, and its closure marked the end of an era in photography. In pictorial terms it might be called the Age of Representation, for all those involved were fascinated by the process of picturing and even by representation for its own sake. Fox Talbot, in his book of calotypes and commentaries of 1844–6 called *The Pencil of Nature*, remarked: 'The picture, divested of the ideas which accompany it, and considered only in its ultimate nature, is but a succession or variety of stronger lights thrown upon one part of the paper, and of deeper shadows on another.' He suggests that there are ideas implicit in his pictures, which may be the case, but most pictures from the 1840s and 1850s are about little more than 'stronger lights' and 'deeper shadows' or about how things appear in photographs. It was an imperfect medium, at least by comparison with painting, and photographers had to make do with lights and shadows available. They were attracted

to the kinds of things which would show themselves well in photographs, and Calvert Richard Jones, for instance, took many pictures of beached ships as sculptural items defined by highlight and shadow. Portraits, too, were made according to the same premises, especially by the Scottish calotypists David Octavius Hill (1802–70) and Robert Adamson (1821–48). The two worked together until Adamson's death in 1848, and from 1843 collaborated on a series of portrayals of men, women, and children from the fishing community of Newhaven, near Edinburgh [**543**]. The pictures may have been intended to illustrate a charitable appeal, for fishing was a dangerous business; but they survived less because of any documentary element than because of the kind of evidence they offer to the eye. The men wore dark jackets and white canvas trousers, and the women shawls and skirts made from a black and white striped material, as if they had dressed to suit the limitations of the camera. They appear contoured, especially the women, which made the pictures attractive to modernist audiences in the 1920s and 1930s.

Photography's aesthetic until the late 1850s was both liberal and romantic. It was addressed to individuals who were asked to attend carefully to decipherment of the picture and to its possible meaning, to what Fox Talbot called 'the ideas which accompany it'. Spectators were asked to take responsibility for the working out of pictures, a task which was made all the more difficult by the inclusion of 'a multitude of minute details which add to the truth and reality of the representation, but which no artist would take the trouble to copy faithfully from nature'— with respect to his famous picture of *The Haystack* [**540**]. The 'minute details' in this instance are not many—a ladder and a hay-knife principally—but they take time to discern, or long enough to register a memory from Isaiah (40: 6) that 'All flesh is grass', and transient in relation to the word of God. Photography's meanings surface, that is to say, but as no more than troubling possibilities remembered, perhaps, from scripture.

The era of salt prints and waxed negatives passed away during the late 1850s, although not entirely because of the coming of albumen and of collodion with its shortened exposures. The pioneers were, in effect, members of an avant-garde. Many of the British calotypists either knew or were related to Fox Talbot. The great French photographers of the 1850s had trained together in Paris in the late 1840s, particularly in the studio of the painter Paul Delaroche (1797–1856). Principally, though, photography began to develop a public. Major events such as the Great Exhibition in London in 1851 and the Exposition Universelle of 1855 in Paris helped to bring a mass audience into being, and this new audience was served

above all by the stereograph, a development of the late 1850s often only grudgingly acknowledged in histories of the medium.

Stereographs are vulgar and commonplace, and hardly look as if they should play an important role in any major history. In 1850 Sir David Brewster (1771–1868) invented a hand-held viewing stereoscope which made it possible to view twin pictures through paired lenses. The result of the two pictures combined is a miraculous sense of real depth, with three-dimensional objects realized in the foreground as they might be in a diorama against very distant horizons. Many millions of stereocards were produced, from the 1850s until the 1930s, and the process is usually accorded its own history, as if it were unassimilable into the normal aesthetic history of the medium. It has always been difficult to give aesthetic credibility to such a promiscuous art. Street scenes, scraps of coral, stones, huts, trees, and planetary bodies are examples of a subject-matter which changed by the season. Manufacturers introduced refinements, which made stereocards more amazing than ever. In particular they made gaps in the card on which the picture was laid, and into these gaps inserted coloured membranes behind, for instance, street-lamps and windows. An adjustment in light levels would then transform daylight into dusk punctuated by gaslight. Stereo manufacture spread to take in all subjects imaginable, from the most sober geographical surveys to manufactured tableaux featuring ghosts, skeletons, and knights in armour. Thousands of companies were established: most notably the London Stereoscopic Co., E. Anthony (1818–88) and H. T. Anthony (1813–84) in the USA , and Léon Levy in Paris. Stereo statistics given by historians are phenomenal: in 1862, for instance, the London Stereoscopic Co. sold more than 300,000 views of the International Exhibition in London within six months. Charles Pollock, a Boston manufacturer, claimed in the early 1870s that his factory produced between three and four thousand stereographs per day. By 1900 the two major stereo companies in the world were both American: that of Underwood & Underwood, set up in 1882, and the Keystone view company founded by B. L. Singley, from Meadville, Pennsylvania.

The stereo revolution had many consequences. It spelled out what had been implicit in photography from the beginning, that representation was interesting in its own right and more or less indifferent to categories. Passers-by, tea-pickers, a rhinoceros, stones, and a fallen log could all be represented, and in a stereo a log might be as impressive as any exotic beast. For a long time any topic sufficed and stereo 'artists' were free to invent new categories promiscuously, as long as such subjects could be arranged in depth. A favourite stereo genre was that of the Alpine guide, in a dark suit at the head of a string of clients disposed in depth against snow and ice [549]. It seemed, however, that the public had lost or never developed any powers of discrimination and it was decades before news and geography emerged as dominant genres. By the 1890s stereo operators were beginning to cover major events: the Spanish-American War of 1898, the Boer War of 1899–1902, and the Russo-Japanese War of 1904. They made introductory series on geography and history, and established the terms of reference which would obtain in the illustrated press as it developed in the 1920s and after.

Stereo culture was disquieting. Photography in the 1840s and 1850s had been a minor medium, specific to artists and amateurs. Commercially it made little impact, and even the ground-breaking pictures from Roger Fenton (1819–69) of the Crimean War in 1855 failed to find buyers. Yet apparently a public existed, interested in anything but high culture. High culture was sufficiently stung to respond, and even to steal some of the trappings of this ubiquitous new art. Stereos presented distinct items: a dog in front of a kennel in front of a house. Henry Peach Robinson (1830–1901) [552], a British art-photographer, determined to outdo stereo aesthetics by assembling composite prints, taken from a series of separate negatives. Robinson was trained by a Swedish photographer working in Britain, Oscar Rejlander (1813–75), whose major work, *The Two Ways of Life* (1857), was a combination print based on Raphael's *The School of Athens* (1511). Rejlander's choice was between virtue and vice, or between virtuous self-control and a lascivious world of the senses and of idle curiosity—the world of stereo culture. Robinson's topics were extreme and affecting states of mind: death, for example, was at issue in 1858 in *Fading Away*, an early combination print made from five negatives. Robinson was also impressed by the poetry of Alfred Lord Tennyson, and in 1861 illustrated the tragic story of *The Lady of Shalott,* a self-isolated heroine finally destroyed by exposure to the charms of everyday life—another stereo fable by stealth. Robinson's successor and contemporary in art was Julia Margaret Cameron (1815–79), a self-taught photographer even more impressed by Tennyson than was Robinson. A typical Tennysonian subject from her list is *The Farewells of Lancelot and Queen Guinevere* [551] of 1874: lovers sworn to physical abstinence. Cameron's art was typological, which is to say that she believed in the re-emergence of personalities and of types. She took pictures of contemporaries as biblical notables, as King Jephthah or King Ahasuerus as it were reborn, and subject to the same tragic destiny as their precursors. Cameron's subjects, permeated by the grandeur of their originals, belonged to a world apart—or apart, at least, from that of the average stereo culture with its insatiable appetite for pure spectacle.

In France, too, the new public culture was transcended, in particular by the portraitist Gaspard Félix Tournachon (1820–1910), best known under his pseudonym Nadar. His brother Adrien (1825–1903), with whom he originally collaborated, had been instructed in the early 1850s by Gustave Le Gray. Nadar established himself as a portraitist in Paris in the late 1850s, and took pictures of most of the outstanding artists, writers, musicians, and bohemians of the age. They presented themselves to his camera for the most part impassively against plain backgrounds, Eugène Delacroix, photographed in 1858, holds a Napoleonic pose. Nadar's aesthetic was backward-looking and romantic, premissed on individualism of a strength which would be impervious to the distractions of the new age. Nadar's pantheon helped to establish an idea of Frenchness invoked in later periods of crisis.

In the USA where stereo culture was most welcomed and developed there was a response of sorts in the survey photography of the 1860s. The USA was a special case for the Civil War of 1862–5 had led to an unprecedented organization of American photography. Operatives, employed by Mathew Brady

(*c.*1823–96) and then by Alexander Gardner (1821–82), photographed the Northern war effort in general and with special reference to feats of engineering and provisioning. Several of the photographers who undertook this work—most notably Timothy O'Sullivan (1840–82)—subsequently volunteered for geological surveys of the American West: with Clarence King's Geological Exploration of the Fortieth Parallel, 1869–72, and with Lieutenant George Wheeler's Survey of Idaho, Utah, and Arizona, undertaken in 1871. Survey pictures of broad deserts and wild mountain scenery complemented the business landscapes which characterized the Civil War and the new stereo vision of New York as a bustling metropolis—as seen in the work of the E. & H. T. Anthony Co., for example [**547**, **548**].

The stereo revolution brought an agenda to photography. Quite casually it introduced a range of new genres: street pictures, for instance, and documentary. Stereo pictures themselves, though, seemed incapable of development. A firm such as the Anthony Co. of New York might make more and more pictures of the city's streets, but they all tended to look the same; and stereo operatives never became recognized artists. Nevertheless, the implications of the stereo revolution were taken up and expanded elsewhere. Everyday life had been shown to be interesting, even if in stereocards it looked like no more than passing traffic. Photography's response was the panoramic camera which was able to show the everyday to excess, even as an epic. The sight of fifty or sixty people sauntering across a panoramic frame expressed the concept of the everyday much more emphatically than stereo aesthetics had done. Panoramic photography was taken up in Britain in the 1890s by George Davison (1854–1930) and A. H. Robinson (1864–1930), both of whom used the new Kodak panoramic equipment.

Stereo vision introduced objects in what looked like real space with discernible gaps between. It suggested that time and space could somehow be accessed even more thoroughly than before, and in the USA Edward Muybridge (later Eadweard Muybridge), an Englishman, set himself the task of investigating instantaneity. He had made commercial stereo pictures in San Francisco, in Woodward's Amusement Park, of acrobats, statues, and preserved animals. He applied himself to taking multiple pictures of figures in motion, to see how exactly horses galloped or men ran, boxed, or wrestled. His specimens acted against calibrated backgrounds, there for the sake of making measurements, and later on—from the 1940s—these often bizarre scenes came to stand for a vitiated objectivity, or mankind as mechanism. Muybridge's experiments continued into the 1890s, and they were paralleled in France by those of his exact contemporary, Étienne Jules Marey (both 1830–1904). Their researches, especially those of Marey, contributed to the development of film proper—moving pictures.

Stereo vision was distinctive. It dealt in illusions as nothing else did. Cards placed in a machine were nothing in themselves, but gave rise to a beguiling impression of space which had little to do with the kind of pictorial art practised by the calotypists of the 1840s. Phenomena, it seemed, were sufficient, but the effect was to belittle audiences who were deprived of the opportunity to read and to reconstruct, as was always the case in front of the pictorial photography of the pioneers. The result was a revival of pictorialism, although not exactly in the terms of the calotypists. The pictures of Hill and Adamson were rediscovered and printed in the 1890s by one of the new art photographers, James Craig Annan (1864–1946). The original pictorialism was structural, dependent on gauging, the recalculation of an original appearance by means of natural signs—mainly highlights and shadows. The new pictorialism was, by contrast, spiritual. It proposed that the photographer was an artist capable of special access to phenomena, gifted enough to detect harmonies underlying appearance. Somewhere amongst all the empirical details which came photography's way there was an ideal version, which might either be detected in things or even projected on to them—the Pictorialists, as they were known, were never quite sure. Empirical evidence, what Fox Talbot called, apropos of *The Haystack*, 'a multitude of minute details', was treated as distraction and suppressed as far as possible by soft-focus. The Pictorialists—Alvin Langdon Coburn (1882–1966), George Davison, Robert Demachy (1859–1936), J. C. Annan, Alfred Steiglitz (1864–1946), Clarence White (1871–1925), and many others—all believed in the primacy of harmonic formats, expressed in framing, repetition, and ideal proportional systems. The truth was to be sensed rather than seen, and this meant that they easily understood their pictures as metaphors. Harmonies could, of course, be best detected in nature undisturbed, in the woods, on the coast, or among the mountains, but the Pictorialists specialized in the city, too, in part because it would be imagined as an organism held together by forces which could only be sensed: telephony and all those other force fields which integrate the profusion of the city.

X-ray photography was also part of the background to the new Pictorialism. It had been discovered by Wilhelm Röntgen (1845–1923) in 1895, and X-ray pictures were published very soon afterwards—compelling evidence of an underlying invisible reality. Photography's other great achievement was amongst the stars, which had been on the agenda since the outset. In 1887 astronomers world-wide decided to make a photographic chart of the heavens on a uniform plan. The picturing of the spiral nebulae of Orion and Andromeda around 1890 was another major event.

Photography, however, soon countered Pictorialism with a new challenge, long expected. In 1907 the French inventors Auguste and Louis Lumière introduced a colour transparency process, called 'Autochrome'. This involved powdering one side of a glass plate with starch grains coloured red, blue, and green. The grains were covered with panchromatic emulsion. Autochromes were beautiful, and continued so until they were discontinued in the 1930s, but they revived the problem which had worried the Pictorialists, because they restored phenomena to pride of place. Now, though, after 1907, the phenomena were no longer the rocks and stones and trees of the stereo revolution, but surfaces and atmospheres: tinted mist, oranges and lemons, delicious and aromatic surfaces of all sorts. The world might be appreciated as never before but scarcely analysed and understood, or consumed but not controlled. Colour's hedonism was, in fact, out of step with the ethos of a period increasingly preoccupied by social and national questions, news and information. Colour, with its value-free implications, continued to signal hedonism and to hint at degeneracy. IJ

Pioneers

Pioneer photographers were faced with the issue of what might be represented, and how. Their medium, even though convincing, gave an impoverished account of appearances which had to be interpreted from such naturally occurring signs as cast shadows.

Fox Talbot's famous *Haystack* [**540**], for instance, features a ladder, the kind of calibrated motif on which the pioneers relied. Most calotypes, or salted paper prints of the 1840s, have to be investigated with respect to highlights and shadows. Distance, too, was impossible to represent without making use of schemata: salt pans in Malta [**541**], in one notable instance by Calvert Richard Jones.

Daguerreotypes, registered on silver-coated copper plates, gave an altogether different account of the world as bathed in what sometimes looks like intensified moonlight. That sense of ghostly or phenomenal existence was always enhanced by the glazing used to keep daguerreotypes from exposure to the air. Difficult to decipher, because of their mirrored surfaces, they were sometimes intended to serve as a basis for engravings, in which their contents would be simplified and shown in a clearer light.

Dr Alexander Ellis's many large-scale daguerreotypes, made in Italy in 1840–1, were the first systematic use of Daguerre's invention [**542**]. They were meant to be engraved, although they never were. The virtue and drawback of the daguerreotype was that it gave the minutest attention to particulars of the kind which would normally have been excluded from pictures—graffiti and scraps of stone, for instance.

370

540 Above: William Henry Fox Talbot (1800–77), *The Haystack* (*c*.1842), salted paper print, Bath, The Royal Photographic Society

541 Right: Richard Calvert Jones (1804–77), *Salt Flats, Saint Paul's Bay, Malta* (1845–6), salted paper print, Bradford, National Museum of Photography, Film and Television

542 Above: Alexander John Ellis (1814–90), *Piazza di Monte Cavallo* (5 June 1841), daguerreotype, Bradford, National Museum of Photography, Film and Television

Calotypes, on the other hand, seemed to edit appearances as they transcribed them, and this has been counted to their credit. Ellis's Italy remains an astonishing curiosity, whereas the portraits of David Octavius Hill and Robert Adamson [**543**], taken in the mid-1840s by Fox Talbot's calotype process in the Scottish fishing port of Newhaven, have for long been classed as art. Designed to introduce the fisher-people to charitable donors, the portraits were made out of doors in strong light, giving a sculpted and generalized effect. That project too seems to have come to nothing at the time, but it was the first wide-ranging study of working people in photography, and it prefigured the kind of representative portraiture which would be typical of the ideological arts in the 1930s and after. IJ

543 David Octavius Hill (1802–70) and Robert Adamson (1821–48), *Alexander Rutherford, William Ramsay, and John Liston* (c.1844–5), salted paper print from calotype negative, Bath, The Royal Photographic Society

Representation

The year 1850 marked a watershed in the aesthetics of the medium. In May the French photographer and printer Louis-Désiré Blanquart-Evrard introduced albumen paper, and in June Gustave Le Gray—another Frenchman, who would become one of the major artists in the history of photography—announced the waxed negative process.

To the schematic frameworks of the 1840s these new processes added aerial perspective or a palpable sense of space. Some of the paraphernalia of the 1840s survived—balustrades, ladders, spoked wheels, and fences—but waxed paper and albumen made it possible to represent what formerly could only be imagined: depth across water, through forests, and within architecture. Le Gray, for instance, made extensive land- and sea-scapes

centred on tiny motifs which mainly served to counterpoint the vastness beyond [**544**]. Indeed, sometimes so disproportionate is the relationship as to belittle humanity. Le Gray often worked with two cameras, and printed from two negatives: one for the sky, and the other for the darker earth or ocean.

Le Gray's was a romantic art, and tragic even—at least with respect to the imperilled place it allowed to

mankind. This tragic aspect characterizes photography in the 1850s, including that of Le Gray's great English contemporary, Roger Fenton, best known for his reports from the Crimean War in 1855, but author too of sublime landscapes, such as this prospect from the terrace of Harewood House [**545**].

There were other outstanding photographers in the epoch, including Charles Clifford, an

Englishman who photographed in Spain from 1852 until 1863. Clifford worked to the same romantic premisses, except that he gave pride of place to ancient architecture [**546**]. It was a period given over above all to the photographing of historic sites: temples in Egypt and India, churches in Spain. Ancient remains, tokens of decayed empires, also put the present moment in its place as no more than an instance in the grand trajectory.

The introduction of stereo photography in the late 1850s coincided with the apogee of the romantic mode and gave a miraculous, sensational aspect to these heroic themes of Le Gray and Fenton. By the mid-1860s photography's romantic era was all but over, for it was incompatible with the quotidian subjects then beginning to emerge in art, and with which stereo was perfectly equipped to deal.

IJ

544 Opposite, top: Gustave Le Gray (1820–62), *Marine, le vapeur* (*c*.1856), albumen print, London, Michael Wilson Collection

545 Opposite, bottom: Roger Fenton (1819–69), *Terrace and Park at Harewood House* (1860), albumen print from a wet collodion negative, Bath, The Royal Photographic Society

546 Charles Clifford (1800–63), *Porte du College S. Grigoin* (*c*.1860), albumen print, London, Michael Wilson Collection

The age of stereo

The age of stereo began in the late 1850s and petered out in the 1920s. Stereocards, although collected, were never accepted into the art history of photography, in part because they dealt in spectacle and illusion, but also because they look anomalous.

Street photography, for example, is supposed to have a gradual trajectory peaking in New York in the

1960s; but it was a staple in early stereo in the 1860s, in the New York cards of E. & H. T. Anthony and Co. [**547**, **548**]. Almost every movement, style, and subject associated with photography was first tried out in stereo. Anything which could be represented in space suited the stereo aesthetic: the street, roads, staircases, bridges, rooms with chandeliers.

In the mid-1860s transparent tissue cards were introduced, often

374

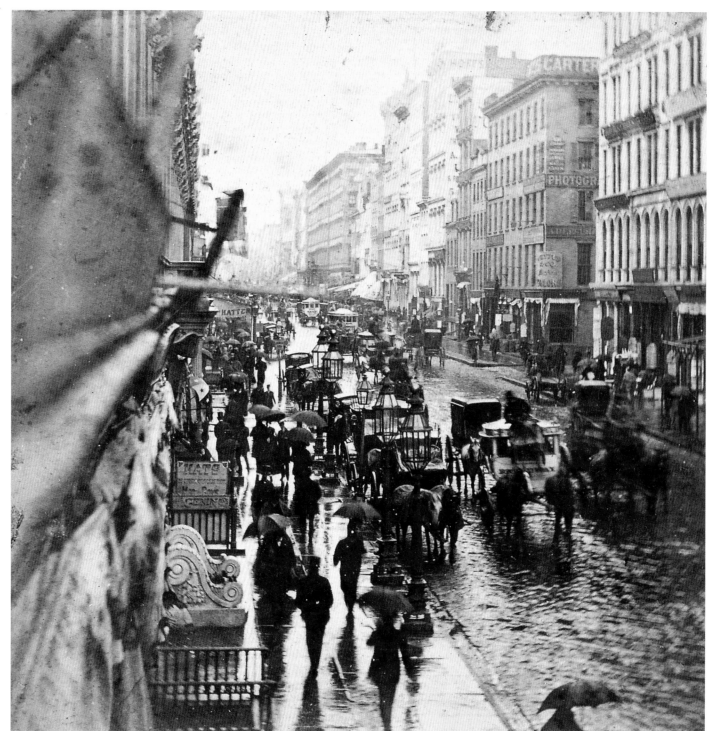

with coloured membranes placed behind windows, doors, and eyes. Because the light in stereo viewers could be adjusted, daylight scenes could be dimmed to twilight and dusk to show the moon, stars, and lighted windows.

Stereocards showed urban sites in particular as enchanted domains, imbued with mystery. The purest of all stereo topics, however, were alpine scenes, taken most notably by

Adolphe Braun of Dornach and by Tairraz and Co. of Chamonix. They developed a genre featuring guides and clients strung out in depth across snowfields, outright representatives of pictorial space [**549**].

In the beginning stereo artists worked on a small scale as prospectors in an unexplored market, but by 1900 the market had been surveyed and companies amalgamated to secure benefits of scale. Cards were

distributed in sets of 100 on topics of geographical and historical interest. The stereo business had, in fact, sobered up, after its experimentations of the 1860s, but largely because its audiences had come to a more responsible, planetary sense of themselves as participants on an international stage. It was stereo itself which had given rise to this state of mind, owing in general to its appetite for diverse subjects and in particular

because of its fixation on phenomena, amongst which the moon—emblem of space and the planets—took pride of place [**550**]. IJ

547 Opposite, top: E. H. Anthony (1818–88) and T. C. Anthony (1813–84), *Broadway on a Rainy Day, New York* (c.1860), albumen printed stereocard, Bradford, National Museum of Photography, Film and Television

548 Opposite, bottom: detail of **547**

549 Above right: Adolphe Braun (1811–77), *Glacier in Dornach, Switzerland* (c.1860), albumen printed stereocard, Bradford, National Museum of Photography, Film and Television

550 Right: George W. Griffith, *Full Moon* (1900), stereocard, silver gelatin print, Bradford, National Museum of Photography, Film and Television

Epic and individual

In the stereo era, which began in the late 1850s, photography developed a market and lost whatever aesthetic reputation it had already gained. Henceforth the medium would always be troubled by this problem of ease of access.

Mrs Cameron, who began to take pictures in 1863, proposed a culture apart, in which her immediate contemporaries would act traditional roles from the Bible and other epics. She made use of a theory of types, drawn from Bible studies, in which, for example, Joseph raised from the pit might stand for Christ resurrected. Her subjects were, up to a point, understood as reincarnations of heroic and tragic prototypes. Because contemporary culture was materialistic she favoured topics of abstention. In this instance, intended to illustrate Alfred Lord Tennyson's *Idylls of the King*, for an edition of 1875, the illicit lovers say farewell [**551**]—both have a prior duty to King Arthur, Lancelot's liege lord and Guinevere's husband. In a comfortable bourgeois society, heroism was out of the question and thus became an aspiration.

Henry Peach Robinson's subject in *She Never Told Her Love* [**552**] is suffering borne in silence. The title is Viola's in *Twelfth Night* describing herself in disguise as 'sat like patience on a monument'. Robinson made composite pictures from several negatives and a similar pose to this appears in *Fading Away*, a composition of 1858 on the subject of death by consumption. On the other hand, the French response to the problem of this new mass culture was to inaugurate a pantheon of contemporary artists, but along Romantic lines. The author was Nadar (Gaspard Félix

551 Above: Julia Margaret Cameron (1815–79), *The Farewells of Lancelot and Queen Guinevere* (1874), albumen print from a wet collodion negative, Bath, The Royal Photographic Society

552 Above right: Henry Peach Robinson (1830–1901), *She Never Told Her Love* (1857), albumen print from a wet collodion negative, Bath, The Royal Photographic Society

553 Right: Nadar (Gaspard Félix Tournachon) (1820–1910), *Théophile Gautier* (c.1855), albumen print from a wet collodion negative, Los Angeles, The J. Paul Getty Museum

Tournachon), who undertook the business in the mid-1850s and portrayed painters, musicians, and writers [**553**] against plain backgrounds and often in robust outdoor dress—as if they had just that moment stepped in from the inhospitable streets of bohemian Paris.

In the USA, of course, the Civil War in the early 1860s focused attention on practicalities. It also confirmed an idea of the hero as entrepreneur, awaiting a stage, of the kind which the giant expanses of the more or less uninhabited West so flatteringly provided. Free of weather and presented in terms of glacial calm the West of Carleton Watkins [**554**] looks like a fixed commodity in waiting or a set of finite materials part of no organic system. IJ

554 Carleton E. Watkins (1829–1916), *Sheer Cliffs* (1867), albumen silver print from glass negative, 52.2 × 38.8 cm. (20½ × 15¼ in.) New York, Gilman Paper Company Collection

Pictorialism

Pictorial photography developed in the 1890s and survived into the 1920s. It was a movement of artist print-makers working in a culture where photography meant stereo and the new snapshot idioms of Kodak, both of which were arts of focus. Pictorial photographs, by contrast, were intended to be taken synchronically or as ensembles, for they were premissed on a generalized and intuited relationship between viewer and landscape. In the gum print *Abend* [**555**], by the Hofmeister brothers, the haymaker it will be noticed returns home against the background of a distant landscape which exists as a screen or ground to her thoughts. She represents a way of being inhabited by space, whereas in the commonplace aesthetics of the era the environment stood apart objectively.

555 Above: Theodor Hofmeister (1863–1943) and Oskar Hofmeister (1871–1937), *Abend (The Haymaker)* (1899), sanguin gum print, Bath, The Royal Photographic Society

556 Left: Frederick H. Evans (1853–1943), *The Sea of Steps* (1900), platinum print, Bath, The Royal Photographic Society

Pictorialists were also idealists who thought in harmonic terms, usually expressed in proportional arrangements: most often the division between earth and sky, as here, but sometimes in terms of the rhythms established by screens of trees on a river bank. Frederick Evans, the great British photographic artist of the era, invested Pictorialist harmonics with a Christian programme. In *The Sea of Steps* [**556**], for example, the swell of

steps in the foreground represents the heaving sea in an image centred on a block of stone, symbol of the steadfast soul.

Meaning in Pictorialism had, as a rule, to be implicit, and in this respect the movement anticipated the 'straight' photography of the 1920s and 1930s. Meanings imposed by the artist, or merely illustrated by photography, were likely to be no more than arbitrary or artificial, and

thus detestable. A 'great' artist was one to whom the environment vouch-safed confidences, as seems to have happened to Alfred Stieglitz, the German-American *commendatore* and editor of *Camera Work* (1903–17). In *The Steerage* [**557**], published as a photogravure in 1907, what looks at first sight like a documentary study of working-class travellers begins to invite interpretation: the women on the lower deck, for example, and the

sunlit gangplank, appearing as secret sign or ciphers. What Stieglitz did with his symbolist inheritance was to give it a personal, even a private, bias. Where the Hofmeisters' had been a collective art, that of Stieglitz after 1900 established a pattern in American vanguard photography which lasted well into the century, into the 1970s at least. IJ

557 Alfred Stieglitz (1864–1946) *The Steerage* (1907), photogravure, Bath, The Royal Photographic Society

Design and Industry

In the century and a half from 1770 to 1914 industrialization, urbanization, the growth of empires, and the rise of mass markets impacted at different periods and different rates on Western countries. Nevertheless, broadly similar patterns can be identified which influenced design, manufacture, and consumption. Industrialization transformed the way in which objects were made. Urbanization transformed patterns of consumption. The growth of empire transformed the range of materials available, diversified markets, and introduced new tastes. And access to fashionable styles, once the preserve of élites, now became available to a larger and more heterogeneous clientele. Between them these changes served to fuel a new interest in design, whether as a symbol of national identity, marker of economic competitiveness, or focus of consumer aspirations.

The history of design in this period is traditionally told as one of a succession of styles, from Neoclassicism to the Modern Movement [558–66]. A difficulty with this approach is that most styles have been named retrospectively and style names are not watertight: many styles overlap with one another either/both chronologically and/or in certain ideological precepts or formal features, thus one specialist's Aesthetic Movement is another's Arts and Crafts. Furthermore, the naming of styles suggests a consistency of attitude and practice within styles which is often absent, in effect. Although most styles of this period share the common feature that they were revivals and that their practitioners looked to the past as much for ideological as for aesthetic reasons, there were differences of approach: whilst some designers sought archaeological correctness others interpreted their historical sources much more freely. And by no means were all styles adopted by the majority of countries or across social classes. The Biedermeier style, for example, remained largely the preserve of German-speaking countries and of the bourgeoisie. By contrast the Arts and Crafts Movement was widely diffused geographically; but, despite its ambitions to be accessible, its products, too, were mostly outside the reach of any but the well-off.

A notable feature of the period is that the pace at which styles succeeded one another was considerably speeded up compared with previous periods; nevertheless, there were differences in lifespan. Some styles—notably Neoclassicism—enjoyed considerable longevity, whilst others—such as Art Nouveau—were relatively short-lived. One reason for the speed with which styles changed was to do with the increase in the production and circulation of design-related publications [567–71]. Another was the voracity of manufacturers for new patterns. Already by the 1760s the Lyons silk industry had

introduced twice yearly collections, to enhance product differentiation and stimulate trade as well as to combat the problem of plagiarism in the absence of effective copy protection measures. The practice was widely adopted by other textile manufacturers: by 1800 patterns in printed cotton for dresses changed routinely from season to season and every two to three years for furnishing fabrics. And in the 1840s the *Journal of Design* estimated that 'There are upwards of six thousand patterns for calico printing registered annually'.

At the beginning of the period handcraft production was still widespread, although it had begun to be undermined by the decline in apprenticeship and the rise of mechanization. The illustrations to Diderot and d'Alembert's *Encyclopédie* of 1765 [572] show the spectrum of the artistic trades as they were known before mechanization was widespread. Synoptic views of workshop activities and visual inventories of equipment indicate the sequence of processes and the specialist hand-tools involved in the practice of crafts such as silversmithing, printing, and cabinet-making. They indicate the range of skills with which a master craftsman would have had to be acquainted, but they also remind us that, by the late eighteenth century, the principles of the division of labour and of specialization, which would be key features of mechanized production, were well established within handcraft production.

As the period progressed, handwork was increasingly replaced by mechanized production and by what came to be known as the 'American system'. This was the process by which, as the American inventor Eli Whitney (1765–1825) put it, the 'correct and effective operations of machinery' were substituted for 'that skill of the artist which is acquired only by long practice and experience'. By means of the separation of design from production, the adoption of standardized and interchangeable parts, and the use of simplified, rationally sequenced operations and powered machines, volume production of goods by semi-skilled and unskilled labour became possible. The principles of the system had been known in Europe in the eighteenth century, but were first widely adopted and developed effectively in the USA from *c*.1800, notably in the arms and the lock-making industries and later in other sectors of manufacture. And towards the end of the nineteenth century further measures to rationalize and co-ordinate industrial processes were introduced, in order to maximize productivity, particularly in industries producing new types of goods. 'Taylorism'—the theory of scientific management developed by the American engineer and industrial sociologist Frederick Winslow Taylor (1856–1915)—was first fully developed in the American automobile industry, and thereafter applied elsewhere.

Mechanized processes—of cutting, printing, stamping, moulding, casting, spinning, and weaving—and rationalization were not uniformly developed. The pace of industrialization varied considerably from one sector to another. Mechanization was widespread in the textile industries by the end of the eighteenth century; by contrast, the furniture industry remained largely unmechanized until the second half of the nineteenth century, when new and more stable materials became available as a result of advances in timber technology. Nevertheless, the adoption of new materials and processes had widespread consequences for handcraftworkers, designers, and industrial artisans. They institutionalized the separation of design from making, undercut the work of skilled artisans, and—as standardization became more pervasive—reduced opportunities for the designer to express artistic individualism and for the industrial artisan to introduce variations.

Industrialization and the growth of empires brought about geographical changes in the distribution of design-dependent manufacturing, and new centres of production began to challenge the dominance of traditional ones. In England, for example, the growth—with new methods of manufacture—of competitiveness of fusion-plated silverware [**574**] allowed Sheffield and Birmingham to challenge London as the source of luxury metalwares by the second half of the eighteenth century, although it was still largely in the metropolis that fashions originated. And, by 1820, the geographical centre of textile printing had moved from London to Lancashire. In France the rise of the fashion for printed cotton and muslin saw a decline in the Lyons silk industry from the 1780s; and, as new textile printing centres developed in Alsace and Normandy in the first half of the nineteenth century, the fortunes of one of the most famous and commercially successful French textile printing manufactories (which had been designated a *manufacture royale* in 1783), at Jouy-en-Josas, declined.

The application of new technology also contributed to the growth of new classes of consumer. Printing from engraved cylinders [**575**] on to rolls of paper allowed the mass-production of wallpapers in a wide range of patterns and qualities from the 1840s. As a consequence, printed wallpapers became accessible not only to the growing 'middling' classes but, increasingly, to the skilled working classes as well. In the furniture industry new techniques of moulding and pressing began to be employed [**576**], and the machine cutting of veneers put fancy cabinet-work within the reach of a new clientele. And, from the mid-nineteenth century, the combination of the availability of cheap printed fabrics, of printed paper patterns, and of credit schemes for the acquisition of domestic sewing machines allowed a wider

cross-section of society than hitherto to adopt the latest fashions in dress. New technology also contributed to the wider dissemination of information about, and comment on, goods and issues of their design [**567–71**] and thus contributed to the construction of markets.

In earlier periods ornament had been a means by which the craftsman could demonstrate virtuoso skills; it was therefore associated with expense and with the patronage of the aristocracy and the wealthy. Yet, although mechanized production tended to favour the design of objects with simple structures and easily repeated types of ornament, the Industrial Revolution saw a proliferation of ornament. The reasons for this seeming paradox are not too difficult to identify. For the manufacturer ornament was a means of underlining the ingenuity of machine production, of masking imperfections in the techniques or materials used, of differentiating goods, and of manipulating—or responding to—consumer aspirations. For many designers ornament was synonymous with the expression of artistic values and individualism. And for the public at large ornament connoted Art.

Ornament distinguished consumer goods from the utilitarian objects associated with the workplace, conjured up associations with skilled, labour-intensive production and luxury consumption, and was considered an expression of refinement and aspiration. Thus new techniques and materials—such as electro-plating and die-stamping, papier mâché and gutta-percha—as well as ornament [**561**, **574**] were used to simulate the skilled handcraft techniques and often elaborate styles of luxury production. But where illusionistic effects (such as *trompe l'œil*) and sham materials (such as *scagliola*) had been employed to acclaim by eighteenth-century artists and designers, by the mid-nineteenth century there had emerged a body of opinion which was critical of both simulated effects and the unrestrained use of ornament. In part this was probably a question of snobbery; as A. W. N. Pugin (1812–52) the British architect and designer observed, the widening production and distribution of ornamented goods allowed ordinary people 'to assume a semblance of decoration far beyond either their means or their station'. But it was also a question of design principles. For Pugin simulated effects were dishonest—materials should be deployed in such a way as to reveal their intrinsic nature—and the indiscriminate use of ornament represented 'the false notion of disguising instead of beautifying utility'.

Pugin, like many mid-nineteenth-century design 'reformers' was not opposed to ornament *per se*—it represented a necessary constituent of design and a marker of the progress of civilization—but to its indiscriminate and incorrect use, which

seemed endemic to machine production. His moralizing sentiments found a ready audience in mid-Victorian Britain, and were shared, with some differences of emphasis, by others in Britain and elsewhere—including the British art critic John Ruskin (1819–1900) and designer William Morris (1834–96). Morris saw the tyranny of the commercial imperative which drove industrial production as the central problem. He believed that mechanized production removed those opportunities for individual creativity and fellowship which gave a humane dimension to labour, and that these could be restored through the revival of the handcrafts [573]. And his writings and practical example—across a wide spectrum of handcraft practice—had a powerful influence in the later part of the century. Numerous craft-based associations and communities were founded in Britain and elsewhere to bring together like-minded theorists and practitioners. And it was partly as a result of the criticisms of commentators like Ruskin and Morris that a number of manufacturers instated hand-made or hand-finished 'art' ranges amongst their products.

It was not only amongst architects and designers that issues of design and production quality caused concern. Widespread recognition of the role of manufactured goods in economic success prompted a number of official enquiries into the relationship of art and industry, as well as initiatives to educate public taste and stimulate the development of design. Amongst these were the mounting of large-scale national and international exhibitions, the reform and extension of design education, and the creation of museums of applied art.

Already by the end of the eighteenth century exhibitions had become a means both of addressing questions of taste and promoting manufactured goods. The English aesthetician Horace Walpole (1717–97) noted a growing enthusiasm amongst the London public for such exhibitions, whether institutionally or commercially organized. And, increasingly, official bodies and governments assumed a role in mounting exhibitions of this kind. In France, the decline in the fortunes of the former *manufactures royales* following the French Revolution prompted an exhibition of their wares in 1797 to promote sales. Considerable interest was aroused, for—as an official report on a subsequent exhibition observed—a display of this kind 'stirs up the competition of manufacturers; it increases their instructions; it forms the taste of the consumers in giving them knowledge of the beautiful'. Popular interest, coupled with the need to provide a stimulus to national economic recovery in the wake of the Revolution and Napoleonic Wars, prompted the adoption, as national policy, of a regular programme of exhibitions in France [577]. Their apparent success in achieving their aims led to similar national exhibitions elsewhere in Europe as well as in America. And they were followed, in 1851, by the first of the more ambitious international exhibitions.

The aims of the Great Exhibition, held in London in 1851 [578], were broadly similar to those of the earlier national exhibitions, although its overt emphasis was on materials and production processes. The exhibition's international scope allowed the comparison of techniques and products of competitor nations. But—at least as far as manufactured goods were concerned—it was not a critical success. As Jacob von Falke (1825–97), the German writer and museum curator,

wrote: '*there* lay the wretchedness in its full measure, before the very eyes of those who had the wish and ability to see'. It thus gave an impetus to the views of design reformers. Nevertheless, the exhibition's popular success and the stimulus it provided to international trade prompted a succession of similar exhibitions elsewhere—in Paris in 1855, 1867, and 1900; in London again in 1862; in Vienna in 1873; in Philadelphia in 1876; and in Chicago in 1893. Such exhibitions also created new expectations of ready access to consumer goods, and their growth was paralleled by the development of new retailing establishments which catered to these aspirations [579].

International exhibitions were one amongst several factors which highlighted the shortcomings of design education. Between the sixteenth and eighteenth centuries, although craftsmen were often skilled in design, it had been common for artists—and later architects—to supply decorative designs for the so-called 'minor' arts, either directly or through the medium of engraved prints or pattern books. From about the second half of the eighteenth century, however, the effects of the progressive breakdown of the guild system, the changing scale and nature of production, and the emergence of new types of goods for which such a tradition could supply no formal precedents had begun to focus attention on the need for specialized design education. Industry now needed not only increased numbers but new kinds of designers, as well as visually and technically literate artisans capable of developing blueprints for industrial production.

Private schools for the training of decorative artists to work in the luxury industries had existed since the Renaissance. And state-supported, as well as industry-specific, schools had developed in France from the seventeenth century. Thereafter both publicly and privately supported schools of art were established close to centres of production. They were extended and their curriculum developed from the mid-eighteenth century, and their particular success in training decorative artists was frequently considered as a model suitable for application elsewhere. In Germany, Prussia and Bavaria established *Gewerbe* (trade) schools, linked to local manufacturers, and some high-class manufactories—such as the Meissen porcelain factory—had links with local art academies. In Russia the S. Petersburg Academy provided a route for artists destined for work in the decorative industries, and it was joined by others. Provision was now more routinely made, albeit usually on a limited scale, for the training of women in the decorative arts [580], partly because of a belief that women had 'a more refined and correct taste' and partly because women's labour was cheaper than that of men.

In England, as in a number of other countries, specialized design education was slow to develop on a significant scale. By the mid-eighteenth century some artists and industrialists recognized the need for an academic training to be available to those destined for 'such manufactures as require fancy and ornament, and for which the knowledge of drawing is absolutely necessary'. But others opposed dedicated provision, believing that taste in design could only be formed by the allegedly superior practice of the fine arts. The influential painter Joshua Reynolds (1723–92), first President of the Royal Academy of Arts, asserted that 'If it has an origin no higher, no taste can ever be formed in manufactures; but if the higher Arts of Design

flourish, these inferior ends will be answered of course.' This attitude prevailed, and was abandoned only when the lack of competitiveness of British goods, despite their acknowledged technical excellence, became apparent in the 1820s and 1830s. The result was the setting up of a nationwide system of publicly funded schools of design in the 1840s; reformed in the light of the lessons of the Great Exhibition these would, in turn, influence provision elsewhere.

Design education in the nineteenth century was not solely directed towards mechanized industry, however. As concerns grew about the loss of distinctive national and regional vernacular craft skills, and the export value of nationally identifiable goods was recognized, there were initiatives, especially in northern and eastern Europe, to promote the production of 'improved' traditional and folk crafts as well as to adapt their characteristics to other facets of manufacturing [564].

The development of specialized museums of applied arts, from the mid-nineteenth century onwards, was linked with educational initiatives to improve design. One of the first and most important of these museums was the Museum of Manufactures (now the Victoria & Albert Museum, or V&A), created by the civil servant, designer, and writer Henry Cole (1808–82) in 1852. Founded in the wake of the Great Exhibition, the Museum's mission was to promote art and design and consumer education and thereby to contribute to an improvement in the quality and competitiveness of British goods, to counter criticisms that, although technically excellent, they lacked taste. The nucleus of the Museum's collections was formed by objects acquired from the Great Exhibition, representing the main branches of production—metalwork, woodwork, textiles, ceramics and glass, and so on. They were intended to demonstrate both the application of 'correct' principles of design and the consequences of their absence. And the Museum's displays were directed towards students, artisans, and manufacturers, as well as a popular audience. Even in Cole's time, however, and more explicitly under his successors, the Museum's mission was rapidly adapted in practice. Its more instrumental aims were toned down; collecting for collecting's sake became the order of the day, and the antiquarian displaced the contemporary.

Even so, the Museum's perceived success in fulfilling its early aims—demonstrated by the number of prizes awarded to British goods at the 1862 London international exhibition compared with 1851—encouraged other countries to follow suit. Thus between the 1860s and the early 1890s numerous museums of applied or 'industrial' art were founded, by national and municipal governments as well as by private initiative, all over Europe, in North America, and within the British Empire. By 1890 almost every European capital city had acquired a dedicated museum. In Germany alone some thirty such museums were founded in major cities. The aims and practices of these institutions were broadly the same as those of the V&A. And many seem to have followed the V&A's lead in eschewing, as time passed, the collection of contemporary industrial design, thus undermining—at least in part—their original rationale. By the end of the century, however, the applied art museum boom was over, although some attempts would be made in the early twentieth century—notably in Germany—to represent the contemporary in a museum context.

By no means had all mid-century reformers endorsed the need for ornament or were they nostalgic for a return to handcraft. Some saw the need for a different approach in the era of industrial production, although they drew on different kinds of model for their 'functionalist' arguments. Thus the American sculptor Horatio Greenough (1805–52) saw nature as providing evidence for his belief that 'the redundant must be pared down, the superfluous dropped, the necessary itself reduced to its simplest expression, and then we shall find ... beauty'. By contrast, the German architect and theorist Gottfried Semper (1803–79) saw comparable lessons for design in contemporary engineering, observing that 'objects in which seriousness of purpose does not permit superfluities ... show more soundness in the perfection and nobility of their forms, prescribed strictly by function'.

By the early twentieth century designers had come increasingly to accept that handcraft production was no longer economically viable and even that machine production had some advantages. They also began to acknowledge that there was no natural affinity between industrial production and the abuse of ornament, that variety could be achieved with a restricted repertoire of standardized parts [581, 582, 584], and that integrity of design and truth to materials—and thus beauty—were compatible with machine production. For the American architect and designer Frank Lloyd Wright (1867–1967) the machine was not only democratic—in making it possible for 'the poor as well as the rich [to] enjoy ... beautiful surface treatments of clean strong forms'—but 'capable of carrying to fruition high ideals in art' and able 'ultimately to emancipate human expression'. For Wright, and later for the Swiss architect and designer Le Corbusier (Charles Édouard Jeanneret) (1887–1965), machine production demanded congruence of form and function and, at its best, was capable of producing pure forms comparable with those of selected examples of high-class handcraft production. For the Austrian architect and designer Adolf Loos (1870–1933)—author of an essay titled 'Ornament and Crime'—it was no longer a question merely of applying 'correct' principles of ornament, but of dispensing with it altogether: ornament was not a marker of the progress of civilization but of 'savagery', or the dominance of instinct over intellect.

The accommodation of progressive designers with mechanized production and the emergence of the 'machine aesthetic' was marked by the formation of new associations, such as the Deutscher Werkbund [583], founded in 1907 to bring together designers with manufacturers and retailers committed to developing high-quality designs for mass-production. Nevertheless, even within such organizations, the spectre of machine production as antagonistic to the expression of the designer's individualism would remain. Such fears combined with the experience of the mechanized slaughter of the First World War to turn even some pre-war converts, including the German architect and designer Walter Gropius (1883–1969), at least temporarily against machine production in the years immediately following the war. The 1920s, however, would see the re-emergence, amongst progressive designers (including Gropius and Le Corbusier), of a commitment to rational design for mechanized production. CB

Revivals

By the 1770s the Rococo had begun to be superseded by Neoclassicism [**558**]. At its zenith in the late eighteenth and early nineteenth centuries, Neoclassicism lasted well into the 1860s in some media and some countries.

As the nineteenth century progressed and élite patronage was challenged by the growth of consumption by the rising 'middling' classes, the grip of France as an arbiter of taste and the Classical past as a source of inspiration was diminished. From *c*.1815 to 1850 the unostentatious Biedermeier style [**559**] was widely diffused in Germany and Austria; it had parallels, slightly later, in Scandinavia.

Elsewhere Neo-Gothic [**560**], which had first made an appearance in the mid-eighteenth century and was

558 Neoclassicism. Wedgwood, Jasperware vase decorated with the Apotheosis of Homer (1786), London, British Museum

559 Biedermeier. Carl Wilhelm Gropius, *Living room of the Gropius Family at Stallstrasse 7* (*c*.1835), watercolour on paper, 30.8 × 30.5 cm (12⅓ × 12⅕ in.), Berlin, Stadtmuseum Berlin

now associated with religious revival-
ism and/or structural rationalism,
enjoyed some success, as did—in
France—the Second Empire style.

In the mid-nineteenth century the
elaborate and eclectic designs often
classed as 'Victorian' [**561**] were
widespread in the Anglo-Saxon world
and, in some areas, Neo-Renaissance
and Neo-Rococo flourished. CB

560 Left:
Neo-Gothic.
William Burges
(1827–81), pine
and mahogany
painted,
stencilled, and
gilded cabinet
(*c*.1858), London,
Victoria & Albert
Museum

561 Above:
'Victorian'. Gutta-
percha console
table, mirror glass
frame, and
bracket, exhibited
at the Great
Exhibition in 1851

Novelty, nationalism, and reform

The second half of the nineteenth century saw designers drawing on even wider-ranging sources of inspiration, as well as a reaction against industrial production. From the 1850s the opening up of Japan made available a new source of motifs and techniques for manufacturers hungry for novelty and designers nostalgic about the decline of the handcrafts [563]. Increasingly, too, designers began to look to national or regional materials and traditions of production, and to folklore and regional flora and fauna for motifs.

Arts and Crafts precepts of truth to materials, fitness for purpose, and handcraft values were widespread by the 1880s and remained influential into the 1900s [562]. In the same

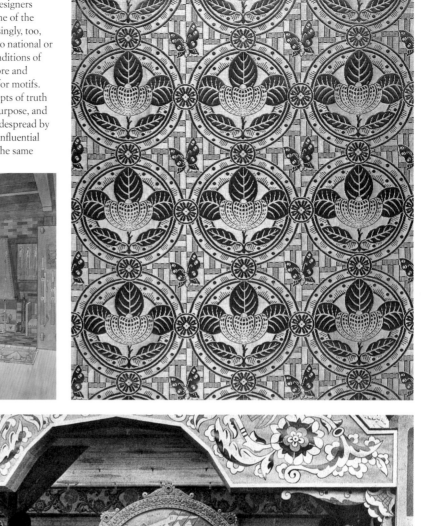

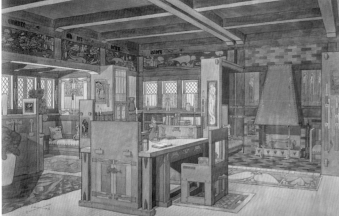

386

562 Above, left: Arts and Crafts: W. H. Bradley (1868–1962), drawing for a library (1901), San Marino, California, Huntington Library, Art Collections and Botanical Gardens

563 Above, right: The Japanese influence. Designed by E. W. Godwin, *Butterfly* (*c.*1874), woven by Warner, Sillet & Ramm, brocatelle, silk damask, woven silk, London, Victoria & Albert Museum

564 Right: National Romanticism: Oak furniture in the Russian style, designed by A. N. Durnovo, made by peasant craftsmen in Nizhnii Novgorod province (*c.*1914)

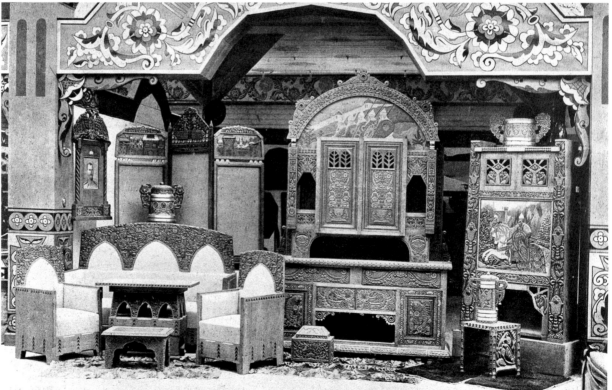

period, and overlapping in many ways with the Arts and Crafts Movement, the Vernacular or National Romantic Revival—which sought to revive vernacular traditions in ways appropriate to contemporary tastes and patterns of consumption— emerged [**564**].

The 1890s and early 1900s were also marked by the sinuous forms and naturalistic vocabulary of Art Nouveau [**565**]. Towards the end of the period a number of designers found ways of reconciling some of the values of the handcrafts with machine production, in the pared-down, rectilinear forms of the Modern Movement [**566**]. CB

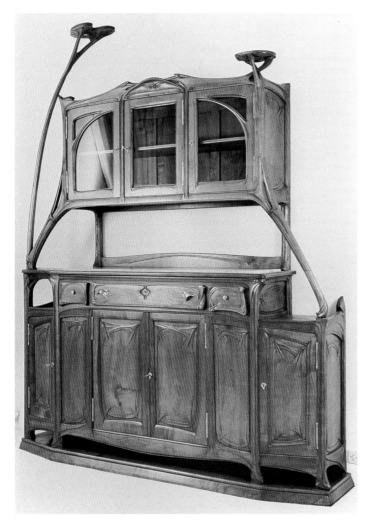

565 Art Nouveau: Hector Guimard (1867–1942), sideboard for the Castel Henriette at Sèvres (*c*.1899–1900), Berlin, Bröhan Museum

566 Modern Movement: Bruno Paul (1874– 1968), desk and cabinet; part of a series of *Typenmöbel*—or unit furniture— made by the Vereinigte Werkstätten für Kunst (1908), Berlin, Kunst-gewerbemuseum

Design and printing

In previous centuries engraved ornamental prints and pattern books had been important conduits for the transmission of fashionable styles to collectors and connoisseurs as well as to craftsmen [567]. From around the end of the eighteenth century these began to be superseded by the circulation of a much greater variety of illustrated publications addressed to manufacturers, designers, and the wider public [569]. They included trade catalogues (and later mail order brochures), specialist manuals, encyclopaedias of ornament—of which Owen Jones's *Grammar of Ornament* [571] is one of the best known—and generalist and specialist magazines. In the 1890s alone over one hundred new decorative arts journals were launched. Between them these publications provided

388

routes by which information about styles and the availability of goods reached a wide and distributed audience [**568**]. They were complemented by new developments in printing technology and by the rapid growth and diversification of advertising—including the development of large-scale pictorial advertising on public sites [**570**]—which reached wide audiences and created new areas of design specialization. CB

567 Opposite, top left: engraved plate from a commercial traveller's catalogue of Sheffield-made fused plate (*c*.1785), London, Victoria & Albert Museum

568 Opposite, top right: Hungarian decorative art magazine cover (1914), Budapest, Museum of Decorative Arts

569 Opposite, bottom left: Title-page of *Répertoire de l'ornemaniste* (1841), London, Victoria & Albert Museum

570 Opposite, bottom right: Jan Toorop (1858–1928), poster advertising Delft *Slaolie* (salad oil) (1894), Washington, DC, Library of Congress

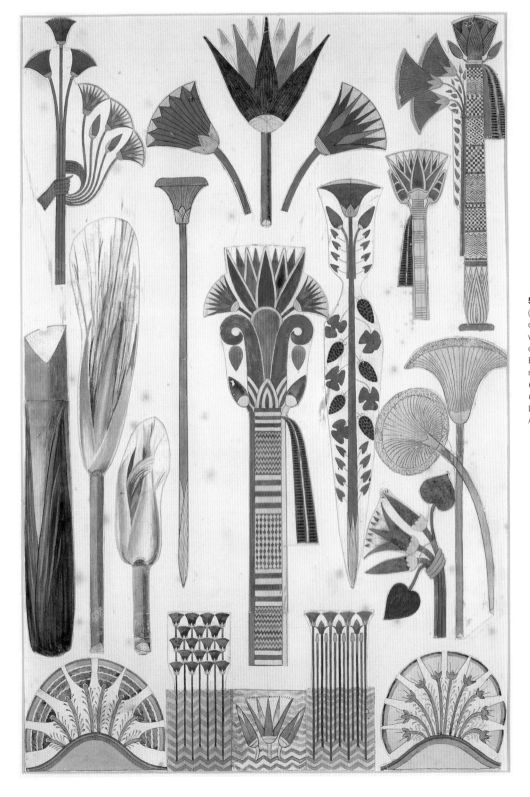

571 Owen Jones (1809–74), original watercolour drawings of Egyptian ornaments for his *Grammar of Ornament* (1856), London, Victoria & Albert Museum

Hand vs machine

During the period 1770–1914 hand-craft production [**572, 573**] was increasingly displaced by mechanized production. In some areas of production industrialized methods of stamping [**574**] and moulding and the use of new, adapted, or synthetic materials allowed the images of skilled handcraft methods and precious materials to be simulated astonishingly

successfully at a fraction of the cost of the real thing.

The mechanization of textile and paper printing [**575**] allowed many hundreds—perhaps thousands—of metres to be printed in the time it took to handblock-print a length, thus substantially reducing unit costs and making printed fabrics and wallpapers available to a wide public. New techniques of laminating and moulding woods were sometimes employed, in

conjunction with carving, to achieve highly elaborate effects in relatively lightweight woods [**576**]; but, in the same period, similar techniques of bending and moulding were also used to achieve quite different kinds of effects [**584**]. In this context it is perhaps not surprising that the Arts and Crafts Movement's efforts to revitalize handcraft production encountered economic obstacles to its ambitions. CB

572 Craft production. Silversmithing as represented in Diderot and d'Alembert's *Encyclopédie* (1765)

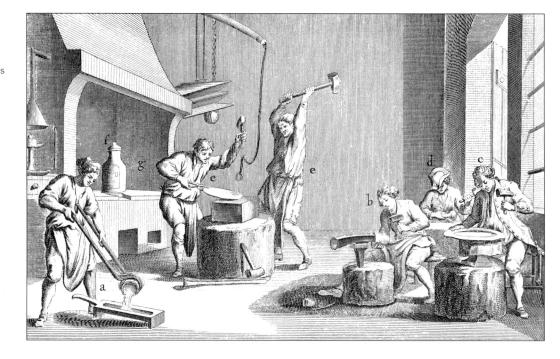

573 William Morris's printers handblock-printing textiles in the Merton Abbey printing shed (1880s)

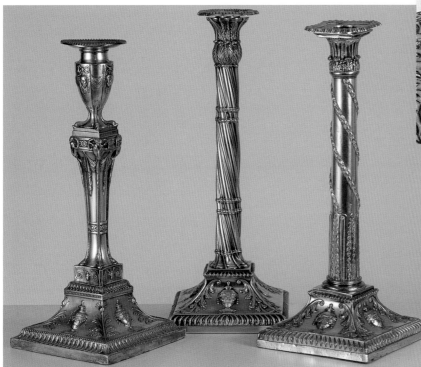

574 Left: Winter, Parsons & Hall, Sheffield, three candlesticks, made from die-stamped components assembled in different combinations (1770s and 1780s). The central candlestick is silver; the others are made of fused plate, Sheffield, City Museum

575 Above: Printing roller for the machine printing of wallpaper, Sassenheim, Netherlands, Sikkens Schildersmuseum

576 Below: J. H. Belter (1804–63), sofa (c.1856), laminated and carved rosewood, with chestnut or oak strengthening blocks, London, Victoria & Albert Museum

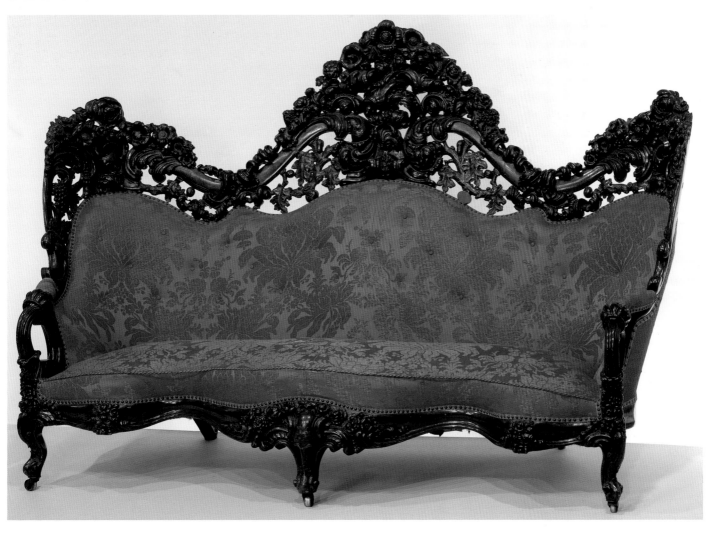

Public participation

The growth and proliferation of industrially produced goods and popular interest in exhibitions prompted their use by commercial concerns for promotional ends and by official bodies for the education of public taste in the interests of economic competitiveness [577].

Museums of decorative art were founded to support the same ends.

International exhibitions (or 'World Fairs') with their wealth of goods and materials—drawn not only from Western countries but their imperial possessions—also influenced the commercial sphere to promote a culture of abundance.

This was most visible in the development, from the mid-nineteenth century onwards, of the new phenomenon of department stores. Like Paxton's 'Crystal Palace'

[578] for the Great Exhibition of 1851, the department stores' buildings drew on new materials technology to create dramatic, light, spacious, and inviting interiors as backdrops for the display of an abundance of goods [579]. They also deployed theatrical techniques of *mise-en-scène* to promote shopping as an enjoyable leisure activity, although some—such as the Bon Marché in Paris, which had a reading room and an art gallery

presented like a gallery in the Louvre museum—tempered their invitations to uninhibited consumption with a veneer of high seriousness.

Women were increasingly catered to, both as producers [580] and consumers. CB

392

577 Left: Exhibition of French industrial products at the Louvre (1819)

578 General view of the interior of the Crystal Palace during the Great Exhibition, London (1851)

MAGASINS DE NOUVEAUTÉS DU TAPIS ROUGE,
67 et 69, rue du Faubourg-Saint-Martin.

579 Au Tapis Rouge department store, Paris; the textiles and clothing department (1867)

580 The Philadelphia School of Design for Women (*c.*1880; founded 1853)

Mass manufacture

Already in the eighteenth century Wedgwood had shown—in his successful 'Queensware' creamware range [581], often decorated with transfer prints—that the use of standardized forms and decorative techniques was not incompatible with an impression of variety.

From the mid-nineteenth century the mass manufacturer of bentwood furniture Gebrüder Thonet demonstrated that a repertoire of standard parts could be used in different combinations to create a wide range of cheap—and often elegant—but durable furniture [584]. Thonet chairs were used in a vast number of public environments as well as in domestic contexts. Certain models assumed an iconic status for early twentieth-century modernist designers, including Adolf Loos and Le Corbusier, who saw their economy of form and material as benchmarks of the aesthetic quality of which industrial production was capable.

Examples of the early twentieth-century use of standard components and normative type forms to create both continuity and variety are demonstrated both by Bruno Paul's *Typenmöbel*, or unit furniture [566], and by Peter Behrens's designs for electrical appliances [582] for the Allgemeine Elektrizitäts Gesellschaft (AEG). Both Behrens and Paul were members of the Deutscher Werkbund, for which the graphic designer F. H. Ehmcke (also a member) designed publicity material [583]. CB

394

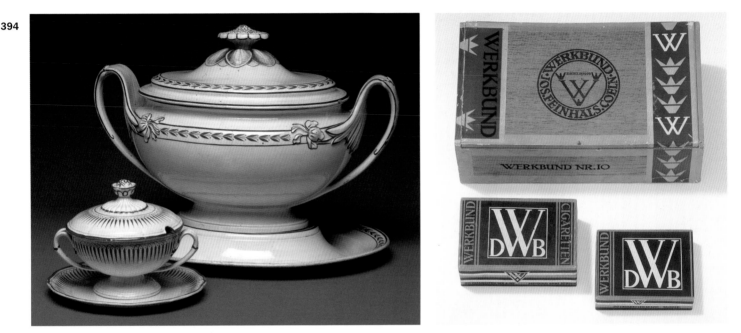

581 Above: Large size Queen's Ware (fine earthenware) tureen, lid and stand, hand enamelled with a stylised 'Laurel' border in brown and blue. Impressed 'WEDGEWOOD'. Height (including final) 30 cm. (12 in.), (*c*.1787). Small cream bowl/tureen, lid and stand. Queen's Ware, hand enamelled with the 'Pink Antique' border pattern. Impressed 'WEDGEWOOD'. Height overall 15 cm. (6 in.), (*c*.1773)

582 Right: Peter Behrens (1869–1940), octagonal electric tea and water kettles, in various finishes, for the AEG company (1909)

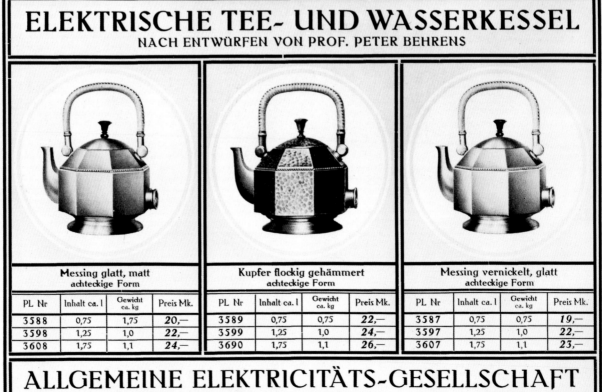

ELEKTRISCHE TEE- UND WASSERKESSEL
NACH ENTWÜRFEN VON PROF. PETER BEHRENS

Messing glatt, matt achteckige Form				Kupfer flockig gehämmert achteckige Form				Messing vernickelt, glatt achteckige Form			
PL Nr	Inhalt ca. l	Gewicht ca. kg	Preis Mk.	PL Nr	Inhalt ca. l	Gewicht ca. kg	Preis Mk.	PL Nr	Inhalt ca. l	Gewicht ca. kg	Preis Mk.
3588	0,75	1,75	20,—	3589	0,75	0,75	22,—	3587	0,75	0,75	19,—
3598	1,25	1,0	22,—	3599	1,25	1,0	24,—	3597	1,25	1,0	22,—
3608	1,75	1,1	24,—	3690	1,75	1,1	26,—	3607	1,75	1,1	23,—

ALLGEMEINE ELEKTRICITÄTS-GESELLSCHAFT
ABT. HEIZAPPARATE

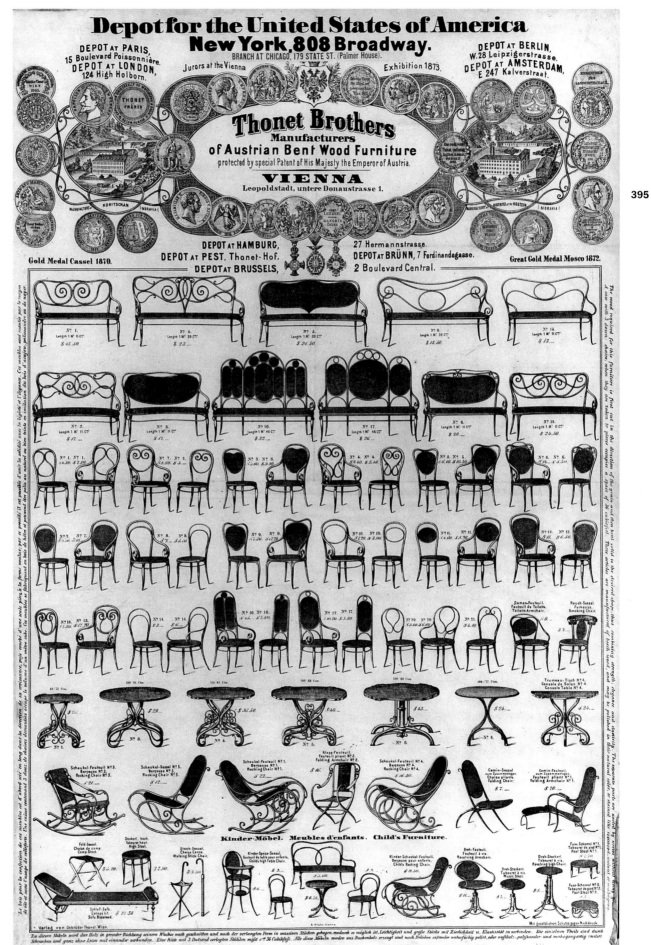

583 Opposite, top right: F. H. Ehmcke (1878–1965), packaging designs for cigar and cigarette boxes for the Deutscher Werkbund (1914), Munich, Die Neue Sammlung, Staatliches Museum für angewandte Kunst

584 Right: Gebrüder Thonet, broadsheet bentwood furniture catalogue (1873), The New York Historical Society

The Rise of Art History

To many people the question of what art history is as an academic discipline is easily answered. It involves discovering who created which works, what subject-matters they represent and how they represent them, how they came to be commissioned and executed, what kind of audience they were intended for, how they were received at the time of their creation, and how they have been interpreted subsequently. However, this conception of art-historical practice did not come into existence ready-made. It evolved gradually. Indeed, it is much more complicated than it at first sight appears. For all these individual aspects of art-historical practice are themselves complex. They involve investigative procedures whose conceptual frameworks have evolved gradually under specific historical conditions.

The emergence of such procedures has been protracted. In ancient times figures such as the Roman Pliny the Elder (AD 23–79) wrote about artists in at least anecdotal terms. It was not, however, until the growth of the Renaissance in Italy that art history began to be pursued in more systematic terms. Not the least significant contributions in this respect are combined historical and theoretical works by artists themselves—for example, the architect Leon Battista Alberti (1404–72) and the sculptor Lorenzo Ghiberti (1378–1455). Alberti's *On Painting* (1435) was especially influential. It championed recent artists such as Masaccio (Tomaso Guidi) (1401–28), Ghiberti, and Donatello (Donato di Betto Bardi) (c.1386–1466), comparing their works favourably with those of Classical antiquity.

The first important step in the development of art history as a discipline is also contributed by an Italian artist—Giorgio Vasari (1511–74). As well as pursuing his artistic career he also wrote an enormously influential *Lives of the Artists* (1550). This work consists of detailed (if not always reliable) biographies of most of the major artists of his own time and of the two centuries before. Vasari's analysis is of special interest because he combines it with a general theory of artistic change, based on a crude organic metaphor. In the broadest terms, for Vasari, Classical antiquity was the period of the highest artistic flowering. The Middle Ages were a predominantly dormant period, and it is only in Italian art of Vasari's own century (and the two preceding ones) that the achievements of antiquity begin to be paralleled. The fourteenth century embodies a rebirth of artistic excellence; the fifteenth century is the youthful period of this efflorescence; and the sixteenth century is its maturity.

This general theory is all-important because it implies that whilst the development of art is necessarily tied to the lives of individual artists, it also follows an identifiable trans-personal pattern. It is, accordingly, a legitimate object of study in historical as well as biographical terms.

An equally important root of art history as a systematic discipline is found in some of those complex Mannerist theories of art which dominated the Italian art scene after Vasari. Central figures here include Gian Paolo Lomazzo (1538–c.1590) and Federico Zuccaro (c.1542–1609). Lomazzo's *Idea of the Temple of Picturing* (1590) summarized neo-Platonist notions of art, and assigned a primacy to conceptual frameworks over biographical approaches. One result of this intellectual emphasis was the rise of a doctrine thereafter closely associated with pedagogic theory in academies of art. The French theorist André Felibien (1619–95), for example, evolved a mode of understanding art which focused on evaluative distinctions made between different types of subject-matter. This hierarchical scale ranged from still life at the lowest level, through landscape, animal painting, portraiture, genre, in progressing levels of spiritual value, with history painting (broadly conceived) as its highest stage. Such painting was understood as the deepest expression of art's definitive function, namely the elevation of form towards an Ideal beauty which exceeds anything given in nature.

By the mid-eighteenth century discourse about art had reached a considerable level of sophistication in terms of the range of analytic principles available to it. One of its greatest achievements is the critical writing of the Frenchman Denis Diderot (1713–84). Diderot's reviews of the annual Salon exhibitions in Paris were important in establishing the reputation of artists such as Jacques-Louis David (1748–1825), and in criticizing the popular aristocratic taste for the Rococo style of François Boucher (1703–70), Jean-Honoré Fragonard (1732–1806), and others. Diderot was also important in mounting a challenge to the primacy of rules in critical discourses on art.

It was also in the latter half of the eighteenth century that one of the most decisive contributions of all to the emergence of art history was made. This was found in the work of the German Johann Joachim Winckelmann (1717–68). In his seminal book *The History of Ancient Art* (1764) Winckelmann locates individual works within broad stylistic categories, and within those more specific historical conditions—bound up with ancient societies and cultures, and physical contexts—which make individual achievements possible. Winckelmann's own reading of the importance of *The History of Ancient Art* was one which emphasized the way in which he was able to analyse Greek art as a successive exploration of different styles. But of equal importance is his sense (although it is not given a theoretically viable justification) that art is a logically distinct form of human artifice, subject to laws of Ideal beauty.

Winkelmann exerted an enormous influence throughout Europe. One of the most striking manifestations of this was a

multi-volume work by the French writer B. L. G. Seroux d'Agincourt (1730–1814). Entitled *Histoire de l'art par les monuments* (published posthumously between 1811 and 1823) it is a study of European art from the Greeks to the fifteenth and sixteenth centuries and is as remarkable for its organization as for its extraordinary scope. Seroux d'Agincourt deploys a wealth of detailed research based not only on paintings and sculpture, but also on engravings and building-plans. The third volume, indeed, consists of a detailed explanatory list of plates, and the fourth volume presents the plates themselves. The particular significance of this work in terms of subject-matter is that it embodies the first comprehensive study of medieval art.

In other respects—despite his professed indebtedness to Winckelmann—Seroux d'Agincourt's book remains quite traditional and, in particular, its uses an evolutionary approach to art based on the organic model established by Vasari. Vasari's continuing legacy is also manifest in the work of the Italian Luigi Lanzi (1732–1810). His *Story of the Pictorial Art of Italy* (1789) is a comprehensive study which goes beyond Vasari in its emphasis on local Italian schools rather than individuals.

The major refinements of Winckelmann's innovations are, as one might expect, to be found in the German-speaking world. It is there that the theoretical basis of art's claim to logical distinctiveness first begins to be addressed in systematic terms. This question becomes especially important for those thinkers associated with Romanticism, or who are implicated in its rise. In this latter category falls Johann Wolfgang von Goethe (1749–1832). His powerful early essay *On German Architecture* (1772) not only presents a strong case for the worth of Gothic art, but also propounds a view of art as an autonomous and irreducible mode of formative activity. This conception of art is developed and refined in greater detail by many thinkers, most notably Immanuel Kant (1724–1804) in his *Critique of Judgement* (1790) and Friedrich Schiller (1759–1805) in his *Letters on the Aesthetic Education of Mankind* (1799). Rather than identifying artistic beauty with the Ideal alone, both these thinkers link it to powers of imagination, understanding, and individuality.

So far, we have seen a gradual transition from biographical approaches to art history, to complex principles of classification, to a sense of art being part of a broader cultural whole whilst, at the same time, being an autonomous form of activity. In the work of the German philosopher G. W. F. Hegel (1770–1831) these last factors are articulated in the most emphatic terms. Hegel's *Lectures on the Philosophy of Fine Art* (published posthumously between 1835 and 1838) serve to locate art within a complex and massively systematic metaphysical framework. The main trajectory in the formation of art history as a discipline is,

thereafter, powerfully shaped by Hegel's influence or by reactions against it. It is, therefore, worth investigating Hegel in greater detail.

In the very broadest terms reality is, for Hegel, a World-Spirit seeking to achieve self-comprehension. Art plays a necessary role in this. It is the means whereby finite (that is, human) spirit 'externalizes' and thence comprehends its own spiritual reality at the level of sensible phenomena. At the same time, art has an intrinsic metaphysical significance. This is because the artwork's style (in terms of both form and subject-matter) exemplifies not only the artist's individual vision, but also the more general way in which his or her culture or society conceives the nature of reality itself. The artwork shows, in effect, the level of self-comprehension which the World-Spirit has attained at that specific historical period.

For Hegel it is this need for accumulating self-comprehension which actually induces cultural change. As societies progress, their conception of what is ultimate becomes correspondingly more complete. New conceptions displace old ones whilst preserving what is positive in them. Art is both a manifestation and vehicle of such change. It illuminates the nature of the World-Spirit, and, indeed, its own limitations as a medium of metaphysical expression, even as it moves through its clearly defined stages of logical and historical progression.

Hegel's philosophy of art history, then, is profoundly *historicist*. It holds that art is a relatively autonomous sensible form of meaning which expresses the general spiritual character of its culture and time of origin, and which evolves historically on the basis of recognizable laws. Such a conception not only offers a systematic basis for historical understanding, but also sees the phenomenon of art-historical change as intellectually significant in its own right. Given this, it is hardly surprising that art history as a formal academic discipline sees its rise in the German-speaking world in the post-Hegelian eras.

Hegel's legacy, however, is an extremely complex one. The German Karl Schnaase (1798–1865) attended Hegel's Berlin lectures in the 1820s and in his multi-volume *Netherlandish Letters* (1834) and other works provides a specific application of Hegel's philosophy of art. An even more celebrated inheritor of some aspects of Hegel is the Swiss scholar Jacob Burckhardt (1818–97). He had tenure of a full Professorship of History at the University of Basle, and from 1874 gave lectures on art history as a formal part of his duties. His major work *The Culture of the Renaissance in Italy* (1860) is of seminal importance in defining those broader cultural and spiritual conditions which create the Renaissance as an epoch and which find sensible expression in its artistic achievements.

Hegel's emphasis on artistic form as a bearer of spiritual meaning is also influential on another tendency in German art history. This tendency is, however, one which would contest the grand historicist narrative in terms of which Hegel understands the history of art. It emphasizes, rather, the importance of art as a sensible analogue of specific spiritual states, notably empathy. The philosopher-psychologists Wilhelm Wundt (1832–1920) and Theodor Lipps (1851–1914) are influential figures in this tendency, but of more central significance is Robert Vischer (1847–1933). Vischer held the Chair in Art History at Göttingen from 1892, and published (amongst many other works) a book entitled *Studies in Art History* in 1886. He develops empathy theory so as to illuminate the spiritual depth of the artwork, rather than the empirical details of the individual work and its specific circumstances of production and reception.

Two other notable German writers also emphasize the spiritual significance of art as a mode of giving form to sensible material. These are Conrad Fielder (1841–95) and Adolf Hildebrand (1847–1921). In Fielder's *On Judging Works of Art* (1876) the question of form is given a profound emphasis. He argues that the function of arts development is not to reflect the existing sensible world but to create forms which are of significance in their own right. It should be noted that whilst an approach of this sort might be used to ratify the invention of abstract art, Fielder in no way develops this possibility. Indeed, in *The Problem of Form in the Fine Arts* (1893) by his close friend Hildebrand, a position in broad harmony with Fielder's approach is used to clarify a problem in the historical development of figurative representation, namely the relation between the picture plane and those figurative forms which are emergent from it. In the broadest terms, the artist's handling of this formal relation (and especially, the way it is treated in Classical Greek relief sculpture) is one which both intensifies and clarifies the nature of visual perception itself.

We are thus led to tendencies which are more divergent from Hegel and his diverse legacy. A useful starting point is the neo-materialist art history of the German Gottfried Semper (1803–79). His two-volume *Style in the Technical and Tectonic Arts* (1861, 1863) was especially influential. In it he adapts ideas from (amongst others) the French palaeontologist Baron Georges Cuvier, so as to articulate a theory of art-historical change which emphasizes the importance of materials, techniques, and responses to practical needs and functions. These centre upon hearth-gathering, making mounds, roofing, and the enclosure of space within walls. It is important, however, to notice that even Semper preserves a vestige of the Hegelian notion of art as a vehicle of spiritual expression.

This is found in his controversial interpretation of the painting of walls. For him, Mesopotamian civilization marks a point where textile wall-hangings were re-expressed in terms of tiles, mosaic, and other varieties of inorganic material. This tendency was extended further by Greek architecture through its coating of material surfaces with thinly applied paint. In Semper's terms, this transformation amounts to a dematerialization of the surface's practical function in favour of a more spiritually expressive significance.

Semper's position, therefore, is not wholly materialist. The work of the Frenchman Hippolyte Taine (1828–93) does,

however, move in a more purely materialist direction. His *Philosophy of Art* (1872, in two volumes) proposes an extremely anti-metaphysical 'positivist' approach to the understanding of art and its history. An approach of this kind is one which sees knowledge as progressing beyond religious and metaphysical interpretations of the world towards scientific ones where analysis or inductive generalization based on empirical observation is paramount. In Taine's approach to art this takes a reductive character, in that he emphasizes how all individual creativity can be explained in scientific terms as a function of the material conditions of environment, its times, and its racial context. In concert, these factors are the basis of Taine's concept of milieu. Any parallel with Hegel here is only superficial, for whilst Hegel sees the individual creative genius as actively articulating the character of his or her society and times, in Taine's theory such an individual is fundamentally an effect of the surrounding milieu.

In Britain, the hugely influential art critic and social theorist John Ruskin (1819–1900) also offered a systematic approach to the history of art which also offers no real parallel to the Hegelian legacy. His five-volume *Modern Painters* (published between 1843 and 1860) is famous for its defence of the English painter William Turner (1775–1851), but in this (and other works) he is also extremely attentive to other art, most notably Italian works of the thirteenth and fourteenth centuries. Ruskin's basic theoretical position is fundamentally ethical and religious rather than metaphysical in the particular way he identifies goodness and beauty with truth, and translates the pursuit of artistic truth in terms of detailed attentiveness to the minutiae of nature. For him the realization of this aim requires qualities of honest observation and craftsmanship, rather than those powers of genius which are so emphasized by the Romantic tradition.

Another important alternative to Hegelian historicism is found in an object-based connoisseurship most closely identified with the Italian Giovanni Morelli (1816–91). Morelli's background was in medical science. He devised a method for resolving issues of problematic attribution by attending to very fine details of a kind which would characterize the work of the particular artist, but which would not be the sort of feature to which a copyist or forger of that artist's work would be attentive.

Perhaps the most sustained alternative to Hegelian approaches to art history is that of the so-called 'Berlin School'. This label encompasses a very diverse set of individuals rather than some well-defined method. However, the figures broadly associated with the school are 'object-centred' rather than theory-based. Indeed a number of them had curatorial connection with specific Berlin galleries and collections.

The first important figure in the school is K. F. von Rumohr (1785–1843). His *Italian Investigations* (1827) emphasizes the importance of research based on original documentary sources, and a connoisseurship grounded on direct acquaintance with original artworks. Franz Kugler (1800–58) wrote works such as the *Handbook of Art History* (1842) with a similar emphasis to Rumohr's, but covering a much broader range of periods. Gustav Waagen (1800–58) was both a Director of the Berlin Gemäldegalerie and the holder of a university Chair in Art History (established at Berlin in 1844). He wrote extensively on art in British collections.

Towards the end of the nineteenth century, Hegelian historicism and the object and collection-based approach of the Berlin School were brought into broad conjunction. This occurred through the development of the Vienna School. The focus of this again involved close connections between historical practice and specific galleries and collections. In 1864, for example, Rudolf von Eitelberger (1817–85) founded the Austrian Museum for Art and Industry. This institution kept close links with art-historical studies at Vienna University, most notably during the tenancy by Franz Wickhoff (1853–1909) and Alois Riegl (1858–1905) of Chairs there. Wickhoff was influenced by Morelli, but more importantly in *Vienna Genesis* (1895) and other works was able to extend the purview of art-historical study so as to encompass both periods usually dismissed as 'decadent', and even aspects of non-Western art. This breadth of approach also characterized the work of the successor to Wickhoff's Chair, Max Dvořák (1874–1921). As well as addressing such unfashionable artists as El Greco, and catacomb paintings in his *History of Art as the History of Spirit* (published posthumously in 1924) he was also willing to examine contemporary Expressionist works. This willingness is symptomatic of a specific theoretical orientation in Dvořák's work, namely his belief that the expression of inner emotion is a much more potent factor for art-historical change than the desire to give naturalistic expression to perception.

An even greater breadth of approach is found in Alois Riegl, the greatest figure in the Vienna School, also, perhaps, the first systematically modern art historian. It is, accordingly, worth examining his views at some length. Riegl studied law and philosophy as well as history at Vienna University. From 1887 to 1897 he was Director of the Textile Department in the Austrian Museum for Art and Industry. In 1897 he received a full Chair at the University of Vienna. His first studies were predominantly of oriental carpets, but it was his *Problems of Style* (1893) which first gained him widespread attention. This work addressed the development of vegetal ornament in the ancient world and immediately beyond. Riegl focuses specifically on the stylistic development of the lotus and acanthus as fundamental decorative motifs. Semper and his followers had suggested that the invention and development of such motifs was due primarily to the influence of broader material circumstances. Riegl, in contrast, argues that what drives stylistic transformations of ornamental motifs is a will to form or basic art-impulse which cannot be reduced to a mere effect of material circumstances.

The theme of a will to form internal to art itself is taken up again in Riegl's next major work—*The Late Roman Art Industry* (1901). Here it is given a specific technical name, *Kunstwollen*. Riegl investigates the way in which the late Roman *Kunstwollen* is expressed in architecture, painting, sculpture, and the applied arts. The importance of the book, however, consists as much in its new sense of method as in its analyses of specific works. Riegl argues that whilst the products of the late Roman *Kunstwollen* differ appreciably from those of earlier phases of antiquity, this really is a case of difference rather than decadence or decline. Specifically, late Roman artworks have an optical or long-sighted emphasis; the art of ancient Egypt has a haptic (that is, tactile) or near-sighted emphasis; while the art of Classical Greece occupies a 'normal-sighted' position in-between.

Literally, then, for Riegl art-historical change is bound up with different ways of seeing. The *Kunstwollen* of a specific age embodies its own distinctive perceptual schema and this (as Riegl makes clear in the Conclusion of his book) is bound up with much broader societal factors involving patterns of culture, religion, and government.

In the final major work published during his lifetime—*The Dutch Group Portrait* (1902)—Riegl further refines his already sophisticated theoretical framework. Of particular importance is the way in which he distinguishes between the cohesion of the internal pictorial space of a work, and its linkages to the external viewing space in which the observer is situated. At the heart of these linkages are not only strictly perceptual relations, but psychological relations which link the external observer to participants in the work's internal narrative.

Having surveyed Riegl's views we are now in a position to illustrate why he occupies such a seminal position. The first important point is that Riegl radicalizes the descriptive and universalist approach of the Vienna School. As we saw earlier, since the Renaissance discourse concerning art had been dominated by a hierarchy of genres focusing on the Ideal art and the primacy of Classical antiquity. (This normative conception even extends as far as Hegel, and members of the Berlin School.) Riegl's emphasis on *Kunstwollen*, and form as the vehicle of stylistic transformation, replaces this normative conception with a primarily descriptive art-historical approach. This allows a much broader range of periods and, indeed, non-European tendencies (though Riegl himself does not address the latter), to function as legitimate objects of art-historical investigation. Art history thus acquires a more universal orientation.

A second key point is that whilst Riegl is by no means a rigid Hegelian historicist, he sees formal transformations as embodying distinctive and identifiable perceptual shifts. The *Kunstwollen* is a universal drive in human beings, but its specific historical products vary systematically and issue in different ways of seeing the world.

A third major point is that these changes of perceptual schema are themselves bound up with much broader societal and cultural structures (though, admittedly, Riegl himself does not offer much explanation and analysis of the nature of these broader connections).

In conjunction, these three points offer the possibility of a universal descriptive procedure which traces systematic changes of visual style in the context of broader cultural conditions. Art history thus appears, in Riegl's work, as a well-defined discipline of investigation, with its own framework of methods. It is a branch of historical understanding, but one whose visual objects demand special analytic concepts.

This focusing of art history into a relatively autonomous discipline of universal investigation is a very modern conception. It is, in effect, a continuation of that resolution of human knowledge into its logically distinctive component areas which is so much a feature of the Enlightenment and the origins of the modern world. This conception of art history has, of course, been challenged subsequently, but not before the three basic points which comprise it have figured (either individually or in concert) in some of the most important twentieth-century approaches to art history. PC

Art Criticism and Aesthetic Ideals

In 1846, two years before social revolution spread from France to Germany, Austria, Hungary, and Italy, Charles Baudelaire (1821–67) asked, 'What is the good of criticism?' It was a question he had already answered, in the dedication of his review of the Salon of 1846 'to the bourgeoisie': if art now addresses the third estate, then the function of art criticism is to teach the middle class how to take its leisure from business, law, and science in the aesthetic pleasure to be gained from art. Baudelaire went on to declare that, just as art had value only if it issued from a strongly expressed individuality, art criticism only did any good if it was partisan—if it took a side, entered into dialogue with other criticism as well as with the art that was its object, differentiated itself, and diversified its audience by being 'partial, passionate, and political'.

Baudelaire wrote at mid-century, when daily and weekly newspapers proliferated in Paris, the bottom-of-the-page *feuilleton* with its dose of gossip, fiction, light news, and art and literature reviews had become an institution, and the staff art reporter was beginning to be commonplace. But Baudelaire's notion that art criticism served a widened audience of art viewers and with it a new field of values was not a novel one; it went back to the late eighteenth century. In the 1760s and 1770s, when there was no such thing as a specialized art critic, the encyclopaedist *philosophe* Denis Diderot (1713–84) addressed a narrow, élite audience (numbering no more than 15 princely subscribers) in the *Salons* he wrote for Baron Grimm's biweekly manuscript, the *Correspondance littéraire*, explicitly separating his accounts from the widening field of Salon commentary written without illustrations for the larger Salon-going public. Yet Diderot entered into the fray of the Salon, alluding to its hanging and his passage through its spaces, allowing the imagined noise of its mass of visitors to intrude upon the intimacy of fantasy conversations invented for the purposes of escaping it, and framing his memories of pictures within the phenomenal experience of spectatorship, one that theoretically could be had by anyone. And Diderot, who simultaneously mocked and upheld the academic hierarchy of genres and its accompanying system of specialized skills and pictorial values, used a light tone that later would seem especially suited to *feuilleton* journalism.

Journalism in France began to be liberalized in the 1770s; with the first French Revolution the freedom of the press was officially declared in 1789 and resulted in an immense expansion of sanctioned political newspapers, only to be halted by waves of censorship beginning in 1792, followed by decades of contraction, and a lasting tendency, within journalistic art criticism, towards allegorized political commentary. By 1800 art and culture journalism was exempted from censorship—art criticism was to be understood as politically neutral. As a consequence, art reviews began to be signed, and journals devoted to cultural reporting grew rapidly in number. On the eve of the Revolution, however, art criticism was explicitly political, and responded to the monopoly of the Royal Academy of Painting and Sculpture in a stream of underground pamphlets that treated art as a political affair: when Jacques-Louis David's (1748–1825) royalist, Academy-sponsored *Oath of the Horatii* [**442**] was presented in the Salon of 1785, its infractions against the academic system were treated as matters of social rhetoric and class style. Then, following on the Revolution, reversals in David's political reputation would be roped to changes in the politics of art criticism. The secretary-general of the Committee of Public Instruction, Jean Baptiste Publicola Chaussard (1766–1823), treated David as the representative of the republican value of stoic classicism, while Charles Paul Landon (1760–1826), the art critic for the oldest newspaper in France, the *Gazette de France*, who published a series of engraving-illustrated *Salons* and *Annals of the Museum and Modern School of Fine Arts* during the Napoleonic period, treated David as a grand imperial artist. The writer to be most closely associated with the name of David after the end of the Napoleonic regime was Etienne Delécluze (1781–1863), who for forty years was the official art critic for the *Journal des débats*, the powerful right-wing newspaper that was a model of a new brand of professional journalism. Where the majority of nineteenth-century critics were literary men and women, some had been trained as painters; such was the case of Delécluze, who had been a student in David's studio, and who would write the first major biography of the artist in 1855. For Delécluze, who stressed the artist's 'life and times' as the key to his art, David was the 'grand master' of what was by then the old school—the Ancients as opposed to the Moderns. Thus art criticism was structured around a series of oppositions in which the artists and objects of its analysis were changeably positioned, according to the political demands of the moment.

Late eighteenth-century Germany saw the beginnings of another tradition of art writing, based on the university lecture. With *The Critique of Judgement* (1790) by Immanuel Kant (1724–1804), the field of aesthetics as a branch of philosophy came into being. Not concerned with exhibitions or individual works of art, or even with art as such, Kant posited aesthetic feeling as the mark of the autonomy of the free human subject, liberated from the low pleasures and contingencies of bodily sensation and survival, and differentiated between the 'beautiful' and the 'sublime' as modes of the subject's relation to the objective world. When Georg Wilhelm Friedrich Hegel

(1770–1831) gave his *Introductory Lectures on Aesthetics* in Berlin in the 1820s, he responded critically both to Kant's aesthetic system and to the privileging of ancient art by Johann Joachim Winckelmann (1717–68). Treating art as Kant had not, he traced a dialectical progression from the internal coherence and self-sufficiency of classical sculpture to the fragmentation, disintegration, and sublimity of the 'Romantic' arts of painting and literature. Absorbed into philosophical and literary theories of artistic modernism, and put in contention with the positivist cry of progress, Hegel's conception of the Romantic phase as one of dissolution, in which 'art falls to pieces', would constitute one of two important strands of thought about the fate of art in modernity. This view of modern art underlay French art fiction that focused on the downfall of the modern artist and the disintegration of his art in a proto-abstract chaos of colours, as far apart as *The Unknown Masterpiece*, the novella published in 1845 by Honoré de Balzac (1799–1850), *Manette Salomon*, the 1867 novel about art in the era of the Universal Expositions by Edmond and Jules de Goncourt (1822–96 and 1830–70), and *The Masterpiece* of 1886 by Émile Zola (1840–1902).

'Romanticism' denoted, not a unified style, but a modern attitude. For German writers such as Friedrich von Schlegel (1772–1829), it was aligned with a resurgence of Christian spiritualism and nationalist conceptions of 'German genius' (and with German artist groups such as the Nazarenes in Rome); for Heinrich von Kleist (1777–1811), it was tied to the upwelling of 'Emotions' in the face of Germanic nature, 'upon Viewing Friedrich's Seascape' (Berlin, 1810). For Stendhal (1783–1842), in his *Salon of 1824*, it meant the 'dawn of a revolution in the fine arts'—'good modern painting' as against the 'system of David'—and a 'personal manner of feeling' as opposed to the skill- and style-consciousness of the Greek school. And it meant colour rather than drawing—although Stendhal did not care much for the exemplar of this kind of painting that was on view in 1824, *Massacre at Chios* by Eugène Delacroix (1798–1863). Delacroix's painting fared better in the *Critical Conversations on the Salon of 1824* by Auguste Jal (1795–1873), written in the style of Diderot as a fictional dialogue between a philosopher and an artist, and devoted to the principle that 'Romanticism is flooding through society and, since painting is also the expression of society, painting becomes romantic'. A year after the July Revolution of 1830, Heinrich Heine (1797–1856) reported on the Salon of 1831 (and the public's reactions to it) for a German newspaper and, with the murmur of the Salon 'crowd' growing into the roar of a revolutionary 'mob' in the background behind him, brought the concept of 'Romanticism' up to its political moment—although he felt that modern

clothes, in particular the bourgeois coat and top hat that showed up in Delacroix's *Liberty Leading the People* [**438**], were too dull to make good painting. In 1846, Baudelaire brought many of these strands together in his *Salon*, with sections on 'Romanticism' and 'Colour' following on his address to the bourgeoisie and his pronouncement of the political nature and partisan function of criticism, and a closing tribute to the 'Heroism of Modern Life', emblematized in the black frock-coat that Heine had disparaged. At the same time he aligned himself with the medium of painting as an expression of the Romantic temperament, as against the classicism of sculpture. And he focused on the art of Delacroix, describing him as the quintessential Romantic artist.

Art criticism in England, as in the United States, was necessarily less respondent to the tides of social revolution. Until well into the nineteenth century, English aesthetic thought was dominated by the idealist views expressed by the first president of the Royal Academy, Sir Joshua Reynolds (1723–92), in the 15 academic *Discourses on Art* given in the 1770s and 1780s. Between the 1790s and the 1830s, contrary ideas about what was aesthetically appealing emerged out of travel, nature, and garden writing that celebrated picturesque effects in Nature itself. William Hazlitt (1778–1830), with his nonconformist attachment to the heritage of the French Revolution, was one of those to articulate the concept of the attention-capturing 'picturesque', and to write in favour of the principle of subjective 'originality', in essays published in the *Encyclopaedia Britannica*, his own *Table Talk*, and *The Atlas*. However, it wasn't until John Ruskin (1819–1900) published the first volume of his *Modern Painters* in 1843 that Reynolds's values were directly challenged and modern English painting (primarily Joseph Mallord William Turner (1775–1851)) found a critical champion. Ruskin advocated a principled fidelity to both the specificity and the system of Nature and, for his binary opposition, chose to set Turner, the representative of his view of observed Nature, against Claude (Claude Lorrain) (1600–82), the representative of conventionalized landscape representation. Ruskin's name soon became linked to the Pre-Raphaelite Brotherhood in an 1851 exchange with the critic for *The Times*; by the 1850s he was the Victorian aesthetician *par excellence*, whose influence was felt strongly in the United States, as in its first major art periodical *The Crayon*. But though Ruskin's *Elements of Drawing* (1857) was prescient in its use of colour theory, its articulation of what would be the Impressionist 'spot', and its understanding of the relation between optics and painting, by 1877 he would find himself on the other end of the critical spectrum in his condemnation of *Nocturne in Black and*

Gold (1874) by James Whistler (1834–1903). In the famous trial that resulted in 1878 from Whistler's charge of libel against Ruskin, the artist (who was bankrupted by his unsuccessful action) argued against the critic's moralism and for art for art's sake. Walter Pater (1839–94) promoted the same view. In an 1868 review of the poetry of William Morris he argued for the artist's intensive, 'flamelike' experience as a value in itself. In a piece on Venetian Renaissance art published in the *Fortnightly Review* in 1878 he also articulated the medium-specificity of the arts, and their striving after the condition of music.

The earliest exponent of the art-for-art's-sake attitude was Théophile Gautier (1811–72) in France, who responded to a newspaper attack in a scathing preface to his novel *Mademoiselle de Maupin* (1834), in which he mocked the positivism of the Comte de Saint-Simon (1760–1825) and its commitment to social utility in the arts, and argued instead for the beneficial uselessness of art in the modern age. In his derogation of external circumstances and his paean to the spiritualism of the senses, for which 'the sight of an authentic Raphael or a beautiful woman naked' were equally emblematic, Gautier performed a perverse twist on the Kantian notion of the autonomy of the 'beautiful'. He went on to write art criticism for what was then the premier art periodical in Paris, *L'Artiste*, though he was not always on the side of the modern in later years.

Against 'art for art's sake' was arrayed a host of writers, whose forces were gathered in the Second Republic in France around the figure of Gustave Courbet (1819–77). Foremost among them was Champfleury (Jules Fleury) (1821–89), the novelist-cum-journalist who applied his interest in popular art and vernacular culture to Courbet's *Burial in Ornans* in 1851 [**460**], and in 1857 published a study of *Realism* as the cultural movement with which Courbet was identified. The Saint-Simonian philosopher and social theorist Pierre-Joseph Proudhon (1809–65) made Courbet the current representative of the utopian-socialist argument of *On the Principle of Art and Its Social Destination* (1865), explicitly opposing the art-for-art's-sake argument in favour of an understanding of art as the highest and most virtuous form of unalienated labour. By the Second Empire, the less politically charged concept of 'Naturalism' replaced the republican-identified 'Realism' of 1848, and the baton was passed to critics like Jules-Antoine Castagnary (1830–88) and Théophile Thoré (1807–69, alias William Bürger, when he was in political exile from France between 1849 and 1859). These critics were interested both in the history of Dutch, Spanish, and French art and the 'new school' of French painting, addressing the social 'milieu' and forward movement of art under the leadership of an avant-garde (also a Saint-Simonian idea).

When the young journalist and novelist Émile Zola entered the fray in 1866, it was to make Édouard Manet (1832–83) the representative of the 'new manner in painting'. In 1867, when Manet, like Courbet, held his retrospective outside the Universal Exposition, Zola wrote an essay on him for *Le Dix-Neuvième Siècle*, which he then republished as a pamphlet. In that essay he combined biography with a formalist emphasis upon the structuring of Manet's paintings around the *tache* (spot or patch) and its dependence on the physiology of the painter's eye. In so doing, Zola applied to the work of a contemporary artist the positivist principle of the influence of the physiology, milieu, and history of a culture on its art, as expressed contemporaneously by Hippolyte Taine (1828–93) in lectures on the *Philosophy of Art* at the École des Beaux-Arts. The positivist conception, as applied to historical art, was by now widespread; it was shared by Charles Blanc (1813–82), founder of the illustrated *Gazette des Beaux-Arts* in 1859 and author of the influential *Grammar of the Arts of Design* (1867), when he compiled his encyclopaedic *History of the Painters of All the Schools* over the course of the 1860s and 1870s.

Zola set himself up as Manet's spokesman in direct competition with Baudelaire, who had published *The Painter of Modern Life* from abroad in 1863, celebrating the urban values of the *flaneur* (boulevard stroller) and the clothes and cosmetics of modern women, and who, although he wrote almost nothing about his friend Manet, would be increasingly linked to him. At the same time, Zola argued with the critical and caricatural onslaught against Manet's paintings in the Salon des Refusés of 1863, and countered the reading of the infamous *Olympia* as an ugly cartoon of a common streetwalker flung in the face of the bourgeoisie when it was shown in the Salon of 1865. Zola suggested that the modernity of Manet's paintings lay not in the modern life of their subject-matter, but in their optical form. He denied other obvious features of Manet's paintings, such as their dependence on the Old Masters on view in museums and in print reproductions in journals like the *Gazette des Beaux-Arts*. Zola's pamphlet, which helped to determine the way Manet the 'modernist' would be understood in the future, is an excellent case of two important facts about modern art criticism: first, that it is in dialogue with other critics; and second, that it is a construction put on art objects that decides how they are construed thereafter as well.

When critics began to attend to the Impressionist circle in the 1870s, they did so in similar terms, treating Manet as the founder of the new school, despite his refusal to join the group's exhibitions. In 1874 Louis Leroy (1812–85) effectively gave the group the name that held fast in his review of the first group exhibition in *Charivari*, beginning the trend that would result in the sobriquets *fauve* and *cubique*, when those terms were coined later by the critic Louis Vauxcelles (1870-?), to speak derogatorily of works by Henri Matisse (1869–54) and others on view at the Salon d'Automne in 1905, and by Georges Braque (1882–63) at Kahnweiler's gallery and the Salon des Indépendants in 1908 and 1909, respectively; they stuck so hard that they became the names of movements. So it was with 'Impressionism', in Leroy's flippant little article, with its Diderotian dialogue between the critic and an exaggeratedly outraged academician who could not see what the paintings represented for all their 'palette-scrapings' (a trope from the days of Courbet), 'impressions', 'black tongue-lickings', and imitation-marble effects. This was criticism designed to be entertaining, as befits the satirical journal for which it was written.

In 1876, there were more serious reviews, one by the poet Stéphane Mallarmé (1842–98) and another by Edmond Duranty (1833–80), a Naturalist journalist from the days of Courbet. Mallarmé wrote 'The Impressionists and Edouard Manet' in English for a London journal, treating Manet as the founder of the new school, decrying the mistreatment of him by the Salon

jury and public (an important trope of modern criticism), joining Baudelairean modern life to Zola's Naturalism, and interpreting Impressionism as the optical re-creation of 'nature touch by touch'. At the same time, he addressed the figure of woman, both as the object and the subject of painting, expending particular effort on the work of Berthe Morisot (1841–95), which, like other critics of the time, he treated as a 'feminine' Impressionism. For his part, Duranty's pamphlet *The New Painting*, entering into dialogue with the current art-historical discussion of Dutch painting, gave Impressionism a Naturalist history going back to Diderot, and treated it as the next, unfinished advance in the positivist progress of modern art towards the future. In 1877, Georges Rivière (1855–1943) created the short-lived partisan journal *L'Impressionniste*, declaring that 'What distinguishes the Impressionists from other painters is that they treat a subject for its tonal values and not for the subject-matter itself.' Impressionism had an international critical reception too; in 1879, for instance, Diego Martelli (1839–96), Florentine art critic and advocate of the *Macchiaioli* (spot-makers), published an Italian review of the fourth Impressionist exhibition and the next year put together *The Impressionists and Modern Art* for Italian consumption.

The 1880s saw the disintegration of the Naturalist school of writing and criticism, the efflorescence of a series of avant-garde literary magazines, and the arising of a set of prominent new critical voices tied closely to the making of new artistic reputations, who argued in dialectical response to the artistic and literary movements out of which they had emerged. One such was the writer Joris-Karl Huysmans (1848–1907), a Zola-follower who wrote *Salons* and reviews of the Impressionist shows in the late 1870s and early 1880s. In 1886, he attended the last Impressionist show, focusing on Degas's series of nudes as a farewell both to the public of the Impressionist exhibitions and to the principles of positivist criticism. The novel with which he marked his turnabout from Naturalism to a medievalizing primitivism was also an extended piece of art criticism, *A Rebours* (*Against the Grain*, 1884); among other artists it focused on Gustave Moreau (1826–98) and his depictions of Salomé as representative of the turn from the modern milieu to the internalized Orient and lapidary sexuality of the decadent artist and the *femme fatale*, recycling themes from Baudelaire—the splenetic Baudelaire of the *Flowers of Evil* (1857), whose 'forest of symbols' and theory of the *correspondances* between sounds, scents, and colours would be so important for the Symbolist generation. Symbolism, here, was a new 'art for art's sake', a newly perverse Romanticism.

The year 1886, with the call to Symbolism sounded by Jean Moréas (1856–1910) in the literary supplement of the *Figaro*, was a turning-point year in the history of advanced criticism. Félix Fénéon (1861–1944), the anarchist who co-founded the *Revue indépendante* and wrote for the *Revue Wagnérienne*, *Le Symboliste*, and the Belgian *L'Art moderne*, used 'The Impressionists in 1886' to turn the terms of criticism around—towards an account of the subjectivism of contemporary art. In general, the criticism of this period was self-consciously avant-garde and decidedly theoretical in orientation; litterati joined artists who published their thoughts on the history and principles of modern art, as well as scientists who shifted the terms of aesthetics away from Enlightenment idealism towards a physical-cum-psychological comprehension of form and colour. Gustave Kahn (1859–1939), who also wrote for the Symbolist magazines, produced a piece on Georges Seurat (1859–91) in *L'Art moderne* in 1891, to be followed by the divisionist artist Paul Signac (1863–1935), who published *From Eugène Delacroix to Neo-Impressionism* in 1899, quoting heavily from Delacroix's journals in order to give Neo-Impressionist modernism a history. Both writers emphasized colour theory, which in modern aesthetics went back to Johann Wolfgang von Goethe's (1749–1832) *Theory of Colours* (1810) and Eugène Chevreul's *The Laws of Simultaneous Colour Contrast* (1839), but which was now brought up to date by the American physicist Ogden Rood (1831–1902) in his 1879 *Modern Chromatics*, and the French mathematician and psychologist Charles Henry (1859–1926) in *The Chromatic Circle* of 1888. With these points of reference avant-garde criticism gave itself a scientific pedigree; as G.-Albert Aurier (1865–92), champion of Vincent van Gogh (1853–90) the 'isolated one' and Paul Gauguin (1848–1903) the Symbolist, wrote in his 'Essay on a New Method of Criticism' (1890–3), criticism should be 'scientific', above all else.

This kind of criticism continued apace in the years prior to the First World War, in international debates around the modern art of that period. Against the chorus of negative voices in the French press, the poet Guillaume Apollinaire (1880–1918) joined André Salmon (1881–1969) and others in defence of Fauvism and Cubism, writing an article on Matisse in 1907, the catalogue essay for Braque's show at Kahnweiler's gallery in 1908, and the second major book on *The Cubist Painters* in 1913. (The first was the 1912 *On Cubism* by the painters Albert Gleizes, 1881–1953, and Jean Metzinger, 1883–1956.) In Italy, Ardengo Soffici (1879–1964) took up cudgels for Picasso and Braque in 1911, publishing *Cubism and Beyond* in 1913 (revised as *Cubism and Futurism* in 1914), while in New York writers for *Camera Work* promoted modern art, including Gertrude Stein (1874–1946), who published pieces on Matisse and Pablo Picasso (1881–1973) there in 1912. And in London Bloomsbury formalism aligned itself with new French painting. Following on the 1908 defence of Matisse in *The Nation* by his mentor Bernard Berenson (1865–1959), Roger Fry (1866–1934) began to turn his attention away from historical art and towards 'Manet and the Post-Impressionists' in an Oxford lecture on 'Expression and Representation in the Graphic Arts' in 1908, a 1909 'Essay in Aesthetics', and the two controversial Grafton Gallery exhibitions of 1910 and 1912 and the apologia that accompanied them. Sharing a commitment to the empathetic reception of form celebrated in German aesthetics of the turn of the century, and continuing the Enlightenment's privileging of individual 'self-expression' and the subjectivity of the bourgeois élite, Fry codified most of the terms of twentieth-century formalism, including its canon and trajectory, its opposition between literary content and material form, and its foregrounding of the self-reflexivity of the medium, as a 'plane surface covered with colours' (Maurice Denis, 1870–1943). And he brought art criticism up to date, joining the aesthetics lecture to the curatorial and journalistic defence of contemporary art and its art-historical lineage. CMA

403

Art Museums and Galleries

Art museums and art galleries are, historically speaking, recent inventions, but the accumulation and display of prized objects is not. From the most ancient of times, people have collected objects thought to be imbued with special virtues or powers. Effigies of gods, relics of saints, the skulls of deceased ancestors are among the things that have been collected and ritually displayed. As cultural strategies, collections can have any number of purposes. They may function as a means by which a group distinguishes itself from other beings, real or imagined, or as a way of maintaining connections between the living and the dead or between human and superhuman communities. Many collections, be they of bones or oil paintings, are thought to align the present with a mythic or idealized past. The accumulation and exhibition of art objects are no less symbolically charged than other forms of ritual display. Indeed, the solemn atmospheres and impressive spaces of art museums are fully comparable to ritual settings of other times and places.

The Louvre Museum was the first truly public art museum. Its significance as a public space is intimately bound up with its origins in the French Revolution of 1789 and the ideological needs of the emergent modern state. This meaning of the Louvre becomes especially clear when compared to the state displays it supplanted, namely, princely galleries.

In the seventeenth and eighteenth centuries, men of power throughout Europe formed collections of rare and costly oil paintings, bronzes, and other *objets d'art*. These were often installed in sumptuously decorated reception halls where they could impress both foreign and local dignitaries with the prince's magnificence and luxury. Displays of paintings by Titian, the Carracci, Rubens, Poussin, and other Old Masters became especially fashionable, and quantities of them (including copies) were sometimes used literally to cover entire walls. By the eighteenth century, as educated Europeans became increasingly interested in art, some of the great collections opened their doors to tourists. None, however, were truly 'public' in the modern sense: one entered as a privilege, not as a right, and access was limited to those with credentials or letters of introduction, in short, the well-born or well-connected.

In the later eighteenth century, several important picture collections, including state collections in Dresden, Vienna, Paris, and Florence, were newly installed according to current, aristocratic fashions in connoisseurship. The new installations called attention not only to the collector's wealth but also to his discriminating judgement—what gentlemanly culture called 'good taste' and took as a sign of noble breeding and intelligence. This taste was manifested in the actual arrangement of pictures: unlabelled works from the different 'schools' were hung in ways that invited stylistic comparison and contrast. Such installations assumed predominantly male aristocratic visitors, as women were rarely taught the critical codes that enabled them to recognize the distinctive qualities of the masters on display.

In 1792, the French government seized an opportunity to dramatize the end of monarchy and the birth of a new state by retitling the king's art collection as the Museum of the French Republic and installing it in the Louvre Palace. The former royal residence, now open to everyone by right and without charge, brilliantly demonstrated the government's commitment to the principle of equality. The museum would become much more than a public display of royal treasure or gentlemanly taste. In time it would be the site for a new civic ritual in which the relationship between the individual as citizen and the state as benefactor would be enacted and idealized. However, despite a policy of open and free admission, the gallery's programme addressed itself most directly to male visitors, in particular bourgeois males, the new state's most fully enfranchised citizens.

By 1810, the Musée Napoléon, as it was now called, had been reinstalled according to the dictates of a new discipline: art history. As visitors advanced through its halls, they literally retraced the evolution of the principal European 'schools' of painting—Italian, Flemish, Dutch, and French. The ground floor featured the development of Italian Renaissance and Classical Antique sculpture, the two epochs thought to have most attained ideal beauty. Gentlemanly galleries catered to the aesthetic predilections of a cultivated aristocracy; the new museum treated visitors as self-improving bourgeois individuals in search of spiritual and intellectual edification. Its clearly labelled exhibits were conceived as instruments of enlightenment, designed to guide citizen-visitors to the very summit of civilized culture. It should be added that the early museum owed much of its extraordinary wealth to the French army, which confiscated vast quantities of art from churches and palaces all over Europe. Installed in the Louvre, these treasures and artefacts from other times and places now became the cultural patrimony of the new French nation.

The Louvre's programme quickly became a model for and, eventually, a defining feature of state and municipal collections everywhere. Its central premiss, that all art worthy of the name progressed towards a single, universal ideal of beauty, would be qualified as educated viewers learned to value a greater range of art-historical periods. But the habit of treating ancient and Renaissance art as defining moments in the history of civilization would long persist [589].

The Louvre demonstrated the ideological usefulness of public art museums in a world of emerging bourgeois power.

After its example, there was a flurry of national gallery founding throughout Europe, whose heads of state, seeking a more liberal image, often designated existing royal collections as public art museums. Napoleon's occupying armies created several public art museums, most notably in Madrid, Naples, Milan, and Amsterdam. By 1815, almost every western capital, monarchical or republican, had one, although some of these 'national galleries' were but old-fashioned princely collections with new names. The Hermitage Museum in St Petersburg, for example, required full dress of all its visitors until 1866.

But not every state wanted a public art collection. Such institutions had come to signify state recognition of the middle-class presence in the nation as a whole. In Britain efforts by liberals to found a free public art gallery were part of a larger struggle to gain middle-class power and prestige at the expense of aristocratic privilege. Not surprisingly, the ruling conservative oligarchy remained decidedly cool to such efforts. Only in 1823 did the gentlemen who ran Parliament allow the creation of the National Gallery. Even after it opened in 1824, it would be decades before the new institution would find sufficient funding and political support to rival the Louvre [585–87], and that only after middle-class political power became strong enough to intervene in its management.

American art-museum building took off in the 1870s, in the midst of the post-Civil War economic boom. First in Boston, New York, and Chicago [590, 591], and then in other cities, museums conferred social distinction on their benefactors and effectively announced the arrival of a city's business community. The rise of American museums should also be seen in relation to the waves of immigrants—Irish, Jewish, Italian, and others—who were swelling the cities. 'Old-stock', Anglo-Saxon Americans, fearful of being culturally and politically swamped, hoped that such institutions would unite the disparate elements of society into one nation with a single culture. Informed Americans were especially convinced that exhibits of the decorative arts could civilize the working classes, improving their morality and elevating their taste. London's Victoria & Albert Museum was regarded as a model urban museum and inspired virtually every American art museum to found a decorative arts department. The new institutions, however, would remain the province of genteel America.

We should note an important difference between American art museums and their European models. The Louvre and the National Gallery in London came into being in the context of bourgeois struggles to end aristocratic privilege. In contrast, American museums began as displays of privilege: their rich benefactors were given special galleries for their exclusive use, so that museums became a series of separate, jealously guarded collections. As the *New York Times* of 9 May 1925 complained about the Metropolitan Museum of Art, the place was 'not so much an institution for the instruction and the pleasure of the people as a sort of joint mausoleum to enshrine the fame of American collectors'. Eventually, museum directors found ways to impose greater art-historical unity on their collections, but the practice of granting millionaire donors their own space became a feature of American museums.

From their beginnings, art museums carefully defined what could be framed as 'art'. At first, this meant primarily the representational arts of western Europe and their ancient Near Eastern antecedents. But as the nineteenth century progressed, interest in non-Western societies intensified, and a growing number of ethnographic collections exhibited objects made by non-European peoples [588]. Designated as 'artefacts', these objects were arranged to illustrate presumably natural laws of social, cultural, or biological evolution; meanwhile, things made by Europeans, designated as 'art', were displayed as unique objects of individual contemplation. These separate museo-logical approaches were rooted in the conviction that the cultural achievements of civilized Europe were not simply better than but categorically different from what more 'primitive' peoples could produce. According to this thinking, 'backward races', still mired in the realm of necessity, produce only arte-facts, objects of purely practical or, like fetishes, instrumental value. Only art, by definition a product of civilization, can produce aesthetic pleasure, philosophical enlightenment, or spiritual elevation. As such, it serves mankind's highest aspir-ations: the attainment of spiritual freedom and self-knowledge. (For some, European decorative arts occupied an intermediate category between art and artefact, one in which the opposition between material and spiritual values could be resolved.)

It should not surprise us that such ideas flourished at the same time that imperialist greed was extracting as much wealth as possible from the 'undeveloped' world, and in the process, inflicting irreversible damage to its peoples and cultures. The Western states into which the world's wealth flowed had reason to embrace ideas that elevated a European 'us' over a non-European 'them' and represented the destruction of 'their' cultures as a triumph of civilization. In today's post-colonial world, traditional museum culture, including the art–artefact dichotomy on which much of it was built, has itself become an object of critical scrutiny. And, as we have come to see, the magic ascribed to 'primitive' artefacts may not be so different from the civilizing powers credited to art museum collections.

CD

'Civilization' and 'natural history'

Throughout the nineteenth century, the Louvre used its ceilings to explicate the political and educational intentions of its installations. Increasingly the iconography of the museum's ceilings featured sequences of names or portraits of the men whose genius marked the progress of

civilization. Every nineteenth-century French government funded at least one such ceiling. In **585**, commissioned in 1848 by the newly constituted Second Republic, winged victories hold crowns and palm leaves over hexagons with profiles of canonized French artists.

The Salle des États [**586**], opened in 1886, states its nationalist message with Neo-Baroque bombast: over each door, an allegorical figure of

France, one ancient, one modern, protects the arts, while around the cornice, masters of the French School are celebrated in oversized stucco reliefs painted to look like bronze. The whole is now hidden behind a false ceiling.

Although opened in 1824, London's National Gallery began to rival the Louvre in the richness of its collections and the ostentation of its architectural settings only later in the

century. The Barry Rooms [**587**], opened in 1876, were the Gallery's most pompous to date. Sculptural embellishments include relief portraits of great artists, illustrations of key art-historical moments, and insignia of the British state, the standard ingredients of genius ceilings in countless national galleries and public art museums.

While art museums displayed objects thought to represent the

406

585 Hall of Seven Chimneys, detail of ceiling (1848–51), Paris, Louvre

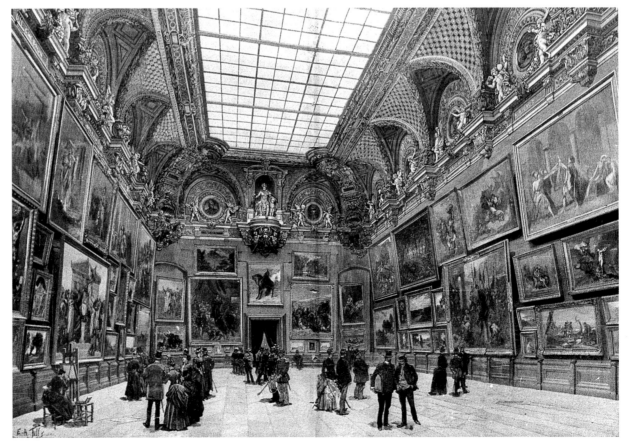

586 The New Salle des États, Paris, Louvre, from *L'Illustration*, 30 October 1886

civilized heights of human achievement, ethnography and anthropology museums collected 'artefacts' from 'primitive' cultures and presumably 'backward races', arranging them to illustrate beliefs about 'early man' or 'the dawn' of human society. Installation practices were developed to show that non-white, non-European peoples were lower on the evolutionary ladder than white Europeans. The 1910 display of African objects [**588**] in the American Museum of Natural History, New York, actually challenged evolutionist theories of culture. Its organizers believed that societies develop not according to universal laws but each in relation to the specifics of its environment and the particular accidents of its past. In this installation, objects were meant to be understood as belonging to a unique cultural whole. Despite the liberal views informing it, however, the installation's location in a museum of natural history and the inclusion of zoological exhibits perpetuated the idea that the lives of non-European peoples are dominated by nature and necessity, while Europeans live a history—they rise above nature and shape their existence. As framed here, African artefacts appeared as scientific specimens, evidence of simpler or less developed peoples, while a few streets away, in the Metropolitan Museum of Art, comparable artefacts of European social and religious life were seen as signifiers of high spiritual achievement. CD

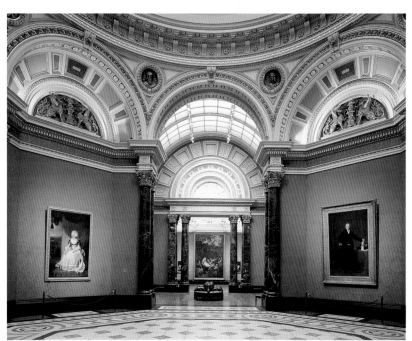

587 Left: Barry Rooms (1876), London, National Gallery

588 Below: The African Hall in the American Museum of Natural History (1910)

Reflected glories

The Louvre Museum's monumental Daru Stairway [589] was begun in the Second Empire as part of a building campaign that vastly expanded the palace complex (the Louvre housed not only the art museum, but also state offices and assembly rooms). Besides connecting the palace's new and old wings, the Daru Stairway also served as the museum's grand opening statement. The magnificent *Victory of Samothrace*, dramatically situated on the central landing, unequivocally reasserted the supreme status accorded by the museum to Classical Antique culture.

Also visible in **589** are some of the mosaic decorations given to the stairway's overhead spaces in the 1890s. Each of the stairway's several domes was dedicated to one of the principal epochs in the history of Western art. Predictably, the two largest and most central domes were given to Classical antiquity and (visible in this photograph) the Italian Renaissance (a portrait of Raphael can be seen directly above the *Victory*). Smaller side domes celebrated the Dutch, English, and post-Renaissance French schools. Like the Louvre's other ceiling decorations, the new programme stated yet again the Louvre's core art-historical doctrine: the French nation is the heir to the genius of past civilizations. The mosaics, never well received by critics, were removed in 1934.

The businessmen from Boston, New York, and Chicago who founded America's first major museums were well acquainted with the splendours of the great European state collections. Having put their cities in the front rank of the world's economic powers, they now determined to put

589 Above: The Daru Stairway in 1930, Paris, Louvre

590 Above: Proposed staircase and dome for the Art Institute of Chicago, ink and wash drawing (1894)

them in the same cultural league as Paris, London, Vienna, and the other European centres of urban civilization. Accordingly, they erected showy new museum buildings and combed Europe for Old Master paintings, antique furniture, rare china and glass, and much else. When they could not buy or dig up originals, they purchased quantities of plaster casts of ancient and Renaissance sculpture.

Chicago's Art Institute is a typical art museum of the gilded age. Erected at the same time and in the same spirit as Chicago's famous World's Fair of 1893, it freely borrows features from Greek and Renaissance monuments, including the Parthenon and the Library of San Marco in Venice. The grand staircase, as proposed in 1894 [**590**] was obviously inspired by the Louvre's Daru Stairway. Although the dome was eventually dropped, the

plaster *Victory* was duly installed [**591**]. Clearly, Chicago's business élite wanted it known, as the sculptor Loredo Taft speaking at a dedication ceremony in 1913 put it, that art and culture had arrived to 'crown [Chicago's] commercial life as was crowned the commercial life of Athens and Florence and Venice'. CD

591 The Art Institute of Chicago's Grand Staircase around 1910

5 Modernism and After
1914–2000

For the most recent era, it is harder to determine the most effective period divisions than for ages more distant in time. The self-proclaimed dominance of international modernism—an attitude rather than a coherent style—is examined under the heading 'The International Style'. The attitude was characterized by a series of shared assumptions: that originality is paramount; that the artist is accountable only to the cult of 'Art'; that the public takes time to catch up; and that creativity does not lie in the naturalistic imitation of nature. The exploitation of new materials characteristic of twentieth-century technologies is also a notable feature of modernism, as outlined in 'Alternative Media'.

With hindsight, it is now easier to respect traditions outside the mainstream of modernism as possessing their own individual vitality, both in embracing and in reacting against international fashions. The sections on 'alternative centres' in Soviet, Latin American, Indian, African and Afro-Caribbean, Canadian, and Australian art show the variety of relationships between established visual cultures and new ideas from outside.

The development of the 'art industry' continued with unabated vigour, replacing the traditional academies with a gallery culture, nourished by organizations for the marketing of art and by vehicles for the broadcasting of criticism. The complementary rise of art history as a professional discipline is examined in a special essay. Postmodernism, in the final section, presents a challenge to the sovereignty of modernism on the basis of a rejection of the autonomous value of the 'aesthetic object' in favour of a pluralism of values and stylistic eclecticism.

Themes

The First World War serves to mark the climax of developments initiated in the late eighteenth century and the advent of the 'Modern' world. The relatively coherent radicalism of pre-war movements was dispersed across a range of initiatives, extending from the drive towards autonomous abstraction, through the aesthetic 'anarchy' of Surrealism and Dada, to social comment-ary in Weimar Germany, and the social realism favoured by the Communist states. Alongside the self-conscious avant-gardes, there continued to exist a wide variety of creative practice in less radical modes that continued to satisfy various demands.

Those artists and movements who placed themselves in the vanguard did so both by proclaiming their own ideals—often with the direct involvement of missionary critics—and by rejecting tradition on a combination of aesthetic and social grounds. One of the paradoxes of the wish to overthrow establishment practice was the production of a new élite, subject to is own highly specialized codes of practice, appreciation, and advocacy. Contemporary art often seemed to be becoming as esoteric as quantum physics.

Europe and an expansionist America exported the idea of 'Art' to areas of the world which had their own rich traditions of functional imagery. Initially the export comprised institution-alized training, but, increasingly, the more radical stances became known and emulated, not least via indigenous artists who carried the message back from avant-garde centres. America came to assume—or more particularly to claim on its own behalf—a dominant role in defining the latest movements in terms of a series of modernist initiatives, such as Abstract Expressionism, Pop art, and Conceptual art. The international impact of the new art emanating from the dominant world power was underwritten by its promotion through cultural institutions whose air of officialdom stood in apparent conflict with the artists' anti-establishment instincts. The concept of rebellion had itself become institutionalized.

By the 1970s, the international sovereignty of Modernism was coming under challenge from a variety of directions. These included a reassertion of national or regional agendas in the face of international homogeneity, the search for more direct social 'relevance' than art for art's sake, the questioning of the Western value systems that underpinned the production and consump-tion of 'Art', and a sense that there was no one style (in terms of period, geographical origin, or any other category) that could be considered as superior to any other. The spread of art history and theory did much to provide the ammunition for the 'relativist' attitudes that fed upon such factors as post-colonial guilt and the multi-cultural society. Towards the end of the century, which has witnessed the collapse of the Communist bloc in Russia and Europe, the extraordinary globalizing of travel and communication, the increasing use of alternative media such as installation, video, and computers, and the huge diversification of the production of imagery, any unified definition of 'Art' requires an elasticity that renders it at least as general and unhelpful as any definition of 'literature'. MK

592 Opposite: Henri Matisse (1869–1954), *Icarus* (1943), maquette for *Jazz,* first published in 1947, gouache on paper cut-out, 40.5 × 27 cm. (16 × 10½ in.), Paris, Musée National d'Art Moderne – Centre Georges Pompidou

The International Style

In the period since 1914, modern art has increasingly become an international language. Artists have engaged in a dialogue made ever easier by improvements in long-distance travel and by a mushrooming of publications about art and art ideas. This dialogue has taken place within a context of drastic social, political, and economic change, including two world wars, the Russian Revolution of 1917, the rise of Fascism in the 1930s, the Spanish Civil War, and the tensions of the Cold War. It is against this background of a shrinking, but increasingly complex and often unstable, world that the works of major twentieth-century artists—some of the most spectacular, diverse, innovative, and controversial art ever produced—should be considered.

The artist at war

The period commenced, in the most dramatic and tragic of fashions, with the major European nations marching to war. Many artists joined the mass ranks of soldiers mobilized to fight in the trenches. Some, including the Italian Futurist painter and sculptor Umberto Boccioni (1882–1916) and the German Expressionist Franz Marc (1880–1916) paid with their lives. Others, including the Englishman Paul Nash (1889–1946), the Frenchman Fernand Léger (1881–1955), and the Germans Otto Dix (1891–1969) and John Heartfield (Helmut Herzfelde) (1891–1968), would be affected by their experiences.

Before the war, Nash had worked largely as a landscape painter, producing scenes of the English countryside. In early 1917, however, under the auspices of Lord Beaverbrook's newly established War Artists Commission, Nash set off for France to witness firsthand the bloody conflict. Unsurprisingly, Nash was horrified at what he saw. In a letter to his wife he described scenes at the front as a 'frightful nightmare…unspeakable, utterly indescribable'. Aware that British censors would be unlikely to allow images of mutilated corpses to be displayed at home, Nash instead drew on his old experiences and, in *We Are Making a New World* (1918) [**618**], focused on the landscape of war. Nash used bright, lurid colours and jagged forms to express the violence perpetrated against nature itself. Viewed as if peering cautiously from a trench, the violated earth and shattered, amputated tree stumps, reminiscent of the mass amputations of limbs, lie dormant beneath a blood-red sky obscuring the sun's attempts to shine through. The 'New World' to which the title of the work refers appears not to be a world of glorious victory over evil, but one of mass destruction in which the scarred landscape acts as a metaphor for the loss of life and of hope.

Nash was not alone in focusing on the tragic element of the war. On the opposite side of the trenches, a German medical orderly by the name of Wilhelm Lehmbruck (1881–1919) produced a sculptural figure to express his sense of the futility of the conflict. Lehmbruck's *Fallen Man* (1915–16) [**609**] embraced the traditional sculptural emphasis on the nude figure. Yet his figure is notably elongated and emaciated. With its slender proportions it seems barely able to carry its own weight, as if the burdens of the world are too much for the body to sustain. In 1919 Lehmbruck's own sense of utter despair led him to commit suicide. Today *Fallen Man* offers a fitting memorial to the artistic representation of a modern tragedy.

Dada and the machine aesthetic

Whilst Nash and Lehmbruck focused on the traditional themes of the landscape and the body to symbolize the destruction caused by the conflict, other artists adopted more radical agendas. During the war, Zurich in neutral Switzerland provided refuge for a number of exiles, expatriates, and pacifists. It was here that the movement known as Dada first emerged. The term Dada refers to a diverse group of artists working in Zurich, Cologne, Berlin, Paris, and New York roughly between the years 1916 and 1922. Significantly, these artists adopted no unified style and often worked in ignorance of each other's activities. What linked them, however, was a sense of protest against the corrupted values of modern bourgeois society which, they believed, were responsible for the horrors of the war. Marcel Duchamp (1887–1968), perhaps more than any other Dada artist, captured this iconoclastic mood. In 1919, Duchamp produced the ultimate satire on contemporary notions of art when he took a reproduction of the *Mona Lisa*, drew on a graffiti moustache and goatee beard, and included the five letters *L.H.O.O.Q.* as a caption beneath the image [**593**]. Duchamp's irreverence worked on several levels. First, by using a standard reproduction of Leonardo's masterpiece, Duchamp devalued the importance of the individual artist's hand. Here, he implied that the reproduction had as much value as art as the original work. Secondly, by altering the image and confusing the gender identity of the *Mona Lisa* herself, Duchamp drew attention both to Leonardo's homosexuality, and his own ambiguous attitudes to gender identity. And thirdly, by adding the letters L.H.O.O.Q., Duchamp introduced a kind of semantic code which, when read letter by letter in French, translated as 'She's got a hot ass' ('elle a chaud au cul').

The French-born artist Francis Picabia (1879–1953) had met Duchamp in New York during the early war years. Adopting a similarly irreverent approach to social and artistic convention Picabia focused, in particular, on the image of the machine as a metaphor for the absurdity and inhumanity of the modern world. In *Girl Born Without a Mother* (1916–18),

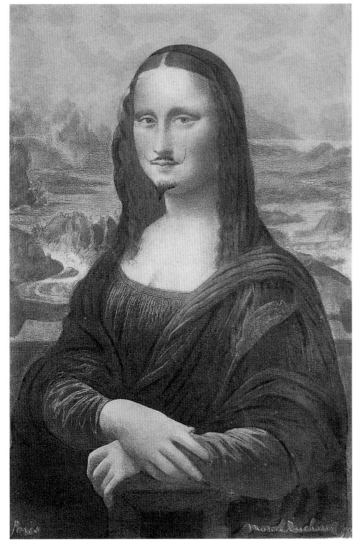

593 Above: Marcel Duchamp (1887–1968), *L.H.O.O.Q.* (1919), pencil on a print of Leonardo's *Mona Lisa*, 19.4 × 12.2 cm. (7⅝ × 4¾ in.), private collection

Picabia linked the regular movements of machine parts to the procreative process, simultaneously parodying the sexual act and traditional religion. The mechanomorphic *Girl Born Without a Mother* offered a clear parallel to the 'son born without a father', so central a concept in Christian philosophy.

In post-war Germany Dada artists adopted a more overtly political approach. For example, in Otto Dix's *Card-Playing War Cripples* (1920) [**619**], the conflation of human beings with machines carried much more explicit connotations for the tragic and horrific casualties of war. Dix represented three men playing cards in a city café. Each of these figures is grossly mutilated, missing limbs having been replaced with prosthetic parts, whilst faces are bolted, tied, and stitched into place. To emphasize further the *ad hoc* nature of these half-men, half-machines, Dix constructed this image with a multiplicity of collage materials, including real newspapers and playing cards. In this way he

offered an ironic reminder of pre-war Cubist collage techniques. Dix did not have to go far to find the wounded and mutilated veterans that he represented in this work; many could still be found begging on the streets of major German cities.

Not all artists perceived technology and the machine in such negative terms. In post-war Paris, for example, two painters, Charles-Édouard Jeanneret (better known as Le Corbusier) (1887–1966) and Amédée Ozenfant (1886–1966), launched a movement which they named Purism in their own journal *L'Esprit Nouveau*. Le Corbusier and Ozenfant opposed the irrationality which typified Dada. Rejecting what they referred to as 'the capricious march of intuition', they proposed instead logic, order, and mathematical precision, qualities which they perceived in such modern industrial products as aeroplanes, automobiles, and ocean liners. Within the Purist aesthetic simple, geometrical forms lay at the heart of all good design, a factor which would later influence Le Corbusier's approach to architecture as much as to painting. In his *Still Life with a Pile of Plates* (1920) [**599**], Le Corbusier offered a useful insight into Purist ideas. Here, the artist presented a still-life scene incorporating ordinary, everyday objects: bottles, plates, pipes, a guitar. These objects are represented in a simplified, flattened, and schematic manner, with more than one viewpoint employed—the pipes, bottles, and plates, for example, are simultaneously seen in profile and from above. Here, Le Corbusier was clearly invoking the legacy of the pre-war Cubist still lifes of Georges Braque (1882–1963), Pablo Picasso (1881–1973), and Juan Gris (1887–1927). Yet, at the same time, he was taking Purism beyond Cubism. By incorporating the dual viewpoints of an architect's plan and elevation, in contrast to the multiple viewpoints of Cubism, Le Corbusier evolved Purism into a new, rationally inspired style. Ultimately, in a post-war era of reconstruction, the Purists' optimistic faith in technology as a potentially liberating force contrasts notably with the iconoclasm of the Dada artists.

Other artists, not directly associated with the Purist movement also adopted the imagery of the machine and mass-production. In 1921 Fernand Léger exhibited a large-scale work entitled *Three Women* (*Le Grand Déjeuner*) [**608**] at the Salon d'Automne. The painting shows three nude females in a domestic interior surrounded by modern, mass-produced objects. Notably, however, even the women themselves have the appearance of objects, their hard, shiny, metallic bodies displayed like mannequins in a shop window. For Léger geometric ordering and composition dominated exoticism and voluptuousness. Indeed Léger claimed that 'in the mechanical order the dominant aim is utility, strictly utility'. Although deeply problematic in its attitudes

towards gender, Léger's mass-production fantasy clearly appealed to the Purist sentiment. In 1923, a reproduction of *Three Women* was included in *L'Esprit Nouveau* positioned, significantly, alongside a photograph representing a prime example of modern technological splendour, the Ocean Liner *Paris*.

Neoclassicism and modern art

Despite its overtly modern handling, Léger's focus on the traditional theme of the female nude did reflect a renewed post-war interest in the Classical past. During the war, for example, Picasso was producing more highly naturalistic drawings and paintings alongside his Cubist works. In the immediate post-war years he produced a number of images representing monumental figures, often clothed in Classical garb, such as *Mother and Child* (1921) [**596**], a statuesque mother carefully nursing a child playfully stretching out on her lap. Three simple horizontal bands of colour, indicating sky, sea, and shore, give the work a calmness and stability, qualities much sought in the wake of the war. Picasso was addressing a deeply personal theme. That very year he witnessed the birth of his first son, Paul. At the same time, however, the theme of maternity struck a wider chord in early 1920s France. Indeed the subject of birth, nurturing, and growth was frequently deployed by artists as a key metaphor for the necessary rebirth and rebuilding of the post-war nation.

Geometrical experimentation

Whilst artists in western Europe struggled to find a new meaning and identity in the post-war era, those in Russia were rising to a quite different challenge. In 1915, Kasimir Malevich (1878–1935) had launched his Suprematist movement at the exhibition in Petrograd (St Petersburg). Pride of place was given to the notorious work entitled *Black Square* (1914–15) [**625**]. In this work Malevich perceived a veritable negation of all prior representational painting, describing the work as 'the first step in pure creation in art'. The origins of *Black Square* have been traced to a stage-set designed by Malevich for the avant-garde, irrationalist play *Victory Over the Sun*, written by Aleksei Kruchenykh in 1913. His simple design, consisting of little more than a black square seen against a white border, symbolized the final victory of darkness over light. Yet for Malevich, this victory was seen not as a culminating point but as a new beginning, a *tabula rasa* upon which new cultural forms and ideas could be developed. After 1917, and Lenin's victory in the October Revolution, Malevich was quick to align his radical cultural agenda with the politics of the new regime. In the early post-revolutionary years his reputation went from strength to strength and he occupied a key role in Soviet art education. As early as the mid-1920s, however, voices increasingly questioned the worth and relevance of Malevich's Suprematism for a Socialist Revolution.

At this time other artists, such as Lyubov Popova (1889–1924), were looking more to the fields of construction and industry to inform their art. For example, Popova's *Spatial Force Construction* (1920–1) [**600**] is notably executed not on a primed canvas, but on a plain piece of wooden board. On to this surface she inscribed a series of lines and circles in black and red paint. These are not drawn free-hand, but precisely with the aid of ruler and compass, technical aids more commonly used by engineers than by artists. In this way, Popova denied a personal, intuitive approach in favour of a more controlled, diagrammatic handling. Furthermore, the whole image is made up of a series of components, circles, lines, areas of shading, which signify the process of construction itself, the building of a whole from its component parts. At this stage, artists such as Popova, Alexander Rodchenko (1891–1956), and Varvara Stepanova (1894–1958) were still producing paintings based upon this aesthetic of construction. Soon, however, they took the approach to its logical conclusion by rejecting easel painting altogether in favour of working directly in factory production.

This rationalist-inspired approach of reducing objects to their most basic components also took hold in other European nations, although often to dramatically different ends. In Holland, the painters Piet Mondrian (1872–1944) and Theo Van Doesburg (1883–1931) had launched the magazine and movement known as De Stijl (Style) in 1917. From this point onwards Mondrian's works were characterized by the representation of purely geometrical forms, squares, and rectangles contained by a simple structural framework of horizontal and vertical lines [**626**]. For Mondrian, this reduction of forms was not a simple attempt to replace representational art with a new abstraction. Like Vasily Kandinsky (1866–1944) [**627**], Mondrian was an ardent follower of Theosophy, an occultist religion which elevated the spiritual world over the material. Thus painting, for Mondrian, was a means to the representation not of the physical world but of a notionally higher, spiritual realm characterized by pure geometrical forms and primary colours. Despite its deeply spiritual foundations, Mondrian's style was frequently deployed to more direct and practical ends. In 1918, for example, the De Stijl furniture designer Gerrit Rietveld (1888–1964) produced a chair in which every component was similarly reduced to a pure, cuboid geometrical form. Originally finished in polished wood, Rietveld adapted the chair in the early 1920s, painting the back rest red, the seat blue and the structural framework black with yellow ends. Rietveld's chair, known in its new manifestation as the *Red and Blue Chair* [**612**], has subsequently become an icon of modern design, although its emphasis upon functional simplicity and visual appearance perhaps overrides any potential for domestic comfort. The functionalism within De Stijl design had a major influence upon one of the twentieth century's best-known design centres, the Bauhaus in Germany.

In particular, Rietveld's chair was to be a major influence on a young Bauhaus student by the name of Marcel Breuer (1902–81). Breuer enjoyed cycling in the flat countryside surrounding Dessau. On these excursions, he became increasingly fascinated with the design of the bicycle and, in particular, the strength and lightness of tubular steel. In 1926, Breuer produced a tubular steel frame to which he attached broad leather straps and thus created the famous '*Vassily*' *Chair* [**613**], so named because it was much admired by Kandinsky, then teaching at the Bauhaus. Breuer's chair is just one example of the design approach adopted by Bauhaus students. Its emphasis on structure and function over and above ornament and decoration, caused something of a revolution in the design world and continues to influence design to this day.

Beyond the conscious: the rise of Surrealism

In France, another group of artists was also defining itself as revolutionary. Their revolution, however, was not confined solely to the political sphere. In December 1924, a new journal entitled *La Révolution Surréaliste* appeared for the first time. Earlier that year, the journal's editor André Breton (1896–1966) had also published a 40-page *Manifesto of Surrealism* attacking contemporary cultural practices and proclaiming the need for a new approach to art and literature.

Like many of his contemporaries, Breton had experienced the war firsthand, not as a front-line soldier, but as a medical orderly working amongst victims of shell-shock in a psychiatric ward. Here he had encountered the psycho-therapeutic techniques recently developed by Sigmund Freud. Breton particularly embraced the Freudian notion of the 'unconscious', the memories and experiences retained in the mind but usually repressed in consciousness in accordance with the codes and conventions of social life. For Freud, gaining access to the 'unconscious' was a means to a specifically therapeutic end, a way to help those suffering from mental trauma and disorder. For Breton and his followers, however, the 'unconscious' offered an exciting, magical world in which the nature of human existence might be revealed.

In their attempts to represent the 'unconscious' the Surrealists developed two principal techniques: automatism and the visual representation of dreams. The key aim of automatism was to produce an image 'in the absence of any control exercised by reason, exempt from aesthetic and moral concern'. Artists adopted various strategies to achieve this condition. André Masson (1896–1987), for example, often forced himself to work under conditions of extreme duress, after long periods without sleep or food, or under the influence of drugs. Only in this state of semi-consciousness, he believed, might his works reveal the nature of the unconscious mind. Another automatist technique was based upon the children's game Consequences, in which a piece of paper is folded into four horizontal strips and several participants each draw a part of a body without seeing the parts drawn by their fellow collaborators. For the Surrealists this process resulted in a synthesis of different, notionally unconnected thoughts and ideas, produced without any unified or rational control. Many of these drawings were subsequently published in *La Révolution Surréaliste* and called, in a suitably Surrealist mode, *Exquisite Corpse*.

When attempting to represent the world of dreams, the Surrealists particularly looked to the precedent of the Italian artist Giorgio de Chirico (1888–1978). As early as 1914 de Chirico had produced paintings such as *The Song of Love* [**602**] in which a strange assortment of unrelated objects—a plaster head of the *Apollo Belvedere*, a surgeon's rubber glove, and a croquet ball—are juxtaposed and placed within a deep perspectival and sharply defined townscape. What appealed most to the Surrealists in de Chirico's work was precisely these strange and inexplicable juxtapositions and the sense of magic and mystery they evoked. Both Max Ernst (1891–1976) and Salvador Dalí (1904–89) drew on de Chirico's works, introducing strange, metamorphic creatures in eerie, dream-like landscapes [**601**, **604**]. The Surrealists adored mystery, yet it was a mystery with a dark, sinister, and frequently violent edge.

As a child, the Belgian painter René Magritte (1898–1967) spent much of his time in the newly expanding cinemas watching silent movies recounting the exploits of the Keystone cops, Charlie Chaplin, and detectives such as Nat Pinkerton. His favourite movies, however, featured the character Fantômas, a mysterious, black-cloaked criminal and master of disguise who was constantly pursued, but never caught, by the bowler-hatted detective Juve. In *The Menaced Assassin* (1926) [**603**] Magritte presented a scene reminiscent of a still from a detective movie. Two bowler-hatted assailants wait in ambush, about to capture a besuited gentleman who has seemingly perpetrated a violent, sexual crime. But who is this man and his victim, why has a murder been committed, and why does he delay his escape by listening to a gramophone record? Furthermore, what part is being played by the men whose heads appear through the background window? Magritte offers no answers to these questions. Indeed it is the very inconclusive sense of mystery which gives this work its dream-like quality. Surrealist artists also operated beyond the realms of painting, taking ordinary, everyday objects and investing them with magical, dream-like qualities. In 1936, an Exhibition of Surrealist Objects was staged in Paris. Amongst the objects on display—tribal masks, found objects, and specially made works—was Meret Oppenheim's (1913–85) fur-covered tea-cup which was given the title *Luncheon in Fur* by André Breton.

Art and anti-Fascism

The rise of Fascism in Germany and Italy during the inter-war years impacted heavily upon modern art production. Notably, Fascism did not adopt a unified policy towards the visual arts. In Italy the political presence of the champion of Futurism, Filippo Tommaso Marinetti (1876–1944), ensured that modernist styles still had a part to play in official culture. In Germany, however, Hitler attacked avant-garde artists and promoted styles reminiscent of the late nineteenth-century German Romantics whom he most admired. Opposition to Fascism generated some of the most striking works of political protest produced this century. As a staunch Socialist and official member of the German Communist Party, John Heartfield always gave his art a deeply political content. Forced to flee his native Germany on Hitler's assumption of power, Heartfield continued to express his protest by producing dozens of photo-montages parodying the Fascist leader. One of the best known of these works, *Don't Worry! He's a Vegetarian* (1936) [**620**], portrays Hitler as a bloodthirsty con-man, about to slit the throat of an unsuspecting cockerel symbolically representing France. Heartfield's adoption of photo-montage, a technique originally developed in the nineteenth century, was particularly suited to his form of political protest. By using actual photographs but altering their original context, Heartfield created a powerful critique of the Fascist state, simultaneously utilizing and exposing the ways in which notionally 'authentic' documentary images could be put to specifically ideological, propagandist ends.

Heartfield was not alone in using the visual arts as a means to express a political message. In 1937, Picasso produced the large-scale painting *Guernica* [**594**], a work which has subsequently become one of the most famous anti-war statements made in the history of art. *Guernica* was originally produced in

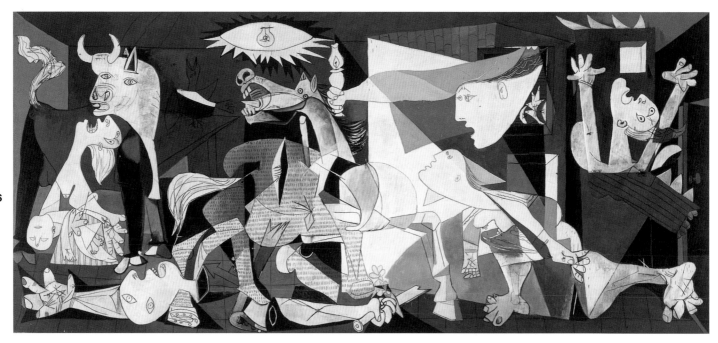

response to a commission from the Spanish Republican government for a work to be installed in their pavilion at the 1937 Paris International Exhibition. Uncertain, at first, how to approach the commission, Picasso was soon swayed by the events of 26 April 1937. On that day Franco's forces, assisted by the German Condor Legion, bombed the small Basque town of Guernica, killing hundreds of civilians. The atrocity made international headlines and photographs of the destruction were reproduced in many newspapers world-wide. Picasso's *Guernica* draws attention both to the possibilities and the limitations of using a modernist visual vocabulary to produce what is, in effect, a large-scale history painting. His schematic handling and tortured, fragmented forms adequately symbolize the tragedy of civilian bombing, whether through the representation of the agonized mother carrying a dead child in the left of the image, or through the noiseless scream of the dying horse which dominates the centre. By producing the whole image in black and white, Picasso also alluded to the newspaper and newsreel coverage of the event in the international arena. Nonetheless, Picasso's complex stylistic handling, composition, and symbolism were unlikely to appeal to a broad audience, making his work inaccessible to many. Following its exhibition in Paris, *Guernica* was sent on tour to Britain and the United States to raise money for the Spanish Republican cause. After the final victory of Franco, the work remained in the Museum of Modern Art in New York. It was not until 1981, and after the deaths of both Franco and Picasso, that the work would finally return to Spain.

The wartime struggle for modern art

In 1939 the Second World War sent Europe into turmoil for the second time in a generation. By June 1940 Paris was occupied by German forces and a collaborationist government was set up at Vichy under Marshal Pétain. Art production was now clearly a low priority when weighed against the sheer struggle for survival. Nonetheless, many artists did remain active. The most notorious case is that of Picasso, who remained in Paris throughout the entire conflict. Protected by his personal fame and

594 Pablo Picasso (1881–1973), *Guernica* (1937), oil on canvas, 3.49 × 7.77 m. (11 ft. 5½ in. × 25 ft. 6 in.), Madrid, Museo Nacional Centro de Arte Reina Sofia

fortune, close friends, and incredible good luck, he was mostly left alone by the occupying forces, despite the fact that he was a figure much loathed by the National Socialist cultural élite. By the time of the liberation of Paris in 1944, he had produced more than 400 paintings and several sculptures, the latter produced at a time when public monuments were being melted down for armaments. Amongst other artists working in Paris during the Occupation was Jean Fautrier (1898–1964), a French-born painter who had been raised in London and studied at the Royal Academy and Slade School but returned to Paris in 1917. During the Occupation, Fautrier was arrested by the Gestapo under suspicion of being involved in Resistance activities. As no evidence was found against him, however, Fautrier was released and decided to lay low in a small studio in the outskirts of Paris. In the surrounding woods, Nazis tortured and summarily executed prisoners. The images he produced at this time specifically address the annihilation of the human form. Drawing on the influence of the 'primitivist' images [**605**] of Joan Miró (1893–1983), themselves reminiscent of cave-paintings, Fautrier's *Heads of Hostages* [**621**] are small panels upon which countless layers of oil, glue, and rag suggest the unrecognizable remains of crushed, destroyed, and mutilated bodies. The dense and thickly worked surfaces of his panels also appear as if they are the very walls against which victims have been executed.

Unlike Picasso and Fautrier, Henri Matisse (1869–1954) did not live in Paris after the Occupation. By now 71 years of age, he retired to his villa in the south of France. In 1941 Matisse underwent a major intestinal operation which confined him to bed for some time. Undeterred by his illness he developed a new technique in which pieces of painted paper were cut with scissors and montaged together to form an image. The most famous examples of the technique appear in the book entitled *Jazz* which Matisse published later in 1947. Describing the

bright, almost luridly coloured images in *Jazz* Matisse said that the 'vivid and violent tones…resulted from crystallizations of memories of the circus, popular tales, or travel. Personal memories.' Amongst these 'memories', however, are images which appear to be specifically related to the war. Most notable is the illustration entitled *Icarus* [**592**]. Taking his source from Ovid's *Metamorphoses*, Matisse updated mythology, for the black outline falling through the sky is not a victim of having flown too near to the sun. Instead, a single, red circle on the chest suggests that this is a modern pilot who has been shot down, and falls through a sky illuminated with flashes of gunfire. Matisse's Icarus is a modern hero, a martyr whose fall symbolizes the destruction of life and hope in the midst of modern warfare.

Existentialism and alienation in post-war art

The end of the Second World War was greeted more with a sense of relief that the immediate horrors of war were finally at an end than with joyousness at glorious victory. In the post-war era a new world order emerged. With Soviet troops occupying much of eastern Europe and popular support for Communism rapidly expanding, the United States took on a new role as the primary defender of capitalism. With the two new super-powers in staunch opposition and, by now, both in possession of weapons of mass destruction, world peace seemed more threatened than ever. In this climate, the culture of post-war Europe was dominated by a sense of alienation and anxiety epitomized by the Existentialist writings of Jean-Paul Sartre (1905–80). In the visual arts, this mood was strongly conveyed by, amongst others, Alberto Giacometti (1901–66), Germaine Richier (1904–59), and Francis Bacon (1909–92).

During the first half of the 1930s Giacometti had been associated with Breton and the Surrealists but was rejected by them after his return to working from the figure. During the war, Giacometti escaped to his native Switzerland where he produced plaster figures which grew ever smaller until they were little more than an inch in height. After his return to Paris in 1945, he continued to work on plaster figures which, through constant reworking, grew taller, thinner, and more and more emaciated [**622**]. Whether presented singly or in groups, the gauntness and attenuation of these figures, their very isolation amongst the immensity of surrounding space, aptly conveyed the desperation of the human condition in the post-war world. Germaine Richier, a former student of the sculptor Émile Antoine Bourdelle (1861–1929), similarly used figurative sculpture to emphasize this condition. The surfaces of her bronze-cast figures are often scarred and lacerated as if these bodies carry the signs of the wrongs perpetrated during the conflict. At the same time they suggest the natural cycle of decay, as if the works have been neglected and left to the elements for years. The figurative tradition was revitalized not only in sculpture.

In the early post-war years, the Irish-born painter Francis Bacon also focused on the representation of the human figure, mostly with a similar sense of dread and angst to that found in Giacometti's sculptures. One of Bacon's best-known works is his Portrait of Pope Innocent X, produced in 1953 [**623**]. He used a famous art-historical source, a painting by the seventeenth-century Spanish artist Diego Velázquez. Yet whilst Velázquez's work conveys the quiet confidence of papal authority, Bacon's

expresses suffering and torment. Far from being enthroned, this Pope appears to be imprisoned in an instrument of torture and emits a scream as his form dissipates before our very eyes.

Whilst artists such as Giacometti, Richier, and Bacon aptly captured the mood of post-war angst and alienation, other artists took a more hopeful line. In France, the reputation of the Catholic Church had been considerably tarnished by its pro-Vichy stance during the conflict. Aware of the need to re-establish popularity, particularly amongst the French intellectual fraternity, the church adopted an ambitious plan to encourage modern artists to produce works for churches throughout the nation. As a part of this project, Matisse was invited to decorate a small Dominican chapel in the town of Vence near his own villa [**624**]. By now approaching his eightieth birthday, Matisse was largely confined to his bed. From here, however, he designed everything for the chapel, including the stained glass, the Stations of the Cross, the crucifix which adorns the altar, and even the priests' vestments. For the stained glass, Matisse relied largely upon the paper cut-out technique he had earlier used in his illustrations for the book *Jazz*. This time, however, he used specific colours, blue, green, and yellow, reminiscent of the sky, trees, and sand of the Mediterranean landscape that had inspired him throughout his entire lifetime. Speaking of the Vence chapel Matisse claimed: 'I want those who enter my chapel to feel purified and relieved of their burdens.'

The rise of New York

Although Paris continued to attract artists in the post-World War Two era, its previous reputation as the art capital of the world was by now being increasingly usurped by New York. During the 1920s, New York had become a thriving centre for avant-garde artists, particularly because of the exhibiting policies of figures such as the photographer Alfred Stieglitz whose Gallery 291 had shown major European artists such as Picabia, Matisse, and Picasso, as well as home-grown talents such as Georgia O'Keeffe (1887–1986) and Stuart Davis (1894–1964) [**615**, **629**]. By 1929, with the foundation of the Museum of Modern Art New York's reputation as a major avant-garde art centre increased dramatically as significant examples of European modernism were publicly displayed to American audiences.

The real leap forward, however, came with the war. As modern art had been particularly castigated by the Nazi regime, many artists fled Europe for the safety of the United States. Amongst those who stayed in New York during the war years were Breton, Léger, Mondrian, and Ernst. By the late 1940s, with much of Europe still in economic turmoil and the United States playing a new, dominant role in global politics, young American artists also began to attract increasing critical attention. Amongst those broadly publicized were proponents of what came to be called Abstract Expressionism, artists such as Jackson Pollock (1912–56) [**606**], Barnett Newman (1905–70), and Mark Rothko (1903–70) [**616**]. All three artists eschewed the representation of natural phenomena and produced work on an enormous scale, often several metres in length and height. Their stylistic approaches were also distinct. Pollock's drip-painting technique has probably attracted the most attention. Pollock had originally trained with the American Regionalist

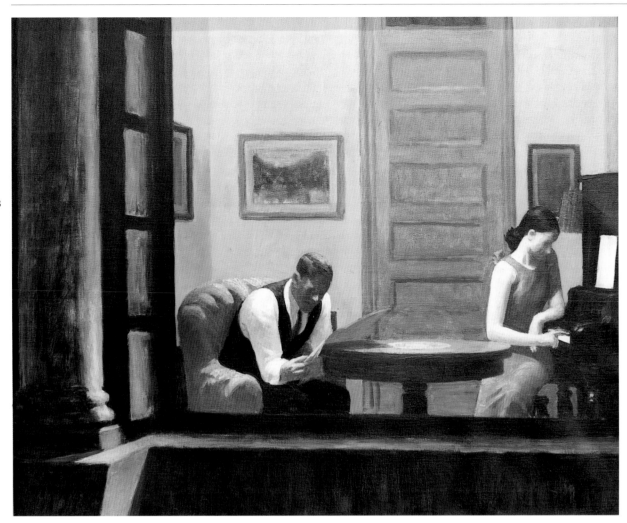

595 Edward Hopper (1882–1967), *Room in New York* (1932), oil on canvas, 73.7 × 91.5 cm. (29 × 36 in.), Lincoln, Sheldon Memorial Art Gallery, University of Nebraska

painter Thomas Hart-Benton (1889–1975) and during the 1930s was familiar with American Realists such as Charles Sheeler (1883–1965) [**598**] and Edward Hopper (1882–1967) [**595**]. In the late 1940s, however, he began to lay his canvases flat on the floor and drip thick commercial paints over the surface to produce dense, web-like layers of pure colour. The origins of Pollock's technique were diverse. First, his dependence upon the laws of fluid motion seemed to allude to the 'uncontrolled' techniques developed by the European Surrealists. Yet Pollock's drips and splashes were never accidental, each colour and layer carefully and thoughtfully applied to build up a rich, luminous surface. Secondly, Pollock openly declared a debt to the technique of sand painting developed by Native Americans, where different coloured sands were ritually poured on to a horizontal surface to build up an image. Pollock's works, such as *Number 1, 1950 (Lavender Mist)* [**606**], reveal both his affinities to Native American culture—raised in Cody, Wyoming, he was himself a child of the American West—and to the vastness and openness of the American landscape.

By the late 1950s Abstract Expressionism was broadly promoted throughout Europe in a touring exhibition called 'The New American Painting'. Recently, it has been suggested that this exhibition, sponsored by institutions attached to American Government agencies, may have had a specific agenda with regard to Cold War cultural politics. More particularly, it has been claimed that the official promotion of Abstract Expressionism may have been intended specifically to display individualism, freedom, and liberalism as qualities unique to the West, and in contrast to Soviet censorship and repression. This claim reflects in no way upon the artists involved in the exhibition. Rather, it reveals the ways in which works of art have, throughout history, been deployed to express or to reinforce political power. Indeed Abstract Expressionism was the triumph of American painting.

Abstraction and realism in post-war Europe

The Americans, however, did not hold a monopoly on the production of large-scale, abstract works. In Europe cultural debates focused largely on the issue of abstraction versus realism, a reflection of the perceived cultural policies of the two new super-powers, with a significant body of artists supporting both camps. Amongst those producing notionally abstract works were Fautrier, the German-born artists Wols (Alfred Otto Wolfgang Schülze) (1913–51), and Hans Hartung (1904–), the Italian Alberto Burri (1915–), and the Spaniard Antoni Tàpies (1923–). Although each artist produced works of a highly individual, expressionist nature, they have often been linked under the label Art Informel (Informal Art), a term first coined by the French art critic Michel Tapié. Art Informel emerged as a parallel to American Abstract Expressionism, adopting a similar emphasis upon spontaneity and gestural expressiveness as revelatory of the creative inner being.

Yet, perhaps more than the Americans, artists in Europe frequently introduced new and unconventional materials, emphasizing the three-dimensional, tactile surface of their works. Burri, for example, used coarse, stained sackcloth in his collages, giving the appearance of blood-soaked bandages—indeed Burri had originally trained as a physician and worked as a field doctor in North Africa during the Second World War. Similarly, Tàpies produced sparsely coloured collages, built up with an assortment of materials including newspaper, string, crushed marble, and even rice. The finished object is more reminiscent of a scarred, weather-beaten, and graffiti-covered wall than a work of art designed to hang in an elegant domestic or gallery interior.

In northern Europe, a group of young artists originating from Copenhagen, Brussels, and Amsterdam, and adopting the name Cobra from the initial letters of each of these cities, extended the vocabulary of Art Informel. Between 1948 and 1951 the Cobra artists, most particularly Karel Appel (1921–) and Asger Jorn (1914–73), produced highly coloured, spontaneous works expressing the importance of individual gesture and action. At the same time, however, they reintroduced figurative elements into their paintings; strange creatures deriving from the folklore and mythology of Nordic culture. This conflation of the gestural vocabulary of Abstract Expressionism with the reintroduction of figuration links the works of Cobra artists with those of the Dutch-born American painter Willem de Kooning (1904–).

The conflation of an abstract, gestural stylistic vocabulary with a reintroduction of figurative elements perhaps reached its apogee in the work of the Russian-born French painter Nicolas de Staël (1914–55). In the immediate post-war era, de Staël developed an abstract style based upon solid patches of colour scraped thickly across the surface of the canvas with a palette knife. By the late 1940s, however, de Staël turned to the representation of more conventional subjects—still lifes, landscapes, figure scenes—yet maintained the bold colour patches which had characterized his earlier work. In this way, a notionally abstract vocabulary was deployed to representational ends. Despite the reintroduction of figuration in the paintings produced by the Cobra group and de Staël, stylistically their works remained firmly within the international modernist tradition. It should not be forgotten, however, that many European artists, including Boris Taslitzky (1911–) and André Fougeron (1912–) [**630**] in France, and Renato Guttuso (1912–) in Italy, continued to reject such stylizations in favour of a Communist-inspired, Social Realist vocabulary.

From Jasper Johns to Pop Art

In 1950s America, culture was frequently deployed to express the patriotism generated by the Cold War. In 1958, a young American painter named Jasper Johns (1930–) addressed this issue in his series of Flag paintings. He took the most familiar and potent symbol of American identity, the stars and stripes, and presented it in unfamiliar ways. In his *White Flag* (1955) [**617**], for example, he produced a replica of the American flag in which all colour has been removed, leaving behind a bleached-out ghost of the national symbol. *White Flag* has, by now, become such a familiar icon of American modernism that it

is perhaps difficult to perceive how controversial it was, not least of all in the context of the anti-Communist backlash generated by Senator Joe McCarthy in the 1950s.

The flag was not the only symbol of America to attract artists. In mid-1950s Britain, the image of American consumerism marked a stark contrast to the continuing post-war austerity which characterized everyday life. In 1956, at an exhibition entitled *This is Tomorrow*, staged at the Institute of Contemporary Arts in London, Richard Hamilton (1922–) exhibited a small collage which alluded ironically to this condition. *Just What Is It That Makes Today's Homes So Different, So Appealing?* [**631**] was collaged from images cut from popular magazines. The inclusion of the latest consumer goods—a television, a tape recorder, a vacuum cleaner, and tinned food—defines this interior as ultra-modern. The 'high' art portrait on the wall is notably overshadowed by the larger illustration from a popular romance magazine, whilst these images, in turn, give way to the dominance of Hollywood movies, signified by the huge Al Jolson billboard seen through the window. Yet it is not just the goods themselves which signify a new consumerist age. Here, even the inhabitants of the room, the Charles Atlas muscle-man and soft-porn female model present their physiques to the viewer as examples of consumer goods. Hamilton's collage has often been seen as a progenitor of Pop Art.

It was on the other side of the Atlantic, however, that this movement was fully developed in the works of Andy Warhol (1928–87) and Roy Lichtenstein (1923–97). Having started as a commercial illustrator, Warhol had a heightened awareness of advertising and image-making. In the works he produced in the mid-1960s, he used this language to comment on the nature of modern life. In an age of mass-production and mass-consumption Warhol loved repetition and often took such mundane objects as Campbell's soup cans or Brillo boxes as his subject. However, he also recognized how Hollywood stars were presented more as products than as real people. In his *Marilyn Monroe Diptych* (1962) [**632**], for example, the face of the movie star was replicated countless times, the only alteration being the inconsistencies with which the areas of colour fail to match their allotted spot. Lichtenstein also gave his hand-painted images the appearance of mass production. For him, however, it was the American comic book and its rough dot-printing technique that held most appeal. In *Drowning Girl* (1963) [**633**], Lichtenstein took the throwaway single-frame from a comic book and enlarged it to monumental proportions. In contrast to Abstract Expressionism both Warhol and Lichtenstein eschewed the personal, heroic style in favour of an anonymous, mechanical art in which transient imagery, the kind of images that are normally glanced at and forgotten, are placed centre stage. Reproducing such images on an enormous scale and presenting them within the context of an art gallery ultimately changed their meanings and challenged the very notion of what we understand art to be.

The modern era has been, and continues to be, one of constant and rapid change. In the cultural arena, the visual arts have both responded to this change and contributed to the generation of new ideas and philosophies. In the final analysis, the study of painting, sculpture, and design in the modern period marks a major contribution towards our own understanding of the period in which we now live. MO'M

419

One foot in the past

Whilst many twentieth-century artists willingly embraced modernity, the grand traditions of the Classical, Renaissance, and Rococo eras continued to influence art practices. In the wake of the First World War, the once optimistic faith in technology and progress was seriously shaken. Subsequently, many artists introduced references to historical traditions in their works, re-evaluating the past and seeking the security and stability enshrined within previously glorious epochs.

Such historical references, however, could be used to suggest a multiplicity of ideas. In *Mother and Child* [**596**], Pablo Picasso rejected his pre-war Cubist style in favour of a more naturalistic handling. The statuesque proportions and facial features of both figures here make a clear allusion to the Classical past whilst the Mediterranean landscape of sky, sea, and sand provides a stable background against which a mother both nurtures and plays with her child. Picasso's work operates on both an individual and a societal level, alluding to the very real bond between a parent and an infant whilst simultaneously symbolizing the natural cycle of rebirth following the tragedy of war.

Gino Severini, formerly a member of the Italian Futurists, also adopted a more naturalistic style and historicizing subject in his *Two Punchinellos* [**597**]. By representing figures from the Italian *commedia dell' arte* tradition, Severini alluded to the eighteenth-century Rococo emphasis on leisure and theatricality. Fruit and wine placed on the table alongside the musicians here suggests an abundance in stark contrast to the experiences of

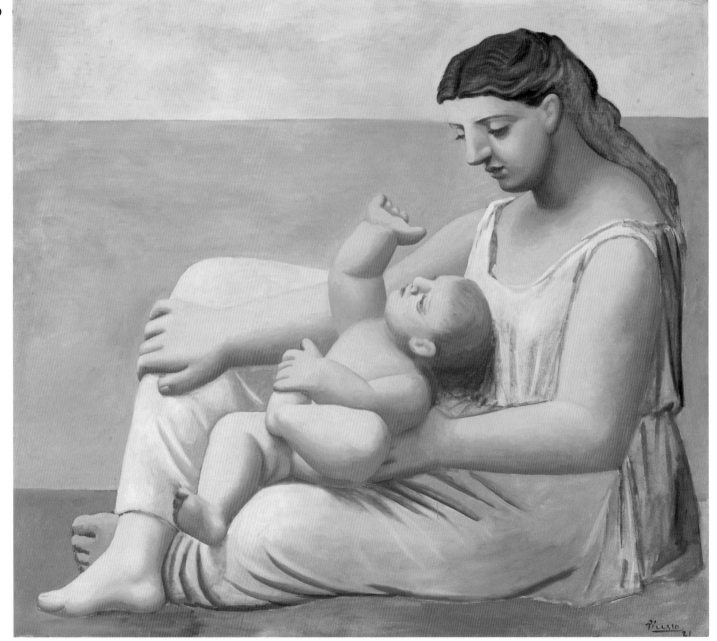

the immediate post-war years. However, the distracted and melancholic expressions, discernible beneath the two figures' stage masks, also suggest a sense of reverie for the passing of a lost age.

For Marcel Duchamp, tradition was something not to be venerated, but challenged. In *L.H.O.O.Q.* [**593**], he took the ultimate symbol of Renaissance authority, Leonardo's *Mona Lisa*, and defaced it by adding a graffiti moustache and goatee beard. By presenting such an overt act of vandalism as itself a work of art, Duchamp fundamentally questioned the validity of traditionally acquired artistic skills. Nonetheless his emphasis on such an icon of past art simultaneously revealed the weight of tradition and its continuing impact upon modern artists. MO'M

421

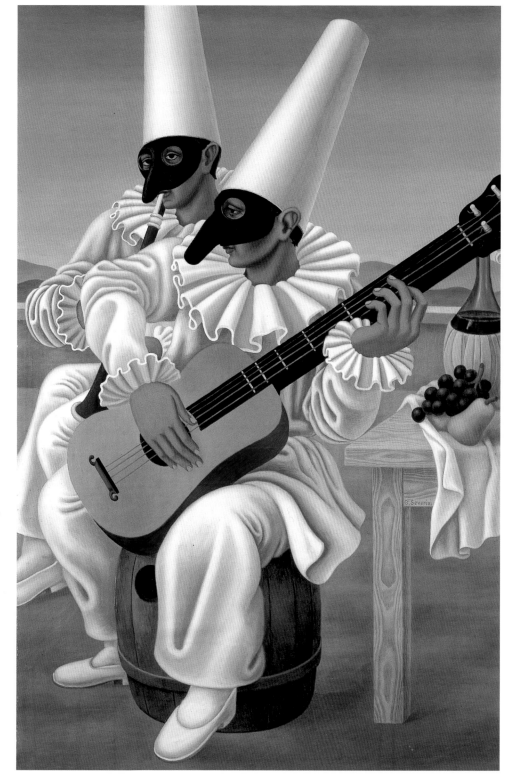

596 Opposite:
Pablo Picasso
(1881–1973),
Mother and Child
(1921), oil on
canvas, 142.9 ×
172.7 cm. (56½ ×
64 in.), Art
Institute of
Chicago

597 Right:
Gino Severini
(1883–1966),
Two Punchinellos
(1922), oil on
canvas, 92 × 61
cm. (36¼ × 24 in.),
The Hague, Haags
Gemeente-
museum

Back to the drawing board

As a corollary to the expansion of industry and the ever-increasing presence of machine-made objects, many artists developed styles more dependent upon technical and engineering diagrams than traditional art practices. The artist and architect Le Corbusier particularly extolled the virtues of geometric form and simple, clear design. In *Still Life with a Pile of Plates* [**599**], for example, he adopted the dual viewpoints of plan and elevation—the objects are simultaneously seen in profile and from above.

In *Spatial Force Construction* [**600**], the Russian artist Lyubov Popova revealed the degree to which artists in the new Soviet Union were embracing industry. However, the association between industry and the

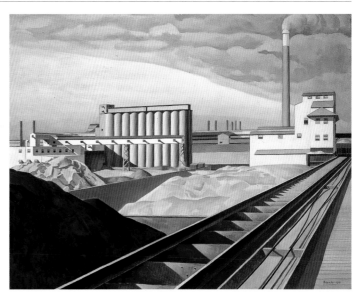

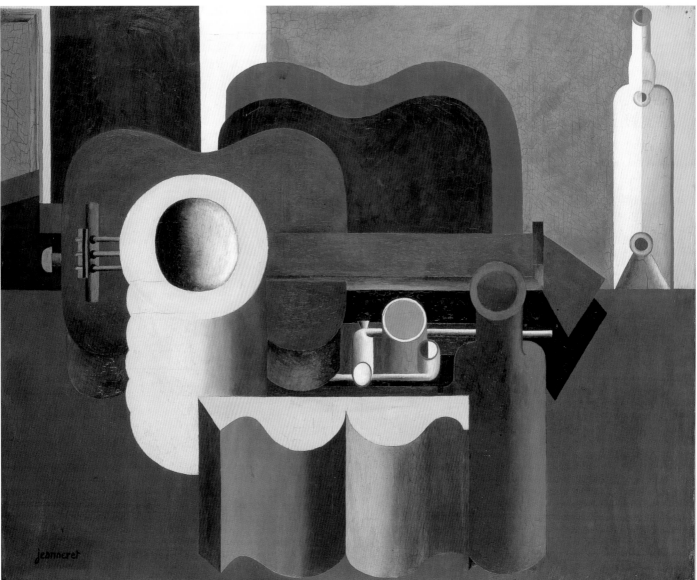

cult of labour carried specifically political and ideological connotations appropriate to the first workers' state.

Whilst the Soviet Union increasingly embraced mass-production techniques, the real expertise in this field lay across the Atlantic, most particularly in Henry Ford's River Rouge car factory. In 1931, Charles Sheeler produced a work entitled *Classic Landscape* [**598**], representing the factory as accurately in detail as any architect's blueprint. Sheeler's heroic images of the River Rouge factory, however, excluded the very workers whose labours kept the grand machinery rolling. MO'M

598 Opposite, top: Charles Sheeler (1883–1965), *Classic Landscape* (1931), oil on canvas, 64 × 83 cm. (25¼ × 32⅝ in.), St Louis, collection of Mr and Mrs Barney A. Ebsworth Foundation

599 Opposite, left: Le Corbusier (Charles-Édouard Jeanneret) (1887–1966), *Still Life with a Pile of Plates* (1920), oil on canvas, 81 × 100 cm. (32 × 39⅜ in.), Basel, Öffentliche Kunst-sammlung Basel, Kunstmuseum

600 Left: Lyubov Popova (1889–1924), *Spatial Force Construction* (1921), on veneer with bronze powder, 113 × 113 cm. (44½ × 44½ in.), Moscow, Tretyakov Gallery

In the realm of dreams

Inspired by Sigmund Freud's theories of the unconscious, many Surrealist artists considered the representation of the realm of dreams as revelatory of the human psyche. In their various attempts to illustrate this dream world they expressed their fascination with mystery, violence, and sexuality.

In his *Elephant of Celebes* [601], Max Ernst created a sense of mystery by taking an innocuous photograph of a corn container and metamorphosing this simple piece of agricultural equipment into a two-footed elephantine creature waddling through a landscape inhabited by headless mannequins and fish that swim through the sky.

Ernst's transformation of the ordinary into extraordinary fantastical beings was a technique similarly deployed by Salvador Dalí. In his *Metamorphosis of Narcissus* [604], the process of transformation is manifested before our very eyes as a hand holding an egg echoes the body of Narcissus himself, positioned alongside.

The Surrealists were much influenced by the Italian artist Giorgio de Chirico, whose uncanny juxtapositions of unrelated objects, such as *The Song of Love* [602], conveyed a sense of mystery tinged with fear. The Belgian Surrealist René Magritte particularly exploited this mood. In his *Menaced Assassin* [603], he represents a murder mystery reminiscent of the detective novels and movies of the period. Here sex and violence go hand in hand; the victim is a naked woman with her throat cut, yet the impassive faces of the characters involved reflect no sense of horror. MO'M

424

602 Above: Giorgio de Chirico (1888– 1978), *The Song of Love* (1914), oil on canvas, 73 × 59.1 cm. (28¾ × 23⅜ in.), New York, The Museum of Modern Art

601 Above: Max Ernst (1891– 1976), *The Elephant of Celebes* (1921), oil on canvas, 1.23 × 1.05 m. (48½ × 41⅜ in.), London, Tate Gallery

604 Salvador
Dalí (1904–89),
*Metamorphosis of
Narcissus* (1937),
oil on canvas, 50
× 75 cm. (19¾ ×
29½ in.), London,
Tate Gallery

603 Below:
René Magritte
(1898–1967),
*The Menaced
Assassin* (1926),
oil on canvas,
150.4 × 195.2 cm.
(59 × 76¾ in.),
New York, The
Museum of Modern
Art

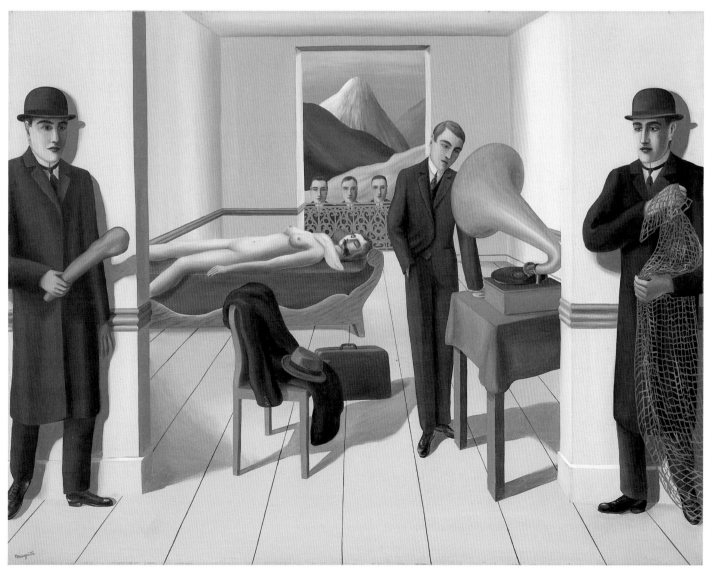

Relinquishing control?

Throughout the twentieth century artists have developed new methods of artistic production. Frequently, they have attempted to relinquish the artist's individual control and introduce other determinants into the production of a finished work.

The rejection of individual, rational control was the prime objective. In one instance (*Exquisite Corpse*) several artists each drew a section of a body without seeing the part previously drawn. The resulting hybrid was, accordingly, a collective work generated without the control of any individual participant.

In other works, however, the suggestion of spontaneity or the accidental has perhaps obscured the degree of careful planning and organization undertaken by the artists concerned. In Joan Miró's 'dream-painting' *The Birth of the World* [605], for example, the dripped and overlaid background and irregularly drawn geometric forms give the impression of an untutored hand, reminiscent of child art, graffiti or even the recently discovered prehistoric cave paintings. In fact, Miró had carefully worked out the precise composition before producing the final image, a factor borne out in the artist's sketch book.

In 1950s America Jackson Pollock developed his 'drip technique'. By throwing and splashing paint over a flat canvas, as in *Number 1, 1950* (*Lavender Mist*) [606], Pollock seemed to be relinquishing the tight control generated by the direct touch of the paint brush. However, Pollock refined this technique to such a degree that his works maintain a sense of balance and harmony that belies their means of production.

426

605 Joan Miró (1893–1983), *The Birth of the World* (1925), oil on canvas, 250.8 × 200 cm. (98¾ × 78¾ in.), New York, The Museum of Modern Art

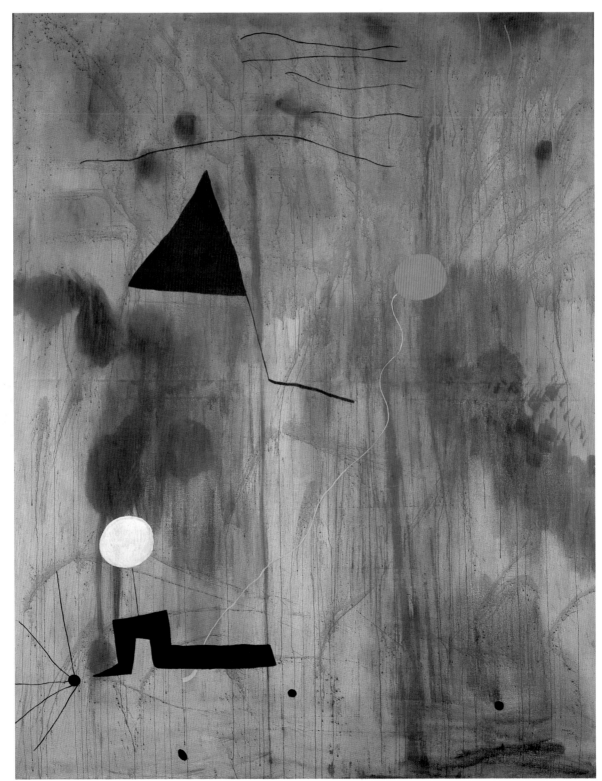

One of the more outrageous and controversial 'techniques', however, was developed by the French artist Yves Klein. His *Ant 23* [607, 634] were produced by imprinting the painted body of a naked woman on to a canvas. Effectively spoofing Pollock's 'drip painting' Klein produced these works before a public audience with a string quartet playing his 'Monotone Symphony' as an accompaniment. MO'M

607 Yves Klein (1928–62), *Ant 23* (1960), pigment and synthetic resin on paper, 93 × 55.5 cm. (36¾ × 21⅘ in.), private collection, Paris

427

606 Below: Jackson Pollock (1912–56), *Number 1, 1950 (Lavender Mist)* (1950), oil, enamel, and aluminium on canvas, 2.210 × 2.997 m. (87 × 118 in.), Washington, National Gallery of Art

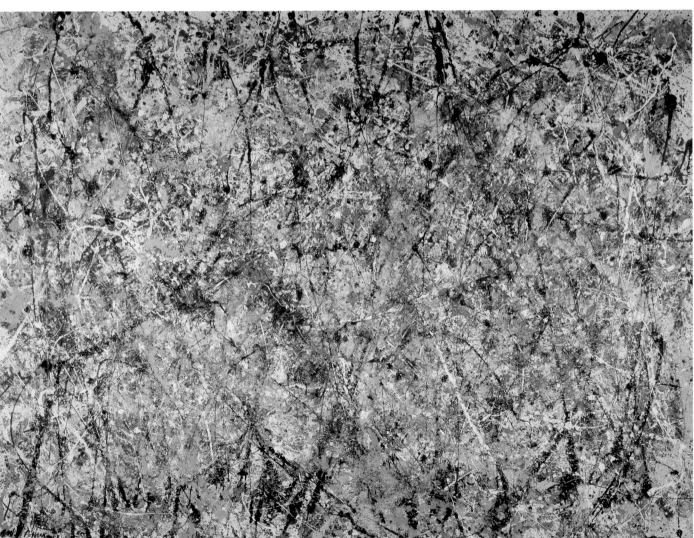

Modern nudes

The human form has remained an important site upon which artists have mapped various ideas and ideologies. Whilst some twentieth-century artists rejected naturalistic representation, others continued to place the human body at the centre of their work. This contrasting group suggests how the male and the female body have been used to convey ideas such as historical tragedy, the relationship of the body to the machine, the body as landscape, the notion of luxury and leisure, and the problems of gendered representation.

In sculpture, the nude male body traditionally emphasized strength, heroism, and beauty. In the aftermath of the First World War, however, nudity expressed exposed vulnerability for Wilhelm Lehmbruck. The sheer exhaustion of his emaciated bodies in works such as *Fallen Man* [**609**] symbolized the tragedy and loss of life and hope engendered by the war.

In his large-scale painting *Three Women (Le Grand Déjeuner)* [**608**], Fernand Léger perpetuated the tradition of the French nineteenth-century harem scene, a motif that also appealed to Matisse. Léger's nudes, however, hardly appear to be made of flesh and blood, their shiny, metallic surfaces and geometricized body parts more reminiscent of precision-made machines.

The British artist Henry Moore linked the body to the landscape in works such as *Reclining Figure* [**610**]. Inspired by Cycladic and Mexican sculptures, some of which he had seen at the British Museum, Moore sought to emphasize the natural qualities of stone and thus equate the forms of the female body with the landscape in nature.

428

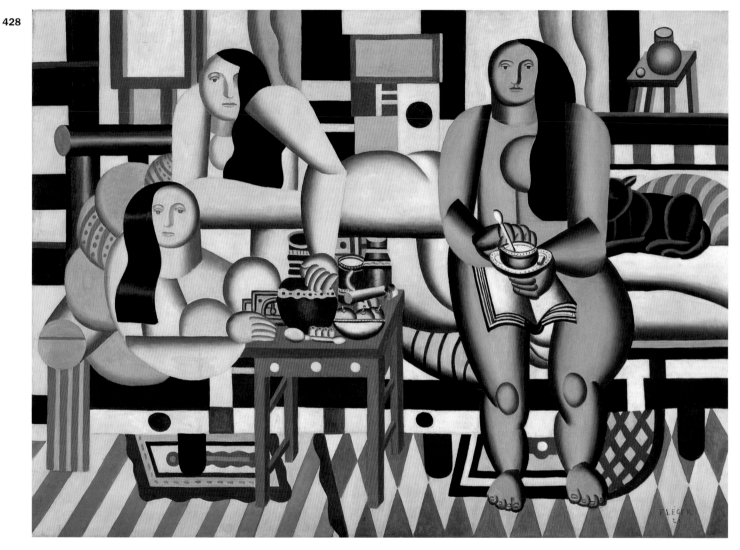

608 Above: Fernand Léger (1881–1955), *Three Women (Le Grand Déjeuner)* (1921), oil on canvas, 183.5 × 251.5 cm. (72 × 98¾ in.), New York, The Museum of Modern Art

In 1966, Niki de Saint-Phalle parodied male attitudes to the female body in her 82-foot sculpture *Hon (She)* [**611**]. Here the female body is reclaimed as a site of fun and celebration, rather than serving as an object of male voyeurism and sexual fantasy. MO'M

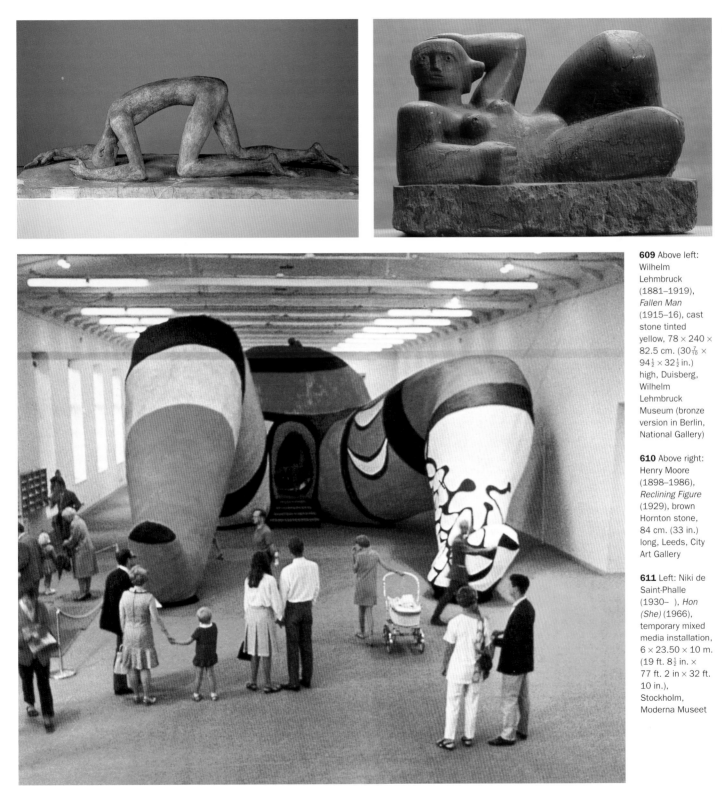

609 Above left: Wilhelm Lehmbruck (1881–1919), *Fallen Man* (1915–16), cast stone tinted yellow, 78 × 240 × 82.5 cm. ($30\frac{7}{10}$ × $94\frac{1}{2}$ × $32\frac{1}{2}$ in.) high, Duisberg, Wilhelm Lehmbruck Museum (bronze version in Berlin, National Gallery)

610 Above right: Henry Moore (1898–1986), *Reclining Figure* (1929), brown Hornton stone, 84 cm. (33 in.) long, Leeds, City Art Gallery

611 Left: Niki de Saint-Phalle (1930–), *Hon (She)* (1966), temporary mixed media installation, 6 × 23.50 × 10 m. (19 ft. $8\frac{1}{2}$ in. × 77 ft. 2 in × 32 ft. 10 in.), Stockholm, Moderna Museet

Sleek lines, hard edges

Modern art styles and modern design frequently went hand in hand. Many artists were themselves designers, or taught within design schools, thus generating an important dialogue between the design world and the fine arts. This can be seen particularly in the field of furniture design.

For example, the geometrical compositions of Piet Mondrian clearly influenced Gerrit Rietveld in his famous *Red and Blue Chair* [**612**]. Similarly, Marcel Breuer's *'Vassily' Chair* [**613**], named in honour of Vassily Kandinsky and produced in the Design Schools of the Bauhaus before its closure by the Nazis in 1933, owed a significant debt to the work of the Russian Constructivists.

Many poster designs produced during the inter-war years also reveal an affiliation to modern art movements. In Cassandre's *L'Étoile du Nord* [**614**], the geometrical simplicity and stylization, combined with an overt paean to the modernity of the railway, drew a great deal from the Purism of Le Corbusier and Ozenfant. Cassandre's highly stylized posters made a major contribution to the Art Déco movement. MO'M

430

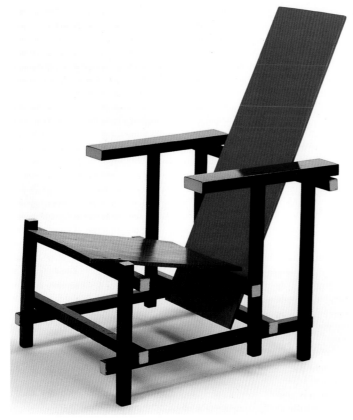

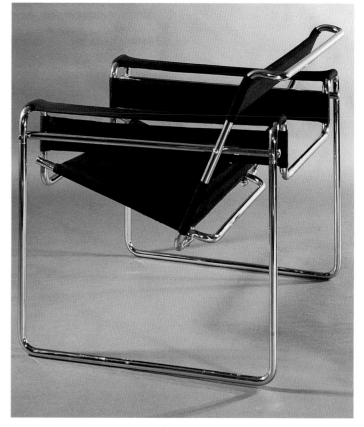

612 Above: Gerrit Rietveld (1888–1964), *Red and Blue Chair* (c.1918), painted wood, 86.5 × 66 × 83.8 cm. (34⅛ × 26 × 33 in.), New York, The Museum of Modern Art

613 Above: Marcel Breuer (1902–81), *Club Armchair Model B3* ('Vassily' Chair) (1927–8), chrome-plated tubular steel with canvas, 71.4 × 76.8 × 70.5 cm. (28⅛ × 30¼ × 27¾ in.), New York, The Museum of Modern Art

614 Opposite: A. M. Cassandre (Adolphe Jean-Marie Moreau) (1901–68), *L'Étoile du Nord* (1927), poster design, Haags Gemeentemuseum

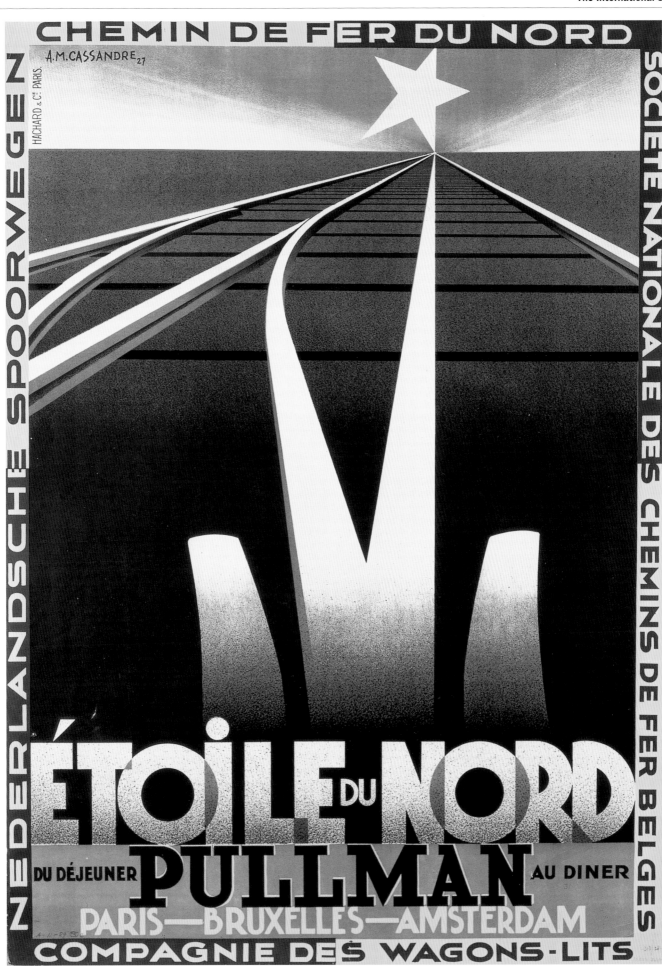

Brave new world

American artists became increasingly aware of European modernism as the century advanced. Whilst many were influenced by contacts with Europe, they nonetheless produced works with a uniquely American flavour.

During the inter-war years, New York became linked to the notion of modernity. In the mid-1920s Georgia O'Keeffe produced images that emphasized the colossal grandeur of the city's skyline. In *New York with Moon* [**615**], O'Keeffe represented the city at night, the large, dark forms of the tall skyscrapers contrasting with the light emanating simultaneously from street lamps and windows. However, overhead the moon throws a bright light linking the artificiality of the city with the grandeur of nature.

For Edward Hopper, the city was a strange, alienating space. Hopper claimed that his *Room in New York* [**595**] was 'suggested by glimpses of lighted interiors seen as I walked along city streets at night'. Proximity, yet simultaneous isolation, in the two figures bespeaks the paucity of communication between city-dwellers living at close quarters.

In 1950s America, the large-scale Abstract Expressionist works of Barnett Newman, Mark Rothko [**616**], and Jackson Pollock [**606**] reflected the nation's new-found confidence on the world stage. Abstract Expressionism was soon exported to Europe where it was promoted as heroic, visionary, and courageous, qualities much sought in the context of the burgeoning Cold War. In the wake of Abstract Expressionism, even the American Flag itself became an icon of modern art, although represented with a degree of irony in the work of Jasper Johns [**617**].　　　　MO'M

432

615 Left: Georgia O'Keeffe (1887–1986), *New York with Moon* (1925), oil on canvas, 122 × 77 cm. (48 × 30⅓ in.), Madrid, Collection Carmen Thyssen-Bornemisza

616 Above: Mark Rothko (1903–70), *Ochre on Red on Red* (1954), oil on canvas, 235.3 × 161.9 cm. (92⅝ × 63¾ in.), Washington, The Phillips Collection

617 Jasper Johns
(1930–), *White
Flag* (1955–58),
encaustic and
collage on canvas,
1.99 × 3.07 m.
(6 ft. 6¾ in. ×
10 ft. ¾ in.),
private collection

The horrors of war

The horrors and devastation of international conflicts have inevitably affected the ways in which artists have represented the societies in which they lived. Artistic representations of war have often been given a peripheral role in twentieth-century historical accounts yet, in some senses, they capture the essence of modern experience.

Both Paul Nash and Otto Dix witnessed the atrocities of the First World War firsthand, albeit from opposite sides of No-Man's Land. Whilst focusing on different subjects—the tortured landscape in Nash's *We are Making a New World* [**618**], and the victims of war in Dix's *Card-Playing War Cripples* [**619**]— both artists vividly expressed the meaningless destruction perpetrated upon nature and humankind.

434

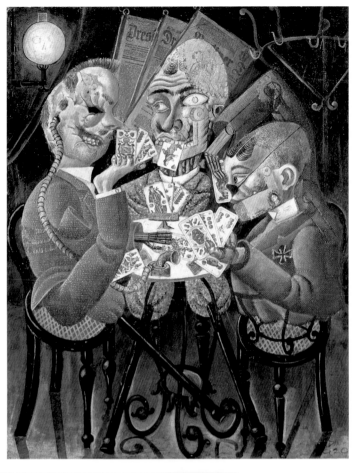

619 Right: Otto Dix (1891–1969), *Card-Playing War Cripples* (1920), oil on canvas with montage, 110 × 87 cm. (43¼ in. × 34¼ in.), Berlin, National-Galerie

618 Below: Paul Nash (1889–1946), *We Are Making a New World* (1918), oil on canvas, 71 × 91.5 cm. (28 × 36 in.), London, Imperial War Museum

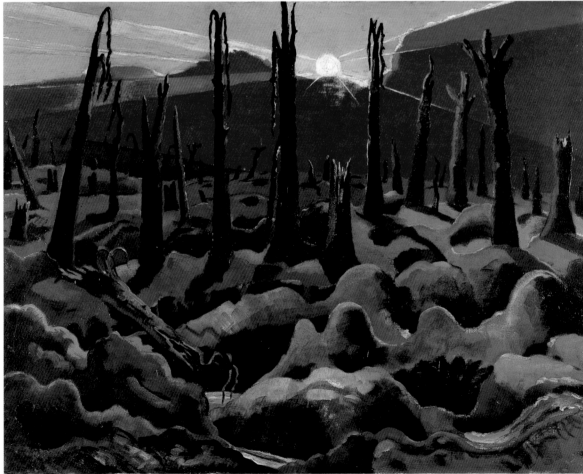

Opposition to Hitler's rise to power also generated some of the most powerful political images of the modern age. In the photo-montage *Don't Worry! He's a Vegetarian* [**620**] the German artist John Heartfield parodied the aggressive intentions of Germany against France by presenting a caricatural image of Hitler as a bloody butcher about to cut the throat of an unsuspecting French cockerel. Similarly, Picasso also introduced suffering animals to symbolize Fascist brutality in his mural-sized canvas *Guernica* [**594**]. Here Picasso has placed a dying Spanish bullfighter's horse centre stage, its violent death representing the destruction that has already been, and will further be, upon civilian populations by Fascist forces.

During the Second World War, many artists continued to produce paintings despite seemingly insurmountable obstacles. Amongst these artists were Jean Fautrier and Henri Matisse whose works offer a striking contrast. Fautrier's *Head of a Hostage* [**621**] suggests violence, the crushed and mutilated surface of the work recalling the beaten and murdered bodies found buried or simply discarded in the Occupied territories. In contrast, Matisse's *Icarus* [**592**], with its bright colours and free-flowing forms, seems, at first glance, more optimistic, more celebratory. Yet Matisse's work also alludes to the victims of war, this time through the image of a shot-down pilot falling gracefully, and timelessly, and even majestically through the sky.

MO'M

435

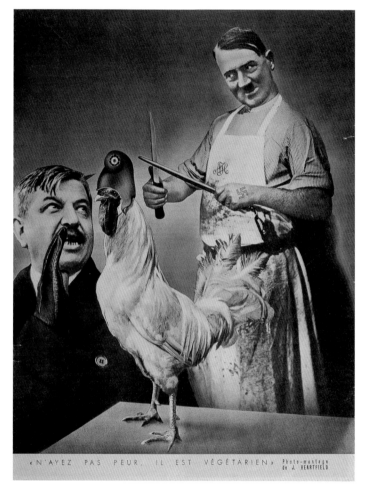

620 Left: John Heartfield (Helmut Herzfelde) (1891–1968), *Don't Worry! He's a Vegetarian* (1936), photo-montage first published in *Regards*, 7 May 1936, Berlin, Akademie der Künste

621 Below: Jean Fautrier (1898–1964), *Head of a Hostage* (1943), oil on paper, 35.5 × 28 cm. (14 × 11 in.), Sceaux, Musée de l'Île de France

In the shadow of
the bomb

In the immediate aftermath of the Second World War, the work of many artists inevitably reflected recent experiences of the atrocities of war, not least of all through emerging information about the horrors of the Holocaust. Simultaneously, artists addressed the anxieties inherent

within a new post-war world order, most notably fears of global destruction generated by the Cold War.

In France the sculptor Alberto Giacometti [**622**] focused on the representation of the human body. As in Lehmbruck's earlier work, he used figurative sculpture to express the human condition in the wake of the disasters of war. The scarred and pitted surfaces of his figures graphically convey the appalling violence

perpetrated upon humankind in the prisons and death camps as much as on the war front. Furthermore, the fragility and isolation in space of Giacometti's emaciated figures accurately expressed the climate of existential angst characterized in the post-war writings of Jean-Paul Sartre.

In Britain, Francis Bacon also alluded to the human condition in his study of Pope Innocent X [**623**]. The screaming, imprisoned figure of the

ultimate symbol of religious authority expresses the desperation and helplessness of humankind in the shadow of the bomb.

In contrast to the horror implicit in the work of Giacometti, Richier, and Bacon, Henri Matisse maintained his cult of beauty in his designs for a Catholic chapel in the southern French town of Vence [**624**]. The commission, part of a post-war 'Sacred Art' revival promoted by the

436

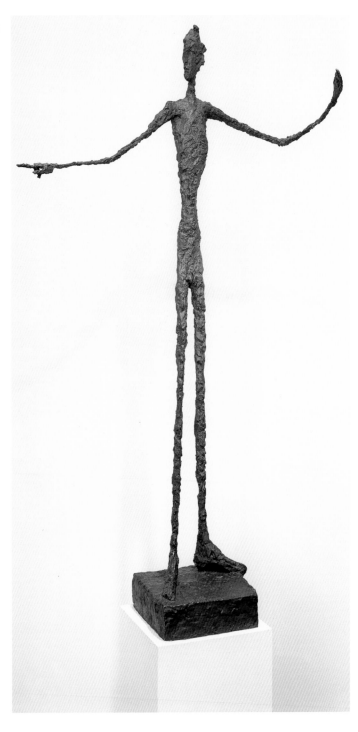

622 Left: Alberto Giacometti (1901–66), *Man Pointing* (1947), bronze, 179 × 103.4 × 41.5 cm. (70½ × 40¾ × 16⅜ in.), at base 30.5 × 33.7 cm. (12 × 13¼ in.), New York, The Museum of Modern Art

623 Above: Francis Bacon (1909–92), *Study After Velázquez's Portrait of Pope Innocent X* (1953), oil on canvas, 1.53 × 1.18 m. (60¼ × 46½ in.), Des Moines Art Center

Catholic Church in France, called upon Matisse to design an entire interior environment, including wall decoration, stained glass windows, altar, and ecclesiastical furnishings. The chapel, with its white tiled walls, and brightly coloured stained glass, provides one of the century's most contemplative and meditative interior spaces. MO'M

624 Henri Matisse (1869–1954), decorations for the chapel at Vence (*c*.1950)

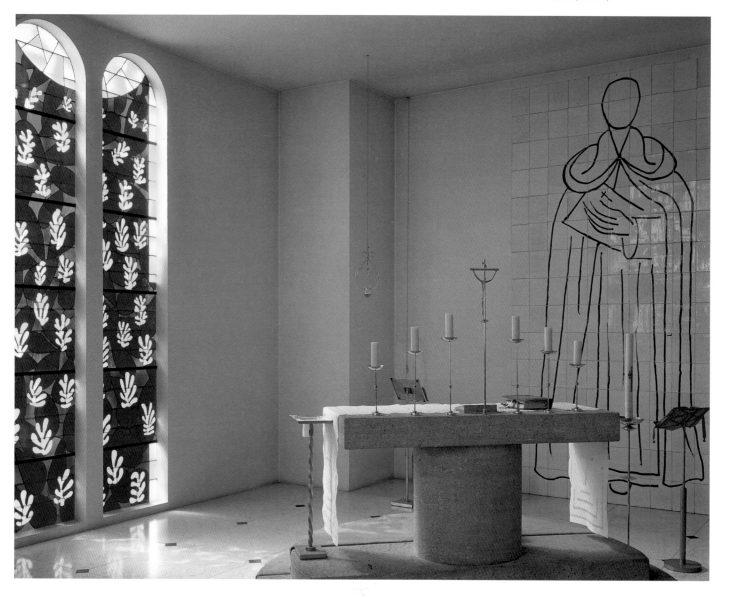

Geometrical worlds

Throughout the twentieth century, many artists have rejected the representation of exterior appearances in favour of works based upon non-representational, geometric forms. These have long been explained in purely formal terms, suggesting an evolutionary path followed by artists leading from nineteenth-century Realism, through early twentieth-century Cubism, and finally to a form of abstract art. The forms of geometrical 'abstraction' adopted by various artists, however, were equally informed by social, political, and spiritual factors.

For Kasimir Malevich [**625**], the notion of reducing art to its bare minimum, a black square on a white border, was bound up with contemporary conditions in his native Russia. Indeed, his revolutionary proposal that artists start over from a new beginning was, to a certain extent, a parallel to the political climate of revolution that exploded in 1917. At this time, Malevich was quick to associate his radicalism with that of the new state.

Both Piet Mondrian [**626**] and Vassily Kandinsky [**627**] similarly reduced forms to basic geometrical shapes. Their work, however, was not so much a rejection of representation, as an attempt to represent a higher spiritual realm. Both Mondrian and Kandinsky were deeply influenced by Theosophy, an esoteric cult movement which was widely embraced in intellectual circles throughout Europe in the early twentieth century. Theosophical discourse expounded Neo-Platonist ideas in which the real, physical world was regarded as little more than an adulterated form of the ideal spiritual realm. Thus, for both

438

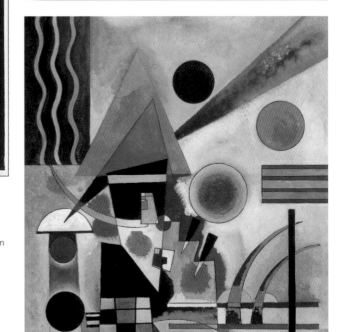

625 Above: Kasimir Malevich (1878–1935), *Black Square* (1914–15), oil on canvas, 106 × 106 cm. (41$\frac{7}{10}$ × 41$\frac{7}{10}$ in.), St. Petersberg, State Russian Museum

626 Above right: Piet Mondrian (1872–1944), *Composition No. III Composition in Red, Yellow, and Blue* (1920), oil on canvas, 50 × 50.5 cm. (19$\frac{7}{10}$ × 19$\frac{9}{10}$ in.), Switzerland, private collection.

627 Right: Vassily Kandinsky (1866–1944), *Swinging* (1925), oil on millboard, 70.6 × 50.1 cm. (27$\frac{3}{4}$ × 19$\frac{3}{4}$ in.), London, Tate Gallery

628 Opposite: David Hockney (1937–), *A Bigger Splash* (1967), acrylic on canvas, 2.44 × 2.44 m. (96 × 96 in.), London, Tate Gallery

Mondrian and Kandinsky, abstract forms came to symbolize the perfection of a new, higher reality.

The intense geometrical structuring of a picture could also be used to more ironic ends. In *A Bigger Splash* [**628**], for example, David Hockney (1937–) used a visual language incorporating strict horizontals and verticals, and flat colour to convey the feeling of Californian leisure. Here, however, Hockney has invaded the stillness of this geometrical world; the splash breaking the flat surface of the water and suggesting, though not revealing, a physical presence. MO'M

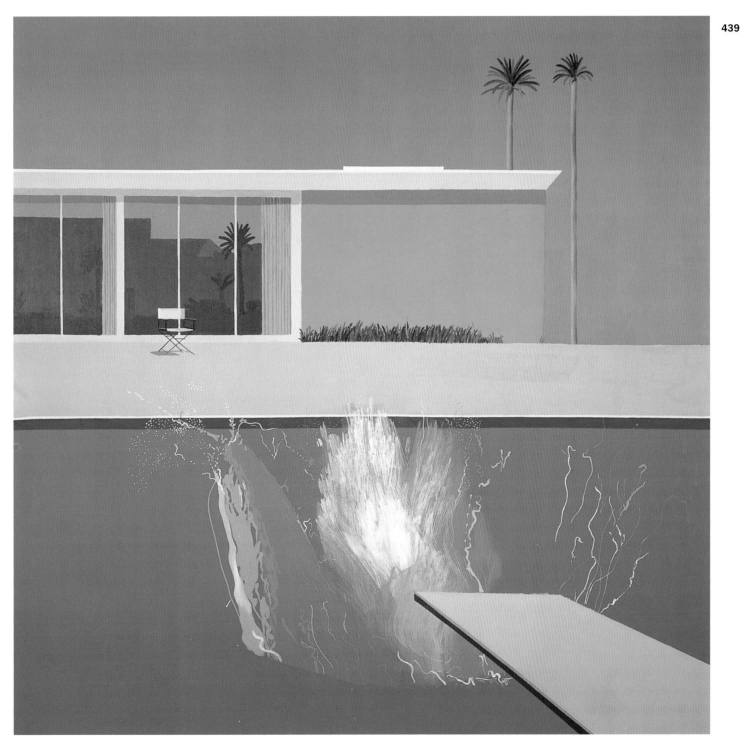

The future for sale

In an age of mass-production artefacts usually associated with 'popular' culture rather than notional 'high' art soon attracted the attention of artists. Since the beginning of the century, Picasso and Braque had introduced items such as drinks labels and newspaper advertisements into their still-life collages. In America, Stuart Davis adapted this interest. In *Lucky Strike* [629], he took an ordinary cigarette packet, enlarged it several times and made this the principal subject of his work. Here Davis was embracing European modernism whilst simultaneously continuing the American nineteenth-century tradition of *trompe l'œil* painting.

The inclusion of consumer items in André Fougeron's *Atlantic Civilization* [630] carried a more political significance. As a member of the French Communist Party, Fougeron perceived America's post-war presence in Europe as anti-pathetical, a sign of oppression rather than liberation. Thus the presence of a Blue Buick and armed GIs satirized the political basis upon which American consumerism was founded.

In 1956, the notion that the future would be dominated by consumerism was ironically parodied in British artist Richard Hamilton's wry *Just What Is It That Makes Today's Homes So Different, So Appealing?* [631] The true invasion of consumerism into modern art, however, came on the opposite side of the Atlantic in the 'Pop' art movement. For Roy Lichtenstein, the cheap comic book of the 1960s provided a constant source of inspiration, as in *Drowning Girl* [633]. Andy Warhol chose rather to focus upon repetition and mass production. In *Marilyn Monroe*

440

629 Stuart Davis (1894–1964), *Lucky Strike* (1921), oil on canvas, 84.5 × 45.7 cm. (33¼ × 18 in.), New York, The Museum of Modern Art

631 Right: Richard Hamilton (1922–), *Just What Is It That Makes Today's Homes So Different, So Appealing?* (1956), collage, 26 × 25 cm. (10¼ × 9¾ in.), Tübingen, Kunsthalle

630 André Fougeron (1912–), *Atlantic Civilization* (1953), oil on canvas, 3.80 × 5.60 m. (12 ft. 6 in. × 18 ft. 4½ in.), collection of the artist

Diptych [**632**], Warhol even high-lighted the ways in which the Hollywood system operated like a factory, churning out countless movie stars as consumer products. MO'M

633 Roy Lichtenstein (1923–97), *Drowning Girl* (1963), oil and synthetic polymer paint on canvas, 171.6 × 169.5 cm. (67⅝ × 66¾ in.), New York, The Museum of Modern Art

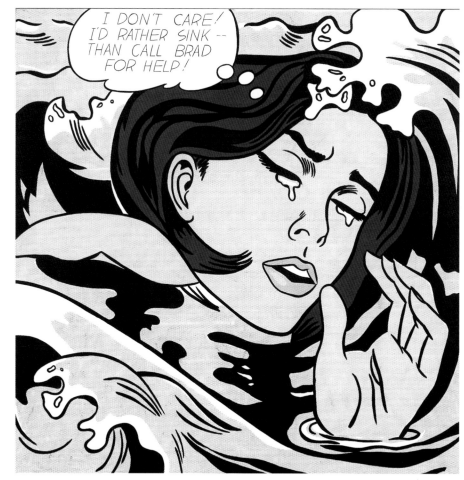

632 Andy Warhol (1928–87), *Marilyn Monroe Diptych* (1962), oil on canvas 2.08 × 2.90 m. (6 ft. 10 in. × 9 ft. 6 in.), London, Tate Gallery

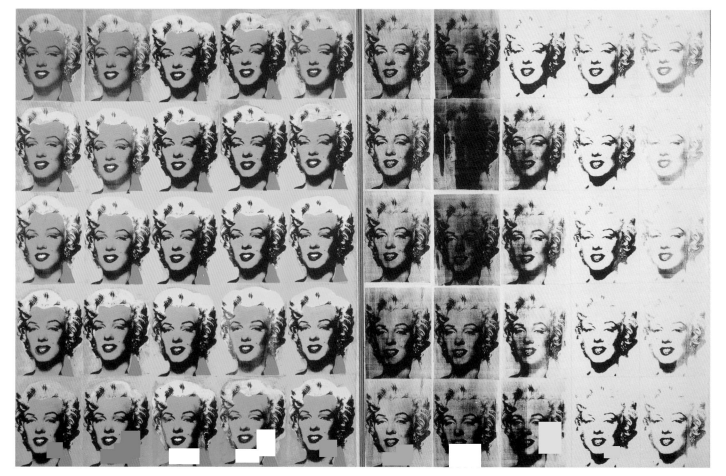

Alternative Media

Experimentation with new media has been part of artistic practice for as long as art has been known. Often, new genres are precipitated by or coincident with periods of social and technological change. Periods of material experimentation in the arts followed in the wake of the Russian Revolution, the First and Second World Wars, the consumer boom of the 1950s and 1960s, and the last three decades of the twentieth century: the period of advanced electronic technology which produced the personal computer, the fax-modem, and satellite communications. Two of the most important and enduring technologies of the nineteenth century, photography and film, continue to affect most twentieth-century art.

In general, artists embracing alternative media do so for three types of reason: celebratory (of the new century, a new social order, delight in new materials), critical (of the decadent old order, of outmoded genres or ideologies), or formalist (which may overlap with either category, but where formal experimentation or playfulness predominate). Individual artists concerned may participate in several movements at different times with differing experimental intentions.

Italian Futurism's combination of aggressive bombast, multi-sensational experimentation and effective propaganda make it the archetypal vanguard art movement of the twentieth century. Its senior artist, the painter Giacomo Balla (1871–1958), who also worked in furniture and costume design and even experimental cookery, staged multimedia events with Fortunato Depero (1892–1960) and Luigi Russolo (1886–1947) which foreshadowed the 1960s' 'happenings' and involved riotous onslaughts on the spectators of noise, costume, and even pails of water and the use of noise machines or 'Motorumoriste' (1915). These semi-mechanical objects were used to produce a variety of non-harmonic sounds which both ironicized past musical genres and celebrated the new era of mechanization. After the war, 'Secondo futurismo' experimented with aerobatics and smoke canisters as the new heroic art of the Machine Age. Both Umberto Boccioni (1882–1916) and Anton Giulio Bragaglia (1890–1960) experimented with multiple-exposure photography to suggest motion and temporality in an otherwise static image.

Artists in Zurich and Germany responded to the brutalities of the 1914–18 war by creating a nihilistic but also whimsical anti-art entitled Dada, whose intention was both ironic and socially critical. Kurt Schwitters (1887–1948) made collages of cigarette packets and bus tickets, culminating in his proto-installation in Hanover entitled *Merzbau* (1914–18) which filled two houses with sculptural constructions and found objects, including his guests' socks. Marcel Duchamp's (1887–1968) use of 'ready-made' objects from the real world, from snow-shovel to urinal, tends to devalue traditional art skills, craft, and prestige [**636**]. The archetypal Dada exhibition, held in Cologne in 1922, presented the viewers with an axe to demolish the exhibits. The paintings and constructions of Francis Picabia (1879–1953), Hans Arp (Jean Arp) (1887–1966), and Tristan Tzara (1886–1963) and the collages of Hannah Hoch (1889–1978), Richard Huelsenbeck (1892–1974), John Heartfield (Helmut Herzfelde) (1891–1968), and Raoul Haussmann (1886–) all contributed to the unfolding of this bizarre and troubling anti-aesthetic. Dada has continued to influence artists as diverse as the Italian Piero Manzoni (1933–63), British artist Richard Hamilton (1922–), and Americans Robert Rauschenberg (1925–) and Jasper Johns (1930–).

The 1917 revolution in Russia produced a lively culture of experimentation in the arts. Vladimir Tatlin's (1885–1953) *Monument to the Third International* (1920) is a fusion of architecture, engineering, kinetic sculpture, and abstract symbolism to celebrate the new world order of Communism. His 'corner-relief' constructions used a variety of materials including wire, glass, and sheet metal to make radical new objects for Soviet interiors. El (Eleazar) Lissitzky (1890–1941) devised a series of works collectively entitled PROUN involving multimedia displays of light, sculpture, and architecture to celebrate the new Soviet state. Naum Gabo (1890–1977) was among the first artists to utilize electric light in his 1929 proposal to illumine a site in Berlin.

Between 1913 and 1920, Tatlin, Gabo, and Duchamp created the first Kinetic and Lumino-kinetic art involving mechanical motion and/or electric light. Alexander Rodchenko (1891–1956), the leading Russian typographer, photographer, interior and graphic designer, also produced, with Man Ray (1890–1977) and Tatlin, the first 'mobiles' or suspended, freely moving sculptures. The Hungarian-born László Moholy-Nagy (1895–1946) worked in painting and typography as well as producing one of the masterpieces of Lumino-kinetic sculpture [**637**]. Mobiles were developed independently by Alexander Calder (1898–1976) and developed into a major art form [**638**]. Other major exponents were Bruno Munari (1907–), George Rickey (1907–), a leading kinetic sculptor and authority on Constructivism, and the British Constructivist Kenneth Martin (1905–).

The early work of Niki de Saint-Phalle (1930–) involved her shooting her collages of plaster and everyday objects with a rifle. Her partner Jean Tinguely (1925–91) continued the tradition of Neo-Dada and Kinetic art [**639**]. Both were members of Pierre Restany's 'Nouveau Réalisme' movement in Paris.

Where Kinetic art involves physical movement by the artwork or spectator, Lumino-kinetic art uses both light and movement in a more performative manner. The first use of neon as a principal sculptural material was by Gyula Kosice, in Buenos Aires (1946). Kosice was inspired by Lucio Fontana (1899–1968), himself a pioneer of the use of electric light in artworks designed for interior spaces [**640**]. Dan Flavin (1933–) is one of the leading American artists to use neon. He uses standard, factory-length, coloured fluorescent tubes as ready-made materials which are then subtly combined for specific installations. Other leading exponents of neon art have been Bruce Naumann (1941–), Joseph Kosuth (1945–), Vito Acconci (1940–) and Chryssa (1933–). Nicholas Schöffer (1912–) pursued the idea of multi-sensational light and movement happenings in his 'Lumino-Dynamic Spectacles' held in the Saint-Cloud Park, Paris (1954), and Liège (1961), in a tradition which has now moved to rock musicians like Pink Floyd and Jean-Michel Jarre.

In the late 1950s, following suggestions by the composer John Cage (1912–) and the choreographer-dancer Merce Cunningham (1919–), artists like Robert Rauschenberg, Claes Oldenburg (1929–), Alan Kaprow (1927–) and Red Grooms (1937–) developed theatrical 'happenings' in New York. The international Fluxus movement which followed attempted both to avoid the traditional gallery system and break down the separation between art, public, and life. In Paris, Yves Klein (1928–62) experimented with fire, smoke, and sponge to make artworks, but is important also for his *Anthropométries* [**607**, **634**]: performances where models dipped in paint imprinted themselves on the canvas, sometimes to monotone music. Body art and Performance art have straddled theatre, music, video, film, dance, and fine art practices. Leading exponents of Performance art include Joseph Beuys (1921–86), Hermann Nitsch (1938–), Robert Wilson (1941–), and Laurie Anderson (1947–).

In the 1950s and 1960s, Art Informel legitimated the use of many non-traditional materials in art, from Alberto Burri's (1915–) sacking and tar, Antoni Tàpies' (1923–) sand, and Eva Hesse's (1936–70) use of felt. Since the 'crisis of painting' in the 1970s, artists have increasingly turned to installation and

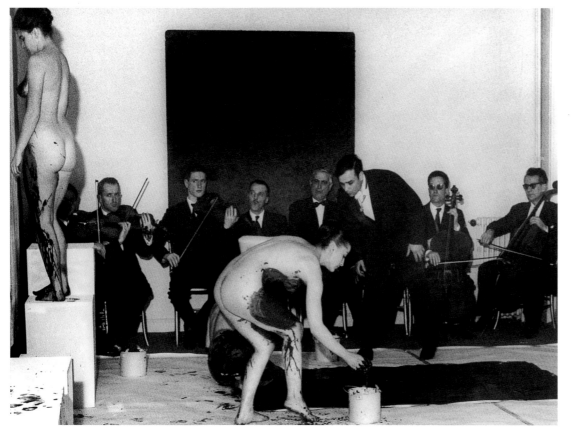

634 (see also **607**) Yves Klein (1928–62), *Anthropométrie et Symphonie monotone* (9 March 1960), event at the Galérie Internationale d'Art Contemporain, Paris

alternative materials as resources. Early precedents include Pablo Picasso's (1881–1973) later sculpture which incorporated such diverse materials as bicycle handlebars and a saddle (*Bull's Head*, 1943), and Manzoni's use of bread rolls, eggs, cotton balls, and, most notoriously, his own shit as art materials, which have extended the repertoire infinitely.

The 1960s are characterized by an increase in artistic movements with relatively focused agenda. Collectives like the Zero Group, founded by Otto Piene (1928–) and Heinz Mack (1931–) in Düsseldorf in 1958; the Gruppo T ('technologia'), founded in Milan in 1960 by Gianni Colombo (1937–) and others; USCO, founded in Garnerville, New York (1962), by Gerd Stern; and La nouvelle Tendance in Paris, all focused on the impact of technology on art. The Zero Group produced the poetic *Light Ballet* in 1959 before Günther Ücker (1930–) joined them in 1961 for the first 'zero demonstration': an outdoor multimedia event involving audience participation, props, and live action.

In Paris, Le Groupe de Recherche d'Art Visuel (GRAV), founded in July 1960 by Julio Le Parc (1928–) and others, produced 'labyrinths' in Paris, New York, and Eindhoven in an attempt to involve the spectator in the creation of both the artwork and the environment. In Russia, Lev Nusberg founded the Dvizdjenje ('movement') group in 1962, and the 'World Kineticist Movement' to pursue Suprematist and Constructivist notions of movement in art. Lettrisme and later Situationism developed from Surrealism, Dadaism, and radical student politics in response to the Vietnam War, the Cuban missile crisis, and the invasion of Czechoslovakia. These anarchic and often witty collectives introduced graffiti as a new poetics and direct action as the only appropriate politics.

From Pop art, Op and Kinetic art took up the celebratory and ironic critique of the high seriousness of traditional art for a new and playful aesthetic of the everyday and ephemeral. In general, fairly simple technology (motors, lights) was used to activate optically confusing surfaces which often have a 'machine-made' look. The work of Victor Vassarley (1908–), Yaacov Agam (1928–), Takis (Panyiotis Vassilakis) (1925–), Carlos Cruz-Diez (1923–), and Bridget Riley (1931–) is representative.

In the mid-1960s Minimalism and Land Art for the most part utilized elemental or industrial materials in keeping with their aesthetic. Richard Artschwager (1924–) experimented with Formica and Walter De Maria (1935–) employed naturally occurring lightning in a dramatic terrain of steel poles in New Mexico. Christo (Javacheff)'s (1935–) 'wrapped islands' (1980–3) or miles of *Umbrellas* (Japan/USA, 1984–91) can only be appreciated via the media or by air.

Lasers in art have been used in three principal directions: as audio-visual displays, as large-scale environmental works, and in holography. The Israeli artist Dani Karavan [641] has used lasers in urban projects in Heidelberg and Paris (1983) and his permanent laser installation now runs along the central axis of Cergy-Pontoise in France (1986). Horst Baumann also works on the environmental scale with laser displays linking prominent parts of the city in Düsseldorf (1976), Kassel (1977, now permanently installed), and Berlin (1985), while Rockne Krebs was amongst the first artists to incorporate lasers in a gallery setting in *Aleph 2* at the Corcoran Art Gallery in Washington (1969), and was probably also the first artist to employ lasers on an urban scale in night-time diplays at Minneapolis, Buffalo, New Orleans, and Philadelphia from the 1970s onwards. Iannis Xenakis, Joël Stein, Carl Fredrik Reuterswärd, Paul Earls, and Otto Piene have also incorporated lasers in multimedia displays involving sound, performance, and installation.

One of the pioneers of holographic art, Margaret Benyon, has produced a rich and varied body of work dealing with the environment, the body, and forging links with the earliest paleolithic art ('Cosmetic Series', 1991). Harriet Casdin-Silver contributed holographic images to an environmental sculpture entitled *Centrebeam* for the 1977 Documenta at Kassel and, like Benyon, makes feminist work dealing with the body. Michael Wenyon and Susie Gamble collaborated in a project at the Royal Greenwich Observatory producing holograms of myriad points of light which echoed the galaxies beyond. Other holographic artists include Rudie Berkhout, Georges Dyens, Dieter Jung, Paula Dawson, Douglas Tyler, and Shinsike Mitamura.

Nam June Paik (1932–), whose background was in performance, pioneered the use of robotics and video in spectacular multiple-screen installations [642]. Artists using computers do so for three main reasons: to assist them in some task that would previously have been done in other media (non-linear video editing, photo-retouching, graphic design); to originate work that could not be produced otherwise but whose final form is a fairly traditional object (soundtrack, print, film, photograph); and to produce new work whose outcome exists only in computer terms (virtual works, CD-ROMs, web-sites, or communications events). Within these categories distinctions can be made between apparently two- and three-dimensional work, static and animated work, and 'natural' (imitative of reality) or 'synthetic' work (generative of new forms). Ben F. Laposky was the first to use an analogic computer with an oscillograph to produce *Electronic Abstractions* in 1952. K. Aslenben and W. Fetter in Germany followed with the first computer graphics in 1960. In 1965 digital imagery was developed simultaneously by Germans Frieder Nake and George Nees and Americans A. Michael Noll, B. Julesz, and K. C. Knowlton. While Karen Guzak and Miguel Chevalier use the computer to generate abstract images subsequently output as prints, Vera Molnar sees computers as extending traditional media through virtuality and audience interaction.

A pioneer of 'cyberspace', Tom De Witt developed his 'Pantomation' system to create virtual objects whose appearance is modulated by the physical motion of a spectator/participant. Gilles Roussi's *The Great Technological Futility* (1980) follows Tinguely and Dada into the computer age with his useless robots, programmed to disobey. William Latham uses a computer program to generate fractal 'sculptures' rendered and lit in apparent three dimensions [635]. Yoshiro Kawagushi similarly creates virtual worlds whose objects—'fleshy growths' or 'embryo'—echo a visceral materiality. Jaron Lanier developed the 'Data Glove' and 'Eyephones' as bodily extensions to interact with a computer-generated virtual space. Using another interface—a fixed 'bicycle' in front of a video projection screen—participants can 'cycle' round Jeffrey Shaw's *Legible City* (1990)—a virtual Manhattan where coloured text towers

Using a computer program called 'Mutator', developed with scientists Stephen Todd and Peter Quarendon, Latham creates fractal shapes which take on apparent three-dimensional form and go through a series of evolutionary transformations in a virtual space within the computer, analogous, in their mix of chance and order, to the processes of 'natural selection' operating in nature. Films of the sequential creation of these forms were exhibited at the 'Artifices' exhibition in Saint-Denis (1990).

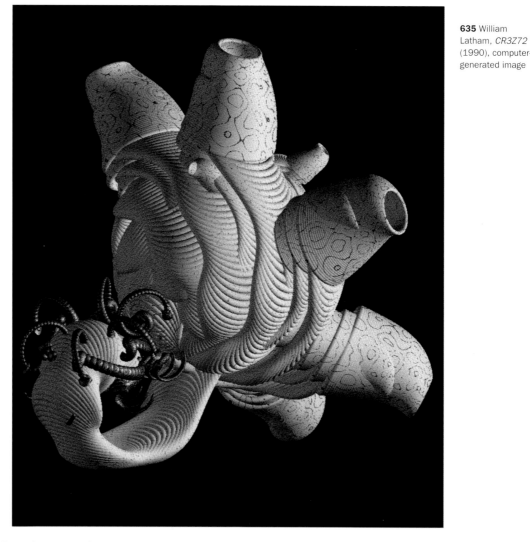

635 William Latham, *CR3Z72* (1990), computer-generated image

above you in three dimensions along the street plan, creating sentences as you move. Matt Mullican's *City Project* (1989) creates a similar navigable virtual architecture. That the human/computer interface can be poetic is proved by Edmond Couchot, Michel Bret, and Marie-Hélène Tramus's *I Sow to the Four Winds* (1990) where a simulated dandelion head moves gently in a virtual breeze. By breathing on the screen the spectator can 'blow' the seeds away until only the stalk is left, whereupon a new flower forms. Rebecca Allen has collaborated with the German music group Kraftwerk in animated three-dimensional renderings of virtual persons. Recently, musicians Brian Eno and Peter Gabriel have created musical compositions and installations using computer-randomized sequences and interactive CD-ROMs.

Developments in telecommunications such as ISDN links and video-conferencing have led Roy Ascott to coin the term 'telematics' for his interactive global networking art which involves artistic collaborations and spectator participation via modem and video links across multiple, geographically distinct, sites. Both Chryssa and Jenny Holzer (1950–) explore and attempt to subvert electronic advertising by adapting it to their ends [**643**].

Fax art, Mail-art, and Xerox art have flourished as informal and hard to document 'underground' forms of telematic art for as long as these media have been available.

David Hockney (1937–) is one of the few high-profile artists to have used them.

Organic and found materials, installation and body art continue as alternative media from mid-twentieth century. Joseph Beuys typically employed fat, sulphur, felt, blackboard chalk, a coyote, and a dead hare along with his trade-mark padded waistcoat and felt hat in a discursive and performance-oriented practice. The Austrian Rudolf Schwartzkogler (1940–69) and French artist Orlan have used the body, and Andres Serrano (1950–) body fluids, as material, employing varying degrees of self-mutilation, from auto-castration to plastic surgery and blood-letting. Stelarc (Stelios Arcadion) performs with robotic additions to his body [**644**].

Andy Goldsworthy's *Snowflakes* and Tony Friedman's sculptures made from chewing gum or tennis ball fuzz continue the ephemerality of Performance and Land Art. The tradition of utilizing animal carcasses in art stretches from Hermann Nitsch's 1960s gory performances with live chickens to Damien Hirst's (1965–) presentation of pickled sheep, fish, sharks, and cows. The American Mike Kelly typically uses stuffed toys, blankets, and cassette tapes, radios, or automatic deodorant dispensers in his multi-sensational installations. Installation opens the way for any material to be incorporated into artworks, now that media *per se* are not the issue. KH

Early experiments

The use of the term 'alternative' as against 'new' media generally denotes the specific use of science and technology by artists in the making of artworks and coincides with the convergence of science and technology in the late nineteenth century. Initially the technology was mechanical but as the twentieth century progressed, electronics became the dominant force. The key early twentieth-century experiments with the fusion of art and industrial processes are Italian Futurism, German and Swiss Dada, Russian Constructivism, and the Bauhaus in Weimar.

Marcel Duchamp's *Revolving Glass Plates* (1920) [**636**] blends a straightforward fascination with commonplace technology and a whimsical purposelessness which seems to mock Kant's aesthetic dictum.

László Moholy-Nagy's *Light-Space Modulator* (1922–30) [**637**] employed 140 coloured spotlight bulbs, switched on by contact with a rotating metal drum, to project ever-changing patterns through sheets of celluloid and screens of different metals on to the interior surfaces of a cube. KH

446

636 Marcel Duchamp (1887–1968), *Revolving Glass Plates* (1920), wood, metal and painted glass, motorized, 1.50 m. (59 in.) high, New Haven, Connecticut, Yale University Art Gallery

637 Opposite: László Moholy-Nagy (1895–1946), *Light-Display Machine* (*Light-Space Modulator*) (1922–30), metal, wood, and plastic, motorized, 151.1 × 69.9 × 69.9 cm. (59$\frac{1}{2}$ × 27$\frac{1}{2}$ × 27$\frac{1}{2}$ in.), Cambridge, Massachusetts, Busch-Reisinger Museum, Harvard University Art Museums

New forms, new media

Following the Second World War, there was first a return to painting and then a shift of emphasis to utilizing diverse raw and natural materials in artworks in Art Informel, Minimalism, and Land Art. The technological insights of the pre-war period continued in Kinetic and Lumino-kinetic art, before resurfacing once more in Op art and the new alternatives of experimental film, video, and performance.

Mobiles were developed independently by Alexander Calder from Cubism's formal experimentation in rendering the three-dimensional world in two dimensions utilizing non-traditional materials such as cardboard, painted papers, or welded metal [638]. Jean Tinguely produced a long series of mechanical Neo-Dada sculptures, often as functional waterfalls, or, as in *Homage to New York* (1960) [639], as auto-destructive pyrotechnic assemblages. A pioneer of the use of electric light in artworks designed for interior spaces, Lucio Fontana produced a startling neon piece for the IX Triennial in Milan (1951): *Spatial Decoration* [640], where the openness of the looped structure seems to pull the space and light of the room into and through the sculpture. KH

448

638 Above: Alexander Calder (1898–1976), *Red Polygons (Red Flock)* (1949–50), hanging mobile, metal, 86.3 × 154.9 cm. (34 × 61 in.), Washington, DC, Philips Collection

639 Right: Jean Tinguely (1925–91), *Homage to New York* (1960), self-destructing installation, Garden of the Museum of Modern Art, New York, 17 March 1960 (destroyed)

640 Opposite: Lucio Fontana (1899–1968), *Spatial Decoration* (1951), fluorescent neon tubing (destroyed), IX Milan Trienniale

New technologies

Pop art and Conceptualism and a widespread feeling of crisis within traditional media have encouraged artists since the 1960s to explore many alternative media. Developments in personal computers, electronics, video and satellite communications as well as the open boundaries of installation art have shifted the emphasis to process rather than product.

The Israeli artist Dani Karavan projected a single laser from the Forte Belvedere to the top of the Duomo in Florence in 1978 as part of his exhibition *Homage to Galileo Galilei* [**641**]. Nam June Paik, whose background is in performance, pioneered the use of robotics and video in spectacular multiple-screen installations. Here, the video tapes are 'interrupted' by the water and the swimming fish [**642**].

Jenny Holzer's 'Spectacolor' light displays [**643**] combine the visual impact of contemporary advertising with a questioning and often disturbing message which is inserted directly into the channels of distribution and consumption.

Stelarc's use of an electronic prosthesis in live-art performances explores the realm of the Cyborg, literally enacting the Futurist formula: 'Man + machine' [**644**]. KH

450

641 Opposite, top: Dani Karavan, *Homage to Galileo Galilei* (1979), laser installation, Florence, Forte Belvedere

642 Opposite, bottom: Nam June Paik (1932–), *Video Fish* (1975–9), video installation—five aquariums, five monitors, two video tapes, live fish, 66 × 280 × 75 cm. (26 × 110¼ × 29½ in.), Paris, Musée National d'Art Moderne–Centre Georges Pompidou

643 Top, right: Jenny Holzer (1950–), *Private Property Created Crime*, 'Spectacolor' electronic display sign, Times Square, New York, temporary March 15–30 1982

644 Bottom right: Stelarc (Stelios Arcadion), *Scanning Robot/ Involuntary Arm*, live performance, Edge Bienniale, London

Photography

Although the Great War scarcely features in histories of photography its consequences were far-reaching. It was reported on at length by operatives whose pictures were distributed by Phototek (Germany), Topical (Britain), and Alfieri (France). Front-line action, which was understandably difficult to represent, was seen as work for illustrators whilst photography dealt with day-to-day events behind the lines, provisioning, transport, recreation, and entrenchment. Photographers warmed to their task, especially in 1914–15, and took note of a whole range of practicalities, including rat-catching, de-lousing, and the supply of drinking water in unhygienic circumstances. In the 1950s and after, this would have been known as documentary photography, but originally it passed without comment. What, after all, could be more natural than that people back home should be interested in the details of such an unprecedented enterprise?

The war, which had been entered into as an adventure, took many turns for the worse resulting in the kind of carnage for which it would be known. Reporting, however, could hardly give an honest account of the worsening conditions, and the quasi-official photographers who reported for the agencies continued to represent business-as-usual: columns of prisoners, official visits to the front line and improvisation in the trenches. However, many ordinary soldiers, especially in the German and Austro-Hungarian armies, were enthusiastic amateurs equipped with the light-weight cameras which had been introduced in the first decade of the twentieth century. They chose to give a more accurate and informal account of front-line life, and some even went into business making reports on the aftermath of major battles. This photography found its way into albums, which were a feature of the Great War, and in itself had little direct effect on the future of photography. There developed, though, an idea that photography's remit also involved the truth behind the scenes. On the one hand there was the official version of events, and on the other realities which could not be acknowledged; and when reportage developed in the late 1920s it was with this second category that it would be concerned. Many of the formative photographers of the modernist era had front-line experience: the photo-journalist Felix Mann (1893–1985), for example, and André Kertész (1894–1985), and Josef Sudek (1896–1976).

The functional or modernist style which developed during the 1920s owed a lot to war-time experience. Conscription meant that a generation, which would have been expected to go into bureaucratic work, found itself improvising an existence in Galicia or the Argonne, coping with floods, frost, and incoming fire. The many amateur albums from the period show quite elaborate hand-made environments, even amongst the mud of the Western Front. Those who survived had been introduced to handwork and to artisan aesthetics which would become characteristic of vanguard art in the inter-war years.

Paradoxically, and fatally, the war came to an inconclusive ending. It seemed, in 1918, as if warfare itself was on the point of transition, for the last years of hostilities had been marked by widespread use of aircraft and tanks. At some point in the foreseeable future it was possible to imagine a war carried out at long range and at a remove, from the air and from armoured vehicles. Such a prospect lay half way between tourism and terrorism, and photography was the medium which gave it credence. Aerial pictures had been taken increasingly during the war, at first from balloons and then from aircraft, as an aid to artillery fire. The aerial picture, of field systems lying around a pock-marked front line, became part of the war's aesthetic, and it familiarized contemporaries with the notion that landscape might be overseen and analysed. Clarity was all-important in this new instrumental aesthetic, and it infiltrated most branches of photographic practice in the 1920s and after, eventually driving out the Pictorial and Symbolist regard for soft focus.

Modernist aesthetics, as they developed in the 1920s, are sometimes credited to technological changes. Two cameras are usually mentioned in this context: the Leica, introduced in 1925 by the Leitz Co. in Wetzlar, and the Ermanox (1923), from the firm of Ernemann in Dresden. The Leica was a manœuvrable miniature camera, and the Ermanox had a lens which made it possible to take pictures in 'available light'. Tim Gidal (1909–96), a Berlin photo-journalist of the era, described them as little better than toys, but the Ermanox did allow Erich Salomon (1886–1944), the pioneer of 'candid' photography, to take pictures in and around the great international conferences of the late 1920s. Salomon's conferees, however, including most of the great statesmen of the day, looked even then like elderly bourgeois and horse-traders, anachronisms unfit to manage the catastrophic economic crises of the period.

Of more consequence in the history of the medium was the invention in 1890 of rotogravure by Karel Klič (1841–1926), an engraver in Vienna. Klič had invented photogravure in 1879, a process which transferred photographs to etched copper plates. He then succeeded in applying the process to rotary cylinder presses, capable of making high-quality photographic reproductions at speed. In 1905 *Das Illustrirte Blatt* became the first weekly to be printed in rotogravure. At first it was confined to special supplements and inserts, but during the 1920s whole magazines used the new technique. Rotogravure gave an unprecedented depth and resonance to printed photographs,

and led to the establishment in Germany during the 1920s of any number of illustrated weeklies: *Deutsche Illustrierte* (1925), *Arbeiter-Illustrirte Zeitung* (1925), and *Der Querschnitt* (1921) are no more than a few examples. Rotogravure was also employed by established magazines, such the *Berliner Illustrirte Zeitung* (1890) and *Die Woche* (1899). Between them they created an unprecedented demand for photography, which was served by agencies, mostly set up in Berlin. The agencies often depended on one or two leading lights, and flourished for a year or two before fading. Principals fell ill or left to set up new agencies; and after 1933 and the Nazi take-over in Germany, many left altogether for Paris, London, and New York. Some of the outstanding agencies were virtually one-man operations, such as Fotoaktuell, set up in Berlin by Willi Ruge (1892–1961), who had made his name as an aerial photographer in the Great War and then with street-fighting pictures from Berlin in 1919.

The post-war modernist was an adventurer, often fresh to the medium and prepared to take nothing for granted. Man Ray (1890–1976), an American artist in Paris, practised a cameraless photography to make rayographs, his name for what others called photograms. In these constructed images, gathered items—pieces of string, a glove, a hand, for example [**647**]—were placed on photographic paper and then exposed briefly to light. The paper was developed to give negative silhouettes. Ray's contemporaries in Germany, such as László Moholy-Nagy (1895–1946) and Frank Roh (1890–1965), experimented with mirrors, double exposures and sandwiched negatives, to the degree that experimentalism came to epitomize the period.

This era, which lasted from 1919 until 1933, witnessed the establishment of modern photography—more or less as a new art, although closely related to illustration. The new photographers of this era were, of course, photo-journalists, but few of them thought as reporters. They tended, by and large, to manufacture pictures on contemporary themes. They imagined themselves as directors interested in many aspects of popular life: how to behave in a restaurant, or how to identify contemporary phobias. There was a demand for novelty pictures, of unusual items seen often from unusual angles. Editors were all-important, for they paired and otherwise arranged what the photographers provided. To escape from editorial domination would eventually become a preoccupation, but it would only be achieved during the 1940s and 1950s by certain celebrity photographers banded together under the name of Magnum Photos. Agencies developed specialities, in health, education, country life, or eastern Europe; and within agencies photographers also specialized—within the Berlin agency of Pacific & Atlantic, for example, around 1930 Alfred Eisenstaedt

(1898–1996), later to become a major photo-journalist with *Life* magazine in the USA, specialized in high society and the metropolis, leaving traditional and working-class subjects to his companion Eric Borchert (*c*.1900–42), who went on to become an outstanding war reporter in Poland, France, and Africa.

Prior to 1914–18 photo-journalists had been operatives and adventurers, only mentioned by name in exceptional circumstances. From the 1920s onwards, and as a consequence of the rise of illustrated magazines, more and more photographers began to be known by name. This was less because photographers became celebrities—that would only begin to happen in the 1950s—than because of recruitment to the agencies and the need to distinguish between tiros and seasoned professionals. Naming was a sign of achievement and also of ambition. To secure an international reputation, in photographic circles at least, it was necessary to publish in the annual surveys of photography: *La Photographie* and *Das deutsche Lichtbild.*

The establishment of photography as an important modernist medium was helped by the discovery, in the late 1920s, of a forgotten master, Eugène Atget (1857–1927), subject in 1930 of *Atget, Photographe de Paris*, the first major book in photography history. Atget, who died in 1927, had been noticed by vanguard artists of the younger generation, in particular by the American photographer Berenice Abbott (1898–1991), who preserved his archive and arranged for its transfer to New York. Atget, who had begun work in photography in 1900, after time spent as an actor and on transatlantic liners, merely made record pictures of Paris, for sale to painters and to museums of decorative arts. He used a plate camera and amassed a large collection of Parisian details: statuary, shop doorways [**652**], facades, fountains, and alleyways. These studiously taken pictures attracted a following less because of their cultural interest than because of their connotations of solitude. To make objective studies Atget had been forced to work at quiet points in the day and the result was a private, even a reclusive view of the city. This might not have mattered at any other time, but by 1930 most photography was taken and published within an ideological framework.

Atget's projection of the photographer was as someone able to work undisturbed, free from editorial demands, and apart from politics. This, of course, was an ideological position in its own right, for apartness from politics in 1930 inevitably meant opposition—even if implicit—to the totalitarian systems of the period. Russian photography, in particular, was widely distributed through a magazine, *USSR in Construction*, established by Maxim Gorki in 1921 with the specific purpose of putting the Russian point of view to the world at large. In the

1920s the Russians were ultra-modern, especially Alexander Rodchenko (1891–1956), a graphic designer who took up photography in 1924 after working on Dziga Vertov's newsreel *Cine Eye*. Rodchenko, associated in the 1920s with the magazine *Lef*, envisaged an idealized culture of athletes, artists, and writers. He photographed from acute angles between the street and Moscow's balconies, showing the citizenry of the new USSR as activists and enthusiastic spectators. Rodchenko's coercive vision of the revolution as carnival fell out of official favour in the late 1920s, in part because it was so radically at odds with the peasant life-style of so many in the USSR. Nevertheless, Rodchenko's dynamism set up a standard and identified modernism with Bolshevism.

Modernist aesthetics, as developed in the 1920s, were incompatible with the radical political climate of the 1930s. Rodchenko's modernism was élitist and metropolitan, even if it could be applied to industrial and agricultural subjects. In Germany after 1933 the cosmopolitan, functional qualities of the new photography were clearly at odds with nationalist values. On the other hand the authorities in neither country felt able to reject modernism out of hand, and the result in both cases was a hybrid style, naturalistic with modern touches often applied in a studio.

Russian and German photographers worked for internal and external audiences. In the USA, by contrast, state-sponsored photography was meant to address local conditions. The Great Depression of 1929 and after had severe consequences in manufacturing and agriculture. In 1935 President Roosevelt set up the Resettlement Administration as part of the New Deal. The intention was to improve the lot of poor farmers and of migrant farm workers. To further the project the organization, which became known as the Farm Security Administration (FSA) in 1937, appointed Roy Stryker, a young economics lecturer in Columbia University, to prepare a pictorial documentation of rural hardship in the USA. Stryker appointed several documentary photographers including Walker Evans (1903–75), Ben Shahn (1898–1969), Dorothea Lange (1895–1965), Arthur Rothstein (1914–85), Russell Lee (1903–86), John Vachon (1914–75), and Marion Post Wolcott (1910–90). They took around 270,000 documentary pictures before the project was discontinued in 1943. This work of the FSA is the greatest collective enterprise in the history of the medium, although not simply because of its documentary interest. Evans, for instance, who had been a photographer since 1928, was impressed by Atget's posthumous book of 1930 and addressed the streets and structures of rural and small-town America with the same concern for detail. Evans implied that the citizenry of the USA were not only artisans but even artists at heart, if one paused long enough to take in the style and management of vernacular building. Evans and the others also made portraits, for which the project is especially well known. Their Russian and German contemporaries heroized the people, but this was hardly an option amongst communities which had suffered from debt, bad weather, and mismanagement. The result was a portrait gallery of individuals, quite unlike any of the idealized, representative figures who characterize European documentary in the 1930s. Although FSA photographs were meant to illustrate the plight of rural America and to mobilize public opinion they were little

used at the time, and only came into their own in the 1960s and 1970s as expressive, perhaps, of a bygone authenticity. In the 1930s the principal outcome of the enterprise was Walker Evans's *American Photographs*, published in 1938 by the Museum of Modern Art, New York.

Evans's close equivalent in American landscape was Ansel Adams (1902–84). Adams had been a pictorialist photographer in the 1920s, using soft focus. Around 1930, influenced by Paul Strand (1890–1976), he committed himself to 'the simple dignity of the glossy print' in an attempt to do justice to 'the continuous beauty of the things that are', by which he meant all those elements which go to make up a landscape: rock, water, sky, and verdure. He reminded Americans and others of a nature more or less integrated, and sometimes even hospitable to human interventions.

Documentary, which had been developed during the First World War, became the norm during the 1930s and continued as the major mode in photography until the 1950s. The term itself, however, is misleading for whereas it implies a strictly objective stance *vis-à-vis* conditions in the world it usually harboured a personal poetics; indeed it was a mark of opposition to totalitarianism, and even to the oppressive rule of editors, that it should do so.

Many of the documentarists of the 1930s were aliens, often east Europeans driven by ambition or oppression to work in Berlin, Paris, or London, where they kept company with vanguard artists and came to share their tastes and outlook. Poetic documentary culminated in 1952 with the publication of *Images à la sauvette* (*The Decisive Moment*) by Henri Cartier-Bresson (1908–).

Documentary's other major event was *The Family of Man* exhibition of 1955, described by its originators at New York's Museum of Modern Art as 'the greatest photographic exhibition of all time—503 pictures from 68 countries'. A total of 273 photographers were involved, and their pictures—selected by Edward Steichen (1879–1973), himself a distinguished Pictorialist from the generation of 1900—presented the world at large in terms of cultural diversity rather than international rivalry. Staged at the end of a period of widespread decolonization, it was a timely exhibition, although its pastoralism looked naive in the context of atomic weaponry and the Cold War.

The Family of Man marked the end of an era in documentary which had begun with the establishment of *VU* magazine in Paris in 1928, and of *Life* and *Picture Post* in 1936 and 1938, in New York and in London respectively. Their documentary manner, seen by many as 'natural', was liberal and humanist, giving full value to the figure writ large and clear. There were, however, photographers who objected to the rule of documentary and who tried to establish an alternative, most notably the German Otto Steinert (1915–78), founder in 1951 of 'Subjektive Fotografie'. Subjective photography, which was to some degree an intensification of the poetic documentary of Cartier-Bresson and his contemporaries André Kertész and Brassai (Gyula Halász) (1899–1984), made space for individual creativity. This phase was inaugurated in 1951 through an exhibition organized by Steinert in Saarbrücken, and although most of its manifestations through the 1950s were small in scale its consequences were considerable; in particular it helped to establish the

concept of an independent art photography which could be made known to discriminating audiences by means of exhibitions and specialist magazines. This model for ambitious photography obtained right through into the 1980s, and is well exemplified by the quarterly magazine *Aperture*, set up in the USA in 1952 and having as its first editor Minor White (1908–76), a photographer who believed in 'equivalence' or a congruence between states of mind and pictured landscape.

The documentary tradition, which was so triumphantly concluded in *The Family of Man*, held that photography had a social function in which children, for instance, represented the future, just as manual workers represented the dignity of labour. Documentarists were propagandists for mankind, but for a mankind defined during the 1930s. In the 1950s, however, the material conditions of life were changing, and very much for the better in the USA. Inherited stereotypes were out of place amongst the juke boxes and Chevrolets of the new order—and furthermore belief in the glories of the future had been shaken by knowledge of the A-bomb and memories of the Holocaust. One outcome of the new disenchantment was an informal, even an existentialist, style in which the photographer appeared as no more than a traveller and a solitary, attentive to the moment but uncommitted to the well-being of humanity. The greatest instance of this was from Robert Frank (1924–): *Les Americains*, first published by Robert Delpire in Paris in 1958, and then brought out in 1959 as *The Americans*, with a foreword by Jack Kerouac. In 1962 Delpire published *Die Deutschen*, a comparable book by René Burri (1933–), another Swiss photographer.

New photography, as it evolved during the 1950s, was premissed on intuition rather than technique. A successful photographer, like a successful jazz musician, intuited a significance in the moment and found its formal equivalent. Decisive moments in the 1930s had been structured, but in the 1950s they were more like ciphers. John Szarkowski, an influential curator of photography at New York's Museum of Modern Art, and author in 1966 of *The Photographer's Eye*, described photographs as 'mysterious and evasive images'. They might achieve coherence or seem 'significant beyond their limited intention'; it all depended on the imaginative capabilities of artists, editors, and curators. Europe's demiurge, the equivalent to Steichen and then to Szarkowski, was the editor Robert Delpire, whose aesthetic—sensitive to the vital force in pictures—is summed up in *In Our Time*, a survey of pictures by Magnum Photos, published in 1990.

The subjective aesthetic, because it depended on intuition, was hard to predict, to control, and to assess. Intuition might be in touch with the moment, but it might just as easily disappear never to return. It seemed to volunteer itself most readily in exciting urban contexts, that of New York in particular, and its preferred mode was what was known in the 1960s and 1970s as street photography. The street delivered minor adventures and a whole range of authentic experiences, but the problem with that kind of experience was that although marked by authenticity it was equally and increasingly seen to be anachronistic in an age— the 1960s—infatuated by the transmission of pictures. Documentary, as practised in the 1930s, was premissed on an idea of immediate access to its subjects, but in the Age of Transmission, which dawned with the spread of television in the 1950s, it was

what happened to images after their inception which attracted the attention of artists. Direct reporting from the streets began to look archaic, as if its adepts were trying to save the old humanist photography by sleight of hand.

Representative men and women had starred in the documentary era, and then subjectivist photographers themselves, with their hard-won gifts and powers of intuition, took their place. In the next phase, especially associated with the New Topography, photographers virtually absented themselves, at least in a conventional 'creative' sense. The term itself was introduced in 1975 by William Jenkins, organizer of the exhibition *New Topographics: Photographs of a Man-Altered Landscape* at George Eastman House, in Rochester, New York. The New Topography was objective, even forensic. In the USA its subject was recent urban developments, photographed in a style which recalled the western survey pictures of the 1860s and 1870s. *The New West* (1974) by Robert Adams (1937–) is the *locus classicus* of the movement. In Europe its focus was less on recent encroachments on landscape than on the apocalyptic aspects of industrial decay, most successfully realized by Gabriele Basilico (1944–), whose pictures are anthologized in *L'Esperienza dei luoghi* (1994). Implicit in this painstaking manner with its wide and even panoramic formats is a belief that artists should forgo an editorial role as far as possible leaving audiences to make inferences of their own from the evidence available—even if some of it is hard to discern.

Cognate with the New Topography, and as important, especially in Europe, was the example of Bernd (1931–) and Hillar (1934–) Becher, authors in 1970 of a book on industrial building, *Anonymous Sculptures: A Typology of Technical Construction*. This was followed by other surveys of industrial building, such as pit-heads, watertowers, and blast furnaces. In part the Bechers' art is a homage to an older heroic age, when industry was imagined in epic terms by its sponsors, but all of their pictures—in the manner of the New Topography—present evidence on structure and style which might eventually be read through to a conclusion. Influential teachers, the Bechers imbued their students—including Andreas Gursky (1955–), Candida Hofer (1944–), and Axel Hütte (1951–)—with the belief that photographs should provide a wealth of evidence in the absence of clearly defined subjects.

The new aesthetic sensibility of the 1970s and after also made use of colour as never before. Colour had been a factor in photography since the introduction of the Autochrome process in 1907, but its luxuriant Touring Club aesthetics were incompatible with the seriousness which was expected of documentary. However, once the ideological phase waned in the 1950s and 1960s colour became an obvious option, in part because it gave a disinterested and even a seductive account of all those material elements which monochrome had suppressed on behalf of the all-important human figure. In the absence of any very clearly defined or uplifting vision of the future—as there once had been in the era of *The Family of Man*—the present became all-important, and it was colour which gave the most complacent and even mocking account of this sometimes catastrophic moment. Colour became the medium for news stories from the myriad small wars of the era, which it presented increasingly as a kind of poisoned tourism.

IJ

Modernism

The modern outlook was objective and functional, and at odds with the spirit of 1900 which recognized truths beyond appearance, truths which might be intuited. Photographers began, in the 1920s, to think of their pictures more sculpturally than pictorially [647], to consider the picture space as a shallow box holding shapes in relief: rocks, stones, abraded landscape, faces, and torsos. Small apertures down to f.64 with long exposures delivered these objective studies—and in 1932 a group of Californians, including Edward Weston [646], established a movement for 'straight' photography which they called f.64. Audiences were invited to scan such pictures minutely and to think of vision in relation to the sense of touch. The modernist thus defined could be considered an engineer or an artisan dealing with materials which could be assessed and manipulated. New photographers in the 1920s were drawn to manageable materials, to whatever might be manœuvred and which might cast a shadow—shadows were valued because they were indicators and schematic representations of the thing itself. Josef Sudek, who would become well known in the 1950s for his pictures of Prague [645], was one such modernist in the 1920s and through much of the 1930s, when modernism began to fall into disfavour as an aesthetic which provided too many options. The problem with modernism, at least from a totalitarian viewpoint, was that it held to a playful view of society as subject to reconstruction at will, as in a kit or shop window. Artists and designers could imagine themselves, in theory at least, as demiurges, inventors of

645 Joseph Sudek (1896–1976), *Alleyway, Prague* (*c*.1925), New York, Salander-O'Reilly Gallery

blueprints for this new superhuman-ist venture. It was, of course, all a game practised by vanguardists on a low budget, earning a living from fashion and advertising, but it familiarized the public with the possibility that society could be re-invented in the studio. As its most exuberant, and as it was practised in Berlin in the late 1920s, modernism liked to replace man with manikin and vice versa. Carousels, cosmetics, kitchen equipment constitute important elements in the iconography of modernism, at least in the vernacular variants of the photo-graphers, and the rediscovery of this iconography played an important part in the establishment of Pop art in the 1960s—another utopian moment imbued with the spirit of carnival. IJ

646 Above: Edward Weston (1886–1958), *Shells* (1927), London, Michael Wilson Collection

647 Above: Man Ray (1890–1976), untitled rayograph (1928), 24 × 17 cm. ($9\frac{1}{2}$ × $6\frac{3}{4}$ in.), Art Institute of Chicago, Levy Collection

Reportage

Although the term 'reportage' only came into common use in the late 1920s, photographers had reported on news events almost since the origins of the medium. Around 1900 stereo-photographers took pictures of the Boer War, for instance, for such stereo picture agencies as Underwood and Underwood. Nonetheless, Erich Salomon was the first 'candid'

cameraman, the first to go behind the scenes to show international politics in formation [648].

His intimate studies of great men, often taken at a disadvantage, were never surpassed, in part because great men came to realize that privileged access could work to their disadvantage. Salomon's view of bourgeois politics also became out-moded in 1933 with the establishment of Nazi rule in Germany.

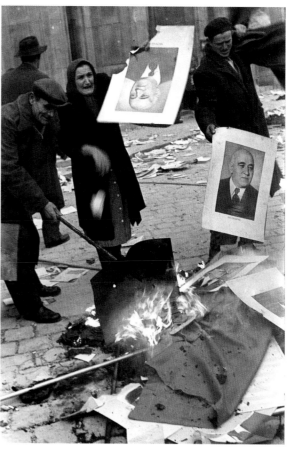

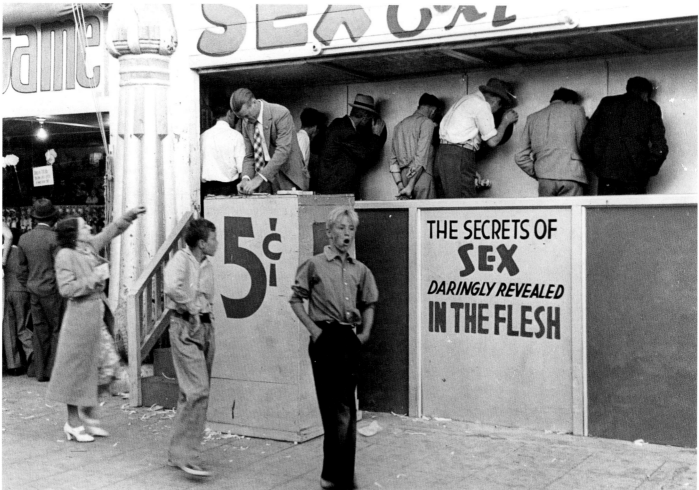

Despite the capacity to photograph in 'available light' from the early 1920s—thanks to the coming of the Ermanox camera in 1923—it was always difficult to establish a thoroughgoing reportage. Significant events were hard to predict and could be dangerous when predicted. Photographers chose instead to report on significant trends and to reflect on history by proxy—a study of a hypnotist, for example, might stand in for a new direction in politics. Photographers also became social investigators, travelling far and wide, as the unknown photographer did who photographed this American fairground scene in 1933 [**649**].

Thereafter ideology prevailed through the rest of the 1930s and into the era of the Cold War. Reporters were able to make use readily of the politically charged motifs which figured everywhere: national flags, political emblems, statuary. Events, such as the burning of flags and political portraits [**650**], might be staged with publicity in mind. The coming of television and with it the age of transmission in the 1950s altered the rules of engagement, and photographers more and more set themselves to compensate for the haste with which news was gathered and used up. Philip Jones Griffiths's book, *Vietnam Inc.* of 1971 [**651**] exemplifies this corrective tendency, with all its attention to particulars and to consequences rather than to the events themselves. IJ

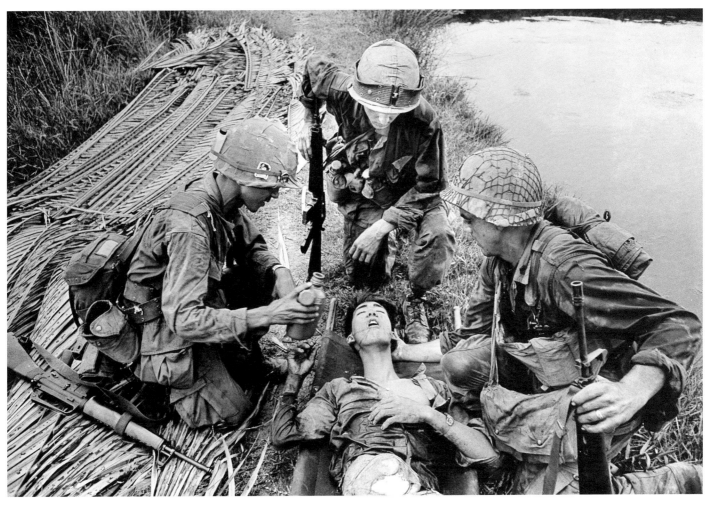

648 Opposite, top left: Erich Salomon (1886–1944), German and French ministers in late night session at The Hague reparations conference (1930), 27.8 × 36 cm. (10⅞ × 14⅛ in.), Cologne, Rhemisches Bildarchiv

649 Opposite, bottom: Unknown photographer, *5 cents for sex* (1933), London, The Archive of Modern Conflict

650 Opposite, top right: Erich Lessing (1923–), *Uprising in Budapest* (1956), Magnum Photos

651 Above: Philip Jones Griffiths (1936–), *Wounded Vietcong* (1971), Magnum Photos

The liberal imagination

The liberal imagination as it manifests itself most notably in photography is represented by four artists. Eugène Atget probably considered that he was doing no more than a job of work, recording an interesting decorated doorway in old Paris [652]. However, it was this kind of picture which made his reputation in the 1930s after the publication in 1930 of *Atget,*

Photographe de Paris. The doorway itself, with its ghostly figure, remarks on the human measure, and whilst its facture and motifs point to artisanship the whole, under its seagoing sign, recalls home and a locality.

Atget first undertook photography in the 1890s when it was taken for granted that individuals, even if they were no more than street types and tradesmen, should be shown in context and in particular in personal

space. August Sander, too, was a photographer from that generation and imbued with its ethics. His idea was to complete a wide-ranging survey, to be called *People of Our Time*, drawn from every section of the community. Yet even though his approach was objective and impassive Sander seems to have been incapable of conferring representative status on any of his subjects, each one of whom seems distinguished and sometimes

burdened by sheer weight of character and physical circumstance [653]. His vision of a nation of individuals, very markedly distinguishable one from another, was unwelcome to the type-conscious Nazi turn of mind, and the project was banned.

Atget's admirer and successor was the great American documentarist of the 1930s, Walker Evans. His approach was dictated by conditions. Working for the Farm Security

652 Eugène Atget (1857–1927), *Au Petit Dunkerque, quai de Conti* (*c*.1900), Paris, Musée Carnavalet

Administration, his task was to bear witness to a worthy people fallen on hard times, and they were best served by their own testimony and appearance [654]. The American tendency was always liberal, or mindful of individual identity. Paul Strand, author in 1950 of *Time in New England*, held, as part of his modernist inheritance, that actualities and concepts were mutually dependent, that the one failed to register in the absence of the other. When he photographed Susan Thompson [655] at Cape Split, Maine, in 1945 a set of eight nail heads barely visible on the plank on the right represents her in abstract, but faintly as if he meant to keep the idea no more than on the edge of consciousness. IJ

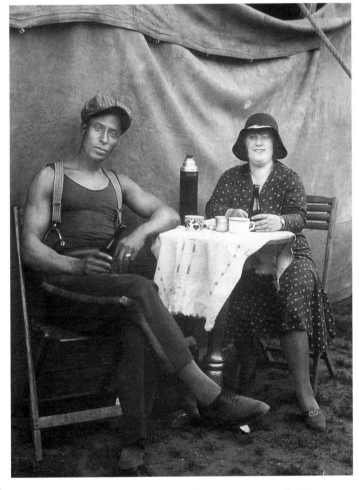

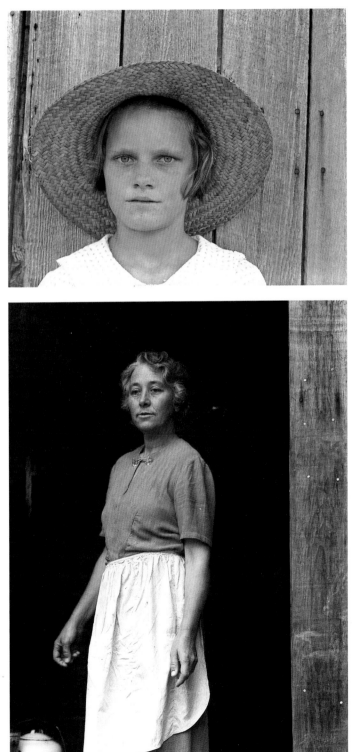

653 Above: August Sander (1876–1964), *Circus People in Front of Tent* (1926), Cologne, August Sander Archive

654 Above right: Walker Evans (1903–75), sharecropper's daughter: Hale County Alabama (1935), Washington, Library of Congress

655 Right: Paul Strand (1890–1976), Susan Thompson, Cape Split, Maine (1945), New York, Aperture Foundation Inc., Paul Strand Archive

Modern poetics

Modernist photographers were poets—sometimes extravagantly so, entranced by emblems, symbols, figures of all sorts. They were, after all, working in an ideological age, one in which ideas took precedence.

Henri Cartier-Bresson's subject [**656**], for instance, is the people at large, passing in the street, and if it were of no more interest than that it would only be a commonplace, but the wall beyond with its array of windows reiterates the crowd in abstract, large and small, diagrammatically. André Kertész's equally famous picture [**657**] also concerns the people, signified less as individuals than modules or as hats engrossed by spectacle. The acrobat in his turn looks like a thoroughly modernist figure loaned, you might imagine, by the Bauhaus for an amateur performance. The key, however, to Kertész's composition is that isolated figure on the bridge, a sort of privileged viewer from whom no secrets are hid.

The modernist idea, at least as mediated in photography, leaned towards analysis. A scene, sufficiently studied, gave up its secrets; and if it was a social scene it might even be controlled or managed. Insight, too, is implicit in the modernist ethic.

Kertész's perception in 1929, and prophetic of the years to come, is of a mass beguiled by a performance. Hajek-Halke, an important influence in German photography right through into the 1950s, proposes—with his more psychoanalytic turn of mind—that it is eroticism which is the key to everyday life [**658**]. IJ

462

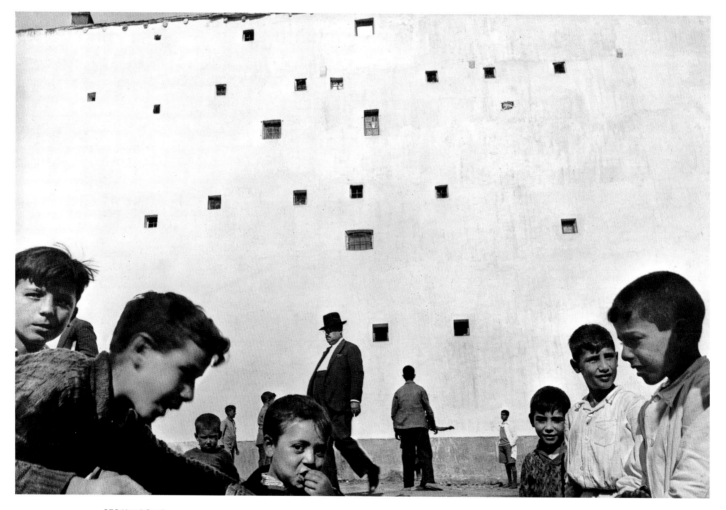

656 Henri Cartier-Bresson (1908–), *Madrid* (1933), Magnum Photos

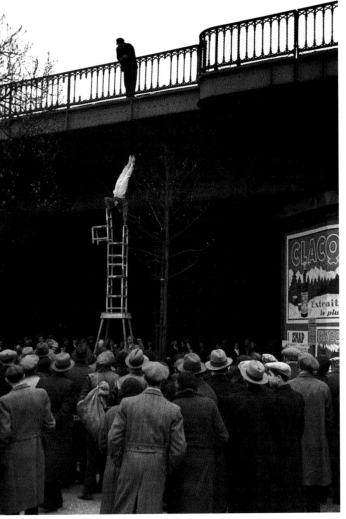

657 Left: André
Kertész
(1894–1985),
Acrobat, Paris
(1931)

658 Above: Heinz
Hajek-Halke
(1898–1983),
Defamation
(1926–7), Berlin,
Michael Ruetz
Collection

Compassion in world photography

Compassion came late to photography. Around 1900 it was sufficient to document the plight of the disadvantaged, but not to present them person to person. In the First World War, too, photographers merely introduced the evidence without empathy. Modernism, perhaps because of its objective biases, made a difference. Cubism, with its range of tactile motifs (drinking glasses, accordion keys, and cigarette papers included), brought haptic elements to vanguard art, including photography in the 1920s. Photographers, accustomed to Cubist idioms, began to think in terms of a humanity in touch with materials rather than as simply existing in isolation. American documentarists working for the Farm Security

464

660 Right: John Vachon (1914–75), *Gravedigger, Edmore, North Carolina* (1948), Louisville, Kentucky, Photographic Archives, University of Louisville

659 Edwin and Louise Rosskam, *Amateur radio night, Powell, Wyoming* (1944), Louisville, Kentucky, Photographic Archives, University of Louisville

Administration in the 1930s and for Standard Oil in the early 1940s were the first to exploit this new aesthetic.

Work scenes in particular introduced the people to the people, for many were familiar with the use and weight of tools. John Vachon's picture of a gravedigger [660] in Edmore, North Dakota, in 1948 is a canonical instance of this aesthetic; not only is it hard, cold weather but the ground is under snow deep enough to encroach on the names of the dead—and the gravedigger wears glasses, significant signifiers of the senses.

Edwin and Louise Rosskam, working for Standard Oil in 1944 after the discontinuation of the FSA in 1943, not only invoke sound, in the figure of the microphone and that of the singing child [659], but bring to mind the act of inscription, given in those innocent graffiti. Wall drawings and torn posters played an important part in the iconography of the 1940s and 1950s, primarily because they stood for impulsive individual action.

Werner Bischof [661], a Swiss and one of the most benign of all post-war photographers, introduced exemplary local cultures with respect to the evidence of the senses, evidence which would bring them to life in the minds of metropolitan audiences. *The Family of Man*, Edward Steichen's great exhibition of 1955, was premissed on the idea of this kind of haptic and empathetic access to the lives and sometimes to the plight of others. Wayne Miller, Steichen's assistant in 1955, contributed one of the most moving of the exhibition's images, of a cotton picker and his wife [662]—a pair at the end of their marriage, and both making the kind of (imitable) neurotic gestures indicative of discontent and irrevocable words unspoken.　IJ

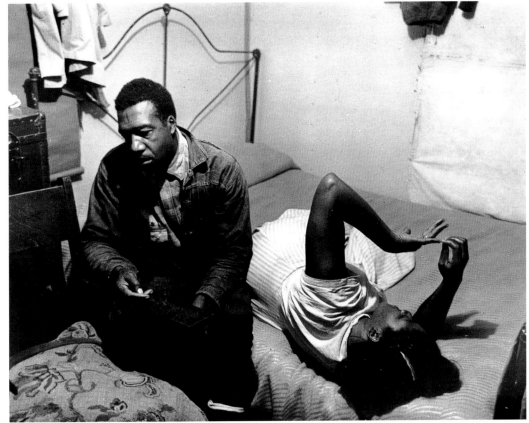

661 Above: Werner Bischof (1916–54), *Farmers' Inn in the Puszta, Hungary* (1947), Magnum Photos

662 Right: Wayne Miller (1918–), *The Cotton Picker* (1950), Magnum Photos

Beginning again

New photographers in the 1950s turned aside from the old order with all its utopian baggage and its confidence in well-made pictures. The old order was ideological, even if it was committed to the future good of humanity. It was difficult to keep all of that moral grandeur in mind when most of the present looked so humdrum—especially the kind of low-rent present encountered by young artists making their way through a landscape of railway stations and ruined cities (Europe) or one of cheap diners and bus stations (USA). The People, as encountered in the 1930s and immediately after the war, may have been oppressed but they were potentially heroic. Those who featured in the 1950s, by contrast, existed elsewhere, contented or distracted amongst new furnishings: automobiles, juke boxes, and cigarette dispensers. The old (modern) aesthetic relished quick-wittedness and physical vigour, but the evidence—as presented to the new generation on its travels—was often of mere endurance, of keeping going in unpromising settings, in mean dilapidated streets.

The previous aesthetic, especially as it applied to social documentary, had been premissed on insight into the minds and lives of others. That, though, was presumptuous to the new photographers who chose instead to present others as they found them, simply on site. The new style, as practised by Robert Frank [663] and René Burri, was both intimate and secretive, a candid photography taken in the shadows, of incidents which were neither significant nor decisive. Audiences, who had once been flattered by the intelligence of their photographic guides, were now

663 Left: Robert Frank (1924–), *Bar, New York City* (1955)

664 Below: Bruce Davidson (1933–), *Hackensack, New Jersey* (1966)

665 Opposite: Joseph Sterling (1936–), *Teenagers* (c.1960), From *The Age of Innocence*

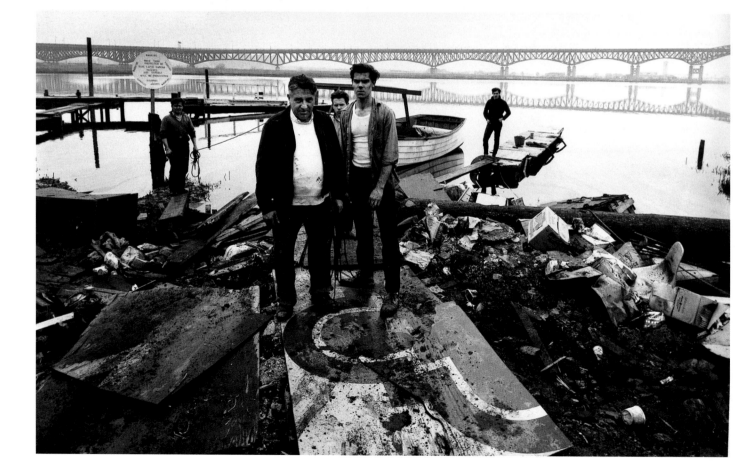

expected simply to bear witness to the journey with all its chance encounters.

Although there are many refined observations and poetic turns of phrase in this new photography they are always introduced companionably, by artists who suggest that they represent no one but themselves. Frank's *The Americans* (1959) and Burri's *Die Deutschen* (1962) appeared in the same series, edited by the French publisher Robert Delpire.

Davidson's pictures [**664**] appeared in the formative exhibition of 1966, Nathan Lyons's *Toward a Social Landscape*—at the George Eastman House, Rochester, New York. Sterling's teenagers [**665**] starred in the same year in John Szarkowski's important exhibition at New York's Museum of Modern Art, *The Photographer's Eye*, the event which more than any other introduced this secretive poetics to the public. IJ

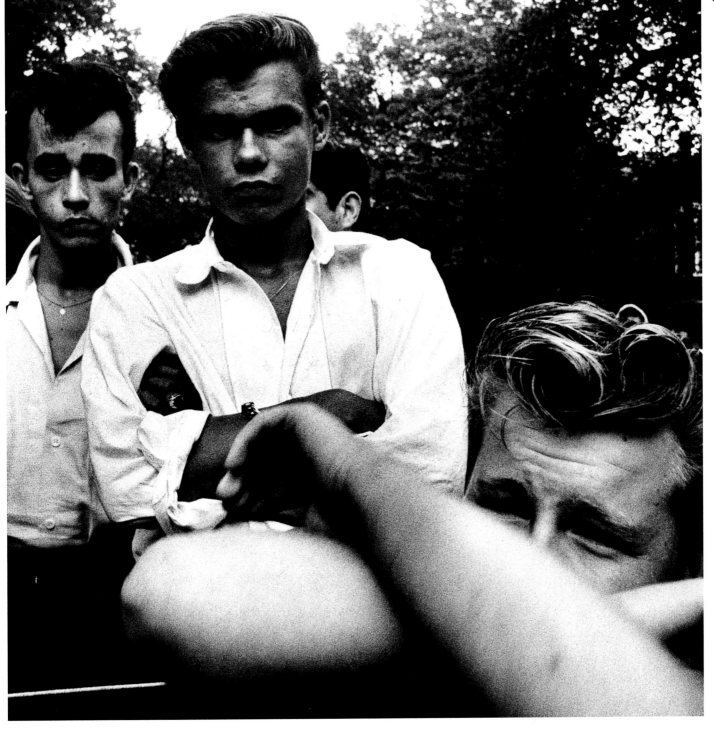

Varieties of Postmodernism

Postmodernism is the dark side to the modernist coin. Photographers, like their contemporaries from the 1930s through into the 1950s, had been sustained by visions of better times ahead. In the 1940s and 1950s these involved culture, epitomized by the family at home in localities. It was,

however, society which emerged at the expense of culture, and society's emblems—tokens of social mobility—were the automobile, television, and corporate logos, motifs which knew no boundaries.

The social landscapists of the 1950s gave advance notice of Postmodernism, but modernist premises were overturned only in the 1960s and after. In Richard Kalvar's convulsive aesthetic lone survivors act

out remembered aspirations in what looked like the abandoned ruins of the city—New York, in this case, the Xanadu of the post-war world [666].

Joseph Koudelka, like Kalvar a member of Magnum Photos, also projected a systematically contra-dictory account of the modernist vision, showing traditional cultures—the gypsies of Slovakia, for instance—reduced to subsistence levels, even in a professedly utopian communist

society, and other traditional cultures in disarray, as in this Spanish tableau [667] in which Harry Lime keeps company with a murdered geisha.

Early Postmodernists, like Kalvar and Koudelka, imagined utopia disrupted. Their successors, though, were less affected by modern memories, and preferred to present themselves as being at a loss, confronted by a cryptic present, which although it might be rich in inscriptions was

666 Richard Kalvar (1944–), *New York* (*c*.1960), Magnum Photos

667 Below: Joseph Koudelka (1938–), *A float for the Las Fallas festival in Valencia* (1973), Magnum Photos

simply hard to decipher. From the 1970s onwards specialists in the social landscape represented it often literally through screens and subject to reflections and shadows. Television news may have introduced society at large in terms of major stories, forming part of a central stream of history, but photographers—most notably Gilles Peress [**668**] in his formative book of 1984 on the Iranian Revolution of 1980, *Telex Persan*—chose

rather to present themselves as travellers along the margins, witnesses to the aftermath of catastrophe.

It was also, and increasingly, an age of transmission, mediated by many hands and screens to a point of a beguiled no confidence. Lise Sarfati [**669**], a specialist in the decayed USSR, identifies a representative citizen in this new order of the pervasive image or of media saturation in Postmodern society. IJ

469

668 Gilles Peress (1946–), *Teheran street scene* (*c.*1980), Magnum Photos

669 Lise Sarfati (1965–), *Backstage at the Maiakowski Theatre, Moscow* (1997), Magnum Photos

Alternative Centres: The Soviet Union

The search for a new and characteristically proletarian visual culture initially led the Soviet regime to collaborations with the progressive avant-garde. Under its first Commissar, Anatolii Lunacharsky (or Anatoly Lunacharskii) (1875–1933), NarKomPros (Ministry for Popular Enlightenment) became the focus for what has been described as a dictatorship of the avant-garde, and for a while the various strands of modernist creation, notably Suprematism and Constructivism, played a major part in shaping the new cultural consciousness. Though disparate in means, the avant-garde shared the common objective of assisting the material and ideological transformation of life, a utopian strain that was to be taken up forcefully by Soviet Realism. There were notable successes from this partnership, particularly in propagandistic material, industrial design, and cinema, but the honeymoon was short-lived.

Whilst approving the political probity of much avant-garde activity, the Bolshevik leadership, including Lenin, were largely antipathetic towards its products, a view seemingly endorsed by public bewilderment or derision of much public art produced under modernist influences. The early 1920s witnessed a return by many artistic factions to some form of figurative style and narrative content, exemplified in 1922 by the foundation of the fiercely pro-Bolshevik AKhRR (Association of Artists of Revolutionary Russia) whose huge influence and astute self-publicity was to prefigure both the style and monolithic structure of the centralized unions that were to follow. The absence of private markets, which effectively made the proletariat the sole patron in the new Soviet structure, saw large state funds channelled through NarKomPros to various commissioning bodies, notably the Red Army and trade unions, whose conservative preference for intelligible images was well served by the Association.

Many other artistic groupings of the 1920s turned voluntarily to more comprehensible means of expression in an effort to engage a still largely uneducated population. OSt (Society of Easel Painters), formed in 1925, strove to unite modern formal means with contemporary subjects and won the endorsement of Lunacharsky, but increasingly the tone of official pronouncements, state decrees, and publication of Lenin's views on art presaged the abandonment of experimental art in favour of traditional models propounding the ideals of the Revolution in a style most accessible to the majority. This was, however, an evolutionary process in which it is difficult to disentangle the strands of genuine artistic proclivity, state intimidation, and public receptivity. An end to debate was signalled by the April Decree of 1932 which dissolved all existing art groups and replaced them with a single union, signalling a centralized

political control of the arts. This was followed by the 1934 First All-Union Congress of Writers, which on behalf of the Soviet arts ratified Socialist Realism as the only acceptable method of cultural production and advanced the principles of typicality, revolutionary romanticism, and 'Partiinost' (Party-mindedness) which became its theoretical hallmarks.

At the same time, in line with the wider political and cultural purges of the 1930s, the state began to root out formalist and individualizing elements. In a climate of fear and counter-denunciation, 'undesirable' artists, their bourgeois styles deemed redolent of a similar political inclination, were branded as class enemies and subjected to show-trial methods of persecution by their own unions. Some successfully recanted but many, too tainted by past avant-garde associations, were removed to labour camps or executed. The persecution played a large part in determining the future direction of Soviet Realism since the Congress of 1934 had talked more of method than style, promising an art that was socialist in content but diverse in form. This ambiguity disappeared during the purges as artists adapted their practices to fit a largely homogeneous style derived from nineteenth-century sources. Party-appointed professors, traditional techniques, and a centralized practice disseminated from the All-Russian Academy of Arts ensured a consistency of product in line with the collective ethos of state policy.

In 1936 the Committee on Arts superseded NarKomPros, maintaining a stricter adherence to party ideology, but despite the representational principles of Soviet Realism a photographic naturalism did not emerge, nor was it specifically advocated. A crude vitality persisted in formal arrangement and colouration and some artists managed to retain a distinct stylistic identity and creative flair within the constraints of the official method. In general, however, until the death of Stalin in 1953, Soviet art conformed largely to a purely realist style relentlessly propounding the values of the Communist regime in terms of a boundless optimism and, particularly after the Second World War, an increasingly Russian racial bias, which found outlet in a series of favoured thematic approaches. Chief of these was the huge cult built around its leadership in which pre-eminence was given to images of Lenin and Stalin as the architects of Soviet life, inspiration and executive of everything from political wisdom and scientific achievement, to military and cultural excellence.

Other notable genres included a cult of the body which through the propagation of dedicated, physically robust, and athletic images of the new Soviet person resulted in a frequently idealized but uniform treatment of gender. Elsewhere scenes of industrial triumphs and agrarian fecundity dominated a state-approved subject-matter which through its espousal of

670 Sergei Merkurov (1881–1952), *Monument to Comrade Stalin in the Square of the All-Union Agricultural Exhibition* (1939), ferro-concrete, 30 m. (98 ft. 6 in.), destroyed

revolutionary romanticism gave form to those aspects of socialist building which as yet existed only in idea, but whose 'coming into being' were perceived as part of the communal reality. Public reception of Soviet art appears to have been largely positive with viewing figures being consistently high, though organized viewings of exhibitions were common and in terms of critical reception the influential Party organs assiduously toed a politically servile line, a partisanship matched only by Western deprecations of Soviet art, making written evidence for this period of art history frequently unreliable. The death of Stalin

dealt a severe blow to Soviet Realism which, though it barely relaxed and lived on into the Glasnost period of the 1980s (it continues to have its adherents and practitioners today) was seriously undermined as an artistic philosophy. More recent researches from both Russia and the West have begun the scrutiny of those art forms marginalized by Soviet Realism and, whilst still guarded in how to approach this highly problematic and mutually misrepresented area of art history, show a greater willingness to engage in a dispassionate and critical analysis of this exemplar of the totalizing art form.

DJ

Strands of Soviet art

Though generally conceived as an unvarying paean to socialist construction, some diversity of style and approach remained intact. Deineka's work [671], derived from earlier attempts by OSt to fuse modern styles and subjects, retains an individual style whilst successfully celebrating the synchronicity of technical and human efficiency.

Gustav Klucis [672], however, despite impeccable Party credentials, fell victim of the purges on Formalism and died in a labour camp for his 'crime', proving that stylistic deviation was for the few, and within limits. Whether by inclination or intimidation most artists adopted a realist style in the service of Party propaganda. Brodsky's image of the intellectually absorbed Lenin [673] derives from nineteenth-century precedent, but served the

contemporary cult of the leadership. Lenin's image was later superseded by Stalin's, epitomized by Merkurov's gargantuan statue [670], one of many that eulogized the god-like status of the nation's 'wise leader'. A staple product of 'revolutionary romanticism', the cult was a designer image that purported to show the leadership as imagined by the Soviet peoples, in turn proclaimed a social 'reality', since what the masses envisaged must be

essentially 'true'. This will to document a reality not yet achieved, but to which the masses were striving, resulted in many joyful, optimistic but objective falsifications of triumphs of socialist production. Plastov [674] depicts the catastrophe of collectivized farming as a rural idyll genially overlooked by an image of Stalin. The banner proclaims one of Stalin's favourite aphorisms: 'Living has got better, Living has got jollier.' DJ

472

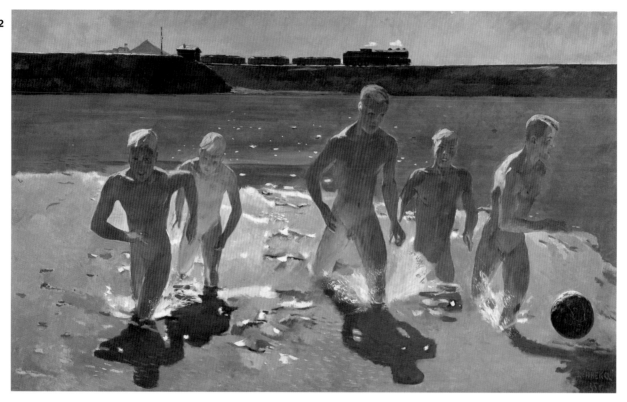

671 Aleksandr Deineka (1899–1969), *Lunch Break in the Donbas* (1935), oil on canvas, 1.495 × 2.485 m. (4 ft. 10⅞ in. × 8 ft. 2 in.), Moscow, Tretyakov Gallery

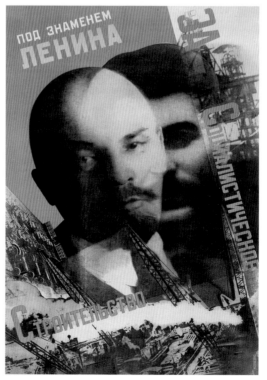

672 Gustav Klucis (1895–c.1944), *Under the Banner of Lenin for Socialist Construction* (1940), offset lithograph, 97.5 × 72 cm. (38⅜ × 28⅜ in.), London, Victoria & Albert Museum

673 Opposite, top: Isaak Brodsky (1884–1939), *Lenin in Smolny* (1930), oil on canvas, 1.9 × 2.87 m. (6 ft. 2¾ in. × 9 ft. 5 in.), Moscow, Tretyakov Gallery

674 Opposite, bottom: Arkadi Plastov (1893–1972), *Collective Farm Festival* (1937), oil on canvas, 1.88 × 3.07 m. (6 ft. 2 in. × 10 ft. 1 in.), St Petersburg, State Russian Museum

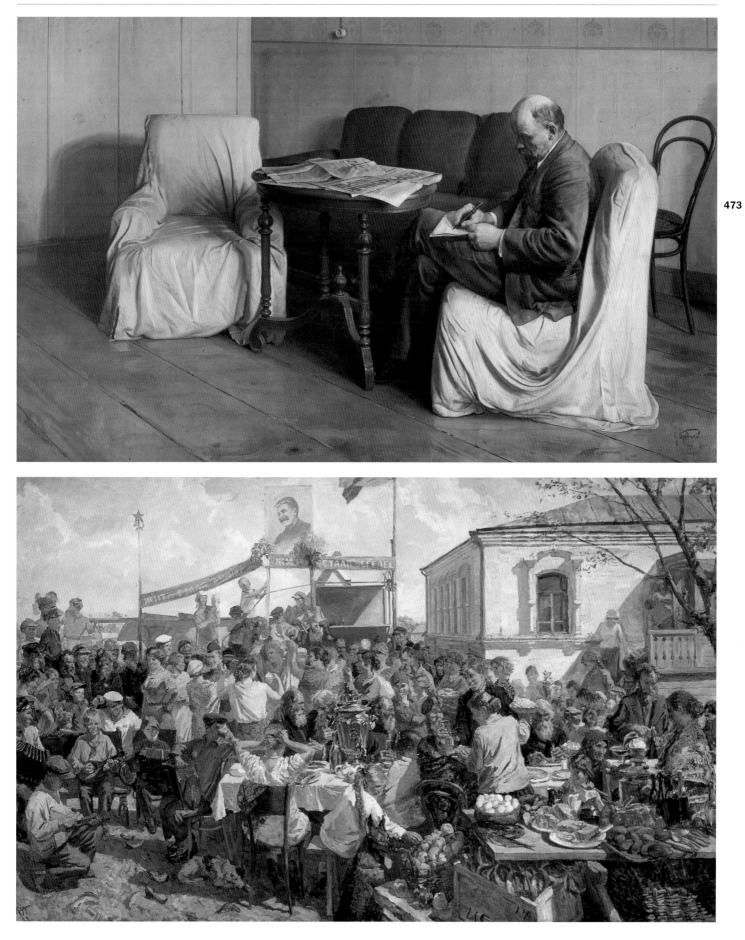

Alternative Centres: Latin America

Reacting against the post-independence supremacy of positivism in late nineteenth-century Latin America, with its encouragement of European influences and rejection of the African-American and Amerindian components of its societies, some élite groups started to develop a critical interest in the popular sources of their culture during the 1910s and 1920s. Finally acknowledging their process of cultural *mestizaje* with Amerindians and Africans, this intelligentsia now became able to question the absolute importance of European input. With the Vanguardist movement in Hispanic America and the Modernist movement in Brazil, many new and original forms of artistic expression were forged: modernist manifestos in Mexico and Brazil, the avant-garde review magazine *Revista de Avance* in Cuba (1927), socio-political dialogues in Peru.

Latin American artists now chose to assume a non-submissive attitude towards their European sources. In Mexico, modernist tendencies were closely linked to the political life of the country, expressing the ideals of the 1910 revolution and culminating in the Mexican mural movement from 1921. Diego Rivera (1886–1957) [**675**] was the only main participant in this movement who sought to create an 'art for the people' in indigenist terms, reinterpreting pre-Columbian structures and iconography such as the boustrophedon form of Mixtec and Aztec screenfold writing. The other main protagonists, José Clemente Orozco (1883–1949) and David Alfaro Siqueiros (1898–1974), concentrated rather on portraying contemporary issues.

In Brazil, Tarsila do Amaral (1886–1973) [**677**] sought to combine her modernist interest in contemporary industrial life—depicted in an impersonal and minimalist visual language, betraying the influence of Fernand Léger (1881–1955)—with her deep interest in specifically Brazilian subjects. Incorporating the vivid colours of folk decoration, tropical fauna and flora, and dark-skinned figures within a refined Cubist idiom, Tarsila contributed to the development of unmistakably Brazilian forms, embodying the principles proposed in two important contemporary artistic movements, the *Pau-Brazil Manifesto* (1924) and the *Anthropophagic Manifesto* (1928).

By the mid-1930s, the Uruguayan Joaquín Torres-García (1874–1949) had started single-handedly to introduce Modernism to his country. A theorist, sculptor, and painter, he was deeply attracted to Platonic thinking, searching for a universal form of expression based on the plastic elements of art, such as colour, line, and form. He was also attracted to pre-Columbian art, which enabled him to root his notion of universal spiritual art and humanistic values in local history and culture. His Constructivist style combined abstract forms with a cosmic symbolism based on pre-Columbian motifs and images from contemporary industrial life, like trains, steamships, and man-made architecture [**678**].

From the late 1930s to the 1950s, a fresh Latin American intellectual context developed in response to the Spanish Civil War, the Second World War, and the Cold War. Rapid urbanization accompanied the growth of the middle classes and the advent of populist policies which underlay the alliance between the state and the new industrial groups. Social concerns dominated Latin American artistic production of this time, as in

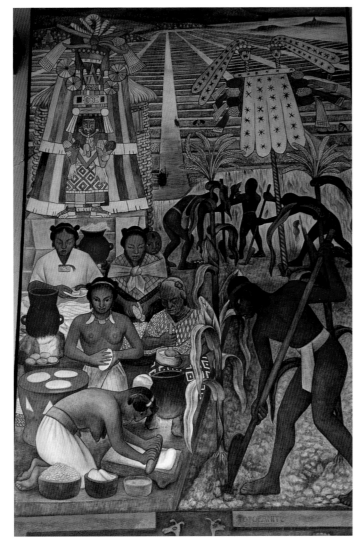

675 Diego Rivera (1886–1957), *The Huastec Civilization* (1950), fresco, Mexico City, Palacio Nacional

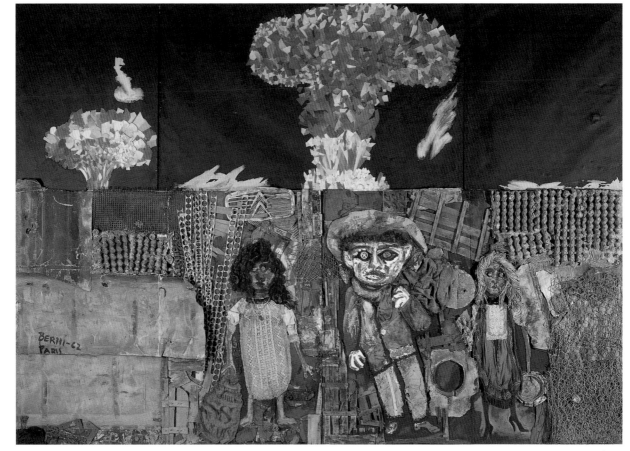

676 Antonio Berní (1905–81), *The World Promised to Juanito Laguna* (1962), collage on corrugated cardboard, 3 × 4 m. (9 ft. 10 in. × 13 ft. 1½ in.), Buenos Aires, Galería de Arte Ruth Benzacar

the late work of Tarsila do Amaral. In their idealized indigenist vision, Diego Rivera's late murals appear distant from more immediate contemporary concerns. The work of Rivera's wife, Frida Kahlo (1907–54), became internationally known after its 'discovery' by André Breton in 1938. Seeking inspiration in ancient Mexican culture, she expressed her perceptions of her emotional reality through direct and sometimes violent visual metaphors [**679**]. And in Cuba, Wifredo Lam (1902–82) combined his elaborate Surrealist vision and his love of Picasso's work with elements derived from his experience of Afro-Cuban religion.

Parallel to these developments, the cultural life of all disempowered groups proceeded undisturbed, unaware of its significant role in the development of cultured forms of Latin American art and thought. During the 1960s philosophical schools of phenomenology and existentialism played a part in shaping élite views of this culture, making possible a *prise de conscience* by artists and writers who 'marvelled' at the inability of their societies to integrate fully into Western rationalism, capitalism, and political agendas. The Argentinian Antonio Berní (1905–81), a member of the Communist Party, used figurative language to express his social criticism in a series of collage-constructions, commenting on the life of the dispossessed through popular characters [**676**]. In contrast, the Brazilian Hélio Oiticica (1937–80) produced his *Parangolés* (Capes)—spatial sculptures created through the movement of the spectator—to reinterpret samba dance movements.

Presented at the Modern Art Museum in Rio de Janeiro in 1964, Oiticica's *Parangolés* brought ordinary members of the Samba Schools into the refined environment of the museum, paradoxically pointing to the gap that still existed between popular and élite culture.

Concerns with politics and identity remain relevant as Latin American artists become internationally known. Abstraction, installation, and performance have developed side by side with figuration, which continues to be important. For instance, the work of Colombian painter Fernando Botero (1932–) subtly reflects the South American condition. His well-known painting *The Presidential Family* (1967) [**680**], for instance, recalls Goya's satirical group portrait of the Spanish King Ferdinand and his family, commenting on the relationship between the traditional power groups in Colombia: the army, the landowning aristocracy, and the more conservative wings of the Catholic Church. In recent years the tension experienced by many Latin American artists, of whether to address a restricted local audience or a wider international one, has increased. Cuban art is a case in point. Having responded to overtly revolutionary needs during the 1960s, particularly in its production of posters, it now flourishes abroad, especially in the United States. In her sophisticated work, the exile Ana Mendieta (1948–85) went beyond immediate social concerns, particularly in her Body art, to explore the feminist and ecological issues she shared with the contemporary North American art scene [**681**]. TCT

Shaping identities

Throughout Latin America, twentieth-century modernists expressed their desire to reassess their complex mixed identity with its European, Amerindian, and African contributions. Concerns with identity and politics prompted a populist approach in the 1930s, followed in the 1960s by right-wing dictatorships and widespread unrest on the left.

Diego Rivera's desire to reshape Mexican history led him increasingly to concentrate on its pre-Columbian past. His *Huastec Civilization* [**675**], one of 11 narrative paintings done for the National Palace in 1942–51, depicts an idyllically prosperous society, an apology for Rivera's socialist beliefs.

Brazilian artist Tarsila do Amaral completed **677** in 1928, depicting a single monumental figure, with tiny head and gigantic feet, next to a cactus plant. It functions as a powerful icon of 'Brazilianness', reflecting the Anthropophagic Manifesto with its call for Brazilian artists to devour outside influences and regurgitate them in transformed and original ways.

In **678** the Uruguayan Joaquín Torres-García sums up his Constructivist ideal of translating the diversity of nature into simplified structural forms carrying philosophical and cosmological content.

Frida Kahlo's iconography, based on the Mexican ex-voto tradition, creates a vehicle for her own highly emotional individual concerns. In **679**, strapped in a brace and pierced by nails, she makes us confront the excruciating pain she endured all her life after a bus accident at the age of eighteen shattered her spine (*columna* in Spanish).

476

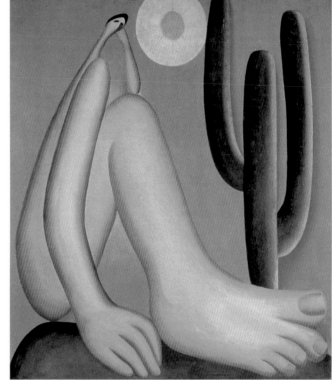

677 Right: Tarsila do Amaral (1886–1973), *Abaporu* (1928), oil on canvas, 85 × 73 cm. (34 × 29 in.), São Paulo, collection of Eduardo Constantini

678 Joaquín Torres-García (1879–1949), *Composition* (1932), oil on canvas, 81.9 × 65.4 cm. (32¼ × 25¾ in.), Santa Barbara Museum of Art

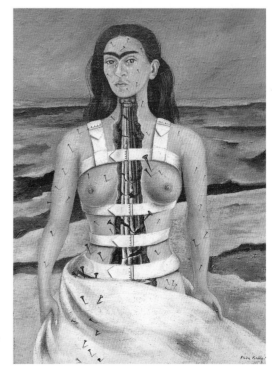

679 Right: Frida Kahlo (1907–54), *The Broken Column (La columna rota)* (1944), oil on masonite, 40 × 30.7 cm. (16 × 12 in.) Mexico City, Dolores Olmedo Patino Foundation

The Argentinian artist Antonio Berní made a series of collage constructions portraying two imaginary popular characters, Juanito Laguna (from 1960) and Ramona Montiel (from 1963). Using discarded materials, Berní placed his figures on the fringes of industrialized Latin America, in the shanty towns of Buenos Aires and Rio de Janeiro, as a bitter comment on the miserable condition of the urban poor [676].

In the work of Fernando Botero [680], monumentally fat men and women convey the artist's understanding of his Colombian roots and experience, now inserted into the artistic circuit of New York and Paris. Botero's iconography is self-consciously based on Latin American folk elements, filtered through his view of the work of artists like Piero della Francesca and Ingres, and often used for critical social comment.

Cuban exile Ana Mendieta [681] was influenced by her interest in Afro-Cuban religion as well as by the work of French sociologist-philosopher Georges Bataille and Mexican writer Octavio Paz. She often used her own body in violent sacrificial performances, thus offering a powerful cultural critique of not just Latin American but world-wide bourgeois society. TCT

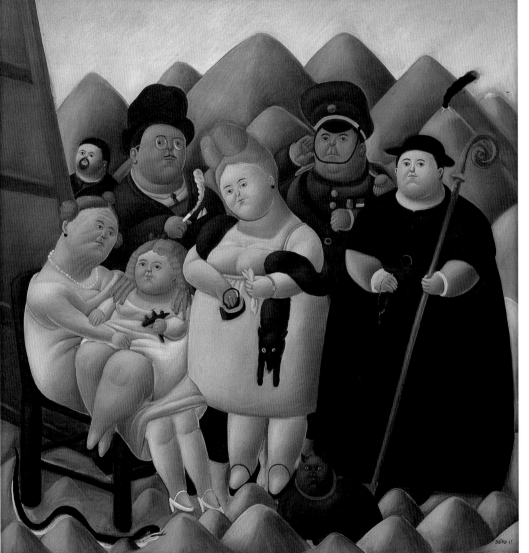

680 Left: Fernando Botero (1932–), *The Presidential Family* (1967), oil on canvas, 203.5 × 196.2 cm. (6 ft. 8⅛ in. × 6 ft. 5¼ in.), New York, The Museum of Modern Art

681 Above: Ana Mendieta (1948–85), *Old Mother Blood* (*Itiba Cahubaba*) (1981), amategram, acrylic on bark paper, 40.6 × 29.2 cm. (16 × 11½ in.), collection of Raquelín Mendieta

Alternative Centres: India

In 1914 India was a much prized part of George V's British Empire. However, British dominion was not so enthusiastically endorsed by those Indians who were arguing for Home Rule. The roots of this movement, which eventually led to independence in 1947, stretch back into the nineteenth century when, just as English political and administrative systems dominated the country, so too did English-style cultural institutions. Art schools devised along the lines of those in Britain had been established in Bombay, Calcutta, and Madras to train Indians in the production of European-style fine and decorative arts. However, a dissenting voice emanated from one of these institutions. The English principal of the Calcutta School, E. B. Havell (in post from 1896 to 1908), was the first to argue that an English-style art education was inappropriate for Indians. This position was in many ways confirmed by the emergence of the most successful artist of the late nineteenth century, the self-trained Raja Ravi Varma (1848–1906). His oil paintings of Indian mythological and religious figures gained acclaim both in India and abroad when he won two awards at the World's Columbian Exhibition in Chicago in 1893. At home, Varma's observations made from prints of European portraits proved to be a highly popular formula for depicting the Indian élite [683]. Though the style and technique of Varma's images were clearly indebted to European academic realism local viewers embraced the opportunity to patronize home-grown talent rather than visiting European artists. Thus some of the basic criteria which define a modern artist in the West—the production of works by a named individual of exceptional talent, a market for his or her products, a series of institutions in which 'art' was taught and, it should be added, debating circles, exhibitions, and publications which added value to those products—were all in place in India in the late nineteenth century. But Varma was not only successful in high art circles. In 1894 the Ravi Varma Fine Art Lithographic Press began making prints from his paintings which circulated around the land. They were also used in advertising. The mass-production of such images has continued unabated into the twentieth century, so that today even the lowliest autorickshaw driver may be guided on his journey by a print of a goddess painted by Varma a century ago.

Though Varma images became part of popular culture in India the evolution of a modernist art movement amongst the élite in Bengal can in part be attributed to a reaction against his work and a desire to revive historic art styles, motifs, and techniques of the subcontinent. The idea of a return to Indian sources was both a cultural and political drive, famously espoused by the art historian A. K. Coomaraswamy in 1912 in *Art and Swadeshi* (indigenousness) and even more effectively put into practice by M. K. Gandhi. In this climate the 1905 painting by a member of the Bengali intelligentsia, Abanindranath Tagore (1871–1951), was viewed as an appropriate icon of Indian identity and a statement of anti-colonialism. *Bharat Mata* (*Mother India*) envisaged the emergent nationalist cause as a kind of secular goddess: pure, feminine, and spiritualized. It was couched in a pared-down, flattened style reflecting the artist's research into Mogul miniature painting and the influence of Japanese aesthetics, which had been taught in Calcutta by the ex-director of the Japanese imperial art academy, Okakura Tenshin (1862–1913). By the time poet Rabindranath Tagore (1861–1941) (Abanindranath's uncle) set up the Visva Bharati University at Santiniketan (in 1917) such Pan-Asianism was a part of its cultural agenda alongside continued interest in indigenous traditions such as 'folk art'. But Rabindranath was also responsible for bringing the first exhibition of contemporary European art to India. The show, by members of the Bauhaus, stunned the Indian art world in 1922. When the poet took up painting himself, his works were radical departures from any pre-existing Indian art [684] and are arguably the first modernist paintings by an Indian. Rather than defining Indian modernism as a weak echo of Western art movements we must see it as a parallel history which developed as much in response to local conditions as to events in Europe's cultural capitals.

When India finally gained independence in 1947 the Goan painter F. N. Souza (1924–) heralded the new era by establishing the Progressive Artists' Group (PAG) in Bombay (Mumbai) [686]. Emphasizing progress and internationalism rather than what they saw as the retrospective and local concerns of their predecessors, the group intended to challenge their viewers in form and content. However, the shocked reaction to Souza's naked '*Self-Portrait*' (1949) led him to leave the country for London. Other members of the PAG continued to pursue a radical agenda within India. M. F. Husain's (1915–) Cubistic treatment of mythological subjects and works inspired by billboards and the urban–rural divide have gained him as powerful a reputation as Ravi Varma's in the previous century [682]. In the decades since independence thousands of artists have been trained in modernist styles in art schools in India's cities or at the important provincial institutions at Baroda and Santiniketan. During the British period few women pursued an art education (Amrita Sher-Gil (1913–41) was a notable exception) but since 1947 many have gained national and international recognition as painters and sculptors [687] and it is in the latter field that Indian artists such as Anish Kapoor (1954–) [688] and Dhruva Mistry (1957–) have recently made the greatest impact on the international art world. CHr

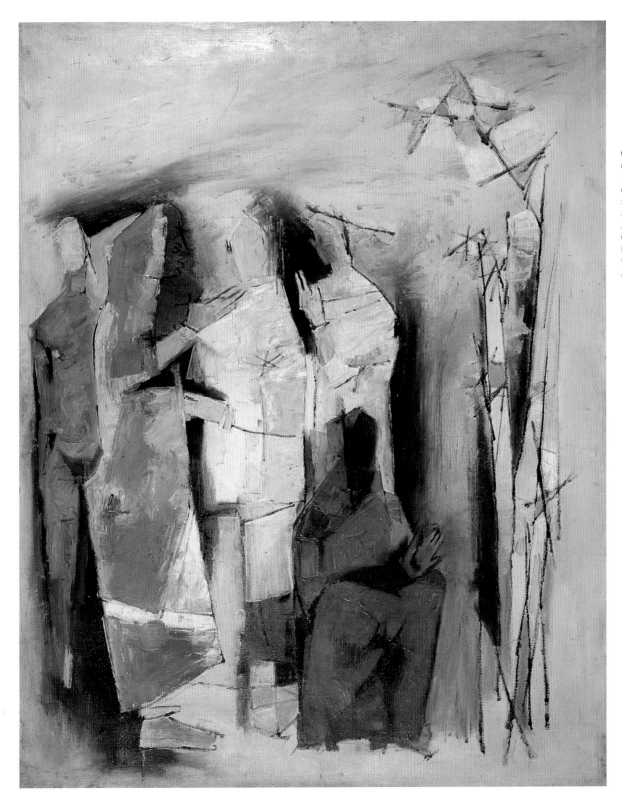

682 M. F. Husain (1915–), *Under the Tree* (1959), oil on canvas, 96 × 76 cm. (37¾ × 30 in.), Bombay, Jehangir Nicholson Collection at the National Centre for the Performing Arts

The rise of Indian modernism

In the period before independence modern Indian art evolved from a reaction against the academic realism of artists like Raja Ravi Varma. Works such as *Portrait of a Woman* [683], in which an Indian beauty presents herself for the viewer's admiration, were thought too derivative of the portrait style of Reynolds and Gainsborough. Abanindranath Tagore studied Mogul and Japanese art in order to create a non-European style. His foremost student Nandalal Bose, however, sought inspiration from local art traditions of Bengal such as the Kalighat paintings sold to pilgrims in Calcutta. The anti-realist style of his *Mother and Child* [685] may strike Western viewers as modernist but its formal precursors are in India.

Bose later became an art teacher at the foremost cultural institution of pre-independence India, Santiniketan. Its founder, the poet Rabindranath Tagore, had envisaged a university which would encourage both tradition and modernity in the arts so long as they assisted his nationalist agenda. In 1929 he started to make images himself in an evocative non-figurative [684] style which was drastically unlike that of Varma.

The end of colonial rule energized the Indian art world and led a group of artists based in Bombay to set up the Progressive Artists' Group. Their leader Francis Newton Souza produced paintings in which he challenged the bourgeois and moralizing values of his upbringing in the erstwhile Catholic state of Goa [686].

M. F. Husain has had a varied and prolific career since he began as a

480

683 Right: Raja Ravi Varma (1848–1906), *Portrait of a Woman* (c.1895), oil on canvas, 53.6 × 36 cm. (21⅛ × 14⅛ in.), London, Victoria & Albert Museum

684 Right: Rabindranath Tagore (1861–1941), *Vase* (1928–9), pen and ink on paper, 21 × 23.5 cm. (8¼ × 9¼ in.), New Delhi, National Gallery of Modern Art

685 Above: Nandalal Bose (1883–1966), *Mother and Child* (1942), tempera on paper, 52.5 × 58.5 cm. (20⅞ × 23 in.), New Delhi, National Gallery of Modern Art

686 Left: F. N. Souza (1924–), *Black Nude* (1955), oil on canvas, 1.83 × 1.22 m (72 × 48 in.), London, Victoria & Albert Museum

painter of cinema posters. *Under the Tree* [**682**] is characteristic of his experiments with form in which an Indian village scene is broken down into planes of monochrome colour. He has exhibited alongside Picasso, with whom he is often compared.

Of the many artists now making successful careers in India and abroad the few mentioned here can only suggest the richness of Indian modern art. The diversity includes Gogi Saroj

Pal's *Swayambram* [**687**], an installation which comments on the oppressive nature of marriage in the sub-continent. In their works the land- and dreamscapes of India are still re-created whilst for Anish Kapoor [**688**], now working in Britain, only the pigments of India remain as a dusting of colour on his abstract sculpture. CHr

687 Above: Gogi Saroj Pal (1945–), *Swayambram* (1992), mixed media installation, Aberystwyth Touring Exhibition (1993)

688 Left: Anish Kapoor (1954–), *To Reflect an Intimate Part of the Red* (1981), pigment and mixed media, 2 × 8 × 8 m. (6 ft. 6¾ in. × 26 ft. 3 in. × 26 ft. 3 in.), London, Lisson Gallery

Alternative Centres: African and Afro-Caribbean

African and Afro-Caribbean artists share a continuity of creative ancestral heritage, and parallel experiences of European enslavement, colonialism, and hegemony. These factors and more have provided the context for a discourse on art and identity that has given rise to the modernist experience in their art. Modernity as a European construct was articulated initially and most forcefully when Africa was being colonized. On the eve of the emancipation in the mid-nineteenth century, as Caribbean societies eased their way out of slavery into the exploitative phase of the colonial economy, Africa began to experience a European colonialism which would last more than half a century. These same developments shaped Western Modernism at its roots, in its fascination with the so-called 'primitive', and its appropriation of the African and other non-Western art. In theory and practice, many Afro-Caribbean modern intellectuals, from C. L. R. James and George Padmore to Fanon and Marcus Garvey, have given Pan-Africanism its characteristic façade and have been in the forefront of forging its basic tenets.

By Western standards the history of the modernist expression is relatively short in Africa and the Caribbean, and it differs from one place to another. In Egypt, for example, one can trace it to the early 1920s, in the works of the sculptors Mahmud Mukhtar (1891–1934) and Jamal Elsigini (1917–77), while in Nigeria or Sudan such experimentation started in the late 1940s or 1950s. In general it is possible to say that the majority of modern African and Afro-Caribbean artists belong to the first or second generation of a Western-educated élite that emerged in the second decade of colonial rule. It is clear, moreover, that it was the exposure to contemporary Western artistic practices which catalysed the dialogue of African and Afro-Caribbean artists with Modernism. Yet, the history of Modernism tends to exclude not only the plurality of cultures within the larger

689 Amir Nour (1939–), Sudanese living in Chicago, *Grazing at Shendi* (1969), stainless steel, 202 pieces, 304 × 411 cm. (119¾ × 161¾ in.), variable, collection of the artist

690 LeRoy Clarke (1938–), *In the maze, there is a single line to my soul* (1986), oil on canvas, 1.31 × 1.56 m. (51½ in. × 61½ in.), Trinidad, Port of Spain, collection of the artist

picture, but also the objects of high culture produced by non-Westerners, especially in Africa and the Caribbean themselves.

The encounter with Western colonialism and post-colonial conditions in Africa and the Diaspora have disrupted cultures rich in the visual arts, religions, oral traditions, and social and political formations. Yet this disruption was not complete, especially in the artistic and creative domains. A serious look at the modern African and Afro-Caribbean art scene contradicts assumptions about its authenticity and creative essence. If anything, the encounter with the West has been far more complex than previously thought. Within the African and Afro-Caribbean modernist experiences, assimilation of Western techniques, materials, ideas, and forms has been creative, selective, meaningful, and highly original. The result has been a continuous re-creation of forms and styles.

Afro-Caribbean art

Many influences intrude in Caribbean art, so its history often requires social and cultural references. The Spanish-, French-, and English-speaking island populations established from the sixteenth century still reflect the cultural mix that the Atlantic trade in sugar, spice, and slaves provoked. Caribbeans of African descent often have some Asian, Middle Eastern, or European heritage. Caribbean art is similarly hybrid. Creolization, decolonization, nationhood, and migration have determined a separate path for Afro-Caribbean art stemming from its shared cultural history with Africa. Its styles and idioms reflect this common history as well as an accommodation of Western modernism.

Afro-Caribbean art can be called modern because, aside from the work of itinerant artists, there is sparse evidence of

such work in any of the islands prior to the twentieth century. With the exception of Haiti, the schizophrenic nature of colonial societies meant that art was created by European expatriates concerned with exhibiting in the mainstream centres of their mother countries. Up to 1900, they largely ignored regional institutions and ideas about creole identity.

Afro-Caribbeans were inclined to look to these institutions and were more comfortable with their Caribbean identity. But plantation economies could ill afford art in the leisurely sense, so their early forms of expression were manifested in Performance art such as carnival. Afro-Caribbeans have only recently seen what they do as art. Caribbean populations took long to recognize the value of the black creativity that had been promoted by Europeans in Paris, New York, and London after 1914.

By 1920, the Caribbean became a vogue muse to Europe, as did Africa and other so-called 'primitive' cultures. It attracted artists such as Edna Manley (1900–87) in Jamaica, Richmond Barthe (1901–89) there and in Haiti, and Wifredo Lam (1918–82) in Cuba; all keen to capture aspects of Paul Gauguin's artistic paradise. Like him, they sought identity in distant lands where they believed they had some cultural connection. The art of these progressive liberals provoked a racial awareness and prefigured the use of the black physiognomy in painting and sculpture. This coincided with shifts in political power from colonial administrations to a growing local middle class attracted by cultural nationalist sentiments, Pan-Africanism, and the 'new negro' philosophies of the Harlem Renaissance that swept through American cities in the 1930s. By the 1940s, the perception of the Caribbean changed from exotica to that of an accommodating cultural hub for America and Europe, where black ideas about Africa and European ideas of the 'primitive' could safely interact.

Early Caribbean art was an uneasy mix of styles. Loosening colonial ties and a more rooted creole community's desire for autonomy encouraged local themes. Some artists bowed to the rigours of traditional figure and landscape painting. Others flirted with relatively modern Impressionist and Post-Impressionist styles for painting, or Art Deco forms for sculpture. Still others explored spiritual concerns inherited from African art. Often, all these styles converged in a single art work. The result was a cultural expression that was tense, inelegant, technically inconsistent but nevertheless challenging.

Apart from this mainstream trend towards a Caribbean aesthetic, there was a parallel resurgence of creativity by artisans and craftsmen, normally of peasant or lower-class backgrounds. The work of these self-taught artists is closer to African art: traditional, spiritual, often reliant on an inner vision of reality. It has a tendency to overall patterning, a varied and integrated use of colour, flatness of forms reminiscent of textile design, and the inclusion of written narratives. In Caribbean sculpture, African approaches are also visible in the techniques for selecting, honing, dying, and polishing woods. The function of such art is similar. In Africa, carvings are perceived as objects of power. In the Caribbean, their medicinal and spiritual meanings are heavily disguised in the unorthodox Afro-Christian religions of Obeah, Santeria, Rastafarianism, and Voodoo.

Self-taught artist movements in all the islands share affinities. Their creativity was clearly suppressed during the colonial period. Western 'discovery' and patronage (as with Dewitt Peters, 1902–66, in Haiti) was a big factor. Significant international success and the attendant problems of kitsch commercialism (especially where the art market is tourist-based) compromised their integrity.

Few regional institutions have understood how to show this type of art successfully, without exploiting the original vision of these artists. Integrating their art into mainstream gallery exhibitions has also been tricky. Local audiences are reluctant to accept these predominantly black and mystical expressions as valuable reflections of their own heritage. Informed art criticism is still needed to educate Caribbean audiences and offer alternatives to their traditionally European and conservative tastes.

The upheavals in the region in the 1960s and 1970s fractured the cohesive nationalist sentiments reflected in Caribbean art of earlier decades. The Cuban Revolution (and subsequent United States embargo), independence for most of the islands, the Black Power movement, and cruel dictatorships incited political instability. The turbulence registered in two diametrically opposed art forms. Many artists exposed to art training abroad and disillusioned with art movements in their small islands abandoned a local vernacular for a more international modern style. To counter their Western training, others delved even more deeply into their roots for African imagery. Their work made conscious statements about racial and class awareness but was often disguised in political allegory intended to challenge Western styles and values. In the face of American cultural hegemony, this approach has become a platform for contemporary Afro-Caribbean art.

In the 1980s and 1990s, Afro-Caribbean art depicts Postmodern preoccupations with cultural diversity and identity and has consequently attracted attention outside the region. Despite its open-ended and eclectic nature, however, such art is still married to the notion of ancestral heritage and regional identity. At biennials in Santo Domingo and Havana, the exhibits displayed a self-conscious and satirical embracing of cultural memory styled in unconventional settings, installations, and off-the-wall works that straddle African traditions and European Postmodern ideas of 'primitive' creativity. Such imagery shows that even now Afro-Caribbean artists are still grappling with the region's complex cultural history. It is their engagement with the past that makes art in this region so compelling. PAS

Modern African art

In Africa, several factors provide important connections to the rise of modern art and art movements. One is the rise of European and Western patronage and intervention—the establishment of art workshops by European expatriates, mostly colonial administrators, liberal colonial educators, or missionaries. Examples of such workshops include the Oshogbo or the Mbari Mbayo Club in Nigeria, established by Ulli Beier in the 1960s, and the Frank McEwen Workshop School and the National Gallery of Salisbury in Zimbabwe (then Rhodesia) in 1957. Despite the positive aspects of European patronage and intervention, it was nevertheless founded on paternalistic attitudes towards Africa and African artists. Recently, the role of the European expatriate in African modern art has been questioned as a myth of the 'teachers who do not teach'. In reality,

484

those European expatriates and teachers had intervened and introduced many techniques and styles which are European in origin, and which imposed limitations on the creative potential of those early African artists who worked alongside them.

A second and related factor is the establishment of formal art schools and academies, often fashioned on the Western art educational model, which can be traced from the 1940s. In many African countries, the history of the modern art movements was very deeply embedded in the colonial educational system and specifically linked to the rise of higher education. Art graduates of those schools were exposed to Western artistic traditions in terms of techniques, materials, and forms. The artwork produced by these pioneers formed the genesis of the modern art movement. Some of the early graduates even travelled to England, France, and other European countries for further studies. In form, style, and aesthetic, however, their art work reflects a strict adherence to the Western academic schooling they received in Europe, demonstrated by the Nigerian painter Aina Onabolu (1882–1963). With few exceptions, their work did not crystallize a new style, in spite of the fact that in content their work dealt with subjects derived from their environment and their experience as Africans. This early chapter in the history of the modern art movement in Africa did not produce any clear philosophical orientation or definitive aesthetic trends, nor did it reflect an interest in sociopolitical and intellectual issues. Perhaps these pioneers felt too pressured by the Western criteria of academic skills to explore in new directions. This they left to the next generation of artists, who inherited the skills and techniques of the early pioneers and were ready to move forward.

The history of modern art in Africa would not be complete if we ignore the important contribution of a group of 'self-trained' artists who have been working in the modern genre at least since the turn of the century. These artists should be credited for preparing the way for the generation of academically trained African artists who followed in their footsteps. Unfortunately, viewed as non-academic 'naïve' painters, the contributions of this group have never been seriously studied or fully documented. During the colonial period, expanding urbanization introduced new aesthetic needs, and hence, new genres in music, poetry, and the visual arts. In cities such as Khartoum, Lagos, and Nairobi, a group of self-taught artists exposed to Western traditions in art started to produce new types of works. These were mostly landscape paintings of rural or modern urban life, genre portraits of women dressed in folkloric costumes and hairstyles, and important historical figures. Bought and sometimes commissioned by foreign expatriates, tourists, and the relatively prosperous urban families, works of these self-trained artists were hung on the walls of private homes or in restaurants and cafés. What is more, some of these artists exhibited in cafés and other public spaces, thereby introducing a new culture of art and aesthetic appreciation.

The real breakthrough came in the late 1940s and early 1950s with the work of artists such as Ben Enwonwu (1921–97) (Nigeria), Ibrahim el-Salahi (1930–) (Sudan), Farid Belkahia (1934–) (Morocco), Skunder Boghossian (1937–) (Sudan), Papa Ibra Tall (1935–) (Senegal) to name only a few leaders of the distinct new movement. These pioneers laid the foundation for one of the most active modern art movements in Africa, transforming it from a narrow academic framework to the exploration of new aesthetic and intellectual concerns. Moreover, modernism in the African context, as elsewhere, entails an attempt to break with the past and a search for new forms of expression. This breakthrough is certainly embedded in the cultural resurgence that swept many newly independent African countries where government patronage and interest in the arts became part of the national agenda.

Works accomplished by the modern African artists vary widely in terms of media, technique, and style. Subject-matter ranges from ceremonial and historical themes to genre activities and landscape, and can be executed in the Realist, Impressionist or Abstract Expressionist manners. They provide a commentary on social life or even protest. Like their subject-matter, the style of these artists is as heterogeneous as their training in art and their ideological orientation. Nevertheless, we can identify a few definitive trends. First, there are artists who advocate rejection of Western influences and return to traditional sources. Second, we find artists whose works incorporate the latest styles, trends, and techniques of contemporary Western art and who have thus been criticized for rejecting their traditional culture and heritage. There are also those artists who advocate in their work a synthesis between traditional heritage and modern Western art and techniques. The major question for all these groups has been: 'To what extent have the exposure to Western art forms and ideas tainted the "Africanness" of these new art forms?'

In the 1970s and 1980s new art movements and initiatives emerged either in reaction to or rejection of Western schooling as offered through various venues in both Africa and the West. These include movements such as the Laboratoire Agit Art group in Senegal, the Vohou-Vohou group in Ivory Coast, the Bogolan Kasobane in Mali, and the Crystallists in Sudan. The basic quest of these new movements has been to establish a more culturally rooted, self-conscious, and 'African' aesthetic expression. Their art is an expression of the rich heritage and wealth of experience which is further strengthened by their experience in Western centres of Modernism. Their work reflects cross-currents of ancient and contemporary influences in Africa, the West, and beyond. The result has been the creation of new African artists, art movements, art associations, and festivals, all attempting to construct new tropes of self-representation.

Today, several African-based forums of contemporary art, such as the biennials of Cairo, Johannesburg, Dakar, or the Ouagadougou and Carthage Film Festivals have become important events in the contemporary art world, providing African artists with more opportunities to encounter the latest developments in the international scene. In reality, African artists living in Africa or in Western centres have been on the forefront of Modernism and even Postmodernism. Several African artists have effectively used the latest techniques in multimedia and installation in their forays into Conceptual Art. New discourses of identity, race, gender, and sexuality have been essential to works produced by African artists today and their counterparts elsewhere, as they interpret and translate their aesthetic and social experiences into new idioms of artistic expression related to their cultural heritage, and connected to a new global Modernism or Postmodernism. SMH

485

The spirit of Afro-Caribbean art

These works were created at different times in various parts of the region, but common features such as their modernist primitivizing techniques, African imagery, and intuitive approaches define them as Afro-Caribbean. They share a symbolism related to ancestral heritage and utopian aspirations. Informed by the syncretic religions of the Caribbean such as Santeria [691], Obeah [690], Rastafarianism [693], and Voodoo [694], they are transformative, agitating for liberation, rebirth, and change in the condition of the Caribbean man. Edna Manley's *Tomorrow* 1938 [692], with its upward thrust and hands raised in heavenly praise, opens the way for a future for the Jamaican 'new negro' recently politically aroused by labour struggles of that year. *Tomorrow*'s vertical schema separates it from the works of the four other artists. Whereas the strong vertical forms of Manley's sculpture reinforce a conventional Christian reading of heaven and earth, the others reflect a cosmic world where forms are overlapping, interrelated, and non-linear. Although modernist in feel, Wifredo Lam's *Jungle* owes a greater debt to the Afro-Cuban beliefs in Santeria. Consequently, *Jungle* has much in common with the more intuitive spiritual expressions of Clarke, Brown, and Duval-Carrié. Colour, overall patterning, and an edgeless unified network of images reinforce the sense of integration in their work. Aside from visual similarities, a conceptual thread runs through all these works that is an underlying spiritualism and denial of Western perceptions of the world. PAS

486

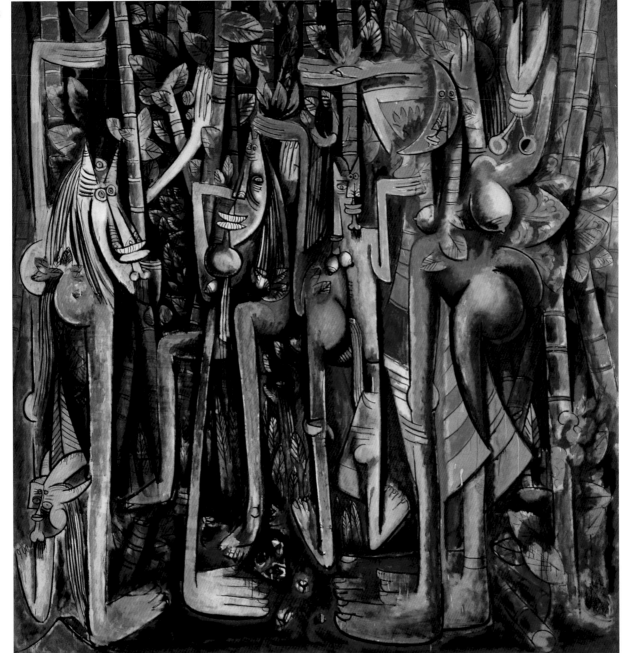

691 Left: Wifredo Lam (1918–82), *The Jungle* (1943), gouache on paper mounted on canvas, 239.4 × 229.9 cm. (7 ft. 10¼ in. × 7 ft. 6½ in.), New York, The Museum of Modern Art

692 Opposite, top left: Edna Manley (1900– 87), *Tomorrow* (1938), bronze (after mahogany original), 63.5 cm. (25 in.) high, private collection

693 Opposite, top right: Everald Brown (1917–), *Ethiopian Apple* (1970), oil on canvas, 63 × 90 cm (25 × 35½ in.), Kingston, National Gallery of Jamaica

694 Opposite, bottom right: Édouard Duval-Carrié (1954–), *The Sacred Forest* (1992), multimedia installation, triptych 3 paintings, oil on canvas, 177.8 × 419 cm. (70 × 165 in.), in artist's frames, 16 sculptures, Collection Gregory and Beatrice Meus

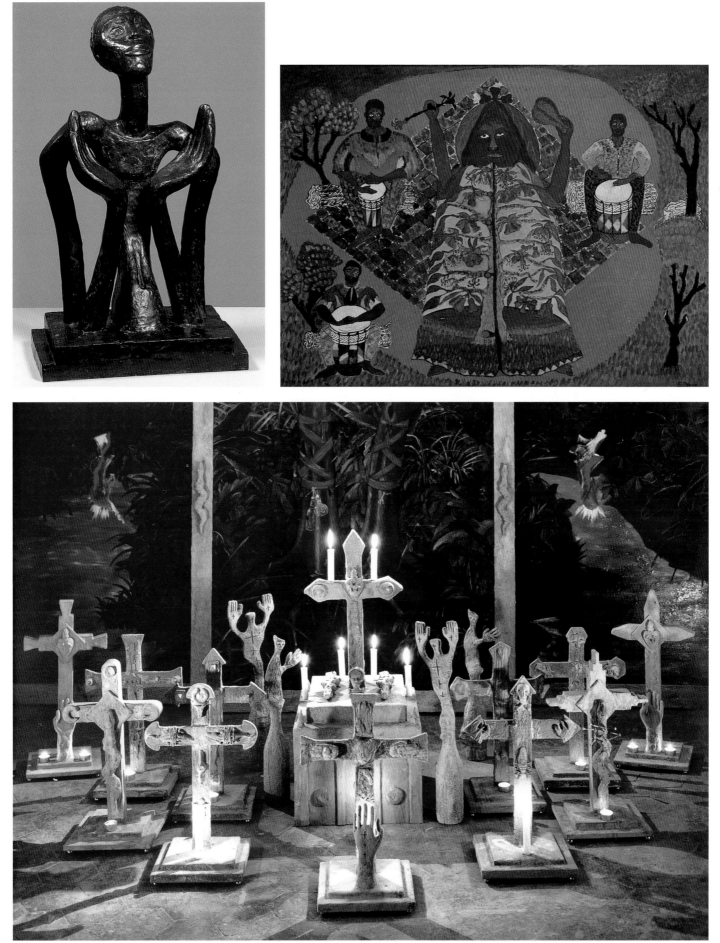

African Modernism

These images represent the diversity and complexity of the modernist experience in African art.

Ibrahim El Salahi [**695**] represents the new visual vocabulary of the 1960s. It is a comment on Lumumba's assassination and Apartheid violence in South Africa, showing Salahi's concern with the new style of representation of the human figure.

Under a crescent moon, an Islamic motif, mourners carry the deceased aloft. The figures, with mask-like faces, are elongated and emaciated, and points of articulation are emphasized in a style similar to traditional African sculpture.

Amir Nour's **689** is typical of the Conceptualist mode pioneered by him in the 1960s, emphasizing exploration of form and light. This has been taken to new levels by El Anatsui [**696**],

whose explorations of innovative techniques of burning and chain sawing wood transform it into canvas-like media, in a search for history and recovery of the past.

Abdoulaye Konaté [**697**] and Jane Alexander [**698**] have pushed the frontier of Conceptualism into the heart of Postmodernism. In Konaté's work issues of memory, culture, and tradition collide with the present and the need of a new rebirth. Alexander

is one of a group of contemporary South African artists whose works have dealt heavily with the politics of power, race, gender, and violence in the context of Apartheid and its aftermath. SMH

488

695 Ibrahim El Salahi (1930–), Sudanese living in Oxford, England, *Funeral and a Crescent* (1963), oil on treated wood board, 94 × 98 cm. (37 × 38.5 in.), private collection

696 El Anatsui (1944–), Ghanaian living in Nigeria, *Unfolding the Scroll of History* (1995), wood relief, oke-ofo, oyili-oji, akpatara, okpo ocha, woods, tempera, 16 pieces, 61 × 141 × 2.5 cm. (24 × 55½ × 1 in.), private collection

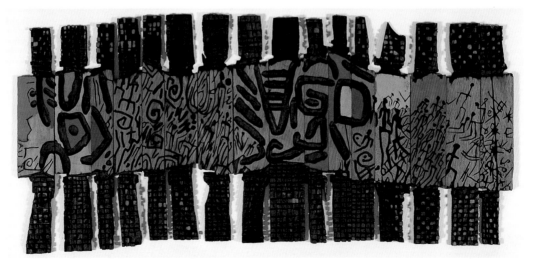

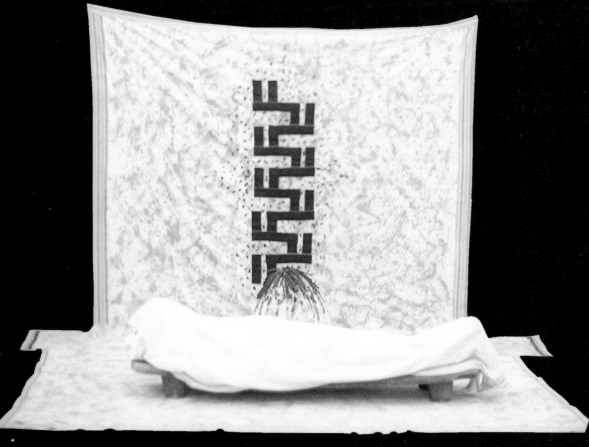

697 Abdoulaye Konaté (1953–), Malian living in Bamako, Mali, *Death, Birth, and Culture* (1993), mixed media installation, 3 × 3 × 3 m. (9 ft. 10 in. × 9 ft. 10 in. × 9 ft. 10 in.) Paris, collection of Afrique en Créations

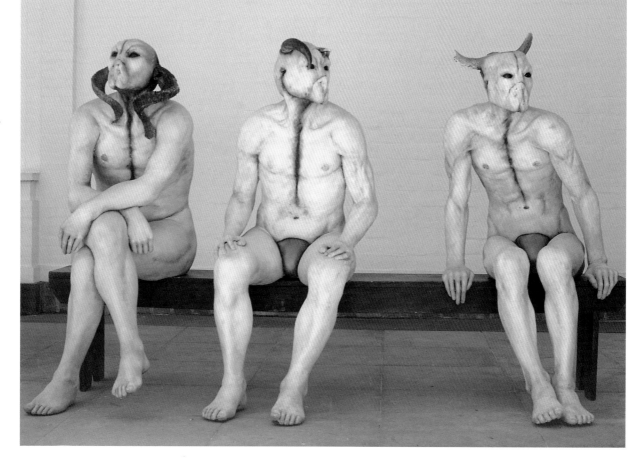

698 Jane Alexander (1959–), South African living in Johannesburg, *Butcher Boys* (1985–6), mixed media (plaster, bone, horn, paint, and wooden bench), Cape Town, South African National Gallery

Alternative Centres: Canada and Australia

Participation in the First World War, membership in the League of Nations, and removal in the 1930s of the last vestiges of imperial control over their foreign relations confirmed an emerging national consciousness in the British dominions of Canada and Australia. In parallel with these events each country tried to consolidate a cultural identity that would be distinctive from Britain's while coming to terms both with the increasing internationalization of art and with internal tensions between indigenous and European, minority and majority identities.

Canadian modernism

The first self-proclaimed group of modern Canadian painters, the Group of Seven, hailed from Toronto, the financial and cultural capital of anglophone Canada. Five graphic designers, all members of the Arts and Letters Club, constituted the core of the group. Inspired by Canadian literature, which extolled the Great North as a poetic and political ideal, they sought national distinctiveness principally through the choice of northern subject-matter. Influenced by their experience of graphic design, they employed an amalgam of modern European idioms—Art Nouveau, Fauvism, and Scandinavian Symbolism—which they adapted to the wilderness of Ontario's northland [**699**].

Although at the time of their founding exhibition (1920) they were considered iconoclastic, by the 1930s the Group of Seven had attained a sterile dominance. The priority of landscape troubled some of its members, notably Frederick Varley (1881–1969). Although the Seven's expansion in 1933 into the Canadian Group of Painters assimilated figure painters and even women artists—such as Prudence Heward (1897–1847) of the Beaver Hall Hill Group—their claim to exemplify Canadian art created increasing resentment. The concerns of anglophone Canadian nationalism had become irrelevant both to French Canadians and to a Toronto-based intelligentsia increasingly attracted by anarchism and international socialism. Meanwhile, other independent artists, such as the mystical pantheist Emily Carr (1871–1945) and the internationalist David Milne (1882–1953) established alternative voices. Carr's emphasis on west coast totemic imagery expressed a need to broaden out Canadian art.

In Montreal in 1939, John Lyman (1886–1967) founded the Contemporary Art Society to counterbalance the Canadian Group of Painters and promote more innovative work. Its members had no common style, but tended to draw inspiration from Paris, particularly from Matisse and Picasso, in their emphasis on formal values. Its membership drew on both the English and French-speaking communities, but its composition hinted at an imminent transfer to a francophone leadership.

Although francophone Canada's connections with France might have made it a natural home of artistic innovation, its conservatism, cultural and religious, had long prevented significant development. Only in 1948 was the spell broken, at the cost of his teaching post, by Paul-Émile Borduas (1905–60). He and his followers' publication in that year of an anti-clerical and anarchistic manifesto, *Refus global*, marked the advent of Canada's first artistic movement of indubitably international importance, les Automatistes (1947–54). Although its members shared the Surrealist concern with the subconscious, they rejected its illusionistic idiom, preferring instead an intuitive abstraction inspired by André Breton's automatism [**702**].

The next major *Québécois* movement drew inspiration from the Automatistes' rejection of Quebec's conservative past, but opposed their Expressionism. Les Plasticiens (1955–9), including Fernand Toupin (1930–) and Louis Belzile (1929–), advocated instead an abstraction inspired by the work of Piet Mondrian and the theories of the American critic Clement Greenberg: hard-edged geometric shapes of pure colour arranged on a flat picture plane. In anglophone Canada, reaction to the Canadian Group of Painters, was beginning to form in Toronto and the west, where respectively Painters Eleven and the Regina Five practiced the pure abstraction advocated by Greenberg. Together the three groups marked the entry of abstract art into the mainstream and the eclipse of predominantly European influences by those of the United States.

Opposition to American involvement in Vietnam and to American influence over Canada's economy and media climaxed in the mid-1970s, and many rejected non-representational art on the grounds that it didn't apply itself to regional or national concerns. In Ontario, this populist movement included Greg Curnoe (1936–), and Joyce Wieland (1931–); in the west, Joe Fafard (1942–), and Claude Breeze (1938–). Others experimented with approaches such as conceptual and multimedia art. These more literary manifestations of the international avant-garde included feminism, notably explored by Jana Sterback (1955–), and the struggle of Canada's indigenous peoples, expressed by Edward Poitras (1953–) [**704**].

Canadian artists tried repeatedly to develop a recognizably Canadian form of expression; but the Group of Seven had irrevocably associated Canadian art with landscape. Struggling with this legacy, later artists have often sought inspiration in the variety of cultural traditions which compose the country's identity. Yet, unable to draw on any one of these traditions without alienating the others, many Canadian artists have instead found their identity in the internationalism of contemporary Western art.

KCG

Australian modernism

To record its experience of the First World War Australia sent established artists to the front, including Arthur Streeton (1867–1943) and George W. Lambert (1873–1930). Their images, although powerful, were conservative. They fostered the myth of the self-sacrificing 'pioneer spirit' forged in the rugged Australian bush—ignoring the fact that most Australians lived in the industrialized towns of the southeast. In the post-war era the sense of Europe as a theatre of chaos inspired negative attitudes to European modernism. As a result modernism entered Australia as a decorative 'style', via the applied arts. Into the world of fine art it percolated only slowly, at second hand, through the enthusiasm of students who had studied in London and Paris, and through illustrations in periodicals.

Post-Impressionism was brought to Sydney during the years of the war. Its influence was felt most keenly by Grace Cossington Smith (1892–1984), Roland Wakelin (1887–1971), and Roy de Maistre (1894–1968). Cossington Smith developed an enduring pictorial language encompassing Australian scenes both domestic and rural. Roland Wakelin and Roy de Maistre carried their experiments to greater extremes. In 1919 they exhibited abstracted colour-music paintings ('synchromies'), evoking a connection between visual and aural harmonies. The blend of abstraction with distinctive Australian forms—both natural and man-made—became a recurrent trope in the work of several women painters and printmakers, including Ethel Spowers (1890–1947), Jessie Traill (1881–1967), and Margaret Preston (1875–1963) [**700**].

In the 1930s Australian knowledge of the wider developments of European art increased through a series of international touring exhibitions, as well as through the arrival of European refugees. Australian artists began to draw on such traditions as German Expressionism and Surrealism. The focus for this response was Melbourne rather than Sydney. It found its most intense expression in the work of the artists associated with the magazine *Angry Penguins* (1940–6): Albert Tucker (1914–), Sydney Nolan (1919–92), and Arthur Boyd (1920–). Tucker's splenetic vision was defined in such grotesque and surreal series as *Images of Modern Evil*. Nolan expressed his alienation with more detachment, drawing it out from his understanding of the harsh bush landscape. Boyd forged his own personal mythology in crowded Breughelesque scenes, creating work of extraordinary passion and intensity.

The artistic impetus created by the Second World War continued after it but with declining force. Attention turned inward. Australia itself had been threatened during the conflict and this experience provoked a defiant restatement of Australian identity. In the aftermath of the war Nolan began his great Ned Kelly series [**701**]. Russell Drysdale (1912–81) revealed the inhabitants of outback Australia, both 'Western' and Aboriginal. Arthur Boyd, too, addressed the subject of the Aboriginal inhabitants in his series *Love, Marriage and Death of a Half-Caste*. Personal experience stood as the foundation for much Australian art in the 1950s. Artists sought to assert an individual vision against the tyranny of a conventional society. The stylized portraits of William Dobell (1899–1970) achieved this to startling effect, provoking outrage.

But the personal voice of Australian art was threatened by the spread of abstraction in its various forms, particularly from New York. Many artists embraced this trend, feeling that it offered an escape from the perceived provincialism of Australian art. In response to this prevailing tide, a group of Melbourne artists, including Boyd, John Perceval (1923–), Charles Blackman (1928–), and John Brack (1920–) joined with the art historian Bernard Smith in 1959 to mount an exhibition—and issue a manifesto—asserting the enduring claims of the image in modern art. Abstract painting, however, remained the dominant practice throughout the 1960s. It was, at its best, given a distinctly Australian slant. John Olsen (1928–) owed much to the European abstract tradition, but it was his introduction of the aerial perspective of Aboriginal sand-painting and his engagement with the outback landscape that gave his work its originality and force. Fred Williams (1927–82) was another artist to combine the tropes of Abstractionism with a study of the Australian landscape.

There were other voices of dissent, looking to the engaged traditions of Dada, Surrealism, and Pop. The Annandale Imitation Realists, of whom Colin Lancely (1938–) has been the most enduring, exhibited their hectic assemblages of trash, children's sketches, magazine photos, industrial junk, and 'primitive' art in 1962. Richard Larter (1929–) and Jeffrey Smart (1921–), in their different ways, developed their practice from a pop sensibility. And popularity, if not pop art, lies behind the success of Brett Whiteley (1939–93), whose sexually exuberant images created a compelling sense of antipodean hedonism.

The 1970s crisis in painting cut many young Australian artists adrift. Imants Tillers (1950–) found an escape through his challenging and ironic Postmodernism. For the most part, the hiatus was filled by the extraordinary florescence of the Australian aboriginal desert art movement, originating in 1971 in Papanya Tula. Its enormous commercial, critical, and artistic success has both unbalanced and stimulated the 'Western' tradition. Some artists such as Tim Johnson (1947–) have attempted to borrow from the new tradition. RH

National landscapes

Although reflecting different cultural identities, Canada and Australia exhibit conspicuous analogies in the forging of their relationships to international modernism.

Australian and Canadian artists alike have celebrated their natural surroundings. They have drawn inspiration from the land, making it part of their sense of identity. Even many of the abstractionists and multi-media artists who have reacted against landscape painting have produced work strongly suggestive of sparsely populated open-air settings.

In Canada the Toronto-based Group of Seven (1920–32) tried to develop a Canadian style for land-scape. They claimed that the wilderness encapsulated the Canadian character: ruggedness, durability, independence [**699**]. Endorsed by the National Gallery (established in 1880), their formula became so successful that all other Canadian painters had to either conform or wrestle with it.

Like the Canadian Emily Carr (painting on the coast of British Columbia), Margaret Preston, one of the early Australian modernist innovators, tried to see the landscape through the eyes of the indigenous inhabitants. Preston posited an intriguing link between approaches to spatial representation in Cubist and Aboriginal art. Her pioneering experiments in this line, such as *Aboriginal Landscape* [**700**], although not taken up at the time, have continued to inspire later generations of artists.

Man's place in the land was one of the themes underlying the Australian Sidney Nolan's series of Ned Kelly paintings [**701**]. The ambiguous image of the anti-heroic bushranger in

492

699 Frederick H. Varley (1881–1969) *Stormy Weather, Georgian Bay* (1921), oil on canvas, 1.326 × 1.628 m. (52⅕ × 64 1/10 in.), Ottawa, National Gallery of Canada

700 Above: Margaret Preston (1875–1963) *Aboriginal Landscape* (1941), oil on canvas, 40 × 52 cm. (15¾ × 20½ in.), Adelaide, Art Gallery of South Australia

701 Left: Sidney Nolan (1919–92) *Ned Kelly* (1946), enamel on composition board, 0.908 × 1.215 m. (35¾ × 47⅚ in.), Canberra, National Gallery of Australia

his DIY armour traversing the hostile yet accommodating wilderness was one that Nolan returned to often. It is an image that suggests both alienation and empathy.

The Second World War coincided with a tremendous growth in modern Canadian painting, particularly in French-speaking Canada. In Montreal, a band of radicals began developing their images by the Surrealist method of free association, in particular André Breton's automatism. The leader and most significant painter of this group was Paul-Émile Borduas, whose *Automatisme 1.47* or *Leeward of the Island* [**702**] inspired a critic to christen the Montreal movement 'les Auto matistes'.

Fred Williams was one of several Australian artists from the 1960s onwards to borrow from the flattened simplifications of contemporary abstract art to reveal a new direction in landscape painting [**703**]. His images are amongst the most compelling. He brilliantly evoked not only the sparseness of the land but also the whole experience of being part of the extreme outback environment.

Today, Canadian artists draw inspiration from an ecclectic range of cultural traditions, rather than focusing on one subject or movement. Drawing on both his native Métis traditions and the art of Marcel Duchamp [**593**, **636**], Edward Poitras combines nature, identity, and ritual in conceptual works such as *Untitled (Over the Gulf)* [**704**]. By juxtaposing symbols of Canada's indigenous and white societies, Poitras provokes reflection about their complex relationship. RH, KCG

493

702 Paul-Émile Borduas (1905-60) *Automatisme 1.47* or *Leeward of the Island* (1947), oil on canvas, 1.147 × 1.477 m. (45⅛ × 58⅛ in.), Ottawa, National Gallery of Canada

703 Fred Williams (1927–82) *Upwey Landscape II* (1965), oil on canvas, 1.832 × 1.476 m. (72⅛ × 58⅛ in) Canberra, National Gallery of Australia

704 Edward Poitras (1953–) *Untitled (Over the Gulf)* (1991), feathers, doll, oil, lead, hair beads, plasticine, wood, souvenirs, tape, bison skull, 48.5 × 37 × 10, 25 × 69 × 15.5, 83 × 44 × 2, 33 × 36 × 37.0 cm. (19$\frac{1}{10}$ × 14⅜ × 3¾, 9⅔ × 27⅕ × 6$\frac{1}{10}$, 32 × 7 × 17¼ × ⅔, 12¾ × 14⅕ × 14⅜ in.), Regina, Dunlop Art Gallery

Postmodernism

Since the early 1980s it has become widely accepted that the character of the times has changed drastically. The great epoch of Modernism—which we may see as beginning with the eighteenth-century Enlightenment—has come to an end; we now live in a Postmodern era.

The nature of these changes and, indeed, dating when they began is a subject of great controversy. There is, however, some loose consensus on which factors are relevant to the understanding of such issues. In the economical and technological sphere, for example, it is clear that the traditional heavy industrial base of first-world societies has given way to a more service-industry-based economy, with accordingly more 'flexible' conditions of work. At the heart of these changes are innovations in computer and relevant technology. In everyday social life, indeed, a massive amount of information and advertising saturates consumers through mass media based on the new technology.

Given this plethora of information, it is hardly surprising that traditional fixed categories of social, national, gender, and racial identity have been called into question in the most radical terms. This scepticism about categories has been further complemented by those bodies of intellectual theory loosely known as Poststructuralism which have been developed since the 1960s. In the work of French thinkers such as Roland Barthes, Jacques Lacan, Michel Foucault, and Jacques Derrida, the very notions of meaning and self are seen as unstable and ill-defined functions of the fluid linguistic structures in which they are expressed.

The upshot of all these sceptical changes in the cultural sphere is a lack of any overall principle of unification. In Modernist art, for example, given any single decade since about 1860, there has always been at least one putatively well-defined 'ism' which the most progressive artists of the time would tend to congregate around. Indeed, if those critics, such as Clement Greenberg (1909–), who emphasize the importance of art's formal properties are to be believed, Modernist art *per se* has (with a few exceptions such as Futurism and Surrealism) been dominated by a unifying impulse—towards purer and flatter-looking paintings.

However, any putative cohesion of this sort has now, manifestly, been shattered beyond recognition. The origins of this shattering might, in the case of the visual arts at least, be loosely traced to the 1960s. In the first years of that decade much art practice embodied a high level of formal purity. An example of this in three-dimensional media is the 'minimalism' of Carl André (1935–) and others, and, in painting, a tendency influenced by Greenberg's writings and described by him as 'post-painterly abstractionism'. This tendency included artists such as Kenneth Noland (1924–) and Jules Olitski (1922–) and was characterized by a willingness to suppress all evidence of the physical presence of the painted surface, so as to affirm the quality of the two-dimensional picture plane alone.

At the same time, however, 'Pop art' was in full swing. This tendency fully embraced images from the world of popular culture, its gadgets, and advertising. Such imagery had, of course, been excluded both by traditional art, and even by many of the key Modernist tendencies. In a sense, Pop art involves Modernism coming full circle through celebrating the Baudelairean 'heroism of modern life' (with which Modernity in the visual arts begins) and taking it into overdrive.

This breaking of the barriers between art and broader culture was amplified by the revolutionary political fervour of the 1960s. Marcel Duchamp's subversions from early on in the century now found a new audience. For him art was primarily about *ideas*, and this permitted the use of 'found' objects not made by the artist. On these terms, the notion of art as a specialist craft breaks down. Anyone can be an artist, and anything can be art. Art thereby intersects with political utopianism. By the end of the 1960s artists such as Joseph Beuys (1921–86) had turned this into a credo, and the practice of Conceptual art—where any kind of object (real, abstract, or imaginary) could be used to express art ideas—was widespread.

Given Pop art's subversions of traditional notions, and Conceptual art's extreme amplification of these, it is hardly surprising that Modernism in art came to an end. If, in principle, anyone can be an artist, and anything can be art, then Modernism and perhaps (on another reading of this development) even art itself have been taken to a *logical* extreme. Whatever comes next will have to define itself by returning to or combining idioms which have already been established, or by doing all these things with a primarily critical intent.

And this is precisely what has happened. In the *very* broadest sense Postmodern art exploits all these factors either individually or in combination. There is no immediately apparent unifying tendency, no dominant 'ism' but rather a number of complex strands, sometimes competing, sometimes overlapping. To be Postmodern is not to possess a specific style but rather to exist in a culture wherein all styles are permissible. In what follows, we shall trace the major strands and key figures, beginning with a tendency which has good claim to be (though this is by no means generally accepted) the first distinctively Postmodern development.

The tendency in question is Super Realism. This involves a return to figuration, but in a rather startling way which mixes in both elements of Pop and Conceptual art. Its most fundamental

feature is the creation of painted images which can scarcely be distinguished from large-scale photographic prints. As early as 1963 the American Audrey Flack (1931–) had tentatively experimented with this, but it was Malcolm Morley (1931–) (a British artist in New York) who made the decisive move in 1965. In that year he began producing paintings derived from post-cards of ocean liners, magazine illustrations, and even photographs of paintings [**705**]. American and British artists quickly took up the approach. The subject-matter varied, but the British artist John Salt (1937–) and the American Richard Estes (1936–) are highly representative. The former focused on photographic details of big American cars, whilst the latter concentrated on images derived from photographs of hotels and shop fronts. A sculptural counterpart to Super Realism also developed using fibreglass casts taken from models. Figures of American tourists and the like by Duane Hanson (1928–) are the major exemplars of this disconcerting tendency [**706**].

The inspiration for Super Realist work is itself telling. Many of the artists following Morley's lead did so with little more intention than to produce spectacular works with (as it turned out) a ready market and high value. Such works are, in theoretical terms, *passive*. Morley himself, however, produced paintings which underlined the aesthetic tension between the literal originality of their presence, and their origins as exaggerated transcriptions of mechanically reproduced 'originals'. His Super Realist work had, in other words, a Conceptual element which questioned and to some degree erased the strict boundaries between painting and photography.

This duality of a conceptually passive, and a conceptually active dimension also marks a second major strand of Post-modern painting. Again it involves a return to figuration, but this time of a more eclectic and painterly sort. Morley is once more a decisive figure. In many works of the 1970s he uses motifs derived from photographs but this time disrupted and rendered chaotic both by the agitated handling of paint and the intrusion of imagery—such as children's toys—with more personal associations. These works overlap and throw key classificatory categories of Modernism completely out of joint. They are in a sense Expressionist and Surrealist but, at the same time, neither of these.

Similar boundary blurrings are found in other figurative painters of the mid- and late 1970s. Particularly notable are bizarre, 'goofy', 'realist' works by Philip Guston (1913–80) which seem like deliberate attempts to produce fine examples of formally *bad* paintings. This challenge to standard notions of good taste in art can also be found in inverted images by Georg Baselitz (1938–) from 1969 onwards [**709**], and in New York

graffiti-inspired works by Jean-Michel Basquiat (1960–88) of the late 1970s.

The case of Baselitz here is perhaps the more interesting. For his challenge to good taste must also be seen in the context of his being a German painter working in the post-Second World War period. The philosopher Theodore Adorno famously remarked that after Auschwitz lyric poetry is no longer possible. Baselitz faces a parallel problem of how painting and the visual arts can continue to be even meaningful in the aftermath of the wartime catastrophes. How can art ever hope to give expression to experience again?

This tension between the possibility of meaning and the disasters of history also marks the work of two German painters, Anselm Kiefer (1945–) and Gerhard Richter (1932–), who have produced some of the most impressive Postmodern art. Kiefer's work in the late 1970s takes the tension between art and national catastrophe as its explicit theme. His means to this are large-scale works (sometimes painted over landscapes) which use heavy impasto, written allusions to places and events, and much foreign material such as sand and straw [**708**]. Richter's pictorial means in the late 1970s and 1980s are rather more subtle [**710**]. Again he employs painted-over photographs of subjects with direct or indirect pertinence to recent German history, but the mode of painting is more fluid and hallucinatory. It clouds the original in a haze which is as much psychological as painterly. The past appears as present, but not in the form of direct retrievable memory. Rather it is something which cannot be fixed except through a mist of evasiveness and ambiguity.

The eclectic and painterly figurative artists' work is loaded with a conceptually active and critical dimension. Many such painters, however, are much more conceptually passive. In the late 1970s and 1980s the Americans Julian Schnabel (1951–) [**711**] and Francisco Clemente (1952–), and the Italian Sandro Chia (1946–), for example, produced readily marketable, big painterly works which are fundamentally explorations of the personal realm of fantasy. As the art market contracted at the end of the 1980s and in the early 1990s so their reputation also seemed to decline somewhat. Similar considerations are true of two figurative painters whose imagery is highly charged in terms of erotic content—namely the Americans David Salle (1952–) and Eric Fischl (1948–). Fischl's sometimes-disturbing quasi-voyeuristic works, however, may well turn out to be of more lasting significance [**712**].

Now if, in 1985, the question 'what is Postmodern art?' had been asked, the answer would probably have been given in terms of eclectic painterly figuration. This impression would have been reinforced by the fact that two of the most important

exhibitions of the time—*A New Spirit in Painting* (London, 1981) and *Zeitgeist* (Berlin, 1982) were heavily focused on such paintings. However, this figuration does not now seem quite so decisive. The contraction of the art market is one factor in this, but much more significant is the development of the highly polemical feminist art practice, and its ramifications.

This practice has its origins (loosely) in one of the tendencies which brought Modernism to an end—namely Conceptual art. The reception of Duchamp in a politically charged cultural climate gave renewed impetus to the importance of art as a vehicle of ideas, and to the notion that any object could be appropriated for this task. This latter realm of traditionally excluded items presented a more specific possibility—that it could be used to give voice to those persons who themselves had also tended to be excluded from traditional art practice.

One of the major steps in developing this into a feminist practice is *The Dinner Party* of 1979 [**713**] by Judy Chicago (1939–). The guests of this party consist of major female contributors to the world's cultural development. A couple of years later Cindy Sherman (1954–) produced the first of a still-ongoing series of photographic self-portraits wherein she appropriates standard female roles and images projected by the media. In work by Barbara Kruger (1945–) from the late 1970s on [**714**], appropriation becomes outright polemic. Her characteristic format from this time is to use a patriarchally significant image (often derived from the advertising industry) and subvert it with slogans in Letraset.

The stridency of the Kruger-type approach reached an extreme form in the Whitney Bieniall of 1993. This exhibition foregrounded Conceptual work which subverted patriarchal values or gave voice to various oppressed minorities such as AIDS victims. More recently, a rather more subtle approach to similar themes has emerged in the work of Mona Hatoum (1952–) (a London-based Palestinian artist) [**715**]. Her video and installation pieces explore aspects of female identity, Palestinian identity, and, of course, female Palestinian identity.

It should have become clear by now that installation and assemblage of one sort or another have been vital features of much feminist art practice. Such conceptually based idioms, however, have enjoyed a much broader artistic currency. Indeed, whilst the notions of site-specific installation and assemblage art have been explored before, it is only in the Postmodern era that they have really come into their own.

One major user of these idioms is the Scottish artist Ian Hamilton Finlay (1925–). He uses a complex range of materials and artefacts which are designed and produced in co-operation with other artists. The resulting works explore such themes as purity, moral virtue, political rhetoric, and terror, most notably by drawing on all aspects of the Neoclassical tradition [**717**]. In much broader terms, his work addresses the complex relation between nature and culture. All these themes are focused in the artist's most sustained project—his own house and gardens at Little Sparta in Lanarkshire, Scotland.

Another Scottish artist operates at almost the opposite extreme from Finlay. Assemblages by David Mach (1956–) are witty and comical. They use an extraordinary range of everyday items such as car tyres [**716**], liquid-filled bottles, shoes, and magazines, to make representations of other kinds of item.

Another comical-type strategy is found in the work of the American Jeff Koons (1955–) [**718**]. Since the early 1980s his pieces have increasingly tended to deploy and celebrate the most appallingly (or, some might say deliciously) *kitch* items and values. A much darker vein of humour characterizes the work of Damien Hirst (1965–)—a leading figure in the so-called 'Brit art' of the late 1980s and early 1990s. His assemblages consistently disturb and shock through their wacky but uncompromising evocation of mortality [**720**].

Arguably some of the most significant achievements of installation and assemblage art are found in work by the British artist Cornelia Parker (1956–) of the late 1980s and 1990s. Using materials such as coins or junk from car-boot sales, she subjects them to destructive forces and displays them in a rearranged format—often suspended by wires from the ceilings of exhibition spaces [**719**]. These installations are somewhat discretely and sometimes insistently spectacular. They provide effective evocations of cosmological forces and relations such as expansion and contraction, death and rebirth, and the like.

Given all these tendencies, the reader might be tempted to ask 'whatever happened to that most Modern of idioms—abstract art?' As it happens, abstraction has survived and taken on some new aspects in Postmodern times. In the mid-1980s, for example, the New York artists Peter Halley (1953–) and Ross Bleckner (1949–) explored abstraction in strikingly disparate ways. Halley's 'cell' and 'conduit' works, for example, create ironic versions of those abstract banded colour-fields (associated with artists such as Mark Rothko (1903–70) [**616**]) by using formal structures inspired by electronic circuitry [**721**]. Bleckner's painterly idiom is much more darkly lyrical—sinister even—and hints at deep levels of tragedy [**722**].

In Britain, Fiona Rae (1963–) and Thérèse Oulton (1953–) have produced especially impressive abstract work. Oulton's work from the mid- and late 1980s has a powerful allusive aspect, hovering on the margins of abstraction *per se* and natural processes and forms [**723**]. The painterly means to this achievement involves a creative appropriation of the stylistic traits of Titian, Turner, and Constable, amongst others.

One final strand of Postmodern art needs to be considered. It is often noted how in the Postmodern era well-defined notions of regional identity have broken down. We live in an increasingly global culture. This being said, there have been a few ephemeral flurries of art with a strong regional identity in the current era. For example, the 1980s saw particular robust forms of figurative painting developed by Glasgow-based painters such as Peter Howson (1958–) and Stephen Campbell (1953–) [**725**]. At the same time in Italy, a Neoclassicism featuring witty pastiches of Renaissance painting styles was briefly influential. However, whilst such painting was regionally highly centred, the regional content of these works was much less direct.

This contrasts strongly with certain developments in former regions of the Eastern bloc. During the Gorbachev era, Russian artists such as the duo Komar (1943–) and Melamid (1946–) [**724**], and Eric Bulatov (1933–) [**726**] developed a so-called 'Soc. Art' which directly appropriated the imagery of Soviet culture and Socialist Realism to witty, ironic, and subversive ends. A similar strategy developed slightly earlier in

Slovenia—the northernmost republic of the former Yugoslavia. This took the form of the Neue Slowenische Kunst movement. NSK comprises theatre groups, designers, and, most notably, the five-man painters' collective 'Irwin' [**727**]. The basic NSK strategy is to set up an art 'state' within the Republic of Slovenia, and to create events and artefacts which appropriate the symbols and imagery of those Communist and Fascist regimes which had occupied Slovenia in the twentieth century. These were used alongside imagery expressive of Slovenia's own national identity.

It should be emphasized that whilst, at the end of the 1990s, various forms of Conceptualism are to the fore, none of the tendencies discussed have been able to establish themselves with the kind of authority which, say, Surrealism had for the 1920s and 1930s, or gestural abstraction had for the 1950s. In the Postmodern era, it might be said that 'anything goes'.

It is this very fact which underlines the intensity of the critical debate which has surrounded Postmodern art and culture. Positions have tended to be radically polarized. The French philosopher J.-F. Lyotard (1924–1998), for example, was of seminal importance in stimulating the debate on Postmodern culture, but whilst being in general sympathetic to it, he regards its figurative artistic products as symptoms of a cultural 'slackening'. Even more hostility—especially towards Conceptualism—is evident in the work of aesthetically conservative critics such as the American Hilton Kramer (1927–) and the British writers Peter Fuller (1947–90) and Brian Sewell (1929–).

Major advocates of Postmodern art include the British critic and architectural historian Charles Jencks (1946–), and an international group associated with the American journal *October*. The latter includes, most notably, Rosalind Krauss (1941–), Benjamin Buchloh (1950–), and Thierry de Duve (1933–). The *October* group is to some degree representative of much broader poststructuralist- and feminist-influenced theoretical standpoints, which, in their most extreme forms, are highly sceptical towards traditional notions of art and the aesthetic. For these tendencies, art and the aesthetic are fundamentally historically specific 'constructs'. They simply express and consolidate the tastes and preferences of dominant Western white male middle-class heterosexual power groups. The diversity of Postmodern tendencies—and Conceptualism in particular—is, accordingly, to be welcomed in so far as it 'deconstructs' the link between 'high art' and these vested interests.

In general, then, Postmodern art is composed of different complex strands. It has involved some returns to figuration—often of a painterly eclectic kind—but has also issued in abstract tendencies, and (with installation and assemblage idioms to the fore) various kinds of Conceptualism. It is formidably difficult to assess Postmodernism's significance. There is a case for arguing that it marks the end of art in the sense of having exhausted art's logical possibilities for development. From now on, in effect, all that can happen is a repetition or remix of styles and formats already established. Art based on new technology such as computers or video may seem to offer new possibilities, but in many respects this amounts to little more than clever Conceptualism, or surreal narratives, or (in the case of the 'virtual reality' phenomenon) a kind of Super-Super Realism.

On the other hand, it may be that Postmodern art actually marks out a feverish period of transition. If it is to be meaningful in these terms, what it is transitional to is the invention of new objectively intelligible codes of visual communication. This would mark as revolutionary an innovation as the formalization of perspective, or the invention of Cubism. There are already some clear signs of this occurring. To understand them, it is necessary finally to identify a tendency which runs through a number of idioms discussed in this entry. Of special importance is the British 'Art-Language' group. The group was formed in the late 1960s and, in the late 1990s, was composed of two British artists—Mel Ramsden (1944–) and Michael Baldwin (1945–) —and the British art historian Charles Harrison (1942–).

Art-Language's practices focus both on the production of various complex artworks, and equally importantly, texts which address historical and theoretical issues in art. These two modes specifically function as investigations into the different ways in which signifying practices—such as painting—are profoundly shaped by the immediate historical contexts in which they originate. An equally sophisticated Conceptual orientation can be found in the work of the Belgian artist Marcel Broodthauers (1924–76). Between 1964 and his death in 1976 he moved from being a poet to devising installations that brought about unexpected juxtapositions of visual and linguistic signs. The effect of these was to question the nature of the correspondence between such signs and their relation to reality. In this respect, his strategy has some affinity with poststructuralism in so far as it questions the stability of conventional categories of meaning.

The Conceptual art practices of Art-Language and Broodthauers have an interesting feature in common. They explicitly question the basis of artistic representation as a mode of linking visual signs. In Broodthauer's individual works, indeed, the artist, in effect, creates as it were arbitrary mini-systems of signs—each with its own framework of rules. This strategy finds a broad parallel in the work of Komar and Melamid's 'Soc. Art' and the work of the Irwin group. True, their manipulation of signs has a different significance—bound up with the specific social conditions in which they were created—but both sets of artists take established frameworks of visual signification and use them to create new ones.

Traditionally an artistic practice which explicitly manipulates the pictorial code of which it is an instance, and assumes thereby a self-conscious and, in a sense, manifestly artificial character, is described as mannerism. The tendency which is being described here is manneristic in a very positive sense, in so far as it searchingly questions existing pictorial codes or invents new ones. At the Equrna Gallery (Lubljana) in 1998 an exhibition was held on the very theme of a new mannerism in art. Each artist—including Marietica Potrč (1953–), Alen Ožbolt (1966–), Metka Krašovec (1941–), and Mojca Oblak (1965–)—addressed issues pertaining to the structure of existing artistic codes, or a new code based on verbal associations between visual signs rather than on a relation of resemblance between visual representations and what they represent.

The mannerist tendency, then, runs through Postmodern art. By virtue both of its questioning of existing sign-systems and willingness to experiment with new ones it may thereby be creating the conditions for a revolution in how we expect visual representation to represent reality. It may be the making of a post-Postmodernist art. PC

Beginnings

This group of images overall marks a stage where artists do not simply appropriate images from pop culture (as in Pop art) but actively subvert the boundaries that separate artistic from other forms of representation which the art world has traditionally excluded.

This tendency to erase distinctions or to overlap them marks one of the key visual strategies of much art in the Postmodernism era.

Hanson's *Bus Stop Lady* [**705**] is a sculptural evocation of Super Realism taken from life casts. Such works mark the most complete breakdown between high art and forms of representation—such as photography—which are based on processes of mechanical reproduction.

In Malcom Morley's case, the Super Realist image itself is often literally a copy of a photograph, but even here the notion of realism is itself subverted. This is because in addressing the photographic original, he inverts the photo and blocks out all but the area which he is immediately transcribing. The realist 'effect' is achieved paradoxically, by a kind of cumulative abstraction from mere visual detail.

Morley's *Pacific Telephone–Los Angeles Yellow Pages* [**706**] again addresses a fundamentally photographic image; but here the process of painting actively intervenes on the image which is being transcribed. Indeed, it produces a sense of disruption which is psychological as much as it is visual and formal.

Similar modes of disruption function within paintings by Philip Guston and Jean-Michel Basquiat [**707**]. Basquiat adopts childish imagery and forms disposed in such a

498

706 Above: Malcolm Morley (1931–), *Pacific Telephone–Los Angeles Yellow Pages* (1971), acrylic and encaustic on canvas, 2.20 × 1.70 m. (86½ × 67 in.), Humlebæk, Denmark, Louisiana Museum of Modern Art

705 Right: Duane Hanson (1928–), *Bus Stop Lady* (1983), polyester resin and fibreglass, life-size, New Orleans, collection of the Sydney and Walda Besthoff Foundation

707 Opposite: Jean-Michel Basquiat (1960–88), *Cadillac Moon* (1981), acrylic and crayon on canvas, 1.62 × 1.72 cm. (35½ × 67½ in.), Zurich, Galerie Bruno Bischofberger

way as to evoke the practice of the
graffiti painter rather than the artist as
conventionally understood. PC

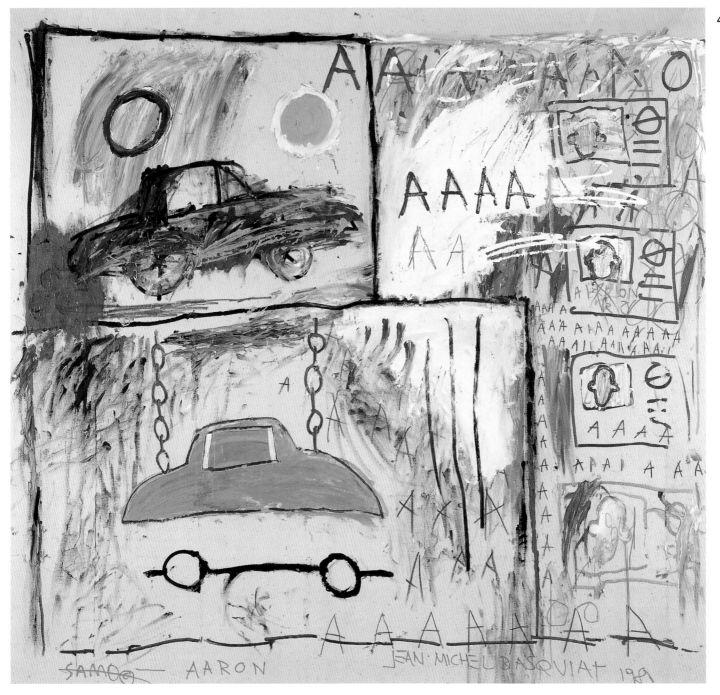

Figuration

The artists featured in this group all use paint and figuration in a complex and insistent way to question our relation to history. This critical dimension has proved to be an important feature in both figurative and other Postmodern tendencies.

Georg Baselitz began to invert his images in 1969. His painting after that time maintains this inverted character, but with an increasing schematization of basic forms, and a much heavier and insistent use of paint. The resulting images are stark and packed with anxiety almost to a point of overload [709]. Some of Baselitz's work alludes to themes with special significance for German history, but in Anselm Kiefer's work from 1969 to the late 1980s these themes are of the most decisive significance. *To the Unknown Painter* [708] draws, of course, an important analogy between the fate of the individual artist and the Unknown Soldier, both of whose identities are swept away in the catastrophic flow of twentieth-century history.

The implications of the relation between art and cultural memory are also key features in the work of Gerhard Richter [710]. His painted-over photographs of dead members of the Baader-Meinhof terrorist group, for example, have a disturbing and macabre quality which does full justice to the problematic position of political terror in recent German history. Richter generalizes the problem of art and memory to a more universal level by rendering photographed landscapes hazy and elusive. The exact character of the individual scene is lost even as it is affirmed in the artist's painterly interpretation of it. PC

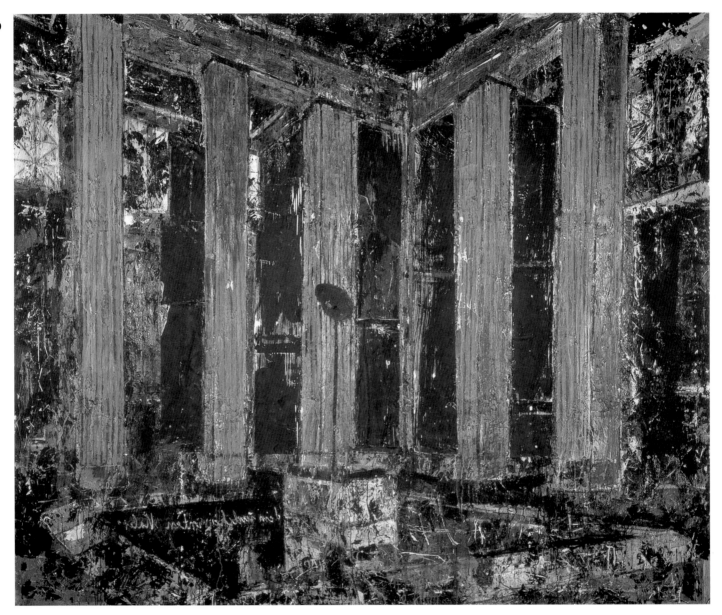

708 Anselm Kiefer (1945–), *To the Unknown Painter* (1982), oil, lino and straw on canvas, 2.80 × 3.41 m. (9 ft. $2\frac{1}{4}$ in. × 11 ft. $2\frac{1}{4}$ in.), Rotterdam, Boijams Van Beuningen Museum

709 Right: Georg Baselitz (1932–), *Orange Eater II* (1981), oil on canvas, 1.46 × 1.14 m. (57½ × 44⅞ in.)

710 Below: Gerhard Richter (1932–), *Venice (Stairs) (No. 586–3)* (1985), oil on canvas, 50 × 70 cm. (19⅝ × 27½ in.), artist's private collection

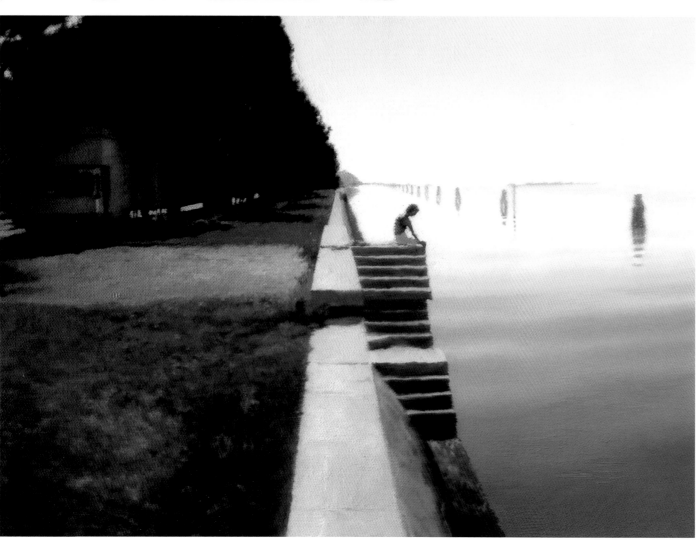

Figuration and critical Conceptualism

In a number of senses Postmodern art involves tendencies which deeply conflict with one another. The works in this group embody a specific case of such conflict.

Julian Schnabel's work [**711**] offers a heavy painterly figuration which (as with Kiefer [**708**]) utilizes much other material—in this case, crockery. This deeply rhetorical approach has been seen by some critics as 'phallocentric', in so far as it seems to affirm a kind of *macho* approach to the very act of painting.

Eric Fischl's work is more ambiguous [**712**]. For whilst on the one hand images (such as the one reproduced here) show the male gaze in action, the viewer's relation to this is more than simply voyeuristic. We are invited to share *and* question the nature of the gaze.

Feminist art has subjected the relation between art, gender, and the gaze to even greater critical scrutiny. Judy Chicago's *Dinner Party* [**713**] presents a space laid out for a banquet of great women in history who have been, in significant respects, excluded from a canon of tradition defined by the patriarchal establishment. Barbara Kruger's installation [**714**] attempts to foreground the abuse of women and racial minorities through constellating words of abuse and images of female terror. Ironically, the formats used derive from, and thence partially subvert, the *modus operandi* of that institution which deals most in stereotypes—namely the advertising industry.

Mona Hatoum's installation [**715**] uses much more subtle means. The abuse of woman in the famous

711 Above: Julian Schnabel (1951–), *The Student of Prague* (1983), oil, plate, and gelatin on wood, 2.95 × 5.79 m. (9 ft. 8 in. × 19 ft.), New York, Emily and Jerry Spiegel Collection

712 Right: Eric Fischl (1948–), *Bad Boy* (1981), oil on canvas, 1.68 × 2.44 m. (66⅛ × 96 in.), New York, Mary Boone Gallery

pornographic film *Deep Throat* is here linked metaphorically to the female serving role in the domestic context. (The 'Throat' in question here focuses on the glass plate beneath which images from a television screen are visible.) PC

713 Detail, Judy Chicago (1939–), *The Dinner Party* (1975), mixed media, each side 14.6 m. (48 ft.) long

714 Left: Barbara Kruger (1945–), *Untitled* (1991), installation at the Mary Boone Gallery, New York, 5–26 January 1991, photographic silkscreen on paper, floor lettering vinyl paint

715 Above: Detail, Mona Hatoum (1952–), *Deep Throat* (1996), table, chair, television set, glass plate, fork, knife, water glass, laser disc player, 74.5 × 85 × 85 cm. ($29\frac{1}{3} \times 33\frac{1}{2} \times 33\frac{1}{2}$ in.) London, The Saatchi Gallery

Installation and assemblage

One of the most widespread tendencies in Postmodern art is that of installation and/or assemblage work. This is often associated with critical activity (as in **713**, **714**, and **715**). However, it has also given rise to other more aesthetically or humorously orientated practices.

Ian Hamilton Finlay's *œuvre* is extremely diverse, ranging from the designing of books and small objects, to two stone piers in the River Clyde [**717**] (one of which is reproduced here). Finlay's artistic obsession is to explore all aspects of that enduring Classical tradition which has been so influential on the history of Western art. *All Greatness Stands Firm in the Storm* is, indeed, a metaphor for the very fact of this endurance.

504

716 Below: David Mach (1956–), *Polaris* (1983), rubber tyres, destroyed after display at Hayward Gallery and Serpentine, London

717 Right: Ian Hamilton Finlay (1925–), *All Greatness Stands Firm in the Storm*, stone, Glasgow, River Clyde

718 Left: Jeff Koons (1955–), *Rabbit* (1986), stainless steel, 104 × 48.3 × 30.5 cm. (41 × 19 × 12 in.), formerly London, The Saatchi Gallery

David Mach's installations, in contrast, play on the very fact of their own transience qua installation and assemblage. *Polaris* represents a monumental and threatening type of object [**716**], but the fact that it is so manifestly made from car tyres subverts the threat through its humorous means. A rather more blatant form of humour characterizes the work of Jeff Koons. *Rabbit* [**718**] is, of course, derived from a child's toy, but is realized in an expensive medium—stainless steel—and presented as high art.

A more philosophical use of installation or assemblage idioms is found in Damien Hirst and Cornelia Parker. Hirst's tiger shark preserved in formaldehyde [**720**] is a powerful image of how difficult it is psychologically to contain the thought of one's own death. Parker's *Cold, Dark Matter—An Exploded View* was created by reconstituting an exploded garden shed (containing bric-à-brac) in a gallery space [**719**]. Suspended from wires, the debris of the explosion offers an image which alludes to ultimate cosmological forces. PC

719 Cornelia Parker (1956–), *Cold, Dark Matter—An Exploded View* (1991), bric-à-brac, destroyed after display at Chisenhale Gallery, London

720 Damien Hirst (1965–), *The Physical Impossibility of Death in the Mind of Someone Living* on display in the Saatchi Gallery (1991), tiger shark, glass, steel, 5% formaldehyde solution, 2.13 × 5.18 × 2.13 m. (7 ft. × 17 ft. × 7 ft.), London, The Saatchi Gallery

Abstraction and Neo-Abstraction

This group of works illustrates some of the idioms which abstract or semi-abstract painting has adopted in the Postmodern era.

Ross Bleckner explores a hazy zone of intersection between abstract and figurative. His *8,122 + As of January 1986* deploys an urn-like form

in an eerie and indeterminate space [**722**]. The work refers to AIDS victims, and engages with that theme in an elegiac rather than polemical way.

Peter Halley's work utilizes forms abstracted from electronic circuitry and other aspects of technology in an advanced urban society [**721**]. By doing so, he not only connects with a key feature of contemporary life, but also satirizes these high metaphysical

722 Ross Bleckner (1949–), *8,122 + As of January 1986* (1986), oil on linen, 1.22 × 1.02 m. (48 × 40 in.), New York, Mary Boone Gallery

721 Peter Halley (1953–), *Yellow and Black Cells with Conduit* (1985), acrylic, day-glo acrylic, and roll-a-tex on canvas, 1.22 × 1.83 m. (48 × 72 in.), formerly London, Saatchi Collection

ambitions which characterized the work of late modernist colour-field painters such as Barnet Newman (1905–70) and Mark Rothko.

Therèse Oulton relates to tradition in a somewhat less critical way. Her works of the 1980s such as *Counterfoil* [**723**] draw in stylistic terms on the painterly techniques of Titian, Turner, and even late Constable. Her rich abstract forms

connote natural interiors—such as cave walls—and, perhaps even more significantly, the power of paint itself to be transmuted from physical reality into aesthetic form. PC

723 Therèse Oulton (1953–), *Counterfoil* (1987), oil on canvas, 233 × 213.4 cm. (92 × 84 in.), London, Marlborough Fine Art

Regional tendencies

This final grouping presents some of the most significant geographically localized tendencies in Postmodern art.

In the 1980s a group of artists associated with the Glasgow School of Art received widespread international attention. Some of this work involved a restatement of robust socialist realist-type figuration, but in others—

such as Stephen Campbell—the artistic strategy is much more complex. His *Not You as Well Snowy* [725] has a characteristic tone of wry humour which links to the Absurd, rather than to the dislocated Surrealist image from earlier on in the century.

Elements of a rather more biting and critical absurdity informed the rise of Soc. Art in the former Soviet Union during the 1980s. Melamid and Komar's *The Origin of Socialist*

724 Above: Melamid (1946–) and Komar (1943–), *The Origin of Socialist Realism* (1982–3), oil on canvas, 1.83 × 1.22 m. (72 × 48 in.), New York, private collection

725 Top: Stephen Campbell (1953–), *Not You As Well Snowy* (1989), acrylic on paper, 186 × 197 cm. ($73\frac{1}{4}$ × $77\frac{1}{2}$ in.), London, Marlborough Fine Art

726 Above: Eric Bulatov (1933–) *Perestroika* (1988), oil on canvas, 2.74 × 2.69 m. (9 ft. × 8 ft. 10 in.), New York, Phyllis Kind Gallery

727 Opposite: Irwin, *Capital* (1991), installation in the Clock Tower Gallery, New York

Realism [**724**], for example, is a magnificently satirical exercise in the officially sanctioned academic style. But it evokes the absurdity of that sanctioning, through restating it as a quasi-Renaissance allegory of inspiration.

Eric Bulatov's *Perestroika* [**726**] gives ironic expression to the power of openness which destroyed the Soviet Union by articulating its energy in terms of the imagery and communicative idioms of Soviet visual propaganda.

One of the most startling local manifestations of geographically localized art in the 1980s occurred in Slovenia—the northernmost republic of the former Yugoslavia. The Neue Slowenische Kunst, the rock band Laibach, as well as designers, theatre groups, and the five-man painters' collective Irwin NSK created in effect an alternative state complete with its own passports. In visual terms the group Irwin are highly representative of NSK strategy. Their paintings, assemblages, and installations [**727**] re-appropriate images and motifs from the totalitarian states which colonized Slovenia, from Slovenian folk culture, and from key modernist figures such as the Russian avant-garde artist Kasimir Malevich (1878–1935). PC

Art History

By the first decade of the twentieth century art history was well established as an academic discipline, most notably in the German-speaking world. *Kunstwollen*, the notion of an innate urge to create artistic form, introduced by Alois Riegl (1858–1905), was especially influential, albeit in rather different directions. Curiously enough this influence is not quite as emphatic as one might expect in the continuing work of the Vienna School. The Austrian Julius von Schlosser (1866–1938), for example, is perhaps its major twentieth-century represent-ative after Max Dvořák (1874–1921). But his major work *The Literature of the Arts* (1924) is primarily a bibliographical and critical interpretation of art theory and historiography from antiquity to the late eighteenth century. And in his emphasis on the individual creative genius in his later works, von Schlosser is indebted to the Italian philosopher Benedetto Croce (1866–1952) rather than to the notion of *Kunstwollen*.

The real inheritors of Riegl's *Kunstwollen* are found else-where in the German-speaking world. The first major inheritor is the German scholar Wilhelm Worringer (1881–1965). The eclectic doctrines in his dissertation on *Abstraction and Empathy* (1907) drew on the Vienna School (notably Riegl) and the empathy theories propounded by Robert Vischer (1847–1933), Theodor Lipps (1851–1914), and others. Worringer links two specific kinds of form—the geometric/inorganic and the naturalistic/organic—to distinctive psychological attitudes and world-views. One result was to restate the relation between 'primitive' and Western art as one of psychological difference, rather than difference of quality.

Worringer's dissertation was supervised by the Swiss art historian Heinrich Wölfflin (1864–1945). Wölfflin's own mature understanding of *Kunstwollen*, however, leads in a direction which emphasizes the formal structures of works of artworks, rather than the psychological attitudes embedded in them. The passage to this interest is clearly discernible in his books *Renaissance and Baroque* (1893) and *Classic Art* (1897). Here, indeed, Wölfflin begins to make important connections between specific ranges of formal structure and specific historical epochs or stages, most notably Renaissance and Baroque.

These connections are most forcefully identified in his *Principles of Art History* (1915), where Wölfflin analyses five pairs of visual categories: linear/painterly, planimetric/recessional, open/closed form, unity/multiplicity, and clarity/indistinctness. Applying these to painting, sculpture, and archi-tecture, Wölfflin holds that the first element in each broadly corresponds to the stylistic features of classic (and most signifi-cantly Renaissance) art, whilst the second elements characterize what, in general terms, can be described as Baroque tendencies.

Wölfflin is careful to emphasize that his paired categories are primarily intelligible in relative terms. A work does not possess linearity, for example, as a simple quality, but funda-mentally on the basis of its contrast with other more painterly works. This being said, like Riegl he also holds that the formal categories express specific modes of visual perception, changes of which are bound up with much more general transformations of historical circumstances.

These broader ramifications of the formal categories are, unfortunately, given very little elucidation by Wölfflin. Similar considerations hold in relation to other important twentieth-century formalist approaches to art history. The work of the British critics and historians Clive Bell (1881–1963) and Roger Fry (1866–1934), for example, emphasizes that what links artworks from different cultures and periods is their possession of 'significant form'—a harmonious combination of lines and colours. Whereas for Wölfflin formal qualities are primarily descriptive features of visual art, for Bell and Fry they are also evaluative. All visual artefacts have line and/or colour, but not all of them have significant form. The recognition of this formal quality, indeed, requires a special kind of sensitive discrimin-ation from the critic or art historian.

Whilst formalist conceptions of art history have been influential (to varying degrees) throughout the twentieth century, other approaches have been equally important. One of the most significant and complex is associated with the work of Aby Warburg (1886–1929) and his intellectual and institutional legacy. Warburg's dissertation on Botticelli was published in 1893, but it was a paper on frescoes in the Palazzo Schifanoia (1912) which first attracted major international attention. In this paper, Warburg offered a novel interpretation of the zodiacal symbols in the work of the Italian painter Francesco Cossa (1436–78). His analysis showed how they involved represen-tation of Olympian gods, but based on a complex route of transmission through medieval and Arabic sources.

The legacy of the Classical tradition and its historical transformations form the major locus of Warburg's 'icono-logical' approach to the study of art history. This approach is not concerned simply with the deciphering of symbols, but also understanding them in relation to other contexts—visual, literary, psychological, social, and philosophical—which might have informed their production. Notable in this respect is his doctoral dissertation on Botticelli. Warburg argues that Botticelli's depiction of life and movement is derived ultimately from the transmission of Classical formal motifs with an inherent expressive power (*pathos formulae*). This attentiveness to the psychological significance of images and their link to

cultural memory is what gives Warburg's iconology its most distinguishing characteristic. At the very end of his life, indeed, he was at work on the 'Mnemosyne' project which sought to create a pictorial history of imagery using images alone. (In this transgressing of conventional art-historical narrative, Warburg to some degree anticipates more controversial means of analysing imagery which have emerged since the late 1980s.)

This breadth of approach had an extraordinary institutional outcome. Warburg was born into a wealthy German banking family, but relinquished his inheritance claims on the condition that he would be allowed unlimited funds for the purchase of books. From around 1901, Warburg began assembling a formidable library which reflected both his breadth of learning in the Classical tradition and his much broader cultural interests. By the 1920s the library had formed close links with the University of Hamburg—links which were only severed by the rise of National Socialism. Thereafter the library was moved to the University of London where it formed the core resource of the Warburg Institute. What is remarkable is the number of outstanding German and Austrian art historians who were associated with the library at various times. The Bohemian-born Fritz Saxl (1890–1948) was appointed as Warburg's assistant in Hamburg in 1913 and became Director of the Library after Warburg's death. He, like his mentor, had a special interest in iconographical issues, most notably those connected with astrology and the Mithraic religion. More influential scholars associated with the library include Edgar Wind (1900–71), Erwin Panofsky (1892–1968), and Ernst Gombrich (1909–).

Edgar Wind was instrumental in supervising the Warburg library's move to London. From 1942, he taught in America, and, from 1955 to 1967, held the Chair in History of Art at the University of Oxford, England. Wind did important work on Renaissance and British art and, in the spirit of Warburg's iconology, had a special interest in the relation between art and broader fields of meaning, most notably philosophy. The link between art and philosophy is explored by him in a particularly striking way in the book *Art and Anarchy* (1963). Here Wind considers the increasing specialization and lack of general social significance in the modern era. He addresses, in effect, the problem of the end or death of art which has so preoccupied critics in the 1980s and 1990s.

By far the most important of the historians associated with Warburg is Erwin Panofsky. Panofsky held a Chair at Hamburg from 1926 until the rise of National Socialism, when he emigrated to America. For many years he held a Chair at Princeton University. Early on in his career, Panofsky established a reputation through papers criticizing Heinrich Wölfflin's and

Alois Riegl's formalism, and through a short work entitled *Perspective as Symbolic Form* (1925) which raised important questions about the history and general significance of perspective. Again the influence of Warburg is important in this work by virtue of the connection which Panofsky makes between those philosophical and scientific theories which formed the broader cultural context within which perspective was explored.

The main corpus of Panofsky's writing encompasses a formidable range of interests, ranging from medieval and Italian Renaissance art and theory through more general methodological issues, and culminating in a major study—*Early Netherlandish Painting* (1953). All these theories converge (to varying degrees) in two enormously influential works—*Studies in Iconology* (1939) and *Meaning in the Visual Arts* (1955). In the latter work, Panofsky included a slightly revised version of the Introduction to the former book, setting out his mature understanding of iconology. However, this term is now incorporated within a tripartite schema. This consists of the *pre-iconographic*, the general kind of subject-matter which an artwork embodies and also its formal structure; the *iconographic*, which involves meanings which can only be recognized through reference to the artist's intentional use of specific literary or other sources; and finally, the *iconological*, which involves a comprehension of how a work expresses broader cultural attitudes (such as philosophical ideas or religious beliefs) which were current in the society where, and the epoch when, it was produced.

The three categories described here must, according to Panofsky, be corrected in their application by reference to some broader historical criteria. These involve a knowledge of the history of style, a knowledge of the history of iconographic types, and an understanding of the way in which essential features of the mind find expression in different ways under different historical circumstances. (In this third point Panofsky draws upon the general philosophical position outlined in Ernst Cassirer's philosophy of symbolic forms.)

Each of the elements in Panofsky's tripartite schema is internally complex perhaps even more so than Panofsky himself realized. However, whatever the internal complexities, there is a case for arguing that, in general terms, the schema articulates the most basic logical core of art-historical method. Any visual representation has the pre-iconographic aspect, and most will also have iconographical and iconological significance too. This means that, whatever an art historian's orientation, he or she will have to attend to all three aspects if a work is to be comprehended in the fullest sense.

Panofsky, then, develops the Warburgian iconological tradition in the direction of greater methodological rigour. The

Austrian Ernst Gombrich effects some equally significant developments. Again his writings are of great scope, with special emphasis on Renaissance topics and of issues in the psychology of art-historical development. Of special interest are *The Story of Art* (1950) and *Art and Illusion* (1960). The former is an introductory text, but one read by a much broader audience than is customary. *Art and Illusion* follows Warburg's lead by bringing an unusually broad range of visual material within the purview of art history. And like Warburg he is also interested in the 'mind sets' involved in different modes of visual representation. Where Gombrich goes far beyond Warburg is in formulating a theory of artistic change. This involves an adaptation of the Austrian philosopher Karl Popper's theory of problem-solving in science. In the broadest terms, visual representation achieves naturalistic and expressive effects not by the artist 'matching' his or her work with reality, but by testing and refining schematic models of specific pictorial forms inherited from tradition.

In addition to the formalist and iconological approaches there has been a third major twentieth-century avenue of inquiry deriving from Marxist traditions of thought. Friedrich Antal (1887–1954) and Arnold Hauser (1892–1978) were Hungarians who emigrated to Britain in the years preceding the Second World War. Antal was a noted authority on Hogarth, whilst Hauser's greatest accomplishments were in the fields of the philosophy of art history and the social history of art. Francis Klingender (1907–55) came to Britain from Germany in the 1920s. His *Art and the Industrial Revolution* (1947) is, in many respects, a classic of Marxist art history. One of the key features of the Marxist approach is to explain cultural (or 'super-structural') changes as the effects of a historically dynamic 'infrastructure' of productive and economic relations. This approach is, accordingly, one which emphasizes the bond which exists between artworks and the social context of their production. Klingender's work explores this relation without reducing artistic change to a mere reflection of economic transformations.

Amongst other notable Marxist art historians is the Romanian Nicos Hadjinocoloau (1930–) whose *Art History and Class Struggle* (English translation, 1978) develops a distinctive notion of visual ideology in relation to the interpretation of style. Another particularly interesting art historian in the Marxist tradition is the German Max Raphael (1889–1952). His work is somewhat unorthodox. Whilst contributing in significant ways to Marxist theory of knowledge, his later analyses of art-historical questions (as in a posthumously published work *The Demands of Art*, of 1968) assign a surprising degree of autonomy to artistic creation. He combines an extremely detailed analysis of specific works by individual artists, such as Cézanne, Degas, Giotto, Rembrandt, and Picasso, with a more general discussion entitled 'Toward an Empirical Theory of Art'. This title is somewhat misleading since what Raphael articulates is a detailed formal and descriptive framework for the analysis of artworks.

Another Marxist scholar is the British novelist, critic, and cultural theorist John Berger (1926–). In 1972 Berger wrote and presented a television series entitled *Ways of Seeing* (with a book of the same title) for the BBC. The series offered a critique of images not only from the history of fine art but also from mass culture, most notably from the advertising industry. Berger's analytic juxtaposition of images from these two sources attempted to reveal politically significant strategies of power and control (bound up with class structures and gender) embodied in such imagery. Berger's analyses were highly influential on subsequent theoretical and practical activity in art schools, and on the emergence of the so-called 'New Art History'.

It should be emphasized at this point that there are, of course, a great number of distinguished art historians whose work falls between or even outside the three dominant approaches. The Frenchman Émile Male (1862–1954) and the German Richard Krautheimer (1897–1994), for example, specialized in highly focused problems of iconography in relation to eighteenth-century French religious painting, and architecture (respectively). The Morellian tradition of connoisseurship also found continuing exemplars, such as the Italian Adolfo Venturi (1856–1941) who, as well as holding a university chair, was Chief Inspector of Fine Arts in Rome.

This tradition was also continued by the Lithuanian-born American scholar Bernard Berenson (1865–1959) and his one-time English secretary Kenneth Clark (1903–83). During his lifetime Berenson was extremely influential through his numerous studies of Italian Renaissance art. His reputation has declined since then, partly as a result of the complex relation which exists between his attributions and their use in the art market. Clark established his own reputation independently of Berenson through important work on the nude in European art, and on landscape painting. His BBC television series *Civilization* and the accompanying book (1969) attained great popularity and may have played an indirect role in the growth of art-historical studies in the English-speaking world in the 1970s.

Rather more difficult to place are Walter Friedlaender (1873–1966) and Meyer Schapiro (1904–96). Friedlaender was close to the Warburg school in terms of interests and friendships. As well as publishing important work on Renaissance and Baroque art, he was enormously influential as a teacher in America after his emigration there from Germany in the 1930s. The American Schapiro produced one of the first important re-evaluations of Romanesque art, and (throughout his life) some very cogent defences of abstract art. His earlier work was strongly influenced by Marxist ideas, but in later works he draws on more diverse sources, including psychoanalysis.

It could be said that the figures and tendencies described so far form, in concert, the high point of specifically *modernist* approaches to art history. This does not simply mean that some of them (such as Bell, Fry, Schapiro, and to a lesser extent Gombrich) champion modern art, but that their very conception of the art-historical enterprise involves attitudes which are highly characteristic of the modern epoch. All the approaches discussed, for example, assume that art is a distinctive form of meaning with a relatively clear canon of major schools and figures. There is, of course, much more controversy about how far artistic transformations are internal to artistic practice and how far they are influenced by (or even dependent upon) broader societal and economic factors. Whatever the case, all the aforementioned approaches assume that the objects of art-historical study are clearly given, as are rigorous methods and rules whereby such objects can be comprehended. All in all (and whatever use it makes of other areas of knowledge), art history is a specialist academic discipline.

Since the 1970s (at least) this view has been radically challenged. An early glimmering of unease can be detected in a work by the British art historian Michael Baxandall (1933–). His *Painting and Experience in Renaissance Italy* (1972) addresses relations between design, technical issues, commercial contexts, ideas, and patronage. Such notions had been addressed before in Renaissance studies, but Baxandall focuses on them with an insistency which diverts attention away from the Renaissance conceived in terms of individuals and tendencies, towards conceiving it in terms of painting as a material practice.

This reorientation is not given any radical political edge by Baxandall. However, later on in the 1970s and 1980s much art history did acquire a strong critical tone. A key figure here is the British scholar Timothy J. Clark (1943–). In three important studies of French art, Clark shifts attention to the broader social, cultural, and political contexts which inform the work of Courbet and Manet. In significant ways Clark revitalizes Marxist approaches to art history through reinterpreting Hegel and by appropriating some of the more sophisticated refinements of Marxist thought made by Guy Debord and others in the 1960s. The upshot is a notion of art history as an area of social history as well as of specifically visual style.

This emphasis on the social history of art as a fundamental concern was also complemented by the convergence of two other tendencies of non-art-historical origin. The first of these is a trenchant feminist critique of the standard assumptions of Western culture. In the context of the visual arts this was first raised in an influential way in a paper 'Why Are There No Great Women Artists?' published in 1971 by the American Linda Nochlin (1931–). Nochlin investigated the historical contexts and social institutional mechanisms which had traditionally excluded women from participation in professional art practice. By the late 1980s literature on the marginalization of women artists and reappraisals of those who had managed to establish professional careers was burgeoning. Important contributions to this literature include *Vision and Difference: Femininity, Feminism, and Histories of Art* (1988) by the British-based art historian Griselda Pollock (1949–).

Pollock's work is especially noteworthy, for it not only explores the social history of art in a feminist context, but draws much of its intellectual substance through an appropriation of ideas from French post-structuralist thinkers such as Barthes, Derrida, Lacan, and Foucault. It is, of course, not easy to summarize what is common to all these thinkers, but there is at least one trajectory of thought which runs through them. It is the idea that the meaning of a sign does not consist of some direct correspondence between the sign and the presence of that which it signifies. Rather any such correspondence is made possible by the relationship between the sign and other signs which are different from it, and its relation to the complex and evolving rules which define sign-systems of specific kinds. If this view is correct, it would follow that meaning—be it of visual signs or of the methods used to analyse them—is radically shifting and unstable. There would be accordingly, systematic ambiguity about the way in which visual representations are classified as 'art' (or otherwise) and about the methods appropriate to understanding these representations and classifications. To suppose otherwise as, for example, the three approaches

described here as modernist do is to perform 'closure', that is to elevate unjustifiably some interpretative position bound up with the historically specific interests of a ruling class, racial, or gender grouping, into a supposedly essential universal truth.

Post-structuralist approaches, therefore, are opposed to any 'essential' notions of universal truths and absolutely fixed analytic categories. This anti-essentialism has had a profound effect on art history since the late 1970s. The discipline has not only broadened out into social history, but has, indeed, developed into a multi-culturalist critique of the history of visual culture as such. More precisely the existence of a recognized canon of art history is now questioned in terms of the social, racial, and gender interests which it has historically excluded but in relation to which it tacitly defines itself. An equally radical development has been a widespread critique of Western art history's 'ocularcentrism'. In works such as *Vision and Painting: The Logic of the Gaze* (1983) by the American-based Norman Bryson (1949–), for example, it is argued that the privilege assigned to the spectator's 'gaze' in the reception of art is one which suppresses an understanding of its structure and function as a discursive or quasi-linguistic sign.

These anti-essentialist disruptions of modernist approaches to art and its history have, as one might expect, been especially significant in relation to the understanding of specific-ally modernist art. In her influential *The Originality of the Avant-Garde and Other Modern Myths* (1986) the American Rosalind Krauss (1941–) attempts to undermine the claims to originality made by avant-garde painters, and rethinks the nature of sculpture on the basis of post-structuralist approaches to the sign. Such anti-essentialist approaches have also found wide-spread application in pre-modern context—as in Bryson's *Word and Image: French Painting of the Ancien Régime* (1981).

The modernist notion of art history as a clearly defined specialist discipline, then, has been seriously challenged. Many scholars are still sympathetic to the modernist approach, but a great number—especially younger ones—think in terms of the cultural and social history of forms of visual representation, rather than in terms of 'art' history. Whether this 'New Art History' (as it is sometimes misleadingly called) will persist is an open question. Much may depend on another interesting development since the 1980s. *The Critical Historians of Art* (1982) by the British art historian Michael Podro (1931–) stimulated interest in the history of the history of art. Since then, there have been significant works—such as *Panofsky and the Foundations of Art History* (1984) by the American scholar Michael Ann Holly (1944–)—which ask searching questions about the nature of art history in all its aspects.

Finally it is worth noting that in recent times with the advent of new technologies, a revolution has taken place in the way images are created, manipulated, and distributed. This invites both theoretical and historical questions about the nature of this visual revolution and its relation to previous ones such as the formulation of mathematical perspective, and the invention of photography. Issues of this kind are currently being explored by the British art historian Martin Kemp (1942–) at Oxford University as the basis of a 'new visual history'. It may be that a cross-disciplinary approach on these lines will become important for art history in the next century. PC

513

Critics and Criticism

Two replies to a questionnaire on the usefulness of art criticism published in 1927 by the newspaper *Paris-Midi* offer what we might term a minimalist view of its function. The author Pierre Mille answered: 'If art criticism did not serve a purpose, art dealers would not have it done.' The couturier (and art collector) Paul Poiret commented: 'Yes it is useful in the sense that it provides a living for a bunch of ignoramuses.' A contrasting, maximalist, assessment is represented by the more recent (1984) suggestion by the American critic Donald Kuspit (1935–) that the task of criticism is to create a 'context of thought' for the work of art, based on 'its possible intended character'—as Oscar Wilde said, 'the critic is artist'. The practice of criticism, in various forms, has certainly been a major feature of the twentieth-century art scene: it is one important element in what the French sociologist Pierre Bourdieu has termed 'the field of artistic production' that, according to him, accords value to works of art in the Western, capitalist system.

The expansion of art communities in different centres, the multiplication of agencies concerned with the exhibition and promotion of art, change and fragmentation in art itself, and the growth of a market for information and opinion in relation to it, have all contributed to this position of critics and their output. Critics, whether full-time journalists or, as has often been the case, poets and writers who combined art writing with more personal literary work, have become key figures in the art world. The development of the art press, particularly in the form of specialized journals, which has been a prominent feature of the twentieth century, has reinforced this role. At the same time, the nature of the critic's role has been a constant subject of debate and often dispute. The history of modern art criticism is a history of writers in different roles and from different intellectual positions both recording the rapid changes that have occurred in art practice and seeking to impose an intellectual order on them. The naming of individual art movements is one characteristic form this has taken; the elaboration of a general framework of interpretation is another. This activity confers power on the critic, as a general interpreter of art for the public and as an intermediary in the art world, with influential links to its institutional and commercial agents. Artists often resent this power, while recognizing its importance for their careers.

By 1914 the role of critics in the promotion of new art was well established in the major centres of Europe, and this role was reinforced in the inter-war years. Paris was the recognized centre of modern art production at this time and this position was supported by an extensive and varied art publishing practice. After the war Louis Vauxcelles (1870–1946), now best known for naming the Fauve movement in 1905, exerted considerable influence through his position as critic on major newspapers and founder of the journal *L'Amour de l'Art*. Vauxcelles practised a form of criticism that was self-consciously journalistic, personal, and polemical. He argued for an art free of academic discipline, based on individual sensibility, engagement with the natural world, and a balance of feeling and reason. He associated these concepts with the ideology of the radical republic and official views of the time did come to correspond to the broad parameters of his understanding of modern art. These included a condemnation of the Cubist movement for its supposed elimination of feeling and tendency towards abstraction that Vauxcelles rejected out of hand. However, he acknowledged that the Cubists had had some beneficial influence through their attention to the structural lessons of Cézanne, and came to consider Braque, with Matisse, Derain, and De Segonzac, as one of the great French artists of the era.

The dominant strand in more 'avant-garde' criticism, represented by the review *Cahiers d'Art* and writers such as its editor Christian Zervos (1889–1970) and Maurice Raynal (1884–1954), adopted a different attitude to Cubism. These critics saw it as a decisive break in the imitative tradition in art that allowed artists to develop new formal languages of expression based on creative intuition. Their critical style and principles allied admiration for the 'poets' criticism' developed by Baudelaire and Mallarmé and practised in their own time by Guillaume Apollinaire (1880–1918), with a form of philosophical idealism influenced by Henri Bergson. This position combined elements of a formalist doctrine, emphasizing the autonomous and structural character of the work of art, with a belief in the exceptional creative individual—exemplified by Picasso—that echoed Nietzsche.

The main alternative reading of avant-garde art in Paris at the time was offered by writers linked to Surrealism. They too valued art as a product of the creative faculties of the mind and violently rejected both imitation and rules. The difference with Raynal and his colleagues lay in a refusal to recognize the importance of formal values *per se*. Painting as such, according to the Surrealist writer André Breton (1898–1966), was a 'lamentable expedient'—the aim of the artist, like that of the writer, was to harness the forces of the unconscious to overcome a limiting, rationalist conception of life and experience. This was a 'revolutionary' programme: in the later 1920s Breton and his colleagues became increasingly concerned to associate their libertarian artistic doctrines with revolutionary politics. In the 1930s Louis Aragon (1897–1982) became an advocate of a 'new realism' that implemented the Communist artistic programme in the French context. Breton, aligning himself with the Trotskyist

opposition to official Soviet doctrine, opposed this view and argued that the revolutionary potential of art could only be realized through complete artistic freedom. This split, which echoed divisions throughout the Marxist camp of the period, established parameters for radical critical discourse on art that were highly influential for many years, not only in France.

In the Soviet Union the doctrine of 'Socialist Realism' became official policy after 1934 and the ideas of critics linked to Constructivism were condemned. A different attack on modern art and criticism was implemented in Germany after 1933, as the Nazi Party developed and imposed a reactionary policy in respect of the visual arts that set out to expunge the modernist initiatives of the Weimar period. (In France also a current of anti-modern, racist criticism gained ground during the 1930s, articulated by writers such as Camille Mauclair (1872–1945): this became the official discourse on art for a short period under the Vichy regime.)

In the 1920s German art centres, particularly Berlin, had nurtured lively critical discussion around contemporary art. These centred on the character and value of the Modern movement, and particularly the significance of 'Expressionism', the role of art in society, and the (long-standing) issue of the relationship between French and German art. In 1918 there was a widespread consensus that the new post-war Germany should provide a context that was favourable to innovative modern art. The identification of this with 'Expressionism' was no longer limited to avant-garde journals such as *Der Sturm,* edited by Herwarth Walden (1879–1941). The established journal *Der Cicerone,* edited by Georg Biermann (1880–1949), adopted a broadly pro-Expressionist position, whose importance was reinforced by the associated book series *Die Junge Kunst*, initiated in 1919. *Das Kunstblatt*, founded in 1917 by Paul Westheim (1886–1963), was an energetic and forceful source of information and interpretation of contemporary innovative art that Westheim initially identified with Expressionist tendencies.

There was, however, argument within this modern 'camp'. Walden identified Expressionism with the focus of contemporary art on the structural elements of painting, but he attributed universal spiritual qualities to these. Other writers, such as Ekhart von Sydow, linked the Expressionist sense of inner values to German cultural identity. Both these lines of interpretation were rejected by other critics from a range of perspectives. Karl Scheffler (1859–1951), editor of the influential Berlin periodical *Kunst und Künstler* that was linked to the 'Liebermann–Cassirer circle', associated with a realist tradition of modernism, condemned both the general tendency to assert movements in contrast to individuals that he saw on the

post-war scene, and the anti-realist premises of Expressionist art. Westheim too argued that quality art was a matter of individuals rather than movements and insisted on the importance of international exchanges in contemporary art.

Contributors to *Das Kunstblatt* in 1920 included Wilhelm Uhde (1874–1947) and Daniel-Henry Kahnweiler (1884–1979), the prominent commercial and critical supporters of French modernism who were deeply sceptical of the general claims of German Expressionist art. This was also true of Carl Einstein (1885–1940), a critic close to Kahnweiler and his German-based colleague Alfred Flechtheim (1887–1937), and co-editor with Paul Westheim of a *Europa Almanach* in 1925. In 1926 Einstein published a pioneering survey, *Die Kunst des 20. Jahrhunderts* (Art of the Twentieth Century) in which he belittled the 'eclecticism' of German art compared to French. He argued that the great achievement of Cubism, unparalleled in German art, was to have developed a way of translating into two-dimensional, non-illustrative structures the modern experience of movement in space. In *Negerplastik* (Negro Sculpture) of 1915 Einstein had proposed an analogous reading of African sculpture, as a 'realist' presentation of sculptural form in space. It was these formal qualities, he argued, that modern painters had recognized in 'primitive' art, because they were related to their own concerns. Here again Einstein was presenting views that were closer to contemporary French modernist criticism than to those current in Germany. This relationship was concretized when he moved to Paris in 1928, where he collaborated with Georges Bataille (1897–1962) on the ground-breaking journal *Documents* (1929–30), which combined art theory and criticism with archaeology and ethnology.

Einstein's identification of quality in modern European art with innovations in artistic form developed in Paris continued a critical position initiated at the turn of the century by Julius Meier-Graefe (1867–1935), although the older writer could not sympathize with Cubist abstraction. Meier-Graefe's analysis of the achievements of French painting had also influenced the thinking of Roger Fry (1866–1934) in England. Fry developed a powerful critical position before the First World War that became widely accepted after the publication of *Vision and Design* in 1920. Drawing on his knowledge of Kant's *Critique of Judgement*, Fry argued that aesthetic emotion was 'disinterested', that is, independent of any practical concern with subject-matter, and generated through a response to the structural features of the work of art. He identified the qualities corresponding to this definition equally in early Renaissance painting and in Cézanne, whom he (like others, including Meier-Graefe) saw as the key painter of the modern period. Fry's younger colleague Clive Bell

(1881–1963) propounded similar ideas in an even more accessible form and with a sharper doctrinaire emphasis. In *Art* (1914) and subsequent texts he put forward as given that the quality of a work of art resided in the degree to which it displayed 'significant form'. This was entirely independent of any representative function and was universal to all art irrespective of date of origin. Like Fry, Bell argued that the modern art that most clearly embodied this quality was 'Post-Impressionism' (a label Fry had invented for an exhibition in 1910) and Cézanne above all. The general effect of their ideas was to promote a 'formalist' understanding of art. Its practical result was to entrench the prestige of French art, from Manet to Matisse, with the British establishment.

Fry's and Bell's principles could be used to justify abstract art, but Surrealism, because it privileged the power of the image over that of form, could not be understood or accepted in these terms. From the mid-1920s onwards another influential English critic, Herbert Read (1893–1968), developed a critical position that took both these art movements into account, drawing on an eclectic range of philosophical and psychological sources including Bergson, Worringer, Freud, and Jung. Like Fry, Read maintained a universalist notion of the character of art. Abstract artists, he argued, developed an idealist concept of form on Platonic lines; Surrealist artists used symbolic form to reconcile the conscious and unconscious elements of the mind, revealing archetypal matter in doing so. Responding to the critical debates of the period, in his essays of the 1930s, including *Art Now* (1933) and *Art and Society* (1936), Read defended modern art as a 'revolutionary' expression of social crisis, rejecting the doctrine of Socialist Realism as being fundamentally opposed to the individual and intuitive nature of art. This position exposed him to attack by critics adopting an orthodox Marxist position, including the younger art historian Anthony Blunt (1907–83), then writing for *The Spectator*, with whom he engaged in a lively polemic on the value of Picasso's current work in 1937. Read's belief that the symbolic and formal qualities of art could be integrated led him to admire Henry Moore in particular. In the post-war era, when his critical authority was widely acknowledged, his support played a significant role in the international promotion of this artist.

Read argued that the romantic tradition in British culture gave it a distinctive quality that artists such as Moore drew on to make an original contribution to modern art. However, like Bell and Fry he understood his task as a critic partly as a combat against British provincialism: he sought to draw British art into the European mainstream dominated by Paris, both before and after the Second World War. In 1954, for instance, he argued that the work of Francis Bacon could be understood in terms of Sartrian existentialism, acknowledging the place that this philosophical tradition might have in an understanding of contemporary art. Negotiation of the status of British art in relation to Parisian models remained a constant feature of British criticism in the post-war period until the mid-1950s: then, through the writing of Patrick Heron (1920–) and Lawrence Alloway (1926–90) in particular, a critical frame of reference that acknowledged the claims of contemporary American art became gradually established. (This in turn was challenged, much later, by the critic Peter Fuller (1947–90), who in the 1980s set out to

assert the distinctiveness of British art *vis-à-vis* both European and American modernism by re-evaluating the significance of English 'Neo-Romantic' art of the 1940s.)

In Paris itself after 1945 critical debate renewed the arguments of the pre-war period, while introducing concepts that could be used to interpret new artistic initiatives such as the 'formless' compositions of Henri Michaux and Wols, and Jean Dubuffet's calculated assault on 'Western values'. Michel Tapié, in 1952, formulated the notions of *un art autre* and *l'informel* in a grand rhetorical effort to assimilate international 'gestural' painting into a continuation of the cultural defiance and existential assertion first developed by Dada. Parisian criticism of the period continued to draw on the literary and intellectual community of the city, including figures such as Louis Aragon, Jean Paulhan, and Jean-Paul Sartre (1905–80). These writers admired, in different ways, the distinctiveness and power of visual art. At the same time, they were often concerned to relate it to broad perspectives in aesthetics, philosophy, and politics over which fierce disagreements persisted. Many of these issues were debated in other artistic centres, including New York. It was a distinctive feature of the American art capital, however, that in the context of a concerted effort to establish the claims of contemporary American art on the international scene a dominant model of interpretation became gradually established over the period 1939–60. This development was closely associated with the critical writing of Clement Greenberg (1909–94).

During the 1930s the key topics for writers on modern art in the United States concerned the relationship between art and society, and the character and appropriateness of American identity in art. The leading figure in defending a 'European' concept of modern art was Alfred Barr (1902–81)—significantly, in terms of the developing pattern of art world structures, director of the new Museum of Modern Art in New York. In an essay for his catalogue of the exhibition *Cubism and Abstract Art* of 1936 Barr put forward a model for the understanding of the history of modern movements that saw art as evolving through an internal dynamic based on the exploration of new formal means. The art historian Meyer Schapiro (1904–96) challenged this model from a Marxist perspective, pointing out that even non-figurative art was based on specific social relations and ideas.

Part of Greenberg's initial brilliance as a critic was to incorporate aspects of both these positions in his defence of 'modernism'. His first essay for the influential radical journal *The Partisan Review*, 'Avant-Garde and Kitsch' (1939), argued that the self-reflexive character of modernist art and literature—their focus on medium rather than content—was a means of safeguarding artistic values from the forces of capitalism that were responsible for the debased cultural products he called 'kitsch'. The essay, like Greenberg's subsequent key texts, including 'Towards a newer Laocoön' (1940) , 'American-Type Painting' (1955), and 'Modernist Painting' (1961), combined a didactic interpretation of the history of art in the modern period with a highly confident assertion of quality in the work of the artists he singled out, including Cézanne, Matisse, Picasso, Kandinsky, and Klee. Greenberg's later texts adopt a more explicit formalist position without the radical socio-political stance of 'Avant-Garde and Kitsch'. They construct a defining narrative for modernist art that emphasizes its purely internal

logic of development. Its history, since the mid-nineteenth century, is that of rigorous self-criticism, the progressive identification of the specific character of its medium. (Like his predecessors, Greenberg drew on the philosophy of Kant to justify his arguments.) In the case of painting, this centres on the acknowledgement of the flat nature of its support. In this view, the representational content of a work of art is irrelevant to its quality—and indeed potentially obtrusive.

Part of Greenberg's aim as a critic, which became more pronounced in the late 1940s, was to assert the claims of contemporary American painting over the School of Paris. He praised the ambition and vitality of young American artists, particularly Jackson Pollock, and argued that their innovations in terms of handling, colour, and formal relations advanced the modernist project further than current French work, including that of Picasso. His defence of 'Abstract Expressionism', however, placed it firmly within a modern tradition to which pure aesthetic experience remained essential. Here the Greenbergian model contrasted sharply with an interpretation of 'New York School' painting that stressed the features of process and gesture it employed. In 1952 Harold Rosenberg (1906–78) developed the concept of 'action painting' in respect of these. He used ideas derived from existentialist thought to claim that artists such as Pollock and De Kooning were engaging in acts of self-definition through the process of art-making. It was this, rather than any aesthetic qualities, that generated the significance of their work. Rosenberg's formulation was powerful because it accounted for the 'raw' unpremeditated look of much of this art, and provided a convincing definition of its significance.

Nonetheless, Greenberg's concept of modernism was ultimately more influential, largely because it sustained the principle of aesthetic quality and placed contemporary art within a recognized tradition. In the context of a growing institutionalization of the American art world, which included the expansion of the art publishing sector, it became a key point of reference for younger critics, for museum curators, and for artists themselves. This modernist 'paradigm' was not, however, universally accepted. Crucially, it could not accommodate several of the major trends of art practice that became increasingly prominent from the late 1950s onwards. 'Pop art', 'Minimalism', and 'Conceptual art' were terms given to trends that refused the aesthetic idealism of the modernist doctrine (and proposed *inter alia* a different reading of the history of modern art). Critics of the 1960s and 1970s in the United States, such as Lawrence Alloway and Robert Pincus-Witten, writing in the influential journals of the time (*Artforum*, *Artsmagazine*, and *Art in America*), acknowledged this diversity of practice and focused on individual notions of quality in relation to it. In response to the impact of the women's movement on art Lucy Lippard (1937–), who in the 1960s was a critical advocate of Conceptual work, adopted a militant and exclusive stance in support of art by women that often failed to fit any established modern art category.

The prosperity and expansion of the international art scene in this period encouraged critical activity that identified and promoted new 'movements'. In 1960 Pierre Restany coined the opportunistic and intellectually fragile concept *le nouveau réalisme* to promote the work of Yves Klein, Arman (1928–),

and other artists who challenged the orthodoxies of the Parisian scene, currently dominated by a variety of forms of non-representational art. In 1967 Germano Celant (1940–) in Italy used the evocative but imprecise term *arte povera* to designate the work of artists, including Jannis Kounellis (1936–), Mario Merz (1925–), and Michelangelo Pistoletto (1933–), who were developing a range of innovative practices based on assemblage. A decade later Achille Bonito Oliva (1939–) launched the concept of the 'Italian Trans-avant-garde' in the review *Flash Art* to explain the eclectic and apparently regressive practices of a new generation of painters. At that time also the term 'Neo-Expressionism' became widely employed as a label for contemporary German painting that could be interpreted as a reassertion of national characteristics in art.

Both these 'movements' were associated with one understanding of the general category 'Postmodernism' that entered art world discourse in the late 1970s : the argument that after the collapse of the 'progressive' and reductive programme of modernism, contemporary art was characterized by a new freedom of expression, by a revival of figurative painting, and by the knowing and often ironic use of material drawn from the art of the past. For others, however, such as the editors of the New York periodical *October*, 'Postmodernism' is linked to a philosophical and political reflection on the character and role of art (itself problematized as a concept) in an age in which the fundamental values of Western civilization are called into question. Both these positions, but particularly the latter, involve a reinforcement of the role of criticism in relation to the art object. Donald Kuspit, who defended the new German painting in the 1980s because of its expressive power, attributes a creative role to the art critic; writers such as Hal Foster (1955–) and Rosalind Krauss (1941–) argue that theory is central to both the understanding of modern art and to its making.

It was commonplace in the 1950s and 1960s to state that New York had displaced Paris as the centre of the art world. In the 1990s it has been widely asserted that significance has shifted from centre to periphery, as the universalist assumptions of Modernism have been dismantled. It might be observed that in the process Paris has exerted a form of intellectual revenge on the United States, since many of the ideas informing Postmodernist discourse originated there, in the work of Michel Foucault (1926–84), Roland Barthes (1915–80), Jacques Lacan (1901–81), Julia Kristeva (1941–), Jacques Derrida (1924–), Jean-François Lyotard (1924–98), and Jean Baudrillard (1929–92). Each of these thinkers has written about visual art, although their principal concerns are elsewhere. Early in the twentieth century critics often had literary interests. Arguably at its end the model critic is a philosopher, like the American Arthur C. Danto (1924–), who in 1984 reflected on the implications of 'The End of Art'. This reflects changes in the art world, in which official institutions including universities have a renewed importance, and the state of art itself. Pierre Bourdieu asserted that discourse about art is 'a stage in the production of the work'. Many twentieth-century artists resisted this notion. In the last quarter of the century, perhaps temporarily, it has become orthodoxy. This discourse has been sustained, essentially, through the written word—but this may change in the digital age of the future. MG

517

Art Museums and Galleries

Curatorial style, architecture, and public awareness form an interlocking network essential to the progress of the visual arts in the twentieth century. The ascent of Modernism saw dramatic developments in the design and management of galleries and museums. The display of modernist art has been crucial to its public understanding, and both display and understanding have in turn encouraged developments in the production of art.

The period since 1914 may be divided into three main phases. In the years to 1939, when the values of high modernist art from Impressionism to abstract art were matters of public debate in the USA and Europe, major new institutional galleries were few in number but influential. Impressionist and Post-Impressionist art, predominantly French, was installed at the Barnes Foundation, Merion, Philadelphia (1922), in an extension to the Tate Gallery, London (W. H. Romaine Walker, 1926) [**728**], and at the Museum of Modern Art of the City of Paris, housed in the Palais de Tokyo, built at the time of the 1937 International Exhibition. By this date the popularity of the fine arts of all styles, combined with the political strains which led to the outbreak of the Second World War, provided a context for the wide use of painting, sculpture, design, and architecture in the definition of national political identity. Between the wars, the evolution of the arts across the West, but particularly in France, Germany, Russia, and the United Kingdom, became part and parcel of an international political arena.

In the USA, national ambitions were served by the founding, in 1929, by three wealthy patrons, of New York's prestigious Museum of Modern Art (MoMA) under Alfred Barr, director from 1929 to 1943 and director of museum collections from 1947 to 1967. In its first decade MoMA, housed in temporary premises, embarked on a programme of 'encouraging and developing the study of modern arts and the application of such arts to manufacture and practical life, and furnishing popular instruction' [**732**]. MoMA moved to its present West 53rd Street building, designed in the International Style by Philip Goodwin and Edward Stone, in 1939.

The ravages of the European war of 1939–45 left the USA in an economically superior position at the beginning of the second phase of museum building, from 1945 to about 1970. American collectors already possessed an abundance of European Impressionist and Post-Impressionist art, but now championed modern and abstract art on a scale few European institutions could match. Frank Lloyd Wright's extraordinary shrine to abstract art, the Solomon R. Guggenheim Museum in New York [**733**], was designed in 1943 and built on a corner site on Fifth Avenue (1956–9). The rapid democratization of the art museum in western Europe was spearheaded by such examples

as the one-storey Kröller-Müller Museum in Otterlo, Holland (1937–54), designed by Henry van de Velde [**729**], the extension to the Stedelijk Museum, Amsterdam (1954), the Kunsthalle in Darmstadt (Theo Pabst, 1956), the Zürich Kunsthaus extension (Hans and Kurt Pfister, 1955–8), or the pastoral ambience and setting of the Louisiana Museum of Art at Humlebaek, near Copenhagen (Jörgen Bo and Vilhelm Wohlert, 1958).

The wide spectrum of novel artistic styles and tendencies of the early and mid-1960s, from Pop to Minimal to Conceptual, from Video to Installation, coincided with further design innovations at the Kunsthalle at Bielefeld, Germany (Kaselowsky–Haus, 1966–8), the University Art Museum at Berkeley, California (Mario J. Ciampi and Associates, 1967–70), and the Hayward Gallery, London (London County Council, 1964–8), which in its controversial use of exposed pre-cast concrete announced a break with the International Style architecture and a wilful embrace of the eclectic and the irregular.

Perhaps the pre-eminent example of the International Style art museum is Ludwig Mies van der Rohe's Neue National-galerie (New National Gallery), Berlin (1962–8) [**734**], which follows his extension to the Museum of Fine Arts, Houston (1958), but in an altogether purer and more Classical style. Like the Brücke Museum (1967) of German Expressionism, in Berlin's Grunewald, the New National Gallery affirmed Germany's own contribution to modern art since the nineteenth century and helped exorcize the trauma still associated with the ban on modern art imposed by the Nazis in the 1930s. Based on Mies's sketches for a Museum for a Small City (1942), his Neue Nationalgalerie is experientially a single flexible space on two levels, reminiscent in its strong outline of K. F. Schinkel's nearby Altes Museum, and whose upper level features a lofty two-storey hall and an extensive sculpture court. Meanwhile, successive *documenta* exhibitions, the first selected by Hans Purrmann in 1955 for the Museum Fridericianum, Kassel, and staged every four or five years thereafter, promoted German aspirations to become a centre for modernist and international art.

France, curiously, was relatively slow in launching new galleries for modern art after 1945. Fiercely protective of its declining international reputation with the shift of attention to New York, the Musée Maison de la Culture at Le Havre (Lagneau, Weill, Dimitrijevic, and Audigier, 1961) became the first art gallery built by the French state since 1937. The Musée Fernand Léger at Biot (1960) and the Fondation Maeght at Saint-Paul-de-Vence (Sert, Jackson, and Gourley, 1961–4) are private institutions. France had to wait for the Centre National d'Art et Culture Georges Pompidou (Renzo Piano and Richard Rogers, 1972–7) [**730**] for a new art museum prototype, and one

which like the Hayward announced the arrival of Postmodernist thinking and a potentially more democratic attitude to high culture. Situated in the centre of the Les Halles district of central Paris, the Pompidou Centre was the model of the new populist art museum, styled with novel colours and externally exposed services, and equipped with library, cinemas, audio-visual displays, a moving escalator up the side of the building, and dramatic views across the Paris skyline.

Hence the third, Postmodernist phase of art museum building has sought to recognize the exponential expansion of cultural tourism while staging architectural innovation at a daring level. The East Wing of the National Gallery of Art, Washington, DC (Pei, Cobb, Freed, and Partners, 1978), combined bold new geometry with the new use of pre-cast concrete to constitute a dramatic focus in the nation's capital—a tendency that over the next two decades would repeat itself across the world as modern and contemporary art reached new heights of fashionability and popular access. At the same time, the rise of a new pluralism in art journalism and art history, combined with the 'return' of painting and the beginnings of a degree of heterogeneity in culture generally, made the experience of art in the gallery one of new intensities and expectations, and, with the onset of the 1980s, new markets.

The evolution of the art museum in the last two decades of the twentieth century has been dynamic indeed. The 1980s particularly saw the 'crisis' of modernism represented in a series of high-profile retrospective exhibitions of the modernist canon that had the appearance of summarizing and assimilating a tradition. The period was also characterized by an exponential rise in the commercial sponsorship of art, the growth of the crowd-pulling 'blockbuster' exhibition, and the articulation of a new museum architecture. Good examples include the Neue Staatsgalerie in Stuttgart, Germany (James Stirling and Michael Wilford, 1977–84), with its coloured detailing and mock-nostalgic references to Classical models. The same architects designed the new Clore Gallery at the Tate Gallery, London (1980–6), the dock warehouse conversion at the Tate Gallery, Liverpool (1986), and the Thyssen Gallery at Lugano, Switzerland. Other distinguished examples include the Carré d'Art in Nîmes, France (Sir Norman Foster, 1984–93), in a very different idiom to the same architect's Sainsbury Centre, Norwich, England (1977), striking a bold but elegant statement within yards of the Roman Maison Carrée. Stylistic playfulness of a new order was achieved at the wedge-shaped Museum of Modern Art in Frankfurt (Hans Hollein, 1987–91) [**731**], which combined virtuoso handling of internal space with a conventional collection of post-war art from Johns and Warhol through

to a generation expressive of German-American domination of the art industry in the 1980s, the generation of Thomas Ruff and Bill Viola. Hollein also designed a Guggenheim Museum for Salzburg, Austria, still not built by the end of the 1990s.

The 1990s have witnessed a range of spectacular, elegant designs by Richard Meier: the Museum of Contemporary Art, Barcelona (1991), carved controversially out of an old working-class district around the Placa dels Angels; the Arp Museum at Rolandseck, Germany (from 1997); and the new Getty Museum complex at Santa Monica, California (1997). The Solomon R. Guggenheim Museum undertook a high-profile programme of expansion, first at the SoHo Guggenheim, New York (a distinguished nineteenth-century building remodelled by Arata Isozaki in 1992), then with Gwathmey Siegel's extension and tower at Fifth Avenue (1992), based on Wright's original schemes for an annexe, and thirdly with Frank Gehry's Bilbao Guggenheim in the Basque capital of northern Spain (1994–7) [**735**]. Bilbao uses a system of sand-blasted stainless steel panels already tested at Gehry's Frederick R. Wiesmann Art and Teaching Museum for the University of Minnesota, but based on the teetering organic shapes of the fantastic architecture first sketched by Vladimir Krinskii, Boris Korolev, and others (but never built) after the Russian Revolution in 1917. In this respect it is ironical that Bilbao houses a collection of predominantly American art—with Spanish and Basque modernism seen as lying outside the post-war canon. Yet the vogue for ever more spectacular art museum projects looks set to continue. The far more sober Tate Gallery of Modern Art, London (Herzog and de Meuron, due to open in 2000), will be the United Kingdom's entry in the race for prestige deriving from large-scale cultural patronage. Other mega-museums will doubtless follow.

Despite enthusiastic notices in the architectural press, critically and historically informed responses to Modernist and Postmodernist museums have been few in number. A statistically informed sociology of art developed by Pierre Bourdieu in his *The Love of Art: European Art Museums and their Public* (in French 1969, English translation 1991) correlated participation in art galleries with education and class. Relations between art museums and cultural power were themselves the concern of conceptual and other artists in the later 1960s and periodically since. Michael Asher and Hans Haacke, and more recently Louise Lawler and Andrea Fraser, have contested institutional structures and the aesthetics of viewing through their work. Anthropologists have made comparative studies of ethnographic and art museums. The nature of the impact upon art museum culture of the new technology, particularly CD-ROM and the world-wide web, remains open to speculation. BT

The spectacular museum

From the 1920s to the 1990s art museums functioned as showcases of contemporary architecture and design. No longer austere institutions for mere scholarship and conservation, they often became spectacular sites for the culturally ambitious, for tourists, and for an expanding leisure class.

The Modern Foreign Galleries at the Tate [728] extended the Classical idiom of the original Victorian building but with improved lighting in the roof.

The Kröller-Müller Museum at Otterlo, completed in 1954 [729], brings to the art museum an elegant rational style to match its exemplary holdings of De Stijl and other works; an extensive sculpture garden offers fresh air and perambulation. By the 1970s and the Georges Pompidou National Art and Culture Centre, Paris [730], art museum architecture had become entertaining in its own right, here combining the technological iconography of the oil refinery with pop colours and styling, the whole set amongst traders and jugglers at street level.

No less eclectic and Postmodern, Hans Hollein's Museum of Modern Art, Frankfurt [731], completed in 1991 on a difficult street-corner site near the city's banking district, resembles part prow of a ship, part slice of cake. BT

520

728 Modern Foreign Galleries (1921–6), Tate Gallery, London

729 Below: Kröller-Müller Museum, the sculpture garden (1937–54), Otterlo, Holland

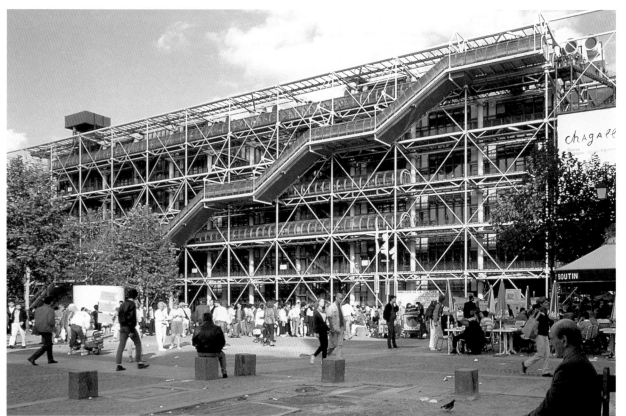

730 Georges Pompidou National Art and Culture Centre (1972–7), Paris

731 Below: Museum of Modern Art (1987–91), Frankfurt

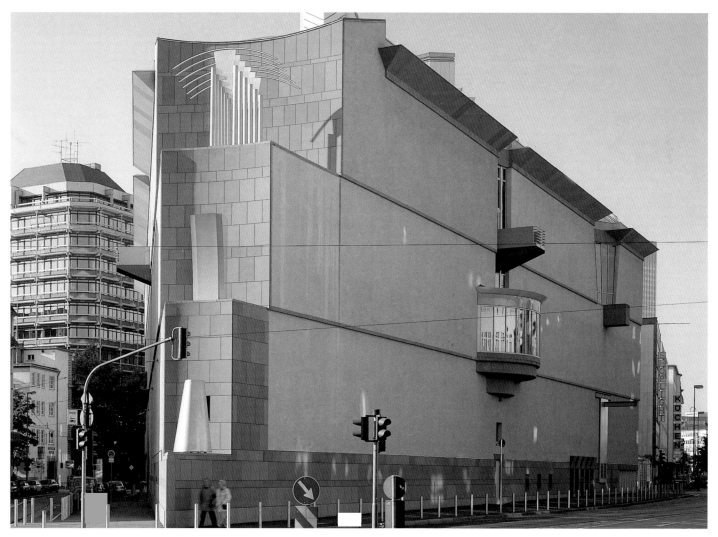

The museum space

As art museums became secular shrines devoted to the challenging and the familiar alike, the condition of the viewing space underwent rapid change.

The early exhibitions at the Museum of Modern Art under A. H. Barr [732] were usually chronologically hung: through shows such as 'The International Style' (1932),

'Cubism and Abstract Art' (1936), and 'Art of Our Time' (1939), MoMA promoted 'modern' art according to an organizing narrative passing from Fauvism and Cubism to Abstraction and covering design and manufacture as well as architecture. They were also disposed on white, decoration-free surfaces in well-lit spaces that connoted rationality and order.

An early departure from the International Style interior was

522

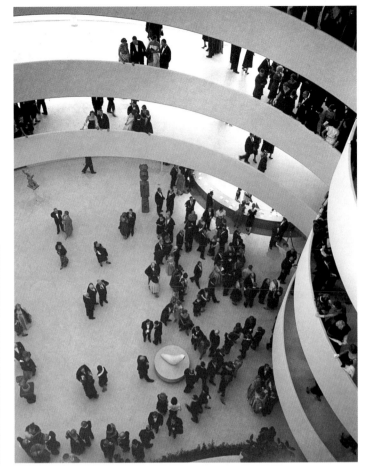

732 Above: The Museum of Modern Art (1929), New York, Installation view of the exhibition 'Cubism and Abstract Art', 2 March–19 April 1936

733 Above right: Solomon R. Guggenheim Museum, New York (1956–9), interior space, inaugural opening of the Solomon R. Guggenheim Museum, October 21, 1959

734 Right: New National Gallery (1962–8), Berlin

Frank Lloyd Wright's Solomon R. Guggenheim Museum, completed in 1959 [**733**]. It was intended from the outset to be a 'temple of the spirit', marshalling Western liberal and spiritual values in opposition to the vast Moscow-dominated east-European public with access only to figurative 'realist' art. Wright's architecture notoriously provided sloping and curving walls for pictures, surrounding a bowl of space no less attractive to visitors than the works themselves. The last major statement of the International Style art museum was Mies van der Rohe's New National Gallery in Berlin [**734**].

By the time of Frank Gehry's Bilbao Guggenheim, completed in 1997 [**735**], the experience of the gallery was one of spatial complexity perhaps unequalled in any other building type, and rivalling if not exceeding that of works of art them-

selves. The rise of spectacular art museum architecture finds further expression at Steven Holl's compact and elegant Museum of Contemporary Art, Helsinki (1998).

BT

735 Guggenheim Bilbao (1994–7), Bilbao, interior view

Epilogue

The opening image in the first part of this book shows the 'Elgin Marbles' from the exterior of the Parthenon in Athens in the grand interior of the Duveen Room in the British Museum. Lord Elgin, whose name is inescapably attached to the carvings, acquired them in 1801–3 from the Turkish authorities who were then in control of Greece. Lord Duveen, whose riches paid for their reinstallation in 1962, was the leading dealer in Renaissance Masters in his generation, aided and abetted in the identification and export of art from Italy by Bernhard Berenson (1865–1959), the Lithuanian-American art historian who was a leading authority on Italian Renaissance painting. The final picture shows the Guggenheim Museum, opened in Bilbao in 1997. Financed by the trust established by the American philanthropist Solomon R. Guggenheim, whose family fortune derived from the mining and smelting industries, it is one of four Guggenheim Museum buildings world-wide, devoted to the display of modern American and European art. The first was Frank Lloyd Wright's spectacular spiral structure in New York. Frank Gehry's titanium extravaganza in Bilbao comparably sustains the idea that a temple for art should proclaim itself to be a work of art. As a self-consciously sensational object in a historic city, it simultaneously sustains Solomon Guggenheim's ambitions for his beneficence to outlive him, proclaims the cultural capital of high art in the Western style, stands as a monument to Gehry's architectural creativity, and acts as a key visual sign of Basque international status within Spain.

This framing of the body of the book by images which speak not just of the works of art within their own time but also of the roles of wealthy and aristocratic collectors, enterprising dealers, historians, and museums, was not deliberately planned from the outset, but it does make a telling comment on how our experience of art of the past and present is dependent on a series of agencies which have determined what has survived, who can aspire to possess it, where it has been located, the settings which affect how it looks, and the framework of ideas within which we attune our viewing.

On the face of it, works that are still in their original settings, like the Sistine ceiling by Michelangelo which provides our frontispiece, should be visible with the intervention of fewer of these agencies. Indeed, the striking and controversial campaign to clean the ceiling, under the sponsorship of Nippon Television from Japan, was founded on the premiss that it would allow us to see the 'original' released from a veil of grime in a way that had not been possible since the early years of its existence. However, any visitor to the Chapel after its unveiling to the public—squeezing into the space through a narrow side corridor, jostled by fellow cultural tourists, scolded to keep quiet

in multi-lingual announcements triggered automatically by the Babel of tongues, and encouraged to purchase paraphernalia of Michelangelo merchandising on departure—is hardly enjoying an experience which shares much with the circumstances that the artist and patron envisaged. Michelangelo's great images of the beginning of it all, the Creation and the Fall, were commissioned to decorate the vault of the prime chapel in Christendom, in which the supreme Pontiff held personal sway over acts of spiritual devotion and paraded his ecclesiastical might in company with his cohorts of cardinals. Experiencing the Sistine ceiling as Michelangelo's great masterpiece of art on a visit to the Vatican Museums is to set it in a very different framework for viewing than that of a Renaissance worshipper in the chapel of the papal court. Faced with such later transformations, the primary job for art history is to work backwards in time towards the visual, social, political, and spiritual environments which the works were designed to inhabit, helping us to look with what has been called the 'period eye'.

This book has aspired to help the reader view an exceptionally large number of artefacts through the lenses of past and present, using an understanding of how we have come to interpret art to refine our ability to recover its meaning within its historical context—to the extent that such a recovery is ever possible. The viewing of art is a questing business, with every viewer potentially an active participant. In this quest, the questions that are posed are as important as the answers which we have suggested for the reader's consideration.

Continuity and change

The earliest two-dimensional image in the book depicts funerary rites in Attica, involving schematic figures and horses disposed in linear rhythms around a ceramic vessel which marked the site of burial. The first sculpture, a marble *kouros* from Attica, also served a memorial function, commemorating a slain warrior named Kroisos. If we then turn to two later images that demonstrate the complex naturalism subsequently developed by ancient artists, the dynamic painting of Persephone's abduction by Hades and the affecting Roman marble of a mortally wounded Celtic trumpeter (based on a bronze by Epigonos of Pergamum), we can see that notable 'developments' have taken place in the handling of motion in space, facility in handling the medium, and, above all, in the verisimilitude with which the human figure can be represented.

If we then look at a quartet of four of the most recent works of art—a figurative painting by Eric Fischl [**712**], an abstract canvas by Peter Halley [**721**], the shiny metal rabbit by Jeff Koons [**718**], the exploded shed in a state of suspension by

Cornelia Parker [**719**]—we can discern a number of features which can be recognized as relevant to the viewing of the ancient works. The eloquence of simplification in the toy-like *Rabbit* plays on an enduring pleasure in the way that minimal criteria of resemblance can evoke potentially complex reactions in the spectator. The geometrical abstraction by Halley testifies to our puzzling but enduring fascination with shape in relation to shape, figure to ground, colour to colour, even in the absence of recognizably figurative elements. The picture of the interior with forms modelled in directional light stands at the end of a long tradition in which artists have striven to transform paint into illusion without losing its qualities as paint. The debris of Parker's exploded shed and its contents are seen as if in a moment of suspended time, a feature of any static piece of art which deals with some kind of narrative.

Yet the differences are enormous, above all in the way that the later artists have positioned the prime features of the works in relation to their function in the world of art. Koons's simplification 'with a smile' is knowingly in dialogue with notions of 'high art' and with developed naturalism in the depiction of animals, as achieved by generations of sculptors. Halley's painting self-consciously refers back to earlier modes of minimalist abstraction through the figurative representation of the elements of electronic circuitry. Fischl's figuration embodies a deliberate stance in relation to non-figurative art and the business of making a painting out of paint, while Parker has made an 'installation', a form of art which treats the space of a gallery as a site for a kind of theatre of artefacts, in a way that has no precise counterpart in earlier centuries. What the four apparently disparate works by the modern 'masters' have in common is their existence in an artistic climate where very diverse styles, media, and meanings co-exist (even sometimes in the *œuvre* of one artist), and their knowing references to the aesthetic criteria which have been devised to characterize the history of art. However, we have seen that even in Classical antiquity later artists self-consciously referred back to older modes, not simply as sources to imitate but in order to evoke the character of the images as objects embodying characteristics from other ages. In almost every respect, it is notable how what we take to be the distinguishing qualities of the art of later ages can be discerned, at least in embryonic form, in the range of proclivities exhibited by artists and commentators in ancient Greece and Rome.

By saying that qualities are apparent in 'embryonic form' is immediately to imply that the metaphor of human development —embodying birth, growth, maturity, and death—is applicable to the story of art. In the introduction, we touched on the

problem of development, with the related notion of progress, and I think it will provide a fitting epilogue (very much not a *conclusion*) to look back on the journey we have made, asking whether we have witnessed a kaleidoscopic succession or taken part in a relentless progression.

Succession and progression

Not everything that has eventually proved possible in art has been possible at any one time in its history, even though at the time in question (just as now) contemporaries tended to think that everything that they were already doing encompassed everything that was conceivable. For instance, there was no free-standing genre of landscape painting in the Middle Ages. Given the functions for art, the painting of an accurate topographical rendering of a scene in the countryside simply had no independent role to play in a church setting, and domestic arts were as yet not concerned with pastoral views. One reason why art changes—as in the development of landscape painting to a point of independent status in the seventeenth century—is that artists, and those involved with the processes through which art comes into being and is viewed, effect change through the creative exploration of new territories, redefining the boundaries of art. The roles of the artist, patron, and other agencies are necessary causes for change, but do not provide a sufficient explanation in themselves for why change occurs. One of the jobs of the history of art is to look at the complex substratum of conditions which lay out the boundaries of the political, social, financial, religious, intellectual, and aesthetic fields within which change can germinate and flourish. There is no set formula to explain change. The pointing to any defined cause can inevitably be trumped by the question, what caused that cause to come into being? Each case has to be looked at on its own merits, within the complex and often chaotic ecology of its own time, always allowing that images can play a formative role in the interactive dynamics of this ecology and do not simply serve as passive vehicles for other factors which serve to determine the stabilities and instabilities in the environment.

The biological metaphor which we have noted previously, and which enjoys a wide if generally casual usage—as in 'the birth of Renaissance' or the 'rebirth of perspective'—can be used, judiciously, to help us examine the question of change versus progress. Art certainly 'evolves', in the sense that we can trace lines of descent of styles, motifs, media, and so on. Although biological evolution has been seen in terms of the 'ascent of man', implying that it proceeds towards the 'highest' form of intelligent life, it is more properly characterized in terms of mutations, diversification, specialization, extinctions,

survivals, and complexity (on an individual and collective basis). There is no reason to think that a 'primitive' life form, originating millions of years before man and still surviving today, is less successful than 'man', and it may be that if we induce catastrophic changes in the environment that the 'primitive' forms will prove more robust than the complex ones. The amoeba, in this scheme, is not to be ranked 'lower' than humans, but it can be properly characterized as less evolved.

If we take this view of evolution into the visual arts, we can see some broad equivalents of mutation, diversification, specialization, extinctions, survivals, and complexity. Some simple, early forms, such as patterned decoration, survive throughout the ages, while others, such as a polyptych altarpiece with predella panels, are no longer a current form (apart from occasional archaizing revivals). There are discernible evolutions with respect to forms, styles, subject-matter, meaning, and so on. If we take the altarpiece again, we can see the transformation of the many-panelled altarpiece into a more unified form, centred on a dominant single image of figures set in perspectival space. Perspective itself is an example—perhaps the prime example— of a technique that was invented, perfected, and successively explored in more complex forms. The ability of Dutch seventeenth-century artists to construct complex interior spaces and locate objects at various angles according to the rules of perspective far exceeded in technical terms what Masaccio had been able to accomplish in the early fifteenth century. Yet we do not say that Masaccio was a lesser artist than a skilled technician of seventeenth-century perspective, and it is misleading to see Masaccio as providing the first step on the road to the Dutch achievements. It is not right to see any intervening painting as standing in a 'transitional' position or 'anticipating' later developments. No artist ever makes 'transitional' or 'anticipatory' works. The work they are making is for there and then, something that is meant to have its own validity in itself, not as a 'stepping stone'. It is only when later artists take up and develop facets of an earlier work that it apparently becomes located within some kind of sequence or development. There is no inevitability in any line of development; it is just that later achievements may make it seem inevitable.

There are successions that can be characterized as developments in all aspects of artistic production. Subject-matter typically becomes more wide-ranging, embracing themes not previously tackled, though some subjects (such as some of the more obscure moral tales from Classical antiquity favoured in the academies) effectively become obsolete. The portrayal of narrative goes through phases during which more complex and subtle effects supersede basic story-telling, but can also be subject to waves of resimplification. Portraiture, to take another example, undergoes major developments towards increasing verisimilitude, both in ancient Rome and from the Renaissance to the nineteenth century, but can also undergo reversals into schematization. The ability of artists to exploit each medium also increases, through an accumulation of knowledge and experimentation with techniques (as with bronze casting), and, more generally, the range of available media has progressively expanded over the ages. The advent of new media stands in a complex relationship to the invention of new technologies. On the one hand, the quest for new effects may lead to the discovery

of new media, while on the other a new medium can arise quite independently of artistic usage (computers, for example) and subsequently be adopted to achieve new effects. In most cases, neither of these models prevails in their simplest form. We have also seen huge developments in the way the written word can be brought to bear on artefacts, and in the producers' related consciousness of aesthetic and institutional values as promoted by the industry of art. This consciousness is not readily subject to loss or reversal.

The limits of the evolutionary model are as apparent as its utility. Artistic change is driven by purposeful agents who manifest intention, not by unplanned mutation and natural selection. Any laws of progress, towards greater complexity or mastery of space, for instance, can be wilfully reversed by an artist who aspires to revive the 'purer' values of an earlier age. A recurrent dynamic of change has been the revival of earlier modes, whether the Renaissance quest for a style to equal the ancients or Picasso's adoption of features from 'primitive' sculpture. The revivals could lead to new complexity or new simplification.

There is nothing in art that corresponds in a one-to-one way with the species that provided Darwin with his fundamental unit, nor the gene, more recently touted as the basic entity. We could see artistic species defined through various criteria, such as medium, format, genre, subject-matter, location, and so on. The varieties of taxonomies adopted by different slide and photographic collections, and the different types of taxonomy often found in parts of the same collection, show that we are not dealing with something that submits itself to the same kind of taxonomic ordering as biologists have devised for the products of natural evolution.

What we see in art, therefore, are successions which may sometimes be reasonably characterized as evolutionary developments or embodying development in one or more of their aspects, but we are not seeing progress, if progress carries the implication of something proceeding to a better or higher state. Indeed, a development in art might, as we noted, consciously overthrow the 'advanced' in favour of the 'primitive'. Above all, the super-abundant creativity we have witnessed in the book—creativity which can delight or disturb, revive the old or invent the new, meet or offend the aspirations of entities and individuals of every kind—ultimately undermines any absolute faith we place on the interpretative generalizations that we use to approach the works. We cannot make any active approach without pre-established expectations. The dilemma for the art historian is to refine our expectations so that our modes of looking are enriched without laying down rigid prescriptions for what we *ought* to see.

Commissions and omissions

It would be wrong to end with an apology, since the authors have, I believe, collectively presented a rich spectrum of art and interpretative strategies. But it is fair to acknowledge that exclusions have been made, some on the basis of deliberate if uncomfortable decisions and some out of editorial ignorance (which are unrecognized and therefore unacknowledged).

The position of Byzantium has presented a problem. The decision to centre the history of European and (later) Western

developments explains why the Byzantine art of Turkey and the 'Near East' have not been covered. The early traditions in East Asia and, particularly, Russia, are also excluded, though Russia features when it 'rejoins' the European mainstream. Celtic art features patchily, and I greatly regret that the reader is not introduced to some of the beauties of Celtic metalwork in the centuries before Christ. Although we have looked at the out-reach of Western art into some non-Western areas, we have not attempted to cover the 'Far East', where the traditions are of such historic richness that they would have needed to be tackled in their own right. I am conscious that readers from a number of countries, regions, and groupings that have not been discussed in themselves will feel that their story has not been told.

To a large extent, any book such as this is dependent on its own kind of laws of supply and demand. Those areas which are most richly represented in the literature become best known and inevitably command the editor's attention. In commissioning sections of text and picture groups, the prior existence of expertise plays a powerful shaping role on what can be done. Inevitably, we have given an overview of the state of the discipline of art history, at least as perceived by the editor, as well as an overview of Western Art. Accepting that any history, however comprehensive, is partial in both coverage and attitudes, I have not attempted to iron out the individuality of views expressed by authors, since it is better that the reader is aware that we are all in the business of enthusiastic interpretation rather than disinterested summary.

Ultimately, there is no reason to look at art. It does not fill our bellies, keep us warm, or stave off disease. But many of us cannot stop doing it, and it clearly meets fundamental human needs visually, intellectually, and psychologically. This book is designed to assist in meeting those needs. MK

527

Chronology

Artistic events		The contemporary world
Proto-Geometric period in Greek art *c.***1100–***c.***900** Geometric patterns in vase painting		Greeks trade with east, adopt Phoenician alphabet, develop cities, colonies, aristocratic rule
Geometric period in Greek art *c.***900–700** Animals, then human figures introduced		
Orientalizing period in Greek art *c.***700–600** Egyptian and Middle Eastern influences, aristocratic patronage	776	Traditional date for first Olympic Games
	*c.*700	Greeks colonize Sicily and southern Italy; rise of Greek tyrants; Corinth leading power
*c.*630 Earliest known marble kouroi	630	Greek colony of Naukratis in Egypt
Archaic period in Greek art *c.***600–480** Kouroi and korai; black-figure, then red-figure in vase painting; patronage by tyrants		
	*c.*600	Rise of Athenian power
*c.*520 Red-figure replaces black-figure	510	Republican revolution at Athens
	490	Persians repulsed at battle of Marathon
Classical period in Greece *c.***480–323** Flourishing of the arts in rising Athenian empire	480	Persians defeated at battle of Salamis
	478	Beginnings of Athenian empire
447 Work begins on Parthenon	449	Pericles inaugurates Athenian building programme
	431	Peloponnesian War between Athens and Sparta begins
	404	Athens defeated
	399	Socrates condemned to death
Flourishing of arts through Macedonian patronage		Alexander the Great rules Macedon 336–323 (invades Asia 334)
Hellenistic period in Greek art 323–168 Dissemination of Greek culture and flourishing of arts, particularly in Macedonia, Egypt and Pergamon		Hellenistic rulers dominate the eastern Mediterranean 323–168
	279	Celts invade Greece
	237	Attalos I of Pergamon defeats Celts
*c.*210 Conquests and looting in Sicily and southern Italy bring Greek art to Rome for public and private display; Greek artists in Rome; Roman arts flourish	212	Romans take Syracuse in Sicily
	209	Romans take Taranto in southern Italy
		Late republican Rome 2nd–1st centuries BC
	168	Rome conquers Macedon
	146	Southern Greece a Roman province
	133	Pergamon a Roman province
Pompeian paintings *c.*100 BC–AD 79	33	Egypt becomes a Roman province
		Imperial Rome 1st–5th centuries AD
AD 40 Triumphal arch of Tiberius	AD 64	First persecutions of Christians in Rome
	AD 79	Eruption of Vesuvius buries Pompeii, Herculaneum, Boscotrecase, Stabiae
AD 112 Trajan's Column		
*c.*AD 200 Catacomb paintings of Christian subjects		
*c.*AD 240 Murals of biblical subjects in the baptistery at Dura-Europos (Syria)		
*c.*AD 250 Christ-Helios mosaic in mausoleum of the Julii in the necropolis of S. Peters, Rome		

The contemporary world

303–5	Last Roman persecution of Christians
c.AD 319	Constantine's basilica of S. Peter on the Vatican Hill
AD 330	Constantinople founded
AD 395	Final split between east and west in Roman empire
AD 407	Germanic tribes invade west
AD 410	Rome sacked by Visigoths
	Christian missions to Ireland, early 5th century
476	Last western emperor deposed
498	Clovis, king of the Franks, baptized
540	Ravenna captured by Byzantium
568	Lombards invade Italy
596	S. Augustine undertakes mission to the Anglo-Saxons
711	Muslims seize Spain
	Iconoclast controversy in Byzantium 726–843
735	Christian missions to Germany
	Charlemagne makes Frankish kingdom into a European empire 772–814
840	Treaty of Verdun divides empire between Charlemagne's grandsons
910	Abbey of Cluny founded; Vikings settle in Normandy
	Bohemia, Poland, and Hungary christianized 950s–980s
962	Otto I, king of Germany and Italy, crowned Holy Roman emperor
1054	Schism between Greek Orthodox and Latin Christians
1066	Norman conquest of England
	Christian Reconquista of Spain from Muslims 1085–1492
	First Crusade 1095–99
	S. Dominic 1170?–1221
	S. Francis of Assisi 1182–1226
	Pope Innocent III consolidates church power 1198–1215
1204	Western Crusaders seize Constantinople from Byzantines
	S. Thomas Aquinas *c*.1225–74
	Mongols conquer Russia 1236–40
1264	Feast of Corpus Christi instituted
1290	Work begins on Florence Cathedral
1291	Muslims take Acre, last Crusader state in Palestine

Artistic events

AD 315	Arch of Constantine in Rome
c.AD 359	Sarcophagus of Junius Bassus
AD 388	Silver missorium of Theodosius I
	Illuminated manuscripts in Byzantium early 5th century
	Vatican Vergil illuminated early 5th century
c.425	Decoration of mausoleum of Galla Placidia, Ravenna
c.490	Mosaic decoration of S. Apollinare Nuovo, Ravenna
	Mosaics of Justinian and Theodora, S. Vitale, Ravenna 547–8
	Gospels of S. Augustine illuminated late 6th century
	Romanesque style 6th–12th centuries Relief sculpture as architectural ornament; decorative painting, especially manuscript illumination; accent on pattern, simple forms, and emphatic narrative
	Book of Kells illuminated 8th or 9th century
	Manuscript illumination flourishes in Byzantium *c*.950–*c*.1200
	Gothic style 12th–15th centuries Stained glass, manuscript illumination, architectural sculpture, wall painting, all largely linear and stylized
	Abbey Church of Saint-Denis glazed 1140s
1181	Nicholas of Verdun signs the Klosterneuburg ambo
1220	Glazing completed in eastern arm of Canterbury Cathedral
	Chartres Cathedral glazed *c*.1220–35
1260	Nicola Pisano completes Pisa baptistery pulpit
	Renaissance style 14th–16th centuries Intense development of naturalistic styles and perspective; rise of the individual artist

Artistic events	The contemporary world

Artistic events

1300 Giovanni Pisano completes the S. Andrea Pistoia pulpit; *c*.1300 yellow stain introduced for stained glass
Giotto: Arena chapel frescoes in Padua 1305–13

York Minster nave glazed 1307–39
Duccio's *Maestà* for Siena Cathedral 1308–11
Franciscan church of Königsfelden glazed *c*.1325–30
1336 Andrea Pisano completes doors for Florence baptistery
Ambrogio Lorenzetti's *Allegory of Good and Bad Government* 1337–40

Bourges Cathedral, New College, Oxford, and Winchester College glazed in the 'international style' *c*.1380–*c*.1400

1403 Lorenzo Ghiberti: second set of Florentine baptistery doors
Donatello: *S. Mark* (Florence, Orsanmichele) 1411–13
c.1413 Brunelleschi's experimental perspective panels
1423 First dated woodcut
Masaccio and Masolino: Brancacci chapel frescoes *c*.1424–7
Lorenzo Ghiberti: third set of Florence baptistery doors 1425–52
Masaccio: *Trinity c*.1426–7
1428 Piero della Francesca completes *Flagellation of Christ*
1434 Jan Van Eyck: *Arnolfini Marriage Portrait*
1435 Leon Battista Alberti: *Treatise On Painting*
1437 Filippo Lippi: Barbadori altarpiece
1438 Fra Angelico: S. Marco altarpiece

1446 First dated engraving
1453 Installation of Donatello's equestrian monument to Gattamelata
First monogrammed engravings *c*.1460s

1475 Mantegna: *Camera degli Spori*
1481 Leonardo da Vinci: *Adoration of the Magi*; *c*.1481 Peter Hemmel commissioned to make Volkammer window for the parish church of S. Lorenz, Nuremberg
1495 Albrecht Dürer visits Italy; installation of Andrea del Verrocchio's equestrian monument to Bartolommeo Colleoni
1497 Leonardo da Vinci completes *Last Supper*
1498 Publication of Dürer's *Apocalypse* in Nuremberg
c.1500 First etchings

1504 Installation of Michelangelo's *David*
1505 Giovanni Bellini: S. Zaccaria altarpiece
Albrecht Dürer in Italy 1505–7
1508 First dated chiaroscuro woodcut
Michelangelo: Sistine chapel ceiling frescoes 1508–12
Raphael: Stanza della Segnatura 1509–12
1511 Publication of Dürer's *Life of the Virgin* in Nuremberg
1513 First dated etching; Dürer: *Meisterstiche* 1513/14
Titian: *The Assumption of the Virgin c*.1515–18

Raphael: Loggia di Psiche 1517–19
Andrea del Sarto in France 1518–19

Mannerist style 16th century Exaggerated stylishness in colour and form
1527 Jacopo Sansovino arrives in Venice
Rosso Fiorentino in France after 1530
1532 Holbein settles in England
Primaticcio in France after 1532
1534 Michelangelo leaves Florence for Rome; Bandinelli's *Hercules and Cacus* unveiled
Michelangelo: *Last Judgement* (Sistine chapel) 1535–41

1537 Holbein becomes painter to Henry VIII
Benvenuto Cellini in France 1537, 1540–5

The contemporary world

1302 Boniface VIII claims absolute power for the papacy
1305 Philip IV of France detains Boniface VIII at Avignon: 'Babylonian Captivity' of the popes until 1377

1308 Dante begins *Divine Comedy*

Hundred Years War: 1338–1453
The Black Death 1348–9

1387 Chaucer begins *Canterbury Tales*
1396 Revival of Greek in Florence

Brunelleschi's dome for Florence Cathedral 1420–30

1434 Cosimo de' Medici becomes dominant in Florence

1453 Ottoman Turks take Constantinople
c.1456 Guttenberg prints Bible
Lorenzo the Magnificent rules Florence 1462–92
1469 Translation of Plato's *Dialogues* begins

1492 Columbus sails to the Caribbean
1494 Charles VIII of France invades Italy

1497 Jean Cabot reaches Labrador
1498 Vasco da Gama reaches India
1500 Erasmus: *Adagia*
1501 First African slaves to Caribbean
Portuguese create trading empire in Indian Ocean and far east 1505–15

1511 Erasmus: *In Praise of Folly*

1514 Smallpox arrives in South America
1516 Machiavelli: *The Prince*
1517 Protestant Reformation begins: iconoclasm in northern Europe
1519 Hernán Cortes seizes Mexico City
1523 Reformation reaches Switzerland
1527 Troops of the Holy Roman emperor Charles V sack Rome
1528 Baldassarre Castiglione: *The Courtier*
1529 Ottoman Turks reach gates of Vienna
1532 Rabelais: *Pantagruel*
1533 Rabelais: *Gargantua*
1534 Henry VIII supreme head of church in England; Jesuit Order founded
1536 Lutheranism reaches Scandinavia; dissolution of the monasteries in Britain 1536–40

The contemporary world

1541	Calvin begins preaching in Geneva
1543	Copernicus: *De revolutionibus*; Vesalius: *De corporis*
	Council of Trent defines Catholic doctrine 1545–63
1549	Jesuit missionaries reach Japan
	Philip II rules Spain 1556–1598
	Elizabeth I rules England 1558–1603
1559	Amyot's translation of Plutarch's *Lives*; Huguenots establish French synod of reformed churches
1566	Church of the Netherlands founded
1572	St Bartholomew's Day massacre
	Dutch revolt against Spanish rule 1572–1648
1580	Spain annexes Portugal
1588	England defeats Spanish Armada
1590	William Shakespeare begins writing
1594	Edict of Nantes
1600	English East India Company formed
1601	Jesuit missionaries reach China
1602	Dutch East India Company formed
	French and English colonies founded in America, early 17th century
1609	Kepler: *New Astronomy*
1610	Galileo: *Starry Messenger*
	Thirty Years War 1618–48
1623	Pope Urban VIII Barberini elected
1626	Dutch found New Amsterdam (becomes New York 1664)
	English Civil War 1642–51
	Louis XIV rules France 1643–1715
1644	Descartes: *Principles of Philosophy*
1649	Charles I beheaded
1652	Dutch settlement established in South Africa
	Cromwell rules England 1653–8
1660	Restoration of the English monarchy
1667	Racine: *Andromaque*
1669	Work begins on Versailles
1670	Spinoza: *Tractatus Theologico-politicus*
	Christopher Wren: S. Paul's Cathedral 1675–1710
1683	Ottoman Turks repulsed at Vienna

Artistic events

1550	1st edn. of Vasari's *Lives of the Artists*; *c*.1550 wall-paintings in Ixmiquilpan church, Hidalgo, Mexico
	Pieter Brueghel in Italy 1551–*c*.1554
1554	Cellini's *Perseus and Medusa* unveiled
	Titian: *Diana and Actaeon* 1556–9
1557	Ludovico Dolce publishes *Aretino*
	Pietro Candido (Pieter de Witte) in Italy *c*.1558–86
	Giambologna (Jean Boulogne) in Italy after 1558/9
1560	Ammannati wins competition to execute *Fountain of Neptune* in Piazza della Signoria, Florence; *c*.1560 Denis Calvaert visits Italy
	Giuseppe Arcimboldo in Vienna and Prague 1562–87
1563	Accademia del Disegno founded in Florence
	Bartolomeus Spranger in Italy 1565–75
1568	2nd edn. of Vasari's *Lives of the Artists*; *c*.1568 Pieter Brueghel: *Peasant Dance*
	Karel van Mander in Italy 1573–*c*.1577; Friedrich Sustris in Munich after 1573
	Hans von Aachen in Italy *c*.1574–*c*.1591
1579	El Greco: *Trinity*
?1580	Fernando de Alva Ixtlilxóchitl produces illustrated *Codex Ixtlilxóchitl*
	Leone Leoni in Spain 1582–89
1583	Giambologna's *Rape of the Sabines* unveiled
	Federico Zuccaro in Spain 1585–88
	Hendrick Goltzius in Italy 1590–1
	Annibale Carracci: Farnese Gallery ceiling 1597–1600
	N. Hilliard publishes *Arte of Limning* 1598–1602/3
	Baroque style inaugurated *c*.**1600** Blends naturalism, idealization, complex space, and ornament
	Rubens in Italy 1600–8; Annibale Carracci and Caravaggio: paintings for the Cerasi Chapel, S. Maria del Popolo, Rome *c*.1600–1
1604	Isaac Oliver becomes linmer to Queen Anne of Denmark
c.1605	Bernini arrives in Rome
	Jesuits train artists in the Paraguay-Paraná basin 1610–1767
	Rubens: *The Descent from the Cross* 1616–17
1623	Velázquez appointed court painter to Philip IV
	Rubens in London 1629–30
1632	Van Dyck becomes painter to Charles I of England
	Pietro da Cortona: *Divine Providence* ceiling fresco 1633–9
	The Dutch painter Albert Eckhout in Brazil 1637–44
	Zurbarán paints cycles of Carthusian subjects at the monasteries of Jerez de la Frontera and Guadalupe 1638–9
1642	Rembrandt: *The Night Watch*; Invention of mezzotint
	Bernini: decoration of the Cornaro Chapel 1645–52
1648	Royal Academy of Painting and Sculpture established in Paris
1656	Velázquez: *Las Meninas*
1661	Peter Lely becomes painter to Charles II of England
	Charles Lebrun directs the French Royal Academy of Painting and Sculpture 1663–83
1665	Bernini visits Paris; Vermeer: *Allegory of Painting* ?*c*.1665–?*c*.1670
1666	French Academy established in Rome
	Murillo: *Works of Charity*; church of the Charity Hospital, Seville 1667–70
	Baciccio: Gesù vault fresco 1676–9

	Artistic events		The contemporary world
		1687	Newton: *Principia Mathematica*
	Andrea Pozzo: S. Ignazio vault fresco 1691–4		
1692	First auction house in London		
	Rococo style spreads from France to Austria, Germany, and Italy, early 18th century Elaborate complexity, ornamental foliage, scrolls, shells		War of the Spanish Succession 1701–14
1717	Watteau: *Pilgrimage on the Island of Cythère*		
	Annual Salons at the Salon Carée of the Louvre 1737–51	1735	Hogarth's Copyright Act
			Maria Theresa rules Austria 1740–80;
			Frederick II rules Prussia 1740–86
	Canaletto in England 1746–51		Carnatic Wars 1744–54
	Joshua Reynolds in Italy 1749–52		Diderot's and d'Alembert's *Encyclopédie* 1751–65
1751	Salons become biennial		
1752	Real Academia de Bellas Artes de San Fernando founded		
*c.*1752	The painter Miguel Cabrera flourishes in New Spain		
1753	William Hogarth publishes *The Analysis of Beauty*		
			Seven Years War 1756–63
		1759	Voltaire: *Candide*
1760	First public exhibition of contemporary art in London	*c.*1760	Beginnings of Industrial Revolution in England
1760s	Invention of aquatint	1762	Rousseau: *The Social Contract*
1763	Benjamin West settles in London	1763	France surrenders North American territories to Britain
1764	J. J. Winkelmann publishes *The History of Ancient Art*		
1768	Royal Academy of Arts, London, established under the presidency of Joshua Reynolds		
1770	Benjamin West: *The Death of General Wolff*		
	Neoclassical style mid-18th–early 19th century Programmic use of forms and motifs from Greek and Roman antiquity		
1774	John Singleton Copley leaves America, eventually settling in London	1774	Goethe: *Sorrows of Young Werther*
	Antonio Canova: *Theseus and the Minotaur* 1781–3		American Revolution 1775–83
		1781	Emmanuel Kant: *Critique of Pure Reason*; Herschel sees Uranus
1785	Jacques-Louis David's *The Oath of the Horatii* exhibited at the Salon	1788	First British settlers in Australia
	Jean-Antoine Houdon sculpts *George Washington* 1786–96	1789	French Revolution begins with storming of the Bastille
	Romanticism late-18th–early 19th centuries Reaction to rationalism and Neoclassicism; imagination and emotion over intellect and formalism		Paris: the Terror 1793–94
1792	Museum of the French Republic installed in Louvre Palace; death of Reynolds; Benjamin West succeeds as head of Royal Academy	1794	Fall of Robespierre; abolition of slavery in French colonies
1797	Bertel Thorvaldsen arrives in Rome		Napoleon's Egyptian campaign 1798–99
1798	Alois Senefelder invents lithography		
1799	Goya named first painter to Charles IV of Spain		
1804	Antoine-Jean Gros: *Napoleon Visiting the Pesthouse in Jaffa*		Napoleonic Wars 1803–15
1808	Anti-Neoclassical Nazarene brotherhood founded in Rome by German artists		Revolutionary wars in Spain's New World colonies 1809–25
1810	Colonne Vendôme inaugurated in Paris		
	Biedermeier style *c.*1815–*c.*1848 Unpretentious bourgeois style of furniture and interior decoration, particularly in Germany and Austria	1815	Napoleon defeated at Waterloo; French monarchy restored
1818	François-Frédéric Lemot's equestrian statue of Henri IV unveiled in Paris		
1819	Théodore Géricault: *Raft of the Medusa*; Thorvaldsen commissioned to design *The Lion of Lucerne;* Ernst von Bandel begins the colossal *Arminius* (Hermannsdenkmal)	1820	Austria crushes revolts in Italy
		1821	Greeks rise against Turkish rule
1823	National Gallery founded in London		
1824	Constable exhibits at the Paris Salon		
1825	National Academy of Design founded in New York	1825	First steam railway in England
1826	The Kreuzberg Monument, designed by Karl Frederick Schinkel, with sculpture by Christian Daniel Rauch, unveiled in Berlin		
1827	Delacroix: *Death of Sardanapalus*; Ingres: *Apotheosis of Homer*		
1833	Emile Seurre's *Napoleon as the Little Emperor* on the Colonne Vendôme	1830	July Revolution in France; Louis-Philippe rules France 1830–48; Compte publishes positivist philosophy 1830–42
	Hegel's *Lectures on the Philosophy of Fine Art* published 1835–8		
1836	François Rudes' *The Marseillaise (Departure of the Volunteers of 1792)* installed in the Arc de Triomphe de l'Étoile, Paris		
1837	David d'Anger's pedimental sculpture for the Pantheon unveiled in Paris: *To the Great Men from a Grateful Fatherland*		Reign of Queen Victoria 1837–1901
	Victorian style 1840s–*c.*1900 Revivalist styles, especially Gothic, competing forms of naturalism, and mass-produced goods and images	1838	Brunel's steamship *Great Western* crosses Atlantic
1847	François Rude's *Napoleon Awakening to Immortality* unveiled at Fixin; Clesinger's *Woman Bitten by a Snake* shown at the Paris Salon		
1848	Pre-Raphaelite Brotherhood founded in England	1848	Nationalist revolts throughout Europe; February Revolution in France; Marx and Engels: *The Communist Manifesto*; California gold rush
	French Realist style mid-19th century Scenes from ordinary life represented without idealization by painters associated with Courbet		

532

The contemporary world

1851	Napoleon III founds Second Empire in France
1859	Darwin: *Origin of Species*
1861	Kingdom of Italy proclaimed
	American Civil War 1861–5
1862	Bismarck Chancellor of Prussia
1864	First International Workers Association formed
1865	Tolstoy: *War and Peace*
1867	Canada becomes a dominion
1869	Zola begins his naturalist *œuvre*
	Franco-Prussian War 1870–1
1871	German unification complete; Paris in revolt: the Commune
	French and British compete for colonies in Africa 1870s–1890s
1876	Bell patents telephone; Victoria proclaimed Empress of India; Battle of the Little Big Horn
1880	Edison develops light bulb
	European powers and Japan encroach on China from 1880s
1883	World economic depression
1889	Eiffel Tower built
1897	Peugeot Automobile Company founded
1898	Spanish-American War
	Boer War 1899–1902
1900	Sigmund Freud: *The Interpretation of Dreams*
1901	Australia becomes a dominion
1902	Méliès' film *A Voyage to the Moon*
1903	Wright brothers' first flight
1905	First Russian Revolution
1907	*Lusitania* crosses the Atlantic in five days
1908	Einstein's quantum theory of light
1909	New Zealand becomes a dominion
	Mexican Revolution 1910–20
1912	Chinese Republic proclaimed
	Balkan Wars 1912–13
1913	German standing army increases from 544,000 to 870,000
	World War I 1914–18
1915	Einstein: general theory of relativity
1916	400,000 French and German soldiers die at Verdun; 500,000 Allied and German soldiers die at the Somme

Artistic events

1850	Courbet: *A Burial at Ornans*
1851	Great Exhibition, London

Second Empire style 1850s–60s Ornate, ostentatious, and eclectic style of interior design in France

1855	Universal Exposition in Paris
1859	Whistler settles in London

Arts and Crafts Movement from *c*.1860 'Truth to materials' in domestic arts, 'honesty' of form, and 'integrity' of decoration

Gottfried Semper publishes *Style in the Technical and Tectonic Arts* 1861–3

Impressionism from *c*.1860 Pictorial impressions captured by reproducing fleeting effects of light with short strokes of pure colour

1863	Manet's *Déjeuner sur l'herbe* causes scandal in Paris; Baudelaire publishes *The Painter of Modern Life*; Auguste Dumont's *Napoléon* replaces Émile Seurre's on the Colonne Vendôme
1867	Universal Exposition in Paris; Albert Memorial completed in Hyde Park, London
1868	Harriet Hosmer's *Senator Thomas Hart Benson* dedicated in St Louis
1869	Monet and Renoir paint together at La Grenouillère outside Paris; Carpeaux's *La Dance* unveiled on the Paris Opera
1870	Metropolitan Museum of Art founded in New York
1871	Colonne Vendôme pulled down by Communards
1873	Pissarro and Cézanne paint side by side in the environs of Pontoise
1874	First Impressionist exhibition in Paris; Emanuel Fremiet completes his equestrian statue of Joan of Arc for the Place des Pyramides, Paris
1875	Ernst von Bandel completes *Arminius*; Colonne Vendôme restored in Paris
1877	Grosvenor Gallery opens in London

Art Nouveau 1880s–*c*.1910 Asymmetrical, curvilinear motifs with frequent use of ornament derived from plant or other organic forms

1880	Auguste Rodin commissioned to make a bronze portal for a new museum of the decorative arts in Paris, a project that evolves into *The Gates of Hell* 1881 Degas's *Little Dancer* shown at the Impressionist exhibition
1886	Last Impressionist exhibition; Van Gogh arrives in Paris; Seurat: *Sunday Afternoon on the Island of La Grande Jatte*; Bartholdi's *Statue of Liberty* dedicated at Bedloe's Island
1891	Monet exhibits first serial works in Paris; Gauguin departs for Tahiti
1893	Alois Riegl publishes *Problems of Style*
1895	Rodin's *Burghers of Calais* unveiled in Calais
1898	Vienna Secession founded by Klimt and other artists; Société des Gens de Lettres rejects plaster of Balzac commissioned from Rodin
1899	Dalou's *The Triumph of the Republic* erected in Paris

Post-Impressionism from late 1880s Renewed emphasis on subject, formal structure, and style in painting

Modern Movement early 20th century Abstraction, expression, and competing 'isms', often as conscious break with the past in the fine and applied arts in the context of the machine age

1901	Alois Riegl publishes *Late Roman Art Industry*
1902	Frampton's Jubilee Monument to Queen Victoria unveiled in Calcutta; Alois Riegl publishes *The Dutch Group Portrait*

Fauvism *c*.1905–*c*.1908 Brilliant pure colours and boldly distorted forms

1905	Die Brücke ('The Bridge') founded in Dresden; Tagore: *Bharat Mata*
1907	Picasso: *Les Demoiselles d'Avignon*; Deutscher Werkbund founded; Alfred Stieglitz's '291' gallery in New York begins to show work by modern European painters and sculptors
	Braque and Picasso create Cubism 1908–12
1909	Marinetti launches Futurism in *Le Figaro*, Paris
1911	Der Blaue Reiter ('The Blue Rider') founded in Munich
1912	Futurists exhibit in Paris; Kandinsky: *On the Spiritual in Art*; Aby Warburg's paper on Francisco da Cossa's frescoes in the Schifaroia Palace; A. K. Coomaraswamy publishes *Art and Swadeshi*
1913	Armory show in New York, Boston and Chicago; Duchamp's mobile, *Bicycle Wheel*
1915	Kazimir Malevich launches Suprematism at the *0.10* Exhibition in Petrograd (St Petersburg); Heinrich Wölfflin publishes *The Principles of Art History*; Italian Futurists experiment with multi-media events

Dada in Zurich and Berlin 1916–22

533

	Artistic events		The contemporary world
1917	Launch of the De Stijl Movement in Holland; War Artists' Commission created in London; Rabindranath Tagore sets up Santiniketan	1917	German U-boats sink 841,118 tons of shipping in April; Bolshevik Revolution in Russia in November
	Cubo-Futurism, Constructivism, LEF, Proletcult, and other Soviet movements 1917–20	1918	1 million German troops are killed or wounded in spring offences; Allied counterattacks end war
1918	Russian Imperial Academy replaced by State Free Art Education Studios; Lenin issues Decree on Monumental Propaganda	1919	Spartakusbund attempts socialist revolution in Germany
1919	Walter Gropius founds Bauhaus at Weimar	1920	League of Nations founded; Mohandus Gandhi launches non cooperation movement against British rule in India
1920	Le Corbusier and Amédée Ozenfant publish the Purist Manifesto in *L'Esprit Nouveau*; Vladimir Tatlin: *Monument to the Third International*; Margaret Preston returns to Australia with modernist ideas after study in Europe		Italian neo-realist cinema 1920s–1930s
	Neue Sachlichkeit in Germany 1920s		
	Group of Seven active in Toronto 1920–32		
	'Secondo Futurismo' and 'Aeropittura' in Italy increasingly allied to Fascism		
1921	Fernand Léger's *Le Grand Déjeuner* exhibited at the Salon d'Automne; Stuart Davis: *Lucky Strike*; Man Ray: rayographs	1921	Ludwig Wittgenstein: *Tractatus Logico-Philosophicus*
1922	Ludwig Hirschfeld-Mack: *Reflected Light Plays*; AKhRR (Association of Artists of Revolutionary Russia) founded	1922	Benito Mussolini comes to power in Italy; T. S. Eliot: *The Wasteland*; James Joyce: *Ulysses*
	Beginnings of the Mexican mural movement 1922–4		
1923	El Lissitzky: *Spectacle Machinery*	1923	Hyperinflation in Germany
1924	Introduction of the journal *La Révolution surréaliste*; André Breton publishes the *Manifesto of Surrealism*.	1924	Leica camera in mass production in Germany
1925	Marcel Duchamp: *Rotative Semi-Sphere*; Bauhaus moves to Dessau	1925	Adolf Hitler: *Mein Kampf*
1928	Tarsila do Amaral: *Abaporu*	1928	First television broadcasts in USA
1929	Naum Gabo's *Light Festival*; Museum of Modern Art opens in New York	1929	Wall Street Crash; Hubble confirms that Universe is expanding
1930	László Moholy-Nagy's *Light-Display Machine*		Great Depression 1930s
	Alexander Calder makes mobiles 1930s		
1932	Decree on the Reconstruction of Literary and Artistic Organizations imposes Socialist Realism in Soviet Union	1932	First Venice film festival; famine in the Soviet Union
1933	Nazis close Bauhaus; John Heartfield, Erwin Panofsky, Edgar Wind, and other German artists and scholars go into exile; Warburg Library moves to London	1933	Hitler becomes German Chancellor
1935	The Uruguayan artist and theorist Joaquín Torres-García launched his manifesto *The School of the South* and founds the Association of Constructive Art; Hitler attacks modern art	1934	Successful German liquid-fuel rocket
		1935	Italy invades Ethiopia; German rearmament begins
	Soviet Union purges 'Formalism' in the arts mid–late 1930s		Political purges and show trials in the Soviet Union mid–late 1930s
1936	Exhibition of Surrealist Objects at the Galérie Charles Ratton in Paris	1936	Spanish Civil War
1937	Picasso paints *Guernica* for display in the Spanish Pavilion at the Paris International Exhibition; Hitler stages exhibition of 'degenerate art'	1937	Spanish Basque town of Guernica bombed
1938	Albert Speer: *Light Cathedral*	1938	Otto Hahn splits the uranium atom
1939	Erwin Panofsky publishes *Studies in Iconology*		Second World War 1939–45
1940	Angry Penguins formed in Adelaide	1940	Fall of France; Battle of Britain; prehistoric paintings discovered in the Lascaux caves in France
1941	Matisse develops paper cut-out technique; first Stalin Prizes awarded in the Soviet Union; Cuban surrealist Wifredo Lam: *Malembo, God of the Crossroads*	1941	Germany invades USSR; Japan attacks Pearl Harbor
	Diego Rivera paints eleven narrative paintings for the National Palace in Mexico City 1942–50	1942	Battles of El Alamein and Stalingrad
1943	Jean Fautrier working in hiding on outskirts of Paris; Pablo Picasso: *The Bull's Head* (sculpture); Henry Moore: *Madonna and Child*	1943	Nazi destruction of Warsaw Ghetto
1944	Francis Bacon: *Three Figures at the Base of a Crucifixion*		
1945	Henry Moore: *Family Group*	1945	German defeat; newsreels of death camps; atomic bombing of Japan
1946	Lucio Fontana: *Manifesto Blanco*		
	Soviet Union purges foreign influences and Impressionism 1946–56		
1947	Gyula Kosice: *Light Relief*; Academy of Arts of the USSR created at Leningrad; Progressive Artists' Group founded in India	1947	Marshall Plan inaugurated in Europe; partition of India—independence
	Les Automatistes in Montreal 1947–55		Cold War 1947–90
1948	Automatistes publish *Refus global*	1948	First Arab-Israeli War
1950	Matisse works on chapel at Vence		Korean War 1950–1
1951	Kenneth Martin: mobiles		Le Corbusier: church of Notre-Dame-du-Haut, Ronchamp 1950–5
1952	Willem de Kooning: *Woman I*		
1953	Bruno Munari: *Direct Projections*; abolition of Central Art Committee in the Soviet Union: functions transferred to Ministry of Culture	1953	Francis Crick and James Watson describe the structure of DNA
1954	Pablo Picasso: *Sylvette*	1954	Viet Minh victory at Dien Bien Phu
1955	Richard Hamilton: *Just What Is It That Makes Today's Homes So Different, So Appealing?*		Algerian War 1954–62
			Beatnik counterculture mid-1950s–mid-1960s
1956	*This is Tomorrow* exhibition in London; Soviet state decree criticizes the excesses of art under Stalin	1956	Hungarian uprising; Suez Crisis; Elvis Presley: 'Heartbreak Hotel'
1957	Vlassis Takis: *Fireworks*; Yves Klein: *Blue Lights*; First Congress of the Union of Soviet Artists	1957	Soviet Union launches *Sputnik I* and *Sputnik II*

534

The contemporary world

	Charles de Gaulle president of France 1958–69
1959	Alain Resnais' Nouvelle Vague film *Hiroshima mon amour*
1960	Nigeria, Mali, Mauritania, Somalia independent; first communications satellite launched
1961	Yuri Gagarin first man in space
1962	Cuban Missile Crisis; Bob Dylan: 'Blowin' in the Wind'
1963	John F. Kennedy assassinated; Beatles' first album
	Hippy counterculture mid-1960s–mid-1970s
1967	Six Day War in Middle East
	Nigerian Civil War 1967–70
1968	Warsaw Pact invades Czechoslovakia; student rebellions in west
1969	Neil Armstrong is first man on Moon
1973	Watergate; Yom Kippur War
	Punk counterculture from mid-1970s
1977	Richard Rogers: Pompidou Centre
1981	IBM launches personal computer
1982	Falklands War
	Ethiopian famine 1984–5
1985	Gorbachov announces *Perestroika*
1989	Berlin Wall comes down
1990	Cold War ends; Nelson Mandela freed in South Africa
1990s	Conflicts in Balkans and Persian Gulf

Artistic events

1958	'Zero Group' founded in Düsseldorf; Exhibition *The New American Painting* tours Europe
1959	Otto Piene, 'Light Ballet'; Frank Lloyd Wright: Guggenheim Museum, New York
	Op, Pop, Conceptual, Kinetic art, Land art, Fluxus, happenings; beginnings of post-modernism 1960s
1960	Yves Klein produces his *Anthropometries* in Paris; Jean Tinguely: *Homage to New York*; Groupe de Recherche d'Art Visuel founded in Paris; 'Gruppo T' founded in Milan; Brazilian Helio Oiticica produces the Parangolés
1962	Andy Warhol: *Marilyn Monroe*
1963	USCO: 'Be-in' event; Roy Lichtenstein: *Whaam!*
1964	'Dvizdjene Environment' in the Soviet Union
1965	Malcolm Morley creates first Super Realist works
1967	Colombian artist Fernando Botero paints *The Presidential Family*, using monumentally fat figures to satirize wealth and power
	Video, Performance, Body art, Environmental art, experimental film, Computer art, lasers, holography, telematics, Communication art, New Expressionism in Germany, Italy and Scotland, Postmodernism, Simulation, Pattern and Decoration, Neo-Geo, Installation art 1970s–1980s
1971	Malcolm Morley: *St John's Yellow Pages*; start of Aboriginal desert art movement at Papanya Tula, Australia
1975	Judy Chicago: *Dinner Party*
1976	Nam June Pak: *Fish Flew in the Sky* (video installation)
1978	Dani Karavan: *Homage to Galileo Galilei*
1981	Picasso's *Guernica* returns to Spain; 'New Spirit of Painting' exhibition, London
1982	'Zeitgeist' exhibition in Berlin
1985	'Neue Slowenische Kunst' exhibition in London
1986	Rosalind Krauss publishes *The Originality of the Avant-Garde and Other Modernist Myths*
	Installation and neo-conceptualism; artistic use of Web pages, multimedia, virtual reality 1990s
1993	Whitney Biennial Exhibition in New York a Postmodernist landmark
1999	Restoration of Leonardo's *Last Supper* complete

535

Glossary

à la poupée inking In colour printing, the use of a *poupée* (a rag-stump, a 'doll' or 'puppet' in French) to ink parts of the plate, block, or stone separately. This approach is an alternative to printing multiple plates, blocks, or stones, each inked in only one colour and registered on a single sheet of paper.

antependium A structure (painted, or of metalwork or fabric) which hangs in front of an altar.

aquamanile Secular or ecclesiastic pouring vessel for hand-washing, often in the form of an animal or figure.

aquatint A type of etching in which acid-resistant resin granules are sifted on to a heated plate. When the plate is immersed in acid, the acid etches around the granules adhering to the plate, thus producing a grainy tone when the plate is inked and printed. The value of the tones in aquatint is controlled by the size of the resin grains and the length of immersion.

arcade A series of arches carried on columns. When the columns and arches are fixed against a wall, this is known as a blind arcade.

Archaic period Period from *c.*600 to *c.*480 BC when Greek art was chiefly patronized by tyrants and (*c.*520) red-figure vase painting replaced black-figure.

ars sacra Literally, 'sacred art'. The phrase was used as the title of an exhibition of early medieval art held in Bonn in 1949, but has, thanks to the book with this name (Peter Lasko, 1972), more recently been applied to the small-scale arts of metalworking and ivory carving of the period.

Art Deco Style of decorative art of the 1920s and 1930s, characterized by smooth lines, bold colours, minimalist design, and the use of new materials, such as tubular steel, plate glass, and plastic.

Art Nouveau A style that emerged in Europe and the USA in the 1880s and continued into the early twentieth century. It was characterized by asymmetrical, curvilinear forms and motifs and, frequently, by the use of ornament derived from plant or other organic forms.

Arts and Crafts Movement A tendency originating in England around 1860 (and particularly associated with William Morris) that also manifested itself elsewhere in Europe and in the USA. It was characterized by a belief in 'truth to materials', honesty of form, and integrity of decoration, and was frequently associated with a commitment to hand-craft (rather than mechanized) means of production.

autographic Revealing or seeming to reveal an artist's hand or touch.

Baroque Post-Renaissance artistic style, especially of the 1600s, characterized by elaborate ornamentation, complexity, and extravagance.

Biedermeier style A term first used in the 1850s to characterize an unpretentious bourgeois style of furniture and interior decoration found particularly in Germany and Austria from about 1815 to 1848.

cameo A jewel or semi-precious stone, often with layers of different colour, which has an image cut in raised relief.

capital The architectural member at the top of a column which forms the transition between a column below and the arch above.

capriccio (Italian: 'caprice') An imaginative or fanciful subject, such as an architectural view based on composite or totally invented buildings and/or ruins.

cassone (plural: *cassoni*) (Italian: 'large chest') Term generally used to refer to decorated Italian wedding chests.

certosina Geometric patterned inlay of wood, bone, mother of pearl, and metal favoured in north Italian centres such as Venice.

champlevé An enamelling technique in which the glass is contained within engraved depressions in a metal (usually copper alloy) plate.

chevet French term for the east end of a church with chancel, ambulatory, and radiating chapels.

chiaroscuro (From the Italian *chiaro*, 'light', and *oscuro*, 'dark') Use of light and dark; modelling or shading. Also describes drawings with white highlights on tinted paper. In woodcut printing, multiple blocks are used, each inked in a different colour and typically combined with a line block, all being aligned and printed on the same sheet to give an effect comparable to a wash drawing.

chromolithograph A colour lithograph made for commercial or reproductive purposes. Chromolithography was especially important in the nineteenth century in Europe and America.

Classical period Period from *c.*480 to 323 BC during which the arts flourished in Greece.

cloisonné A means of setting cut stones or enamel between thin metal 'walls' which have been fixed to a backplate.

contrapposto A figural pose in which one part of the body turns or twists away from another, usually an asymmetrical pose characteristic of classical Greek and Roman figure sculpture, in which the weight is carried by one leg while the other is relaxed. This system of figural articulation was revived and much exploited during the Italian Renaissance.

corbel A block of stone projecting at right angles from the wall in order to support the springing of an arch or the eaves of a roof.

counterproofing In printmaking, taking an impression from another impression before the ink has dried. This allows the artist to see the image in the same direction it was drawn in order to correct mistakes, or to achieve visual effects made possible by printing the image twice.

Counter-Reformation Roman Catholic evangelical movement in reaction to the Protestant Reformation, during which the religious arts flourished in Catholic countries.

crayon manner An eighteenth-century intaglio process (also called 'chalk manner') that employed spiked wheels (roulettes) to establish grainy areas on an etching ground. The etched areas imitated chalk (*crayon* in French) marks when printed. Crayon manner was used primarily to reproduce the sanguine chalk drawings popular in the eighteenth century.

Creole Born or assimilated into the Caribbean region.

Dada An artistic and literary movement (1916–*c.*1920) seeking to supplant artistic traditions with chaos. Dada poets and artists, including André Breton, Marcel Duchamp, and Jean (Hans) Arp, went on to develop Surrealism.

dado Lower part of the room-wall when it is faced or coloured differently from the upper part.

Deconstruction Method of critical analysis which asserts that art can have no fixed meanings because it can be viewed only subjectively.

die-stamping A process of impressing the form or ornament of a manufactured object by means of a metal stamp (a die).

dossal A panel painting hung behind an altar.

drypoint An intaglio printmaking technique in which a needle is used to scratch a plate, typically copper. The ink rests in the grooves until the plate is pressed into the paper.

diptych A two-panelled, usually hinged, picture.

di sotto in su (Italian: 'with beneath made above') Perpendicular to the picture plane.

écorché Sculpture of a human or an animal without skin, usually for use in teaching anatomy to sculpture students.

electro-plating A process of coating an object with a thin layer of chromium, silver etc., by means of electrolysis (the chemical reaction produced by passing an electric current through an electrolyte).

electrotype A duplicate of a plate or block (especially a wood-engraving block) produced by the use of electrolysis to coat a mould of the block with a thin layer of metal; invented in 1839, the electrotype supplanted the stereotype.

engraving An intaglio printmaking technique in which a wedge-shaped implement called a burin is pushed with considerable pressure, carving a deep and regular groove into a plate, typically copper, into which ink is pushed and held until printing.

estampes galantes (French: 'gallant or gay prints') Eighteenth-century reproductive prints (usually combinations of etching and engraving) after the Rococo painters. They were generally amorous or erotic in their subject-matter.

Expressionism An early twentieth-century movement associated with Chaïm Soutine, Oskar Kokoschka, and Georges Rouault, which reacted against Impressionism by emphasizing through distortion and violent colour the expression of inner experience. German Expressionism is particularly associated with the group known as die Brücke (1905–13).

faience Earthenware with an opaque glaze.

Fauvism A movement in painting of c.1905–c.1908 associated with Henri Matisse, which used brilliant pure colours and boldly distorted forms.

filé A core of linen or silk wound with flat gold thread or strip (lamella).

foreshortening Portrayal of an object with the apparent shortening and narrowing associated with visual perspective.

fresco Watercolour painting on wet plaster.

frisée Like a filé except that the metal thread is twisted instead of flat.

genre painting Painting that depicts a scene from daily life.

Geometric period Period from c.900 to c.700 BC when geometric motifs on Greek vases formed a background first for animals, then for human figures.

gesso A gypsum mixture used as ground for painting or gilding and, in relief, for modelled or carved decoration (*pastiglia*).

Gothic style The style of art, decoration, and especially architecture which spread from France in the twelfth century.

graphic art A broad term including all printmaking media. Sometimes drawing may also be included.

grisaille (from the French for grey) White glass decorated with foliage designs (conventionalized or naturalistic), executed in monochrome glass-painting pigment.

grotesque Decoration in the manner of grotto sculptures, especially with fantastic interweaving of human and animal forms with foliage.

gutta-percha A grey-black substance that can be moulded for decorative purposes, derived from latex obtained from certain types of oriental tree.

hagiography The writing of saints' lives.

Hellenic Of or relating to Greece.

Hellenism Greek civilization.

Hellenistic period Period from 323 to 168 BC when the Greek language and Greek art dominated the eastern Mediterranean in numerous kingdoms established by the successors of Alexander the Great, including Ptolemaic Egypt.

historiated Decorated with elaborate ornamental designs and figures, especially in a narrative (historical, religious, or classical) scene.

iconoclasm (Greek: 'image-breaking') The rejection of imagery as offensive to God, especially in the Byzantine Empire between c.730 and 843. Iconoclasts argued that religious images had come to be regarded by worshippers as idols, and hence must be displeasing to God. Iconophiles adduced a range of arguments from the Bible and Christian tradition legitimating their use.

iconography That aspect of the history of art that deals with the identification, meaning, and interpretation of the subject-matter of works of art.

impasto (Italian: 'mixture') A blob of oil paint which is left in relief on the finished surface.

Impressionism Movement in painting from the 1860s that aimed to create impressions of moments in time by reproducing fleeting effects of light by short strokes of pure colour. It was mainly associated with Claude Monet, Camille Pissarro, and Alfred Sisley, but originally involving in addition Paul Cézanne, Edgar Degas, Édouard Manet, and Pierre Auguste Renoir.

inlay Decoration in wood or other materials set into a matrix that forms the background.

intaglio A jewel or semi-precious stone into which a recessed image has been cut. In printmaking, any of several techniques in which lines are cut or corroded into a plate and which then print positively—the artist's mark is what appears in the print, rather than the surface the artist left untouched.

intarsia Decoration of different coloured woods inlaid into an excavated wood ground.

istoriato (Italian: 'historiated') Italian Renaissance maiolica decorated with a narrative (historical, religious, classical) or other figural scene.

jamb The edge of a door or window opening.

Jesse Tree Tree illustrating Christ's descent from Jesse.

Kleinmeister (German: 'little Masters') Engravers who followed Albrecht Dürer and were known for small, Italianate engravings prized by collectors.

kore (plural: *korae*) (Greek: 'girl') A Greek statue of a girl or young woman.

kouros (plural: *kouroi*) (Greek: 'boy') A Greek statue of a boy or young man.

lift-ground etching A form of aquatint etching in which an artist paints the design on the plate with a sugary liquid. The plate is covered with acid-resistant varnish and submerged in water, which causes the sugary areas to lift off. The exposed parts are then aquatinted and etched. The aquatint ground can also be laid on the plate before the sugar-lift is applied.

lintel The horizontal block of stone spanning the opening of a door. The lintel was frequently surmounted by a tympanum.

lithography A planographic (flat-surfaced) printmaking technique invented by Alois Senefelder in 1798, employing limestone slabs, or alternatively zinc plates, and the chemical antagonism of grease and water. An artist draws on the stone with any greasy medium. The stone is then 'etched' with a mixture of nitric acid and gum arabic to set the image, and then wetted down, inked, and printed.

Mannerism A sixteenth-century reaction, spreading from Italy, against the high Renaissance style of Raphael and others. Exponents such as Parmigianino (Francesco Mazzola) and Tintoretto (Jacopo Robusti), using vivid colour, painted contorted, elongated figures that lacked classical balance. Mannerist sculpture is exemplified by the work of Giambologna (Jean Boulogne, or Giovanni da Bologna).

mattoir In intaglio printmaking, a hand-held instrument with a blunt, spiked head that achieves tone by stippling the plate.

mezzotint An intaglio method of printmaking based on tone rather than line, in which the artist works from dark to light. The plate is first scored all over with a rocker (at this stage, the plate would print totally black

537

after inking). Then the scoring is smoothed out in varying degrees to arrive at lighter values. Mezzotint was widely used in England as a reproductive printmaking technique (hence its alternate name, 'the English manner').

Minnekästchen Small love casket; term used for northern European boxes decorated with scenes of courtly love, chivalric romance, or similar themes.

modernism Successive late-nineteenth-century and twentieth-century movements that have broken with the past in search of new forms of expression.

Modern Movement A late-nineteenth-century and early twentieth-century tendency in architecture and design. Often characterized by the use of rectilinear forms and abstract motifs, it was frequently associated with an intention of mechanized mass-production.

monotype A form of printmaking that produces only one or two images; a plate or glass sheet (or virtually any surface) is painted with ink or paint, and paper pressed against this surface. A traced monotype is made by drawing on a top sheet placed over another sheet containing some sort of pigment, thus transferring the image to a sheet on the bottom.

Neoclassical style A predominantly mid-eighteenth- and early nineteenth-century style, in evidence in Europe and the USA. It drew (with varying degrees of accuracy) on the forms and motifs of Greek and Roman antiquity.

Neo-Gothic style The name given to various revivals in architecture and design, in Europe and the USA, from the mid-eighteenth century onwards, of medieval forms and decorative motifs. It was associated in mid-nineteenth century Europe particularly with the work of architects such as A. W. N. Pugin and E. Viollet-Le-Duc.

Neo-Renaissance style The name given to mid- to late nineteenth-century revivals, in architecture and design, of Italian and French styles of the sixteenth century and of English Tudor and Jacobean styles.

Obeah Rituals and magic retained in the Caribbean from African spiritual practices used in punishment or retaliation.

opus tessellatum A mosaic technique using relatively large *tesserae.*

opus vermiculatum A Hellenistic mosaic technique associated with Sophilos employing tiny *tesserae* of cut stone, glass, and faience.

Orientalizing period Period in Greek art from *c.*700 to *c.*600 BC when Eastern influences were introduced by Phoenicians and Syrians.

papier-mâché Material made of paper pulp, which can be moulded. Used for a wide range of decorative wares in Europe during the eighteenth and nineteenth centuries, the technique was imported from Japan and its use in Europe was often associated with oriental effects.

pastel manner The colour form of the crayon manner in printmaking, used primarily to reproduce pastels.

pastiglia Decoration of moulded gesso or white lead paste, often gilded, on paintings and furnishings such as large chests (*cassoni*) and small boxes.

peintre-graveur (French: 'painter-engraver') Original printmaker, in contradistinction to a professional, reproductive printmaker.

pilaster Rectangular column, especially one engaged in a wall.

polychrome Multi-coloured.

porcelain Generic term for a fine, hard, translucent ceramic substance, used for the production of table and decorative wares. First made in China in the seventh and eighth centuries AD, it was made in Europe only from the eighteenth century, when Meissen, Sèvres, and other manufactories began production.

positivism Extreme form of nineteenth-century empiricism that sought objective fact above all else.

Post-Impressionism Movement in French painting that reacted against Impressionism by emphasizing the subject, formal style, and structure of a work. It was associated with Paul Cézanne, Paul Gauguin, and Vincent Van Gogh.

Postmodernism Movement predominating in the 1980s and 1990s in reaction to the adoption of limitations by art movements. In principle, to be postmodernist is to accept that any style can be appropriate, anyone can be an artist, and any object can be a work of art.

putto (plural: *putti*) Small child, winged or not, common in Classical and classicizing art.

quadro riportato (Italian) A framed picture.

Rastafarianism Belief originating in Jamaica that venerates the Ethiopian emperor Haili Salassie (called Ras Tafari before his coronation). It teaches the eventual redemption of black people and their repatriation to Africa, considered a spiritual Eden.

Realism Adherence to accurate representation; rejection of idealization.

Reformation Reform movement in the sixteenth-century church that escalated into a religious revolution. Protestant denominations concentrated in northern Europe broke away from Roman Catholicism, concentrated in the south. In several Protestant areas iconoclastic outbursts resulted in the destruction and prohibition of religious art.

reliquary A container of relics, which may take any form, from a simple box to a representational image, and which can either conceal or reveal the relic within.

Renaissance (French: 'rebirth') Intellectual and cultural revival that succeeded the Middle Ages. Spreading from Italy from the fourteenth to the sixteenth centuries, it drew on Classical models and a renewed study of man and nature to introduce realism into artistic works stamped with the individuality of their creators and their subject-matter.

resist-painted Painted on woven fabric.

retable A structure (architectonic, carved, painted, or of metalwork) positioned behind the altar.

retroussage A technique of wiping an etching plate so that ink is drawn up out of the lines, thus producing softer, richer effects.

Rococo style Style of architecture and decoration which developed out of the Baroque with elaborate ornamentation, especially in imitation of foliage, scroll-work, shells. Spreading from France in the early eighteenth-century, it became popular in Austria, Germany, and Italy.

rocker A hand-held, spiked instrument used in mezzotint that scores the plate when rocked over it. The scoring is then smoothed out to produce values ranging from dark to light when the plate is inked and printed.

Romanesque Style of architecture predominant in Europe from the mid-eleventh to mid-twelfth centuries, based on rounded Roman arches and massive walls.

Romanticism Cultural reaction in the late eighteenth and early nineteenth centuries against rationalism and Neoclassicism. It emphasized imagination and emotion over intellect and formalism.

roundel A circular or oval panel of white glass (less commonly rectangular) of approximately 20 cm. in diameter, made of a single piece decorated with monochrome glass-paint and yellow stain. Later examples also display enamel colours. They depict religious and secular subject-matter and were designed to be viewed at close quarters, often in domestic and other secular settings. They became popular in the last quarter of the fifteenth century, and the largest number were made in the Low Countries.

roulette A hand-held instrument with a spiked wheel that produces a grainy mark over an etching ground or directly on an intaglio plate. It was used in eighteenth-century tonal processes such as the crayon and pastel manners.

Santeria An African Cuban religion derived from Yoruba beliefs and rituals.

scagliola Material used to imitate stone, particularly marble; made of plaster mixed with glue.

Second Empire style The ornate, ostentatious, and largely eclectic style current in interior design in France under the reign of Napoleon III (reigned 1848–70).

semiotics The study of signs and sign-systems.

spalliera (plural: *spalliere*) (from the Italian *spalla*, 'shoulder') Ornamented or figurated panel about shoulder height of textile or, when set into the wall or on furniture, of painted wood.

spandrel The curved triangular area left between an arch, the vertical from which it springs, and the horizontal across its apex.

stereotype A metal cast of a mould of a wood-engraving block. The duplicate of the original block enabled more efficient printing of images on steam-driven presses. It was invented in 1829.

stipple In intaglio printmaking, dotting the plate with various instruments to produce areas of tone.

strapwork Ornamentation imitating plaited straps.

studiolo A small private study in a secular setting such as a house or palace.

sugar-lift etching see **lift-ground etching**

Surrealism Movement based in Paris between the First and Second World Wars that sought to access a superior reality through contact with the subconscious mind by means of dream imagery and spontaneous creation. Its chief theoretician was André Breton.

tableau vivant A group of figures posed motionlessly to represent a historical event or some other scene.

techne Greek term for technical skill in making and representing.

tempera Paint produced by dissolving powdered pigment in water and mixing with gum or egg white.

terracotta Literally, 'baked earth'. Clay is fired in a kiln or allowed to dry in sunshine to become hard and rigid. The term normally describes a material used for modelling sculptural forms (or architectural decorations) in clay, rather than for making pottery vessels.

tessera Any small object used in constructing a mosaic.

trompe l'œil (French: 'deceit of the eye') Illusionistic two-dimensional representation of three-dimensional space and/or form.

trumeau A central support for a tympanum in a large doorway.

tympanum The space between the lintel and the arch above a doorway filled in with stone.

typology A common medieval narrative mode in which events in the Old Testament are presented as prefiguring events in the New Testament.

veduta (Italian: 'view') Topographical paintings and prints especially popular in the eighteenth century. Although these were generally of real locations, the term could incorporate imaginative views as well, albeit realistically conceived.

Victorian style The style prevalent in architecture and design in Britain during the reign of Queen Victoria (reigned 1837–1901). Usually characterized by a profusion of elaborate surface decoration and glittering effects, it was often associated with shoddy materials and industrial processes. The term is sometimes used to designate similar styles of architecture and design current elsewhere (for example, in the USA) during this period.

Vodou (Voodoo, Vodun, Voudoun) The religion of the majority of the Haitian people, which combines West African and European spiritual practices.

woodcut A relief printmaking technique in which a plank, typically pear or boxwood, is carved negatively, so that the ridges left from the original surface are inked and printed.

wood-engraving A relief technique of printmaking using end grain blocks of wood, sometimes bolted together to produce larger surfaces, and a burin to carve them. Usually wood-engravings had a highly detailed, white-on-black appearance that required smooth manufactured papers which could pick up the detail. Wood-engravings were used extensively from the late eighteenth century on for journal and book illustrations.

Further Reading

540

General

Baxandall, M., *Patterns of Intention: On the Historical Explanation of Pictures* (1985).
Belting, H., *The End of Art History* (1987).
Fernie, E., *Art History and its Methods* (1995).
Gombrich, E. H., *Reflections on the History of Art* (1987).
——— *The Story of Art* (16th edn., 1995).
Holly, M. A., *Panofsky and the Foundations of Art History* (1984).
Janson, H., *The History of Art* (revised 5th edn., 1997).
Panofsky, E., *Meaning in the Visual Arts* (1955).
Pollock, G., *Vision and Difference, Femininity, Feminism, and the Histories of Art* (1988).
Preziosi, D., *The Art of Art History* (1998).

The following lists have been compiled by the contributors specifically to serve this volume.

Part 1: The Foundations: Greece and Rome
*c.*600 BC–AD 410

Greek Sculpture

Boardman, J., *The Diffusion of Classical Art in Antiquity* (1994).
——— *Greek Sculpture: The Late Classical Period* (1995).
Davis, W., *The Canonical Tradition in Ancient Egyptian Art* (1989).
Furtwängler, A., *Masterpieces of Greek Sculpture* (ed. and trans. E. Sellers, 1895; 2nd edn. by A. N. Oikonomedes, 1964).
Mattusch, C. C., *Greek Bronze Statuary: From the Beginnings Through the Fifth Century* BC (1989).
——— *Classical Bronzes: The Art and Craft of Greek and Roman Statuary* (1996).
Moon, W. (ed.), *Polykleitos, the Doryphoros, and Tradition* (1995).
Palagia, O., and Pollitt, J. J. (eds.), 'Personal Styles in Greek Sculpture', *Yale Classical Studies*, 30 (1996).
Pollitt, J. J., *The Ancient View of Greek Art* (1974).
——— *Art in the Hellenistic Age* (1986).
——— *The Art of Ancient Greece: Sources and Documents* (1990).
Potts, A., *Flesh and The Ideal: Winckelmann and the Origins of Art History* (1994).
Richter, G. M. A., *The Portraits of the Greeks* (abridged and revised edn. by R. R. R. Smith, 1984).
Ridgway, B. S., *Roman Copies of Greek Sculpture: The Problem of the Originals* (1984).
——— *Hellenistic Sculpture, 1: The Styles of 330–200* BC (1990).
——— *Fourth-Century Styles in Greek Sculpture* (1997).
Rolley, C., *Greek Bronzes* (1986).
Smith, R. R. R., *Hellenistic Sculpture* (1991).
Stewart, A., *Greek Sculpture: An Exploration* (1990), with extensive earlier bibliography.
——— *Faces of Power: Alexander's Image and Hellenistic Politics* (1993).
——— *Art, Desire, and the Body in Ancient Greece* (1996).
Winckelmann, J. J., *The History of Ancient Art* (trans. G. Henry Lodge, 1880).
Zanker, P., *The Mask of Socrates: The Image of the Intellectual in Antiquity* (1995).

Greek Pictorial Arts

Andronikos, M., *Vergina: The Royal Tombs and the Ancient City* (1984).
Brown, A. B., *Ptolemaic Paintings and Mosaics and the Alexandrian Style* (1957).
Hurwit, J. M., *The Art and Culture of Early Greece, 1100–480* BC (1985).
Pollitt, J. J., *Art in the Hellenistic Age* (1986).
Robertson, M., *Greek Painting* (1979).

Greek Art Beyond Greece

Boardman, J., *The Diffusion of Classical Art in Antiquity* (1994).
Spivey, N. J., *Etruscan Art* (1997).
Zwalf, W., *A Catalogue of the Gandhara Sculpture in the British Museum* (1997).

Roman Sculpture

Kleiner, D. E. E., *Roman Sculpture* (1992).
Koch, G., and Sichtermann, H., *Römische Sarkophage* (1982).
Koortbojian, M., *Myth, Meaning, and Memory on Roman Sarcophagi* (1995).
Kuttner, A. L., *Dynasty and Empire in the Age of Augustus: the Case of the Boscoreale Cups* (1995).
Pollitt, J. J., 'The Impact of Greek Art on Rome', *Transactions of the American Philological Association* 108 (1978).
Smith, R. R. R., *Hellenistic Royal Portraits* (1988).
——— *Hellenistic Sculpture* (1992).
——— 'Typology and Diversity in the Portraits of Augustus', *Journal of Roman Archaeology*, 9 (1996).
——— 'Cultural Choice and Political Identity in Honorific Portrait Statues in the Greek East in the Second Century AD', *Journal of Roman Studies*, 88 (1998).
Strong, D., *Roman Imperial Sculpture* (1961).
Torelli, M., *Typology and Structure of Roman Historical Reliefs* (1982).
Walker, S., *Memorials to the Roman Dead* (1985).
——— *Catalogue of Roman Sarcophagi in the British Museum* (1990).
Zanker, P., *Klassizistische Statuen: Studien zur Veränderung des Kunstgeschmacks in der römischen Kaiserzeit* (1974).
——— *Power and Images in the Age of Augustus* (trans. H. A. Shapiro, 1988).
——— 'Romana, arte: Età tardo-republicana e imperiale fino alla Tetrarchia', *Enciclopedia dell' arte antica classica e orientale* (Secondo supplemento 1971–94 V).
——— *The Mask of Socrates* (trans. H. A. Shapiro, 1995).
——— *Pompeii: Society, Urban Images, and Ways of Living* (German edn. 1988, translation forthcoming).
——— *Pompeii: Public and Private Life* (1998).

Roman Painting and Mosaics

Clarke, J. R., *The Houses of Roman Italy, 100* BC–AD *250* (1991).
Cohen, A., *The Alexander Mosaic* (1997).
Henig, M., *A Handbook of Roman Art* (1983).
Ling, R., *Roman Painting* (1991).
——— *Ancient Mosaics* (1998).

Theory and Criticism

Pollitt, J. J., *The Ancient View of Greek Art: Criticism, History, and Terminology* (1974).

Ancient Paradigms from Augustus to Mussolini

GENERAL
Greenhalgh, M., *The Classical Tradition in Art* (1978).
Haskell, Francis, and Penny, Nicholas, *Taste and the Antique* (1981).
Highet, G., *The Classical Tradition: Greek and Roman Influences on Western Literature* (1949).
Vermeule, C. C., *European Art and the Classical Past* (1964).

ON THE ROMAN APPROPRIATION OF CLASSICAL GREEK ART
Vermeule, Cornelius C. C., *Greek Sculpture and Roman Taste* (1977).
Zanker, Paul, *The Power of Images in the Age of Augustus* (1988).

ON CLASSICAL SURVIVALS IN EARLY CHRISTIAN ART AND THE ART OF THE MIDDLE AGES
Greenhalgh, M., *The Survival of Roman Antiquities in the Middle Ages* (1989).
Oakeshott, W., *Classical Inspiration in Medieval Art* (1959).

Zanker, Paul, 'The Cult of Learning Transfigured', in *The Mask of Socrates* (trans. H. A. Shapiro, 1995).

ON THE REVIVAL OF ART IN RENAISSANCE ITALY
Gombrich, E. H., 'The stile all'antica: imitation and assimilation', in *Norm and Form: Studies in the Art of the Renaissance* (1966).
Weiss, R., *The Renaissance Discovery of Classical Antiquity* (1969).

ON THE RESURRECTION OF THE PAGAN GODS AND CLASSICAL MYTHOLOGY
Seznec, Jean, *The Survival of the Pagan Gods: The Mythological Tradition and its Place in Renaissance Humanism and Art* (trans., 1953).
Wind, Edgar, *Pagan Mysteries of the Renaissance* (2nd edn., 1967).

ON EIGHTEENTH AND NINETEENTH CENTURY NEO-CLASSICISM
Honour, Hugh, *Neo-Classicism* (1968).
Jenkyns, Richard, *Dignity and Decadence* (1991).

Part 2: Church and State: The Establishing of European Visual Culture 410–1527

Early Christian Art
Beckwith, J., *Early Christian and Byzantine Art* (2nd edn. 1979).
Grabar, A., *The Beginnings of Christian Art, 200–395* (1967).
Hutter, I., *Early Christian and Byzantine* (1989).
Runciman, S., *Byzantine Style and Civilisation* (1975).
Talbot Rice, D., *Art of the Byzantine Era* (1963).
Strong, D., *Roman Art* (1976).

Illuminated Manuscripts
BYZANTIUM
Buchthal, H., *Art of the Mediterranean World, AD 100 to 1400* (1983).
—— and H. Belting, *Patronage in Thirteenth-Century Constantinople* (1978).
Byzance, exhib. cat. (Paris, Musée du Louvre, 1992).
Byzantium, exhib. cat. ed. D. Buckton (London, British Museum, 1994).
Carr, A. W., *Byzantine Illumination, 1150–1250* (1987).
Corrigan, K., *Visual Polemics in the Ninth-Century Byzantine Psalters* (1992).
Cutler, A., *The Aristocratic Psalters in Byzantium* (1984).
The Glory of Byzantium, exhib. cat. (New York, Metropolitan Museum of Art, 1997).
Lowden, J., *Illuminated Prophet Books* (1988).
—— *The Octateuchs* (1992).
—— *Early Christian and Byzantine Art* (1997).
Nelson, R. S., *The Iconography of Preface and Miniature in the Byzantine Gospel Book* (1980).
Pelekanidis, S., *et al.*, *The Treasures of Mount Athos, Illuminated Manuscripts* (4 vols., 1973–91).
Sevcenko, N. P., *Illustrated Manuscripts of the Metaphrastian Menologion* (1990).
Weitzmann, K., *Studies in Classical and Byzantine Manuscript Illumination* (1971).
—— *Late Antique and Early Christian Book Illumination* (1977).
Williams, J. (ed.), *Imaging the Early Medieval Bible* (1998).

THE WEST
Age of Chivalry: Art in Plantagenet England, exhib. cat. (London, Royal Academy, 1987).
Alexander, J. J. G., *Insular Manuscripts: 6th to the 9th Century* (1978).
—— *The Decorated Letter* (1978).
—— *Medieval Illuminators and their Methods of Work* (1992).
Avril, F., *Manuscript Painting at the Court of France: The Fourteenth Century* (1978).
Backhouse, J., *The Illuminated Page: Ten Centuries of Manuscript Painting in the British Library* (1997).
Cahn, W., *Romanesque Manuscripts: The Twelfth Century* (1996).
Calkins, R. G., *Illuminated Books of the Middle Ages* (1983).
de Hamel, C., *Scribes and Illuminators* (1992).
—— *A History of Illuminated Manuscripts* (2nd edn., 1994).
Dodwell, C. R., *Painting in Europe 800–1200* (1971).
Dogaer, G., *Flemish Miniature Painting in the 15th and 16th Centuries* (1987).
English Romanesque Art 1066–1200, exhib. cat. (London, Hayward Gallery, 1984).
Evans, M. W., *Medieval Drawings* (1969).
The Golden Age of Dutch Manuscript Painting, exhib. cat. (New York, Pierpont Morgan Library, 1990).
Harthan, J., *Books of Hours and their Owners* (1977).
Henderson, G., *From Durrow to Kells: The Insular Gospel-Books 650–800* (1987).

Kauffmann, C. M., *Romanesque Manuscripts 1066–1190* (1975).
The Last Flowering, exhib. cat. (New York, Pierpont Morgan Library, 1982).
The Making of England: Anglo-Saxon Art and Culture AD 600–900, exhib. cat., 1991 (London, British Museum).
Les manuscrits à peintures en France 1440–1520, exhib. cat. (Paris, Bibliothèque Nationale de France, 1993).
Mayr-Harting, H. M. R. E., *Ottonian Book Illumination: An Historical Study* (1991).
Meiss, M., *French Painting in the Time of Jean de Berry* (1967–74).
Morgan, N. J., *Early Gothic Manuscripts 1190–1250* (1982–7).
Pächt, O., *Book Illumination in the Middle Ages* (1989).
The Painted Page, exhib. cat. (London, Royal Academy; New York, Pierpont Morgan Library, 1995).
Mütherich, F., and Gaehde, J. E., *Carolingian Painting* (1976)
Renaissance Painting in Manuscripts: Treasures from the British Library, exhib. cat. (London, British Library, 1983).
Sandler, L. F., *Gothic Manuscripts 1285–1385* (1986).
Scheller, R. W., *Exemplum: Model-book drawings and the Practice of Artistic Transmission in the Middle Ages (ca.900–ca.1470)* (1995).
Scott, K. L., *Later Gothic Manuscripts 1390–1490* (1996).
Temple, E., *Anglo-Saxon Manuscripts 900–1066* (1976).
Thomas, M., *The Golden Age: Manuscript Painting at the Time of Jean, Duc de Berry* (1979).
Weitzmann, K., *Illustrations in Roll and Codex: A Study of the Origin and Method of Text Illustration* (revised edn., 1970).
—— *Late Antique and Early Christian Book Illumination* (1977).
Wieck, R. S., *Time Sanctified: The Book of Hours in Medieval Art and Life* (1988).
Williams, J., *Early Spanish Manuscript Illumination* (1977).

Ars Sacra to c.1200
The Age of Spirituality: Late Antique and Early Christian Art, exhib. cat. (New York, Metropolitan Museum of Art, 1979).
Gauthier, M-M., *L'époque romane* (1987).
Goldschmidt, A., *Die Elfenbeinskulpturen aus der Zeit der karolingischen und sächsischen Kaiser, VIII–XI Jahrhundert*, vol. I (1914) and vol. II (1918).
—— *Elfenbeinskulpturen aus der romanischen Zeit, XI–XIII Jahrhundert*, vol. III (1923) and vol. IV (1926).
Kornbluth, G., *Engraved Gems of the Carolingian Empire* (1995).
Lasko, P. E., *Ars Sacra 800–1200* (2nd edn., 1994).
Ornamenta Ecclesiae: Kunst und Künstler der Romanik, exhib. cat. (Cologne, Schnütgen-Museums, 1985).
Palol, P. de, and Hirmer, M., *Early Medieval Art in Spain* (1967).
Panofsky, E. (ed.), *Abbot Suger on the Abbey Church of St-Denis and its Art Treasures* (2nd edn., 1979).
Schramm, P. E., and Mütherich, F., *Denkmale der deutschen Könige und Kaiser: Ein Beitrage zur Herrschergeschichte von Karl dem Grossen bis Friederich II, 768–1250* (2nd edn., 1981).
Schuette, M., and Muller-Christiansen, S., *The Art of Embroidery* (1964).
Swarzenski, H., *Monuments of Romanesque Art: The Art of Church Treasures in North-Western Europe* (2nd edn., 1974).
Theophilus, *The Various Arts (De diversis artibus)* (ed. C. R. Dodwell, 1961, 1986).
The Treasury of San Marco, Venice, exhib. cat. (London, British Museum, 1984).
Les Trésors des églises de France, exhib. cat. (Paris, Musée des Arts Decoratifs, 1965).
Volbach, W. F., *Elfenbeinarbeiten der Spätantike und des frühen Mittelalters* (3rd edn., 1976).

Monumental Sculpture to c.1300
Artistes, artisans et production artistique au moyen âge, vols. I, II, and III (1986, 1987, 1990).
Cassidy, B. (ed.), *The Ruthwell Cross* (1992).
Conant, K. J., *Carolingian and Romanesque Architecture 800–1200* (1974).
Dodwell, C. R., 'The Meaning of "Sculptor" in the Romanesque Period', in *Romanesque and Gothic: Essays for George Zarnecki* (1987).
Duby, Georges, Altet, Xavier Barral I, and de Sudauirant, Sophie Guillot, *Sculpture, The Great Art of the Middle Ages from the Fifth Century to the Fifteenth Century* (trans. Michael Heron, 1996).
Krautheimer, R., *Early Christian and Byzantine Architecture* (revised edn. R. Krautheimer and S. Curcic, 1986).
Salzman, L., *Building in England down to 1540* (1967).
Sauerländer, W., *Gothic Sculpture in France 1140–1270* (trans. J. Sondheimer, 1972).
Schapiro, M., 'On the Aesthetic Attitude in Romanesque Art', *Romanesque Art* (1977).

Williamson, P., *Gothic Sculpture 1140–1300* (1995).
Zarnecki, G., *Romanesque* (1971).
—— *Studies in Romanesque Sculpture* (1979).

Stained Glass

Alexander, J., and Binski, P., *Age of Chivalry: Art in Plantagenet England 1200–1400* (1987).
Becksmann, R., *Deutsche Glasmalerei des Mittelalters* (1988).
Brown, S., and O'Connor, D., *Medieval Craftsmen: Glass Painters* (1991).
—— *Stained Glass: An Illustrated History* (1992).
—— and MacDonald, L. (eds.), *Life, Death and Art: The Stained Glass of Fairford Parish Church* (1997).
Caviness, M. H., *The Early Stained Glass of Canterbury Cathedral* (1977).
Grodecki, L., *Le Vitrail roman* (1977).
—— and Brisac, C., *Gothic Stained Glass* (1988).
Husband, T., *The Luminous Image: Painted Glass Roundels in the Lowlands, 1480–1560* (1995).
Kemp, W., *The Narratives of Gothic Stained Glass* (1997).
Leproux, Guy-Michel, *Vitraux parisiens de la Renaissance* (1993).
Marchini, G., *Italian Stained Glass Windows* (1957).
Marks, R., *Stained Glass in England during the Middle Ages* (1993).
O'Connor, D., and Haselock, J., 'The Stained and Painted Glass', in G. E. Aylmer and R. Cant (eds.), *A History of York Minster* (1977).
Panofsky, E. (ed.), *Abbot Suger on the Abbey Church of St-Denis and its Art Treasures* (2nd edn., 1979).
Theophilus, *The Various Arts (De diversis artibus)* (ed. C. R. Dodwell, 1961, 1986).
Thompson, D. V. (ed.), *The Craftsman's Handbook 'Il Libro dell'Arte: Cennino d'Andrea Cennini* (1960).
Wayment, H. G., 'Twenty-four *vidimuses* for Cardinal Wolsey', *Master Drawings*, 23–4 (1985–6).
Zakin, H., *French Cistercian Grisaille Glass* (1979).

The volumes of the international Corpus Vitrearum Medii Aevi *should also be consulted.*

Painting in the High Middle Ages

Alexander, J., and Binski, P. (eds.), *Age of Chivalry: Art in Plantagenet England 1200–1400* (1987).
Bomford, D., Dunkerton, J., Gordon, D., and Roy, A., *Italian Painting before 1400* (1990).
Castelnuovo, E. (ed.), *Il Duecento e il Trecento* in *La pittura in Italia*, ed. C. Pivano (revised edn., 1986).
Demus, O., *Romanesque Mural Painting* (trans., 1970).
Dodwell, C. R., *The Pictorial Arts of the West, 800–1200* (1993).
Lowden, J., *Early Christian and Byzantine Art* (1997).
Stejskal, K., *European Art in the 14th Century* (1978).
White, J., *Art and Architecture in Italy 1250–1400* (2nd revised edn., 1987).

The Altarpiece

Bomford, D., *et al.*, *Italian Painting before 1400* (1990).
Borsook, E., and Gioffredi, F. Superbi, *Italian Altarpieces 1250–1550* (1994).
Davies, M., *The Early Italian Schools before 1400* (rev. D. Gordon, 1988).
Dunkerton, J., Foster, S., Gordon, D., and Penny, N., *Giotto to Dürer; Early Renaissance Painting in the National Gallery, London* (1991).
Gordon, D., *Making and Meaning: The Wilton Diptych* (1993).
Humfrey, P., and Kemp, M., *The Altarpiece in the Renaissance* (1990).
van Os, H., *Sienese Altarpieces* (1988).

Ars Sacra c.1200–1527

Duffy, E., *The Stripping of the Altars* (1992).
Gauthier, M.-M., *Les Routes de la foi* (1983).
Mâle, E., *Religious Art in France: The Late Middle Ages* (1986).
Rubin, M., *Corpus Christi: The Eucharist in Late Medieval Culture* (1994).
van Os, H., *The Art of Devotion* (1994).

Monumental Sculpture c.1300–1527

Ames-Lewis, F., *Tuscan Marble Carving, 1250–1350* (1997).
Müller, T., *Sculpture in the Netherlands, Germany, France and Spain, 1400 to 1500* (1966).
Olsen, R., *Italian Renaissance Sculpture* (1992).
Pope-Hennessy, J., *Italian Renaissance Sculpture* (2nd edn., 1971).
—— *Italian Gothic Sculpture* (3rd edn., 1985).
Seymour, C., *Sculpture in Italy, 1400–1500* (1966).

The New Painting: Italy and the North

Baxandall, M., *Giotto and the Orators: Humanist Observers of Painting in Italy and the Discovery of Pictorial Composition 1350–1450* (1986).
—— *Painting and Experience in Fifteenth-Century Italy* (2nd edn., 1988).
Chambers, D. (ed.), *Patrons and Artists in the Italian Renaissance* (1970).
Gilbert, C. (ed.), *Italian Art 1400–1500* (1980, repr. 1992).
Harbison, C., *The Art of the Northern Renaissance* (1995).
—— *The Mirror of the Artist: Northern Renaissance Art in its Historical Context* (1995).
Humfrey, P., *Painting in Renaissance Venice* (1995).
Kemp, M., *The Science of Art: Optical Themes in Western Art from Brunelleschi to Seurat* (1992).
—— *Behind the Picture: Art and Evidence in the Italian Renaissance* (1997).
Klein, R., and Zerner, H. (eds.), *Italian Art 1500–1600* (1989).
Panofsky, E., *Early Netherlandish Painting* (2 vols., 1953 and subsequent reprints).
Shearman, J., *Only Connect: Art and the Spectator in the Italian Renaissance* (1992).
Stechow, W. (ed.), *Northern Renaissance Art, 1400–1600* (1966, repr. 1995).
Wackernagel, M., *The World of the Florentine Renaissance Artist: Projects and Patrons, Workshop and Art Market* (trans. A. Luchs, 1981).
Welch, E., *Art and Society in Italy 1350–1500* (1996).
Snyder, J., *Northern Renaissance Art: Painting, Sculpture, the Graphic Arts from 1350 to 1575* (1985).

Domestic Arts

Callman, Ellen, *Family Pride: The Italian Renaissance House and its Furnishings* (1984).
Evans, Helen, and Wixom, William (eds.), *The Glory of Byzantium* (1997).
Geijer, Agnes, *A History of Textile Art, A Selective Account* (1979).
The Secular Spirit: Life and Art at the End of the Middle Ages, exhib. cat. (New York, Metropolitan Museum of Art, 1975).
Thornton, Peter, *The Italian Renaissance Interior 1400–1600* (1991).
Wilson, Timothy, *Ceramic Art of the Italian Renaissance* (1987).

The Print

Andrea Mantegna, exhib. cat. (New York, Metropolitan Museum of Art; London, Royal Academy, 1992).
Early Italian Engravings from the National Gallery of Art, exhib. cat. (Washington DC, National Gallery of Art, 1973).
Eisenstein, Elizabeth, *The Printing Press as an Agent of Change* (2 vols., 1979).
Hind, A. M., *Early Italian Engraving: A Critical Catalogue* (7 vols, 1938–48, repr. 1978).
Hults, Linda C., *The Print in the Western World: An Introductory History* (1996).
Landau, David, and Parshall, Peter, *The Renaissance Print, 1470–1550* (1994).
Livelier than Life: The Master of the Amsterdam Cabinet or the Housebook Master, c.1470–1500, exhib. cat. (Amsterdam, Rijksmuseum, 1985).
The Prints of Lucas van Leyden and his Contemporaries, exhib. cat. (Washington DC, National Gallery of Art, 1983).
Strauss, Walter, *The Illustrated Bartsch: Albrecht Dürer, Commentary*, vol. 10 (1981), formerly vol. 7.

Part 3: The Art of Nations: European Visual Regimes 1527–1770

The International Style

Blunt, A., *Art and Architecture in France, 1500–1700* (1970).
Fiamminghi a Roma, 1508–1608, exhib. cat. (Brussels, Palais voor Schone Kunsten, 1995).
Kaufmann, T. D., *The School of Prague* (1988).
Kubler, G., *Art and Architecture in Spain and Portugal and their American Dominions, 1500 to 1800* (1959).
—— *Building the Escorial* (1982).
Leveque, J. J., *L'École de Fontainebleau* (1984).
Llewellyn, N., *Art and Society in Early Modern Europe, 1500–1750* (forthcoming).
Shearman, J., *Mannerism* (1967).
van der Osten, G., and Vey, H., *Painting and Sculpture in Germany and the Netherlands, 1500–1600* (1969).

Forms in Space 1527–c.1600

Avery, Charles, *Florentine Renaissance Sculpture* (1970).
—— *Giambologna: the Complete Sculpture* (1987).
Keutner, H., *Sculpture: Renaissance to Rococo* (1969).

Molesworth, H. D., *European Sculpture* (1965).

Pope-Hennessy, J., *Italian High Renaissance and Baroque Sculpture* (1966, 1996).

Wittkower, R, *Sculpture: Processes and Principles* (1977).

Forms in Space *c.*1600–*c.*1700

Berger, R., *Versailles: The Château of Louis XIV* (1985).

Campbell, M., *Pietro da Cortona at the Pitti Palace* (1977).

Dempsey, C., *Annibale Carracci: The Farnese Gallery* (1995).

—— ' "Et Nos Cedamus Amori": Observations on the Farnese Gallery', *Art Bulletin,* 50 (1968).

Enggass, R., *The Painting of Baciccio: Giovanni Battista Gaulli 1639–1709* (1964).

Held, J., and Posner, D., *Seventeenth and Eighteenth Century Art* (1979).

Hood, W., 'The *Sacro Monte* of Varallo: Renaissance Art and Popular Religion', in T. Verdon, *Monasticism and the Arts* (1984).

Hibbard, H., *Bernini* (1965).

—— *Caravaggio* (1983).

Lavin, I., *Bernini and the Unity of the Visual Arts* (2 vols., 1980).

Martin, J. R., *The Farnese Gallery* (1965).

Scott, J. B., *Images of Nepotism: The Painted Ceilings of Palazzo Barberini* (1991).

Steinberg, L., 'Observations in the Cerasi Chapel', *Art Bulletin,* 41 (1959).

Wittkower, R., ' "Sacri Monti" in the Italian Alps,' in *Idea and Image: Studies in the Italian Renaissance* (1978).

—— *Art and Architecture in Italy 1600–1750* (5th edn., 1982).

Free-Standing Sculpture *c.*1600–*c.*1700

Avery, C., *Bernini: Genius of the Baroque* (1997).

Blunt, A., *Art and Architecture in France, 1500–1700* (1953).

—— (ed.), Paul Freart de Chantelou, *Diary of the Cavaliere Bernini's Visit to France* (1985).

Boucher, B., *Italian Baroque Sculpture* (1998).

Haskell, F., *Patrons and Painters: A Study in the Relations between Italian Art and Society in the Age of the Baroque* (revised edn., 1980).

Montagu, J., *Alessandro Algardi* (2 vols., 1985).

—— *Roman Baroque Sculpture: The Industry of Art* (1989).

—— *Gold, Silver and Bronze: Metal Sculpture in the Roman Baroque* (1996).

Penny, N., *The Materials of Sculpture* (1993).

Toman, R. (ed.), *Baroque: Architecture, Sculpture, Painting* (1998).

Weston-Lewis, A. (ed.), *Effigies and Ecstasies, Roman Baroque Sculpture and Design in the Age of Bernini* (1998).

Whinney, M., *Sculpture in Britain 1530–1830* (2nd edn., 1980).

Williamson, P. (ed.), *European Sculpture at the Victoria and Albert Museum* (1996).

Wittkower, R., *Art and Architecture in Italy 1600–1750* (5th edn., 1982).

—— *Bernini: The Sculptor of the Roman Baroque* (revised edn., 1990).

The Picture: Italy and France

SIXTEENTH CENTURY

Blunt, A., *Artistic Theory in Italy 1450–1600* (1959).

Chastel, A., *French Art* (3 vols., trans. D. Dusinberre, 1995), vol. 2: *The Renaissance 1430–1620*, with useful bibliography including monographs on individual artists.

Cox-Rearick, J., *The Collection of Francis I: Royal Treasures* (1995).

Freedberg, S. J., *Painting in Italy 1500–1600* (3rd edn., 1993), with useful bibliography including monographs on individual artists.

Shearman, J., *Mannerism* (1967).

—— *Only Connect: Art and the Spectator in the Italian Renaissance* (1992).

Vasari, G., *The Lives of the Artists* (trans. J. C. Bondanella and P. Bondanella, 1991).

SEVENTEENTH CENTURY

Blunt, A., *Art and Architecture in France 1500–1700* (1953; 4th edn., 1981), with useful bibliography including monographs on individual artists.

Cropper, E., and Dempsey, C., *Nicolas Poussin: Friendship and the Love of Painting* (1996).

Haskell, F., *Patrons and Painters: A Study in the Relations between Italian Art and Society in the Age of the Baroque* (1963).

Hibbard, H., *Caravaggio* (1982).

Mérot, A., *Nicolas Poussin* (1990).

—— *French Painting in the Seventeenth Century* (trans. C. Beamish, 1995).

Wittkower, R., *Art and Architecture in Italy 1600–1750* (5th revised edn., 1982), with useful bibliography including monographs on individual artists.

EIGHTEENTH CENTURY

Chastel, A., *French Art* (3 vols., trans. D. Dusinberre, 1996), vol. 3: *The Ancien Régime 1620–1775*, with useful bibliography including monographs on individual artists.

Conisbee, P., *Painting in Eighteenth-Century France* (1981).

Crow, T., *Painters and Public Life in Eighteenth-Century Paris* (1985).

Fried, M., *Absorption and Theatricality: Painting and the Beholder in the Age of Diderot* (1980).

The Glory of Venice: Art in the Eighteenth Century, exhib. cat. (London, Royal Academy; Washington, DC, National Gallery of Art, 1994–5).

Vidal, M., *Watteau's Painted Conversations* (1992).

The Picture: Spain

Ayala Mallory, Nina, *El Greco to Murillo: Spanish Painting in the Golden Age, 1556–1700* (1990).

Brown, Jonathan, 'Philip II as Art Collector and Patron', in R. L. Kagan (ed.), *Spanish Cities of the Golden Age* (1989).

—— *The Golden Age of Painting in Spain* (1991).

El Greco of Toledo, exhib. cat. (Washington, DC, National Gallery of Art, 1982).

Painting in Spain during the Later Eighteenth Century, exhib. cat. (London, National Gallery, 1989).

Painting in Spain in the Age of the Enlightenment: Goya and his Contemporaries, exhib. cat. (Indianapolis, Museum of Art, 1996).

Tomlinson, Janis, *Painting in Spain: El Greco to Goya, 1561–1828* (1997).

The Picture: Dutch and Flemish

The Age of Rubens, exhib. cat. by Peter C. Sutton, Marjorie E. Wieseman *et al.* (Boston, Museum of Fine Arts; Toledo, Ohio, Museum of Art, 1993–4).

Brown, Christopher, *Images of a Golden Past: Dutch Genre Painting of the 17th Century* (1984).

Freedberg, David, *Dutch Landscape Prints of the Seventeenth Century* (1980).

Haak, Bob, *The Golden Age: Dutch Painters of the Seventeenth Century* (trans. and ed. Elizabeth Willems-Treeman, 1984).

Johannes Vermeer, exhib. cat., ed. Arthur K. Wheelock, Jr. (Washington, DC, National Gallery of Art; The Hague, Mauritshuis, 1995–6).

Kahr, Madlyn Millner, *Dutch Painting in the Seventeenth Century* (1978).

Liedtke, Walter, *The Royal Horse and Rider: Painting, Sculpture, and Horsemanship 1500–1800* (1989).

Masters of Seventeenth-Century Dutch Genre Painting, exhib. cat. by Peter C. Sutton *et al.* (Philadelphia, Museum of Art; Berlin, Gemäldegalerie, Staatliche Museen Preussischer Kulturbesitz; London, Royal Academy, 1984).

Masters of 17th-Century Dutch Genre Painting, exhib. cat. by Peter C. Sutton *et al.* (Amsterdam, Rijksmuseum; Boston, Museum of Fine Arts; Philadelphia, Museum of Art, 1987–8).

North, Michael, *Art and Commerce in the Dutch Golden Age* (trans. Catherine Hill, 1997).

Schama, Simon, *The Embarrassment of Riches: An Interpretation of Dutch Culture in the Golden Age* (1987).

Schwartz, Gary, *Rembrandt, his Life, his Paintings* (1985).

Slive, Seymour, *Dutch Painting 1600–1800* (1995).

Turner, Jane (ed.), *The Dictionary of Art* (34 vols., 1996).

Vlieghe, Hans, *Flemish Painting 1600–1800* (1998).

Westermann, Mariët, *A Worldly Art: The Dutch Republic 1585–1718* (1996).

The Picture: England

The Artist's Model: Its Role in British Art from Lely to Etty, exhib. cat. by I. Bignamini and M. Postle (Nottingham, University Art Gallery; London, Kenwood, Iveagh Bequest, 1991).

Bignamini, I., 'George Vertue, Art Historian and Art Institutions in London, 1689–1768: A Study of Clubs and Academies', *Walpole Society,* 54 (1988).

Bindman, D., *Hogarth* (1981).

—— (ed.), *The Thames and Hudson Encyclopaedia of British Art* (1985).

Burke, J., *English Art 1714–1800* (1976).

Croft-Murray, E., *Decorative Painting in England 1537–1837* (2 vols, 1962, 1970).

Dobai, J., *Die Kunstliteratur des Klassizismus und der Romantik in England, 1700–1840* (3 vols., 1974–7).

Deuchar, S., *Sporting Art in Eighteenth-Century England* (1988).

Dynasties: Painting in Tudor and Jacobean England 1530–1630, exhib. cat., ed. K. Hearn (London, Tate Gallery, 1995).

Grand Tour: The Lure of Italy in the Eighteenth Century, exhib. cat., ed. A. Wilton and I. Bignamini (London, Tate Gallery, 1996).

Howarth, D., *Lord Arundel and his Circle* (1985).

MacGregor, A. (ed.), *The Late King's Goods: Collections, Possessions and Patronage of Charles I in the Light of the Commonwealth Sale Inventories* (1989).

Manners & Morals: Hogarth and British Painting 1700–1760, exhib. cat. by E. Einberg *et al.* (London, Tate Gallery, 1987).

Mercer, E., *English Art 1553–1625* (1962).

Millar, O., *Sir Peter Lely 1618–80*, exhib. cat. (London, National Portrait Gallery, 1978).

Murdoch, J., Murrell, J., Noon, D. J., and Strong, R., *The English Miniature* (1981).

Paulson, R., *Hogarth: His Life, Art, and Times* (2 vols., 1971).

Pears, I., *The Discovery of Painting: The Growth of Interest in the Arts in England, 1680–1768* (1988).

Reynolds, exhib. cat., ed. N. Penny (London, Royal Academy, 1986).

Rococo: Art and Design in Hogarth's England, exhib. cat., ed. M. Snodin (London, Victoria & Albert Museum, 1984).

Rowlands, J., *Holbein* (1985).

Solkin, D. H., *Painting for Money: The Visual Arts and the Public Sphere in Eighteenth-Century England* (1988).

Talley, M. K., *Portrait Painting in England: Studies in the Technical Literature before 1700* (1981).

Thomas Gainsborough, exhib. cat,. by J. Hayes (London, Tate Gallery, 1980).

Van Dyck Paintings, exhib. cat., ed. A. K. Wheelock Jr., S. J. Barnes, and J. S. Held (Washington, DC, National Gallery of Art, 1990).

Waterhouse, E., *Painting in Britain 1530 to 1790* (1978).

—— *The Dictionary of British 18th Century Painters* (1981).

—— *The Dictionary of 16th & 17th Century British Painters* (1988).

Whinney, M. D., and Millar, O., *English Art 1625–1714* (1957).

The Print

Freedberg, D., *Dutch Landscape Prints of the Seventeenth Century* (1980).

Godfrey, R. T., *Printmaking in Britain: A General History from Its Beginnings to the Present Day* (1978).

Hults, L. C., *The Print in the Western World: An Introductory History* (1996).

Italian Etchers of the Renaissance and Baroque, exhib. cat. (Boston, Museum of Fine Arts, 1989).

Graven Images: The Rise of Professional Printmakers in Antwerp and Haarlem, 1540–1640, exhib. cat. (Northwestern University, Evanston, Illinois, Mary and Leigh Block Gallery, 1993).

Lambert, S., *The Image Multiplied: Five Centuries of Printed Reproductions of Paintings and Drawings* (1987).

Landau, D., and Parshall, P., *The Renaissance Print, 1470–1550* (1994).

Melot, M., Griffiths, A., and Field, R., *Prints: History of an Art* (1981).

Paulson, R., *Hogarth's Graphic Works* (2 vols., 1965).

Printmaking in the Age of Rembrandt, exhib. cat. (Boston, Museum of Fine Arts, 1981).

Regency to Empire: French Printmaking, 1515–1814, exhib. cat. (Baltimore, Museum of Art, 1985).

Rizzi, A., *The Etchings of the Tiepolos: Complete Edition* (1971).

Robison, A., *Piranesi, Early Architectural Fantasies: A Catalogue Raisonné of the Etchings* (1986).

Wax, C., *The Mezzotint: History and Technique* (1990).

White, C., *Rembrandt as an Etcher: A Study of the Artist at Work* (2 vols., 1969).

The World in Miniature: Engravings by the German Little Masters, 1500–1550, exhib. cat. (University of Kansas, Lawrence, Spencer Museum of Art, 1988).

The Interior

Atterbury, Paul (ed.), *The History of Porcelain* (1982).

Blakemore, Robbie G., *History of Interior Design and Furniture: From Ancient Egypt to Nineteenth-Century Europe* (1997).

Beard, Geoffrey, *Craftsmen and Interior Decoration in England 1660–1820* (1981).

Bristow, Ian, *Architectural Colour in British Interiors 1615–1840* (1996).

Charleston, R. J., *World Ceramics: An Illustrated History* (1968).

Fleming, John, and Honour, Hugh, *The Penguin Dictionary of the Decorative Arts* (1977).

Girouard, Mark, *Life in the English Country House: A Social and Architectural History* (1978).

McCorquodale, Charles, *The History of Interior Decoration* (1983).

Praz, Mario, *An Illustrated History of Interior Decoration from Pompeii to Art Nouveau* (1964).

Saumarez Smith, Charles, *Eighteenth-Century Decoration: Design and the Domestic Interior in England* (1993).

Scott, Katie, *The Rococo Interior: Design and Social Spaces in Eighteenth-Century Paris* (1985).

Snodin, Michael, and Howard, Maurice, *Ornament: A Social History since 1450* (1996).

Standen, E. A., *European Post-Medieval Tapestries and Related Hangings in the Metropolitan Museum of Art* (1985).

Thornton, Peter, *Seventeenth-Century Interior Decoration in England, France and Holland* (1978).

—— *Authentic Decor: The Domestic Interior 1620–1920* (1984).

—— *The Italian Renaissance Interior 1400–1600* (1991).

Walton, Guy, *Louis XIV's Versailles* (1986).

Wittkower, Rudolf, *Art and Architecture in Italy 1600–1750* (5th edn., 1982).

Form and Space *c*.1700–1770

Baker, Malcolm, *Figured in Marble: The Making and Viewing of Sculpture in Eighteenth-Century England*, (2000).

Bindman, David, and Baker, Malcolm, *Roubiliac and the Eighteenth-Century Monument: Sculpture as Theatre* (1995).

Cellini, Antonia Nava, *La scultura del Settecento* (1987).

Draper, James David, and Scherf, Guilhem, *Augustin Pajou: Royal Sculptor 1730–1809* (1997).

Enggass, Robert, *Early Eighteenth-Century Sculpture in Rome* (1976).

Levey, Michael, *Painting and Sculpture in France 1700–1789* (1993).

Souchal, François, *French Sculptors: The Reign of Louis XIV* (vols I–III, 1977–87, vol IV, 1993).

Volk, Peter, *Rokokoplastik* (1981).

Whinney, Margaret, *Sculpture in Britain 1530–1830* (rev. John Physick, 1988).

Academies, Theories and Critics

Barzman, Karen-edis, *The Discipline of Disegno: The Florentine Academy and the Early Modern State, 1563–1737* (forthcoming).

Crow, Thomas E., *Painters and Public Life in Eighteenth-Century Paris* (1985).

Hutchison, Sidney C., *The History of the Royal Academy, 1768–1986* (1986).

Johns, Christopher M. S., 'Papal Patronage and Cultural Bureaucracy in Eighteenth-Century Rome: Clement XI and the Accademia di San Luca', in *Eighteenth-Century Studies*, 22 (1988).

Pevsner, Nikolaus, *Academies of Art, Past and Present* (1940).

Smith, Gil. R., *Architectural Diplomacy: Rome and Paris in the Late Baroque* (1993).

Vazquez, Oscar E., 'Learning to Draw in Spanish: Pedagogy, Discipline, and the Spaces of Exclusion in Mexico's San Carlos Academy' (forthcoming in *(In)disciplinas: estetica e historia del arte en el cruce de los discursos*, Mexico City, Universidad Nacional Autonoma).

The International Diaspora

Bayón, Damian, and Marx, Murillo, *History of South American Colonial Art and Architecture* (1992).

Bennett, Ian, *A History of American Painting* (1973).

Fane, Diana (ed.), *Converging Cultures: Art and Identity in Spanish America* (1996).

Gruzinski, Serge, *Painting the Conquest: The Mexican Indians and the European Renaissance* (1992).

Prown, Jules David, and Rose, Barbara, *American Painting From the Colonial Period to the Present* (2nd edn., 1977).

Reid, Dennis, *A Concise History of Canadian Painting* (1973).

Part 4: The Era of Revolutions 1770–1914

Pictures and Publics

Adolph Menzel, exhib. cat. (Washington, DC, National Gallery of Art, 1996–7).

The Age of Rossetti, Burne-Jones and Watts: Symbolism in Britain 1860–1910, exhib. cat. (London, Tate Gallery, 1997).

The Art of Paul Gauguin, exhib. cat. (Washington, DC, National Gallery of Art; Chicago, Institute of Art, 1988).

Baigell, Matthew, *A Concise History of American Painting and Sculpture* (revised edn., 1996).

Barbizon Revisited, exhib. cat. (Boston, Museum of Fine Arts, 1962).

Berger, Klaus, *Japonisme in Western Painting from Whistler to Matisse* (1992).

Boccioni, exhib. cat. (New York, Metropolitan Museum of Art, 1988).

Boime, Albert, *Art in the Age of Revolution, 1750–1800* (1988).

—— *Art in an Age of Bonapartism, 1800–1815* (1990).

Cézanne, exhib. cat. (Paris, Grand Palais; Philadelphia, Museum of Art, 1995–6).

Clark, T. J., *Image of the People: Gustave Courbet and the 1848 Revolution* (1973).

—— *The Painting of Modern Life: Paris in the Art of Manet and his Followers* (1985).

Clay, Jean, *Romanticism* (1981).

Craske, Matthew, *Art in Europe 1700–1830* (1997).

Crow, Thomas, *Painters and Public Life in Eighteenth-Century Paris* (1985).

—— *Emulation: Making Artists for Revolutionary France* (1995).

Degas, exhib cat. (New York, Metropolitan Museum; Ottawa, National Gallery of Canada, 1988).

Eisenman, Stephen F., *et al.*, *Nineteenth Century Art: A Critical History* (1994).

Eitner, Lorenz E., *Géricault: His Life and Work* (1983).

Flam, Jack, *Matisse: The Man and his Art, 1869–1918* (1986).

Fried, Michael, *Manet's Modernism, or, The Face of Painting in the 1860s* (1996).

Gage, John, *J. M. W. Turner: 'A Wonderful Range of Mind'* (1987).

Georges Seurat, 1859–1891, exhib. cat. (New York, Metropolitan Museum of Art; London, National Gallery, 1991).

Gustave Courbet 1819–1877, exhib. cat. (London, Royal Academy, 1978).

James McNeil Whistler, exhib. cat. (London, Tate Gallery, 1994).

Koerner, Joseph Leo, *Caspar David Friedrich and the Subject of Landscape* (1990).

Goldwater, Robert, *Symbolism* (1979).

Herbert, James, *Fauve Painting: The Making of Cultural Politics* (1992).

Herbert, Robert L., *Impressionism: Art, Leisure and Parisian Society* (1988).

Honour, Hugh, *Neo-classicism* (1968).

—— *Romanticism* (1979).

Hulsker, Jan, *The Complete Van Gogh: Paintings, Drawings, Sketches* (1980).

Janson, H. W., and Rosenblum, Robert, *19th-Century Art* (1984).

Jobert, Barthelemy, *Delacroix* (1998).

Johns, Elizabeth, *Thomas Eakins: The Heroism of Modern Life* (1983).

Lloyd, Jill, *German Expressionism: Primitivism and Modernity* (1991).

Lost Paradise: Symbolist Europe, exhib. cat. (Montreal, Museum of Fine Arts, 1995).

Nochlin, Linda, *Realism* (1971).

Novak, Barbara, *American Painting of the Nineteenth Century* (revised edn., 1979).

Novotny, Fritz, *Painting and Sculpture in Europe, 1780–1880* (2nd edn., 1978).

Origins of Impressionism, exhib. cat. (New York, Metropolitan Museum of Art, 1995–6).

Picasso and Braque: Pioneering Cubism, exhib. cat. (New York, Museum of Modern Art, 1989).

The Pre-Raphaelites, exhib. cat. (London, Tate Gallery, 1984).

Pressley, William L., *The Art of James Barry* (1981).

Rewald, John, *The History of Impressionism* (4th edn., 1973).

—— *Post-Impressionism from Van Gogh to Gauguin* (3rd edn., 1978).

Richardson, John, *A Life of Picasso*, vol. II: *1907–1917: The Painter of Modern Life* (1996).

Rosenblum, Robert, *Cubism and Twentieth-Century Art* (revised edn., 1976).

—— *Transformations in Late Eighteenth-Century Art* (1967).

Rosenthal, Michael, *Constable: The Painter and His Landscape* (1983).

Schapiro, Meyer, *Impressionism: Reflections and Perceptions* (1997).

Selz, Peter, *German Expressionist Painting* (1957).

Tomlinson, Janis, *Francisco Goya y Lucientes, 1746–1828* (1994).

Treuherz, Julian, *Victorian Painting* (1993).

Tucker, Paul Hayes, *Claude Monet: Life and Art* (1995).

Vaughan, William, *German Romantic Painting* (1980).

—— *Arts of the 19th Century*, vol. I: *1780 to 1850* (1998).

Vienna 1900: Art, Architecture and Design, exhib. cat. (New York, Museum of Modern Art, 1986).

Vigne, Georges, *Ingres* (1995).

Whitford, Frank, *Egon Schiele* (1981).

The 'Wild Beasts': Fauvism and Its Affinities, exhib. cat. (New York, Museum of Modern Art, 1976).

Winslow Homer, exhib. cat. (Washington, DC, National Gallery of Art, 1995).

Wright of Derby, exhib. cat. (London, Tate Gallery, 1990).

Sculptures and Publics

Bluhm, Andreas, *et al.*, *The Colour of Sculpture 1840–1910* (1996).

Janson, H. W., *Nineteenth Century Sculpture* (1985).

—— and Fusco, Peter, *The Romantics to Rodin: French Nineteenth-Century Sculpture from North American Collections* (1980).

Kendall, Richard, *Degas and the Little Dancer* (1998).

Le Normand-Romain, Antoinette, *et al.*, *Sculpture*, vol. 4: *The Adventure of Modern Sculpture in the Nineteenth and Twentieth Centuries* (1996).

Penny, Nicholas, *The Materials of Sculpture* (1993).

Rubenstein, Charlotte Streifer, *American Women Sculptors: A History of Women Working in Three Dimensions* (1990).

Wagner, Anne Middleton, *Jean-Baptiste Carpeaux, Sculptor of the Second Empire* (1986).

The Print

The Art of Paul Gauguin, exhib. cat. (Washington, DC, National Gallery of Art, 1988).

The Artistic Revival of the Woodcut in France, 1850–1900, exhib. cat. (Ann Arbor, University of Michigan Museum of Art, 1984).

Brücke: German Expressionist Prints from the Granvil and Marcia Specks Collection, exhib. cat. (Northwestern University, Evanston, Illinois, Mary and Leigh Block Gallery, 1988).

Castleman, R., *Prints of the Twentieth Century* (revised edn., 1988).

The Charged Image: French Lithographic Caricature, 1816–1848, exhib. cat. (Santa Barbara, Museum of Art, 1989).

The Color Revolution: Color Lithography in France, 1871–1914, exhib. cat. (New Brunswick, Rutgers University Art Gallery, 1978).

The Cubist Print, exhib. cat. (University of California at Santa Barbara, University Art Museum, 1981).

Essick, R., *William Blake: Printmaker* (1980).

George, M., *Hogarth to Cruikshank: Social Change in Graphic Satire* (1967).

German Expressionist Prints and Drawings, Robert Gore Rifkind Center for German Expressionist Studies, Los Angeles County Museum of Art, (2 vols., 1989).

Gilmour, P. (ed.), *Lasting Impressions: Lithography as Art* (1988).

Goya and the Spirit of Enlightenment, exhib. cat. (Madrid, Prado Museum, 1989).

Graphic Evolutions: The Print Series of Francisco Goya, exhib. cat. (Columbia University, New York, Wallach Art Gallery, 1989).

Hults, L., *The Print in the Western World: An Introductory History* (1996).

Käthe Kollwitz, exhib. cat. (Washington, DC, National Gallery of Art, 1992).

Mary Cassatt: The Color Prints, exhib. cat. (Washington, DC, National Gallery of Art, 1989).

Melot, M., *Graphic Art of the Pre-Impressionists* (1980).

—— *The Impressionist Print* (1996).

—— Griffiths, A, and Field, R., *Prints: History of an Art* (1981).

Picasso the Printmaker: Graphics from the Marina Picasso Collection, exhib. cat. (Dallas, Museum of Fine Arts, 1983).

Prelinger, E., *Edvard Munch: Master Printmaker* (1983).

The Print in Germany 1888–1933: The Age of Expressionism, exhib, cat. (London, British Museum, 1984).

Watrous. J., *A Century of American Printmaking, 1880–1980* (1984).

Weisberg, G., *The Etching Renaissance in France, 1850–1880*, exhib. cat. by G. Weisberg (Salt Lake City, Utah Museum of Fine Arts, 1971).

Photography

Clarke, Graham, *The Photograph* (1997).

Garnsheim, Helmut, and Garnsheim, Alison, *The History of Photography: From the Camera Obscura to the Beginning of the Modern Era* (revised and enlarged edn., 1969).

Frizot, Michael (ed.), *Nouvelle histoire de la photographie* (1994).

Jeffrey, Ian, *Photography: A Concise History* (1981).

—— *The Photography Book* (1997).

—— *Timeframes* (1998).

Kosloff, Max, *Photography and Fascination* (1979).

—— *The Privileged Eye: Essays on Photography* (1987).

—— *Lone Visions, Crowded Frames: Essays on Photography* (1994).

On the Art of Fixing a Shadow: One Hundred and Fifty Years of Photography, exhib. cat. (Washington, DC, National Gallery of Art; Chicago, Institute of Art, 1989).

Trachtenberg, Alan, *Reading American Photographs: Images as History, Mathew Brady to Walker Evans* (1989).

The Waking Dream: Photography's First Century, exhib. cat. for selections from the Gilman Paper Company Selection (New York, Metropolitan Museum of Art, 1997).

Weaver, Mike, *The Photographic Art: Pictorial Traditions in Britain and America* (1985).

Design and Industry

Bronner, J. (ed.), *Consuming Visions: Accumulation and Display of Goods in America, 1880–1920* (1989).

Forty, A., *Objects of Desire: Design and Society 1750–1980* (1986).

Heskett, J., *Industrial Design* (1980).

Noblet, J. de (ed.) *Industrial Design: Reflections of a Century* (1993).

Pirovano C. (ed.) *Storia del disegno industriale* (1990).

Snodin, M. and Howard, M., *Ornament: A Social History since 1450* (1996).

Thornton, P. *Authentic Decor: The Domestic Interior 1620–1920* (1984).

The Rise of Art History

Fernie, E. (ed.), *Art History and its Methods: A Critical Anthology* (1995).

Kultermann, U., *The History of Art History* (1993).

Minor, V. H., *Art History's History* (1994).

Podro, M., *The Critical Historians of Art* (1982).

Art Criticism and Aesthetic Ideals

Harrison, Charles, Wood, Paul, and Gaiger, Jason (eds.), *Art in Theory 1815–1900: An Anthology of Changing Ideas* (1998).

Holt, Elizabeth Gilmore, *The Triumph of Art for the Public: The Emerging Role of Exhibitions and Critics* (1979).

Orwicz, Michael R., *Art Criticism and its Institutions in Nineteenth-Century France* (1994).

Taylor, Joshua C., *Nineteenth-Century Theories of Art* (1987).

Art Museums and Galleries

ART/artifact: African Art in Anthropology Collections, exhib. cat. with essays by Susan Vogel *et al.* (New York, Center for African Art, 1988).

Bazin, Germain, *The Museum Age* (trans. J. van Nuis Cahill, 1967).

Dimaggio, Paul, 'Cultural Entrepreneurship in Nineteenth-Century Boston', *Media, Culture and Society*, 4 (1982).

Duncan, Carol, *Civilizing Rituals: Inside Public Art Museums, London and New York* (1995).

Haskell, Francis, *Rediscoveries in Art: Some Aspects of Taste, Fashion and Collecting in England and France* (1976).

Holst, Niels von, *Creators, Collectors and Connoisseurs* (trans. B. Battershaw, 1967).

McClellan, Andrew, *Inventing the Louvre: Art, Politics, and the Origins of the Modern Museum in Eighteenth-Century Paris* (1994).

Price, Sally, *Primitive Art in Civilized Places* (1989).

Part 5: Modernism and After 1914–2000

The International Style

Ades, Dawn, *Dada and Surrealism Reviewed* (1978).

American Art in the Twentieth Century: Painting and Sculpture 1913–1993, exhib. cat. (London, Royal Academy, 1993).

Chadwick, Whitney, *Women, Art and Society* (1990).

Cone, Michèle C., *Artists Under Vichy: A Case of Prejudice and Persecution* (1992).

Fer, Briony, Batchelor, David, and Wood, Paul, *Realism, Rationalism, Surrealism: Art between the Wars* (1993).

Frascina, Francis, and Harris, Jonathan (eds.), *Art in Modern Culture: an Anthology of Critical Texts* (1992).

Green, Christopher, *Cubism and its Enemies* (1987).

Guilbaut, Serge, *How New York Stole the Idea of Modern Art: Abstract Expressionism, Freedom and the Cold War* (1983).

Harrison, C., and Wood, P. (eds.), *Art in Theory 1900–1990: An Anthology of Changing Ideas* (1992).

Hughes, Robert, *The Shock of the New: Art and the Century of Change* (1980).

On Classic Ground: Picasso, Léger, de Chirico and the New Classicism, 1910–1930, exhib. cat. (London, Tate Gallery, 1990).

Silver, Kenneth, *Esprit de Corps: The Art of the Parisian Avant-Garde and the First World War, 1914–25* (1989).

Taylor, Brandon, *Art and Literature Under the Bolsheviks*, vol 1 (1991) and vol. 2 (1992).

Wood, Paul, Frascina, Francis, Harris, Jonathan, and Harrison, Charles, *Modernism in Dispute: Art since the Forties* (1993).

Alternative Media

The Arts for Television, exhib. cat., by Kathy Rae Huffman and Dorine Mignot, 1987 (Los Angeles, The Museum of Contemporary Art; Amsterdam, Stedelijk Museum).

Benjamin, Walter, 'The Work of Art in the Age of Mechanical Reproduction', *Illuminations* (1992).

del Buffalo, Dario (ed.), *Catalogue of the 42nd Venice Biennale* (1986).

Burnham, Jack, *Beyond Modern Sculpture* (1968).

Fineberg, Jonathan, *Art since 1940: Strategies of Being* (1995).

Kunst-Licht-Kunst, exhib. cat. by Frank Popper (Eindhoven Stedelijk Van Abbemuseum, 1966).

Lovejoy, Margot, 'Art, Technology and Postmodernism: Paradigms, Parallels, and Paradoxes', *Art Journal* (Fall 1990).

McLuhan, Marshall, *The Medium is the Massage* (new edn., 1997).

—— *War and Peace in the Global Village* (new edn., 1997).

Popper, Frank, *Art of the Electronic Age* (1993).

Rickey, George, *Constructivism: Origins and Evolution* (1967).

Sharp, Willoughby, 'Luminism and Kineticism', in Gregory Battcock (ed.), *Minimal Art: A Critical Anthology* (1995).

Tisdall, Caroline, and Bozzolla, Angelo, *Futurism* (1978).

Wheeler, Daniel, *Art since Mid-Century* (1991).

Photography

Clarke, Graham, *The Photograph* (1997).

Garnsheim, Helmut, and Garnsheim, Alison, *The History of Photography: From the Camera Obscura to the Beginning of the Modern Era* (revised and enlarged edn., 1969).

Frizot, Michael (ed.), *Nouvelle histoire de la photographie* (1994).

Jeffrey, Ian, *Photography: A Concise History* (1981).

—— *The Photography Book* (1997).

—— *Timeframes* (1998).

Kosloff, Max, *Photography and Fascination* (1979).

—— *The Privileged Eye: Essays on Photography* (1987).

—— *Lone Visions, Crowded Frames: Essays on Photography* (1994).

On the Art of Fixing a Shadow: One Hundred and Fifty Years of Photography, exhib. cat. (Washington, DC, National Gallery of Art; Chicago, Institute of Art, 1989).

Trachtenberg, Alan, *Reading American Photographs: Images as History, Mathew Brady to Walker Evans* (1989).

The Waking Dream: Photography's First Century, exhib. cat. for selections from the Gilman Paper Company Selection (New York, Metropolitan Museum of Art, 1997).

Weaver, Mike, *The Photographic Art: Pictorial Traditions in Britain and America* (1985).

Alternative Centres: The Soviet Union

Banks, M. (ed.), *The Aesthetic Arsenal: Socialist Realism Under Stalin* (1993).

Cullerne Bown, M., *Art Under Stalin* (1991).

—— and Taylor B., (eds.), *Art of the Soviets: Painting, Sculpture and Architecture in a One-Party State, 1917–1992* (1993).

Groys, B., *The Total Art of Stalinism: Avant Garde, Aesthetic Dictatorship and Beyond* (1992).

Prokhorov, G., *Art Under Socialist Realism: Soviet Painting 1930–50* (1995).

Soviet Socialist Realist Painting, exhib. cat. (Oxford, Museum of Modern Art; Newcastle, Laing Art Gallery, 1992).

Taylor, B., *Art and Literature under the Bolsheviks* (2 vols. 1991).

Alternative Centres: Latin America

Ades, Dawn (ed.), *Art in Latin America: The Modern Era, 1820–1980* (1989).

Baddeley, Oriana, and Fraser, Valerie, *Drawing the Line* (1989).

Day, Holliday T., and Sturges, Hoollister, *Art of the Fantastic: Latin America, 1920–1987* (1987).

Fletcher, Valerie (ed.), *Crosscurrents of Modernism: Four Latin American Pioneers: Diego Rivera, Joaquín Torres-García, Wifredo Lam, Matta* (1992).

Mosquera, Gerardo (ed.), *Beyond the Fantastic: Contemporary Art Criticism From Latin America* (1995).

Traba, Marta, *Art of Latin America, 1900–1980* (1994).

Alternative Centres: India

Araeen, R., *The Other Story* (1989).

Clarke, J., *Modernity in Asian Art* (1993).

Guha-Thakurta, T., *The Making of a New Indian Art* (1992).

Khanna, B, and Khurta, A., *Art of Modern India* (1998).

Mitter, P., *Art and Nationalism in Colonial India 1850–1922* (1994).

Alternative Centres: African and Afro-Caribbean

AFRO-CARRIBEAN ART

Archer-Straw, Petrine, and Robinson, Kim, *Jamaican Art: An Overview, with a Focus on Fifty Artists* (1990).

Boxer, David, *Edna Manley: Sculptor* (1990).

—— *Jamaican Art 1922–1982* (1993).

Camnitzer, Luis, *New Art of Cuba* (1994).

Caribbean Art Now, exhib. cat. by Emma Wallace *et al.* (London, Commonwealth Institute, 1986).

Lerebours, Michel Philippe, *Haiti et ses peintres, de 1804 à 1980* (1989).

Lewis, Samella S. *Caribbean Visions : Contemporary Painting and Sculpture* (1995).

MacLean, Geoffrey, 'Trinidad and Tobago: Contemporary Painting', in *Trinidad and Tobago: Contemporary Painting*, exhib. cat. (London, October Gallery, 1992).

Made in Havana: Contemporary Art from Cuba, exhib. cat., by Charles Mereweather and Gerraldo Mosquera (Sydney, Art Gallery of New South Wales, 1988).

Mereweather, Charles 'Banality and Tragedy: A History of the Present in Haiti', in *Edouard Duval Carrie, Marco*, exhib. cat. (Monterrey, Museo de Arte Contemporaneo, 1992).

Njami, Simon, *et al.*, 'Caribbean Art and Literature', *Revue noire, 2* (1993).
—— *et al.* 'Caribbean Art and Literature', *Revue noire, 6* (1993).
Nunley, John, and Bettelheim, Judith (eds.), *Caribbean Festival of Arts: Each and Every Bit of Difference* (1988).
Sullivan, Edward J., *Latin American Art in the Twentieth Century* (1996).

AFRICAN MODERNISM
Araeen, Rashid, 'Our Bauhaus, Others' Mudhouse', *Third World Perspectives on Contemporary Art and Culture, 6* (1989).
Barber, Karen, 'Popular Arts in Africa', *African Studies Review, 3* (1987).
Beier, Ulli, *Contemporary Art in Africa* (1968).
Bender, Wolfgang, 'Modern Art to the Ethnographic Museums!', in Elizabeth Biasio, *The Hidden Reality; Three Contemporary Ethiopian Artists* (1989).
Brown, Evelyn S., *Africa's Contemporary Art and Artists* (1966).
Cabral, Amilcar, 'The Role of Culture in the Liberation Struggle', in A. Malterart and S. Siegelaub (eds.), *Communcation and Class Struggle*, vol. I (1979).
Contemporary African Art, exhib. cat. (London, Studio International, 1970).
Contemporary African Artists: Changing Traditions, exhib. cat. (New York, Studio Museum in Harlem, 1990).
Duerden, Dennis, *The Invisible Present: African Art and Literature* (1975).
Fosu, Kojo, *20th-Century Art of Africa* (1986).
Hassan, Salah, 'Contemporary African Art: Towards a Critical Understanding', in Philip Altbach and Salah Hassan (eds.) *The Muse of Modernity: Essay on Culture as Development in Africa* (1996).
—— (ed.) *Gendered Visions: The Art of Africana Women Artists* (1997).
—— and Enwezor, Okwui, 'New Visions: Recent Works By Six African Artists', in *New Visions*, exhib. cat. (Orlando: Zora Neale Hurston Museum of Fine Art; Ithaca, New York, Cornell University, 1995).
Hobsbawm, Eric and Ranger, Terence (eds.), *The Invention of Tradition* (1983).
jegede, dele, 'African Art Today', in *Contemporary African Artists: Changing Traditions*, exhib. cat., (New York, Studio Museum in Harlem, 1990).
Kasfir, Sidney L., 'One Tribe, One Style? Paradigms in the Historiography of African Art', *History in Africa, 1* (1984).
Kennedy, Jean, *New Currents, Ancient Rivers: Contemporary African Artists in a Generation of Change* (1992).
McEwen, Frank, *New Art From Rhodesia* (1963).
Mohammed Omer Khalil, Etching; Amir Nour, Sculpture, exhib. cat., by Sylvia Williams (Washington, DC, National Museum of African Art, 1994).
Mount, Marshall Ward, *African Art: The Years Since 1920* (1973).
Oguibe, Olu, *Uzo Egonu: An African Artist in the West* (1995).
Ottenberg, Simon, *New Traditions form Nigeria: Seven Artists of the Nsukka Group* (1997).
Panorama of Passages: Changing Landscape of South Africa: Johannesburg, exhib. cat. (University of the Witwatersrand, University Art Galleries; Washington, DC, Meridian International Center, 1995).
Vogel, Susan (ed.), *Africa Explores: 20th Century African Art* (1991).
Miller, Judith von D., *Art in East Africa: A Guide to Contemporary Art* (1975).
Williamson, Sue, *Resistance Art in South Africa* (1989).
—— and Jamal, Ashraf, *Art in South Africa: The Future Present* (1996).

Alternative Centres: Canada and Australia
CANADA
Bringhurst. R., *et al.* (eds.), *Visions: Contemporary Art in Canada* (1983).
Burnett, D., and Schiff, M., *Contemporary Canadian Art* (1983).
Fenton, T., and Wilkin, K., *Modern Painting in Canada: Major Movements in Twentieth Century Canadian Art* (1978).
Reid, D., *A Concise History of Canadian Painting* (2nd edn., 1988).

AUSTRALIA
Allen, Christopher, *Art in Australia, from Colonizaton to Postmodernism* (1997).
Hughes, Robert, *The Art of Australia* (1966, revised edn. 1970, repr. 1987).
McCulloch, Alan, *The Encyclopedia of Australian Art* (revised edn. Susan McCulloch, 1994).
Smith, Bernard, *Australian Painting 1788–1990* (3rd edn. 1991).

Postmodernism
Berrtens, Hans, *The Idea of Postmodernism* (1995).
Crowther, Paul, *Critical Aesthetics and Postmodernism* (1993).
Docherty, Thomas (ed.), *Postmodernism: A Reader* (1993).
Foster, Hal (ed.), *Postmodern Culture* (1982).
Jencks, Charles, *What is Postmodernism?* (1986).

Art History
Fernie, E. (ed.), *Art History and its Methods: A Critical Anthology* (1995).
Holly, M. A., *Panofsky and the Foundations of Art History* (1984).
Kultermann, U., *The History of Art History* (1993).
Minor, V. H., *Art History's History* (1994).
Podro, M., *The Critical Historians of Art* (1982).
Rees, A. L., and Borzello, F., *The New Art History* (1986).

Critics and Criticism
Danto, Arthur C., *After the End of Art: Contemporary Art and the Pale of History* (1997).
Gee, Malcolm (ed.), *Art Criticism since 1900* (1993).
Frascina, Francis, and Harrison, Charles, (eds.), *Modern Art and Modernism* (1982).
Wallis, Brian (ed.), *Art After Modernism: Rethinking Representation* (1984).

Art Museums and Galleries
Altschuler, B., *The Avant-Garde in Exhibition: New Art in the 20th Century* (1994).
Berger, J., 'The Historical Function of the Museum', in *The Moment of Cubism and Other Essays* (1969).
Bourdieu, P., *The Love of Art: European Art Museums and Their Public* (1969, 1991).
Brawne, M., *The New Museum: Architecture and Display* (1965).
Duncan, C., *Civilizing Rituals* (1995).
—— and Wallach, A., 'The Museum of Modern Art as Late Capitalist Ritual: an Iconographic Analysis', *Marxist Perspectives,* I (1978).
Foster, H., *Recodings: Art, Spectacle, Cultural Politics* (1985).
Fraser, A., 'Museum Highlights: a gallery talk', *October,* 57 (1991).
Haacke, H., *Framing and being Framed* (1975).
Karp, I., and Lavine, S. (eds.), *Exhibiting Cultures: The Poetics and Politics of Museum Display* (1988).
Krauss, R., 'The Cultural Logic of the Late Capitalist Museum', *October,* 54 (1990).
O'Doherty, B., *Inside the White Cube: The Ideology of the Gallery Space* (1986).
Pointon, M. (ed.), *Art Apart: Art Institutions and Ideology Across England and North America* (1994).
Steele, J., *Museum Builders* (1996).
Szeemann, H., 'Problems of the Museum of Contemporary Art: Exchanges of Views of a Group of Experts', *Museum,* 24 (1972).
Taylor, B., *Art for the Nation: Exhibitions and the London Public 1747–2001* (1999).

547

Picture Acknowledgements

548

The publishers wish to thank the following who have kindly given permission to reproduce illustrations as identified by the following caption numbers;

1 © The British Museum
2 © The British Museum
3 © G. Dagli Orti, Paris
4 Scala, Florence
5 Deutsches Archäologisches Institut, Rome
6 The J. Paul Getty Museum, Malibu, California
7 N. Kontos/Photostock, Athens
8 Vasari, Rome
9 Staatliche Antikensammlungen und Glyptothek, Munich, photo: Koppermann
10 © bpk 1999, photo: Jürgen Liepe
11 Kontos/Photostock, Athens
12 © G. Dagli Orti, Paris
13 The J. Paul Getty Museum, Malibu, California
14 Staatliche Antikensammlungen und Glyptothek, Munich, photo: Koppermann
15 © G. Dagli Orti, Paris
16 Scala, Florence
17 Archaeological Receipts Fund, Athens
18 © bpk 1999, photo: Jürgen Liepe
19 © G. Dagli Orti, Paris
20 © Photo RMN - H. Lewandowski
21 Archaeological Receipts Fund, Athens
22 © G. Dagli Orti, Paris
23 © Photo RMN - H. Lewandowski
24 The State Hermitage Museum, St. Petersburg, Russia
25 © Photo RMN - H. Lewandowski
26 Scala, Florence
27 © G. Dagli Orti, Paris
28 Ekdotike Athenon, Athens
29 Werner Forman Archive
30 The State Hermitage Museum, St. Petersburg, Russia
31 Archaeological Receipts Fund, Athens
32 Ekdotike Athenon, Athens
33 Giraudon
34 Archivio Fotografico dei Musei Capitolini
35 Soprintendenza Archeologica Etruria Meridionale, Rome, photo: M. Benedetti
36 e.t. archive
37 Prof. Dr. Orhan Bingöl
38 Institut Amatller d'Art Hispànic
39 © The British Museum
40 © The British Museum
41 © The British Museum
42 Westfälische Wilhelms-Universität, Munster
43 Scala, Florence
44 Scala, Florence
45 Scala, Florence
46 New York University Excavations at Aphrodisias
47 Soprintendenza Archeologica per la Toscana, Florence
48 Vasari, Rome
49 Ny Carlsberg Glyptotek, Copenhagen
50 Rapuzzi
51 New York University Excavations at Aphrodisias
52 Vasari, Rome
53 Vasari, Rome
54 New York University Excavations at Aphrodisias
55 Scala, Florence
56 Index, Florence
57 Deutsches Archäologisches Institut, Rome
58 Soprintendenza Archeologica Etruria Meridionale, Rome, photo: M. Benedetti
59 © The British Museum
60 Scala, Florence
61 © bpk 1999, photo: Jürgen Liepe
62 Scala, Florence
63 Scala, Florence
64 Luciano Pedicini/Archivio dell'Arte, Naples
65 Scala, Florence
66 Scala, Florence
67 Luciano Pedicini/Archivio dell'Arte, Naples
68 Luciano Pedicini/Archivio dell'Arte, Naples
69 Luciano Pedicini/Archivio dell'Arte, Naples
70 Ancient Art & Architecture Collection
71 Luciano Pedicini/Archivio dell'Arte, Naples
72 reproduced by permission of the Provost and Fellows of Eton College
73 Scala, Florence
74 Bischöfliches Dom- und Diözesanmuseum, Trier, photo: R. Schneider
75 Scala, Florence
76 Vasari, Rome
77 Ny Carlsberg Glyptotek, Copenhagen, photo: Ole Haupt
78 © bpk 1999, photo: Jürgen Liepe
79 New York University Excavations at Aphrodisias
80 Kunsthistorisches Museum, Vienna
81 Scala, Florence
82 Scala, Florence
83 National Museum of American Art, Smithsonian Institution, transfer from the U.S. Capitol
84 Sotheby's

85 Archivi Alinari
86 © National Gallery, London
87 Scala, Florence
88 Vasari, Rome
89 Scala, Florence
90 Bayerisches Nationalmuseum, Munich
91 Real Academia de la Historia, Madrid
92 Scala, Florence
93 Scala, Florence
94 Scala, Florence
95 Scala, Florence
96 Österreichische Nationalbibliothek, Vienna
97 Bibliothèque Nationale de France
98 British Library
99 Orcorte
100 © Biblioteca Apostolica Vaticana
101 Bibliothèque Nationale de France
102 Bibliothèque Nationale de France
103 Bibliothèque Nationale de France
104 Bibliothèque Nationale de France
105 © Biblioteca Apostolica Vaticana
106 University Library, Utrecht
107 The Master and Fellows of Corpus Christi College, Cambridge
108 The Board of Trinity College, Dublin
109 The Pierpont Morgan Library/Art Resource, NY
110 British Library
111 © Biblioteca Apostolica Vaticana
112 The Archbishop of Canterbury and the Trustees of Lambeth Palace Library
113 Munich, Bayer. Staatsbibliothek/Artothek
114 The Master and Fellows of Trinity College, Cambridge
115 Universitätsbibliothek, Heidelberg
116 Bibliothèque Nationale de France (Ms Lat. 9471 fol 159r)
117 Österreichische Nationalbibliothek, Vienna (Ms 1857 fol 14v)
118 British Library
119 © Biblioteca Apostolica Vaticana
120 Bibliothèque Nationale de France
121 The Bodleian Library, Oxford
122 The Pierpont Morgan Library/Art Resource, NY
123 © The British Museum
124 Scala, Florence
125 Scala, Florence
126 Index/Sforza
127 © G. Dagli Orti, Paris
128 Scala, Florence
129 R.Matz,A.Schenk/Dombauarchiv, Cologne
130 Institut Amatller d'Art Hispànic
131 Institut Amatller d'Art Hispànic
132 Kunsthistorisches Museum, Vienna
133 Hungarian National Museum, photo: Károly Szelényi
134 Crown ©: The Controller of HMSO Norberto/Edilesa
135 Crown ©: reproduced by permission of Historic Scotland
136 S. Halliday & L. Lushington/Sonia Halliday Photographs
137 © G. Dagli Orti, Paris
138 Michael Holford Photographs
139 N.Jinkerson/Jarrold Publishing and University College, Durham
140 Adam Woolfitt Photography
141 © Woodmansterne
142 photo by Roger Musgrave from Deborah Kahn, 'Canterbury Cathedral and its Romanesque Sculpture'
143 The Bridgeman Art Library
144 Scala, Florence
145 Erich Lessing/AKG London
146 Dr Gottfried Frenzel
147 The Dean and Chapter of Canterbury
148 British Library (Add Ms 35211 fol 177)
149 333
150 S. Halliday & L. Lushington/Sonia Halliday Photographs
151 S. Brown
152 Leicester City Museums
153 Sonia Halliday Photographs
154 © Crown Copyright. NMR
155 © The British Museum
156 Photo David O'Connor by kind permission of the Dean and Chapter of York
157 V&A Picture Library
158 photo:Oeffentliche Kunstsammlung Basle, Martin Bühler
159 Musées Royaux des Beaux-Arts de Belgique, Brussels, photo by Speltdoorn
160 Westfälisches Landesmuseum für Kunst und Kulturgeschichte, Munster: Long-term loan from a private collection
161 S. Halliday & L. Lushington/Sonia Halliday Photographs
162 S. Halliday & L. Lushington/Sonia Halliday Photographs
163 Institut d'Estudis Catalans, photo: Ramon Roca I Junyent; table discovered by Dr Joàn Vila Grau
164 Barley Studio, York
165 S.Halliday & L. Lushington/Sonia Halliday Photographs
166 S. Halliday & L. Lushington/Sonia Halliday Photographs
167 Musée de l'Oeuvre Notre Dame de Strasbourg
168 © Crown Copyright. NMR
169 S.Brown
170 Barley Studio, York

172 Hirmer Fotoarchiv
173 © Dean and Chapter of Westminster
174 Lauros-Giraudon
175 Institut Amatller d'Art Hispànic
176 The Diocese of Chichester
177 Archivio Fotografico Sacro Convento, Assisi
178 Archivio Fotografico Sacro Convento, Assisi
179 Lensini
180 Ateliér Paul, Prague
181 Ornello Paolo Tofani
182 Index/Summerfield
183 © National Gallery, London
184 © National Gallery, London
185 Lensini
186 Prof. John White and Thames & Hudson
187 Lensini
188 Index/Mela
189 Scala, Florence
190 Index, Florence
191 Museum Archidjecezjalne, Gniezno
192 St Michaels and All Angels, Hamstall Ridware/The Lichfield Heritage Centre
193 Adrian Arbib
194 Institut Amatller d'Art Hispànic
195 © Kunstverlag Hofstetter, 4910 Ried im Innkreis, Austria
196 V&A Picture Library
197 Giraudon
198 © bpk 1999, photo: Hirmer
199 Lensini
201 Germanisches Nationalmuseum, Nuremberg
202 Scala, Florence
203 A.F. Kersting
204 Index/Orsi Battaglini
205 Scala, Florence
206 AKG London/Erich Lessing
207 Luciano Pedicini/Archivio dell'Arte, Naples
208 Werner Forman Archive
209 Index/Tosi
210 Kunsthistorisches Museum, Vienna
211 Scala, Florence/Ufficio Beni Culturali, Curia Patriarcale di Venezia
212 Luciano Pedicini/Archivio dell'Arte, Naples
213 Magliani
214 © photo RMN - J.G. Berizzi
215 Index/Tosi
216 Scala, Florence
217 Index, Florence
218 © National Gallery, London
219 Index/Summerfield
220 Index, Florence
221 Scala, Florence
222 Index/Pizzi
223 © Museo del Prado, Madrid
224 © Museo del Prado, Madrid
225 AKG London
226 © The Frick Collection, New York
227 Scala, Florence
228 Scala, Florence
229 © Aachen Cathedral, photo: Münchow
230 The Metropolitan Museum of Art, Rogers Fund, 1912. (12.49.8) Photograph © 1983 The Metropolitan Museum of Art
231 © photo RMN-R.G. Ojeda
232 V&A Picture Library
233 The Metropolitan Museum of Art, John Stewart Kennedy Fund, 1913. (14.39) Photograph © 1986 The Metropolitan Museum of Art
234 The Metropolitan Museum of Art, Fletcher Fund, 1930. (30.93.2) Photograph © 1993 The Metropolitan Museum of Art
235 The Metropolitan Museum of Art, Fletcher Fund, 1930. (30.93.2) Photograph © 1993 The Metropolitan Museum of Art
236 The Metropolitan Museum of Art, Purchase in memory of Sir John Pope-Hennessy: Rogers Fund, The Annenberg Foundation, Drue Heinz Foundation, Annette de la Renta, Mr. and Mrs. Frank E. Richardson, and The Vincent Astor Foundation Gifts, Wrightsman and Gwynne Andrews Funds, special funds, and Gift of the children of Mrs Harry Payne Whitney, Gift of Mr. and Mrs. Joshua Logan, and other gifts and bequests, by exchange, 1995. (1995.7) Photograph © 1995 The Metropolitan Museum of Art
237 The Cleveland Museum of Art, Gift from J.H. Wade, 1924.859
238 The Metropolitan Museum of Art, Robert Lehman Collection, 1975. (1975.1.1019) Photograph © 1988 The Metropolitan Museum of Art
239 The Metropolitan Museum of Art, Rogers, Pfeiffer, Harris Brisbane Dick and Fletcher Funds, 1982. (1982.45) Photograph © 1982 The Metropolitan Museum of Art
240 Scala, Florence
241 Rijksmuseum, Amsterdam
242 © The Cleveland Museum of Art
243 © The Cleveland Museum of Art, Gift of the Print Club of Cleveland, 1931.205
244 © The British Museum
245 © The British Museum
246 © The British Museum
247 photo:Oeffentliche Kunstsammlung Basle, Martin Bühler

248 © The British Museum
249 © The British Museum
250 © The British Museum
251 © The British Museum
252 Rijksmuseum, Amsterdam
253 © The Cleveland Museum of Art, Purchase from the J.H. Wade Fund, 1967.127
254 © The British Museum
255 © The British Museum
256 Topkapi Museum, Istanbul
257 © Museo del Prado, Madrid
258 Kunsthistorisches Museum, Vienna
259 Rijksmuseum, Amsterdam
260 Kunsthistorisches Museum, Vienna
261 Scala, Florence
262 Giovetti
263 Lauros-Giraudon
264 Narodni Galerie, Prague, photo: M. Posselt
265 Kunsthistorisches Museum, Vienna
266 © bpk 1999, photo: Jörg P. Anders
267 © Photo RMN-Daniel Arnaudet
268 Index/Tosi
269 Archivi Alinari/The Bridgeman Art Library
270 Index/Orsi Battaglini
271 Index/Orsi Battaglini
272 Archivi Alinari/The Bridgeman Art Library
273 Scala, Florence
274 V&A Picture Library
275 R.C.S. Libri Spa/Cassetta
276 Kunsthistorisches Museum, Vienna
277 Kunsthistorisches Museum, Vienna
278 Museo Nacional de Escultura, Valladolid
279 Institut Amatller d'Art Hispànic
280 Augsburg Tourist Information
281 © G.Dagli Orti, Paris
282 Kunsthistorisches Museum, Vienna
283 Scala, Florence
284 Index, Florence
285 Scala, Florence
286 Scala, Florence
287 Vasari
288 Vasari
289 Vasari
290 Vasari
291 Index, Florence
292 Scala, Florence
293 © photo RMN
294 John Beldon Scott
295 Scala, Florence
296 Scala, Florence
297 © bpk 1999
298 Vasari
299 The Metropolitan Museum of Art, Harris Brisbane Dick Fund, 1926. (26.49.50)
300 © photo RMN - Gérard Blot
301 © The Royal Collection, Stockholm, photo: Sven Nilsson (Inv. Nr. HGK SS 143)
302 © Photo RMN
303 Vasari
304 Collection of the Prince of Liechtenstein
305 Ravenna
306 V&A Picture Library
307 Index, Florence
308 © Museo del Prado, Madrid
309 © National Gallery, London
310 Kunsthistorisches Museum, Vienna
311 © Museo del Prado, Madrid
312 Scala, Florence
313 Rijksmuseum, Amsterdam
314 Vasari
315 The Minneapolis Institute of Arts
316 © National Gallery, London
317 © Photo RMN - Jean
318 © Photo RMN - Hervé Lewandowski
319 © Photo RMN - Jean
320 The Metropolitan Museum of Art, Bequest of William K. Vanderbilt, 1920. (20.155.9) Photograph © 1993 The Metropolitan Museum of Art
321 Giraudon
322 © Photo RMN - J.G. Berizzi
323 © Photo RMN - Jean
324 Board of Trustees, National Gallery of Art, Washington, Ailsa Mellon Bruce Fund
325 Board of Trustees, National Gallery of Art, Washington, Ailsa Mellon Bruce Fund
326 The Royal Collection © Her Majesty Queen Elizabeth II
327 Scala, Florence
328 © Photo RMN - Arnaudet; J. Scho
329 Antonio Pareja, Toledo
330 © Museo del Prado, Madrid
331 Museo Diocesano, Vitoria-Gasteiz
332 © The Cleveland Museum of Art, 1998, Leonard C. Hanna, Jr., Fund, 1960.117
333 Institut Amatller d'Art Hispànic
334 © Museo del Prado, Madrid
335 © Museo del Prado, Madrid
336 © National Gallery, London
337 © National Gallery, London
338 Museo de la Real Academia de Bellas Artes de San Fernando, Madrid
339 © Mauritshuis, The Hague (inv. 824)
340 © Elke Walford, Hamburg
341 © Photo RMN - P. Bernard
342 The Metropolitan Museum of Art, Rogers Fund, 1919. (19.164) Photograph © 1998 The Metropolitan Museum of Art
343 Alte Pinakothek, Munich/Blauel/Gnamm - Artothek
344 Collection of the Prince of Liechtenstein
345 © Mauritshuis, The Hague (inv. 146)
346 © Mauritshuis, The Hague (inv. 155)

347 Board of Trustees, National Gallery of Art, Washington, Patrons' Permanent Fund
348 The Metropolitan Museum of Art, Bequest of Benjamin Altman, 1913. (14.40.602) Photograph © 1978 The Metropolitan Museum of Art
349 Los Angeles County Museum of Art
350 The Metropolitan Museum of Art, Marquand Collection, Gift of Henry G. Marquand, 1889. (89.15.21) Photograph © 1993 The Metropolitan Museum of Art
351 © National Gallery, London
352 The Royal Collection © Her Majesty Queen Elizabeth II
353 V&A Picture Library
354 © National Portrait Gallery, London
355 © National Portrait Gallery, London
356 © National Gallery, London
357 The Trustees of Dulwich Picture Gallery
358 © Jeremy Marks/Woodmansterne
359 The Trustees of Sir John Soane's Museum
360 © Tate Gallery, London
361 National Maritime Museum, London
362 English Heritage Photographic Library
363 The Royal Collection © Her Majesty Queen Elizabeth II
364 Photograph © The British Museum.
365 Rijksmuseum, Amsterdam.
366 Photograph © 1999 Board of Trustees, National Gallery of Art, Washington, Print Purchase Fund (Rosenwald Colection).
367 Photograph © The British Museum.
368 Cincinnati Art Museum, Bequest of Herbert Greer French, 1943 (1943.461) (Photograph: Forth, 12/1990).
369 Photograph © The British Museum.
370 Photograph © The British Museum.
371 The Art Institute of Chicago, The Singer Collection; Wallace L. DeWolf and Joseph Brooks Fair funds, 1920.2199, photograph © 1998, The Art Institute of Chicago. All Rights Reserved.
372 Photograph © The British Museum.
373 Photograph © The British Museum.
374 Philadelphia Museum of Art, given by Lessing J. Rosenwald.
375 Photograph © The British Museum.
376 Photograph © The British Museum.
377 Photograph © The British Museum.
378 Photograph © The British Museum.
379 Reproduced by permission of the Syndics of the Fitzwilliam Museum, Cambridge.
380 Photograph © The British Museum.
381 Photograph © The British Museum.
382 Scala, Florence.
383 Foto, Musei Vaticani.
384 Index, Florence.
385 © Photograph RMN.
386 National Trust Photographic Library/Bill Batten.
387 Scala, Florence.
388 © G. Dagli Orti, Paris.
389 AA Photo Library.
390 © Florian Monheim, Meerbusch-Büderich.
391 Scala, Florence.
392 Photograph © Staatliche Museen Kassel.
393 Courtesy Graf von Schönborn Kunstsammlungen, Schloss Weissenstein, Pommersfelden.
394 Yale Center for British Art, Paul Mellon Collection (Photograph: Richard Caspole/Yale Center for British Art).
395 V&A Picture Library.
396 Photograph courtesy Haddon Hall, Bakewell, Derbyshire
397 National Trust Photographic Library.
398 © Lisa Hammel, Dortmund.
399 Philadelphia Museum of Art, given by the Samuel H. Kress Foundation (Photograph: Graydon Wood, 1994).
400 National Trust Photographic Library/Bill Batten.
401 National Trust Photographic Library/Andreas von Einsiedel.
402 © Rubenshuis Antwerpen.
403 V&A Picture Library.
404 The Royal Collection, Stockholm (Photo: Håkan Lind).
405 © The National Trust Waddesdon Manor.
406 (left) National Trust Photographic Library/John Bethell, (right) National Trust Photographic Library/Angelo Hornak.
407 Scala, Florence.
408 V&A Picture Library.
409 Bibliothèque Nationale de France
410 Ancient Art & Architecture Collection
411 © G.Dagli Orti, Paris
412 © The Frick Collection, New York
413 National Gallery of Ireland
414 Buckinghamshire County Museum
415 A.F. Kersting
416 © The Dean and Chapter of Westminster
417 © The British Museum
418 © The British Museum
419 Bibliothèque Nationale de France
420 Pushkin Museum, Moscow/Bridgeman Art Library
421 Yale Center for British Art, Paul Mellon Collection
422 Gemäldegalerie der Akademie der bildenden Künste in Wien
423 V&A Picture Library
424 © bpk 1999

549

Index

550 A page number in *italics* indicates an illustration, a diagram or a reproduction of a work of art.

A

Aachen, Hans von 183
Abaporu (Tarsila do Amaral) *476*
Abbatini, Guidobaldo 198
Abbott, Berenice 453
Abduction of Helen, House of
 stag hunt mosaic *30*
Abend (*The Haymaker*) (Theodor and
 Oskar Hofmeister) *378*
Aboriginal desert art
 movement 491
Aboriginal Landscape (Margaret Preston)
 492
The Absinthe Drinker (*In a Café*) (Edgar
 Degas) *330,* 331
Abstract Expressionism 8, 410, 418, 432
abstraction and artistic 'progress' 3–4
The Academicians of the Royal Academy
 (Johann Zoffany) *253*
Académie d'Architecture 293
Académie de France 293
Académie Royale 293
Académie Royale de Peinture et de
 Sculpture 292
academies 5, 7, 246, 247, *253,* 290–3
Accademia del Disegno 290–1
Accademia del Nudo 292
Accademia di San Luca 291, 293
Acconci, Vito 443
Acrobat, Paris (André Kertész) *463*
action painting 517
Adalberon, Archbishop, on early stained
 glass 108
Adam, Robert 265
 Etruscan Drawing Room,
 Osterly Park *267*
Adam in stained glass, Trinity Chapel,
 Canterbury 109
Adams, Ansel 454
Adamson, Robert 367, 371
 *Alexander Rutherford, William
 Ramsay, and John Listen* 371
Adoration of the Lamb (Baccacio) 200
Adoration of the Magi (Leonardo da Vinci)
 154
Adoration of the Magi (Strozzi Altarpiece)
 (Gentile da Fabriano) 152, 158, *158*
Adrian VI, pope 181, 238
Aesthetic Movement—*see* Arts and Crafts
 Movement
Aethelwold, S.
 Anglo-Saxon illuminations 86
 Benedictional *87*
Aetion 65
agalma (Greek religious sculpture) 12
Agam, Yaacov 444
Aguerre, Louis 264
Ahorn, Lukas
 The Lion of Lucerne 343, *344*
AKhRR (Association of Artists of
 Revolutionary Russia) 470
akribeia (accuracy) in Greek sculpture
 60–1
Alari, Pier Jacopo (Antico) 163
Alberti, Leon Battista 125, 262, 293
 On Painting 152, 155, 159, 396
Alberti, Romano
 nobility of painting 291
Albert Memorial, London 341, *345*
Alcázar, Luis Paret y 233
Aleph 2 (Rockne Krebs) *444*
aletheia (truth) in Greek sculpture 60–1

Alexander, Jane 488
 Butcher Boys *489*
*Alexander Rutherford, William Ramsay, and
 John Listen* (Octavius Hill and Robert
 Adamson) 371
Alexander the Great depicted
 Alexander Mosaic, Pompeii
 52, *54*
 *The Wedding of Alexander and
 Roxanne* (Il Sodoma) *65*
 Yannitsa portrait 22
Alexandria personified in mosaic floor 25,
 30
Alfonso the Great
 Arca Santa 98
Algardi, Alessandro 210
 The Beheading of Saint Paul
 210, 214, *215*
Algemeine Elektrizitäts Gesellschaft (AEG)
 394
Aline, daughter of Herodas
 funerary portrait 62
Allegory of Good and Bad Government
 (Ambrogio Lorenzetti and Andrea Vanni)
 125, *128*
Allegory of Taste tapestry *165*
*Allegory of the Missionary Work of the
 Jesuits* (Andrea Pozzo) *201*
Allegory of Venus, Cupid, Folly and Time
 (Agnolo Bronzino) 217, *220*
Allen, Rebecca 445
Alleyway, Prague (Josef Sudek) *456*
All Greatness Stands Firm in the Storm (Ian
 Hamilton Finlay) *504*
Alloway, Lawrence 516–17
All-Russian Academy of Arts 470
Alma-Tadema, Sir Lawrence
 Antony and Cleopatra *67*
Almedina, Yáñez de la (Fernando Yáñez)
 230
Alonso Sánchez Coello 230
Alphand monument (Aimé-Jules Dalou)
 342, *347*
Alphege, S., in stained glass, Trinity Chapel,
 Canterbury 109
altarpieces 7, *69,* 130–7, 138, *140,141,* 154,
 209, 219, *231,286*
Altdorfer, Albrecht 154, 170,
 254, 256
 *Landscape with a Double
 Pine* *256*
alternative media and materials 8–9, 442–
 51
Altes Museum, Berlin 518
Altichiero Crucifixion fresco 130
Alva Ixtlilxóchitl, Fernando de 296
Amaral, Tarsila do 474–5, *476*
 Abaporu *476*
*The Ambassadors (Jean de Dinteville and
 Georges de Selve)* (Hans Holbein the
 Younger) 248, *248*
American Museum of Natural History, New
 York 407
 African Hall *407*
American Realism 417
Amiens Cathedral
 monumental sculpture 101
 west facade *104*
Ammannati, Bartolommeo
 Fountain of Hercules *192*
 Fountain of Neptune 188,
 190, *191*
Amor (Parmigianino) 216
Amour de l'Art magazine 514
The Analysis of Beauty (William Hogarth)
 281, *288*

Analytic Cubism 359
The Anatomy Lesson of Dr Nicolaes Tulp
 (Rembrandt) *243*
Anderson, Laurie 443
André, Carl 494
Andrea del Sarto 182
The Angel with the Crown of Thorns
 (Gianlorenzo Bernini) 210, *214,* 215
Angelico, Fra—*see* Fra Angelico
Angry Penguins magazine 491
Annan, James Craig 369
Annandale Imitation Realists 491
Annunciation and Visitation window, S.
 Ouen, Rouen *113*
Annunciation window, Bourges Cathedral
 111, *121*
Antal, Friedrich 512
Anthony, E. and H. T.
 Broadway on a Rainy Day 368
Anthropométries (Yves Klein) 426, *427,*
 443, *443*
Antico (Pier Jacopo Alari) 163
Antikythera bronze 22
Antiochus I relief at Arsameia *37*
Antoine, duc de Lorraine
 equestrian statue by Jiorné Viard
 341, *351*
*Antonio Canova in his Studio with Henry
 Tresham and a Model for 'Cupid and
 Pysche'* (Hugh Douglas Hamilton) *354*
Antony and Cleopatra (Sir Lawrence Alma-
 Tadema) *67*
Apelles 3, 52, 61
Aperture magazine 455
Aphaia temple east pediment
 dying Trojan 18, *19*
Aphrodisias (personifying
 frieze) *47*
Aphrodite 46
 Anadyomene 40
 of Aphrodisias *46*
 with Athena and Eros *28*
 Esquiline 40, *46*
 of Knidos (Praxiteles) 15,
 20, *21*
 with Pan and Eros (Delos
 marbles) *21*
Aphrodite-Venus symbolism 46
Apocalypse (Albrecht Dürer) 170
Apollinaire, Guillaume 403, 514
Apollinaris, Sidonius, bishop
 of Clermont, on early stained
 glass 108
Apollo depicted 33
 Apollo and Daphne
 (Gianlorenzo Bernini) *212*
 Apollo Belvedere 213, 292, 415
 Apollo Tended by the Nymphs
 (François Girardon) 212–13,
 213
 *Contest between Apollo and
 Marsyas* (maiolica theme) *168*
 The Four Continents with Apollo
 (Giambattista Tiepolo) *283*
 Gigantomachy frieze, Great
 Altar of Pergamum *19*
Appel, Karel 419
The Apotheosis of Homer (Ingres)
 306, *312*
applied arts 4, 7, 162–6, 262–79, 380–95
aquatint 260
Aragon, Louis 514, 516
Aranhuez porcelain panels *278*
Ara Pacis Augustae (Augustan altar of
 peace) *42*
Arcadion, Stelios—*see* Stelarc

Arca Santa of Alfonso the Great 98
Archaic period in Greece 15, 25, 60
Arch of Constantine 70, *72*
Arch of Titus 41, *48,* 49
Arezzo, Margarito of
 The Virgin and Child Enthroned
 132
Arezzo Cathedral
 stained glass 111
Aristion of Paros
 Siphnian treasury frieze *18*
Aristonothos (Greek artisan) 32
 mixing vessel *34*
Aristotle
 on the status of sculptors 12
 Peter Ugelheimer's fifteenth-
 century edition *79, 91*
Ark of the Covenant 92
Arma Christi 139, 142, *143*
Arminius (Hermannsdenkmal) (Ernst von
 Bandel) 343, *344*
arm reliquary of S. Lawrence *142*
*The Army of the Potomac – A Sharp-Shooter
 on Picket Duty* (Winslow Homer) *364*
Arnolfini bethrothal portrait (Jan van Eyck)
 158
Arnstein-an-der-Lahn, abbey church of
 Moses and the Burning Bush
 window *118*
Arp, Hans (Jean Arp) 442
Arp Museum, Rolandseck 519
*Arrangement in Grey and Black: Portrait of
 the Artist's Mother* (Whistler) 310
Arsameia reliefs 37
ars sacra 7, 92–9, 138–43
art 2–4, 6, 8–9
 development of 525–6
 for art's sake 5, 403
 science and 242–3
art criticism 219, 290–3, 400–3, 514–17
 Greek 62
 Roman 62–3
Art Déco 430
Artemis depicted
 Corfu temple 14
 Gigantomachy frieze, Great
 Altar of Pergamum *19*
 Gigantomachy frieze, Siphnian
 Treasury 18
art history 3–4, 8, 9, 396–9, 510–13, 524–7
 Hellenistic 62, 64
Art Informel 418, 443, 448, 516
Art Institute of Chicago 408–9
 drawing for Grand Staircase
 408
 Grand Staircase *409*
L'Artiste periodical 402
artists' status 3, 5, 8
 in Greece 12
 in Rome 38
 medieval 78, 92–3, 111
 sixteenth-century 216, 290, 291
 seventeenth-century 246, 290,
 291–2
 eighteenth-century 247, 281,
 290–1, 292–3
 nineteenth-century 354–5
Art-Language group 497
art museums and galleries 8, 302, 392,
 404–9, 518–23
Art Nouveau 380
 furniture *386*
Art of Our Time exhibition, Museum of
 Modern Art, New York 522
Arts and Crafts Movement 380, 386, 390
Arts and Letters Club, Toronto 490

Artschwager, Richard 444
Arundel, Thomas Howard, Earl of 246, 250, *250*
Ascension and *Three Maries at the Sepulchre* (early Christian ivory relief) 71, *72, 73*
Ascott, Roy 445
Asher, Michael 519
Aslenben, K. 444
As of January 1986 (Ross Blechner) *506*
assemblage 504–5
Assisi frescoes *128*
Assumption of the Virgin (Annibale Carracci) 197, 202, *203*
Assumption of the Virgin (El Greco) 230, *231*, 232
Assumption of the Virgin (Francesco Rosselli) 170
Assunta altarpiece (Titian) 154, *161*
Astronomy (Giambologna) *180*
Atget, Eugène 453, 460
 Au Petit Dunkerque, Quai de Conti 460
Athena depicted
 with Aphrodite and Eros *28*
 with Heracles *29*
 in Parthenon *14*
Atlantic Civilisation (André Fougeron) 440, *440*
At the Foundry (Jean-François Raffaelli) 353
Audubon, John James
 Birds of America 359
Augsburg Castle staircase *269*
Augsburg Cathedral window
 Daniel, Hosea, David, and Jonah 108, 109, *112*
Augustine, S.
 Gospels 84
Augustus portrayed
 Altar of Peace *42*
 crossroads altar *42*
 Gemma Augustea *80*
 with Victory *43*
Aurier, G.-Albert
 'Essay on a New Method of Criticism' 403
Austerlitz Column—*see* Vendôme Column
autochrome 369, 455
Automatisme 1.47 (*Leeward of the Island*) (Paul-Émile Borduas) *493*
Automatistes 490, 493
avant-garde art 6
Averlino, Antonio 155

B
Bad Boy (Eric Fischl) *502*
Baccacio (Giovanni Batista Gaulli)
 Adoration of the Lamb 200
 Triumph of the Name of Jesus 208
 Vision of Heaven 200
Bacchus (Caravaggio) 218
Bacchus, Room of, Villa Barbaro, Maser (Paolo Veronese) 264, *266*
Backstage at the Maiakowski Theatre, Moscow (Lise Sarfati) *469*
Bacon, Francis 417, 436
 Study after Velázquez's Portrait of Pope Innocent X 417, *436*
Baldinucci, Filippo 291
Baldung, Hans 154
Baldwin, Michael 497
Balla, Giacomo 311, 442
Balliol College, Oxford
 stained glass 111

Balzac, Honoré
 The Unknown Masterpiece 401
Bamboccio—*see* van Laer, Pieter
banausoi (Greek artisan-labourers) 12
Bandinelli, Baccio 170, 171
 Academia 290
 Hercules and Cacus 188, *190*
Bandel, Ernst von 343, 344
 Arminius (Hermannsdenkmal) 343, *344*
Banquet Piece with Mince Pie (Willem Claesz Heda) *244*
banquet ware *168*
Barbari, Jacopo de'
 View of Venice 170, 174, *175*
Barbedienne bronze foundry 341
Barberini Palace ceiling 206
Barbizon School 307, 321
Bar, New York City (Robert Frank) *466*
Barocci, Federico 254
Baroque style 7, 178, 218, 222, 223, 232–3, 238, 239, 254, 256, 263, 264, 280, 283, 294, 295, 296
Barr, Alfred 516, 518, 522
Barthe, Richmond 484
Barthes, Roland 494, 517
Bartholdi, Frédéric-Auguste
 Statue of Liberty under construction 353
Bartolini, Lorenzo
 tomb of Sophia Zamoyska, Countess Czartoryska 351
Bartsch, Adam
 catalogue of the imperial print collection, Vienna 358
Barye, Antoine Louis
 Eagle Grasping a Heron 352
Baselitz, Georg 495, 500
 Orange Eater II 501
Basil I, emperor 82
Basil II, Menologion of 82, *83*
Basilico, Gabriele
 L'esperienza dei luoghi 455
Basquiat, Jean Michel 495
 Cadillac Moon 498, *499*
Bassano, Francesco 221
Bassano, Jacopo 216, 221
Bassus, Junius
 sarcophagus *72*
Bataille, Georges 515
The Bath (Mary Cassatt) *362*
Baths of Diocletian
 Roman copy of Greek athlete *60*
Battista, Giovanni 255
Battle of Anghiari (Leonardo da Vinci) 154
Battle of Cascina (Michelangelo) 154
Battle of Milvian Bridge (tapestry designed by Rubens) 274
Battle of the Nudes (Antonio del Pollaiuolo) 176
Bauche, M.
 aristotype of Auguste Rodin 355
Baudelaire, Charles 308, 359, 400, 401, 402, 403, 514
Baudrillard, Jean 517
Bauhaus design centre 414, 446, 478
Baumann, Horst 444
Baxandall, Michael
 Painting and Experience in Renaissance Italy 513
Baxter, George
 Gems of the Great Exhibition 348, *349*
Bayard, Hippolyte 366

Bayeu, Francisco 233, 236
 S. James being Visited by the Virgin with a Statue of the Virgin of El Pilar 237
Bazzi, Giovanni Antoni (Il Sodoma)
 The Wedding of Alexander and Roxanne 65
Bean Eater (Annibale Carracci) 217, *222*
Beatus of Liébana 86
 Morgan Beatus *86*
Beauchamp Chapel, Warwick
 stained glass 111
Beauneveu, André
 stained glass 111
beauty as an ideal in Greek art 62
 Polyclitus on 14
Beaver Hall Hill Group 490
Becerra, Gaspar 230
Becher, Bernd and Hiller
 Anonymous Sculpture 455
Becket, S. Thomas 109
 Canterbury Cathedral window *113*
 vidimus sketch *118*
Beckford, William 265
Bede on early stained glass 108
Beham, Barthel 254
Beham, Hans Sebald 171, 254
 Night 254
The Beheading of Saint Paul (Alessandro Algardi) 210, 214, *215*
Behrens, Peter
 electric kettle designs 394
Beier, Ulli 484
Belkahia, Farid 485
Bell, Clive 510, 515–16
Bellange, Jacques 182
Belleville Breviary 111
Bellini, Gentile 153
Bellini, Giovanni 153, 160
 The Ecstasy of S. Francis 161
Bellori, Giovanni Pietro 293
 Description of the Stanze of Raphael 292
 Lives of the Artists 292
Bellotto, Bernardo 229
Belter, J. H.
 sofa *391*
Belzile, Louis 490
Benedict, Abbot, on early stained glass 108
Benedict, S.
 depicted by El Greco in S. Domingo el Antiguo, Toledo *231*
 life (illuminated book) 86, *87*
Benedict XIV, pope
 patronage of Accademia del Nudo 292
Beninbrough Hall
 Dining Room *273*
Benjamin Franklin (Jean-Antoine Houdon) 356, *356*
Benton, Senator Thomas Hart, sculpted by Harriet Hosmer *354*
Benyon, Margaret
 Cosmetic Series 444
Berenice II mosaic (personification of Alexandria) 25, *30*
Berenson, Bernard 512, 524
 The Nation 403
Berger, John 512
 Ways of Seeing 512
Bergson, Henri 514
Berkeley, California, University Art Museum 518

Berkhout, Rudie 444
Berlin School 398
Berlinghieri, Bonaventura
 Pescia panel 132
Bernard, S.
 depicted by El Greco in S. Domingo el Antiguo, Toledo *231*
 on images 79
Berní, Antonio 7, 475, 477
 The World Promised to Juanito Laguna 475
Bernini, Gianlorenzo 183, 198, 204, 211, 215, 264
 Angel with the Crown of Thorns 210, *214*, 215
 Apollo and Daphne 212
 The Ecstasy of S. Teresa 204
 Louis XIV bust 211, *212*
Berretini, Pietro—*see* Cortona, Pietro da
Berruguete, Alonso 189, 194
 The Sacrifice of Isaac 194
Berzé-la-Ville chapel frescoes 126, *127*
The Bethrothal of Arnolfini (Jan van Eyck) 158
Beuys, Joseph 443, 445, 494
Bewitched Groom (Hans Baldung Grien) 254
Bezaleel, artist of the Tabernacle 92
Bharat Mata (*Mother India*) (Abanindranath Tagore) 478
bibles
 Gutenberg 170
 illuminated 80–1, *87*
biblia pauperum 170
 influence on stained glass 111
Biedermeier style 380, 384
 Livingroom of the Gropius Family at Stallstrasse 7 (Carl Wilhelm Gropius) *384*
Bien, Julius 359
Bienaimé workshop 341
Bierstadt, Albert 311
A Bigger Splash (David Hockney) *439*
Bilbao Guggenheim museum 519, 523, *523*, 524
Bingham, George Caleb 328
 Raftsmen Playing Cards 328
Biondo, Giovanni del
 Rinuccini Polyptych 136, *137*
Birth of Venus (Botticelli) *157*
The Birth of the World (Joan Miró) *426*
birth trays 163, *167*
Bischof, Werner 465
 Farmers' Inn in the Puszta, Hungary 465
Black Nude (F. N. Souza) *480*
Black Square (Kasimir Malevich) 414, *438*
Black Sow, tomb of *34*
Blackman, Charles 491
black-figure in Greek pictorial arts 24–5, 27
Blackburn, Joseph
 The Winslow Family 301
Blake, William 257, 306, 358
 The Sick Rose 362
Blanc, Charles
 Grammar of the Arts of Design 402
 History of the Painters of All the Schools 402
Blanchard, Gabriel
 The Chariot of Diana 206
Blanquart-Evrard, Louis-Désiré 366–7, *372*
Blaue Reiter movement 310

Blechner, Ross 496
 8,122+ As of January 1986 506
Bloemaert, Abraham 238
Blois Château
 chamber of secret cupboards 272
Blunt, Anthony 516
Bo, Jörgen 518
The Boating Party (Mary Cassatt) 325
Bochert, Eric 453
Böcklin, Arnold 309, 310
 The Island of the Dead 334
Body Art 443, 445
Boghossian, Skunder 485
Bogolan Kasobane movement, Mali 485
Bologna, Giovanni—*see* Giambologna
Bon Marché department store, Paris 393
Bonheur, Rosa
 The Horse Fair 325
Bonnard, Pierre 359
Bonnet, Louis-Marin
 Head of Flora 261
Book of Kells 78, 84, *85*
books
 Byzantine 76–9, *80–3*
 medieval Western 76, 79, *84–91*
 of Hours 79, *88, 89*, 111
Borduas, Paul-Émile 490, 493
 Automatisme 1.47 (Leeward of the Island) 493
 Refus global 190
Borghese, Cardinal Scipione 210, 212
Borghini, Raffaello 291
Bosch, Hieronymus 183
 Garden of Earthly Delights 160, *160*
Bose, Nandalal 480
 Mother and Child 480
Bosse, Abraham 212, 254
 Intaglio Printing 261
 The Sculptor in his Studio 212
Botero, Fernando 477
 The Presidential Family 475, *477*
Both, Jan 238
Botticelli (Sandro di Filipepi)
 Birth of Venus 157
Boucher, François 219, 396
 Head of Flora copied by Louis Marin Bonnet 261
 The Toilet of Venus 226
Boulogne, Jean—*see* Giambologna
Boulogne, Valentin da 218
A Bouquet of Flowers (Roelant Savery) 242
Bourdelle, Émile Antoine 417
Bourdieu, Pierre 517
 The Love of Art 519
Bourges Cathedral
 stained glass 109, *111*, 121
Bowles, Thomas
 The Inside of Westminster Abbey 286
Boy Bitten by a Lizard (Caravaggio) 218
Boyd, Arthur 491
 Love, Marriage and Death of a Half-Caste 491
Boy Drinking (Annibale Carracci) 217
Boys, Thomas Shotter 359
Boy with a Basket of Fruit (Caravaggio) 222, *223*
Brabo Fountain (Jef Lambeaux) 342, *347*
Brack, John 491
Bradley, W. H.
 drawing for a library *386*
Brady, Mathew 368
Bragaglia, Anton Giulio 442
Brailes, William de 79
Braque, Georges 338, 359, 402, 413
 The Portuguese 338
Brassaï (Gyula Halász) 454
Braun, Adolphe 375
 Glacier in Switzerland 375
The Breakfast Table (Jean-Baptiste Siméon Chardin) 227
Breeze, Claude 490
Bret, Michel 445
Breton, André 415, 475, 514
 Manifesto of Surrealism 415
Breuer, Marcel 414
 'Vassily' Chair *430*

Brewster, Sir David 368
Bridges, the Reverend George 367
Bril, Paul 218
Briosco, Andrea—*see* il Riccio
Bristol Cathedral
 chapter house interior *105*
'Brit Art' 496
British Museum 6
Broadway on a Rainy Day (E. and H. T. Anthony) 368
Brodsky, Isaak
 Lenin in Smolny 473
The Broken Column (Frida Kahlo) *476*
bronze casting 151
 Greek 13
 Renaissance 163
 nineteenth-century 352, *353*
Bronzino, Agnolo (Angelo di Cosimo di Mariano) 217
 Allegory of Venus, Cupid, Folly and Time 217, *220*
Broosthauers, Marcel 497
Brouwer, Adriaen 327
Brown, Everald 486
 Ethiopian Apple *487*
Brown, Ford Maddox 308, 322
 The Last of England 308, *322*
Brücke movement 310, 359, 364–5
Brücke Museum of German Expressionism, Berlin 518
Bruegel, Jan, the Elder 238
Bruegel, Pieter, the Elder 183, 238, 242, 254, 255
 The Harvesters 242
 Peasant Dance 182
Brühl Castle—*see* Schloss Brühl
Brunelleschi, Filippo 152, 155, 158
Bruni, Leonardo
 tomb (Bernardo Rossellino) *351*
Brunn, Heinrich
 history of Greek art 12
Bryson, Norman 513
 Vision and Painting 513
 Word and Image 513
Buchloh, Benjamin 497
Buddhist art influenced by Greece 33, 37
Bulatov, Eric 496
 Perestroika 508, *509*
Bulloz, Jacques-Ernest
 Rodin's Bust of Mrs Simpson 357
Bulls of Bordeaux (Francisco de Goya) 358
Buonarotti, Michelangelo—*see* Michelangelo
Buono, Marco del
 cassone with the conquest of Trebizond *166*
Buontalenti, Bernardo 192
 the Great Grotto *192*
Burchard of Halle on Gothic architecture 124
Burckhardt, Jacob
 The Culture of the Renaissance in Italy 397
Bürger, William 402
Burges, William
 Neo-Gothic cabinet *385*
Burgundy, Mary of
 Book of Hours *88, 89*
Burne-Jones, Edward 310
Burri, Alberto 418, 443
Burri, René
 Die Deutschen 455
Bus Stop Lady (Duane Hanson) 498
Butcher Boys (Jane Alexander) 489
Butcher Shop (Annibale Carracci) 217
Byzantine art 6, 126, 166, 164
 illuminated books 76–9, *80–3*
 influence in West 1100–1350 124

C
Cabrera, Miguel
 Don Juan Joachín Gutiérrez Altamirano Velasco 295, 300–1
Cadart, Alfred 359, 362
Cadillac Moon (Jean Michel Basquiat) 498, *499*
Cage, John 443
Caillebotte, Gustave 309
 Paris, Rainy Weather 331

Calder, Alexander 448
 Red Polygons (Red Flock) 448
Caliari, Paolo—*see* Veronese, Paolo
calico printing 380
Callot, Jacques 254
calmes (leads for glazing) 121, *121*
calotypes 366, 370–1
Calvaert, Denis 183
Calzetta, Severo 163
cameos in Greek art 64
cameras 452
Camera Work magazine 311
Cameron, Julia Margaret 368, 376
 The Farewells of Lancelot and Queen Guinevere 368, *376*
Campagna, Girolamo 188
Campagnola, Giulio 171, 172
 Venus Reclining in a Landscape 172
Campbell, Stephen 496, 508
 Not You as Well Snowy *508*
Campi, Vincenzo 217
Canadian Group of Painters 490
Canaletto (Giovanni Antonio Canale) 219, 229, 255
 A Regatta on the Grand Canal 229
Cancelleria Palace, Rome
 Sala dei Cento Giorni *266*
Cancelleria reliefs 41, 49
 Emperor Domitian's embarkation *48*
Cano, Alonso
 Immaculate Conception 234
Canova, Antonio 66, 229, 342
 Antonio Canova in his Studio with Henry Tresham and a Model for 'Cupid and Pysche' (Hugh Douglas Hamilton) *354*
 portrait of Napoleon 66
Canterbury Cathedral
 S. Gabriel's Chapel *106*
 stained glass 109
 Trinity Chapel 109, *113*
Capital (Irwin) *509*
Capodimonte porcelain panels 278
Capriccio of Roman Ruins (Marco Ricci) *228*
capriccios 219, 22, 255
Caprichos (Francisco de Goya) 255, 358
Caravaggio (Michelangelo Merisi) 7, 197, 202, 218, 233
 Bacchus 218
 Boy Bitten by a Lizard 218
 Boy with a Basket of Fruit 222, *223*
 Cardsharps 218
 Concerts 218
 Conversion of S. Paul 197, *202*
 Crucifixion of S. Peter 197, *202*
 Fortune Teller 218
Caravaggio, Polidoro da 181
Carceri (Prisons) (Giovanni Battista Piranesi) 255, *257*
Card-Playing War Cripples (Otto Dix) 413, *434*
Carducho, Vicente 233
 Diálogos de la pintura 233
Carolingian Renaissance 84
Carpeaux, Jean-Baptiste 341, 354
 Carpeaux (Albert Maignan) *354*
 La Danse 341
carpets 270
Carpi, Ugo da
 S. Jerome 173
Carr, Emily 490, 492
Carracci, Agostino 217, 254
Carracci, Annibale 197, 202, 217–18, 254
 Assumption of the Virgin 197, 202, *203*
 Bean Eater 217, *222*
 Boy Drinking 217
 Butcher Shop 217
 Farnese Gallery ceiling 197, 197–8, *204, 205*, 217–18
Carracci, Ludovico 217
Carré d'Art, Nîmes 519
Carreño, Juan 233
Cartier-Bresson, Henri 462
 The Decisive Moment 454
 Madrid 462
cartoons

fresco 129
 stained glass 120
Carucci, Jacopo (Jacopo Pontormo) 217
Casdin-Silver, Harriet
 Centrebeam 444
Cassandre, A. M. (Adolphe Jean-Marie Moreau)
 L'Étoile du Nord 430, *431*
Cassatt, Mary 325, 359, 362
 The Bath 362
 The Boating Party 325
Cassirer, Ernst 511
cassoni 162–3, 166
Castagnary, Jules-Antoine 402
Castelfranco, Giorgio da—*see* Giorgione
Castelnuovo triumphal arch, Naples (Francesco Laurana) 145, *151*
caste painting (Luis de Mena) *300*
Castiglione, Baldassare
 The Courtier 180, 246
Castiglione, Giovanni Benedetto 254, 256
Castiglione-Colonna, Duchess —*see* Marcello
catacomb decorations 70
Catherine, S., in stained glass 110
Catholic cultures 7
ceilings 53, *58, 128*, 184–5, *197*, 197–200, *199, 201*, 205–8, 262, *263*, 266, 268–9, *268–9, 283*
Celant, Germano 517
Cellini, Benvenuto 182, 188, 189, 190, 193
 Autobiography 188
 Nymph of Fontainebleau 189
 Perseus and Medusa 188, 189, 190, *191*
 salt-cellar with Neptune and Ceres 193, *193*
 Satyr-Caryatids 189
 Treatises 188
Cennini, Cennino
 Book of Art (Libro dell'Arte) 117, 155
Centrebeam (Harriet Casdin-Silver) 444
centres 9
Cephalus and Procris Reunited by Diana (Claude Lorraine) 224, *224*
ceramics 278
 Greek 24
 Renaissance 163
 sixteenth–eighteenth centuries 278–9, *278–9*
Cerasi, Monsignor Tiberio 202
Cerasi Chapel, S. Maria del Popolo, Rome 197, 202–3, *202–3*
Cézanne, Paul 3, 309
 Madame Cézanne in a Red Armchair 324, 325
 Still Life with Plaster Cupid 332, *333*
chalices 96, 140, *140*
Chambers, Sir William 265
Chantrey, Francis 340
Chardin, Jean-Baptiste Siméon 219
 The Breakfast Table 227
The Chariot of Diana (Gabriel Blanchard) *206*
Charles IV, holy Roman emperor
 patronage in Bohemia 125
Charles V, holy Roman emperor 6, 230
Charles I, king of England
 portrayed by Anthony van Dyck 238, *250*
Charles II, king of Spain 233
Charles III, king of Spain 233
Charles IV, king of Spain
 portrayed by Goya 306
Charles Towneley's Library in Park Street (Johann Zoffany) *289*
Chartres Cathedral
 monumental sculpture 101
 stained glass 109, 110, *119*
 west portal *103*
Château de Blois
 chamber of secret cupboards *272*
Château de Maisons 264
Château de Versailles—*see* Versailles Palace
Chaussard, Jean Baptiste Publicola 400
Chavannes, Pierre Puvis de 309
Chéron, Louis 247
Chertsey Abbey tiles 116, *116*
Chetwode Church, Buckinghamshire
 stained glass 110

Chevreul, Eugène
 *The Laws of Simultaneous
 Colour Contrast* 403
Chia, Sandro 495
chiaroscuro 300
 in Greek painting 61
Chicago, Art Institute of 408–9
 Grand Staircase drawing *408*
 Grand Staircase *409*
Chicago, Judy
 The Dinner Party 496, 502, *503*
Chichester bishop's palace chapel
 Virgin and Child roundel
 124, *127*
Chigi, Agostino 263
Chirico, Giorgio de—*see* de Chirico,
 Giorgio
Christ depicted
 The Baptism (Menologian of Basil II)
 83
 Berzé-la-Ville fresco *127*
 Book of Kells *85*
 *Christ and the Elders in the
 Temple* (Giotto di Bondone)
 125, *128*
 *Christ and the Virgin in the
 House at Nazareth* (Francisco
 de Zurbarán) 234
 Christ-Helios mosaic, Grotte
 Vaticane *70*, 74
 Christ in Majesty altar frontal
 140
 Christ of the Apocalypse portal,
 Moissac Abbey *104*
 Christ Presented to the People
 (Rembrandt) 255
 cross of Ferdinand and Sancha
 98
 The Deposition of Christ (Rogier
 van der Weyden) 160
 The Descent from the Cross
 (Rubens) 241
 The Descent from the Cross
 (Vorsterman) *258*
 early Christian art 64, 70,
 70–1, 74
 The Entombment
 (Parmigianino) *256*
 The Flagellation of Christ (Piero
 della Francesca) *159*
 Karlštejn Castle frescoes *129*
 Lambeth Bible *87*
 Last Supper (Leonardo da Vinci) *159*
 Last Supper mosaic,
 S Apollinare, Ravenna *74*
 Lorsch stained glass 108
 Magdeburg stained glass 108
 Monreale Cathedral, Sicily *65*
 Passion of Christ (Jacopo
 Sansovino) 188
 Pièta (Guido Mazzoni) *149*
 Pièta with Arma Christi 143
 Procession to Calvary (Martin
 Schongauer) *174*
 Ravenna mosaics *74*
 Ravenna stained glass 108
 S. Clemente de Tahull fresco *127*
 Simeon in the Temple
 (Rembrandt) 240
 Schwarzach stained glass 108
 Tribute Money (Masaccio) *159*
 Trinity (El Greco) 231
 Trinity (Masaccio) 152, *158*
 Trinity Chapel, Canterbury,
 stained glass 109
 Virgin and Child 109, 124, *127*,
 129, 131, *132*, *133*, *134–5*, *136*,
 137, *143*, *176*
 Wissembourg stained glass 108,
 122, *122–3*
Christian art 3, *6–7*, 100
 Classical ideals 64
 early 6, 63, 64, *70–5*
 see also ars sacra
Christo (Javacheff)
 Umbrellas 444
 'wrapped islands' 444
Chrysostom, John 83
Chryssa 443, 445
church and state 5, 68
 ars sacra 93
Church, Edwin 311, 329
 Twilight in the Wilderness 329

Cicero on Greek art 62
The Circumcision in the Manner of Dürer
 (Hendrick Goltzius) *258*
Circus People in Front of Tent (August
 Sander) *461*
City Project (Matt Mullican) 445
The City Rises (Umberto Boccioni) *339*
Civiltà Italiana, Palazzo della *67*
Claesz, Pieter 239
Clark, Kenneth 512
Clark, Timothy J. 513
Clarke, LeRoy 486
 *In the maze, there is a single line
 to my soul* 483
Classical ideals 7, *60–7*, 262, 265
Classical period in Greek art 24
Classic Landscape (Charles Sheeler) *422*,
 423
Claude Lorraine (Claude
 Gellée) 218
 *Cephalus and Procris Reunited by
 Diana* 224, *224*
Clement VIII, pope 291
Clement XI, pope *291–2*
Clemente, Francisco 495
Cleopatra VII and pictorial arts 25
Clesinger, Jean-Baptiste 341
 Woman Bitten by a Snake
 341, *342–3*
Clifford, Charles 373
 Porte du College St Grigoin 373
Clot, Auguste 359
Club Armchair ('Vassily' Chair) (Marcel
 Breuer) *430*
*Coat of Arms with a Peasant Standing on his
 Head* (Master of the Housebook) *172*
Cobra artists 419
Coburn, Alvin Langdon 369
Cochin, Charles Nicolas
 *Monument to Louis XV,
 Reims* 287
Cock, Hieronymus 254
Codex Ixtlilxóchitl 294, *296*
Coeur, Jacques
 patron of Bourges Cathedral
 window 111, *121*
Colbert, Jean-Baptiste 218, 293
Cold, Dark Matter—An Exploded View
 (Cornelia Parker) *505*, 525
Cold War 419, 436
Cole, Henry 383
Cole, Thomas 311, 329
 *The Course of Empire:
 Desolation* 321
collection and display of art 7, 8, *220–1*,
 221, 246, 250, 281, 404
Collective Farm Festival (Arkadi Plastov)
 473
Colleoni monument (Andrea del
 Verrocchio) 145
Cologne Cathedral
 stained glass 110
Colombo, Gianni 444
Commodore Augustus Keppel (Sir Joshua
 Reynolds) 247, *253*
communion cups 140, *140*
Composition (Joaquín Torres-García) 476
Composition No. III (Piet Mondrian) *438*
Composition No. 10, Pier and Ocean (Piet
 Mondrian) *339*
computer graphics 444, *445*, 450
Conceptual Art 8, 410, 450, *494–6*, 497,
 517
Congo exhibition, Brussels-Tervuren 342
Constable, John 307, 320
 Dedham Vale 320
Constantine, emperor 6, 7
 Arch of *70*, *72*
Constantinople 6
 early stained glass 108
Constructivism 442, 470
Contemporary Art Society, Montreal 490
Contest between Apollo and Marsyas
 (maiolica theme) *168*
contrapposto posture 15, 124
Conversion of S. Paul (Caravaggio) 197,
 202
Coomaraswamy, A. K.
 Art and Swadeshi 478
Coornhert, Dirck Volkertsz 254
Copley, John Singleton 311
Cordier, Charles-Henri-Joseph 342, 357
 Sudanese in Algerian Dress *356*

Cornaro Chapel, S. Maria della Vittoria,
 Rome 204
Corneille, Pierre 313
Cornelisz, Pieter (?)
 The Lost Son in Poverty 117
coronation cope of Roger II of Sicily *98*
Coronation of the Virgin altarpiece, S.
 Wolfgang, Salzburg (Michel Pacher) 141,
 141
coronation spoon, English crown jewels *99*
Correggio (Antonio Allegri) 216
 Jupiter and Io 216, *220*
Cort, Cornelis 254
Cortona, Pietro da (Pietro Berretini) 291
 Divine Providence 198, 200,
 207, 208
 Sala di Venere ceiling, Pitti
 Palace, Florence 199, *199*
 Vision of S. Philip Neri 208
Cortona, Stefano da (Sassetta) 132
Cosimo I de' Medici 190, 217,
 220, 290
Cossa, Francesco 510
Cotán, Juan Sánchez 236
 *Still Life with Game Fowl, Fruit,
 and Vegetables* 236
*The Côte des Boeufs at l'Hermitage, near
 Pontoise* (Camille Pissarro) *339*
The Cotton Picker (Wayne Miller) *465*
Couchot, Edmond 445
Counter-Reformation 5
Courbet, Gustave *307–8*
 A Burial in Ornans 307, *322*
 The Stonebreakers 307
The Course of Empire: Desolation (Thomas
 Cole) *321*
Cozens, Alexander 253
Cozens, John Robert 253
CR3Z72 (William Latham) *445*
Cranach, Lucas 171, 254
The Crayon art periodical 401
crayon manner (pastel manner) prints 260,
 260
creativity 3
Creusa depicted on Roman sarcophagus 51
criticism 8, 219, *290–3*, *400–3*, *514–17*
 Greek *60–3*
 Roman *62–3*
Croce, Benedetto 510
crosses, medieval 100
 Ferdinand and Sancha *98*
 Ruthwell 100, *102*
Crouchback, Edmund, Earl of Lancaster
 tomb chest 116
Crown of Hungary *99*
Crown of Thorns, Sainte-Chapelle, Paris
 139
Crucifixion fresco (Altichiero) 130
Crucifixion of S. Peter (Caravaggio) 197,
 202
Crucifixion window, Poitiers 109
Cruz, Juan Pantoja de la 230
Cruz, Juana Inés de la 295
Cruz-Diez, Carlos 444
Crystal Palace, Great Exhibition, London
 392
Crystalist movement, Sudan 485
Cubism 5, 8, 302, 304, 311, 336, *338–9*,
 402, 403, 413, 448, *514–15*
 Analytic Cubism 359
 photography 464
Cubism and Abstract Art exhibition,
 Museum of Modern Art, New York 522,
 522
Cunningham, Merce 443
Cupid and Psyche (François Gérard) 305,
 312, 313
Curnoe, Greg 490
Currie, Ken 496
Currier and Ives prints 359
Cuvellis, François 265
Cuvier, Baron Georges 398
Cuzco School 295, 299
Czartoryska, Countess Sophia Zamoyska
 tomb in S. Croce, Florence
 341

D
D'Angers, David 340
Dada 6, *412–13*, 442, 444, 446, 516
d'Affry, Adele—*see* Marcello

Daguerre, Louis-Jacques-Mandé 366
daguerreotypes 366, *370*
Dali, Salvador 415
 Metamorphosis of Narcissus 424,
 425
Dalou, Aimé-Jules
 Alphand monument 342,
 346, *347*
 *Mirabeau Answering Dreux-
 Brézé* 352
 Triumph of the Republic 350
'dampfold' in medieval drapery 124, 126
Dänae (Titian) 220
Dance of the Tapuias (Albert Eckhout) 300
Daniel, prophet, in stained glass
 Augsburg Cathedral 108, *112*
Danti, Vincenzo 290
Danto, Arthur C.
 'The End of Art' 517
Danube School 256
Daru Stairway, Louvre *408*
Datini, Francesco 163
Daubigny, Charles-François
 307, 359
 Tree with Crows 362, *363*
Daucher, Hans 195
Daumier, Honoré 360
 *Rue Transnonain, le 15 avril
 1834* 360
David (Michelangelo) 144, *146–7*
 copy in the Piazza della Signoria
 190
David, Jacques-Louis 7, 66, 218, 293,
 304–5, 343, 396
 Triumph of the People of France
 350
 Oath of the Horatii 304, *312–13*,
 313, 400
David, king, in stained glass, Llanrhaeadr,
 Wales 120
David, Ludovico 292
David, prophet, in stained glass
 Augsburg Cathedral, 108, *112*
David and Melody (Paris
 Psalter) *80*
Davidson, Bruce
 Hackensack, New Jersey 466
Davidson, Robert Delphire 467
Davis, Stuart 417
 Lucky Strike 440
Davison, George 369
Dawson, Paula 444
dealers 8, 281, 289, 304
Death, Birth and Culture (Abdoulaye
 Konaté) 489
The Death of General Wolfe (Benjamin
 West) 295, 301, *301*
Death of Germanicus (Nicolas Poussin)
 218, *224*
The Death of Sardanapalus (Eugène
 Delacroix) 306, *319*
Death of the Virgin, Strasbourg Cathedral
 tympanum 101, *106*
Debord, Guy 513
de Brailes, William 79
de Chirico, Giorgio 415, 424
 The Song of Love 415, *424*
deconstruction 4
decorative arts—*see* applied arts
de Dene, Canon Peter
 heraldic window 110
Dedham Vale (John Constable) *320*
de Duve, Thierry 497
Deep Throat (Mona Hatoum) *503*
Defamation (Heinz Hajek-Halke)
 463
de Fonteny, H. 367
Degas, Edgar 309, 353, 359, 403
 In a Café (The Absinthe Drinker)
 330, *331*
 Interior (The Rape) 327
 Little Dancer Aged Fourteen 343
 study in the nude for *Little
 Dancer Aged Fourteen* 353
de Hooch, Pieter 239
Deineka, Aleksandr 472
 Lunch Break in the Donbas 472
Le Déjeuner sur l'herbe (Édouard Manet)
 308
De Kooning, Willem 419
Delacroix, Eugène 305, 306, 359, 368
 The Death of Sardanapalus 306,
 319

Liberty Leading the People 303, 401
Massacre at Chios 401
de la Cruz, Juan Pantoja 230
de la Cruz, Juana Inés 295
Delaroche, Paul 367
Delâtre, Auguste 359
Del Biondo, Giovanni
Rinuccini Chapel polyptych, S. Croce, Florence 136, *137*
Delécluze, Étienne 400
Delft ceramics 278
Delightful Land (Nave Nave Fenua) (Paul Gaugin) *364*
Del Medico marble merchants 341
de l'Orme, Philibert 182
Delos businessman sculpted *22, 23*
Delphire, Robert
In Our Time survey 455
Demachy, Robert 369
de Maistre, Roy 491
de Mamesfeld, Henry
donar portrait in Merton College windows *118*, 119
de Maria, Walter 444
Les Demoiselles d'Avignon (Pablo Picasso) 311, *336*
Demosthenes portrait statue
Roman copy *61*
Demuth, Charles 311
Depero, Fortunato 442
The Deposition of Christ (Rogier van der Weyden) 160
Derain, André 310
Derby Day (William Powell Frith) *323*
Derrida, Jacques 494, 517
The Descent from the Cross (Rubens) 238, *241*
The Descent from the Cross (Vorsterman) *258*
deschi da parto (birth trays) 163, *167*
de Staël, Nicolas 419
De Stijl magazine 414
Deutscher Werkbund 383, 394
development of art 525–6
Devis, Arthur
John Bacon and his Family *270*
de Vries, Adriaen
Fountain of Hercules 194
Man of Sorrows 214, *215*
de Vries, Hans Vredeman 263
De Witt, Tom 444
de Witte, Emanuel 245
The Old Church in Amsterdam *240*
Diana the Huntress (School of Fontainebleau) *187*
Diane de Poitiers 186
Diderot, Denis 219, 293, 396
Encyclopédie 380, 390
Salons 400
die-stamping 381
The Dinner Party (Judy Chicago) 496, 502, *503*
Dionysos depicted
Phiale Painter *29*
Siphnian Treasury frieze *18*
Dio of Prusa 63
dioramas 302
Dioscurides of Samos 52
mosaic of street musicians *56*
Dipylon Master
attributed crater painting *26*
Disasters of War (Francisco de Goya) 358, 362–3
disegno 290
Disparates (Francisco de Goya) 358
Ditchley portrait of Elizabeth I (Marcus Gheeraerts the Younger) 248, *249*
Divine Providence (Pietro da Cortona) 198, 200, *207*, 208
Dix, Otto 412
Card-Playing War Cripples 413, *434*
Dobell, William 491
Dobson, William 247
Doge Embarking on a Bucintoro (Francesco Guardi) 219, *229*
Doge's palace, Venice, 263
vault of the Scala d'Oro 268
Domenichino (Domenico Zampieri) 218
Domenico, Giovanni 219

domestic arts 7
medieval and Renaissance 162–9
Domitian, emperor *48*
Donatello (Donato di Betto Bardi) 143, 144, 152
Gattamelata monument 145, *151*
Judith and Holofernes 190
S. George 144,146, *147*
Don Juan Joachín Gutiérrez Altamirano Velasco (Miguel Cabrera) 295, 300, 301
donor portraits
stained glass 110, 118, 119
Don't Worry! He's a Vegetarian (John Heartfield) 415, *435*
Doria, Andrea 290
Dorigny, Nicola 292
Doryphoros (Spearbearer) (Polyclitus) 15, 16, *17*, 40
Dou, Gerard 239
Douris of Samos on artists 62
Dove, Arthur 311
The Drawbridge (Giovanni Battista Piranesi) *257*
Drevet, Pierre 255
Drogo Sacramentary 90, *91*
Drolling, Martin
Kitchen Interior 326
Drottningholm Palace
bedroom of Queen Hedvig Eleonora *276*
Drowning Girl (Roy Lichtenstein) 419, 440, *441*
The Drunkenness of Noah, vault painting, Saint-Savin-sur-Gartempe *126*
drypoint printmaking 172
Drysdale, Russell 491
Dubuffet, Jean 516
Du Camp, Maxime
Égypte, Nubie, Palestine et Syrie 367
Duccio 129, 132, 134
Maestà 134–5, *134–5*
Rucellai Madonna 130, *131*, 134
Duchamp, Marcel 412, 442, 496
L.H.O.O.Q 412, *413*, 421
Revolving Glass Plates 446
Dunstan, S., Archbishop of Canterbury
depicted in stained glass, Trinity Chapel, Canterbury 109
skill in working precious materials 92
Dupré, Jules 307
The Pond 320, *321*
Durand, Asher B 311
Duranty, Edmond 402
The New Painting 403
Dürer, Albrecht 6, 172, 174, 183, 215, 238, 254, 258
Apocalypse 170
Four Apostles 160
Knight, Death and Devil 171, 176, *177*
Landscape with a Cannon 174, *175*
The Men's Bath 177
S. Jerome (Albrecht Dürer) *172*
The Whore of Babylon *173*
Durham Castle
twelfth-century archway *105*
Durnovo, A. N.
furniture design *386*
Duval-Carrié, Édouard 486
The Sacred Forest *487*
Duveen, Lord 542
Dvizdjenje group 444
Dvořák, Max
The Literature of the Arts 510
Dyens, George 444
Dying Celtic Trumpeter (Epigonos of Pergamum)
Roman copy *18*

E
E. & H. T. Anthony Co 369, 374
Eadfrith
Lindisfarne Gospels 78, *90*
Eagle Grasping a Heron (Antoine Louis Barye) *352*
Eakins, Thomas 311, 329
The Gross Clinic 328
easel painting 222–3
Ecce Homo chapel at Varallo *196*

Eckhout, Albert 295, 300
Dance of the Tapuias 300
The Ecstasy of S. Francis (Giovanni Bellini) 161
The Ecstacy of S. Teresa (Gianlorenzo Bernini) 204
Education of Cupid by Venus and Mercury (Louis-Michel van Loo) 233, *237*
Ehmcke, F. H.
packaging designs 394
Einstein, Carl
Art of the Twentieth Century 515
Negro Sculpture 515
Eisenstaedt, Alfred 453
Ekkehard and Uta, Naumburg Cathedral sculpture 101, 106, *107*
El Anatsui 488
Unfolding the Scroll of History 488
electro-plating 381
The Elephant of Celebes (Max Ernst) *424*
Elgin Marbles 6, 11, 13, 342, 524
El Greco (Domenikos Theotokopoulos) 230–2
S. Domingo el Antiguo, Toledo, altarpiece 230, *231*, 232
elephant silk, Byzantine *164*
Eligius, bishop of Noyon
skill in working precious materials 92
Elizabeth I, queen of England
Ditchley Portrait (Marcus Gheeraerts the Younger) 248, *249*
Elizabeth I Receiving Dutch Ambassadors 270
Elizabeth of York
tomb by Pietro Torrigiani *149*
Ellis, Alexander 370
Piazza di Monte Cavallo 370
El Mudo (Juan Fernández de Navarrete) 230
El Salahi, Ibrahim 485, 488
Funeral and a Crescent 488
Elsheimer, Adam 218, 242
The Flight into Egypt 242
Elsigini, Jamal 482
Embarkation for Cythera (Nicolas-Henri Tardieu) *259*
emblemata (Roman picture panels) 58
emblem books 295
Embriachi workshop 162
'English manner' engraving 260, *260*
English School 246–7, 252–3
English Set (Théodore Géricault) 358
engraving 170–2, 174, 176–7, 254–5, 258–61, *260*
book illustration 170
reproductive 254, 258–9
Enlightenment 7
utopianism 304
L'Enseigne de Gersaint (Jean-Antoine Watteau) 288, *289*
Ensor, James 310
The Entombment (Parmigianino) 256, *257*
Entry of Emperor Rudolf into Basel in 1273 (Franz Pforr) *318*
Enwonwu, Ben 485
Epigonos of Pergamum
Dying Celtic Trumpeter *18*
Equestrian Monument to the Grand-Duke Cosimo I de' Medici (Giambologna) 188, 190, *191*
Equestrian Portrait of Charles I (Anthony van Dyck) 238, *250*
Ermanox camera 452
Ernst, Max 415
The Elephant of Celebes 424
Eros depicted *21, 28*
Escorial palace 230
Espinosa, Jerónimo Jacinto de 233
Esposizione Universale di Roma
Fascist Neo-Classical buildings *67*
Esquiline hill, Rome
tomb paintings 52, *54*
Odyssey Landscape fresco *55*
Venus *46*
Estes, Richard 495
etching 170–5, 254–7, *260*, 260–1, 358–9, 362–5

L'Étoile du Nord (A. M. Cassandre) 430, *431*
Ethiopian Apple (Everald Brown) 487
Etruscan Drawing Room, Osterly Park *267*
Evans, Walker 454, 460
American Photographs 454
Sharecropper's Daughter: Hale County Alabama 461
'evolution' of art 525–6
Eworth, Hans 246
Henry Stewart, Lord Darnley, and his brother Charles Stewart, Earl of Lennox 248, *248*
Exeter Cathedral, west front 144, 146, *147*
exhibitions 281, 289, 302, 382, 340, 392
African Hall, American Museum of Natural History *407*
Museum of Modern Art, New York 522, *522*
Exposition Universelle 342, 367
French industrial products at the Louvre 392
A Friday at the Salon des Artistes Français (Jules-Alexandre Grün) *348*
Gems of the Great Exhibition (George Baxter) 348, *349*
Great Exhibition, London 348, *349*, 392
New Salle des États, Louvre 406
photography 367
The Salon of 1767 (Gabriel-Jacques de Saint-Aubin) *289*
Salons 289, 293, 340, 348, *348*, 396, 402
Expressionism 365, 515
Expulsion of Hagar (Lucas van Leyden) 176
Ezechiel depicted
Paris Gergory *82*

F
Fabius Pictor 52
Fabius, Q.
tomb painting of *54*
Fabriano, Gentile da
Adoration of the Magi (Strozzi Altarpiece) 152, 158, *158*
Fafard, Joe 490
Fairford Church, Gloucestershire
stained glass 111
Faith, S.
reliquary *96*
Falke, Jacob von 382
Fallen Man (Wilhelm Lehmbruck) 412, 428, *429*
The Family of Man
photographic exhibition 454
Family of Peasants (Le Nain brothers) 225
The Family of Philip V (Louis-Michel van Loo) 233
Fannius, M.
tomb painting of *54*
The Farewells of Lancelot and Queen Guinevere (Julia Margaret Cameron) 368, *376*
Farmers' Inn in the Puszta, Hungary (Werner Bischof) *465*
Farnese, Alessandro
equestrian monument by Francesco Mochi 210
Farnese Gallery 197
ceiling fresco by Annibale Carracci 197–8, 204, *205*, 217–18
Farnesina villa, Rome
Loggia di Psiche (Raphael and assistants) *184*, 196
Fascism and art 415, 435
Classical ideals 66–7
Faun, House of the, Pompeii
Alexander Mosaic *54*
Fautrier, Jean 416, 435
Head of a Hostage 435
Fauves 310, 336, 402, 403, 514
Faveau, Félicie
Monument to Dante 341
fax art 445
Fayum mummy portraits *58, 62*
Fehr, Henry Charles 342
historical frieze *347*
Félibien, André 224, 293, 396

feminism
 in art 444, 475, 502–3
 in art history 4
 see also women
Fénéon, Félix 403
Fenton, Roger 368, 373
 Terrace and Park at Fenwood House 372
Ferdinand and Sancha, cross of 98
Fête Champêtre (Giorgione) 308
fêtes galantes 219
Fetter, W. 444
Feuerbach, Anselm 309
Fichte, Johann Gottlieb 306
Fielder, Conrad
 On Judging Works of Art 398
Filarete (Antonio Averlino) 155
Filipepi, Sandro di—*see* Botticelli
film art 448
Fine Arts 4, 178, 302
Finelli, Giuliano 210
Finlay, Ian Hamilton 496, 504
 All Greatness Stands Firm in the Storm 504
Fiorentino, Rosso 182
Fire (Francisco de Goya) 317
Firenze, Andrea di Bonaiuto da
 The Virgin and Child with Ten Saints 132
First World War 5, 8, 412, 434, 491
 photography 452, 464
Fischl, Eric 495, 502
 Bad Boy 502, 524–5
FitzEllis, Margaret, in stained glass, S. Mary's, Waterperry, Oxfordshire 122
Flack, Audrey 495
The Flagellation of Christ (Piero della Francesca) 159
Flaming June (Frederic Leighton) 310, 335, 335
Flavin, Dan 443
Flechtheim, Alfred 515
The Flight into Egypt (Adam Elsheimer) 242
A Float for the Las Fallas Festival in Valencia (Josef Koudelka) 468
Florence Triumphant over Pisa (Giambologna) 188
Floris, Frans 183, 238
Flötner, Peter 195
Flower, Barnard, King's Glazier 111
Fluxus movement 443
Flying Mercury (Giambologna) 188, 193, 193
Foley, John Henry
 'Asia', Albert Memorial, London 345
Fondation Maeght 518
Fontainebleau School 182, 217, 263, 264
 Diana the Huntress 187
Fontana Maggiore, Perugia 144
Fontana, Lucio 443
 Spatial Decoration 448, 449
foreshortening 159, 197
 in Greek painting 61, 62
The Fortune Teller (Georges de La Tour) 218
Foster, Sir Norman 519
Foucault, Michel 494, 517
Fougeron, André 419
 Atlantic Civilisation 440,
found materials 445
Fountain of Hercules
 Bartolommeo Ammannati and Niccolò Tribolo 192
Fountain of Hercules
 Adriaen de Vries 194
Fountain of Neptune (Bartolommeo Ammannati) 190
Fountain of Neptune (Giambologna) 188
Four Apostles (Albrecht Dürer) 160
The Four Continents with Apollo (Giambattista Tiepolo) 283
Four Evangelists (Jacopo Sansovino) 188
The Four Trees (Claude Monet) 334
Fox Talbot, William Henry 366, 370, 371
 The Haystack 367, 370
 The Pencil of Nature 367
Fra Angelico (Guido di Pietro)
 paintings in S. Marco, Florence 152
Fragonard, Jean-Honoré 219, 255, 281, 396

The High Priest Corésus Sacrifices himself to Save Callirhoé 312
The Progress of Love: The Meeting 284
Rinaldo and Armida 219, 229
Fra Filippo Lippi 152
France Bringing the Faith to the Indians of New France (Père Luc) 298
Francesca, Piero della
 The Flagellation of Christ 159, 159
 De Prospectiva Pingendi 155
Francis I of France 220, 263
Francis of Assisi, S., depicted
 S. Francis, Assisi, frescoes 125, 128
 The Ecstasy of S. Francis (Giovanni Bellini) 161
 S. Francis Renounces the World (Königsfelden window) 114
François, Claude (Père Luc) 298
 France Bringing the Faith to the Indians of New France 298
Frank McEwen Workshop School 484
Frank, Robert 467
 Bar, New York City 466
 Les Américains 455
Franklin, Benjamin, sculpted by Jean-Antoine Houdon 356, 356
Fraser, Andrea 519
Frederick R. Wiesmann Art and Teaching Museum 519
Free Society of Artists (eighteenth-century London) 247
fresco techniques 129
Freud, Sigmund
 influenced by Symbolism 335
 influence on Surrealism 415, 424
A Friday at the Salon des Artistes Français (Jules-Alexandre Grün) 348
Friedlaender, Walter 512
Friedman, Tony 445
Friedrich, Caspar David 306
 Wanderer above the Mists 320
Frith, William Powell 308
 Derby Day 308
The Frugal Repast (Pablo Picasso) 365
Fry, Roger 310, 403, 510, 515–6
 Vision and Design 515
Fuller, Issac 247
Fuller, Peter 497, 516
Full Moon (George W. Griffith) 375
Funeral and a Crescent (Ibrahim El Salahi) 488
funerary art
 Corinthian votive plaque from Pitsa 27
 early Christian 70
 Greek 13, 14, 15, 24, 27, 28
 Greek-influenced 32, 34–5
 Roman 41, 50–1, 52, 62
 Renaissance 145
 modern 340–1
 modern African 488–9
furniture and furnishings 276–7, 386–7, 394–5
 medieval and Renaissance 163
 sixteenth-century 263
Furtwängler, Adolph
 history of Greek art 12
Fuseli, Henry 306
Futurism 302, 311, 442, 446, 494

G
Gabo, Naum 442
Gabriel, Peter 445
Gainsborough, Thomas 253
 Mary, Countess Howe 253
Galen on Greek art 60
Galerie François I, Fontainebleau (Fiorentino Rosso) 185
Galileo 242, 291
Galla Placidia mausoleum 71
 Good Shepherd mosaic 74
Galle, Cornelis 255
Galle, Philipp 254
galleries and museums 8, 302, 392, 404–9, 518–23

Gamble, Susie 444
Gandhara reliefs 33, 34
Gandhi, M. K. 478
Garden of Earthly Delights (Hieronymus Bosch) 160
Gardner, Alexander 369
Garvey, Fanon 482
Garvey, Marcus 482
Gattamelata (Donatello) 145, 151, 151
Gaugin, Paul 310, 333, 342, 353, 359, 364
 Manao-Tupapau —The Spirit of the Dead Watches 333
 Nave Nave Fenua (Delightful Land) 364
Gaulli, Giovanni Battista—*see* Baccicio
Gautier, Théophile 343, 359
 Mademoiselle de Maupin 402
 photographed by Nadar 376
Gazette des Beaux-Arts 402
Gehry, Frank
 Guggenheim Bilbao Museum 523, 524
Gelasian Sacramentary 90
Gemma Augustea cameo 64
Gems of the Great Exhibition (George Baxter) 348, 349
gender issues 9
Genesis pilaster (Lorenzo Maitani?), Orvieto Cathedral 146
genius 5
Gentileschi, Artemisia
 Judith and the Head of Holofernes 218
Geometric Period in Greek art 24
 Dipylon Master 26
George, S.
 by Donatello 144, 146, 147
 by Tommaso da Modena 129
George I and his Family (James Thornhill) 251
George Washington (Horatio Greenough) 66, 67
Georges Pompidou National Art and Culture Centre, Paris 518, 521
Gérard, François 305
 Cupid and Psyche 305, 312, 313
Gerhard, Hubert 189
Géricault, Théodore 305, 306
 English Set 358
 The Raft of the Medusa 306, 315, 317
 Severed Limbs 317
Gerlachus 119
 Moses and the Burning Bush window 118
German Idealist philosophers 307
Gérôme, Jean-Léon 329
 Café House, Cairo 326
Gerona Cathedral
 glaziers' table 120, 120–1
Gersaint art shop 281, 289
Getty bronze 16, 17
Getty goddess 20, 21
Getty Museum, Santa Monica 519
Gewerbe (trade) schools 382
Gheeraerts, Marcus, the Younger 246
 Queen Elizabeth I (Ditchley Portrait) 248, 249
Ghiberti, Lorenzo 144, 152, 396
 Commentaries 155
 S. John the Baptist 144
 S. Matthew 146, 147
Ghirlandaio, Domenico 154
Ghisi, Giorgio 254
Giacometti, Alberto 417, 436
 Man Pointing 436
Giambologna (Jean Boulogne or Giovanni Bologna) 180, 183, 192, 195, 193
 Astronomy 180
 Equestrian Monument to the Grand-Duke Cosimo I de' Medici 188, 190, 191
 Florence Triumphant over Pisa 188
 Flying Mercury 188, 193, 193
 Fountain of Neptune 188
 Rape of a Sabine 190, 191
 Samson Slaying the Philistines 188
Giaquinto, Corrado 233
Gibson, John
 Tinted Venus 343

Gidal, Tim 452
gigantomachy friezes
 Great Altar of Pergamum 19
 Siphnian treasury 18
Gilbert, Alfred 341
Gilling Castle
 Great Chamber 268
Gillray, James 358
Giordano, Luca 199
Giorgio, Francesco di 155
Giorgione (Giorgio da Castelfranco) 6, 154, 216, 220
 Fête Champêtre 308
 Sleeping Venus in a Landscape 216
 Tempesta 161
Giotto di Bondone 3, 125, 128, 155
 Christ and the Elders in the Temple 125, 128
 Nativity frescoes, Assisi 125
 Purification 125
Giovanni, Apollonio di 163
 cassone with the conquest of Trebizond 166
Giovanni, Bertoldo di 154
Girardon, François 211
 Apollo Tended by the Nymphs 212–13, 213
Girl Born Without a Mother (Francis Picabia) 412–13
Girodet, Anne-Louis 305
Glaber, Raoul 100
Glacier in Switzerland (Adolphe Braun) 375
glasnost 471
glaziers' guilds 111
glaziers' tables 120–1, 120
glazing—see stained glass
The Gleaners (Jean-François Millet) 308, 322
Gleizes, Albert and Jean Metzinger
 On Cubism 403
Gnosis 31
 mosaic floor 30
Godwin, E. W.
 fabric design 386
Goethe, Johann Wolfgang von
 On German Architecture 397
 Theory of Colours 403
Goldsworthy, Andy
 Snowflakes 445
The Goldweigher's Field (Rembrandt) 255
Goltzius, Hendrick 171, 183, 238, 254, 255, 258
 The Circumcision in the Manner of Dürer 258
Gombrich, Ernst 511, 512
 Art and Illusion 512
 The Story of Art 512
Goncourt, Edmond and Jules de
 Manette Salomon 401
Gonon, Eugène 352
Good Shepherd mosaic, Galla Placida mausoleum 74
Goodwin, Philip 518
Gorki, Maxim 453
Gospels of Otto III 88
Gospels of S. Augustine 84
Gossaert, Jan, (Mabuse) 183, 238
 Neptune and Amphitrite 186, 187
Gothic style
 monumental sculpture 101, 103, 106
 painting 124
 stained glass 109–111
Goujon, Jean 182
Gower, George 246
Goya, Francisco de 7, 233, 257, 306, 314
 Bulls of Bordeaux 358
 Caprichos 255, 358
 Disasters of War 358, 362–3
 Disparates 358
 Fire 317
 Tampoco (Not in this Case Either) 363
 The Third of May, 1808 306, 314
Grammar of Ornament (Owen Jones) illustrations for 389
Le Grand Déjeuner (Three Women) (Fernand Léger) 428
Grand Tour 246, 247, 281

GRAV (Groupe de Recherche d'Art Visuel) 444
Gravedigger, Edmore, North Carolina (John Vachon) *464*
grave goods
 exported by Greeks 28, 32
 see also funerary arts 28
Grazing at Shendi (Amir Nour) *482, 488*
Great Exhibition, London 342, 345, 348, 367, 382, 385, 392, *392*
Great Grotto (Bernardo Buontalenti) *192*
Greek art 6, 10–37
 concept of art and 3
 looted by Romans 52
 theory of 60–2
Greenberg, Clement 8, 490, 494, 516–17
Greene, John Beasley
 Le Nil 367
Greenough, Horatio 383
 George Washington 66, *67*
Greenwich Hospital
 Painted Hall (Sir James Thornhill) 251, *251*
Gregory I, pope (the Great) 84
 on images 79
 on stained glass windows 124
Gregory of Nazianzus
 Paris Gregory 82, *82*
Gregory of Tours on early stained glass 108
Grenier, Pasquier
 Trojan War tapestries 162
La Grenouillière (Claude Monet) *330*
Greuze, Jean-Baptiste
 The Marriage Contract 219
Grien, Hans Baldung 254
 Bewitched Groom 254
Griffith, George W.
 Full Moon 375
Griffiths, Philip Jones
 Vietnam Inc. 459
 Wounded Vietcong 459
Gris, Juan 413
grisaille glass 110, 112, *113*
 Saint Denis, abbey church of 109
Grooms, Red 443
Gropius, Carl Wilhelm
 Livingroom of the Gropius Family at Stallstrasse 7 384
Gropius, Walter 383
Gros, Antoine-Jean 305, 314
 Napoleon in the Plague House at Jaffa 306, *314*, 315
The Gross Clinic (Thomas Eakins) *328*
Grosvenor Gallery, London 310
grotesques 262
Grotte Vaticane
 Christ-Helios mosaic 70, *74*
grottos
 the Great Grotto, Boboli Gardens, Florence (Bernardo Buontalenti) *192*
 Grotto of Thetis, Versailles *282*
Groupe de Recherche d'Art Visuel 444
Group of Seven 490, 492, *492*
grozing irons 121
Grün, Jules-Alexandre
 A Friday at the Salon des Artistes Français 348
Grünewald, Matthias 183
 Isenheim Altarpiece 154
Gruppo T 444
Guardi, Francesco 219, 229
 Doge Embarking on a Bucintoro 219, *229*
Guernica (Pablo Picasso) 8, 415–16, *416*, 435
Guerrini, Giovanni 67
Guggenheim, Solomon R. 524
Guggenheim Museum
 Bilbao 519, 523, *523*, 524
 Soloman R. 518, 519, 522, *522*, 523
 SoHo 519
Guimar, Hector
 Art Nouveau furniture 387
Günther, Ignaz
 high altar, Rott am Inn *286*
Günther, Matthäus 199
Gursky, Andreas 455
Guston, Phillip 495
Guttuso, Renato 419

H
Haacke, Hans 519
Hackensack, New Jersey (Bruce Davidson) *466*
Haddon Hall
 Long Gallery *272*
Hadjinicolaou, Nicos 512
 Art History and Class Struggle 512
Hadrian's Villa, Tivoli
 dove mosaic 53, *58*
Hajek-Halke, Heinz 462
 Defamation 463
Halley, Peter 496, *506*
 Yellow and Black Cells with Conduit *506*, 524–5
Hall of Seven Chimneys, Louvre *406*
Hals, Frans 238, 239
 Civic Guard Companies 239
 Young Man and Woman in an Inn (Yonker Ramp and his Sweetheart) 239, *244*
Ham House
 Queen's Closet *274*
Hamilton, Hugh Douglas
 Antonio Canova in his Studio with Henry Tresham and a model for 'Cupid and Pysche' 354
Hamilton, Richard 419, 440, 442
 Just What Is It That Makes Today's Homes So Different, So Appealing? 419, *440*
Hampton Court Chapel
 vidimus sketches for windows 118, *118*
Hamstall Ridware chalice *140*
handblock printing 390
Handel, George Frederick
 Vauxhall Gardens statue by Louis-François Roubillac 280, *286*
Hanson, Duane 495
 Bus Stop Lady 498
Hardouin-Mansart, Jules
 Salon de la Guerre, Versailles *267*
Hardwick Hall
 High Great Chamber 264
Harlem Renaissance 484
Harrison, Charles 497
Hart-Benton, Thomas 417
Hartley, Marsde 311
Hartung, Hans 418
The Harvesters (Pieter Bruegel the Elder) *242*
Haterii
 tomb of *50*
Hatoum, Mona 496, 502
 Deep Throat 503
Haus, Kaselowsky 518
Hauser, Arnold 512
Haussmann, Raoul 442
Havell, E. B. 478
The Haymaker (*Abend*) (Theodor and Oskar Hofmeister) *378*
The Haystack (William Henry Fox Talbot) 367, *370*
Hayward Gallery 518, 519
Hazlitt, William 401
Heade, Martin Johnson 311, 329
 Thunderstorm over Narragansett Bay 328, *329*
Head of a Hostage (Jean Fautrier) *435*
Head of Flora (Louis-Marin Bonnet) *261*
Healing of the Cripple and Raising of Tabitha (Masolino da Pannicale) 152
Heartfield, John (Helmut Herzfelde) 412, 415, 442
 Don't Worry! He's a Vegetarian 415, *435*
Hecate depicted
 Gigantomachy frieze, Great Altar of Pergamum 19
Heckel, Erich 310
Heda, Willem Claesz 239
 Banquet Piece with Mince Pie 244
Hedvig Eleonora bedroom, Drottningholm Palace *276*
Hegel, Georg Wilhelm Friedrich 306, 398

Introductory Lectures on Aesthetics 400–1
Lectures on the Philosophy of Fine Art 397
Hegeso, daughter of Proxenos gravestone 20
Heine, Heinrich 401
Heintz, Joseph 183
Helios depicted 33
 as Christ 70
Hellenistic art 32, 61
 Classical ideals 62, 64
 dispersal after Alexander 25
 patronage 14
 sculpture 15, 18
Heller, Jacob
 patron of Dürer 170
Hemmel, Peter, workshop of 111
 Volckamer window *115*
Henneman, Nicolaas 367
Henri II, king of France
 tomb by Germain Pilon *195*
Henry VII, king of England
 tomb by Pietro Torrigiani 148, *149*
Henry, Charles
 The Chromatic Circle 403
Henry Stewart, Lord Darnley, and his brother Charles Stewart, Earl of Lennox (Hans Eworth) 248, *248*
Hera sanctuary at Samos 24
Heracles depicted 26, 27, 29, 32, 37
Hercules and Cacus (Baccio Bandinelli) 188, *190*
Hercules and Omphale (Bartolomeus Spranger) *187*
Hercules fountains—see *Fountain of Hercules*
Hermannsdenkmal (*Arminius*) (Ernst von Bandel) 343, *344*
Hermes depicted 29, 33
Hermitage Museum, Saint Petersburg 405
The Hermits (Egon Schiele) 336, *337*
Heron, Patrick 516
Herrera, Francisco de, the Younger 233
Herrera, Juan de 183
Herzfelde, Helmut—see Heartfield, John
Hesse, Eva 443
Highcross Street, Leicester, glass *114*
The High Priest Corésus Sacrifices himself to Save Callirhoé (Jean-Honoré Fragonard) 312, *312*
High Renaissance 6, 154
Hildebrand, Adolf
 The Problem of Form in the Fine Arts 398
Hill, David Octavius 367, 371
 Alexander Rutherford, William Ramsay, and John Listen 371
Hilliard, Nicholas 246, 248
 Art of Limning 246
 Young Man among Roses 248
Hirst, Damien 445, 496, 505
 The Physical Impossibility of Death in the Mind of Someone Living 505
history of art—see art history
Hoch, Hannah 442
Hockney, David 445
 A Bigger Splash 439
Hodler, Ferdinand 310
 Night 10, 334, *335*
Hofer, Candida 455
Hofmeister, Theodor and Oskar
 Abend (*The Haymaker*) *378*
Hogarth, William 247, 252–3, 255, 258–9, 288, 358
 Analysis of Beauty 281, *288*
 Marriage à la Mode 258, 259
 The Rake's Progress 252
 The Tête à Tête 259
Holbein, Hans, the Younger 246
 Jean de Dinteville and Georges de Selve (The Ambassadors) 248, *248*
Holl, Steven 523
Holly, Michael Ann 513
holographic art 444
Holy Roman emperors 5, 6
Holy Trinity, Tattershall, Lincolnshire stained glass 111
Holzer, Jenny 445

Private Property Created Crime 451
'spectacolor' 450
Homage to Galileo Galilei (Dani Karavan) *450*
Homage to New York (Jean Tinguely) *448*
Homer 32, 36
Homer, Winslow 311, 358, 364
 The Army of the Potomac—A Sharp-Shooter on Picket Duty 364
 The New Book 326, *327*
homoerotic Greek art 12, 15
Hon (*She*) (Niki de Saint-Phalle) *429*
Honthorst, Gerard 238, 239
Hooch, Pieter de 239
Hopfer, Daniel 172
 Two Cupids with Sudarium *173*
Hopfers of Augsburg, armourers 170
Hopper, Edward 418, 432
 Room in New York 418, *432*
The Horse Fair (Rosa Bonheur) *325*
Hosea, prophet, in stained glass
 Augsburg Cathedral 108, *112*
Hosmer, Harriet 340, 354
 Senator Thomas Hart Benson 354
Houasse, Michel-Ange 233
Houdon, Jean-Antoine 340
 Benjamin Franklin 356, *356*
Hours, Books of 79, *88*, *89*, 111
Housebook, Master of—see Master of the Housebook
House of the Abduction of Helen, Pella
 stag hunt mosaic 30
House of the Faun, Pompeii
 Alexander Mosaic 54
House of the Vetti, Pompeii
 Ixion Room *57*
Howard, Thomas, Earl of Arundel 246, 250, *250*
Howson, Peter 496
The Huastec Civilization (Diego Rivera) *474*, 476
Hudson River School 311
Huelsenbeck, Richard 442
Hugo of Bury Saint Edmunds
 ars sacra 93
Hullmandel, Charles 359
Hungary, royal crown of 99
Hunt, William Holman 308
Husain, M. F. 478, 481
 Under the Tree *479*, 481
Hütte, Axel 455
Huy, Rainer of
 Liège font *94*
Huygens, Constantijn 239
Huysmans, Joris-Karl 403

I
Icarus (Henri Matisse) *411*, 417, *435*
iconoclasm 3, 5, 70
 Byzantine 76, 100
 Western medieval 79
ideal beauty 183
idealism 343
 in Greek and Roman art 60–2
 in early Christian and Byzantine art 71
Ignaz Gunther, Ignaz
 altarpiece at Rott am Inn *281*
il Bamboccio—see van Laer, Pieter
illuminated manuscripts 76–91
illusionism
 in Greek pictorial art 61
 in interiors 266
il Morazzone
 Ecce Homo chapel *196*
il Riccio (Andrea Briosco) 163, 169
 bronze satyr *168*
Immaculate Conception (Alonso Cano) 234
I Modi (Marcantonio Raimondi) 171
imperialism and museums 405
Impressionism 5, 302, 304, 308–9, 330–1, 359, 402–3
In a Café (*The Absinthe Drinker*) (Edgar Degas) 330, *331*
The Inauguration of the Trevi Fountain (Giovanni Paulo Panini) *287*
In the maze, there is a single line to my soul (LeRoy Clarke) *483*
individuality 3

industrialization 380–1
l'informel—see Art Informel
Ingres, Jean-Auguste-
Dominique
Apotheosis of Homer 306, *318*
Mme Inès Moitessier Seated 324
Innocent X, pope
portrayed by Francis Bacon 417, *436*
The Inside of Westminster Abbey (Thomas
Bowles) 286
installation art 443, 445, 450, 504–5
Intaglio Printing (Abraham Bosse) *261*
intarsia 163, *169*
Interior (The Rape) (Edgar Degas) 327
interiors 7, 262–79
International Modernism—*see* Modernism
The International Style exhibition, Museum
of Modern Art, New York 522
Irwin 497, 508
Capital 509
Isabella of Aragon
bust by Francesco Laurana *150*
Isenheim Altarpiece (Matthias Grünewald)
154
The Island of the Dead (Arnold Böcklin)
334
I Sow to the Four Winds (Hélène Tramus)
445
Isozaki, Arata 519
Italian Trans-avant-garde 517
Itiba Cahubaba (Old Mother Blood)
(amategram by Ana Mendieta) *477*
ivory carving 73, 92–4, 162
Ixion Room, House of the Vettii, Pompeii
57
Ixmiquilpan parish church
wall paintings 294, *297*
Ixtlilxóchitl codex 294, *296*

J
jagged style (*Jackenstil*) 124
Jal, Auguste
*Critical Conversations on the Salon of
1824* 401
James I, king of England 238
James, C. L. R. 482
Jamnitzer, Wenzel
silver table ornament *181*
Japanese Imperial Art Academy 478
Japanese textiles 386
Jarrow early stained glass 108
Javacheff (Christo)
Umbrellas 444
'wrapped islands' 444
*Jean de Dinteville and Georges de Selve (The
Ambassadors)* (Hans Holbein the
Younger) 248, *248*
Jegher, Christoffel 255
Jencks, Charles 497
Jerome, S.
drypoint by Albrecht Dürer *172*
woodcut by Ugo da Carpi *173*
Jeronimus Tonneman and his Son (Cornelis
Troost) *285*
Jesse Trees
Lambeth Bible 86, *87*
windows 109, *120*
John Bacon and his Family (Arthur Devis)
270
John Chrysostomos, S. 83
John VI Kantakouzenos, emperor 82, *82*
John the Baptist, S.
in altarpiece by El Greco,
S. Domingo el Antiguo,
Toledo *231*
sculpted by Lorenzo Ghiberti
144
window by Engrain Le Prince
114
John the Evangelist, S.,
by Dürer *160*
by El Greco *231*
Johns, Jasper 419, 432, 442
White Flag 419, *433*
Johnson, Tim 491
Jonah, prophet, in stained glass
Augsburg Cathedral 108, *112*
Jones, Calvert Richard 367
*Salt Flats, Saint Paul's Bay,
Malta 370*
Jones, Inigo 246
Jones, John
Miss Frances Kemble 260

Jones, Owen
Grammar of Ornament 388
watercolour illustration *389*
Jongheling, Jacques 189
Jordaens, Jacob 238, 239
Jorn, Asger 419
Joseph's Brothers with Benjamin before Jacob
(Vienna Genesis) 77
Judgement of Paris, Kul Oba Barrow,
Crimea 28
Judgement of Paris (Marcantonio Raimondi)
174, *308*
Judgement of Paris (Raphael) 174, 308
Judith I (Gustav Klimt) *335*
Judith and Holofernes (Donatello) 190
Judith and the Head of Holofernes
(Artemisia Gentileschi) 218
Julesz, B. 444
Julii mausoleum
Christ-Helos mosaic *70*
The Jungle (Wifredo Lam) *486*
Junius, Hadrianus 183
Jupiter and Io (Antonio Allegri Correggio)
220
Jupiter and Juno on Mount Ida (James
Barry) 316, *317*
Justinian mosaic, S. Vitale,
Ravenna *74*
Justinianic Renaissance 76
*Just What Is It That Makes Today's Homes
So Different, So Appealing?* (Richard
Hamilton) 419, *440*

K
Kahlo, Frida 475, 476
The Broken Column 476
Kahn, Gustave 309, 334, 403
Kahnweiler, Daniel-Henry 515
Kalighat paintings 480
Kalvar, Richard 468
New York 468
Kandinsky, Wassily 310, 414, 438
On the Spiritual in Art 311
Swinging 438
Kant, Immanuel 517
The Critique of Judgement
397, 400, 515
The Critique of Pure Reason 305
Kapoor, Anish 478, 481
*To Reflect an Intimate Part of the
Red 481*
Kaprow, Alan 443
Karavan, Dani 444
Homage to Galileo Galilei 450
Karlštejn Castle
Holy Cross Chapel 125, *129*
Kawagushi, Yoshiro 444
Kazanluk tomb painting 35
Kells, Book of 84, *85*
Kelly, Mike 445
Kemp, Martin 513
Kensett, John Frederick 311
Kent, William 265
Kertész, André 452, 454, 462
Acrobat, Paris 463
Kiefer, Anselm 495
To the Unknown Painter 500
Kinetic art 442, 444, 448
Kipling, Rudyard
on Greek influences in Persian
art 33
Kirchner, Ernst Ludwig 310, 364
*Women on Potsdamer Platz,
Berlin* 365
Kitchen Interior (Martin Drolling) 326, *326*
Klein, Yves 426
Anthropométries 426, 427,
443, *443*
Kleinmeisters of Nuremberg 254, 258
Kleist, Heinrich von 401
Klimt, Gustav 310
Judith I 335
Klingender, Francis 512
*Art and the Industrial
Revolution* 512
Klíč, Karel 452
Klosterneuburg pulpit (Nicholas of
Verdun) 124
Klucis, Gustav 472
*Under the Banner of Lenin for
Socialist Construction 472*

Kneller, Godfrey 247
Knidos, Aphrodite of
Praxiteles 15
Roman copies 15, 20, *20*
Knight, Death and Devil (Albrecht Dürer)
171, 176, *177*
Knole House 264
Knowland, Kenneth 494
Knowlton, K. C. 444
Købke, Christian
*View of Lake Sortedam (near
Dosseringen) 321*
Kodak cameras 369, 378
Kolamar and Melamid—*see* Melamid and
Kolamar
Kolb, Anton, of Nuremberg 170
Kollwitz, Käthe 358–9, 365
*Woman with Dead Child
364*, 365
Konaté, Abdoulaye 488
Death, Birth and Culture 489
Koons, Jeff 496
Rabbit 504, 505, 524–5
korai (female Greek memorial statues) 14,
15, 20, *20*
Kosice, Gyula 443
Kosuth, Joseph 443
Koudelka, Josef 468
*A Float for the Las Fallas Festival
in Valencia 468*
Kounellis, Jannis 517
kouroi (male Greek memorial statues) 14,
15, 16, *16*
Kramer, Hilton 497
Krauss, Rosalind 497
*The Originality of the Avant-Garde and
Other Modern Myths* 513
Krautheimer, Richard 512
Krebs, Rockne
Aleph 2 444
Kresilas of Kydonia
Pericles 22, *23*
Kristeva, Julia 517
Kroisos memorial statue *16*
Kröller-Müller Museum, Otterlo 518, 520,
520
Kruger, Barbara 496, 502
untitled installation *503*
Kugler, Franz
Handbook of Art History 398
Kunsthalle, Bielefeld 518
Kunsthalle, Darmstadt 518
Kunsthaus, Zürich 518
Kunstwollen 510
Kuspit, Donald 514, 517

L
Laboratoire Agit Art, Senegal 485
Lacan, Jacques 494, 517
Lady and Unicorn tapestries 165
La Font de Saint-Yenne, Étienne 219
La Grenouillière (Claude Monet) *330*
Lam, Wifredo 475, 484
The Jungle 486
L'Amour de l'Art magazine 514
Lambeaux, Jef
Brabo Fountain 342, *347*
Lambert, George W. 491
Lambeth Bible 86, *87*
Lampadii ivory diptych 44, *45*
Lancely, Colin 491
Land Art 444–5, 448
Landon, Charles Paul 400
Landscape with a Cannon (etching by
Albrecht Dürer) 174, *175*
Landscape with a Double Pine (Albrecht
Altdorfer) 256
Lane, Fitz Hugh 311
Lange, Dorothea 454
Lanier, Jaron
Data Glove and Eyephones 444
Lanzi, Luigi
*Story of the Pictorial Art of
Italy* 397
La Padula, Ernesto Bruno 67
Laposky, Ben F
Electronic Abstractions 444
La Révolution Surréaliste magazine 415
L'Artiste periodical 402
Lartner, Richard 491

Las Meninas (Diego Velázquez) *179*
lasers in art 444, 450
Last Judgement in stained glass 110
The Last of England (Ford Maddox Brown)
308, *323*
Last Supper (Leonardo da Vinci) 159, *159*
Last Supper mosaic, S Apollinare Nuovo,
Ravenna 74
Late Antique period in Roman art 63,
70–91
Latham, Peter 445
Latham, William 444, 445
CR3Z72 445
La Tour, Georges de
The Fortune Teller 218
Penitent Magdalene 218
La Trinité, Vendôme
Virgin and Child in stained
glass 109
Laurana, Francesco 145, 151
Castelnuovo triumphal arch,
Naples 145, *151*
Isabella of Aragon bust *150*
Lavender Mist (Number 1, 1950) (Jackson
Pollock) 418, 426, *427*
Lavoro, Palazzo del 67
Lawler, Louise 519
Lawrence, S.
arm reliquary *142*
Lazzerini marble merchants 341
leads for glazing 121, *121*
Leah (Michelangelo) 188
Le Brun, Charles 199, 218, 293
Salon de la Guerre,
Versailles 267
Le Corbusier (Charles-Édouard Jeanneret)
383, 394, 413, 430
Still Life with a Pile of Plates
413, *422*
Le Déjeuner sur l'herbe (Édouard Manet)
308
Lee, Russell 454
Leeward of the Island (Automatisme 1.47)
(Paul-Émile Borduas) *493*
Léger, Fernand 412, 474
*Three Women (Le Grand
Déjeuner)* 413, *428*
Legible City (Jeffrey Shaw) 444
Le Grand Déjeuner (Three Women)
(Fernand Léger) 413, *428*
Le Gray, Gustave 366–7,
372, 373
Marine, le Vapeur 372, 372–3
Lehmbruck, Wilhelm
Fallen Man 412, 428, *429*
Leibl, Wilhelm 308
Three Women in Church
308, *323*
Leica cameras 452
Leighton, Frederic 310, 335
Flaming June 310, 335, *335*
Leinberger, Hans
Tödlein 195
Lely, Peter 247, 295
Sleeping Nymphs by a Fountain
250, *251*
Le Nain brothers 218, 225
Family of Peasants 225
Lenin in Smolny (Isaak Brodsky) *473*
Lenin on art 470
L'Enseigne de Gersaint (Jean-Antoine
Watteau) 288, *289*
Leo X, pope, Room of, Palazzo Vecchio,
Florence
pavement *270*
Leo XII, pope
visiting Thorvaldsen's studio *349*
Léon Cathedral
tomb of Bishop Martin II
Rodriguez 101, *102*
Leonardo da Vinci 154, 155, 182
Adoration of the Magi 154
Battle of Anghiari 154
Last Supper 159, *159*
Mona Lisa 154
Leoni, Leone and Pompeo 189
funerary statues of Philip II and
his family *194*
Leopold Wilhelm, Archduke
picture gallery 221
Lepautre, Jean
The Grotto of Thetis, Versailles
282

Le Parc, Julio
 labyrinths 444
Le Prince, Engrain
 S. John the Baptist window 114
Leroy, Louis 402
Les Demoiselles d'Avignon (Pablo Picasso) 311, *336*
Lessing, Erich
 Uprising in Budapest 458
Lessing, Gotthold Ephraim 292
L'Étoile du Nord (A. M. Cassandre) 430, *431*
lettering, illuminated 90–1, *90–1*
lettrisme 444
Levy, Léon 368
L.H.O.O.Q (Marcel Duchamp) 412, *413*, 421
Liberty Leading the People (Eugène Delacroix) 303, 401
Lichtenstein, Roy 419
 Drowning Girl 419, 440, *441*
Liébana, Beatus of—*see* Beatus
Liège font (Rainier of Huy) 94
Life magazine 454
Light-Display Machine (*Light-Space Modulator*) (László Moholy-Nagy) 446, *447*
L'Impressionniste journal 403
Lindisfarne Gospels 78, 90, *90*
l'informel—see Art Informel
The Lion of Lucerne (Lukas Ahorn) 343, *344*
Lippard, Lucy 517
Lippi, Filippino 263
Lippi, Fra Filippo 152
Lipps, Theodor 398, 510
Lissitzky, Eleazar
 PROUN multimedia displays 442
lithography 358, 360, 360–1
Little Dancer Aged Fourteen (Edgar Degas) 343
 study for *353*
Little Hours of Anne de Bretagne 111
Livia, Villa of, Primaporta
 garden paintings 53, 55, *55*
Llanos, Fernando de 230
Llanrhaeadr stained glass *120*
Loggia di Psiche, Villa Farnesina, Rome (Raphael) *184*, 196
Loggie of Raphael, Vatican Palace *266*
Lomazzo, Giovanni Paolo 246, 396
Lombard, Lambert 183
Lombardo, Tullio
 tomb of Doge Andrea Vendramin, SS Giovanni e Paolo, Venice 145, *150*
Longhi, Pietro 219
 Masked Figure with a Fruit Seller 229
Loos, Adolf 394
 'Ornament and Crime' 383
Lorenzetti, Ambrogio
 Allegory of Good and Bad Government 125, *128*
Lorraine, Claude 225
 Cephalus and Procris Reunited by Diana 224, *224*
Lorsch stained glass 108
The Lost Son in Poverty (Pieter Cornelisz?) *117*
lost-wax casting 151
Louis XIV 213, 218, 264, 265, 280
 bust by Gianlorenzo Bernini 211, *212*
 Louis XIV (Hyacinth Rigaud) 218, *225*
Louis XV sculpted by Jean-Baptist Pigalle 281, *287*
Louisiana Museum of Art, Humlebaek, Denmark 518
Louvre Museum 219, 404–6, *406*, 408, *408*
 industrial exhibition 392
Lubin, S., in stained glass
 Chartres Cathedral 110, 119, *119*
Luc, Père 298
 France Bringing the Faith to the Indians of New France (Père Luc) 298
Lucian (Greek art critic) 63
Lucky Strike (Stuart Davis) 440
Ludovisi battle sarcophagus 41, *51*

Luke the Evangelist portrayed in Gospels of S. Augustine 84
Lumière, Auguste and Louis 369
lumino-kinetic art 442, 448
Lunch Break in the Donbas (Aleksandr Deineka) 472
Luther, Martin 5–6
 on printing 171
Lyman, John 490
Lyons, Nathan
 Toward a Social Landscape 467
Lyotard, Jean-François 497, 517
Lysippos of Sikyon 15
Lysippus 62

M
Mabuse—*see* Gossaert, Jan
Maccabees, church of, Lyon
 early stained glass 108
macchiaioli (spot-makers) 403
Machiavelli, Niccolo
 The Prince 180
Macedonian Renaissance 76
Mach, David 496
 Polaris 504, 505
Mack, Heinz 444
Madame Cézanne in a Red Armchair (Paul Cézanne) 324, 325
Madame du Barry 284
Mme Inès Moitessier Seated (Ingres) 324
Mademoiselle Léonie Seated on a Chaise Lounge (Pablo Picasso) 365
Madonna and Child (Andrea Mantegna) *176*
Madonna and Scenes from the New Testament, S. Maria Maggiore, Alatri 130, *131*
Madonna with Saints (Vigoroso da Siena) 131
Madrid (Henri Cartier-Bresson) 462
Maella, Mariano Salvador 233
Maesta (Duccio) 134–5, *134–5*
Magdeburg stained glass 108
Maggiore Fountain, Perugia 144
Magi shrine (Nicholas of Verdun) 96, *96*
Magnum Photos 453, 468
Magritte, René 415, 424
 The Menaced Assassin 415, 424, *425*
Maholy-Nagy, László 442, 453
Maiano workshop, Florence
 studilio 168
Maignan, Albert
 Carpeaux 354
mail-art 445
maiolica (Renaissance pottery painting) 163, 169, *278*
Maitani, Lorenzo, and workshop
 Genesis pilaster, Orvieto Cathedral *146*
Male, Émile 512
Malevich, Kasimir 414, 438, 509
 Black Square 414, *438*
Mallarmé, Stéphane 514
 'The Impressionists and Édouard Manet' 402
Mamesfeld, Henry de—*see* de Mamesfeld, Henry
Manao-Tupapau—The Spirit of the Dead Watches (Paul Gaugin) 333
Manesse Codex 88, *88*
Manet, Édouard 308–9, 358–9, 402
 Le Déjeuner sur l'herbe 308
 Olympia 308, 324, 402
Manetti, Antonio
 Life of Brunelleschi 155
Manley, Edna 484
 Tomorrow 486, *487*
Mann, Felix 452
Mannerism 189, 192–3, 216–17, 230, 238, 396
Man of Sorrows (Adriaen de Vries) 214
Man Pointing (Alberto Giacometti) 436
Mansart, François 264, 267
 Salon de la Guerre, Versailles *267*
Mantegna, Andrea 170, 254
 Madonna and Child 176
 Saint Sebastian 176
manufactures royales 264, 381, 382
manuscript illuminations 76–91
Manzoni, Piero 442, 444

Maratta, Carlo 292
Marc, Franz 310, 412
Marcantonio (Marcantonio Raimondi) 171, 174, 254, 258
 I Modi 171
 Judgment of Paris 174
 The Massacre of the Innocents 258
Marcello (Adele d'Affry, Duchess Castiglione-Colonna) 340
Marcillat, Guillaume de
 stained glass 111
Marco del Buono 163
Marey, Étienne Jules 369
Mariano, Angelo di Cosimo di—*see* Bronzino, Agnolo
Marilyn Monroe Diptych (Andy Warhol) 419, 440, *441*
Marine, le Vapeur (Gustave Le Gray) 372, 372–3
Marinetti, Filippo Tommaso 311, 415
Mark, S., depicted
 Four Apostles (Albrecht Dürer) 160
 S. Mark's Corpse Dragged through the Streets of Alexandria (Jacopo Sansovino) 193
Marot, Daniel 264, 276
 design for room decorated with porcelain 279
 design for state bedroom 276
Marriage à la Mode (William Hogarth) 258, 259
The Marriage Contract (Jean-Baptiste Greuze) 219, 227
Mars depicted
 Mars (Diego Velázquez) 236
 Ostia altar 47
Martelli, Diego 403
 The Impressionists and Modern Art 403
Martens, Hans Ditlev Christian
 Pope Leo XII Visiting Thorvaldsen's Studio on S. Luke's Day 349
Martin, Kenneth 442
Martin II Rodriguez, Bishop
 tomb of *102*
Martini, Simone 132
 Virgin and Child altarpiece, S. Catherine, Pisa 132, *136*
Marxism 8
Mary, Countess Howe (Thomas Gainsborough) 253
Mary of Burgundy
 Book of Hours 88, *89*
Masaccio (Tommaso Guidi) 152, 526
 Tribute Money 152, 158, *159*
 The Trinity 158, *158*
Masked Figure with a Fruit Seller (Pietro Longhi) 229
Masolino da Pannicale 152
 Healing of the Cripple and Raising of Tabitha 152
Massacre at Chios (Eugène Delacroix) 401
The Massacre of the Innocents (Marcantonio Raimondi) 258
Massacre of the Innocents pulpit, S. Andrea, Pistoia (Giovanni Pisano) 148
The Mass of S. Giles (Master of S. Giles) 69, 140–1
Mass of S. Gregory 142
Masson, André 415
Master of S. Giles
 The Mass of S. Giles 69, 140–1
Master of the Housebook
 Coat of Arms with a Peasant Standing on his Head 172
Master Robert
 stained glass 111
Masters 7
Master Theodoric 71, 129
 Holy Cross Chapel paintings, Karlštejn Castle 125, 129
Matthew, S., sculpted by Lorenzo Ghiberti 146, *147*
Matisse, Henri 6, 310, 416–17, 435–6
 The Happiness of Life 366, *336*
 Icarus 411, 417, 435
 Jazz 416
 Vence chapel decorations 417, *437*

Mauclair, Camille 515
Mausolus, king of Caria
 sculpted *37*
 tomb 14, 33
Maximian, Bishop
 throne of *94*
Mayas 294
Mazo, Juan Bautista del 233
Mazzola, Francesco—*see* Parmigianino
Mazzoni, Guido 145
 Pietà 148, *149*
Mbari Mbayo Club 484
mechanization
 impact on arts and crafts 380–2
 textile and paper printing 390
Media depicted on Roman sarcophagus 51
media experimentation 8–9, 442–51
Medici family 145, 163, 188, 217
Medici, Catherine de'
 tomb by Germain Pilon 195
Medici, Cosimo I de' 190, 217, 220, 290
 equestrian monument by Giambologna 188, 190, *191*
Medici, Lorenzo de' 167
 birth tray *167*
 tomb by Michelangelo *150*
Meier-Graefe, Julius 515
Melamid and Kolamar 496
 The Origin of Socialist Realism 508, 509
Mena, Luis de
 caste painting 300
The Menaced Assassin (René Magritte) 415, 424, 425
Menander sculpted 61
Mendieta, Ana 475, 477
 Old Mother Blood (*Itiba Cahubaba*) 477
Mengs, Anton Raphael 292
Las Meninas (Diego Velázquez) 179
Menologion of Basil II 82, *83*
The Men's Bath (woodcut by Albrecht Dürer) 177
Menzel, Adolf von, 308
 Studio Wall 330, 331
Merkurov, Sergei 472
 Monument to Comrade Stalin 471
Merisi, Michelangelo—*see* Caravaggio
Merton College, Oxford
 stained glass 110, *118*, 119
Meryon, Charles 359
Merz, Mario 517
Merzbau (Kurt Schwitters) 442
Metamorphosis of Narcissus (Salvador Dali) 424, *425*
Metrodorus 52
Metropolitan Museum of Art, New York 405, 407
Metzinger, Jean and Albert Gleizes
 On Cubism 403
mezzotint 260, *260*
Michaux, Henri 516
Michelangelo (Michelangelo Buonarotti) 6, 154–5, 183, 188
 Battle of Cascina 154
 ceiling design 268
 David 144, 146–7, *190*
 Leah 188
 Lorenzo de' Medici's tomb *150*
 Pietà 188
 Rachel 188
 Sistine Chapel ceiling *ii*, 154, 196, 524
 Slaves 188, *192*
 Times of Day 193
 Victories 188
Mikon 25
Millais, John Everett 308
Mille, Pierre 514
Miller, Wayne 465
 The Cotton Picker 465
Millet, Jean-François 308, 359
 The Gleaners 308, *322*
Milne, David 490
minimalism 444, 448, 517
 and artistic 'progress' 4
Mirabeau Answering Dreux-Brézé (Aimé-Jules Dalou) 352
Miracles of S. Mark (Jacopo Sansovino) 188
Miró, Joan 416, 426
 The Birth of the World 426

Miss Frances Kemble (John Jones) 260
missorium of Theodosius I 71, *73*
Mistry, Dhruva 478
Mitamura, Shinsike 444
Mithras depicted 33
mobiles 442, 448
Mochi, Francesco
 equestrian monument to
 Alessandro Farnese 210
Modena, Nicolas Bellin' da 263
Modena, Tommaso da 129
 Holy Cross Chapel paintings,
 Karlštejn Castle 125, *129*
Modena Cathedral frieze 106
Modern Movement 380, 386
 furniture style *387*
Modernism 6, 8, 364, 410, 494, 496
 photography 456, 464
Moholy-Nagy, László
 Light-Space Modulator 446, *447*
Moissac Abbey
 Christ of the Apocalypse portal
 104
 monumental sculpture 100
Moliones depicted *26*
Molnar, Vera 444
Mona Lisa (Leonardo da Vinci) 154
Mondrian, Piet 414, 430, 438
 Composition No. III 438
 *Composition No. 10, Pier and
 Ocean* 339
Monet, Claude 309, 330, 334, 338
 The Four Trees 334
 La Grenouillère 330
Monkwearmouth early stained glass 108
Monreale Cathedral, Sicily
 Christ Pantocrator 65
Montefeltro, Duke Frederico da
 studiolo of 169, *169*
Montorsoli, Agnolo 290
Monument to Comrade Stalin (Sergei
 Merkurov) *471*
Monument to Louis XV, Reims (Charles
 Nicolas Cochin) *287*
Moore, Albert 310
Moore, Henry 428
 Reclining Figure 428, *429*
Mor, Antonis 230, 246
Mora, José de
 The Virgin of Sorrows 211, *214*
Moran, Thomas 311, 358
Moréas, Jean 403
Moreau, Adolphe Jean-Marie
 —*see* Cassandre, A. M.
Moreau, Gustave 309
Morelli, Giovanni 398
Morgan Beatus *86*
Morisot, Berthe 309, 403
Morley, Malcolm 495
 *Pacific Telephone—Los Angeles
 Yellow Pages 498*
Morris, William 382, 390, 402
Moses and the Burning Bush (Gerlachus
 window) *118*
Mosselman, Alfred 343
The Mossy Tree (Hercules Pietersz Seghers)
 256
Mother and Child (Nandalal Bose) *480*
Mother and Child (Pablo Picasso) 414, *420*
Mother India (Bharat Mata) (Abanindranath
 Tagore) 478
Moulin-Rouge: La Goulue (Henri de
 Toulouse-Lautrec) *361*
Mukhtar, Mahmud 482
Müller, J. S.
 *Triumphal Arches, Mr Handel's
 Statue &c. in the South Walk,
 Vauxhall Gardens 286*
Mullican, Matt
 City Project 445
multimedia 444–5
mummy portraits in Roman Egypt 53, *58*,
 62
Munari, Bruno 442
Munch, Edvard 310, 359, 364
Münter, Gabriele 310
Murillo, Bartolomé Esteban
 232, 233
 *S. Thomas of Villanueva Giving
 Alms* 234, *235*
Musaeum Tradescantium 246
Musée d'Ethnographie du Trocadéro, Paris
 342

Musée d'Histoire Naturelle, Paris 342
Musée Fernand Léger, Biot 518
Musée Maison de la Culture, Le Havre 518
Museum Fridericianum, Kassel 518
Museum of Contemporary Art, Barcelona
 519
Museum of Contemporary Art, Helsinki
 523
Museum of Fine Arts, Houston 518
Museum of Manufactures, London 383
Museum of Modern Art, New York 518,
 522
Museum of Modern Art, Frankfurt 519,
 520, *521*
Museum of Modern Art of the City of Paris
 518
museums and galleries 8, 302, 392, 404–9,
 518–23
 Classical ideals 66–7
Muybridge, Edward 369
Myron of Athens 60, 62
Mysteries Room, Villa of the Mysteries,
 Pompeii 53, *56*
Mytens, Daniel 250
 *Thomas Howard, Earl of
 Arundel 250*

N
Nadar (Gaspard Félix Tournachon) 368,
 376
 portrait of Théophile
 Gautier *376*
Nake, Fieder 444
Nanteuil, Robert 255
Napoleon in the Plague House at Jaffa
 (Antoine-Jean Gros) 306, *314*, 315
NarKomPros (Soviet Ministry for Popular
 Enlightenment) 470
Nash, Paul 412, 434
 We are Making a New World
 412, *434*
National Academy of Design, New York
 311
National Gallery, London 405, 406
 Barry Rooms *407*
National Gallery of Art, Washington DC
 357, 519
National Gallery of Canada 492
National Gallery of Zimbabwe 484
National Romantic style in furniture 386
naturalism
 and artistic 'progress' 3
 in Baroque art 222–3
 in Christian art 71, 73
 in Greek art 33
 in Renaissance art 139
 in Spanish religious painting
 234
 in writing and criticism 403
Naumann, Bruce 443
Naumberg Cathedral
 Ekkehard and Uta 101, 106, *107*
Navarrete, Juan Fernández de (El Mudo)
 230
Nave Nave Fenua (*Delightful Land*) (Paul
 Gaugin) *364*
Nazarene Brotherhood 318
Nebot, Balthasar
 The Wilderness at Hartwell 285
Ned Kelly (Sidney Nolan) *291*
Nees, George 444
Nègre, Charles 367
Negreti, Jacopo (Palma Vecchio) 216, 221
Nelson's Column, London 343
Neo-Classical style 8, 66–7, 229, 304–5,
 312, 380, 384
Neo-Expressionism 517
Neo-Gothic furniture 384–5, *385*
Neo-Impressionism 304
Neptune and Amphitrite (Jan Gossaert)
 186, *187*
Neptune fountains
 Bartolommeo Ammannati *190*
 Giambologna 188
Nereid Eulimene story cloth *30*
Nereid Monument 32, *36*
Neue Slowenische Kunst 497
Neue Staatsgalerie, Stuttgart 519
Neumann, Balthasar 280
Neuwiller-lès-Saverne
 S. Timothy in stained glass 109
The New American Painting exhibition 418
The New Book (Winslow Homer) *326*, 327

New College, Oxford
 stained glass 123, *123*
New National Gallery, Berlin
 522, 523
A New Spirit in Painting
 exhibition 496
New Topographics exhibition 455
New York (Richard Kalvar) *468*
New York with Moon (Georgia O'Keeffe)
 432
Newman, Barnett 417, 507
Newton, Sir Isaac 242
Nicephoros Botaneiates, emperor *83*
Nicholas of Verdun
 Klosterneuburg pulpit 124
 Shrine of the Three Magi 96, *97*
Niebuhr, Barthold Georg, sculpted by
 Christian Daniel Rauch *356*
Niépce, Nicéphore 366
Night (Hans Sebald Beham) *258*
Night (Ferdinand Hodler) 334, *335*
The Night Watch (Rembrandt) 239
Nijmegan, Arnold of
 stained glass 111
Niobid Painter
 attributed painting on clay *29*
Nitsch, Hermann 443, 445
Nochlin, Linda 513
 'Why Are There No Great
 Women Artists?' 513
Nocturne in Black and Gold (Whistler)
 401–2
Nolan, Sidney 291, 292–3
 Ned Kelly 291
Nolde, Emil 310
Noll, A. Michael 444
Nollekens, Joseph 340
Northern Baroque 189
Nossa Senhora da Conceição 298
Not in this Case Either (*Tampoco*)
 (Francisco de Goya) *363*
Not You as Well Snowy (Stephen
 Campbell) *508*
Nour, Amir 488
 Grazing at Shendi 482, 488
Nouveau Réalisme 442
Novalis (Friedrich von Hardenberg) 305
nudes 15–16, 177, 233, 258, 428–9
Number 1, 1950 (*Lavender Mist*) (Jackson
 Pollock) 418, 426, *427*
Nusberg, Lev 444
Nymph of Fontainebleau (Benvenuto
 Cellini) 189

O
The Oath of the Horatii (Jacques-Louis
 David) 304, 312–13,
 313, 400
Obeah in Afro-Caribbean art 483, 486
Ochre on Red on Red (Mark Rothko) *432*
Odysseus depicted 32, 55
Odyssey Landscapes 53, 55
 *Odysseus at the Entrance to the
 Underworld 55*
Oiticica, Hélio
 Parangolés 475
O'Keeffe, Georgia 417, 432
 New York with Moon 432
The Old Church in Amsterdam (Emanuel de
 Witte) *240*
The Old Man and Death (Wright of Derby)
 316
Old Mother Blood (*Itiba Cahubaba*) (Ana
 Mendieta) *477*
Oldenburg, Claes 443
Olsen, John 492
Olitski, Jules 494
Oliver, Isaac 246
Olympia (Édouard Manet) 308, *324*, 402
Olympic victor bronze (follower of
 Lysippos) *17*
Onabolu, Aina 485
Op Art 444
Oppenheim, Meret
 Luncheon in Fur 415
opus francigenum 124
opus tessellatum 59
opus vermiculatum 25, 56, 59
Orange Eater II (Georg Baselitz) *501*
Oratio frieze, Arch of
 Constantine *72*
The Origin of Socialist Realism (Melamid
 and Kolamar) *508*, 509

originality 3
Orlan 445
Ormesby Psalter 90, *91*
Orozco, José Clemente 474
Or San Michele, guild church of 144, 146,
 152
 S. George (Donatello) *147*
 S. Matthew (Lorenzo
 Ghiberti) *147*
Orvieto Cathedral 144, 146
 Genesis pilaster *146*
Oshogbo 484
OSt (Society of Easel Painters) 470
Ostade, Adriaen 327
Osterley Park 267
 Etruscan Room *265*
 Tapestry Room *274*
O'Sullivan, Timothy 369
Otto III, emperor
 gospel book of 78, *88*
Oulton, Thérèse 496, 507
 Counterfoil 507
Over the Gulf (Edward Poitras) *493*
Ozenfant, Amédée 413, 430

P
Pabst, Theo 518
Pacheco, Francisco 232, 233
 Arte de la pintura 232
Pacher, Michel
 Coronation of the Virgin
 altarpiece, S. Wolfgang,
 Salzburg *141*
*Pacific Telephone—Los Angeles Yellow
 Pages* (Malcolm Morley) *498*
Paciotto, Francesco 183
Pacuvius 52
Padmore, George 482
Paik, Nam June 444, 450
 Video Fish 450
Painters Eleven 490
The Painter's Studio (Pierre Subleyras) 288,
 288
Pal, Gogi Saroj
 Swayambram 481
Palaiologan Renaissance 76, 125
Palaiologina Gospels 80
 decorated Canon Tables *81*
Palazzo della Civiltà Italiana (Palazzo del
 Lavoro) *67*
Palazzo del Te, Mantua 263
 Sala di Psiche *185*
Palazzo Grimani
 stuccoed interiors 263
Palazzo Vecchio, Florence 217
 pavement in Room of Leo X *270*
Palladio, Andrea 264
Palomino, Antonio 233
pan-Africanism 484
pan-Asianism 478
Pan depicted with Aphrodite and Eros *21*
panelling 272–3
Panini, Giovanni Paolo 219
 *The Inauguration of the Trevi
 Fountain 287*
 Interior of S. Peter's, Rome 228
Pannicale, Masolino da—*see* Masolino
Panofsky, Erwin 511
 *Early Netherlandish
 Painting* 511
 Meaning in the Visual Arts 511
 *Perspective as Symbolic
 Form* 511
 Studies in Iconology 511
panoramic photography 369
Pantomation 444
Papanya Tula art movement 491
Paris grec 83
Paris Gregory 82
 Vision of Ezechiel 82
Paris Psalter
 David and Melody *80*
Paris, Rainy Weather (Gustave Caillebotte)
 331
Parker, Cornelia 496, 505
 *Cold, Dark Matter—An
 Exploded View 505*, 525
Parmigianino (Francesco Mazzola) 216,
 254
 Amor 216
 The Entombment 256, *257*
Parthenon 14–15, 18
 Elgin Marbles 6, *11*, *13*, 342, 542

560

Passerotti, Bartolomeo 217
Passion of Christ (Jacopo Sansovino) 188
pastel manner (crayon manner) 260, *260*
Pater, Walter 402
Patinir, Joachim 242
patronage 5, 7–8, 12–14, 24–5, 32, 38–9, 50, 54–5, 71, 79, 88, 93, 98–9, 110, 118–19, 125, 144, 132, 152, 170, 183, 216–17, 222, 247, 265, 282, 293, 384, 518
Pau-Brazil Manifesto 474
Paul, Bruno
 Typenmöbel 387, 394
Paul, S., depicted
 The Beheading of Saint Paul (Alessandro Algardi) 210, 214, *215*
 Conversion of S. Paul (Caravaggio) 197, *202*
 Four Apostles (Albrecht Dürer) *160*
Paulhan, Jean 516
Paulus, Silentarius, on early stained glass 108
Pausanias
 on Greek art 12, 25, 63
 on status of artists 12
pax with Virgin and Child *143*
Peachman, Henry
 Art of Drawing 246
 Compleat Gentleman 246
 Gentleman's Exercise 246
Peake, Robert 246
Peasant Dance (Pieter Bruegel the Elder) *182*
Pechstein, Max 310
peintres-graveurs 358
Penitent Magdalene (Georges de La Tour) 218
People of Our Time survey (August Sander) 460
Perceval, John 491
Peress, Gilles
 Teheran street scene *469*
 Telex Persan 469
Perestroika (Eric Bulatov) 508, *509*
Performance Art 8, 443, 445, 448
Pergamum, Great Altar of
 Gigantomachy frieze *19*
Pericles sculpted by Kresilas of Kydonia 22, *23*
 temple-building programme 14
peripheries 9
Permoser, Balthasar 280
 sculpture for the Zwinger 282, *282*
Perrault, Charles 293
Persephone abducted by Hades *31*
Persepolis frieze *34*
Perseus and Medusa (Benvenuto Cellini) 188, 189, 190, *191*
perspective 158–9, *159*, 526
 in Greek painting 61
Pescia panel (Bonaventura Berlinghieri) 132
Petel, Georg 211
 Salt-cellar with *Triumph of the Sea-born Venus* 213
Peter, S., depicted
 Crucifixion of S. Peter (Caravaggio) *197*
 Four Apostles (Albrecht Dürer) *160*
 S. Peter Nolasco's Vision of the Crucified S. Peter (Fransisco Zurbarán) 232, 234, *234*
 S. Peter Repentant (Agostino da Piedade) 294, *298*
Peters, Dewitt 484
Petrarch (Francesco Petrarca) 155, 163
Pfister, Hans 518
Pfister, Kurt 518
Pforr, Franz
 Entry of Emperor Rudolf into Basel in 1273 318
Phiale Painter
 attributed Attic calyx-crater *29*
Phidias 15, 62
 Athena Parthenos 14
 Centaur and Lapith, Parthenon *13*
 Zeus 12
Philadelphia School of Design for Women *393*

Philip, king of Macedon
 patronage 25
 Vergina Tomb II 25, *30*, 53
Philip II, king of Spain 5, 216, 230
 funerary statues (Leone and Pompeo Leoni) *194*
Philip IV, king of Spain 232, 233
 Philip IV in Brown and Silver (Diego Velázquez) *236*
Philipon, Charles 358
Philoxenos of Eretria 52
The Photographer's Eye exhibition 467
photography 8, 366–79, 452–68
Phototek 452
physical contexts 9
The Physical Impossibility of Death in the Mind of Someone Living (Damien Hirst) *505*
Piazza Armerina, Sicily
 hunt mosaic 53, *59*
Piazza della Signoria, Florence 188, 190–1, *190–1*
Piazza di Monte Cavallo (Alexander Ellis) *370*
Piazzetta, Giovanni Battista 219
Picabia, Francis 442
 Girl Born Without a Mother 412–13
Picasso, Pablo 3, 6, 8, 311, 336, 338, 359, 365, 413, 444
 Les Demoiselles d'Avignon 311, *336*
 The Frugal Repast 365
 Guernica 8, 415–16, *416*, 435
 Mademoiselle Léonie Seated on a Chaise Longue 365
 Mother and Child 414, *420*
Pictor, Fabius 52
The Picture Gallery of Archduke Leopold Wilhelm of Austria (David Teniers the Younger) *221*
Picture Post magazine 454
Piedade, Agostinho da
 S. Peter Repentant 294, *298*
Piene, Otto 444
Pièta (Guido Mazzoni) 148, *149*
Pietà (Michelangelo) 188
Pièta with *Arma Christi* *143*
Pigalle, Jean-Baptist
 statue of Louis XV at Reims 281, *286*
Piles, Roger de 293
Pilgrimage on the Isle of Cythera (Jean-Antoine Watteau) 226, *226*, 259
Pilon, Germain 189
 tomb of Henri II and Catherine de' Medici *195*
Pincus-Witten, Robert 517
Piranesi, Giovanni Battista 229, 255
 The Drawbridge 257
 Prisons (*Carceri*) 255, 257
Pisano, Giovanni 144, 148
 Massacre of the Innocents pulpit, S Andrea, Pistoia 145, *148*
Pisano, Nicola 156
Pisano, Tommaso 136
 Virgin and Child, Angels, Saints and Christological Cycle, S. Francesco, Pisa 131, *136*
Pissarro, Camille 309, 330, 359
 The Côte des Boeufs at l'Hermitage, near Pontoise 330
Pistoletto, Michelangelo 517
Pitti Palace, Florence 206
 Sala di Venere ceiling (Pietro da Cortona) *199*, 199
The Place des Victoires, Paris (Thomas Rowlandson) *287*
Plasticiens 490
Plastov, Arkadi 472
 Collective Farm Festival 473
Plato on art 61, 63
Platonic tradition in Christian art 70
Pliny 396
 on art 12, 52, 62
 on artists 12, 396
Plotinus on art 63
Plutarch on the status of sculptors 12
Podro, Michael
 The Critical Historians of Art 513

Poelenburgh, Cornelis 238, 239
pointillism 332
Poiret, Paul 514
Poitiers Crucifixion window 109
Poitras, Edward 490, 493
 Untitled (Over the Gulf) 493
Polaris (David Mach) 504, 505
Pollaiuolo, Antonio del 170, 176
 Battle of the Nudes 176
Pollock, Charles 368
Pollock, Griselda 513
 Vision and Difference: Femininity, Feminism, and Histories of Art 513
Pollock, Jackson 417, 426, 432
 Number 1, 1950 (*Lavender Mist*) 418, 426, *427*
Polyclitus of Argos 14, 15, 60, 62
 Doryphoros (Spearbearer) 15, 16, *17*, 40
Polygnotos 25, 52
Pompidou National Art and Culture Centre, Paris 518, *521*
The Pond (Jules Dupré) *320*, 321
Pontormo, Jacopo (Jacopo Carucci) 217
Pop Art 8, 410, 419, 444, 450, 494–5, 498, 517
Pope Leo XII Visiting Thorvaldsen's Studio on S. Luke's Day (Hans Ditlev Christian Martens) *349*
Popova, Lyubov 414
 Spatial Force Construction 414, 422–3, *423*
Popplemann, Daniel 280
Popper, Karl 512
porcelain 265, 278
Porcuna warrior figure *36*
Porte du College Saint Grigoin (Charles Clifford) *373*
Portrait of a Man (Young Englishman) (Titian) 217
Portrait of a Woman (Raja Ravi Varma) *480*
The Portuguese (Georges Braque) *338*
Post-Impressionism 310, 334, 359, 491, 516
Postmodernism 494–9, 517
 photography 468–9
Poststructuralism 4, 494
Potosí Mountain, Virgin of 295, *299*
Postumus, Agrippa,Villa of
 landscapes 53, *57*
Poussin, Nicolas 7, 218, 224, 255, 293
 Death of Germanicus 218, *224*
Pozzo, Andrea 200, 208
 Allegory of the Missionary Work of the Jesuits 201
 S. Ignatius in Glory 200
Pöppelmann, Matthaes Daniel
 the Zwinger 280, *282*
Praxiteles of Athens 3, 15, 62
 Aphrodite of Knidos, Roman copy 15, 20, *21*
Prendergast, Maurice 311
The Presidential Family (Fernando Botero) 475, *477*
Pre-Raphaelite Brotherhood 308, 322–3, 401
Preston, Margaret 491, 492
 Aboriginal Landscape 492
Prieur, Barthélémy 189
Primaticcio, Francesco 182, 263
printed patterns 388
printmaking 7, 170–7, 254–61, 358–65, 478
Prisons (*Carceri*) (Giovanni Battista Piranesi) 255, 257
Private Property Created Crime (Jenny Holzer) *451*
Procession to Calvary (Martin Schongauer) *174*
Procopius of Caesarea on early stained glass 108
'progress', artistic 3–4, 525–4
Progressive Artists' Group, Bombay 478
The Progress of Love: The Meeting (Jean-Honoré Fragonard) 284
Protestantism 7, 194, 254
PROUN multimedia displays (Eleazarm Lissitzky) 442
Prudde, John, King's Glazier 111
Prudentius on early stained glass 108
psalters 79

Psiche, Loggia di, Villa Farnesina, Rome (Raphael) *184*, 196
Psiche, Sala di, Palazzo del Te, Mantua (Giulo Romano) *185*
publics 8
Pucelle, Jean 111
Pugin, A. W .N. 381
Purgatory in stained glass 110
Purification (Giotto di Bondone) 125
purpura 93
Purrmann, Hans 518
Pythagoras of Rhegion 60

Q

Queen Elizabeth I (the Ditchley Portrait) (Marcus Gheeraerts the Younger) 248, *249*

R

Rabbit (Jeff Koons) 504, 505, 524–5
Rachel (Michelangelo) 188
racial issues 9
Rae, Fiona 496
Raffaeli, Jean-François 352
 At the Foundry 353
The Raft of the Medusa (Théodore Géricault) 306, *315*, 317
Raftsmen Playing Cards (George Caleb Bingham) 328, *328*
Raimondi, Marcantonio—see Marcantonio
Rainer of Huy
 Liège Font *94*
The Raising of the Cross (Rubens) 238
The Rake's Progress (William Hogarth) 252
Ramsden, Mel 497
Ranc, Jean 233
The Rape (*Interior*) (Edgar Degas) 327
Rape of a Sabine (Giambologna) 190, *191*
Raphael (Rafaello Sanzio) 3, 6, 143, 154, 155, 170, 181,182, 184, 254, 263, 274
 Judgement of Paris 174, 308
 Loggia di Psiche, Villa Farnesina, Rome *184*, 196
 Loggie of Raphael, Vatican Palace *266*
 The School of Athens, Stanza della Segnatura *157*, 368
 Stanza della Segnatura, Vatican Palace 154, 156,*157*, 368
Raphael, Max 512
 'Toward an Empirical Theory of Art' 512
 The Demands of Art 512
Raque, Georges 311
Rastafarianism in Afro-Caribbean art 486, *487*
Rauch, Christian Daniel 340
 portrait of Barthold Georg Niebuhr and his wife *356*
Rauschenberg, Robert 442–3
Ravenna mosaics 74
Ravenna stained glass 108
Ravi Varma Fine Art Lithographic Press 478
Ray, Man 442, 452, 453
 rayograph *457*
Raynal, Maurice 514
rayographs 452, *457*
Read, Herbert
 Art and Society 516
 Art Now 516
Real Academia di San Fernando 292
realism 5, 302, 304, 307, 322, 471
 in Greek and Roman art 15, 60–2
 in early Christian and Byzantine art 71
 in Soviet art 470–3
reception 9
Reclining Figure (Henry Moore) 428, *429*
Recueil Jullienne 255
Red and Blue Chair (Gerrit Rietveld) 414, *430*
red-figure in Greek pictorial arts 25
Red Polygons (*Red Flock*) (Alexander Calder) 490
A Regatta on the Grand Canal (Canaletto) *229*
reflections in Greek painting 61
Reformation 5, 139
Regina Five 490
Reichle, Hans 189
Rejlander, Oscar 368

The Two Ways of Life 368
reliquaries 96, 97, 98, 139, 142, *142*
Rembrandt (Rembrandt van Rijn) 7, 238, 255, 256, 362
 The Anatomy Lesson of Dr Nicolaes Tulp 243
 Christ Presented to the People 255
 The Goldweigher's Field 255
 The Night Watch 239
 Simeon in the Temple 240
 The Three Crosses 255
 The Three Trees 256
Renaissance 3, 6–7, 124, 152, 155, Classical ideals 65–6, 159
 historical origins 124
 space and perspective 158–9
Renoir, Pierre-Auguste 309, 330
reparations conference ministers (Erich Salomom) 459
Répertoire de l'Ornemantiste title page 388
reproductive prints 254, 255, 258
Restany, Pierre 442, 517
Revista de Avance review 474
Revolving Glass Plates (Marcel Duchamp) 446
La Révolution Surréaliste magazine 415
Reynolds, Sir Joshua 247, 255, 260, 282, 305
 Commodore Augustus Keppel 247, *253*
 Discourses on Art 306, 401
rhythmos in Greek sculpture 60–1
Riace Warrior A *16*, 22
Ribalta, Francisco 233
Ricci, Giovanni Battista 197
Ricci, Marco (Antonio)
 Capriccio of Roman Ruins 228
Ricci, Sebastiano 228
Richardson, Jonathan, the Elder 247
 Theory of Painting, Essay on the Art of Criticism, and Science of a Connoisseur 247
Richier, Germaine 417, 436
Richter, Gerhard 495, 500
 Venice (Stairs) (No. 586-3) *501*
Rickey, George 442
Riegl, Alois 510, 511
Rietveld, Gerrit 414
 Red and Blue Chair 414, *430*
Rigaud, Hyacinth 225
 Louis XIV 218, *225*
Riley, Bridge 444
Riley, John 247
Rinaldo and Armida (Jean-Honoré Fragonard) 219, *227*
Rinuccini Polyptych (Giovanni del Biondo) 136, *137*
Rivera, Diego 474–5
 The Huastec Civilization 474, *476*
Rivière, Georges 403
Rizi, Francisco 233
Robert, Master—see Master Robert
Robinson, Henry Peach 368
 Fading Away 368, 376
 photographic illustrations for *The Lady of Shalott* 368
 She Never Told her Love 376
Robusti, Jacopo—see Tintoretto
Rockox, Nicolaes 238
Rococo style 7, 178, 219, 396
Rodchenko, Alexander 414, 442, 454
Rodin, Auguste 66, 340, 348, 353, 355, 357
 aristotype by M. Bauche *355*
 The Burghers of Calais 342, *346*
 Rodin's Bust of Mrs Simpson (Jacques-Ernest Bulloz) *357*
Roemer, Georg
 reconstruction of Polyclitus' Doryphoros *17*
Roger II, king of Sicily
 coronation cope *98*
Roh, Frank 453
Rohan Hours *88*
Roma depicted
 Gemma Augustea *64*
Romanesque style 124, 126
 monumental sculpture 100–1, 103, 106
Romano, Giulio 181, 182, 183, 184, 263

Sala di Psiche, Palazzo del Te, Mantua *185*
Romano, Mario 67
Romanos Chalice *96*
Romanticism 5, 6, 7, 229, 304, 305, 401, 403
 Classical ideals 66–7
Rombouts, Theodoor 238
Rome: S. Peter's and the Vatican from the Janiculum (Richard Wilson) 252
Rood, Ogden
 Modern Chromatics 403
Room in New York (Edward Hopper) 418, 432
Room of Bacchus, Villa Barbaro, Maser (Paolo Veronese) 264, *266*
Rosa, Salvator 218, 254
Rose and Crown Club 247
Rosenberg, Harold 517
Rosselli, Alessandro 170
Rosselli, Cosimo 170
Rosselli, Francesco 170
 Assumption of the Virgin 170
Rossellino, Bernardo
 monument to Leonardo Bruni *351*
Rossetti, Dante Gabriel 308, 310
Rosskam, Edwin and Louise
 Amateur Radio Night, Powell, Wyoming 464, *465*
Rosso, Fiorentino 184, 189, 269
 Galerie François I, Fontainebleau *185*
Rothko, Mark 417, 432, 496, 507
 Ochre on Red on Red 432
Rothstein, Arthur 454
rotogravure 452–3
Rott am Inn high altar (Ignaz Günther) 286
Roubillac, Louis-François
 Vauxhall Gardens statue of Handel 280, *286*
Round Dance in the Antique Manner (anonymous engraving) *177*
roundel windows 114
Rousseau, Henri 337
 The Snake Charmer 337
Rousseau, Jean-Jacques 304
Rousseau, Théodore 307
Roussi, Gilles
 'The Great Technological Futility' 444
Rovere, Guidobaldo della, duke of Urbino 216
Rowlandson, Thomas 358
 The Place des Victoires, Paris 287
Royal Academy, London 247, *253*, 292, 348
Royal Academy of Fine Arts, San Fernando, Madrid 233
Royal Academy of Painting and Sculpture, Paris 218–19
Röntgen, Wilhel 369
Rubens, Peter Paul 7, 183, 211, 233, 238, 239, 241, 246–7, 255, 258
 Battle of Milvian Bridge (tapestry design) 274
 The Descent from the Cross 238, 241
 The Raising of the Cross 238
Rubens House
 leather hangings 275
Rucellai Madonna (Duccio) 130, *131*, 134
Rudolf II, emperor 215, 238
Rue Transnonain, le 15 avril 1834 (Honoré Daumier) 360
Rumohr, K. F. von
 Italian Investigations 398
Ruskin, John 382, 402
 Elements of Drawing 401
 Modern Painters 398, 401
Russian Constructivism 430, 446
Ruthwell Cross 100, *102*
Ruysch, Rachel 239

S

Sabas, monk 83
sacramentaries 90–1
Sacred and Profane Love (Titian) 216
The Sacred Forest (Édouard Duval-Carrié) 487
The Sacrifice of Isaac (Alonso Berruguete) *194*
Sacri Monti chapels 196, *196*

S. Andrea, Pistoia
 Massacre of the Innocents pulpit (Giovanni Pisano) 145,*148*
S. Andrea al Quirinale, Rome
 interior by Bernini 264
S. Anna dei Lombardi *Pièta* (Guido Mazzoni) 148, *149*
S. Anne, parish church of, Cuzco 294
S. Apollinare Nuovo, Ravenna 71
 Last Supper mosaic *74*
Saint-Aubin, Gabriel-Jacques de 219, 255
 The Salon of 1767 289
S. Catherine, Pisa
 Virgin and Child altarpiece (Simone Martini) 132, *136*
S. Clemente de Tahull fresco 127
S. Croce, Florence, Rinuccini Polyptych (Giovanni del Biondo) 136, *137*
Saint-Denis, abbey church of
 ninth-century altar frontal 69, 140–1
 stained glass 108–9
S. Domingo de Silos cloister *105*
S. Domingo el Antiguo, Toledo, altarpiece (El Greco) 230, *231*, 232
Sainte-Chapelle, Paris
 Crown of Thorns 139
 stained glass 109
Sainte-Chapelle, Riom, Switzerland
 stained glass 111
S. Étienne-du-Mont, Paris
 stained glass 111
S. Francesco, Assisi
 Life of S. Francis (Giotto di Bondone) 125
S. Francesco, Borgo Sansepolcro
 high altar by Sassetta 132
S. Francesco, Pisa
 altarpiece by Tommaso Pisano 131, *136*
S. Francis Gives his Cloak to a Poor Knight (Assisi, Upper Church) *128*
S. Francis Renounces the World (Königsfelden window) *114*
S. Gabriel's Chapel, Canterbury
 crypt capital *106*
Saint-Gall, Tuotilo of 93
S. George (Donatello) 144, 146, *147*
S. Giles, Master of—see Master of S. Giles
S. Godard, Rouen
 stained glass 111
S. Ignatius in Glory (Andrea Pozzo) 200
S. Jerome (Albrecht Dürer) *172*
S. Jerome (Ugo da Carpi) *173*
S. John Lateran
 cathedral facade 292
S. John the Baptist (Lorenzo Ghiberti) 144
S. Lorenz, Nuremberg
 Volckamer window 114, *115*
S. Lorenzo, Florence
 tomb of Lorenzo de' Medici (Michelangelo) *150*
S. Marco, Florence
 paintings by Fra Angelico 152
S. Mark's Corpse Dragged through the Streets of Alexandria (Jacopo Sansovino) *193*
S. Maria, Vallicella
 frescoes 200
 Vision of S. Philip Neri (Pietro da Cortona) *208*
S. Maria della Vittoria, Rome
 Cornaro Chapel *204*
S. Maria del Popolo, Rome
 Cerasi Chapel 197, 202–3, *202–3*
 Chigi Chapel 263
S. Maria Gloriosa degli Frari, Venice
 Assunta altarpiece (Titian) 216
S. Maria Maggiore, Alatri
 Madonna and Scenes from the New Testament 130, 131
S. Maria Novella, Florence
 Strozzi family chapel 263
S. Mary's, Fairford, Gloucestershire
 Virgin Mary in stained glass *120*
 head of Nero's victim in stained glass *123*
S. Mary's, Krakow
 Death of the Virgin altarpiece (Veit Stoss) 145, *148*
S. Mary's, Waterperry, Oxfordshire
 stained glass *122*

S. Matthew (Lorenzo Ghiberti) 146, *147*
S. Merry, Paris
 stained glass 111
S. Ouen, Rouen, Annunciation and Visitation window 112, *113*
Saint-Père-en-Vallée abbey church
 stained glass 110
S. Peter Nolasco's Vision of the Crucified S. Peter (Fransisco Zurbarán) 232, 234, *234*
S. Peter Repentant (Agostino da Piedade) 294, *298*
S. Peter's Rome
 interior (Giovanni Paolo Panini) *7*
 Rome: S. Peter's and the Vatican from the Janiculum (Richard Wilson) 252
Saint-Phalle, Niki de 442
 Hon (She) *429*
Saint-Rémi, church of, Rheims
 early stained glass 108
Saint-Savin-sur-Gartempe
 The Drunkenness of Noah *126*
S. Sebastian (Andrea Mantegna) *156*
S. Sebastian's Carriage (follower of Diego Tito) 294
SS Giovanni e Paolo, Venice
 tomb of Doge Andrea Vendramin (Tullio Lombardo) 145, *150*
SS Peter and Paul, abbey of, Wissemburg
 stained glass 108, 122, 122–3
Saint-Simon, Claude-Henri, comte de 402
S. Thomas of Villanueva Giving Alms (Bartolomé Esteban Murillo) 234, *235*
Saint-Urbain, church of, Troyes
 stained glass 110
S. Vitale, Ravenna 71, 74
 early stained glass 108
 sanctuary interior *75*
S. Wolfgang, Salzburg
 Coronation of the Virgin altarpiece (Michel Pacher) *141*
Sala dei Cento Giorni, Cancelleria Palace, Rome (Vasari and workshop) *266*
Sala di Porcellana, Aranjuez, Spain *278*
Sala di Psiche, Palazzo del Te, Mantua *185*
Sala di Venere ceiling, Pitti Palace, Florence (Pietro da Cortona) 199, *199*
Salisbury Cathedral
 stained glass 109, 110, *113*
Salle des États, Louvre Museum 406, *406*
Salle, David 495
Salmon, André
 The Cubist Painters 403
Salomon, Erich 452, 458
 German and French ministers photographed *458*
Salon de la Guerre, Versailles 267
Salon exhibitions 289, 293, 340, 348, *348*, 396, 402
The Salon of 1767 (Gabriel-Jacques de Saint-Aubin) 289
Salt, John 495
Salt Flats, Saint Paul's Bay, Malta (Calvert Richard Jones) 370
Salviati, Francesco 182
Salzmann, Auguste
 Jerusalem 367
Samson Slaying the Philistines (Giambologna) 188
Sander, August
 Circus People in Front of Tent 461
 People of Our Time survey 460
Sansovino, Jacopo 182, 188
 Four Evangelists 188
 Miracles of S. Mark 188
 Passion of Christ 188
 S. Mark's Corpse Dragged through the Streets of Alexandria 193
 Virtues of Venice 188
Sanssouci Castle—see Schloss Sanssouci
Santa Cruz College, Mexico City 296
Santeria in Afro-Caribbean art 486
Sanzio, Rafaello—see Raphael
Sappho Painter
 attributed Athenian funerary plaque 27
sarcophagi 41, 50

Junius Bassus 72
Ludovisi 51
Media and Creusa 51
Sarfati, Lise 469
Backstage at the Maiakowski
Theatre, Moscow 469
Sarto, Andrea del 182
Sartre, Jean-Paul 417, 436, 516
Sassetta (Stefano da Cortona) 132
Savery, Roelant 243
A Bouquet of Flowers 242
Savino, Guido di 278
Saxl, Fritz 511
scabello stools 166, 167
Scala d'Oro vault, Doge's Palace, Venice
268
Scanning Robot/Involuntary Arm (Stelarc)
451
Scenes from Genesis (Wiligelmo) 106
Schapiro, Meyer 512, 516
Scheggia, lo (Ser Giovanni, Giovanni di)
birth tray of Lorenzo de' Medici
167
Schick, Gottlieb 313
Wilhelmine von Cotta 312
Schiele, Egon 310
The Hermits 336, 337
Schiller, Friederich
Letters on the Aesthetic
Education of Mankind 397
Schinkel, K. F.
Altes Museum 518
Schlegel, Friedrich von 305, 401
Schloss Brühl, Augsburg
staircase with illusionistic ceiling
269
Schloss Sanssouci, Potsdam
Library 272
Schloss Weissenstein, Pommersfelden
Mirror Room 271
Schlosser, Julian von 510
Schmidt-Rottluff, Karl 310
Schnaase, Karl
Netherlandish Letters 397
Schnabel, Julian 495, 502
The Student of Prague 502
Schongauer, Martin 170
Procession to Calvary 174
Schöffer, Nicholas
lumino-dynamic spectacles 443
The School of Athens, Stanza della
Segnatura (Raphael) 157, 368
Schülze, Alfred Otto Wolfgang
(Wols) 418
Schwartzkogler, Rudolf 445
Schwarzach stained glass 108
Schwitters, Kurt 442
Merzbau 442
science and art 242–3
Scott, Samuel 253
Scrots, Guillim 246
The Sculptor in his Studio (Abraham Bosse)
212
The Sea of Steps (Frederick H. Evans) 378
Sebastian, S., depicted
S. Sebastian (Andrea Mantegna)
156
S. Sebastian's Carriage (follower
of Diego Tito) 294
Second World War 416, 435–6, 516
Seghers, Hercules Pietersz 255, 256
The Mossy Tree 256
Self-Portrait (Thomas Smith) 295
Self-Portrait (F. N. Souza) 478
Self-Portrait (Allessandro
Vittoria) 192
Semper, Gottfried 383
Style in the Technical and
Tectonic Arts 398
Senator Thomas Hart Benson (Harriet
Hosmer) 354
Senefelder, Alois 358
Ser Giovanni, Giovanni di (lo Scheggia)
birth tray of Lorenzo de' Medici 167
Serlio, Sebastiano 171, 263, 269
Seroux, B. L. G. 397
Histoire de l'art par les
monuments 397
Serrano, Andres 445
Séry-les-Mézières abbey site
early stained glass 108
Seurat, Georges 309, 310
A Sunday Afternoon on the

Island of the Grand Jatte
309, 332
Severed Limbs (Théodore Géricault)
317
Severini, Gino 420
Two Punchinellos 420, 421
Sewell, Brian 497
Shahn, Ben 454
sharecropper's daughter: Hale County,
Alabama (Walker Evans) 461
Shaw, Jeffrey
Legible City 444
She (Hon) (Niki de Saint-Phalle) 429
Sheeler, Charles 418
Classic Landscape 423, 423
Sheer Cliffs (Carleton E. Watkins) 377
Shells (Edward Weston) 457
She Never Told her Love (Henry Peach
Robinson) 376
Shepherd and Washerwoman (Pieter van
Laer) 222, 223
Sher-Gil, Amrita 478
Sherman, Cindy 496
Shrine of the Three Magi
(Nicholas of Verdun) 96, 97
The Sick Rose (William Blake) 362
Siena, Vigoroso da
Madonna with Saints 131
Signac, Paul
From Eugène Delacroix to Neo-
Impressionism 403
signatures on Greek pictorial arts 24
silversmithing 390
Simeon in the Temple (Rembrandt) 240
Siphnian Treasury
Gigantomachy frieze 18
Siqueiros, David Alfaro 474
Sistine Chapel ceiling (Michelangelo) ii,
154, 196, 524
situationism 444
Skopas of Paros 15
Slaves (Michelangelo) 188, 192
Slave Ship (J. M. W. Turner) 319
Sleeping Nymphs by a Fountain (Peter Lely)
250, 251
Sleeping Venus in a Landscape (Giorgione)
216
Smart, Jeffrey 491
Smith, Bernard 491
Smith, Grace Crossington 491
Smith, Joseph 228–9
Smith, Thomas
self-portrait 295
The Snake Charmer (Henri Rousseau) 337
Snow Storm: Hannibal and His Army
Crossing the Alps (J. M. W. Turner) 315
Snyders, Frans 238
'Soc. Art' 496
Socialist Realism 496, 515
Société des Aquafortistes (Society of
Etchers) 359
Society of Antiquaries (eighteenth-century
London) 247
Society of Artists (eighteenth-century
London) 247
Society of Dilettanti (eighteenth-century
London) 247
Il Sodoma (Giovanni Antonio Bazzi)
The Wedding of Alexander and
Roxanne 65
Socrates 5
Soffici, Ardengo
Cubism and Beyond 403
Solomon R. Guggenheim Museum, New
York 518, 519, 522, 522, 523
The Song of Love (Giorgio de Chirico) 424
Sophilos 25, 31
mosaic floor 30
Sorgheloos in Poverty (glass roundel) 117
Sosos of Pergamum 53
Souza, Francis Newton 478, 480–1
Black Nude 480
Self-Portrait 478
Soviet Realism 470–3
Spatial Decoration (Lucio Fontana) 448,
449
Spatial Force Construction (Lyubov Popova)
414, 422–3, 423
Spearbearer (Doryphoros) (Polyclitus) 15,
16, 17, 40
Spencer, Robert C.
plans for Grand Staircase, Art
Institute of Chicago 408

Spowers, Ethel 491
Spranger, Bartolomeus 183, 238
Hercules and Omphale 187
Stabiae street musicians 56
stained glass 7, 108–23
Stanza della Segnatura, Vatican Palace
(Raphael) 154, 156,
157, 368
Stanze restorations 292
Starry Night (Vincent Van Gogh) 333
Statue of Liberty (Frédéric-Auguste
Bartholdi) 343
under construction 353
status of artists—see artist's status
Stedelijk Museum, Amsterdam 518
The Steerage (Alfred Stieglitz) 379
Steichen, Edward 454
The Family of Man 465
Stein, Gertrude 403
Stein, Joël 444
Steinert, Otto 454
Stelarc (Stelios Arcadion) 445
Scanning Robot/Involuntary
Arm 451
Stella, Joseph 311
Stendhal (Henri Beyle) 401
Stepanova, Varvara 414
Stephanus, Eddius, on early stained glass
108
Sterback, Jana 490
stereographs 368
Sterling, Joseph
Teenagers 467
Stern, Gerd 444
Stieglitz, Alfred 311, 369, 417
Camera Work 379
The Steerage 379
Still Life with a Pile of Plates (Le Corbusier)
413, 422
Still Life with Game Fowl, Fruit, and
Vegetables (Juan Sánchez Cotán) 236
Still Life with Plaster Cupid (Paul Cézanne)
332, 333
Stone, Edward 518
Stone, Henry 247
The Stonebreakers (Gustave Courbet) 307
Stormy Weather, Georgian Bay (Frederick
Varley) 492
Stoss, Veit
Death of the Virgin altarpiece,
S. Mary's, Krakow 145, 148
Stradanus or Stradano (Jan van der Straet)
183
Strand, Paul
Susan Thompson, Cape Split,
Maine 461
Strasbourg Cathedral
Death of the Virgin tympanum 106
monumental sculpture 101
Streeton, Arthur 491
Strong, Augustus 283
Strozzi Altarpiece (Adoration of the Magi)
(Gentile da Fabriano) 152, 158, 158
Strozzi chest 166
Strozzi family chapel, S. Maria Novella,
Florence 263
Stryker, Roy 454
Stubbs, George 253, 358
studiolos 169
Duke Frederico da
Montefeltro's 169
Studio Wall (Adolf von Menzel) 330, 331
Study after a Portrait of Pope Innocent X by
Velázquez (Francis Bacon) 417, 436
'Subjective photography' 454
Subleyras, Pierre 281
The Painter's Studio 288
Sudanese in Algerian Dress (Charles-Henri-
Joseph Cordier) 356
Sudek, Josef 456
Alleyway, Prague 456
Suger, Abbot, on stained glass at Saint-
Denis 108–9
A Sunday Afternoon on the Island of the
Grand Jatte (Georges Seurat) 309, 332
Super Realism 495
Suprematism 470
Surrealism 6, 415, 424, 444, 490, 494
Susanna Crystal 94
Susan Thompson, Cape Split, Maine (Paul
Strand) 461
Sustris, Friedrich 183
Sustris, Lambert 183

Swayambram (Gogi Saroj Pal) 481
Swinging (Wassily Kandinsky) 438
Sydow, Ekhart von 515
Symbolism 304, 309–10, 335, 339, 355,
359, 364, 403
symmetria in Greek sculpture 60–1
synchronomies 491
Szarkowski, John 467
The Photographer's Eye 455

T
Tabernacle art 92
Taft, Loredo 409
Tagore, Abanindranath 478, 480
Bharat Mata (Mother India) 478
Tagore, Rabindranath
Vase 480
Taine, Hippolyte
Philosophy of Art 398, 402
Tairraz and Co. of Chamonix,
photographers 375
Takis (Panyiotis Vassilakis) 444
Tall, Papa Ibra 485
Tampoco (Not in this Case Either)
(Francisco de Goya) 363
tapestry 162, 274
Tapié, Michel 516
Tàpies, Antoni 443
Tapis Rouge department store, Paris 393
Tardieu, Nicolas-Henri
Embarkation for Cythera 259
Taslitzky, Boris 419
Tate Gallery, Liverpool 519
Tate Gallery, London 518, 519, 520
Modern Foreign Galleries 520
Tatlin, Vladimir
Monument to the Third
International 442
Taurin, S.
reliquary shrine 142
'taxonomic' ordering of art 526
Taylor, Baron Isidore
Voyages Pittoresques 358
Taylor, Frederick Winslow 380
tazza da impagliata (ceramic birth service)
163
techne (Greek craft) 12, 32, 63
techniques 9
bronze casting 13, 151, 163,
352, 353
early photography 366–71
fresco 129
printmaking 172, 255, 260,
260–1, 360, 360, 358
stained glass 120–3, 121
sculpture 352–3
technology and mechanization 381, 410,
442, 446, 450
Teenagers (Joseph Sterling) 467
Teheran street scene (Gilles Peress) 469
telematics (interactive global networking
art) 445
Telephos commemoration frieze 14
tempera 131
in Roman painting 58
Tempesta (Giorgione) 154, 161
Temple of Aphaia at Aegina
Trojan warrior 19
Teniers, David, the Younger 221
The Picture Gallery of
Archduke Leopold Wilhelm
of Austria 221
Tenshin, Okakura 478
Ter Brugghen, Hendrick 238
Teresa, S., sculpted
The Ecstacy of S. Teresa
(Gianlorenzo Bernini) 204
Terrace and Park at Fenwood House (Roger
Fenton) 368, 372, 373
The Tête à Tête (William Hogarth) 259
textiles
ars sacra 93
Greek pictorial arts 30
Middle Ages and Renaissance
162, 164
printing technology 381
Téynard, Felix
Égypte et Nubie 367
Tezozomoc, Don Fernando de Alvarado
296
Themis depicted 18
Theodolinda, Queen
treasures of 93

562

Theodore Psalter *80*

Theodoric, Master—*see* Master Theodoric

Theodosius I
missorium of 71, *73*

Théophile Gautier (Nadar) *376*

Theophilus
De diversis artibus 92–3, 155
on making stained glass
108–9, 121

Theotokopoulos, Domenikos
—*see* El Greco

Thetis depicted *32*

The Third of May, 1808 (Francisco de
Goya) 306, *314*

Thomas, apostle, in stained glass
Merton College Chapel, Oxford
118

Thomas à Becket, S.—see Becket, S.
Thomas

Thomas Glazier (Thomas of Oxford) 111
New College, Oxford, windows
123, *123*

Thomas Howard, Earl of Arundel (Daniel
Mytens) *250*

Thomas of Villanueva, S., depicted
S. Thomas of Villanueva Giving Alms
(Bartolomé Murillo)
234, *235*

Thonet, Gebrüder, furniture makers 394–5

Thoré, Théophile 343, 402

Thornhill, James 247, 251
George I and his Family 251

Thornton, John
stained glass 111

Thorvaldsen, Bertel 66, 340

The Three Crosses (Rembrandt) 255

Three Maries at the Sepulchre and *Ascension*
(early Christian ivory relief) 71, *72, 73*

The Three Trees (Rembrandt) *256*

Three Women (*Le Grand Déjeuner*)
(Fernand Léger) *428*

Three Women in Church (Wilhelm Leibl)
308, *323*

Thunderstorm over Narragansett Bay
(Martin Johnson Heade) *328, 329*

Thyssen Gallery, Lugano 519

Tibaldi, Pellegrino 230

Tiepolo, Giambattista 199, 219, 228, 233,
255, 280, 358
*The Four Continents with
Apollo 283*

Tiepolo, Giovanni Domenico 228, 255
tiles
Chertsey Abbey 116, *116*
Flemish 278, *278*

Tillers, Imants 491

Times of Day (Michelangelo) 193

Timothy, S., in stained glass at Neuwiller-
lès-Saverne 109

Tinguely, Jean 442
Homage to New York 448

Tintoretto (Jacopo Robusti) 161, 182

Titian (Tiziano Vecellio) 6, 154, 216, 221,
230, 233, 238, 254, 255
Assunta altarpiece 154, *161*
Danäe 220
Portrait of a Man (*Young
Englishman*) *217*
Sacred and Profane Love 216
Venus of Urbino 216

Tito, Diego Quispe 294, 299

Titus, Arch of *48*

The Toilet of Venus (François Boucher) *226*

Tödlein (Hans Leinberger) *195*

Toledo, Juan Bautista de 183

Tomorrow (Edna Manley) 486, *487*

Tonneman, Jeronimus 281, 284
Jeronimus Tonneman and his Son
(Cornelis Troost) *285*

Toorop, Jan
salad-oil poster 388

To Reflect an Intimate Part of the Red
(Anish Kapoor) *481*

Torres-García, Joaquín 474, 476
Composition 476

Torrigiani, Pietro
tomb of Henry VII and
Elizabeth of York,
Westminster Abbey 148, *149*

To the Unknown Painter (Anselm Kiefer)
500

Toulouse-Lautrec, Henri de 359, 360
Moulin-Rouge: La Goulue 361

Toupin, Fernand 490

Tournachon, Gaspard Félix—*see* Nadar

Tours Cathedral
stained glass 110

Towneley, Charles 289

Traditio Legis 71
sarcophagus of Junius Bassus
71, *72*

Tradescant, John 246

Traill, Jessie 491

Trajan
statue *42, 43*
column 41, *49*
frieze 41, *49*

Tramus, Hélène
I Sow to the Four Winds 445

Trans-avant-garde 517

Tree of Jesse—*see* Jesse Trees

Tree with Crows (Charles-François
Daubigny) 362, *363*

Tresham, Henry 354

Treppenhaus stairway and ceiling (Balthasar
Neumann and Giambattista Tiepolo) *282*

Trevi Fountain, Rome 281, *287*

Tribolo, Niccolò 192
Fountain of Hercules 192

Tribute Money (Masaccio) *159*

Trier frescoes 53, *58*

Trinity (El Greco) *231*

Trinity (Masaccio) 152, *158*

Trinity Apocalypse 88

Trinity Chapel, Canterbury, stained glass
109

*Triumphal Arches, Mr Handel's Statue &c. in
the South Walk, Vauxhall Gardens* (J. S.
Müller) *286*

Triumph of the Name of Jesus
(Baccacio) *208*

Triumph of the People of France (Jacques-
Louis David) *350*

Triumph of the Republic (Aimé-Jules Dalou)
350

Triumph of the Sea-born Venus (Georg
Petel) *213*

Trivulzio Candlestick *95*

Troost, Cornelis 181
Jeronimus Tonneman and his Son
285

Trzemeszno chalice 140, *140*

Tucker, Albert 491
Images of Modern Evil 491

Tunnoc, Richard, stained glass patron 110

Turin Prophet Book 80, *81*

Turner, Joseph Mallord William 307, 401
Liber Studiorum 358
Slave Ship 319
*Snow Storm: Hannibal and His
Army Crossing the Alps* 315

Tussaud, Marie 343

Twilight in the Wilderness (Edwin Church)
329

Two Cupids with Sudarium (Daniel Hopfer)
173

Two Punchinellos (Gino Severini) 420, *421*

The Two Ways of Life (Oscar Rejlander)
368

Tyler, Douglas 444

Typenmöbel (unit furniture) *387, 394*

Tzara, Tristan 442

U

Ücker, Günther 444

Udine, Giovanni da 263

Ugelheimer, Peter
Aristotle edition *79, 91*

Uhde, Wilhelm 515

Umbrellas (Christo) 444

un art autre 516

*Under the Banner of Lenin for Socialist
Construction* (Gustav Klucis) *472*

Under the Tree (M. F. Husain)
479, 481

Unfolding the Scroll of History
(El Anatsui) *488*

Uprising in Budapest (Erich Lessing) *458*

Upwey Landscape II (Fred Williams) *493*

Urbino, Nicola da
maiolica service for Isabella
d'Este 168

Usak tomb painting 35, *37*

USCO group 444

Ussolo, Luigi 442

Utrecht Psalter 78, *84*

V

Vachon, John 454, 465
*Gravedigger, Edmore, North
Carolina 464*

Vaga, Perino del 181

van den Wyngaerde, Anton 230

van der Geest, Cornelius 238

van der Heyden, Jan 245
*A View of the Herengracht in
Amsterdam 244*

van der Rohe, Ludwig Mies
518, 523
New National Gallery, Berlin
518, *522*, 523

van der Straet, Jan (Stradanus or Stradano)
183

van der Werff, Adriaen 239

van der Weyden, Rogier
Deposition of Christ 160

van de Velde, Henry 518

Van Doesburg, Theo 414

van Dyck, Anthony 233, 238, 239, 241,
244, 246–7, 250–1, 255
Charles I on Horseback
(*Equestrian Portrait of
Charles I*) 238, *250*

van Eyck, Jan 160
Betrothal of Arnolfini 158

Van Gogh, Vincent 310, 333
Starry Night 333

van Goyen, Jan 239

van Heemskerck, Maerten 183, 238, 254
*Venus and Cupid in the Smithy of
Vulcan 186, 186*

van Huysum, Jan 239

van Laer, Pieter (il Bamboccio)
Shepherd and Washerwoman
222, *223*

van Leyden, Lucas 170–1, 238, 254
Expulsion of Hagar 176

van Loo, Louis-Michel 233, 236
*Education of Cupid by Venus and
Mercury 233, 237*
The Family of Philip V 233

van Mander, Karel 183, 238, 239
The Book of Painting 181

van Miereveld, Michiel 239

van Ruisdael, Jacob
*View of Haarlem with Bleaching
Grounds 242, 243*

van Ruysdael, Salomon 239

van Rijn, Rembrandt—*see* Rembrandt

van Scorel, Jan 238

vanishing point *159*

Vanni, Andrea 129
Allegory of Good and Bad Government
125, *128*

Vanvitelli (Gaspar van Wittel) 219

Varallo, Tanzio da 196
Ecce Homo chapel *196*

Varchi, Benedetto 291

Varley, Frederick 490
Stormy Weather, Georgian Bay 492

Varma, Raja Ravi 478, 480
Portrait of a Woman 480

Vasari, Giorgio 70, 154, 171, 183, 290
Lives of the Artists
155, 181, 396
on windows of Arezzo
Cathedral 111
Sala dei Cento Giorni, Cancelleria
Palace, Rome 266

Vase (Rabindranath Tagore) *480*

vase painting 24, 25, 26, 32

Vassarely, Victor 444

Vassilakis, Panyiotis (Takis) 444

'Vassily' Chair (Marcel Breuer)
430

Vatican Palace 291
Loggie of Raphael 266
Stanza della Segnatura
154, 156,*157,* 368

Vatican Vergil *84*

Vauxcelles, Louis 402, 514

Vauxhall Gardens, London
Roubillac's statue of Handel
280, *286*

Vecchio, Palma (Jacopo Negreti) 216, 221

Vecchio, Veronese 221

Vecellio, Tiziano—*see* Titian

vedute 219, 228, 255

Vela, Vicenzo 340

Velázquez, Antonio González 233

Velázquez, Diego 7, 232, 233, 417
Las Meninas 179
Mars 236
Philip IV in Brown and Silver 236

Velázquezin, González 233

Vence chapel decorations (Henri Matisse)
417, *437*

Vendôme Column, Paris 343 344, *345*

Vendramin, Doge Andrea
tomb, SS Giovanni e Paolo,
Venice (Tullio Lombardo)
145, *150*

Venice (Stairs) (No. 586–3) (Gerhard
Richter) *501*

Venturi, Adolfo 512

Venus depicted
Birth of Venus (Botticelli) *157*
Esquiline Venus *40*
Ostia altar *47*
Sleeping Venus in a Landscape
(Giorgione) *216*
The Toilet of Venus (François
Boucher) *226*
*Venus and Cupid in the Smithy of
Vulcan* (Maerten van
Heemsckerck) *186, 186*
Venus of Urbino (Titian) 216
Venus Reclining in a Landscape
(Giulio Campagnola) *172*

Verdun, Nicholas of
Klosterneuburg pulpit 124
Shrine of the Three Magi 96, *97*

Verethragna depicted 33, *37*

Vergina Tomb I
Hades abducting
Persephone *31*

Vergina Tomb II 25, *30*, 53

Vermeer, Johannes 238, 239, 245
Young Woman with a Water Jug
245

Veroli Casket *166*

Veronese, Paolo (Paolo Caliari) 161, 216,
264
Room of Bacchus, Villa Barbaro,
Maser *266*

Verrio, Antonio 264

Verrocchio, Andrea del
Colleoni monument, Venice 145

Versailles Palace 199, 206, 212–13, 264–5,
280, 282
Grotto of Thetis 280
Salon de la Guerre *267*

Vertov, Dziga
Cine Eye 454

Vertue, George 247
Musaeum pictoris Anglicanum
247

Vetti, House of the, Pompeii
Ixion Room *57*

Viard, Jiorné
equestrian statue of Antoine,
duc de Lorraine 341, *351*

Victoria & Albert Museum 383, 405

Victoria Jubilee Monument, Calcutta 342,
345

Victorian furniture 385

Victories (Michelangelo) 188

video art 448

Video Fish (Nam June Paik) *450*

vidimus drawings 118, *118*

Vienna Genesis 77, 80

Vienna School 510

viewing 9

View of Haarlem with Bleaching Grounds
(Jacob van Ruisdael) 242–3, *243*

View of Lake Sortedam (near Dosseringen)
(Christian Købke) 321, *321*

View of the Farnese Gallery (Giovanni
Volpato) *197*

A View of the Herengracht in Amsterdam
(Jan van der Heyden) *244*

View of Venice (Jacopo de' Barbari) 170,
174, *175*

Vignier, Viscount Joseph
Album des Pyrénées 367

Vignola, Giacomo Barozzi da
Rule of the Five Orders 291

Villa Barbaro, Maser
Room of Bacchus (Paolo
Veronese) *266*

Villa Borghese, Rome 210

Villa Farnesina, Rome 196
Loggia di Psiche *184*

Villa of Agrippa Postumus, Boscotrecase
 landscapes 53, *57*
Villa of Livia, Primaporta
 garden paintings 53, 55, *55*
Villa of the Mysteries, Pompeii 53
 Mysteries Room *56*
Virgin Mary depicted
 Assumption of the Virgin
 (Annibale Carracci)
 197, 202, *203*
 Assumption of the Virgin
 (El Greco) 230, *231*, 232
 Assumption of the Virgin
 (Francesco Rosselli) 170
 Assunta altarpiece (Titian)
 154, *161*
 *Christ and the Virgin in the
 House at Nazareth* (Fransisco
 Zurbarán) 232, 234, *234*
 Death of the Virgin altarpiece,
 St Mary's, Krakow (Veit Stoss)
 145, *148*
 Immaculate Conception
 (Alonso Cano) *234*
 Karlštejn Castle
 Holy Cross Chapel 125, *129*
 Madonna and Child (Andrea
 Mantegna) *176*
 *Madonna and Scenes from the
 New Testament*, S. Maria
 Maggiore, Alatri *130*, 131
 Madonna with Saints (Vigoroso
 da Siena) 131
 Maestà (Duccio) 134–5
 pax with Virgin and Child *143*
 Rinuccini Polyptych (Giovanni
 del Biondo) *136*, *137*
 stained glass, S. Mary's, Fairford,
 Gloucestershire *120*
 stained glass, Trinity Chapel,
 Canterbury *109*
 *Virgin and Child, Angels, Saints
 and Christological Cycle*, S.
 Francesco, Pisa (Tommaso
 Pisano) 131, *136*
 The Virgin and Child Enthroned
 (Margarito of Arezzo)
 131, *132*
 Virgin and Child in stained
 glass, La Trinité, Vendôme *109*
 Virgin and Child roundel,
 Bishop's Palace Chapel,
 Chichester 124, *127*
 Virgin and Child with Saints
 (Simone Martini), S.
 Catherine, Pisa 132. *136*
 *The Virgin and Child with Ten
 Saints* (Andrea di Bonaiuto da
 Firenze) 132
 The Virgin of Sorrows (José de
 Mora) 211, *214*
 Virgin of the Candlestick, Cuzco
 School 295
 Virgin of the Potosí Mountain
 295, *299*
 Wilton Diptych *133*
virtual art 444
Virtues of Venice (Jacopo Sansovino) 188
Vischer bronzesmiths 195
Vischer, Robert 510
 Studies in Art History 398
Vision of Ezechiel (Paris
 Gregory) *82*
Vision of Heaven (Baccacio) 200
Vision of S. Philip Neri (Pietro da Cortona)
 208
visual truth
 Classical ideal 60–3
Vitruvius 53, 262

Vittoria, Alessandro 188, 193
 self-portrait *192*
Virtuosi of Saint Luke 247
Vliminck, Maurice 310
Volckamer window, S. Lorenz, Nuremberg
 114, *115*
Vohou-Vohou group, Ivory Coast 485
Volpato, Giovanni
 View of the Farnese Gallery *197*
Voodoo in Afro-Caribbean art 486
Vorsterman, Lucas 255
 The Descent from the Cross 258
Vouet, Simon 218, 298
VU magazine 454

W
Waagen, Gustav 398
Waddesdon Manor
 French tapestry armchair *277*
Wagner, Richard 309
Wakelin, Ronald 491
Walker, Robert 247
wall hangings 274–5
wallpaper 381
 printing roller *391*
Walpole, Horace 265, 382
Wanderer above the Mists (Caspar David
 Friedrich) *320*
War Artists Commission 412
Warburg, Aby 510–11
Warburg Institute 511
Warhol, Andy
 Marilyn Monroe Diptych 419,
 440, *441*
Washington, George, sculpted by Horatio
 Greenough 66, *67*
Washington Memorial 343
Watkins, Carleton E. 377
 Sheer Cliffs 377
Watteau, Jean-Antoine 219, 255, 258, 281
 L'Enseigne de Gersaint
 288, *289*
 Pilgrimage on the Isle of Cythera
 226, *226*, 259
Watts, George Frederic 310
Wayland the Smith 92
We are Making a New World (Paul Nash)
 412, *434*
wedding chests (cassoni) 162, *163*, 166
The Wedding of Alexander and Roxanne
 (Il Sodoma) *65*
Wedgwood
 Jasperware *384*
 Queensware *394*
Weissenstein Castle—*see* Schloss
 Weissenstein
Wenceslas, S., depicted
 Holy Cross Chapel, Karlštejn
 Castle *129*
Wenyon, Michael 444
Werkbund, Deutscher 383, 394
West, Benjamin 295, 301, 311
 The Death of General Wolfe 295, *301*
Western art 3–4
Westminster Abbey 281, 286
 Chertsey Abbey tiles *116*
 The Inside of Westminster Abbey
 (Thomas Bowles) *286*
 stained glass *109*, 111
 tomb of Henry VII and
 Elizabeth of York
 145, *148*, *149*
 Westminster Retable *126*
Weston, Edward 456
 Shells 457
Whistler, James Abbott McNeil 310, 359
 *Arrangement in Grey and
 Black: Portrait of the Artist's
 Mother* 310

Nocturne in Black and Gold
 401–2
White Flag (Jasper Johns) *433*
White, Clarence 369
Whitely, Brett 491
Whitney, Eli 380
Whitney Bieniall 496
The Whore of Babylon (Albrecht Dürer)
 173
Wieland, Joyce 490
Wieskirche 209
Wigston, Roger 114
Wilde, Oscar 514
The Wilderness at Hartwell (Balthasar
 Nebot) *285*
Wilhelmine von Cotta (Gottlieb Schick)
 312
Wiligelmo
 Scenes from Genesis, Modena
 Cathedral *106*
Wilkie, David 340
William III, king of England 264
William of York, S., in stained glass
 110
Williams, Fred 491
 Upwey Landscape II 493
Wilson, Richard 253
 *Rome: S. Peter's and the Vatican
 from the Janiculum 252*
Wilson, Robert 443
Wilton Diptych 132, *133*, 134
Winchester Old Minster
 early stained glass 108
Winckelmann, Johann Joachim 292, 304,
 396, 397, 401
 history of Greek art 12, 15, 66
 The History of Ancient Art
 396
Wind, Edgar 511
 Art and Anarchy 511
The Winslow Family (Joseph Blackburn)
 301
Winston, Charles
 watercolour of Salisbury stained
 glass *113*
Winter, Parsons & Hall, Sheffield
 candlesticks *391*
Wissembourg stained glass
 head of Christ 108, *122*, 122–3
Wissing, Willem 247
Wohert, Vilhelm 518
Wolcott, Marion Post 454
Wölfflin, Heinrich 510–11
 Classic Art 510
 Principles of Art History 510
 Renaissance and Baroque 510
Wols (Alfred Otto Wolfgang Schülze) 418
Wolsey, Cardinal Thomas
 in *vidimus* sketch *118*
Woman Bitten by a Snake (Jean-Baptiste
 Clesinger) 341, 342–3
Woman with Dead Child (Käthe Kollwitz)
 364, *365*
women
 artists 4, 325, 478, 513, 517
 decorative arts 382
 Philadelphia School of Design *393*
 portrayed in Greek sculpture 20
 portrayed Roman art 39, 62
 sculptors 340, 354
 see also feminism
Women on Potsdamer Platz, Berlin (Ernst
 Ludwig Kirchner) *365*
wood engravings 358, 364
woodcuts 170, 172, 365
Wordsworth, William 307
World Kineticist Movement 444
The World Promised to Juanito Laguna
 (Antonio Berní) *475*

World War I—*see* First World War
World War II—*see* Second World War
Worringer, Wilhelm
 Abstraction and Empathy 510
Wounded Vietcong (Philip Jones Griffiths)
 459
'wrapped islands' (Christo) 444
Wren, Sir Christopher 265
Wright, John Michael 247
Wright, Joseph, of Derby
 The Old Man and Death 316
Wright, Frank Lloyd 383, 518, 523, 524
written evidence 9
Wundt, Wilhelm 398

X
X-ray photography 369
Xenakis, Iannis 444
Xenocrates of Sikyon on Greek
 art 62
Xerox art 445

Y
Yáñez, Fernando (Yáñez de la Almedina)
 230
Yellow and Black Cells with Conduit (Peter
 Halley) *506*, 524–5
Yenn, John 265
Yonker Ramp and his Sweetheart (*Young
 Man and Woman in an Inn*) (Frans Hals)
 239, *244*
York Minster stained glass
 108, *109*, 110, 111, *116*
 chapterhouse window *117*
Young Englishman (*Portrait of a Man*)
 (Titian) *217*
Young Man among Roses (Nicholas Hilliard)
 248
Young Man and Woman in an Inn (*Yonker
 Ramp and his Sweetheart*) (Frans Hals)
 239, *244*
Young Woman with a Water Jug (Johannes
 Vermeer) *245*
Yzeure, church of
 early stained glass 108

Z
Zackenstil (German jagged style) 124
Zamoyska, Sophia, Countess Czartoryska
 tomb in S. Croce, Florence
 341
Zampieri, Domenico—*see* Domenichino
Zeitgeist 496
Zero Group 444
Zervos, Christian 514
Zeus depicted 33
 sculpted by Phidias 12
Zeuxis 61
Zimmermann, Dominikus, and
 Zimmermann, Johann Baptist 200
 Die Wieskirche 209
Zoffany, Johann
 *The Academicians of the Royal
 Academy* 253
 *Charles Towneley's Library in
 Park Street 289*
Zoilos, Iulius
 commemorative frieze *47*
Zola, Émile 309, 402
 The Masterpiece 401
Zuccaro, Federico 230, 291, 396
Zurbarán, Fransisco de 232,
 233, 294
 *Christ and the Virgin in the
 House at Nazareth* 232,
 234, *234*
 *S. Peter Nolasco's Vision of the Crucified
 S. Peter* 232, 234, *234*
the Zwinger, Dresden 282, *282*